THE MUSEUM OF INNOCENCE

Orhan Pamuk, winner of the Nobel Prize in Literature 2006, is the author of many books, including *The White Castle* and *The Black Book*. In 2003 he won the International IMPAC Award for *My Name Is Red*, and in 2004 Faber published the translation of his novel *Snow*, which Margaret Atwood called 'essential reading for our times'. *Istanbul*, a memoir of his life in the city, was shortlisted for the BBC Four Samuel Johnson Prize and described by Katie Hickman in the *New Statesman* as 'an extraordinary and transcendentally beautiful book'. Orhan Pamuk lives in Istanbul.

In addition to her work with Orhan Pamuk on *The Museum of Innocence*, Maureen Freely has translated *Snow*, *Istanbul*, *The Black Book* and *Other Colours*. Her work has been praised as 'fluent and lucid' (John Updike in the *New Yorker*), 'seamless' (*Observer*) and 'so fluent that you have to keep reminding yourself that it is a translation at all' (*Independent*).

The Museum of Innocence

Orhan Pamuk

Translated from the Turkish by Maureen Freely

faber and faber

First published in the UK in 2009
by Faber and Faber Limited
Bloomsbury House, 74–77 Great Russell Street, London WC1B 3DA
Published in the United States by Alfred A. Knopf, a division of Random House, Inc.,
New York
This paperback edition first published in 2010

Originally published in Turkey as *Masumiyet Müzesi* by Iletişim Yayınları,
Istanbul, in 2008. Original Turkish text copyright © 2008 Orhan Pamuk

Printed in England by CPI Bookmarque, Croydon

A CIP record for this book
is available from the British Library

ISBN 978-0-571-23702-9

2 4 6 8 10 9 7 5 3 1

To Rüya

These were innocent people, so innocent that they thought poverty a crime that wealth would allow them to forget.

—*from the notebooks of Celâl Salik*

If a man could pass thro' Paradise in a Dream, and have a flower presented to him as a pledge that his Soul had really been there, and found that flower in his hand when he awoke—Aye? and what then?

—*from the notebooks of Samuel Taylor Coleridge*

First I surveyed the little trinkets on the table, her lotions and her perfumes. I picked them up and examined them one by one. I turned her little watch over in my hand. Then I looked at her wardrobe. All those dresses and accessories piled one on top of the other. These things that every woman used to complete herself—they induced in me a painful and desperate loneliness; I felt myself hers, I longed to be hers.

—*from the notebooks of Ahmet Hamdi Tanpinar*

CONTENTS

CONTENTS

CONTENTS

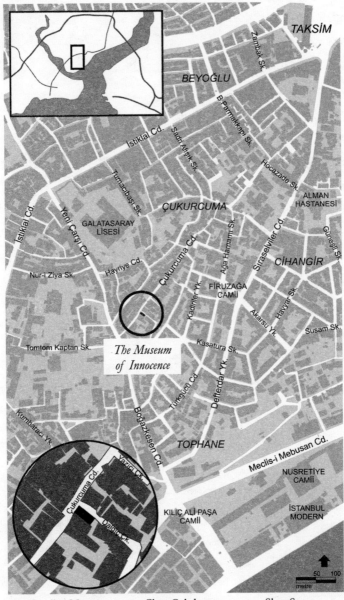

Camii = Mosque	Çk = Cul-de-sac	Sk = Street
Cd = Avenue	Lisesi = Lycee	Yk = Hill

ORHAN PAMUK expresses his gratitude to Sila Okur for ensuring fidelity to the Turkish text; to his editor and friend George Andreou, for his meticulous editing of the translation; and to Kiran Desai for generously giving her time to read the final text, and for her invaluable suggestions and ideas.

The Museum
of Innocence

I

The Happiest Moment of My Life

IT WAS the happiest moment of my life, though I didn't know it. Had I known, had I cherished this gift, would everything have turned out differently? Yes, if I had recognized this instant of perfect happiness, I would have held it fast and never let it slip away. It took a few seconds, perhaps, for that luminous state to enfold me, suffusing me with the deepest peace, but it seemed to last hours, even years. In that moment, on the afternoon of Monday, May 26, 1975, at about a quarter to three, just as we felt ourselves to be beyond sin and guilt so too did the world seem to have been released from gravity and time. Kissing Füsun's shoulder, already moist from the heat of our lovemaking, I gently entered her from behind, and as I softly bit her ear, her earring must have come free and, for all we knew, hovered in midair before falling of its own accord. Our bliss was so profound that we went on kissing, heedless of the fall of the earring, whose shape I had not even noticed.

Outside the sky was shimmering as it does only in Istanbul in the spring. In the streets people still in their winter clothes were perspiring, but inside shops and buildings, and under the linden and chestnut trees, it was still cool. We felt the same coolness rising from the musty mattress on which we were making love, the way children play, happily forgetting everything else. A breeze wafted in through the balcony window, tinged with the sea and linden leaves; it lifted the tulle curtains, and

they billowed down again in slow motion, chilling our naked bodies. From the bed of the back bedroom of the second-floor apartment, we could see a group of boys playing football in the garden below, swearing furiously in the May heat, and as it dawned on us that we were enacting, word for word, exactly those indecencies, we stopped making love to look into each other's eyes and smile. But so great was our elation that the joke life had sent us from the back garden was forgotten as quickly as the earring.

When we met the next day, Füsun told me she had lost one of her earrings. Actually, not long after she had left the preceding afternoon, I'd spotted it nestled in the blue sheets, her initial dangling at its tip, and I was about to put it aside when, by a strange compulsion, I slipped it into my pocket. So now I said, "I have it here, darling," as I reached into the right-hand pocket of my jacket hanging on the back of a chair. "Oh, it's gone!" For a moment, I glimpsed a bad omen, a hint of malign fate, but then I remembered that I'd put on a different jacket that morning, because of the warm weather. "It must be in the pocket of my other jacket."

"Please bring it tomorrow. Don't forget," Füsun said, her eyes widening. "It is very dear to me."

"All right."

Füsun was eighteen, a poor distant relation, and before running into her a month ago, I had all but forgotten she existed. I was thirty and about to become engaged to Sibel, who, according to everyone, was the perfect match.

The Şanzelize Boutique

THE SERIES of events and coincidences that were to change my entire life had begun a month before on April 27, 1975, when Sibel happened to spot a handbag designed by the famous Jenny Colon in a shop window as we were walking along Valikonağı Avenue, enjoying the cool spring evening. Our formal engagement was not far off; we were tipsy and in high spirits. We'd just been to Fuaye, a posh new restaurant in Nişantaşı; over supper with my parents, we had discussed at length the preparations for the engagement party, which was scheduled for the middle of June so that Nurcihan, Sibel's friend since her days at Notre Dame de Sion Lycée and then her years in Paris, could come from France to attend. Sibel had long ago arranged for her engagement dress to be made by Silky İsmet, then the most expensive and sought-after dressmaker in Istanbul, and that evening Sibel and my mother discussed how they might sew on the pearls my mother had given her for the dress. It was my future father-in-law's express wish that his only daughter's engagement party be as extravagant as a wedding, and my mother was only too delighted to help fulfill that wish as best as she could. As for my father, he was charmed enough by the prospect of a daughter-in-law who had "studied at the Sorbonne," as was said in those days among the Istanbul bourgeoisie of any girl who had gone to Paris for any kind of study.

It was as I walked Sibel home that evening, my arm wrapped lovingly around her sturdy shoulders, noting to myself with pride how happy and lucky I was, that Sibel said, "Oh what a beautiful bag!" Though my mind was clouded by the wine, I took note of the handbag and the name of the shop, and at noon the next day I went back. In fact I had never been one of those suave, chivalrous playboys always looking for the least excuse to buy women presents or send them flowers, though perhaps I longed to be one. In those days, bored Westernized housewives of the affluent neighborhoods like Şişli, Nişantaşı, and Bebek did not open "art galleries" but boutiques, and stocked them with trinkets and whole ensembles smuggled in luggage from Paris and Milan, or copies of "the latest" dresses featured in imported magazines like *Elle* and *Vogue,* selling these goods at ridiculously inflated prices to other rich housewives who were as bored as they were. As she would remind me when I tracked her down many years later, Şenay Hanım, then proprietress of the Şanzelize (its name a transliteration of the legendary Parisian avenue), was, like Füsun, a very distant relation on my mother's side. The fact that she gave me the shop sign that had once hung on the door as well as any other object connected to Füsun without once questioning the reasons for my excessive interest in the since-shuttered establishment led me to understand that some of the odder details of our story were known to her, and indeed had had a much wider circulation than I had assumed.

When I walked into the Şanzelize at around half past twelve the next day, the small bronze double-knobbed camel bell jingled two notes that can still make my heart pound. It was a warm spring day, and inside the shop it was cool and dark. At first I thought there was no one there, my eyes still adjusting to

the gloom after the noonday sunlight. Then I felt my heart in my throat, with the force of an immense wave about to crash against the shore.

"I'd like to buy the handbag on the mannequin in the window," I managed to say, staggered at the sight of her.

"Do you mean the cream-colored Jenny Colon?"

When we came eye to eye, I immediately remembered her.

"The handbag on the mannequin in the window," I repeated dreamily.

"Oh, right," she said and walked over to the window. In a flash she had slipped off her yellow high-heeled pump, extending her bare foot, whose nails she'd carefully painted red, onto the floor of the display area, stretching her arm toward the mannequin. My eyes traveled from her empty shoe over her long bare legs. It wasn't even May yet, and they were already tanned.

Their length made her lacy yellow skirt seem even shorter. Hooking the bag, she returned to the counter and with her long, dexterous fingers she removed the balls of crumpled cream-colored tissue paper, showing me the inside of the zippered pocket, the two smaller pockets (both empty) as well as the secret compartment, from which she produced a card inscribed JENNY COLON, her whole demeanor suggesting mystery and seriousness, as if she were showing me something very personal.

"Hello, Füsun. You're all grown up! Perhaps you don't recognize me."

"Not at all, Cousin Kemal, I recognized you right away, but when I saw you did not recognize me, I thought it would be better not to disturb you."

There was a silence. I looked again into one of the pockets she had just pointed to inside the bag. Her beauty, or her skirt,

which was in fact too short, or something else altogether, had unsettled me, and I couldn't act naturally.

"Well . . . what are you up to these days?"

"I'm studying for my university entrance exams. And I come here every day, too. Here in the shop, I'm meeting lots of new people."

"That's wonderful. So tell me, how much is this handbag?"

Furrowing her brow, she peered at the handwritten price tag on the bottom: "One thousand five hundred lira." (At the time this would have been six months' pay for a junior civil servant.) "But I am sure Şenay Hanım would want to offer you a special price. She's gone home for lunch and must be napping now, so I can't phone her. But if you could come by this evening . . ."

"It's not important," I said, and taking out my wallet—a clumsy gesture that, later, at our secret meeting place, Füsun would often mimic—I counted out the damp bills. Füsun wrapped the bag in paper, carefully but with evident inexperience, and then put it into a plastic bag. Throughout this silence she knew that I was admiring her honey-hued arms, and her quick, elegant gestures. When she politely handed me the shopping bag, I thanked her. "Please give my respects to Aunt Nesibe and your father," I said (having failed to remember Tarık Bey's name in time). For a moment I paused: My ghost had left my body and now, in some corner of heaven, was embracing Füsun and kissing her. I made quickly for the door. What an absurd daydream, especially since Füsun wasn't as beautiful as all that. The bell on the door jingled, and I heard a canary warbling. I went out into the street, glad to feel the heat. I was pleased with my purchase; I loved Sibel very much. I decided to forget this shop, and Füsun.

Distant Relations

NEVERTHELESS, AT supper that evening I mentioned to my
mother that I had run into our distant relation Füsun while
buying a handbag for Sibel.

"Oh, yes, Nesibe's daughter is working in that shop of
Şenay's up there, and what a shame it is!" said my mother.
"They don't even visit us for the holidays anymore. That beauty
contest put them in such an awkward position. I walk past
that shop every day, but I can't even bring myself to go inside
and say hello to the poor girl—nor in fact does it even cross my
mind. But when she was little, you know, I was very fond of
her. When Nesibe came to sew, she'd come too sometimes. I'd
get your toys out of the cupboard and while her mother sewed
she'd play with them quietly. Nesibe's mother, Aunt Mihriver,
may she rest in peace—she was a wonderful person."

"Exactly how are we related?"

Because my father was watching television and paying us
no mind, my mother launched into an elaborate story about
her father, who was born the same year as Atatürk and later
attended Şemsi Efendi School, also just like the founder of
the Republic, as you can see in this school photograph I found
many years later. It seems that long before he (Ethem Kemal,
my grandfather) married my grandmother, he had made a very
hasty first marriage at the age of twenty-three. Füsun's great-
grandmother, who was of Bosnian extraction, had died during

the Balkan Wars, during the evacuation of Edirne. Though the unfortunate woman had not given Ethem Kemal children, she already had a daughter named Mihriver by a poor sheikh, whom she'd married when she was "still a child." So Aunt Mihriver (Füsun's grandmother, who had been brought up by a very odd assortment of people) and her daughter Aunt Nesibe (Füsun's mother) were not strictly speaking relatives; they were more like in-laws, and though my mother had been emphasizing this for years, she had still directed us to call the women from this distant branch of the family "aunts." During their most recent holiday visits, my mother had given these impoverished relations (who lived in the backstreets of Teşvikiye) an unusually chilly reception that led to hurt feelings because two years earlier, Aunt Nesibe, without saying a word, had allowed her sixteen-year-old daughter, then a student at Nişantaşı Lycée for Girls, to enter a beauty contest; and on subsequently learning that Aunt Nesibe had in fact encouraged her daughter, even taking pride in this stunt that should have caused her to feel only shame, my mother had hardened her heart toward Aunt Nesibe, whom she had once so loved and protected.

For her part, Aunt Nesibe had always esteemed my mother, who was twenty years older, and who had been supportive of her when she was a young woman going from house to house in Istanbul's most affluent neighborhoods, in search of work as a seamstress.

"They were desperately poor," my mother said. And lest she exaggerate, she added, "Though they were hardly the only ones, my son—all of Turkey was poor in those days." At the time, my mother had recommended Aunt Nesibe to all her friends as "a very good person, and a very good seamstress,"

and once a year (sometimes twice) she herself would call her to our house to sew a dress for some party or wedding.

Because it was almost always during school hours, I wouldn't see her during these sewing visits. But in 1957, at the end of August, urgently needing a dress for a wedding, my mother had called Nesibe to our summer home in Suadiye. Retiring to the back room on the second floor, overlooking the sea, they set themselves up next to the window from which, peering through the fronds of the palm trees, they might see the rowboats and motorboats, and the boys jumping from the pier. Nesibe having unpacked her sewing box, with the view of Istanbul adorning its lid, they sat surrounded by her scissors, pins, measuring tape, thimbles, and swatches of material and lace, complaining of the heat, the mosquitoes, and the strain of sewing under such pressure, joking like sisters, and staying up half the night to slave away on my mother's Singer sewing machine. I remember Bekri the cook bringing one glass of lemonade after another into that room (the hot air thick with the dust of velvet), because Nesibe, pregnant at twenty, was prone to cravings; when we all sat down to lunch, my mother would tell the cook, half joking, that "whatever a pregnant woman desires, you must let her have, or else the child will turn out ugly!" and with that in mind, I remember looking at Nesibe's small bump with a certain interest. This must have been my first awareness of Füsun's existence, though no one knew yet whether she would be a girl or a boy.

"Nesibe didn't even inform her husband; she just lied about her daughter's age and entered her in that beauty contest," said my mother, fuming at the thought. "Thank God, she didn't win, so they were spared the public disgrace. If the school had gotten wind of it, they would have expelled the girl. . . . She

must have finished lycée by now. I don't expect that she'll be doing any further studies, but I'm not up-to-date, since they don't come to visit on holidays anymore. . . . Can there be anyone in this country who doesn't know what kind of girl, what kind of woman, enters a beauty contest? How did she behave with you?"

It was my mother's way of suggesting that Füsun had begun to sleep with men. I'd heard the same from my Nişantaşı playboy friends when Füsun appeared in a photograph with the other finalists in the newspaper *Milliyet*, but as I found the whole thing embarrassing I tried to show no interest. After we had both fallen silent, my mother wagged her finger at me ominously and said, "Be careful! You're about to become engaged to a very special, very charming, very lovely girl! Why don't you show me this handbag you've bought her. Mümtaz!"—this was my father's name—"Look—Kemal's bought Sibel a handbag!"

"Really?" said my father, his face expressing such contentment as to suggest he had seen and approved the bag as a sign of how happy his son and his sweetheart were, but not once did he take his eyes off the screen.

4

Love at the Office

MY FATHER was looking at a rather flashy commercial that my
friend Zaim had made for Meltem, "Turkey's first domestic
fruit soda," now sold all over the country. I watched it carefully
and liked it. Zaim's father, like mine, had amassed a fortune
in the past ten years, and now Zaim was using that money to
pursue ventures of his own. I gave him occasional advice, so I
was keen to see him succeed.

Once I'd graduated from business school in America and
completed my military service, my father had demanded I
follow in my brother's footsteps and become a manager in his
business, which was growing by leaps and bounds, and so when
I was still very young he'd appointed me the general manager
of Satsat, his Harbiye-based distribution and export firm.
Satsat had an exaggerated operating budget and made hefty
profits, thanks not to me but to various accounting tricks by
which the profits from his other factories and businesses were
funneled into Satsat (which might be translated into English as
"Sellsell"). I spent my days mastering the finer points of the
business from worn-out accountants twenty or thirty years my
senior and large-breasted lady clerks as old as my mother; and
mindful that I would not have been in charge but for being the
owner's son, I tried to show some humility.

At quitting time, while buses and streetcars as old as Satsat's
now departed clerks rumbled down the avenue, shaking the

building to its foundations, Sibel, my intended, would come to visit, and we would make love in the general manager's office. For all her modern outlook and the feminist notions she had brought back from Europe, Sibel's ideas about secretaries were no different from my mother's: "Let's not make love here. It makes me feel like a secretary!" she'd say sometimes. But as we proceeded to the leather divan in that office, the real reason for her reserve—that Turkish girls, in those days, were afraid of sex before marriage—would become obvious.

Little by little sophisticated girls from wealthy Westernized families who had spent time in Europe were beginning to break this taboo and sleep with their boyfriends before marriage. Sibel, who occasionally boasted of being one of those "brave" girls, had first slept with me eleven months earlier. But she judged this arrangement to have gone on long enough, and thought it was about time we married.

As I sit down so many years later and devote myself heart and soul to the telling of my story, though, I do not want to exaggerate my fiancée's daring or to make light of the sexual oppression of women, because it was only when Sibel saw that my "intentions were serious," when she believed in me as "someone who could be trusted"—in other words, when she was absolutely sure that there would in the end be a wedding—that she gave herself to me. Believing myself a decent and responsible person, I had every intention of marrying her; but even if this hadn't been my wish, there was no question of my having a choice now that she had "given me her virginity." Before long, this heavy responsibility cast a shadow over the common ground between us of which we were so proud—the illusion of being "free and modern" (though of course we would never use such words for ourselves) on account

of having made love before marriage, and in a way this, too, brought us closer.

A similar shadow fell over us each time Sibel anxiously hinted that we should marry at once, but there were times, too, when Sibel and I would be very happy making love in the office, and as I wrapped my arms around her in the dark, the noise of traffic and rumbling buses rising up from Halaskârgazi Avenue, I would tell myself how lucky I was, how content I would be for the rest of my life. Once, after our exertions, as I was stubbing out my cigarette in this ashtray bearing the Satsat logo, Sibel, sitting half naked on my secretary Zeynep Hanım's chair, started rattling the typewriter, and giggling at her best impression of the dumb blonde who featured so prominently in the jokes and humor magazines of the time.

5

Fuaye

NOW, YEARS later, and after a long search, I am exhibiting here an illustrated menu, an advertisement, a matchbook, and a napkin from Fuaye, one of the European-style (imitation French) restaurants most loved by the tiny circle of wealthy people who lived in neighborhoods like Beyoğlu, Şişli, and Nişantaşı (were we to affect the snide tone of gossip columnists, we might call such folk "society"). Because they wished to give their customers a subtler illusion of being in a European city, they shied away from pompous Western names like the Ambassador, the Majestic, or the Royal, preferring others like Kulis (backstage), Merdiven (stairway), and Fuaye (lobby), names that reminded one of being on the edge of Europe, in Istanbul. The next generation of nouveaux riches would prefer gaudy restaurants that offered the same food their grandmothers cooked, combining tradition and ostentation with names such as Hanedan (dynasty), Hünkar (sovereign), Pasha, Vezir (vizier), and Sultan—and under the pressure of their pretensions Fuaye sank into oblivion.

Over dinner at Fuaye on the evening of the day I had bought the handbag, I asked Sibel, "Wouldn't it be better if from now on we met in that flat my mother has in the Merhamet Apartments? It looks out over such a pretty garden."

"Are you expecting some delay in moving to our own house once we've married?" she asked.

15

"No, darling, I meant nothing of the sort."

"I don't want any more skulking about in secret apartments as if I were your mistress."

"You're right."

"Where did this idea come from, to meet in that apartment?"

"Never mind," I said. I looked at the cheerful crowd around me as I brought out the handbag, still hidden in its plastic bag.

"What's this?" asked Sibel, sensing a present.

"A surprise! Open and see."

"Is it really?" As she opened the plastic bag and saw the handbag, the childish joy on her face gave way first to a quizzical look, and then to a disappointment that she tried to hide.

"Do you remember?" I ventured. "When I was walking you home last night, you saw it in the window of that shop and admired it."

"Oh, yes. How thoughtful of you."

"I'm glad you like it. It will look so elegant on you at our engagement party."

"I hate to say it, but the handbag I'm taking to our engagement party was chosen a long time ago," said Sibel. "Oh, don't look so downcast! It was so thoughtful of you, to go to all the effort of buying this lovely present for me. . . . All right then, just so you don't think I'm being unkind to you, I could never put this handbag on my arm at our engagement party, because this handbag is a fake!"

"What?"

"This is not a genuine Jenny Colon, my dear Kemal. It is an imitation."

"How can you tell?"

"Just by looking at it, dear. See the way the label is stitched to the leather? Now look at the stitching on this real Jenny Colon I

bought in Paris. It's not for nothing that it's an exclusive brand in France and all over the world. For one thing, she would never use such cheap thread."

There was a moment, as I looked at the genuine stitching, when I asked myself why my future bride was taking such a triumphal tone. Sibel was the daughter of a retired ambassador who'd long ago sold off the last of his pasha grandfather's land and was now penniless; technically this made her the daughter of a civil servant, and this status sometimes caused her to feel uneasy and insecure. Whenever her anxieties overtook her, she would talk about her paternal grandmother, who had played the piano, or about her paternal grandfather, who had fought in the War of Independence, or she'd tell me how close her maternal grandfather had been to Sultan Abdülhamit; but her timidity moved me, and I loved her all the more for it. With the expansion of the textiles and exports trade during the early 1970s, and the consequent tripling of Istanbul's population, the price of land had skyrocketed throughout the city and most particularly in neighborhoods like ours. Although, carried on this wave, my father's fortune had grown extravagantly over the past decade, increasing fivefold, our surname (Basmacı, "cloth printer") left no doubt that we owed our wealth to three generations of cloth manufacture. It made me uneasy to be troubled by the "fake" handbag despite three generations of cumulative progress.

When she saw my spirits sink, Sibel caressed my hand. "How much did you pay for the bag?"

"Fifteen hundred lira," I said. "If you don't want it, I can exchange it tomorrow."

"Don't exchange it, darling, ask for your money back,

because they really cheated you."

"The owner of the shop is Şenay Hanım, and we're distantly related!" I said, raising my eyebrows in dismay.

Sibel took back the bag, whose interiors I had been quietly exploring. "You're so knowledgeable, darling, so clever and cultured," she said, with a tender smile, "but you have absolutely no idea how easily women can trick you."

6

Füsun's Tears

AT NOON the next day I went back to the Şanzelize Boutique carrying the same plastic bag. The bell rang as I walked in, but once again the shop was so gloomy that at first I thought no one was there. In the strange silence of the ill-lit shop the canary sang chik, chik, chik. Then I made out Füsun's shadow through a screen and between the leaves of a huge vase of cyclamens. She was waiting on a fat lady who was trying on an outfit in the fitting room. This time she was wearing a charming and flattering blouse, a print of hyacinths intertwined with leaves and wildflowers. When she saw me she smiled sweetly.

"You seem busy," I said, indicating the fitting room with my eyes.

"We're just about finished," she said, as if to imply she and her customer were at this point just talking idly.

My eyes flitted from the canary fluttering up and down in its cage, a pile of fashion magazines in the corner, and the assortment of accessories imported from Europe, and I couldn't fix my attention on anything. As much as I wanted to dismiss the feeling as ordinary, I could not deny the startling truth that when looking at Füsun, I saw someone familiar, someone I felt I knew intimately. She resembled me. That same sort of hair that grew curly and dark in childhood only to straighten as I grew older. Now it was a shade of blond that, like her clear complexion, was complemented by her printed blouse. I felt I could easily

put myself in her place, could understand her deeply. A painful memory came to me: my friends, referring to her as "something out of *Playboy*." Could she have slept with them? "Return the handbag, take your money and run," I told myself. "You're about to become engaged to a wonderful girl." I turned to look outside, in the direction of Nişantaşı Square, but soon Füsun's reflection appeared ghostlike in the smoky glass.

After the woman in the fitting room had huffed and puffed her way out of a skirt and left without buying anything, Füsun folded up the discarded items and put them back where they belonged. "I saw you walking down the street yesterday evening," she said, turning up her beautiful lips. She was wearing a light pink lipstick, sold under the brand name Misslyn, and though a common Turkish product, on her it looked exotic and alluring.

"When did you see me?" I asked.

"Early in the evening. You were with Sibel Hanım. I was walking down the sidewalk on the other side of the street. Were you going out to eat?"

"Yes."

"You make a handsome couple!" she said, in the way that the elderly do when taking pleasure at the sight of happy young people.

I did not ask her where she knew Sibel from. "There's a small favor we'd like to ask of you." As I took out the bag, I felt both shame and panic. "We'd like to return this bag."

"Certainly. I'd be happy to exchange it for you. You might like these chic new gloves and we have this hat, which has just arrived from Paris. Sibel Hanım didn't like the bag?"

"I'd prefer not to exchange it," I said shamefacedly. "I'd like to ask for my money back."

I saw shock on her face, even a bit of fear. "Why?" she asked.

"Apparently this bag is not a genuine Jenny Colon," I whispered. "It seems that it's a fake."

"What?"

"I don't really understand these things," I said helplessly.

"Nothing like that ever happens here!" she said in a harsh voice. "Do you want your money back right now?"

"Yes!" I blurted out.

She looked deeply pained. Dear God, I thought, why hadn't I just disposed of this bag and told Sibel I'd gotten the money back? "Look, this has nothing to do with you or Şenay Hanım. We Turks, praise God, manage to make imitations of every European fashion," I said, struggling to smile. "For me—or should I have said for us—it's enough for a bag to fulfill its function, to look lovely in a woman's hand. It's not important what the brand is, or who made it, or if it's an original." But she, like me, didn't believe a word I was saying.

"No, I am going to give you your money back," she said in that same harsh voice. I looked down and remained silent, prepared to meet my fate, and ashamed of my brutishness.

As determined as she sounded, I sensed that Füsun could not do what she was supposed to do; there was something strange in the intensely embarrassing moment. She was looking at the till as if someone had put a spell on it, as if it were possessed by demons, so that she couldn't bring herself to touch it. When I saw her face redden and crinkle up, her eyes welling with tears, I panicked and drew two steps closer.

She began to cry softly. I have never worked out exactly how it happened, but I wrapped my arms around her and she leaned her head against my chest and wept. "Füsun, I'm so

sorry," I whispered. I caressed her soft hair and her forehead. "Please, just forget this ever happened. It's a fake handbag, that's all."

Like a child she took a deep breath, sobbed once or twice, and burst into tears again. To touch her body and her lovely long arms, to feel her breasts pressed against my chest, to hold her like that, if only for a moment, made my head spin: Perhaps it was because I was trying to repress the desire, more intense each time I touched her, that I conjured up this illusion that we had known each other for years, that we were already very close. This was my sweet, inconsolable, grief-stricken, beautiful sister! For a moment—and perhaps because I knew we were related, however slightly—her body, with its long limbs, fine bones, and fragile shoulders, reminded me of my own. Had I been a girl, had I been twelve years younger, this is what my body would be like. "There's nothing to be upset about," I said as I caressed the blond hair.

"I can't open the till to give you back your money," she explained. "Because when Şenay Hanım goes home for lunch, she locks it and takes the key with her, I'm ashamed to say." Leaning her head against my chest, she began to cry again, as I continued my careful and compassionate caresses of her hair. "I just work here to meet people and pass the time. It's not for the money," she sobbed.

"Working for money is nothing to be embarrassed about," I said stupidly, heartlessly.

"Yes," she said, like a dejected child. "My father is a retired teacher. . . . I turned eighteen two weeks ago, and I didn't want to be a burden."

Fearful of the sexual beast now threatening to rear its head, I took my hand from her hair. She understood at once and collected herself; we both stepped back.

"Please don't tell anyone I cried," she said after she had rubbed her eyes.

"It's a promise," I said. "A solemn promise between friends, Füsun. We can trust each other with our secrets. . . ."

I saw her smile. "Let me leave the handbag here," I said. "I can come back for the money later."

"Leave the bag if you wish, but you had better not come back here for the money. Şenay Hanım will insist that it isn't a fake and you'll come to regret you ever suggested otherwise."

"Then let's exchange it for something," I said.

"I can no longer do that," she said, sounding like a proud and tetchy girl.

"No really, it's not important," I offered.

"But it is to me," she said firmly. "When she comes back to the shop, I'll get the money for the bag from Şenay Hanım."

"I don't want that woman causing you any more upset," I replied.

"Don't worry, I've just worked out how to do this," she said with the faintest of smiles. "I'm going to say that Sibel Hanım already has exactly the same bag, and that's why she's returning it. Is that all right?"

"Wonderful idea," I said. "But why don't I say the same thing to Şenay Hanım?"

"No, don't you say anything to her," Füsun said emphatically. "Because she'll only try to trick you, to extract personal information from you. Don't come to the shop at all. I can leave the money with Aunt Vecihe."

"Oh please, don't involve my mother in this. She's even nosier."

"Then where shall I leave your money?" Füsun asked, raising her eyebrows.

"At the Merhamet Apartments, 131 Teşvikiye Avenue, where my mother has a flat," I said. "Before I went to America I used it as my hideout—I'd go there to study and listen to music. It's a delightful place that looks out over a garden in the back. . . . I still go there every lunchtime between two and four and shut myself in there to catch up on paperwork."

"Of course. I can bring your money there. What's the apartment number?"

"Four," I whispered. I could barely get out the next three words, which seemed to die in my throat. "Second floor. Good-bye."

My heart had figured it all out and it was beating madly. Before rushing outside, I gathered up all my strength and, pretending nothing unusual had happened, I gave her one last look. Back in the street, my shame and guilt mixed with so many images of bliss amid the unseasonable warmth of that May afternoon that the very sidewalks of Nişantaşı seemed aglow with a mysterious yellow. My feet chose the shaded path, taking me under the eaves of the buildings and the blue-and-white-striped awnings of the shop windows, and when in one of those windows I saw a yellow jug I felt compelled to go inside and buy it. Unlike any other object acquired so casually, this yellow jug drew no comment from anyone during the twenty years it sat on the table where my mother and father, and later, my mother and I, ate our meals. Every time I touched the handle of that jug, I would remember those days when I first felt the misery that was to turn me in on myself, leaving my mother to watch me in silence at supper, her eyes filled half with sadness, half with reproach.

Arriving home, I greeted my mother with a kiss; though pleased to see me early in the afternoon, she was nevertheless

surprised. I told her that I had bought the jug on a whim, adding, "Could you give me the key to the Merhamet Apartments? Sometimes the office gets so noisy I just can't concentrate. I was wondering if I might have better luck at the apartment. It always worked when I was young."

My mother said, "It must be an inch thick with dust," but she went straight to her room to fetch me the key to the building, which was held together with the key to the apartment by a red ribbon. "Do you remember that Kütahya vase with the red flowers?" she asked as she handed me the keys. "I can't find it anywhere in the house, so can you check to see if I took it over there? And don't work so hard. . . . Your father spent his whole life working hard so that you young ones could have some fun in life. You deserve to be happy. Take Sibel out, enjoy the spring air." Then, pressing the keys into my hand, she gave me a strange look and said, "Be careful!" It was that look my mother would give us when we were children, to warn us that life held unsuspected traps that were far deeper and more treacherous than, for instance, any consequence of failing to take proper care of a key.

The Merhamet Apartments

MY MOTHER had bought the flat in the Merhamet Apartments twenty years earlier, partly as an investment, and partly as a place where she could retire occasionally for some peace and quiet; but before long she began to use it as a depot for old furniture she deemed to have gone out of fashion and new acquisitions that she immediately found tiresome. As a boy I had liked the back garden, where neighbor- hood children used to play football in the shade of the giant trees, and I had always loved the story my mother enjoyed telling about the name.

After Atatürk instructed the Turkish people to take surnames for themselves in 1934, it became fashionable to attach one's new name to one's newly constructed apartment building. Since in those days there was no consistent system for street names and numbers, and large, wealthy families tended to live collectively under one roof, just as they had done in the days of the Ottoman Empire, it made sense for the sake of navigating the city that these new apartment buildings be known by the name of the owners. (Many of the rich families I shall mention own eponymous apartment buildings.) Another aspirational fashion was for people to name buildings after high-minded principles; but my mother would say that those who gave their buildings names like Hürriyet (freedom), İnayet (benevolence), or Fazilet (charity) were generally the ones who had spent their entire lives making a mockery of those

same virtues. The Merhamet (mercy) Apartments had been built by a rich old man who had controlled the black market in sugar during the First World War and later felt compelled to philanthropy. His two sons (the daughter of one of them was my classmate in primary school), upon discovering that their father planned to turn the apartment house over to a charity, distributing any income it generated to the poor, had their father declared incompetent and put him into a home for the indigent, whereupon they took possession of the building, but without bothering to change the name that I had found so peculiar as a child.

On the following day, Wednesday, April 30, 1975, I sat in the Merhamet Apartments between 2 and 4 p.m., waiting for Füsun, who never came. I was a little heartbroken and confused; returning to the office, I felt troubled. The next day I went back to the apartment, as if to temper my disquiet, but again Füsun didn't come. Sitting in those airless rooms, surrounded by my mother's old vases and dresses and dusty discarded furniture, going one by one through my father's amateurish snapshots, I recalled moments from my childhood and youth that I hadn't even realized I'd forgotten, and it seemed as if these artifacts had the power to calm my nerves. The next day, while eating lunch at Hacı Arif's Restaurant in Beyoğlu with Abdülkerim, the Kayseri dealer of Satsat (and a friend from my army days), I recalled with shame that I had spent two consecutive afternoons waiting for Füsun in an empty apartment. I was so embarrassed I decided to forget about her, the fake handbag, and everything else. But twenty minutes later, as I glanced at my watch, it occurred to me that Füsun might be walking toward the Merhamet Apartments at that very moment with the refund for the handbag; making

up a lie for Abdülkerim, I wolfed down my food and rushed off.

Twenty minutes after I got there, Füsun rang the bell. Or rather, the person who could only be Füsun rang the bell. As I ran to the door I remembered that the previous night I had opened the door to her in a dream.

In her hand was an umbrella. Her hair was dripping wet. She was wearing a yellow pointille dress.

"Well, well, well, I thought you'd forgotten all about me. Come on in."

"I don't want to disturb you. Let me just give you the money and go." In her hand was a worn envelope on which were imprinted the words "Outstanding Achievement Course," but I didn't take it. Taking hold of her shoulder, I pulled her inside and shut the door.

"It's raining hard," I said, although I'd not noticed the rain myself. "Sit for a while. There's no reason why you should rush out into the rain and get wet again so soon. I'm making some tea. At least warm yourself up." I headed for the kitchen.

When I returned, Füsun was looking over my mother's old furniture, her antiques, dusty clocks, hatboxes, and accessories. To make her feel more at home, and to encourage conversation, I told her how my mother had bought all these things on impulse from the most fashionable shops of Beyoğlu and Nişantaşı, pashas' mansions whose furnishings were being sold off, Bosphorus *yalı*s half destroyed by fire, antique dealers, and even vacated dervish lodges, not to mention all the shops she visited on her European travels, but that after using them for a short while she brought them here and forgot all about them. At the same time I was opening trunks packed with clothes reeking of mothballs, and the tricycle that we'd both ridden as

children (my mother was in the habit of giving our old ones to poor relations), a chamber pot, and finally the Kütahya vase that my mother had asked me to find for her; then I showed her the hats, box by box.

A crystal sweet bowl reminded us of holiday feasts she had attended. When she'd arrive with her parents for their holiday visit, they'd be offered an assortment of sugar and almond candies, marzipan, sugar-covered coconut "lion bars," and *lokum,* or Turkish delight.

"Once when we came here for the Feast of the Sacrifice, I remember we went out for a ride in the car," said Füsun, her eyes shining.

I remembered that outing. "You were a child then," I said. "Now you have become a very beautiful and enchanting young woman."

"Thank you. I should leave now."

"You haven't even drunk your tea. And the rain hasn't stopped." I pulled her over to the balcony door, gently parting the tulle curtain. She looked out the window; in her eyes was the light that you see only in children arriving at a new place, or in young people still open to new influences, still curious about the world because they have not yet been scarred by life. For a moment I gazed longingly at her neck, the nape of her neck, and her fine complexion, which made her cheeks so beautiful, and the countless freckles on her skin, which were invisible from a distance (hadn't my grandmother had such freckles?). My hand, as if it was someone else's, reached out and took hold of the barrette in her hair. Painted on it were four sprigs of verbena.

"Your hair is very wet."

"Did you tell anyone that I cried in the shop?"

"No. But I'm very curious to know what made you cry."

"Why?"

"I've been spending a lot of time thinking about you," I said. "You're very beautiful, very different from anyone else. I remember so well what a lovely little dark-haired girl you were. But I never imagined you would turn into such a beauty."

She smiled the measured smile of well-mannered beauties accustomed to compliments, but at the same time she raised her eyebrows in suspicion. There was a silence. She took one step back.

"So what did Şenay Hanım say?" I asked, changing the subject. "Did she happen to acknowledge that the handbag was a fake anyway?"

"She was very annoyed when she realized you had demanded your money back, but she didn't want to make a drama about it. She told me just to forget the whole thing. She knew the bag was a fake, I guess. She doesn't know I'm here. I told her that you'd stopped by at lunchtime to collect the money. I really have to go now."

"But you haven't had your tea!"

I brought the tea in from the kitchen. I watched her as she blew lightly on the surface to cool it, before taking careful, hurried sips. I was caught between admiration and shame, tenderness and joy. . . . Again answering its own will, my hand reached out to caress her hair. I brought my face close to hers; seeing that she did not pull away, I gave her a quick delicate kiss on the side of her lips. She blushed. As she was holding the hot teacup with both hands, she couldn't defend herself. She was both angry and confused. I could see this, too.

"I like kissing," she said proudly. "But now, with you, of course it is out of the question."

"Have you done a lot of kissing?" I asked, in a clumsy imitation of a child.

"I've kissed, of course. But that's all."

With a look to suggest that men, alas, were all alike, she cast her eyes around the room one last time, eyeing the furniture, and the bed with blue sheets in the corner, which, with evil intentions, I had contrived to leave half made. She had sized up the situation, but I—perhaps out of shame—could think of no way to keep the game going.

When I'd arrived, I'd found sitting on a chest a fez of the type they make for tourists, and I'd placed it on a coffee table as a sort of ironic statement. Now I could see that when I'd gone to fetch the tea she'd left the money envelope propped against it. She saw me notice the envelope against the fez but still she said, "I left the money over there."

"You can't leave until you've finished your tea."

"It's getting late," she said, a little more assertively, but she didn't leave.

As we drank our tea, we chatted about our relatives, our childhood years, and our shared memories, and we spoke ill of no one. They had all been afraid of my mother, for whom her mother had a great deal of respect, but who, when Füsun was a child, had been so attentive to her; when her mother came to sew, my mother would lay out our toys for her—our windup animals, the dog and the chicken, which Füsun loved so much but was afraid of breaking. Every year, until the beauty contest, my mother had sent our chauffeur Çetin Efendi over to bring her a present on her birthday: There had been a kaleidoscope, for example, and she still had it. . . . If my mother sent her a dress, she would always get it a few sizes too big lest the girl outgrow it too quickly. So there had been a tartan skirt fastened

with a large safety pin that Füsun had been unable to wear for a whole year: She loved it so much that even later, when it was not in fashion, she'd worn it as a miniskirt. I told her that I had seen her in Nişantaşı once wearing that skirt. We changed the subject to avoid mentioning her fine waist and her beautiful legs. There was an uncle Süreyya who was not right in the head. Every time he came from Germany, he would pay ceremonious visits to all the branches of the family, now mostly scattered and out of touch, but thanks to him, they were all kept aware of what the others were doing.

"That time we came to visit you for the Feast of the Sacrifice and you and I went out in the car—Uncle Süreyya was in the house that day, too," said Füsun excitedly. She threw on her raincoat and she began to hunt for her umbrella. She couldn't find it, because on one of my trips to the kitchen I'd thrown it behind the mirrored wardrobe in the entrance hall.

"Do you remember where you left it?" I said as I helped her conduct a thorough search.

"I think I left it here," she said innocently, pointing at the mirrored wardrobe.

As we scoured the apartment, looking even in the most unlikely places, I asked her what she did in her "spare time"— as it was called in the celebrity magazines. The year before, she had not scored high enough on her university entrance exam to gain admission to the university course of study she had wanted. So now, whatever time she had left over from the Şanzelize Boutique, she spent on the Outstanding Achievement Course. There were only forty-five days left before this year's examination, so she was studying very hard.

"What course do you want to take?"

"I don't know," she said, a bit embarrassed. "What I'd like, actually, is to go to the conservatory to train as an actress."

"Those classes are good for nothing; they're all in it for profit, every last one of them," I said. "If you find you're struggling, especially with mathematics, why don't you come over, since I'm here working every afternoon? I can teach you quickly."

"Do you help other girls with mathematics?" she asked mockingly, raising her eyebrows in that way again.

"There are no other girls."

"Sibel Hanım comes to our shop. She's very beautiful, and very charming, too. When are you getting married?"

"The engagement party is in a month and a half. Will this umbrella suit you?" I said, offering her a parasol my mother had brought back from Nice. She said that of course she could not return to the shop with such an oddity. She wanted to leave now and was prepared to abandon her umbrella. "The rain has stopped," she said joyfully. As she opened the door, I panicked, thinking I might never see her again.

"Please, come again and we'll just drink tea," I said.

"Don't be angry, Kemal, but I don't want to come back. And you know I am not going to. Don't worry, I won't tell anyone you kissed me."

"What about the umbrella?"

"The umbrella belongs to Şenay Hanım but it can stay here," she said, giving me a kiss on the cheek that was hasty but not devoid of emotion.

8

Turkey's First Fruit Soda

HERE I am exhibiting the newspaper advertisements, the commercials, and the bottles of strawberry, peach, orange, and sour cherry flavors of Turkey's first domestic fruit soda, Meltem, in memory of our optimism and the happy-go-lucky spirit of the day. That evening Zaim was celebrating the launch of his new product with an extravagant party in his perfectly situated Ayaspaşa apartment which had a sweeping view of the Bosphorus. Our whole group would be together again. Sibel was happy to be among my rich friends—she enjoyed the yacht trips down the Bosphorus, the surprise birthday parties, and the nights at clubs, which would end with all of us piling into our cars to roam the streets of Istanbul—but she didn't like Zaim. She thought he was a show-off, too much a playboy and rather "coarse"; and his party tricks—like the "surprise" belly dancer at the end of the evening or his habit of lighting girls' cigarettes with a lighter bearing the Playboy logo—she found "banal." Sibel was even more disapproving of his dalliances with minor actresses and models (the latter a new phenomenon in Turkey, and still viewed with suspicion), whom he knew of course he would never marry, on account of their being known to have had sex; nor could she bear his misleading the nice girls he also took out with no intention of letting a relationship develop. That is why, when I phoned her to say that I was feeling unwell and unable to

attend the party, or to go out at all, I was surprised to find Sibel disappointed.

"They say the German model in the Meltem campaign is going to be there!" Sibel said.

"But I thought you felt that Zaim was a bad influence on me. . . ."

"If you can't even drag yourself to a Zaim party, you really must be sick. Now you have me worried. Shall I come over?"

"There's no need. My mother and Fatma Hanım are looking after me. I should be fine by tomorrow."

As I stretched out on my bed, fully clothed, I thought about Füsun; I decided once more to forget her, in fact never to see her again for as long as I lived.

9

F

THE NEXT day, May 3, 1975, Füsun arrived at the Merhamet Apartments at half past two in the afternoon and for the first time in her life she made love. I did not go to the apartment that day with the hope of seeing her. As I tell my story so many years later, I wonder how this could be true, but on that day it honestly hadn't occurred to me that she might appear. . . . I'd been thinking about what we'd talked about the day before, and our common childhood possessions, and my mother's antiques, the old clocks, the tricycle, the strange light in the dim apartment, the smell of dust and decay, and I longed to be alone, to gaze down at that back garden. . . . These must have been the thoughts that drew me there. True, I wanted to reflect on our meeting the day before, to relive it, to pick up Füsun's teacups and wash them, to tidy my mother's belongings and forget my transgression. While I was tidying up the room, I found a picture my father had taken from the back room, showing the bed, the window, and the garden, and it struck me how very little the place had changed in all those years. When the doorbell rang, my first thought was "Mother!"

"I came to collect my umbrella," said Füsun.

She wouldn't come in. "Why don't you come in?" I said. For a moment she hesitated. Perhaps deciding it would be rude to stand there at the door, she stepped inside. I shut the door

behind her. This is the fuchsia dress in which she appeared to mesmerizing effect that day, with its white buttons and the white belt with the large buckle, which made her waist seem all the more slender. In my youth, I like so many other men had found myself unnerved by girls I found beautiful and mysterious; my way of overcoming this unease was blunt candor, and though I thought I had outgrown this frankness and innocence, I was wrong: "Your umbrella is here," I said. Reaching behind the mirrored wardrobe, I didn't even ask myself why I hadn't retrieved it beforehand.

"How did it get back there?"

"Actually, I hid it there yesterday, so that you wouldn't leave right away."

For a moment she was not sure whether to smile or scowl. Taking her by the hand, I led her into the kitchen, on the pretext of making tea. It was dark in the kitchen and smelled of dust and damp. Everything speeded up once we were in there; unable to restrain ourselves, we began to kiss. The kisses got longer and more passionate. She gave so much of herself away with those kisses, wrapping her arms around my neck and shutting her eyes so tightly, that I sensed the prospect of "going all the way," as was said.

Since she was a virgin this could not happen, of course. Though as our kissing continued, there was a moment when it dawned on me that Füsun had perhaps made one of the most important decisions of her life in coming here. I quickly reminded myself, however, that such things only happened in foreign films. It seemed strange that a girl would suddenly choose to give herself to me here, of all places. So, perhaps, I reasoned, she wasn't actually a virgin at all. . . .

Kissing still, we left the kitchen and sat down on the edge

of the bed, and with scarcely any coyness, though never once looking each other in the eye, we took off most of our clothes and slipped under the blanket. The rough blanket was too heavy and scratched my skin, just as it had done when I was a child, so after a while I pulled it off, and we lay there, half naked. We were both perspiring, and for some reason this relaxed us. The sun filtering through the drawn curtains was a yellowish orange, and that made her moist skin look more tanned than it was. That Füsun could look at my body as I could hers, that she could gaze down at my nether regions so near her without panicking, that, far from finding it strange, she could even look at my sex with calm desire and something akin to tenderness— seemed proof enough that she had seen other men naked in other beds, on divans and car seats, and that made me jealous.

Soon the worried looks we were giving each other betrayed how daunted we both were by the difficult task we'd set ourselves. Füsun removed her earrings (one of which is now the first exhibit in our museum) and placed them on the side table. She did this as carefully as a nearsighted girl might remove her glasses before swimming, and once again I sensed her determination. In those days it was the style for young people to wear bracelets, necklaces, and rings bearing their names or initials but that afternoon I didn't notice if her earrings were of this kind. But once she had peeled off her outer garments item by item, she removed her little panties in the same purposeful manner and I saw the indisputable evidence of what she was prepared to do. In those days, girls who did not wish to "go all the way" were in the habit of keeping at least their panties on, as Western girls might when trying to sun themselves.

I kissed her shoulders, which smelled of almond, and with my tongue I felt her damp velvety skin, and when I saw that

even by May her breasts were one shade lighter than her robust Mediterranean skin, I shivered. If the lycée teachers studying this book in their class are now beginning to get nervous, they can advise the students to skip this page. If there are visitors to my museum who wish to know more, I would suggest that they kindly cast their eyes on the furnishings; the scene will be enough to make them understand that what I had to do I did first and foremost for Füsun, looking at me with such frightened and sorrowful eyes, and second for our common good, and only after all these imperatives were satisfied, just a little for my own pleasure. It was as if we were hoping to overcome an obstacle that life had thrown in our way. So as her eyes stared into mine and as I pressed against her uttering tender words, asking, Does it hurt, darling?, her silence did not alarm me. At the moment when we were closest I felt the fragility of her trembling so deeply (think of sunflowers quivering in a faint breeze) it was as if her pain became mine.

Seeing her eyes slip away to examine the lower regions of her body with a doctor's scrutiny, I understood that she wanted to experience this alone, and I wanted to finish what I was doing, to concentrate on my own satisfaction so that I could emerge from this arduous challenge feeling some relief. By now we both intuitively knew that to savor fully the pleasures that would bind us together meant to savor them in solitude as well; in that merciless embrace, greedy and unsparing, we were using each other for our own pleasure. There was something about the way Füsun pressed her fingers into my back; it made me think of that innocent, nearsighted girl learning how to swim in the sea, so fearful as she clung to her father who rushed out to save her when she feared she might drown. Ten days later, as she was embracing me with her eyes closed, I asked her what

film she might be watching in her mind. "I was watching a field of sunflowers," she told me.

The boys whose joyful shouts and curses and screeches would accompany our lovemaking in the days that followed were there too that first day, playing football in the old garden of Hayrettin Pasha's derelict mansion, cursing and screeching while in the house we made love. When they stopped their chatter for a while, a marvelous silence fell over the room, broken only by a few shy gasps from Füsun, and one or two happy moans that escaped me. In the distance we could hear the policeman's whistle in Nişantaşı Square, and car horns, and a hammer hitting a nail: A child kicked a can, a seagull mewed, a cup broke, the leaves of the plane trees rustled in the breeze.

We were lying in the silent room with our arms around each other, trying to banish thoughts of the bloody sheet, the discarded clothes, our still unaccustomed nakedness—all those primitive social rituals and embarrassing details that anthropologists so like to analyze and classify. Füsun for a while had cried silently. She had paid little attention to my words of consolation, only saying that she would remember this day till the end of her life, before beginning to cry again, and then falling silent once more.

Having become—with the passage of time—the anthropologist of my own experience, I have no wish to disparage those obsessive souls who bring back crockery, artifacts, and utensils from distant lands and put them on display for us, the better to understand the lives of others and our own. Nevertheless, I would caution against paying too much attention to the objects and relics of "first love," for these might distract the viewer from the depth of compassion and gratitude that now arose between us. So it is precisely to

illustrate the solicitude in the caresses that my eighteen-year-old lover bestowed upon my thirty-year-old skin as we lay quietly in this room in each other's arms, that I have chosen to exhibit this floral batiste handkerchief, which she had folded so carefully and put in her bag that day but never removed. Let this crystal inkwell and pen set belonging to my mother that Füsun toyed with that afternoon, noticing it on the table while she was smoking a cigarette, be a relic of the refinement and the fragile tenderness we felt for each other. Let this belt whose oversize buckles that I had seized and fastened with a masculine arrogance that I felt so guilty for afterwards bear witness to our melancholy as we covered our nakedness and cast our eyes about the filth of the world once again.

Before leaving, I told Füsun that if she wanted to win a university place, she was going to have to work very hard during this final month and a half.

"Are you worried I'll be a shopgirl forever?" she said with a smile.

"Of course not . . . But I'd like to tutor you for the exam. . . . We could work here. Which books are you using? Are you studying classical mathematics or modern?"

"At lycée we did classical. But we're doing both in my course. Because the answers are matched in the answer sheet. The whole thing makes my head spin."

We agreed to meet the next day in the same place to work on mathematics. As soon as she was gone I bought the books they used in the lycée and the course from a bookstore in Nişantaşı; once back in the office I leafed through them as I smoked a cigarette, and I saw that I would actually be able to help her. The thought that I might be able to tutor Füsun in mathematics lightened the emotional burden and left me with

a feeling of joy and a strange sort of pride. My neck, my nose, my skin, all ached with happiness, an exultation that I could not hide from myself. In one corner of my mind I kept thinking that Füsun and I would be meeting many more times in the Merhamet Apartments to make love. But I understood that the only way I could carry this off would be to act as if nothing out of the ordinary were happening.

City Lights and Happiness

THAT EVENING Sibel's old classmate Yeşim was getting engaged at the Pera Palas; everyone was going to be there, so I went. In her shiny silver dress, over which she had thrown a knitted shawl, Sibel seemed delighted, as if this party were a rehearsal for our own engagement, and she took an interest in every detail, mingling with all the guests, smiling constantly.

By the time Uncle Süreyya's son (whose name I always forget) introduced me to Inge, the German model who'd done the Meltem commercials, I had downed two glasses of *rakı* and felt relaxed.

"How are you finding Turkey?" I asked her in English.

"I've only been in Istanbul," said Inge. "I'm so surprised. I never imagined anything like this."

"What sort of thing *did* you imagine?"

For an awkward moment we stared at each other in silence. This was a wise woman. Having evidently learned how easily she could break a Turk's heart by saying the wrong thing, she smiled, and in broken Turkish, she repeated the Meltem slogan that had captivated the whole country: "You deserve it all!"

"All of Turkey has come to know you in the space of a week. How does that feel?"

"The police recognize me, and so do the taxi drivers, and everyone in the street, too," she said, as gleeful as a child. "There was even a balloon seller who stopped me, gave me a balloon,

and said, 'You deserve it all.' It's easy to become famous in a country that has only one television channel."

Did she know how rude she was being even as she struggled to be humble? "So how many channels do you have in Germany?" I asked. Realizing that she had said something wrong, she blushed. I thought there had been no need for me to say that after all. "Every morning on my way to work, I see your picture blown up so large it covers the side of an entire apartment building, and it's lovely," I said, by way of recovery.

"Oh, yes, you Turks are way ahead of Europe as far as advertising is concerned."

These words made me so pleased that for a moment I forgot she was just trying to be polite. I searched the merry, chirping crowd for Zaim. He was across the room, chatting with Sibel. It pleased me to think they might yet become friends. Even all these years later, I can remember the haze of euphoria that enveloped me. Sibel had coined a private nickname for him: "You-Deserve-It-All Zaim"; she found Meltem's promotional slogan to be selfish and insensitive. In a poor and troubled country like Turkey with young leftists and rightists busy killing each other, it was, she felt, ugly.

A lovely spring breeze was wafting through the balcony's grand doors, carrying the scent of linden trees. The lights of the city shone on the Golden Horn below. Even the slums and shantytowns of Kasımpaşa looked beautiful. I thought how happy I was, even feeling as if this was a prelude to yet greater happiness. The gravity of what had transpired with Füsun confused me, but I told myself that everyone has his secrets, fears, and moments of worry. No one could guess how many of these elegant guests felt similarly uneasy or carried secret spiritual wounds, but it was when we were in crowds like this,

surrounded by friends—and having downed a glass of *rakı* or two—that we persuaded ourselves how trivial and transitory those sentiments were.

"You see that nervous man over there?" Sibel said. "He's the famous Cold Suphi. He picks up every matchbox he can lay his hands on and saves them all. Apparently he has rooms and rooms full of them. They say he became that way after his wife left him. Let's not have the waiters wear such weird outfits at our engagement party, promise? Why are you drinking so much? Listen, I have something to tell you."

"What?" I said.

"Mehmet's really smitten with the German model—he won't leave her side—and Zaim is getting jealous. Oh, the one over there, the one who's the son of your uncle Süreyya . . . He's also related to Yeşim. Is there something upsetting you, something I should know about?"

"No, not at all, there's nothing wrong. I'm actually feeling very content."

Even all these years later I remember that Sibel spoke to me sweetly. Sibel was fun, and clever, and sympathetic, and I knew that with her at my side I would be fine, not just then but for the rest of my life. Late that night, after I had taken her home, I walked for a long time through the dark and empty streets, thinking about Füsun. What I couldn't stop thinking about, what perturbed me was not just that Füsun had given me her virginity; it was that she had shown such resolve in doing so. There had been no coyness, no indecision, not even when she was taking off her clothes.

At home I found our sitting room empty; sometimes I would come home to find that my father, having gotten up in the middle of the night, was sitting out there in his pajamas,

and I would enjoy chatting with him before I went to bed; but tonight both he and my mother were asleep—through their bedroom door, I could hear his snores and her sighs. Before going to bed I poured myself another *rakı* and smoked another cigarette. But even so I did not drop off to sleep at once. My head was still swimming with visions of our lovemaking, and these began to mix with the details of the night's engagement party.

The Feast of the Sacrifice

As I was drifting off to sleep I thought about my distant relation Uncle Süreyya, and about his son, whom I'd seen at Yeşim's party and whose name I kept forgetting. Uncle Süreyya had been at the house for one of Füsun's holiday visits—the time we'd gone out for a ride in the car. As I lay in bed, stalking sleep, a few images from that cold, gray morning came back to me. As they paraded before my eyes, they seemed both very familiar and very strange, as memories do when they find their way into dreams: I remembered the tricycle, and I remembered going outside with Füsun, watching silently as a lamb was slaughtered, and then taking a ride in the car.

"We returned that tricycle from our house," said Füsun, who remembered everything much better than I did when we met the next day at the Merhamet Apartments. "After you and your brother outgrew it, your mother gave it to me. But by then I'd grown too old for it as well, so I didn't ride it anymore, and when we went to visit you that year, my mother brought it back."

"And then my mother must have brought it here," I said. "Now I can remember Uncle Süreyya also being there that day."

"Because he was the one who asked for the liqueur," said Füsun.

Füsun's recollection of that impromptu car excursion was likewise better than my own. I would like to pause here to relate

the story that came back to me once she'd told it to me. Füsun was twelve and I was twenty-four years old. It was February 27, 1969, the first day of the Feast of the Sacrifice. On that morning, as on all holidays, our home in Nişantaşı was packed with relatives close and distant, all delighted to have been invited for lunch, and dressed up in suits and ties and their finest dresses. The doorbell kept ringing and newcomers arrived, for example, my younger aunt with her bald husband and her nosy but beautifully dressed children, and everyone would stand to shake hands and kiss them on both cheeks. Fatma Hanım and I were passing out sweets when my father took my brother and me to one side.

"Uncle Süreyya's complaining again that we have no liqueurs. Listen, boys, could one of you go down to Alaaddin's shop and buy some peppermint and strawberry liqueur?"

My mother had previously banned the customary serving of peppermint and strawberry liqueur in crystal glasses on a silver tray, because sometimes my father drank too much. She'd done this for his health. But two years earlier, on just such a holiday morning, when Uncle Süreyya had lodged his familiar complaint about there being no liqueur, my mother, hoping to cut the discussion short, had asked, "Why would anyone serve alcohol on a religious holiday?" a question that had paved the way for an endless back-and-forth about religion, civilization, Europe, and the Republic between my mother and my fervently secularist pro-Atatürk uncle.

"Which one of you is going?" my father asked, peeling off a crisp ten-lira note from the wad of cash he'd taken out of the bank to pass out to the janitors and the watchmen and all the children who kissed his hand.

"Let Kemal go!" said my brother.

"No, let Osman go," I said.

"Why don't you go, my boy," my father said to me. "And don't tell your mother what you're up to. . . ."

On my way out of the house I saw Füsun.

"Come out to the store with me, why don't you."

She was a skinny twelve-year-old girl with matchstick legs, the daughter of a distant relation, that was all. Apart from her immaculate clothes and the sparkling white butterfly-shaped bows of ribbon holding her shiny black braids, there was nothing particularly striking about her. All those years later, Füsun reminded me of the uninspired questions I'd asked that young girl in the lift: "What grade are you in?" (The first year of middle school.) "What school do you go to?" (Nişantaşı Girls' Lycée.) "What do you want to be when you grow up?" (Silence!)

We had just left the building and taken a few steps into the cold when I saw that a crowd had gathered around the little linden tree next to a muddy empty lot and they were about to sacrifice a lamb. If my level of understanding had been what it is today, I would have asked myself whether a girl that age might find it upsetting to watch a lamb's throat being slit, and I wouldn't have brought Füsun any closer.

But I was curious, and insensitive, and so we walked on. It was our cook, Bekri Efendi, and our janitor, Saim Efendi, who had rolled up their sleeves and were holding down a lamb whose legs were bound together and whose coat of wool was red with henna. Next to the lamb was a man in an apron, wielding a large butcher's knife, but the lamb was thrashing so violently that he couldn't do the job. After a struggle, the cook and the janitor succeeded in stilling the lamb, leaving behind them a trail of frozen breath. Taking the lamb by its mouth and its sweet nose, the butcher pushed its head roughly to one side

and held the knife against the throat. There followed a short silence. "Allah Akbar, Allah Akbar," said the butcher. Swiftly he slid the knife back and forth across the lamb's throat. When the butcher pulled the knife away dark red blood gushed out. The lamb was shuddering and you could see its life ebbing away. Everything was still. Suddenly a gust of wind shook the bare branches of the linden tree. The butcher dragged the lamb by its head across the ground to drain the blood into a hole that had been dug in advance.

In the crowd I saw grimacing children, and our chauffeur, Çetin Efendi, along with an old man who was praying. Füsun had silently taken hold of the sleeve of my jacket. Every now and again, the lamb shuddered, but these were its last throes. The butcher who was now wiping the knife on his apron was Kazım, whose shop was next to the police station—I'd not recognized him at first. Coming eye to eye with Bekri the cook, I realized that it was our lamb; in those days, we bought sacrificial lambs, and this was the one that had been tied up on a rope in the back garden for a week.

"Come on, let's go," I said to Füsun.

Without speaking, we walked up the street. Was I troubled by my indifference to a little girl's witnessing such a thing? I felt guilty, but I wasn't quite sure why.

Neither my mother nor my father was religious. I never saw either of them pray or keep a fast. Like so many married couples who had grown up during the early years of the Republic, they were not disrespectful of religion; they were just indifferent to it, and like so many of their friends and acquaintances they explained their lack of interest by their love for Atatürk and their faith in the secular republic. Even so, our family, like most other secularist bourgeois families living in Nişantaşı, would

sacrifice a lamb for the Feast of the Sacrifice and distribute the meat and the skin to the poor according to custom. But my father would have nothing to do with the sacrifice itself, and neither would anyone else in the family: We left it to the cook and the janitor to distribute the alms. Like my relatives, I had always kept my distance from the annual ritual sacrifice in the empty lot next door.

As Füsun and I, still silent, walked up to Alaaddin's shop a cool wind hit us passing Teşvikiye Mosque and I felt almost as if it was my disquiet that made me shiver.

"Did that frighten you back there?" I asked. "We shouldn't have looked. . . ."

"The poor lamb," she said.

"You know why they sacrifice the lamb, don't you?"

"One day, when we go to heaven, that lamb will take us over the Sırat bridge, which is thin as a hair and sharp as a sword. . . ."

This was the version for children and people with no education.

"There's more to the story," I said, with a teacherly air. "Do you know how it begins?"

"No."

"The prophet Abraham was childless. He prayed to God, saying, 'O Lord, if you give me a child, I'll do anything you ask.' In the end his prayers were answered, and one day his son Ismail was born. The prophet Abraham was filled with joy. He adored his son; kissing and caressing him all day long, the prophet was exultant and every day he thanked God. One day God came to him in his dream and God said, 'Now slit your son's throat and sacrifice him.' "

"Why did he say that?"

"Listen now. . . . The prophet Abraham did as God instructed. He took out his knife, and just as he was about to slit his son's throat . . . at that very moment, a lamb appeared."

"Why?"

"God showed mercy to Abraham: He sent him the lamb so that he could sacrifice it in his son's place. God saw that Abraham had been obedient."

"If God hadn't sent the lamb, would the prophet Abraham really have slit his son's throat?" asked Füsun.

"He really would have," I said uneasily. "It was because He was sure that Abraham would slit his son's throat that God loved him so much and sent the lamb to spare him terrible grief."

I could see that I had not told the story in such a way as to make it clear to a twelve-year-old girl why a doting father would try to kill his son. My unease was now turning into annoyance at my failure to explain the sacrifice.

"Oh no, Alaaddin's shop is closed!" I said. "Let's go check the shop on the square."

We walked as far as Nişantaşı Square. Reaching the crossroads, we saw that Nurettin's Place, which sold newspapers and cigarettes, was also closed. We turned back, and as we walked silently through the streets, I thought up an interpretation of the story of the prophet Abraham that Füsun might like.

"At the beginning, of course, the prophet Abraham has no idea that a lamb will take the place of his son," I said. "But he believes in God so much, loves Him so much that in the end he trusts no harm can come from Him. . . . If we love someone very much, we know that even if we give him the most valuable thing we have, we know not to expect harm from him. This is what a sacrifice is. Who do you love most in the world?"

"My mother, my father . . ."

We met Çetin the chauffeur on the sidewalk.

"Çetin Efendi, my father wants some liqueur," I said. "All the shops in Nişantaşı are closed, so could you take us to Taksim? And after that maybe we could go for a ride."

"I'm coming too, aren't I?" Füsun asked.

Füsun and I sat in the back of my father's '56 Chevrolet, which was a deep cherry red. Çetin Efendi drove us up and down the hilly, bumpy cobblestone streets as Füsun looked out the window. Passing Maçka, we continued down the hill to Dolmabahçe. Apart from a few people in their holiday best, the streets were empty. But as we passed Dolmabahçe Stadium, we saw another group performing a sacrifice.

"Oh, please, Çetin Efendi, could you tell the child why we make sacrifices? I wasn't able to explain it to her properly."

"Oh Kemal Bey, I'm sure you explained it beautifully," said the chauffeur. But he still seemed pleased to be acknowledged as more expert in matters of religion. "We make the sacrifice to show we're as loyal to God as the prophet Abraham was. . . . By this sacrifice we say that we are willing to lose even the thing that is most precious to us. We love God so much, little lady, that for Him we give up even the thing we love most. And we do that without expecting anything in return."

"Isn't there any heaven at the end of it?" I asked slyly.

"As God has so written . . . That will become clear on Judgment Day. We don't make the sacrifice to get into heaven. We make the sacrifice because we love God, and without expecting anything in return."

"You know a lot about religion, Çetin Efendi."

"Kemal Bey, you're embarrassing me. You're so educated, you know so much more. Anyway, you don't need religion or

a mosque to know such things. If there is something we value greatly, something we have lavished with care, and we give it to someone truly out of love, it is without expecting anything in return."

"But wouldn't the person for whom we have performed this selfless act then feel upset?" I said. "They'd worry that we want something from them."

"God is great," said Çetin Efendi. "He sees everything and understands everything. . . . And He understands that we expect nothing in return for our love. No one can fool God."

"There's a shop open over there," I said. "Çetin Efendi, could you stop here? I know they sell liqueurs."

In a minute Füsun and I had bought two bottles of the government monopoly's famous liqueurs, one peppermint and one strawberry, and climbed back into the car.

"Çetin Efendi, we still have time, can you take us on a little drive?"

So many years later Füsun was able to remind me of most of the things we talked about during our long drive around the city. In my own memory only one image remained of that cold, gray holiday morning: Istanbul resembled a slaughterhouse. It was not just in the poor areas, or the empty lots in dark and narrow backstreets, or among the ruins and burned-out lots—even on the big avenues and in the richest neighborhoods, people had been slaughtering lambs, tens of thousands of them since the early hours of the morning. In some places the sidewalk and the cobblestones were covered in blood. As our car rolled down hills and across bridges and wound its way through the backstreets, we saw lambs that had just been slaughtered, lambs being chopped into pieces, lambs being skinned. We took the Galata Bridge across the Golden Horn. Despite the holiday and

the flags and the crowds in their finery, the city looked tired and sad. Beyond the Aqueduct of Valens we turned toward Fatih. There we saw hennaed lambs for sale in an empty lot.

"Are these going to be slaughtered, too?" asked Füsun.

"Maybe not all of them, little lady," said Çetin Efendi. "It's almost noon, and these still haven't been sold. . . . Maybe, if they're not bought by the end of the holiday, these poor animals will be saved. But eventually, the drovers will sell them to butchers, little lady."

"We'll get there before the butchers and buy them, and save them," said Füsun. She wore an elegant red coat and as she smiled, she gave me a courageous wink. "We can rescue the sheep from this man who wants to slaughter his children, can't we?"

"We certainly can," I said.

"You're very clever, little lady," said Çetin Efendi. "Actually the prophet Abraham didn't want to kill his son at all. But the command was from God. If we don't submit to God's every command, then the world will turn upside down, the Judgment Day will be upon us. . . . The foundation of the world is love. The foundation of love is the love we feel for God."

"But how could a child whose father wants to kill him understand this?" I asked.

For a moment I met Çetin Efendi's eyes in the rearview mirror.

"Kemal Bey, I know you are just saying these things to tease me and have a good laugh, just like your father," he said. "Your father loves us very much and we respect him greatly, so we never get upset at his jokes. Your jokes don't upset me either. I'll answer your question with an example. Have you seen the film called *The Prophet Abraham*?"

"No."

"No, of course not—you'd never go to a film like that. But you should see this film and take this little lady with you. You won't be bored. . . . Ekrem Güçlü plays Abraham. We took the whole family—my wife, my mother-in-law, and all our children—and we all cried to our hearts' content. When Abraham took out his knife and looked at his son, we all cried then, too. . . . And when Ismail said, 'Dear Father, do whatever God commands!' just like he does in the Glorious Kuran . . . we cried again. Then, when the sacrificial lamb appeared in the place of the son who was to have been slaughtered, we wept with joy, together with everyone else in the cinema. If we give what we treasure most to a Being we love with all our hearts, if we can do that without expecting anything in return, then the world becomes a beautiful place, and that, little lady, is why we were crying."

I remember going from Fatih to Edirnekapı, and from there we turned right to follow the city walls all the way to the Golden Horn. As we passed the poor neighborhoods, as we advanced along the crumbling city walls, the three of us fell silent, and we remained so for a very long time. As we gazed upon the orchards between the old castle walls, and the empty lots strewn with rubbish, discarded barrels, and debris, and the run-down factories and workshops, we saw the occasional slaughtered lamb, and skins that had been tossed to one side, with their innards and horns, but in the poor neighborhoods, with their unpainted wooden houses, there was less sacrifice, and more festivity. I remember how delighted Füsun and I were to look out over the lots where carousels and swings had been set up for the celebrations, and at the children buying gum with their holiday money, and the Turkish flags set like little horns

on the tops of buses, and all the scenes that I would later find in photographs and postcards, and collect so ardently.

As we drove up Şişhane Hill a crowd was milling in the middle of the road and the traffic had come to a standstill. At first I thought it was another holiday gathering, but when the crowd parted before us we found ourselves right beside two vehicles that had crashed only moments ago, and the dying victims. The truck's brakes had failed, and the driver had swerved into the oncoming lane, then mercilessly plowed into a private car.

"God is great!" said Çetin Efendi. "Please, little lady, make sure you do not look."

We caught a glimpse of someone still trapped inside the car, whose front was completely crushed, her head bobbing as she fought for her life. I shall never forget the crunch of shattered glass under our tires as we drove on or the quiet that followed. We hurried on up the hill, and as we sped through the deserted streets from Taksim to Nişantaşı, it was as if in flight from death itself.

"Where have you been all this time?" my father asked. "We were getting worried. Did you get the liqueur?"

"It's in the kitchen!" I said. The sitting room smelled of perfume, cologne, and carpet. As I joined the crowd of relations, I forgot all about little Füsun.

Kissing on the Lips

THE FOLLOWING afternoon, Füsun and I reminisced again about our drive around the city on that holiday morning six years earlier, before giving ourselves over to kisses and lovemaking. As the linden-scented breeze rustled through the tulle curtains to lap against her honey-colored skin, I was driven to distraction by the way she clung to me with all her strength, as to a life raft, eyes tightly shut, and I could neither see nor reflect on the deeper meaning of what I was experiencing. Still I concluded that if I was to avoid sinking into the dangerous depths where guilt and suspicion serve only to induce the helplessness of love, I should seek out the company of other men.

On Saturday morning, after I'd been with Füsun three more times, my brother rang to invite me to the match that Fenerbahçe was to play that afternoon against Giresunspor; if Fenerbahçe won—as the oddsmakers expected—it would take the championship. So off we went to the İnönü Stadium, formerly known as the Dolmabahçe Stadium. Apart from its name, it pleased me to note, it was just the same as it had been twenty years ago. The only real difference was that, adopting European convention, they had tried to grow grass on the playing field. But as the seed had taken root only in the corners, the playing field resembled the head of a balding man with just a scattering of hair on the temples and the back. The

more affluent spectators in the numbered stands did the same as they had done in the mid-1950s: Whenever the exhausted players approached the sidelines, especially the less glorious defensemen, they would shower them with abuse, rather as the Roman masters cursed gladiators from the tribunes ("Run, you gutless faggots!"); while from the open stands, the poor, the unemployed, and students echoed the angry curses in unison, hoping to make their voices heard, too. As the sports pages would confirm the next day, it was something of a rout, and when Fenerbahçe scored a goal, I jumped to my feet with the rest of the crowd. In this festive atmosphere, with men on the field and in the stands conjoined in ritual embrace and congratulation, in this sudden community I felt my guilt recede, my fear transform into pride. But during the quiet moments of the match, when all thirty thousand of us could hear a player kick the ball, I turned to look at Dolmabahçe Palace, and the Bosphorus glimmering behind the open stands, and as I watched a Soviet ship moving behind the palace, I thought of Füsun. I was profoundly moved that she, hardly knowing me, had yet chosen me, had so deliberately elected to give herself to me. Her long neck, the dip in her abdomen that was like no other, the blending of sincerity and suspicion in her eyes at the same instant, their melancholic honesty when they looked right into mine as we lay in bed, and our kisses, all played on my mind.

"You seem preoccupied. It's the engagement, I guess," said my brother.

"Yes."

"Are you very much in love?"

"Of course."

With a smile both compassionate and worldly-wise, my

brother turned back to watch the ball in midfield. In his hand was a Turkish Marmara cigar—he had taken up this habit two years earlier, "just to be original," he said. The light wind blowing in from Leander's Tower ruffling the teams' great banners as well as the little red corner flags carried the stinging smoke right into my eyes, making them water just as the smoke from my father's cigarettes had done when I was a child.

"Marriage will do you good," said my brother, his eyes still on the ball. "You can have children right away. Don't wait too long and they can be friends with ours. Sibel is a woman with a lot of sense; she has her feet on the ground. While you sometimes get carried away with your ideas, she'll provide a good balance. I hope you don't wear out Sibel's patience the way you did with all those other girls? Hey, what's wrong with this ref? That was a foul!"

When Fenerbahçe scored its second goal, we all leapt up—"Goooal!"—and threw our arms around one another and kissed. When the match was over, we were joined by Kadri the Sieve, an army buddy of my father's, and a number of football-loving lawyers and businessmen. We walked up the hill with the shouting, chanting crowd and went into the Divan Hotel, where we talked football and politics over glasses of *rakı*. And my thoughts turned again to Füsun.

"Your mind is elsewhere, Kemal," said Kadri Bey. "I guess you don't like football as much as your brother."

"I do, but lately . . ."

"Kemal likes football very much, Kadri Bey," said my brother in a mocking tone. "It's just that people don't pass him many good balls."

"As a matter of fact I can give you the whole 1959 Fenerbahçe lineup from memory," I said. "Özcan, Nedim,

Basri, Akgün, Naci, Avni, Mikro Mustafa, Can, Yuksel, Lefter, Ergun."

"Seracettin was in there, too," said Kadri the Sieve. "You forgot him."

"No, he never played on that team."

The discussion continued and as always in such situations, led to a wager, Kadri the Sieve betting that Seracettin had played on the 1959 team, and I betting that he hadn't. The loser would buy dinner for the entire group of *rakı* drinkers at the Divan.

As we walked back to Nişantaşı, I parted from the other men. Somewhere in the Merhamet Apartments was a box in which I had kept all the photographs of football players I had collected from the packs of chewing gum that they used to sell once upon a time. It was just the sort of item my mother would banish to the apartment. I knew that if I could find that box, with all those pictures of football players and film stars that my brother and I had collected, Kadri the Sieve would be buying dinner for everyone.

But as soon as I entered the apartment I understood that my real reason for coming again was to dwell on the hours spent there with Füsun. For a moment I looked at the unmade bed, the unemptied ashtrays at the head of the bed, and the unwashed teacups. My mother's accumulated old furniture, the boxes, the stopped clocks, the pots and pans, the linoleum covering the floor, the smell of dust and rust had already merged with the shadows in the room to create a little paradise of the spirit in which my mind could wander. It was getting very dark outside, but still I could hear the cries and curses of the boys playing football in the garden.

On that visit to the Merhamet Apartments, on May 10, 1975, I did indeed find the tin in which I had kept all the

pictures of movie stars from Zambo, but it was empty. The pictures the museum visitor will view are ones I bought many years later from Hıfzı Bey, during days whiled away conversing with shivering and miserable collectors in various crowded rooms. What's more, on reviewing my collection years later, I realized that during our visits to the bars frequented by film people—Ekrem Güçlü (who'd played the prophet Abraham) among them—we had met quite a few of these actors. My story will revisit all these episodes, as will the exhibit. Even then I sensed this room mysterious with old objects and the joy of our kisses would be at the core of my imagination for the rest of my life.

Just as for most people in the world at the time, my first sight of two people kissing on the lips was at the cinema and I was thunderstruck. This was definitely something I'd want to do with a beautiful girl for the rest of my life. At the age of thirty, except for one or two chance encounters in America, I had still seen no couples kissing offscreen. It was not just when I was a child, though even then, the cinema seemed to be the place to go to watch other people kissing. The story was an excuse for the kissing. When Füsun kissed me, it seemed as if she was imitating the people she had seen kissing in films.

I would now like to say a few things about our kisses, though I have some anxieties about steering clear of trivialities and coarseness. I want to tell my story in a way that does justice to its serious points regarding sex and desire: Füsun's mouth tasted of powdered sugar, owing, I think, to the Zambo Chiclets she so liked. Kissing Füsun was no longer a provocation devised to test and to express our attraction for each other; it was something we did for the pleasure of it, and as we made love we were both amazed to discover love's true essence. It was

not just our wet mouths and our tongues that were entwined but our respective memories. So whenever we kissed, I would kiss her first as she stood before me, then as she existed in my recollection. Afterward, I would open my eyes momentarily to kiss the image of her a moment ago and then one of more distant memory, until thoughts of other girls resembling her would commingle with both those memories, and I would kiss them, too, feeling all the more virile for having so many girls at once; from here it was a simple thing to kiss her next as if I were someone else, as the pleasure I took from her childish mouth, wide lips, and playful tongue stirred my confusion and fed ideas heretofore not considered ("This is a child," went one idea—"Yes, but a very womanly one," went another), and the pleasure grew to encompass all the various personae I adopted as I kissed her, and all the remembered Füsuns that were evoked when she kissed me. It was in these first long kisses, in our lovemaking's slow accumulation of particularity and ritual, that I had the first intimations of another way of knowing, another kind of happiness that opened a gate ever so slightly, suggesting a paradise few will ever know in this life. Our kisses delivered us beyond the pleasures of flesh and sexual bliss for what we sensed beyond the moment of the springtime afternoon was as great and wide as Time itself.

Could I be in love with her? The profound happiness I felt made me anxious. I was confused, my soul teetering between the danger of taking this joy too seriously and the crassness of taking it too lightly. That evening Osman came over with his wife, Berrin, and their children to my parents' place for supper. I remember that while we were eating, I kept thinking of Füsun, and our kisses.

The next day I went to the cinema alone at lunchtime. I had

no particular wish to see a film, but I couldn't face eating in the usual little place in Pangaltı with Satsat's aging accountants and the kindhearted, plump secretaries who so enjoyed reminding me what a sweetie I had been as a child. I wanted to be alone. To indulge my thoughts of Füsun and our kisses, longing for two o'clock to come, while joking with my employees, playing the "humble friendly boss" and all the while eating, would have been too much to manage.

As I wandered through Osmanbey, down Cumhuriyet Avenue, gazing at the shop windows, I was drawn into a film by a poster advertising a Hitchcock week. This film too had a kissing scene with Grace Kelly. This cigarette I smoked during the five-minute intermission, this usher's flashlight, and this Alaska Frigo ice cream (which I display as a reminder to all housewives and lazy truants who ever attended a matinee) should imitate the desire and solitude I knew as a youth. I savored the coolness of the cinema after the heat of the spring day, the stale air heavy with mold, the handful of cineastes whispering excitedly, and I loved letting my mind wander as I gazed into the dark corners and the shadows at the edges of the thick velvet curtains; the knowledge that I would soon be seeing Füsun sent wave after wave of delight radiating through my body. After leaving the cinema, I walked through the higgledy-piggledy backstreets of Osmanbey, passing little clothes shops, coffeehouses, hardware stores, and laundries where they starched and ironed shirts, until I reached Teşvikiye Avenue and I remember telling myself as I headed toward our meeting place that this would have to be our last time.

First I would make an honest effort at teaching her mathematics. The way her hair tumbled onto the paper, the way her hand traveled across the table, the way she'd chew

and chew a lead pencil, only to slip its eraser between her lips, as if sucking a nipple, the way her bare arm grazed my own from time to time—all this sent my head spinning, but I held myself in check. As she set out to balance an equation, Füsun's face would fill with pride, and all of a sudden she would forget her manners and blow a puff of smoke straight at the book (and sometimes straight into my face), and throwing me a look from the corner of her eye, as if to say, Did you notice how fast I worked that one out?, she managed to ruin the whole thing because of a simple addition mistake. Unable to find her answer in a, b, c, d, or e, she would turn sad, and then upset, and she would make up excuses, like, "It wasn't out of stupidity; it was carelessness!" So that she wouldn't make the same mistake again, I would arrogantly tell her that being careful was a part of being clever, and I would watch the tip of her pencil pecking like the beak of a sparrow as she pounced on a new problem; she would pull at her hair nervously as she simplified an equation with some skill, and I would follow her work anxiously, with the same impatience, the same rising agitation. Then suddenly we would start to kiss, kissing for a long time before we'd make love, and while we made love, we would feel the entire weight of lost virginity, shame, and guilt—this we sensed in each other's every movement. But I also saw in Füsun's eyes her pleasure in sex, her growing amazement at discovering delights that she'd wondered about for so long. She called to mind an adventurer of old who, after years of dreaming of a distant legendary continent, sets out across the seas, and who, having crossed oceans, suffered hardships, and shed blood, finally steps onto its shores, to meet each tree, each stone, each creature with awe and enchantment, drawing from the same elation to savor each flower she smelled, each fruit

she put into her mouth, exploring each novelty with a cautious, bedazzled curiosity.

Leaving aside the man's tool, what interested Füsun most was not my body, nor was it the "male body" in general. It was her own form and her own pleasure that most occupied her. She needed my body, my arms, my fingers, my mouth, to find the pleasure spots and potentials of her body, her soft skin. Lacking experience, Füsun was sometimes shocked by the possibilities of what I was teaching her as her eyes turned inward with a lovely haziness, pleasure spreading through her veins to the back of her neck and her head, like a gradually intensifying shiver, and she would follow pleasure's flow with awe, sometimes letting out a blissful cry, then once more await my assistance.

"Do that again, please? Do it like that again!" she whispered now and again.

I was very happy. But this was not an elation I could weigh in my mind and understand. It was something that I felt on the nape of my neck when I answered the phone, or at the tip of my spine when running up the stairs, or in my nipples when ordering food at a Taksim restaurant with Sibel, to whom I was to become formally engaged in four weeks' time. I would carry this feeling around with me all day, like a scent on my skin, sometimes forgetting it was Füsun who had given it to me, as when, on several occasions, I was in my office after hours, hurriedly making love to Sibel, and it seemed to me I was in the grace of one great, all-consuming beatitude.

Love, Courage, Modernity

ONE EVENING, as we were eating at Fuaye, Sibel gave me a fragrance called Spleen that she'd bought for me in Paris; I exhibit it here. Though in fact I didn't like wearing fragrance, I dabbed some on my neck one morning, just out of curiosity, and after we'd made love, Füsun noticed it.

"Was it Sibel Hanım who bought this cologne for you?"

"No. I bought it for myself."

"Did you buy it because you thought Sibel might like it?"

"No, darling, I bought it because I thought *you* might like it."

"You're still making love with Sibel Hanım, aren't you?"

"No."

"Please don't lie to me," said Füsun. An anxious expression formed on her perspiring face. "I would consider it normal. Of course you are having sex with her, aren't you?" She fixed her eyes on mine, like a mother gently steering a child away from his lie.

"No."

"Believe me, lying will hurt me a lot more. Please tell me the truth. So why aren't you making love, then?"

"Sibel and I met last summer in Suadiye," I said, wrapping my arms around Füsun. "Our winter home was closed for the summer, so we would come to Nişantaşı. Anyway, in the autumn she went to Paris. I visited her there a few times over the winter."

"By plane?"

"Yes. This December, after Sibel finished university and returned from France to marry me, we used the summer house to meet through the winter. But the house in Suadiye would get so cold that after a while it took the pleasure out of sex," I continued.

"So you decided to wait until you had found a warm house?"

"At the beginning of March, two months ago, we went back to the house in Suadiye one night. It was very cold there. While we were trying to light a fire the house filled with smoke, and we had an argument, too. After that Sibel came down with a bad case of the flu. She had a fever, wound up in bed for a week, and we didn't ever want to go back there to make love."

"Which of you didn't want to?" asked Füsun. "Her or you?" As curiosity consumed her, compassion gave way to desperation, and her expression, which a moment ago was saying, Please tell me the truth, now was pleading, Please tell me a lie. Don't hurt me.

"I think Sibel is hoping that if we make love less before we marry, I might prize the engagement, our marriage, and even her, a bit more," I said.

"But you're saying that before all this you did make love."

"You don't understand. This is not about making love for the first time."

"You're right, it isn't," said Füsun, lowering her voice.

"Sibel showed me how much she loved me, and how much she trusted me," I said. "But the idea of making love before marriage still makes her uncomfortable. . . . I understand this. She's studied in Europe, but she's not as modern and courageous as you are. . . ."

There was a very long silence. Having spent years pondering the meaning of this silence, I think I can now summarize it in a balanced way. That last thing I'd said to Füsun had an implied meaning. I had suggested that what Sibel had done before marriage out of love and trust, Füsun had done out of courage and a modern outlook. I have suffered many years of remorse for labeling Füsun as "modern and courageous," for the compliment also said that I would feel no special obligations to her just because she'd slept with me. If she was "modern," she would not see sex with a man before marriage as a burden, and neither would she worry about being a virgin on her wedding day. Just like those European women we entertained in our fantasies, or those legendary women who were said to wander the streets of Istanbul. How could I have said those words believing Füsun would warm to them?

Though I may not have understood everything quite so clearly during that silence, these thoughts went through my mind as I watched the trees in the back garden slowly swaying in the wind. After making love, as we lay in bed chatting, we would look out the window at those trees, the apartment houses behind them, the random flights of crows among their branches.

"Actually, I'm not modern or courageous!" Füsun said, after a long while.

At the time I took these words to express her unease at discussing this weighty subject, and even humility, and I didn't dwell on them.

"A woman can love a man like crazy for years without once making love to him," Füsun added cautiously.

"Of course," I said. There was another silence.

"Are you telling me that you're not making love at all right now? Why weren't you bringing Sibel here?"

"It never occurred to us," I said, amazed that it hadn't until after I'd met Füsun in the shop. "This used to be the place I'd come to study and listen to music with friends—whatever the reason, it was because of you that I remembered it."

"I can certainly believe that it never occurred to you," said Füsun with skepticism. "But there's a lie in what you said before that. Isn't there? I don't want you to tell me any lies. I can't believe you aren't having sex with her these days. Swear to me, please."

"I swear I'm not making love to her," I said.

"So when were you going to start making love to her again? Will it be when your parents go to Suadiye this summer? When are they due to leave? Tell me the truth. I'm not going to ask you anything else."

"They're moving to Suadiye after the engagement party," I mumbled shamefacedly.

"So did you tell me any lies just now?"

"No."

"Why don't you think it over for a while."

I arranged to look thoughtful and for a brief time I did think. Meanwhile Füsun took my driver's license from my jacket pocket and began to fiddle with it.

"Ethem Bey, I have a middle name, too," she said. "Never mind. Have you thought it over?"

"Yes, I've thought it over. I didn't tell you any lies."

"Just now, or in the recent past?"

"Never," I said. "We're at a stage when there is no need for us to lie to each other."

"How is that?"

I explained that we had no designs on each other, and neither were we connected by work, and though we hid it from

the world, we were bound together by the purest and most elemental emotions, and by a passionate sincerity that left no room for deceit.

"You've lied to me—I'm sure of it," said Füsun.

"It hasn't taken you long to lose respect for me."

"Actually, I would have preferred it if you had lied to me . . . because people only tell lies when there is something they are terribly frightened of losing."

"Obviously, I am telling lies *for* you. . . . But I am not lying *to* you. But if you like, I can do the other, too. Let's meet again tomorrow. Can we do that?"

"Fine!" said Füsun.

I embraced her with all my strength and breathed in the scent of her neck. It was a mixture of algae, sea, burnt caramel, and children's biscuits, and every time I inhaled it a surge of optimism would pass through me, yet the hours I spent with Füsun did not change by one iota the course on which my life was set. This may have been because I took my bliss for granted. Still it was not because I fantasized myself to be (like all Turkish men) always in the right, or even that I imagined myself to be continually wronged by others; it was more that I was not yet aware of what I was experiencing.

It was during these days that I first began to feel fissures opening in my soul, wounds of the sort that plunge some men into a deep, dark, lifelong loneliness for which there is no cure. Already, every evening, before going to bed, I would take the *rakı* from the refrigerator and gaze out the window as I drank a glass alone in silence. Our apartment was at the top of a tall building opposite Teşvikiye Mosque, and our bedroom windows looked out on many other families' bedrooms that resembled ours; since childhood I had found strange comfort

in going to my dark bedroom to look into other people's apartments.

As I gazed out on the lights of Nişantaşı, it would occasionally occur to me that if I was to continue my happy, beautiful life in the manner to which I was accustomed, it was essential that I not be in love with Füsun. For this reason I felt it was important to resist befriending her or taking too great an interest in her problems, her jokes, and her humanity. This was not too difficult, as there was so little time left after we had done our math lessons and made love. When, after hours of lovemaking, we quickly dressed and left the apartment, I sometimes thought that Füsun was also taking care not to get "carried away" by her feelings for me. A proper understanding of my story depends, I think, on a full appreciation of the pleasure we took from these sweet shared moments. I am certain that the fire at the heart of my tale is the desire to relive those moments of love, and my attachment to those pleasures. For years, whenever I recalled those moments, seeking to understand the bond I still felt with her, images would form before my eyes, crowding out reason; for example, Füsun would be sitting on my lap, and I would have taken her large left breast into my mouth. . . . Or while drops of perspiration fell from the tip of my chin onto her graceful neck, I'd gaze with awe at her exquisite backside. . . . Or, after crying out rapturously, she would open her eyes for just one second. . . . Or at the heights of our pleasure, the look on Füsun's face . . .

But as I later came to understand, these images were not the reason for my elation, but merely provocative representations of it. Years later, as I struggled to understand why she was so dear to me, I would try to evoke not just our lovemaking but the room in which we made love, and our surroundings, and

ordinary objects. Sometimes one of the big crows that lived in the back garden would perch on the balcony to watch us in silence. It was the spitting image of a crow that had perched on our balcony at home when I was a child. Then my mother would say, "Come on now, go to sleep. Look, the crow is watching you," and that would frighten me. Füsun, too, had had a crow that had frightened her that way.

On some days it was the dust and the chill in the room; on others it was our pallid, soiled, spectral sheets, our bodies, and the many sounds that filtered in from the life outside, from the traffic, from the endless noise of construction work and from the cries of the street vendors that led us to feel our lovemaking belonged not to the realm of dreams but to the real world. Sometimes we could hear a ship's whistle from as far away as Dolmabahçe or Beşiktaş, and together we would try to guess what sort of ship it was, as children might do. As we continued to meet, making love with ever-escalating abandon, I came to locate the source of my happiness not only in that real world outside, but also in the tiny flaws on Füsun's body, the boils, pimples, hairs, and her dark and lovely freckles.

Apart from our measureless lovemaking with childlike abandon, what was it that bound me to her? Or else why was I able to make love to her with such passion? Did the pleasure of satisfying our ever-renewing desire give birth to love, or was this sentiment born of, and nurtured by, other things as well? During those carefree days when Füsun and I met every day in secret, I never asked myself such questions, behaving only like a child greedily gulping one sweet after another.

Istanbul's Streets, Bridges, Hills, and Squares

ONCE, WHEN we were talking aimlessly, Füsun happened to mention a teacher she'd liked at lycée, saying, "He wasn't like other men!" and when I asked her what she meant by that, she did not answer. Two days later I asked her once again what she'd meant by his not being "like other men."

"I know you are asking this question in all seriousness," said Füsun. "And I want to give you a serious answer. Shall I try to do that?"

"Of course . . . Why are you getting up?"

"Because I don't want to be naked when I say what I have to say to you."

"Shall I get dressed, too?" I said, and when she didn't answer I too got dressed.

The cigarette packets exhibited alongside this Kütahya ashtray, retrieved from a cupboard elsewhere in the flat and brought to the bedroom, are—like the teacup (Füsun's), the glass, and the seashell that Füsun kept fingering so nervously as she told her stories—assembled here to evoke the room's heavy, draining, crushing atmosphere at that moment. Füsun's girlish hair clip should remind us that the stories she told had happened to a child.

Füsun's first story was about the owner of a little shop on Kuyulu Bostan Street that sold tobacco, toys, and stationery. This Uncle Sleaze was a friend of her father's, and from time

to time he and Uncle Sleaze would play backgammon together. When Füsun was between the ages of eight and twelve, and most particularly during the summers, her father often sent her to this man's shop for soft drinks, cigarettes, or beer; every time she went, Uncle Sleaze would say, "I don't have the correct change. Why don't you stay for a while. Let me give you a soft drink," and having used such pretexts to keep her in the shop, when no one was around he'd find some other excuse ("Oh, look, my poor child, you're perspiring") to feel her up.

When she was somewhere between ten and twelve, there was Shithead-with-a-Mustache, the neighbor who visited in the evenings once or twice a week with his fat wife. Her father liked this man very much, and while the two of them were listening to the radio and chatting, drinking tea and eating biscuits, this man would put his arm on her waist, or her shoulder, or the side of her buttocks, or her thigh and leave it, as if he had forgotten it was there, and all this in a way that no one else could see, so that even Füsun had a hard time understanding what exactly was going on. And sometimes this man's hand would "accidentally" plop down on her lap, as a wily fruit might arrange to fall into a basket, and there it would quiver, moist and hot, fingering its way, with Füsun staying as still as if there were a crab crawling between her buttocks and her legs, this man all the while drinking tea with his other hand and engaging in the conversation in the room.

When she was ten, she would ask her father if she could sit on his lap while he was playing cards, and when he said no ("Stop, my girl, I'm busy, can't you see?"), one of his card-playing friends (Mr. Ugly) invited her onto *his* lap, saying, "Come over here and bring me luck," and he went on to caress her in a way that she would later understand to be far from innocent.

Istanbul's streets, bridges, hills, cinemas, buses, crowded squares, and isolated corners were filled with these shadowy Uncles Sleaze, Shithead, and Ugly, who, though they appeared like dark specters in her dreams, she could not bring herself to hate as individuals ("Perhaps it was because none of them ever really shook me to the core"). What Füsun found hard to reckon was that even though one of every two family visitors quickly turned into an Uncle Sleaze or a Mr. Shithead, her father never noticed them squeezing or touching her in the corridors or the kitchen. When she was thirteen, she was convinced that being a good girl obliged her not to complain about this pack of shifty, sleazy, loathsome men with their restless paws. During those same years, when a lycée "boy" who was in love with her (about which Füsun had no complaints) wrote "I love you" on the street, just in front of the house, her father pulled her to the window by her ear to point at the writing and gave her a smack.

Because so many Shameless Uncles had a penchant for exposing themselves in parks, empty lots, and backstreets, she, like all presentable Istanbul girls, learned to avoid such places. Yet there were inevitably exceptions. One reason that these violations had not strained her optimism was that, even as they all repeated the secret refrain of the same dark music, the malefactors were at the same time eager to reveal their vulnerabilities. There was an army of followers—men who had seen her in the street, caught sight of her at the school gate, in front of the cinema, or on the bus; some would follow her for months on end, and she would pretend she hadn't noticed them, but she never took pity on any of them (I was the one who'd asked if she had). Some of her followers were not so besotted, or patient, or polite: After a certain interval, they would start pestering her ("You're very beautiful. Can we walk

together? There's something I'd like to ask you. Excuse me, are you deaf?"), and before long they'd get angry, saying rude things to her and cursing her. Some would walk about in pairs; some would bring along friends to show them the girl they had been following in recent days and get a second opinion; some would laugh lewdly among themselves as they followed her; some would try to give her letters or presents; some would even cry. Ever since one of her followers had pushed her into a corner and tried to force a kiss on her, she had stopped challenging them the way she occasionally used to do. By the age of fourteen, she knew all the tricks that men played and could read their intentions so men could no longer catch her unawares and touch her, and perhaps she no longer fell into their traps so easily, though the streets were never short of men finding imaginative new ways to touch her, pinch her, squeeze her, or brush her from behind. The men who stretched their arms out through car windows to fondle girls walking down the street, the men who pretended to trip on the stairs in order to press themselves against girls, the men who abruptly started to kiss her in the elevator, the men who took with their change an illicit stroke of her fingers—it had been some time since any of them could surprise her.

Every man in a secret relationship with a beautiful woman is obliged to jealously hear various stories about the various men who were infatuated with, or putting the moves on, his beloved, reports to be greeted with smiles, an abundance of pity, and ultimately contempt. At the Outstanding Achievement Course there was a sweet, gentle, handsome boy her age who was always inviting her to go to the cinema or sit in the tea garden on the corner, and whenever he saw Füsun he was so excited that for the first few minutes he was speechless. One

day when she mentioned that she didn't have a pencil he gave her a ballpoint pen, and he was ecstatic to see her using it to take notes in class.

At the same college there was an "administrator"—in his thirties, his hair always slick with brilliantine, edgy, obnoxious, and taciturn. He was ever finding excuses to call Füsun to his office, as in "Your identity papers are not complete," or "One of your answer sheets is missing," and once she was there, he'd begin discussing the meaning of life, the beauty of Istanbul, and the poems he had published until, seeing that Füsun was giving him not a word of encouragement, he would turn his back on her, gazing out the window, and he would hiss, "You may leave."

She would not even discuss the hordes—a woman in one instance—who came to the Şanzelize Boutique and fell in love with her on sight, and went on to buy loads of dresses, accessories, and trinkets from Şenay Hanım. Naturally, I pressed her for more details, and only to placate my curiosity, passing for concern, did she agree to talk about the most ridiculous one, a man in his fifties, short, fat as a jar, with a brush mustache, but stylish and rich. He would chat with Şenay Hanım, now and again pushing long French sentences out of his little mouth, and when he left the shop his cloud of perfume would linger for some time, upsetting Lemon the canary!

As for the suitors found by her mother through a matchmaker (supposedly without Füsun's knowing) there was one man she'd liked, who had been more interested in her than in marriage; she'd gone out with him a few times, liked him, and kissed him. Last year, during a music competition among many schools at the Sports Arena, she'd met a Robert College boy who'd fallen head over heels in love with her. He'd meet

her at the school gate, and every day they'd leave together, and they'd kissed two or three times. Hilmi the Bastard, however, despite a flurry of dates, she'd not even kissed, because his sole aim in life seemed to be getting girls into bed. She'd felt close to Hakan Serinkan, the beauty contest emcee, not because he was famous, but because, in this place where everyone was conspiring backstage and being openly unfair to her, he'd gone out of his way to be gentle and kind; and because when it came time for the culture and intelligence questions that made the other girls so nervous, he'd whispered them to her backstage in advance, along with the answers. But later, when this old-style crooner had made insistent phone calls to the house, she'd refused to answer, and, anyway, her mother didn't approve. Rightfully inferring jealousy—though she thought it had to do with the singer's fame—she told me tenderly (but with obvious pleasure) that she had not been in love with anyone since the age of sixteen, and then she made a pronouncement that shocks me still. Although she, like most girls, enjoyed the perpetual celebration of love in magazines and television and songs, she didn't regard the subject fit for idle talk, and was convinced that people exaggerated their feelings just to appear superior. For her, love was something to which one devoted one's entire being at the risk of everything. But this happened only once in a lifetime.

"Have you ever felt anything close to this?" I asked, as I lay down beside her on the bed.

"Not really," she said, but then she thought a bit and with a reserve born of willful scrupulousness, she told me about someone.

There was a man so madly and obsessively in love with her that she had thought she could love him back—he was rich,

handsome, a businessman, and "married, of course." In the evenings when she left the shop he would pick her up in his Mustang at the corner of Akkavak Street. They would go to that place next to the Dolmabahçe Clock Tower where people parked and drank tea and looked at the Bosphorus or to that empty lot in front of the Sports Arena, and as they sat there in the dark, and sometimes in the rain, they would kiss for a long time, and then, forgetting his circumstances, this thirty-five-year-old man would ask her to marry him. I could smile over this man's predicament, suppressing my jealousy, much as Füsun intended, even as she told me what kind of car he had, what sort of work he did, and how lovely his large green eyes were; but when Füsun told me his name, I was flooded by an envy that confounded me. This man whom she intimately called Turgay, who had made his fortune in textiles, was a "business associate" and family friend of my father, my brother, and me. I often saw this tall, handsome, ostentatiously hale and hearty man strolling around Nişantaşı with his wife and children, a contented family man. Could my regard for him—as a committed family man, and an honest and hardworking businessman—have somehow inspired this great jealous surge? Füsun recounted how this man had come to the Şanzelize for months on end to "catch" her, and because Şenay Hanım was wise to him, he'd been obliged almost to buy out the entire shop.

Şenay Hanım had pressured her, saying, "Don't cause any heartbreak to my kind customer," and so Füsun had accepted his presents, and then later, when she was sure of his affections, she had started to meet with him "out of curiosity," and even felt "strangely close" to him. One snowy day, at Şenay Hanım's insistence, she'd gone with this man to "help" a friend who'd opened up a boutique in Bebek; on the way back, they'd stopped

in Ortaköy for a bite to eat, and after he'd drunk a few too many *rakı*s, "Turgay Bey the playboy factory-owner" began to press her to go with him to his *garçonnière* in a backstreet in Şişli, to "drink some coffee." When Füsun turned him down, that "elegant, sensitive man," losing all sense of proportion, said, "I'd buy you anything!" Thus rebuffed he then drove the Mustang to empty lots and backstreets trying to kiss her like before, until, with Füsun refusing his advances, he'd tried to "possess" her by force. "And all the while he was saying that he was going to give me money," said Füsun. "The next evening, when the shop closed, I didn't meet him. The day after that, he came to the shop, and either he'd forgotten what he'd done or he chose not to remember. He pleaded with me ardently, even leaving a Matchbox Mustang for me with Şenay Hanım. But I never got into that Mustang again. In retrospect, I should have been stern and told him never to come back again. But he was so in love with me, like a child, really; he was prepared to forget any rejection in the hope of having his love returned, and that moved me, so I couldn't say it. He would come to the shop every day, buying so much and making Şenay Hanım very happy, and if he got me alone for a moment in some corner, his great green eyes almost wet, he would plead with me, saying, 'Can't we just go back to the way we were? I can pick you up every evening. We can drive around in the car. I don't want anything else.' After I met you, I started hiding in the back room every time he visited the shop. Now he doesn't come round so often."

"Those times last winter when you kissed him in the car, why didn't you go further?"

"I wasn't eighteen years old yet," said Füsun, frowning gravely. "I turned eighteen two weeks before you and I met at the shop—on April twelfth."

If the intrinsic evidence of love is to have one's lover or the object of one's affections in mind at all times, then I was truly on the verge of falling in love with Füsun. But inside me was a coolheaded rationalist saying my inability to stop thinking about Füsun was because of all those other men. When it occurred to me that jealousy might be an even more definitive sign of love, my reason (however frantic) concluded that this was merely a transitory manifestation. Indeed, after a day or two, I would assimilate Füsun's catalog of the "other men" who had enjoyed her kisses, and even feel some contempt for those who had failed to compel her to go further. But when we made love that day, rather than tumbling into the usual childish bliss, in which playful curiosity mingled with exuberance, I found myself in the grip of what the newspapers call the urge to "master her," and making my desires plain with ever harsher force, I was surprised by my own behavior.

A Few Unpalatable Anthropological Truths

HAVING RAISED the question of "mastery," I would like to return to a matter at the very foundation of my story. Many readers and visitors will already understand it only too well, but in the expectation that much later generations—such as those who will visit our museum after 2100—might find the term opaque, let me now lay aside fears of repeating myself and set down a certain number of harsh—in times past, the preferred word would have been "unpalatable"—truths.

One thousand nine hundred and seventy-five solar years after the birth of Christ, in the Balkans, the Middle East, and the western and southern shores of the Mediterranean, as in Istanbul, the city that was the capital of this region, virginity was still regarded as a treasure that young girls should protect until the day they married. Following the drive to Westernize and modernize, and (even more significantly) the haste to urbanize, it became common practice for girls to defer marriage until they were older, and the practical value of this treasure began to decline in certain parts of Istanbul. Those in favor of Westernization hoped that as Turkey modernized (and in their view, became more civilized) the moral code attending virginity would be forgotten, along with the concept itself. But in those days, even in Istanbul's most affluent Westernized circles, a young girl who surrendered her chastity before marriage

could still expect to be judged in certain ways and to face the following consequences:

a) The least severe consequences befell the young people who, as in my story, had already decided to marry. In wealthy Westernized circles, just as in the case of Sibel and me, there was a general tolerance of young unmarried people who were sleeping together if they had proven themselves "serious," either by formal engagement or another demonstration that they were "destined for marriage." Even so, well-born, well-educated girls who had slept with their prospective husbands before marriage were disinclined to say they had done so out of their trust in these men and their intentions, preferring to claim that they were free and modern enough to disregard tradition.

b) In cases where such trust had yet to be established, or coupledom yet to be socially recognized, should a girl fail to "hold herself back" and instead give away her virginity, perhaps to a man who had forced himself on her, or perhaps because she was passionately in love, or had succumbed to any number of other enemies of prudence—such as alcohol, temerity, or mere stupidity—the traditional code required that any man wishing to protect the girl's honor should marry her. It was after one such accident that Ahmet, the brother of my childhood friend Mehmet, came to marry his wife, Sevda; and though he is now very happy, the union was made in fear of regret.

c) If the man tried to wriggle out of marrying the girl, and the girl in question was under eighteen years

of age, an angry father might take the philanderer to court to force him to marry her. Some such cases would attract press attention, and in those days it was the custom for newspapers to run the photographs with black bands over the "violated" girls' eyes, to spare their being identified in this shameful situation. Because the press used the same device in photographs of adulteresses, rape victims, and prostitutes, there were so many photographs of women with black bands over their eyes that to read a Turkish newspaper in those days was like wandering through a masquerade. All in all, Turkish newspapers ran very few photographs of Turkish women without bands over their eyes, unless they were singers, actresses, or beauty contestants (all occupations suggestive of easy virtue, anyway), while in advertisements there was a preference for women and faces that were evidently foreign and non-Muslim.

d) Because no one could conceive of a sensible young girl who gave her virginity under such circumstances to a man who had no intention of marrying her, it was widely believed that anyone who had done such a thing was not sane. The most popular Turkish films of the era included many exemplary tales, painful melodramas of girls at "innocent" dance parties where the lemonade had been spiked with sleeping potions, after which their honor was "soiled" and they were robbed of their "greatest treasure"; in these films the good-hearted girls always died, and the bad ones all became whores.

e) That some girls could be led astray by sexual desire was accepted, of course. But a girl so uncalculating, childish, and passionate that she could not restrain

her desires, heedless of the tradition that settled such matters with bloodshed, was regarded as a surreal creature, frightening even her prospective husband, who anticipated that the same sexual appetite might cuckold him after marriage. When an ultraconservative friend from my army days told me that he had separated from his sweetheart because they had "made love too frequently before marriage" (though only with each other) there was a tinge of embarrassment in his voice, and not a little regret.

f) Despite the rigidity of these rules, and all the attendant penalties for breaking them, which ranged from mere ostracism to ritual murder, quite a few of the city's young men believed that there were innumerable young women willing to sleep with a man just for the fun of it. Such beliefs, which social scientists call "urban legends," were so prevalent among the poor, the petite bourgeoisie, and recent immigrants from the provinces, who clung to the notion as fervently as Western children cling to Santa Claus, so readily accepting and rarely disputing them that even modern, Westernized young men in the wealthy neighborhoods of Taksim, Beyoğlu, Şişli, Nişantaşı, and Bebek became susceptible (most especially under circumstances of sexual deprivation). It seemed a universal conviction that these women, who did not cover their heads, wore miniskirts, and made love with men for pleasure ("just like women in Europe"), all lived in places like Nişantaşı (where our story takes place). Young men like my friend Hilmi the Bastard imagined these women of legend to be rapacious creatures so eager to get to know a rich

boy like him, and to climb into his Mercedes, that they would do anything; and on Saturday nights, desperate for sex, after downing a few beers and getting drunk, the Hilmis would prowl Istanbul in their cars, street by street, avenue by avenue, sidewalk by sidewalk, hoping to find one such girl. Ten years earlier, when I was twenty, we spent a winter's night cruising the streets in the Mercedes of Hilmi the Bastard's father (the monicker was affectionate, not technical); after failing to find any women in long skirts or short, we went to a luxury hotel in Bebek, where there were two fun-loving girls who did belly dances for tourists and rich, middle-aged local men, and who, after we had paid their pimps handsomely, were ready to receive us in one of the rooms upstairs. I would like to make clear now that I take no preemptive offense if readers from later, happier centuries disapprove of my conduct. But I would like to defend my friend Hilmi: Despite all his coarse machismo, he did not consider every miniskirted girl to be one of these mythological nymphs who slept with men in simple pursuit of pleasure; on the contrary, if he saw a girl being followed for no reason except that she had bleached her hair or was wearing a miniskirt and makeup, he would defend her from the marauding hordes, slapping and punching them to tutor the unwashed and the unemployed on how women should be treated, and what it meant to be civilized.

Clever readers will have sensed that I have placed this anthropology lesson here to allow myself a chance to cool off from the jealousy that Füsun's love stories provoked, the prime

object of which was Turgay Bey. I reasoned that this must be because he was a well-known industrialist living, as I did, in Nişantaşı—and that my jealousy, however overpowering, was natural, and would pass.

Jealousy

THAT EVENING, after having heard Füsun boast about Turgay Bey's obsessive love, I went to supper with Sibel and her parents at the old Bosphorus mansion in Anadoluhisarı that they used as their summer home, and after we had eaten I went to sit at Sibel's side for a while.

"Darling, you've had a lot to drink tonight," said Sibel. "Is there something about the preparations you're not happy with?"

"Actually, I'm very glad that we're having the engagement party at the Hilton," I said. "As you know, the person who most wanted such a party was my mother. She's so delighted that—"

"So what's troubling you?"

"Nothing . . . Could I have a look at the invitation list?"

"Your mother gave it to my mother," said Sibel.

I stood up, took three steps, straining, it seemed, the whole dilapidated building, with each floorboard expressing a distinctive creak, and sat down beside my future mother-in-law. "Madam, would you mind if I took a look at the invitation list?"

"Of course not, my child. . . ."

Although I was seeing double from the *rakı,* I found Turgay Bey's name at once and crossed it out with a ballpoint pen, and then, propelled by a sudden sweet compulsion, I put down the names of Füsun and her parents, along with their

Kuyulu Bostan Street address, and in a low voice, I said: "My mother doesn't know this, Madam, but the gentleman whose name I crossed out, though a valued family friend, was recently overzealous about a yarn business deal. It saddens me to say that he has knowingly done our family a great wrong."

"Friendship has lost its value, Kemal Bey, as has humanity—in today's world. Those old ties count for nothing," said my future mother-in-law, blinking wisely. "May those people whose names you've added never cause you similar trouble. How many are they?"

"A history teacher and his wife, who's distantly related to my mother and worked for many years as her seamstress, and their lovely eighteen-year-old daughter."

"Oh good," said my future mother-in-law. "We've invited so many young men that we'd begun to worry that there weren't going to be enough beautiful young girls for them to dance with."

As Çetin Efendi drove us home in my father's '56 Chevrolet, I dozed off, opening my eyes from time to time to contemplate the chaos on the main avenues, which were dark as ever; and the beauty of the old walls covered with cracks, political slogans, mold and moss; the searchlights of the City Line ferries as they lit up the landing stations; and the high branches of the hundred-year-old plane trees receding in the rearview mirror; and all the while I listened to my father, who had been rocked to sleep as the car bumped over the cobblestones, and now softly snored.

My mother beamed with contentment at seeing her wishes coming true. As always on rides home after an evening out, she wasted no time sharing her views of the gathering we had just left and of those in attendance.

"Yes, it was all very good; these are fine people, straight arrows, not lacking in humility, or in elegance either. But what dreadful shape that beautiful mansion is in! Can it be that they can't afford to fix it up? Surely not. But don't misunderstand me, son—I don't believe you could find another girl as charming, graceful, and sensible in all of Istanbul."

After leaving my parents in front of the apartment, I felt like going for a walk, which took me past Alaaddin's shop. This was where my mother had taken my brother and me when we were little, to buy cheap Turkish-made toys, chocolates, balls, water guns, marbles, playing cards, Zambo Chiclets that came with pictures, comics, and so much else. The shop was open. Alaaddin had taken down the newspapers he displayed on the trunk of the chestnut tree outside, and he was just then turning out the lights. With an unexpected warmth he invited me inside, and while he bundled the last of the newspapers he would exchange for the new ones delivered at five in the morning, he tolerated my browsing to pick out this cheap baby doll. I calculated that it would be another fifteen hours before I could give it to Füsun as a present, and wrap my arms around her and forget all my jealous thoughts; and for the first time I felt pain at being unable to call her on the phone.

It was a burning sensation, from inside me, and it felt like remorse. What was she doing at this moment? My feet were not carrying me home but in just the opposite direction. When I reached Kuyulu Bostan Street, I walked past a coffeehouse where my friends used to play cards and listen to the radio when we were young, and then past the schoolyard where we'd played football. My inner rationalist, though weakened by all the *rakı* I'd drunk, was not yet dead, and now it warned me that it would be Füsun's father who'd open the door and that the

consequences might be scandalous. I walked only far enough to be able to see their house in the distance, and the lights in the windows. Just to see the second-floor windows reached by the chestnut tree was enough to make my heart pound.

I commissioned this painting to exhibit right here in our museum, providing the artist with all the necessary details, and while it offers a fine impression of the orangey lamplight cast onto the interior of Füsun's apartment, and the chestnut tree shimmering in the moonlight, and the depth of the dark blue sky beyond the line of rooftops and chimneys of Nişantaşı, does it also, I wonder, convey to the visitor the jealousy I acknowledged as I beheld that view?

As drunk as I was, I was now seeing things clearly—yes, I had come here on this moonlit night to catch a glimpse of Füsun, perchance to kiss her, to speak to her, but in equal part to ensure that she was not spending this evening with someone else. Because now, having gone "all the way" with one man, she might possibly be curious about the experience of making love with one of those other admirers she had enumerated. What fed the ever-growing jealousy festering inside me was that Füsun had embraced the pleasures of lovemaking with the enthusiasm of a child given a wonderful new toy, and that when we made love she was able to give herself over to pleasure completely, in a way I had rarely observed in a woman. I do not remember how long I stood there looking at the windows. It was, I know, quite late by the time I got home, the baby doll present still in my hand, and went to bed.

In the morning, on my way to work, I thought about the things I had done the night before, taking measure of the jealousy I had been unable to banish from my heart. I was gripped then by the fear that I might be besotted. As she drank from a bottle

of Meltem, Inge the model eyed me saucily from the side of an apartment building, warning me to be careful. I considered discussing my secret in jest with friends like Zaim, Mehmet, and Hilmi, so as to release the obsession from the confines of my mind, where it could only intensify. But because my best friends all seemed to like Sibel a great deal—indeed found her very attractive to the point of being envious—I doubted they would give me a sympathetic hearing, or feel much pity. For I knew that as soon as I broached the subject, I would find my calculated and affected mockery crumbling under the weight of my passion, until my longing to speak of Füsun sincerely could no longer be denied, and my friends would conclude that I was indeed undone. And so as the Maçka and Levent buses (the same ones I used to ride with my mother and brother on the way back from Tünel) went rumbling past the windows of my office, I concluded that there was, for now, little I could do to master my desire for Füsun without destroying the chance of the happy marriage that I still wanted very much; and that, rather, I should leave things as they were, avoiding panic, and making the most of all that life had so generously conferred on me.

My Whole Life Depends on You Now

BUT WHEN Füsun was ten minutes late for our next rendezvous at the Merhamet Apartments, I immediately forgot my resolutions. I kept glancing at my watch, a present from Sibel, and at the Nacar brand alarm clock Füsun so loved to shake until it jangled, and I peeked continually through the curtains at Teşvikiye Avenue, pacing up and down the creaky parquet floor, unable to take my mind off Turgay Bey. Soon I bolted the apartment and went outside.

I kept a careful eye on both sides of the street, to make sure I didn't miss Füsun walking toward me, and I proceeded as far as the Şanzelize Boutique. But Füsun wasn't in the shop either.

"Kemal Bey! How can I help you?" said Şenay Hanım.

"We've decided I should buy that Jenny Colon handbag for Sibel Hanım after all."

"So you've changed your mind," said Şenay Hanım. I could see a hint of mockery on her curled lips, but not for long. If I was embarrassed because of Füsun, she must have felt some shame for knowingly selling me a fake. We both fell silent. With torturous slowness, she retrieved the bag that had been restored to the arm of the mannequin in the window, dusting it off with the ritualized care of a seasoned shopkeeper. I directed my attention to Lemon the canary, who was having a dreary day.

After I had paid and was on my way out with my purchase, Şenay Hanım said, "Now that you trust us, perhaps you can

grace our shop more often." She took obvious pleasure in her double meaning.

"Of course." If I didn't buy enough from Şenay Hanım, might she plant the seed of suspicion in Sibel, who came into this shop from time to time? It grieved me less to imagine myself falling slowly into this woman's trap than to catch myself making such petty calculations. I imagined that Füsun had gone to the Merhamet Apartments while I was out, and not finding me, had left. In the bright spring day the sidewalks were swarming with housewives out shopping, young girls clomping around in the latest platform shoes paired with ill-fitting short skirts, and pupils swarming out of the schools from which they had just been dismissed. Still searching for Füsun, I cast my eyes over the gypsy flower seller, and the vendor of black market American cigarettes (who everyone said was a plainclothes policeman), and the other denizens of Nişantaşı.

A water tanker with the words LIFE—CLEAN WATER on its side sped by, and Füsun emerged from behind it.

"Where have you been?" we said in unison, joyous smiles coming to our lips.

"The witch stayed in during lunchtime, and she sent me off to a friend's shop. So I got to the apartment late, and you weren't there."

"I got worried, so I went to the shop. Look, I bought the bag as a memento."

Füsun was wearing the earrings of which one is displayed at the entrance to our museum. We walked down the street together. We turned off Valikonağı Avenue into Emlak Avenue, which was not so crowded. We had just passed the apartment that housed the dentist to whom my mother brought me when I was a child (as well as the doctor in whose office I had first

felt the unforgettable hardness of the cold tongue depressor shoved into my mouth) when we saw that a crowd had gathered at the foot of the hill; a few others were running down to join it, while others still were coming toward us, their faces contorted by what they had seen.

There had been an accident; the road was closed. Only a few minutes earlier the "Life–Clean Water" tanker had swerved into the left lane while heading down the hill and had crushed a *dolmuş*. The driver of the shared taxi was cowering in a corner, his hands trembling as he smoked a cigarette. The weight of the water tanker had crushed the long nose of a 1940s Plymouth that did the Taksim–Teşvikiye route. All that survived was the taxi meter. Beyond the ever-growing crowd of onlookers, amid the shards of glass and broken car parts, I saw the body of a woman trapped in the front seat, and recognized her as the dark-haired woman I'd passed on my way out of the Şanzelize Boutique. The street was now covered with debris. Taking Füsun by the arm, I said, "Let's go." But she paid me no mind. She stood there silently, staring at the woman pinned inside the wreck, until she had had her fill.

By now the crowd had grown considerably, and I was beginning to feel uneasy, less on account of the dead woman inside the car (yes, she must have been dead by then) than out of fear that I might run into someone I knew, when at last a police car came into view; wordlessly we moved away from the accident. As we walked without speaking up the street where the police station was, straight to the Merhamet Apartments, we were fast approaching the "happiest moment of my life" mentioned at the beginning of this book.

In the coolness of the Merhamet Apartments stairwell, I took her in my arms and kissed her. I kissed her again when we

THE MUSEUM OF INNOCENCE

went into the apartment, but there was a certain shyness in her playful lips, a certain reserve in her manner.

"I have something to say to you."

"Then say it."

"I'm afraid you might not take it seriously enough, or that you might react exactly the wrong way."

"Trust me."

"Well, I'm not sure I can, but I'm still going to tell you," she said. She looked as if she'd made up her mind, as if the arrow had already left the bow and there was no longer any point in holding it back. "If you take it the wrong way, I'll die."

"Forget the accident, darling, and please, just tell me."

She began to cry silently, just as she had done that afternoon in the Şanzelize Boutique, when she'd been unable to give me a refund. Her sobs were almost sullen, as those of a child who was furious at being wronged.

"I've fallen in love with you. I'm head over heels in love with you!"

Her voice was both accusatory and unexpectedly gentle. "I think about you all day long. I think about you from morning until night."

She covered her face with her hands and cried.

Let me confess that my first impulse was to grin stupidly. But I didn't. Instead I frowned, assuming a tender expression of concern, until finally I had overcome the force of my own feelings. Here, at one of the deepest, most profound moments of my life, there was something contrived in my demeanor.

"I love you very much, too."

Though I was being utterly sincere, my words were neither as forceful nor as truthful as hers. She'd said it first. Because I'd said it after Füsun, my own truthful declaration of love had

taken on a consoling, tactful, echoing tone. Now it didn't matter if my feelings might in fact be stronger than hers, since Füsun had gone first in confessing the fearful dimensions of her sentiments, and so had lost the game. The "sage of love" within me (acquired from who knew what egregious experience) was crowing about Füsun's misstep: By speaking too sincerely, she had lost. From this reaction I deduced that my jealous worries and obsessions would soon subside.

When she began to cry again, she took out of her pocket a crumpled, childish hankie. I embraced her, and while caressing the lovely velvety skin on her neck and shoulders, I said there could be nothing more ridiculous than the idea of a beautiful girl like her, whom everyone adored, in tears just for having admitted to falling in love.

Still crying, she said, "What do you mean—that beautiful girls never fall in love? If you know so much about everything, then tell me this . . ."

"What?"

"What's going to happen now?"

This was the real question, and she now fixed me with a look as if to say she was not going to be distracted by sweet generalities about love and beauty, and that it was of the utmost importance that I give her the right answer.

I had no answer to give her. But this is how it seems now, so many years later. Sensing that such a question might come between us, I felt an unease for which I secretly blamed her and I began to kiss her.

Driven by desire and helplessness, our kisses grew more passionate. She asked if this was the answer to her question. "Yes," I said. Content with this, she asked, "Weren't we going to do some mathematics?" When I had bestowed another

kiss, by way of an answer, she acknowledged it by kissing me back. To embrace, to kiss—it felt so much more genuine than any contemplation of the impasse to which we had come, so full of the irresistible power of the present moment. As she peeled off her clothes, Füsun changed from a fearful girl made sad by helpless passion into a healthy and exuberant woman ready to give herself over to love and sexual bliss. Thus did we enter what I have called the happiest moment of my life.

In fact no one recognizes the happiest moment of their lives as they are living it. It may well be that, in a moment of joy, one might sincerely believe that they are living that golden instant "now," even having lived such a moment before, but whatever they say, in one part of their hearts they still believe in the certainty of a happier moment to come. Because how could anyone, and particularly anyone who is still young, carry on with the belief that everything could only get worse: If a person is happy enough to think he has reached the happiest moment of his life, he will be hopeful enough to believe his future will be just as beautiful, more so.

But when we reach the point when our lives take on their final shape, as in a novel, we can identify our happiest moment, selecting it in retrospect, as I am doing now. To explain why we have chosen this moment over all others, it is also natural, and necessary, to retell our stories from the beginning, just as in a novel. But to designate this as my happiest moment is to acknowledge that it is far in the past, that it will never return, and that awareness, therefore, of that very moment is painful. We can bear the pain only by possessing something that belongs to that instant. These mementos preserve the colors, textures, images, and delights as they were more faithfully, in fact, than can those who accompanied us through those moments.

We made love for the longest time, somewhere in the middle reaching the point when we were both out of breath; I had just kissed Füsun's moist shoulders and entered her from behind, biting first her neck and then her left ear, and it was at this, the happiest moment of my life, that the earring whose shape I'd failed to notice fell from Füsun's lovely ear onto the blue sheet.

Anyone remotely interested in the politics of civilization will be aware that museums are the repositories of those things from which Western Civilization derives its wealth of knowledge, allowing it to rule the world, and likewise when the true collector, on whose efforts these museums depend, gathers together his first objects, he almost never asks himself what will be the ultimate fate of his hoard. When their first pieces passed into their hands, the first true collectors—who would later exhibit, categorize, and catalog their great collections (in the first catalogs, which were the first encyclopedias)—initially never recognized these objects for what they were.

After what I call the happiest moment of my life had passed, and the time had come for us to part, and the fallen earring unbeknownst to us still nestled between the folds of the sheet, Füsun looked into my eyes.

"My whole life depends on you now," she said in a low voice.

This both pleased and alarmed me.

The next day it was much warmer. When we met at the Merhamet Apartments, I saw as much hope as fear in Füsun's eyes.

"I lost one of those earrings I was wearing," she told me after we had kissed.

So now I said, "I have it here, darling," as I reached into the right-hand pocket of my jacket hanging on the back of a chair. "Oh, it's gone!" For a moment I glimpsed a bad omen, a hint of malign fate, but then I remembered that I'd put on a different jacket that morning, because of the warm weather. "It must be in the pocket of my other jacket."

"Please bring it tomorrow. Don't forget," Füsun said, her eyes widening. "It is very dear to me."

Belkıs's Story

THE ACCIDENT featured prominently in all the papers. Füsun hadn't read them, but Şenay Hanım had talked about the dead woman all morning—until it seemed to Füsun as if people were coming into the shop just to talk about the accident. "Şenay Hanım is going to close the shop tomorrow at lunchtime, so that I can go to the funeral, too," said Füsun. "She's acting as if we all adored that woman. But that was not the case. . . ."

"What was the case?"

"It's true that this woman came to the shop a lot. But she'd take the most expensive dresses—the ones just in from Italy and Paris—and she'd say, 'Let me try out this one and see how it goes,' and after wearing it at some big party she'd bring it back, saying, 'It doesn't fit.' Şenay Hanım would get angry—after everyone had seen the woman wearing that dress at that party, it would be hard to sell. Also this woman drove a hard bargain, so Şenay Hanım was always talking behind her back, but she didn't dare cross her, because she was too well connected. Did you know her?"

"No. But for a while she was the sweetheart of a friend of mine," I said, stopping there because I reckoned I would better enjoy recounting the sordid background details to Sibel, yet I was amazed that this calculation left me feeling deceitful, since less than a week ago it would have caused me no discomfort to hide something from Füsun or even to tell her a lie—lies,

it had seemed to me, were an inevitable and rather enjoyable consequence of the playboy life. I considered whether I could cut the story here and there, adapting it for her consumption, when I realized that this would be impossible. Seeing she had guessed that I was hiding something, I said this: "It's a very sad story. Because this woman had slept with quite a few men, people spoke ill of her."

This wasn't my true impression. That's how recklessly I answered. There was a silence.

"Don't worry," said Füsun, almost in a whisper. "I won't ever sleep with anyone else for the rest of my life."

Returning to my office at Satsat, I felt at peace with myself, and for the first time in ages turning myself over to work, I took pleasure from making money. Together with Kenan, a new clerk who was a bit younger and bolder than I was, I went down the list of our hundred or so debtors, pausing now and again for a bit of levity.

"So what are we going to do with Cömert Eliaçık, Kemal Bey?" he asked, with a smile and his eyebrows raised, seeing as the man's name meant "Generous Open-Hand."

"We'll just have to open his hand a little wider. We can't help it if his name condemns him to loss."

In the evening, on the way home, I walked past the gardens of the old pasha's mansion, which had not yet burned down, and I breathed in the fragrance of lindens, seeking the shadows of the plane trees of Nişantaşı, now in full blossom. As I considered men angrily blowing their horns in the traffic jam I felt content, the love storm had passed, I was no longer racked with jealousy, and everything was back on track. At home I took a shower. As I took a clean ironed shirt out of the wardrobe, I remembered the earring; not finding it in the pocket

of the jacket where I thought I'd left it, I searched my wardrobe and every drawer, checked the bowl where Fatma Hanım put stray buttons, collar bands, and any spare change or lighters she found in my pockets, but it wasn't there either.

"Fatma Hanım," I called softly. "Have you seen an earring around here?"

The bright side room where my brother had lived until he married was scented with steam and lavender. Fatma Hanım had spent the afternoon ironing, and now, as she put away our handkerchiefs, shirts, and towels, she said she hadn't seen "earrings or anything." From the heap of unpaired socks in the basket, she pulled out one sock as if it were a naughty kitten.

"Listen to me, Claw Nails," she said, using one of her nicknames for me when I was a child, "if you don't cut your nails, you won't own a single sock without a hole in it. I'm not darning these for you anymore—that's final."

"All right, Fatma Hanım."

In the sitting room, in the corner that overlooked Teşvikiye Mosque, my father, covered by a spanking white apron, was sitting in a chair, with Basri the barber cutting his hair, and my mother, as always, sitting across from him, bringing him up to date.

"Come on over," she said when she saw me. "I'm reporting the latest gossip."

Basri had been feigning concentration on his work, but stopped trimming and, with a grin that showed his huge teeth, made it clear he'd been listening attentively all along.

"What's the latest?"

"You know how Lerzan's younger son wanted to become a race car driver? Well his father wouldn't let him, and so . . ."

"I know. He crashed his father's Mercedes. Then he rang the police saying it had been stolen."

"All right then. But did you hear what Şaziment did to marry her daughter off to the Karahans' son? Where are you going?"

"I'm not here for supper. I'm picking up Sibel. We're invited out."

"Go tell Bekri so that he doesn't fry the red mullet tonight for nothing. He went all the way to the fish market in Beyoğlu today just for you. Promise you'll come for lunch tomorrow so that we can eat them then."

"I promise!"

The corner of the carpet had been rolled up to protect it from my father's thin, white hair falling strand by strand onto the parquet floor.

I got the car out of the garage and as I bumped over the cobblestone streets I turned on the radio, tapping my fingers on the steering wheel in time with the music. In an hour I had crossed the Bosphorus Bridge and was in Anadoluhisarı. Sibel heard me and ran out to the car seconds after I had honked the horn for her. The first thing I said was that the woman who had died in the crash the day before had once been Zaim's lover ("You mean 'You-Deserve-It-All Zaim,' " she said with a smile); then I told her the whole story.

"Her name was Belkıs; she was a few years older than me, thirty-two or thirty-three, I guess. She came from a poor family. After she entered society, her enemies began to gossip about her mother's headscarf. In the late 1950s, when Belkıs was a lycée student, she'd met a boy at field day celebrations of the nineteenth of May, and they fell in love. This boy, Faris, was her age, the youngest son of the Kaptanoğlus, who had, as you know, made a fortune in shipping by then, to become one of

Istanbul's richest families. This romance between the rich boy and the poor girl was right out of some Turkish film and it went on for years. Their passion was so great or they were so stupid that these teenagers were making love and flaunting it. Certainly they should have married, but the boy's family convinced themselves that the poor girl had surrendered her virtue just to trick him into marriage, and that everyone knew this, so they opposed the match. It's clear that the boy lacked the strength, the cast of mind, and the personal income to stand up to his family, take the girl by the hand, and marry her. So the family's solution was to pack the boy off to Paris with the girl to live out of sight as an unmarried couple. Three years later because of drugs or despair the boy somehow died in Paris. Instead of running off with a Frenchman and never returning to Turkey, as might be expected in such situations, Belkıs returned to Istanbul, and launched herself into affairs with a string of other rich men, enjoying quite a colorful love life, as she drew the silent envy of other society women. Her second lover was Sabih the Bear; when she left him, she had an adventure with the eldest Demirbağ boy, who was then on the rebound from another romance. Because her next lover, Rıfkı, was similarly afflicted, society men began to refer to her as the 'Consoling Angel,' and they all dreamed of having affairs with her. As for all those rich married women who had slept with no one in their lives but their husbands, or at the most taken a lover in shame and secrecy, never with much satisfaction—when they saw this Belkıs openly courting the most eligible bachelors, to say nothing of her secret married lovers, they were so jealous they would have found a way to drown her in a spoonful of water, given the opportunity. But no need. As hard living had already taken a toll on her looks and as she was short of funds

it was becoming a struggle to keep herself presentable. So you could say the day of drowning was fast approaching. You could say that the accident put this woman out of her misery."

"It surprises me that not a single one of these men would marry her," said Sibel. "It means that no one ever loved her enough to take the plunge."

"Actually, men fall madly in love with women like that. But marriage—that's something else. If she had been able to marry the Kaptanoğlu boy, Faris, right away, and without having slept with him, people would have been quick to forget how poor her family was. Or if Belkıs had come from a wealthy family, they would have overlooked her not being a virgin when she married. Because she didn't take account of the rules and went on enjoying her sex life, all those society women, envious just a moment ago, began calling her the 'Consoling Whore.' But maybe for that very reason, because she gave herself to the first boy she ever loved, gave herself to her lovers without hiding it from anyone, perhaps we should have some respect for Belkıs, too."

"Do *you* feel respect for her?" asked Sibel.

"No, to be honest, I found the deceased repulsive."

The party—I forget the occasion—was on the long concrete patio of a house on the Suadiye shore. Sixty or seventy people were standing there with drinks in hand, conversing in near whispers as they looked to see who was there, who was just arriving. Most of the women seemed concerned about the length of their skirts, with the ones in short skirts uneasy in the extreme, imagining their legs were too short or too thick. Perhaps this was why, at first sight, they all looked like awkward, surly bar girls. Right next to the patio, on the jetty, a big sewer was emptying into the sea, producing quite a smell for guests as white-gloved waiters wandered among them.

After wandering around a bit myself, I met a "psychiatrist" who had just returned from America and opened an office; he gave me his new card the moment we met, and at the incitement of a vivacious middle-aged woman, he offered up a definition of love to the cluster of guests who were discovering him: When one forsook all other opportunities, wishing only to make love consistently with the same person, this feeling, which he held to be conducive to happiness, was "love." After the discourse on love, a mother, having introduced me to her beautiful eighteen-year-old daughter, sought my advice about where to send the girl to university, so as to spare her the Turkish universities' continual politically motivated boycotts. The conversation began with a discussion of a report in that day's papers about how, to prevent the theft of the question booklets for the university entrance exams, the printers had been subject to a prolonged sequestration.

Much later, Zaim appeared on the patio. He cut a handsome figure with his long limbs, sculpted chin, and beautiful eyes, and especially with the German model Inge, just as tall and elegant, on his arm. What stung hearts most about Inge, with her blue eyes, long and slender legs, fair skin, and natural blond hair, was the merciless reminder to the women of Istanbul society that even as they bleached their hair, plucked their eyebrows, and scoured boutiques for outfits that might let them feel more European, their darker skin and fuller figures were never entirely redeemed by such efforts. But I was less struck by the woman's northern looks than by her familiar smile that I enjoyed seeing every day in the newspaper ads and on the side of the apartment building in Harbiye—it was like seeing an old friend. Soon enough the inevitable crowd had gathered around her.

On the drive home Sibel broke the silence. "That You-Deserve-It-All Zaim, yes, I can see he is a good egg. But that fourth-rate German model, who looks like she would sleep with any Arab sheikh who asked . . . Wasn't it enough to use her in his ad campaign? Must he parade her around just so everyone knows he's bedded her?"

"I give Zaim credit for making a go of that new soft drink of his. I remember he once told me that Turks relish the taste of a modern Turkish product much more once they've seen Westerners enjoying it, too. . . . You know, it's highly likely that, in her friendly way, this model sees no difference between us and Arab sheikhs."

"When I was at the hairdresser I saw a photo of her with Zaim in *Hafta Sonu,* the centerfold, no less, and there was also an interview plus a very tacky picture of her half-naked."

The silence returned and remained for some time. At last I smiled and said: "You know that guy who was prattling away in broken German, complimenting her on the ads, and staring at her hair just to avoid looking at her breasts falling out of her dress—that big, bashful guy, Sabih the Bear . . . Well that was Belkıs's second lover."

But as we drove under the Bosphorus Bridge, obscured in the haze, I saw that Sibel had fallen asleep.

19

At the Funeral

THE NEXT day at noon I left Satsat and went home to eat fried red mullet with my mother as promised. As we removed the delicious and brilliant pink membranous skin, and with the care of a surgeon cut away the fine, translucent spine, we discussed the state of arrangements for the engagement party and the latest rumors (my mother's preferred word for gossip). Including those who had contrived to have themselves invited and a few other eager acquaintances whose hearts she couldn't bear to break, the list reached 230; so for that day, the maître d'hôtel of the Hilton had been obliged to take steps to ensure there would be enough "foreign liquor"—the term made it sound like a fetish. For this purpose he had begun to contact colleagues in the other big hotels as well as to cajole liquor importers with whom he'd had dealings. As for Silky İsmet, Şaziye, Left-handed Şermın, Madame Mualla, and all the other seamstresses who catered to society ladies and had once been friends and competitors of Füsun's mother, their order books were full and their apprentices were now working until dawn every night to outfit our guests in the elaborate dresses they had ordered for the engagement party. My mother seemed to have spurred our whole world to action, except for my father, who had been complaining of fatigue and was now dozing in the bedroom. It was not on account of his health, my mother thought, but rather that he was feeling despondent, though she

could scarcely imagine what could make him so upset, with his son on the verge of getting engaged, and so she began probing to see whether I might know the reason. When Bekri, as he had done since my childhood, brought in the pilaf that he invariably served after fish to aid digestion—this was an unbendable household rule—it seemed almost as if the fish had been the source of her high spirits, because once it was cleared away my mother took on a mournful tone.

"I feel so bad about that woman," she said, with genuine sorrow. "She suffered so much, and so many people were jealous of her. In fact she was a very good person. Very."

Without once referring to Belkıs by name, my mother recounted how years ago, when the Demirbağs' eldest son, Demir, had been her lover, my parents had spent time with them in Uludağ; and whenever my father and Demir went off to play poker, my mother and Belkıs would stay up long after midnight, drinking tea and knitting and chatting in the hotel's "rustic bar."

"She suffered so much, the poor woman, first on account of being so poor and then on account of men. Such suffering," my mother said, before turning to Fatma Hanım to say, "Bring my coffee out to the balcony. We're going to watch the funeral."

Except for my years in America, I had spent my whole life in this big apartment whose sitting room and wide balcony overlooked Teşvikiye Mosque, where one or two funerals took place every day, and when I was a child, these spectacles initiated us into the fearful mystery of death. Not just Istanbul's rich but also famous politicians, generals, journalists, singers, and artists had their funeral prayers said at the mosque, considered a prestigious point of departure for the "final journey," whereby the coffin was carried slowly on shoulders to

Nişantaşı Square—the procession accompanied, depending on the rank of the deceased, by a military band or the city council ensemble playing Chopin's Funeral March. When my brother and I were little we would put long, heavy bolsters from the divan on our shoulders and Bekri Efendi, Fatma Hanım, Çetin the chauffeur, and others would follow us as we hummed the funeral dirge, swaying slightly, just as the bearers of the dead did, on our way down the corridor. Just before a funeral of broad public interest—if the deceased was a prime minister, a famous tycoon, or a singer—the doorbell would ring and unexpected guests would appear, saying, "I was just passing by, and I thought I'd drop in," and though my mother never let her manners lapse, later on she would say, "They didn't come to see us but to see the funeral." And so we began to think of the ceremony not as a comfort against the sting of death or a chance to pay one's last respects to the deceased, but as an amusing diversion.

"Come over to this side, you'll have a better view," my mother said as I joined her at the small table on the balcony. But when she saw me suddenly go pale, with no evident enjoyment at watching the crowd of mourners, she drew the wrong conclusion: "You know, it's not that father of yours napping inside who is keeping me from attending the funeral of this woman I loved dearly. It's the men down there like Rıfkı, like Samim, who are wearing their dark glasses not to hide their tearful eyes, but to hide that they shed no tears. Well, anyway, you can see it much better from here. What *is* wrong with you?"

"Nothing. I'm fine."

Below the gate to the Teşvikiye Mosque courtyard, in the shaded area where women gathered as if by instinct, I'd seen Füsun among the covered women and the society women who,

for the occasion, had draped chic, fashionable scarves over their heads, and at that moment, my heart had begun to race. She was wearing an orange scarf. As the crow flies there were seventy, perhaps eighty meters between us. She was breathing, she was frowning, her soft skin was perspiring slightly in the midday heat; annoyed by the crowd of covered women pressing against her, she was biting her lower lip, shifting the weight of her slender body from one foot to the other—of course, I did not just see all these things, I felt them inside me. I longed to cry out to her from the balcony and wave, but as in a dream I had no voice, and my heart continued to pound.

"Mother, I have to go."

"Ah! What's come over you? Your face is deathly white."

On the street I watched her from afar. Şenay Hanım was next to her. As she listened in to her employer's conversation with a potential if not actual customer, a stocky but stylish woman, she ran her fingers over the ends of the scarf she had tied so awkwardly under her chin. The scarf had endowed her with a proud and sacred beauty. The Friday sermon was blaring on loudspeakers in the courtyard, but the sound was so bad that no one could make out what the preacher was saying, except for a few words about death being the last station and his boorish and insistent repetition of the word "Allah," a calculated bit of intimidation, I thought. From time to time, someone would rush into the crowd, as if arriving late to a party, and as all heads turned, a little black-and-white photograph of Belkıs would be pinned onto the latecomer's collar. Füsun carefully eyed everyone around her, as they greeted one another with a wave across the crowd, arms open for embrace, a hug of consolation, and mutual concern.

Like everyone else Füsun was wearing the photograph of Belkıs on her collar. It had become commonplace at funerals following political assassinations (so frequent in those days), and the custom had quickly gained currency among the Istanbul bourgeoisie. Many years later I was able to assemble a small collection of these tokens, and I display them here. When crowds of sighing (but inwardly content) socialites sporting sunglasses took to such displays, like so many right- and left-wing militants, these photographs would give an ordinary lighthearted society funeral intimations of an ideal that might be worth dying for, a hint of common purpose, and a certain gravitas. In imitation of the Western conceit, the photograph was framed in black, by which formerly happy images appropriated for death notices assumed the cast of mourning, and the most frivolous images could attain in death the somber dignity usually reserved for victims of political assassination.

I left without coming eye to eye with anyone, rushing off to the Merhamet Apartments, where I impatiently awaited Füsun. Every now and then I glanced at my watch. Much later, and without giving it much thought, I found myself parting the dusty curtains to look through the always closed window that gave onto Teşvikiye Avenue, and I saw Belkıs's coffin pass below slowly in the funeral car.

Some people spend their entire lives in pain, owing to the misfortune of being poor, stupid, or outcast from society— this thought passed through me, gliding by with the measured pace of the coffin, then disappeared. Since the age of twenty I had felt myself protected by an invisible armor from all variety of trouble and misery. And so it followed that to spend too much time thinking about other people's misery might make me unhappy, too, and in so doing, pierce my armor.

Füsun's Two Conditions

FÜSUN ARRIVED late. This upset me, but she was even more upset than I was. She explained that she had run into her friend Ceyda, but it sounded less like an apology than an accusation. Some of Ceyda's perfume had brushed off on her. Füsun had met Ceyda during the beauty contest. She'd been unfairly treated, too, coming in third. But now Ceyda was very happy because she was going out with the Sedircis' son, and this boy was serious; they were thinking about marriage. "That's wonderful, isn't it?" said Füsun, and as she gazed into my eyes her sincerity was arresting.

I was about to nod when she said there was a problem. Because the Sedircis' son was so "serious," he didn't want Ceyda working as a model.

"For example, now that it's summer, she's booked to do an ad for a swing set. But her boyfriend is very strict, very conservative. So he is forbidding her to appear in a commercial for a covered swing set built for two—forget about wearing a miniskirt, he won't even let her do it if she wears a dress that shows nothing. And Ceyda has completed a professional modeling course. Her picture is already in the papers. The manufacturer of the canopies for the swing sets is willing to use Turkish models, but the boy just won't have it."

"You should warn her that this man could have her under lock and key in no time."

"Ceyda has been ready to marry and become a housewife for ages," said Füsun, annoyed that I had failed to understand what she was talking about. "But her fear is that this serious man might not be so serious about her. I promised to get together and talk about it. What do you think, how can you tell if a man is serious?"

"How would I know?"

"You know exactly how men like this are. . . ."

"I know nothing about rich conservative types from the provinces," I said. "Come on, let's look at your homework."

"I didn't do any homework. Okay?" she said. "Did you find my earring?"

My first impulse was to go through the motions like some sly drunk driver stopped for a police search who knows full well that he has left his license at home, yet searches his pockets, his glove compartment, his bags, in a parody of good faith. But I caught myself in time.

"No, dear, I looked for your earring but couldn't find it," I said. "But don't worry—it will turn up sooner or later."

"I've had enough! I'm leaving and I'm never coming back!"

I understood from the misery on her face as she looked around to gather her things, even as she fumbled, unsure where to put her arms, that this outburst was not just theater. I planted myself in front of the door like a bouncer and begged her not to go, pelting her with professions of how deeply in love with her I was (all true), until I could see, from the hint of a happy smile in the corners of her mouth, and the effort she made to hide her pity—slightly raising her eyebrows—that she was beginning to relent.

"All right, I won't go," she said. "But I have two conditions. First, tell me who you love most in the world."

She saw at once that she had confused me, and that I could not answer with Sibel's name or her own. "Give me the name of a man. . . ." she said.

"My father."

"Fine. My first condition is this. Swear on your father's head that you'll never ever lie to me."

"I swear."

"Not like that. Say the whole sentence."

"I swear on my father's head that I'll never ever lie to you."

"That was too easy for you."

"What's your second condition?"

But before she could announce her second condition, we were kissing and soon gaily making love. We put so much into it this time and our love so intoxicated us that we felt ourselves transported to an imaginary place, a new planet. In my own mind's eye it was an alien surface, a silent, rocky desert island, the first photographs from the moon. Later Füsun would tell me her vision: a dark garden thick with trees, a window overlooking it, and in the distance the sea and a bright yellow hillside where sunflowers waved in the wind. Such scenes came to us at moments like this when our lovemaking surprised us— for example when I had taken into my mouth Füsun's breast and her ripe nipple, or when Füsun had buried her nose in the place where my neck joined my shoulders and was locking me in her arms with all her might, or when we read in each other's eyes a startling intimacy that neither of us had ever felt before.

"Okay, so now, my second condition," said Füsun, after our lovemaking, her voice full of elation.

"One day you're going to come to my house for supper with my mother and father, and you'll bring my earring and the tricycle I rode when I was little."

"Of course I will," I said, with the lightness that comes after lovemaking. "Except—what are we going to tell them?"

"If you ran into a relative on the street, wouldn't you ask after her mother and father? Wouldn't she invite you over? Or that day you walked into the shop and saw me—might you not have said you wanted to see my mother and father? Is it so unlikely that a relative would offer a girl a little help with her mathematics before the university entrance exam?"

"I certainly will come for a visit one evening, and I'll bring the earring, I promise. But let's not tell anyone about these math lessons."

"Why not?"

"You're very beautiful. They'll know at once that we're lovers."

"In other words, are you saying that this isn't Europe, so men can't be shut up in a room to do math with a girl without it leading to something else?"

"On the contrary, they can. I'm saying that because this is Turkey, everyone will assume they aren't there to do math, but something else. And knowing that everyone is thinking this, they start thinking about it, too. Worried about staining her honor, the girl will begin to say things like, 'Let's keep the door open.' Nevertheless, if a girl remains in that room with him for long, the man will think she's making a pass at him, and even if he hasn't done anything to her yet, he will eventually have to, because otherwise his manhood would be called into question. Before long their minds will be defiled with thoughts of the things everyone thinks they are already doing, and those thoughts will be irresistible. Even if they don't make love, they will begin to feel guilty and lose all confidence that they can stay in that room for long without succumbing to temptation."

There was a silence. With our heads on the pillow, our view was of the radiator pipe, the lidded hole for the stovepipe, the window cornice, the curtain, the lines and corners where the walls met the ceiling, the cracks in the wall, the peeling paint, and the layer of dust. It is to evoke that abiding silence for the museum visitor that, years later, we have re-created this view in such minute detail.

My Father's Story: Pearl Earrings

ON A SUNNY Thursday at the beginning of June—nine days before the engagement party—my father and I had a long lunch together at Abdullah Efendi's restaurant in Emirgân, and I knew even then that I would never forget it. My father, whose recent gloom was so troubling to my mother, had invited me, saying, "Before the engagement, let's go out, just the two of us, so that I can give you some advice." As we sat in the '56 Chevrolet, with Çetin Efendi at the wheel, where he had been since I was a child, I listened respectfully to my father's counsel (for instance, that I shouldn't confuse my business associates with my friends), for I assumed this was yet another pre-engagement ritual; and as I listened I opened my mind to the Bosphorus views slipping past the windows, the beauty of the City Line ferries as they rode the currents, and the shadows of the wooded gardens of the yalıs on the shores of the Bosphorus: Even at midday they were almost dark as night. Instead of repeating the lectures he'd perhaps heard as a child—instead, that is, of warning against laziness, frivolity, and daydreams, instead of compelling me to shoulder my duties and responsibilities—he reminded me, as the fragrance of the sea and pine trees blew through the open windows, that I needed to make the most of life, because God's gift is fleeting. Here I display the plaster bust by Somtaş Yontunç (it was Atatürk himself who had given him his name, which

means "Solid-Stone Sculptor") created ten years earlier, when, thanks to booming textile exports, and our soaring fortunes, my father had, on the advice of a friend, agreed to pose for this sculptor, who was connected to the Academy. I added the plastic mustache out of contempt for the academician, who rendered my father's whiskers far thinner than they really were, so that he would look more Western. When I was small and he scolded me for idleness, I would watch my father's mustache quiver as he spoke. When he warned me that working too hard might cause me to miss life's great beauties, I took it to mean that my father was satisfied with the innovations I had implemented at Satsat and the other firms. When he asked that in the future I also involve myself with some of the business dealings in which my older brother had recently expressed an interest, and I eagerly agreed, adding that we had all paid dearly for my brother's deeply conservative half measures in every family concern he touched, it wasn't just my father who smiled appreciatively—Çetin the chauffeur smiled, too.

Abdullah Efendi's restaurant had formerly been in Beyoğlu, on the main avenue next to Ağa Mosque. Back in those days it was where the rich and famous would stop for lunch if they were passing through the area or on their way to the cinema, but several years ago, after most of his customers had acquired cars, he had moved to the hills above Emirgân, to a little farm overlooking the Bosphorus. As we walked into the restaurant, my father assumed a jovial smile, shaking hands with the waiters he had known for years from the old Abdullah's and other restaurants. Then he surveyed the large dining room, searching for anyone he knew among the customers. As the headwaiter was guiding us to our table, my father stopped to chat with one party, and waved in the direction of another,

and flirted breezily with an elderly lady sitting at a third table with her daughter; this lady remarked how fast I'd grown up, how much I resembled my father, and how handsome I was. Once we had been seated by the headwaiter (who'd called me "little gentleman" throughout my childhood and, at some point, without anyone's quite having noticed, began calling me "Kemal Bey"), my father ordered a few hors d'oeuvres for us to share—pastries, smoked fish, and suchlike—and also *rakı*.

"You do want some, don't you?" he asked me, adding, "You know you can smoke, too, if you like," as if we had not come to a mutual understanding about my smoking in his presence after I'd returned from America.

"Bring an ashtray for Kemal Bey," he told one of the waiters.

He picked up a few of the cherry tomatoes that came from the restaurant's own greenhouse and sniffed them; as he knocked back his *rakı,* it seemed that there was something specific on his mind, though he had not yet decided how to broach the subject. For a moment we both looked out the window at Çetin Efendi in the distance, chatting with the other drivers waiting outside the entrance.

"Never forget Çetin Efendi's worth," my father said, sounding as if he were dictating his last testament.

"I do know his worth."

"I'm not sure you do. . . . I know he is always telling religious stories, but you should never laugh at them. He's an honest man, Çetin, and he's a gentleman, a thoroughly decent human being. He's been like that for twenty years. If anything should ever happen to me, don't send him away. Don't change cars every two minutes like those nouveau riche upstarts. The Chevrolet's a good car. . . . This is Turkey, look . . . when the

state banned the import of new foreign cars ten years ago, it turned Istanbul into a museum for old American cars, but what does it matter; we've ended up with the best repair shops in the world."

"I grew up in that car, Father, so you don't need to worry," I said.

"I'm glad to hear it," said my father, in a tone suggesting he had come to the real subject. "Sibel is very special, a very charming girl," he said, but no, this wasn't what he had brought me here to discuss. "You don't find such a person every day, do you? A woman, a rare flower like her—you must make sure you never break her heart. You must care for her always, and treat her with the utmost tenderness." Suddenly a strange, shameful expression appeared on his face. He began to speak impatiently, as if something had irritated him: "Do you remember that beautiful girl? . . . You know, the one you saw me with once in Beşiktaş. When you first saw her, what did you think?"

"Which girl?"

My father got even more annoyed. "Oh come on now, I'm talking about that very beautiful girl you saw me with in Beşiktaş, in Barbaros Park, you know, ten years ago."

"No, Father, I don't have any memory of this."

"My son, how could you not remember? We came eye to eye. There was a very beautiful girl sitting next to me."

"What happened next?"

"Not wishing to shame your father, you politely averted your eyes. Do you remember now?"

"No, I don't."

"No, you did see us!"

I truly had no such memory, but there was no convincing my father. After a long, awkward discussion, we agreed I must

have wanted to forget and succeeded in doing so. Or perhaps he and the girl had merely panicked, thinking I'd seen them. This is how we came to the real subject.

"That girl was my lover for eleven years, and she was very beautiful," said my father, proudly combining the two most important facts into a single sentence.

It was clear that my father had long dreamed of talking to me about this woman's beauty, and the thought that I might not have seen it with my own eyes, or, even worse, that I might have seen her but forgotten how beautiful she was—this had dampened his spirits a little. He pulled a small black-and-white photograph from his pocket. It was of a dark, sorrowful girl—very young—standing on the back deck of a City Line ferry in Karaköy.

"That's her," he said. "It was taken the year we met. It's a shame she's so sad here; you can't see how beautiful she was. She is beautiful, isn't she? Do you remember now?"

I said nothing. It annoyed me to listen to my father talking about an affair, no matter that it was ancient history. Though at that moment, I could not understand what exactly it was that bothered me.

"Look, I don't want you repeating any of what I say here to your brother," my father said, slipping the photo back into his pocket. "He's too stern, he wouldn't understand. You've been to America, and I'm not going to be telling you anything that would shock you. All right?"

"Of course, Father dear."

"So now listen," said my father, and as he took tiny sips of *rakı,* he told his story.

It was "seventeen and a half years ago on a snowy day in January 1958" that he'd first met that girl and was instantly

struck by her pure and innocent beauty. The girl was working at Satsat, which my father had only just started. At first it was just a working relationship, but despite the twenty-seven-year difference in their ages it became something more "serious and emotional." One year after the girl had begun relations with her handsome boss (my father, by my instant calculation, would have been forty-seven years old at the time) he forced her to leave Satsat. Again at my father's behest, she did not look for another job; instead she went quietly to live in an apartment in Beşiktaş that my father set up for her, dreaming that one day they would marry.

"She was very good-hearted, very sensitive, and clever—a very special person," said my father. "She wasn't like other women at all. I've had a few escapades in my life, but I never fell for anyone the way I fell for her. My son, I thought a lot about marrying her. . . . But what would have happened to your mother? What would have happened to you and your brother? . . ."

For a time we were silent.

"Don't misunderstand me, my child, I'm not saying I made sacrifices so that you could be happy. In fact, of course, she was the one who really wanted marriage. I kept her dangling for years. I just couldn't imagine life without her, and when I couldn't see her I suffered enormously. But there was no one to share my pain with. Then one day she said, 'Make up your mind!' Either I left your mother and married her, or she was going to leave me. Pour yourself some *rakı*."

There was a silence. "When I refused to leave you boys and your mother, she left me," said my father. To admit this exhausted him, but it also relaxed him. When he looked at my

face and saw that he could go on confiding in me, he became
more relaxed still.

"I was in pain, great pain. Your brother had married, and
you were in America. But of course I tried to hide my anguish
from your mother. To steal into a corner like a thief and suffer
in secret—that was another agony. Your mother had sensed
the existence of this mistress, just as she had with the others;
understanding that something serious was going on, she said
nothing. Your mother, and Bekri and Fatma Hanım—we lived
together like a cast of characters imitating a happy family in
a hotel room. I could see that I would find no relief, that if
it carried on this way I would go mad, but I couldn't bring
myself to do what was necessary. At the same time, *she*"—my
father never said her name—"was suffering just as much. She
announced that an engineer had proposed marriage and that
if I didn't decide soon, she was going to accept. But I didn't
take her seriously. . . . I was the first man she had ever been
with. I thought she could not possibly want anyone else, that
she must be bluffing. Even when I doubted my reasoning and
started to panic, I was still paralyzed. So I tried just not to think
about it. You remember that summer when Çetin drove us all
to Izmir, to the fair. . . . When we got back I heard that she had
got married, but I couldn't believe it. I was convinced she had
just put the news out to get my attention, and make me suffer.
She refused my every attempt to see her, even to speak with
her; she wouldn't answer the phone. She even sold the house
I'd bought for her and moved somewhere I couldn't find her.
Had she really married? Who was this engineer husband? Had
she had children? What was she doing? For four years I couldn't
ask anyone these questions. I feared the answers I might get,
but to know nothing was agony, too. To imagine her living in

another part of Istanbul, opening the papers to read the same news, watching the same TV programs, yet never to see her— it left me desolate. I began to feel as if life itself was futile. Please don't misunderstand me, my son—I certainly felt proud of you, and the factories, and your mother. But this suffering was unimaginable."

Because he'd been using the past tense, I sensed that the story had reached some sort of conclusion, and that my father had found some relief in his confession, but for some reason this displeased me.

"In the end, curiosity got the better of me, and one afternoon I rang her mother. The woman certainly knew all about me, but of course she didn't recognize my voice. I lied to her, passing myself off as the husband of one of her girl's lycée classmates. 'My wife is ill and it would boost her spirits if your daughter could come to see her in the hospital,' I said. Her mother said, 'My daughter is dead,' and began to cry. She'd died of cancer! I hung up at once so that I wouldn't cry, too. I wasn't expecting this, but I knew at once that it was true. She had never married an engineer. . . . How terrifying life can be, how empty it all is!"

When I saw the tears forming in my father's eyes, for a moment I felt utterly helpless. I understood his pain even as I felt anger, and the more I reflected on the story he had told me, the more my mind became muddled and I behaved as if I were a member of a tribe an old-fashioned anthropologist might describe as "primitive" and unable to think about its own taboos.

"So anyway," my father said, pulling himself together after a short silence, "I didn't bring you here just to upset you with tales of all my woes. But you're about to get engaged,

so it's fitting for you to know your father better. But there is something else I want you to know. Can you understand?"

"What is it?"

"What I feel now is only remorse," said my father. "I never paid her enough compliments, and I would give anything to be able to tell her a thousand times over what a charming, precious person she was. She truly had a heart of gold, a lovely, modest, utterly enchanting girl. . . . She wasn't like other beauties I've seen here. She never flaunted it, as if her loveliness were her own doing; she was never demanding, never expected gifts or flattery. You see, it's not just that I lost her; it's also that I know I didn't treat her as she deserved—that's why I still suffer. My son, you must know how important it is to treat women well—but now, not later, not when it is too late."

There was something ceremonial about that last pronouncement, as he reached into his pocket to bring out a faded velvet-covered jewel box. "That time we all went to the Izmir Fair, I bought these for her, so that she wouldn't be angry with me, so that she'd forgive me, but fate did not allow me to give them to her." My father opened the box. "Earrings were very becoming on her. These are pearls, very fine ones. For years I hid them away. But when I'm gone, I don't want your mother finding them. You take them. I've given it some thought; these will look very good on Sibel."

"Father dear, Sibel is not my mistress; she's going to be my wife," I said, looking into the box he'd handed to me.

"Come on, now," said my father. "You won't tell Sibel the story behind the earrings; she will never be the wiser. But when you see her wearing them, you'll remember me. You will never forget the wisdom I've imparted to you today. You'll treat that girl perfectly. . . . Some men always treat women badly, and

they're proud of it. Don't ever be one of them. Let my words remain on your ears as the earrings remain on Sibel's."

He closed the box, and with an old-fashioned gesture, pressing it into my hand with his own, as an Ottoman pasha might have pressed a tip into the hand of an inferior. "My boy," he said to the waiter, "why don't you bring us a bit more *rakı* and some ice. What a beautiful day it is, don't you think?" he said to me. "What a beautiful garden they have here. It smells of spring with all the linden trees."

It took me another hour to convince him that I had a meeting I couldn't cancel, and that, no, it wouldn't do for the big boss to phone Satsat and call off his son's appointment.

"So that's what you learned in America," he said. "I'm impressed."

I didn't want to refuse my father his happiness, so I drank another glass of *rakı,* though all the while I kept glancing at my watch, not wanting to be late for my rendezvous with Füsun, on this of all afternoons.

"Don't rush off, my son, let's sit here a little longer. See how easy we are with each other, a lovely conversation between father and son. Give me a moment before you go off to get married and forget us!" my father said.

"Father dear," I said, as we were leaving, "I can see how much you've suffered, and I will never forget this invaluable advice you've given me today."

As he got older, whenever he was overcome by a great emotion my father's lips would quiver at the edges. He took my hand and squeezed it with all his might. When I squeezed his in return, just as hard, it was as if I'd squeezed a sponge hidden in his cheeks, because suddenly his eyes welled.

He quickly composed himself, calling for the bill, and on

the way home, as Çetin drove so carefully that the car scarcely rumbled over the cobblestones, he dozed off.

Once at the Merhamet Apartments, I didn't suffer much indecision. After Füsun arrived, we kissed for a very long time, and then I took the velvet box from my pocket, explaining that I smelled of spirits because I'd had lunch with my father.

"Open it," I said.

And she did so, with great care.

"These are not my earrings," she said. "These are pearl."

"Do you like them?"

"Where is *my* earring?"

"It vanished into thin air, and then one morning I looked at my bedside, and there it was, with its mate. I put them both into this velvet box to reunite them with their beautiful owner."

"I'm not a child," said Füsun. "These are not my earrings."

"They are in spirit, darling—as I see it, anyway."

"I want my own earring."

"I'm giving you these as a present," I said.

"I couldn't ever wear these. . . . They're very expensive. Everyone would want to know where they're from. . . ."

"Don't wear them, then. But don't refuse my present."

"But this is something you've given me to replace my earring. . . . If you hadn't lost the one I left behind, you would never have brought me these. I have no way of knowing what you really did with it, if you actually lost it."

"I'm sure it will turn up one day, in some drawer at home."

"One day . . ." said Füsun. "How easily you say that. How irresponsible you are. When do you expect it to turn up exactly? How long will I have to wait?"

"Not very long," I said, scrambling to save the moment. "It

will be the day I take that tricycle and come to your house to have supper with your parents."

"I'll be waiting to hear from you, then," said Füsun. Then we kissed. "You reek of drink."

But I went on kissing her, and as we began to make love we forgot all our troubles. As for the earrings my father had bought for his lover—I left them at the flat.

The Hand of Rahmi Efendi

As THE day of the engagement party approached, I was so distracted by the preparations that there was no time left to worry about affairs of the heart. I recall sounding out my friends at the club, whom I'd known since childhood and whose fathers were my father's friends, and had long conversations on how to procure the champagne and other "European" beverages that we hoped to serve to our guests at the Hilton. May I remind visitors entering my museum in the future that in those days the import of foreign alcohol was strictly, one might even say jealously, limited by the state, and that even the state lacked the foreign currency reserves to pay importers for the full quantities allowed under the quotas, with the result that very little champagne, whiskey, or indeed any foreign alcohol came into the country legally. But there was never any shortage of champagne, whiskey, or American cigarettes, for delicatessens in rich neighborhoods were well stocked with black market goods, as were the bars in the city's most fashionable hotels, and likewise the thousands of tombala men who roamed the streets with their bags of black market raffle tickets. Anyone organizing an elaborate party felt compelled to offer "European" drinks, and it was left to the host to hunt down provisions for the hotel. Most head barmen at the larger establishments knew one another and would in such situations depend on colleagues to funnel extra bottles their way, thus

ensuring that unusually large functions came off without an embarrassing shortfall. Still one had to be mindful that the society pages enjoyed reporting the day after an event how much "real foreign" alcohol had been served, and how much of it was mere Ankara Viski.

If ever I had a free moment amid all this, Sibel would pick up the phone and we'd be off to see a new house with an enviable view, either in the hills above Bebek and Arnavutköy, or in the then emerging neighborhood of Etiler. Like her, I came to enjoy standing in these unfinished apartments that still smelled of plaster and cement, imagining the bedroom and the dining room, trying to figure out where the long divan we had seen in a Nişantaşı furniture store might be placed to provide the best possible prospect of the Bosphorus. At parties in the evenings Sibel did not rest from her day's calculations and only too happily regaled friends with impressions of the new neighborhoods, discussing our plans with others, apartment locations, their advantages and drawbacks; whereas I, feeling oddly constrained by shame, would change the subject, talk to Zaim about football, the success of Meltem soda, or the new bars, clubs, and restaurants that had just opened for the summer. My secret bliss with Füsun had made me more subdued in the company of friends, and more and more I preferred to watch the goings-on from the sidelines. Sorrow was slowly consuming me, though at the time I couldn't see it clearly, recognizing it only now, so many years later, as I tell this story. Then I noticed only that I had become more "quiet," as others were noting, too.

"You've been pensive lately," said Sibel late one night as I was taking her home in the car.

"Really?"

"We haven't exchanged a word for half an hour."

"That lunch I had with my father a while ago . . . my mind keeps going back to it. He can deny it, but to me he sounds like a man preparing for death."

On Friday the sixth of June, eight days before the engagement party and nine days before Füsun's university entrance exam, my father, my brother, and I went with Çetin in the Chevrolet to a house between Beyoğlu and Tophane, just below Çukurcuma Hamam, to offer our condolences. The deceased, an old employee from Malatya, had been with my father since he'd first gone into business. This kindly, hulking man was a part of the company family, and he'd been running errands for as long as I could remember. He had an artificial hand, his real one having been crushed in a machine on the factory floor. My father, who had liked this hardworking man a great deal, had transferred him to the office, and that was when we'd gotten to know him. In the beginning, my brother and I were terrified of the artificial hand, but because of Rahmi Efendi's big smile and his unfailing kindness to us, in time he made the hand into a toy for us. Once, I remember Rahmi Efendi going into an empty room, putting his artificial hand to one side, and spreading out his prayer rug; then he knelt down to say his prayers.

Rahmi Efendi had two strapping sons who were as good-hearted as he was. They both kissed my father's hand. His still buxom, pink-skinned, but careworn wife burst into tears the moment she saw my father, wiping her eyes with the edges of her headscarf. As he consoled her with a sincerity that neither my brother nor I could ever have matched, embracing the two sons and kissing their cheeks, he managed, in no time, to make all the other visitors in the room feel as if they shared one soul,

one heart. At the same time, however, my brother and I were each overcome by a crisis of guilt, he speaking in a didactic tone of voice, and I unable to resist reciting memories.

At times like this what matters is not our words but our demeanor, not the magnitude or elegance of our grief but the degree to which we can express fellowship with those around us. I sometimes think that our love of cigarettes owes nothing to the nicotine, and everything to their ability to fill the meaningless void and offer an easy way of feeling as if we are doing something purposeful. My father, my brother, and I each took a cigarette from the packet of Maltepes offered to us by the elder son of the deceased, and once they were all lit with the same burning match that the teenager artfully offered us, there followed a strange moment when all three of us crossed our legs and set about puffing in unison, as if enacting a ritual of transcendental importance.

A kilim hung on the wall in the way Europeans hang a painting. It must have been the unfamiliar taste of the Maltepe that caused me to entertain the illusion that I was having deep thoughts. The most important matter in life is happiness. Some people are happy, and others are not. Of course, most people fall somewhere in the middle. I myself was very happy in those days, but I didn't want to recognize it. Now, all these years later, I think that the best way to preserve happiness may be not to recognize it for what it is. I ignored it then, not out of a wish to protect it, but rather out of a fear of a great misery fast approaching, a fear that I might lose Füsun. Was it this that had made me so touchy and subdued?

As I looked around the small, threadbare, but immaculate room (there was a lovely barometer of the type so fashionable in the 1950s, and a beautifully executed framed calligraphy

saying Bismallah), there was a moment when I thought I was going to join with Rahmi Efendi's wife in crying. On top of the television was a handmade doily, and upon that was displayed a china dog. The dog looked as if it was about to cry, too. Nevertheless I remember that I felt comfort at seeing that dog, and thought about Füsun.

23

Silence

As the day of my engagement party approached, the silences between Füsun and me grew longer and deeper, and though we met every day for at least two hours, making love with ever greater passion, these silences infiltrated us like a poison.

"They've sent my mother an invitation to the engagement party," she said. "My mother was very pleased, and my father said we had to go, and they want me to come, too. Thank God the university exam is the next day, so I won't have to fake an illness to stay home."

"My mother sent the invitation," I said. "Under no account should you come. I don't even want to go myself."

I'd been hoping that Füsun would answer saying, "Then don't go!" but she said nothing. As the day of the engagement party drew near, we would embrace more forcefully, even perspiring more profusely, each wrapping arms and legs around the other, in the manner of longtime lovers who, when reunited, are desperate to close even the least space between them; and then we would lie there, quiet and still, as we watched the tulle curtains flutter in the breeze entering through the door.

Until the day of the engagement party, we met daily at the same time in the Merhamet Apartments. We never discussed our predicament, the engagement, what would happen afterward, instinctively avoiding any subject that called to mind these concerns. But this avoidance could precipitate

great silences. We would listen to the shouts and curses of the children playing football outside. Though in the early days we'd also refrained from discussing what was to become of us, there had nevertheless been no end of cheerful chatter, about our relatives in common, and evil men, and everyday Nişantaşı gossip. Now we were saddened to see our carefree days had ended so quickly. We felt the loss, a kind of unspoken misery. But the dreadful ache did not drive us apart—in a strange way it brought us closer together.

I sometimes caught myself thinking that I would be able to continue seeing Füsun after the engagement. This heaven, in which everything would go on as before, slowly evolved from a fantasy (let's call it a dream) into a reasonable hypothesis. If she and I could be this passionate, this generous, making love, then she could not possibly leave me, or so I reckoned. In fact, this was my heart talking, not my reason. I was hiding these thoughts even from myself. But in one part of my mind I was paying close attention to Füsun's words and actions, hoping they might tell me what she was thinking. Because Füsun was well aware of this scrutiny, she gave me no clues, and so the silences grew longer still. At the same time she was watching what I did, and making her own desperate calculations. Sometimes we would stare at each other like spies trying to probe each other's secrets. Here I display Füsun's white panties with her childish white socks and her dirty white sneakers, without comment, to evoke our spells of sad silence.

The day of the engagement party was soon upon us, and all the guessing came to naught. That day there was a champagne and whiskey crisis (one of the dealers had refused to surrender the bottles without cash in hand), and once I had resolved it I went to Taksim to have a hamburger and an *ayran* at the

Atlantic, my favorite buffet since childhood, and then on to my childhood barber, Cevat the Chatterbox. In the late 1960s, Cevat had moved shop from Nişantaşı to Beyoğlu, whereupon my father and the rest of us had moved on to another Nişantaşı barber named Basri, but whenever I happened to be in the neighborhood, and in the mood for some fun, I would go to Cevat's place just down the road from Ağa Mosque for a shave. Cevat was overjoyed to hear it was the day of my engagement party, and he went on to give me a "groom's shave," sparing no luxury, using imported shaving foam and a lotion he assured me was odorless, applying it with close attention to every hair and follicle. I walked all the way back to Nişantaşı, to the Merhamet Apartments.

Füsun arrived at the usual time. A few days earlier, I had muttered that we'd better not meet on Saturday, as her exam was on the next day, but after working so hard, she'd wanted to rest her mind. After all, she'd skipped work at the Şanzelize Boutique for two days on the pretext of studying for her exam. The first thing she did when she walked in was to sit down at the table and light a cigarette.

"I think about you so much that there's no room in my mind for mathematics," she said, laughing self-mockingly, as if what she'd said meant nothing, as if it were a stock phrase taken from a film, but then she turned deep red.

Had she not blushed so deeply, and betrayed such sorrow, I would have gone along with the joke. We would have acted as if it hadn't occurred to either of us that this was the day of my engagement party. It wasn't that way, though. An overwhelming and unbearable sorrow weighed down on both of us that no amount of joking and no amount of distracting talk could assuage; we understood that even sharing the misery would

not make it lighter, that the only escape from it was making love. But the melancholy inhibited our lovemaking and finally tainted it. At one point Füsun lay stretched out on the bed, as if she were a patient listening to her pain, and watching mournful clouds pass overhead. I stretched out beside her and joined her in looking at the ceiling. The children playing football outside had gone quiet, and all we could hear was the ball being kicked around. Then the birds stopped singing, until there was nothing to hear. Then, in the distance, a ship blew its horn, and then another.

We shared a whiskey in a glass that once belonged to Ethem Kemal—my grandfather, who was her great-grandmother's second husband—and we began to kiss. As I write these words I feel I should take care not to cause undue upset to those concerned souls who have taken an interest in my story, for a novel need not be full of sorrow just because its heroes are suffering. As always, we fiddled with the things in the room—my mother's discarded dresses, hats, and china figurines. As always, we kissed each other gracefully, having become so proficient in this art. Instead of pulling you into our melancholy, let me say that it felt as if Füsun's mouth had melted into mine. As our kisses grew ever longer, a honeyed pool of warm saliva gathered in the great cave that was our mouths combined, sometimes leaking a little down our chins, while before our eyes the sort of dreamscape that is the preserve of childish hope began to take form—and we surveyed it as if through a kaleidoscope. From time to time, one of us would, like a ravenous bird taking a fig into its beak, suck upon the other's upper or lower lip, as if about to swallow it, biting the imprisoned lip, as if to say, "Now you're at my mercy!" and having enjoyed this adventure of lips, and the frisson of being

at someone else's mercy, and awakening, at that moment, to the thrilling prospect of complete surrender, not just of one's lips but of one's entire body to a lover's mercy, we recognized that the gap between compassion and surrender is love's darkest, deepest region.

After making love we both fell asleep. When a sweet breeze blew in through the balcony, lifting the tulle curtains and dropping them like a silk veil onto our faces, we both awoke with a start.

"I dreamt I was in a field of sunflowers," said Füsun. "And the sunflowers were swaying strangely in the breeze. For some reason they scared me. I wanted to scream, but I couldn't."

"Don't be afraid," I said. "I'm here."

I won't say how we left, how we dressed and reached the door. After telling her to stay calm during her exam, and warning her not to forget her registration card, and assuring her that everything would go well, that she was sure to attain the score she needed, I said the thing that I had been repeating in my mind for days, thousands of times over, trying to make it sound as natural as possible.

"Let's meet at the same time tomorrow, okay?"

As she averted her eyes, Füsun said, "Fine."

I watched with love as she took her leave, and I knew at once that the engagement party would be a great success.

The Engagement Party

THESE POSTCARDS of the Istanbul Hilton were acquired
some twenty years after the events I describe; I picked up
some of them while strolling through small museums and
flea markets in this city and elsewhere in Europe, and others
I purchased in transactions with Istanbul's foremost collectors
in the course of assembling the Museum of Innocence. When,
after a lengthy bargaining session with the famously neurotic
collector Halit Bey the Invalid, I was able to acquire one of
these postcards depicting the hotel's modernist international-
style facade, and granted permission to touch it, I was
reminded not just of the evening of my engagement party, but
of my entire childhood. When I was ten, my parents attended
the opening of the hotel, a very exciting occasion for them,
along with all of Istanbul society, as well as the long-forgotten
American film star Terry Moore. We could see the new building
from our house, and though at first it looked foreign against
Istanbul's tired old silhouette, during the years that followed
my parents grew accustomed to it, going there whenever
they could. Representatives from the foreign firms to whom
my father sold goods—they were to a man all interested in
"Oriental" dancing—all stayed at the Hilton. On Sunday
evenings, when we would go as a family to eat that amazing
thing called a hamburger, a delicacy as yet offered by no other
restaurant in Turkey, my brother and I would be mesmerized

by the pomegranate-colored uniform with gold braids and flashy buttoned epaulettes of the doorman with the handlebar mustache. In those years so many Western innovations made their first appearance in this hotel that the leading newspapers even posted reporters there. If one of my mother's favorite suits got stained, she would send it to the dry cleaner at the Hilton, and she liked to drink tea with her friends at the patisserie in the lobby. Quite a few of my friends and relatives had their weddings in the grand ballroom on the lower level. When it became clear that my future in-laws' dilapidated house in Anadoluhisarı was not quite suitable for the engagement party, the Hilton was everyone's first choice. And it enjoyed one other distinction: The Hilton had been, since the day it opened, one of the few civilized establishments in Turkey where a well-heeled gentleman and a courageous lady could obtain a room without being asked for a marriage certificate.

There was still plenty of time to spare when Çetin Efendi dropped my parents and me at the revolving doors, which were shaded by a canopy in the form of a flying carpet.

"We still have half an hour," said my father, who always cheered up the moment he stepped into this hotel. "Let's go and have something to drink."

After we had chosen a corner of the lobby with a good view of the entrance, my father greeted the elderly waiter, who recognized him, and ordered "quick *rakı*s" for the men and tea for my mother. We enjoyed observing the evening crowds and—as the appointed time grew closer—watching our guests arrive, and reminiscing about the old days. Acquaintances, curious relations, and other party guests paraded just in front of us one by one in their chic outfits, but the thick leaves of a potted cyclamen shielded us from view.

"Aaah, look how much Rezzan's daughter has grown; she's so sweet," my mother said. "They should ban miniskirts on anyone who doesn't have the legs," she said, frowning at another guest. Then: "It wasn't us who seated the Pamuk family all the way at the back!" she said in answer to a question posed by my father, whereupon she pointed out some other guests: "Look at what's become of Fazıla Hanım. She used to be such a beauty, but nothing remains of it. Oh, I wish they had left her at home, if only I hadn't seen that poor woman like this. . . . Those headscarf people must be relations of Sibel's mother. . . . I've had no use for Hicabi Bey since he left that lovely rose of a wife and his children to marry that coarse woman. I'm going to thrash Nevzat the hairdresser—that shameless man gave Zümrüt exactly the same style as me. Who are these people? Look at the noses on that couple—my God, don't they look just like foxes? . . . Do you have any money on you, my son?"

"What for?" my father said.

"The way he came racing home, changing into his clothes as if he were just dashing off to the club, instead of going to his engagement party. Kemal darling, look at you, did you even remember your wallet?"

"I did."

"Good. Stand up straight when you walk, all right? Everyone's watching you. . . . Come on now, it's time for us to get going."

My father gestured to the waiter to bring him a single *rakı*, and after looking me in the eye, and gathering my own need for one, he repeated the hand gesture, indicating me this time.

"Now, you're not overdoing it, are you?" my mother said to my father. "I thought you'd picked yourself up and shaken off that gloom you've been wearing like an old coat."

"Can't I drink and enjoy myself at my son's engagement party?"

"Oh, how beautiful she looks!" said my mother when she saw Sibel. "And her dress, it's gorgeous; those pearls look perfect. But this girl is such a splendid creature that anything would look wonderful on her. What a charming sight, how elegant that dress looks on her, don't you think? My son, do you have any idea how lucky you are?"

Sibel was embracing two friends who had walked past us just a few minutes earlier. The girls were taking scrupulous care with the long, thin filtered cigarettes they had just lit, making an exaggerated effort not to muss each other's hair, makeup, or dress; their lovely bright red lips touched nothing as they exchanged kisses, giggling as they looked each other over and showed each other necklaces and bracelets not often removed from their boxes.

"Any intelligent person knows that life is a beautiful thing and that the purpose of life is to be happy," said my father as he watched the three beauties. "But it seems only idiots are ever happy. How can we explain this?"

"Here it is, one of the best days in the boy's life, so why are you spouting such thoughts, Mümtaz?" said my mother. She turned to me. "Go on, my son, what are you waiting for? Go to Sibel. Spend every moment at her side, share her joy!"

I put down my glass, and as I came out from behind the potted plant and walked toward Sibel I saw her face light up. "Where have you been?" I asked as I kissed her.

After Sibel had introduced me to her friends, we both turned around to watch the great revolving door.

"You look so beautiful, my darling," I whispered in her ear. "No one else comes close."

"And you're very handsome. . . . But let's not stand here."

All the same we continued to stand there, and not at my insistence. As people came flowing into the hotel—friends and strangers, guests and a handful of well-dressed tourists—heads kept turning to look at us, and Sibel liked being the center of so much admiring attention.

It is only now, so many years later, as I recall each and every person who came through those revolving doors, that I realize how insular and intimate was this circle of rich, Westernized families, and how familiar we all were with everyone else's business. There was the Halis boy, known to us since the days when my mother would take us to Maçka Park to play with our pails and shovels, and whose family fortune in olive oil and soap from Ayvalık did not prevent him from taking a wife with the same lantern jaw as everyone else in his clan ("inbreeding!" my mother charged). . . . There was Kadri the Sieve, my father's friend from the army, and mine from football matches, the former goalkeeper and now a car salesman, arriving with his daughters, each glittering with earrings, bracelets, necklaces, and rings. . . . The thick-necked son of a former president, who had gone into business and blackened his good name with corruption, arriving with his elegant wife. . . . And Doctor Barbut, who'd taken out the tonsils of every member of Istanbul society in the days when that operation was still fashionable—it wasn't just me but hundreds of other children as well who went into a panic at the mere sight of his briefcase and camel-hair coat. . . .

"Sibel's still holding on to her tonsils," I said, as the doctor gave me a warm embrace.

"Well, these days modern medicine has more modern ways of scaring beautiful girls into submission," said the doctor, repeating one of his oldest jokes as he gave me a wink.

As Harun Bey, the handsome representative for Siemens in Turkey, passed by, I feared my mother would notice and get annoyed. She judged this serene, mature man to be "an oaf, a disgrace," for undaunted by all the society cries of "Scandal! Calamity!" he had taken as a third wife the daughter of his second wife (in other words, his step-daughter). With his cool manner and his sweet smile, he had eventually been accepted back into the fold, though he still had to bear the occasional glare. Then there was Cüneyt Bey with his wife, Feyzan. Cüneyt Bey had bought up for next to nothing the factories and other assets of the Greeks and Jews who were sent off to work camps when they were unable to pay the "wealth tax" imposed on minorities during the Second World War. Though his overnight transformation from loan shark to industrialist offended my father, it was more by reason of jealousy than righteousness, and he was still a treasured friend. Their eldest son, Alptekin, had been my classmate in primary school, and when we discovered that their younger daughter, Asena, had been Sibel's, we were all so pleased as to agree the lot of us should get together very soon.

"Don't you think it's time to go downstairs now?" I said.

"You're very handsome, but you must learn to stand up straight," Sibel said, unknowingly parroting my mother.

Our cook, Bekri Efendi, Fatma Hanım, Saim Efendi the janitor, and his wife and children came through the revolving doors, one behind the other, looking very bashful in their best clothes, and each in turn shook Sibel's hand. Fatma Hanım and Saim Efendi's wife, Macide, had taken the chic scarves my mother had brought them from Paris and fashioned them to look like traditional headscarves. Their pimply sons were in suits and ties, and though they did not stare at her, they

could not hide their admiration for Sibel. After that we saw my father's friend Fasih Fahir and his wife, Zarife. My father didn't like it that his dear friend was a Freemason, and at home he would rail against the clandestine network of "influence and privilege" that had infiltrated the world of business, clucking his tongue whenever he pored over the lists of Turkish Masons put out by anti-Semitic publishing houses; but whenever Fasih was expected at the house, my father would hide away all the books with names like *Inside the Masons* and *I Was a Mason* that had so fascinated him.

Just behind him was a woman known to everyone in society, whom at first glance I mistook for one of our guests: Deluxe Şermin, the only female pimp in all of Istanbul (and perhaps the entire Muslim world). Around her neck was the purple scarf that was her trademark (since it concealed a scar from a knife wound, and she could never take it off) and at her side, in impossibly high heels, was one of her beautiful "girls." Walking into the hotel like guests, they headed straight for the patisserie. And here was the strange, bespectacled Faruk the Mouse (as children we used to go to each other's birthdays, because our mothers were friends), and there, behind him, were the Maruf boys, onetime playmates of mine, as our nurses were friends. Their family, whom Sibel knew well from the club Cercle d'Orient, had made a fortune in tobacco.

The aged and rotund former foreign minister, Melikhan, who was to present our rings, came through the revolving doors with my future father-in-law, and because he had known Sibel as a child, he threw his arms around her and kissed her. He looked me over and turned back to her.

"I'm very happy for you!" he said. "And he's handsome! Congratulations, my boy," he said, and he shook my hand.

Sibel's girlfriends, all smiles, came to join us. The former foreign minister took on the air of a playboy, heaping extravagant praise on them for their dresses, their jewelry, and their upswept hair, in that tongue-in-cheek way that is the preserve of indulged old men, and when he had kissed each one on the cheek he went downstairs, as if never more pleased with himself.

"I've never liked that bastard," said my father, heading down the stairs.

"For God's sake, let it go!" said my mother. "Watch the steps."

"I can see them," said my father. "I'm not blind yet, thank God." When he saw the view from the garden—Dolmabahçe Palace and beyond it the Bosphorus, Üsküdar, and Leander's Tower—and the crowd of chattering guests, he cheered up. I took him by the arm, and as we walked among the waiters offering colorful canapés, we began the long process of greeting our guests, offering each kisses on the cheek and a suitable interval of small talk.

"How proud you must be of your son, Mümtaz Bey. He's the spitting image of you at that age. . . . I feel as if I'm looking at you when you were young."

"I'm still young, madam," said my father. "But I'm afraid I don't recognize you. . . ." Then he turned to me. "Would you mind letting go of me?" he whispered sweetly. "You're holding my arm too tight and I'm not lame."

I discreetly extracted myself. The garden sparkled with beautiful girls. Most were wearing stylish open-toed high heels, and I imagined the expectant and joyful care with which they must have painted their toenails fire engine red. Though they were in sleeveless or backless dresses with plunging necklines,

it cheered me to see how much more at ease they were in this fashion than they were in their usual short skirts. Just like Sibel, they were clutching small shimmering handbags with metal clasps.

Sometime later Sibel took me by the hand and introduced me to a large number of relatives, childhood friends, classmates, and other chums I'd never heard of.

"Kemal, I'd like to introduce you to a very dear friend of mine," she said each and every time, her face beaming, and she would go on to praise that person in a voice that, for all its joyous sincerity, still carried the weight of obligation. The joy was most certainly the effect of life having gone her way, exactly the way she planned. She had devoted such an effort to the perfect placement of every pearl on her dress, made sure every crimp and curl was in impeccable harmony with every curve on her body, and now with the evening proceeding so smoothly, she assumed that she could just as smoothly slip into a happy future. This was why Sibel treated each passing moment, each new face, each embrace, as a fresh cause for jubilation. From time to time she would nestle up to me, and with maternal attentiveness she would use her thumb and her forefinger to pick off an imaginary hair or piece of lint from my shoulders.

Whenever there was a pause in the greeting and joking, I raised my head to survey the guests and the waiters carrying trays of canapés among them and I could tell from the level of laughter and chatter that the drinks were beginning to relax them. All the women were lavishly made up and extravagantly dressed. In their filmy, tight-waisted, sleeveless dresses, they looked as if they would soon be feeling the chill, while the men seemed trussed up in their stylish white suits, buttoned

up as tightly as boys in their outgrown holiday best—and ties that were colorful by Turkish standards, aping the wide, loud, patterned "hippie" ties so fashionable three or four years earlier. It was clear that many rich, middle-aged men had either not heard or refused to believe that the rage for big sideburns, Cuban heels, and long hair had finally run its course. The effect of these overlong and now outdated sideburns, kept in deference to fashion, together with the more traditional black mustaches, was to make the men's faces look very dark. As the smells of aftershave and brilliantine (applied with particular liberality on the thinning hair of men over forty), the ladies' heavy perfumes, the clouds of cigarette smoke to which everyone contributed, more out of habit than for pleasure, the odor of cooking oil from the kitchens—as the confluence of odors swirled into the spring breeze, I was reminded of being a child at my parents' parties. Even the elevator music that the orchestra (the Silver Leaves) was playing, half ironically, to set the mood for the evening, whispered to me that I was happy.

By now the guests, especially the elderly, had tired of standing, and hungry people were already looking for their tables, with little children forging ahead ("Granny! I found our place!" "Where? Stop, don't run, you'll fall"). Just then, the former foreign minister came up from behind to take me by the arm. With consummate diplomatic skill he drew me to one side to remind me that he had known Sibel since she was a child, and to impress on me, at great length, how elegant and refined she was, and what charming, cultured people her parents were, illustrating these points with examples from his own fond memories.

"Old, sophisticated families like theirs are in short supply these days, Kemal Bey," he said. "You are in the world of

business, so you know better than I do that we're being swamped by ill-mannered nouveaux riches, and provincials with their headscarf-wearing wives and daughters. Just the other day I saw a man with two wives trailing him, draped in black from head to toe, like Arabs. He'd taken them out for ice cream to Beyoğlu. . . . So tell me, are you ready to marry this girl and do everything to make her happy for the rest of your life?"

"Yes, sir, I am," I said. I could not help noticing that the former minister was disappointed by the lack of jolliness in my reply.

"Engagements are not to be broken. It means that this girl's name will be linked with yours until the end of your lives. Have you given this serious thought?"

The guests were already pouring in and forming a circle around us.

"I have."

"Well then, let's get you engaged so that we can eat. If you would take your place . . ."

I could tell he hadn't warmed to me, but that did not dampen my mood. The former foreign minister began by telling the assembled guests a story from his army days. He, like Turkey itself, had been very poor forty years ago, and he recounted, with genuine feeling, how he and his dear departed wife had become engaged without fanfare or ceremony. He declared his high regard for Sibel and her family. There wasn't much wit in what he said, but even the waiters who had retired to the side holding their trays smiled as if listening to an entertaining story. When Hülya, the sweet, bucktoothed ten-year-old whom Sibel loved dearly (and who was utterly fascinated by her), came forward with the silver tray bearing the rings I display here, the crowd fell silent. Sibel and I were so excited, and the former

foreign minister so distracted, that we got into a hopeless muddle about which ring went where. But by now the guests were ready for a laugh, and so when a few people cried out, "Not that finger, it goes on the other hand," a general titter circulated through the crowd, until the rings finally found their proper places, and then the former foreign minister cut the ribbon binding them, to a spontaneous round of applause sounding like a flock of pigeons taking flight. Even though I had prepared myself for this, the sight of so many people I had known all my life clapping for us and warmly smiling made me as giddy as a child. But this was not what set my heart racing.

For in the back of the crowd, standing next to her mother and father, I'd seen Füsun. A rapturous wave washed over me. As I kissed Sibel's cheeks, as my mother came to our side and I embraced her, and then my father, and my brother, I realized what it was that had made me so joyful, though I still thought I could hide it, not just from the crowd, but from myself, too. Our table was right on the edge of the dance floor. Just before we sat down I saw Füsun sitting with her parents at the very back, right next to the table for the Satsat employees.

"You both look so happy," said my brother's wife, Berrin.

"But we're so tired, too," said Sibel. "If this is what it takes to pull off an engagement party, just imagine how tiring the wedding is going to be."

"You'll be very happy on that day, too," said Berrin.

"How do you define happiness, Berrin?" I asked.

"Goodness, what a question," said Berrin, and she behaved as if she were considering her own happiness, but because even to joke about such a thing made her uncomfortable, she smiled bashfully. Amid the babble of conversation, the guests' chatter, occasional cries, the clink of knives and forks, and the strains

of music, we both heard my brother's loud, shrill voice as he regaled someone with a story.

"Family, children, and good company," Berrin said. "Even if you're not happy"—here, she indicated my brother with her eyes—"even when you're having your worst day you live your life as if you are. All sorrows fade away when you're surrounded by your family. You should have children right away. Have lots of children, just like peasants."

"What's going on here?" said my brother, joining us. "Tell me what you're gossiping about."

"I'm telling them to have children," said Berrin. "How many should they have?"

No one was looking, so I downed my half glass of *rakı* in one gulp.

A little later Berrin whispered into my ear: "That man at the end of the table, and that charming girl next to him—who are they?"

"That's Nurcihan, Sibel's dear friend since lycée days—they also went to France together. Sibel has seated her next to my friend Mehmet, hoping to get something started."

"Doesn't look very promising so far!" said Berrin.

Sibel felt a mixture of admiration and compassion for her friend Nurcihan. When they were students in Paris, Nurcihan had had several love affairs, which she'd courageously consummated, even moving in with a few of these men (Sibel had enviously told me all these stories), and all the while keeping this life secret from her wealthy parents in Istanbul; but with time these adventures had left her feeling sad and drained, so now, under Sibel's influence, she was plotting a return to Istanbul. "But for obvious reasons," I added, after telling all this to Berrin, "she'll need to fall in love with someone who

appreciates her worth, someone at her level, who won't be troubled by her French past, or her old lovers."

"Well, if you ask me, it's not happening tonight," she whispered. "What sort of business is Mehmet's family in?"

"They have money. His father is a well-known building contractor."

As Berrin saucily raised an eyebrow in snobbish suspicion, I told her that although his family was very religious and conservative, Mehmet was a trusted friend of mine from Robert College, an honest and decent man who had for years refused to let his headscarf-wearing mother arrange a marriage for him to an educated Istanbul girl, because he wanted to marry someone of his own choosing, a girl he could go out with. "But so far he's got nowhere with the modern girls he's found for himself."

"He'll never get anywhere," said Berrin with a knowing air.

"Why not?"

"Just look at him. You can tell that type from a mile off," said Berrin. "Men like him from the heart of Anatolia . . . Girls would rather marry him through a matchmaker because they know if they go gallivanting about town with him too much, a man like this will secretly begin to think of them as whores."

"Mehmet doesn't have that mentality."

"But he's from that mold. That's what his family is like, that's where he comes from. A girl with brains doesn't judge a man by the way he thinks. She looks at his family, at the way he deports himself."

"You do have a point," I said. "I've seen brainy girls like this—no need to mention names—who shy away from Mehmet, even when he's clear he's serious about them, but when they're around other men, even when they're not sure the

men would marry them, they're much more relaxed, and much better at getting the ball rolling."

"Exactly," said Berrin proudly. "I can't tell you how many men in this country treat their wives with disrespect even years later, just for having allowed them some intimacy before marriage. Let me tell you something: Your friend Mehmet has never really been in love with any of those girls who did not allow him to approach them. If he had been, those girls would have sensed it, too, and they would have treated him differently. I'm not saying they would have slept with him, of course, but they would have let him get close enough to make marriage a possibility."

"But the reason that Mehmet couldn't fall in love with them was that they wouldn't let him get close enough, because they were conservative and frightened."

"That's not the way it works," said Berrin. "You don't have to sleep with someone to be in love. The sex is not what matters. Love is *Leyla and Mecnun*."

I said something like "Hmmmmm."

"What's going on over there?" my brother shouted from the other end of the table. "Tell us, please! Who's sleeping with whom?"

Berrin gave him a look that said, There are children listening! Then she whispered into my ear. "That's the crux of it," she said. "Why can't this seemingly meek Mehmet of yours fall in love with any of these girls he wants to meet, or start something serious with them?"

Out of respect for Berrin's intelligence, I was tempted for a moment to tell her that Mehmet was an incorrigible patron of whorehouses. He had "girls" he visited regularly in four or five private establishments in Sıraselviler, Cihangir,

Bebek, and Nişantaşı. Even as he struggled in vain to form deep attachments with the women he met at work—virgins in their early twenties with lycée diplomas—he'd continued to frequent the high-class brothels for wild all-nighters with girls impersonating Western movie stars, though when he drank too much it became obvious what a hard time he had keeping up the pace, or even thinking straight. Nevertheless, when we emerged from a party in the wee hours, instead of returning to his house where his father was forever fretting over his worry beads and his mother brooded in her headscarf, and everyone, including his sisters, kept the fast during Ramadan, he would bid us good-bye and head to one of the pricier brothels of Cihangir or Bebek.

"You're drinking rather a lot this evening," said Berrin. "Slow down a little. There are a lot of people here and they're all watching the family."

"Fine," I said, as I lifted my glass with a smile.

"Just look at Osman, how responsible he is," said Berrin. "Then look at you, so mischievous at your own engagement. . . . How could two brothers be so different?"

"Actually," I said, "we're very similar. And anyway, from now on I'm going to be even more serious and responsible than Osman."

"Well, don't go overboard. People can be so boring when they're too serious," Berrin began, and she continued in this half-hectoring vein until, much later, I heard, "You're not even listening to me."

"What? Of course I'm listening."

"All right, then tell me what I just said!"

"You said, 'Love has to be the way it is in the old legends. Like *Leyla and Mecnun.*' "

"I knew you weren't listening to me," said Berrin with a half smile, from which I could see she was worried about me. She turned to Sibel, to see if she had noticed what condition I was in. But Sibel was talking to Mehmet and Nurcihan.

That I'd not been able to put Füsun out of mind all this while; that throughout my conversation with Berrin I'd felt her presence behind me, at her table in the back; that I kept wondering how she was doing and what she must be thinking—I'd been trying to hide this from myself just as I've been keeping it from my readers, but enough! You already know that I failed. So from now on I'll be straight with you.

I found an excuse to leave the table. I can't remember what pretext I came up with. I cast my eyes over the back of the garden, but I couldn't see Füsun. The place was very crowded, and as always, with everyone talking at once, shouting to be heard, and children shrieking as they played hide-and-seek among the tables, and the clink of knives and forks going on over their heads—a cacophony the orchestra only exacerbated—it added up to quite a roar. I walked through this infernal din toward the back, hoping to catch sight of Füsun.

"Many congratulations, my dear Kemal," I heard someone say. "How much longer till the belly dance?"

This was Selim the Snob, who was sitting at Zaim's table. I laughed, as if he'd said something hilarious.

"You've made an excellent choice, Kemal Bey," a nice matron told me. "You probably don't remember me. I'm your mother's . . ."

But before she could make the connection, a waiter with a tray pushed me aside to make his way between us. By the time I had gathered my bearings, the well-wishing woman had been carried away in the flow of the crowd.

"Let me see your ring!" said a child, roughly twisting my hand.

"Stop, don't be rude!" said the child's fat mother, seizing the child roughly by the arm. She lunged, as if to slap him, but the brat was wise to her ways and wriggled out just in time. "Come here and sit down!" cried his mother. "I'm so sorry . . . and congratulations."

A middle-aged woman I'd never seen before was laughing herself red in the face, but when our eyes met she suddenly became serious. Her husband introduced himself—he was a relation of Sibel's, but apparently we'd both done our military service at the same time in Amasya—and he invited me to sit down with them. I surveyed the tables at the back of the garden, hoping to catch sight of Füsun, but she seemed to have vanished into thin air. Misery spread through my body.

"Are you looking for someone?"

"My fiancée is waiting for me, but of course I'd love to sit down and have a drink with you. . . ."

They were very pleased, and at once they pushed together their chairs to make room for one more. No, I didn't need a place setting, just a little more *rakı*.

"Kemal, my friend, have you ever been introduced to Admiral Erçetin?" the man asked, pointing at the gentleman across the table.

"Yes, of course," I said. In fact I had no memory of him.

"Young man, I am Sibel's father's aunt's sister's husband!" the admiral told me humbly. "I congratulate you."

"Please excuse me, Admiral. I didn't recognize you out of uniform. Sibel speaks highly of you."

In fact, Sibel had told me how a distant cousin of hers had years ago spent the summer in Heybeliada and fallen in love

with a handsome naval officer; thinking that this admiral must be one of those grandees that rich families treat so well so as to have someone to pull strings whenever they have dealings with the state, or when they need to arrange the deferment of some son's military service, I hadn't paid particular attention to her tale. I now had a strange urge to ingratiate myself by saying, "When is the army going to step in, sir? How much longer can we be pushed to the brink by communists on the one side and reactionaries on the other?" but I was composed enough to know that if I said these things in my present addled state, I would be judged drunk and disrespectful. Suddenly something prompted me to stand up, and there, in the distance, I saw Füsun.

"I'm afraid I'm neglecting our other guests. I think I'd better get up, gentlemen!"

As always after drinking too much, I felt like my own ghost trying to take its first solo walk outside the body.

Füsun had returned to her table in the back. In a dress with spaghetti straps, her bare shoulders had a healthy glow. She'd had her hair done, too. She was so very beautiful that even from that distance it filled my heart with joy and excitement to catch a glimpse of her.

She acted as if she hadn't seen me. Four tables closer was the fidgety Pamuk family, and so, to close the distance between me and Füsun, I went over to greet Aydın and Gündüz Pamuk, who at some point had done some business with my father. All the while I kept my antennae tuned to Füsun's table, whose proximity to the Satsat table had created the opportunity for my young and ambitious employee Kenan, who could not take his eyes off Füsun, to strike up a conversation with her.

Like so many formerly rich families that had squandered their fortunes, the Pamuks had turned in on themselves and found it upsetting to come face-to-face with new money. Sitting with his beautiful mother, his father, his elder brother, his uncle, and his cousins was the chain-smoking twenty-three-year-old Orhan, nothing special about him beyond his propensity to act nervous and impatient, affecting a mocking smile.

Rising from the tedious Pamuk table, I walked straight over to Füsun. How to describe the expression on her face when she realized that she couldn't ignore me—that I had been so bold as to approach her with love in my eyes? At once she blushed, her deep pink skin glowing with life. From the looks Aunt Nesibe was giving me, I guessed that Füsun had told her everything. First I shook her hand, which was dry, and then I shook hands with her father, who had long fingers and slender wrists like his daughter's, and he gave no sign of knowing anything. When it was my beloved's turn, I took her hand, and with tenderness and propriety, I kissed her on both cheeks, furtively inhaling the tender spots on her neck and below her ears that had brought me such pleasure only hours ago. The question I couldn't get out of my head—"Why did you come?"—now took the form of "How good of you to come!" She had put on just a bit of eyeliner and some pink lipstick. With her perfume, the makeup gave her an exotic womanly air. But her eyes were red and puffy like a child's, so I knew that after we had parted that afternoon she had gone home and spent the early evening crying; but no sooner had I worked this out than she assumed the demeanor of a confident, well-bred woman who knew her own mind.

"Kemal Bey, I know Sibel Hanım. You've made a very wise choice," she said bravely. "Congratulations."

"Oh, thank you."

"Kemal Bey," her mother said at the same time. "I can only imagine how busy you are. God bless you for giving so much of your time to helping our daughter with her mathematics."

"Her exam is tomorrow, isn't it?" I asked. "She should be heading home early to get plenty of rest."

"I understand you have every right to be concerned," said her mother. "But while she was working with you she got very upset. Give her your permission to have a little fun for an evening."

I gave Füsun a compassionate, teacherly smile. With all the noise from the crowd and the music, it seemed that no one could hear us. I saw in the looks Füsun was giving her mother the same flashes of anger I'd seen during our trysts in the Merhamet Apartments; I took one last look at her beautiful, half-exposed breasts, her wondrous shoulders, and her childish arms. As I turned away I felt happiness overwhelm me like a giant wave crashing.

The Silver Leaves were playing "An Evening on the Bosphorus," their version of "It's Now or Never." If I didn't believe with all my heart that absolute happiness in this world can only happen while living in the present and in the arms of another, I would have chosen this instant as "the happiest moment of my life." For I had concluded from Füsun's mother's words and her own hurt and angry looks that she could not bring herself to end our relationship, and that even her mother seemed to have resigned herself to this state of affairs, though with certain expectations. If I proceeded with great care and let her know how much I loved her, Füsun, I now understood, would be unable to break off relations with me for as long as I lived! The manly pleasures outside the realm of morality that God granted just a few favored slaves—the happiness that my

father and my uncles had had only a taste of, and rarely before their fifties, not before they had suffered terrible torment—it seemed to me now that I was going to be able to enjoy the same good fortune—partaking of all the pleasures of a happy home life with a beautiful, sensible, well-educated woman, and at the same time enjoying the pleasures of an alluring and wild young girl—all this while I was still in my thirties, having scarcely suffered for it, or paid a price. Though not at all religious, I have engraved in my memory what I still regard as a postcard of bliss, sent by God: the image of merry guests, now dispersed to the outer reaches of the garden, and beyond them among the plane trees and the colored lamps, the landscape, the lights of the Bosphorus and the deep blue sky.

"Where have you been?" said Sibel. She'd come out to look for me. "I was worried. Berrin said you had had a bit too much to drink. Are you all right, darling?"

"Yes—I did overdo it in there, but I'm feeling better now, dear. My only problem now is that I'm too happy."

"I'm also very happy, but we have a problem."

"What?"

"It's not working with Nurcihan and Mehmet."

"Well, if it's not to be, it's not to be. What matters tonight is that we're happy."

"No, no, they both want this. If only they could let their guard down a little, I'm positive they'd be on the road to marriage in no time. But they just can't seem to break the ice. I'm afraid that they'll miss their chance."

I watched Mehmet from a distance. He just couldn't get Nurcihan to warm to him, and when he realized how clumsy he'd been he got angry and damned himself into still further awkwardness.

I motioned to Sibel to sit with me at a small service table piled high with clean plates. "We may be too late for Mehmet. . . . It may not be possible to find him a proper, decent wife."

"Why?"

As her eyes grew large with fear and curiosity, I told Sibel that Mehmet would never find happiness anywhere but in a heavily perfumed room with red lamps. I ordered a *rakı* from the waiter who darted over as soon as we were seated.

"You seem to know quite a bit about these places!" said Sibel. "Did you visit them with him before you knew me?"

"I love you so much," I said, putting my hand on hers, and I didn't mind when the waiter shot an inquisitive glance at our engagement rings. "But Mehmet must surely be wondering if he can ever be deeply in love with any decent girl. In fact he must be panicking."

"Oh, what a pity!" said Sibel. "It's all because of those girls who shied away from him. . . ."

"Well, he shouldn't have scared them off. The girls are right to be careful. What happens to them if they have slept with a man and he doesn't marry them? If word gets out and she's left in the lurch, what is she to do?"

"It's something she just knows," said Sibel carefully.

"What is?"

"Whether she can trust a man or not."

"It's not so simple. Many girls suffer terribly, being unable to make up their minds. Or else they give in to desire but are too afraid to take any pleasure from it. . . . I don't even know if there is any girl out there who can enjoy it for what it is and damn the consequences. And Mehmet, if he hadn't listened to all those stories of sexual freedom in Europe with his mouth watering, he might not have got it into his head that he had to have sex

with a girl before marrying her, just to be modern or civilized; he'd probably have been able to make a happy marriage with a decent girl who loved him. Now look at him, squirming in that chair next to Nurcihan."

"He knows that Nurcihan slept with men in Europe. . . . I know this intrigues him, but it scares him, too," said Sibel. "Come on, let's go give him a hand."

The Silver Leaves were playing "Happiness," a mawkish piece of their own composing. But I was in the mood and it moved me. As I felt my love for Füsun coursing through my veins—such pain, and such bliss—I was nevertheless able to appear paternalistic, lecturing Sibel that Turkey, too, would probably be modern like Europe in a hundred years' time, and that when that day arrived everyone would be free of worries about virginity and what people thought, free to make love and be happy as it is promised one in heaven. But until then most people would continue to agonize over love, and suffer sexual pain.

"No, no," said my beautiful and good-hearted fiancée. "If we can be this happy *today,* then so can they. Because we're definitely going to get Nurcihan and Mehmet married."

"Okay, then, what's the plan?"

"What a fine sight—engaged for only an hour and already off in a corner by yourselves?" This was a portly gentleman neither of us knew. "May I join you, Kemal Bey?" Without waiting for an answer he grabbed a chair from the side and sat down next to us. He was relatively young, perhaps in his forties, to be sporting a white carnation on his lapel and wearing a sickly sweet perfume, for women, and enough of it to make one faint. "When the bride and groom retire to a corner, a wedding loses its joy."

"We're not a bride and groom yet," I said. "We're only engaged."

"But everyone is saying that this splendid engagement party is more sumptuous than the grandest wedding, Kemal Bey. Where might you have the wedding, apart from the Hilton?"

"Excuse me, but with whom have I the pleasure of speaking?"

"Forgive me, Kemal Bey, you have every right. We writers assume that everyone knows who we are. My name is Süreyya Sabır. You may know me by my pen name, 'White Carnation,' in *Akşam*."

"Yes, of course, there can't be anyone in Istanbul who doesn't read you to find out the latest society gossip," said Sibel. "I always assumed you were a woman—you know so much about fashion and clothes."

Carelessly I interrupted her to ask, "Who invited you?"

"Thank you for the compliment, Sibel Hanım. But in Europe, refined men with a knowledge of fashion are not uncommon. And Kemal Bey, the Turkish press regulations allow journalists to attend gatherings that are open to the public, on condition that we show this press card. By statute, any gathering announced by invitation is 'open to the public.' All the same, I have never once attended a party to which I had not been invited. I am here this lovely evening at the invitation of your esteemed mother. Because of her modern outlook, she knows the value of what you call society gossip, which I prefer to call news, so she invites me to many of her parties. So great is the trust between us that sometimes when I can't attend a particular party we'll speak of it on the phone the next day, and when I sit down to write I quote her word for word. Because— like you, my dear girl—she pays precise attention to everything

and never gives false reports. There has never been a mistake in my society news column, Kemal Bey, and there never will be."

Sibel mumbled something like, "I'm afraid you misunderstood Kemal's question. He meant nothing by it."

"Just now there were a number of vipers saying Istanbul's entire supply of black market whiskey and champagne must be in this room. Our country is suffering from a shortage of foreign currency reserves, we don't have the wherewithal to keep our factories going or to buy diesel! There are some, Kemal Bey—jealous enemies of wealth—who would write articles asking, 'Where does all this black market alcohol come from?' just to cast a cloud over this lovely evening. . . . Because I would never dream of trying to upset you, I shall forget your thoughtless words at once, for all eternity. Because we have a free press in Turkey, I shall ask that you answer a single question truthfully."

"Of course, Süreyya Bey."

"Just a moment ago I caught you two wrapped up in a serious discussion, and I was curious. What were you talking about, so soon after your engagement?"

"We were wondering whether the guests had enjoyed their food," I said.

"Sibel Hanım, I have good news for you," said White Carnation in joyous tones. "Your future husband just doesn't know how to tell a lie!"

"Kemal has a very good heart," said Sibel. "What we were talking about was this: Who knows how many people at this gathering are in anguish over who knows what trouble with love, marriage, or even sex."

"Oooh, yes," said the gossip columnist, at her uttering of the word that had recently been discovered by the press, indeed,

had turned into something of a fetish; and because he couldn't decide whether it was better for him to act as if he had just heard an admission worthy of scandal, or whether he might be better advised to show his empathy for the depth of human suffering, for a moment he fell silent. "You, of course, are modern, happy people, at ease in this new age," he said at last. "You've put all this pain behind you." He did not say this sardonically, but with an effortless sincerity cultivated through experience, which taught that in difficult situations the best thing was always to flatter people. Feigning feeling for others not as fortunate as we, he began to tell tales about our guests: the daughter who was hopelessly in love with so-and-so's son; the girl who was being ostracized by good families for being too free in her ways while all the men lusted after her; the mother who had set her cap for a certain rich playboy as her son-in-law; the slovenly son of another wealthy family who had fallen in love, though he was promised to another. Sibel and I could not help but be entertained by his stories, and when White Carnation saw this he relished telling them all the more. He was just explaining that all these "disasters" would be obvious once the dancing had begun, when my mother arrived to tell us we were being very rude, and everyone was looking at us; she ordered us back to our table.

No sooner had I taken my seat next to Berrin than the image of Füsun fired up in my mind's eye with full force, as if a television set had just been plugged in. But this time the light from that image exuded joy, not sadness, illuminating not just this evening but my entire future. For a brief moment I recognized myself among those men whose real source of happiness is their secret lover, but who pretend it is their wives and children—I, too, was acting as if it was Sibel who made me happy, and we weren't even married yet.

After chatting for a while with the gossip columnist, my mother came over to our table. "Take care around these journalists, will you?" she said. "They write all sorts of lies; they do terrible mischief. And then they make threatening calls to your father, asking him to buy more advertising space. Why don't you two get up and start the dancing. Everyone is waiting for you." She turned to Sibel. "The orchestra is warming up. Oh how sweet you are, how beautiful."

Sibel and I danced to a tango that the Silver Leaves were playing. All the guests were watching, and this gave our happiness the illusion of depth. Sibel draped her arm over my shoulder as if to embrace me, and pressed her face against my chest as close as if we were dancing alone in a dark corner of a discotheque; from time to time she smiled and murmured something, and after we'd made a turn I would look over her shoulder at whatever person she had remarked on a moment ago—the waiter whose heavy tray had not prevented his pausing to smile at our bliss, or her mother weeping for joy, or a lady whose hair resembled a bird's nest, or Nurcihan and Mehmet turning their backs on each other now that we had left them alone, or the ninety-year-old gentleman who had made his fortune during the Great War and who could no longer eat without the help of his servant, who was wearing a string tie—but I did not once look at the back of the garden, where Füsun was sitting. As Sibel kept up her cheerful chatter, it was better if Füsun didn't see us.

There was a burst of applause; it didn't last long, and we carried on dancing as if nothing had happened. When other couples got up to dance, we returned to our table.

"You did very well. You looked so good together," said Berrin. At that point, I think, Füsun was not yet among the

dancers. Sibel was fretting so over Nurcihan and Mehmet's lack of progress that she asked me to speak to Mehmet. "Tell him to come on a little stronger," said Sibel, but I did nothing. Berrin got involved at this point, and in a whisper she told us that forcing the issue was a bad idea; she'd been watching the whole thing from her side of the table and it wasn't just Mehmet; they had both been standoffish, or at least nervous, and if they didn't like each other there was no point in pushing them together. "No," said Sibel, "weddings cast a kind of spell. It's at weddings that many people meet the person they end up marrying. It's not just girls that get into the mood at weddings; it's boys, too. But you have to help them along. . . ." "What are you talking about? Tell me, too," said my brother as he joined the whispering conversation, and once he had been apprised of things, he pointed out in hortatory tones that while the days of arranged marriages were over, Turkey wasn't Europe, and there weren't many ways couples could get to know each other, with the result that a lot of the burden had fallen on the shoulders of well-meaning informal matchmakers. Then, apparently forgetting that Nurcihan and Mehmet had sparked the debate, he turned to Nurcihan, saying, "I imagine, for example, that you would never consent to a marriage arranged by a matchmaker, am I right?"

"So long as the man is nice, it doesn't matter how you find him, Osman Bey," said Nurcihan with a giggle.

We all laughed as if we'd heard something so outrageous it could only be a joke. But Mehmet turned deep red and looked away.

"Don't you see?" Sibel whispered into my ear a bit later. "She frightened him off. He thought she was making fun of him."

I was not watching the people on the dance floor at all. But when our museum was established, Mr. Orhan Pamuk recalled that Füsun had danced with two people early on. He didn't know or couldn't remember her first dance partner, though I worked out that it must have been Kenan from Satsat. The second, however, was the young man with whom I had exchanged glances a short time earlier while visiting the Pamuk family table—Orhan Pamuk himself, as he proudly told me years later. Those interested in Orhan Bey's own description of how he felt while dancing with Füsun should look at the last chapter, entitled "Happiness."

While Orhan Bey was dancing the dance that he would describe to me with utter frankness many years after the fact, Mehmet decided he had had enough of Nurcihan's giggles and our double entendres about love, marriage, matchmakers, and "modern life" and left the table. At once our spirits dropped.

"That was very rude of us," said Sibel. "We broke the boy's heart."

"Don't say that looking at me," said Nurcihan. "I didn't do any more than you did. You've all had a lot to drink and you're having a good time. Mehmet is the one who is frustrated in life."

"If Kemal brings him back to the table, will you behave nicely, Nurcihan?" asked Sibel. "I know you could make him very happy. And he you. But you have to treat him well."

It seemed to please Nurcihan to see Sibel so openly determined to set her up with Mehmet. "No one's talking about getting married tomorrow," she said. "He met me, he could have said one or two nice things to me."

"He is trying. He's just not used to talking with a girl as self-possessed as you are," said Sibel; giggling, she whispered the rest of what she had to say into Nurcihan's ear.

"Do you people know why boys in this country never learn how to flirt with girls?" asked my brother. He assumed that charming expression he wore whenever he'd had something to drink. "There's nowhere to flirt. We don't even have our own word for 'flirt.'"

"I remember your idea of flirting," said Berrin. "Before we got engaged, you'd take me to the cinema on Saturday afternoons. . . . You'd bring a portable radio with you, so that you could find out about the Fener match during the five-minute intermission."

"Actually, I didn't bring the radio with me to tune in to the match, but to impress you," said my brother. "I was proud to be the owner of the first transistor radio in Istanbul."

Then Nurcihan admitted that her mother used to brag about being the first person in Turkey to use an electric blender. She went on to tell us how, in the late 1950s, years before canned tomato juice became available, her mother was offering her friends tomato, carrot, celery, beet, and radish juice when they came over to play bridge, and as the ladies were all sipping from crystal glasses, she would proudly take them into the kitchen to show them the first electric blender to arrive in the country. As we listened to light music from that era, we remembered how the Istanbul bourgeoisie had trampled over one another to be the first to own an electric shaver, a can opener, a carving knife, and any number of strange and frightening inventions, lacerating their hands and faces as they struggled to learn how to use them. We talked about all those tape recorders brought back from Europe that usually broke on first use, and the hair dryers that blew the fuses, the coffee grinders that frightened the servant girls, the mayonnaise makers for which no spare parts were to be found

in Turkey, but which no one had the heart to throw away and so relegated to a remote corner of the house to gather dust. Meanwhile, as we were laughing about all this, You-Deserve-It-All Zaim sat down in the seat Mehmet had vacated, and within four or five minutes he had managed to enter the swim of the conversation and was whispering into Nurcihan's ear, making her laugh.

"What happened to that German model of yours?" Sibel asked Zaim. "Did you ditch her like all the others?"

"Inge wasn't my lover. She's gone back to Germany." Zaim spoke without losing any of his good humor. "We were just business associates, and I was only taking her out to show her Istanbul by night."

"So you're telling me you were just friends," said Sibel, using one of the expressions newly popularized by the celebrity magazines.

"I saw her today, at the cinema," said Berrin. "She turned up on the screen, sipping that soft drink with that same beckoning smile." She turned to her husband. "I went at lunchtime—the power was out at the hairdresser's. I went to the Site—it was Jean Gabin with Sophia Loren." She turned to Zaim. "I see her everywhere—in every single kiosk in the city; and it's not just children drinking Meltem now, it's everyone. You're to be congratulated."

"We timed it well," said Zaim. "We've been lucky, too."

Seeing the puzzlement in Nurcihan's eyes, and knowing that Zaim would expect me to explain, I quickly informed Nurcihan that my friend was the owner of Şektaş, the company that had recently launched Meltem, and that he'd also introduced us to Inge, a lovely German model who could be seen in the advertisements all over the city.

"Have you had the opportunity to taste our fruit-flavored soft drinks?"

"Of course I have. I especially liked the strawberry," said Nurcihan. "Even the French haven't been able to put out something that good in years."

"Do you live in France?" asked Zaim.

Zaim invited all of us to visit the factory that weekend, also promising a Bosphorus cruise and a picnic in Belgrade Forest just outside the city limits. The entire table watched him and Nurcihan. A short while later they got up to dance.

"Go find Mehmet," said Sibel. "Get him to rescue Nurcihan from Zaim."

"Are we sure she wants to be rescued?"

"I don't want to see my friend swallowed whole by this embarrassing Casanova whose only ambition in life is to lure girls into bed."

"Zaim has a very good heart, and he's honest. He just has a weakness for women. Can't Nurcihan have a bit of fun here as she did in France? Is it absolutely necessary for her to get married?"

"French men don't look down on a woman just because she's slept with a man before marriage," said Sibel. "But here even a little fun can get you a reputation. Besides, I don't want to see Mehmet's heart broken."

"I don't either. But I also don't want other people's love affairs to overshadow our engagement."

"You don't seem to appreciate the pleasures of match making," said Sibel. "If these two get married, just think of it, Nurcihan and Mehmet could be our closest friends for years."

"I doubt Mehmet is going to be able to peel Nurcihan away from Zaim tonight. He shies away from confrontations with other men at parties."

"That's why you have to go have a word with him, tell him not to be scared. I'll handle Nurcihan, don't you worry. Go— go and bring him back here right away." As I stood up she gave me a tender smile. "You're very handsome," she said. "Don't stop and gab. Come back at once and take me off to dance."

It had occurred to me that I might run into Füsun as I made my way from table to table in search of Mehmet, through the crowds of merry, shouting, half-intoxicated revelers, shaking my hand. There were three friends of my mother's who had come to our house every Wednesday during my childhood to play bezique. With the same spontaneity that must have prompted them all to dye their hair the exact same shade of brown, they and their three husbands simultaneously began waving to me from their table, calling "Ke-maaaal" as if summoning a child. Next I saw an importer friend of my father's who ten years later would be notorious for bringing down the minister of customs and excise who'd asked him for an obscenely large bribe, which he'd delivered inside an enormous baklava box packed with stacks of bills with a picture of Antep on the top. He'd later released to the public verbatim the intimate conversation that had ensued, recorded on the tape machine he'd secured under his arm with Gazo brand tape. He is now etched in my memory with his white tuxedo, his gold cuff links, his manicured nails that were doused in the perfume that remained on my hand long after he shook it.

As it was with so many of the faces in the photographs my mother trimmed so meticulously for arrangement in our albums, I found many of the faces in the crowd so familiar,

so close, that it made me terribly uneasy when I was unable to work out the relations among them—who was whose husband, or whose sister.

"Kemal darling," said an amiable middle-aged woman at just that moment. "Do you remember proposing to me when you were six years old?" It was only when I saw her stunning eighteen-year-old daughter that I recognized her. "Oh, Aunt Meral, your daughter looks just as you did then!" I said to my mother's second cousin. When the mother told me that they were regretfully obliged to leave early, because the daughter was taking the university exam the next day, I realized that between me and my jovial aunt there were as many years— twelve, to be exact—as between me and her gorgeous daughter, an awareness that produced a momentary stupor, before I yielded to the urge to glance in the very direction I had been avoiding, but Füsun was not visible at the table in the back or on the crowded dance floor. It was shortly thereafter that this photograph was taken of me with "Ship-Sinker Güven," who ran an insurance company. You can't see my face, just my hand in the photo that I acquired years later from a collector whose home was littered with piles and piles of photographs of weddings and other parties from the Hilton. In another that would be taken three seconds later, the gentleman banker in the background would be shaking my hand, having introduced himself as an associate of Sibel's father, this revelation having caused me to remember with some surprise that every time— that is to say, both times—I had been to Harrods in London, I'd seen this gentleman banker lost in thought as he was picking out an appropriately dark suit for himself.

Making my way through the crowd, stopping to pose for souvenir photographs, I marveled at how many brunettes

had bleached their hair blond; and how many of the rich, flashy men were wearing almost identical ties, watches, rings, and thick-soled shoes, and how their mustaches and sideburns were trimmed to equally disturbing uniformity, but at the same time I recalled that I knew them all and that we had many fond memories in common, and this was enough to stir a wave of nostalgia, and also wonderment at the blessed life before me, and the unparalleled beauty of the summer evening that carried the scent of mimosa. I greeted Turkey's first Miss Europe, who had, after the age of forty, and two failed marriages, devoted herself to fund-raising balls sponsored by associations working on behalf of the poor, the disabled, and the orphaned ("Forget idealism, my dear, she takes a percentage," my mother used to say), and who visited my father's office once every two months, seeking his support. I remarked on the beauty of the evening to the lady whose shipping magnate husband had been shot in the eye and killed during a family feud, and who had, ever after, been teary-eyed at family gatherings. It was with great respect that I shook the soft hand of Celâl Salik (I display a column by him here), then Turkey's best-loved, strangest, and most courageous columnist. I sat down for a photograph with the sons, daughter, and grandchildren of the late Cevdet Bey, one of Istanbul's first Muslim businessmen. At another table of some guests invited by Sibel, I entered into a wager about the likely outcome of *The Fugitive,* the television series that had captivated all of Turkey and whose final episode was to be aired the following Wednesday: Dr. Richard Kimble had been hunted down for a crime he didn't commit, and being unable to prove his innocence, would always, always be on the run!

In the end I did find Mehmet comfortably perched on a stool in the bar adjacent to the garden, drinking *rakı* with Tayfun, a classmate of ours.

"Oooh, all the bridegrooms are here at last," said Tayfun as I sat down to join them. It was not just that we were delighted to see each other; his remark brought back happy memories that caused us all to smile. During our last year at Robert College the three of us would often hop into Tayfun's father's Mercedes on an afternoon and head for a glitzy brothel lodged in an old pasha's mansion in the hills above Emirgân, where every time we would sleep with the same charming, lovely girls. These girls, who'd joined us for a spin in the car a few times and for whom we felt a deep affection we were at pains to conceal, charged us much less than they did the aging loan sharks and drunken businessmen they serviced in the evenings. The madam, an old, high-class prostitute, always treated us courteously, as if we were meeting at a society ball at the Cercle d'Orient in Büyükada. But every time she saw us in our school jackets and ties, clearly on our lunch hour, in the hallway where in the evenings her miniskirted girls would sit on divans, smoking and reading *photoroman*s while waiting for customers, the madam would burst out laughing, and call out, "Giii-iirls! Your schoolboy bridegrooms are here!" Thinking it might cheer Mehmet up to recall those happy days, I reminded him of the time when, having drifted off to sleep after making love in those rooms warmed by the spring sun streaming through the closed shutters, we gave as our excuse to the aged schoolmistress: "We were studying biology, madam," and that from then on, "studying biology" was our code word for visiting the brothel. We remembered there was a sign on the front of the mansion, reading CRESCENT HOTEL-RESTAURANT, and that the girls

had botanical aliases—Flower, Leaf, Daphne, Rose. Once on an evening visit we'd just retired upstairs with the girls when a famous tycoon turned up with his German partners; knocking on our doors, the madam had quickly extracted her girls and sent them downstairs to belly dance for the foreign guests. As consolation, we were given permission to sit quietly at a table in the back of the restaurant to watch. And as they gyrated in their sparkling, sequined harem outfits, we knew it was us, and not the aging moneybags, whom they were trying to entrance. We spoke with longing of watching them dance, knowing that we'd loved them and that we'd never forget our times in that place.

Whenever I returned from America for summer vacation, my chums Mehmet and Tayfun were always keen to fill me in on the latest bizarre developments, for every time there was a new chief of police, the rules of engagement changed. For example, there was an establishment occupying a seven-story Greek building on Sıraselviler Avenue; for a time the police were raiding it daily, but sealing off only one floor, obliging the girls there to take their admirers to another one that was, nonetheless, adorned with the same furniture and mirrors. . . . In one of the side streets of Nişantaşı there was an old mansion where the bouncers ejected any guest or interested party whom they deemed not rich enough. And then there were the mobile services of Deluxe Şermin, whom I'd seen earlier that evening at the hotel entrance, and who a dozen years ago had been known to cruise around in her finned 1962 Plymouth, making a tour of the Park Hotel, the Divan, and Taksim, stopping occasionally for her two or three girls to be claimed. If you phoned ahead, she would even do "home deliveries." My friends' wistful tones suggested that they had found far greater satisfaction in these places, and with these girls, than they ever

could in the company of "good" girls atremble with worries about their honor and virginity.

I couldn't see Füsun at her table, but her mother and father were still sitting there. I ordered another *rakı* and asked Mehmet about the newest establishments. Tayfun boasted that he had all the most up-to-date information on the newest and most luxurious brothels, and then, as if to prove the point, he presented me with a malicious recitation of famous deputies caught during vice raids, married acquaintances who once spotted in the waiting room would gaze abruptly out the window to avoid his eye, and generals well known for their presidential aspirations who had died of heart attacks in the arms of twenty-year-old Circassian girls in beds overlooking the Bosphorus, though the official story would have them dying in bed beside their wives. As a soft, sweet, melody laden with memories played in the background, I could see that Mehmet balked at Tayfun's venom. I changed the subject, reminding him that Nurcihan had come back to Turkey to marry, adding that she had even told Sibel she liked him.

"She's dancing with Zaim the Sodaman," said Mehmet.

"Only to make you jealous," I said, without once looking at the couple on the dance floor.

After a few moments of coyness, Mehmet admitted that he had found Nurcihan attractive, and that if she "really was serious" then of course he would be glad to sit next to her and whisper sweet nothings, and that if everything worked out, he would be grateful to me for life.

"Then why didn't you treat her well from the very beginning?"

"I don't know, I just couldn't."

"Come on, let's go back to the table, before someone takes your place."

Heading to the table, stopping en route to embrace many guests, I was glancing at the dance floor, scanning it for Nurcihan and Zaim, when I saw Füsun dancing . . . with Satsat's young and handsome new clerk Kenan. . . . Their bodies were far too close. . . . An ache spread through my stomach as I returned to my seat.

"What happened?" asked Sibel. "No matter, it's not going to happen with Nurcihan, she's just mad about Zaim. Just look at the way they're dancing. Oh, don't look so sad. I'm sure you did your best."

"You've got it wrong. Mehmet's willing."

"Then why are you looking so grim?"

"I'm not."

"My darling, it's very clear that the joy has gone out of you," said Sibel with a smile. "It's about time you stopped drinking."

The orchestra going without pause from one number to the next was now playing a slower, more soulful tune. At the table there was a silence, a very long one, and I could feel jealousy's venom mixing with my blood. But I did not wish to acknowledge this. Neither Mehmet nor I was looking at the dance floor, but I could tell from the looks on people's faces that the change in tempo had pushed couples there closer together, to the pleasure of some at the table and the annoyance of others. My brother was talking, and after so many years I can't remember a thing he said, but I do remember trying to pay close attention. Just then the orchestra began to play a number even more syrupy and romantic than the one before, and now even Berrin and Sibel, oblivious a moment ago, were

registering reactions to the sight of the dancing couples as they wrapped their arms around each other even tighter. My heart and mind were in utter disarray.

"What were you saying?" I asked Sibel.

"What? I wasn't saying anything. Are you all right?"

"Shall we send the Silver Leaves a note, requesting a short break?"

"Why? Oh, for goodness' sake, let the guests dance," said Sibel. "Look, even the shy ones are dancing with the girls they've had their eyes on all evening. Believe me, half of them will end up marrying these same girls."

I did not look. Neither did I let my eyes meet Mehmet's.

"Look, here they come," said Sibel.

For a moment I thought it was Füsun approaching with Kenan, and my heart began to race. But it was Nurcihan and Zaim who were returning to the table. My heart was still beating madly. I jumped up and took Zaim by the arm.

"Come, let me introduce you to a special drink at the bar," I said, and I took him over there. As we made our way through the crowd, again through a gauntlet of hugs and kisses, Zaim exchanged a few pleasantries with two girls who'd shown interest in him. Seeing how hopelessly one of them gazed at him (she had long black hair and the Ottoman hooked nose) I remembered hearing gossip about her falling desperately in love a few summers earlier, and attempting suicide.

"All the girls adore you," I said when we sat down. "What's your secret?"

"Believe me, I don't do anything special."

"Did nothing special happen even with the German model?"

Zaim flashed a coy, cool smile. "I'm not at all happy about my reputation," he said. "If I ever found someone as

wonderful as Sibel, I'd really want to get married, too. I have to congratulate you—I mean it. Sibel is a fabulous girl. And I can see in your eyes how happy you are."

"Actually I'm not so happy right now. This is what I wanted to talk to you about. I need some help."

"I'd do anything for you, you know that," he said, looking deep into my eyes. "Trust me, and tell me right away."

As the bartender was preparing our *rakı*s, I looked over at the dance floor. Had Füsun, swaying with the sentimental swill, let her head fall onto Kenan's shoulder? That part of the floor was too dark for me to see, and every attempt to catch sight of her refreshed my pain.

"There's a girl who's a distant relation of my mother's," I said. "Her name's Füsun."

"The one who was in the beauty contest? She's dancing over there."

"How do you know?"

"She's too beautiful," said Zaim. "I see her whenever I walk past that boutique in Nişantaşı. Like everyone else, I slow down when I'm passing and look inside. She has the sort of beauty you just can't get out of your head. Everyone knows who she is."

Worrying that Zaim might now say something that would make it awkward for both of us, I said, "She's my lover." I saw a ripple of jealousy cross my friend's face. "Just to see her dancing with someone else causes me pain right now. I might even say I am madly in love with her. I'm trying to think of a way out. I wouldn't want something like this to go on for too long."

"Yes, the girl is wonderful, but the situation couldn't be worse," said Zaim. "And you're right, you can't let something like this go on for too long."

I didn't ask him why. Nor did I ask myself whether it was in fact jealousy or contempt I saw in my friend's face. But it was clear that I couldn't tell him right away what I wanted him to do. I felt a need to tell him first about the depth and sincerity of this thing between Füsun and me; I wanted him to respect it. But as I began to reveal how I felt for Füsun, it was clear to me that my drunkenness would allow me to express only the most ordinary parts of the story, and that if I attempted emotional candor he would think me feeble and laughable, and even, despite his own dalliances, hold it against me. I suppose that in the end what I really wanted from my friend was his recognition, not of how sincere I was, but how lucky, and how happy. So it seems all these years later, but at the time, I myself could not acknowledge these things at all, and so, while we both watched Füsun dancing, and my head was spinning with drink, I told Zaim my story. I told him that I was the first man Füsun had ever slept with, describing the bliss we had discovered making love, and of our lovers' quarrels and a string of other strange particulars that happened to pop into my head at that moment. "In short," I said, suddenly inspired, "what I want more than anything else in life right now is to hold on to this girl until I die."

"I understand."

When I perceived in him a manly sympathy, free of reproach for my selfishness or moral judgment of my happiness, I relaxed.

"What's upsetting me right now is that she's dancing with Kenan, the young clerk at Satsat. She's putting his job in jeopardy just to make me jealous. . . . Of course, I'm also worried that she'll actually fall for him. For truth be told, Kenan would be an ideal husband for her."

"I understand," said Zaim.

"In a short while I am going to invite Kenan to my father's table. What I would like you to do is to go straight over to Füsun and keep her busy, shadow her every move, like a good football defender, so that I don't die of jealousy tonight—and so that I can get to the end of this evening without succumbing to fantasies of firing Kenan. Füsun and her parents will be leaving soon, as she is taking the university entrance exam tomorrow. And anyway, this impossible love affair of ours must end very soon."

"I can't be sure your girl will take much interest in me tonight," said Zaim. "There's another matter, too."

"What?"

"I can see Sibel is trying to keep me away from Nurcihan," said Zaim. "She wants to get something going between her and Mehmet. But I think Nurcihan likes me. And I like her, a lot. So I'd like you to help me with this a little. I know Mehmet is our friend, but let us compete on a level field."

"What do you want me to do?"

"I couldn't get very far this evening, not with Sibel and Mehmet working against me, and now if I have to defend this girl of yours from the clerk, that will cut into the time I can spend with Nurcihan. So you have to make it up to me. Promise me now that you will bring Nurcihan with you to the picnic at the Meltem factory."

"I promise."

"Why does Sibel want to keep me away from Nurcihan anyway?"

"Well, you do make an impression, with your German models, and your dancers. . . . Sibel doesn't like those things. She wants to marry her friend off to someone she trusts."

"Please tell Sibel that I'm not a bad person."

"I tell her all the time," I said as I stood up. There was a silence. "I appreciate the sacrifices you're making for me," I said. "But when you are minding Füsun, be careful, don't let yourself fall for her. Because she's very sweet."

Zaim's expression, so full of understanding, liberated me from feeling shame for my jealousy. It brought me peace, if only short-lived.

Back at my parents' table I told my father, who had drunk himself into a stupor, that I wanted to introduce a very clever and industrious young clerk named Kenan, who was sitting at the Satsat table. So as not to inflame the other ambitious Satsat employees, I jotted down a note in my father's name and gave it to Mehmet Ali, a waiter who'd known us since the time the hotel had first opened, instructing him to pass it to Kenan at the next pause in the music. At that moment, my mother reached out and tried to grab my father's *rakı*, saying, "You've had enough," and in the tussle, spilled some on his tie. They were serving ice cream in glasses when the Silver Leaves took a break. In those days, we would all enjoy a cigarette before each new course. The bread crumbs, the tumblers smeared with lipstick, the stained napkins, overflowing ashtrays, lighters, dirty plates, and crumpled cigarette packets all fired painful sensations in my muddled mind that the evening's end was fast approaching. At one point, a little boy, perhaps six or seven years old, climbed onto my lap, and Sibel seized the excuse to come over to sit beside me and play with him. The sight of this moved my mother to remark, "What a lovely way you have with him." People were still dancing. A few moments later my young, handsome, dapper clerk had joined the table and as the former foreign minister rose to his feet, a courtly Kenan

told him and my father what an honor it was to meet them both. After the former foreign minister had lumbered off, I explained how Kenan Bey had given considerable thought to Satsat's potential expansion into the provinces, and that he was particularly knowledgeable about Izmir. I praised him at length so that everyone at the table could hear. My father then began to ask him the same questions he asked all the new clerks. "What foreign languages do you speak, my child? Do you read books, do you have any hobbies, are you married?" "He's not married," my mother said. "Just a moment ago he was dancing very nicely with Nesibe's daughter, Füsun." "She's blossomed into quite a beauty," said my father. "Don't let this father and son wear you down with business talk, Kenan Bey," said my mother. "You must want to get back to your friends." "Not at all, madam! The honor of meeting Mümtaz Bey—meeting all of you—is much more important." "Such a courteous, refined young man," my mother whispered, though loud enough for Kenan to hear. "Shall I invite him over one evening?"

When my mother liked or generally approved of someone, she would make sure he heard it when she discreetly told us so, because she enjoyed seeing in his embarrassment proof of her own power. My mother was smiling with this satisfaction when the Silver Leaves resumed with a very slow, sentimental number. I saw Zaim escort Füsun to the dance floor. "Let's talk about Satsat's chances in the provinces now, while my father is here, too," I said. "My son, are you telling me that you are going to talk business now, at your own engagement party?" "Madam," said Kenan to my mother, "you may not be aware of this, but three or four times a week, when everyone else has gone home, your son stays very late and carries on working." "Sometimes Kenan and I work late together," I added. "Yes.

Kemal Bey and I enjoy our work," said Kenan. "Sometimes when it's very late we make up expressions that rhyme with the names of the people who owe us money." "That's fine," said my father. "But what do you do with the bounced checks?" "I would like for us to meet the distributors to discuss this, Father," I said.

As the orchestra played one slow dance after another, our talk ranged from possible innovations at Satsat, to the places of entertainment that my father had frequented in Beyoğlu when he was Kenan's age, to the methods adopted by İzak Bey (my father's first accountant), to whose table we now turned, raising our glasses in what must have seemed to the accountant a puzzling tribute, after which we went on to contemplate what my father hailed as the beauties of youth and of this evening, and, he added in jest, of "love." Despite my father's pressing the matter, Kenan would not be made to admit whether or not he was in love. This did not stop my mother from grilling him about his family, and upon learning that his father was employed by the city council and had for years worked as a streetcar driver, she said with a sigh, "Oh how beautiful they were, those old streetcars!"

More than half the guests had left by now. My father was having a hard time keeping his eyes open.

As my mother and father kissed us each on our cheeks, preparing to take their leave, my mother said, "Don't you stay out too late either, my son," looking into Sibel's eyes, not mine.

Kenan wanted to return to his friends at the Satsat table, but I wouldn't let him go. "Let's find my brother and discuss this shop we might open in Izmir," I said. "It's not often that the three of us are together in one place."

I took it upon myself to introduce Kenan to my brother, and my brother (who had known him for some time) raised an eyebrow in disdain, declaring that I must be seriously drunk. Then he looked at Berrin and Sibel, nodding in the direction of the glass in my hand. Yes, I had downed two glasses of *rakı* at around that time, one after the other, because every time I caught a glance of Zaim dancing with Füsun, the *rakı* was my only relief from a ridiculous jealousy. As my brother talked to Kenan about the logistics of collecting on overdue accounts, everyone at our table, including Kenan, watched Zaim dancing with Füsun. Even Nurcihan, who had her back to them, sensed that Zaim had taken an interest in someone else and she was becoming uneasy. At one point I said to myself, "I am happy." As drunk as I was, I still felt as if everything was going to go my way. On Kenan's face I recognized an all too familiar species of disquiet, and so I took this long, slender glass (see exhibit) and poured a consoling *rakı* for my ambitious greenhorn friend, who, on account of his bosses having taken a sudden interest in him, had lost the girl he'd been holding in his arms only a few minutes before. At that moment, Mehmet finally asked Nurcihan to dance, and Sibel turned to give me a conspiratorial wink, adding sweetly, "You've had enough, darling. Don't have any more."

Charmed by her solicitude, I took Sibel to the dance floor, and the moment we got there I knew I had made a mistake. The Silver Leaves were playing "A Memory from That Summer," which called to mind the previous summer, when Sibel and I had been so happy, and as the music evoked these memories with arresting force—just as I hope the exhibits in my museum are doing—Sibel embraced me as if for the first time. How I wanted in return to embrace with the same ardor my fiancée,

the one with whom I was to share the rest of my life. But I could think only of Füsun. Because I was trying to catch a glimpse of her in the crowd, because I did not want her to see me in a warm embrace with Sibel, I held myself back. I let the other couples distract me. They smiled at me affectionately, as people will at seeing a groom a little worse for wear at the end of his engagement party.

At one point we came shoulder to shoulder with the best-loved columnist of that era dancing with an attractive dark-haired woman: "Celâl Bey, love has nothing in common with a newspaper column, does it?" I said. When Mehmet and Nurcihan came alongside us, I treated them as if they'd been lovers for ages. I slurred an attempt at a quip in French to Zümrüt Hanım, who spoke French whenever she visited my mother, even when there was no one around, supposedly to keep the servants from understanding her. By now Sibel had given up on having a dance she would remember forever, and was whispering into my ear, telling me how sweet I was when I was drunk, apologizing for having forced me into matchmaking, which she'd done, she insisted, only to make our friends happy, and alerting me that the fickle Zaim had moved on from Nurcihan and set his sights on that girl who was my distant relation. Frowning, I told her that Zaim was a very good person, and a trusted friend. I added that Zaim had wanted to know why she was treating him so badly.

"So you were talking about me with Zaim? What did he say?" said Sibel. During the break between songs, we came alongside Celâl Salik the columnist again. "I've worked out something love has in common with a good newspaper column, Kemal Bey," he said. "What is it?" I asked. "Love, like a newspaper column, has to make us happy *now*. We judge the

beauty and power of each by how deep an impression it makes on the soul." "Master, please write that up in your column one day," I said, but he was listening not to me but to his raven-haired dance partner. At that moment I noticed Füsun and Zaim beside us. Füsun had placed her head very close to his neck and was whispering to him, and Zaim was smiling gaily. It seemed to me that they could see us perfectly well, but were pretending not to notice as they spun around the dance floor.

Without losing a beat I maneuvered Sibel in their direction and then, like a pirate ship pursuing a merchant galleon, I caused us to ram Füsun and Zaim from the side.

"Oh, excuse us," I said with a silly laugh. "How are you?" The confused joy on Füsun's face brought me back to my senses and at once I spied in my drunkenness a good excuse for bold action. I turned to Zaim, proferring Sibel's hand. "May I offer you the honor of this dance?" Zaim took his hand off Füsun's waist. "You two are going to have to get to know each other better," I said, "and you might as well start now." Completing my gesture of self-sacrifice, I put my hands on their backs and pushed them together. As Sibel and Zaim began to dance, with obvious reluctance, Füsun and I looked for a moment into each other's eyes. Then I put my hand on her waist and with a few gentle turns, moved her as far away as I could, like any elated suitor preparing to abscond with his sweetheart.

How to describe the peace that came over me the moment I took her in my arms? The noise of the crowd that had so addled me, the ungodly racket that I had taken to be the aggregate of the silverware, the orchestra, and the roar of the city—now I knew what I'd heard was only my disquiet at being far from her. Like a baby who will stop crying only in the arms of one particular person, I felt a deep, soft, velvety bliss of

silence spreading through me. From her expression I could see that Füsun felt the same; taking the enveloping silence as our mutual recognition of shared enchantment, I wished that the dance would never end. But soon I realized that her half of the silence meant something altogether different from mine. Füsun's silence harked back to the question I had brushed off earlier as a joke ("What will become of us?"), and now I had to give an answer. I decided that this was what she had come for. The interest that men had shown her this evening, the admiration that I'd seen even in the eyes of the children—all this had given her confidence, had lightened her suffering. Now she might even be able to view me in perspective, as a "passing fancy." As I began, in my drunkenness, to realize that the night was coming to an end, I was seized by the terrifying thought of losing Füsun.

"When two people love each other as we do, no one can come between them, no one," I said, amazed at the words I was uttering without preparation. "Lovers like us, because they know that nothing can destroy their love, even on the worst days, even when they are heedlessly hurting each other in the cruelest, most deceitful ways, still carry in their hearts a consolation that never abandons them. Trust me that after tonight I'll stop all this, I'll sort this out. Are you listening to me?"

"I'm listening."

When I was sure that no one dancing nearby was looking at us, I said, "We met at an unfortunate time. In the early days neither of us could have known how rare this love was between us. But now I am going to put everything right. Our most immediate concern is your exam tomorrow. This evening you shouldn't waste any more time worrying about us."

"Then tell me, what is going to happen now?"

"Tomorrow, as always" (for a moment, my voice trembled) "at two o'clock, after you've finished your exam, let's meet at the Merhamet Apartments. Then I'll be able to tell you what I plan to do next, without having to rush. If I fail to win your trust, then you never have to see me again."

"No, tell me now, and I'll come."

How sweet it was to imagine in my drunken stupor that she would come to me at two o'clock the next day, that we would make love as always, that we would remain together until the end of my days, and as I touched her wondrous shoulders and her honey-colored arms, I resolved that I would do everything I could, whatever it took.

"No one will ever come between us ever again," I said.

"All right then, I'll come tomorrow after the exam, and you, God willing, won't have gone back on your word, and you'll tell me how you're going to do this."

While we both remained standing, perfectly straight, with my hand lovingly clamped on her hip, and in time to the music, I tried to tug her closer to me. She resisted, refusing to lean into me, and that excited me all the more. But when it became apparent that my attempt to wrap my arms around her in front of everyone was being viewed not as a sign of love but proof of my drunkenness, I pulled myself together and relented.

"We have to sit down," she said. "I feel as if everyone is looking at me." She was leaving my arms. "Go right home and get some sleep," I whispered. "During the exam, just think about how much I love you."

When I got back to our table there was no one there except for Berrin and Osman, both frowning and bickering with each other. "Are you all right?" said Berrin.

"Perfectly fine," I said, gazing upon the disordered table and the empty chairs.

"Sibel didn't want to dance anymore, and Kenan Bey took her with him to the Satsat table, where they were playing some sort of game."

"It's good that you danced with Füsun," said Osman. "In the end, it was wrong for our mother to give her the cold shoulder. It's important for Füsun and everyone else to know that the family takes an interest in her, that the nonsense with the beauty contest is forgotten, and she can depend on us. I worry for the girl. *She thinks she is too beautiful*," he said in English. "That dress is too revealing. In six months she's gone from being a child to a woman; she's really bloomed. If she doesn't marry the right sort of man very soon, first she'll get a reputation and that can lead only to misery. What was she telling you?"

"Apparently she is taking her university entrance exam tomorrow."

"And she's still here dancing? It's after midnight." He watched her walk toward her table. "I really did like your Kenan, by the way. I say she should marry *him*."

"Shall I tell them both?" I shouted, having moved away from him already. I had been doing this since childhood. Whenever my brother began to speak, I would do the opposite of what he asked, and retreat to the most remote corner, ignoring the fact that he was still talking.

In later years I would often reflect on my bliss and joy at that point in the evening, on my way from our table to the tables in the back where the Satsat employees, Füsun, and her parents were sitting. I had just put everything right, and in thirteen hours and forty-five minutes I would meet Füsun at

the Merhamet Apartments. A brilliant future beckoned, and the promise of happiness sparkled like the Bosphorus at our feet. Even as I laughed with the lovely girls now weary of dancing, their dresses in charming (and revealing) disarray, and I joked with the last of the guests, and old friends, and affectionate aunties I'd known for thirty years, a voice inside me warned that if I continued on this path, I'd end up marrying not Sibel but Füsun.

Sibel had joined the untidy Satsat table, where they were holding a mock séance, really just a drunken game based on no particular knowledge of spiritualism. When they were unable to summon any spirits, the group began to disperse. Sibel moved over to the next table, which was empty except for Kenan and Füsun, with whom she immediately struck up a conversation before I could join them. Seeing me approaching, Kenan asked Füsun to dance. Füsun, having seen me, turned him down, saying that her shoes were pinching her toes, and with youthful pride Kenan responded as if the point of it were not Füsun but the dance, and went off as the Silver Leaves played one of the evening's fast numbers to do the latest step with someone else. So now, at the edge of the Satsat table, by now almost empty, a chair awaited me between Füsun and Sibel. So I went and sat down between Füsun and Sibel. How I wish someone had taken a photograph of us that I might have now displayed!

I sat down to discover with contentment that Füsun and Sibel were discussing spiritualism like two Nişantaşı ladies who had been acquainted for years but still maintained a social distance, their language markedly formal, almost ceremonial. Füsun, whom I'd assumed had little religious education, declared that souls certainly existed, "as our religion decrees,"

but that for us in this world to attempt communication with them was a sin. Here she glanced at her father at the next table. This idea had come from him.

"Three years ago I disobeyed my father and went with some classmates to a séance—just out of curiosity," said Füsun. "I was asked for a name and I remembered a childhood friend who was very dear to me, though I'd lost touch with him, and without pausing to think, I wrote his name down, just to play along. . . . But this name I'd written down, without really believing, just for the fun of it—well, his spirit did come and I felt *so* guilty."

"Why?"

"I could tell from the way the coffee cup was rattling that my lost friend Necdet was in enormous pain. It was rattling as if it had a life of its own, and I felt that Necdet must be trying to tell me something. Then suddenly the coffee cup went still. . . . Everyone said that this person must have died at that very moment. . . . How could they have known?"

"How *did* they know?" asked Sibel.

"That same night I was at home and looking through my drawers for a missing glove, and I found a handkerchief that Necdet had given me as a present many years before. Maybe it was a coincidence. But I don't think so. I learned a lesson from this. When we lose people we love, we should never disturb their souls, whether living or dead. Instead, we should find consolation in an object that reminds you of them, something . . . I don't know . . . even an earring."

"Füsun, darling, time to go home," said Aunt Nesibe. "You have your exam tomorrow morning, and your father can barely stay awake."

"Just a minute, Mother!" said Füsun in a firm voice.

"I don't believe in séances, either," said Sibel. "But if I'm invited to one, I never pass it up, because I like watching the games people play, and seeing what they fear."

"But if you love someone, and you miss them terribly, which would you do?" asked Füsun. "Would you gather up your friends and try to summon his spirit, or would you look for some old possession of his, like a cigarette box?"

As Sibel groped for a polite answer, Füsun shot up out of her seat and, reaching over to the next table, picked up a handbag, which she placed in front of us. "This handbag reminds me of my embarrassment . . . my shame for having sold you a fake," she said.

When it was on Füsun's arm earlier I had not recognized it as "that" bag. But hadn't I bought it in the Şanzelize Boutique from Şenay Hanım, shortly before the happiest moment in my life, and, after having run into Füsun in the street, hadn't I taken it back with us to the Merhamet Apartments? Just yesterday that talismanic Jenny Colon bag was still there. How could it be here now? I was like some spectator dumbfounded by a juggler's trick, and my head was spinning.

"It looks very good on you," said Sibel awkwardly. "So lovely with the orange, and your hat, that when I first saw it I felt jealous. I was sorry I'd returned it to you. How beautiful you are!"

It occurred to me that Şenay Hanım must have had more than one fake Jenny Colon bag in stock. Having sold one to me, she might have put another in the window, and even lent a third to Füsun for this evening.

"After you realized that the bag was a fake, you stopped coming to the Şanzelize," said Füsun, smiling graciously at Sibel. "This upset me, because of course you were right."

Opening the bag, she showed us the inside. "Our craftsmen make excellent fakes of European products, bless them, but never enough to fool someone with your experienced eye. But now I must say something." She swallowed and fell silent, and I feared she was going to cry. But she pulled herself together, and with a frown she recited the speech that she must have rehearsed at home. "For me, it's not in the least important whether something is or isn't a European product. And it's not in the least important to me either if a thing is genuine or fake. If you ask me, people's dislike of imitations has nothing to do with fake or real, but the fear that others might think they'd 'bought it cheap.' For me, the worst thing is when people care about the brand and not the thing itself. You know how there are some people who don't give importance to their own feelings, and care only about what other people might say"—here she glanced in my direction. "This handbag will always remind me of tonight. I congratulate you. It's been an evening I'll never forget." She rose to her feet, and as she squeezed our hands, my darling girl kissed us each on the cheek. As she turned to leave, she noticed Zaim approaching the next table and she turned back to Sibel. "Zaim Bey is a very good friend of your fiancé, isn't he?" she asked.

"Yes, they're very close," said Sibel. As Füsun took her father's arm, Sibel turned to me and asked, "What did she mean by that question?" but there was no contempt for Füsun in her expression. I saw instead something akin to excitement, even adoration.

As Füsun headed slowly for the stairs, flanked by her mother and father, I watched her from behind with love and pride.

Zaim came and sat down beside me. "You know, at that Satsat table behind us, they've been having quite a laugh at your expense all evening," he said. "As your friend, I thought you should know."

"You must be joking! What exactly could they be laughing about?"

"Well, I didn't hear it directly, of course. Kenan told Füsun. And she told me. . . . And she was quite upset, too. Apparently it's general knowledge at Satsat that every night at quitting time, you and Sibel would meet there for a romp on the divan in the corner office. This is what all the snickering was about."

"What's happened now?" asked Sibel as she came back to us. "You're depressed again, aren't you?"

25

The Agony of Waiting

I DID NOT sleep at all that night. In fact, Sibel and I had been
meeting at Satsat only rarely, but this was hardly an extenuating
circumstance in the indictment I feared would cost me Füsun.
Toward dawn I dozed off briefly. The moment I woke up I
shaved and went for a walk. I took the long way back, passing
in front of the Technical University's 115-year-old Taşkışla
Building, where Füsun was taking her exam. Around the door,
through which Ottoman soldiers sporting fezzes and pointed
mustaches had once passed on their way to drill, mothers in
headscarves and chain-smoking fathers sat in rows waiting for
their children. Some were reading newspapers; others were
chatting or looking blankly up at the sky. I could not see Aunt
Nesibe among them. Between the windows in the stone facade,
sixty-six years on, you could still see the bullet holes left by
the Action Army upon the deposition of Sultan Abdülhamit.
Fixing my eyes on one of those high windows, I said a prayer,
asking God to help Füsun answer the questions, and to send
her skipping joyously back to me when the exam was over.

But Füsun did not come to the Merhamet Apartments that
day. I told myself her anger would pass. As the strong June sun
filtered through the curtains and the room grew steadily hotter,
I waited two hours past our usual meeting time. It hurt to look
at the empty bed, so I went out for another walk. As I walked
through the park, past soldiers idly killing time and children

feeding the pigeons under the gaze of their families, and people reading their newspapers on the benches at the edge of the sea or watching the ships go by, I tried to convince myself that Füsun would come at the usual time the next day. But she did not come the next day, or the four days that followed.

Every day I went to the Merhamet Apartments at the customary hour, to begin my wait. Having realized that getting there early only aggravated my pain, I resolved not to arrive before five minutes to two. I would go into the apartment trembling with impatience, and during the first ten or fifteen minutes hopeful anticipation would ease the pain, an excitement wreathing my head down to the tip of my nose even as my heart ached and my stomach cramped. From time to time I would part the curtains to look down at the street and inspect the rust on the lamppost in front of the entrance, and then I'd tidy the room a bit. I would listen to footsteps passing one floor below, and from time to time I would hear high heels clicking past in that decisive way of hers. But they would continue on without slowing down, and I would realize with pain that the woman who had entered the building, lightly shutting the door behind her in such a familiar way, was in fact someone else.

I have here the clock, and these matchsticks and matchbooks, because the display suggests how I spent the slow ten or fifteen minutes it took me to accept that Füsun was not coming that day. As I paced the rooms, glancing out the windows, stopping in my tracks from time to time, standing motionless, I would listen to the pain sluicing within me. As the clocks in the apartment ticked away, my mind would fixate on the seconds and the minutes to distract itself from the agony. As the appointed hour neared, the sentiment "Today, yes, she's coming, now" would bloom inside me, unbidden, like spring

flowers. At such moments I wanted time to flow faster so that I could be reunited with my lovely at once. But those minutes would never pass. For a moment, in a fit of great clarity, I would understand that I was fooling myself, that I did not want the time to flow at all, because Füsun might never come. By two o'clock I was never sure whether to be happy that the hour had arrived, or sad that with every passing minute her arrival was less likely, and the distance between me and my beloved would grow as that between a passenger on a ship leaving port and the one he had left behind. So I would try to convince myself that not so very many minutes had passed, toward this end I would make little bundles of time in my head. Instead of feeling the pain every second of every minute, I resolved to feel it only once every five! In this way I would take the pain of five discrete minutes and suffer it all in the last. But this too was for naught when I could no longer deny that the first five minutes had passed—when I was forced to accept that she was not coming, the forestalled pain would sink into me like a driven nail. In the subsequent desperation I would repeat the exercise, struggling to tell myself that Füsun had often been ten or fifteen minutes late for our meetings, an assertion I was not really sure of, but which allowed me a respite at least for four-fifths of the next five-minute bundle, and hope would return, as I dreamed that in a moment's time she would ring the bell, that in just a moment she would be there with me, as suddenly as the second time we met. I would imagine what I'd do when she rang the bell—whether I would be angry at her for not having come for so many days, or whether I would forgive her on sight. These fleeting dreams would mix with memories when my eyes lit upon this teacup, from which Füsun drank during our first encounter, or upon this little old vase that she picked

up for no reason while impatiently pacing the apartment. After fending off the ever more hopeless awareness that the fourth and fifth five-minute bundles had come and gone, my reason would force me to accept that on that day Füsun would not be coming, and at that moment the agony inside was such that I could do nothing but throw myself like an invalid onto the bed.

An Anatomical Chart of Love Pains

THIS DEPICTION of the internal organs of the human body is taken from an advertisement for Paradison, a painkiller on display in the window of every pharmacy in Istanbul at the time, and I use it here to illustrate to the museum visitor where the agony of love first appeared, where it became most pronounced, and how far it spread. Let me explain to readers without access to our museum that the deepest pain was initially felt in the upper left-hand quadrant of my stomach. As the pain increased, it would, as the overlay indicates, radiate to the cavity between my lungs and my stomach. At that point its abdominal presence would no longer be confined to the left side, having spread to the right, feeling rather as if a hot poker or a screwdriver were twisting into me. It was as if first my stomach and then my entire abdomen were filling up with acid, as if sticky, red-hot little starfish were attaching themselves to my organs. As the pain grew more pervasive and intense, I would feel it climb into my forehead, over the back of my neck, my shoulders, my entire body, even invading my dreams to take a smothering hold of me. Sometimes, as diagrammed, a star of pain would form, centered on my navel, shooting shafts of acid to my throat, and my mouth, and I feared it would throttle me. If I hit the wall with my hand, or did a few calisthenics, or otherwise pushed myself as an athlete does, I could briefly block the pain, but at its most muted I could still

feel it like an intravenous drip entering my bloodstream, and it was always there in my stomach; that was its epicenter.

Despite all its tangible manifestations, I knew that the pain emanated from my mind, from my soul, but even so I could not bring myself to cleanse my mind and deliver myself from it. Inexperienced in such feeling, I was, like a proud young officer ambushed in his first command, forced into a mental rout. And it only made matters worse that I had hope—with every new day, new dreams, new reasons that Füsun might appear at the Merhamet Apartments—which by making the agony bearable prolonged it.

In my more lucid moments, I would think that she was scorning me, punishing me, not just for the engagement but for hiding from her my trysts with Sibel at the office, for letting my jealousy get the better of me at the engagement party and playing tricks to keep her away from Kenan, and also, of course, for failing to solve the mystery of the earring. But I also felt, most powerfully, that her denial of the unparalleled happiness we had shared was no less a punishment for her than for me, and that, like me, she would not be able to bear it for long. For I had to endure the pain, face the torment stoically, so that when we met, she might yet feel compelled to acknowledge my suffering. But all such calculation was overshadowed by remorse—having recklessly invited her to the party, and having failed to recover the missing earring or to teach her mathematics properly, or to return her childhood tricycle to her house, and attend the promised supper with her family. The pain of regret was shorter and more contained; it would make itself felt in the back of my legs and in my lungs (see diagram), mysteriously sapping my strength. But it was no less debilitating, leaving me barely able to stay on my feet, longing to collapse onto a bed.

Sometimes I wondered whether this was all happening because her entrance exam had gone badly. Afterward in my guilty dreams I would give her long, exacting math lessons; my pain would abate, especially when the math lessons were over and we would make love. But the dream would end abruptly when I remembered that she had broken the promise made while we danced at the engagement party—to come to me as soon as the exam was over—and when I recalled that she had not even furnished me with an excuse, I would begin to feel angry at her, my resentment fed, too, by her lesser crimes— trying to make me jealous at the party, listening while the Satsat employees joked at my expense. These grievances I would use to distance myself from her, thus answering with my silence her desire to punish me.

By half past two Friday afternoon, and with that day's recognition that she wasn't coming despite my every petty resentment, conjured hope, and self-deceiving trick, I collapsed in defeat. The pain had now become fatal, eating me up like a wild beast without pity for its prey. I lay like a corpse on the bed, inhaling her fleeting scent on the sheets, remembering how happily we'd made love there, only six days earlier, asking myself how I would live without her, even as jealousy irresistibly mixed with the anger. I imagined Füsun wasting no time taking a new lover. This shameful and debilitating fantasy had come into my head at other times, too, but now I was unable to fend it off, imagining as my rival Kenan, or Turgay Bey, or any number of other admirers, even Zaim, whoever fetched up first. A woman like her, who had taken such pleasure from lovemaking, would certainly not refrain now from seeking the same pleasure with others, particularly with her anger toward me driving her to revenge. Though in one part of my mind I could see

these feelings for what they were, I surrendered, nevertheless, allowing this degrading dream to engulf me. Resolving that desire and anger would drive me mad, I rushed out of the apartment and made straight for the Şanzelize Boutique.

I remember my heart pounding with hopeless hope as I raced down Teşvikiye Avenue. Fueled by the certitude that seeing her would restore me, I gave no thought to what I might say. The moment I saw her, my pain would disappear, at least for a time—this I knew. She had to hear me out; there were things I had to say. This wasn't what we'd agreed at the dance— we were to have gone to a patisserie to talk.

The little bell on the door of the Şanzelize Boutique rang and my heart seized up. The canary was gone. I had already worked out that Füsun was not there either, but out of fear and helplessness I tried to convince myself that she was hiding in the back room.

"Kemal Bey, welcome," Şenay Hanım said with a diabolical smile.

"I'd like to take a look at that white embroidered evening bag in the window," I whispered.

"Oh, yes, that's a very nice piece indeed," she said. "You're very discerning. Whenever something beautiful comes to the shop, you're the first to see it, and you snap it up. This just came in from Paris. Note the precious stone in its clip. There's a change purse inside, and a mirror, all made by hand, of course." As she lumbered over to the window to extract the bag, she carried on exaggerating its finer points.

I glanced through the curtains into the back room. Füsun was not there. When the woman brought me this elegant floral bag, I pretended to examine it carefully and accepted without question the exorbitant price quoted. As the witch

was wrapping it up, she spent a very long time telling me how impressed everyone had been by the engagement party. Just to keep the transaction going, I told her to wrap up a pair of cuff links that I happened to notice. Emboldened by the pleasure I saw on her face, I asked, "So what's become of that relation of ours? Hasn't she come in today?"

"Oh dear, didn't you know? Füsun quit suddenly."

"Is that so?"

She'd guessed at once that I'd come looking for Füsun, and deduced from this that we were no longer seeing each other, and now she was eyeing me closely, trying to figure out what had happened.

I managed to contain myself, asking her nothing. Despite my pain, I reached calmly into my pocket, to hide the fact that I was not wearing my engagement ring. As I paid her I noticed her looking at me with a certain compassion: It was as if, having both lost Füsun, we had been drawn closer together. And yet I could not help casting a further incredulous glance in the direction of the back room.

"This is what it's like these days," the woman said. "Today's young people aren't interested in earning their money. They want it all the easy way." It was that last sentiment that hurt in particular.

I managed to hide all this from Sibel. My fiancée registered and was affected by my every expression, my every new gesture, and yet, during the first days following our engagement, she asked me nothing, but on the third day, at supper, when I was twisting with evident discomfort, she remarked, with the sweetest of expressions, that I was knocking back drinks rather quickly, and she asked, "What's going on, darling?" I said that problems at work with my brother were getting the better

of me. The following Friday night—with one shaft of pain shooting up from my stomach, and its mate shooting down in the opposite direction, from the nape of my neck into my legs, as I wondered what Füsun might be doing—Sibel repeated her question. I managed to invent a whole skein of details to give credible life to this story about the argument with my brother. (With such symmetry as only God can fashion, these inventions would come true many years later.) "Never mind," said Sibel with a smile. "Shall I tell you what tricks Mehmet and Zaim are hatching to get close to Nurcihan at the picnic this Sunday?"

Don't Lean Back That Way, You Might Fall

To REFLECT the synthesis of traditional pleasures and inspirations drawn from French home and garden magazines favored by Sibel and Nurcihan, the picnic basket displayed here—the thermos filled with tea, stuffed grape leaves in a plastic box, boiled eggs, some Meltem bottles, and this elegant tablecloth passed down to Zaim from his grandmother—evokes our Sunday excursion that may offer the visitor some relief from the oppressive succession of interior settings, as well as my own agony. But neither the reader nor the visitor should on any account think that I could forget my pain even for an instant.

That Sunday morning we went first to the Bosphorus, to the Meltem factory in Büyükdere. On the sides of its buildings were giant pictures of Inge next to leftist slogans that had been painted over. Even as we toured the sterilizing and bottling lines, where silent women wearing headscarves and blue aprons worked under the direction of loud, cheerful supervisors (there were only sixty-four employees in all, despite the countless advertisements Meltem had plastered all over the city), and even as I expressed my distaste for the modish belts, blue jeans, and leather boots that the others in our party had chosen to wear that day—accoutrements that were, like their easy and open demeanor, overly European—I had to muffle my mournful beating heart, pitifully crying, Füsun, Füsun, Füsun.

We piled into two cars and moved on to Belgrade Forest, to a green field overlooking Bentler and offering much the same view as this one painted 170 years ago by the European artist Melling, and here we spread out a *déjeuner sur l'herbe*. I remember lying down on the grass toward noon and gazing up at the bright blue sky. Sibel and Zaim were busy trying to set up an old swing from the Persian gardens with new ropes, and I remember how struck I was by her grace and beauty. At one point I played the children's game Nine Stones with Nurcihan and Mehmet. As I inhaled the sweet smell of grass and the cool breeze coming from the lake behind Bentler, redolent of pine and roses, I thought that the wondrous life before me was a gift from God, thought how all this beauty had been bequeathed to me unconditionally; how colossally stupid—and perhaps sinful—it was to let it be poisoned by these pangs spreading from my stomach to every part of my body. I still felt shamed that the pain of not seeing Füsun had reduced me to this, and that with my self-confidence undermined, I succumbed to jealousy. As Mehmet, managing to keep immaculate the white shirt and tie he wore with trousers and suspenders, set out the food, and Zaim went off with Nurcihan, supposedly to pick blackberries, I realized that I was happy he was here because it meant he could not be meeting with Füsun. But I could not further assume that Füsun was not with Kenan or someone else. Chatting with my friends, playing ball, watching Sibel swing like a child, even slashing my ring finger as I struggled with a new kind of can opener—at intense moments of this order I was distracted from my pain. I could not stanch the flow from my finger. Was this because love had poisoned my blood? At one point I sat on the swing and began to propel myself with all my strength. When the

swing came down so fast it seemed to be in free fall, the pain in my stomach abated slightly. As the ropes creaked, and I described a great arc in the air, throwing my head way back, so that I was almost upside down, my pain almost gave way to true relief.

"Kemal, are you crazy? Stop, don't lean back that way. You might fall!" cried Sibel.

In the noon sun it was hot even in the shade of the trees. I told Sibel that I couldn't stop my finger from bleeding, and that, feeling unwell, I wanted to go to the American Hospital for a few stitches. She was shocked. She opened her eyes wide. Couldn't I wait until evening? She bound my finger tight. I will confess to my readers that I secretly dug into the cut, to exacerbate the flow. "No," I said. "Don't let me ruin this lovely picnic, and, darling, it would cause offense if we both left. You can get a ride back to the city with the others in the evening." As she walked me back to the car, I again saw that shaming question in my lovely fiancée's wise and clouded eyes. "What is wrong with you?" she asked, sensing that my ailment was more serious than the flow of blood. How I longed to throw my arms around her at the moment, to master my pain, and throw off my obsession, or at the very least, to tell her how I felt! Instead I jumped into the car, swaying like an idiot, panicked by the pounding of my heart, without pausing even to whisper a few sweet nothings to Sibel. Nurcihan and Zaim were still off picking blackberries, but, sensing that something was wrong, they began to walk toward us. If I had to look Zaim in the eye, I was sure he would guess at once where I was going. But I shall not dwell on the expression of genuine concern and sorrow on my fiancée's face as I started up the car—lest readers judge me as heartless.

I drove like a madman through that bright, warm summer afternoon, reaching Nişantaşı in forty-seven minutes flat, all because the moment I put my foot on the accelerator, my heart told me that today, at last, Füsun would come to the Merhamet Apartments. Wouldn't she have waited a few days before making her first visit? Parking the car just fourteen minutes before two o'clock (I'd cut my finger not a moment too soon), I was racing to the Merhamet Apartments when I was stopped in my tracks by a middle-aged woman screeching my name.

"Kemal Bey, Kemal Bey, you are a very lucky man!"

I turned around, saying "What?" as I struggled to remember who she was.

"At your engagement party, you came to our table and we made a bet about the last episode of *The Fugitive* . . . remember? You were right, Kemal Bey! In the end, Dr. Kimble managed to prove his innocence!"

"Oh really?"

"When are you going to collect your winnings?"

"Later," I said, running down the street.

Of course I'd decided that Dr. Kimble's happy ending was a good omen: Today Füsun would come. Joyfully believing that in ten or fifteen minutes we would be making love, I took out the key with trembling hands and let myself into the apartment.

The Consolation of Objects

FORTY-FIVE minutes later Füsun still had not come, and I was lying on the bed like a corpse, though in pain and intensely aware of it, like an animal listening helplessly to its last breath. The pain was deeper and harsher than anything I had felt until that day, afflicting every part of me. I felt that I should get out of bed, distract myself, look for a way out of this predicament, or at the very least this room, and these sheets and pillows that still carried her scent, but I just couldn't summon the will.

I now began to regret fleeing the picnic. With a week having passed since we had last made love, Sibel was hazily aware that something strange had happened to me, but she couldn't put her finger on it or find a way to ask. I longed for Sibel's compassion, dreaming that my fiancée could distract me. But I couldn't bestir myself, let alone jump back into the car and return to her. So afflicted was I with the pain shooting so violently through my abdomen, my back, my legs, pain so violent it took my breath away—that I couldn't even find the strength to seize relief. Just knowing this exacerbated my desolation, provoking a remorse as fierce and lacerating as the pain of love itself. It was a strange, irrational conviction that took hold: Only by giving over to this pain (like a flower folding its petals shut), by surrendering to its full intensity, then and only then could I come closer to Füsun. In one part of my mind, I knew I might be chasing an illusion, but I had no way

of dispelling the weird belief. (Anyway, if I left the apartment now, she might arrive and not find me.)

As I gave myself over to the pain, as acid-filled grenades exploded in my blood and bones, I sorted through my bundle of memories, one by one, distracting myself, briefly and intermittently, sometimes for ten or fifteen seconds, though sometimes for only one or two, until these same memories would propel me even deeper into the void of the present moment, the pain stunning me as if for the first time, a heretofore unknown magnitude of agony. One palliative for this new wave of pain, I discovered, was to seize upon an object of our common memories that bore her essence; to put it into my mouth and taste it brought some relief. There were those nut and currant crescent rolls to be found at all the patisseries of Nişantaşı in those days, which I'd bring to our rendezvous, because Füsun liked them so much. Putting one in my mouth, I would remember the things we'd laughed about when eating them together (like the fact that Hanife Hanım, the wife of the Merhamet Apartments' janitor, still believed that Füsun was a patient of the dentist on the upper floor), and this would cheer me up. The time she took a hand mirror from one of my mother's drawers and used it as a microphone, imitating the famous singer Hakan Serinkan; the way she'd play with my toy Ankara Express train, the same one my mother had given her to play with when her seamstress mother brought her along on house calls; the space gun, another favorite toy of mine—we'd shoot at each other and then mirthfully search the disordered room for the plastic projectile—all of them had the power to console me. The sugar bowl in this exhibit is from the day when a cloud of melancholy darkened our happiness, plunging us into one of our occasional silences, when Füsun, suddenly

picking up this same bowl, asked, "Would you be happier if we had met before you met Sibel Hanım?"

Beside my head was the side table on which she had left her watch so carefully the first few times we made love. For a week, I had been aware that in the ashtray now resting there was the butt of a cigarette Füsun had stubbed out. At one moment I picked it up, breathing in its scent of smoke and ash, and placing it between my lips. I was about to light it (imagining perhaps for a moment that by loving her so, I had become her), but I realized that if I did so there would be nothing left of the relic. Instead I picked it up and rubbed the end that had once touched her lips against my cheeks, my forehead, my neck, and the recesses under my eyes, as gently and kindly as a nurse salving a wound. Distant continents appeared before my eyes, sparkling with the promise of happiness, and scenes from heaven; I remembered the tenderness my mother had shown me as a child, and the times I had gone to Teşvikiye Mosque in Fatma Hanım's arms, before pain would rush in again, inundating me.

Toward five o'clock, still in bed, I remembered how, after my grandfather died, my grandmother changed not just her bed, but her bedroom in order to withstand her grief. With all my will, I resolved to extract myself from this bed, this room, and these objects that had aged so beautifully, that were so heavy with the fragrance of happy love, each one murmuring, creaking, rustling of its own accord. But I could not help doing the opposite, and embracing these objects. Either I was discovering the astonishing powers of consolation that objects held, or I was much weaker than my grandmother. The joyful shouts and curses of the children playing football in the back garden bound me to that bed until nightfall. It was only that

evening, after I had downed three glasses of *rakı,* and Sibel phoned to ask me about my cut, that I realized it had long since stopped bleeding.

Thus I continued to visit the Merhamet Apartments every day at two o'clock in the afternoon, until the middle of July. As the pain I felt while wondering whether Füsun might come grew less intense each day, I sometimes convinced myself that I was slowly growing accustomed to her absence, but there was no truth to this, none at all. It was simply that I was growing more adept at distracting myself with the happiness I found in objects. A week after the engagement party, she still occupied my every thought, and though these thoughts were not always overwhelmingly urgent, though I sometimes managed to banish them to the back of my mind, the sum total of my agony—to speak arithmetically—was not diminishing; against every hope, it was continuing to grow. It was almost as if I was going to the apartment so as not to lose the habit, or the hope of seeing her.

I would usually spend my two hours in the apartment daydreaming in bed, having selected some object charmed with the illusion of radiating the memories of our happiness—for example, this nutcracker, or this watch with the ballerina, with Füsun's scent on its strap, with which I would stroke my face, my forehead, my neck, to try to transfer the charm and soothe the ache—until two hours had passed, and the time had come when we would have been awakening from the velvet sleep our lovemaking induced, and, depleted, I would try to return to my everyday life.

The light had gone out of my life by now. Having still not managed to make love to Sibel since our engagement (advancing as my excuse the embarrassment that the people at Satsat knew about our trysts in the manager's office), I realized that my

fiancée had come to see my nameless malady as some variety
of nonspecific premarital panic, some form of melancholia
for which medicine as yet had neither diagnosis nor cure. She
accepted this affliction with a solemnity that made me admire
her all the more, and because she secretly blamed herself for
having failed to pull me out of it, she treated me very well.
And I treated her as well in return, taking her to restaurants
we'd never visited before, and introducing her to the new
friends I managed to make. We continued to attend parties,
and to visit the Bosphorus restaurants and clubs where the
Istanbul bourgeoisie gathered in the summer of 1975 to display
their wealth and happiness. Though I joined her merriment
at watching the pleased Nurcihan torn between Mehmet and
Zaim, I laughed knowingly. Happiness no longer seemed God's
gift to me from birth; no longer was it the right I could claim
without effort; it had become a state of grace that only the
luckiest, brightest, and most cautious people could attain, and
with the most assiduous cultivation. One night, at the newly
opened Mehtap, where bodyguards milled about the entrance, I
was standing alone at the bar next to the pier extending over the
Bosphorus drinking Gazel red wine (Sibel and the others were
chatting cheerfully at our table) when I came eye to eye with
Turgay Bey, and my heart began to race as fast as if I'd seen
Füsun herself, and the tide of jealousy rushed in.

By Now There Was Hardly a Moment
When I Wasn't Thinking About Her

WHEN TURGAY Bey chose not to give me his customary bland, affable smile, turning his head instead, this wounded me more than I could have anticipated. Reason told me that he had every right to take offense at my not having invited him to the engagement party, but reason was no match for the paranoid hypothesis—that Füsun might have gone back to him to take revenge on me. I was seized by the urge to run after him and inquire the cause for this snub. Perhaps that very afternoon he had made love with Füsun in his garçonnière in Şişli. It would have sent me over the edge if he had so much as seen her, spoken to her. Though my humiliation was mitigated by the knowledge that he had been in love with Füsun before me, and once suffered an agony like mine, for the same reason I had never felt more loathing toward him than now. I knocked back quite a few drinks at the bar. Later on I wrapped my arms around the ever patient and compassionate Sibel, swaying with her as Pepino di Capri sang "Melancholy."

Drinking was my sole defense, albeit temporary, against jealousy. When I woke up the next morning with a headache and my envy refreshed, I realized, with growing panic, that the pain was not abating, and that I felt more helpless than ever. As I walked to Satsat (Inge still smiling saucily at me from the Meltem poster on the side of the apartment), and later that

morning, as I tried to bury my thoughts in paperwork, I was forced to acknowledge that the pain was gradually increasing, and that, far from forgetting Füsun as time wore on, I was thinking about her ever more obsessively.

Time had not faded my memories (as I had prayed to God it might), nor had it healed my wounds as it is said always to do. I began each day with the hope that the next day would be better, my recollections a little less pointed, but I would awake to the same pain, as if a black lamp were burning eternally inside me, radiating darkness. How I longed to think about her just a little less, and to believe that I would, in time, forget her! There was hardly a moment when I wasn't thinking about her; in truth, with few exceptions, there was not a single moment. These "happy" interludes of oblivion were fleeting—a second or two—but then the black lamp would be relit, its baleful darkness filling my stomach, my nostrils, my lungs, until I could barely breathe, until merely to live became an ordeal.

As much as I would long for an escape from this suffering, I longed for someone to confide in, to find Füsun and talk to her, but when that longing went unfulfilled I would yearn to pick a fight with someone, anyone to whom I could attribute this damning, furious resentment. For all my willed self-restraint, to see Kenan at the office was to slip into temporary insanity. Though I had decided that there was nothing between them, I could not forget Kenan's flirtatious attentions at the engagement party, which Füsun might well have enjoyed, and this was reason enough to hate him. By noon I would be concocting pretexts for his termination. Oh, he was a sly one, wasn't he? Lunchtime brought the relative calm of knowing that I would go to the Merhamet Apartments, to wait for Füsun—even a tiny hope sustained me, even when the fear that she would not come

was fulfilled. But I understood with fear that when she did not come, the pain of waiting brought to its excruciating climax, the prospect of the next day held out nothing but the same vain hope of the last.

A question likewise debilitating took root in my mind: If I was suffering all this pain, how could she bear it, even if it was half as intense? I had to conclude that she must have found someone else right away, for otherwise she couldn't have stood it. The joys of making love, disclosed to her only seventy-four days earlier—Füsun must now be sharing them with another . . . as I lay every day in agony, a bedridden idiot, a corpse. No, I wasn't an idiot: She had tricked me. We'd known an immense happiness together, and despite the horrible awkwardness of the engagement party, we'd still had our dance together, during which she had promised to come to me the next day, right after her exam. If my engagement had broken her heart, she would have been entirely justified in wanting to end it with me, but then why lie to me? The pain within transmuted into a furious need to remonstrate with her, and lay bare her wrong. I would then prepare myself for an imaginary argument, during which I would be mollified in time, the accusations yielding to the heavenly images of our indelible hours together and the disarming power of her presence. I would all the same rehearse points I wanted to argue, one by one. She would have to tell me to my face that she was leaving me. If the university exam had gone badly I was not to blame. If she was going to leave me I had the right to know. For hadn't she said that she would continue to see me for the rest of her life? Didn't she owe me one last chance—at least to find the earring and bring it to her at once? Did she really believe that other men could love her as I did? With such resolve, I got out of bed and rushed out into the street.

Füsun Doesn't Live Here Anymore

I RAN ALL the way to their house. Even before I passed the corner where Alaaddin had his shop, I was euphoric, already imagining how I would feel when I saw her. As I smiled at a cat dozing, shaded from the July sun, I asked myself why it had not occurred to me before simply to go to their house. The pain in the upper left-hand quadrant of my stomach was already abating; the leadenness in my legs and the fatigue in my back were even now gone. As I approached the house, however, the fear of not finding her set in, and so my heart began to race: What would I say to her, what was I going to say if it was her mother who came to the door? At one point I thought of turning back to collect the childhood tricycle. But I knew the moment we saw each other there would be no need for excuses. Like a ghost I entered the cool foyer of the little apartment house on Kuyulu Bostan Street, walked up the steps to the second floor, and rang the bell. Visitors to the museum might wish to press down on the button alongside this exhibit to hear the sound of a chirping bird—so fashionable as a door chime in Istanbul at that time—which I heard as my heart fluttered like a bird, trapped between my mouth and my throat.

It was her mother who answered the door. The foyer was so dark that at first she wrinkled her nose at this tired stranger, as if he might be an annoying salesman. Then she recognized

me, and her face lit up. Taking hope from this, the pain in my stomach eased slightly.

"Oh! Kemal Bey! Do come in!"

"I was just passing by, Aunt Nesibe, so I thought I'd drop in," I said, sounding like the earnest neighborhood teenager in a radio play. "I just noticed the other day, Füsun's not working at the shop anymore. So I was wondering; she never dropped by to tell me how she did on the university exam."

"Oh, Kemal Bey, my poor boy, come inside so that we can share our troubles."

Without pausing to register what she might have meant by "sharing our troubles," I went into that dingy backstreet apartment that my mother had never once visited, in spite of all those cozy sewing sessions at our home and all the talk of our being related. Slipcovered armchairs, a table, a buffet holding a candy bowl, a set of crystal tumblers, and a television crowned by a sleeping china dog—I found these things beautiful, because they had all assisted in the making of the wondrous miracle that was Füsun. In a corner I saw a pair of sewing scissors, lengths of cloth, threads of many colors, pins, the pieces of a dress that was being sewn together by hand. So Aunt Nesibe was still working as a seamstress. Was Füsun at home? She didn't seem to be, but here was her mother, standing there waiting, as if about to bargain with me, or present me with a bill, and from this I drew hope.

"Do sit down, Kemal Bey," she said. "Let me make you a coffee. You look pale. You need to relax. Would you like some water from the refrigerator, too?"

"Isn't Füsun here?" asked the bird caught inside my parched throat.

"Noooo. Noooo," said the woman, in a tone to suggest, if only you knew what has happened! "How would you like your coffee?" This time she used the polite word for "you."

"Medium sweet!" I said.

What I now realize, all these years later, is that the woman went into the kitchen not to make me a coffee but to cook up an answer. But at the time, even with my senses on full alert, my mind was whirling from being in a house where the scent of Füsun was everywhere, and dizzy with the hope that I might see her. There, in its cage, was my friend the canary from the Şanzelize Boutique; its impatient twitter was something of a salve on my heart, and this confused me all the more. On the low table in front of me was the Turkish-made, thirty-centimeter wooden ruler with its fine white edge. I had given it to Füsun as a present at our seventh meeting, by my later calculations, for use in her geometry lessons. It was clear that Füsun's mother was now using the ruler for her sewing. I picked it up, brought it to my nose, and as I remembered the scent of Füsun's hand, there, before my eyes, she came to life. As Aunt Nesibe returned from the kitchen, I slipped the ruler into my jacket pocket.

She put the coffee down and sat across from me. She lit a cigarette, something in the gesture reminding me she was her daughter's mother, and then she said, "Füsun's exam did not go well, Kemal Bey." She had by now worked out how she was going to address me. "She was so upset. She left in tears before she could finish—we haven't even bothered to find out her results. She was in a terrible state. My poor daughter is never going to be able to study at university now. She was so traumatized she gave up her job. Those lessons with you really harmed her. You surely saw how sad she was on the night

of your engagement party. . . . It all got to be too much for her. You're not the only one responsible, of course. . . . She's a fragile young girl. She had only just turned eighteen. But she was heartbroken. So her father took her away, far, far away. So very far away. You should forget all about her. She will forget you, too."

Twenty minutes later, as I lay in our bed at the Merhamet Apartments, staring at the ceiling, tears dripping silent and slow onto the pillow, I thought about the ruler. I had used such a ruler as a child, which perhaps explains why I had given Füsun this standard lycée ruler, so it is hardly surprising that it should have become one of the first significant pieces in our collection. It was an object that reminded me of her, the first that agony had provoked me to take from her world. I put the end marked "30 centimeters" into my mouth, keeping it there for the longest time, despite the bitter aftertaste. For two hours I lay in bed, playing around with the ruler, trying to recast the hours it had spent in her hands, which introduced a relief, a happiness almost akin to seeing her.

The Streets That Reminded Me of Her

I KNEW by now that if I didn't make a plan to forget her, there would be no continuing my normal daily life. Even the least observant employees at Satsat had noticed the black melancholy that had settled over their boss. My mother, assuming there was some problem between me and Sibel, kept grilling me, and during the infrequent meals that we ate together she took to warning me against drinking too much, just as she warned my father. The more pain I felt, the more anxious and gloomy Sibel became, and we were fast approaching a dreaded point of explosion. Knowing Sibel's support was crucial if I was ever to be rescued from this quandary, I feared losing her no less than I feared a total breakdown.

I forbade myself from going to the Merhamet Apartments, waiting for Füsun, and caressing the things that reminded me of her. I'd tried to impose these prohibitions before—a regime that took every ounce of my will—but having found any number of ways to evade them (I would, for instance, set out to buy Sibel flowers from a place near the Şanzelize Boutique), I now decided on more drastic measures and removed from my mental map a number of streets and places where I had spent a large part of my life.

Here I display a modified Nişantaşı map that I devised, after considerable effort, the streets or locations marked in red representing regions from which I was absolutely banned. The

Şanzelize Boutique, near where Teşvikiye Avenue crosses with Valikonağı Avenue; the Merhamet Apartments, on Teşvikiye Avenue; the police station and the corner where Alaaddin had his shop—on my mental map, they were all restricted areas, marked in red. I banned Kuyulu Bostan Street, where Füsun and her family lived, and the street that was still called Emlak Avenue, though not Abdi İpekçi Avenue or Celâl Salik Street, its official names in later years (although Nişantaşı residents would continue to call it "the street where the police station is"). Even the side streets leading off these main thoroughfares were prohibited. The streets marked in orange I allowed myself entry in the case of absolute necessity, provided I'd had nothing to drink and crossed them at a gallop in under a minute and did not linger. My home and Teşvikiye Mosque were, like so many side streets, marked in orange because I knew that prolonged exposure could inflame my suffering. I had to be careful, too, on all streets marked in yellow. My accustomed path from Satsat to our meetings at the Merhamet Apartments, the road that Füsun had taken every day from the Şanzelize to her home (I kept imagining this journey)—these were full of land mines and snares of recollection that might plunge me into agony. Also marked on the map were other places that figure in my brief history with Füsun, for example, the empty lot where the devout sacrificed lambs when we were children, and even the corner of the mosque courtyard where she'd stood as I watched her from afar. I kept this map always in my mind, its restrictions inviolable out of belief that only this sort of ascetic regimen would cure, however slowly, my illness.

The Shadows and Ghosts I Mistook for Füsun

SADLY, IN spite of banishing myself from the streets where I'd lived all my life and keeping far from all objects reminiscent of her, I was unable to forget Füsun. For now I'd begun to see her ghost in crowded streets and at parties.

The first encounter was the most shocking; it happened one evening at the end of July, on a car ferry, as I was going to join my parents in our summer place in Suadiye. It was the ferry connecting Kabataş with Üsküdar, and as we approached the latter, I, like all the other impatient drivers, had started up my engine, when I glanced over at the side entrance for pedestrians and saw Füsun. Since the car ramp had not yet been lowered, I could have reached her only by bolting out of the car and racing after her, thus blocking the vehicles trying to move off the ferry. I jumped out of the car and was about to call to her at the top of my voice when the lower torso came into view and I was pained to notice that I saw it was thicker and coarser than my beloved's, and the face, too, took on the aspect of someone else. But during those eight or ten seconds, my pain became elation, and over the days that followed I lived this moment many times over, being convinced that this was how we would indeed meet.

A few days later I went to the Konak Cinema, just to kill some time, and as I was ascending the long, wide stairs to the ground floor, I saw her ten steps ahead of me. The sight of

her long, bleached blond hair and her slender body sent a jolt first to my heart and then to my legs. I ran toward her ready to cry out, but when I saw it wasn't her I was struck mute, as in a dream.

I was spending more time in Beyoğlu, as there were fewer potential reminders of her there, but one day I had the shock of seeing her image reflected in a shop window. Another time a girl was skipping through a crowd in Beyoğlu, in a way I believe unique to Füsun. I gave chase but couldn't catch up. Uncertain whether this person had been another mirage or my quarry, I went back at the same time for several days in a row to pace back and forth between Ağa Mosque and the Palace Cinema; failing to catch a glimpse of her, I'd take refuge in a beer hall and sit at the window, watching the passing crowds.

Those halcyon moments were so brief. This photograph of Füsun's white shadow in Taksim captures an illusion that lasted only two minutes.

Over time I came to notice how many of our young girls and women shared Füsun's figure, and how many dark Turkish girls bleached their hair blond. The streets of Istanbul were full of Füsun's doubles, who would appear for a second or two and then vanish. But whenever I got a good look at one of these ghostly figures, I would see that she did not resemble my Füsun in the slightest. Once, while playing tennis with Zaim at the Tennis, Fencing, and Mountaineering Club, I spotted her among three giggling young girls, drinking Meltem at one of the tables; my greater surprise was not at seeing her, but at her having been admitted to this club. Another time her specter had just stepped off the Kadıköy ferry onto the Galata Bridge and was trying to hail a shared taxi. It was a while before my heart grew accustomed to these mirages, and then my mind.

Once, during the intermission between two films at the Palace Cinema, four rows ahead of me in the balcony I saw her sitting with her sisters, enjoying a chocolate Mirage Ice, and I chose to forget that she had no sisters, for I had learned that until I could harvest the pleasure of an illusion there was no sense in dispelling it, at the expense of my aching heart.

There she was, standing before the Dolmabahçe Clock Tower, or walking through the Beşiktaş Market carrying a macramé bag like a housewife, or most surprising and unsettling, gazing down at the street from the window of a third-floor apartment in Gümüşsuyu. When she saw me in the street looking up at her, Füsun's ghost stared back at me. When I waved, she waved back. But her manner of waving sufficed to tell me that she wasn't Füsun, so I walked off in shame. Nevertheless, the apparition at the window prompted me to imagine that her father had quickly married her off in shame, perhaps to help her forget me. In my dream she was beginning her new life in that apartment but still wanted to see me.

Discounting the second or two of consolation that the first sightings of these ghosts brought me, I never for long forgot that they were not Füsun but figments of my unhappy imagination. Still, I could not live without the occasional sweet feeling, and so I began to frequent those crowded places where I might see her ghost; and eventually I would mark these places, too, on my mental map of Istanbul. Those places where her ghosts had appeared most often were the ones where I was most regularly to be found. Istanbul was now a galaxy of signs that reminded me of her.

Because I came across her ghost when wandering slowly through the streets, staring into the distance, I took to wandering slowly through the streets, always looking afar. When I was out

at a club or a party with Sibel and had drunk too much *rakı,* Füsun would appear dressed in all sorts of outfits, and I would have to remind myself that I was engaged and that rising to the bait of a mirage would imperil the one thing that was real. I have chosen to display these views of the beaches of Kilyos and Şile because it was most often on a summer's afternoon when my guard was down, dulled by heat and fatigue, that I saw her among the crowds of young girls and women so embarrassed to be seen in their maillots and bikinis. Forty-five years after Atatürk's revolution and the founding of the Republic, the Turkish people had still not worked out how to go to the beach in bathing suits without embarrassment, and at times like this, it would occur to me how much Füsun's fragility reflected the bashfulness of the Turkish people.

In these moments of unbearable longing, I would leave Sibel to play ball in the sea with Zaim, and walk off into the distance to lie down in the sand, leaving my awkward body, love-starved into senselessness, to be scorched by the sun. Watching the sand and the shore from the corner of my eye, I would, inevitably, see a girl running toward me and think that it was her. Why had I not once brought her to Kilyos Beach, knowing how much she'd have wanted to go? How could I not have recognized the value of this great gift God had given me! When was I going to see her? As I lay there in the sun, I wanted to cry, but knowing I was guilty, I couldn't allow myself, and instead I buried my head in the sand, and felt damned.

33

Vulgar Distractions

LIFE HAD receded from me, losing all the flavor and color I'd found in it until that day. The power and authenticity I'd once felt in things (though, sad to say, without fully realizing it) was now lost. Years later, when I took refuge in books, I found, in a work by Gérard de Nerval, the best expression of the crude dullness I was feeling at that time. After understanding that he has lost forever the love of his life, the poet, whose heartbreak eventually leads him to hang himself, writes somewhere in his Aurélia that life has left him with nothing but "vulgar distractions." I, too, felt that whatever I did during these days without Füsun, it was vulgar, ordinary, and meaningless, and toward persons and things that had led me to such coarseness I felt only anger. Still, I never stopped believing that I would find Füsun, that I would have another chance to speak to her, or even that I would embrace her; this was what I thought bound my soul to my body still, however tenuously, though when thinking back on these days, I would remorsefully acknowledge that such hope only prolonged my grief.

On one particularly hot July day, my brother rang to tell me, with righteous anger, that Turgay Bey, our partner in so many successful ventures, felt injured at not having been invited to the engagement party, and now wished to withdraw from a big bedsheet contract that we'd jointly bid for and won, a mess for which Osman held me personally responsible (Osman having

heard from my mother that it was I who had scratched his name off the guest list). I calmed him down by promising to put matters right with Turgay Bey tomorrow.

As I sat in the car the next day in the withering heat, on my way to his giant factory in Bahçelievler, I looked out at the hideous neighborhoods of ever uglier new apartment blocks, depots, little factories, and dumping grounds, and the pain of love no longer felt unbearable. This abatement could only be on account of my impending meeting with someone who might give me news of Füsun, someone with whom I might be able to talk about her. But in similar circumstances (when I spoke with Kenan or ran into Şenay Hanım in Taksim) I could not admit the reason for my welcome joy, trying to convince myself that simply pursuing "business" was having a beneficial effect. Indeed, if I hadn't gone to such lengths of self-deception, this visit I had made "only for business" might have gone better.

That I had come all the way from Istanbul to apologize to Turgay Bey had assuaged his pride, and this was quite enough for him to treat me well. He gave me a tour of his weaving operation, through halls where hundreds of girls were working on giant looms and when, behind one of them, I saw Füsun's ghost with her back turned, my real purpose in coming announced itself to me. And so, as I admired the modern new offices and "hygienic" cafeterias, I abandoned my aloof manner, amicably suggesting what a shame it would be if we could not do business with him. Turgay Bey wanted us to eat lunch with the workers, according to his custom, but I, convinced that this would not allow me to apologize properly, told him that a bit of drink not to be found on the premises might help me broach certain "important matters." I looked at him closely—

so ordinary looking, with his mustache—and there was nothing in his expression to suggest an awareness that I was alluding to Füsun. Finally I mentioned the engagement party, and he, by now mollified, said proudly, "It was just an oversight, I'm sure. Let's put it behind us." But I continued to insist, forcing this honest and industrious man whose mind scarcely strayed from his work to invite me out to a Bakırköy fish restaurant. In his Mustang I remembered Füsun telling me how many times they had kissed while sitting in those same seats, how their thrashing was reflected in the gauges and the rearview mirror, and I remembered how he had groped her, felt her up, before she'd even turned eighteen. I wondered again whether Füsun had gone back to him, and, haunted still by all her ghosts, unable to convince myself that this man in all likelihood had no news of her, I remained tightly coiled in readiness.

At the restaurant, as Turgay Bey and I sat across from each other like two old ruffians, as I saw him put the napkin on his lap with his hairy hands, and looked at his great pockmarked nose and his impudent mouth from up close, I had a strong intuition that this would not go well. When he wasn't shouting for the waiter, he was wiping the corners of his mouth with his napkin, an elegant gesture stolen from a Hollywood film. Still I managed to rein myself in, and until the middle of the meal, I remained in control. But soon the *rakı* I drank to escape the evil within me flushed it to the surface. In the most polite way, Turgay Bey allowed that any misunderstanding about the bedsheet contract could be easily settled and that there should be no ill will between us as partners. "We're both going to do very well," he said soothingly, when I blurted, "What matters most is not that our business goes well, but that we be good people."

"Kemal Bey," he said, glancing at the *rakı* glass in my hand, "I have the greatest respect for you, and your father, and your family. We've all had our bad days. Living as we do in this beautiful but impoverished country, we enjoy a good fortune that God bestows only on his most beloved subjects; and let us give thanks for that. Let us not be too proud, and let us remember Him in our prayers—that is the only way to be good."

"I had no idea you were so religious," I said mockingly.

"My dear Kemal Bey, what did I do wrong?"

"Turgay Bey, you broke the heart of a young girl who happens to be a member of my family. You treated her badly. You even offered her money. I'm talking about Füsun of the Şanzelize Boutique—she's a very, very close relation on my mother's side."

His face turned ashen, and he looked down. That was when I realized that I was jealous of Turgay Bey not because he had been Füsun's lover before me, but because, once the affair was over, he'd managed to get over her and return to his normal bourgeois life.

"I had no idea she was related to you," he said with shocking sincerity. "I feel deeply shamed. If your family could not bear to see me, you had every right not to invite me to the engagement party. Do your father and your older brother feel equally offended? What can we honorably do about this—should we end our partnership?"

"Let's end it," I said, regretting my words even as I uttered them.

"In that case, let us say it is you who have canceled the contract," he said, lighting a Marlboro.

The pain of love was now exacerbated by my shame at having misplayed my hand. Though I was very drunk by now, I

drove myself back to the city. Since I'd turned eighteen, driving in Istanbul and especially on the shore road, along the city walls, had brought me huge pleasure, but now, with my sense of impending doom, the ride had become a form of torture. It was as if the city had lost its beauty, as if I could do nothing but put my foot on the accelerator in order to escape this place. Driving through Eminönü, under the pedestrian overpasses in front of the New Mosque, I very nearly ran someone over.

Reaching the office, I decided that the best thing to do was to convince Osman that ending the partnership with Turgay Bey was not such a bad idea. I summoned Kenan, who was well informed about this particular contract, and he listened, very intently, to what I had to say. I summarized the situation thus: "For personal reasons, Turgay Bey is behaving badly and has asked if we might fill this contract on our own," adding that we had no option other than to part ways with Turgay Bey.

"Kemal Bey, if at all possible, let's try and avoid this," said Kenan. He explained that we could not possibly manage alone, and if we failed to fulfill the order in time, it would harm not just Satsat but the prospects of the other firms involved, and subject us to heavy penalties in the New York courts. "Is your brother aware of all this?" he asked. I must have been spouting *rakı* fumes like a chimney, else he wouldn't have questioned his boss so insolently. "The arrow has already left the bow," I said. "We'll have to carry on without Turgay Bey." I knew this was impossible, even if Kenan hadn't said so. But my reason had now shut down altogether, yielding to a troublemaking devil. Kenan remained in front of me, insisting that I needed to speak to Osman.

It goes without saying that I did not then hurl the stapler displayed here, or the accompanying ashtray bearing the

Satsat logo, at Kenan's head, however much I longed to do so. I do remember noting that, however laughable his tie was, it resembled the company ashtray in both ungainly size and coloring. "Kenan Bey," I roared, "you are not working in my brother's firm. You are working for me!"

"Kemal Bey, please don't take offense. Of course I'm aware of this," he said slyly. "But you introduced me to your brother at the engagement party, and since then we've been in touch. If you don't ring him right away to talk about a matter this important, he's going to be very upset. Your brother is aware that you've not been having the easiest time recently, and like everyone else, he only wants to help you."

The words "everyone else" almost detonated my anger. I was tempted to fire him then and there, but I feared his audacity. Suffering like a trapped animal, I became aware that I would only feel better if I could just see Füsun once. To the world I was indifferent, because by now everything was so futile, so very vulgar.

34

Like a Dog in Outer Space

BUT INSTEAD of Füsun I saw Sibel. My pain was now so great, so all-consuming that when the office emptied out, I knew at once that if I remained by myself for too long I would feel as lonely as this dog after the Soviets sent him off in his little spaceship into the dark infinity of outer space. By calling Sibel to the office after hours, I gave her the legitimate expectation that we would be resuming our pre-engagement sex life. My well-intentioned fiancée was wearing Sylvie, a perfume I'd always liked, and these imitation net stockings that, as she knew very well, aroused me, with high-heeled shoes. She arrived elated, thinking that my "sickness" was retreating, and I could not bring myself to tell her that, quite to the contrary, I had called her here to rescue me from the scourge, however briefly; that I longed to embrace her as I had embraced my mother when I was a child. So Sibel did as she had done with such relish in the past: She walked me backward and sat me down on the divan, and proceeded to do her dumb secretary impression, cheerily peeling off her clothes, layer by layer, until, smiling sweetly, she sat on my lap. Let me not describe how the scent of her hair and her neck made me feel utterly at home, or how relaxed, even restored, I was by that familiar intimacy, because the reasonable reader, like the attentive museum visitor, will then assume that we went on to make love. He would be disappointed, as Sibel was, too.

But it felt so good to embrace her that I had soon drifted off into a peaceful, happy sleep, and my dream was of Füsun.

When I woke up, in a sweat, we were still lying there in each other's arms. The room was dark and we dressed in silence, Sibel lost in her own thoughts, and I wallowing in guilt. The headlights of the cars in the avenue and the purple sparks from the trolleybus rods illuminated the office just as they had in the days when we had made careless love.

Without discussion, we repaired to Fuaye, and when we sat down at our sparkling table in the crowded, bustling dining room, I thought once again how charming, beautiful, and understanding Sibel was. I remember that after we had talked about this and that for an hour, and laughed with various tipsy friends who had stopped by our table, we discovered from the waiter that Nurcihan and Mehmet had been in for supper earlier. But there was no avoiding the real issue indefinitely, as our evening was punctuated by longer and longer silences. I ordered a second bottle of Çankaya wine. By now Sibel was drinking a lot, too.

At last she said, "What's going on with you? It's time—"

"If I only knew," I said. "There seems to be a part of my mind that doesn't want to acknowledge the problem, or understand it."

"So you don't understand it either, is that what you're saying?"

"Yes."

"If you ask me, you know a lot more than I do," said Sibel with a smile.

"What do you think I know so much more about than you do?"

"Do you ever worry what I might be thinking about your troubles?" she asked.

"I worry that if I don't snap out of this, I'll lose you."

"Don't worry about that," she said, stroking my hand. "I'm patient and I love you dearly. If you don't want to talk about it, then you don't have to. And don't worry, I don't have any wild theories about all this. We have plenty of time."

"What wild theories?"

"Well, for example, I'm not worried that you might be a homosexual or something," she said, smiling at once, to show that she wanted to reassure me, too.

"Oh, thanks. What else?"

"I don't think it's a sexual illness or some deep childhood trauma, or anything like that. But I still think that it might help to see a psychologist. There's nothing wrong with that. In Europe and America, everyone goes to them. . . . Of course, you'd have to tell this person what you can't tell me. . . . Come on, darling, tell me, don't be afraid. I'll forgive you."

"I *am* afraid," I said with a smile. "Shall we dance?"

"Then you admit there is something you know and I don't."

"Mademoiselle, please don't decline my invitation to dance."

"Oh, monsieur! I am engaged to a troubled man!" she said, and we rose to our feet.

I have recorded these details, and displayed these menus and glasses, to evoke the uncanny intimacy, the private language, and—if that's the right word for it—the deep love that existed between us during those hot July nights when, seeking relief, we'd go to clubs and parties and restaurants and drink with abandon. It was a love fed not by sexual appetite but by a fierce compassion, and on nights when, having both had

a lot to drink, we rose to dance, it wasn't so far from physical attraction. As the orchestra in the background played "Lips and Roses," or as the disc jockey (a new fixture in Turkey at that time) spun his 45s, the songs would filter through the leaves of the still and silent trees on humid summer nights and I would take my beloved fiancée in my arms, embracing her no less passionately than on the divan in the office, and however motivated to protect myself, I treasured our camaraderie and common bonds; breathing in the scent of her neck and her hair, I found peace, and I would see how senseless it was to feel as lonely as a canine cosmonaut in space; and assuming that Sibel would always be at my side, I would woozily draw her closer. As we danced under the gaze of other romantic couples, we would sometimes lurch, as if to take a drunken spill onto the floor. Sibel enjoyed these alcoholic trances we fell into, as they transported us from the everyday world. Outside in the streets of Istanbul, communists and nationalists were gunning each other down, robbing banks, throwing bombs, and spraying coffeehouses with bullets, but we had occasion, and license, to forget the entire world, all because of my mysterious ailment, which in Sibel's mind gave life a certain depth.

Later, when we sat down at our table, Sibel would again drunkenly broach the subject, now not as something she understood but something she accepted without fully understanding. Thus, thanks to Sibel's efforts, my mysterious moods, my melancholy, and my inability to make love to her amounted to no more than a premarital test of my fiancée's compassion and commitment, a limited tragedy soon to be forgotten. It was as if our pain gave us the distinction of standing apart from our coarse, superficial, rich friends, even as we boarded their speedboats. We no longer needed to join the

careless drunks who jumped from the pier into the Bosphorus at the end of a party. My pain, and my strangeness, had graced us with a degree of difference. It pleased me to see Sibel embrace my pain with such dignity, and this, too, drew us closer together. But even amid all this drunken earnestness, if I heard a City Line ferry blowing its sad whistle in the distance, or if I glanced into the crowd and in the least likely of places spotted someone I thought was Füsun, Sibel would notice the strange expression on my face and intuit painfully that the danger lurking in the shadows was far more fearsome than she'd thought.

And so it was that by the end of July, Sibel's loving suggestion that I see a psychiatrist turned into a requirement, and unwilling to lose her wonderful compassion and companionship I agreed. The famous Turkish psychoanalyst who the careful reader will recall offering an analysis of love was at that time recently returned from America and working hard, with his bow tie and his pipe, to convince a narrow segment of Istanbul society that they could no longer do without his profession. Years later, when I was trying to establish my museum, and I paid him a visit to ask what he remembered of that era (and also to solicit his donation of that same pipe and bow tie), I discovered that he had no memory of the troubles I was suffering at the time; what's more, he'd heard nothing of my painful story, which was by then common knowledge in Istanbul society. He remembered me as being like so many of his other patients at that time—perfectly healthy individuals who rang his bell only out of curiosity. I shall never forget how Sibel insisted on coming with me, like a mother taking her ailing child to the doctor, and how she said, "I'll just sit in the waiting room, darling." But I hadn't wanted her to come at all. Sibel, with the felicitous intuition so prevalent in the

bourgeoisies of non-Western countries, and most particularly Muslim countries, saw psychoanalysis as a "scientific sharing of confidences" invented for Westerners unaccustomed to the curative traditions of family solidarity and shared secrets. When, after talking about this and that and neatly filling out the necessary forms, I was asked what my "problem" was, I felt compelled to disclose that I had lost the woman I loved and now felt as lonely as a dog sent into outer space. But instead I said that I had been unable to make love to my beautiful and cherished fiancée since our engagement. And he asked me what was the cause of my loss of desire—a surprise since I thought he would be the one to answer this question. Today, so many years later, when I remember the words that came to my mind with God's help, I still smile, but I also see some truth in them: "Perhaps I'm afraid of life, Doctor!"

This would be my last visit to the psychoanalyst, who could do no more than send me off with the words: "Don't be afraid of life, Kemal Bey!"

The First Seeds of My Collection

HAVING EVADED the snare of the psychoanalyst, I tricked myself into thinking that I was on the road to recovery, convinced that I was strong enough to return, just for a while, to the streets I had marked in red. It felt so good for the first few minutes, to be walking past Alaaddin's shop, down streets where my mother had taken me shopping as a child, and to breathe in the air in those shops, so good that I came to believe I was not afraid of life and that my illness was abating. These hopeful thoughts emboldened me to think I could walk past the Şanzelize Boutique without pain—but this was a mistake. Just seeing the shop from a distance was enough to unnerve me.

For the pain was merely dormant, just waiting to be triggered, and in a moment its darkness suffused my heart. Desperate for an instant cure, I told myself that Füsun might be in the shop, and my heart started racing. With my head swimming, and my confidence draining fast, I crossed the street and looked in the window: Füsun was there! For a moment I thought I was going to faint; I ran to the door. I was about to walk in when I realized that it was not Füsun I'd seen but another specter. Someone had been hired to replace her! Suddenly I felt unable to stand. The life of nightclubs, those parties at which I'd taken drunken refuge—they revealed themselves now in all their falsity and banality. There was only one person in the world with whom

I could live, only one person whose embraces I craved; the heart of my life was elsewhere, and to try to fool myself for nothing with vulgar distractions was disrespectful both to her and to myself. The regret and the guilt-ridden chaos that had enveloped me since my engagement now grew monstrous with a new realization: I had betrayed Füsun! I had to think only of her. I had to go at once to the place nearest to where she was.

Eight to ten minutes later I was lying on the bed at the Merhamet Apartments, trying to pick up Füsun's scent in the sheets, and it was almost as if I was trying to feel her inside me, almost as if I wanted to become her, but her scent had grown fainter. With all the strength I could muster, I embraced the sheets and then reached out to pick up the glass paperweight on the table, desperate for traces of the scent of her hands. As I inhaled deeply from the glass, I felt instant relief in my nose, my lungs. I lay there holding and sniffing the paperweight, for I don't know how long. According to calculations made later from memory, I had given her this paperweight on June 2, as a present, and as with so many other presents I gave her, she, not wishing to arouse her mother's suspicions, elected not to take it home.

I reported to Sibel that despite the length of my visit to the doctor, it had not moved me to confess anything of interest, and that as the doctor had nothing of his own to offer me, I would not be seeing him again, but that I did feel a bit better.

Unmentioned was that my therapy had consisted of going to the Merhamet Apartments and lying down on that bed, and fondling something she had touched. No matter, since a day and a half later, my agony was as intense as before. Three days on I went back to lie in that bed, holding in my hands another object that Füsun had touched, a brush splattered with oil

paints of many colors, and I was sweeping it across my skin, and taking it into my mouth, like an infant examining a new toy. Again, I found relief for a time. In one part of my mind I knew that I had become habituated, addicted to objects that brought me relief, but that my addiction was in no way helping me forget Füsun.

These two-hour visits I made every two or three days to the Merhamet Apartments I hid not just from Sibel—it was as if I was hiding them from myself as well, which may be why I came to believe I was reducing my suffering to a manageable condition. In the beginning, when I looked at the old turban case that had been passed down to us from my grandfather, and the fez Füsun would put on when she was clowning around, or at my mother's discarded shoes (she'd tried these on, too; both were a size 38), it was not with the eyes of a collector. I was a patient taking stock of his medicines. On the one hand I had a longing for any object that reminded me of Füsun; on the other hand, even as my pain abated under therapy, I longed to run away from this house and these objects that had both healed me and reminded me of my affliction, holding out the ever elusive hope that I was beginning to recover. This hope gave me courage, and I began to dream—within pain, but gladly—that I could soon return to my former life, and that I would make love to Sibel, and that we would marry and begin a normal, happy married life.

But these fantasies were short-lived; before a day had passed, the old familiar suffering was again upon me, and again I would be returning to the Merhamet Apartments to take the cure. I would make straight for a teacup, a forgotten hair clip, a ruler, a comb, an eraser, a ballpoint pen—whatever talisman I could find of those blissful days when we sat side by side, or I

would rummage through the useless things that my mother had banished here, knowing that Füsun had touched or played with them all, leaving particles of her scent in incalculable measures. To find them was to see all the memories attached to each thing parade before my eyes, and so my collection loomed ever larger.

To Entertain a Small Hope That
Might Allay My Heartache

IT WAS during these important days—as I was collecting the first objects for my museum—that I wrote the letter displayed here. It remains in its envelope to keep a long story short, and to spare me a full disclosure of the shame it caused me still, twenty years later, when I was founding the Museum of Innocence. If readers and the visitors to my museum could open the letter, they would find me groveling to Füsun. I abjectly confessed to her my error; I was full of remorse, and suffering terribly; avowing that love was a sacred feeling, I promised that if only she would come back to me, I would leave Sibel. After writing the last words, I felt even more contrite. I knew that in fact what I needed to say was that I had broken off with Sibel for good, but my only hope that night was to drink myself into oblivion, nestling up with Sibel, and so I could not bring myself to take that extreme though necessary measure. When I discovered the letter ten years later in Füsun's drawer, its contents seemed less important than its very existence; it surprised me to see the extent of my self-deception at that time. With one hand I was trying to deny the intensity of my love for Füsun and my own helplessness while conjuring up ridiculous omens to convince myself that we would soon be reunited; with the other hand, I clung to my dreams of a happy family life with Sibel. Should I have broken off my engagement and proposed marriage to

Füsun in this letter? I don't think this thought ever crossed my mind until it arose during my meeting with Ceyda, Füsun's dear friend from the beauty contest, and the carrier of my letter.

Knowing that visitors to my museum must by now be sick and tired of my heartache, I display here a lovely news clipping. It features Ceyda's official beauty contest photograph, along with an interview in which she states that her aim in life is a happy marriage with the "ideal man" of her dreams. I would like to take this opportunity to thank Ceyda Hanım, who knew my sad story in full, who respected the love I felt for her friend, and who was generous enough to donate this lovely photograph of herself as a young woman to the museum. Realizing that I could not send my anguished letter to Füsun through the post—lest her mother intercept it—I decided to send it care of Ceyda, whom I tracked down with the help of my secretary, Zeynep Hanım. Füsun had confided to her friend every detail of our liaison from the very beginning, and when I said that I wanted to meet her to discuss a matter of great importance, Ceyda was not at all coy. When we met in Maçka, I noticed at once that I felt no embarrassment in telling Ceyda of my suffering. Perhaps this was because I attributed to her a mature understanding of the matter, or perhaps it was because I could see how happy, how very happy Ceyda was when we met. She was pregnant, and her rich, conservative lover, the Sedirci boy, had decided to marry her. She didn't hide any of this from me, even reporting that the wedding would be soon. Was there a chance I might see Füsun there? Where was Füsun? Ceyda's answers were evasive. Füsun must have warned her. As we walked in the direction of Taşlık Park, she said deep and serious things about how deep and serious love is. As I listened, I fixed my eyes on Dolmabahçe Mosque,

shimmering like a dream in the distance, taking me back to childhood.

I could not bring myself to put too much pressure on her, or even ask her how Füsun was. Ceyda, I sensed, hoped that I would break off my engagement to Sibel and marry Füsun, allowing our two families to see each other socially, and it was only when she said all this in as many words that I realized her dreams were also mine. Upon entering Taşlık Park that afternoon, and seeing the view, the beauty of the mouth of the Bosphorus, the mulberry trees before us, the lovers sitting at the tables of the rustic coffeehouse drinking Meltem, the mothers with their baby carriages, the children playing in the sandbox just ahead, the students chatting and laughing as they nibbled on chickpeas and pumpkin seeds, the pigeons picking at the husks, along with two swallows—everything in this crowded setting reminded me of what I had been on the verge of forgetting: the beauty of ordinary life. And so, when Ceyda opened her eyes wide, saying she would give my letter to Füsun, and she sincerely believed it would be answered—I succumbed to a great hope of which I was never more susceptible.

But there was no reply.

One morning at the beginning of August I was forced to acknowledge that in spite of all my precautions and palliative measures, my pain, far from abating, was still increasing at a steady rate. If I was working in the office or talking on the phone, I did not think any new thought about Füsun, but the pain in my stomach would take on the form of some obsessive thought and race through my brain, silently, like an electric current, until I could think of nothing else. The various things I did to cultivate such small hopes as could allay the pain and distract me for a time were never effective for long.

I began to take an interest in coded messages, mysterious signs, and newspaper horoscopes. I put the most faith in the "Your Sign, Your Day" column in *Son Posta* and the astrologist of *Hayat* magazine. The cleverest astrologers would say to their readers, and most especially to me: "Today you will receive a sign from a loved one!" They said much the same thing to those born under other signs, but that was only right, as it takes two to make such an event happen; and I was so convinced I would read these horoscopes very carefully, but having no systematic belief in the stars, I did not spend hours playing with them, as bored housewives are given to do. My need was urgent. I made my own system of signification: I would say to myself, "If the next person who walks through that door is a female, then I shall be reunited with Füsun, and if it is a man, all will be lost."

The world, life, all reality were swarming with signs sent by God so that we could discern our fortune. I would stand at the Satsat window, counting the cars as they passed, and I would say to myself: "If the first red car moving down the avenue has come from the left, I am going to have news from Füsun, and if from the right, my wait will continue." Or I might divine: "If I am the first person to jump off the ferry when it lands, I'll see Füsun soon." And I would jump before they'd even thrown the rope. Behind me the rope men would cry: "The first person to jump to shore is a donkey!" Then I would hear a ship's whistle, taking it for an omen, and I would imagine what sort of ship it was. I would tell myself, "If the number of steps in the overpass is an odd number, I'll see Füsun soon." If it turned out to be an even number, my agony would increase, but if the omen augured well I would enjoy a moment of relief.

The worst was the pain that woke me up in the middle of the night and would not let me get back to sleep. In such cases,

I would drink *rakı,* and then, out of desperation, chase it with a few glasses of whiskey or wine, trying to silence my mind as if turning down the volume of a relentlessly blaring radio that was robbing me of my peace. Sometimes, with my mother's old deck of cards and a glass of *rakı* in my hand, I would play solitaire, trying to learn my fortune. Some nights I'd pick up the dice that my father played with only rarely and, telling myself that each time was the last, throw them a thousand times over. When I was well and truly drunk I would begin to take a strange satisfaction from my anguish, taking a foolish pride in my predicament, telling myself that it was worthy of a novel, a film, even an opera.

One night, while I was staying at the summer house in Suadiye, I awoke a few hours before dawn; when it became clear that sleep would not return, I tiptoed quietly through the darkness out to the terrace overlooking the sea; lying on a chaise longue, in the fragrant breeze of the pine trees, I gazed at the flickering lights of the Princes' Islands and tried to lull myself to slumber.

"You can't sleep either?" my father whispered. In the darkness I had not noticed him lying on the other chaise longue.

"I've been having some trouble lately," I whispered guiltily.

"Don't worry, it will pass," he said softly. "You're still young. It's still very early for you to be losing sleep over this kind of pain, so don't fret. But when you get to my age, if you have some regrets in life, you'll have to lie here counting the stars until dawn. Beware of doing things that you might regret later."

"All right, Father," I whispered. It was not long before I sensed I might be able to forget my pain, if only for a while, and drift off. Here I display the collar of the pajamas my father was wearing that night, and one of his slippers, just the sight of which makes me sad.

Perhaps because I gave them no importance, or perhaps because I didn't want readers and visitors to my museum to feel too much contempt for me, I have concealed a few habits picked up during this period, but now for the sake of my story's integrity I feel obliged to make a brief confession about one of them. At lunchtime, when my secretary Zeynep Hanım went out with the rest of the office, I would sometimes dial Füsun's number. It was never Füsun who answered, which told me that she had not yet returned from wherever she'd gone, and her father wasn't around either. It was always Aunt Nesibe who picked up the phone, which meant that she was sewing at home, but I persisted in hoping that one day it would be Füsun who answered. Or at least that Aunt Nesibe, as she waited for the caller to speak, would let slip some facts about Füsun. Or that as I waited patiently, without saying a thing, Füsun would say something in the background. When Aunt Nesibe picked up the phone, there was a stretch of time when it was easy to be silent, but the longer and more exasperatedly she spoke, the harder it was to hold back, for Aunt Nesibe would quickly lose her nerve, succumbing to her panic as she writhed in a way that a telephone pervert would love: "Hello? Hello? Who is this? Who am I speaking to? For God's sake, would you please say something? Hello, hello, who are you? Why are you calling?" She would make random arrangements, strings of such phrases, her fear and anger audible in every word, but it never occurred to her to hang up immediately, or at least before I did. Over time I began to feel sorry, even desperate, for this distant relation of mine acting like a trapped rabbit, and so I finally broke the habit.

There was no sign of Füsun.

37

The Empty House

AT THE end of August, as flocks of storks flew over the Bosphorus, the house in Suadiye and the Princes' Islands, leaving Europe to fly for Africa, we decided, at my friends' steady insistence, to go ahead with the end-of-summer party I was in the habit of giving in the empty apartment in Teşvikiye Avenue just before my parents' return from their summer home. Sibel busied herself with the shopping, shifted the tables around, took the carpets out of mothballs and rolled them out over the parquet floors, and instead of going to help her, I again dialed Füsun's home number for old times' sake. For a few days now it had been ringing and ringing without answer, and that had worried me. This time, when I heard the broken tones that indicated the line was cut off, the pain in my stomach spread to every part of my body, every part of my mind.

Twelve minutes later, having passed through streets I'd been evading studiously since marking them in orange, I found myself walking like a wraith toward Füsun's family's house in Kuyulu Bostan Street. Looking up at the windows from a cautious distance, I could see that the curtains were gone. I rang the doorbell; no one answered. I knocked gently on the door before pounding it, and still no one answered, and I thought I was going to die. "Who's there?" cried the janitor's old wife from the dark basement apartment. "Haaa,

the people in number three, they've moved. Those people have left."

I told her I was interested in renting the apartment. Slipping her twenty lira, I used her key to let myself in. Dear God! How can I describe the loneliness of those empty rooms, or the state of the crumbling tiles in that tired and disintegrating kitchen, the dilapidated tub in which my lost love had bathed throughout her life, the mystery of the gas heater that had scared her so, the bare nails in the wall, and the shadows where for twenty years frames and mirrors had hung? The scent of Füsun in the rooms, the shadow falling in a corner, the layout of this house where Füsun had spent her whole life, these rooms that had made her the person she was, the walls and the flaking paint—I lovingly imprinted all these details in my memory. There was this wallpaper, of which I tore off a large piece to take with me. And the handle of the door to the small room I assumed had been hers—thinking about her hand grasping this handle for eighteen years, I pried it off and dropped it into my pocket. The porcelain handle of the toilet chain in the bathroom came loose even more easily.

From the heap of discarded papers and rubbish in the corner, I extracted the arm of a baby doll that had once been Füsun's. I slipped that into my pocket, along with a large mica marble and a few hairpins that I had no doubt were hers. Imagining the comfort I would eventually extract from these things in privacy, I relaxed. Why, I asked the janitor's wife, had the tenants chosen to leave after so many years? She said they had been haggling with the owner over the rent for ages. "It's not as if rents are lower in other neighborhoods," I said. Money was losing value, and prices were going up.

"So where did these people move to?" "We don't know," said the janitor's wife. "They were cross with us when they left, and with the owner. Imagine, after twenty years, such a falling-out." I felt I would suffocate on the spot.

It was then that I realized how I had always depended on the hope that one day I would come here, ring their doorbell, plead my way in, and see Füsun. Now that I'd been robbed of this chance I had not even realized I was counting on, I didn't know where I would turn next.

Eighteen minutes later I was in the Merhamet Apartments, lying on our bed, finding such relief as I could from the new objects recovered from the empty apartment. Sure enough, these things that Füsun had touched, these objects that had made her who she was—as I caressed them, and gazed at them, and stroked them against my shoulders, my bare chest, and my abdomen—released their analgesic and soothed my soul.

38

The End-of-Summer Party

MUCH LATER, and without first stopping off at the office, I did go to Teşvikiye to help with the preparations. "I was going to ask you what to do about the champagne," said Sibel. "I rang the office a few times, but every time they said you weren't there."

Offering her no explanation, I went directly to my bedroom. I remember lying on my bed, and thinking how unhappy I was, and feeling the party was doomed. By dreaming of Füsun, by conjuring with her things and taking consolation in them, I had sacrificed my self-respect, even as my distracted dreaming opened the door to another world that I wanted to explore more fully. The party that Sibel was so vigorously preparing required a rich, intelligent, cheerful, healthy man as host, one who knew how to take his pleasures, but I was in no condition to play that role. And there was no getting away with playing the sullen twenty-year-old, scowling and contemptuous, at a party in my own house. Sibel might be prepared to tolerate the effects of my nameless illness, but I could not expect such indulgence from our guests, eager for fun at the last party of summer.

At seven that evening I ushered the first guests to the bar we had set up—it was fully stocked with all the requisite foreign liquor bought under the counter from the city's delicatessens—and like a good host, I offered them drinks. I remember occupying myself with the music for a time, and that I played

Sergeant Pepper—I liked the cover—and Simon and Garfunkel. I danced—and laughed—with Sibel and Nurcihan. In the end, Nurcihan had chosen Mehmet over Zaim, but Zaim didn't seem to mind. When Sibel told me, with a frown, that she thought Nurcihan had slept with Zaim, I could not understand why my fiancée was so upset by that, but I didn't even try. There was beauty to behold in the world, that was all there was to it: the summer night was cooled by the north wind blowing off the Bosphorus, rustling the leaves of the plane trees in the courtyard of the Teşvikiye Mosque, and causing them to whisper in that lovely soft way I remembered from childhood; and at nightfall the swallows were screeching as they swooped over the dome of the mosque and the rooftops of the 1930s apartment buildings. As the sky grew darker still, I could begin to see the flickering lights of television sets in the homes of those who had not fled the city for the summer, among them a bored girl on one balcony and, sometime later, on another balcony, an unhappy father, gazing absently at the traffic in the avenue below. But as I watched all this listlessness, I felt as if I were watching my own feelings, and I was frightened by the thought that I might never be able to forget Füsun. As I sat there on our balcony, enjoying the cool evening, listening to the vivacious chatter of those who joined me from time to time, I drank like a fish.

Zaim had arrived with a lovely girl who was in high spirits because she had scored very high on the university entrance exam. Her name was Ayşe; I made pleasant conversation with her. I drank with a friend of Sibel's—a shy fellow who worked as a leather exporter and could really hold his *rakı*. Long after the sky had turned a velvety black, Sibel said, "You're being rude. Come inside for a while." Wrapping our arms around

each other, embracing each other with all our strength, we danced that hopeless dance of ours, which to others looked so romantic. We'd turned off a few lights, so that it was dim in the sitting room, giving the apartment, in which I had spent my entire childhood, and indeed most of my life, the aspect and colors of a very different place; with this image came the idea of an entire world snatched away from me, and I embraced Sibel even more desperately as we continued dancing. Because so much of my misery that summer had infected my lovely fiancée—along with my drinking habits—she was as unsteady as I was.

In the parlance favored by the gossip columnists of the day, "as the evening progressed, under the effect of alcohol," the party got out of hand. Glasses and bottles were broken, 45s and 33s destroyed, some couples who had fallen under the influence of European magazines began to kiss openly, or went into my or my brother's bedroom, allegedly to make love, but possibly to pass out, and it was as if this group of young rich friends was in a collective panic, afraid that their youth, and their aspirations to be modern, would soon come to an end. Eight or ten years earlier, when I'd begun giving these end-of-summer parties, they'd been anarchic affairs, fueled by anger toward our parents; my friends would fiddle with our pricey kitchen appliances, often breaking them; they would go through my parents' cupboards, pulling out old hats, perfume spray bottles, electric shoe buffers, bow ties, and dresses, convinced all the while that their destructive energy was political, and so enjoying it all the more.

In the years that followed, only two members of this large crowd took to politics in a serious way; one would be tortured by the police in the aftermath of the 1971 coup, and remain

in prison until the 1974 amnesty; and it is likely that both of them dismissed the rest of us as "irresponsible, spoiled, and bourgeois," but for whatever reason, they cooled to our company and lost touch.

Now, as dawn approached, and Nurcihan went through my mother's drawers, it was not out of anarchic anger, but a womanly curiosity, expressed with refinement and no small degree of respect. "We're going to Kilyos for a swim," she told me solemnly. "I was just checking to see if your mother had a swimsuit." Suddenly flooded with intense remorse and pain for never having taken Füsun to Kilyos, where she had so longed to go, it was all I could do to collapse onto my parents' bed. From where I lay, I could see drunken Nurcihan pretend to look for a swimsuit as she covetously fingered my mother's embroidered stockings from the 1950s, the elegant umber lace-up corsets, and the hats and scarves that she had not exiled to the Merhamet Apartments. Also passing through Nurcihan's appreciative hands were the titles for all the houses, apartments, and lots that we owned, and that my mother kept in a drawstring pouch in her stockings drawer, because she didn't trust the bank's safe deposit box, and piles and piles of keys to locks unknown, apartments that had been sold or rented out. There was also a thirty-six-year-old clipping from a gossip column, featuring my parents' wedding, and another from the society pages of *Hayat* magazine, dated twelve years later, with my mother looking very chic and attractive at a party. "How lovely your mother was, she was such an interesting woman," Nurcihan said. "She's still alive," I said, still lying like a corpse on the bed, and thinking how wonderful it would be to spend the rest of my life with Füsun in this room. Nurcihan let out a sweet and happy laugh, and it was this, I think, that drew

Sibel into the room, followed soon after by Mehmet. Sibel and Nurcihan went through the rest of my mother's things with drunken ceremony, while Mehmet sat on the bed (in just the place where my father would sit in the morning, staring absently at his toes before putting on his slippers), gazing at Nurcihan with love and admiration. He was so very happy, having, for the first time in years, fallen head over heels in love with a woman he could marry, and it seemed to come as a shock to him, as if he were ashamed of being that happy. But I did not envy him, because I sensed an overwhelming fear of being deceived—the ever-lurking possibility that things would come to a bad and degrading end—and regret.

Here I display a number of the items Sibel and Nurcihan were extracting from my mother's drawers with such care. From time to time they laughed, reminding each other that they were meant to be searching for swimsuits.

The search for swimsuits and the discussions about going to the beach went on until first light. In fact no one was sober enough to drive. I knew that drink and sleeplessness, together with my anguish about Füsun, would overwhelm me at Kilyos, so I wasn't about to go. Promising that Sibel and I would follow afterward, I dragged my feet until the others were ready to leave. At sunrise I went out to the balcony where my mother drank coffee and watched funerals, and I waved and shouted down to my friends below. Standing on the street were Zaim and his new girlfriend, Nurcihan and Mehmet, and a few others, all drunkenly carousing, tossing around a shiny red plastic ball, running after it whenever it escaped their grasp, making enough noise to wake up all of Teşvikiye. When the doors of Mehmet's car finally slammed shut, I saw the old people walking slowly toward Teşvikiye Mosque for morning

prayer. Among them was the janitor from the apartment across the street, who dressed up as Father Christmas on New Year's and sold lottery tickets. Just then, Mehmet's car took off, its tires squealing, before skidding to an abrupt halt, going into reverse, and stopping again; the door opened, and Nurcihan stepped out of the car, calling up to us on the sixth floor that she had left behind her silk scarf. Sibel ran inside, and in no time brought the scarf out to the balcony, and threw it down to the street. I shall never forget standing there with Sibel on my mother's balcony, watching the purple scarf's slow descent, as it swayed like a kite in the light breeze, opening and closing, puffing up and twisting. This is my last happy memory of my fiancée.

Confession

WE HAVE now come to the confession scene. It was my express desire that all the frames, backgrounds, everything in this part of my museum be painted a cold yellow. Yet it wasn't long after our friends had left for Kilyos, and I had returned to my parents' bed, that a giant sun rose from behind the hills of Üsküdar, casting a deep orange glow over the spacious bedroom. The echo of a ship's horn rose from the Bosphorus. "Come on," said Sibel, sensing my lack of enthusiasm, "let's not stay here forever. Let's try to catch up with them." But seeing how I lay there, she knew I was not fit to go to the beach (though it had not crossed her mind that I was too drunk to drive); and that was not all: She sensed that my mysterious illness had brought us to the point of no return. I could tell that she wanted to avoid discussing it, because she kept averting her eyes from mine. But in the way that people will sometimes confront their worst fears without forethought (some call this courage), she was the one to broach the subject.

"Where were you actually, yesterday afternoon?" she asked. But she regretted the question at once, adding sweetly, "If you think this is going to be embarrassing for you later on, if you don't want to tell me, then don't."

She lay down next to me on the bed, pawing me like an affectionate kitten, with such compassion but trepidation, too; sensing that I was about to break her heart, I felt ashamed. But

the djinn of love had escaped Aladdin's lamp and was prodding me, telling me that I could no longer keep this secret to myself.

"Do you remember that evening in early spring, darling, when we went to Fuaye?" I began with these harmless, careful words. "You saw that Jenny Colon bag in a shop window, and as we passed you said you liked it. We both stopped to look at it."

My darling fiancée knew at once that this was about more than a handbag—that I was about to speak of something real and serious; as her eyes widened, I told her the story that readers will recall and visitors to the museum have known since viewing the very first object on exhibit. Nevertheless, displayed here is a series of small pictures of the most important objects; it will, I hope, serve as an aide-mémoire for visitors making their way through the extensive collection, or for those who are so impetuous as not to start at the beginning.

I told Sibel the story in careful chronological order. As I launched into the painful tale of my first encounter with Füsun, and the relationship that followed, my remorse was palpable, as was the aura of atonement; this endowed my lapse with the gravity of a great sin. But I may well have been the one to add these colors to my story, so as to lighten the tone of my rather ordinary crime, and to suggest I was talking about something from the distant past. Having, of course, omitted the details of sexual bliss at the heart of my tale, I made it sound like a typical Turkish man's silly indiscretion on the eve of his marriage. I could not, seeing Sibel's tears, continue with my original aim— to be straight with her—and I was sorry for having brought it up at all.

"You're a disgusting person, and it's only now I can see it," said Sibel. Picking up an old bag of my mother's—rose-printed, and full of her loose change—Sibel hurled it at me, and next

came one of my father's summer spectator shoes. Neither projectile hit its mark. The loose change went flying across the floor like broken glass. Tears were streaming from Sibel's eyes.

"I broke this off ages ago," I said. "But I was destroyed by what I did. . . . This feeling has nothing to do with this girl or anyone else."

"This is the girl whose table we visited at the engagement party, am I right?" Sibel asked, too afraid to mention her by name.

"Yes."

"She's a common shopgirl. She's disgusting! Are you still seeing her?"

"Of course I'm not. . . . Once we were engaged, I broke it off. And she has gone missing. I hear she married someone else." (Even now, I am shocked that I could throw out this lie.) "This was why I was so withdrawn after the engagement, but that's all over now."

Sibel would cry a little, and then she would wash her face, pull herself together, and ask me more questions.

"So you can't get over her, is that it?" This was how my clever fiancée summed up the truth in her own words.

What man with a heart could answer this question in the affirmative? "No," I said reluctantly. "You don't understand. To have treated a girl so badly, to have deceived you and broken our trust, to carry all this in my conscience, it wore me down. It took all the joy out of life."

Neither of us believed what I was saying.

"Where were you after lunch yesterday?"

How I longed to tell someone—someone who would understand, someone other than Sibel—of having taken mementos of her into my mouth, how I had rubbed them

against my skin, and how, as I did so, I conjured up images of her and burst into tears. All the same I was sure that if Sibel left me, I would lose my mind. What I needed to say was, Let's get married right away. There were countless solid marriages—marriages that were the bedrock of our society—that had been made in an effort to forget stormy and unhappy love affairs.

"I wanted to play around with some of my childhood toys before we got married. I had a space gun, for example. . . . It was still working. I guess you could call it a strange sort of nostalgia. That's what I was doing there."

"You are never to go back to that apartment again!" said Sibel. "Did you meet her there often?"

Before I could answer, she started sobbing. When I took her in my arms and caressed her, she cried even harder. As I embraced my fiancée I felt a deep gratitude—and an amity that was deeper than love; I treasured our closeness. After Sibel had cried for a very long while and dropped off to sleep in my arms, I, too, nodded off.

It was almost noon when I awoke; Sibel had been up for a good while, had showered and put on her makeup and even prepared my breakfast in the kitchen.

"If you want you can go buy some bread from the shop across the street," she said in a cool voice. "But if you don't have the energy, I can slice the stale bread and toast it."

"No, I can go," I said.

We had breakfast in the sitting room, which after the party looked like a war zone, at the table where my parents had sat across from each other for more than thirty years. Here I display an exact replica of the loaf I bought from the grocery store across the street. Its function is sentimental, but also documentary, a reminder that millions of people in Istanbul ate

no other bread for half a century (though its weight did vary) and also that life is a series of repeated instances that we later assign—without mercy—to oblivion.

That morning Sibel was strong and decisive in a way that shocks me even today. "This thing you thought was love—it was just a passing obsession," she said. "I'll look after you. I'll rescue you from this nonsense you got mixed up in."

She'd used a lot of powder to conceal the puffiness under her eyes. To see her choosing her words so carefully, so as not to hurt me, even though she was in terrible pain herself—to feel her compassion—made me trust her all the more, and so certain was I that only Sibel could deliver me from my agony, that I decided then and there to agree to whatever she said. And so it was while we ate our breakfast of fresh bread, white cheese, olives, and strawberry jam that we agreed to leave this house and to stay away from Nişantaşı, these neighborhoods and streets, for a long while. The orange zone and red zone prohibitions were now in full force.

Sibel's parents had by now returned to their house in Ankara for the winter, and so the *yalı* in Anadoluhisarı was empty. They would turn a blind eye on our staying there alone together now that we were engaged, of this she was certain. I was going to move there with her at once, abandoning all the habits that had kept me in thrall to my obsession. As I packed my bags, I felt sad but also hopeful of recovery, like a lovesick girl dispatched to Europe. I remember that when Sibel said, "Take these, too," throwing a pair of winter socks into my suitcase, I was struck by the painful thought that my cure might take a very long time.

The Consolations of Life in a Yalı

I WAS EXUBERANT at the thought of beginning anew, and greatly soothed by the consolations of life in a yalı, so much so that during the first few days I convinced myself that a rapid recovery was in prospect. No matter what amusements we'd partaken in on the previous evening, no matter how late we'd come back, and no matter how much I'd had to drink, in the morning, as soon as the light began to stream through the gaps in the shutters, casting its strange reflections of Bosphorus waves onto the ceiling, I would arise to throw open the shutters, each time amazed at the beauty that rushed in, that almost exploded, through the window. There was, in my amazement, the elation that comes only from a reawakening, a discovery of life's forgotten beauties—or so I wished to believe. The ever-perspicacious Sibel, sensing that mood, would come to my side in her silk nightgown, the wooden floorboards creaking lightly under her bare feet, and together we would admire the beauty of the Bosphorus, and the red fishing boat bobbing in the waves as it passed by, and the mist rising above the dark wooded hills on the opposite shore, and the way the first ferry of the morning listed in the current as it cut through the water, hissing like a ghost.

Sibel, too, became a believer in the idea that the pleasures of *yalı* life would be curative. As we sat at the bay window overlooking the water, eating our evening meal like a couple

who were able to live on nothing but love, the City Line ferry named *Kalender* would leave the Anadoluhisarı landing stage, and there at the wheel we would see the mustached captain with his cap; so close that he could see the crackling mackerel at our table, and the eggplant purée and fritters, the white cheese, the melon and *rakı,* he would cry, "Good appetite," which Sibel took for yet another charming ritual bound to advance my cure and make us happy. In the morning, as soon as we awoke, my fiancée and I would jump into the cool waters of the Bosphorus; we would go to the Ferry Station Coffeehouse for tea with *simit*s—sesame rolls—and to read the paper; we would cultivate the peppers and tomatoes in the garden; toward noon we would rush over to the fishing boats just returned with fresh fish to buy gray mullet and sea bream, and on very warm September evenings when not a leaf would rustle, when, one by one, the moths flew too close to the lights, we would splash once again in the sea now sparkling phosphorescent. Sibel's faith that these rituals would heal me was clear when, in bed at night, she would gently drape her fragrant body around me as if changing the dressing on a wound. When the shooting pains in my stomach stopped me from making love to Sibel, I would awkwardly laugh it off, saying, "We're not married yet, dear," and my darling fiancée would laugh along to soothe my unease.

Sometimes, after whiling away the night alone in a chaise longue on the terrace, or gorging on a boiled cob of corn bought from a vendor in a rowboat, or having planted two kisses on Sibel's cheeks like any young husband getting into the car in the morning on the way to work, I could see in Sibel's eyes a certain contempt, a budding hatred. Certainly my failure to make love to her was a cause, but there were more frightening reasons: Could Sibel have been thinking that her extraordinary show of

love and restraint in the hope of "making me better" had come to nothing, or even worse, that, once cured, I would continue to see Füsun after our marriage? In my worst moments, I, too, wanted to believe in this last possibility, dreaming that one day I would receive news of Füsun, which would permit an immediate return to the happy routine of old. Our daily meetings in the Merhamet Apartments, while furnishing the ultimate remedy for the pain of love, would, of course, enable me also to make love to Sibel as before, in which state we would go on to marry and have children, enjoying the full blessings of normal family life.

But it was only when I had lifted my spirits by drinking heavily or when a beautiful morning inspired hope that I could entertain such dreams, and even then rarely so. More typically she crowded out every other thought in my mind, and by now the pain of love was caused not so much by Füsun's absence but by the more abstract prospect of agony without end.

Swimming on My Back

TO BE SURE, those painful September days had their dark beauty, and as the month wore on I discovered an important new way of making them bearable: If I swam on my back, the pain would ease. To make this happen, I had to throw my head very far back to the point where I could see all the way to the bottom of the Bosphorus, but upside down, and I had to carry on swimming in this attitude for some time without coming up for air. As I backstroked through the current and the waves, I would open my eyes to see the inverted Bosphorus changing colors, fading into a blackness that awakened me to a vastness altogether different from the boundless pain of love—offering me a glimpse of a world without end.

Because the Bosphorus is so deep so close to the shore, there were times when I could see the bottom and times I couldn't, but to glimpse this brilliantly colored realm, albeit upside down, was to see a great, mysterious whole, at whose sight one could not but rejoice to be alive, humbled at the thought of being part of something greater. Gazing down at the rusty cans, the bottle caps, the gaping mussels, and even the ghosts of ancient ships, I would contemplate the vastness of history and time, and my own insignificance. At times like these I would notice that I could enjoy concentrating on my love and being absorbed by it. Exposed, and grieving ever more deeply, I could cleanse my soul.

What mattered was not my pain, but my connection with this mysterious infinity shimmering beneath me. As the waters of the Bosphorus poured into my mouth, my throat, my ears, my nostrils, I could tell that the djinns inside me, governing equilibrium and happiness, were well pleased. A sort of sea drunkenness would overtake me as I propelled myself backward, stroke after stroke, until there was no pain in my stomach at all. I would feel a deep compassion for Füsun welling up inside me at that same moment, and this reminded me of how much anger I felt, too.

Seeing me racing backward toward a Soviet oil tanker or a City Line ferry anxiously tooting its horn, Sibel would jump up and down on the shore, frantically calling to me, but most of the time I would not hear her cries. In this habit of swimming so dangerously close to the steady procession of City Line ferries, international oil tankers, cargo ships laden down with coal, passenger boats, and barges distributing beer and Meltem to the Bosphorus restaurants, almost as a challenge to those vessels great and small, Sibel saw an unhealthy impulse and in her heart she wanted me to stop bobbing backward in the Bosphorus in front of the house, but knowing what good it did chasing away the pain, she didn't insist. Rather, sometimes she would suggest I take myself to a secluded beach, or on windless days, when the sea was calm, to Şile Beach on the Black Sea, or else go with her to one of the empty coves beyond Beykoz, and without taking my head out of the water, I could swim as far as my thoughts would take me, with no end in sight. Later, when I had swum back to shore and lay exhausted under the sun with my eyes closed, I would entertain the hopeful thought that all serious and honorable men who happened to fall passionately in love went through the same things as I did.

Still, there was one unsettling difference: The mere passage of time brought me none of the healing it seemed to offer everyone else. Despite Sibel's tireless encouragement during our silent nights together (when all that could be heard was the gentle putter of a barge passing in the distance), we were both daunted by the awareness that my pain would not simply ebb away. Sometimes I sought escape by willing myself to see this agony as a figment of my imagination or as proof of spiritual frailty, but to be cast in this light, as helplessly dependent on the mercy of a redeeming mother-angel-lover, was itself unbearable, so most of the time I could do nothing but continue to master the pain in the only way I knew, by swimming on my back, though I knew full well that I was deceiving myself.

During the month of September I went three times to the Merhamet Apartments, hiding each visit from Sibel and, in a way, from myself, each time lying on the bed and touching things Füsun had touched, enacting the consolatory rituals already known to my readers. I could not forget her.

The Melancholy of Autumn

IN THE early days of autumn, after a storm had blown in from the north, the fast-moving waters of the Bosphorus were too cold for swimming, and my melancholy had soon darkened beyond the point at which I could still hide it. Night was falling earlier each day, and all at once the shore and the back garden were carpeted with leaves; the yalı apartments that served as summer homes fell empty; rowboats were pulled out of the sea, and after the first days of rain, overturned bicycles littered the suddenly empty streets, and for us a deep autumn gloom set in. With growing panic, I sensed that Sibel would soon be unable to bear my apathy or the misery that could no longer be concealed or consoled, or the consequence that I was now drinking like a fish.

By the end of October, Sibel had had her fill of the rusty water that poured from the old taps, the dankness of the ramshackle kitchen, the *yalı*'s leaks and drafty cracks, and the icy north wind. Gone were the friends who had dropped by on hot September evenings, getting drunk and giddily jumping into the sea from the dark landing, now that there was more fun to be had in the autumn in the city. Here I display the damp and broken stones of the back garden and the shells of snails that crawled over them, along with our solitary friend, the panicky lizard (now petrified), who disappeared during the rains—all represent the abandonment of *yalı* life

by the nouveaux riches with the approach of winter, and the attendant melancholy of the season.

It was clear by now that any decision to stay on in the *yalı* with Sibel for the winter depended on my proving to her sexually that I had forgotten Füsun, but as the weather grew colder, we struggled to heat the high-ceilinged bedroom, we each grew more withdrawn and hopeless, and on the few nights when we were moved to embrace, it was only in camaraderie and compassion. Despite our express contempt in ordinary days for those who used electric heaters in wooden *yalı*s—those irresponsible philistines who subjected combustible historical buildings to risk—every evening, when we began to feel cold, we would plug that infernal device into the deadly socket. At the beginning of November, when we knew the heat had come on in our winter homes, we grew curious about the autumn parties we might be missing in town, and the new nightclub launches, and the old haunts that had been renovated, and the crowds gathering outside cinemas, so we began to make excuses for returning to Beyoğlu, and even Nişantaşı, and the streets from which I was banned.

One evening, while in Nişantaşı for no good reason, we decided to stop off at Fuaye. We ordered *rakı* on the rocks, which we drank on empty stomachs, and exchanged greetings with the waiters we knew, speaking at length with Haydar and the headwaiter, Sadi, and like everyone else we complained about the ultranationalist gangs and leftist militants who were throwing bombs right, left, and center, bringing the country to the brink of disaster. As always, the elderly waiters were much more circumspect than we were about enlarging on politics. As we saw people we knew coming into the restaurant, we gave them welcoming looks, but no one came over.

In a mocking tone Sibel asked why my mood had suddenly dropped again. Without having to exaggerate too much, I explained that my brother had patched things up with Turgay Bey, and that they were starting up a new business, with room for Kenan—how I regretted never having found a way to fire him—and this lucrative new enterprise taken together with my reaction to Turgay Bey would now furnish a pretext to exclude me.

"Kenan—is he the Kenan who was such a good dancer at the engagement party?" Sibel, I knew, was using the words "good dancer" as a way to allude obliquely to Füsun without mentioning her name. Both of us recalled the engagement party with some pain, and being unable to find an excuse to change the subject, we fell silent. This was a change. During the early days, when the reasons for my "illness" had first come to light, Sibel, even at the worst moments, had shown a lively and robust talent for changing the subject.

"Is this Kenan now to be the director of the new firm?" asked Sibel in the sarcastic voice that she'd slowly been cultivating. As I looked sadly at her hands, which were trembling, and at her heavily made-up face, it occurred to me that Sibel had changed from a healthy Turkish girl with the veneer of a French education into a cynical Turkish housewife who had taken to drink after becoming engaged to a difficult man. Was she needling me because she knew I was still jealous of Kenan on account of Füsun? A month ago, such a suspicion would not have crossed my mind.

"They're resorting to trickery just to make a bit of loose change," I said. "It's not worth thinking about."

"There's more than a bit of loose change at stake—this could be quite lucrative, you know, or your brother wouldn't

bother. You shouldn't sit by and let them exclude you, or deny you your share. You have to stand up to them, challenge them."

"I don't care what they do."

"I don't like this attitude," said Sibel. "You're letting everything go, you're withdrawing from life; it's almost as if you enjoy being ground down. You have to be stronger."

"Should we order two more?" I said, lifting my glass with a smile.

As we waited for the drinks to arrive, we stayed silent. Between Sibel's eyebrows appeared a furrow that always reminded me of a question mark, and told me she was annoyed or angry.

"Why don't you ring Nurcihan and company?" I said. "Maybe they'd like to join us."

"I just checked, but the pay phone here is broken," said Sibel in an angry voice.

"So, what did you do today? Let's see what you bought," I said. "Open those packages of yours. Let's have a little fun."

But Sibel was not in the mood for opening packages.

"I am quite sure that you could not be as in love with her now as you were," she said, with a startling airiness. "Your problem is not that you're in love with another woman—it's that you are not in love with me."

"If that were so, then why am I always at your side?" I said, taking her hand. "Why is it that I don't want to go through a day without you? Why am I always here, holding your hand?"

It wasn't the first time we'd had this discussion. But this time I saw a strange light in Sibel's eyes, and I feared that she would say: "Because you know that left alone you wouldn't be able to bear the pain of losing Füsun, and that it might even kill you!" But luckily Sibel still didn't realize that the situation was quite that bad.

"It's not love that keeps you close to me; it just allows you to continue believing you have survived a disaster."

"Why would I need that?"

"You've come to enjoy being the sort of man who is always in pain and turns his nose up at everything. But the time has come for you to pull yourself together, darling."

I made my usual solemn assurances—that these difficult days would pass, that in addition to two sons, I was hoping we'd have three daughters who would look just like her. We were going to have a big, wonderful, happy family; we would have years and years of laughter, and lose none of the pleasures of life. To see her radiant face, to listen to her thoughtful words, to hear her working in the kitchen—these things gave me no end of joy, I told her, and made me glad to be alive. "Please don't cry," I said.

"At this point, it doesn't seem to me as if any of these things could ever come true," said Sibel as the tears began to flow faster. She let go of my hand, picked up her handkerchief, and wiped her eyes and her nose; then she took out her compact and dabbed a great deal of powder under her eyes.

"Why have you lost faith in me?" I asked.

"Maybe because I've lost faith in myself," she said. "I've even lost my looks—that's what I think now sometimes."

I was squeezing her hand and telling her how beautiful she was when a voice said, "Hello, young lovers!" It was Tayfun. "Everyone's talking about you—did you know that? Oh dear, what's wrong?"

"What are people saying about us?"

Tayfun had come to visit us at the *yalı* many times in September. When he saw Sibel had been crying, all the jolliness left his face. He wanted to leave the table, too, but seeing Sibel's expression, he was paralyzed.

"The daughter of a close friend died in a traffic accident," said Sibel.

"So what was it everyone was saying about us?" I asked mockingly.

"My condolences," said Tayfun, looking left and right in search of an escape, and finally shouting in an overloud voice at someone who had just walked in. Before peeling himself away, he said, "People have been saying that you are so in love it's got you worried that marriage might kill it, as happens with so many Europeans, and that, because of this, you're thinking of not getting married. If you ask me, you should just get married. Everyone is just jealous of you. There are even people saying this *yalı* of yours is unlucky."

As soon as he was gone we ordered more *rakı*. All summer long Sibel had ably masked my "illness" from others with invented excuses, but there was no way forward. Our decision to live together before marriage had become fodder for gossip. It had been noted, too, that Sibel had begun needling me and making jokes at my expense and that I'd begun to swim great distances on my back, and, of course, there was the ridicule of my low spirits for some to savor.

"Are we going to call Nurcihan and company and ask them to join us, or should we order our food?"

Sibel seemed anxious. "You go find a telephone somewhere and call them. Do you have a token?"

Among those taking an interest in this story fifty or a hundred years on, there might be a temptation to turn up their noses at Istanbul circa 1975, when there was still a shortage of running water (obliging even the richest neighborhoods to be supplied water by private trucks), and where the phones rarely worked. In an effort to elicit reflective

sympathy rather than reflexive disdain, I have displayed a telephone token with serrated edges that could be bought in those days at any tobacconist's. During the years when my story begins, there were very few phone booths in the streets of Istanbul, and even if they had not been vandalized, they were usually out of order. I do not recall being even once able to make a call from a PTT phone booth during that entire period. (Such success was only managed, it seemed, in Turkish films, whose stars copied what they saw done in Western films.) However, one clever entrepreneur had managed to sell metered phones to grocery stores, coffeehouses, and other outlets; it was by using these that our needs were met. I offer these details as explanation of why I was obliged to go from shop to shop in the streets of Nişantaşı. Finally, in a lottery ticket outlet, I found a phone not in use. But Nurcihan's phone was busy, and the man wouldn't let me make a second attempt to call, and some time had passed before I was able to ring Mehmet from a phone in a florist's. I found him at the house with Nurcihan, and he said they would join us at Fuaye in half an hour.

By going from store to store, I had arrived at the heart of Nişantaşı. It occurred to me that being this close to the Merhamet Apartments, I might as well see if I could do myself some good by dropping in for a brief while. I had the key with me.

As soon as I entered the apartment, I washed my face and hands, and carefully removed my jacket, like a doctor preparing for an operation. Sitting shirtless on the edge of the bed where I had made love to Füsun forty-four times, and surrounded by all those memory-laden things (three of which I display herewith), I spent a happy hour caressing them lovingly.

By the time I got back to Fuaye, Zaim was there as well as Nurcihan and Mehmet. As I gazed upon the genial chatter of Istanbul society, and all the bottles, ashtrays, plates, and glasses on the table, I remember thinking how happy I was, and how much I loved my life.

"Friends, please excuse me for the delay. You'll never guess what happened to me," I said, as I tried to think up a good lie.

"Never mind," said Zaim sweetly. "Sit down. Forget the whole thing. Come and be happy with us."

"I'm already happy, actually."

When I came eye to eye with the fiancée I was about to lose, I saw at once that, drunk as she was, she knew exactly what I'd been up to and had finally decided I was never going to recover. Though furious, Sibel was in no condition to do anything about it. And even when she sobered up, she would not make a scene—because she still loved me, and because the prospect of losing me still terrified her, as did the socially disastrous consequences of breaking off the engagement. This might explain why I felt even then a strong bond with her, although perhaps there were other reasons that I still did not understand. Perhaps, I reasoned, this enduring attachment would restore her faith in me, and she would return to believing in my eventual recovery. For that night, however, I felt that her optimism had run out.

For a while I danced with Nurcihan.

"You've broken Sibel's heart. She's very angry at you," she said as we danced. "You shouldn't leave her sitting alone in restaurants. She's so in love with you. She's also very sensitive."

"Without thorns, the rose of love has no fragrance. When are you two getting married?"

"Mehmet wants us to marry right away," said Nurcihan.

"But I just want to get engaged first as you two did—and have a chance to enjoy love a bit before we settle into marriage."

"You shouldn't use us as your model, not to that extent, anyway. . . ."

"Why—are there things I don't know?" said Nurcihan, trying to hide her curiosity behind a fake smile.

But I paid her no mind. The *rakı* was easing my obsession from a strong, steady ache into an intermittent specter. I remember that at a certain point in the evening, Sibel and I were dancing, and, like a teenage lover, I made her promise never to leave me, and she, impressed by the ardor of my pleas, tried sincerely to allay my fears. Many friends and acquaintances stopped by our table, inviting us to join them elsewhere when we had tired of Fuaye. Some wanted to play it safe and drive out to the Bosphorus for tea, others were saying we should go to the tripe restaurant in Kasımpaşa, there were even those proposing we all go to a nightclub to listen to Turkish classical music. There was a moment when Nurcihan and Mehmet wrapped their arms around each other with exaggerated abandon and amused everyone as an instantly recognizable impression of the romantic dance that Sibel and I were given to dancing. At daybreak, and in spite of pleas from a friend leaving Fuaye with us, I insisted on driving. Seeing how I was drifting back and forth across the road, Sibel began to scream, so we took a car ferry to the other side. At dawn, as the ferry approached Üsküdar, we both fell asleep in the car. A sailor woke us by pounding on the window, because we were blocking food trucks and buses. We made our way along the shore, under ghostly plane trees shedding their red leaves, reaching the *yalı* without incident, and, as we always did following our all-night adventures, we wrapped our arms tightly around each other and drifted off to sleep.

43

Cold and Lonely November Days

In the days that followed, Sibel didn't even ask where in Nişantaşı I'd spent the hour and a half that I'd gone missing, but there was little room for doubt. After that night we had both become resigned to the fact that I was never going to get over my obsession. It was clear that strict regimens and prohibitions had been useless, though we still enjoyed living together in this once grand, now crumbling yalı. However hopeless our situation, there was something about this decrepit house that bound us together and made our pain bearable by endowing it with a strange beauty. The yalı added gravity and historical depth to this doomed love of ours; our sorrow and defeat were so great that the vestigial presence of a vanished Ottoman culture could furnish what we had lost as old lovers, as a newly engaged couple. The world evoked protected us somehow from the pain we felt at being unable to make love.

If, of an evening, we set up our table beside the sea—and, resting our arms and our elbows against the iron balcony rail, drank Yeni Rakı together and found our spirits lifting—I would sense from the way Sibel looked at me that in the absence of sex the only thing that could bind us together was marriage. Weren't there plenty of happy married couples—not just in our parents' generation but in our own—who led chaste lives together, as if everything were normal? After our third

or fourth glass, we would play guessing games about young and old couples we knew—sometimes from a distance, sometimes more intimately—asking each other, "Do you think they still do?" and giving the question half-serious consideration. Our mockery, which now seems so very painful to me, owed a great deal, no doubt, to a dubious supposition that we would soon be returning to a satisfying love life. In our strange complicity and in these conversations that walled us off from the outside world, there was the veiled aim of convincing ourselves that we could marry in this condition, and peacefully await the return of that sex life of which we had once been so proud. At least Sibel would come to believe this, even on her most pessimistic days; swayed by my teasing, my jokes, and my compassion, she would grow hopeful, and content, even sitting on my lap, as if to trigger a reaction. In my more hopeful moments I, too, would feel the thing I thought Sibel was feeling, and it would occur to me to say that we must marry at once, but I held back, fearing that she might decline my proposal quickly and definitively, and then abandon me. For it seemed to me that Sibel was waiting for an opportunity to end our relationship with a retaliatory blow that would also restore her self-respect. Unable to accept that she had lost the lifetime of marital bliss that had stretched out before us only four months ago—that enviable, unsullied existence, rich with children, friends, and diverse amusements—she could not bring herself to strike first. In this way, we both derived emotional utility from the strange love that still bound us and for the time being, whenever in the middle of the night despair awoke us from the slumber that only drink can induce, we would continue the custom of wrapping our arms around each other, ignoring the pain as best we could.

From mid-November onward, whenever we awoke on a windless night—raw from misery, or thirst, because we'd had so much to drink—we began to hear a fisherman splashing around in his rowboat, just beyond our closed shutters, moving through the still waters of the Bosphorus, casting his net. Sometimes the boat would drift beneath our bedroom. Accompanying this quiet, soft-spoken fisherman was a slim little boy whose voice was sweet and who did everything his father asked. As the lamp hanging from their boat filtered through our shutters, casting a lovely glow on the ceiling, we could hear the sounds of their oars cutting into the silent water, and the water cascading through their net as they lifted it from the sea, and at times only the boy's coughing as the two went wordlessly about their work. We would wake up to their arrival and clinging to each other we listened to them rowing five or six meters from our bed, little knowing that we were in here listening; we heard them throw stones into the sea, to scare the fish into the net, and on rare occasions they spoke: "Hold it tight, my son," the fisherman would say, or, "Pick up the basket," or, "Now backwater." Much later, in the midst of the deepest silence, the son would say in his sweet voice, "There's another one over there!" and Sibel and I lying enfolded would wonder what the child was pointing at. Was it a fish, or a dangerous spike, or some sea creature we could only imagine from our bed? I do not remember ever talking about the fisherman and his son during the waking hours that followed. But at night we wafted between sleep and wakefulness, sometimes hearing the fishing boat drift away after its night's work and sometimes missing it we would nevertheless enjoy without fail a precious interval of immense peace, as if there was nothing to fear as long as we'd been visited by the fisherman and his son.

With every passing day, Sibel would resent me a bit more, entertain a few more painful doubts about her beauty; each day her eyes would well up more frequently, as our altercations and little tiffs and skirmishes became more unpleasant. It typically happened that Sibel would give herself over to a gesture to make me happy, by baking a cake, perhaps, or finding at a great price some marvelous coffee table for the house, but when I, sitting there with a *rakı* in my hand, dreaming of Füsun, would not respond in the way she had hoped, she would leave and slam the door in fury; though I would sit where she had left me, cursing myself for the shame that kept me from going after her to apologize—and when I finally did, I would see that she was too far lost to resentment.

If she broke off the engagement, society, noting how long we had "lived together" without marrying, would look askance at Sibel. Sibel knew full well that no matter how high she held her head, no matter how "European" her friends were in their outlook, this affair would not be seen as a love story if we did not marry. It would become the story of a woman whose honor had been stained. Of course, we didn't discuss these things, but she knew each passing day worked against her.

With the occasional visit to the Merhamet Apartments to lie down on the bed and distract myself with Füsun's things, I sometimes felt better, and then I would fool myself into believing that my pain might pass and that this might give Sibel hope, too. There continued as well the evening outings, parties, and get-togethers with friends, which revived Sibel's spirits, if not mine, but none of it could revoke the invidious truth that, apart from the hours we spent very drunk, or the minutes we spent listening to the fisherman and his son, Sibel and I were very unhappy. It was during this time that—desperate to

discover where Füsun was, and how she was—I pleaded with Ceyda, then about to give birth; I even offered her bribes, but she would only report that Füsun was somewhere in Istanbul. Would I have to search the city street by street?

At the beginning of winter, on one of our particularly cold and bleak days at the *yalı,* Sibel said she was mulling over a trip to Paris with Nurcihan. Nurcihan wanted to go at Christmastime to do some shopping and tie up loose ends before becoming formally engaged (and then married) to Mehmet. When Sibel showed an interest in going, I encouraged her, planning, once she had left, to move heaven and earth to find Füsun; I would search every corner of Istanbul, and if I failed, I would throw off this pain, this remorse that was breaking my will, and when Sibel returned, I would marry her. Sibel met my encouragement with due suspicion, but I told her that a change of scene and rhythm would do us both good, adding that when she returned we would pick up where we'd left off at the *yalı;* in the course of saying all this, I used the word "marriage" once or twice, though without too much emphasis.

In truth, I still assumed that I would marry Sibel, who was now ready to pin her hopes on the chance that a trial separation might restore us both to health by the time of her return. We drove out to the airport with Nurcihan and Mehmet, and, having arrived early, sat down at a little table in the new terminal to drink Meltem sodas, as recommended by Inge on the poster that was there. When I embraced Sibel in farewell and saw tears in her eyes, I became afraid, thinking that there would be no return to our old life after this, sensing I would not see her again for a very long time, and then I chided myself for taking such a dark view of things. On the way back in the car, Mehmet, for whom this would be the first separation from Nurcihan in

many months, broke the long silence: "Life is just so empty, isn't it, without the girls."

That night the *yalı* indeed felt so empty and sad that I couldn't bear it. It wasn't just the creaking floorboards: Now that I was alone, I discovered that the sea itself was invading the old frame, each time moaning a new tune. The waves crashing against the concrete terrace made a very different noise than those that hit the rocks, and the murmuring currents hissed past the boats tethered below. Toward morning, with the north wind blowing into every corner of the house, as I lay in bed in a drunken stupor, it occurred to me that it had been a very long while since the fisherman had last come in his boat with his son. There was still one part of my mind sound enough to see things clearly, and it was telling me that a chapter of my life was now coming to a close, but the greater part of me was still too anxious and fearful of being alone to let me accept this truth.

44

Fatih Hotel

THE NEXT day I met with Ceyda. In exchange for her agreeing to carry my letters, I had found work for a relative of hers in the accounting department of Satsat. I knew though that if I spoke a bit harshly she could be cowed into giving me Füsun's address. But Ceyda responded to my demands by falling into a mysterious mood and speaking elliptically. She hinted that I would not be so glad to see Füsun, for life, love, and happiness were difficult things, and people did what they had to do in this mortal world, seizing what chance for happiness they could! It was strange coming from someone who, as she spoke, kept touching her bump, by now very large, and who had a husband who did everything she wished.

I couldn't find it in myself to push Ceyda too hard. And as there were still no private detective bureaus of the type one saw in American films (it would be another thirty years before they arrived), I could not hire someone to tail her. Earlier on I had gone to Ramiz, who handled my father's less savory business dealings and also, for a time, his security (in the old days we would have called him a bodyguard); telling Ramiz that we were making discreet inquiries into a robbery, I sent him off on a secret mission to find Füsun, her father, and Aunt Nesibe, but he'd come back empty-handed. Even our friend Selami Bey, the retired police commissioner who had helped Satsat when problems arose with Customs or the Ministry of Finance, was

of no help: After making a few inquiries at registry offices, police stations, and council offices, he told me that as the person I was seeking—Füsun's father—had no criminal record, it would be next to impossible to find him. Masquerading as a grateful student wishing to kiss the hand of his former teacher, I paid visits to Vefa and Haydarpaşa Lycées, the two schools at which Füsun's father had taught history before his retirement, but to no avail. And so I tried hunting down Aunt Nesibe among the Nişantaşı and Şişli households she sewed for. Of course, I could not ask my own mother. But Zaim discovered from his mother that almost no one did that kind of work anymore. She put out feelers to see whether anyone knew where to find Nesibe Hanım the seamstress, but no one did. These disappointments exacerbated my pain. I would spend my lunch hours at the Merhamet Apartments, sometimes returning to the office afterward, and sometimes taking the car out for an aimless drive around the city, hoping to find Füsun by chance.

As I scoured every neighborhood, every street of the city, it never crossed my mind that I would recall the hours I spent hunting for her as happy ones. When Füsun's ghost began to appear in the poor neighborhoods of the old city—Vefa, Zeyrek, Fatih, Kocamustafapaşa—I concentrated on that side of the Golden Horn. I would be driving through their narrow backstreets, smoking a cigarette as the car rumbled over the cobblestones and potholes, when suddenly Füsun's ghost would dash out in front of me, impelling me to park the car at once, and luxuriate in a deep affection for her beautiful and impoverished neighborhood. With all my heart I would bless these streets with their tired aunties in headscarves, and young toughs staring at the strangers roaming the neighborhood in search of the ghosts, and the old people and the unemployed

idling in the coffeehouses, reading newspapers in air thick with coal smoke. When a careful study of an apparition in the distance proved it was not Füsun, I would not leave the neighborhood right away; rather I would continue wandering around, convinced by some irrational logic that if a double had appeared here, the true Füsun must be close at hand. And so I came upon a broken marble fountain, 220 years old, sitting in the middle of a cat-infested square, and the sight of slogans and death threats scratched on every visible surface, scrawled by "factions" of the various left- and right-wing parties, brought me no disquiet. With my heart convinced that Füsun was somewhere nearby, these defaced streets were for me enchanted. I resolved that I needed to spend more time walking through these streets, more time in these coffeehouses, drinking tea, gazing out the window, and waiting for her to walk by; that if I was to get closer to her and her family, I needed also to live more like them.

Shortly thereafter, I stopped frequenting the newest restaurants of Nişantaşı and Bebek; I lost interest in the society amusements that had once consumed my nights. I had already tired of meeting up every evening with Mehmet, who saw it as our common fate to spend hours discussing what "our girls" were buying in Paris. Even if I managed to shake him off, Mehmet would track me down at whatever club I went to afterward, and his eyes shining, he would go on and on about what Nurcihan had said to him that day on the phone. When Sibel rang me, I would panic, for I had nothing to say to her. There were times, I admit, when I longed for the consolation of Sibel's embrace, but I was so guilt-ridden, so worn down by my evil duplicity, that ultimately her absence was a comfort. Relieved of the pretenses that our situation demanded, I

became convinced that I had returned to my old self. As my old self, though troubled, I would wander through the city's old neighborhoods, looking for Füsun, cursing myself for having neglected to seek out these charming streets, these old neighborhoods, much sooner. And I regretted not having broken off with Sibel before our engagement, or not finding a way to break off the engagement afterward, before it got to be too late.

In mid-January, two weeks before Sibel was due to return from Paris, I packed my bags, left the *yalı,* and moved to a hotel between Fatih and Karagümrük. Displayed here is one of its keys, on which you can see its insignia, likewise on its headed stationery from my room, and a replica of its little sign, which I found many years later. The day before, I'd spent the afternoon exploring the neighborhoods between Fatih and the Golden Horn, looking in every street, and every shop, peering into the windows of each and every family living in the neglected stone houses and the teetering unpainted wooden houses left behind by the Greeks who had fled the city, when, having had my fill of their joy, noise, misery, and crowded poverty, I had stepped into the hotel to escape the rain. By that time night had fallen, and unwilling to wait until I had crossed the Golden Horn to have my first drink, I walked up the hill, entering a new beer hall near the main drag. Chasing vodka with beer, I sat there with the other men watching television, and before long—it wasn't even nine o'clock—I was paralytic. When I went outside I could not even remember where I'd parked my car. I walked for a long time in the rain, thinking more about Füsun, and my life, than about my car, and I remember that as I walked these dark and muddy streets, my dreams of Füsun, painful as they were, still brought me happiness. So it was that in the middle

of the night I found myself back at the Fatih Hotel; having secured a room, I was soon asleep.

For the first time in months I slept soundly. I would continue to sleep soundly in that same hotel during the nights that followed. This took me by surprise. Sometimes, toward morning, I would be visited in my dreams by a sunny memory from my childhood or early youth. I would awake with a shudder, just as I had done when I'd heard the fisherman and his son, and my only wish was to go right back to sleep in that hotel bed, to return to the same sunny dream.

After the first restful night I had gone back to the *yalı* to pack up my clothes, my woolen winter socks and my other belongings, and determined to avoid the worried looks and anxious questions of my parents, I moved into the hotel rather than going home. I went to Satsat early as usual, but left the office early to run back to the streets of Istanbul. My hunt for Füsun was a boundless joy, and in the evening I would go content to beer halls to rest my weary legs. But as with so many chapters of my life, I would realize only much later that my days at the Fatih Hotel, far from being painful, as I then imagined, were in fact full of happiness. Every lunch hour I would go to the Merhamet Apartments for the distraction and consolation drawn from things; every day I would remember more of them, cherishing each newly found object; in the evenings I would drink and take long walks, my mind fogged by drink as I prowled the backstreets of Fatih, Karagümrük, and Balat, peering through parted curtains on the good fortune of families eating their evening meal, telling myself over and over that "Füsun must be in one of them," and finding ever fresh comfort in the thought.

Sometimes I felt that my happiness issued not from the possibility that Füsun was near, but from something less

tangible. I felt as if I could see the very essence of life in these poor neighborhoods, with their empty lots, their muddy cobblestone streets, their cars, rubbish bins, and sidewalks, and the children playing with a half-inflated football under the streetlamps. My father's expanding business, his factories, his growing fortune, and the attendant obligation to live the "elegant European" life that befit this wealth—it all now seemed to have deprived me of simple essences. As I walked these streets, it was as if I was seeking out my own center. As I meandered drunkenly up and down these narrow ways, the muddy hills and curving alleys that turned abruptly into steps, the world would suddenly seem uninhabited except by dogs, and a chill ould pass through me, and I would gaze admiringly at the yellow lamplight filtering through drawn curtains, the thin funnels of blue smoke rising from chimneys, the reflected glow of televisions in windows and shop fronts. So the next night, when I was sitting with Zaim at a tavern inside the Beşiktaş Market, drinking *rakı* and eating fish, these dark scenes would return, their protection beckoning me from the world into which Zaim's stories might pull me.

It was his usual conversational fare, reports of parties and dances, gossip about people at the club, and the growing popularity of Meltem, no one subject dwelt on for long. He knew I'd moved out of the *yalı* and was not at my parents' in Nişantaşı, but to avoid triggering my gloom he refrained from asking about Füsun or my broken heart, though from time to time I tried to lead us in that direction, for I longed to know what he knew about her past. When it was clear that he was disinclined or unable to feed my obsession, regarding the complexity as too reckless or simply a bore, I assumed the air of a self-possessed man, and made sure

he knew that I was going to the office every day and working hard.

It was snowing in late January when Sibel rang the office from Paris; in some agitation she told me that she'd heard from the neighbors and the gardener that I had moved out of the *yalı*. It had been a long time since we'd spoken on the phone, and certainly this was an indication of our estrangement, but in those days it wasn't easy to make international calls. The line would crackle with strange noises, and one had to shout into the receiver. Daunted by the prospect of proclaiming my love to Sibel at the top of my lungs (and without meaning a word of it) for the entire office to hear, I kept finding reasons not to talk to her.

"You've moved out of the *yalı,* but I hear you're not at your parents'!" she said.

"Yes, that's right."

I did not remind her that we had decided together that returning to my parents in Nişantaşı would exacerbate my illness. Neither could I ask who had told her I was not spending my nights at home. My secretary Zeynep Hanım had jumped from her seat to close the door between us, so that I could speak to my fiancée in private, but I still had to shout for Sibel to hear me.

"What are you doing? Where are you staying?" she asked.

No one but Zaim knew I was staying in a hotel in Fatih, I now remembered. But I didn't want to shout this either, for the whole office to hear.

"Have you gone back to her?" asked Sibel. "You have to be straight with me, Kemal."

"No!" I said, but I wasn't able to shout it loud enough.

"I can't hear you, Kemal."

"No," I said, louder this time. But still my response was muffled in the whoosh of the international line, whose sound was that of a seashell held to the ear.

"Kemal, Kemal, I can't hear you, please. . . ." Sibel shouted.

"I'm here!" I was shouting as loud as I could.

"Let me have it straight."

"There's nothing to tell you!" I said, shouting even louder.

"I understand!" said Sibel.

A strange sea sound came down the line, then a crackle, before the line went dead and the voice of the operator cut in. "The line to Paris has been disconnected, sir. Would you like me to try to connect you again?"

"No thank you, my girl," I said. It was my father's habit to address all female clerks, no matter their age, as "my girl." It shocked me to notice how soon I was taking on my father's habits. It shocked me to hear Sibel sounding so sure of herself. . . . But I was tired of telling lies. Sibel did not ring me from Paris again.

45

A Holiday on Uludağ

I HEARD of Sibel's return in February, at the start of the fifteen-day school holiday when families went to Uludağ to ski. Zaim, too, had called me at the office, suggesting we meet for lunch. As we sat together at Fuaye, eating lentil soup, Zaim fixed me with an affectionate gaze.

"You've run away from life. Every day I see you turning into a sadder and more troubled man, so I'm worried about you."

"Don't worry about me," I said. "I'm fine. . . ."

"You do not look fine," he said. "Try to be happy."

"You think the point of life is to be happy," I said. "That's why you believe I'm not happy and have run away from life. . . . I'm on the threshold of another life that will bring me peace."

"Fine . . . Then tell us about this life, too. We're genuinely curious."

"Who are 'we'?"

"Don't do that, Kemal," he said. "How is any of this my fault? Am I not your best friend?"

"You are."

"We . . . Mehmet, Nurcihan, myself, and Sibel . . . We're going to Uludağ in three days' time. Why don't you come, too. Nurcihan was planning to keep an eye on her niece, and so we decided to make it a group excursion. It will be fun."

"So Sibel is back."

"It has been ten days now. She came back the Monday before last. She wants you to come to Uludağ." Zaim smiled, his face shining with goodness. "But she doesn't want you to know it. . . . I'm telling you all this without her knowledge, so whatever you do, don't make any mistakes in Uludağ."

"I won't—I'm not coming."

"Come, it will do you good. This business will be over soon, and you'll forget all about it."

"Who knows? Do Nurcihan and Mehmet know?"

"Sibel knows, of course," said Zaim. "She and I talked about this. She understands very well how someone as caring as you could get pulled into something like this, and she wants to help you out of it."

"Is that so?"

"You've taken a wrong turn, Kemal. We all fall for the wrong people sometimes. We all fall in love. But in the end we all pull ourselves out of it before we ruin our lives."

"Then what about all those love stories, all those films?"

"I love romantic films," said Zaim. "But I've never seen one that justifies a case like yours. Six months ago, you had that huge engagement party. You and Sibel stood in front of everyone and exchanged rings. What a lovely evening that was. You moved in together, before you even were married. You even had parties at your house. We all thought, How elegant, how civilized. And because everyone knew you were getting married, everyone accepted it, not a soul took offense. I even heard people saying it was so chic, they wanted to do the same. But now you've moved out of the *yalı,* and you're on your own. Are you leaving Sibel? Why are you running away from her? You're not explaining yourself. You're acting like a child."

"Sibel knows. . . ."

"No, she doesn't," said Zaim. "She has no idea how to explain the situation. How is she going to face people? What can she say? 'My fiancé fell in love with a shopgirl, so we've separated'? She's very upset, she's heartbroken. You have to speak to her. In Uludağ you could patch things up, put all this behind you. I guarantee you, Sibel is ready to go on as if this never happened. Nurcihan and Sibel will be staying in a room together at the Grand Hotel. Mehmet and I have taken the corner room on the second floor. There's a third bed in that room. You know, you can see the misty mountaintop from there. You can stay with us. We can stay up all night ragging one another just like we did when we were young. Mehmet is so smitten with Nurcihan he's burning up. Think of the fun we could have with him."

"Actually the person you'd be having fun with would be me," I said. "And anyway, Mehmet and Nurcihan are already a couple."

"Believe me, I would never joke at your expense," Zaim said, somewhat hurt. "Nor would I let anyone else."

From his words it was clear that already Istanbul society—or at least the people in our own circle—had begun to make jokes about my obsession. But I had already guessed this.

I was full of admiration for Zaim's delicacy in setting up this trip to Uludağ, just to help me. When I was young, my family would go to Uludağ every winter, along with most of my father's business associates, his friends from the club, and so many other wealthy Nişantaşı families. I had so loved those vacations—when everyone knew or would come to know everyone, and you could make new friends, and play at matchmaking, as even the shiest girls danced the night away—that even years later, if I happened on an old mitten of my

father's at the back of a drawer, or the goggles that my brother had used and then passed on to me, my spine would tingle. During my time in America, whenever I looked at the postcards my mother sent me from the Grand Hotel, I felt a wave of happy longing.

I thanked Zaim but said, "I'm not coming. It would be too painful. But you're right. I need to talk to Sibel."

"She's not at the *yalı*. She's staying with Nurcihan," said Zaim. Turning his head to survey the other diners, who were in high spirits—and like him, getting richer by the day—he was able for a moment to forget my troubles and smile.

Is It Normal to Leave Your Fiancée in the Lurch?

I COULDN'T bring myself to call Sibel until the end of February, when she was back from Uludağ. I was afraid that the dreaded talk might end in unpleasantness, anger, tears, and reproach, and hoping she might take the initiative and send back the ring with a fully justified excuse. But one day I could bear the tension no longer, so I picked up the phone and rang her at Nurcihan's house; we agreed to meet for supper.

I'd thought it would be good to go to Fuaye because neither of us was likely to succumb to sentimentality, anger, or excess surrounded by people we knew. And so it was in the beginning. At the tables around us were Hilmi the Bastard with his new wife, Neslihan, and Tayfun, and Güven the Ship Sinker with his family, and (at a very crowded table) Yeşim and her husband. Hilmi and his wife even came over to our table and said how very pleased they were to see us.

Over mezes and Yakut red wine, she talked about her trip to Paris, describing Nurcihan's French friends, and telling me how beautiful that city was at Christmas.

"How are your parents?" I asked.

"They're fine," she said. "They have heard nothing about our situation as yet."

"Don't worry about that," I said. "We don't have to say anything to anyone."

"I don't," said Sibel, and then she fell silent, with a look as if to ask, So what's going to happen now?

Changing the subject, I told her that my father seemed to be withdrawing from the world a little more every day. Sibel told me about her mother's new habit of hiding away her old clothes and other belongings. I told her how my mother was even more radical about banishing all her discarded things to another apartment. But this was a dangerous subject, so we fell silent again. Sibel's expression told me she inferred no malice in my having brought it up just to keep the conversation going, but she also understood that my avoiding the real subject meant I had nothing new to say to her.

So she got to the point herself, saying, "I see you've come to accept your condition."

"What do you mean?"

"For months now we've been waiting for your illness to pass. But after all this waiting, there are no signs of recovery—and instead you seem to greet your illness with open arms. It's very painful to see, Kemal. In Paris I prayed for your recovery."

"I'm not ill," I said. I looked at the jolly crowd of diners around us. "These people might see it that way. But you shouldn't."

"When we were at the *yalı*," Sibel said, "didn't we both agree it was an illness?"

"We did."

"So what has changed now? Is it normal to leave your fiancée in the lurch like this?"

"What?"

"For a shopgirl . . ."

"Why are you mixing things up like that? This has nothing to do with shops, or wealth, or poverty."

"It has everything to do with it," said Sibel, with the determination that attends having given something a great deal of thought and reached a painful conclusion. "It's because she was a poor, ambitious girl that you were able to start something with her so easily. If she hadn't been a shopgirl, maybe you could have married her without causing yourself embarrassment. So that's what made you ill, in the end. You couldn't marry her. You couldn't find the courage."

Believing that Sibel was saying these things to me to make me angry, I got angry. But this is not to say that the fury owed nothing to my partial awareness that she was right.

"It isn't normal, darling, for someone like you to do all these bizarre things for the sake of a shopgirl, to go to live in a hotel in Fatih. . . . If you want to get better, you have to concede that I have a point."

"First of all, I'm not in love with that girl the way you think I am," I said. "But just for the sake of argument, don't people ever fall in love with people who are poorer than they are? Don't rich and poor ever fall in love?"

"The art of love is in finding a balance of equals," Sibel said. "As there is with you and me. Have you ever seen a rich girl fall in love with Ahmet Efendi the janitor, or Hasan Usta, the construction worker, just for his good looks? Outside Turkish films, I mean."

Sadi, the headwaiter, was walking toward us, his face beaming at the sight of us, but when he saw how intently we were talking, he broke off the approach. I indicated with my head that he had been right to do so and turned back to Sibel.

"I believe in Turkish films," I said.

"Kemal, in all these years I have never seen you go to a

Turkish film, not even once. You don't even go with your friends to the summer cinemas, just for a laugh."

"Life at the Fatih Hotel is just like a Turkish film, believe me," I said. "At night, before I go to sleep, I walk around those desolate and impoverished streets. It does me good."

"In the beginning I thought this whole business with the shopgirl was Zaim's fault," she said pointedly. "I thought you were aping *La Dolce Vita*. I thought you wanted to have some fun with dancers, and bar girls, and German models before you got married. I discussed this with Zaim. But now I've decided you're suffering from some sort of complex"—this word had just come into fashion—"some sort of complex about being rich in a poor country. Of course, this is a lot deeper than some little fling with a shopgirl."

"You may be right," I said.

"In Europe the rich are refined enough to act as if they're not wealthy. That is how civilized people behave. If you ask me, being cultured and civilized is not about everyone being free and equal; it's about everyone being refined enough to act as if they were. Then no one has to feel guilty."

"Hmmmmm. I see your time at the Sorbonne was not a waste," I said. "Shall we order our fish now?"

Sadi now came to our table, and after we'd asked him how he was ("Extremely well, praise be to God!") and how business was going ("We're a family, Kemal Bey. It's the same people every night!"), we talked about the general state of affairs ("Ah, with all this terrorism between leftists and rightists, it's almost impossible for a decent citizen to go out into the street!") and the comings and goings of the regulars ("Everyone's back from Uludağ now!"). I'd known Sadi since childhood. Before Fuaye opened, he'd worked at Abdullah Efendi's in Beyoğlu,

where my father had eaten all the time. He'd come to Istanbul thirty years earlier, at the age of nineteen, never having seen the sea before, and quickly learned the intricacies of picking and preparing fish from the old Greek tavern owners and the city's most famous Greek waiters. He brought us a tray of red mullet, large, oily bluefish, and sea bass that he'd bought with his own hands at the fish market that morning. We smelled the fish, looked at the brightness of the eyes, and the redness of the gills, and confirmed that it was fresh. Then we complained about how polluted the Sea of Marmara was getting. Sadi told us that Fuaye had a private company deliver a tanker full of water every day because of the cuts in the water supply. They had not yet ordered a generator to cope with the power cuts, but the guests seemed to like the atmosphere on those evenings when they had to depend on candles and gas lamps. After topping off our wineglasses, Sadi went on his way.

"There was that fisherman with his son," I said. "We used to listen to them in the *yalı*. Not long after you left for Paris, they disappeared, too. After that the *yalı* got even colder and lonelier, until I couldn't bear it anymore."

Sibel heard the note of apology in my voice as I spoke of this development, hoping to redirect the conversation. (My father's pearl earrings crossed my mind.) "This father and his son were probably going after the schools of bonito or bluefish." There had been plenty of both this year, I told her; even in the backstreets of Fatih, I'd seen them sold from horse-drawn carts, followed everywhere by cats. As we ate our fish, Sadi told us that the price of turbot had gone up dramatically, because they'd arrested those Turkish fishermen who'd gone into Russian and Bulgarian waters to fish turbot. As we were discussing this story, I saw that Sibel was looking more distressed than

ever. She knew I was talking about all these things so as not to speak of our predicament, about which I had nothing new to say and no hope to offer. I did want to find an easy way to talk about it, but I couldn't think of any. Now, seeing her sad face, I knew I couldn't lie to her, and that made me frantic.

"Look, Hilmi and his wife are getting up to leave," I said. "Shall we invite them to join us?" Before Sibel could say anything, I waved at them, but they didn't see me.

"Don't ask them to join us," said Sibel.

"Why? Hilmi's a very nice boy. And I thought you liked his wife, what's her name?"

"What's going to happen to us?"

"I don't know."

"When I was in Paris, I talked to Leclerq." This was Sibel's economics professor, whom she admired greatly. "He thinks I should do a dissertation."

"So you're going to Paris?"

"I'm not happy here."

"Shall I come, too?" I asked. "Though I have a lot of work here."

Sibel did not answer. It was clear that she'd already made up her mind about this meeting, and also about our future, but I sensed that she had one more thing to say.

"Go to Paris, then," I said, tiring of the halting discussion. "I can see to things here and come later."

"There's one more thing I have to say. I apologize for bringing it up, but there's the question of virginity, Kemal. Perhaps you feel some obligation to this shopgirl. But I think virginity is not important enough to justify what you've done."

"What do you mean?"

"If we're really meant to be modern in our outlook, if we're

really European, as I said, it has no importance. If, on the other hand, we're still tied to tradition, and virginity matters to you, as something you want everyone to respect, then everyone's should be considered in the same way!"

At first I frowned, because I wasn't sure what Sibel was trying to say. Then I remembered that I had been her first lover. "It's not the same burden for you as for her," I wanted to say. "You're rich and modern!" But instead I looked down in shame.

"And there's something else that I'm never going to be able to forgive, Kemal. If you weren't going to be able to break it off with her, then why did we get engaged? Why didn't you break off the engagement?" Her voice trembled with bitterness. "If it was going to come to this, why did we move to the *yalı*? Why did we give parties? Why, in a country like this, did we live openly as a couple without being married?"

"The innocent, sincere companionship I shared with you in the *yalı*—I've never known such a thing with anyone else."

I could see how angry my answers were making her. She was so angry and miserable that she was about to cry.

"I'm sorry," I said. "I'm so very sorry."

There was a terrible silence. To keep Sibel from crying, to keep this from going any further, I waved frantically at Tayfun and his wife, who were still waiting for a table. They were glad to see us. When I insisted, they sat down at our table.

"Do you know, I've already begun to miss the *yalı*!" said Tayfun.

They had come to visit us a lot during the summer. Tayfun had strolled up and down the wharf and through the house as if they belonged to him, he'd opened up the refrigerator to get drinks for himself and others, sometimes he'd feel inspired

to spend hours in the kitchen cooking, while consumed by the need to hold forth on the particularities of the Soviet and Romanian tankers steaming by.

"Do you remember that evening when I passed out in the garden?" he said, reminiscing fondly. Seeing Sibel sitting there listening to Tayfun, saying jovial things in reply, without betraying a hint of her inner feelings, I could not help but feel something akin to admiration.

"So then, when are you two getting married?" asked Tayfun's wife, Figen.

Was it possible that she had not heard the gossip about us?

"In May," said Sibel. "At the Hilton again. You'll all have to promise to wear white, as in *The Great Gatsby*. Have you seen it yet?" Suddenly she looked at her watch. "Oh no, I have to meet my mother at the corner of Nişantaşı in five minutes." In fact her parents were in Ankara.

She jumped up and kissed first Tayfun and Figen, and then me, on both cheeks. After sitting for a while with Tayfun and Figen, I, too, left Fuaye and went to the Merhamet Apartments to find my customary consolation. A week later, Sibel returned her engagement ring to me, via Zaim. Although news of her came to me from all directions, I would not see her again for thirty-one years.

47

My Father's Death

THE NEWS of my broken engagement spread fast; Osman came to the office one day to berate me; he was ready to intervene and mollify Sibel's heart. Meanwhile, a wide variety of rumors reached my ears: I'd gone soft in the head; I'd become a creature of the night; I'd joined a secret Sufi sect in Fatih; there were even those who said I'd become a communist and, like so many militants, gone to live in a shantytown—but none of this upset me much. On the contrary, I hoped that when Füsun heard I had broken my engagement, she would be impressed and send word from wherever she was hiding. By now I had given up all hope of recovery; instead of seeking to relieve it, I made the most of my pain. I took to wandering aimlessly through those forbidden streets of orange light, and four or five times a week I would repair to the Merhamet Apartments for the peace of my memories and the therapeutic comfort of the things I kept there. With Sibel out of my life, I could have gone back as a bachelor to my old bedroom in my parents' house in Nişantaşı, but my mother, herself unable to accept the broken engagement, had concealed the bad news from my father, whom she described as "listless and weak," and as she was unwilling to discuss this dangerous subject openly, there would be long silences at the table when I went to have lunch with them, which I did frequently, though I never stayed the night. In fact, my stomachaches worsened whenever I was in the Nişantaşı house.

But when my father died at the beginning of March, I went home to stay. It was Osman who came to the Fatih Hotel in the Chevrolet to bring me the bad news. I would never have wanted him to come up to my room and see the strange objects I'd bought during my walks through the poor neighborhoods, from junk dealers, grocers, and stationers, all of them hoarded in my shamefully ramshackle room. Refraining from his customary scolding, this time he just looked at me sadly, embracing me with tender sincerity, and no reproach; half an hour later I had packed up my things, paid the bill, and left the Fatih Hotel. Teary-eyed Çetin Efendi looked so distraught, and I remembered that my father had entrusted both him and the car to my care. It was a gloomy, leaden winter's day, and as Çetin Efendi drove us over the Atatürk Bridge, I looked at the Golden Horn, its icy aquamarine swirling with oil slicks, its coldness chiming with my loneliness.

My father had died of heart failure, a few minutes after seven, as the morning prayers were being sung; my mother had awoken thinking her husband was still asleep beside her; when she realized what had happened, she became hysterical, so they had given her a Paradison tablet to calm her down. Now seated in the sitting room in her usual chair, across from my father's, she would from time to time begin to cry, and gesture toward the empty seat. She brightened when she saw me. We threw our arms around each other; neither of us spoke.

I went in to see my father. He was lying in his pajamas on the walnut bed he had shared with my mother for almost forty years; though still in a sleeping position, he was rigid, and the expression on his pallid face suggested not a slumberous peace but deep distress. He had awoken to see death before him; his eyes were wide with panic, frozen on his face a look of fear

and awe, the sort you would expect on someone helpless in the path of fast-approaching traffic. His wrinkled hands gripping the blankets, their scent of cologne, their crooked curves, their hairs and moles; these hands had caressed my hair, my back, my arms thousands of times when I was a child, making me so happy; these were hands I knew. But now their whiteness scared me; and I could not bring myself to kiss them. I wanted to pull off the blanket and see his whole body in those blue-and-white-striped silk pajamas he always wore, but the blanket was stuck somewhere.

While I was pulling at it, his left foot poked out. I felt compelled to look at his toe. My father's big toe was absolutely identical to my own, and as one will gather from this detail of an old photograph that I've had enlarged, his toes had a unique shape. Ever since my father's old friend Cüneyt had first noticed this strange resemblance twelve years earlier when we were sitting in our swimsuits on the Suadiye shore, he would greet us with the same old joke whenever he saw us together: "How are the father-and-son toes doing?"

I locked the bedroom door and sat down, preparing to take the opportunity to cry over Füsun for a very long time while thinking about my father, but the tears wouldn't come. Instead I gazed with new eyes at the bedroom where my father had spent so many years with my mother, this intimate chamber of my childhood still entirely redolent of cologne, carpet dust, floor polish, old wood, curtains, my mother's perfume, and the oil from our hands that clung to the barometer that my father would take me on his lap to show me. It was as if the center of my life had dissolved, as if the earth had swallowed up my past. Opening up his cupboard, I took out the outmoded ties and belts, and one of the pairs of shoes that were still occasionally

shined, though he hadn't worn them in years. When I heard footsteps in the corridor, I felt the same tinge of guilt I'd felt when rummaging through this wardrobe as a boy, and I quickly shut its creaking door. On my father's bedside table were medicines, crossword puzzles, folded newspapers, a much loved photograph from his army days, taken when he'd been drinking *rakı* with the officers, his reading glasses, and also his false teeth, in a glass. The false teeth I took from the glass, wrapping them in my handkerchief, and put them in my pocket; then I went to be with my mother in the front room, taking my father's chair.

"Mother dear, don't worry—I took Father's false teeth," I said.

She nodded, as if to say, Fine, you know best. By noon the house had filled with relatives, friends, acquaintances, and neighbors. They all kissed my mother's hand and embraced her. The front door was open and the lift in constant use. Before long there were so many people that I could not help but remember the holiday feasts we'd had here. I felt that I loved this crowd of people, these sounds of family life, and the warmth; surrounded by all these relatives, all these cousins with the same potato noses and wide foreheads, I felt happy. For a while I sat with Berrin on the divan, gossiping amiably about the cousins. It pleased me that Berrin followed them all so closely, that she knew the family news better than I did. Like everyone else, I whispered the occasional little joke, I talked about the latest football match, which I'd watched in the lobby of the Fatih Hotel (Fenerbahçe 2–Boluspor 0), and I sat down at the table set by Bekri, who, despite his pain, was frying up more cheese pastries; and I went often to the bedroom in the back to look in on my father's pajama-clad body. Yes, he was

perfectly still. From time to time I opened up his drawers, to touch the things that carried so many of my early memories. My father's death had turned these familiar props of childhood into objects of immeasurable value, each one the vessel of a lost past. I opened the bedside table drawer, and as I breathed in the fumes of cedar and my father's sugary cough syrup, I gazed for a long time at the old phone bills, the telegrams, my father's aspirins and medicines, as if I were looking at a complicated picture. I remember, too, that before leaving with Çetin to make the funeral arrangements, I stood on the balcony at length, gazing down at Teşvikiye Avenue. With the death of my father, it wasn't just the objects of everyday life that had changed; even the most ordinary street scenes had become irreplaceable mementos of a lost world whose every detail figured in the meaning of the whole. Because coming home now meant a return to the center of that world, there was a happiness I could not hide from myself, and my guilt was even deeper than that of a man whose father has just died. In the refrigerator I found the little bottle of Yeni Rakı that my father had half finished the last night of his life; after all the guests had left and I was sitting with my mother and older brother, I drank what was left.

"Did you see what your father did to me?" said my mother. "Even when he was dying, he didn't let me know."

That afternoon, my father's corpse had been taken to the morgue at Sinan Pasha Mosque in Beşiktaş. My mother, wishing to fall asleep immersed in my father's scent, had not wanted the sheets or pillowcases to be changed. It was late when my brother and I gave our mother a sleeping pill and put her to bed. My mother smelled the pillowcases and the sheets for a time, and cried a little, and fell asleep. When Osman, too, had

left, I went to my own bed, thinking that in the end—as I had so often longed would happen, and dreamed of happening, when I was a child—I had been left alone in this house with my mother.

But it was not this that filled me with excitement; it was (as I in my heart could not deny) the possibility that Füsun might come to the funeral. For this express reason I had included all the names of that distant branch of the family in the death announcements in the papers. I kept thinking that Füsun and her parents would read one of these announcements, somewhere in Istanbul, and come to the funeral. Which newspaper might they read? Of course, they might also hear the news from other relatives mentioned in the death notices. My mother read through all the newspaper death notices over breakfast. From time to time she would grumble: "Sıdıka and Saffet are related both to me and to your dear departed father, so their names should have come just after Perran and her husband. Şükrü Pasha's daughters, Nigân, Türkan, and Şükran, have also been put in the wrong order. There was no need to include Uncle Zekeriya's first wife, Melike the Arab. After all, she couldn't have been married to your uncle for more than three months. That poor little baby of your great-aunt Nesime, who died when she was two months, her name wasn't Gül, it was Ayşegül. Who did you go to for your information when you were writing these up?"

"They're just typographical errors, Mother dear. You know what our newspapers are like," said Osman. Every other minute, my mother was glancing out the window down at the courtyard of Teşvikiye Mosque, fretting about what she was going to wear, and we realized that on an icy, snowy day like this, she should not go outside at all. "You can't wear that fur

as if you were off to a party at the Hilton, and even in that you won't be warm enough."

"I am not going to stay at home on the day of your father's funeral, even if it kills me."

But as she watched the bearers carry my father's coffin from the mosque morgue to the funeral stone, my mother began crying so hard that we immediately knew she would not make it down the stairs and across the street to join the funeral. In spite of all the tranquilizers we'd given her, when she went out to the balcony in her Astrakhan fur, propped up by Bekri on one side and Fatma Hanım on the other, to watch the crowd lift the coffin into the funeral hearse, she fainted. There was a harsh north wind blowing; there were swirls of snowflakes small enough to get into your eyes. Almost no one in the crowd noticed my mother. After Bekri and Fatma had taken her back inside, I too gave my attention to the crowd. These were the same people who had come to our engagement party at the Hilton. As it seemed so often on the streets of Istanbul in winter, the pretty girls I'd noticed during the summer had disappeared; the women had grown uglier, the men, too, darker and more threatening. Just as I had done at the engagement party, I shook hundreds of people's hands, embracing many well-wishers, and every time I met a new shadow in the crowd I felt a pang, because we were burying my father, and because that shadow was not Füsun. When I was sure that neither she nor her parents had come to the funeral or the interment, and that they were not going to come, I felt as if I was being buried under the cold earth along with my father.

The cold seemed to bring the family closer, and after the ceremony was over they wanted to remain together, but I fled them, taking a taxi straight to the Merhamet Apartments. Even

the smell of the apartment brought me peace as I inhaled it from the threshold; I knew from experience that Füsun's lead pencil had the greatest consolatory power of all the things in the apartment, with her teacup, which I had not washed since her disappearance, coming in a close second; I took these things into bed with me. After touching them and stroking my skin with them for a short time, I was able at last to relax.

To readers and museum visitors who are curious to know whether the pain I endured that day was owing to the death of my father or to Füsun's absence, I would like to say that the pain of love is indivisible. The pains of true love reside at the heart of our existence; they catch hold of our most vulnerable point, rooting themselves deeper than the root of any other pain, and branching to every part of our bodies and our lives. For the hopelessly in love, the pain can be triggered by anything, whether as profound as the death of a father or as mundane as a piece of bad luck, like losing a key; such elemental pain can be flamed by any sort of spark. People whose lives have, like mine, been turned upside down by love can become convinced that all other problems will be resolved once the pain of love is gone, but in ignoring these problems they only allow them to fester.

Sitting in the taxi on the day we buried my father, I was able to think these thoughts clearly, but to my regret I could not act accordingly. The anguish of love had disciplined me—brought me to maturity—but in ruling my mind, it gave me scant latitude to use the reason that maturity had brought me. A man like me, too long captive to a destructive passion, will continue on the course his reason tells him is wrong, even if he knows it will bring him to sorrow; in time, he'll see only more and more clearly how wrong was his path. In such situations there is an

interesting phenomenon rarely remarked upon: Even on our worst days, our reason does not stop speaking to us; even if unequal to the power of our passion, it continues to whisper with merciless candor that our actions will serve no purpose but to heighten our love, and therefore our pain. During the first nine months after I lost Füsun, my reason continued to whisper to me, ever more urgently, giving me the hope that one day it would usurp control of my mind and rescue me. But love mingled with such hope (even the simpler hope that I would one day live without pain) gave me the strength to carry on in the face of my agony, while at the same time prolonging it.

As I lay in the Merhamet Apartments, soothing myself with Füsun's things (the loss of my father having now merged with the loss of my love in an amalgam of being alone and unloved), I began to understand why Füsun and her family had not come to the funeral. Still I struggled to accept that Aunt Nesibe and her husband, who had always attached such importance to their relations with my mother and the family, had stayed away because of me. For this conclusion meant inexorably that Füsun and her family were determined to escape me forever. The prospect that I might never see her again for the rest of my life was so unbearable that I could not entertain it for long; I needed to find some way to have hope of seeing Füsun in the near future.

48

The Most Important Thing in Life Is to Be Happy

"I HEAR you're blaming Kenan for Satsat's going off the rails," Osman whispered into my ear one evening. He came often to visit our mother in the evenings, sometimes with Berrin and the children, but mostly he came by himself to make a threesome at supper.

"Where did you hear that?"

"I hear things," said Osman. My mother was in the other room; he gestured in her direction. "You've disgraced yourself in society, but at least don't embarrass yourself at the firm," he said mercilessly. (This despite the fact that he hated the word "society" as much as I did.) "It's your fault you lost out on the sheet business," he added.

"What's going on, what are you talking about?" said my mother. "Please don't have another argument!"

"We're not," said Osman. "I was just saying how good it is that Kemal's returned. Don't you agree, Mother?"

"Oh, yes, my son, it's wonderful. Whatever anybody says, the most important thing in life is to be happy. This city is full of beautiful girls; we'll find one who is even kinder and more beautiful, and more understanding. After all, a woman who doesn't love cats is never going to make a man happy. None of us should waste any more time dwelling on what happened. Just promise me you'll never go back to living in a hotel."

"On one condition!" I said, childishly repeating Füsun's ploy of nine months earlier. "I want to take over my father's car, and Çetin with it."

"Fine," said Osman. "If Çetin is happy with that, then I am, too. But you have to stop messing with Kenan and the new business. I don't want any more mudslinging."

"I don't want you two arguing in front of everyone, ever!" my mother said.

After separating from Sibel, I grew more distant from Nurcihan; and once I distanced myself from her, I began to see much less of Mehmet, who was as ever madly in love with her. Zaim, meanwhile, was spending more time with them, so when he and I met it would be just the two of us, and slowly I removed myself from the group. For a brief time I took to going out with Hilmi the Bastard and Tayfun and a few others who, despite being married, engaged, or as good as engaged, still had a taste for the naughtier side of nightlife, and liked to visit the city's priciest brothels, or I'd go out with friends who knew which hotel lobbies were favored by the slightly more educated and refined girls that we mockingly called the "coeds"; I was not really looking for fun; what I was hoping for was a cure for my illness, but my love for Füsun had emerged from the shadows to claim my entire body. Although it was amusing to be among friends, I was not able to lose myself and forget my troubles. And so most evenings I stayed at home, sitting next to my mother, a glass of *rakı* in my hand, watching whatever was on the single state-controlled channel.

My mother did just as she'd done when my father was alive: a merciless critique of whatever was on the screen; at least once a night, she would tell me not to drink so much, just as she used to tell my father, and then she would fall asleep in her

chair. Fatma Hanım, the maid, and I would then be obliged to whisper about whatever was on television. Unlike the maids who worked for the rich families we saw in Western films, Fatma Hanım did not have a television in her room. For four years now, ever since the broadcasting service had begun and we'd bought our first television set, Fatma Hanım would come into the sitting room every evening to perch tentatively on the bar stool at the far end of the room—by now we had come to think of it as "her chair"—and from this distance she would watch along with us, fiddling with the knot in her scarf at moments of high drama, and sometimes venturing into the conversation. After my father's death, it fell to her to respond to my mother's endless monologues, and so lately we'd been hearing more from her. One night, after my mother had dozed off, there was a live broadcast of a skating competition; as we watched the long-legged Soviets and Norwegians, just as ignorant of the competition rules as the rest of Turkey, Fatma Hanım and I chatted about the warm weather, the political street killings, my mother's health, the futility of politics, and about her son, who, after working with my father, had immigrated to Duisburg, Germany, to open a *döner* restaurant—in other words, we were talking about the sweetness of life, when she brought the subject round to me.

"Clawnails, you're not poking holes in your socks anymore, and this is a good thing. I noticed that you're cutting your nails now, and very nicely, too. So I'm going to give you a present."

"A pair of nail clippers?"

"No, there are already two pairs of nail clippers in the house. Three, counting your father's. This is something else."

"What is it?"

"Come inside," said Fatma Hanım.

From her manner I guessed it was something special, so I followed. Stepping into her room, she picked something up; then she led me into my room and turned on the light; she opened her palm like someone doing a magic trick for a child.

"What's this?" I said, before my heart began to pound.

"It's an earring. What is this—a butterfly with a letter? Isn't it strange?"

"It's mine."

"I know it's yours. Months and months ago I found it in the pocket of your jacket. I set it aside, to give it to you. But your mother saw it and took it. She must have thought your dear departed father had bought it for someone else, and she would spoil his fun, or something like that. Anyway, she had a secret velvet pouch where she hid things from your father"—she smiled—"stole from your father and then hid from him. After your father died, she emptied it out and laid all the contents on top of his bureau, and when I saw this, I recognized it right away, so I grabbed it for you. There is also a photograph I found in one of your father's jackets. Take that, too, before your mother sees it. Did I do well?"

"You did very well, Fatma Hanım," I said. "You are very clever, very wise, and truly wonderful."

With a happy smile, she handed me her gifts. The photograph was the one my father had shown me at Abdullah's Restaurant: a picture of his deceased sweetheart. Looking at this sad girl now, and the ships and the sea in the background, I suddenly saw shades of Füsun.

The next day I called Ceyda. Two days later, we met again in Maçka and walked to Taşlık Park. Her hair was in a bun, and she was radiating with the happiness one sees uniquely in new mothers, and I soon saw she had acquired the confidence

that comes of having to grow up quickly. During the past two days, and without much strain, I had written four or five letters to Füsun, finally putting the most moderate and coolheaded of these into a yellow Satsat envelope. As I had planned in advance, I frowned as I handed Ceyda the letter, telling her there had been a very important development, and that she had to make sure Füsun received this letter. My plan was to tell Ceyda nothing of the letter's contents, creating an air of a mystery of such importance that she could not take responsibility for failing to deliver it. Ceyda's sane, mature, accepting manner disarmed me, and it was with great excitement that I confessed to Ceyda that the letter pertained to a matter that had made Füsun very angry at me, and that when Füsun received the news I was sending her, she would be very glad, as I was, and that apart from lost time, our troubles were over. As I said my good-byes to Ceyda, who was rushing home to nurse her baby, I told her that as soon as Füsun and I married, we would have a child who would be friends with her boy, and that we would laugh one day at these troubles and the contortions it had taken to find true love. I asked her what she had named her child.

"Ömer," said Ceyda. "But life never turns out the way we want, Kemal Bey."

When weeks had passed without an answer from Füsun, Ceyda's parting words came back to me often, but I never doubted that Füsun would answer my letter, for Ceyda had confirmed that Füsun was aware I had broken off the engagement. In my letter I had said that her earring had turned up in a box of my father's, and that I wanted to bring it back to her, along with the other earrings of my father's that I had tried to give her, and the tricycle. The time had come for the

evening we had planned so long ago, when I would come for a meal with her parents.

In the middle of May, on a busy day, I was at the office reading correspondence from our distributorships in the provinces, along with other letters, personal and professional, offering friendship, thanks, complaint, apologies, and threats. Most had been written by hand, and I was struggling with some of them, because I couldn't read the script—and then I came upon a very short letter, which I devoured with my heart pounding:

> *Cousin Kemal,*
>
> *We too would very much like to see you. We await your company at supper on May 19.*
>
> *Our phone line has not yet been connected. If you are unable to join us, send Çetin Efendi to let us know.*
>
> *With our love and respects,*
>
> *Füsun*
>
> *Address: Dalgıç Street, No. 24, Çukurcuma*

There was no date on the letter, but from the postmark I could tell it had been sent from Galatasaray Post Office on May 10. The nineteenth was more than two days hence, and though I longed to bolt straight to that Çukurcuma address, I restrained myself. If my aim was to marry Füsun in the end, and to bind her to me ever after, I should take care not to seem too anxious, I told myself.

49

I Was Going to Ask Her to Marry Me

ON WEDNESDAY, May 19, 1976, at half past seven, I set out for Füsun's family's house in Çukurcuma, telling Çetin Efendi only that we were going over to return a child's tricycle to Aunt Nesibe. I gave him the address and I sat back in my seat, watching rain pour down on the streets, as if someone had upended a giant glass. Not once during my thousands of dreams of our reunion had I imagined such a deluge, or even a light drizzle.

Stopping at the Merhamet Apartments to pick up the tricycle and the pearl earrings that my father had given me in a box, I got completely soaked. Still entirely contrary to my expectations, I felt the deepest peace in my heart. It was as if I had forgotten all the pain I had endured since last seeing her at the Hilton Hotel 339 days earlier. I remember even feeling thankful for every minute I had spent writhing in agony, because it had brought me to this happy ending. I blamed nothing and no one.

I saw stretching out before me the same wondrous life I'd seen at the beginning of my story. Stopping off at a florist on Sıraselviler Avenue, I had them make me a huge bouquet of red roses that was as beautiful as that prospect. To calm myself, I'd had a half glass of *rakı* before leaving home. Should I have stopped off for one more at a *meyhane*—one of the taverns in the side streets leading up to Beyoğlu? Impatience, like the pain,

had taken hold of me. "Be careful!" warned a voice inside. "This time you can make no mistakes!" As we passed the Çukurcuma Hamam shrouded in rain, I suddenly realized what a good lesson Füsun had taught me with these 339 days of agony: She had won. I was ready to do whatever she wanted, to avoid the punishment of never being able to see her again. Once I had recovered from the initial excitement, once I was sure that Füsun was at my side, I was going to ask her to marry me.

As Çetin Efendi peered through the rain, trying to read the house numbers, I conjured up the proposal scene, which I had already imagined somewhere in my mind, hiding it from my consciousness: After entering the house, handing over the tricycle, making a few jokes, taking a seat and settling in—was I up to doing all this?—I would sip the coffee Füsun brought me, and then, summoning my courage, I would look straight into her father's eyes and say point-blank that I had come to ask for his daughter's hand in marriage. The tricycle was just an excuse. We would laugh about it, like so many jokes we would use to keep from ever talking about the agonies, or the sorrows that had caused them. As I drank the Yeni Rakı her father would naturally serve me at the table, I would look into Füsun's eyes and feast on the happiness that my decision had brought me. We could discuss the details of the engagement and the marriage at another time.

The car stopped in front of an old building; the rain made it impossible to see what sort of structure it was. My heart racing, I knocked on the door. Almost at once Aunt Nesibe answered. As I carried the tricycle inside, I remember how impressed she was by the sight of Çetin Efendi, who stood behind me holding an umbrella, and how delighted she was by the roses. I sensed unease in her expression, but I was not the least deterred,

because I was climbing the stairs, and with every step, I was drawing closer to Füsun.

Füsun's father was waiting on the landing. "Welcome, Kemal Bey." I'd forgotten I'd seen him a year earlier at the engagement party, somehow imagining that we hadn't embraced since the last of the old family meals at the Feast of the Sacrifice. Age had not made him less handsome, as is so often the case; it had simply made him less visible.

Then I thought I must be seeing Füsun's sister, because there, standing behind her father in the doorway, I saw not Füsun, but a dark-haired beauty who resembled her. But even as I was thinking this, I realized that this was Füsun. It was a tremendous shock. Her hair was jet-black. "Her natural color, of course!" I told myself, as I tried to calm my nerves. I went inside. My plan had been to ignore her parents, hand her the flowers, and throw my arms around her, but I could tell from the look on her face, and her discomfort as she approached me, that she didn't want me to embrace her.

We shook hands.

"Oh, what lovely roses!" she said, without taking them from my hands.

Yes, of course, she was very beautiful; she had matured. She could tell how distressed I was that our reunion was turning out so differently from what I'd imagined.

"Aren't they lovely?" she said, now addressing someone else in the room.

I came eye to eye with the person she had indicated. The first thought to cross my mind was: "Couldn't they have found another evening to invite over this sweet, fat adolescent neighbor?" But once again, even as the thought passed through my mind, I knew I was wrong.

"Cousin Kemal, let me introduce you, this is my husband, Feridun," she said, trying to sound as if she'd just recalled a detail of minor significance.

I stared at this man called Feridun, not as a real person but as if he were an obscure memory I could not quite place.

"We married five months ago," said Füsun, raising her eyebrows as if waiting for the penny to drop.

I could tell, from the way this fatso shook my hand, that he knew nothing. "Oh, I'm so pleased to meet you!" I said to him, and smiling at Füsun, now hiding behind her husband, I said, "You're a very lucky man, too, Feridun Bey. Not only have you married a wonderful girl, but this girl is now in possession of a nifty tricycle."

"Kemal Bey, we so wanted to invite you to the wedding," said her mother. "But we'd heard your father was ill. My girl, instead of hiding behind your husband, why don't you find a vase for those beautiful roses Kemal Bey is holding in his hands."

My beloved, who had never once been absent from my dreams all year, took the roses from my hands with a small, elegant gesture, first bringing herself close enough for me to see the blush of her cheeks, her ever-inviting lips, her velvet skin, and her neck, and I would have done anything at that moment, just to know I could spend the rest of my life this close. I inhaled the fragrance of her exposed bosom before she drew back. I was dumbstruck, amazed at her reality, as one is amazed at the reality of the natural world.

"Put the roses in a vase," said her mother.

"Kemal Bey, you'll have a *rakı*, won't you?" said her father.

"Tweet tweet tweet," said her canary.

"Oh, yes, I'd love one, yes, I'll have a *rakı*."

They gave me two *rakı*s on the rocks and I knocked them both back, on an empty stomach, hoping they would take immediate effect. I remember speaking for a time about the tricycle I'd brought with me, and a few childhood memories, before we sat down to eat. But alas, I was still sober enough to know that because she was married, I could show none of that lovely brotherly feeling that I'd hoped the tricycle would evoke.

Füsun sat across from me, as if by chance (she'd asked her mother where she should sit), but she would not look me in the eye. During these first minutes I was shocked enough to believe she had no interest in me. I, in turn, tried to look as if I had no interest in her, as if I were a well-meaning, wealthy cousin, here to give a wedding present to a poor relation, while many more important things weighed on my mind.

"Soooo, when can we expect children?" I asked, still playing this role, looking Feridun in the eye first, but failing then to address Füsun.

"We're not thinking of having children right away," said Feridun. "Perhaps after we've moved into our own house."

"Feridun is very young, but he is one of the most sought-after screenwriters in Istanbul today," said Aunt Nesibe. "He's the one who wrote *The Old Lady Who Sells* Simits."

All night I struggled to get it through my skull—as people say. At intervals all evening I conjured up the hopeful dream that this wedding story was a joke, that they'd gotten some neighbor's fat son to masquerade as a childhood sweetheart, dressing him up as her husband, a final lesson to me that they would, at evening's end, own up to. Eventually, as I learned more about the couple, I did accept that they were married, but then it was the various details of that reality that, as they were disclosed, I found unacceptable: Feridun Bey, this son-in-law

who was living with his wife's family, was twenty-two years old, and interested in film and literature; though he wasn't making much money yet, in addition to screenplays for Yeşilçam, he wrote poetry. I discovered that as a distant relation on her father's side, he'd played with Füsun as a child, and that, when he was a child, he had even ridden on the tricycle I'd brought back to the house. Hearing all this, I felt my very soul shriveling up inside me, irritated by the *rakı* that Tarık Bey poured so solicitously into my glass. Whenever I entered a new house, I would always feel uncomfortable until I knew how many rooms it had, and which backstreet the balcony looked out on, and why a table had been positioned in a particular way, but now there were no such questions in my mind.

The only consolation was to sit across from her, to admire her, like a painting. Her hands were always moving, just as I remembered. Although married, she still didn't smoke in front of her father, and that, alas, meant that I could not watch her light her cigarette in that lovely way of hers. But twice, she pulled back her hair the way she used to, and three times, when she was trying to join the conversation, she took a deep breath—like those she had always drawn when we quarreled—and raised her shoulders just slightly, as if waiting for her chance. Each time I saw her smile, hope and joy rose up inside me with the force of blooming sunflowers. I was reminded by her beauty, and by her gestures, which were so dear to me, and by her luminous skin, that the center of the world, the center to which I must travel, was at her side. All other people, places, and pastimes were nothing but "vulgar distractions." It wasn't just in my mind that I knew this, it was in my body; and so sitting across from her I longed to stand up and throw my arms around her. But when I tried to

contemplate my situation, and what would happen next, I felt such an ache in my heart that I could think no more, and then it was not just for the benefit of the others that I played the part of the relative come to congratulate the young couple: It was also for my sake. Though our eyes hardly met during that meal, Füsun caught on at once, and as I carried on acting, she did everything one would expect from a happy young newlywed entertaining a wealthy distant relation come to call in his chauffeur-driven car, teasing her husband, feeding him spoonfuls of fava beans. All this made the eerie silence in my head echo.

The rain that had been pelting down ever faster on the way to the house showed no signs of abating. Tarık Bey had already told me, at the very beginning of the meal, that the neighborhood of Çukurcuma was, as the name implied, a topographical bowl, and that only after buying the house last summer did they learn it had flooded many times in the past, and so I went with him to the bay window to watch the torrent pouring down the hill. Many of their neighbors were out there, with their trousers rolled up and barefoot, using zinc buckets and plastic washtubs to bail out the water rushing over the curbs right into their houses, and arranging piles of stones and rags into makeshift levees. As two barefoot men struggled to clear a blocked grate with their hands, two women, one wearing a green and the other a purple headscarf, were pointing insistently at something in the torrent and shouting. At the table Tarık Bey had commented mysteriously that the sewers dating back to Ottoman times could no longer cope. Whenever the drumming of the rain increased, someone would say something like, "The heavens have opened up," or "It's the flood!" or "May God protect

us," and then rise from the table to gaze anxiously through the window at the floodwaters and the neighborhood, now transfigured in the pale lamplight. I, too, felt compelled to rise, in solidarity with their fears of flood, but I was so drunk I was afraid of being unable to stay on my feet, and knocking over tables and chairs.

"I wonder how your driver is doing out there?" said Aunt Nesibe as she gazed out the window.

"Should we get him something to eat?" asked the bridegroom.

"I could take it down," said Füsun.

But Aunt Nesibe, sensing that I might not like this, changed the subject. For a moment I felt myself to be a lonely drunk under the suspicious scrutiny of the family standing by the bay window. So I faced them and smiled. Just then there was a clatter in the street below—a barrel had overturned—and we heard someone cry in pain. Füsun and I came eye to eye. But she immediately looked away.

How could she manage to show so little interest? This was what I wanted to ask her. But I wasn't asking this question like some addled abandoned lover, who, when asked why he won't leave his beloved alone, claims, I just wanted to ask her something! Well, all right, I was.

She'd seen me sitting here alone, so why didn't she come and sit beside me? Why didn't she seize this perfect opportunity to explain everything? Again we exchanged glances and again she looked away.

Now Füsun will come to sit at your side, said an optimistic voice inside me. And if she came, it would be a sign that one day she would give up on this misalliance, divorce her husband, and be mine.

The sky rumbled. Füsun drew away from the window and taking five steps floated to the table like a feather to sit across from me in silence.

"I beg you to forgive me," she said in a whisper that pierced my heart. "I wasn't able to come to your father's funeral."

The blue glare of a lightning bolt flashed between us like a swath of silk in the wind.

"I was waiting for you," I said.

"I guessed that, but I would never have been able to come," she said.

"That illegal awning over the grocery shop has been blown off—did you see?" said her husband, Feridun, as he returned to the table.

"We saw that, and it's a shame," I said.

"Not a shame at all," said the father, returning from the window.

Seeing his daughter with her hands over her face, like a girl in tears, he first glanced anxiously at his son-in-law, and then at me.

"I still feel so bad about missing Uncle Mümtaz's funeral," said Füsun in a quivering voice. "I loved him so dearly. I was so upset."

"Füsun loved your father very much," said Tarık Bey. Passing his daughter, he kissed her head, and when he sat down he raised his eyebrow with a smile and poured me another *rakı*. Then he offered me a handful of cherries.

I was still drunkenly imagining the moment when I would remove from my pocket my father's velvet box with the pearl earrings, and then the single earring that belonged to Füsun, but that moment never seemed at hand. Churning up inside, I rose to my feet. But I could not stand up to offer her the

earrings formally; on the contrary, I had to remain seated. From the way that father and daughter were looking at me, I knew that they, too, were waiting for something. Maybe they wanted me to go, but no, somehow the atmosphere in the room spoke of a deeper sort of anticipation. I dreamed this scene so many times, but in my dreams, of course, Füsun was not married, and just before I offered my presents, I had asked her mother and father for her hand. Now my intoxicated mind could not decide what to do with the earrings in this unforeseen situation.

I told myself that I couldn't take out the boxes because of my cherry-stained fingers. "May I wash my hands?" I asked. Füsun could no longer ignore the storm raging within me. Feeling her father's prodding gaze, which said, Show him where to go, daughter! she jumped to her feet in a panic. Seeing her standing before me, my memories of all our rendezvous a year earlier came to full life.

I wanted to embrace her.

We all know how the mind will work on two distinct planes when we're drunk. On the first plane I was embracing Füsun as in a dream, as if we were meeting in a place beyond time and space. But on the second plane, we were around that table in the house in Çukurcuma, and a voice minding the second plane warned I must not embrace her, that to do so would be disastrous. But because of the *rakı,* this voice was delayed; instead of coinciding with my dream of embracing Füsun, it came five, six seconds later. During those five, six seconds, my will was free, and precisely for that reason I did not panic, but followed her up the stairs.

The closeness of our bodies, the way we walked upstairs— these too were like things from a dream out of time, and so they would remain in my memory for many years. I saw

understanding and disquiet in her glances and I felt grateful to her for the way she expressed her feelings with her eyes. There, once again, it was clear that Füsun and I were made for each other. I had undergone all this anguish on account of this awareness and it did not matter in the least that she was married; just to feel as happy as I did now, climbing up the stairs with her, I was ready to undergo any further torment. To the visitor stubbornly wed to "realism" who cannot suppress a smile at this, having noticed how small that Çukurcuma house is, with the distance between that table and the upstairs bathroom being perhaps four and a half paces, not counting the seventeen steps, let me state with categorical and liberal-minded clarity that I would have readily sacrificed my very life for the happiness I felt during that brief interlude.

After closing the door to the bathroom on the top floor, I decided that my life was no longer in my control, that my connection to Füsun had shaped it into something beyond my free will. Only by believing this could I be happy, could I indeed bear to live. On the little tray before the mirror bearing Füsun's, Aunt Nesibe's, and Uncle Tarık's toothbrushes, as well as shaving soap, brush, and razor, I saw Füsun's lipstick. I picked it up and sniffed it, then put it into my pocket. I efficiently sniffed the towels hanging on the rack but detected nothing as I remembered it: Clean ones had evidently been put out in expectation of my visit. As I surveyed the small toilet, searching for one other object that might offer me consolation during the difficult days awaiting me after I'd left this place, I saw myself in the mirror, and from my expression I had a shocking intimation of the rift between my body and my soul. Whereas my face was drained by defeat and shock, inside my head was another universe: I now understood as an elemental fact of life

that while I was here, inside my body was a soul, a meaning, that all things were made of desire, touch, and love, that what I was suffering was composed of the same elements. Between the howling of the rain and the gurgling of the water pipes, I heard one of the old Turkish songs that, in my childhood, would make my grandmother so happy whenever she heard it. There had to be a radio nearby. Between the low moan of the lute and the joyous chatter of the kanun was a tired but hopeful female voice, coming to me through the bathroom's half-open window, saying, "It's love, it's love, the reason for everything in the universe." With the help of this singer, I thus lived through one of my life's most profoundly spiritual moments standing in front of the bathroom mirror; the universe was one, and one with all inside it. It wasn't just all the objects in the world—the mirror in front of me, the plate of cherries, the bathroom's bolt (which I display here), and Füsun's hairpin (which I thankfully noticed and dropped into my pocket)—all humanity was one, too. To understand the meaning of this life, one first had to be compelled to see this unity by the force of love.

It was in this good-natured spirit that I took out Füsun's orphaned earring and put it where her lipstick had been. Before taking out my father's pearl earrings, the same music reminded me of the streets of old Istanbul, the stormy loves recounted by aging couples as they sat in their wooden houses listening to the radio, and the reckless lovers who ruin their lives because of passion. Inspired by the melancholy song on the radio, I understood that, as I had become engaged to another, Füsun was perfectly justified and indeed had had no choice but to save herself by marrying. I found myself verbalizing all this, as I peered in the mirror. I recognized in my eyes something of the innocence and playfulness I'd had as a child, and

when I experimented with my reflection, I made a shocking discovery: By imitating Füsun, I could escape my own being by the strength of my love; I could consider—and even feel—all that passed through her heart and mind; I could speak through her mouth, understand how she felt a thing even as she felt it herself—for I was she.

The shock of my discovery must have kept me in the bathroom for an unusually long time. Someone coughed discreetly outside the door, I think. Or knocked: I can't quite remember which, because "the reel had snapped." That was how we'd put it when we were young, and blacked out at parties from too much drink, referring to those maddening interruptions at the cinema, when the projectionist's life was in danger. How I left the bathroom, how I regained my seat, with what excuse Çetin had come upstairs and coaxed me through the door, of these things I have no recollection. There was also a silence at the table; I so remember that, but whether it was owing to the rain having eased up, or to my embarrassment, which could no longer be hidden or ignored, or simply to the defeat that was fast destroying me, with the pain that had become tangible—this I cannot say.

Far from being unnerved by the silence, the son-in-law was enthusing about the film business—perhaps I'd actually said my reel had snapped and he'd taken his cue from this—with a mixture of love and loathing, saying how bad Turkish films were, and how especially bad the films made at Yeşilçam, though the Turkish people were crazy about the cinema. These were perfectly ordinary opinions at the time. Amazing films could be made, if only one could secure a backer who was serious, resolute, and not overly greedy; he had written a screenplay in which he intended to cast Füsun, but what a shame it was that

he could find no one to produce it. What concerned me was not that Füsun's husband needed money and wasn't shy about saying so; what preoccupied me was that Füsun would one day become a "Turkish film star."

On the way home, semiconscious in the backseat while Çetin drove, I remember dreaming Füsun had become a famous actress. No matter how drunk we might be, there are moments when the leaden clouds of our pain and confusion disperse, when for a moment we see the reality we believe, or suspect, that everyone else knows: so here, as Çetin drove and I sat in the backseat, gazing out at the dark, flooded avenues, there was a moment of sudden recognition, and I understood that Füsun and her husband saw me as a rich relative who might help with their dreams of making movies. This was why they had invited me to supper. But deadened as I was by the *rakı*, I felt no resentment; instead I continued wafting off into dreams about Füsun the actress so famous she was known all over Turkey, no ordinary actress but a glamorous film star: At the premiere of her first film, at the Palace Cinema, she would walk on my arm through the applauding crowd toward the stage. And the car was passing right through Beyoğlu at that moment, right in front of the Palace Cinema!

This Is the Last Time I'll Ever See Her!

IN THE morning I saw things as they really were. The night before, at the hands of those householders, my pride had been shattered, I had been ridiculed, even degraded, but I had myself abetted in the humiliation, I now saw, by getting so drunk. Though they knew how much in love I was with their daughter, Füsun's parents must have been in on this plan, having condoned inviting me to supper, for no other purpose but to pander to their son-in-law's childish, stupid dreams of becoming a filmmaker. I would never see these people again. When I felt my father's pearl earrings in my jacket pocket, I was glad. I had given Füsun her own earring back, but I had not allowed my father's valuable gift to be taken by these people who had designs on my money. After a year of suffering, it had also been salubrious to see Füsun one last time: The love I felt for her was owing not to her beauty or her personality; it was nothing more than a subconscious reaction to Sibel and the prospect of marriage. Though never having read a word of Freud, I recall appropriating the concept of the subconscious, widely bandied about in newspapers, to make sense of my life at that time. Our forebears had djinns that drove them to action against their will. And I had my "subconscious," which had driven me not just into a year of such suffering on account of Füsun, but also now to embarrassment in ways I could never have imagined. I could no

longer be its dupe; I needed to turn over a new leaf in my life, and forget everything to do with Füsun.

My first defiant act was to take her letter of invitation from my breast pocket and rip this letter so carefully preserved in its envelope into tiny pieces. The next morning I stayed in bed until noon, determined at last to forbid this obsession that my subconscious had sent me. Giving a new name to my pain and degradation gave me a new strength with which to fight it. My mother, seeing me hungover from the night before, disinclined even to get out of bed, had sent Fatma Hanım to Pangaltı to buy prawns for lunch; she had them cooked in a casserole with garlic just the way I liked them, and for the vegetable some artichokes with olive oil and lots of lemon. Calmed by my decision never to see Füsun and her family again, I was savoring my lunch, enjoying every bite, even having a glass of white wine, as my mother did. She told me that Billur, the youngest daughter of the Dağdelen family, who had made their original fortune in railroads, had finished lycée in Switzerland and had just last week turned eighteen. The family, having since gone into construction, was now in difficult straits, and, being unable to repay various bank loans procured by pulling who knew what strings and paying heaven knew what bribes, the Dağdelens were now keen to marry off their daughter before these difficulties became public: It seemed bankruptcies were imminent. "Apparently the girl is very beautiful!" she then said, with an encouraging air. "If you want I can go and have a look at her. I can't just sit around and watch you spend every night drinking with your men friends, like a gang of officers in the provinces."

"You go and take a look at this girl, Mother dear," I said, without smiling. "I've tried my luck with a modern girl I chose

for myself—I spent time with her and took time to know her, but it didn't work out. Let's try matchmaking this time."

"Oh my darling son, if only you knew how happy I am to hear you say this," said my mother. "Of course, you could still get to know each other, and go out together. . . . You have a beautiful summer before you; it's so lovely, you're both young. Look, I want you to treat this one right. Shall I tell you why it didn't work out with Sibel?"

At that moment I realized that my mother knew all about Füsun, but that she wanted to find some other way of explaining a painful occurrence—just as our ancestors had blamed djinns rather than themselves. Seeing this, I was deeply touched.

"She was very ambitious, very haughty, very proud, that girl," said my mother, looking straight into my eyes. She added, as if giving away a secret, "Anyway, from the time I heard she didn't like cats, I had my doubts."

I had no memory of Sibel's hatred of cats, but this was the second time my mother had used this as a reason to rail against her. I changed the subject. We drank our coffees together on the balcony, watching a small funeral below. Though she still shed a few tears now and again, saying, "Oh, your poor, dear father," my mother was in good health; she had pulled herself together and her faculties were sound. She told me that the person in the coffin set on the funeral stone was one of the owners of the famous Bereket Apartments. As she located it for me, two buildings down from the Atlas Cinema, I found myself daydreaming about a premiere at the Atlas Cinema of a film starring Füsun. After lunch I left for Satsat, where, convinced that I could recover the "normal" life I'd had before Füsun, before Sibel, I threw myself into my work.

Seeing Füsun had alleviated much of the pain I had suffered for so many months. As I worked in the office, part of me was thinking, in all sincerity, that I was lucky to have recovered from my lovesickness, and in this thought was a great serenity. As I carried on shuffling papers, I checked myself periodically, and I was glad to note that indeed I had no desire to see her. There was no longer any question of my returning to that dreadful house in Çukurcuma, that rat's nest with its mud and its floods. My disdain was fueled less by love for Füsun than by resentment of her conniving family and that fatso they called their son-in-law. But I grew angry for feeling enmity for a mere boy, just as I cursed my stupidity in enduring a year of agony on account of this "love." But was I really angry at myself? I wanted to believe that I had embarked on a new life, and that my heartache was over; these powerful new dark feelings were necessary proof my life had changed, and as such I needed them, genuine or not. So I resolved to see the old friends I had been shunning, to have fun, to go to parties, though for some time I kept my distance from Zaim and Mehmet, lest they bring back memories of Füsun and Sibel. Sometimes, after midnight, having had a lot to drink at a nightclub or a party, I would see my rage directed not at society's idiocies, its tedious conventions, nor my own foolishness in succumbing to my obsession; my anger was directed at Füsun; in a walled-off corner of my mind, I would fretfully acknowledge that I was in perpetual argument with her, at times thinking secretly that she had chosen to reject the pleasant life I could have given her, in favor of this flooded rat's nest in Çukurcuma, and so she was to blame for my natural inability to continue caring about someone who would bury herself alive in such a stupid marriage.

I had a friend from my army days, Abdülkerim, the son of a wealthy Kayseri landowner. After our military service had ended, he had kept in touch with holiday and New Year's cards, which he signed in a careful floral script, and so I had made him the Kayseri distributor for Satsat. Because I'd thought Sibel would find him far too "à la Turca" I had not spared him much time during his visits to Istanbul over the last few years, but four days after my visit to Füsun's family, I took him to a new restaurant named Garaj that had found immediate favor with Istanbul society. As we reminisced, it was almost as if I were seeing my life through his eyes; to make myself feel better, I told him stories about the wealthy patrons entering and leaving the restaurant, sometimes even just before or after they had visited our table to offer us polite and affable handshakes. Before long it was clear that Abdülkerim was less interested in stories of ordinary human frailty, pain, and transgression than in the sex lives, scandals, and domestic peccadillos of rich Istanbullus whom he hardly knew; one by one he focused on each girl rumored to have had sex before marriage, or even before her engagement, and I did not like this. Perhaps this is why, by the end of the evening, having fallen into a contrarian frame of mind, I told Abdülkerim my own story, describing the love I'd felt for Füsun, but telling it as if it had all happened to some other rich idiot. As I told the story of the young rich man, much admired in society, who had fallen so madly in love with a "shopgirl," only for her, in the end, to marry someone else, I was so anxious to keep Abdülkerim from suspecting that "he" was me that I pointed out a young man sitting at a distant table.

"Well, no harm done. This promiscuous girl has been married off, so the poor man is off the hook," said Abdülkerim.

"Actually, when I think of what that man risked for love, I can't help feeling a lot of respect for him," I said. "He broke off his engagement for this girl. . . ."

For a moment Abdülkerim's face lit up with gentle understanding; but then he turned to look covetously at Hicri Bey, the tobacco magnate, with his wife and two swanlike daughters, making their way toward the exit. "Who are those people?" he asked without looking at me. The younger of Hicri Bey's two dark-haired daughters—her name was Neslişah, I think—had bleached her hair. I did not like the way Abdülkerim looked at them, half mocking, and half admiring.

"It's late. Shall we go?" I said.

I asked for the bill. We said nothing to each other until we had left the restaurant and were saying our good-byes.

I did not walk straight home to Nişantaşı; instead I headed for Taksim. I had returned Füsun's orphaned earring to her, but not formally—in my stupor, I had merely left it in the bathroom. This was demeaning, both for them and for me. My pride demanded that I make it clear to them that this had been no mistake but something I'd done deliberately, intending she would find it. So I would have to apologize, and being secure in the knowledge that I would never see her again, I could smile at Füsun and say one last indifferent good-bye. As I walked through the door, Füsun would understand that this was to be her last glimpse of me, and perhaps she would panic, but I would elude her in a deep silence, as she had done to me for the past year. I would not even say that we would never see each other again, but I would wish her well in such a way that she could not conclude otherwise and would thus be undone.

As I slowly made my way toward Çukurcuma through the backstreets of Beyoğlu, it crossed my mind that there was a

chance Füsun might not be undone at all; it was possible she was perfectly happy, living in that house with her husband. But if that was the case, if she loved that dullard so much that she would choose to live penuriously in that rickety house, then I would surely have no wish to see her again anyway. Along the narrow streets, uneven sidewalks, and stairs, I looked through the half-drawn curtains to see families turning off their television sets and preparing for bed, or poor, elderly couples sitting across from each other, smoking their last cigarettes of the day, and it struck me on this spring evening, in the pale lamplight, that the people living in these silent backstreets were happy.

I rang the doorbell. A bay window on the second floor swung open. "Who is it?" Füsun's father called out into the darkness.

"It's me."

"Who?"

As I stood there, wondering if I should run away, her mother opened the door.

"Aunt Nesibe, I am sorry to disturb you at such a late hour."

"Never mind, Kemal Bey. Do come in."

As I followed her up the stairs, just as I had done on my first visit, I told myself, "Don't be bashful! This is the last time you'll see Füsun!" I went inside, fortified by my resolve never to let myself be degraded that way again, but as soon as I saw her, my heart began to pound and I felt embarrassed. She was sitting in front of the television with her father. When they saw me, they both jumped to their feet in a surprised confusion that softened apologetically when they noticed my furrowed brow and the liquor on my breath. During the first four or five minutes, which I do not like to remember, not at all, I

told them laboriously how very sorry I was to have disturbed them, but that I had just been passing by and had something on my mind that I wished to discuss with them. In that interval I had discovered that her husband was not at home ("Feridun went out with his film friends"), but I couldn't find a way to broach my subject. Her mother went into the kitchen to make tea. After her father got up without excusing himself, we found ourselves alone.

"I'm very sorry," I said, as we both kept our eyes on the television. "I meant no harm. It was because I was drunk that I left your earring next to the toothbrushes that evening, though I meant to hand it back to you properly."

"There wasn't any earring near the toothbrushes," she said with a frown.

As we looked at each other, struggling to make some sense of this, her father came in holding a bowl of semolina and fruit *helva,* which he said was just for me. After taking one spoonful, I praised the *helva* to the skies. For a moment we were silent, as if it were for the *helva* that I had come here in the middle of the night. That was when I realized, as drunk as I was, that the earring had been an excuse: I had come here to see Füsun. And now she was teasing me, telling me she had not found the earring. During that silent interlude I remarked to myself that the pain of not seeing Füsun had been far more soul-destroying than the shame I had suffered in order to see her. I also knew at that moment that I was prepared to endure more situations like this to be spared the pain of not seeing her, though I was more defenseless in the face of shame than in that of longing. Caught now between the fear of humiliation and the fear of suffering her absence, I had no idea what to do, so I stood up.

There, right across from me, I saw my old friend Lemon. I took one step toward its cage, coming eye to eye with the bird. Füsun and her parents had stood up with me, perhaps relieved to see me go. Again I was delivered to the dreadful awareness that had driven me from this wretched house the last time. Füsun was married now; I would not be able to lure her away. Remembering, too, what conclusion I had drawn following the last visit—that she was after my money—I resolved once more that this was the last time I'd ever see her. I was never going to set foot in this house again.

Then the doorbell rang. This oil painting captures that moment when Lemon and I were staring at each other, while Füsun and her parents were staring at me and the canary from behind, just before the doorbell rang and we all turned to look at the door: I commissioned it many years after these events. Because the point of view is that of Lemon the canary, with whom I had identified in some strange way at that moment, none of our faces are depicted. It portrays the love of my life, viewed from the back, just as I remembered, and every time I see it, this painting brings me to tears; and let me add with pride that the artist has caught the night peeking through the parted curtains, the dark neighborhood of Çukurcuma in the background, and the room's interior with perfect fidelity to my descriptions.

Füsun's father went over to the bay window to look down at the mirror that was mounted in such a way as to reflect the front and, announcing that it was one of the neighbors' children ringing the bell, he went downstairs. There was a silence. I went to the door. As I put on my coat I lowered my head and stayed silent. As I opened the door, it occurred to me that all was not lost: This could be the "revenge" scene I had been preparing

for a year now, but keeping this fact to myself, I simply said, "Good-bye."

"Kemal Bey," said Aunt Nesibe. "We cannot begin to tell you how glad we were that you rang our bell as you were passing by." She glanced at Füsun. "Don't pay any attention to her pouting. She's afraid of her father. If she weren't, she'd have shown herself as happy as we were to see you."

"Oh, Mother, please," said my beloved.

It did cross my mind to begin the parting ritual with some pronouncement along the lines of Well, I can't bear her hair being black, but I knew these words would ring false: I was willing to suffer all the pain in the world for her, and what's more I knew that willingness would be the death of me.

"No, no, she looks fine," I said, looking meaningfully into Füsun's eyes. "Seeing how happy you are has made me happy, too."

"It was seeing you that made us happy, too," said Aunt Nesibe. "Now that your feet know how to get here, we hope you'll visit us often."

"Aunt Nesibe, this is the last time I'll be visiting you," I said.

"Why? Don't you like our new neighborhood?"

"It's our turn now," I said with fake jocularity. "I'm going to talk to my mother and ask her to invite you over." There was, I'd like to say, a certain indifference in the way I walked down the stairs, not once looking back at them.

"Good-night, my son," said Tarık Bey softly when I met him at the door. The neighbor's child had given him a package, saying, "This is from my mother!"

As I felt the fresh air cool my face, I thought how I would never again see Füsun, and for a moment I believed I had an untroubled, carefree, happy life before me. I imagined that

Billur, the Dağdelens' daughter, whom my mother was going to visit, would be charming. But with every step I took, farther from Füsun, I felt as if I were leaving a piece of my heart behind. As I walked up Çukurcuma Hill, I could feel my soul quivering in my bones, straining to return to the place I'd just left, but I still believed it was only a matter of letting this fever break and then I'd be over it.

I'd come a long way. What I needed now was to find ways to distract myself, to remain strong. I went into one of the *meyhane*s that was about to shut, and sitting in the atmosphere of thick blue cigarette smoke I drank two glasses of *rakı* with a slice of melon. When I went back out into the street, my soul was telling my body we had not gone far from Füsun's house. At this point I must have lost my way. In a narrow street I came across a familiar shadow that sent an electric shock through me.

"Oh, hello!" he said. It was Füsun's husband, Feridun.

"What a coincidence," I said. "I'm just coming back from your house."

"Is that so?"

Once again I was shocked to see how young this husband was—how childish, in fact.

"Ever since my last visit, I've been thinking about this film business," I said. "You're right. We have to make art films in Turkey, too, just as they do in Europe. . . . But since you weren't there, I didn't have a chance to talk about all this. Shall we get together some evening?"

I could sense an immediate confusion in his evidently tipsy mind (by the whiff of him, he'd had at least as much to drink that evening as I had).

"Why don't I come and pick you up on Tuesday evening at seven?" I said.

"Füsun can come too, right?"

"Of course, if we are to make a European-style art film, we must have Füsun play the lead!"

For a moment we smiled at each other like two old friends who, having shared the long, trying years of school and military service, had at last seen their ship come in. In the lamplight I looked probingly into Feridun Bey's eyes, each of us imagining he'd gotten the better of the other, and we parted in silence.

Happiness Means Being Close to the One You Love, That's All

I REMEMBER that when I reached Beyoğlu, its shop windows were glittering and I was glad to walk among the crowds streaming out of the cinemas. My happiness—the joy I could take in life—was impossible to deny. That Füsun and her husband had invited me to their house so that I would invest in their preposterous film dreams should perhaps have caused me only shame and humiliation, but so great was the happiness in my heart that I felt no embarrassment whatsoever. That night my mind was fixed on one fantasy: the film premiere, and Füsun holding the microphone, speaking to the admiring audience at the Palace Cinema—or was the New Angel Cinema a better choice?—thanking me first and foremost. When I came on stage, those attuned to the latest gossip would whisper that during the filming the young star had fallen in love with the producer and left her husband. The photograph of Füsun kissing me on the cheek would appear in all the newspapers.

There is no need to dwell on the dreams my imagination was churning out, much as the rare safsa flowers that secrete their own opiated elixir and fall off to sleep. Like most Turkish men of my world who entered into this predicament, I never paused to wonder what might be going on in the mind of the woman with whom I was madly in love, and what her dreams might be; I only fantasized about her. Two days later, when I

went to collect her and Feridun in the Chevrolet, with Çetin Efendi at the wheel, I saw, as soon as my eyes met hers, that our evening would in no way resemble the conjurings of my imagination, but being happy just to see her, I lost none of my enthusiasm.

I invited the newlyweds to sit in the backseat, while I sat in the front beside Çetin, and as we passed through streets darkened by the city's shadows, and through dusty, disorderly squares, I tried to lighten the mood by turning my head around continually to make jokes. Füsun was wearing a dress the color of blood oranges and fire. To expose her skin to the exquisite fragrance of the Bosphorus breeze, she had left the top three buttons undone. I remember that as the car bumped over the cobblestones on the Bosphorus roads, every time I turned around to address them, happiness flamed up in me. That first night we went to Andon's Restaurant in Büyükdere, and—as would become the rule whenever we met to discuss our film project—I soon realized that I was the one who was the most animated of our party.

We had just selected our mezes from the tray that the old Greek waiters brought to us, when Feridun, whose self-confidence I almost envied, said, "For me, Kemal Bey, cinema is the only thing in life that matters. I say this so that my age does not undermine your confidence in me. For three years now I've been working in the heart of Yeşilçam, our own Hollywood. I'm very lucky, I've met everyone. I've worked as a set hand, carrying lights and props, and I've worked as an assistant director. I've also written eleven screenplays."

"And all of them were shot, and they did very well," said Füsun.

"I'd really like to see those films, Feridun Bey."

"Of course, Kemal Bey, we could go and see them. Most of them are still playing at summer cinemas, and some are still showing in Beyoğlu. But I'm not happy with those films. If I were content to produce work of that caliber, the people at Konak Films say that I'd be ready to start directing. But I don't want to make that sort of film."

"What sort of film would that be?"

"Commercial, melodramatic, mass audience stuff. Don't you ever go to Turkish films?"

"Very rarely."

"The rich of our country who have been to Europe only go to Turkish films to laugh at them. When I was twenty I thought that way, too. But I don't look down on Turkish films the way I used to. Füsun now likes Turkish films very much."

"Teach me, too, for God's sake, so I, too, may love them as much," I said.

"I'd be happy to teach you," said Mr. Son-in-law, smiling sincerely. "But the film we make with your help won't be at all like those, have no fear. For example, we won't make a film in which Füsun leaves the village for the city, and three days later, thanks to her French nanny, becomes a lady."

"Anyway, I'd be fighting with that nanny from the very beginning," said Füsun.

"And you won't see her playing Cinderella, despised by her rich relatives because she's poor," Feridun continued.

"Actually, I wouldn't mind playing a despised poor relation," said Füsun.

Although I didn't believe she was mocking me, I felt in her words a buoyancy, a lightheartedness, that pained me all the same. It was in the same blithe spirit that we shared family memories; after recalling how we'd long ago toured Istanbul in

the Chevrolet, with Çetin at the wheel, we discussed recent and imminent deaths of distant relations living in the narrow streets of distant neighborhoods, and much else. Our discussion of how to make stuffed mussels ended with the extremely pale Greek chef coming all the way from the kitchen to tell us, with a smile, that a dash of cinnamon was required. The son-in-law, whose innocence and optimism were beginning to win me over, was not overbearing as he promoted his screenplay and his film ambitions. When I dropped them off at the house, we agreed to meet again four days later.

During the summer of 1976 we dined together at many Bosphorus restaurants. Even years later, every time I looked out at the Bosphorus through the windows of those restaurants, I would remember being caught between my elation at sitting across from Füsun and the cool I needed to maintain to win her back, and would feel the same confusion that had beset me. At these meals I would listen respectfully to her husband holding forth on his dreams, on Yeşilçam films and Turkish audiences, keeping my doubts to myself; it was, after all, not my aim to offer the Turkish filmgoer "the gift of an art film in the Western sense of the term," and so I would discreetly create difficulties; for example, asking to see the finished screenplay, only to express my excitement about another story before the first script came to hand.

Once, after Feridun (whom I had discovered to be cleverer and more adroit than many Satsat employees) had engaged me in a conversation about the cost of a "good and proper" Turkish film, I worked out that the cost of making Füsun a star would be roughly half that of a small apartment in the backstreets of Nişantaşı, but if we were unable to accomplish this purpose, it was not because this figure was unacceptable; it

was because I had realized that seeing Füsun twice a week on the pretense of making a film was enough to assuage my pain, at least for now. After suffering so much I was content with what I now had. Even to wish for more was too daunting. It was as if, having endured such agony, I needed to give myself a little rest.

If, after our meal, Çetin drove us to İstinye for chicken breast pudding with lots of cinnamon on top, or he took us to Emirgân for a stroll, to laugh and talk as we ate paper *helva* and ice cream sandwiches and gazed into the dark waters of the Bosphorus, it would seem to me that there could be no deeper happiness in all the world. One evening, when I had placated the djinns of love and found peace in Yani's Place, just by sitting across from Füsun, I recall being struck by the simple, ineluctable formula: Happiness means being close to the one you love, that's all. (Taking immediate possession is not necessary.) Just before acknowledging this enigmatic mantra, I had looked out the restaurant window at the opposite shore; seeing the twinkling lights of the *yalı* where Sibel and I had spent the previous summer together, I realized that love was no longer lacerating my stomach.

It was not just that the searing pains of love would disappear the moment I sat down at the same table with Füsun; I would immediately forget that until just now, this same pain had brought me to thoughts of suicide. So, at Füsun's side, with the agony having subsided, I would forget my wretched undoing; convincing myself that I had been restored to "normal," I returned to my old self; I would succumb to the illusion that I was strong, decisive, even free. But after our first three outings I came to notice that such ecstasy was inevitably followed by the familiar despair, and so, as I sat across from her, thinking

how soon I would miss her, foreseeing the pain of the days to come, I would discreetly pilfer various objects from the table as reminders of the happiness I'd felt there and then—and to fortify myself later when I was alone. This little tin spoon, for example: One evening, at Aleko's Place in Yeniköy, I had a short conversation with her husband about football—it was fortunate we were both Fenerbahçe supporters, which spared us shallow arguments—when Füsun, getting bored, put this spoon into her mouth, toying with it for some time. This saltshaker: Just as she picked it up a rusty Soviet tanker rumbled past the window, the violence of its propeller shaking the bottles and glasses on our table, and she held it for a good long time. On our fourth meeting, we went to Zeynel in İstinye, and as we all strolled, I was just behind her, Füsun cast off this half-eaten cone, which I retrieved from the ground and pocketed in a flash. Returning home, I would gaze drunkenly at these objects; a day or two later, not wishing my mother to see them, I would take them over to the Merhamet Apartments to arrange them among similarly precious artifacts, and as the agonies of love set in, I would conjure my relief with them.

During that spring and summer my mother and I grew closer—our camaraderie now resembled nothing we had known before. The reason, no doubt, was that she had lost my father, just as I had lost Füsun. Loss had brought us both greater maturity, and made us more indulgent. But how much did my mother know of my grief? Were she to find the spoons and ice cream cones I brought home with me, what would she think? If she had interrogated Çetin, how much would she have learned of my movements? Sometimes, in moments of misery, I would worry about such things; on no account did I want my mother to grieve for me; I did not want her thinking of me in

the grip of an intolerable obsession driving me to mistakes I might "regret for a lifetime."

Sometimes I would feign being in higher spirits than she was; I could never tell her, even in jest, that her attempts to arrange a marriage for me were pointless, and so I would still listen intently to her detailed reports on the girls she had investigated on my behalf. One of these was the Dağdelens' youngest daughter, Billur; according to my mother, the spate of bankruptcies that had now come to pass had not arrested their "life of dissipation," complete with cooks and servants; though she conceded that the girl had a pretty face, she added that she was very short, and when I said I was not prepared to marry a dwarf, she closed the case file. (From our earliest youth, our mother had been telling us, "Don't you take any girl under 1 meter 65 centimeters, please; I don't want you marrying a dwarf.") As for the Mengerlis' middle daughter, whom I had met with Sibel and Zaim at the Cercle d'Orient in Büyükada early the previous summer, my mother decided that she wasn't suitable either: The girl had been very recently left in the lurch by the eldest Avunduk son, with whom she had been madly in love, and whom she hoped to marry—a state of affairs that, as my mother had only lately discovered, had been scrutinized by all Istanbul society. My mother continued her search all summer long, and always with my blessing, sometimes because I actually hoped that her efforts might somehow produce a joyous outcome, and sometimes because I hoped this project would bring her out of the reclusiveness she had entered after my father's death. On any given afternoon, my mother might call the office from her house in Suadiye to tell me of a girl she really wanted me to see: She had been coming in the Işıkçıs' motorboat to spend her evenings on our neighbor Esat Bey's

wharf, and if I came over to the other side before it got dark and went down to the shore, I could have a look and if I wished, I could meet her—this intelligence all relayed as dutifully as a peasant might do when leading hunters to the place where the partridges had gathered.

At least twice a day my mother would find an excuse to ring me at the office, and after telling me how long she had cried after coming across some possession of my father's at the back of a wardrobe—his black-and-white summer spectator shoes, for example, one of which I respectfully display here—she would say, "Don't leave me alone, please!" and would go on to remind me that I shouldn't stay in Nişantaşı, that it wasn't good for me to be alone either, and that she was definitely expecting me for supper in Suadiye.

Sometimes my brother would come with his wife and his children. After supper—while my mother and Berrin discussed children, relatives, old habits, new shops and fashions, the ever-spiraling prices, and the latest gossip—Osman and I would sit under the palm tree, where my father had once sat alone in his chaise longue, gazing at the islands and the stars and dreaming of his secret lovers. Here we would discuss the business and the settlement of my father's affairs. My brother would do as he always did in those days, urging me to come in on this business with Turgay Bey, but never insisting too much; and then he would tell me, again, what a good thing it had been promoting Kenan to the managerial ranks; he would go on to denounce the difficulties I'd made with Kenan, and my refusal to be part of this new venture; after warning me that this was my last chance to change my mind, and muttering that I would live to regret losing this opportunity, he would complain that I seemed to be avoiding him, and all our mutual

friends, indeed, running away from success and happiness, both in private life and at work. "What's eating you?" he would ask with a frown.

My answer would be that I was worn out after the loss of our father and the awkward ending of my engagement to Sibel—and left feeling a bit introverted. It was a very hot July evening when I told him that I wished to be alone with my grief, and I could see from Osman's face that he saw this as a form of madness. It seemed to me that, for now at least, my brother was willing to tolerate this as a species of severe depression; but if my affliction got any worse, he would find himself caught between embarrassment and the agreeable prospect of seizing permanent control of our business dealings through the pretext of my incapacity. But I was only afflicted by such anxieties if I'd seen Füsun very recently; if a longer time had elapsed since I'd last seen her, and I was racked with the pain of her absence, my thoughts would be only of her. My mother could sense my obsession, and the darkness inside me, but although it worried her, she did not truly want to know the details. After every meeting with Füsun I was overcome by the innocent wish to convince myself that the love I felt was of no great importance; in much the same way, I tried to persuade my mother, without quite putting it into words, that the obsession more and more evidently ruining my life was nothing to worry about. To prove to my mother that I didn't have a "complex," I told her that I had taken Füsun, the daughter of Aunt Nesibe the seamstress, along with her husband, out to eat on the Bosphorus, also mentioning that, at the young husband's insistence, we had all gone to see one of the films of which he was the screenwriter—such diversions as an obsessive could hardly afford to entertain!

"Goodness," said my mother. "I'm glad they're doing well. I'd heard how the child was spending time with film people, Yeşilçam people, and it made me very sorry. What can you expect for a girl who enters beauty contests! But if you say they're all right . . ."

"He seems to be a reasonable boy."

"You are going to the movies with them? You should still be careful. Nesibe has a very good heart, and she's very good company, but she's a conniver." Then, changing course, she said, "There's going to be a party on Esat Bey's wharf this evening; they sent a man over with an invitation. Why don't you go—I can have them put my chair under the fig tree, and I can watch you from here."

A Film About Life and Agony Should Be Sincere

From the middle of June 1976 to the beginning of October, we went to see more than fifty films at the summer cinemas, whose ticket stubs I display here, along with the lobby photographs and advertisements I was able to acquire in subsequent years from Istanbul's collectors. Toward nightfall I would go with Çetin to the house in Çukurcuma to collect Füsun and her husband in the Chevrolet, just as I had done on evenings when we went out to eat along the Bosphorus. In the morning Feridun would have discovered from managers and distributors he knew where the film we wished to see was showing, noting the neighborhood and the district on a piece of paper, and under his direction, we would try to find our way. Istanbul had grown wildly over the previous ten years while fires and new buildings had changed its face, and the narrow streets were so packed with fresh arrivals that we often lost our way. Only by frequently stopping to ask directions did we eventually find the cinema, and even then we were obliged to run, often arriving to find the garden already in darkness, and so we would have no idea what sort of place it was until the lights came on during the five-minute intermission.

In later years these cinema gardens would disappear—the mulberry and plane trees would be chopped down, replaced with apartment buildings or turned into parking lots, or mini football fields covered with AstroTurf; but in those days, each

time I set eyes on these mournful places—surrounded by whitewashed walls, little factories, teetering old wooden houses, and two- or three-story apartments with too many balconies and windows to count—I was shocked by how crowded they were. Intermingled in my mind with the drama on the screen was the lively humanity I sensed in all those big families, the mothers in their headscarves, the chain-smoking fathers, the soda-sipping children, the single men, the barely suppressed fidgetiness of these people munching disconsolately on their pumpkin seeds as we watched the film, almost always a melodrama.

It was on one such screen in a gigantic open-air cinema that I first saw Orhan Gencebay, who with his songs and his movies, his records and his posters, was becoming a fixture in the lives of the entire Turkish public at that time—the king, in fact, of music and domestic film. The cinema was on a hill behind the new shantytowns between Pendik and Kartal, overlooking the Sea of Marmara, the sparkling Princes' Islands, the factories, large and small, whose walls were covered with leftist slogans. The smoke, which looked even whiter by night, rising like puffs of cotton from the chimneys of the Yunus Cement Factory in Kartal had covered the entire area in white ash, and together with the plaster dust falling onto the audience produced an effect like snow in a fairy tale.

In this film Orhan Gencebay played a poor young fisherman named Orhan. There was a rich, evil man who was his patron, to whom he felt indebted. This patron's spoiled son was even worse, and when the boy and his friends happened upon the girl played by Müjde Ar (who was just making her first films at the time) and raped her, mercilessly and at length, tearing off her clothes to give us a better view, the audience fell silent. Under pressure from his patron, to whom he felt so indebted, Orhan

was then obliged to whitewash the whole affair by marrying Müjde. At this point, Gencebay cried out, "Down with the world, down with everything!" and once again he would sing the song he had made famous throughout Turkey.

During the film's most affecting scenes, we would hear nothing but a rustling noise coming from the hundreds of people seated around us, munching pumpkin seeds (the first time I heard this, I thought it was coming from some machine in a nearby factory). Whenever I heard this sound, I felt as if we had all been abandoned to sorrows gathering up within us for many years. But the film's ambience, the jostling of people who had come out to have a bit of fun, the wisecrackers in the section for single men at the front, and, of course, the implausible plot elements all hindered my ability to let myself go and luxuriate in my suppressed fears. But when Orhan Gencebay cried out in anger, "All is darkness, where is humanity?" I was very happy to be sitting in that cinema, among the trees and under the stars, with Füsun at my side. While I kept one eye on the screen, with my other I watched how Füsun squirmed in her blue jeans, in her wooden chair, how her chest rose and fell with each breath, and how, as Orhan Gencebay cried, "My destiny be damned!" she crossed those legs. I watched her smoke, and wondered how much she shared in the passions on-screen. When Orhan was forced to marry Müjde, and his angry song took on rebellious tones, I turned to Füsun, smiling with a look both impassioned and arch. But, caught up in the film, she didn't even turn to look at me.

Because his wife had been raped, Orhan the fisherman did not make love with her—he kept his distance. When she understood that her pain would not be assuaged by this marriage, Müjde attempted suicide; Orhan took her to the

hospital and saved her. The most emotional scene was on the way back from the hospital, when he told his wife to take his arm, and Müjde turned to him and asked, "Are you ashamed of me?" It was then that I finally felt an intimation of the shame that had remained buried inside me. The crowd had fallen into a deathly silence, aghast at the shame of marrying and walking arm in arm with a woman who had been raped, her virginity stolen.

My own shame was compounded by anger. Was I embarrassed that virginity and chastity were being discussed so openly, or because I was watching this with Füsun? As these thoughts passed through my mind, I could feel Füsun fidgeting in her chair. The children sitting in their mothers' laps had fallen asleep, and the angry youths in the front row had stopped making wisecracks at the heroes and had grown quiet, and Füsun, seated next to me, put her right arm behind her chair—how I longed to hold it!

The second feature gave the shame inside me a new shape, casting it as the ailment that afflicted the entire country, and even the stars in the sky: the pain of love. This time Orhan Gencebay had dark, sweet Perihan Savaş at his side. In the face of unbearable pain, he showed no anger, rather availing himself of those other, greater weapons that we all possess—humility and forbearance—summarizing his feelings, and the film, in this song, which the museum visitor can have the pleasure of listening to:

> *Once you were my sweetheart*
> *I yearned for you even when you were near*
> *Now you've found another love*
> *May happiness be yours*

And mine the trials and troubles
Let life be yours, be yours.

By now all the children were asleep on their parents' laps, and the rowdy, soda-swilling, chickpea-throwing boys in the front rows had fallen silent—was it owing to the lateness of the hour or to the respect they felt for Orhan Gencebay in transforming the pain of fear with sacrifice? Could I do likewise and live without further misery or humiliation, just by wishing for Füsun's happiness? If I did all that was necessary for her to star in a Turkish film, would I find peace?

Füsun's arm was no longer close to me. When Orhan Gencebay told his sweetheart, "May happiness be yours, and may the memories be mine!" someone at the front yelled "You fool!" but almost no one laughed approval. We were all silent. That was when it occurred to me that the lesson this country had learned or yearned to learn, above all others, the skill we most wanted to master and pass along, was that of gracefully accepting defeat. The film had been shot in a Bosphorus *yalı,* and perhaps because it awakened memories of last summer, and last autumn, for a brief time I felt a lump in my throat. Just off the coast of Dragos a white ship was slowly advancing across the Sea of Marmara toward the sparkling lights of the Princes' Islands where happy people were summering. Lighting a cigarette, I crossed my legs and gazed at the stars, dazzled by the beauty of the universe. I had been drawn into this film, coarse as it was, by the audience's hushed response. If I had been watching the film at home alone on television, it would not have affected me so, and had I been sitting with my mother, I would not have watched it to the end. It was only because I was sitting next to Füsun that I felt the bond of fellowship with the rest of the audience.

When the lights went up we were as quiet as the mothers and fathers bearing sleeping children in their arms; not once did we break this silence on our return journey. As Füsun dozed in the backseat, her head resting on her husband's chest, I smoked a cigarette and gazed through the window at the somber streets, the little factories, the shantytowns, the youths defacing walls with leftist slogans under cover of darkness, the trees that looked so much older at night, the aimless packs of dogs, and the tea gardens about to close, while Feridun whispered to me his good-natured analysis of the film's key moments, which I never once turned my head to acknowledge.

One warm evening we went to the Yeni İpek Cinema, located in a long and narrow garden squeezed between the shanties near İhlamur Palace and the backstreets of Nişantaşı, where we sat under the mulberry trees to watch *The Agony of Love Ends with Death* and a second melodrama, *Listen to My Crying Heart,* featuring the child star Papatya. As we sat holding our soft drinks during the intermission, Feridun mentioned that the tough guy with the thin mustache playing the crooked accountant in the first film was a friend of his, and was willing to play a similar role in our film. This was the point I realized it would be very difficult for me to enter the Yeşilçam film world purely for the sake of being close to Füsun.

My evasive eyes lit on one of the balconies overlooking the cinema garden, and from the black curtains obscuring its door I realized that this old wooden house was one of Nişantaşı's two most secret and exclusive backstreet brothels. The girls there loved to joke about how, on summer nights, as they lay with their rich gentlemen clients, their cries of love would mingle with the music on the sound track, and the clashing of swords, and actors declaring, "I can see, I can see" in melodramas featuring

a pair of sightless eyes suddenly opened. The house had once belonged to a famous Jewish merchant, and his former parlor now served as a waiting room, so whenever the high-spirited, miniskirted girls got bored, they could go up to one of the empty rooms in the back and watch the film from the balcony.

At the little Yıldız Garden Cinema in Şehzadebaşı, overflowing balconies surrounded the garden on all three sides, in a way that recalled boxes at La Scala. Once, during a scene from *My Love and My Pride,* a father was castigating his son ("If you marry that good-for-nothing shopgirl I will cut you out of my will and disown you!"), while an argument broke out on one of the balconies, causing some of us to confuse the two disputes. In the Yaz Çiçek Cinema Garden, just next to the wintertime Çiçek Cinema in Karagümrük, we watched *The Old Lady Who Sells* Simits, whose screenplay was written by son-in-law Feridun, based, he told us, on a new adaptation of the novel *The Bread Seller Woman* by Xavier de Montépin. This time it was not Türkan Şoray in the leading role but Fatma Girik, and just above us there was a fatso father unhappy with this state of affairs, so as he sat there in his underwear on the balcony, surrounded by his family, drinking his *rakı* and eating his mezes, he kept saying, "Now would Türkan ever have deigned to play the part like this? Not on your life, brother, what a travesty!" To make matters worse, having seen the film the previous evening, he kept sarcastically announcing what was about to happen, in a voice loud enough for the entire audience to hear. When drawn into a shouting match with those below who pleaded, "Shhh, shut up so we can watch the film," he scorned the film all the more, picking fights with the audience. Füsun, doubtless thinking that all this was upsetting her husband, nestled up to him, and I burned up inside.

On the way back, as she joined the conversation or dozed off in the backseat, she would rest her head on her husband's shoulder or his belly, or wrap her arms around him, which I had no wish to see. In the car, with Çetin driving slowly and carefully, I was directing my attention to the warm and humid night, our way lit by fireflies, listening to crickets, breathing in the fragrance of honeysuckle, rust, and dust blowing in the backstreets through the half-open windows, and gazing out into the darkness. But when we were watching a film and I sensed that they were nestling up against each other, as happened, for example, at the Incirli Cinema in Bakırköy, where we saw two thrillers inspired by American films and set in Istanbul's backstreets, a black mood would instantly swamp me. And sometimes, like the fierce hero of *Caught in the Crossfire* who swallowed his grief, I would seal my lips tight. Sometimes it would seem to me that Füsun was leaning on her husband's shoulder just to make me jealous, and in my mind she and I were dueling to see which of us could make the other feel worse. Then I would act as if I had not even noticed the newlyweds whispering to each other and giggling, and I would pretend I was immersed in the film, enjoying it tremendously; just to prove it, I would laugh at something only the most obtuse person in the audience would find funny. Or I would snigger as if, having noticed a bizarre inconsistency everyone else had missed, and, like so many intellectuals being uneasy at having come to see a Turkish film, I couldn't help railing against such nonsense. But I didn't like this cynical mood of mine. If at an emotionally charged moment her husband draped his arm around Füsun, something he did only rarely, I did not feel at all uncomfortable, but if Füsun took such a moment to rest her head lightly on Feridun's shoulder, I felt utterly crushed and

couldn't prevent myself from feeling that Füsun was heartless and trying to hurt me, and I would get angry.

At the end of August, when the first flocks of storks had flown over Istanbul, en route from the Balkans to the south, to Africa (it didn't even cross my mind that Sibel and I had given an end-of-summer party at just this time the previous year), and the weather had turned cool and rainy, we went one evening to see a film at the large garden inside the Beşiktaş Market that was known as the Hunchback's Place and served as the summer venue for the Yumurcak Cinema, and as we sat there, watching *I Loved a Penniless Girl*, I sensed that underneath the pullover that she had draped over her lap the two were holding hands. I took the same measures as I had at other times, in other cinemas, when I was overcome by this same jealousy, and just after I had convinced myself that I had put it out of my mind, I crossed my legs and lit a cigarette so that I could take another look and see if the happy couple were indeed holding hands beneath that pullover. Bearing in mind that they were married, and shared a bed, and had so many other opportunities to touch each other, I had to wonder why they were doing so now, in front of me.

Whenever my mood plummeted, it would seem to me that the film on the screen (like all the others we had seen over the past few weeks) was perversely awful, preposterously shallow, and deplorably disconnected from the real world. I'd had my fill of half-witted lovers, continually bursting into song, of those headscarfed servant girls with painted lips who became chanteuses overnight. I didn't care for those plots about bands of sergeants that were "rip-offs of a French adaptation" of *The Three Musketeers,* as Feridun would tell me with a smile, nor did I like watching other bands of ruffians who proved themselves men by taunting girls in the street. We saw *The Kasımpaşa Trio*

and *The Three Fearless Musketeers* with its black-shirted heroes at the Desire Cinema in Feriköy, where competition had forced the managers to show three badly cut and therefore incomprehensible films every evening. All those lionhearted lovers ("Stop! Stop! Tanju is innocent; the one you want is me!" as Hülya Koçyiğit declares in *Under the Acacias,* which we were unable to see to the end because of a rainstorm); and those mothers who would sacrifice everything so that their blind children could have the operation (as in *Broken Heart,* shown in the Üsküdar People's Garden Cinema, where a troupe of acrobats entertained us between features); those friends who said, "Keep running, my lion, while I distract them" (Erol Taş, who Feridun said had promised to appear in our film, was once to speak those immortal lines); I found them no less tiring than the honorable and selfless neighborhood boys who refused happiness saying: "But you are my friend's sweetheart." At a gloomy, hopeless moment like this, even the heroines who said, "I am a penniless shopgirl, while you are the son of a wealthy factory owner"—even the miserable wretch who went to see his beloved in a chauffeur-driven car on the pretext of visiting distant relatives couldn't stir my sympathies.

The pleasures of sitting beside Füsun, the fleeting happiness of being at one with the audience as I watched the film, if chilled by a wind of jealousy, could produce a darkness benighting everything under the sun. But on some transcendent occasions the whole world seemed illumined: When, for instance, amid the misery of heroes forever losing their sight, my arm would brush against the velvet skin of her arm, and, not wishing the wondrous sensation to end, I would hold my arm still, continuing to watch the film without following the action, until I could believe that she had actually let her arm

brush against me, I would almost faint from happiness. At the end of the summer, in the Arnavutköy Çampark Cinema, while watching *Little Lady*, about a spoiled rich girl's adventures with the chauffeur who brings her to her senses, our arms brushed against each other that way, and remained intensely in contact as the fire of her skin ignited mine, and until my body reacted with an entirely unexpected elation. So transported was I by the dizzying sensation that for a time I paid no attention to arresting my body's impudence, and so when the lights came on, and the five-minute intermission began, I was obliged to hide my shame by draping my navy pullover over my lap.

"Shall we get some soda?" said Füsun. At the interval she usually went with her husband to buy soda and pumpkin seeds.

"Sure, but give me a moment, would you?" I said. "I just had a thought I'm trying to remember."

Just as I had done as a lycée student, whenever I needed to hide my body's importune excitement from my classmates, I raced through memories of my grandmother's death, the real and imaginary funeral rites of my childhood, the times when my father had scolded me, and then I imagined my own funeral, the grave terrifyingly dark, my eyes filled with earth. Half a minute later I was ready to stand up without betraying myself.

Walking together toward the soda vendor, I noticed as if for the first time how tall she was and how fine her posture. How pleasant it was to walk among families, chairs, running children without worry of being seen. . . . I liked to observe the notice she attracted in the crowd, and it made me so happy to imagine that they saw us as a couple, husband and wife. That this short walk together was worth all the pain I had suffered, that I was living through a moment unlike any other, that this

walk was one of the happiest moments in my life, seemed certain even as it was happening.

As always, there was no queue for the soda vendor, only a crowd of children and adults all shouting at once. So we took our place behind them and began to wait.

"So what was this serious thought you were trying to remember just now?" Füsun asked.

"I liked the film," I said. "I was wondering how it was I could now enjoy all these films that I used to laugh at in the old days, or just ignore. At that moment it seemed to me the answer was on the tip of my tongue if I could only concentrate."

"Do you really like these films? Or do you like coming with us to see them?"

"Of course I like them. They make me so very happy. Most of the ones we've seen this summer, they speak to a sorrow inside me, and I find them consoling."

"But life is not as simple as these films, actually," said Füsun, as if disturbed to see me so fanciful. "But I am enjoying myself. I'm glad you've come with us."

For a moment we were silent. What I wanted to say was, It is enough for me to sit beside you. Had it been by chance that our arms had stayed pressed together for so long? How excruciating it was, longing to express these hidden thoughts, knowing that the crowds at the cinema like the whole world in which we lived would not allow it. Through the loudspeakers hanging from the trees we heard Orhan Gencebay's song from the film we'd seen two months ago in the hills of Pendik, overlooking the Sea of Marmara. "Once you were my sweetheart. . . ." It summoned all my memories of the summer, now passing before my eyes like a picture show, those sublime moments of sitting in Bosphorus restaurants drunkenly admiring Füsun and the moon on the sea.

"I've been very happy this summer," I said. "These films have taught me how. The important thing in life is not to be rich. . . . What a pity it is . . . all this agony . . . this suffering. . . . Don't you think?"

"A film about life and agony," said my beauty, as her face clouded, "should be sincere."

When one of the children squirting soda at one another came hurtling toward her, I took Füsun by the waist and pulled her toward me. A bit of the soda had splashed on her.

"You sons of donkeys!" said one old man as he slapped one of them on the neck. He looked to us for approval, and his eyes fell on my hand, still on Füsun's waist.

How close we were to each other in that cinema garden, not just physically but spiritually! Füsun, fearful of the way I was looking at her, backed away, walking through the crowd of brats to reach for the soda bottles sitting arranged in the laundry basin; she had already broken my heart.

"Let's buy one for Çetin Efendi, too," said Füsun. She had two bottles opened.

I paid for the sodas and then I took one over to Çetin Efendi, who would never join us in the "family section" when we went to films, but sat alone in the section for single men.

"You shouldn't have, Kemal Bey," he said with a smile.

When I turned around I saw a child staring in awe as Füsun drank straight from her soda bottle. The child was bold enough to approach us.

"Are you an actress, sister?"

"No."

Because the fashion has now passed, let me remind my readers that in those days this question was a way of telling girls they were pretty, and served as a popular pickup line for

playboys wishing to approach well-groomed girls in outfits slightly more revealing than the norm, and who were not exactly upper-class. But this child, who looked to be about ten years old, had no such motives. He insisted: "But I've seen you in a film."

"Which one?" asked Füsun.

"*Autumn Butterflies,* and you were wearing the same dress, you know. . . ."

"What part was I playing?" Füsun asked, smiling with pleasure at this child's fantasy.

But the child, now realizing his mistake, fell silent.

"Let me ask my husband now," she said to spare the little boy's feelings. "He knows all these films."

You will have understood that when Füsun said "husband," and looked across the chairs to pick him out in the crowd, and the child realized I was not the man in question, I felt wounded. But spurred on by the joy of being so close to her, drinking soda with her, I said this: "The child must have sensed that we'll be making a film soon that will make you a star."

"So you're saying that you really are going to shell out the money to make this film? Please don't take offense, Cousin Kemal, but Feridun is too embarrassed even to bring up the subject, but let me tell you, we're sick and tired of waiting."

"Is that so?" I said. I was dumbstruck.

An Indignant and Broken Heart
Is of No Use to Anyone

I DID not say another word all night. Because so many languages describe the condition I was in as "heartbreak," let the broken porcelain heart I display here suffice to convey my plight at that moment to all who visit my museum. The pain of love no longer manifested itself as panic, hopelessness, or anger, as it had done the previous summer. By now it had become a more viscous substance that coursed through my veins. Because I had been seeing Füsun every other day if not every day, the heartache of absence had lessened, and I had developed new habits to cope with the new milder pain of her presence; after a summer of careful practice these habits had become second nature, making me a new man. I no longer spent my days battling with my pain; instead I could suppress it, veil it, or act as if there were nothing wrong with me.

The new pain, the pain of presence, was in fact the pain of humiliation. It seemed that Füsun did take care to spare me pain of that kind, shying away from subjects and situations that might wound my pride. But in the face of those crude last words of hers, I finally realized that to pretend nothing was amiss was no longer possible.

I had tried at first pretending not to hear them reverberating in my mind: "shell out the money . . . We're sick and tired of waiting." But my feeble mumbled rejoinder ("Is that so?") was

proof that I had heard her. I could not, therefore, act as if no offense had been taken; and, anyway, who could have missed my grim expression, which spoke of spirits plummeting and utter humiliation. Her insult ringing in my head, I went back to my chair and sat down, still clutching my soda bottle. It was hard for me to move. The worst part was not even those cutting words, but Füsun's evident awareness of my humiliation and the upset it caused me.

I forced myself to think of something else, ordinary matters. I remember asking the same question I would ask myself in my youth whenever I thought I would explode from boredom, surrendering to metaphysical musing, as in: "What am I thinking now? Am I thinking that I'm thinking?" After repeating this sentence silently many times over, I turned to Füsun in a decisive way and said, "They want us to return the empties," and, taking the empty bottle from her hand, I stood up and walked away. In my other hand was my own bottle. There was still some soda in it. No one was looking, so I poured my soda into Füsun's bottle, handing mine, now empty, back to the boys selling the sodas. So I was able to return to my seat with Füsun's bottle, which I display here.

Füsun was talking to her husband; they didn't notice me. I cannot recall a single thing about the film we watched next. This is because the bottle that had touched Füsun's lips only a few moments earlier was now in my trembling hands. I had no interest in anything else. I wanted to return to my own world, to my own things. This bottle would remain for many years on the bedside table at the Merhamet Apartments, meticulously preserved. Visitors will recognize it by its shape as a bottle of Meltem soda, the soda launched at the time our story begins, and now available throughout the country,

but the soda inside was not Zaim's highly praised recipe. For already very poor imitations of our first great national soda brand were turning up everywhere. There were little local pirate soda plants operating underground that would collect empty Meltem bottles, fill them with the cheap counterfeit, and distribute them to unsuspecting or indifferent vendors. When he noticed me with the bottle against my lips as we drove back in the car, Feridun, quite unaware of my conversation with his wife, said, "This Meltem soda is great stuff, isn't it, brother?" I told him that the soda wasn't "genuine" Meltem, from which he deduced the scheme and felt compelled to comment: "In the backstreets of Bakırköy there's a secret propane-filling depot. They fill Aygaz canisters with cheap cooking gas. We bought it, too, once. Brother Kemal, please believe me when I tell you—the fake burned better than the real thing."

I brushed the bottle against my lips with care. "This one tastes better, too," I said.

As the car rumbled over the silent backstreets, passing through pools of pale lamplight and shuddering gently over the cobblestones, the shadows of trees and leaves flickered on the windshield as they do in dreams. Sitting in the front next to Çetin the chauffeur as always, I could feel my heart swelling painfully, so I did not turn around to look at them, even when the usual talk about the films began. Çetin Efendi was not inclined to join these conversations we had on the way home, and it was perhaps because the silence was making even him uncomfortable that he ventured to observe how certain parts of the film were not credible. An Istanbul chauffeur would never scold the young lady he worked for, not even politely, as in the film, he insisted.

"But he's not really a chauffeur," said Feridun the son-in-law. "He's the famous actor Ayhan Işık."

"You're right, sir," said Çetin. "And that's why I liked it. In a way, it was educational. . . . As entertaining as the films we've seen this summer have been, I love them more for offering lessons about life."

Füsun was silent, as was I. When I heard Çetin Efendi say "this summer," my pain grew sharper. For his words reminded me that these lovely summer nights were drawing to a close: No longer would we be coming to these cinema gardens to see films; the joy I'd known sitting beside Füsun under the stars would soon be a memory, and I was ready to talk about anything that might have popped into my head, just to hide my distress from her, but my lips remained pressed so tightly shut one couldn't have pried them open with a knife. I was sinking into a bitterness that would, I suspected, last a very long time.

I didn't want to see Füsun at all, or indeed anyone who would have befriended me just to help her husband make a film—in other words, just for money. It was a bald fact and in a way thrilling that she would not even bother to conceal her venal purpose, thrilling because I knew I could never be attracted to such a person, and in this recognition I could glimpse an easy break.

That night, when I dropped them off in the car, contrary to custom, I appointed no date for the next trip to a cinema. For three days I did not get in touch. It was during this period that I began to exhibit (first in the recesses of my mind, but gradually in a more pronounced way) a new manner of brooding. I thought of it as "diplomatic pique," for it derived less from the pain of heartbreak than from a sense of protocol: Abuse of friendship must be answered accordingly so as to decry such

behavior and preserve our pride. Obviously the retribution I had in mind for Füsun was a refusal to back her husband's film, and with it the death of her dreams of becoming a movie star. "Let's see what happens," I told myself, "if this film doesn't get made!" Having come to feel my previously formal pique viscerally I began, on the second day, to imagine in some detail the ways in which Füsun might be suffering in reaction to her punishment. Unfortunately in my imagination it was the dimming of her as yet unrisen star that upset Füsun and not the prospect of no longer seeing me. Perhaps this was not an illusion, but the truth.

The pleasure of imagining Füsun remorseful had, by the second day, overwhelmed my visceral pique. By the evening of that day, as I sat eating silently with my mother in Suadiye, I realized I had begun to miss Füsun. My viscera having healed, I knew that I could only maintain my pique for the sake of punishing her. As I ate my supper I tried to put myself in Füsun's place and adopt a cruel pragmatism. I imagined the agony and remorse I'd be feeling if I were a beautiful young woman, on the verge of starring in a film directed by my husband, when with a thoughtless remark I had shattered the feelings of the wealthy producer, and with them, the hope of becoming a star. But for my mother's continued interruptions ("Why didn't you finish your meat? Are you going out this evening? Summer's almost over. We don't have to wait until the end of the month—we can go back to Nişantaşı tomorrow. How many glasses does that make for you tonight?") I might have succeeded in putting myself in Füsun's place.

In the course of my drunken struggle to guess what Füsun might be thinking, the possibility occurred to me that from the moment I'd heard the ugly words ("So you're saying that you

really are going to shell out the money. . . .") provoking my "diplomatic pique," a vengefulness in me had been exposed. I wanted to take revenge on Füsun, but because it both frightened and shamed me to entertain such a wish, I instead convinced myself that I "never wanted to see her again." This was the more honorable way, as it would allow me to take my revenge with a clear conscience, whereas exaggerating my visceral pique could only serve to excuse the sin by cloaking my desire to punish her in a victim's innocence. Realizing this, I decided to forgive Füsun and go to see her, and having so decided, I began to see everything in a more positive light. Still, before I could go see them again, I would have to engage in more thinking, as well as self-deception.

After supper I went out to Baghdad Avenue, where, years ago, when I was young, I had so often "promenaded" with my friends, and as I walked down the wide sidewalks, I again tried as hard as I could to put myself in Füsun's shoes, to figure out precisely how Füsun would interpret the situation were I to stop punishing her. In a blinding flash it came to me: A beautiful woman like her, a woman with brains who knew what she wanted, would have no trouble finding another producer to back her husband's film. A scorching and jealous regret overtook me. The next day I sent Çetin off to find out what was playing in the open-air cinemas of Beşiktaş, which investigation led me to decide that there was "an important film not to be missed." Sitting in my office at Satsat with the receiver pressed to my ear, listening to the phone ringing in Füsun's house, my heart began to pound as I realized that, whoever answered, I would be unable to speak naturally.

As nothing natural could come of trying to satisfy the conflicting demands of visceral and diplomatic pique, I felt

compelled at least to prolong the latter for as long as no apology was forthcoming. So it was that we passed our last summer evenings in Istanbul's cinema gardens, our dignity chastened, having little fun, speaking even less, feigning mutual indignation. My grimace was infectious—and of course Füsun responded in kind. I resented her obliging me to make this pretense, and now this in turn would make me genuinely indignant. Over time, the persona I assumed in her presence came to supplant my true self. It must have been then I first came to realize that for most people life was not a joy to be embraced with a full heart but a miserable charade to be endured with a false smile, a narrow path of lies, punishment, and repression.

While these Turkish films kept telling us that one could find "the truth" leaving behind this "world of lies," by now I could no longer believe in the films we saw in the open-air cinemas, with ever dwindling audiences. I could no longer submit to that sentimental realm. By the end of summer, the Star Cinema in Beşiktaş was so empty that it would have looked strange for me to sit too close to Füsun, so I left a seat empty between us, and as the winds grew colder, my contrived sulking hardened into icy remorse. Four days later we went to the Club Cinema in Feriköy, but instead of a film, there were beds with penniless boys tended by headscarf-wearing aunties, and it amused us when we realized that the city council had organized a circumcision ceremony, complete with acrobats, magicians, and dancers, for families who couldn't afford their own rite. But when the good-hearted mustached mayor saw how pleased we were and asked us to join them, Füsun and I, both so determined to present each other a cold shoulder, declined. It was infuriating to see her responding to my diplomatic pique with her own no less contained version while

also keeping the pantomime subtle enough for her husband not to notice.

I managed not to call them for six days. It bothered me that neither Füsun nor her husband had ever once called me. If we were not going to make this film, what excuse could I have for calling them? If I wanted to carry on seeing them, I would have to give them some money, an unbearable truth, one I couldn't accept.

The last film we went to was at the Majestic Garden Cinema in Pangaltı at the beginning of October. It was a warm night, and there were some others in attendance. I was hoping that on this beautiful evening, probably the last of the summer, our recriminations, the diplomatic standoff, might end. But before we took our seats, something happened: I ran into Cemile Hanım, the mother of a childhood friend. She had also been one of my mother's bezique partners in those days, but it was as if she grew ever poorer with age. We exchanged looks, as if to say, What are *you* doing here? in the manner of people who come from old money and feel ashamed and guilty at the loss of their fortunes.

"I was curious to see Mükerrem Hanım's house," said Cemile Hanım, as if making a confession.

I did not understand what she meant. I assumed that some interesting person named Mükerrem Hanım lived in one of the old wooden houses whose interiors you could see from the cinema garden, and so I sat down next to Cemile Hanım, that we might look into this house together. Füsun and her husband went to sit six or seven rows in front of us. When the film began I realized that it was the house in the film she was referring to as Mükerrem Hanım's. This was the princely abode in Erenköy of a prominent aristocratic family—I used to ride past it on my

bicycle when I was a child. After falling on hard times, they (like so many old families of my mother's acquaintance) had taken to renting out their villas to Yeşilçam Films as sets. Cemile Hanım was not here to cry her eyes out watching a film called *More Bitter Than Love,* but to see the wood-inlaid rooms of an old pasha's house serving fictively as the home of an evil family who were evidently new money. I should have stood up and gone to sit next to Füsun. But I couldn't, for a strange shame had immobilized me. I was like a teenager refusing to sit with his parents at the cinema, but also unwilling to acknowledge the source of his shame.

This shame, mingling with my affected pique, which I remain reluctant to acknowledge even so many years later, made it easier to sustain the pretense of being offended. When the film was over, I rejoined Füsun and her husband, whom Cemile Hanım gave a careful look up and down. Füsun was sulking even more than before, and I had no recourse but to respond in kind. On the way back, the silence in the car was hard to bear, and so I fantasized about throwing off this role in which I had cast myself with an unexpected joke, bursting into mad laughter, or getting drunk—but all in vain.

For five days I didn't call them. I survived on elaborate and delicious fantasies of a contrite Füsun preparing to ask my forgiveness. In my dreams I answered her regretful pleas by blaming her, and when I had listed her faults one by one, I had so fully persuaded myself of her anguish that before long I was as genuinely angry as anyone who had been dealt a terrible injustice.

The days I didn't see her became harder and harder to endure. Once again I was in thrall to the dark, dense anguish that had held me captive for a year. I was terrified of making a

mistake for which my punishment would be never to see Füsun again. To keep this from happening, I had to ensure that Füsun did not see the extent of my visceral pique. So now the weapon I'd fashioned of my anger was turned inward, punishing me alone. An indignant and broken heart is of no use to anyone. By continuing to take offense, I was hurting only myself. One night, while thinking about all this, walking alone amid the falling autumn leaves of Nişantaşı, I realized that the happiest resolution—and therefore the most hopeful—would be to see Füsun three or four times a week (and never less than twice). Only then could I return to my old equilibrium without again falling into the bilious black abyss of love. Now I knew I could no longer endure not seeing Füsun—no matter whether out of wanting to protect myself or to injure her. To avoid the hell of the preceding year, I would have to keep the promise I had made in my letter to Füsun sent via Ceyda: I would have to bring her my father's pearl earrings.

The next day, when I went out to Beyoğlu for lunch, the pearl earrings were in my pocket, nestling in the box my father had given me. It was October 12, 1976, a bright, sunny day with a hint of summer's glare. The shop windows were brilliant with color. As I ate my lunch at Hacı Salih, I was candid with myself: I could admit that I had come here on purpose, and if it "happened to cross my mind to do so" there was no harm in nipping straight down to Çukurcuma to spend half an hour with Aunt Nesibe. It was a six- or seven-minute walk from the restaurant table where I was sitting. On my way here I'd glanced into the Palace Cinema and noticed that the next show started at 1:45. After lunch, if I chose, I could lose myself in that darkness that smelled of mold and damp, or at least enter a different world, and find peace. But by 1:40, having got up

and paid my bill, I found myself walking down Çukurcuma Hill. There was food in my stomach, sun on the back of my neck, love on my mind, panic in my soul, and an ache in my heart.

It was her mother who answered the door.

"No, Aunt Nesibe, there's no need for me to come up," I said, reaching into my pocket. "This is for Füsun. . . . It's a present from my father. I thought I would drop it off on my way by."

"Why don't I make you a quick coffee, Kemal. There are a few things I'd like to tell you before Füsun gets back."

She said this in such a furtive way that I relented and followed her up the stairs. The house was flooded with sunlight, Lemon the canary rattling about happily in his cage. I saw that Aunt Nesibe's sewing things—her scissors, her pieces of cut cloth—were spread all over the room.

"Nowadays I never make house calls, but these people were so insistent I couldn't say no, so we're putting together an evening gown as a rush job. Füsun's helping me, too. She should be back soon."

She served me coffee and got straight to the point. "There have been needless heartbreaks, and silent recriminations—all this I understand," she said. "Kemal Bey, she went through a lot of pain, my girl did. Her heart was very badly broken. You need to be patient with her moods, and indulge her. . . ."

"Yes, of course," I said, as if I did know all this.

"You know far better than I do how to do it. Indulge her, do what you think best, so that she can step off this wrong path she has taken."

I gave her an inquiring look, hoping to learn what wrong path Füsun had taken; then I raised my eyebrows.

"Before you got engaged, and on the day of your engagement, and even after the engagement—for months and months, she suffered terribly—oh, how she cried," she said. "She stopped eating, and drinking, she wouldn't go out, she cut herself off from everything. This boy came to see her every day and tried to console her."

"Do you mean Feridun?"

"Yes, but don't worry. He knows nothing about you."

She went on to explain that the girl was in such great pain and distress that she had no idea what she was doing, that Tarık Bey had been the first to propose the idea of marriage as a cure, and that in the end she had agreed to marrying off Füsun to "this child." Feridun had known Füsun since she was fourteen. In those days he was madly in love with her, but Füsun had paid him no attention; she had almost destroyed him with her lack of interest. These days Feridun was not so much in love with Füsun—she raised her eyebrows slightly and smiled, as if saying, This is good news for you, too. Feridun was seldom at home in the evenings, being utterly immersed in the film world and preoccupied with his film-world friends. You might almost think that he had left his dormitory in Kadırga not to marry Füsun, but to be closer to the Beyoğlu cafés where his film friends waste their time. Of course, the two had eventually developed feelings for each other, as healthy young couples entering arranged marriages had always done in the past, but I was not to credit this overmuch. After the ordeal she had suffered, it had seemed only prudent to them that Füsun should marry at once, and so they had no regrets. . . .

By their "ordeal," she left me in no doubt that she was referring not to Füsun's love for me, or the debacle of the university exam: It was clear from her eyes that the heart of the

crisis was Füsun's having slept with me before marriage, and now she took evident pleasure in holding me to account. Only by marrying at once could Füsun save herself from this stain, and, of course, I was responsible for this, too!

"We know—we all know—that Feridun has no real prospects, that he is in no position to give her a good life. But he's Füsun's husband!" said Aunt Nesibe. "He wants to make his wife a movie star. He's an honest and well-meaning boy! If you love my daughter, you'll help them. We thought it would be better to marry Füsun to Feridun than to some rich old goat who would look down on her because of her stained virtue. The boy will introduce her to film people. And you, Kemal, you can protect her."

"Of course, Aunt Nesibe."

If she knew that her mother had been spilling family secrets, Füsun would punish us severely (Aunt Nesibe smiled faintly, as if only slightly exaggerating). "Of course, Füsun was deeply affected by the news that you had broken off your engagement to Sibel, just as she was sorry to hear that you had suffered so much, Kemal. This film-loving boy she has married has a heart of gold, but it won't be long before Füsun sees how inept he is, and when she does, she'll leave him. . . . Until then, you can be at her side, bolstering her confidence."

"All I want, Aunt Nesibe, is to repair the damage I've done, the heartbreak. Please help me win Füsun back," I said, taking out the box with my father's earrings and giving it to her. "This is for Füsun," I said.

"Thank you. . . ." she said, and took the box.

"Aunt Nesibe . . . there's something else. . . . On the first night I came here, I brought back an earring of hers. But it never reached her hands. Do you know anything about this?"

"This is the first I've heard of it. You can give her your present yourself, if you want."

"No, no . . . Anyway, that earring was not a present; it belongs to her."

"Which earring?" asked Aunt Nesibe. When she saw that I was having trouble making up my mind, she said, "If only everything could be sorted out with a pair of earrings. . . . When Füsun was feeling poorly, Feridun came to see us, too. When my daughter was so weak from sorrow that she could barely walk, he would take her by the arm and walk her all the way to Beyoğlu to see a film. Every evening, before he went off to the coffeehouse to see his film friends, he would come and sit with us, and eat with us, watch television with us, he paid Füsun such loving attention. . . ."

"I can do a great deal more than that, Aunt Nesibe."

"If God is willing, Kemal Bey. You are always welcome. Come any evening! Give my best to your mother, but please don't cause her any upset."

As she glanced at the door, so as to warn me that I needed to leave before Füsun caught me there, I left the house at once, feeling at peace as I walked up Çukurcuma Hill to Beyoğlu, freed from indignation, from pique of either kind.

54

Time

FOR SEVEN years and ten months exactly I made regular visits to Çukurcuma for supper to see Füsun. If we bear in mind that my first visit was on Saturday, October 23, 1976—eleven days after Aunt Nesibe's open-ended welcome ("Come any evening!")—and that my last night in Çukurcuma with Füsun and Aunt Nesibe was on Sunday, August 26, 1984, we can see that there were 2,864 days intervening. According to my notes, during the 409 weeks that my story will now describe, I went there for supper 1,593 times. From this we can deduce that I went four times a week on average, but that does not mean I went there four times a week as a matter of course.

There were weeks when I saw them every day, and others when—growing indignant again and again convincing myself that I could forget Füsun—I stayed away. But never did more than ten days go by without Füsun (that is, without my seeing her), because after ten days I would be reduced to those levels of misery that I had endured during the autumn of 1975, which had precipitated the current regime, so it would be correct to say that I saw Füsun and her family (the Keskins) on a regular basis. They, for their part, expected me on a regular basis, and they could always guess when I was likely to turn up. However it happened, before long they had grown accustomed to seeing me at the supper table, as I had grown accustomed to the idea that they were expecting me.

The Keskins never needed to formally invite me to supper, because they always kept a place for me at the table. This provoked a great deal of hand-wringing on my part, when I was not altogether inclined to go and struggled over the decision. I sometimes thought that if I went one more time, I might be imposing on them; and if I didn't go, I not only would face the pain of not seeing Füsun that evening, but might "cause offense" or succumb to fears that my absence might be taken amiss.

I was most preoccupied by such anxieties during my first visits to Çukurcuma, when I was still getting used to the house, Füsun's regular presence, and the domestic routines. I hoped that Füsun would know from the way I looked into her eyes that I was trying to say, Here I am. This was my chief sentiment during my first visit. For the first few minutes after my arrival, I congratulated myself on conquering my shame and disquiet to be there. After all, if it made me this happy to be near Füsun, then why should I make such a fuss over my visits? And here was Füsun, smiling sweetly, as if there was nothing unusual about my being there, as if she was truly happy I had come.

What a pity that we only rarely found ourselves alone during those first visits. Still, I seized every opportunity to whisper things like "I've missed you terribly!" or "It seems I've missed you terribly!" and Füsun would answer, if only with her eyes, seeming to say that she had warmed to my words. There was no possibility of getting any closer than that.

For the sake of any readers who are amazed that I could visit Füsun and her family (it seems so clinical to call them the Keskins) for eight years, and who wonder how I can speak so breezily about such a long interval—thousands of days—I would like to say a few words about the illusion that is time, as

there is one sort of time we can call our own, and another— shall we call it "official" time?—that we share with all others. It is important to elaborate this distinction, first to gain the respect of those readers who might think me a strange, obsessed, and even frightening person, on account of my having spent eight lovelorn years trudging in and out of Füsun's house, but also to describe what life was like in that household.

Let me begin with the big clock on the wall: It was German-made, cased in wood and glass, with a pendulum and a chime. It hung on the wall right next to the door, and it was there not to measure time, but to be a constant reminder to the whole family of time's continuity, and to bear witness to the "official" world outside. Because television had taken over the job of keeping time in recent years, and did so more entertainingly than did the radio, this clock (like hundreds of thousands of other wall clocks in Istanbul) was losing its importance.

Wall clocks first came into fashion in Istanbul at the end of the nineteenth century, when Westernized pashas and wealthy non-Muslims began to furnish their homes with large wall clocks much more ornate than these, with weights and pendulums and winders. In the early years of the twentieth century, and after the founding of the Republic, when the country was aspiring westward, such clocks rapidly gained favor with the city's middle classes. There was a clock like this in my own home when I was a child, and all the other houses that were then part of my life had identical or even larger ones, with even more exquisite woodwork, and by and large you would find them in the entryway or the hall, though people hardly looked at them, since by the 1950s "everyone," even children, had wristwatches, and each house had a radio that was always playing. Until television sets came to dominate the sound

track of domesticity, changing the way people ate, drank, and sat—until the mid-1970s, when our story begins—these wall clocks continued to tick away, as they had done for so long, even though the householders scarcely paid them any attention. In our house you could not hear the ticking or the chimes on the hour and half hour if you were in the sitting room or any of the bedrooms, so the clock never disturbed us. And so for years no one even thought about stopping the clock, and one would indeed continue to stand on chairs to wind it! Some nights, when out of love for Füsun I had drunk a great deal, and misery awoke me, and I arose from my bed to go to have a cigarette in the sitting room, I would hear the clock in the corridor chiming the hour, and it would warm my heart.

In Füsun's house there were times when the clock was ticking and times when it had stopped: It was during the first month that I noticed this difference, and I grew accustomed to it at once. Late in the evening we'd be sitting together watching a Turkish film or a seductive chanteuse crooning an old song, or something about ancient Rome with gladiators and lions, which we'd tuned in to halfway through, and which had such bad subtitles, or such bad dubbing, that we'd immediately begin to joke about it until we could barely follow the action, and were each left to drift off into his own dreams—just then a moment would arrive when by some enchantment a silence would envelop the television set, and the clock hanging right next to the door, whose existence we'd forgotten, would begin to chime. One of us—usually Aunt Nesibe, and sometimes Füsun, too—would turn to the clock with a meaningful look, and Tarık Bey would say, "Who wound it up again, I wonder?"

Sometimes the clock was wound, and sometimes it was forgotten. Even when it had been wound and was ticking away,

the chime would remain silent for months at a time; sometimes it would chime only once, on the half hour; sometimes it would surrender to the ambient silence and let weeks pass before it made another sound. That was when I'd realize, as a chill passed through me, how frightening everything must be when no one was home. Whether or not it was ticking, whether or not the chime sounded, no one looked at the clock to know the time, but they did spend a lot of time talking about whether it had been wound or not, and about how a frozen pendulum might be set in motion again just by touching it once. "Let it be, let it tick, it's not hurting anyone," Tarık Bey would sometimes say to his wife. "It reminds us that this house is a house." I think I would agree, as would Füsun, Feridun, and even the odd visitor. So the wall clock was not there to remind us of the time, or to warn us that things were changing; it was there to persuade us that nothing whatsoever had changed.

During those first months I dared not even dream that nothing would or could change—that I would spend eight years eating supper in Çukurcuma, watching television, and chatting amiably without purpose. During my first visits every word Füsun uttered, every feeling that registered on her face, the way she paced up and down the room—all of it seemed new and different to me, and whether the clock was ticking or not, I paid it no mind. What mattered was to be at the same table with her, to watch her, to feel happy and remain perfectly still as my ghost left my body to kiss her.

Even without our being aware of it, the clock always ticked in the same way, and when we sat at the table, eating our supper, it brought us the peace of knowing we hadn't changed, that all would stay the same with us. That the clock served to make us forget the time, even as it continually brought us back to

the present, reminding us of our relations with others—this paradox was the cause of the cold war that flared up from time to time between Aunt Nesibe and Tarık Bey. "Who wound that clock again, to wake us in the middle of the night?" said Aunt Nesibe, if during a silence she noticed that the clock was working again. "If it wasn't ticking, it would feel as if there was something missing in this house," said Tarık Bey one windy evening in December 1979. He added, "It used to chime in the other house, too." "So then, are you trying to tell me you still haven't become accustomed to Çukurcuma, Tarık Bey?" said Aunt Nesibe, with a much gentler smile than her words implied (she sometimes addressed her husband with the honorific "Bey").

Such measured quips, aspersions, and perfectly timed digs—the couple had honed their craft over many years, and whenever we heard the clock's tick at an unexpected moment or the gong began to chime, the discord would become more intense. "You wound this clock so that I wouldn't get any sleep either, Tarık Bey," Aunt Nesibe would say. "Füsun, dear, could you make it stop?" If you used your finger to still the pendulum in the middle, then no matter how much someone had wound it, the clock would stop, but Füsun would only smile and look at her father; sometimes Tarık Bey would give her a look that meant, All right then, go ahead and stop it! and sometimes he would stubbornly refuse. "I didn't touch it. The clock started on its own, so let it stop itself!" he'd say. Sometimes, when they saw that such mysterious pronouncements made an impression on the neighbors or the children who came to visit on rare occasions, Tarık Bey and Aunt Nesibe would begin an argument of double entendres. "The djinns have got our clock working again," Aunt Nesibe would say. "Don't touch it, you

could get hurt," Tarık Bey would say in a menacing voice as he frowned. "I don't care if there's a djinn ticking inside it," Aunt Nesibe would reply. "I just don't want it waking me up at night like a drunken church bell ringer who can't tell morning from night." "Don't fret so, and, anyway, if you forget the time you'll feel better," Tarık Bey would say. Here he was using "time" to mean "the modern world" or "the age in which we live." This "time" was an ever-changing thing, and with the help of the clock's perpetual ticking, we tried to keep it at bay.

The device by which the Keskin family actually kept time was the television, which, like our radio during the fifties and sixties, was always on. In the days of radio, no matter what the broadcast—a piece of music, a discussion, a mathematics lesson, whatever—you would hear a soft blip on the hour and the half hour, for the benefit of those who cared to know. In the evenings, when we watched television, there was no need for such a signal, as most people had no need to know the time unless they were trying to find out what was on television.

Every evening at seven o'clock, when the enormous clock appeared on the screen a minute before TRT, the country's only television station, began its news program, Füsun would look at her wristwatch (displayed here) as Tarık Bey looked at one of the many pocket watches I saw him use over that eight-year period—either to confirm they had the correct time or to adjust their watches to it. They would do this. It was deeply satisfying to watch Füsun sitting at the supper table, gazing at the enormous clock on the screen and squinting, pressing her tongue against the inside of her cheek as she calibrated her watch with the seriousness of a child copying her father. From my very first visits, Füsun was aware how much I enjoyed this spectacle. When she adjusted her watch, she knew I was

observing her lovingly, and when she got the time right, she would look at me and smile. "Do you have the time right now?" I would ask her just then. "Yes, I've got it!" she would say to me, with a smile that was even warmer.

As I would slowly come to understand over the eight years, it was not merely to see Füsun that I went to the Keskin house but to live for a time in the world whose air she breathed. This realm's defining property was its timelessness. And so it was that Tarık Bey advised his wife to "forget time." When people come to visit my museum and view all the Keskins' old possessions—especially all these broken, rusting clocks and watches that haven't worked for years—I want them to notice how strange they are, how they seem to exist out of time, how they have created among themselves a time that is theirs alone. This is the timeless world whose air I inhaled during my years with Füsun and her family.

Beyond this timeless space was the "official" time outside, with which we kept in touch through television, radio, and the call to prayer; when we talked about finding out what time it was, we were organizing our relations with the outside world, or so I felt.

Füsun did not adjust her watch because life as she lived it called for a clock that was accurate to the second, so that she could be punctual for work or some meetings; like her father, the retired civil servant, she did so as a way of acceding to a directive signaled to her straight from Ankara and the state, or so it seemed to me. We looked at the clock that appeared on the screen before the news much as we looked at the flag that appeared on the screen, while the national anthem was playing at the end of the broadcasting day: As we sat in our patch of the world, preparing to eat supper or bring the evening to a

close by turning off the television, we felt the presence of millions of other families, all doing likewise, and the throng that was the nation, and the power of what we called the state, and our own insignificance. It was when we were watching flags, Atatürk programs, and the official clock (once in a while, the radio would refer to the "national time") that we were most keenly aware that our messy and disordered domestic lives existed outside the official realm.

In *Physics* Aristotle makes a distinction between Time and the single moments he describes as the "present." Single moments are—like Aristotle's atoms—indivisible, unbreakable things. But Time is the line that links these indivisible moments. Though Tarık Bey asked us to forget Time—that line connecting one present moment to the next—no one except for idiots and amnesiacs can succeed in forgetting it altogether. A person can only try to be happy and forget Time, and this we all do. If there are readers who sneer at the things my love for Füsun taught me, at these observations that arise from my experiences during the eight years at the house in Çukurcuma, I would like to ask them please to be careful not to confuse forgetting about Time with forgetting about clocks or calendars. Clocks and calendars do not exist to remind us of the Time we've forgotten but to regulate our relations with others and indeed all of society, and this is how we use them. When looking at the black-and-white clock that appeared on the screen every evening, just before the news, it was not Time we remembered but other families, other people, and the clocks that regulated our business with them. It was for this reason that Füsun studied the clock on the television screen to check if she'd adjusted her watch "perfectly," and perhaps it was because I was looking at her with love that she smiled so happily—and not because she'd remembered Time.

My life has taught me that remembering Time—that line connecting all the moments that Aristotle called the present—is for most of us a rather painful business. When we try to conjure up the line connecting these moments, or, as in our museum, the line connecting all the objects that carry those moments inside them, we are forced to remember that the line comes to an end, and to contemplate death. As we get older and come to the painful realization that this line per se has no real meaning—a sense that comes to us cumulatively in intimations we struggle to ignore—we are brought to sorrow. But sometimes these moments we call the "present" can bring us enough happiness to last a century, as they did if Füsun smiled, in the days when I was going to Çukurcuma for supper. I knew from the beginning that I was going to the Keskin house hoping to harvest enough happiness to last me the rest of my life, and it was to preserve these happy moments for the future that I picked up so many objects large and small that Füsun had touched, and took them away with me.

Late one evening, during the second of the eight years, when the television stopped broadcasting for the night, I listened to Tarık Bey's memories of his time as a young teacher in Kars Lycée. If he had fond memories of these unhappy years, when he was alone and scraping by on a low salary, suffering many misfortunes, it was not because bad memories grow rosier with the passage of time, as most people believe, but because he enjoyed talking about the good moments (the particles of Now) from that troubled phase of his life (beads inevitably strung on that evil line, Time). It was after he had noted this paradox one evening that he remembered for some reason the "East-West" watch he'd

bought while in Kars, which he brought out to show me had two faces, one in Arabic numerals, and the other in Roman.

Let me elaborate this theme with another timepiece: when I see this slender Buren wristwatch that Füsun began to wear in April 1982, what appears before my eyes is the moment when I gave it to Füsun on her twenty-fifth birthday, and the moment when, after she had taken it out of its now lost box, with her parents elsewhere (and Feridun not at home), she kissed me on the cheek, behind the open kitchen door, and the moment when we were all sitting together and she joyously showed the watch to her parents, and the moment when her parents, having long accepted me as an eccentric member of the family, each thanked me in turn. For me, happiness is in reliving those unforgettable moments. If we can learn to stop thinking of our lives as a line corresponding to Aristotle's Time, treasuring our time instead for its deepest moments, each in turn, then waiting eight years at your beloved's dinner table no longer seems such a strange and laughable obsession but rather (as I would discover much later) assumes the reality of 1,593 happy nights at Füsun's dinner table. Today I remember each and every evening I went to supper in Çukurcuma—even the most difficult, most hopeless, most humiliating evenings—as happiness.

Come Again Tomorrow,
and We Can Sit Together Again

FOR EIGHT years, assuming no flood or snow had closed
the roads, and he was not ill or on holiday, and the car was
in good repair Çetin Efendi drove me to Füsun's house in my
father's Chevrolet. I was careful not to break that rule. After the
first few months he'd made friends in the local teahouses and
coffeehouses. He would never leave the car right in front of the
Keskins' house, parking instead near those places with names
like the Black Sea Coffeehouse or the Evening Teahouse; he'd
go into one of these establishments and as he watched the same
television program that we were watching at Füsun's house, he
would read the paper, join in the conversation and sometimes a
game of backgammon, or watch the men playing a card game
known as Konken. After the first few months, everyone in the
neighborhood knew us both on sight, and unless Çetin Efendi
was exaggerating, they thought of me as a humble man who
faithfully visited his poor distant relations just for the pleasure
of their company, and for the love they felt for him.

Over the eight years there were of course those who
claimed I had dark and evil designs. There was idle gossip
not worthy of serious consideration: I was there to buy all
the ruined houses in the neighborhood for next to nothing,
only to demolish them and build apartments; I was looking for
unskilled laborers to work for a pittance in my factories; I was

a deserter from the army; or I was Tarık Bey's illegitimate child (which would make me Füsun's older half brother). But the reasonable majority had deduced, from the bits of information that Aunt Nesibe judiciously dispensed now and again, that I was a distant relation of Füsun's, involved in a film project with her husband that would make her a movie star. From what Çetin told me over the years, I understood that there was nothing unacceptable about these circumstances, and that even if the Çukurcuma neighborhood did not have any particular affection for me, as a rule they looked favorably on me. In any event, by the second year they had come to see me almost as one of their own.

It was a mixed neighborhood: Galata dockworkers, clerks and owners of small shops in the backstreets of Beyoğlu, Romany families who had moved there from Tophane, Kurdish Alevi families from Tunceli, the impoverished children and grandchildren of the Italians and Levantines who had once worked as clerks in Beyoğlu or Bank Street, a handful of the old Greek families who, like them, still could not find it in them to leave Istanbul, and various employees of bakeries and depots, taxi drivers, postmen, grocers, and penniless university students. This multitude did not coalesce into the sort of united community one saw in the traditional Muslim neighborhoods of Fatih, Vefa, and Kocamustafapaşa. But from the help I was continually offered, from the interest the young men took in any unusual or expensive cars that cruised its streets, from the speed with which news and gossip spread through the neighborhood, I inferred a sort of connectedness, a tentative solidarity, or at the very least the buzz of shared experience.

The house in which Füsun's family, the Keskins, lived was on the corner of Çukurcuma Avenue (popularly known as

Çukurcuma Hill) and the narrow lane known as Dalgıç Street. As you can tell from the map, it was a ten-minute walk through the neighborhood's steep and winding streets to Beyoğlu and İstiklal Avenue. Some evenings, on our way home, Çetin would take those winding streets up to Beyoğlu, and sitting in the backseat smoking a cigarette I would gaze inside the houses and the shops and at the people on the sidewalks. Lining these narrow streets were dilapidated wooden houses, overhanging the sidewalks as if on the verge of collapse, and vacant buildings abandoned by the latest wave of Greeks immigrating to Greece; these, and the stovepipes that the impoverished Kurdish squatters in those same buildings stuck through their windows, gave night a fearsome guise. Even at midnight, neighborhoods near Beyoğlu were still alive with small, dark bars, *meyhane*s, cheap nightclubs that described themselves as "drinking establishments," snack bars, grocery shops that sold sandwiches, lottery shops, tobacconists where you could also buy narcotics, black market cigarettes, or whiskey, and even music shops selling records and cassettes, and though all these places were in miserable condition, they struck me as cheerful and lively. Of course, I would only feel this way if I had left Füsun's house in a peaceful frame of mind. There were many nights when I left the Keskin household thinking that I would never go back again, and, revolted by the ugliness of the hurly-burly street, as Çetin drove the car I would lie down miserably on the backseat, as if passed out. Most unhappy evenings of this order date back to the early years.

Çetin would pick me up from Nişantaşı a little before seven in the evening; we'd run into a bit of traffic in Harbiye, Taksim, and Sıraselviler, and then wind our way through the backstreets of Cihangir and Firuzağa, passing in front of

the historic Çukurcuma Hamam as we rolled down the hill. Somewhere along the way I would ask Çetin to stop the car and buy a package of food or a bunch of flowers. Not every time I visited, but on average every other time, I would bring a funny little present for Füsun—some Zambo Chiclets, a brooch or a barrette decorated with butterflies that I had found in Beyoğlu or the Covered Bazaar—and I would give it to her very lightheartedly, as if it were half a joke.

Some evenings, to avoid the traffic, we would go via Dolmabahçe and Tophane, turning right onto Boğazkesen Avenue. Without fail throughout that eight-year period, every time we turned onto the Keskins' street, my heart would begin to race just as it had done when as a child I turned in to the street where my school was, and I felt a disquiet in which joy mingled with panic.

Having tired of paying rent for an apartment in Nişantaşı, Tarık Bey had used his savings to buy the building in Çukurcuma. The Keskins' apartment entrance was on the first floor. They also owned the little ground-floor apartment, and over the eight years a series of tenant families drifted in and out like ghosts, never involving themselves in our story. The entrance of this small apartment (which would later become a part of the Museum of Innocence) was on the side street—Dalgıç Street—and so I rarely crossed paths with the people who lived there. I did hear that Füsun had befriended one of the tenants—a girl named Ayla, who shared the apartment with her widowed mother while her fiancé was doing his military service—and that they'd go together to the cinema in Beyoğlu, but Füsun hid her neighborhood friends from me.

During the first months, when I rang the doorbell at Çukurcuma Hill, it was always Aunt Nesibe who would descend

the flight of stairs to let me in. In all other instances, even if the doorbell rang in the evening, she would always send Füsun down. This was her way of making it clear to me that from my very first visit everyone knew why I was there, and for that purpose she was my natural mediator. But there were times when I felt as if Feridun really didn't suspect a thing. As for Tarık Bey, living as he did in a world of his own, he never gave me much cause for concern.

In the same spirit, Aunt Nesibe always took it upon herself to say something to make my presence seem natural as soon as she opened the door. Her conversation starters were usually inspired by whatever they were watching on television: "A plane was hijacked. Did you hear about it?" "They're showing pictures of the bus crash and they've left out none of the horror." "We're watching the prime minister's visit to Egypt." If I arrived before the news, Aunt Nesibe would always say with the same conviction: "Oh wonderful, you're just in time. The news is just beginning!" And sometimes she'd add, "We've made those cheese pastries you like so much," or "This morning Füsun and I made some lovely vine-leaf *dolma*s, you're going to love them." If her chatter to diffuse the situation seemed too forced, I would feel ashamed and remain silent. But most of the time I would cheerily reply, "Is that so?" or "Oh wonderful, just in the nick of time," and go upstairs repeating the rejoinder with exaggerated enthusiasm when I saw Füsun, hoping to hide the shame and joy I felt at that moment.

"Oh dear, I hope I didn't miss the plane crash, too," I said once.

"The plane crash was yesterday, Cousin Kemal," Füsun replied.

In the winter, I could say things like "How cold it is!" or "Are we having lentil soup?" as I was taking off my coat. After February 1977, when the installation of a buzzer allowed them to admit me without coming downstairs, I had to make my opening gambit as I was walking into the apartment, and that was harder. If Aunt Nesibe saw me struggling to find a way into the domestic routine, she'd draw me in at once: "Oh, Kemal Bey, don't just stand there, sit right down, before your pastry gets cold"; if not she'd make a more typical reference to current events: "The man shot up an entire coffeehouse and now he's bragging about it."

I would frown and take my seat straightaway. My presents also helped me with awkward first moments after my arrival. During the early years, I'd bring pistachio baklava, Füsun's favorite, or water pastries from Latif, the renowned bakery in Nişantaşı, or hors d'oeuvres like salted bonito and taramasalata. Always handing whatever it was to Aunt Nesibe, and without much fanfare. "Oh, you shouldn't have gone to so much trouble!" Aunt Nesibe would say. Then I would give Füsun her special present or leave it somewhere for her to find later, diverting attention by offering Aunt Nesibe a jolly reply: "I was just passing by the shop, and the pastries smelled so good I couldn't resist!," adding a few words of praise for whatever Nişantaşı patisserie I had visited. Then I would take my place discreetly, very much like a pupil who has come to class late, and suddenly my mood would lift. After sitting at the table for some time, I would eventually come eye to eye with Füsun. These were the sublime moments that repaid any amount of trouble I had gone to.

I treasured that moment when our eyes first met—not on first arrival, but while we were sitting down at the table—not

only because it warmed my heart but because it spoke of what sort of evening lay ahead. If I saw some contentment, some tranquillity in Füsun's expression, even if it were a frown, the rest of the evening would assume that tone. If, however, she was unhappy or uneasy and so didn't smile, I wouldn't smile much either; during the first months I wouldn't under such conditions even try to make her laugh, but just sit there drawing as little attention to myself as I could.

My place at the table was between Tarık Bey and Füsun, on the side facing the television, and across from Aunt Nesibe. If he was at home, Feridun would be next to me, as would the occasional guest. At the beginning of the meal it suited Aunt Nesibe to sit with her back to the television, so that she could slip easily in and out of the kitchen, but by the middle of supper, when she had less to do, she would come to sit on my left, between me and Füsun, so that she could watch television more comfortably. For eight years I sat here elbow to elbow with Aunt Nesibe. Sometimes, when he came home late in the evening, Feridun would take a seat along the side of the table Aunt Nesibe had left vacant. And then Füsun would go to her husband's side, and Aunt Nesibe would take her daughter's old seat. Then it became difficult to watch television, but by then the broadcast day would be over anyway, and the television set was turned off.

When something important was on television while there was still something cooking on the stove, Aunt Nesibe would send Füsun in to check it in her place. As Füsun darted between the kitchen and the dining area, which was just next door, carrying plates and pots, she would pass right between me and the television screen. As her mother and father lost themselves in some film, or quiz show, or weather report, or the tirade

by some angry general of ours who had just staged a coup, or the Balkan Wrestling Championship, or the Manisa Mastic Festival, or the ceremony marking the sixtieth anniversary of the liberation of Akşehir, I would watch my beauty pass back and forth in front of me, as though she was not, as her parents might have seen it, blocking the view, but rather was the view itself.

During my 1,593 visits to the Keskin household, I spent a good part of the evening sitting at the dinner table watching television. But I cannot so easily tally the length of individual visits. Out of shame, I would always try to convince myself that I'd gone home far earlier than I had done. It was, without doubt, when the broadcast ended that we remembered the time. The closing ceremony, watched in all the country's coffeehouses and gambling clubs, lasted four minutes: soldiers marching in step, saluting the flag as it was raised up the pole, and the national anthem playing in the background. Considering I usually arrived at around seven o'clock, and left soon after this nightly ceremony around midnight, I suppose I must concede I spent an average of five hours at Füsun's house on each visit, but clearly there were times when I stayed longer.

In September 1980, four years after I began my visits to the Keskin household, there was another military coup; martial law was imposed and with it ten o'clock curfews. These obliged me to leave the house at a quarter to ten, long before my heart had satisfied its hunger. During the last minutes before the curfew, as Çetin drove quickly through the dark and fast-emptying streets, the torment of insufficiency would feel as keen as that of total deprivation. I would feel the pain of not having seen enough of Füsun. Even now, all these years later, whenever I read in the papers of the military's displeasure with the state of

the nation, the evil of military coups I remember most vividly is that of rushing home denied my due ration of Füsun.

My relations with the Keskin family went through their vicissitudes over the years: the meanings of our conversations, our respective expectations and silences were forever changing shape in our minds. Of course, what never changed for me was my reason for going, which was to see Füsun, and I assumed this pleased her and her parents. But because the reason could never be spoken openly, we all had recourse to some form of euphemism. I was there as a "guest," though this term was ambiguous and not altogether convincing in the circumstances, we collectively agreed on an alternative expression that made us less uncomfortable. I went to the Keskins' four times a week to "sit."

Aunt Nesibe was particularly fond of this formulation, familiar to Turkish readers, which foreign guests to our museum might not readily understand, due to its manifold applications—"to pay a visit," "to drop by," or "to spend some time with someone"—not to be found in the dictionary. When I left at the end of an evening, Aunt Nesibe would always bid me farewell with the same gracious words: "Come again tomorrow, Kemal Bey, and we can sit together again."

In so saying she did not imply that we did nothing but sit at the table, of course. We would also watch television, sometimes falling silent for long stretches, and sometimes conversing amicably about this and that, as well as eating and drinking *rakı*. During the early years, to impress upon me how welcome I was, Aunt Nesibe would make particular mention of these other activities. She would say, "Do come again tomorrow, Kemal Bey, we're having those stuffed zucchini you love so much for supper," or, "Tomorrow we can watch the ice-skating

competition, which they'll broadcast live." When she said these things, I would glance at Füsun, hoping for some sign of approval, ideally a smile; if Aunt Nesibe said, "Come, we'll sit," and Füsun seemed to approve, I could let myself believe that there was no deceit in her words, that we were indeed gathering in the same place, as people do, to sit together. Touching in the most innocent way upon my main reason for being there—my desire to be in the same place as Füsun—the word "sit" suited me perfectly. Unlike those intellectuals who deem it a solemn duty to deride the people and who believe that the millions of people in Turkey who talked of "sitting together" every evening were congregating to do nothing, I, to the contrary, cherished the desire expressed in the words "to sit together" as a social necessity amongst those bound by family ties or friendship, or even between people with whom they feel a deep bond, though they might not understand its meaning.

Here I display a model of Füsun's apartment in Çukurcuma (this being the second floor of the building as a whole), which will, I hope, serve as an introduction to the eight-year span of my story. On the floor above the living room was the bedroom that Aunt Nesibe shared with Tarık Bey, and the one Füsun shared with her husband; between them was a bathroom.

A close look at the model will reveal that my place at the dinner table is marked. For those unable to visit our museum, let me explain: I sat across from the television, which was slightly to my left, and with the kitchen just to my right. Behind me was a sideboard, and sometimes, if I tipped back my chair, I would knock against it. Then the crystal glasses inside would shudder along with the porcelain and the silver sugar bowls, the liqueur sets, the never-used coffee cups, the old clock, the silver lighter that no longer worked, the little glass vase with the spiraling

floral pattern whose likeness one could see displayed on the buffet of any middle-class family in the city, other assorted ornamental pieces, and finally the buffet's glass shelves.

Like everyone else at the table, I sat watching television year in and year out, but casting my eyes slightly to my left, I could see Füsun quite well without needing to turn toward her or move in the least. This meant that while I was watching television I was able to look at Füsun for extended periods without anyone noticing, simply by moving my eyes. The temptation was, of course, irresistible, and the more I performed this feat, the more expert I became at it.

If we were watching a film that had reached its climax, or some news story that we found particularly gripping, I took great pleasure in tracking Füsun's expressions; in the subsequent days and months my memory of the images on the screen would merge with that of the expression on her face. Sometimes at home I would first recall Füsun's expression before the affecting scene that had provoked it (an indication that I missed Füsun and had gone too long without coming to supper). The deepest, strangest, and most stirring memories of scenes watched during the eight years at the Keskins' dinner table are indelibly marked with corresponding images of Füsun. My fluency at reading her expressions reached the point where I could look at her from the corner of my eye and deduce with remarkable accuracy what was happening on television, even if I had been paying no attention to the screen.

On the table, next to the place where Aunt Nesibe would come to sit later in the evening, after the food was served, there was a lamp with clawed feet and a shade that was always askew, and next to it was an L-shaped divan. Some evenings, if the eating, drinking, laughing, and talking had proved particularly

exhausting, Aunt Nesibe would say, "Come on, everyone, let's sit on the divan," or "Go relax and I'll bring you coffee!" and then I would sit on the end of the divan closest to the sideboard, while Aunt Nesibe sat on the other end, and Tarık Bey took his place next to the bay windows, on the chair closest to the hill. For a good view of the screen from our new places, it was necessary to pivot the television set, and this Füsun would do, from her place at the table, where she would remain. Although sometimes, having changed the angle of the television, she would take a seat at the far end of the divan, beside her mother, the two nestling together as they watched. Sometimes Aunt Nesibe would stroke her daughter's hair and her back, and, like Lemon the canary, who would be watching us with interest from his cage, I took great pleasure in the spectacle through the corner of my eye.

Late at night, when I had sunk into the cushions on the L-shaped divan, the *rakı* I had drunk with Tarık Bey would make itself felt, and I could almost drop off to sleep, watching the television screen with one eye open, and with the other it was as if I were looking into the depths of my soul; I would feel the shame I had at other times succeeded in banishing, the shame that life had brought me to such a strange place, and an anger would well up urging me to get on my feet and leave the house. It was not uncommon for me to feel this way on those dark, dire nights when Füsun's expressions had displeased me, when she had offered hardly a smile, and even less if I brushed against her, intending nothing, but having done so, requiring a sign of assurance.

At such moments I would stand up and go to the bay window, where Lemon the canary was slowly aging in his cage, and I would peek through the curtains over the middle or right-

hand panes at Çukurcuma Hill. On wet days you could see the light of the streetlamps reflected on the cobblestones. Without taking their eyes off the screen, Aunt Nesibe and Tarık Bey would be prompted to say: "Has he eaten his food?" "Shall we change his water?" "He's not very happy today."

There was one more room on the first floor; it was at the back and had a narrow balcony. Used mostly in the daytime, it was where Aunt Nesibe did her sewing and Tarık Bey read his newspaper. After the first six months, whenever I felt uncomfortable at the table, perhaps wanting to pace nervously for a while, I would often go into this room if the light was on, to look through the balcony window: I enjoyed standing there surrounded by the sewing machine, the shears, the old newspapers and magazines, the open drawer with an array of ornaments, and before leaving I would often pocket something to soothe me later on if I was pining for Füsun.

Through this balcony window I could see a reflection of the room in which we were eating overlaying the prospect of a row of destitute houses in the narrow lane behind the house. On a few nights I spent a long time watching a woman who lived in one of these houses. Every night it was her habit, after putting on her woolen nightdress and before going to sleep, to take one pill from a box of medicine, and with it the crumpled instructions, which she would read with great care. It was only when Füsun came to stand beside me in the back room one night that I realized this was the widow of Rahmi Efendi, the man with the artificial hand who had worked in my father's factory for so many years.

Füsun whispered that she had followed me into the room to find out what I was up to back there. Her casual curiosity moved me, and for a time we stood together in the dark, side-

by-side at the window, looking out at the street. At that moment I came close to grasping what it was that kept me coming to the Keskin house for eight years: I was driven by the very question that lay at the heart of what it meant to be a man or a woman in our part of the world.

In my view, Füsun left the table that evening because she wanted to be close to me. This was clear from the way she stood by me in silence, gazing at what was to her a very ordinary view. But for me, as I cast my eyes upon the roof tiles, and the tin roofs, and the smoke puffing gently from the chimneys, as I peered through lit windows, catching glimpses of families moving about their homes—it all seemed extraordinarily poetic, simply because Füsun was at my side, and the desire was great to put my hand on her shoulder, to wrap my arms around her, or just to touch her.

But my experience at the Çukurcuma house during the first weeks was enough for me to tell that Füsun's response would be severe, perhaps even as cold as if I had tried to molest her; she would push me away and leave the room abruptly, causing extravagant pain, and launching us into our twinned indignation (the game that we would slowly perfect over the years) with the ultimate result that for a time I would not even go to the Keskins' for supper. Even having reasoned this through, the urge to touch her, kiss her, or, at the least, brush against her side persisted. The *rakı* played some part in this. But even if I'd had nothing to drink, this dilemma would have afflicted me nonetheless.

If I held myself back, kept myself from touching her (as I was becoming a master at doing), Füsun would come even closer; she might brush against me, and perhaps she would say a few sweet things. Or (as she had a few days earlier) she

might ask, "Is something bothering you?" In fact, that evening Füsun said, "I love how quiet it is at night. I love watching the cats wandering over the roofs." And again I would be gored by the same painful dilemma. Could I touch her, hold her, kiss her? How I longed to do so. It is possible that during the first weeks, the first months (as I would come to believe afterward, for many years) that she was making no kind of overture at all, but only saying the polite and civilized things that an intelligent, well-mannered girl with a high school diploma was obliged to say to a distant relation who was rich and lovelorn.

During those eight years the dilemma preoccupied me, and damned me. The view you can see in the picture displayed here is the one we beheld standing at the window for at most two or two and a half minutes. I would like the museum visitor in contemplating it to please reflect on my dilemma as he looks at this view, bearing in mind, too, how delicate and refined was Füsun's behavior at this moment.

"I find this view so beautiful, because you are at my side," I finally said.

"Let's go, my parents will begin to wonder what we're up to."

"With you at my side, I could be happy looking at a view like this for years," I said.

"Your food is getting cold," said Füsun, and she went back to the table.

She knew how cold her words were. For it was not long after I had returned to the table that Füsun stopped frowning, giving me two sweet, compassionate smiles as she passed me the saltshaker (later to be added to my collection) and allowing her fingers to brush rather boldly against my hand; with that she made everything right again.

Lemon Films Inc.

ON FIRST discovering that his daughter had entered a beauty contest with the support and approval of her mother, Tarık Bey had been beside himself with fury, but loving his daughter dearly as he did, he could not resist her supplications when she burst into tears; afterward, though, when he heard what people said about her, he would regret tolerating the disgrace. There had been beauty contests during the first years of the Republic during Atatürk's reign, and when girls walked down the catwalk in black swimsuits, they were, in Tarık Bey's view, both manifesting their interest in Turkish history and culture, and also showing the entire world how modern they were, which was all to the good. But by the seventies, the contests had become the province of girls with no culture or manners and coarse hopes of becoming singers and models, and so the significance of beauty contests became something else altogether. The hosts of the old contests would ask the contestants, oh so politely, what sort of man they dreamed of marrying, as a refined way of clarifying that the girls were virgins. And while today's hosts asked girls, "What do you look for in a man?" (the correct answer being "character"), they would grin and smirk like Hakan Serinkan. So Tarık Bey was adamant with his filmmaker son-in-law that while he and Füsun were living under his roof, his daughter was to have no further adventures of this nature.

Out of fear that her father might consider becoming a film star likewise objectionable and thwart her plans in various overt and covert ways, we continued to discuss the "art film" Feridun planned only in hushed tones. In my view, Tarık Bey pretended not to hear our whispering because he looked favorably on my interest in his family and enjoyed drinking and talking with me. And as the art film provided a plausible pretext for my visiting the Keskin family four times a week, it served only too well to conceal the real purpose of my appearances, so well known to Aunt Nesibe. During the first few months, whenever I looked at Feridun's sweet and guileless face, it seemed to me that he knew nothing, but later I would begin to think that he was in on a counterplot, but trusted me with his wife, seeing me as no kind of threat— indeed someone to be made fun of behind my back—and in his desperate need for my backing, simply played along with the deception.

Toward the end of November, after much coaxing from Füsun, Feridun finished the final draft of his screenplay, and one evening after supper, while standing on the landing at the top of the stairs, and under Füsun's frowning gaze, he ceremoniously handed the typescript over to me, as prospective producer, to solicit my decision.

"Kemal, I want you to read this carefully," said Füsun. "I believe in this screenplay and I trust you. Don't let me down."

"I'd never let you down, my dear girl!" I pointed at the typescript in my hand. "Tell me, do you esteem the screenplay so highly because you're meant to star in it, or is it because it's meant to be an 'art film'?" (A new concept in 1970s Turkey.)

"Both."

"Then consider the film made."

The screenplay was entitled *Blue Rain,* and there was nothing in it remotely to suggest an awareness of Füsun, or me, or our romance, or our story. Over the summer I had come to have respect for Feridun's intelligence and his understanding of film; discussing cultivated and highly educated Turkish filmmakers longing to make art films in the manner of the West, he had very astutely identified their typical mistakes (imitation, artificiality, moralism, vulgarity, melodrama, and commercial populism, etc.), so why had he fallen into all the same traps? As I was reading this vexing screenplay, I realized that the longing for art, like the longing for love, is a malady that blinds us, and makes us forget the things we already know, obscuring reality. Even the three scenes, motivated by commercial considerations, in which Füsun's character would appear nude (once making love, once pensively smoking a cigarette in a bubble bath, in the style of the French New Wave, and once wandering through a heavenly garden in a dream) were arty, insipid, and gratuitous!

My confidence in this project was never more than a pose, but after reading these scenes I was even more resolutely and angrily opposed than Tarık Bey would have been. But realizing that I had to keep the project alive for a while longer, I lavishly praised the script to both Füsun and her husband, going so far as to tell them that "as the producer" I was now ready to begin tryouts for actors and technicians, a zealousness for which I gently mocked myself, in the interest of making it more credible.

So with the onset of winter, Feridun, Füsun, and I delayed not a moment in visiting the backstreet haunts, the prospective production offices, and the coffeehouses where second-class actors, would-be film stars, bit players, and set workers played cards, as well as the bars where producers, directors, and

semifamous actors were usually to be found from early evening, eating and drinking until the late hours. All these places were a ten-minute walk up the hill, and whenever I took this route I would remember how Aunt Nesibe had told me that Feridun had married Füsun in order to live within walking distance of such establishments. Some evenings I would collect them at the door, and some evenings we three—Feridun, with Füsun on his arm, and I—would walk together up to Beyoğlu, having had our supper with her parents.

Our most frequent destination was the Pelür Bar, popular with film stars and men with new money hoping to mingle with girls who hoped to become starlets, and the children of Anatolian landowners, now cast into the Istanbul business world by day and letting off steam in the evening, and moderately renowned journalists, film critics, and gossip columnists. All winter long we met many actors who'd played supporting roles in the films we'd seen that summer (including that mustached friend of Feridun's who had played the crooked accountant), and we became part of that society of spirited, bitter, but ever hopeful souls who whiled away the evenings exchanging vicious gossip, recounting their life stories, and describing their ideas for films, and who couldn't get through a day without the company of those like them.

They were very fond of Feridun, and because he held some of them in high esteem, had assisted some others, and wanted to ingratiate himself with the rest, he would go off to their tables, sitting with them for hours, leaving Füsun and me alone, though never happily on my part. When Feridun was with us, Füsun would address me as "Cousin Kemal," only very rarely dropping this half-innocent pretense; if she did deign to speak to me sincerely, I read her change of register as a warning—

about the men who came and went from our table, and her future life in the film world—that I ignored at my peril.

One evening after too much *rakı,* I found myself left alone with her again, and having tired of her aspirational fantasies and the pettiness of this milieu, I suddenly became convinced of the rightness of my next comment and of her receptiveness to it. "Take my arm, darling, let's get up and leave this dreadful place together right now," I said. "We could go to Paris, or Patagonia, to the other end of the world—it doesn't matter so long as we forget all these people, and live happily ever after, just the two of us."

"Cousin Kemal, how can you even say such a thing? Our lives are what they have become," said Füsun.

After we'd been coming to the bar for several months, the drunken lot that gathered there every night (an "it" crowd in their own minds) didn't bother us, having accepted Füsun as the young and beautiful bride and having pegged me with derisive suspicion as the "well-meaning idiot millionaire" who wanted to make an art film. But there were inevitably those who didn't know us, or drunks who knew us but leered at Füsun anyway, or who had caught a glimpse of her from a distance while barhopping, or who nurtured an irrepressible longing to narrate their own life stories (this was an enormous crowd), and collectively they hardly left us alone. While I enjoyed it when a stranger joined us with a glass of *rakı* in his hand, having taken me for Füsun's husband, she would straightaway smile and correct them with an insistence that broke my heart every time, saying, "My husband is the fatso over there," and emboldened the stranger to ignore me and attempt to make a pass at her.

Each attempt took a different form. Some claimed they were looking for a "dark-haired innocent-looking Turkish

beauty" just like her to use in a *photoroman;* some would immediately offer her the lead in some new film on the prophet Abraham, headed imminently into production; some would gaze longingly into her eyes for hours saying nothing; while others would discourse on life's little beauties and all the subtle wonders that no one paused to notice in this materialistic world, where only money mattered; then there were the ones who sat at remote tables reading the work of long-suffering imprisoned poets, poems about love, longing, and the nation; others from distant tables would either pay our tab or send us a plate of fruit. By the end of the winter we were frequenting these Beyoğlu haunts less, but every time we did go, we would inevitably see the same great hulking woman who often played the diabolical prison matron or the leading villainess's bulky sidekick. She would invite Füsun to dance parties at her house, promising "lots of cultivated, well-schooled girls" like her. And there was always an old, squat little critic who wore bow ties and girded his enormous belly with suspenders; he would plant his ugly hand like a scorpion on Füsun's shoulder, foretelling the "great fame" awaiting her, perhaps as the first Turkish actress to gain international renown, provided she gave careful consideration to every step she took.

Füsun would indeed give serious consideration to each and every film, *photoroman,* and modeling offer, however unsuitable or trivial; she would also remember the names of everyone she met, and in the case of film actors, no matter how obscure, she would shower them with outsize, even vulgar compliments, a want of proportion that I couldn't help tracing back to her days as a shopgirl. Even as she tried to flatter and beguile everyone, she was also determined to achieve the often contradictory purpose of making herself seem interesting. Toward these ends

she was ever more often pressing us to visit these places, and if I counseled against giving her phone number to everyone who made her an offer—"What would your father say?"—she would only snap at me that she knew what she was doing, even declaring that she needed options in the event that Feridun's film failed to get made. I took deep offense at the implication and moved to another table, but then she would come over with Feridun and say, "Why don't we three go out for supper, just like we did last summer?"

I had made two new friends among the hard-drinking film crowd of which I was slowly becoming a somewhat embarrassed fixture. One of them was a middle-aged actress named Sühendan Yıldız, who owed her fame as the "evil woman" entirely to her nose, which had been broken by one of Turkey's first cosmetic surgeons and reconstructed in a hideous new shape. The other was a character actor named Salih Sarılı, who having for years played authority figures like army officers and policemen, was now obliged to earn his keep by dubbing semi-legitimate domestic porn films, the absurdities of which enterprise he could be relied upon to recount in a chesty voice, often interrupted by a laugh and a hacking cough.

In a few years' time I would discover that it was not just Salih Sarılı working in the domestic porn industry, but most of the actors we had befriended in the Pelür Bar, and this startled me as if I'd discovered that all my friends belonged to a secret society. Well-mannered middle-aged actresses and actors of strong types like Salih Bey would get by dubbing foreign films that were only moderately obscene, and during the sex scenes, moaning and screaming to suggest the details of the action that the film didn't show. Most of these actors were married with children and admired for their gravitas; they would tell their

friends that they had been forced to take on such work during the economic decline so as not to be entirely cut off from the film world, though at first they hid it from everyone, and especially their families. Even so, their ardent fans, particularly those in the provinces, would recognize their voices and write them letters of hatred or admiration. At the same time, far bolder, greedier actors and producers, most of them regulars at the Pelür, were involved in domestic productions that must go down in history as "the first Islamic porn films." The "love scenes" in their films mixed sex with slapstick, as the gasping and moaning proceeded with ludicrous exaggeration, as the actors assumed all the positions that could be learned from European sex manuals bought on the black market, though all involved, male and female alike, would never remove their underpants.

At the Pelür, as Füsun headed off with Feridun, alighting at every table, meeting everyone she could, I would sit and listen to my two new middle-aged friends, more often the courteous Sühendan Hanım, dispense words of caution. I was, for example, to keep Füsun at all costs away from that producer over there, who looked respectable enough with his yellow tie, crisply ironed shirt, and little brush mustache, but whose greatest claim to fame was trapping women under thirty in his office above the Atlas Cinema where he had no qualms about locking the door and raping them, and afterward he would silence the crying girls with the offer of the lead in one of his films, which role, when the filming began, would turn out to be a bit part—that of the scheming German nanny who upsets the peaceful home of a rich Turkish man with a golden heart. I was to be likewise wary of Muzaffer the producer, also Feridun's old boss, at whose side Feridun still spent so much time, laughing slavishly at every joke, hoping to win this man's technical assistance for the art film.

Not long ago, less than a fortnight, this scoundrel had been sharing a table with the owner of two medium-size production companies with whom he was in constant competition, and he had bet his rival a bottle of black market champagne that he could seduce Feridun's wife within the month. (The films of that era offer copious examples of our fetish for that Western infidel luxury.) As I sat chatting with this renowned film star who had for so many years played the ordinary vixen (never the true she-devil), and who on account of the celebrity magazines was known to the entire Turkish nation as Conniving Sühendan, she would be knitting a tricolored woolen pullover for her beloved three-year-old grandson, and showing me the picture in *Burda* from which she was copying it. If anyone mocked her for sitting in the corner of the bar with balls of red, yellow, and navy blue wool on her lap, she would say, "At least I'm keeping busy while waiting for my next job, which is more than you drunks can say," and if circumstances warranted she would discard her ladylike manners with some ease and launch into foul-mouthed invective.

The intellectuals, filmmakers, and pouting starlets frequenting places like the Pelür would be drunk by eight in the evening: Seeing how scandalized I was by the ensuing vulgarities, my world-weary friend Salih Sarılı gazed across the room with a romantic expression that recalled the noble, idealist policeman roles that he had personified for so many years, and, fixing his eyes on Füsun, who was sitting at a distant table, laughing with someone I didn't know, he allowed that were he a rich businessman, he wouldn't be bringing a beautiful relation to bars like this for the purpose of her becoming a star. This broke my heart. I was now obliged to add my actor-dubber friend to my list of "men who looked at Füsun in the wrong

way." Conniving Sühendan made a more oblique comment one day that I would never forget: My beautiful relative Füsun, she said, was a sweet and good and lovely girl, just the right age to become a very good mother, like the one who had given birth to the grandson for whom she was knitting the red, yellow, and navy blue pullover. But what were we doing here?

I, too, would eventually succumb to such anxieties. For every week Füsun was making new acquaintances in the film bars of Beyoğlu, admirers who were continually proposing to use her in this *photoroman* or that commercial. And so at the beginning of 1977 I signaled to Feridun that the time had come to decide on his technical team. From her friendly smiles and the way she touched me when she whispered funny stories into my ear, Füsun had led me to believe she would leave Feridun soon. As I was planning to marry her the "very next" moment, I told myself that it would be better for her, too, not to become too involved in this sordid world. We could make her an actress without cozying up to such people. It was at about this time that the three of us decided that our joint venture was better managed from an office than in the Pelür Bar. The moment had come to set up a company to finance Feridun's films.

It was at Füsun's jolly suggestion that we agreed to name the company after Lemon the canary. As one can gather from our business card, bearing the likeness of the charming bird, Lemon Films was located next door to the New Angel Cinema.

I arranged for 1,200 Turkish lira to be deposited every month in a personal account at the Beyoğlu branch of the Agricultural Bank. This sum was slightly more than the salaries I paid my two top managers at Satsat: Half would pay Feridun's salary as the firm's managing director, while the rest would cover the rent and the production costs.

On Being Unable to Stand Up and Leave

ONCE I had begun to pay Feridun through Lemon Films, growing more convinced with each passing day that there was no need to rush into production, I felt much better, even about going to Füsun's for supper. Or more truthfully, some nights, when my desire to see Füsun was too strong to resist, and my heart would be seized by a shame no less powerful, I would tell myself that somehow because I was now giving them money there was no longer cause for shame. The need to see Füsun had so fogged my mind that I never examined the logic by which the payments expunged the disgrace. But I remember sitting with my mother in front of the television in Nişantaşı around suppertime one evening in the spring of 1977, yet again caught between desire and shame, doubled up in my father's chair (now mine), paralyzed by indecision, for half an hour, unable to move.

My mother said what she always said now on seeing me at home in the evening. "Why don't you stay in for a change, and we can eat something together."

"No, Mother dear, I'm going out."

"Goodness, I had no idea there were so many diversions in this city. You can't stay away from it for a single night."

"My friends insisted, Mother dear."

"I wish I were your friend instead of your mother, left alone in life. . . . Look, Bekri could run down to Kazım's and buy some lamb chops; he could grill them for you. Sit down

and have supper with me. You can eat your lamb chops and then go see your friends."

"I could go down to the butcher right now," Bekri called out from the kitchen.

"No, Mother, this is an important party," I said. "The Karahans' son is hosting it."

"Then why haven't I heard about it?" my mother said, rightfully suspicious. What did my mother or Osman or anyone else know about the frequency of my visits to Füsun's? I didn't want to think about this. On the nights I went to Füsun's house, I would sometimes have supper with my mother first, just to allay her suspicions, and then go and eat again at Füsun's. On nights like this, Aunt Nesibe would notice at once my lack of interest in the food, and she'd say, "You have no appetite this evening, Kemal; didn't you like the vegetable stew?"

There were times when I would eat supper with my mother, thinking that if I could survive those hours when I missed Füsun most intensely, I would have the strength to stay at home, but one hour and two glasses of *rakı* later, my longing would grow to such proportions that even my mother could not fail to notice.

"Look at you with your legs twitching again. Why don't you walk off your nervousness and come back," she'd say. "But please, don't go far, I beg you, not with the streets as dangerous as they are these days."

I have no desire to interrupt my story with descriptions of the street clashes between fervent nationalists and fervent communists at that time, except to say what we were witnessing was an extension of the Cold War. In those years people were being murdered in the streets continually; coffeehouses would be machine-gunned in the middle of the night, and every other

day there were university takeovers or boycotts, bombs going off, and banks being raided by militants. Slogans had been written over slogans on every wall in the city, and in every color. Like most people in Istanbul, I had no interest in politics, and it seemed to help no one that this war was being waged in the streets by an assortment of ruthless factions, none of which had anything in common with the rest of us. When I told Çetin, who'd been waiting for me outside, to drive carefully, I was speaking as if politics were as natural a cataclysm as an earthquake or a flood, and there was nothing we ordinary citizens could do except try our best to stay out of its way.

If I was unable to stay at home, as on most evenings, I didn't always go to the Keskins'. Sometimes I'd go to a party, hopeful of meeting a nice girl who would help me forget Füsun; sometimes I would go out for a few drinks with old friends and chat. If Zaim had taken me to a party, or, finding myself in the home of some distant relation recently come into society, I ran into Nurcihan and Mehmet, or if, late at night, Tayfun had driven me to a nightclub and, bumping into long-lost friends, we ordered a bottle of whiskey and sat together listening to Turkish pop songs (mostly rip-offs of French and Italian pop songs), I would alight upon the mistaken notion that I was slowly returning to my former healthy life.

It was not the shame and indecision I felt in advance of going to Füsun's that bespoke the gravity of my affliction, but rather the indecisive inertia that overtook me when, having sat with them for hours, eating supper and watching television, the time to go home had come. Besides the shame of ordinary inertia, there was in the extreme instance the shame I felt when I was literally unable to summon the will to leave the Çukurcuma house at all.

The television broadcast would end every evening between half past eleven and midnight, and the images of the flag, Atatürk's mausoleum, and "our boys" in the army would be replaced by a snowfall of blurry dots, which we would also watch for a while, as if some further program might come on by mistake, until Tarık Bey said, "Füsun, my girl, let's turn this thing off now," or else Füsun did so unbidden, with a single touch. And so would begin the particular misery I now wish to analyze. The feeling that if I did not stand up at once and leave there would ensue great discomfort in everyone. I couldn't reckon how apt it was to worry about this. I would just think, I'll be getting up soon. Having heard them speak ill of guests who dashed off the moment the broadcast ended, with scarcely a "good-night," and of neighbors without televisions of their own who did likewise, I deluded myself, imagining I was merely being polite.

Certainly they knew that I did not come calling to watch television, but to be near Füsun, but sometimes to finesse this imperative I would phone ahead, saying to Aunt Nesibe, "Why don't I come over this evening. They're showing *Pages from History*!" But having seized on such a pretext, I had locked myself into a need to be off once the program was over. So at that moment, the television having been turned off, I would sit for a casual while longer, before telling myself, more forcefully now, that I needed to stand up and get going, but my legs would not obey me. In this motionless state I would remain, whether at the table, or on the L-shaped divan, like a figure in a painting, and as I felt the perspiration beading on my brow, many Aristotelian moments would pass, the ticking of the clock punctuating my discomfort, as I exhorted myself, saying, "I'm standing up now!" forty times over, but still to no avail.

Even all these years later this inertia baffles me somewhat, just as I cannot fully comprehend the love that so afflicted me, though I can adduce, perfectly, any number of discrete reasons for my apparent loss of will:

1. Every time I said, "I must get going now," Tarık Bey or Aunt Nesibe would say with sincerity, "Oh, please stay a little longer, Kemal Bey, we were sitting so nicely!"

2. If they did not, Füsun might give me an enchanting smile, with such a mysterious air that I would be all the more confused.

3. Then someone would begin telling a new story, or bring up a new subject. To get up now, before this new story was told, would be rude, I told myself, and so I would sit there, however uneasily, for twenty minutes more.

4. Coming eye to eye with Füsun I would lose all sense of time, until finally glancing at my watch I'd see that forty, not twenty, minutes had passed, and then I'd say, "Oh, look at the time," but I still wouldn't go: I'd just sit there, cursing myself for being so weak, my inertia and shame growing ever deeper, until the moment arrived when it became too heavy to bear.

5. I would search my mind for an excuse to sit there just a bit longer, to give myself a little respite from that burden before going.

6. Tarık Bey might have poured himself another *rakı,* in which case courtesy perhaps required that I should join him.

7. I would try to ease my departure by using the

feeble excuse of waiting for midnight, and then saying, "Oh, it's midnight already, I really should be going."

8. I would tell myself that Çetin was perhaps in the middle of some conversation at the coffeehouse, and that he might not be ready either.

9. And anyway, down in the street, just beyond the door, a group of neighborhood youths were gathered, smoking and blabbing, so to leave just then would make me the object of their idle gossip. (It was not a fantasy: Whenever I ran into the neighborhood youths on my way in or out of the Keskin house, they would fall silent, and for years that disturbed me, though seeing me on such good terms with Feridun, they could never as "defenders of the neighborhood" challenge me.)

Feridun's absence also made me uneasy, oddly more than his presence. I knew already from the way Füsun looked at him that the situation was difficult. But the thought that Feridun might trust his wife implicitly led me to the excruciating conclusion that they might somehow be happily married.

It was far more comforting to explain Feridun's lack of concern by reference to taboos and traditions. Living as we did in a country where it was unthinkable to show interest in a married woman in front of her parents, and where especially among the poor, and in the provinces, even a sidelong glance could lead to death, it would have been virtually inconceivable to Feridun that it might cross my mind to flirt with Füsun every night as we sat watching television like a happy family. The love I felt, like the dinner table at which we ate, was ringed with so many refinements and prohibitions that even

if every fiber in me shouted that I was madly in love with Füsun, we would all be obliged nevertheless to act "as if" there was an absolute certainty that such a love could simply not exist. At times when this occurred to me I would understand that I was able to see Füsun not in spite of all these exquisite customs and proscriptions, but because of them.

Let me offer a counterexample by way of elucidation, as it is central to my story: Had we been living in a modern Western society with more candid relations between men and women, and with the sexes not living in separate realms, my going to the Keskin household four or five times a week would, of course, force everyone eventually to accept that I was coming to see Füsun. The husband would have to be jealous and would be obliged to stop me. And so in such a country my visits could never be so frequent, and neither could my love for Füsun have taken this shape.

On nights when Feridun stayed home, it was less difficult for me to stand up and leave at a suitable time. If, however, Feridun was with his film friends, it could get quite late, the broadcasting having ended, and someone having uttered one of those nightly pleas made out of politeness—"Won't you have another cup of tea before you go?" or "Sit a little longer, Kemal Bey, please!"—because I would sometimes resolve to time my departure around his return. But not once during those eight years could I decide whether it was better to leave just before he got back or just after.

During the first months it seemed far preferable to depart before Feridun returned. Because in those

first moments after he walked in and we came eye to eye, I would feel very, and I mean very, bad. I would have to down at least three more glasses of *rakı* after returning to Nişantaşı just so I could sleep. What is more, getting up the moment Feridun arrived was as good as suggesting that I disliked him and, even worse, as revealing that I was there for Füsun. Hence the habit of my remaining at least half an hour after Feridun's return, despite magnifying both my inhibitions and shame. Better to suffer these feelings than to expose my guilt by avoiding him. I wouldn't follow those dastardly Casanovas in European novels who openly court the countess and scamper out of the castle moments before the count's return! Of course, as an alternative to leaving before Feridun got back, I could have allowed a longish interval between my departure and his arrival. But this would have meant leaving the Keskin house early. And that I could not do. I had trouble leaving late. I had trouble leaving early.

10. If I did wait for Feridun, we might have a chat about this screenplay business. In fact, I tried this a few times; when Feridun got home, I tried to talk to him.

"There's now a faster way of getting cleared by the board of censors, Feridun. Have you heard?" I said once. If I didn't use those exact words, I said something similar, leading to an icy silence at the table.

"There was a meeting with the Erler Films people at Panayot's coffeehouse," said Feridun.

Then he kissed Füsun in the half-heartfelt, half-routine way that husbands in American films kiss their wives when they

get home from work. Sometimes I would see from the way Füsun greeted his embrace with her own that these kisses were genuine, and it would hit me very hard.

Some nights Feridun would sit with us and have supper, but most evenings found him at the cafés with the writers, draftsmen, stagehands, and cameramen of the film world, or visiting them at home. He had been drawn into a communal life with noisy, gossipy people who lacked inner calm and were never without a reason to argue with one another. Feridun had in fact come to attach disproportionate importance to the dreams and disputes of these associates with whom he drank and dined so often, so that while his film friends' passing pleasures brought him instant happiness, their lingering despair left him no less instantly grief-stricken. When he was so afflicted I put my mind at ease and would not worry that my evening visits were keeping Füsun from going out with her husband and enjoying life. Ordinarily, profiting from the nights when I wasn't visiting, Füsun would go out to Beyoğlu once or twice a week, radiant in a chic blouse and adorned with one of the butterfly brooches I had bought her, and with her husband she would sit for hours in a place like the Pelür or Perde, a detailed report of which would come to me from Feridun on the very next visit.

Feridun and I both knew that Aunt Nesibe, too, was keen for Füsun to find the shortest way into the film business. Tarık Bey was secretly on "our" side of reluctance, but we knew that he could never be drawn out into the open in this matter. Still, I wanted Tarık Bey to know that I was his son-in-law's backer. It would be a year after the founding of Lemon Films before I heard from Feridun that his father-in-law was aware of my help.

During that year, I cultivated Feridun as colleague and friend outside the Keskin household. I could not deny he was affable, sensible, and very sincere. From time to time we would meet at the office of Lemon Films to review the status of the screenplay, our application with the board of censors, and the search for Füsun's male lead.

Two quite famous and handsome actors had already expressed an interest in Feridun's art film, but he and I both regarded them with suspicion. These black-mustached braggarts, who specialized in historic films wherein they would kill Byzantine priests and take down forty thieves with one blow, were sure to set their lecherous sights on Füsun. Their standard repertoire included talking lasciviously about their female costars, even those under eighteen, and their loaded remarks would lead to headlines like "The Kisses in the Film Come True" or "The Forbidden Love That Flowered on the Set." In fairness, such scandal was part of the film business, because it made actors into stars and drew in the crowds, but it was an advantage that Feridun and I were determined to forgo where Füsun was concerned. Knowing that to protect her in this manner could be costly to Feridun, I would order Satsat to remit more funds and expand Lemon's budget.

But that I could not buy my way out of every anxiety attending Füsun's entry into the film world around this time did worry me deeply. One evening when I went to the house in Çukurcuma, Aunt Nesibe told me, most apologetically, that Füsun had gone out with Feridun to Beyoğlu. I kept a neutral expression, hiding my misery as I sat down with Tarık Bey and Aunt Nesibe to watch television. Two weeks later, when the same thing happened again, I invited Feridun to lunch, to warn him that if Füsun became too involved with this drunken

film crowd, it could undermine the integrity of our art film. He should use my visits, I advised, as a way of obliging her to spend her evenings at home. A lengthy explanation ensued as to why I thought this would be for the good of both the family and our film.

It troubled me that my advice would be so little heeded. Arriving on yet another evening to find Feridun and Füsun gone out to some place like the Pelür, I again found myself sitting with Aunt Nesibe and Tarık Bey, silently watching television. I stayed until Füsun and Feridun returned at two in the morning, passing the time—whose passing I affected not to notice—by telling stories of America as I had come to know it during my years at university: Americans were very hardworking, well-meaning, and at the same time very naïve; they went to bed early; and even the richest children were obliged by their fathers to go from door to door on their bicycles delivering newspapers early in the morning. They smiled as they listened, as if I were joking, but they were also curious. Tarık Bey asked me to explain something he had wondered about: When phones rang in American films, they sounded different from ours. Did all phones in America ring like that, or just the phones ringing in films? Suddenly I was confused, and I realized that I had forgotten what phones sounded like in America. Long after midnight this awareness gave me the impression that I had left behind my youth, reminding me of the freedom I'd felt in America. Tarık Bey did an impression of a telephone in a typical American film, and a different impression of a phone ringing in a thriller, an even shriller sound. It was after two o'clock and we were still drinking tea together, and smoking, and laughing.

Did I stay so long to discourage Füsun from going out on the evenings of my visits, or did I stay because it would cause me such distress to leave without having seen her? Even all these years later I still don't know. But finally, after one more serious heart-to-heart with Feridun about the perils of Füsun's keeping such louche company, she did stop going out when I was expected for supper.

It was around this time that Feridun and I began to consider whether we should raise funds for the art film in which Füsun would star by first doing a commercial film. It is possible that talk of this prospective interim venture, in which Füsun would play no part, was what inspired Füsun to stay at home, though she did not neglect to communicate her resentment, and on some nights bounded vengefully upstairs to bed before I'd left. Still she clung to her dream, and so the next time I came she would be warmer than ever, asking after my mother, or spooning a bit more pilaf onto my plate unbidden; and then it would be impossible for me to go.

For even as my friendship with Feridun progressed, I remained afflicted by attacks of inertia that kept me from taking my leave. The moment Feridun walked through the door, I would at once feel superfluous, out of place in this world, like something I'd seen in a dream, but unable to give up my stubborn wish to belong to it. I shall never forget Feridun's expression one night in March 1977, when the late news on television had been an endless succession of stories about bombs detonated at political meetings and coffeehouses and leaders of the opposition shot in cold blood; it was very late (in my shame I'd stopped looking at my watch), and he arrived to find me sitting there. It was the sad look of a good man who felt genuine concern for me, but also

tinged with an element of his nature that so mystified me—
an innocence, so light and good and hopeful as to accept
everything as normal.

After the 1980 coup, the ten o'clock curfew constrained
my intervals of inertia. But martial law could not cure my
affliction; indeed squeezing my relief into a shorter parcel
of time made the suffering more intense. During the curfew
hours, the crisis of immobility would intensify from half past
nine, and I would be unable to stand, no matter how furiously
I told myself, "Up now!" As the countdown continued
relentlessly my panic would become impossible to bear by
twenty to ten.

When I finally managed to propel myself downstairs and
into the Chevrolet, Çetin and I would panic as we wondered
whether we would make it to the house by the curfew; invariably
we were four or five minutes late. In those first minutes of
the curfew (which was later extended to eleven o'clock) the
soldiers would never stop the last few stragglers racing down
the avenues. On the way home, we'd see cars that had crashed
in Taksim Square and Harbiye and Dolmabahçe in their haste
to beat the clock, and the drivers were no less quick to get out
of their cars and pummel each other. One night a drunken
gentleman emerged with his dog from a Plymouth, its exhaust
pipe still spewing smoke, and it reminded me of another
occasion when after a head-on collision in Taksim, a taxi's
broken radiator was producing more steam than the Cağaloğlu
Hamam. One night, having navigated the macabre darkness
and the deserted, half-lit avenues, I reached home safely, and
after I had poured myself one last *rakı* before heading for bed,
I pleaded to God to return me to normal life. I cannot say if I
really wanted this prayer to be answered.

Any kind word I heard before I left the house, any gentle or positive remark Füsun or the others offered me, however ambiguous, was enough to sustain hope, to revive the conviction that I would win Füsun back one day, that all these visits had not been in vain. In such a gladly deluded state I could take my leave relatively untroubled.

A pleasant comment from Füsun at the dinner table at an unexpected moment—for instance, "You went to the barber, I see. He took off a lot but it looks good" (May 16, 1977), or turning to her mother, "He enjoys his meatballs like a little boy, doesn't he?" (February 17, 1980), or on a snowy evening a year later, when I had just walked in, "We haven't sat down to eat yet, Kemal. We were just saying how much we all hoped you'd be joining us"—and I would feel so happy, however dark the thoughts I'd brought with me, however discouraging the signs I read as we watched television, that when the time came to leave, I could rise from my chair decisively, retrieving my coat from the hook beside the door, and say, "With your permission, sir, I'll be off!" Leaving the house in this way I would feel serene as Çetin drove me home early, and I could even think not about Füsun, but about the next day's work.

A day or two following such a triumph, when I next went to their house for supper and saw Füsun, I would understand with great clarity two of the things that drew me there:

1. When I was far from Füsun, the world troubled me; it was a puzzle whose pieces were all out of place. The moment I saw her, they all fit back together, reminding me that the world was a beautiful, meaningful whole where I could relax.

2. Anytime I entered the house of an evening and our eyes met, it was like a conquest. In spite of everything, and no matter what had happened to dash my hopes and my pride, there was the glory of being here once more, and most of the time I saw the light of the same happiness in Füsun's eyes. Or so I would believe, and, convinced that my stubbornness, my resolve had made an impression on her, I would find my life's beauty was restored.

Tombala

I SPENT New Year's Eve 1976 playing tombala with the Keskins. Perhaps I remembered this now because I've just been speaking about the beauty I'd found in my life. But it is also important, because celebrating the New Year with the Keskins was proof that my life had changed irrevocably. Having broken off with Sibel, I had been obliged to stay away from our circle of mutual friends, and now, visiting the Keskins four or five times a week, I had mostly abandoned my old habits, but until that New Year's Eve, I would still have myself and those around me believe that I was continuing my old life, or at least that I could return to it whenever I chose.

As for the acquaintances I no longer saw—so as to keep a distance from Sibel, avoid upsetting people with bad memories, and save myself the bother of explaining why I'd disappeared—it was Zaim who kept me abreast of their news. Zaim and I would meet at Fuaye or Garaj or some other society restaurant that had just opened, and there we'd sit having long, pleasant conversations about life and what everyone was up to as intensely as two men discussing business.

Zaim had lost interest in his young girlfriend, Ayşe, who was the same age as Füsun. He told me she was too much of a child, and he couldn't relate to her troubles or anxieties, nor had she managed to fit in with our group; when I pressed him, he insisted that he had no other girlfriend, or even anyone he

was interested in. From what he said, it was clear that Zaim and Ayşe had done no more than kiss, and that the girl would continue to be cautious and prudent so long as her uncertainty about Zaim persisted.

"Why are you smiling?" said Zaim.

"I'm not."

"Yes, you are," said Zaim. "But I don't mind. Let me tell you something you will enjoy even more. Nurcihan and Mehmet meet every day of the week without fail and go from restaurant to restaurant, club to club. Mehmet even takes Nurcihan to *gazino*s and makes her listen to Ottoman music, all the old songs. They've made friends in these places with singers who used to sing on the radio and are now in their seventies and eighties."

"Are you serious? . . . I never saw Nurcihan as someone who would go for that sort of thing."

"All because she fell in love with Mehmet. Actually, Mehmet doesn't know much about these old singers either. He's trying to learn it all, just to impress Nurcihan. They go to the Sahaflar Market together to buy old books, and then they trot off to the flea market looking for old records. In the evenings they go to Maksim and the Bebek Gazino to listen to Müzeyyen Senar. But they never get around to listening to the records together."

"What do you mean?"

"Well, every evening they're out at the *gazino*s," Zaim said carefully. "But they never go anywhere to be alone and make love."

"How do you know that?"

"Where could they possibly go? Mehmet still lives with his parents."

"He used to have a place where he took women, in the backstreets of Maçka."

"He had me over there, for a whiskey," said Zaim. "It's a typical *garçonnière*. Nurcihan is too clever to go near that hideous place; she knows that if she did Mehmet would immediately see it as reason not to marry her. Even I felt strange there: The neighbors were peering through the peephole, to see if this guy had brought back another prostitute."

"So what should Mehmet do? Do you think it's easy for a single man to rent an apartment in this city?"

"They could go to the Hilton," said Zaim. "Or he could buy himself an apartment in a decent neighborhood."

"Mehmet loves living with his family."

"You do, too," said Zaim. "May I say something to you as a friend? But promise me you won't get angry."

"I won't get angry."

"Instead of meeting secretly at the office, as if you were doing something wrong, you should have taken Sibel to the Merhamet Apartments, where you took Füsun; then you two would still be together."

"Did Sibel say that?"

"No, my friend. Sibel doesn't talk about such things with just anyone," said Zaim. "Don't worry."

For a time we were silent. We'd been having so much fun gossiping, but then suddenly it upset me to have my life discussed as if I'd suffered some sort of catastrophe. Zaim noticed that my spirits had fallen, so he told me about how he'd run into Mehmet, Nurcihan, Tayfun, and Faruk the Mouse all sitting together at a soup shop in Beyoğlu late one night.

Zaim may have been recounting this in the hope of luring me back into my old life, but he also enjoyed reporting all the fun he was having; I listened to him go on in detail, often exaggerating, but I didn't pay it much mind until later in the

evening, when I was at the Keskins' and I caught myself reflecting fondly on such outings. But let no one imagine that I was grieving my lost friends or my days of prowling the city. It was just that sometimes at the Keskins' dinner table it would suddenly seem to me that nothing was happening in the world, or if something was happening we were far away—that's all.

On the night we ushered in 1977 I must have succumbed to such a feeling, because I remember a point when I wondered what Zaim, Sibel, Mehmet, Tayfun, Faruk the Mouse, and all the rest were doing. (Zaim had installed electric heaters in his summer house and had dispatched the caretaker to light a fire for a big party to which he had invited "everyone.")

"Look, Kemal, twenty-seven's come up, and you have one on your card!" said Füsun. When she saw I wasn't paying attention, she put a dried bean on the 27 on my tombala card, and smiled. "Stop messing around and play the game!" she said, for a moment looking into my eyes with concern, anxiety, and even tenderness.

It was for just this sort of attention from Füsun that I was going to the Keskin house. I felt an extraordinary happiness, but it hadn't been easy to achieve. Not wanting to upset my mother and my brother, I hid my plans for spending New Year's Eve at the Keskins' by eating supper at home with them. Afterward Osman's sons—my nephews—had cried, "Come on, Grandmother, let's play tombala!" so I was obliged to play a round with them. While we were all playing, I came eye to eye with Berrin, and perhaps she, too, was struck by the pretense of this happy family tableau, because I remember that she raised her eyebrows, as if to say, "Nothing wrong, I hope?"

"Nothing," I whispered. "We're having fun, can't you see?"

Later, rushing toward the door on the pretext of going to

Zaim's party, I caught another look from Berrin, who was not fooled. But I didn't respond.

As Çetin rushed me over to the Keskin house, I was anxious but happy. The first thing I did after running up the stairs and entering—and, of course, savoring the joy of meeting Füsun's eyes—was to take out from the plastic bag some of the presents my mother had prepared for the tombala winners at our house, and to set them out at the end of the table, crying, "For the tombala winners!" Aunt Nesibe, too, had prepared her own little presents for tombala, just as my mother had done every New Year's since I was a child, and we mingled her presents with my mother's. The fun we had playing tombala that night would be repeated every New Year's for the next eight years, and Aunt Nesibe's presents would be thrown together with the ones I had brought with me.

Here I display the tombala set that we used for eight consecutive New Years at Füsun's house. For forty years, from the late 1950s to the late 1990s, my mother used a similar set to amuse first my brother, my cousins and me, and later, her grandchildren. When the New Year's Eve party had come to an end, the game was over, the presents distributed, and the children and the neighbors had begun to yawn and doze off, Aunt Nesibe, like my mother, would carefully gather up the pieces, fill the velvet pouch bag, and count the numbered wooden tiles (there were ninety in all). After also making a deck of all the numbered cards, and tying it with a ribbon, she would collect the dried beans we'd used to mark the numbers and put them into a plastic bag for the next New Year's Eve.

Now, all these years later, as I undertake to explain my love as sincerely as I can, explicating each object in turn, it seems to me that tombala captures the strange and mysterious spirit

of those days. Invented in Naples, and still played by Italian families at Christmas, the game passed, like so many other New Year's rituals and customs, from the Italian and Levantine families of Istanbul into the general population after Atatürk's calendar reform, in no time becoming a New Year's ritual.

Every year Aunt Nesibe would include among her presents a child's handkerchief. Was this to remind us of the old wisdom that "To play tombala on New Year's makes children happy, and so grown-ups should be mindful of being as happy as children on that evening"? When I was a child and an elderly guest won a present intended for a child, they would say without fail, "Oh, this is just the sort of handkerchief I needed!" My father and his friends would then wink at one another, suggesting there was a second meaning beyond our childish reach. Seeing them do this I would feel as if the grown-ups were not taking the game seriously with their sarcasm. In 1982, on a rainy New Year's Eve, when I managed to complete the top line of my tombala card first and cry "Chinko!" like a child, Aunt Nesibe said, "Congratulations, Kemal Bey," and handed me this handkerchief. And, yes, I said, "This is just the sort of handkerchief I needed!"

"It's one of Füsun's childhood handkerchiefs," said Aunt Nesibe, perfectly earnest.

My mother would include a few pairs of children's socks among the presents, as if to imply no lavish indulgence, only the furnishing of a few household essentials. Making the presents feel less like presents did allow us to see our socks, our handkerchiefs, the mortar we used for pounding walnuts in the kitchen, or a cheap comb from Alaaddin's as objects of greater value, if only for a short time. Over at the Keskin household, everyone, even the children, would rejoice not on

account of winning socks, but because they had won the game. Now, years later, it seems to me that this was so because none of the Keskins' possessions belonged strictly to a particular family member, but, like this sock, to the entire household and the whole family, while I had always imagined a room upstairs that Füsun shared with her husband, and in it a wardrobe, with her own belongings; I had many tormented dreams about this room and her clothes and the other things in it.

It was on New Year's Eve 1980 that I brought a surprise tombala present—a memento of my grandfather, Ethem Kemal: the antique glass from which Füsun and I had drunk whiskey at our last rendezvous, on the day of my engagement. Beginning in 1979 the Keskins had detected my habit of pocketing various belongings of theirs and replacing them with more valuable and expensive things, but like my love for Füsun, it was never discussed; so there was nothing remotely strange to them about a fancy glass such as one saw in Rafi Portakal's antique shop turning up among the pencils, socks, and bars of soap. What broke my heart was that when Tarık Bey won, and Aunt Nesibe produced the presents, Füsun did not even begin to recognize it as the crystal glass from the saddest day of our affair.

Every time Tarık Bey used it as his *rakı* glass over the three and a half years that followed, I would want to recall the happiness of the last time Füsun and I had made love, but like a child conditioned by some taboo to drive a certain thought from mind, I could not entertain this memory properly while sitting at the table with Tarık Bey.

The power of things inheres in the memories they gather up inside them, and also in the vicissitudes of our imagination, and our memory—of this there is no doubt. At some other

time I would have had no interest in the bars of Edirne soap in this basket, and might even have found them tawdry, but having served as tombala presents on New Year's Eve, these soaps formed in the shape of apricots, quinces, grapes, and strawberries remind me of the slow and humble rhythm of the routines that ruled our lives. It is my devout, and uncalculating, belief that such sentiments belong not just to me, and that, seeing these objects, visitors to my museum many years later will know them, too.

With the same conviction, I display here a number of New Year's lottery tickets from the period. Like my mother, Aunt Nesibe would buy a ticket for the grand drawing on December 31, to serve as one of the tombala presents. To whomever won the ticket, the others at the Keskin table, as at our home, would say almost in unison: "Oh, look at that, you're lucky tonight. . . . You're sure to win the ticket for the grand drawing, too."

By some strange coincidence, Füsun won the lottery ticket every year between 1977 and 1984. But when the winning ticket was announced on the radio and television a short while later, by an equally strange coincidence, she never won a prize, not even a refund.

At our house as at the Keskin table, the old saw about poker, love, and life was oft repeated, especially when Tarık Bey was playing cards with guests.

"Unlucky at cards, lucky at love."

Everybody said it compulsively, and so in 1981, on New Year's Eve, after we had watched the live broadcast of the grand drawing, supervised by the First Notary Public of Ankara, after it was clear that Füsun had won nothing, I drunkenly, thoughtlessly, uttered it too.

"Seeing as you've lost the lottery, Miss Füsun," I said, imitating the English gentleman hero we watched on television, "you are bound to be a winner at love!"

"I have no doubt about *that,* Kemal Bey!" said Füsun, without missing a beat, just like the clever, elegant heroines of the same films.

Conservative newspapers like *Milli Gazete, Tercüman,* and *Hergün* were forever fulminating against New Year's Eve, which, thanks to tombala, the National Lottery, all this card playing, and the ubiquitous promotions for restaurants and nightclubs, was slowly turning into an orgy of drinking and gambling. When some rich Muslim families in Şişli and Nişantaşı began buying pine trees to decorate and display in windows the way Christians did in films, I remember that even my mother felt uneasy, but because these were people she knew, she refrained from calling them "degenerates" or "infidels" as the religious press would, dismissing them rather as "harebrained."

In the run-up to New Year's there would be thousands of vendors selling tickets for the National Lottery in the streets of Istanbul, and some would go dressed as Santa Claus into the wealthy neighborhoods. One evening in December 1980, when I was choosing what tombala presents to take to Füsun's house, I saw a small mixed group of lycée students deriding one such Santa Claus, pulling his beard of cotton wool and laughing. When I drew closer I saw that this man was the janitor of the apartment house across the street; as the teenagers tugged at his cotton wool mustache, Haydar Efendi stood there silently, holding his tickets, his eyes downcast. A few years later the conservatives' anger at the drinking and gambling during the celebration overflowed when Islamists set off a bomb in the Marmara Hotel on Taksim Square, in the patisserie that had

been decorated for New Year's with an enormous pine tree. At the Keskin dinner table, I recall, the bombing was, of course, an urgent topic, but it was nothing compared to what happened to the belly dancer who was expected to appear on a New Year's Eve telecast. When Sertap, the most famous belly dancer of the day, appeared on television in 1981 despite the angry diatribes in the conservative press, we were dumbfounded, along with almost everyone else in the country. The TRT management had draped the beautiful and curvaceous Sertap in so many layers that not only were her "world-famous" belly and breasts covered, but even her legs.

"They might as well have veiled her, the disgraceful buffoons!" said Tarık Bey. Actually he hardly ever got angry at the television, and no matter how much he'd had to drink, he never shouted at the screen the way the rest of us did when sufficiently annoyed.

For some years, I'd been buying a *Saath Maarif Takvimi,* the calendar indicating the prayer times, from Alaaddin's shop to take to Aunt Nesibe's as a tombala present. On New Year's Eve, 1981, it was Füsun who won it, and at my insistence she tacked it on the wall between the television and the kitchen, but no one would pay attention to the pages on days when I wasn't there, despite there being a poem of the day, a daily note about the historical events whose anniversary it was, and a picture of a clock face, so that those who could not read and write might know the prayer times, as well as recommended recipes, historical anecdotes, and a bit of wisdom.

"Aunt Nesibe, you've forgotten to pull the page off the calendar again," I would say at the end of the evening, when the soldiers would be saluting the flag as they goose-stepped across the screen, and we would have polished off a lot of *rakı.*

"Another day is over," Tarık Bey would say. "Thank God we are not hungry or without shelter, that our stomachs are full, that we are sitting in a warm house—what more could a person want in life?"

For some reason it lifted my heart to hear Tarık Bey say these homely words as the evening wound down, and so—even though I'd noticed on my arrival that they'd forgotten to pull the page off the calendar—I would omit to mention it until the moment I was about to leave, when I was ready to hear this thanksgiving.

"The most important thing is that we're here all together, with our loved ones," Aunt Nesibe would add. As she said this, she would lean over to kiss Füsun, and if Füsun was not at her side, she would call out, "Come here, my little storm cloud, so that I can give you a kiss."

Sometimes Füsun would assume a little girl's expression and sit on her mother's lap, allowing Aunt Nesibe to spend a long time caressing her, kissing her arms, her neck, her cheeks. No matter how mother and daughter were getting along, they kept up this ritual through the eight years. As they laughed and kissed and hugged, Füsun knew full well that I was watching her, but she never looked back at me directly.

There were times, too, when, after Aunt Nesibe pronounced her wisdom about "loved ones," Füsun would not go to her mother's lap, but instead would take a neighbor's child, a fast-growing boy called Ali, onto her lap, and after caressing him and showering him with kisses, she would say, "Time for you to go home now, or else your parents will get angry at us for keeping you." Finally, there were the occasions when Füsun was in a bad mood, because she and her mother had argued that morning, and at Aunt Nesibe's plea, "Come over here, my girl," she would say,

"Oh, Mother, please!" leaving Aunt Nesibe to say, "Then at least pull the page off the calendar, so we don't get our days confused."

This would leave Füsun all smiles suddenly, and after getting up to pull the page off the *Saatlı Maarif Takvimi,* she would read out the day's poem and the recipe in a loud semitheatrical voice and laugh. Aunt Nesibe would comment, "Oh, what a good idea, let's make quince and raisin compote, it's been ages," or, "Yes, they're suggesting artichokes, but you can't pick artichokes when they're still small enough to fit in the palm of your hand." Sometimes she would ask a question that unsettled me: "If I made a spinach pastry, would you eat it?"

If Tarık Bey didn't hear her or was too gloomy to answer, then Füsun would turn to scrutinize me in silence, with a sadistic curiosity based on the expectation that I would not dare presume the prerogative of a full member of the family by telling Aunt Nesibe what to cook.

I knew how to rescue myself from this difficult bind, saying, "Füsun loves savory pastries, Aunt Nesibe, so you should definitely make it!"

Sometimes Tarık Bey would ask his daughter about the important historical dates on the page she'd torn off the *Saatlı Maarif Takvimi,* and she'd read aloud: "On September 3, 1658, the Ottoman army began its siege of Doppio Castle." Or "On August 26, 1071, after the Battle of Malazgirt, Anatolia opened its doors to the Turks."

"Hmmmm, let's have a look at that," Tarık Bey would say. "They've misspelled 'Doppio.' Here, take it back, and read us the saying of the day."

"Home is where the heart is, and where we fill our stomachs," Füsun said, reading in a mocking voice until our eyes met and she turned serious.

Suddenly we all fell silent, as if each was pondering the deeper meaning of those words. After Füsun had finished reading and had put the leaf from the calendar to one side, I picked it up, pretending I wanted to read it for myself, and when no one was looking, I put it into my pocket.

Of course, the pilfering wasn't always so easy, but I have no wish to make myself more risible by going into the full details of my difficulties in acquiring so many objects of such varying size and preciousness from the Keskin household. Let an example from the end of New Year's Eve 1982 suffice: Before I left the house with the little handkerchief I'd won at tombala, little Ali, the neighbor's boy, who grew more in awe of Füsun with every day, came up to me and in a manner quite unlike his usual naughty self he said, "Kemal Bey, you know that handkerchief you won . . ."

"Yes?"

"That's Füsun's hankie from when she was a child. May I see it again?"

"Oh, I have no idea where I put it, Ali, my boy."

"But I know," the brat replied. "You put it in this pocket, so it must be there."

He almost managed to invade my pocket with his hand, but I took a step backward. The rain was pelting down outside, and everyone had gathered at the window, so no one else heard what the child said.

"Ali, my boy, it's getting very late, and you're still here," I said. "Your parents will blame us."

"I'm going, Kemal Bey. But are you going to give me Füsun's hankie?"

"No," I whispered with a frown. "I need it."

Getting Past the Censors

I'D KNOWN for years, from the stories in the news, that all films, domestic and foreign, had to clear the state censors before theatrical release, but before setting up Lemon Films I had no notion of their power in the film business. The papers mentioned the censors only when they banned films much esteemed in the West, as with Lawrence of Arabia, categorically banned for insulting Turkishness, and Last Tango in Paris, trimmed of its sex scenes to make the film more artistic, and more boring than the original.

There was one partner of the Pelür Bar who'd been working at the board of censors for many years; Hayal Hayati Bey was a frequent visitor to our table, and one evening he told us that, actually, he believed in democracy and freedom of expression more fervently than any European, but that he could not allow those who would deceive our innocent and well-meaning nation to exploit the cinematic arts toward that foul end. Like so many other Pelür habitués, Hayal Hayati also worked as a director and a producer, and said he'd accepted the board position so as "to drive the others crazy!"—a claim he punctuated as he did every joke, by giving Füsun a wink. Hayal Hayati got his nickname (meaning "Dream") from the Pelür crowd because he used that term so often when making his rounds of the tables, talking about the films he was going to make. Every time he came to ours he would look soulfully into Füsun's eyes, and he would

tell her about one of his dream films, asking her each time for an "immediate and sincere" appraisal devoid of "commercial considerations."

"That's a beautiful idea for a film," Füsun would say each time.

"When we make it you're going to have to agree to star in it," Hayal Hayati would reply, in the manner of a man who always acted instinctively and from the heart. We were discovering that it would take some time for us to get our first film off the ground.

According to Hayal Hayati, the Turkish film industry was free to do more or less what it liked, provided that films did not include lewdness or sex scenes, or unacceptable interpretations of Islam, Atatürk, the Turkish army, the president, religious figures, Kurds, Armenians, Jews, or Greeks. Of course, he'd smile when he said it, because for half a century the members of the board of censors did not just obey the dictates of the state, banning any subject that made those in power uneasy, but had gotten into the habit of acting on their own agendas, banning whatever happened to annoy or offend them, and like Hayal Hayati, deriving considerable pleasure when using their power arbitrarily.

Hayati Bey told stories about the films he had banned during his time on the board with the relish of a hunter bragging of the bears he'd caught in his traps. We laughed at his stories as much as anyone. For example, he'd banned one film about the adventures of a hapless security guard on the grounds that it "degraded Turkish security guards"; and a film about a wife and mother falling in love with another man because it "insulted the institution of motherhood"; and a film about the happy adventures of a little truant was prohibited for "alienating

children from school." Unfortunately the first film Hayati Bey made after his term on the board ended was itself also banned, "and, sadly, it was a capricious decision motivated by personal matters." Hayati Bey would get very angry whenever it was mentioned. The film, which had been very costly to make, was banned in its entirety on account of a dinner scene in which a man became enraged at the family dinner table because there was no vinegar in the salad, and the censors felt called to "protect the family, the foundation of society."

As he sat with us explaining how this scene and two other family quarrels, likewise offensive to the censors, had been taken in all innocence from his own life, it became clear that what had really upset Hayal Hayati was being betrayed by his old friends at the board of censors when they banned his film. If we were to believe what we were told, one night he'd gone out on a bender with them and ended up brawling in an alleyway with his oldest friend on the board, ostensibly over a girl. When the police picked them up off the muddy street and carted them to Beyoğlu Police Station, neither lodged a complaint, and so were encouraged by the police to kiss and make up. But subsequently, to win approval for theatrical release and save himself from bankruptcy, Hayal Hayati, having still influence enough to win a second consideration, was obliged to remove every quarrel remotely demeaning to the institution of the family, with the exception of the one in which the brute of a son beat up his younger sister at the behest of his devout mother; with this editing, the film passed the board of censors.

Hayal Hayati remained convinced that it was "a relatively good thing in the end" if censorship led only to the cutting of scenes deemed objectionable by the state. For even a heavily cut film could be shown in the cinema, and if it still made sense,

then you could make back your investment. The worst possible outcome was an outright ban. To prevent this disaster, the state was prevailed upon kindly to divide the censorship process into two stages.

In this first phase one would send the screenplay to the board for approval of the subject and the content of the scenes. As was typical of all situations involving work for which citizens had to seek "permission" from the state, a complex bureaucracy of permits and bribery had developed, which in turn gave rise to a network of agents and agencies offering to guide a citizen's application. I myself recall many times during the spring of 1977, sitting across from Feridun in the offices of Lemon Films, smoking cigarettes as we considered at length which agent was right for *Blue Rain*.

There was a hardworking, well-liked Istanbul Greek known as Daktilo Demir, or Demir the Typewriter. His manner of inoculating a screenplay so as not to offend the censors was to rewrite it, on his own famous typewriter, and in his own style. This hulk of a man, a former boxer (he'd once worn the uniform of the Kurtuluş team), was in fact a very refined man possessed of an elegant soul. He knew better than anyone how to make a script acceptable, rounding off its sharp corners, softening into innocence the harsh divisions between rich and poor, worker and boss, rapist and victim, virtue and evil, and offsetting the effect of any harsh or critical pronouncement that the hero might make at the end of the film—words likely to offend the censors but delight the audience—by the addition of a few bromides about the flag, the nation, Atatürk, and Allah. His greatest gift was his flair for taking the sting out of the most vulgar and extreme moments in the screenplay: He would always find a light and witty way of returning it to the innocent

charm of everyday life. Even the big firms that gave regular bribes to the board of censors would entrust their screenplays to Daktilo Demir, even in the absence of unsuitable material, just so that he could inject into them the sweet aura of childish magic that was his trademark.

When we discovered how much we owed to Daktilo Demir for the most lyrical moments in those films that had so affected us the previous summer, the three of us—Feridun thought Füsun should come, too—decided to pay a call on the "Screenplay Doctor's" home in Kurtuluş. In a room filled with the ticking of an enormous wall clock, we saw the old Remington on which he had earned his legendary name, and we felt the same distinct magical aura as in the films he'd rewritten. Demir Bey welcomed us graciously, saying that he would be delighted if we left our screenplay with him, so that if he liked it he could recast it on his typewriter into a version sure to pass the censors. Showing us the stack of project files between the plates of kebab and fruit he had set out, he went on to disclose that the process would not be quick considering his vast workload; gesturing at his twenty-something twin daughters, sitting at the end of the enormous dining table, gazing myopically through their owlish glasses at the screenplays their father couldn't find time for, he allowed, with paternal pride, that they had become "even better" than he was at getting scripts into shape. Füsun was very pleased when the more buxom of the twins remembered her as one of the finalists in the Milliyet National Beauty Contest from years earlier. What a shame it was that so few others did.

The same girl would deliver us back the screenplay, rewritten and polished specially for Füsun, and accompanied by kind words of admiration ("My father says this is a real European art

film"), but by then three more months had passed. Füsun met the delay with pouts and occasionally cross words, compelling me to remind her that her husband's work had been just as slow.

Few opportunities to speak to Füsun privately, away from the table, occurred during my evening visits to Çukurcuma. But toward the end of each evening we would go together to Lemon's cage to make sure the bird had enough food and water and some squid cartilage to peck on (I bought this in the Mısır Çarşısı, or Spice Bazaar). But this was hardly ideal, and we had to whisper.

From time to time an easier opportunity would present itself: When she wasn't spending time with the neighborhood friends she hid from me (mostly unmarried girls or newlyweds), or going with Feridun to film haunts, or doing the housework, or helping her mother with the sewing work Aunt Nesibe still took in, she would go by herself to paint birds. She put it so prosaically, but I sensed the passion behind this amateur's nonchalance, and her paintings made me love her all the more.

This hobby began when a crow landed on the ironwork balcony of the back room on the lower floor, a crow just like those that had landed on the balcony in the Merhamet Apartments: When Füsun approached it, the bird had not flown away. The crow returned on other occasions, and again instead of flying off it just sat there, staring at Füsun from the corners of its bright, scary eyes to the point of intimidating her. One day Feridun took a picture of the crow, a small black-and-white photograph I display here, which Füsun had enlarged for use as her model for a painstaking watercolor that I liked very much. She continued with a pigeon that came to perch on the same iron balcony, and then a sparrow.

On nights when Feridun was not at home, before supper or during a long commercial break, I would ask Füsun, "How's your painting coming along?"

If she was in a good mood, she'd say, "Let's go and have a look at it," and we would go into the back room, which would be strewn with Aunt Nesibe's sewing things, her cloth, and her scissors, and in the pale light of the chandelier we would study the picture together.

"It's truly beautiful, very beautiful," I'd say. My words were no less sincere for the unbearable longing I felt to touch her back, or just her hand. I'd been buying gorgeous "European-made" paper, notebooks, and watercolor sets from a stationery store in Sirkeci as offerings to her.

"I'm going to paint all the birds of Istanbul," Füsun would say. "Feridun's taken a picture of a sparrow. That's next. I'm just doing this for myself, you know. Do you think an owl might ever perch on the balcony?"

"You should definitely mount an exhibition someday," I said once.

"Actually, what I'd like to do is go to Paris and look at the pictures in the museums there," said Füsun.

Sometimes she was irritable and downcast. "I haven't been able to paint for the last few days, Kemal," she'd say.

It was always clear that her low spirits were owing to the film's delay: Not only had we failed to start filming; we'd not even managed to get an acceptable screenplay. Sometimes, having added almost nothing to a picture since the last viewing, Füsun would lead me into the back room to talk about the film.

"Feridun is so unhappy with Daktilo Demir's rewrite, he's doing it all over," she said one night. "I told him myself, but you

have to tell him, too: He can't take too long on this. We just have to get this film of mine started."

"I'll tell him."

Three weeks later we had again gone into the back room. Füsun had finished her crow and was now slowly painting the sparrow.

"It's really coming along," I said after admiring it for a long time.

"Kemal, I finally realize that it's going to be months before we can start shooting Feridun's art film," said Füsun. "The censors don't just wave that sort of film through; they're slow and suspicious. The other day at the Pelür, Muzaffer Bey offered me a role. Did Feridun tell you?"

"No. So you've been going to the Pelür? Be careful, Füsun, those men are wolves, every last one of them."

"Don't worry, Feridun is careful about that, we both are. But this is a very serious offer."

"Have you read the screenplay? Is this really something you want?"

"Of course I haven't read the screenplay. If I agree, they'll have a screenplay written for me. They want to meet me."

"What's the plot?"

"What difference does that make, Kemal? We're talking about one of Muzaffer's romantic melodramas. I'm thinking of accepting."

"Don't rush into this, Füsun. These are bad people. Feridun should go talk to them for you. They could have evil intentions."

"What sort of evil intentions?"

I didn't want to continue this conversation; I went back to the table.

I could easily imagine a skilled director like Muzaffer Bey using Füsun as the main attraction in a commercial melodrama and making her famous from Edirne to Diyarbakır. With her beauty and kindness, she was sure to enchant audiences— the truants, the unemployed, the daydreaming housewives, and the sex-starved single men—who packed into the airless cinemas that stank of the coal stoves heating them. It was not long before it occurred to me that if her dream came true and she became a star, she would take to abusing not just me but Feridun, too, possibly even leaving us both. I couldn't bear to imagine her as the sort of woman who would ruthlessly manipulate magazine writers in pursuit of fame and fortune. But in the looks of the Pelür crowd, I saw a lot of people who would do anything to part "us"—and I use that word because it was the first to enter my mind. If Füsun became a famous film star, it would only magnify my love for her, and with it my fear of losing her.

Füsun's cross looks persisted to the end of the meal, and knowing my lovely was thinking not about me or even her husband, I became anxious, then frantic. I had long since calculated that if Füsun were to run off with some director or famous actor she met at one of these bars, abandoning me and her husband, my pain would be astronomically greater than anything I'd suffered in the summer of 1975.

How much did Feridun understand the danger besetting us both? He must have been at least vaguely aware of the commercial producers plotting to carry her off to a distant, depraved world, the hazards of which I was at pains to remind him—in veiled language—while hinting that the art film would cease to have meaning for me were Füsun to degrade herself by playing in some dreadful melodrama.

Back at home, drinking *rakı* alone, in my father's chair, I would wonder anxiously whether I had revealed too much.

At the beginning of May, as outdoor weather and the filming season approached, Hayal Hayati came to Lemon Films to tell us that a semi-famous young actress lay in the hospital following a beating at the hands of her lover, and that this unfortunate development also proposed a wonderful opportunity for a beautiful and cultivated girl like Füsun, but Feridun, now well aware of my misgivings, courteously declined the offer, and I don't think he ever even mentioned it to Füsun.

Evenings on the Bosphorus, at the Huzur Restaurant

SOMETIMES THE things we were obliged to do to keep Füsun away from the wolves and jackals besieging her on our every visit to the Pelür were less a source of distress than of mirth and even of moral uplift. When, for instance, we had heard that the White Carnation, the gossip columnist readers will remember from my engagement party at the Hilton, planned to write a piece about Füsun, in the "a star is born" genre, we concocted copious evidence of what a cad he was, and so she conspired with us to avoid him like a leper. When a journalist and self-described poet sat down at our table to inscribe a poem that had welled up from his innermost parts, and sweetly dedicated the inspiration to Füsun, I managed to ensure the timeless ode would not outlive that moment or have a single other reader by furtively instructing the elderly waiter Tayyar to toss it in the trash. Later, when Feridun, Füsun, and I would find ourselves alone after such episodes, we would merrily compare notes, and, although each of us withheld details according to his or her purposes, we would laugh in genuine complicity.

After a few drinks, most of the film people and journalists and artists who frequented bars and taverns like the Pelür were given to weepy self-pity, but after only two drinks Füsun would become as cheerful as a child, as chirpy as a flighty girl, and on our visits to summer cinemas and Bosphorus restaurants, I sometimes imagined that the reason for her happiness was

that the three of us were together. Having long tired of all the gossip and wisecracks at the Pelür, I now seldom went there, and when I did it was to spy on those surrounding Füsun, and if possible, before the evening's end, to extract Füsun and Feridun from the bar to drive with Çetin on a dinner excursion to the Bosphorus. Füsun would sulk over leaving the Pelür early, but once in the car she'd have such a good time chatting with Çetin and the rest of us that I'd decide, just as I had in the summer of 1976, that going out to eat together more often would do us all good. But first I had to persuade Feridun. It was out of the question for Füsun and me to go gallivanting to any restaurant on our own, like lovers. As Feridun resisted being dragged away from his film friends, I enlisted Aunt Nesibe to join the party and prevail on Füsun and her husband to come eat fish at Urcan in Sariyer.

In the summer of 1977 we cajoled Tarık Bey into joining us as well, and as he warmed to the idea, the entire team of television-watching Keskins would head out to eat on the Bosphorus, with Çetin at the wheel. I would like every visitor to our museum to find these outings as pleasant as I did, so I shall go into some detail here. After all, isn't the purpose of the novel, or of a museum, for that matter, to relate our memories with such sincerity as to transform individual happiness into a happiness all can share? That summer these excursions to the *meyhane*s of the Bosphorus fast became a custom we all relished. In the years that followed, whether it was winter or summer, we would, at least once a month, get into the car, as excited as wedding guests, and go off to a restaurant or one of the large, famous *gazino*s, to listen to the melodies and aged crooners that Tarık Bey enjoyed so much. There were, of course, intervals when we'd fail to relish our pleasures—moments of tension

or confusion between me and Füsun, anxiety that our film work would never begin—and these joyless spells would last for months until unexpectedly we would be driving around in the car together, and we would notice how delighted we actually were to be together, how close we had become and how much we loved each other.

In those days, the most popular place along the Bosphorus was Tarabya, with its line of crowded restaurants spilling across the sidewalks, and the tombala men wandering among the tables, along with the mussel vendors, the fresh almond vendors, the photographers who took your picture and brought back the developed shots within the hour, the ice cream men, the bands of musicians playing Ottoman music and the traditional singers who performed in most of the restaurants. (Back then you wouldn't see a single tourist.) I remember how Aunt Nesibe laughed admiringly at the speed and daring of the waiters as they darted across the narrow road that divided the restaurants from the tables, weaving their way through the traffic with their heavy trays laden with food.

On our first excursion together we went to a relatively modest restaurant called Huzur (peace), which happened to have a free table, and which Tarık Bey had instantly taken to, because of its proximity to the flashy Mücevher Gazino next door, which meant that one could sit in the restaurant and hear the old Turkish songs being sung "from a distance and for free." The next time, when I proposed that we could better hear the singers if we were actually sitting in the Mücevher itself, Tarık Bey said, "Oh no, Kemal Bey! Why pay to hear that awful band, and that woman who sounds like a crow?" but for the rest of the meal, he gave all his attention, sometimes joyful and sometimes angry, to the music blaring from the *gazino*. He

would correct the "tuneless, tone-deaf" singers in a loud voice, and finish their lines before they could, just to prove he knew the lyrics, and after the third glass of *rakı* he would close his eyes and his head would sway to the music with deep spiritual rapture.

On our Bosphorus excursions from the house in Çukurcuma, to some extent we threw off the roles we played indoors, and that made me relish our trips. Füsun would sit right next to me in the car and at the restaurant, as she never did at the house. And as we sat surrounded by tables, no one noticed if my arm pressed up against her, and as her father listened to the music with his eyes shut and her mother watched the shimmering lights of the Bosphorus in the vaporous darkness, we would whisper to each other over the din, chatting about it didn't matter what—the food, the beauty of the evening, how endearing her father was—as tentatively as two bashful young people who had just met and only recently discovered how a boy might flirt with a girl, or form a relationship with her, as they did in Europe. Füsun was otherwise liberated, too; while ordinarily averse to smoking in front of her father, in Bosphorus restaurants she would puff away on her cigarettes like some formidable European career woman. I remember once, having decided to try our luck, we bought a ticket from a rascally tombala man in dark glasses, and when we didn't win a prize, we glanced at each other and both said, "Unlucky at cards . . . ," inducing in both of us a terrible embarrassment and then elation.

Much as this happiness derived simply from being out of the house, and the twin joys (extolled by many an Ottoman court poet) of drinking wine and sitting beside one's beloved, there was also the diversion of the street crowds, as traffic jams

on the road between the restaurants and the tables provoked quarrels between the people at the tables and the people in the cars: "Why don't you look at the road instead of the girl," someone would say, or "Why did you flick your cigarette at me?" As the evening progressed, drunken revelers would begin to sing, and tables would exchange applause and lusty cries. Suddenly a besequined "oriental" dancer would dash from one restaurant to the next, on her way to do a show, and as her costume and bronzed skin caught the car lights, drivers would lean ecstatically on their horns, like ships blowing their whistles on November 10 to mark the moment of Atatürk's death. On a warm night the wind might suddenly change direction, and all at once the dust and dirt overlaying the rubbish strewn on the cobblestone sidewalk along the shore—the nuts and shells and watermelon rinds and wastepaper and newspapers and soda caps and corncobs and seagull and pigeon droppings and plastic bags—would come to life, and all at once the trees across the street would begin to rustle, and Aunt Nesibe would say, "Beware, the dust has kicked up, children, don't let it get on your food!" and she'd shield the plates with her hands. Then the wind would suddenly change direction again and rush in from the northeast, bringing us cool air that smelled of iodine.

Toward the end of the evening, when people started arguing with the waiters, challenging their bills, and there was singing at every table, Füsun and I would press our arms and legs and hands together even closer, so close sometimes that I thought I would faint. Sometimes in such happiness I couldn't resist stopping a photographer to have him take our picture, or a gypsy woman to tell our fortune as if we had only just met. As I sat there pressed against Füsun, I would imagine the day we

married, I would gaze at the moon and lose myself in dreams, but no sooner had I drunk another *rakı* on the rocks than I would notice that I had grown hard just as in a dream, but now trembling with pleasure I would not panic, for I felt as if I— we—had become like our ancestors in heaven, souls cleansed of guilt and sin, and I would abandon myself to my dreams, my delights, and the bliss of sitting next to Füsun.

I cannot say why we were able to get so much closer outside the house, in the middle of a crowd and under the nose of her parents, than we could at the house in Çukurcuma. But it was during those evenings that I was able to imagine us as a couple living in harmony, and to see that—in the parlance of magazine writers—we "looked good together." It was not pure imagining. I remember with utter contentment how once, as we were talking, she asked, "Would you like a taste of this?" and with my fork I sampled the little dark meatballs on her plate, and how, on another evening, again at her encouragement, I tasted her olives, whose pits I display here. On another evening we turned our chairs around to have a long and friendly conversation with a young couple at the next table (to whom we were attracted, I believe, because they resembled us: the man in his thirties with brown hair, the girl twenty, dark-haired, and fair-skinned).

At the end of that same evening I ran into Nurcihan and Mehmet, coming out of Mücevher Gazino, and without mention of our mutual friends we at once launched into a serious discussion of "which Bosphorus ice cream parlors still open at this hour" was best. As I said my good-nights, I pointed in the direction of Füsun, now getting into the Chevrolet with her mother and father, for whom Çetin held the door, and I said that I had taken some distant relatives out for a tour of the Bosphorus. Let me take this opportunity to remind those

who visit my museum in later years that during the fifties and sixties there were very few private cars, and that those rich enough to import cars from America and Europe often took their relatives and acquaintances on tours of the city. (When I was a child, I remember my mother sometimes turning to my father to say, "Saadet Hanım wants to go out in the car with her husband and children. Would you like to come, too, or shall I just take them out with Çetin?" Sometimes she would just say "the chauffeur." My father's stock response was, "God no! You can take them out. I'm busy.")

On our way back in the car we were in the habit of singing all together, and it was always Tarık Bey who got us started. First he would hum an old tune, and as he tried to remember the words, he'd ask for the radio to be turned on, and as I searched for a familiar song he would begin to sing some old melody that had drifted over to us from the Mücevher Gazino that evening. Sometimes, as I was searching for a station, we would hear voices from distant countries speaking in strange tongues, and for a moment we would be silent. "Radio Moscow," Tarık Bey would say then, in an enigmatic tone. Then as it came back to him, he would sing the first words of a song, and before long Aunt Nesibe and Füsun would join him. As we sped under the dark shadows and great plane trees of the Bosphorus road, I listened to the concert in the backseat, and, turning around, I would try to harmonize as they sang "Old Friends" by Gültekin Çeki, though—to my embarrassment—some of the words eluded me.

Whenever we were singing together in the car, or laughing and dining together in a Bosphorus restaurant, the happiest among us was in fact Füsun, and yet whenever a chance presented itself she still yearned to see her film friends from

the Pelür. For this reason I would continue to depend first on persuading Aunt Nesibe. For her part she never wanted to miss an opportunity to throw Füsun and me together. Another ploy was to entice Feridun, once even including Yani, a cameraman friend that Feridun was loath to leave behind. Feridun was using the Lemon Film facilities to make a few commercials with Yani, and I didn't object, thinking it prudent to let them make a little money, though I did sometimes ask myself how I would manage to see Füsun if one day Feridun actually made a lot of money, and moved out of his in-laws' house, and went off with his wife to live elsewhere. Sometimes I would realize with shame that this consideration underpinned my desire to get along with Feridun.

Aunt Nesibe and Tarık Bey did not come with us to Tarabya that night, so there was no listening to the singers in the *gazino* next door, and no singing on the way home. Füsun sat next to her husband, not me, and immersed herself in film world gossip.

It was the memory of that miserable evening that prompted me, on another occasion, when I was leaving the Pelür with Füsun and Feridun, to tell a friend of Feridun's that there was no room in the car, as we would be picking up Füsun's parents for dinner. I may have phrased it a bit brusquely. The man had a large, handsome forehead; I saw surprise, even fury, in his dark green eyes, but I swept him from my mind. Afterward, having arrived in Çukurcuma, I was able to bring Aunt Nesibe and Tarık Bey around to the idea, with a few words and a little help from Füsun, and then off we went to the Huzur Restaurant in Tarabya.

We had been sitting there eating and drinking for some time, I remember, when I realized there was not peace at that table,

for Füsun's tense demeanor had set the tone for the evening, which would bring me no pleasure. I had just turned around to see whether there might be any tombala men to amuse us, or hawkers of fresh shelled walnuts, when I saw the man with the dark green eyes sitting two tables away. He was with a friend, watching us as he drank. Feridun noticed that I'd seen them.

"Your friend must have jumped into a car and followed us," I said.

"Tahir Tan is not my friend," said Feridun.

"Isn't he the man who asked to come with us as we were leaving the Pelür?"

"Yes, but he's not my friend. He poses for Turkish *photoroman*s, and he plays in blood-and-thunder films. I don't like him."

"Why has he followed us?"

For a moment no one spoke. Füsun, sitting next to Feridun, had heard what we'd said and was growing uneasy. Tarık Bey was lost to the music, but Aunt Nesibe had been listening to us, too. Just then I guessed from Feridun's and Füsun's expressions that the man was approaching us, so I turned around.

"Do excuse me, Kemal Bey," Tahir Tan said to me. "I did not mean to disturb you. I wish to speak to Füsun's mother and father."

He assumed the demeanor of a handsome, well-mannered youth who has seen a girl he likes at an officer's wedding, and who has come to ask her parents for permission before inviting her to dance, following the advice given in newspaper etiquette columns.

"Excuse me, sir, there is something I want to discuss with you," he said as he approached Tarık Bey. "There's a film that Füsun . . ."

"Tarık, look, the man is trying to tell you something," said Aunt Nesibe.

"I'm addressing you, too, madam. You're Füsun's mother, are you not? And you, sir, are her father. Do you know about this? Sir, there are two important producers, Muzaffer Bey and Hayal Hayati—both prominent figures in the Turkish film industry—who have offered your daughter important roles. But we have been given to understand that you would not give your consent because the films included kissing scenes."

"It's nothing like that," Feridun said coldly.

As always in Tarabya, the noise level was very high. Tarık Bey had either not heard, or else—like so many Turkish fathers who find themselves in this situation—acted as if he hadn't.

"Nothing like what?" Tahir Tan said, his voice rough now.

It was clear to all of us that he'd had a lot to drink and was spoiling for a fight.

"Tahir Bey," Feridun said carefully, "we're out for a family dinner this evening, and we have no desire to discuss film business."

"But I do. . . . Füsun Hanım, why are you so afraid? Can't you just say you want a role in this film?"

Füsun looked away. She was smoking calmly and taking her time. I stood up. Feridun did likewise. We both stepped into the space between the man and the table. At the tables surrounding ours, heads began to turn in our direction. We must have assumed the fighting cock stance that Turkish men assume before a fight. No one wanted to miss the drama; all around us, curious, bored drunks settled in for a good show. Tahir's friend rose from their table to approach us.

An elderly waiter who'd seen many years of bar brawls intervened. "Come on now, gentlemen, let's not all crowd in here. Please move back." He added, "We've all had a lot to drink, and tempers will flare. Kemal Bey, we're bringing out your fried mussels and salted fish."

Lest they misunderstand, let me inform visitors who come to our museum centuries hence—those happy generations of the future—that in those days Turkish men seized even the tiniest excuse to come to blows wheresoever they found themselves—be it a coffeehouse, a hospital queue, a traffic jam, or a football match, and that huge dishonor attached even to the appearance of shrinking away from a confrontation. Avoiding a fight or cowering was regarded as dishonor without degree.

Tahir's friend came from behind and put his hand on Tahir's shoulder; he took him away, making as if he wanted them to "be the ones who kept their dignity." And Feridun took *me* by the shoulder, as if to say, "What's the use, anyway?" and he sat me down. I was very grateful to him for doing this.

As the north wind blew, and a ship's searchlight swept through the night, lighting up the choppy waves, Füsun carried on smoking, as if nothing had happened. I looked into her eyes for the longest time, and not once did she look away. There was something challenging, almost haughty, about the way she looked at me; I was suddenly aware that the change she had undergone over the past two years was far bigger and more dangerous than this little trouble we'd had with some drunken actor—and so were her expectations.

Tarık Bey added his voice to the song floating over from the Mücevher Gazino, slowly swaying his head and his *rakı* glass as he intoned Selahattin Pınar's "Why Did I Ever Love

That Cruel Woman." We all joined in, knowing that to share the sorrow of the song would do us all some good. Much later, around midnight, while driving home, singing all together in the car, singing still, it seemed as if we'd utterly forgotten the unpleasant incident.

To Look

But I had not forgotten Füsun's treachery. It was clear that having noticed her at the Pelür, Tahir Tan was besotted with her and had persuaded Hayal Hayati and Muzaffer Bey to offer her film roles. Or, even likelier, having noticed Tahir Tan's interest in Füsun, Hayal Hayati and Muzaffer Bey had offered her roles. After Tahir Tan had backed off, Füsun, acting like a cat that had just tipped over a bowl of milk, confessed that she had, at the very least, encouraged them.

After that night at the Huzur Restaurant in Tarabya in the summer of 1977, Füsun was banned from all the film world's Beyoğlu haunts, and most particularly the Pelür; and her resentment of this regime, whether imposed by her husband, her father, or both, precipitated a sullen fury when I next visited.

Afterward, at the Lemon Films offices, Feridun clarified that Aunt Nesibe and Tarık Bey both had been frightened by the episode. And so not only was the Pelür off limits; for a time they'd even restricted her contacts with her neighborhood friends. She could not go out without asking her mother's permission, as if still unmarried. Feridun tried to soften Füsun's anger over this draconian but short-lived imprisonment by promising that he, too, would stay away from the Pelür. But it was clear to us that getting the art film under way was our only hope of restoring her spirits.

The film, however, was still in no fit state to pass the board of censors, and neither did it seem to me that Feridun could remedy the situation any time soon. In the back room, where she had now begun a painting of a seagull, Füsun revealed to me that she was perfectly and painfully aware of this fact, and I was sad for her, and yet the spectacle of her willfulness moved me to ask only rarely how her painting was going. It was only if I happened to spy her in a good mood, and thus felt certain our conversation would be of painting seagulls, that I followed her into the back.

Most of the time I would arrive to find a listless Füsun and sit down to feel her angry eyes on me. Sometimes she seemed convinced of being able to communicate in eloquent detail through looks alone, and she would fix me in a very particular way that I could only begin to decipher. Even if we'd spent four or five minutes in the back room, gazing at the painting, most of the evening would be devoted to those looks, and my efforts to make sense of them, to figure out what she thought of me, her life, and her feelings. I had once been quite disdainful of such games, but now I had given myself over to the subtleties of nonverbal communication, and before long, had become a very skilled practitioner.

As a young man, out with my friends at the cinema or sitting with them at a restaurant, in springtime on the top deck of a ferry, headed for the islands, I remember whenever one of us said, "Hey, look, those girls over there are staring at us," while the others became eager I was suspiciously indifferent, knowing that, in fact, girls only rarely dared to glance at men in crowded places, and if they happened to come eye to eye with a man, they would look away immediately, as one might avert one's eyes from the sun, never to cast their eyes again in

that direction. During those first months after I'd begun to visit the Keskin household at suppertime, if we were all sitting at the table watching television and at some unexpected moment our eyes met, it was that very sort of aborted look Füsun gave me. It was, I thought, the way a Turkish girl might encounter a stranger in the street, and I didn't like it. Later I began to see this as Füsun's effort to provoke me, but at the time I was still new to the art of exchanging glances.

In the old days, even in Beyoğlu, regardless of whether her head was covered or not, a woman walking in the streets of Istanbul or wandering its shops or markets would not merely avoid the direct gaze of a man, she could hardly be seen casting her eyes in a man's direction. On the other hand—apart from the majority who still lived by arranged marriages—I was young enough to know plenty of couples who having caught each other's eye had proceeded to become acquainted, and eventually got married. "In the beginning we communicated with our eyes," they'd invariably say. And even my mother insisted that before their marriage had been arranged, she and my father had first seen each other from afar at a ball attended by Atatürk, and that, having warmed to each other, they came to an understanding not by talking, but by looking. Though my father never contradicted her account, he once confided that while they had indeed both attended a ball with Atatürk, he sadly had no recollection of the sixteen-year-old in her fashionable dress and white gloves.

It was perhaps because of having spent part of my youth in America that it took me so long to understand what it meant for the sexes to come eye to eye in a world like ours, where tradition dictated that a woman should never meet or come to know a man outside her family circle. It wasn't until my thirties,

when I'd met Füsun. . . . But when I'd discovered this reality I knew the worth of what I'd then come to understand, and how deep these currents were. The look Füsun gave me was the look women gave in the old Persian miniatures, and now to be observed in the love scenes and *photoroman*s of the day. When I was sitting across from her at the table, my attention was not on the television but on reading the looks that beauty cast in my direction. Perhaps because she'd discovered how much pleasure I derived from the exchange and wanted to punish me, but whatever the reason, after a time, whenever our eyes met, Füsun's eyes would dart away, as if she were some shy young girl.

At first I thought she was informing me that she had no desire to remember or to remind me of what we'd been through together, not during a family meal, and that her resentment at our having not yet made her a star burned hot as ever. I felt she had every right to such feelings. But later I came to resent such strenuous avoidance of my gaze as absurd pretense: After all our happy lovemaking, how could she represent herself as a shy virgin confronting a man she did not know? If no one was paying attention to us as we ate supper, and having given ourselves over to television, we had been moved to tears by the spectacle of lovers in some sentimental series saying their last farewells, a chance meeting of our eyes would bring me great joy, and I would have gladly acknowledged having gone there that evening just to look into her eyes. But Füsun would pretend not to notice the happiness of that moment; she would avert her gaze, and this would break my heart.

Did she realize that I was there because I could not forget how happy we'd been together, once upon a time? Eventually I came to feel that she understood from my expressions that

I was immersed in such thoughts, and feelings of hurt. Or perhaps I was just imagining this.

This ambiguous realm in the cleft between the felt and the imagined was my second great discovery under Füsun's tutelage in the intricate art of exchanging glances. Of course, staring was the only way to communicate when there were no words. Everything that was expressed, everything that was to be understood, though, was deeply rooted in an ambiguity we found entrancing. If I'd been unable to understand something Füsun had meant to say with her look, in time I would come to see that the thing the look meant to express was the look itself. There were, at first, those rare moments when a deep and powerful emotion registered on her face, and, sensing her anger, her determination, and her stormy heart, I would be thrown into confusion, feeling as if the ground had shifted beneath my feet. But later, when something on television evoked the happy memories we shared—for example, a couple kissing as we had once done—and my attempt to catch her eye was met with her looking away, and even turning her head, I would become enraged. Out of such emotion did I master the habit of staring at her insistently, stubbornly, without blinking.

I would gaze straight into her eyes and study her carefully, as if there were all the time in the world. Of course, at the dinner table these looks of mine could never last longer than ten or twelve seconds, with my boldest attempt persisting for half a minute. Modern generations may well consider what I was doing as a form of harassment. Because by my insistent looks I was laying out on her family's dinner table the intimacy, the love we had formerly shared, and which Füsun now wished to hide, or perhaps even forget. I cannot excuse myself by saying that we would all have had something to drink, or that

I myself had overindulged. In my defense I can say only that had I denied myself even this joy of staring, I might have gone mad, even lost the will to visit the Keskins.

Most nights Füsun could tell after the first few glances whether I was in that angry, obsessive mood, wherein I would resort to deep looks that evening, and ruthless prosecution of my claim, but she would never panic; rather, like all Turkish women schooled in this art, she would pretend not even to have noticed that a man was sitting across from her with menace in his eyes, and she would give me not so much as a glance in response. This maddening rejoinder would make me even angrier, and I would stare at her all the more fiercely. In his column in *Milliyet,* the famous columnist Celâl Salik had issued many stern warnings to the angry men who prowl our streets: "When you see a beautiful woman," he'd said, "please don't bore into her with your eyes as if intent on murder." And the thought that Füsun might take my intense staring as proof that I was one of those Celâl had addressed made me burn with further fury.

Sibel had talked to me at length about the way men recently arrived from the provinces harassed women; if they saw a beautiful woman wearing lipstick and without a scarf on her head, they would just stand and stare in vicious amazement. Often after a good, long stare, some of these men would stalk their quarry, while others would make their presence known in some more subtly menacing way, from a distance for hours, sometimes even days.

One evening in October 1977, Tarık Bey went upstairs to bed early, saying he was feeling "indisposed." Füsun and Aunt Nesibe were conversing tenderly, and I was watching them somewhat absentmindedly, I think, when suddenly Füsun

looked me straight in the eye. I stared back in that careful way I had recently mastered.

"Don't do that!" Füsun said.

That threw me for a moment. Füsun had done a very good impression of my stare. At first I was too ashamed to answer.

"What are you trying to tell me?" I murmured.

"I am trying to tell you to stop doing it," Füsun said, and then she mimicked me again, this time exaggerating. Her imitation of me made me see my distasteful resemblance to the heroes in *photoroman*s.

Even Aunt Nesibe smiled at this. Then she took fright. "Stop imitating everybody and everything like a child, my girl!" she said. "You're not a child anymore."

"Don't worry, Aunt Nesibe," I said, gathering all my strength. "I understand Füsun very well."

Did I really? It's important, no doubt, to understand the person we love. If we cannot manage this, it's necessary, at least, to believe we understand them. I must confess that over the entire eight years I only rarely enjoyed the contentment of the second possibility, let alone the first.

It was threatening to become one of those evenings when I could not rise from my chair. Deploying my willpower, I finally did, and murmuring that it had gotten very late, I removed myself. At home, drinking myself into oblivion, I resolved never to visit the Keskins again. In the next room my mother was snoring—a painful-sounding moan, but it was perfectly healthy.

The reader will already have guessed that I then sank into deep indignation. But it didn't last long. Ten days later I rang the Keskins' doorbell, as if nothing had happened. Stepping inside, I could see, from the moment our eyes met, that Füsun's were

shining, saying she was glad to see me. At that moment I was the happiest man on earth. We sat down at the table, where we continued to exchange looks.

As the months and years went by, and I was still sitting and talking at the Keskin table, watching television with Tarık Bey and Aunt Nesibe, aimlessly gabbing about this and that—with Füsun joining in at the odd tangent—I tasted pleasures I'd never known before. You could say I was creating a new family for myself. Those nights sitting across from Füsun, taking part in the Keskin family's conversations lifted my spirits and made the world look so bright to me, I almost forgot the sorrow that brought me here.

So it was when in such a mood, late in the evening, at some unexpected moment, I would meet her eye by chance and suddenly I would remember my undying love, and I would bolt upright in excitement, as if having awakened, as if suddenly resurrected. I'd want Füsun to share my elation. For if she could for only a moment awaken as I had from this innocent dream, she would remember the deeper, truer world we'd once inhabited, and in no time she would leave her husband and marry me. But when I saw no such "recollection," no such "awakening" in Füsun's eyes, I would be far too dejected to rise from my chair.

For the whole while our film plans were in limbo, she somehow managed almost never to look at me in a way to suggest any memory of how happy we once were. She looked blandly, pretended to be fascinated by whatever was on television or by the gossip she'd just heard about a neighbor, acting as if her life had found its fulfillment sitting at her parents' dinner table, as if her quest for meaning ended there; it was in effect the abrupt halt of my quest, too—this impression of desolation,

betokening no shared future, no hope that Füsun would ever leave her husband.

Years after these events I saw how much Füsun's indignant glances and the rest of her coded pantomime owed to the expressions of Turkish films. But it was no mere mimicry, for Füsun, like those heroines, was unable to explain her troubles to her mother, her father, or any man, so she channeled all her anger, her desire, and other emotions into those looks of hers, laden with meaning.

To Help Pass the Time

SEEING FÜSUN on a regular basis allowed me to impose some order on the rest of my life as well. Because I was getting enough sleep, I'd get to the office early in the morning. (Inge was still drinking Meltem soda and smiling down mysteriously from the wall of that apartment in Harbiye, but according to Zaim, her effect on sales had abated.) Freed of the need to think obsessively at all times of Füsun, I was even working productively: I could spot people's tricks and make sound decisions.

As expected, it wasn't long before Tekyay, the company to which Osman had appointed Kenan manager, became Satsat's competitor. But its success was not owing to the way Kenan and my brother ran it. Rather it was that the textile mogul Turgay Bey (my spirits plunged whenever I thought of his Mustang, his factory, and his infatuation with Füsun, though for some reason, I no longer felt jealous of him) had signed over the distribution rights of some of his key products to Tekyay. Being a man of fine feelings, Turgay Bey had forgotten all about the snub of the engagement party; he and his family were now on sound terms with Osman and his family. Subscribing to the same travel magazines, they'd go skiing together on Uludağ in the winter, and on shopping trips to Paris and London in the spring.

I was taken aback by Tekyay's aggressive tactics, though I could do little to counter them. Kenan went after the eager

young managers I'd brought into the firm, as well as the two middle-aged ones whose hard work and honesty had been the mainstays of Satsat for many years; lured by the recklessly large salaries he was offering, they defected.

More than once over supper with my mother I complained that Osman was so greedy and keen to seize advantage that he was competing with the firm his own father had founded, but in reply my mother only said, "I really don't want to come between you two, my son." I think Osman had encouraged her to believe that my separation from Sibel, my strange new private habits, and my visits to the Keskins'—of which I was certain she was somewhat aware by now—had rendered me incompetent to run my father's business anyway.

Over the first two and a half years, individual visits to the Keskins' shed their singularity—the looks I exchanged with Füsun, the meals we shared, our conversations, and our excursions to the Bosphorus, which now extended into winter—without exception, each reenacted an event that had happened before; amassed they evoked a sense of the quotidian (with its own beauty) that was out of time. If we couldn't get Feridun's art film into production, the commencement of shooting was forever only months away.

Füsun had resolved, or was acting as if she had resolved, that the art film would take longer than she'd hoped, and that venturing on her own into the commercial film business would leave her vulnerable; however, the anger expressed in her looks was not entirely dissipated. Some nights, if our eyes chanced to meet, instead of looking away like a shy girl, she would bore into me with a fury reminding me of all my faults. I would become despondent at this sudden display of all the anger she

had suppressed, but knowing that this made her feel closer to me, I'd rejoice.

By now I'd resumed asking, as the evening drew to a close, "Füsun, how is your painting going?" regardless of whether Feridun was at home or not. (After that evening at the Huzur Restaurant, Feridun was going out less frequently, and having supper with us instead, as the film business was in trouble by now anyway.) I remember once the three of us got up from the table together to consider the painting of a pigeon that Füsun was then working on, and afterward we discussed it at length.

"I really admire how slowly and patiently you work, Füsun," I whispered.

"I've been saying the same thing. She should have an exhibition!" said Feridun, also in low tones. "But she's too shy. . . ."

"I'm doing these to help pass the time," said Füsun. "The hardest part is getting the feathers on the pigeon's head to shine. Do you see?"

"Yes, we see," I said.

A long silence followed. Feridun had stayed home that night also to watch the sports roundup, I think. When he heard someone scoring a goal, he ran out to the television.

"Füsun, let's go to Paris one day to visit all the museums, and see all the paintings. I'd like that so much," I said.

This was bold: a crime punishable by pouts, frowns, indignation, and the silent treatment for many visits, but Füsun took my words very naturally: "I'd like to go, Kemal."

Like so many children, I'd had a passion for painting during my school years, and for a time, when at middle school and lycée, I had used the Merhamet Apartments to paint "by myself," even dreaming of becoming a painter one day. It was

in those days that I'd first indulged in childish dreams of going to Paris to see all the paintings. From the 1950s until the early 1960s, there was not a single museum in Istanbul in which you could see paintings; there weren't even any art books or catalogs that one could leaf through for pleasure. So neither Füsun nor I knew much about the art of painting. It was enough for us to enlarge black-and-white photographs of birds and other things and color them in.

As one visit to the Keskins' followed another, the streets of Istanbul, the world beyond the house, took on an eerie cast. To look at Füsun's paintings, to witness their slow progress, poring over the photographs of Istanbul's birds that Feridun had taken for her, and musing in hushed voices about which she should paint next—the hawk, the dove, or the swallow—this intimation of security, continuity, and the pleasures of home seemed to fix things for all eternity. It lifted up my heart to behold that we lived in a universe both simple and good. The peace I felt came from the place, the room, our mood, and what we saw around us; it came from Füsun's slow progress painting birds, and the brick red dye in the Uşak carpet on the floor, the pieces of cloth, the buttons, the old newspapers, Tarık Bey's reading glasses, the ashtrays, and Aunt Nesibe's knitting—in my mind they were all one piece. I would inhale the room's fragrance, and later, back in the Merhamet Apartments, the thimble or button or spool I'd pocketed before leaving would help me remember all this, and so prolong my happiness.

After clearing the plates at the end of the meal and putting the big serving platters with the leftover food into the refrigerator (visitors to the museum should pay special attention to the Keskins' refrigerator, which always struck me as possessing supernatural qualities), Aunt Nesibe would go to

fetch her knitting set, which she kept in a capacious old plastic bag, or more typically ask her daughter to fetch it. This was the time when we would retire to the back room. Aunt Nesibe would say, "My daughter, could you bring my knitting when you come back?" Then she would settle in to enjoy knitting and chatting in front of the television. It was because she feared Uncle Tarık, I think, that Aunt Nesibe, who didn't mind our being alone together in the back room, would not let a suspicious length of time elapse before following us into the room and saying, "Where's my knitting? *The Winds of Autumn* is about to begin. Don't you want to watch it?"

We would watch it. During those eight years I must have watched hundreds of films and television series with Füsun and her family; but I, who can remember even the smallest, most trivial details of anything connected to the Keskin household, can recall not a thing about the films and series we saw, and even less of those discussion programs aired to mark national holidays (with titles like *The Conquest of Istanbul: Its Place in World History; Turkishness: What Must It Reflect?;* and *Coming to a Better Understanding of Atatürk*).

Most of what I recall of the things we watched on television were discrete moments (Aristotle, the theorist of time, would have approved). Such moments would combine with an image and remain engraved in my memory. Half of this indelible memory would be made of the image on the screen or even just a fragment of it. The shoe and the trouser cuffs of an American detective racing up the stairs; an old building's chimney, which was of no interest to the cameraman, but which had nevertheless slipped into the frame; a woman's hair, tucked behind her ear, during a kissing scene (while silence reigned at the table); or a timorous girl clinging to her father at a football

match, surrounded by thousands of mustached men (probably there was no one at home to look after her); or the socks worn by the closest of the men bent over in prayer at a mosque in Ramadan, on the Night of Measures; or the Bosphorus ferry in the background in a Turkish film; or the tin from which the villain had eaten *dolma*s; and a good many other things. In my mind these images would combine with a detail of Füsun's face as she watched that scene: a corner of her mouth, her raised eyebrows, the placement of her hand, the way she left her fork on the side of her plate, or her eyebrows suddenly aloft as she stubbed out her cigarette. Often these images would fix themselves in my mind like the dreams we can never forget. In an effort to make them visible in the Museum of Innocence, I provided artists with detailed instructions, which assumed the form either of questions or of images, but to the questions I never found an exact answer. Why was Füsun so moved by that scene? What was it that had pulled her so far into the story? I would have liked to ask her myself, but when a film ended the Keskins were not inclined to discuss how it had affected them, preferring to discuss the denouement in moral terms.

For example, Aunt Nesibe would say, "That filthy brute got what he deserved, but I still pity the boy."

"Oh, come on, they don't even remember the child," Tarık Bey would say. "Men like that worship money and nothing else. Turn it off, Füsun."

When Füsun pressed the button, all those brutes—the strange European men, the American gangsters, that odd, feckless family, and even the despicable writer and director who had created the film—would be sucked into the dark eternity beyond the screen like swirls of cloudy water flushing down a bathtub drain.

Immediately, Tarık Bey would say, "Oh, that feels much better, to put all that behind us!"

"All that" could have been a Turkish film or a foreign one, a panel discussion, the sly emcee of a quiz show, or the idiotic contestants! Those words would add to the peace I felt, and the very phrase seemed to confirm that the most important thing was that I stay here keeping company with Füsun and her family. And so I would realize that I wanted to remain, not just for the pleasure of sitting at the same table in the same room as Füsun, but out of my profound attachment to this house, this building, and every member of the Keskin family. (It is through my reproduction of that enchanted space that museum visitors can wander, as if through Time.) I would particularly like them to note the way my love for Füsun slowly radiated outward to encompass her entire world, and every moment, every object connected with her.

This feeling I had of being outside Time while watching television, the deep peace that made it possible to visit the Keskin family faithfully, and to love Füsun for eight years—it was broken only when the news came on, repeating how the country was sliding fast into civil war.

By 1978, bombs were going off at night even in this neighborhood. The streets leading to Tophane and Karaköy were controlled by nationalist factions, and in the papers it was claimed that many murders had been planned in the local coffeehouses. At the top of Çukurcuma Hill, on the crooked cobblestone streets heading toward Cihangir, by contrast, the residents were petty bureaucrats, workers, and students sympathetic to the Kurds, the Alevis, and various left-wing factions. They were no less fond of weapons, and on occasion militants from both sides would engage in armed combat

to take control of a street, a coffeehouse, or a little square; sometimes, following the explosion of a bomb planted by gangsters controlled from afar by the secret services or some other arm of the state, a fierce pitched battle would ensue. It took quite a toll on Çetin Efendi, who was often caught in the crossfire, and never sure where to park the Chevrolet or at which coffeehouse to wait, but whenever I suggested that I could go to the Keskins' alone, he adamantly refused. By the time I left the Keskins, the streets of Çukurcuma, Tophane, and Cihangir were never safe. Along the way as shadows tacked up posters, plastered notices, and scrawled slogans across walls, we'd exchange fearful looks in the mirror.

With the evening news relaying the details of the bombings, killings, and massacres, the Keskins felt the peace of being safe at home, thank God, but they were worried about the future. The news was so awful, we were disinclined to discuss it, preferring to talk about the charms of Aytaç Kardüz, the host of the day. Unlike the relaxed women newscasters in the West, Aytaç Kardüz sat like a statue, never once smiling, and rushing through her reports as she read from the copy in her frozen hands.

"Slow down, my girl, take a breath, you're going to choke," Tarık Bey would say from time to time.

Although he had made this joke hundreds of times, we would all still laugh as if he were saying it for the first time, because Aytaç Kardüz, so disciplined and devoted to her work, could be quite amusingly terrified of making a mistake; she would race to the end of a sentence without once stopping to breathe, and in the event of a very long sentence she would sometimes turn red before she had got it all out.

"Oh no, she's going red again," Tarık Bey would say.

"Slow down, my child, at least stop to swallow," Aunt Nesibe would say.

Then Aytaç Kardüz would take her eyes off the page from which she was reading, as if having heard Aunt Nesibe's plea; glancing at all of us sitting at the table watching her with a mixture of panic and joy, she would exert the effort of a child who has just had her tonsils out, to swallow, whereupon Aunt Nesibe would say, "Well done, my girl!"

It was from this newscaster that we heard that Elvis Presley had died in his mansion in Memphis, that the Red Brigade had kidnapped Aldo Moro, and that Celâl Salik had been shot and killed outside Alaaddin's shop in Nişantaşı, together with his sister.

There was another way the Keskins had of distancing themselves from the care of the world, and I found it very soothing: They would look for resemblances between the people on the screen and their own friends and relations, and, as we ate, they would remark on the similarities with great attention.

At the end of 1979, as we watched the Soviet invasion of Afghanistan, I recall discussing how Babrak Karmal, the new Afghan president, was virtually the double of a man who worked in the neighborhood bakery, so similar that the two could have been brothers. It was Aunt Nesibe who first mentioned it. She enjoyed the search for resemblances at least as much as Tarık Bey. At first no one could tell whom she meant, but because I had Çetin regularly stop the car in front of the bakery long enough for me to run in and buy a few loaves still hot from the oven, I knew the faces of the Kurds who worked there and could pronounce Aunt Nesibe's observation absolutely right. My endorsement notwithstanding, Füsun and Tarık Bey stubbornly insisted that

the man tending the till bore no resemblance whatsoever to the new Afghan president.

Sometimes Füsun seemed to be contrary just to spite me. She refused, for example, to accept that Anwar Sadat, the Egyptian president who was killed by Islamists while reviewing a military procession from the box of honor, just as our staff officers do, was the spitting image of the newsagent on the corner of Çukurcuma Hill and Boğazkesen Avenue; and if you ask me, it was because I was the one who made the comparison. As the coverage of Sadat's assassination went on for several days, there ensued a war of nerves between me and Füsun that I did not care for at all, and it went on for days, too.

If the majority at the Keskin table agreed on a resemblance, we could, from then on, without dissent, allude to the eminent person on the screen not as Anwar Sadat but as Bahri Efendi the newsagent. By the time I entered my fifth year of eating supper at the Keskins', I too had agreed that Nazif Efendi the quilt seller resembled the famous French actor Jean Gabin (whom we'd seen in many films); and that the awkward weathergirl who sometimes appeared on the evening news resembled Ayla, who lived downstairs with her mother and was one of the friends Füsun hid from me; while the late Rahmi Efendi was a dead ringer for the elderly head of the Islamist party, who would fulminate on the evening news; and Efe the electrician recalled the famous sportswriter who summarized the week's goals on Sunday evenings; and it was I who (mainly on account of his eyebrows) likened Çetin Efendi to President Reagan.

Once pegged, the appearance of one of these famous faces on the screen was the signal to see who among us would crack the first joke. "Hurry over and look at this, children!" Aunt

Nesibe would say. "See how beautiful Bahri Efendi's American wife is!"

But there were instances, too, when we struggled to work out a match for the famous person on the screen. For example, when Kurt Waldheim, the Secretary-General of the UN who was so busy trying to make peace between Israel and Palestine, appeared, Aunt Nesibe would say, as if calling for help, "So let's see, who does this man look like?"; as we all searched our experiences, the table would fall silent for a very long time. These silences could continue long after the famous person faded from the screen, to be replaced by other scenes, news items, or commercials.

Then suddenly I'd hear a ship coming from the direction of Karaköy and Tophane blowing its whistle, and I would remember the noise of the city, and its crowds, and as I tried to conjure up the image of the ferries approaching the piers, I would reluctantly realize just how involved I'd become with the Keskin family, how much time I'd spent eating at this table: As these ships had gone by, blowing their whistles, I'd not even noticed how many months and years had passed us by.

The Gossip Column

As the country slid toward civil war, the exploding bombs and the pitched street battles resulted in fewer people going to the cinema, which absence had devastated the film industry. The Pelür Bar and other industry watering holes were as crowded as ever, but by now, with families no longer even venturing out into the streets in the evening, the film people were all struggling to get by doing commercials or skin flicks and fight films now flooding the market. In just the past two years, big producers had stopped investing in the sorts of films we'd enjoyed over the summer, a development that suddenly elevated me among the habitués of the Pelür Bar, in whose eyes I was the wealthy backer of Lemon Films, and potentially an investor in their ventures. Though I was managing for the most part to stay away from the Pelür, one evening, at Feridun's insistence, I went and saw that the crowd was larger than ever, a fact explained later when I heard from the drunks that unemployment had been a boon to the bars and that "all of Yeşilçam" was "hitting the bottle."

That evening I, too, drank until morning with the miserable film crowd. I even recall chatting amiably with Tahir Tan, the man who had once pursued Füsun all the way to the Huzur Restaurant. By the end of the same evening, Papatya, one of the most charming of the new generation of young actresses, had claimed me as a "friend." Only a few years earlier Papatya had

been starring in family films as the innocent girl who sold *simit*s and looked after her blind mother, or continually dissolved into tears as her stepmother, played by Conniving Sühendan, plotted her ruination; now she, like the others, was out of work and forced to take on dubbing domestic porn films; but there was a screenplay that Feridun had also found interesting, and she was hoping for my backing to produce it. Drunk as I was, I could see that Feridun found Papatya interesting, too—there was what film magazines called a "certain intimacy" between them—and yet I was rather amazed by his annoyance at the attention I paid her. Toward morning, when the three of us left the Pelür, I remember walking together through the dark backstreets, past walls on which drunks had relieved themselves and leftists had scrawled radical slogans, making our way to Cihangir, where Papatya lived with her mother, who worked as a singer in low-rent nightclubs. As menacing packs of dogs followed us down the cold streets, I left it to Feridun to see Papatya home and returned to Nişantaşı, where I lived peacefully with my mother.

After drunken evenings like this, as I drifted in and out of sleep, I was beset by painful thoughts: that my youth was well and truly over; that (as was the case for all Turkish men) my life was taking its ultimate shape before I had even reached the age of thirty-five; that I would—could—never again know great happiness. At times, remembering the love and longing that filled my heart, I would console myself thinking that if my future seemed darker with each passing day, this could only be an illusion induced by the political assassinations, the never-ending street battles, the spiraling prices, and the bankruptcies that filled the news.

But if I had been to Çukurcuma to see Füsun, if we had looked into each other's eyes and spoken, if I had stolen from

the Keskins' house a few objects that would remind me of her later, and if back at home I had a chance to play with them, it would seem to me as if I could never feel unhappy again. There were times when I would survey the knives and forks that Füsun had used, and that I had secreted away from the Keskins' dinner table, as if they formed a single picture, in themselves a complete memory.

Sometimes, convinced of the possibility of a better life elsewhere, beyond the circumscribed world of my obsession, I would struggle to dwell on other things. But if by chance I'd seen Zaim, his report on all the latest society gossip was enough to remind me that I was not missing much by avoiding the company of rich friends, whose lives seemed increasingly boring.

Though they had been seeing each other for three years by now, Mehmet and Nurcihan had (according to Zaim) still not made love, and were telling people that they planned to marry. This was the biggest piece of news. Even though everyone, Mehmet included, knew of Nurcihan's love affairs with French men during her years in Paris, she was determined not to make love with him before marriage, and she made light of this decision, saying that in Muslim countries, the foundation of a true and long-lasting, happy and peaceful marriage was not wealth but premarital abstinence. Mehmet seemed to appreciate this joke; it was part of the tapestry of their common outlook, which they articulated in one voice, telling stories illustrating the wisdom of our ancestors, and the beauty of our old music, and the contentment of the old masters, with their dervish temperaments. Neither the jokes they liked to make, nor their interest in our Ottoman ancestors, had led to their being branded in society as devout or reactionary. Zaim

believed that one reason for this was the amount they both drank at parties, which, however excessive, never compromised their manners or their elegance. When he'd had some wine to drink, Mehmet would proclaim with some excitement that the wines mentioned in Divan poetry were not metaphorical but real libations, and he would recite lines from Nedim and Fuzuli—the accuracy of which no one could judge—and looking carefully into Nurcihan's eyes, he would lift his glass to toast the love of God. There was a reason that society had not been put off by such an exhibition and indeed had even accepted it respectfully: There were far worse things, a lesson that could be traced to the panic among young girls following the dissolution of my engagement to Sibel. This episode had served as potent warning to girls of our generation in Istanbul society not to put too much trust in men before marriage, and, if the rumors were to be believed, inspired terrified mothers with marriageable daughters to urge extreme caution. But lest one attach too much importance to my own experiences, I beg the reader to remember that Istanbul society was such a small and fragile circle that the deep shame of any member was no less universally felt than in a small family.

Especially after 1979 I'd grown well accustomed to the comforts of my new life, and moving between my home and my office, Füsun's house and the Merhamet Apartments, I felt at one with its spirit. I would go to the Merhamet Apartments, and, reflecting upon the happy hours Füsun and I had spent there, I would lose myself in daydreams, admiring my slowly growing "collection" with ever renewed wonder. As these objects accumulated, so did the manifest intensity of my love. Sometimes I would see them not as mementos of the blissful hours but as the tangible precious debris of the storm raging

in my soul. Sometimes I felt ashamed at their very existence, alarmed at the idea that someone else might see them, and a bit afraid that at this rate, my collection would soon fill the rooms in the Merhamet Apartments from floor to ceiling. For I had not begun taking these things from the Keskin household with an eye to what the future might hold, but only that I might be returned to the past. It did not occur to me that there might one day be objects enough to fill rooms and whole houses, because for the better part of those eight years I sustained myself with the conviction that it would be only a few more months, six at most, before I could bring Füsun around to marry me.

Here I exhibit a cutting from *Akşam,* a column from the "High Society" page, dated November 8, 1979:

SOCIETY AND THE CINEMA: A MODEST WARNING

We all like to boast that Turkey's film industry is the third largest in the world after Hollywood's and India's. Sadly, the situation is changing: The new sex films and our citizens' growing reluctance to go outside in the evening, in view of the terror wrought by militants of the left and right, has kept our families away from the cinema. Even the most esteemed Turkish cineastes are now unable to find the audiences or the backers to make their films. The Turkish cinema has never had as great a need as it has today for rich businessmen to come to Yeşilçam to make "art films." In the past, artistic-minded cineastes tended to come from new money—families recently arrived from the provinces—and their aim would be to make the acquaintance of beautiful actresses. Of the many "art films" that our critics praised so lavishly, not a single one has gone on to be shown to the intellectuals of the West, despite what has been claimed, nor have any of them received an honorable mention in the bland small-town festivals of Europe; instead they have served as vehicles for

any number of scions of the nouveau riche to meet and engage in amorous affairs with female "artists." But that was in the old days. Now there is a new fashion. These days our wealthy art lovers don't come to Yeşilçam to have love affairs with beautiful actresses; they come to make girls they already love into stars. As a consequence, we now find the bachelor son of one of the most illustrious families of Istanbul society (having chosen to withhold his full name, we shall call him Mr. K) is so infatuated with a young married woman he describes as a "distant relation" and so jealous of anyone who comes near her that he cannot even bring himself to arrange for the "art film" (for which he has commissioned a screenplay) to go into production. This reporter's sources tell him that Mr. K has gone so far as to admit, "I could not bear to see her kissing someone else!" And such is his jealousy that he shadows the young woman and her director husband, crawling after them in Yeşilçam bars and Bosphorus restaurants, a glass of *rakı* in his hand, and apparently he gets upset if the married would-be actress so much as steps outside her house. According to these sources, our society bachelor—who not so long ago celebrated his engagement to a graduate of the Sorbonne, the adorable daughter of a retired diplomat, with a fabulous party at the Hilton attended by all society and described in lavish detail in this space—was irresponsible enough to break off the engagement, all for the sake of the beautiful relative to whom he has now said, "I am going to make you a star!" We, meanwhile, are reluctant to stand by while this feckless rich boy, who has already done so much harm to the diplomat's lovely young daughter, goes on to blacken the name of F, the beautiful would-be actress, to whose charms a great many philandering gentlemen are particularly susceptible. So, after apologizing in advance to readers who have tired of lectures, we would like to pass on the following wisdom to society's Mr. K: Sir, in this modern age, when the Americans have gone to the moon, it is simply not possible to have an "art film" without kissing scenes! You must decide once and for all, and either marry a headscarf-wearing peasant girl and put Western art and films out of your mind forever, or give up on this

fantasy of making stars out of young girls you guard so closely
that you can't bear anyone else even looking at them. That is,
if making stars is what you're really after.—WC

My mother read the two newspapers delivered daily to our
house from cover to cover, never missing the society gossip. As
we were having breakfast the morning that column appeared,
I waited until she had gone to cut out the offending page, fold
it up, and slip it into my pocket. "Something's bothering you
again—what is it?" my mother asked me as I left the house.
"You're so gloomy!" At the office, too, I tried to feign high
spirits, telling Zeynep Hanım an amusing anecdote, whistling as
I walked down the hallway, and jovially making the rounds of
the aging and ever more idle employees of a moribund Satsat
who whiled away their time by doing the *Akşam* crossword.

By the time everyone came back from lunch, it was clear
from the expressions on their faces and in particular the
compassion—and fear—in Zeynep Hanım's eyes that the
entire staff of Satsat had read the column. Maybe I'm just
imagining things, I told myself afterward. My mother rang me
to say that she'd been expecting me for lunch, and also asked,
"How are you, darling?" straining not to let concern inundate
her normal voice, from which I could tell all the same that
she'd heard about the column, sent out for another copy of
the paper, and had a good cry over it (her "normal" voice now
full of that gravitas people acquire after they've cried); just as
she could tell from the torn-out page that I'd read it, too. "The
world is full of people with monstrous souls, my child," said my
mother. "You are not to let anything upset you."

"What are you talking about, Mother?" I said.

"It's nothing, my child," she said.

I was tempted to pour out my heart to her, but I was certain that if I did, she would, after ample expression of love and understanding, feel obliged to tell me that I was at fault, too, and then press me for all the details of the Füsun story. She might even have burst into tears and told me I'd been bewitched. She might have said, "In some corner of the house, inside a jar of rice or flour, or at the back of one of your drawers at work, there's an amulet hidden—someone's cast a spell on it, and breathed on it, to make you fall in love—so find it and burn it at once!" But I sensed that she was downcast because she'd been unable to share my sorrow, unable even to broach the subject. It was all she could do to show respect for my predicament. Was this an indication of how bad my situation was?

At this moment, I wondered about the readers of *Akşam:* How contemptuously were they regarding me, how heartily were they laughing or raging at my passion, and how many of this report's details did they believe? I couldn't dislodge these questions from my mind, nor the thought of how upset Füsun would be when she read the column. After my mother's phone call, it occurred to me to warn Feridun to keep *Akşam* away from Füsun and everyone else in our family. But I didn't place the call. My first reason was fear that I might be unable to explain things to Feridun in such a way that he wouldn't get so upset as to feel compelled to act. But my second reason was deeper: Despite the humiliation and being made out to be a fool, I was still glad about the column. I hid this satisfaction even from myself, but when I look back now, so many years later, I can see it perfectly well: My relationship with Füsun, my closeness to her by whatever name, had been reported in the papers, and thus, in some sense, society had accepted it! This column was read by absolutely everyone with an interest in Istanbul society;

malicious columns like this one were discussed for months on end. And so I tried to convince myself that this gossip augured my return to my former place in the social order, with Füsun at my side—or, at the very least, to imagine that our story might arrive at this happy resolution.

But such was the hopelessness to which I'd been delivered that I could entertain such sweet dreams. It would not be long before I felt that society gossip and mendacity and innuendo were slowly turning me into a different sort of man. I was no longer the one who had, by force of his own will and passion, embarked on an unconventional course, but someone who had been ostracized after being featured in a gossip column.

The initials over which the column appeared left no room for doubt that it had been written by White Carnation. I was annoyed at my mother for having invited him to the engagement party, and incensed by Tahir Tan, whom I suspected to be the source of many of the manufactured details ("I could not bear to see her kissing someone else!"). How I longed to sit down with Füsun, to curse our enemies together, so that I could console her, and she me. We would need to go to the Pelür Bar and defy them all with our determination. Feridun would have to come, too! Only this could prove the gossip a degrading lie, and silence the slurring drunks of the film world—not to mention our friends in society, who were now reading the column with relish.

But the evening after the column appeared, I could not— hard as I tried—bring myself to visit the Keskins. I was sure that Aunt Nesibe would do her best to put me at ease, and Tarık Bey would affect to know nothing of what had happened, but when I tried to imagine the moment when my eyes met Füsun's, my mind went blank. In that moment there would be no

denying that we were both feeling the same turmoil within, and for some reason, this frightened me. Then I had the following insight: What we would both understand the moment our eyes met was not that there were tempests raging in both our souls, but simply that the false reports were actually true!

Yes, as the reader well knows, quite a few details in White Carnation's column were wrong: I had not broken off my engagement with Sibel to make Füsun a star; I had not commissioned Feridun to write a screenplay. But these were trivial errors. What newspaper readers and all the gossips in the city would take from the column was this simple truth: My love for Füsun and the things I had done for her had led me to disgrace myself! All of them were mocking me, laughing at everything I'd done; even the most well-meaning pitied me. Though I reminded myself that Istanbul society was very small, and that none of these people was seriously rich or genuinely principled, my shame was unrelieved. Rather I felt the sting of my stupidity and ineptitude all the more. Here I was, living in a poor country, yet lucky enough to have been born into a wealthy family; offered such opportunity as God offers so few in this corner of the world—an honest, civilized, and happy life—and I had idiotically thrown it all away! I knew that the only way out of this predicament was to marry Füsun, put my business affairs in order, make my fortune, and then return, victorious, into society, but by now I could not find the strength to realize this plan, and indeed I'd come to hate that tiny set into which I might seek readmittance. Above all, I knew that, once they'd read the offending column, the Keskin household would neither entertain nor abet my dreams.

My love and my shame had brought me to this place where my only inclination was to turn inward and live in silence. For

a week I went to the cinema every night: I went to the Site, the Konak, and the Kent and saw American films. Especially in a world as miserable as ours, the point of films is not to offer verisimilitude but a different new universe to amuse us and make us happy. Particularly, in identifying with the hero, it would seem to me that I was exaggerating my troubles. And at such moments I would castigate myself for having been inept enough to become the idle gossips' object of derision; I even began to believe some of the lies they'd told about me.

Of all the lies, the one that bothered me most was the claim that I had said, "I could not bear to see her kissing someone else!" At moments of greatest discouragement I would become convinced that it was this charge that was chiefly provoking laughter, and it became the center of my obsession to correct the lies. I was also irked to be portrayed as a spoiled rich boy irresponsible enough to break off an engagement, but I assured myself that those who knew me would not fall for that one. That I might have said I didn't want her kissing anyone, however, was credible, because despite all my Western airs, there was something in me of a man who might say such a thing, and I wasn't even sure I hadn't said as much to Füsun, either in jest or in drunkenness. Because, in truth, even for art's sake, I definitely did not want Füsun kissing anyone else.

64

The Fire on the Bosphorus

IN THE early hours of the morning of November 15, 1979, my
mother and I were awoken by the sound of a huge explosion;
we jumped from our beds and ran into the hallway to embrace
each other in terror. For a moment the entire apartment
rocked from side to side, as if caught in a severe earthquake.
Accustomed as we were to bombs going off in coffeehouses,
bookstores, and the city's squares, we assumed that yet another
had been detonated near Teşvikiye Avenue, but then we noticed
the flames rising near the other side of the Bosphorus, just
off the Üsküdar shore. Figuring this was some act of political
violence, for a while we watched the fire with the red clouds
rising from it in the far distance, and then we went back to bed.

A Romanian tanker loaded down with crude oil had
collided with a small Greek ship just off Haydarpaşa; oil had
gushed into the water, causing explosions within and without
the tanker hull and then the fires. The papers rushed to put out
special editions, and the next day the whole city was abuzz with
talk of the Bosphorus set ablaze and the clouds overhanging
Istanbul like a black umbrella. At Satsat that day I could almost
feel the fire inside me, and I sensed it was the same with all the
lady clerks in the office, and the bored managers, and so I tried
to see the conflagration as a good excuse to go to the Keskins'
for supper that evening. The event would utterly preempt the
gossip column, which I wouldn't even have to mention as we

sat at the table talking incessantly about the fire. But, still, like everyone else living in Istanbul, I associated the Bosphorus fires with all the other disasters that were contributing to the general misery: an ensign of the political assassinations, breadlines, hyperinflation, and the impoverished, abject appearance of the entire country. And as I read the latest editions, it seemed to me that I was fascinated by the fire because it spoke to me about the disasters in my own life.

That evening I went to Beyoğlu; as I walked the length of İstiklal Avenue I was surprised to see it so empty. Outside the big cinemas like the Palace and Fitaş, where they now showed sex films, there were only a few fidgety men. When I passed through Galatasaray Square, I realized how close I was to Füsun's house. Sometimes, on summer nights, the whole family would stroll up to Beyoğlu for ice cream. Perhaps we might cross paths. But I could not see a single woman in the streets, or a single family. When I reached Tünel, I again became uneasy about being so close to Füsun's house, so I walked in the opposite direction to resist its pull. Passing alongside the Galata Tower I walked down to the bottom of Yüksekkaldırım. At the corner where Yüksekkaldırım crossed the street of the bordellos, there was the usual crowd of wretched men. Like everyone else, they were looking up at the play of the orange light against the black clouds.

I crossed the Galata Bridge with the crowd watching the fire in the distance. Even those trawling for mackerel from the bridge could not take their eyes off the flames. Without my willing it, my feet followed the crowd as far as Gülhane Park. The lights in the park were out—because either, like most of Istanbul's streetlamps, they had been shattered by stones hurled in rage, or because there'd been a power cut—but the

flames rising from the tanker were so intense that the whole of this large park, and Topkapı Palace, to which it had once belonged, together with the mouth of the Bosphorus, and Üsküdar, Salacak, and Leander's Tower, were as bright as day. The light in the park, coming directly from both the fire and the orange light reflecting off the clouds, provided the cozy glow of a lampshade in a European sitting room, making the large, restless crowd of onlookers seem happier and more peaceful than they really were. Or else the pleasure of watching a spectacle had lifted their spirits. This throng had come from all parts of the city—by bus, by foot, and by car, rich and poor, some obsessively and others simply curious. I could see grandmothers in headscarves; young mothers with their sleeping children in their arms, clinging to their husbands; unemployed men hypnotized by the fire; drivers sitting in their cars and their trucks, listening to music; and street vendors who had rushed in from all quarters to hawk *helva*, stuffed mussels, fried liver, and *lahmacun;* as well as tea vendors darting among the crowd with their trays. Arranged around the base of the Atatürk statue were the men who sold meatballs and hot sausages stuffed in bread; they had lit the grills in their glass-covered carts, and the pleasant aroma of grilled meat filled the air. The boys hawking *ayran* and soda (but not Meltem) had turned the park into a market. I bought a tea from one street vendor, and, finding a place on one of the benches, next to a poor, old, and toothless man, I felt my own happiness as I watched the flames.

I returned each day until the end of the week, by which time the fire was beginning to die. Sometimes the faint flames would flare up again, rising in a wave to the height we had seen on the first day, again casting an orange glow on the faces of

those watching the fire with such fear and awe, as the flames bathed not just the mouth of the Bosphorus, but Haydarpaşa Station, the Selimiye Barracks, and Kadıköy Bay in shades of orange, and sometimes gold. At such moments I would stand motionless with the rest of the crowd, entranced by the view. A while later we would hear an explosion and watch the embers fall, or try to listen as the flames silently shrank. It was the spectators' cue to settle in for eating and drinking and chatting.

During one of these evenings at Gülhane Park, I spotted Nurcihan and Mehmet, but I ran off before they could see me. That I longed to see Füsun there with her parents, and that this had perhaps been my reason for joining this crowd every evening—it was only after seeing a family whose three shadows resembled theirs that I realized this. It was just as it had been during the summer of 1975, now four years past: Every time I saw anyone who looked like Füsun, love would make my heart race. The Keskins were, I thought, just the sort of family to believe most sincerely in the power of disasters to bind us together. I had to visit their house before the fire on the *Independenta* was extinguished; we would live through this catastrophe together, and their fellowship would help me put all the bad things behind me. Could this fire mark the beginning of a new life for me?

There was another evening when as I was looking for a place to sit in the crowded park I ran into Tayfun and Figen. To my great relief, they did not mention the column in *Akşam,* or indeed any other society gossip; they did not even seem to be aware that there was any talk about me, which so pleased me that I left the park with them, as the flames were beginning to die down; we got into their car and went to one of the new

bars that had opened up in the backstreets of Taksim, where we drank until morning.

The next day—on Sunday evening—I went to the Keskins'. I had slept all day and eaten lunch with my mother. By evening I was feeling optimistic, hopeful, even happy. But the moment I walked into the house and came eye to eye with Füsun, all my dreams were destroyed: She was joyless, hopeless, hurt.

"What's new, Kemal?" she said, mimicking a carefree and well-satisfied woman of the world—or rather, her idea of one. But my beauty's heart wasn't in it; even she knew she was faking.

"Nothing much," I said brazenly. "I haven't had time to come over; there's been so much happening at the factory, and the firm, and the business."

In a Turkish film, when a certain intimacy has been established between the young hero and heroine, an understanding matron will cast a certain glance of contentment their way, so that even the most inattentive viewer will appreciate the development and share in the emotions. . . . Well, that is how Aunt Nesibe gazed upon Füsun and me. But soon afterward I could tell from the way she averted her eyes that the gossip column had caused a great deal of pain in this house, and that Füsun had spent many days crying, just as she had done after the engagement party.

"Why don't you bring out some *rakı* for our guest, my girl?" said Tarık Bey.

For three years now Tarık Bey had been acting as if he knew nothing of the situation, always greeting me with warm sincerity, treating me like a relation who'd simply come to supper, which I had always respected. But now it grieved me to see him show so little interest in his daughter's anguish, my own helplessness, and our shared predicament. Let me now

make the heartless observation that I refrained from making, even to myself: Tarık Bey had almost certainly deduced what I was doing there, but his wife had prevailed upon him to accept that it was better "for the family" for him to pretend to know nothing.

"Yes, Füsun Hanım," I said, assuming her father's contrived manner. "Why don't you give me my usual *rakı,* so that I can savor the full happiness of coming home."

Even today I cannot explain why I said this, or what I meant by it. Let us just say that my misery came to my lips. But Füsun understood the sentiment behind the words, and for a moment I thought that she would begin to cry. I noticed our canary in its cage. I thought about the past, and my life, the flow of time, the passing years.

We lived through our most difficult moments during those months, those years. Füsun had not risen to stardom, and I had not succeeded in coming any closer to her. Our impasse had become a public disgrace; we'd been humiliated. It was just as it had been on those evenings when I could not stand up—I saw us unable to stand up and remove ourselves from this predicament. For as long as we continued to see each other four or five times a week, it would be impossible for either of us to start a new life, and this we both knew.

That evening, toward the end of supper, I uttered the usual invitation with more sincerity than ever. "Füsun," I said, "it's been so long since I've seen what's happening to your painting of the dove."

"The dove has been finished for ages now," she said. "Feridun found a lovely picture of a swallow. I've started on that now."

"This swallow is by far the best one yet," said Aunt Nesibe.

We went into the back room. Staying with the formula of the other Istanbul birds perched on various parts of the house—balustrades, windowsills, and chimneys—she had placed a dainty swallow in the bay window of our dining room, overlooking the street. In the background you could see the cobblestones of Çukurcuma Hill, depicted in a strangely childish perspective.

"I'm so proud of you," I said, my voice heavy with defeat despite my best efforts. "One day everyone in Paris should see these!" I said. As always, what I really longed to say was something like "My darling, I love you so much, and oh, how I've missed you. It was so painful being far away from you, and what bliss this is, to see you!" But it was as if the painting's flaws had become the flaws of the world in which we lived, and it was while examining the dove painting, sadly noting its simplicity, innocence, and lack of sophistication, that I understood this.

"It's turned out beautifully, Füsun," I said carefully, inside me nursing a deep pain.

If I say that the painting contained elements recalling Indian miniatures painted under British influence, and Chinese and Japanese bird paintings, with Audubon's attention to detail, and even the bird series that came packaged with a brand of chocolate biscuits sold in stores across Istanbul, please bear in mind that I was a man in love.

We looked at the views of the city that served as backgrounds for Füsun's paintings of Istanbul birds, but far from lifting my heart, this exercise brought me sorrow. We loved our world very much, we belonged to it, and that meant we ourselves were part of the picture's innocence.

"Maybe you could paint the city and the houses in more vibrant colors one of these days. . . ."

"Never mind, my dear," said Füsun. "I'm just passing the time, you know."

She picked up the picture she'd been showing me and put it to one side. I looked at her lovely art supplies—the tubes of paint, the brushes, the bottles, and the cloths stained with all sorts of colors. Like the bird paintings, these things were neatly arranged. Near them were Aunt Nesibe's thimbles and materials. I slipped a colored porcelain thimble into my pocket, and an orange pastel pencil that Füsun had been fiddling with a short time before. It was during these, our darkest days, and most especially the last months of 1979, that I stole the most things from the Keskin household. By now these objects were no longer just tokens of moments in my life, nor merely mementos; to me they were elemental to those moments. For example, the matchboxes on display in the Museum of Innocence: Füsun touched every one of them, leaving behind the scent of her hands with its hint of rosewater. As with so many other things on exhibit in my museum, whenever I held any of these matchboxes back at the Merhamet Apartments, I was able to relive the pleasure of sharing a table with Füsun, and gazing into her eyes. But even before that, whenever I dropped a matchbox into my pocket, pretending not to notice what I had done, there was another reason to rejoice. I may not have "won" the woman I loved so obsessively, but it cheered me to have broken off a piece of her, however small.

To speak of "breaking off" a piece of someone is of course to imply that the piece is part of the worshipped beloved's body. But three years on, every object and person in that house in Çukurcuma—her mother, her father, the dining table, the stove, the coal carrier, the china dogs on the television, the bottles of cologne, the cigarettes, the *rakı* glasses, the sweets

bowls—had merged with my mental image of Füsun. I managed to see Füsun three or four times a week, and as happy as this made me, with each week I still took ("stole" would be the wrong word) from her house (from her life) three or four things, sometimes as many as six or seven, and during the most miserable phases, between ten and fifteen, and having got them to the Merhamet Apartments, I felt triumphant. What bliss it was to hold a saltshaker with which Füsun had so daintily salted her food without taking her eyes off the television—to slip it into my pocket, to know that it was there while I chatted and sipped my *rakı*, to know that I had taken possesion of this trophy was to find the strength to stand up and leave when the evening had drawn to its conclusion. After the summer of 1979, an object in my pocket was the key to prying me out of my chair.

Years later, when I fell in with Istanbul's weird and obsessive collectors; when I visited their houses packed to the rafters with paper, rubbish, boxes, and photographs, every time trying to understand how these soul mates of mine felt about their soda bottle caps or pictures of film stars, and what meaning a new acquisition held—I would remember how I'd felt every time I took something from the Keskins' house.

The Dogs

MANY YEARS after the events I am relating here, I set out to see all the museums of the world; having spent the day viewing tens of thousands of strange and tiny objects on exhibit in a museum in Peru, India, Germany, Egypt, or any number of other countries, I would down a couple of stiff drinks and spend many hours walking the streets of whatever city I was in. Peering through curtains and open windows in Lima, Calcutta, Hamburg, Cairo, and so many others, I would see families joking and laughing as they watched television and ate the evening meal; I would invent all sorts of excuses to step into these houses, and even to have my picture taken with the occupants. This is how I came to notice that in most of the world's homes there was a china dog sitting on top of the television set. Why was it that millions of families all the over world had felt the same need?

I first asked myself a more modest version of this question at the Keskin house. As I would come to know later, the china dog that I noticed upon first walking into the family's apartment on Kuyulu Bostan Street in Nişantaşı had, before television came to Turkey, sat atop the radio around which the family gathered every evening. As in so many houses I saw in Tabriz, Tehran, the cities of the Balkans, in the East, in Lahore and even Bombay, at the Keskins' house, the dog was set on a handmade lace doily. Sometimes a small vase would sit

alongside it, or a seashell (once Füsun picked up the television shell and, smiling, put it to my ear, so that I, too, could listen to the oceanic murmuring trapped inside it), or the dog would be propped against a cigarette box, as if standing guard. Sometimes it was these cigarette boxes and ashtrays that determined where the dog was placed. It was, I thought, Aunt Nesibe who saw to these mysterious arrangements, which might make one think the dog was about to nod—or even to pounce on the ashtray—though there was one evening in December 1979, when, while admiring Füsun, I saw her change the position of the china dog on the television. At a moment when nothing would draw notice to the dog or the television set, when we were all sitting at the table, waiting for her mother to serve the food she had prepared, she had shifted it with an impatient flick of the wrist. But this does not explain the dog's presence in the first place. In later years it would be joined by another dog guarding another cigarette box. For a time there was a fashion for plastic dogs that really did nod their heads; you often saw them in the back windows of private cars and shared taxis; the fashion came and went in the blink of an eye. Little was said about these dogs; if the Keskins began to remark on the comings and goings of these dogs, it was because my interest in their belongings was now evident to them. By the time the dogs sitting on the television set began to change with regularity, Aunt Nesibe and Füsun had either guessed or knew for a fact that I was taking them away, as I did so much else.

Actually, I had no desire to share my collection with others, nor did anyone know I was hoarding things—I was ashamed of what I was doing. After having taken all those matchboxes, and Füsun's cigarette butts, and the saltshakers, the coffee cups, the hairpins, and the barrettes—things not difficult to pick up,

because people rarely notice them missing—I began to set my sights on things like ashtrays, cups, and slippers, gradually beginning to replace them with new ones.

"You know that doggie on top of the television, the one we were talking about the other day? Well, it ended up at my house. Our Fatma Hanım was just putting it away when she dropped it on the floor and broke it. I've brought this to replace it. Aunt Nesibe, I was in the Spice Bazaar, buying birdseed and rapeseed, and I saw it in one of the shops there. . . ."

"Oh, what lovely black ears it has," Aunt Nesibe would say. "He's a real street dog. . . . Come here, old black ears! Now sit. The poor creature brings us peace!"

She took the dog from my hand and placed it on the television set. Sometimes the dogs set there brought us peace by their mere presence, much as the clock ticking on the wall did. Some looked threatening, others ugly and utterly charmless, but even these dogs made us feel as if we were sitting in a place guarded by dogs, and perhaps to feel thus protected was what brought us peace, as the neighborhood echoed with the militants' gunfire and the outside world seemed more surreal with every passing day. The black-eared dog was the most charming of the scores of dogs that came to rest on the Keskins' television during those eight years.

On September 12, 1980, there was another military coup. By instinct I'd woken up before everyone else that morning; seeing that Teşvikiye Avenue and the streets leading off it were all empty, I knew at once what had happened: In those days, coups came every ten years. From time to time army trucks came down the avenue, filled with soldiers singing martial songs. I turned on the television at once, and after watching the images of flags and military parades and listening to the

generals who had seized power, I went out onto the balcony. I liked seeing Teşvikiye Avenue so empty, and the city so silenced, so the rustling leaves of the chestnut trees in the mosque courtyard soothed me. Exactly five years earlier I had stood on this balcony with Sibel after our end-of-summer party, at exactly this hour in the morning, and admired the same view.

"Oh good, I'm so glad. The country was on the brink of disaster," said my mother as she watched the frontier folk singer with the handlebar mustache sing of war and heroism. "But why have they put this ugly brute on television? Bekri won't be able to make it in today, so Fatma, you'll have to cook. What do you have for us in your refrigerator?"

The curfew lasted all day. From time to time we'd see an army truck hurtling down the avenue; from this we knew that politicians, journalists, and many others were being picked up from their houses and taken into custody, and we were thankful that we never had involved ourselves in politics. The newspapers had all produced special editions, welcoming the coup, and all day long I sat with my mother, reading them and watching the generals announce the coup, a recording played many times over, interspersed with old images of Atatürk. From time to time I went to stand by the window and admire the beauty of the empty streets. I was curious to know how things were with Füsun—how everyone was feeling at the house in Çukurcuma. There were rumors of house searches in certain neighborhoods, as had been done during the 1971 coup.

"From now on we'll be able to go out into the streets in peace," my mother said.

With the imposition of the ten o'clock curfew, the military coup cast a long shadow over my evening meals at the Keskins'. During the evening news broadcast on the country's

only television channel, the generals not only railed against politicians and dissident intellectuals but lectured the entire nation about the bad habits that had led them astray.

But it wasn't just politicians and dissident intellectuals—they were also jailing common swindlers, brothel keepers, tombala men who sold black market cigarettes, and anyone who'd violated a traffic ordinance, written a slogan on a wall, or been involved in a porn film. A large number of people linked with terrorism were summarily executed as examples to others. Whenever word of one of these events reached the Keskin table, everyone would fall silent. At such times I would feel closer to Füsun: part of the family. They no longer seized young, long-haired "hippie types" from the streets to shave off their beards, as in the previous coup, but they did immediately fire a slew of university lecturers. The Pelür Bar was emptied out with other such places. In the wake of the coup, I resolved that I, too, would put my life in order: I would drink less, mitigate the disgrace my love had caused, and, if nothing else, tame my urge to collect things.

Less than two months later I found myself alone in the kitchen with Aunt Nesibe just before supper. I'd started coming to the house earlier, so that I could see more of Füsun.

"My dearest Kemal, you know that street dog with the black ears that you bought us—the one on the television? Well, it's gone missing. . . . Your eyes grow accustomed to things, so the moment they're gone, you notice. Whatever happened has happened; it doesn't matter to me—maybe the poor beast decided it was time to get up and go," she said. She let out a sweet little laugh, but when she saw the harsh expression on my face, she became serious. "What shall we do?" she asked. "Tarık Bey keeps asking what happened to the dog."

"Let me take care of this," I said.

That evening I was too upset to speak. But in spite of my silence—or because of it—I was also unable to stand up and leave, a paralysis that intensified as it got close to the curfew hour. I think that Aunt Nesibe and Füsun were both aware of my predicament. Aunt Nesibe was obliged to say, "Oh please don't be late!" several times. Only at five past ten was I able to leave the house.

No one stopped us on the way back, and after we were home safe I spent a long time thinking about the meaning of these dogs, and why I kept bringing them to the Keskins' only to remove them later; in fact, despite Aunt Nesibe's insistence that she'd noticed the disappearance immediately, it had taken them an astonishing eleven months to see that the dog was gone; it seemed to me that it had happened now only because of the coup, and the prevailing sentiment that we should all put our houses in order. Almost certainly, most of those dogs sitting on lace doilies atop the television were holdovers from the days when dogs sat on radios. As people listened to the radio, their heads would naturally turn toward it, and then their eyes would seek out something for distraction, something that offered solace. After radios gave way to televisions as the altars for family meals, the dogs were transferred to the tops of television sets, but now, with all eyes glued to the screen, no one noticed these little creatures anymore. I could take them away whenever I pleased.

Two days after that evening, I brought two china dogs to the Keskins.

"I was walking through Beyoğlu today when I saw these in the Japanese Market," I said. "It's almost as if they were designed to sit on our television."

"Oh, what a lovely pair they make," said Aunt Nesibe. "But why did you go to such trouble, Kemal Bey?"

"I was sorry about the one with the black ears going missing," I said. "Actually, I used to worry that he was lonely, sitting up there on the television. When I saw how happy these two were together, I said to myself that it would be nice to have a frisky pair of dogs up there on the television."

"Were you really worried the dog was lonely up there, Kemal Bey?" said Aunt Nesibe. "What a curious man you are. But that's why we love you."

Füsun was smiling tenderly at me.

"I get upset to see things thrown away and forgotten," I said. "They say the Chinese used to believe that things had souls."

"Before we Turks came here from Central Asia, we spent a huge amount of time with the Chinese; there was something about this on television just the other day," said Aunt Nesibe. "You weren't here that evening. Füsun, do you remember the name of the program? Oh, you've put the dogs where they belong, and don't they look lovely. But do you think they should be facing each other, or looking at us? Right now I just can't make up my mind."

"The one on the left should face us, and the one on the right should face his friend," Tarık Bey said suddenly.

Sometimes, at the strangest moment in a conversation, when we all thought he wasn't even listening, Tarık Bey would suddenly make a judicious comment that showed how he grasped the details even better than we did.

"If we do it like that, the dogs can be friends, and they won't get bored, but they'll also keep an eye on us, and be part of the family," he continued.

As much as I longed to touch them, I kept my hands off those dogs for more than a year. By 1982, the year I finally took them away with me, I had begun to leave money in a discreet corner to cover the cost of the things I took, or else I would bring over some quite expensive replacement the very next day. During those last years, many strange objects of the same form but different function—dogs that were also pincushions, and dogs that were also tape measures—had their time on top of the television.

66

What Is This?

FOUR MONTHS after the coup we were on our way home from the Keskins' one night when, fifteen minutes before curfew, Çetin and I were stopped by soldiers checking people's identity cards on Sıraselviler Avenue. I was stretched out comfortably on the backseat, and as all my papers were in order I had nothing to fear. But as he took my identity card from me, the soldier gave me a dubious look. When I saw his eyes light upon the quince grater at my side, I grew nervous.

By instinct, or by force of habit, I'd picked up the grater at the Keskins' when no one was looking. It made me so happy that I'd been able to leave early without making too much of an effort, and, just before this, I'd taken the prize out of my coat pocket, like a hunter wishing to cast a proud look over a woodcock he'd just bagged, and I'd left it sitting on the seat beside me.

The moment I'd arrived at the Keskins' house that evening, I'd breathed in the lovely fragrance of quince jelly. While we were talking about this and that, Aunt Nesibe mentioned that she and Füsun had been boiling the fruit all afternoon over a low flame, and that they'd had a nice mother-daughter chat. It pleased me to imagine how, while her mother was busy with something else, Füsun had slowly stirred the jelly with a wooden spoon.

After inspecting their occupants' identity cards, the soldiers let some cars continue on their way. In other cases they ordered all the passengers out of the car and subjected them to careful body searches.

Çetin and I got out of the car as ordered. They studied our identity cards carefully. We complied when directed to place our hands on the Chevrolet, like culprits in a film. The two soldiers searched the glove compartment and looked under the seats and everywhere else. The sidewalks of Sıraselviler Avenue, hemmed in on both sides by apartment houses of some height, were wet, and I remember, too, that quite a few passersby turned to look at us. As the curfew drew closer and no people remained in the streets, I could see just ahead that the lights were out in the windows of Sixty-Six, the famous brothel that took its name from its street number, and that, in our last year of lycée, everyone in my class had visited. Mehmet knew quite a few of the girls.

"Whose is this?" asked one of the soldiers.

"It's mine," I said.

"What is it?"

I suddenly realized that I would be unable to say that it was a quince grater. If I did, it seemed to me they would instantly understand that I was obsessed with Füsun and had for years been visiting four or five times a week the house she shared with her family, such a hopeless and humiliating situation as to oblige them to see me as a man with strange inclinations, harboring evil. My head was foggy after an evening of clinking *rakı* glasses with Tarık Bey, but when I think back on this episode so many years later, I do not believe this was the reason for my miscalculation. Only a few minutes earlier this quince grater had been part of the Keskins' kitchen, and now

it seemed so incongruous in the hands of this well-meaning officer from (I thought) Trabzon, that it unexpectedly sounded a deeper chord—something to do with living on this earth, and being human.

"Is this thing yours, sir?"

"Yes."

"What is it then, brother?"

Again I fell silent, surrendering to despair—a new symptom of paralysis; I wanted this soldier, this brother of mine, to understand the wrong I had done without my telling him, but it wasn't to be.

I'd had a classmate in primary school who was odd and rather stupid. Whenever the teacher called him up to the blackboard to ask if he'd done his math homework, he would fall silent just as I had done now, refusing to say yes or no; so weighed down was he by guilt and failure that he could only stand there, shifting his weight from one leg to the other, until the teacher went mad with fury. What I did not understand as I watched him with such amazement in that classroom was that if a person were to fall into such a silence even once, it would never again be possible for him to open his mouth; he would remain silent for years, even centuries. When I was a child, I was happy and free. But that night on Sıraselviler Avenue, so many years later, I discovered what it meant to be unable to talk. I had already had intimations that my passion for Füsun would ultimately turn into such a story of stubborn introversion. My love for her, my obsession, or whatever one could call it—it had rendered me incapable of diverting myself onto a path that would lead me to sharing this world freely with another. Even in the early days I'd known deep in my heart that mutuality could never happen in the world I've been describing, and

so I'd turned inward, to seek Füsun there. I think that Füsun knew, too, that one day I would find her inside me. In the end everything would be fine.

"Officer, that is a grater," said Çetin Efendi. "An ordinary quince grater."

How had Çetin recognized the grater?

"So why couldn't he tell me that himself?" He turned to me. "Look, we're under martial law here. . . . Are you deaf or what?"

"Officer, Kemal Bey is so sad these days. . . ."

"Why is that?" asked the officer, though his job left no room for compassion. "Get back in the car and wait!" he barked. Then he walked away holding the quince grater and our identity cards.

The grater sparkled for a moment in the glare of the bright lights of the cars waiting behind us, before I saw it disappear inside the small army truck just ahead of us.

Inside the Chevrolet, Çetin and I began to wait. The closer it got to curfew, the faster people were driving by, and in the distance we saw cars racing around the corners of Taksim Square. The silence between us was further laden with the fear and guilt that I felt whenever I was searched or my card was being checked or I was simply in the presence of the police. We listened to the car clock ticking, and to keep the silence we remained perfectly still.

I imagined the grater being pawed by a captain inside the truck, and it made me uneasy. As I sat there waiting in silence, I was slowly swamped by anxiety, imagining the pain I would suffer should those soldiers confiscate the quince grater; even years later I would vividly remember how intense this anxiety was. Çetin turned on the radio. Announcers were reading out various bulletins related to the state of martial law: the wanted

list, the prohibitions, the list of suspects who had been caught.
. . . I asked Çetin if he could change the station. After a bit of
crackling we were able to find a more agreeable program from
a distant country. As we tried to distract ourselves, a few drops
of rain fell onto the windshield.

Twenty minutes after the beginning of the curfew, one of
the soldiers came back and handed us our identity cards.

"It's all settled. You can go," he said.

"What if someone stops us for being out after the curfew?"
Çetin asked.

"You can say we stopped you," said the soldier.

Çetin started the engine. The soldier cleared the way for us.
But I stepped out of the car and went over to the army truck.

"Sir, I think you still have my mother's quince grater. . . ."

"Now look at that, it turns out you aren't deaf and dumb
after all, and look how beautifully you speak."

"You can't keep this on your person, sir, it could be used as
a weapon and cause serious injury!" said another soldier, one of
higher rank. "But fine, take it, just be sure you don't bring it out
with you again. What line of work are you in?"

"I'm a businessman."

"Do you pay your taxes on time?"

"I do."

They didn't say anything more. I'd suffered a little heartbreak,
but I was glad to be reunited with the grater. As Çetin drove us
home, slowly and carefully, I realized I was happy. These dark,
empty streets that now belonged to Istanbul's dog packs, these
avenues so ugly by daylight, hemmed in by concrete apartment
buildings in such dreadful condition that it sapped my will just
to look at them—now they looked alluringly mysterious, like
poems.

67

Cologne

IN JANUARY 1981, over lunch at Rejans, Feridun and I talked business as we drank our rakı and ate our bluefish. Feridun was making commercials with Yani, a cameraman he knew from the Pelür, and while that caused me no misgivings, he was upset about doing such work "for the money." Having observed the precocious ease with which Feridun had mastered the art of always looking comfortable and taking life's pleasures as they came, I might at one time have found it hard to understand his moral qualms; but because suffering had caused me to mature beyond my years, I had come to realize that most people are not what they appear.

"I have a screenplay that's ready to go," Feridun said then. "If I'm going to work for the money, it would be better to be working on that. It's a little crude but it has good prospects."

It was at the Pelür Bar that I'd first heard screenplays described as "ready" or "absolutely ready" to be filmed; it meant that the screenplay had passed the board of censors or had been granted all the permissions from the state that would guarantee its safe passage. In times when very few screenplays with popular appeal passed the censors, directors and producers whose livelihood depended on making one or two films a year were prepared to shoot screenplays they'd not even considered, provided they were "ready." Over many years of the board's smoothing over the edges, and cutting the

prickly bits out of everything that was interesting or original, films had assumed a dreary uniformity, and so for most directors it was no hardship to make a film about which they knew nothing.

"Is the plot suitable for Füsun?" I asked Feridun.

"Not in the slightest. It's a very suggestive role, perfect for Papatya. The actress will have to wear revealing clothing, and she also has to strip. Plus the leading man has to be Tahir Tan."

"It can't be Tahir Tan."

We bickered for some time about Tahir Tan, as if the heart of the matter were not our using Papatya instead of Füsun in our first film together. "Let us not be ruled by emotions!" Feridun said, insisting the time had come to forget the incident at the Huzur Restaurant. Suddenly our eyes met. How much was he thinking of Füsun at that moment? I asked what the film was about.

"A rich man seduces a beautiful girl who happens to be his distant relation, and then he abandons her. The girl, having lost her virginity, takes her revenge by becoming a singer. . . . As it happens, the songs were written for Papatya. . . . Hayal Hayati was going to make this film, but when Papatya refused to become his slave he got angry and pulled out. The screenplay was left in the lurch. It's a great opportunity for us."

The screenplay, songs, and all else about this film were so bad as to be not just unsuitable for Füsun but a discredit to Feridun. Though my beauty had been sulking through every supper, bolts of lightning flashing in her eyes whenever she looked at me, I thought there might be a virtue in making Feridun happy, at least, and so before the lunch was over, encouraged by the *rakı,* I agreed to back the film.

In May 1981 Feridun began to shoot his "ready screenplay,"

called *Broken Lives,* after the eighty-year-old novel of the same name by Halit Ziya; but there the resemblance ended, for this tale of love and family ties in the Ottoman mansions of the Westernized bourgeoisie and the imperial elite was a world away from the screenplay set in the muddy streets and *gazino*s of 1970s Istanbul. Sustained only by rage and pure will, our heroine (played by Papatya, who earnestly threw herself into the part) becomes famous for the love songs she performs in the *gazino*s as she devotes many patient years to plotting her revenge against the man who took her virginity; unlike the heroine of the novel, she is miserable not because she is married but because she cannot marry.

We began filming in the old Peri Cinema, in those days the location favored for all films with scenes in nightclubs offering traditional music. The theater seats had been taken out and tables put in to make the place look like a *gazino.* The cinema's stage was wide and deep, if not quite as large as the one at Maksim's, the largest indoor *gazino* of the day, or the Çakıl Gazino, which was housed in a large tent in Yeniköy. From the 1950s through the 1970s there were many such places, modeled on French cabarets, where patrons might eat and drink while being entertained by a lineup of singers, comics, acrobats, and magicians; they featured Turkish singers with Western as well as traditional repertoires, and many musical melodramas were filmed in them. Typically it was in the *gazino* that the heroine would first make a florid confession of her consuming pain, and when, years later, she drew wild applause and tears from another audience, it would be understood that she had achieved victory in the *gazino* as well.

Feridun had explained to me the various ploys Yeşilçam used to avoid paying the extras in scenes where wealthy spectators

applauded impoverished singers pouring their hearts out; in the old days, real singers like Zeki Müren and Emel Sayın would usually play themselves in such musicals, and the filmmakers would admit anyone in a jacket and tie who knew how to sit quietly and politely at a table. The *gazino* would be packed with people eager for a free show, in return serving free as extras. But in recent years filmmakers had begun to use lesser-known actresses like Papatya in musicals. (These young starlets would play singers much more famous than they themselves were, but after one or two films the gap between the film and real life would close, whereupon they could begin to star in films about impoverished singers much less famous than they now were. Muzaffer Bey had once told me that Turkish audiences would quickly tire of anyone who was as rich and famous in real life as represented in films; a film's secret power derived from the discrepancy between the star's real-life circumstances and her character in the film. The very point of the film being, after all, to show how that gap was closed.) As we could find no one willing to put on their best clothes to come to the dusty Peri Cinema and see a minor singer they'd never heard of, free kebabs were offered to any man who turned up wearing a tie and to any woman not wearing a headscarf. In the old days, whenever we were together with our friends or out on the town, Tayfun had always enjoyed making fun of the Turkish films he'd seen over the summer in garden cinemas; after mimicking the affectations and phony gestures of poor extras trying to play the rich spectators with full stomachs, he would, with the genuine pique of someone wronged, insist that rich people in Turkey were nothing like that.

Before we even began filming, I knew from Feridun's stories of his days as an assistant that cheap extras caused problems far

more serious than misrepresenting the rich. Some would try to leave once they'd finished their kebabs, while others sat at their tables reading the newspaper, or carried on joking and laughing with their fellow extras even as the singer star uttered her most affecting lines (though this last detail was at least true to life); some simply grew tired of waiting and fell asleep at their tables.

When I visited the set of *Broken Lives* for the first time, the set manager, his face flushed with anger, was scolding the extras for looking into the camera. For a time I was surveying the proceedings from a distance, like any film producer, when I heard Feridun shout "Action!" Then there was a flash of the crude magic—half fairy tale, half vulgarity—that you see so often in Turkish films, as Papatya stepped down the catwalk, microphone in hand, flanked on either side by the audience.

Five years earlier I had gone with Füsun and Feridun to a garden cinema near İhlamur Palace to see a film also starring Papatya, this time as a golden-hearted little girl who, being also shrewdly diplomatic, finds a way to reconcile her parents, who'd separated following a misunderstanding; now (with a speed indicating the fate of all Turkish children) she had been transformed into one of life's angry, long-suffering victims. Papatya had slipped into the traditional role of the tragic woman—luckless and robbed of her innocence, and destined only for death—as she might slip into a dress that had been tailor-made for her. It was when I remembered Papatya's former childish innocence that I could understand her now, just as I could recognize that childish innocence when I saw the tired, angry woman she had become. Accompanied by a nonexistent orchestra—Feridun would fill in with clips from other films—she walked through the scene with the certainty

of a model, with a hopelessness that seemed almost to rebel against God, and a lust for vengeance so great that we could not but share in her grief, recognizing that, rough as she was, Papatya was a jewel. Dozing extras came back to life, and when the filming began even the waiters who had been bringing out the kebabs stopped to watch her.

In those years, every star held the microphone in a particular way meant to express their personality; that Papatya had found her own new and original way, which made her fingers look like pincers, was proof, according to one journalist I'd met at the Pelür, that she was destined for stardom. *Gazino*s had stopped using fixed microphones, preferring the newer ones connected to long cords that allowed singers to mingle with the audience. But this improvement presented its own problems: Though divas were able to be more expressive, enhancing the lyrics with defiant and bitter gestures, and sometimes even with real tears, they had to yank at the long cord like housewives struggling with a vacuum cleaner. In fact, Papatya was just lip-synching, and the microphone wasn't attached to anything, but still she had to pretend that the cord kept getting stuck in order to show herself adept at managing this little difficulty with small, elegant gestures. It was the same admiring journalist who later likened these gestures to those of young girls swinging a jump rope for their friends.

The filming was progressing fast, and at the next break I congratulated Feridun and Papatya. Even as I uttered these words I heard myself sounding like the producers I'd read about in newspapers and magazines. Maybe this was because journalists took notes! Meanwhile, Feridun had begun to resemble the directors one read about: The chaotic speed of filming having robbed him of his childish air, in two months it

was as if he'd aged ten years, and he now looked every bit the strong, resolute, and even merciless sort of man who always finished what he started.

That day also brought my first intimation that Feridun and Papatya might be in love, or at least involved in a serious relationship, though I wasn't absolutely certain. Whenever journalists were around, all stars and starlets made as if they were conducting secret love affairs. Or was there perhaps something about the gaze of magazine journalists that was so suggestive of sin, guilt, and the forbidden as to compel actors and filmmakers to transgress? When they started taking pictures, I kept my distance, and as scarcely a week went by without Füsun picking up a copy of *Ses* or *Hafta Sonu*, which gave so much coverage of film news, I predicted that she would soon be reading something about Feridun and Papatya. Papatya might just as likely imply that she was having an affair with her leading man, Tahir Tan, or even with me—the producer! Anyway there was no need for independent insinuations: Magazine and film page editors having decided what version would sell best would invent an intrigue, embroider it, and gleefully write it up. Sometimes they would propose their false story to the actors openly, and the actors would gamely help them by providing a suitable "intimate pose."

I was glad to have kept Füsun away from the sordid ambience of such people, but at the same time it saddened me somehow that she would be deprived of the excitement of working on the set, which she craved almost as much as fame. And because, in fact, after a woman had played many variations on the fallen woman, in films and in real life—for audiences, the two were one, after all—after life had knocked her about a bit, a famous film star could settle down to play

respectable matriarchs and conduct the rest of her career like a lady. Could Füsun have been dreaming of some such course? If so, would she first need to find herself a sugar daddy from the underworld or some equally tough, moneyed adventurer inclined to that sort of liaison? The moment such men began affairs with stars, they would prohibit them from all kissing in films, and likewise from exposing too much skin. Lest readers and visitors in future centuries misunderstand, let me clarify that by "exposing" I mean the baring of their shoulders and lower legs. Once a sugar daddy took a star under his wing, he also imposed an immediate ban on all rude, degrading, or snide news pieces about her. Once a younger reporter was shot in the knees because, unaware of the ban, he wrote a story about a large-breasted star then under such august protection, claiming that when still young enough to be a schoolgirl, she had worked as a dancer and had been the mistress of a famous industrialist.

It was painful to remember that, less than ten minutes from the Peri Cinema, Füsun was sitting idle at home in Çukurcuma, even as I enjoyed watching the filming, which would go on all day, right up until the curfew. It alarmed me to think that if my place at the Keskins' table remained empty, Füsun would infer I preferred being in the film world to an evening in her company. So in the evenings, after leaving the Peri Cinema, I would walk down the cobblestone hill to the Keskins' house, urged on by guilt and the promise of happiness. Füsun would be mine in the end, I reasoned; I'd done well to keep her out of films.

Sometimes it would occur to me that ours was a companionship of knowing shared defeat: This made me even happier than love did. Whenever I felt this, everything—the shafts of evening sun on the city streets; the odor of dust, age, and mildew wafting from the old Greek apartment buildings; the

vendors selling fried liver and pilaf with chickpeas; the football bouncing between the boys playing on the cobblestones; and the mock applause when I recovered a strong ball for them on my way down to the Keskin house—everything in the world made me happy.

In those days, everyone in the city—whether on the film set or in the hallways of Satsat, at the coffeehouses or at the Keskins' dinner table—was talking about the exorbitant interest rates being offered by opportunists setting themselves up as "bankers." With the inflation rate nearing 100 percent, everyone wanted to invest his money somewhere. Just before we sat down to eat, Tarık Bey told me that at the neighborhood coffeehouse he visited on occasion, there were a few who had bought gold at the Covered Bazaar, and others who had deposited their savings with bankers promising as much as 150 percent interest, but that everyone else was selling their gold and closing their bank accounts; gingerly, uneasily he sought out my counsel as a businessman.

What with the filming and the curfew, Feridun was seldom home, and he gave Füsun none of the money I'd put into Lemon Films. It was around this time (about a month earlier I'd taken away an old deck of cards belonging to Tarık Bey, scarcely concealing my action) that I stopped replacing the things I took and instead began to leave money.

I knew that Füsun read her fortune with those cards to pass the time. When Tarık Bey played bezique with Aunt Nesibe, he used a different deck, as did Aunt Nesibe when, once in a blue moon, she played cards with a guest (poker with peas, or even seven jacks). A number of cards in the deck I "stole" were dog-eared, and their backs were stained; some of the cards were even bent and broken. Füsun was amused to admit that because she

could recognize some of these cards by their marks and stains, she could make her fortune come up according to her wishes. I'd sniffed the deck, breathing in the mixture of perfume, mildew, and dust particular to old cards, picking up the scent of Füsun's hand. The deck and its scent made my head spin, and as Aunt Nesibe had noticed my interest, I slipped it into my pocket in plain view.

"My mother tries to read her fortune, but it never works out," I said. "This deck seems to offer more favorable results. Once she gets to know the stains and creases, perhaps my mother will have better luck. She's been very low lately."

"Please send my best regards to Sister Vecihe," said Aunt Nesibe.

After I'd promised to buy a new deck from Alaaddin's shop in Nişantaşı, she spent a good while insisting that I "should not go to all that trouble." When I insisted, she did allow that a certain new set had caught her eye in Beyoğlu.

Füsun was in the back room. Feeling very ashamed, I took a roll of cash from my pocket and hid it on the sideboard.

"Aunt Nesibe, would you please buy two of those sets, one for yourself and one for my mother? She will be happy to receive a deck of cards if they come from this house."

"Of course," said Aunt Nesibe.

Ten days later, and again feeling strangely ashamed, I left another wad of bills in the place from which I'd taken a new bottle of Pe-Re-Ja cologne.

During the first few months I was sure that Füsun had no idea that I was replacing objects with money. In fact, I'd been taking cologne bottles from the Keskin household for years and storing them at the Merhamet Apartments. But these were either empty or almost empty bottles, and so bound to be

discarded soon anyway. No one but the children who played with them in the street had any interest in empty bottles.

Whenever I was offered cologne after supper, I would eagerly, even hopefully, rub it into my hands, my forehead, and my cheeks, as if anointing myself with some unction. When Füsun or her parents were offered cologne, I would watch enchanted as they each performed their own rituals. Never taking his eyes off the television, Tarık Bey would slowly and noisily unscrew the heavy bottle's cap, and we all knew that soon, at the next commercial break, he would hand the bottle to Füsun saying, "See if anyone would like some." First Füsun would pour cologne into her father's hands, and Tarık Bey would rub it into his wrists with therapeutic purposefulness, inhaling the fragrance deeply, like someone recovering from shortness of breath, a relief renewed for the rest of the evening by sniffing now and again the tips of his long fingers. Aunt Nesibe would take only a few drops, and with dainty gestures reminiscent of my mother's, she would make as if she were lathering an imaginary bar of soap between her palms. If he was at home, it would be Feridun who took the most cologne when his wife offered it, cupping his hands like a man dying of thirst, slapping it on his face as if intending to gulp it down. This range of gestures led me to feel that cologne had a meaning beyond its pleasant smell and cooling effect (especially since the same rituals were performed on cold winter evenings).

Like the cologne the driver's assistant offered each and every traveler at the beginning of a bus journey, our cologne reminded us that as we gathered around the television we belonged to one another, that we shared the same fate (a sentiment also suggested by the evening news), that even

though we were meeting together in the same house to watch television every evening, life was an adventure, and there was a beauty in doing things together.

I sat impatiently when my turn came, waiting for Füsun to pour cologne into my hands, and for our eyes to meet. We would look deeply into each other's eyes, like two who had fallen in love at first sight. As I smelled the cologne in my hands, I would never look at them, but continue to look deep into her eyes. Sometimes the intensity, determination, and love visible in mine would make her smile, a hint of a smile that would not soon leave the corners of her lips. In that smile I saw a tenderness as well as a derision inspired by my ardor, my evening visits, and life itself, but it didn't break my heart. Rather I would feel more love for her than ever, and so I'd want to take the cologne, this bottle of Altın Damla, Golden Drops, home with me, and a few visits later, when the bottle was almost empty, I would walk over to my coat, hanging near the door, and without stealth slip the bottle into my pocket.

During the filming of *Broken Lives,* as I walked from the Peri Cinema to Çukurcuma at around seven in the evening, just before nightfall, I sometimes felt as if I were reliving a little piece of a former life. In the first life that I was now repeating exactly, there had been no great sorrow, nor any great happiness, and a heavy melancholy was blackening my soul. Perhaps this was because I'd seen the end of the story and knew that no great victory or extraordinary bliss awaited me. Six years after falling in love with Füsun, I was no longer someone who thought of life as a pleasurable adventure, indeterminately full of possibility: I was on the verge of becoming a sad and dejected man. I was slowly being overtaken by the fear of having no future.

"Füsun, shall we look at the stork?" I asked during those spring evenings.

"No, I haven't touched it since last time," said Füsun listlessly.

Once Aunt Nesibe interrupted us to say, "Oh, how can you say such a thing? Why, when last I saw it that stork took off from our chimney and flew so high into the air—Kemal Bey, from where it is now you could see all of Istanbul."

"I'd love to take a look."

"I'm just not in the mood tonight," Füsun would say sometimes, in all honesty.

Then I would sense Tarık Bey's beating heart, and in his longing to protect his daughter, his sadness. It grieved me to think that when she uttered these words, Füsun was talking about not just that night, but about the dead end that was her whole life, and it was then that I decided to stop going to watch the filming of *Broken Lives*. Füsun's answer had also served as a reminder of the war she had been waging against me for many years; in Aunt Nesibe's looks, I could see that she was concerned for me as well as Füsun. The woes and worries of life had blackened our hearts, no less than the dark rain clouds gathering over Tophane had blackened the sky; feeling this, we would sink into a silence we had only three ways to remedy:

1. We'd watch television.
2. We'd pour more *rakı* into our glasses.
3. We'd light another cigarette.

4,213 Cigarette Stubs

DURING MY eight years of going to the Keskins' for supper, I was able to squirrel away 4,213 of Füsun's cigarette butts. Each one of these had touched her rosy lips and entered her mouth, some even touching her tongue and becoming moist, as I would discover when I put my finger on the filter soon after she had stubbed the cigarette out; the stubs, reddened by her lovely lipstick, bore the unique impress of her lips at some moment whose memory was laden with anguish or bliss, making these stubs artifacts of singular intimacy. For nine years Füsun smoked Samsuns, for which brand I gave up Marlboros soon after beginning to dine at the Keskins'. I used to buy Marlboro Lights from tombala men and the black market vendors in the backstreets, and I can recall a conversation with Füsun one night about how both Marlboro Lights and Samsuns were full-flavor cigarettes of a similar taste. Füsun claimed that Samsuns made one cough more, but I said that as we had no way of knowing how many poisons and other chemicals the Americans put into their tobacco, it was possible that Marlboros were even more harmful. Tarık Bey had not yet sat down at the table when, looking deeply into each other's eyes, we each produced a pack to offer the other a cigarette. For eight years I followed Füsun, chain-smoking Samsuns, but as I have no wish to set a poor example for future generations, let me not dwell lovingly on

those seductive details that feature so prominently in old novels and films.

Once they'd been lit, our fake Marlboros, which were produced in the Socialist Republic of Bulgaria and smuggled into Turkey on ships and fishing boats, would burn—just like the real Marlboros produced in America—all the way to the end. But Samsuns would always flame out before that. The tobacco was coarse and moist, not ground well enough, and the cigarettes often contained what looked to be chips of wood, as well as undried lumps of the plant and thick-veined leaves. For this reason, Füsun was in the habit of softening the cigarette before she smoked it by rolling it between her fingers, and over time I had acquired this habit, too, rolling my cigarette between my fingers, just as she did, before lighting up, and I loved it when our eyes met as we were both doing this.

During my first years with the Keskins, Füsun would smoke in a way as if to suggest she was half trying to hide it from her father. Covering her cigarette with the curved palm of her hand, and not using the Kütahya ashtray that her father and I used, but tipping her ashes onto the small saucer of a coffee cup, "without anyone seeing." Her father and Aunt Nesibe and I were heedless of where our smoke went, but when she had to exhale, Füsun would suddenly turn her head to the right, as if about to whisper a secret into the ear of the classmate sitting beside her, directing the fast cloud of dark blue smoke to a point far from the table. I loved to see her face clouding with guilt, panic, and affected shame: It reminded me of our math lessons, and I believed then that I would love her all my life.

The anxious adherence to the forms of deference that we associate with traditional families—sitting straight and never crossing one's legs or smoking or drinking in front of

one's father—had over time slowly disappeared. Tarık Bey certainly saw his daughter smoking, but he didn't respond as one might expect a traditional father would, seeming content with the other gestures by which Füsun showed her respect. It was a great joy to study the myriad social refinements of which anthropologists seem to have so little understanding, and most especially these rituals that allowed families to act "as if" they were respecting tradition, even as they broke with it. This "as if" culture did not seem to me duplicitous: Whenever I watched Füsun making these sweet and lovely gestures, I would remind myself that I was only able to see the Keskins at all because every time I visited we all acted "as if" I wasn't sitting there as the suitor, as I truly was. I was able to see Füsun by reason of acting as if I were merely a distant relation come to visit, however frequently.

When I was not at the house, Füsun would smoke her cigarettes almost down to the filter, as I could tell from those butts she'd left around the house before I arrived. I always knew which ones were hers, not by the brand but rather by the way she'd stubbed them out, which bespoke her mood.

When I came for the evening, she would smoke her cigarettes as Sibel and her friends smoked their long, thin, stylish American "ultra-lights"—never smoking the whole cigarette but putting it out midway.

Sometimes she would stub it out with evident anger, sometimes with impatience. I had seen her stub out a cigarette in anger many times, and this caused me disquiet. Some days she would put out her cigarette against the surface of the ashtray with a series of short, insistent taps. And sometimes, when no one was looking, she would press it down hard, and very slowly, as if crushing the head of a snake, so that I would think that

the collected resentment of her whole life was being expressed with this cigarette stub. At times, when watching television, or listening to the conversation at supper, when her mind was clearly elsewhere, she would snuff the cigarette without even turning her head to look. Quite often, if she needed to free her hand to pick up a spoon or a large pitcher, I would see her doing the job with one quick movement. When she was feeling joyous or glad, she would sometimes press what was left of the cigarette against the ashtray, extinguishing it with the sudden force of her forefinger, as if trying to kill an animal without causing it pain. If she was working in the kitchen, she would do as Aunt Nesibe did, removing the cigarette from her mouth and holding it for a moment under the tap before throwing it into the bin.

This variety of methods ensured that every cigarette to leave her hand had its special shape, and its own soul. Back in the Merhamet Apartments I would retrieve the butts from my pocket for careful examination, likening each to some other form. For example, I would see some as little black-faced people with their heads and necks smashed, their trunks made crooked by the wrongs others had done them; or I would read them as strange and frightening question marks. Sometimes I likened the cigarette ends to crayfish or the smokestacks of City Line ferries; sometimes I saw them as exclamation marks, one warning me to take heed of lurking danger of which another was an omen; or as just so much foul-smelling rubbish. Or I would see them as expressions of Füsun's soul, even fragments of it, and as I lightly passed my tongue over the trace of lipstick on the filter, I would lose myself in communion with her.

When those visiting my museum note that beneath where each of the 4,213 cigarette butts is carefully pinned, I have

indicated the date of its retrieval, I hope they will not grow impatient, thinking I am crowding the display cases with distracting trivia: Each cigarette butt in its own unique way records Füsun's deepest emotions at the moment she stubbed it out. See, for example, the three cigarette butts I collected on May 17, 1981, when the filming of *Broken Lives* began at the Peri Cinema: All are roughly bent, folded upon themselves, and compacted, perfectly recalling the terrible awkwardness of Füsun's silence that day, her refusal to say what was upsetting her, and her vain attempts to pretend nothing was wrong.

As for this pair of well-crushed butts, I trace one of them back to the evening we saw a film called *False Bliss,* which aired on television around that time, with our friend Ekrem from the Pelür (better known as Ekrem Güçlü, the famous star who had once played the prophet Abraham) as the hero. Füsun had stubbed out that cigarette just after he had intoned, "The greatest mistake in life, Nurten, is to want more, to try to be happy," while Nurten, his poverty-stricken beloved, cast down her eyes in silence.

Some stains on a few of the straighter butts come from the cherry ice cream Füsun ate on summer evenings. Kamil Efendi, the ice cream vendor, would trundle his three-wheeled pushcart through the cobblestone streets of Tophane and Çukurcuma on summer evenings, shouting *"Eye-es Gream!"* and slowly ringing his bell; in the winters he would sell *helva* from the same cart. Once Füsun told me that she'd seen Kamil Efendi's cart being repaired by Beşir, the man to whom she'd taken her own bicycle when she was a child.

When I look at another pair of cigarette butts and read the dates recorded beneath them, I think of other warm summer evenings, of fried eggplant with yogurt, of standing together

with Füsun at the open window, she holding a small ashtray in one hand, repeatedly tapping her ash into it with the other. Whenever Füsun chatted with me in front of the window she would always affect this pose, and I would imagine her as a woman at a stylish party. Had she wished, she could have tapped the ash into the street, as I, like all Turkish men, did, or she could have stubbed out the cigarette on the windowsill before shooting it like a dart through the window; she could even have tossed it out still burning, with one flick of the hand, to watch it spiral down through the darkness. But no, Füsun would do none of these things, and I followed her example of poise and elegance. Someone viewing us from afar might take us for a couple enjoying polite conversation in a European country, where men and women could be at ease together; he might imagine us at a party and assume we had retired to a quiet corner to get to know each other better. We would not look into each other's eyes; we would look through the open window, laughing as we chatted about the film we had just seen on television, or remarked on the oppressive summer heat, or the children playing hide-and-seek in the street below. Just then a light breeze would blow in from the Bosphorus, bringing a strong whiff of seaweed, which blended with the overpowering scent of honeysuckle, the fragrance of Füsun's hair and skin, and the pleasing smoke from this cigarette.

Sometimes, when Füsun was stubbing out her cigarette, our eyes would unexpectedly meet. If she was watching a love story, or engrossed in the endless succession of shocking events in a documentary about the Second World War, with a dirge playing in the background, Füsun would stub out her cigarette without ceremony, and without showing much intent. However, if, as in the case of this specimen, our eyes happened to meet, a

charge passed between us, jolting us both, as we remembered at the same time why I was sitting at that table, and her stub would reflect the particular confusion she was feeling, thereby endowing the butt with an unusual shape. Hearing a ship blow its horn from a very great distance, I would then imagine the universe, and my life, as those aboard the ship might view it.

Some nights I would take only one cigarette butt away with me, and some nights I would take away a few; then at the Merhamet Apartments, picking them up one by one, I would recall various "moments" belonging to the past. Of all the objects I collected, it was the cigarettes that I found to correspond most truly to Aristotle's moments.

By now I no longer needed to pick up the objects accumulated in the Merhamet Apartments; I had only to see them once and I could remember the past Füsun and I had shared, the evenings we had spent together at the dinner table. I had associated each and every object—a porcelain saltshaker, a tape measure in the form of a dog, a can opener that looked like an instrument of torture, a bottle of the Batanay sunflower oil that the Keskin kitchen never lacked—with a particular moment, and as the years passed, it seemed as if these remembered moments expanded and merged into perpetuity. And so looking at any of the things gathered in the Merhamet Apartments, even only to remember them, was like looking at the cigarette butts: one by one, they would recall the particles of experience until I had summoned up the entire reality of sitting at the dinner table with Füsun and her family.

Sometimes

SOMETIMES WE'D do nothing but sit there in silence. Sometimes Tarık Bey, tiring of the show—we all did on occasion—would begin to peer at the paper from the corner of his eye. Sometimes a car would clatter noisily down the hill, blowing its horn, and there would be a hush as we listened to it pass. Sometimes it would rain and we would listen to the raindrops against the windowpanes. Sometimes we would say, "How hot it is." Sometimes Aunt Nesibe, forgetting that she'd left a cigarette burning in the ashtray, would light up another in the kitchen. Sometimes I would discreetly stare at Füsun's hand for fifteen or twenty seconds, and feel my adulation grow. Sometimes, during the commercials, a woman would appear on the screen to acquaint us with something that we at the table were eating at that very moment. Sometimes there would be an explosion in the distance. Sometimes Aunt Nesibe would rise from the table to throw one or two more pieces of coal into the stove, or sometimes Füsun would do it for her. Sometimes I'd think that on my next visit I should bring Füsun a bracelet instead of a hair clip. Sometimes I would forget what a film was about even as we were watching it, and though I continued to watch, I would think about my primary school days in Nişantaşı. Sometimes Aunt Nesibe would say, "Why don't I brew some linden tea?" Sometimes Füsun yawned so beautifully that I would think that she had forgotten the entire world and that

she was drawing from the depths of her soul a more peaceful life, as one might draw cold water from a well on a hot summer day. Sometimes I would say to myself that I should not stay there a moment longer, that I should get up and leave. Sometimes, after the barber who worked until all hours in the shop on the ground floor across the street had sent off his last customer, he would lower his iron shutters very fast, and in the silence of the night the echo would reverberate throughout the neighborhood. Sometimes they'd cut off the water, and for two days we'd go without. Sometimes we would notice something other than flames flickering inside the coal stove. Sometimes I would come for supper two nights in a row, because Aunt Nesibe said, "You liked my beans in olive oil, so why don't you come again tomorrow, before they all get eaten up?" Sometimes conversation turned to the Cold War between America and the USSR—the Soviet warships that passed through the Bosphorus by night, and the American submarines that plied the Marmara. Sometimes Aunt Nesibe would say, "It's turned very hot this evening!" Sometimes I could tell from Füsun's expression that she was daydreaming, and I would long to visit the country in her imagination, although everything seemed hopeless—my life, my lethargy, and even the way I sat there. Sometimes the objects on the table looked to me like mountains, valleys, hills, depressions, and plateaus. Sometimes a funny thing happened on television, and we would all burst out laughing at once. Sometimes it would seem ridiculous the way we all got sucked into whatever was happening on the screen. Sometimes I was bothered by the way Ali the neighbor's child climbed onto Füsun's lap and nestled up to her. Sometimes Tarık Bey and I would discuss the vagaries of the economic situation, man to man, and in low voices that suggested conspiracies, deceptions,

and dirty tricks. Sometimes Füsun would go upstairs and linger, which was upsetting. Sometimes the phone would ring, and it would be a wrong number. Sometimes Aunt Nesibe would say, "Next Tuesday I'm going to make candied squash." Sometimes a gang of three or four men would hurtle down the hill, yelling and singing football songs as they continued in the direction of Tophane. Sometimes I would help Füsun pour coal into the stove. Sometimes I would see a cockroach scurrying across the kitchen floor. Sometimes I would sense that Füsun had taken off her slipper underneath the table. Sometimes the watchman would blow his whistle right in front of the door. Sometimes Füsun would get up to tear off the forgotten pages of the Saatlı Maarif Takvimi one by one, and sometimes I would. Sometimes, when no one was looking, I would take another spoonful of semolina helva. Sometimes the picture on the television would go fuzzy, and Tarık Bey would say, "Could you see what you can do, my girl?" and Füsun would fiddle with a button on the back of the set, while I watched the back of her. Sometimes I would say, "I'll smoke one more cigarette, and then I'll go." Sometimes I would forget Time altogether, and nestle into "now" as if it were a soft bed. Sometimes I felt as if I could see the microbes, bugs, and parasites inside the carpet. Sometimes Füsun would go to the refrigerator between programs and take out cold water, while Tarık Bey paid a visit to the bathroom upstairs. Sometimes they'd cook stuffed squash, tomatoes, eggplant, and peppers in clarified butter and eat it two nights in a row. Sometimes when supper was over Füsun would rise from the table, go over to Lemon's cage, and speak to him like a friend, and I would fantasize that she was really talking to me. Sometimes on summer evenings a moth would fly in through the open bay window and flutter faster and faster around the

lamp. Sometimes Aunt Nesibe would mention an old piece of neighborhood gossip that she had only just heard, telling us, for example, that Efe the electrician's father was a famous gangster. Sometimes I would forget where I was and think we were alone together; I would forget myself and show Füsun all my love, gazing at her lovingly for the longest time. Sometimes a car passed so quietly its presence was announced only by the shuddering of the window. Sometimes we heard the call to prayer coming from Firuzağa Mosque. Sometimes, for no apparent reason, Füsun would rise from the table and go over to the window that looked down the hill, and stand there for a long while, as if waiting for someone she missed very deeply, and this would break my heart. Sometimes, while watching television, I would think of something very different, imagining, for example, that we were passengers who had met in the restaurant aboard a ship. Sometimes on summer evenings, after spraying the whole top floor with Temiz İş, Clean Work, Aunt Nesibe would come downstairs with the insecticide, to give those rooms "a quick once-over" and kill more flies. Sometimes Aunt Nesibe spoke about Süreyya, the former queen of Iran, of her anguish when the Shah divorced her for failing to give him an heir, and of her life in high society in Europe. Sometimes Tarık Bey would cry, "How could they put a disaster like that man on television again?" Sometimes Füsun would wear the same outfit two days in a row, though to me it still looked different. Sometimes Aunt Nesibe would ask, "Does anyone want ice cream?" Sometimes I saw someone in the apartment across the way go to the window to smoke a cigarette. Sometimes we ate fried anchovies. Sometimes I observed that the Keskins sincerely believed there was justice in the world, and that the guilty were punished, if not in this life, then in the

next. Sometimes we would fall silent for a long time. Sometimes we would not be the only ones: It would be as if the entire city had gone quiet. Sometimes Füsun would say, "Father, please don't pick at the food like that!" and then I would feel as if they couldn't even feel at home at their own table, because of me. Sometimes I would think the exact opposite, and I would delight in noticing that everyone seemed at ease. Sometimes, after lighting her cigarette, Aunt Nesibe would get so involved with whatever was happening on television that she would forget to blow on the match until it had burned her hand. Sometimes we would eat baked macaroni. Sometimes a plane would fly overhead in the black sky, headed toward the airport at Yeşilköy. Sometimes Füsun would wear a blouse that revealed her long neck and a bit of cleavage, and as I watched television it was all I could do not to stare at the whiteness of her lovely throat. Sometimes I would ask Füsun, "How's the picture going?" Sometimes the television would say "Snow tomorrow," but it wouldn't come. Sometimes an oil tanker would blow its mournful, anxious horn. Sometimes we'd hear gunshots in the distance. Sometimes the next-door neighbor slammed his front door so hard that the cups in the cupboard behind me rattled. Sometimes the phone would ring and Lemon, mistaking it for a female canary, would begin to sing with joy, and we would all laugh. Sometimes a couple would come to visit, and I would feel a bit shy. Sometimes when the Üsküdar Musical Society Women's Chorus was performing old Turkish songs on television, Tarık would join in without leaving his seat. Sometimes two cars would meet nose to nose in the narrow street, and with both drivers too stubborn to give way, an argument would begin, with curses flying, and before long the two would have stepped out of their cars to fight. Sometimes

there would be a mysterious silence in the house, the street, the entire neighborhood. Sometimes I brought them salted fish as well as cheese pastries and smoked fish. Sometimes we would say, "It's awfully cold today, isn't it?" Sometimes, at the end of a meal, Tarık Bey would reach into his pocket with a smile and bring out a few Ferah brand peppermint sweets and offer them to us all. Sometimes two cats at the door began to wail wildly, and then they would screech and begin to claw at each other. Sometimes at supper Füsun would wear the earrings or the brooch I had brought her that very day, and I would tell her in a low voice how well she looked. Sometimes we were so affected by the reunions and kisses in love stories that it was as if we had forgotten where we were. Sometimes Aunt Nesibe would say, "I put very little salt in this, so, please, whoever wants more, add more if you wish." Sometimes we'd see lightning in the distance, and the sky would rumble. Sometimes while we were watching a film, or a series, or a commercial, someone we knew from the Pelür would appear, someone we'd joked about, and I'd want to exchange looks with Füsun, but she would avert her eyes. Sometimes there'd be a power outage and we could see our cigarette embers in the dark. Sometimes someone would pass the front door whistling a familiar tune. Sometimes Aunt Nesibe would say, "Oh, I've smoked too many cigarettes this evening." Sometimes my eyes would fix on Füsun's neck, and for the rest of the evening I would make a point of not looking at it again, without too much trouble. Sometimes we'd suddenly fall silent, and Aunt Nesibe would say, "Someone has just died somewhere." Sometimes Tarık Bey would be unable to get one of his new lighters to work, and I could tell it was time to bring him a new lighter as a present. Sometimes Aunt Nesibe would bring out something from the refrigerator and

ask us what had happened in the film while she'd been away. Sometimes, just across Dalgiç Street, we'd hear a domestic quarrel, and the screams as the husband beat the wife would upset us. Sometimes on winter nights we'd hear the boza seller ringing his bell, crying, "Genuine vefaa!" as he passed our door, and I would have the urge to drink some. Sometimes Aunt Nesibe would say, "Aren't you a bundle of joy today!" Sometimes I'd try very hard not to reach over and touch Füsun. Sometimes, especially on summer evenings, a breeze would stir, slamming the doors. Sometimes I thought about Zaim, and Sibel, and all my old friends. Sometimes flies would land on our food on the table, annoying Aunt Nesibe. Sometimes Aunt Nesibe would take mineral water out of the refrigerator for Tarık Bey and ask me, "Would you like some, too?" Sometimes, before it had even turned eleven, the watchman would pass by blowing his whistle. Sometimes I was overcome by an unbearable longing to say, "I love you!" when all I could do was offer Füsun a light. Sometimes I would notice that the lilacs I had brought on my last visit were still sitting in a vase. Sometimes amid a silence someone in one of the neighboring houses would open a window and toss out rubbish. Sometimes Aunt Nesibe would say, "Now who is going to eat this last meatball?" Sometimes while watching the generals on television I would remember my army days. Sometimes I would be utterly convinced that I was not the only inconsequential one; it was all of us. Sometimes Aunt Nesibe would say, "Who can guess what we have for dessert today?" Sometimes Tarık Bey would have a coughing fit and Füsun would get up to fetch him a glass of water. Sometimes Füsun would wear a pin I'd bought her years earlier. Sometimes I'd begin to think what I was watching on television had a subtext. Sometimes Füsun would ask me a

question about an actor, literary luminary, or professor we saw on television. Sometimes I helped take the dirty plates into the kitchen. Sometimes there was a silence at the table, because all our mouths were full of food. Sometimes one of us would yawn, somehow inducing another of us to do the same, until having all caught the contagion we would laugh. Sometimes Füsun would become so engrossed in the film on television that I'd long to be that film's hero. Sometimes the smell of grilled meat would linger in the house all evening. Sometimes I thought I was abundantly happy, just to be sitting next to Füsun. Sometimes I would say, "It's about time we went out to eat on the Bosphorus one evening," to encourage the making of plans. Sometimes I was absolutely positive that life itself wasn't somewhere else, but right there, at that table. Sometimes we'd argue about something—the lost royal cemeteries of Argentina, the gravity on Mars, how long a person could hold his breath underwater, why it was dangerous to ride motorcycles in Istanbul, the shape of chimney rocks in Capadocia— prompted by nothing more than something we'd seen on television. Sometimes a harsh wind would blow, and the windows would moan, and the stovepipes would clank ominously. Sometimes when Tarık Bey recalled how, five hundred years earlier, Mehmet the Conqueror's galleys had passed Boğazkesen Avenue, only fifty meters from where we were sitting, on their way to the Golden Horn, he would say, "And the man was only nineteen years old!" Sometimes Füsun would rise from the table after supper and go over to Lemon's cage, where after a moment I would join her. Sometimes I would say to myself, "It's good that I came here tonight!" Sometimes Tarık Bey would send Füsun upstairs to fetch the newspaper, the lottery ticket, or his spectacles, or whatever else

he had forgotten there, and Aunt Nesibe would call up the stairs, saying, "Don't forget to put out the lights!" Sometimes Aunt Nesibe said we could go to Paris to attend a distant relation's wedding. Sometimes Tarık Bey would say, "Quiet!" in a forceful voice, and, gesturing with his eyes, direct our attention to a noise coming through the ceiling, and we would be unable to tell whether the creaks we had heard were from a mouse or a burglar. Sometimes Aunt Nesibe would ask her husband, "Is it loud enough for you, darling?" because as time went on, Tarık Bey was slowly losing his hearing. Sometimes the silence that consumed us would have a mysterious air. Sometimes it would snow, and it would stick on the window frames and on the sidewalk. Sometimes there were fireworks, and we would all rise from the table to see whatever we could of the colors streaming across the sky, and later, the smell of gunpowder wafted through the open window. Sometimes Aunt Nesibe would ask, "Shall I fill your glass, Kemal Bey?" Sometimes I would say, "Shall we have a look at your painting, Füsun?" and we would go into the back room, and as Füsun and I looked at her painting, I realized this was the time when I was always happy.

Broken Lives

A WEEK after the curfew was pushed back to eleven o'clock, Feridun made it home with just half an hour to spare. For some time he had not been coming home at night, saying the shooting had run late and he had slept on the set. That night he came in drunk, and very obviously miserable. Seeing us sitting at the table, he forced himself to utter a few pleasantries, but he couldn't keep it up for long. When his eyes met Füsun's, he took on the air of a soldier just returned from a long and disastrous campaign, and saying little more he went upstairs to his room. Füsun should have risen from the table and followed her husband up, but she didn't.

I had fixed my eyes on hers and was watching her carefully. She knew my eyes were on her. She lit a cigarette, smoking it casually, as if nothing had happened. (She no longer took care to blow the smoke to one side, having lost the old pretense of shame to be smoking in front of her father.) She stubbed it out without much expression. I suddenly found myself unable to stand up, an affliction from which I thought I'd recovered, but here it was as if it had never left me.

At nine minutes to eleven, as Füsun placed a new Samsun between her lips, a bit more deliberately than usual, she gave me a long, cautious look. We told each other so much with our eyes at that moment that I felt as if we had been talking freely all evening. Of its own accord, my hand reached out, and I lit

the cigarette between her lips. For a moment Füsun did what Turkish men only see in foreign films, touching the hand that was holding the lighter.

I, too, lit a cigarette, smoking it slowly, as if nothing out of the ordinary had happened. With every moment I felt the curfew drawing closer. Aunt Nesibe was fully aware of what was going on, but, frightened by the seriousness of the situation, she didn't say a word. As for Tarık Bey, he, too, almost certainly realized how strange a turn things had taken, but he couldn't quite figure out whether he needed to pretend he hadn't noticed. I left the house at ten past eleven. I think this was the night that the idea dawned on me that Füsun and I would in fact marry. I was so ecstatically happy to realize that Füsun would prefer me in the end that I forgot what great jeopardy I had put myself in, and Çetin, too, by going out into the streets after the curfew. After dropping me off in front of the house in Nişantaşı, Çetin Efendi would leave the car at a garage on Nigâr the Poetess Street, only a minute's drive away, and from there he would have to walk through the backstreets to his home in the old shantytown nearby, trying to avoid detection. But I was too happy that night to worry, and like a child I couldn't sleep.

Seven weeks later, during the premiere of *Broken Lives* at the Palace Cinema in Beyoğlu, I was with the Keskins at the house in Çukurcuma. As the wife of the director, Füsun should naturally have attended the premiere, as I should have done, being the producer and owning more than half of Lemon Films, but neither of us did. Füsun needed no excuse, as she and Feridun weren't talking, her husband having scarcely been home that summer: Almost certainly he was living with Papatya. He'd drop by the house in Çukurcuma every other week to collect a few things from his room—a shirt, or a book.

I would hear of these visits only indirectly, from Aunt Nesibe's hints and asides, but despite my extreme curiosity, I dared not raise this "forbidden" subject. From the looks she gave me, and her general demeanor, it was clear that Füsun had prohibited any mention of the matter in my presence. But it was Aunt Nesibe who eventually informed me that a fight had broken out during one of Feridun's visits.

I calculated that if I went to the premiere, Füsun would read about it in the papers and, getting upset, would certainly punish me. Still, as the film's producer, I would be conspicuous by my absence. Just after lunch that day I had Zeynep Hanım ring Lemon Films to say that my mother was very ill, and that I would therefore be unable to leave home.

That evening, around the time that *Broken Lives* was to be shown for the first time to the cineastes and journalists of Istanbul, it was raining. When Çetin picked me up in Nişantaşı, I told him to take me to the Keskins' via Taksim and Galatasaray instead of Tophane. As we passed in front of the Palace Cinema I peered through the raindrops on the windows and saw a few well-dressed people walking to the premiere holding umbrellas, and the fancy posters and announcements paid for by Lemon Films, but it was not at all like the Palace Cinema premiere I had imagined for Füsun's first film.

No one mentioned the premiere over supper. Tarık Bey, Aunt Nesibe, Füsun, and I chain-smoked as we ate macaroni with meat sauce, yogurt with cucumbers and garlic, tomato salad, white cheese, and then the ice cream I'd brought from Ömür in Nişantaşı and put straight into the freezer on arrival. We kept rising from the table to look out the window at the rain, the water pouring down Çukurcuma Hill. As the evening dragged on I was tempted on several occasions to ask Füsun

how her bird painting was going, but from her harsh expression and her frowns I deduced that this was not an opportune moment.

Though the critics belittled *Broken Lives* in vicious terms, it met with such enthusiasm among audiences in both Istanbul and the provinces that it was pronounced a box office hit. During the last scenes, when Papatya sings two bitter, anguished songs about her misfortune, it was women in the provinces who cried hardest, but people of all sorts, young and old, left the humid, airless cinemas with puffy eyes. In the penultimate scene, when Papatya kills the evil rich man who had tricked her, staining her honor when she was still a child, but who now stands before her, pleading for his life, there was universal exultation. This scene made such an impression, becoming so familiar that the actor playing the part of the evil rich man (Ekrem Bey, our friend from the Pelür, who typically played Byzantine priests and Armenian militants) stopped going out for a time, tired of being punched and spat upon in the streets. The film was also praised for bringing back the crowds that had stayed away from cinemas during the "terror years"—as people now alluded to the period preceding the military coup. And with the revival of the cinemas, the Pelür Bar had filled up again, too: Sensing the resuscitation of the film business, its former regulars were again coming every day to strike deals or just to be seen. On a windy, rainy night at the end of October, two hours before the curfew, when—at Feridun's insistence—I dropped by the Pelür, I saw that my reputation there was much enhanced; to use the expression of the day, I was in my element. The commercial success of *Broken Lives* had transformed me into a prominent producer to whom many were also prepared to attribute a quick wit

and slyness, and everyone from cameramen to famous actors sought to sit for a while at my table and befriend me.

By the end of that evening, though my head was swimming from the compliments, the attention, and the drink, I remember sitting down with Hayal Hayati, Feridun, Papatya, and Tahir Tan. Ekrem Bey, at least as drunk as I was, kept needling Papatya with mischievous jokes about the photographs of the rape scene that the papers had been reprinting incessantly; but Papatya responded with a good-natured smile, saying that she would never sleep with a penniless, decrepit rooster. At the next table was a dandified critic who had ridiculed her for appearing in such a "vulgar melodrama"; Papatya tried for a time to provoke Feridun into giving him a good thrashing, but the effort was fruitless.

After the film, Ekrem Bey received numerous invitations to appear in bank commercials, though he confessed that he could not understand why: Evil men weren't supposed to be in demand for commercials. But in those days, with everyone talking about the bankers offering 200 percent interest, and these bankers fanning the flames with big advertisements in newspapers and on television using Yeşilçam's most famous faces, the film community was well disposed toward them. Still, as I was in the drunken eyes of the Pelür's clientele a modern businessman (by Hayal Hayati's definition, "A businessman who loves culture is modern"), whenever such subjects came up there was a respectful silence, which, it was hoped, I would fill with my opinion. In the wake of the box office success, I had been credentialed a farsighted "ruthless capitalist"; and everyone forgot that I had first come to the Pelür years ago to make Füsun a star, just as they had forgotten Füsun herself. Just reflecting on how fast Füsun had been forgotten caused

my love for her to flare up inside me, and I would want to see her at once, and then thinking about how she had been able to resist being drawn into this tawdry world to the point of staining her reputation, I loved her all the more—and once again I would congratulate myself on keeping her away from these malevolent people.

It was an aging unknown, a friend of Papatya's mother's, who had dubbed the songs for Papatya in the film. Now, thanks to the success of *Broken Lives,* Papatya was going to make a record in which she sang the songs herself. That October evening we agreed that Lemon Films should back this venture, too, and also get started on a sequel to *Broken Lives.* Actually, the decision to do the sequel was not ours; it was what the cinemas and distributors of Anatolia called for unanimously, and so insistently that any refusal by Feridun would have been seen as "spitting in the face of success," to use another expression of the day. Whatever her intentions, by the end of the film Papatya's character had, like all girls, good or evil, who had lost their virginity, died without realizing her dream of a happy family life. We decided that the best solution was to reveal that Papatya had not really died at all, that having been wounded, she had feigned her death to keep herself safe from other evil men. The sequel's first scene would be in the hospital.

It was three days later that *Milliyet* ran an interview with Papatya in which she announced that shooting was soon to begin. By now there was an interview with her in the papers every day. When *Broken Lives* had first opened, the papers had dropped hints that Papatya and Tahir Tan were having a secret affair in reality, but the life had gone out of this rumor, and now Papatya was denying it. When we spoke on the phone at around this time, Feridun informed me that all the most

famous actors now wanted to play opposite Papatya, and that, anyway, Tahir Tan wasn't suited for the part. For in her latest interviews Papatya had begun revealing that, though she had kissed men, she'd of course never been truly intimate with one. Her fondest and truly most indelible memory remained her first kiss, this with her teenaged sweetheart on a summer's day, in a vineyard buzzing with bees. Sadly, the youth had been martyred while fighting against the Greeks in Cyprus. And after that Papatya had considered intimacy with any man inconceivable, concluding that only another lieutenant might be able to mend her heart. Feridun allowed that he didn't approve of such lies, but Papatya insisted that she'd only told them to help get the sequel past the censors. Feridun made little effort to conceal his relationship with Papatya from me; it was in keeping with his nature as one who picked no fights and had no quarrels, only carrying on, forever the naïf, never bitter or less than sincere— and for this I genuinely envied him.

"Broken Lives," Papatya's first single, came out the first week of January 1982, and though it was not as big a hit as the film, it was much beloved. Posters appeared on the city's walls, so many of which had been whitewashed after the coup, and advertisements, however small, in the papers. But because the censorship board of Turkey's only television channel (actually, it had a more elegant name: the Inspectorate of Music) found the song lacking in moral fiber, Papatya's voice was on neither television nor radio. The record, nevertheless, afforded her another round of interviews, and spurious stories about beatings and other controversies that she fabricated for these occasions made her more famous still. Papatya began to take part in cultural discussions along the lines of "Should a modern Turkish Kemalist girl think first about her job or her

husband?"; posing in front of her bedroom mirror (having bought a traditionally Turkish furniture set, adorned with a few pop features), she would frolic with her teddy bear while musing on what a shame it was that she had yet to meet the man of her dreams; making spinach pastry with her mother in the kitchen, in which there was an enameled pot identical to one at Füsun's, she played the honest housewife to prove that she was far more respectable than Lerzan, the angry, wounded heroine of *Broken Lives*. Her honor had not been stained, and she was perfectly happy, though, she allowed, "Certainly there is something of Lerzan in all of us," hoping to have it both ways. Feridun expressed pride that Papatya was such a professional, never taking the interviews and articles about her to heart. So many of the harebrained stars and starlets at the Pelür had reacted amateurishly, worrying that the lies propagated about them might damage their public image, but Papatya took control of the matter, telling her own lies from the start.

You Hardly Ever Come Here Anymore, Kemal Bey

WHEN MELTEM, now struggling to compete with Coca-Cola and other foreign brands, decided to use Papatya in its early summer advertising campaign, directed by Feridun, I had a final falling-out with my old circle of friends, for whom, though we had grown estranged, I felt no rancor—and it broke my heart.

Zaim was, of course, aware that Papatya was contracted by Lemon Films, and so, planning to discuss this matter amicably, we met for a long lunch at Fuaye.

"Coca-Cola is extending credit to distributors, and giving them huge Plexiglas shop signs for free, as well as calendars, and promotional gifts, and we just can't compete," said Zaim. "The young are like butterflies: Once they've seen Maradona [the greatest footballer of his day] holding a Coca-Cola, they couldn't care less about a Turkish-made drink, even though it's cheaper and healthier."

"Don't take offense, but on those very rare occasions when I have a soda, I drink Coca-Cola, too."

"So do I," said Zaim. "It doesn't matter what *we* drink. . . . Papatya will help us increase sales in the provinces. But what sort of woman is she? . . . Can we trust her?"

"I don't know. She is an ambitious girl who comes from nothing. Her mother is a former nightclub singer. . . . There's no sign of a father. What are you worried about?"

"We're investing so much in this. If she went off and did a belly dance in a porn film afterward, or if—I don't know—she got caught with a married man . . . the provinces wouldn't be able to take it. I hear she's involved with your Füsun's husband."

I didn't like the way he said "your Füsun," and neither did I care for his knowing expression, which I read to imply unspoken awareness of my intimacy with the people in question. Somewhat spitefully I said, "So do they really like Meltem better in the provinces?" Zaim, who had pretension to modern and European sophistication, bristled at the fact that, despite his Western ad campaign with Inge, his product's cachet with the rich and the urban had proved ephemeral.

"Yes, we're more popular in the provinces," admitted Zaim. "Because people in the provinces haven't corrupted their palates yet, because they're pure Turks, that's why! But don't get hostile and tetchy with me. . . . I understand perfectly your feelings for Füsun. In this age of ours, your love is perfectly respectable—whatever anyone might say."

"Who's saying what?"

"No one's saying a thing," said Zaim cautiously.

This meant "Society has written you off." The thought caused us both disquiet. I loved Zaim both because he could be counted on to tell me the truth and because he didn't want to hurt me.

And Zaim saw affection in my eyes. With a friendly and encouraging smile, he raised his eyebrows and asked, "So what's going on?"

"Things are going well," I said. "I'm going to marry Füsun. I'm going to reenter society and bring her with me. . . . Assuming, of course, I can see past those disgusting gossips."

"Just forget them, my friend," said Zaim. "And very soon the whole thing will be forgotten. You look so well, and it's clear you're in good spirits. When I heard the Feridun story, I knew at once that Füsun would come to her senses."

"Where did you hear the Feridun story?"

"Just forget that, too," said Zaim.

"Sooo, what about you? Is there marriage on the horizon?" I asked, reluctantly changing the subject. "Is there someone new in your life?"

"Hilmi the Bastard's just walked in with his wife, Neslihan," Zaim said, looking at the door.

"Oooooh . . . hey, look who's here!" Hilmi said, approaching our table. Neslihan was very fashionably turned out, and that suited Hilmi the Bastard well, for he had no confidence in the tailors and seamstresses of Beyoğlu, and wore only Italian clothes, which he selected with much consideration. It was pleasing to see a pair so well dressed, so affluent, but I knew I would not be able to join in their general disdain of all things and persons not up to their standards. As I shook hands, there was a moment when I thought I saw fear in Neslihan's eyes, and so I remained reserved in their presence, a stance that suddenly seemed all-important. I couldn't believe that a moment ago, speaking to Zaim, I had used that peculiar word "society," an expression lifted from the magazines and celebrity pages my mother perused—and having declared a hope to return to it once I had redeemed myself, I now felt ashamed, and longed to return to Çukurcuma and the world I'd shared with Füsun.

Fuaye was as crowded as ever, and as I surveyed the vases of cyclamen, the plain walls, and the modish lamps like so many pleasant memories, the place looked time-worn, as if it had

aged ungracefully. Would I be able to sit here with Füsun one day with an untroubled heart, sustained purely by the happiness of being alive and together? I let myself believe so.

"Is something on your mind? You have that faraway look. You've floated off into your daydreams," said Zaim.

"I was thinking about your dilemma concerning Papatya."

"Remember this summer she'll be the face of Meltem—this woman has to appear at all our parties and so on. So what do you think?"

"What are you asking?"

"Will she be presentable? Will she know how to act?"

"Why wouldn't she? She's an actress, a star, in fact."

"Well, that's what I mean. . . . You know how those Turkish film types carry on, the poor ones who play rich people. We can't have that sort of thing, can we?"

Zaim owed his turn of phrase to his well-mannered mother, but what he meant was "we won't." Papatya was not the first person to stir up such concerns, which beset him whenever it was a matter of anyone he viewed as lower class. Put off though I was by his bigotry, I nevertheless saw nothing to be gained by showing my friend anger or disappointment as we sat there at Fuaye.

I asked Sadi, the headwaiter at the restaurant for many years, which fish he was recommending.

"You hardly ever come here anymore, Kemal Bey," he said. "Your lady mother doesn't come here, either."

I explained that after my father died, my mother had lost interest in going out.

"Why don't you bring the lady here yourself. Please, Kemal Bey—we could cheer her up. When the Karahans' father died, they brought their widowed mother out to eat three times a

week, and we put her at the table next to the window, where the lady would eat her steak and enjoy watching the passersby in the street."

"Did you know that the lady in question came out of the last sultan's harem?" said Zaim. "She's Circassian, green-eyed, and still beautiful even in her seventies. What sort of fish have you got for us?"

Sometimes Sadi would affect an undecided air and recite the names one by one: "Whiting, bream, red mullet, swordfish, sole," he would say, raising his eyebrows in approval or frowning to indicate the freshness or quality of each. Other times he'd cut it short: "I'm going to give you fried sea bass today, Zaim Bey."

"What will you serve with it?"

"Mashed potatoes, arugula, whatever you like."

"And to start?"

"We have this year's salted bonito."

"Bring red onions with it," said Zaim without raising his eyes from the menu, and then turning it over to the beverage list. "God bless, you have Pepsi, Ankara soda, and even Elvan, but still no Meltem!" he blurted.

"Zaim Bey, your people bring one delivery, and then we never see them again. Cases of empties have been sitting in the back for weeks."

"You're right, our Istanbul distributors are useless," said Zaim. He turned to me. "You know this business. How is Satsat managing? What can we do about our distribution problem?"

"Forget about Satsat," I said. "Osman set up a new firm with Turgay, and he's done us in. Since my father died, Osman cares only for money."

Zaim did not care for Sadi hearing us talk about our private failures. "Bring us each a double Kulüp *rakı* with ice on the

side, would you? That would be best," he said. When Sadi left he frowned as if waiting for an answer. "Your beloved brother, Osman, wants to do business with us, too."

"I'd rather stay out of that," I said. "I'm not about to take it amiss if you choose to do business with Osman. Business is business. What other news, Zaim?"

He knew at once that I meant society news, and hoping to cheer me up, he offered quite a few amusing stories. Güven the Ship Sinker had run a rusty cargo ship aground, this time between Tuzla and Bayramoğlu. Güven specialized in rotting, polluting derelicts that had been decommissioned. He would buy them abroad at scrap prices and with the help of his contacts in the government and the state bureaucracy fiddled the paperwork to make them seem valuable and seaworthy vessels; by bribing the right people he could then take out interest-free loans from the Turkish Maritime Development Fund, putting the ships up as collateral, and soon thereafter he'd sink them and receive big payouts from the state-owned Başak Insurance. And so by the time he'd sold the beached cargo ship to his scrap yard friends, he'd made himself a pot of money without ever getting up from his desk. Plied with a few drinks, Güven would brag to his friends at the club that he was "the biggest shipowner who'd never been aboard a ship."

"The scandal erupted not because of this chicanery, but because he ran the ship aground just next to the summer home he had bought his mistress, so that he wouldn't have to travel far to see the shipwreck. But the residents of those beach and summer homes raised an awful hue and cry over his having polluted the water. Even his mistress couldn't stop crying, apparently."

"What else?"

"The Avunduks and the Mengirlis invested everything with Deniz the Banker and were wiped out, and that, by the way, is why the Avunduks have pulled their daughter out of Notre Dame de Sion and are trying to marry her off."

"That girl is hideous. Good luck to them," I said. "On top of that—who would trust somebody called Deniz the Banker? I've never even heard of him."

"Do you have any money with brokers?" asked Zaim. "Is there a reputable one you know and trust?"

Having arrived at this new profession after running kebab restaurants, truck tire depots, and even lottery shops, these bankers were offering such ludicrously high interest rates that it was clear they would not stay in business indefinitely. But so ubiquitous and seductive was their advertising that they'd taken in enough cash to stay afloat temporarily, because even those who derided and exposed them in the press—among them even economics professors who saw them clearly as con men—were apparently dazzled enough by the advertised rates to invest their own money, "just for a month or two."

"I don't have any money with brokers," I said. "Our companies don't either."

"With those returns it seems idiotic to put money into an ordinary business. To think if I'd given Kastelli the money I've sunk into Meltem, I'd have doubled my investment by now and avoided these headaches."

Whenever I remember that conversation we had among the crowd at Fuaye, it seems to me as empty and meaningless as it did that day. But then as now I did not blame the general idiocy—or more politely, the general unreflectiveness—of the world in which my story takes place, but rather I imputed a sad

want of seriousness, which could never trouble me unduly, and more typically moved me to laugh, to embrace it with pride.

"Is Meltem really not making money?"

I'd said this without intending a dig, but Zaim took offense.

"It's all riding on Papatya—what else can we do?" he said. "I just hope she doesn't embarrass us. I've arranged for her to sing Meltem's jingle accompanied by the Silver Leaves at Mehmet and Nurcihan's wedding. All the press will be there at the Hilton."

I fell silent for a moment. I had heard absolutely nothing about Mehmet and Nurcihan's impending wedding at the Hilton, and I was crushed.

"I know you won't be coming," said Zaim. "But I figured you'd have heard about it by now."

"Why wasn't I invited?"

"Oh, there were endless discussions. As you might have guessed, Sibel doesn't want to see you: 'If he's going to be there, I'm not coming' is what she said. And after all, Sibel is Nurcihan's best friend. She's even the one who introduced Nurcihan to Mehmet, don't forget."

"I'm a good friend of Mehmet's," I said. "You could also say that I had as much to do with introducing them."

"Don't make too much of this—it will only upset you."

"Why do Sibel's feelings take precedence?" I said, knowing even as I spoke that I had no right.

"Look, my friend, everyone sees Sibel as a woman wronged," said Zaim. "You got engaged to her, and after living with her in a Bosphorus *yalı,* and sharing the same bed, you abandoned her. For the longest time there was talk of nothing else, and you'd have thought they were speaking of some evil djinn the way mothers discussed the scandal with their daughters. Sibel

really did not mind, but everyone felt very sorry for her all the same, and naturally they were very angry at you. You can't be indignant that they're on Sibel's side now."

"I'm not indignant," I said indignantly.

We downed our *rakı*s and began to eat our fish, and it was the first time Zaim and I had eaten a meal at Fuaye and fallen silent. I listened to the waiter's hurried footsteps, the steady crackle of laughter and conversation, the clatter of knives and forks. I angrily vowed never to come back, even as I thought how much I loved this place, and how I had no other world.

Zaim said that he wanted to buy a speedboat that summer but that before doing so he needed to find a suitable outboard motor, though there were none to be found in the stores in Karaköy.

"That's enough, now. Stop looking so glum," he said suddenly. "Nobody should get this upset over missing a wedding at the Hilton. I'm sure you've been to one?"

"My friends have turned their backs on me because of Sibel—I don't like that."

"No one's turned their back on you."

"Fine, but what if the decision had been up to you? What would you have done?"

"What decision?" said Zaim, in a way that seemed disingenuous. "Oh, now I see what you mean. Of course, I would have wanted you to come. You and I always have such fun at weddings."

"This is not about fun; it's something much deeper."

"Sibel is very lovely; she's a very special girl," said Zaim. "You broke her heart. Not only that—in front of everyone, you put her in a very precarious situation. Instead of pulling a long face and glaring at me, why don't you just accept what you

did, Kemal? Take it on the chin and then it will be much easier for you to return to your real life, and before you know it, all this will be forgotten."

"So you consider me guilty, too?" I said. I knew it wouldn't be long before I began to regret persevering in this, but I couldn't help myself. "If we insist virginity is still so important how can we pretend we're modern and European? Let's be honest with ourselves, at least."

"Everyone is honest about this. . . . Your mistake was imposing your view on someone else. It might not be important to you, or to me. But it goes without saying that in this country a young woman's virginity is of the utmost importance to her, no matter how modern and European she is."

"You said Sibel didn't care. . . ."

"Even if Sibel didn't care, society did," said Zaim. "I'm sure you didn't care either, but when White Carnation wrote those awful lies about you, everyone was talking. And even though you say you don't care, now you're upset about it—am I right?"

I decided that Zaim was choosing his words—expressions like "your real life"—just to inflame me. Two could play at that game, I thought, yet a voice inside me still counseled prudence, reminding me that I might regret something said in fury after two glasses of *rakı,* but unfortunately I was angry, too.

"Actually, my dear Zaim," I said, quite superciliously, "this plan of yours to get Papatya to sing the Meltem jingle with the Silver Leaves at the Hilton—it really is rather crass. What makes you think it would work?"

"Come on, don't goad me. We're about to sign a contract, for goodness' sake. You don't have to take your anger out on me."

"It's going to look pretty coarse. . . ."

"Well, if that's what you think, don't worry. We chose Papatya for that very reason—because she's coarse," Zaim said with assurance. I thought he was going to tell me that her coarseness had become marketable thanks to the film I'd produced, but Zaim was a good man; such a thing would never cross his mind. He merely preempted further discussion by saying he and his associates would find a way to manage Papatya. "But let me speak to you as a friend," he said. "Kemal, my friend, those people didn't turn their backs on you; you turned your back on them."

"Now how did I do that?"

"By turning in on yourself, and taking no joy or interest in our world. I know you believe you went your own way, in pursuit of something deep and meaningful. You followed your heart; you made a stand. Don't be angry with us. . . ."

"Might it be something simpler than that? The sex was so good that I became obsessed. . . . That's what love is like. Maybe you're the one finding some deep meaning in all this, something projected from your own world. Actually, our love has nothing to do with you and yours!"

Those last words came out of my mouth of their own accord. Suddenly I felt as if Zaim was regarding me from a great distance; he had already given up on me a long time ago, and was only now accepting that he couldn't be alone with me anymore. As he listened to me he was thinking not of me, but of what he would tell his friends. I could read his absence in his face now. And because Zaim was an intelligent man such signals as I had just given were not lost on him, and I could tell that he was angry at me in return. And so the distance was perceptible from either perspective: Suddenly I, too, was seeing Zaim, and my entire past, from a point very far away.

"You're a man of real feeling," said Zaim. "That is one of the things I cherish about you."

"What does Mehmet say about all this?"

"You know how much he cares about you. But he's happy with Nurcihan in a way beyond anyone else's understanding. He's walking on air, and he doesn't want anything—any trouble—to bring him down."

"I understand," I said, resolving to drop the matter.

Zaim read my mind. "Don't think with your heart—use your head!" he said.

"Fine, I'll be rational," I said, and for the rest of the meal we said nothing of any consequence.

Once or twice Zaim offered another serving of society gossip, and when Hilmi the Bastard and his wife stopped at our table on their way out, he tried to relieve the tension with a few jokes, but without success. Those fine clothes on Hilmi and his wife suddenly looked pretentious, even false. Yes, I'd cut myself off from my entire crowd, and all my friends, and perhaps this was cause for sadness, but there was also something more, I felt—a grudge, a rage.

I paid the bill. Saying our good-byes at the door, Zaim and I suddenly threw our arms around each other and kissed each other on the cheeks, like two old friends who knew that one was on the verge of a long journey that would part them for many years. Then we walked off in opposite directions.

Two weeks later Mehmet telephoned Satsat to apologize for having been unable to invite me to the wedding at the Hilton. He added that Zaim and Sibel had been a couple for some time now. He'd assumed I knew, considering everyone else did.

Life, Too, Is Just Like Love. . . .

ONE EVENING at the beginning of 1983 I was about to sit down to supper at the Keskins' when, sensing something strange, something missing, I carefully surveyed the room. The chairs were all in their usual places, and there was no new dog on top of the television, but the sense of something peculiar in the room persisted, as if the walls had been painted black. In those days I'd ceased to think of my life as something I lived in wakeful consciousness of what I was doing: I'd begun instead to think of it as something imagined, something—just like love—that issued from my dreams, and as I had no wish either to fight my growing pessimism about the world or to surrender myself to it unconditionally, I acted as if no such thoughts had entered my mind. It might be said that I had decided to leave everything as it was. I applied the same logic to the unease awakened in me by the dining room as I had to that stirred by the sitting room: I resolved not to dwell on it, to let it pass.

TRT 2, Turkey's arts and culture channel, was at the time showing a series of films starring Grace Kelly, who had just died. It was our old friend Ekrem the famous actor who presented the "Art Film" feature every Thursday evening, reading from the script in his hands, which the alcoholic Ekrem Bey hid behind a vase of roses, so as to hide his shaking hands. His comments were written by a young film critic, who had been an old

friend of Feridun's before they fell out over a scathing review of *Broken Lives*. And Ekrem Bey read the critic's convoluted, intellectualized prose with little comprehension; finally he raised his eyes from the page, and just before saying, "and so here is tonight's feature . . ." he announced that he had met "America's elegant 'princess star' at a film festival many years ago," adding, almost as if it were a secret, that she had a deep love for Turks, his dreamy expression implying that he might even have enjoyed a grand romance with the enchanting star. Füsun, who had heard a great deal about Grace Kelly from Feridun and his film critic friend during the early years of her marriage, would not miss a single one of these films, and since I would not miss a chance to watch Füsun watch the fragile, helpless, but still radiantly beautiful Grace Kelly, I would make sure to take my place at the Keskin table every Thursday.

That Thursday we watched Hitchcock's *Rear Window*, but far from putting my troubled mind at ease, it heightened my anxiety. It was this film I'd gone to see eight years earlier, when, skipping out on my usual lunch with the Satsat employees, I took refuge in a cinema to contemplate Füsun's kisses in solitude and peace. But now it was no consolation to see from the corner of my eye how engrossed Füsun was in the film, nor did it help to remark on something of Grace Kelly's purity and refinement in her. Either in spite of the film or because of it, I had sunk into that stupor that afflicted me, if not often then at regular intervals, during suppers in Çukurcuma. It was like being caught in a suffocating dream, trapped in a room whose walls were advancing toward me. It was as if time itself was getting steadily narrower.

I struggled for a long time to convey for the Museum of Innocence this sensation of being caught in a dream. The

condition has two aspects: (a) as a spiritual state, and (b) as an illusory view of the world.

(a) The spiritual state is somewhat akin to what follows drinking alcohol or smoking marijuana, though it is different in certain ways. It is the sense of not really living in the present moment, this now. At Füsun's house, as we were eating supper, I often felt as if I were living a moment in the past. Only a moment before we would have been watching a Grace Kelly film on television, or another like it; true, our conversations at the table were more or less alike, but it was not such sameness that invoked this mood; rather it was a sense of not abiding in those moments of my life as they were occurring, experiencing these moments as if I were not living them. While my body lived out the present on the screen, my mind was watching Füsun and me from a slight distance, and my soul watched from a greater one. So the effect of that moment I was living was of something I was remembering. Visitors to my Museum of Innocence must compel themselves, therefore, to view all objects displayed therein—the buttons, the glasses, the old photographs, and Füsun's combs—not as real things in the present moment, but as my memories.

(b) To experience this present moment as a memory is to experience a temporal illusion. But I also experienced a spatial illusion. Exhibited here are a pair of optical illusions. Try to detect the seven differences between these two pictures, or decide which one is smaller; this puzzle is of the type that induced a similar disquiet when I was a boy and came across them in magazines for children. When I was a child, games like "Help the king find his way out of the labyrinth!" or "What burrow should the rabbit take to get out of the forest?" amused me as much as they unnerved me. Likewise, during

my seventh year of dining with the Keskins, the supper table slowly became less an amusing and more a stifling place. That evening, Füsun sensed my state of mind.

"What's wrong, Kemal? Didn't you like the film?"

"No, I liked it."

"Maybe you didn't like what it was about," she said cautiously.

"On the contrary," I said, and I fell silent.

It was so unusual for Füsun to show interest in my mood, or ask how I was when we were still at the table, in her parents' earshot, that I was moved to say a few admiring things about the film and Grace Kelly.

"But I know you're feeling low this evening, Kemal, don't try to hide it," Füsun said.

"Fine, then, I'll talk. . . . It's just that it seems as if something has changed in this house, but I can't figure out what it is."

They all burst out laughing.

"We've moved Lemon to the back room, Kemal Bey," said Aunt Nesibe. "We were wondering why you hadn't mentioned it."

"Is that so?" I said. "How could I not have noticed? I mean, I love Lemon. . . ."

"We love him, too," said Füsun proudly. "I've decided to paint his portrait, so I've moved the cage into the other room."

"Have you started painting yet? Could I have a look, please?"

"Of course."

It had been some time since Füsun had given up on her bird series, for which she could no longer summon up the enthusiasm. Entering the room, before looking at Lemon himself, I inspected Füsun's painting of the bird, only just begun.

"Feridun doesn't take bird photographs anymore," said Füsun. "And so I've decided to paint from life instead."

Füsun's mood, her poise as she talked about Feridun as if he were someone from her past—it all set my head spinning. But I kept my calm. "You've made a good start on this, Füsun," I said. "Lemon is going to be your best painting yet. After all, you know your subject so well, and it's by drawing on the subjects one knows best that one makes the most successful art."

"But I'm not aiming for realism."

"What do you mean?"

"I'm not going to paint his cage. Lemon will be perched in front of the window like a wild bird who has alighted there of his own free will."

That week I went three more times to the Keskins' for supper. Each night, when the meal was over, we went into the back room to Lemon's emerging portrait. He seemed happier and livelier outside his cage, and when we went into the back room, we were now more interested in the painting than the bird itself. After an oddly serious but perfectly sincere discussion of the challenges of this project, we would speak of going to see the museums of Paris.

On Tuesday evening, as we gazed at the painting of Lemon, I uttered the words I had prepared in advance, though I was as nervous as a lycée student: "Darling, the time has come for us to leave this house, this life, together," I whispered. "Life is short, and in our stubbornness we have lost many days, many years. What we need is to go to another place to be happy." Füsun acted as if she had not heard me, but Lemon answered with an abbreviated *chk, chk, chk*. "There's nothing to fear anymore, nothing to hold us back. Let's you and I, the two of us, leave this house together, for another place, another house,

our own house, and let us live happily from then on. You are only twenty-five years old—we have half a century of life ahead of us, Füsun. We have suffered enough over these past six years to deserve those fifty years of happiness! Let's leave together now. We've been stubborn with each other for long enough."

"Have we been stubborn with each other, Kemal? That's news to me. Don't put your hand there, you're scaring the bird."

"I'm not scaring him. Look, he's eating from my hand. We can give him the best place in the house."

"My father will be wondering where we are," she said, warmly, as if we were sharing a secret.

The next Thursday, we saw *To Catch a Thief*. Instead of watching Grace Kelly, I watched Füsun watching her, from start to finish. In everything—from the pulsing of the blue veins in my beauty's throat to the way her hand fluttered across the table, straightened her hair, or held her Samsun—I saw her fascination for the screen princess.

When we went into the back room, Füsun said, "Do you know what, Kemal? Grace Kelly was bad at mathematics, too. And she got into acting by working as a model first. But the only thing I really envy her is that she could drive a car."

In his introduction that week, as if he was giving inside information about a very close friend, Ekrem Bey informed Turkey's art film enthusiasts of the odd coincidence: that a year earlier the princess had died in a car accident on the same road she had driven down in this film.

"Why were you jealous?"

"I don't know. Driving made her look so powerful, and free. Maybe that's why."

"I could teach you, if you like."

"No, no, that would be impossible."

"Füsun, I know that in two weeks I can teach you enough for you to get your license and drive comfortably around Istanbul. There's nothing to it. Besides, Çetin taught me how to drive when I was your age [this wasn't true]. All you need to do is to be calm, to have a little patience."

"I'm patient," Füsun said confidently.

Füsun's Driving License

IN APRIL 1983 Füsun and I began to prepare for the drivers' licensing examination, our first tentative plans having been followed by five weeks of indecision, feigned reluctance, and silence. We both knew there would be more at stake than a license since the intimacy between us was to be put to the test, once again in a tutelary setting. We had been given our second chance, and being quite sure that God would not give us a third, I was tense about it.

Still, I was jubilant at Füsun's ultimate agreement and so I nurtured real hope of becoming steadily more relaxed, cheerful, and confident. The sun was emerging from behind the clouds after a long, dark winter.

It was on the afternoon of one such sunny, glistening spring day (April 15, to be exact, three days after we had celebrated her twenty-sixth birthday with a chocolate cake I'd bought at Divan) that I picked up Füsun in the Chevrolet in front of Firuzağa Mosque for her first driving lesson, and off we went, with me at the wheel and Füsun sitting beside me. She'd asked me not to pick her up in front of the house in Çukurcuma but on a corner higher up the hill, five minutes away from the curious eyes of the neighborhood.

It was the first time in eight years that we were going out alone together, though I was too tense and excited to notice my elation. I was meeting this girl after an agonizing eight-year

wait—I had been put to so many tests, endured such pain—yet that is not how it felt. Rather it was as if I was meeting for the first time a splendid young girl who had been found for me by others, and who was, in their view, a perfect match.

Füsun was wearing a becoming print dress of orange roses and green leaves on a white background. It was the same elegant dress—with its V-shaped neckline and its skirt falling just below her knees—that she would wear to each driving lesson, as a sportswoman might wear the same tracksuit for every training session, and by the end of the lesson, her dress would be as dampened as any athlete's suit. Three years after we had begun our lessons, when I spotted it in Füsun's chest of drawers, I would pluck it out, instinctively sniffing its sleeves and its front for her unique scent, longing to remember the pleasure of those tense and dizzying lessons of ours, in Yıldız Park, just above Sultan Abdülhamit's palace.

The underarms of Füsun's dress would be the first to become moist, before the damp patches spread slowly and adorably over her breasts, her arms, and her abdomen. Sometimes the engine would stall in a bright spot in the park, and—just as eight years earlier, when we were making love—we would perspire lightly, feeling the sun on our skin. But it was not so much the sun that made Füsun and me perspire as the fact of being alone in that car, trapped in our own air, our own shame, tensions, and jangled nerves. When Füsun made a mistake, for example, rolling the right-hand front tire over the curb, grinding the gears, or causing the engine to stall, she would redden with anger and begin to perspire, never more profusely than when she bungled the clutch.

Füsun had made a careful study of all the traffic regulations, memorizing the books at home, and her steering wasn't bad,

but—as with so many new drivers—the clutch was her downfall. She'd drive carefully at a low speed down the learner's lane, and slow down for the intersection, approaching the sidewalk as carefully as a captain landing at an island pier, and just as I said, "That's wonderful, my lovely, you're really catching on," she'd take her foot off the clutch too fast and the car would lurch forward and strain for breath like a rasping old man. As the car stumbled on like a coughing invalid, I would cry, "The clutch, the clutch, the clutch!" But in her panic Füsun would hit the accelerator or the brakes instead. When it was the accelerator, the car would rock more menacingly before stalling. I'd observe the sweat pouring down Füsun's red face, her forehead, the tip of her nose, and her temples.

"That's it, I've had enough," she'd say, wiping her face with the back of her hand, full of embarrassment. "I am never going to learn this. I give up! I wasn't put on this earth to be a driver, after all." Then she would step out of the car and storm off. Sometimes she would bolt from the car without a word, and fishing a handkerchief from her handbag, walk away as she wiped off the perspiration, and when she had reached a point forty or fifty paces away, she would stand there by herself, furiously smoking a cigarette. (On one such occasion, two men who thought she'd come to the park alone descended on her within seconds.) Other times she'd light her Samsun without getting out of the car, and it, too, would be saturated with her damp rage as she angrily stubbed it out into the ashtray, saying she was never going to get her license and, anyway, never really wanted it.

Naturally, I would panic, for it seemed not just the license that she was brushing away, but our future happiness, and I would almost beg Füsun to be patient and calm.

With her wet dress clinging to her shoulders, I would gaze at her lovely arms, the panic on her face, her frown, her anxious stretching, and her lithe frame, drenched in perspiration, as it had been during those spring days of making love. Not long after taking the driver's seat, Füsun would become flushed, and in short order she would undo the top button of her dress, and perspire all the more profusely. Seeing the moisture on her neck and temples and behind her ears, I would try to remember, to glimpse those wondrous pear-shaped breasts that, eight years earlier, I had taken into my mouth. (And that night, back at the house, after downing a few glasses of *rakı* in my room, I would dream I had seen her nipples, red as strawberries.) Sometimes when Füsun was driving I would sense her awareness of my intoxication at the sight of her, and feeling that she didn't mind it, even liked it, in fact, I would grow more desirous still. When I'd lean over to show her how to shift gears smoothly in one sweet stroke, and my hand would brush against hers, or against her lovely arm, or her thigh, it would occur to me that before any physical union took place in this car, our two souls had become one. Then Füsun would remove her foot from the clutch too soon again, and my father's '56 Chevrolet would quiver like a poor, feverish horse, trembling violently until it passed out. With the engine stalled, we would notice the deep silence reigning in the park around us, in the summer villa before us, in the world everywhere. We would listen enchanted to the whirring of an insect beginning vernal flight before the onset of spring, and we would know what a wondrous thing it was to be alive in a park on a spring day in Istanbul.

It was in these gardens and villas that Abdülhamit had once hidden from the entire world, governing the Ottoman state from seclusion and playing like a child with the miniature

ship in the great pool (the Young Turks had planned to blow him up with this ship, too); after the founding of the Republic, the grounds had become a public park favored by rich families taking a leisurely spin and equally unhurried student drivers. I had heard from Hilmi the Bastard, Tayfun, and even Zaim that brave couples with nowhere else to go would come here, taking refuge behind the hundred-year-old plane and chestnut trees, to kiss. Whenever we caught sight of them embracing behind the trees, Füsun and I would fall into a long silence.

A lesson would last two hours at most, though to me it would seem as unending as our hours of lovemaking at the Merhamet Apartments; when the lessons were over, we would succumb to the silence that had become our default.

"Shall we go to Emirgân and drink tea?" I would say as we drove through the park gates.

"Yes, all right," she would whisper, like a bashful young girl.

I would be as delirious as a young man who, having acceded to the arrangement of his marriage, found cause only for delight and gratitude following his first meeting with his intended. We drove along the Bosphorus road, parking beside the sea, and sat in the car, sipping tea, and I would be speechless with happiness. It was all we could do following our exhaustion from the emotional undercurrents of our lesson. Füsun would either stay silent or talk about driving.

The windows would sometimes fog over, and once or twice I tried to use that opportunity to touch her, or kiss her, but like any honorable girl disinclined to any sort of physical intimacy before marriage, she politely pushed me away. Yet even having done so, she lost none of her chirpy good humor—and what a joy it was to see that she wasn't angry at me. There was, I think, something in my glad response at being rebuffed that called to

mind a provincial suitor discovering that the girl he is thinking of marrying is "principled."

In June 1983 we drove through almost every neighborhood in Istanbul gathering together the necessary documentation for the driving test. One day, after waiting half a day in a line outside the administrative office of Kasımpaşa Military Hospital, to which all driving applicants were referred owing to the emergency measures in effect, and, following that, an interminable interval at the door of an irritable doctor, we emerged with a report confirming the fitness of Füsun's nervous system and her reflexes and took a triumphal walk around the neighborhood, venturing as far as Piyalepaşa Mosque. Another day we had waited for four hours in a queue in the Taksim First Aid Hospital, only to find the doctor had gone home; to cool our tempers, we ate an early supper at a small Russian restaurant in Gümüşsuyu. On yet another day, after being informed that an ear, nose, and throat specialist we needed to see was on vacation, after we had been sent off to a hospital in Haydarpaşa, we whiled away the time throwing *simit*s to the seagulls from the back deck of the Kadıköy ferry. It was at the Istanbul University's Çapa Hospital that we handed in our collected documents, and, as we waited for them to be processed, took a long walk, wandering through narrow cobblestone streets, going right past the Fatih Hotel. I had suffered such anguish for Füsun in this place, and it was here I had heard the news of my father's death, but now the hotel seemed part of another city.

Whenever we had secured another necessary document, and placed it in the folder that accompanied us everywhere and that by now was covered with stains of tea, coffee, ink, and oil, we would leave the hospital in high spirits, and go celebrate

our success at a simple neighborhood restaurant. Füsun would smoke openly, without feeling nervous, or trying to be discreet; sometimes she would lean toward the ashtray and—as if we were friends from the army—brazenly take my cigarette to light her own, and then cast her expectant, playful gaze about her, looking for the next source of amusement. It stirred me to see my unhappily married beloved enjoying life on the go: watching people, visiting new neighborhoods, beguiled by the surprises of urban life, and keen to make new friends.

"Did you see that man? The mirror he's carrying is taller than he is," Füsun would say. After standing with me on a cobblestone street watching children play football, with a joy more sincere than mine, she would buy us two bottles of soda from the Black Sea Grocer (who, as if to make Zaim's point, had no Meltem!). When a laborer bearing pumps and a huge iron rod came down the street, looking up at the wooden houses' latticed windows and shouting "Sewerman!" to those on the concrete balconies and upper stories, Füsun would seem as fascinated as a child; on the Kadıköy ferry, when a vendor was hawking a kitchen utensil that could peel squash, squeeze lemons, and even slice meat, she would make a careful study of the tin gadget in his hand. "Did you see that boy?" she would say of someone as we walked down the street. "He is practically strangling his little brother." At a crossroads, where a crowd was gathering just in front of a muddy children's playground, she would cry, "What's going on? What are they selling?" and rush over, with me in tow, to a place where we would watch the gypsies and their dancing bear, the schoolchildren in their black smocks, rolling across the middle of the street as they fought, and the sad eyes of two dogs locked in coitus while some cheered in derision and others looked on sheepishly. If

two cars had collided and the drivers got out of them, spoiling for a fight, or if an orange plastic ball escaped from a mosque courtyard to bounce gracefully down a hill, or if an excavator was digging the foundations of an apartment on a large avenue, or a television was on in some shop window, we would stop and look on with everyone else.

To become reacquainted with each other as we explored the city, to see an undiscovered part of Istanbul each day, and an unknown side of Füsun—it was a pleasure that continually renewed itself. When we witnessed the poverty and chaos that reigned in the hospitals, the desperate old people who had to queue outside the entrances in the early hours of the morning to have any chance of seeing a doctor, or when we happened on black market butchers cutting up carcasses in the empty lots of the backstreets, far from the supervising eyes of the city council, it seemed to me that in life's shadowy precincts we were drawn even closer. Though our own story had its own vexing shadows, they were as nothing to the fearsome darkness in the lives of the city and its dwellers that we glimpsed while walking these streets. The city was teaching us to see the ordinariness of our lives, teaching us, too, a humility that banished guilt. There was a consoling power I felt mixing with the city crowds in shared taxis and buses, and admiring Füsun as she conversed with a headscarfed auntie sitting in the next seat, her grandchild asleep in her lap.

With her, I was able to discover all the awkwardness and pleasure of a stroll through Istanbul in the company of a beautiful woman whose head was uncovered. If we entered a hospital reception area, or the office of a state bureaucracy, all heads would turn toward her. Old functionaries accustomed to peering down indifferently on the impoverished and the elderly

would perk up, presenting themselves as diligently devoted to duty, and without first inquiring her age would address her as "young madam." There were those who, habituated to the careless use of the familiar with other patients, pointedly adopted the formal "you," and there were others who didn't dare even to look at her face. Young doctors would approach like urbane gentlemen in European films, to ask, "Might I be of any assistance?" Crusty professors who seemed not even to notice me tried to charm her with quips and courtesies. All this disruption on account of a beautiful woman appearing without a headscarf in the office of a state bureaucracy, sowing momentary alarm, even panic. Some clerks could not bring themselves to discuss the business at hand in her presence, others would stammer, still others fall silent, obliged to seek out a man who could act as intermediary. When they finally saw me, and took me for her husband, they would relax, as would I, in much the same helplessness.

"Füsun Hanım needs a report from the ear, nose, and throat specialist to take to the office of drivers licensing," I'd say. "We were sent here from Beşiktaş."

"The doctor isn't in yet," the orderly in charge would say. Opening the file in our hands, he would glance quickly at the documents inside and say, "Please sign in and take a number." When we noticed how long the line of patients was, he would add: "Everyone is waiting in line. There's no one who doesn't wait."

Once I spied an opportunity to grease the orderly's palm, but Füsun objected, saying, "No, we're going to do this like everyone else."

As we waited in line, chatting with patients and clerks, everyone assumed I was her husband, and this pleased me.

I did not see the mistake as reflecting the assumption that a woman would never go to a hospital with a man who wasn't her husband, but as proof that our growing intimacy was now clear to all. Once we went for a stroll in the backstreets of Cerrahpaşa, while waiting for our number to be called at the University's Çapa Hospital, and at some moment I had lost Füsun, whereupon a window in a ramshackle wooden house opened, and a headscarf-wearing auntie informed me that "your wife" had stepped into the grocery story around the corner. We attracted some notice in these backstreet neighborhoods, but no alarm. A few children might follow us; some adults mistook us for tourists who'd lost their way. Sometimes a smitten youth might shadow us, just to admire Füsun from afar, but when a few streets farther on I would catch his gaze, he would politely retreat. Heads were often to be seen poking out of doors and windows, the women asking Füsun whom we were seeking or what address, and the men asking me. Once, seeing Füsun about to eat a plum she'd bought from a street vendor, an old woman reached out, crying, "Wait a minute, my girl. Let me wash that for you first!" The woman washed our plums in her stone-paved kitchen on the ground floor, made us coffee, and asked us what we were doing in the area; when I said that my wife and I were searching for a beautiful wooden house to live in, the old woman relayed this information to all the neighbors.

All the while, our laborious driving lessons in Yıldız Park continued, and we were also preparing for the written exam. If we were sitting in a tea garden with some time to kill, Füsun would sometimes take a booklet from her bag with a title like *Driving Made Easy* or *Driving Exam Questions Complete with Answers,* and, smiling mischievously, she would quiz me.

"What is a road?"

"I give up."

"The lanes and zones open to traffic for public use," Füsun would say, reciting half from memory and reading the rest. "All right then, what is traffic?"

"Traffic refers to the presence and movement of pedestrians and animals—"

"There is no 'and,' " Füsun would say. "Traffic refers to the presence and movement of pedestrians, animals, vehicular machinery, and tractors with tires on roads."

I enjoyed these question-and-answer exchanges, which caused us to reminisce about middle school, and the curriculum, which relied so heavily on memorization, and our report cards, which included marks for "comportment," and soon I would find myself asking her a question.

"What is love?"

"I don't know."

"Love is the name given to the bond Kemal feels with Füsun whenever they travel along highways or sidewalks; visit houses, gardens, or rooms; or whenever he watches her sitting in tea gardens and restaurants, and at dinner tables."

"Hmmm . . . that's a lovely answer," Füsun would say. "But isn't love what you feel when you can't see me?"

"Under those circumstances, it becomes a terrible obsession, an illness."

"What has this got to do with the driving examination?" Füsun would say. Then she would behave as if this sort of dalliance could not be allowed to go on if a couple was unmarried, and I would take care not to make any more such jokes for the rest of the day.

The written exam took place in Beşiktaş, in a small palace where Numan Efendi, one of Abdülhamit's crazy princes,

had listened to harem girls play the ud as he whiled away the hours doing impressionist paintings of the Bosphorus. After the founding of the Republic the building had been converted by the state into offices that were never properly heated, and as I waited at the entrance, I regretfully remembered, as I had countless times, that I should have waited outside the Taşkışla Building, where she had taken her university entrance exam eight years earlier. Had I broken off the engagement to Sibel and sent my mother to ask for Füsun's hand, we could have had three children by now. But there would still be time for three children, or even more, once we'd married. I was so sure of this that when Füsun came out of the exam looking elated, and announcing, "I answered all the questions!" I was on the verge of informing her how many children we would have, but I held back, mindful of how, in the evenings, we were still sitting, quite solemnly, at the family table, watching television as we ate.

Füsun passed the written exam with a perfect score, but she failed her first road test miserably. They flunked everyone on the first attempt, just to emphasize what a serious business it was to operate an automobile, but we were unprepared for how it turned out. Füsun got into the Chevrolet with the three-man examination committee, and though she had successfully started up the car and put it into motion, she had not gone far before a deep-voiced examiner in the backseat declared, "You didn't look in the mirrors!" and when Füsun turned around to ask, "What did you say?" they instructed her to stop the car at once and get out. Drivers, the regulations clearly stated, were never to look behind them while they were driving. The examiners bolted from the Chevrolet, as if truly frightened to be in a car with such a reckless driver, a degrading show that Füsun found demoralizing.

They scheduled her for a retake four weeks later, at the end of July. Those familiar with the modus operandi of the drivers licensing agency could only laugh to see us so downcast and humiliated, and they lectured us amicably about bribes and how we might go about procuring a license at a particular shantytown teahouse (with four pictures of Atatürk and a clock on its walls) that was frequented by everyone in Istanbul who had a hand in the drivers licensing business. If we were to enroll in one of the pricey driving schools where retired traffic policemen taught (and attendance wasn't compulsory), we were certain to pass, because the examination committee and many policemen were partners in that business.

Paying for this course also afforded one the privilege of taking the test in an old Ford specially modified for the purpose: This vehicle had a huge hole in the floor next to the driver's seat, so that when the driving candidate was called upon to park in a tight space, he could see the colored markings on the road; and if he would but refer to the written guide hidden behind the sun visor, he would know which colored marking indicated that he should turn the wheel as far as it could go to the left, and exactly when he should go into reverse, so as to park the car flawlessly. It was also possible, for a larger sum, to avoid enrolling in a school altogether, a custom which I, as a businessman, knew only too well was sometimes unavoidable. But as Füsun was adamantly opposed to the smallest enrichment of the policemen who had callously failed her, we continued our lessons at Yıldız Park.

The examination guide contained hundreds of minor regulations of which a driver needed to show awareness on the road. It was not enough to operate the car properly in

the presence of the examining committee; one also had to demonstrate, sometimes by exaggerated gestures, mastery of these regulations—for instance, looking into the rearview mirror as required counted for nothing unless you also showed consciousness of doing so by gripping the mirror. A fatherly policeman with long experience of the licensing process explained this to Füsun in a most affable way, saying, "My girl, it's not enough to drive a car during your exam. You also have to look *as if* you're driving. The first you do for your own benefit, and the second for the benefit of the state."

After our driving lessons in the park, when the sun was low in the sky, we would go to Emirgân for coffee and soda on the edge of the Bosphorus, or to a coffeehouse in Rumelihisarı for tea from a samovar, and these pleasures never failed to neutralize the aggravations of the lessons. But let no reader infer from this that we carried on like giddy lovers.

"We're making better progress at these lessons than we did with mathematics!" I said once.

"We shall see," Füsun replied cautiously.

Sometimes we would sit at the table and drink our teas in silence, like some long-married couple who had run out of things to say to each other; as we admired the Russian tankers passing by, or the City Line ferries on their way to Heybeliada, or (as happened once) the *Samsun* heading out on its tour of the Black Sea ports, we seemed lost in misery, in dreams of other lives and other worlds.

Füsun didn't pass her second test either. This time they set her the very difficult task of maneuvering into an imaginary parking space while driving up a hill in reverse. When she made the Chevrolet tremble and judder again, they ordered her out of the car in the same humiliating way.

I had been watching from a distance with a mixed crowd of retired policemen, applicants, letter writers, teaboys, and various gawkers; when one of them saw a bespectacled examiner once again take the wheel from Füsun, he said, "They flunked that chick," and a couple of others laughed.

As we drove back toward the house, Füsun was too upset to speak. Without asking her first, I parked the car in Ortaköy and sat down in a little *meyhane* in the market, where I ordered us some *rakı* with ice.

"Life is short but very sweet, Füsun," I said after a few swigs of *rakı*. "The time has come to stop letting these fiends get the better of you."

"How can they be so vile?"

"They want money. So let's pay them."

"Do you believe women can never be good drivers?"

"It's not what I think, but it is what they think."

"It's what everyone thinks."

"Darling, I beg you, don't be so stubborn about this as well," I said, hoping almost at once that Füsun had not heard me say this.

"I'm not stubborn in anything, Kemal," she said. "But when your pride or your honor is being trampled on, you can't just bow your head. Now I'm going to ask something of you, and I would like you to listen, please, and take it seriously. I am going to get my license without paying a bribe, Kemal, and on no account are you to interfere. Don't you dare pay a bribe behind my back, and don't try to pull any strings, either, because I'll know if you do, and I will be extremely upset."

"All right," I said, looking down.

We drank our *rakı*s saying little more to each other. It was almost evening, and this *meyhane* in the middle of the market

was empty. Impatient flies were perched uncertainly on its trays of fried mussels and little meatballs with thyme and cumin. Years later I went back for another look at that ramshackle *meyhane* whose memory is so dear to me, but the entire building had been razed and in its place were now shops selling evil eyes, trinkets, and other tourist souvenirs.

That evening, after we'd left the restaurant and were getting back into the car, I took Füsun by the arm.

"Do you know what, sweetheart? That was the first time in eight years we have eaten in a restaurant, just the two of us."

"Yes," she said. The light that flickered for a moment in her eyes made me inordinately happy. "I have something else to say to you. Give me the keys, I'm going to drive the car."

"Of course."

The junctions and hills of Beşiktaş and Dolmabahçe made her perspire a little, but even though she'd had a bit to drink, she was able to steer the Chevrolet as far as Firuzağa Mosque without incident. When I picked her up three days later from the usual spot, she wanted to drive the car again, but the city was crawling with police and I talked her out of it. Despite the hot weather, our lesson went amazingly well.

As we were driving back I looked at the whitecaps on the windy Bosphorus and said, "If only we'd brought our swimsuits!"

The next time we went out, when Füsun left the house in the usual floral print dress, she was wearing underneath it the blue bikini displayed here. After our lesson, at Tarabya Beach, she did not take off her dress until just before she jumped off the seawall into the water. For one brief moment of embarrassment, I could see my beloved's body, and then she swam away, so fast you might have thought she was fleeing

me. The bubbles and the churning water in the wake of her plunge, the beautiful light, the midnight blue of the Bosphorus, her bikini—all this gathered in my mind to form an indelible image, a feeling. I spent years searching out that sentiment, and those wondrous colors, in the old photographs and postcards of Istanbul's troubled collectors.

I jumped into the sea right after her. A strange voice inside warned of monsters and evil creatures perhaps lurking underwater, waiting to attack her. I needed to reach her in time and protect her from the depths of the waves. I remember that I was giddy as I searched for her in the choppy sea, that I swam as fast as I could, panicked at the thought that happiness might escape my grasp, and that at one moment at the height of my panic I couldn't breathe. Füsun had been carried away by the Bosphorus currents! At that moment I wanted to die with her; I wanted to die at once. Just then the capricious waves of the Bosphorus opened up and there was Füsun right in front of me. Both of us breathless, we faced each other with the smiles of happy lovers. But when I tried to get closer, so that I might touch her, kiss her, she pulled a long face, like some modest girl with scruples; without further dallying, she did a cool breaststroke away from me. I swam after her, doing the same stroke. As I swam I admired the movement of her beautiful legs, the sweet roundness of her buttocks. Only much later would I notice how far we were from shore.

"Enough!" I said. "Stop running away from me. This is where the currents begin. They could sweep us both up, and we could die."

I turned around, and when I saw how far away the shore was, I was afraid. The city surrounded us, the European shore

now seeming almost as distant as the Asian shore behind us. There was Tarabya Bay, and the Huzur, the restaurant where we'd eaten on so many occasions, and all the other restaurants lining the shore, and the Tarabya Hotel, and the cars, minibuses, and red buses snaking along the shore road, and the hills rising above it, and the shantytowns above Büyükdere—the entire city had receded.

It was as if I were looking at a panoramic miniature painting, not just of the Bosphorus and the city, but of the life I'd left behind. It felt like a dream, this sense I had of being far from the city and my own past. To have reached the middle of the city, in the middle of the Bosphorus, to be so distant from everyone else but together with Füsun, felt like the chill of death. When a wave larger than the others hit Füsun unexpectedly and she let out a shriek, and wrapped her arms around my neck and shoulders to hold on, I knew then that only death would part us.

Just after this fiery touch—we can call it an embrace—she used the excuse of an approaching coal freighter to swim away. She swam gracefully and very fast, so fast I had a hard time keeping up. As soon as she had climbed to the shore, Füsun left me for the bathhouse. None of this called to mind two lovers without shame about each other's bodies. We were as shy, quiet, and prudish as if we'd just been introduced by our families with marriage in mind: We couldn't even look at each other unclothed.

By driving to and from her lessons, and sometimes to the city proper, Füsun had soon learned to drive well. But she did not pass the road test in early August either.

"I flunked, but never mind. Let's forget about those evil men," said Füsun. "Shall we go to the seaside?"

"Let's go."

Like so many applicants who came to the road test with friends, and had their photos taken as if departing for their military service, only to fail the test, Füsun left the scene at the wheel, smoking and honking like an oafish truck driver. (When I went back many years later, those once ugly, bald, garbage-strewn hills had been transformed into luxury housing estates, complete with swimming pools.) We continued our lessons at Yıldız Park until the summer's end, but by now the driver's license was just an excuse for going to a restaurant or the beach. A few times we rented a rowboat from the wharf next to the Bebek ferry station, and together we'd row out to a place far from the jellyfish and the oil slicks, where the bay met with the currents, and there we'd jump into the sea. One of us would keep hold of the rowboat, to keep it from being swept away by the currents, holding the other with his—or her—free hand. I loved renting a rowboat in Bebek, not least for the pleasure of holding hands with her.

This love finally flowering between us after eight long years was not something we embraced with joy; rather we approached it with great caution, like a friendship that beckons but is nevertheless exhausting. The eight years we'd lived through had buried our love deep within, yet it still made itself felt even at moments when we were paying it least attention. But when I saw that Füsun had no taste for risking the dangers of any greater intimacy before marriage, I, too, resisted my never absent desires to embrace or kiss her. I had begun to entertain the idea that couples who lost their heads and capitulated to desire before they wed, heedless of the consequences, were not likely destined for marital bliss, but rather for disillusionment and depression. As for Hilmi

the Bastard, Tayfun, and Mehmet, whom I ran into now and again, I had begun to grow disdainful of these friends of mine, who still patronized brothels and bragged about their womanizing. At the same time, though, I dreamed that after Füsun and I were married I would find release from my obsessive thoughts and reunite with my friends, and everyone in my old circle, with the contentment that only maturity can confer.

At the end of the summer Füsun took another test with the same examiners and failed once more. This unleashed the usual tirades about male prejudice against Istanbul's women drivers, and she railed against them with that same expression on her face I remembered from so many years earlier, when she'd told me about the sleazy "uncles" who had pawed and molested her.

Early one evening, following our driving lesson, we went to Sariyer Beach, and as we sat there drinking Meltem (an indication that Zaim's campaign with Papatya had worked somewhat) we saw a friend of Mehmet's named Faruk, together with his fiancée, and at that moment I felt a strange sort of shame. This was not on account of Faruk's having paid many visits to the *yalı* in Anadoluhisarı during the summer of 1975 or his having witnessed the sort of life Sibel and I had led there; I was ashamed because Füsun and I showed no joy as we sat there silently drinking Meltem. The silence stemmed from our awareness that this would be our last trip to the beach. The first storks flying past us in the evening sky overhead announced to us that this beautiful summer would soon come to an end. One week later, when the beaches closed with the first rains, neither Füsun nor I had any urge to go to Yıldız Park to practice driving.

After failing three more times, Füsun finally passed her road test in early 1984. They had tired of her, and they understood by then that she was never going to pay a bribe. To celebrate the occasion, that night I took her and Aunt Nesibe and Tarık Bey to the Maksim Gazino to hear Müzeyyen Senar sing old Turkish songs.

Tarık Bey

THAT EVENING we all went out to Bebek Maksim, all of us got drunk, and after Müzeyyen Senar came out on stage, everyone at the table began to sing along. As we joined in with the refrains, we would look into one another's eyes and smile. Looking back so many years later, I imagine it had the aura of a farewell ceremony. Actually, it was Tarık Bey, and not Füsun, who most loved Müzeyyen Senar's singing, but I'd thought it would delight Füsun to see her father drinking and blissfully harmonizing with Müzeyyen Senar as he did renditions of songs like "There's No One Else Like You." The most memorable thing about the evening for me was noticing for the first time that Feridun's absence had become ordinary. That evening I reflected happily on how much time I'd spent alone with Füsun and her parents.

Sometimes the passage of time would be marked by seeing a building torn down, or discovering that a little girl had become a high-spirited, buxom woman with children of her own, or I'd notice that some store to which my eyes had grown accustomed had been boarded up, and I would feel anxious. When I saw, at around this time, that the Şanzelize Boutique had closed, I was pained not only at the loss of my own memories, but equally by a sudden feeling that life had gone on without me. In the window where Sibel had spied the counterfeit Jenny Colon handbag nine years earlier, coils of Italian salamis were

now hanging, and wheels of hard yellow cheese, as well as the European brands of bottled salad dressings, the pastas and soft drinks just entering the Turkish market.

And whereas before I had always enjoyed sitting with my mother at the dinner table and listening to her gossip about children, families, and weddings, it was at around this time that such reports began to unsettle me. As my mother, displaying her customary hyperbole, told of how my childhood friend Faruk the Mouse already had his second child—"a strapping boy!"—though he'd been married for only a short time—"three years!"—and as I thought about having been unable to share my life with Füsun, my joy would drain away, but my mother, noticing nothing, would just keep talking.

Ever since Şaziment had (at last) managed to marry off her elder daughter to the Karahan boy, they'd stopped going to ski in Uludağ every February, preferring to spend a month in Switzerland with the rest of the Karahan clan, and taking Şaziment's younger daughter with them. This younger daughter had found herself a rich Arab prince who was staying in the same hotel, and Şaziment had almost succeeded in marrying her off as well when it emerged that the prince had another wife back in his own country—a harem, even. As for the Halis family of Ayvalık, their eldest son—"You remember, the one with the longest chin," said my mother with a laugh, which I could not help sharing—my mother had heard from Esat Bey, her neighbor in Suadiye, that the boy had been caught on a winter's day at their summer house in Erenköy with the German nanny. The eldest son of Maruf the tobacco king—when we were children, we'd played together with shovels and pails in the sandboxes of city parks—had been kidnapped by terrorists, a development my mother was shocked to learn I had not heard

about, not even when he was released following the payment of a ransom. Yes, they'd managed to keep the matter from the press, but because the family had been so slow to cough up the money, everyone had been "scandalized" for months on end by the matter—so how could I not have heard?

I was worried that my mother might have intended this question as a dig about my visits to Füsun's family; maybe she was remembering that whenever I came home on summer evenings with wet swimming trunks, and both she and Fatma Hanım would ask whom I'd gone swimming with, how I'd reply, "I'm working very hard, Mother dear," and try to change the subject (as if it had eluded my mother what dreadful shape Satsat was in). It made me sad that after nine years I'd still found no ways of intimating to my mother my obsessive love for Füsun, let alone confiding in her; I would long for her to tell me another pointless story so that I could forget my troubles. One night she described in great detail about how Cemile Hanım, whom I'd seen at the Majestic Garden Cinema with Füsun and Feridun many summers ago, being no longer able to afford the upkeep on her eighty-year-old mansion, had, like Mükerrem Hanım, another of my mother's friends, taken to renting it out to producers of historic melodramas, only to see "that huge, lovely mansion" burned down, ostensibly due to faulty electrical equipment during filming, though everyone knew the family had deliberately set the fire to erect an apartment building in the mansion's place. The narrative was so vivid that I was in no doubt about my mother's full awareness of my close ties to the film world, the particulars of which Osman must have furnished her.

Though I'd been amused to read in the papers about Melikhan, the former foreign minister, who had taken a

fall having caught his foot on a carpet at a ball and died two days later of a brain hemorrhage, my mother didn't mention it, fearing perhaps that it might remind me of Sibel and the engagement. There were other pieces of news that my mother saw fit to withhold, but that I'd heard from Basri, the Nişantaşı barber. It was he, for instance, who informed me that my father's friend Fasih Fahir and his wife, Zarife, had bought a house in Bodrum; that Sabih the Bear was actually a very decent person "underneath it all"; that gold was actually a foolish investment right now; that prices were bound to fall; that there would be a lot of fixing at the horse races that summer; that even without a hair left on his head, the famously wealthy Turgay Bey, out of attachment to the habits of a gentleman, still came in for regular haircuts; that two years ago Basri had been offered the Hilton concession, but being a "man of principle" (the meaning of which he did not elaborate) he had declined—and in this same spirit proceeded to ply me for any information I might have on this and that. It would irritate me to realize that Basri and all his rich Nişantaşı clients knew all about my obsession for Füsun, and lest I give them more to gossip about, I would sometimes go to Cevat, my father's old barber in Beyoğlu, and from him I would hear tales of the Beyoğlu hoodlums (by now referred to as the mafia) and the film world. It was from him, for example, that I heard of Papatya's involvement with Muzaffer, the famous producer. None of my sources, however, talked to me about Sibel or Zaim, or about Mehmet and Nurcihan's wedding. From this, if nothing else, I should have deduced the universal awareness of my sorrow and suffering, but I didn't: My informants' tact seemed as natural to me as their oft-repeated indiscreet accounts of all the bankers going bankrupt, stories I always welcomed.

It was two years earlier, at the office and also from friends, that I'd begun to hear about all the bankers who'd gone bankrupt, and all the investors who'd lost their fortunes— stories I enjoyed because they proved the utter brainlessness of the Istanbul rich, not to mention their slave masters in Ankara. For her part, my mother relished saying, "Your dear departed father always did insist that no one should trust those conniving bankers!"—a subject she warmed to since, unlike so many others in our circle, we'd not fallen prey to them. (Though I sometimes suspected that Osman had secretly invested some of the profits from his new ventures with them.) My mother felt bad for any friends who'd been fleeced—Kadri the Sieve, whose beautiful daughter she had once hoped I would marry, Cüneyt Bey and Feyzan Hanım, Cevdet Bey and his family, the Pamuks—but when it came to the Lerzans, she would profess amazement that they should have consigned their entire fortune to a "so-called banker" who was the son of an accountant in one of their own factories (and who had worked his way up from security guard), a man who had only recently risen from the shantytowns with no financial credentials, but with an office of some sort, an advertisement on TV, and a checking account with a reputable bank. Closing her eyes as if she would faint and shaking her head half in jest, she would say, "They could at least have gone to someone like Kastelli, who's so close to those actor friends of yours." I would never dwell on the subject of my actor friends; when she marveled that "sensible, reasonable people" (including, as readers will recall, Zaim) could be so harebrained, I would enjoy chiming in.

Tarık Bey numbered among those my mother dismissed as stupid. He had invested money with Kastelli the banker,

who had hired so many of the famous actors we knew from the Pelür to appear in his commercials. When Tarık Bey had admitted losses two years earlier, I'd assumed them to be small, as he gave no indication of serious suffering or hardship.

On Friday, March 9, 1984, two months after Füsun got her driver's license, when Çetin dropped me off at the house in Çukurcuma at suppertime, I saw that all the windows and curtains were open, and the lights were on upstairs and downstairs, this despite Aunt Nesibe's perennial upset at the waste of electricity when a single light was left on upstairs at suppertime; without fail, she would say, "Füsun, my girl, the bedroom light's still on," and without delay Füsun would go straight upstairs to turn it off.

Steeling myself for a family quarrel between Feridun and Füsun, I went upstairs. No one was seated at the table where we'd eaten supper for so many years, nor could I see any food. The television was on, and sitting before it were two neighbors—an old lady and her husband—who seemed at a loss as to what to do. Out of the corners of their eyes they were watching our actor friend Ekrem Bey, who, dressed as the grand vizier, was making a speech about infidels.

"Kemal Bey," said the neighbor, Efe the electrician. "Tarık Bey has passed away. Please accept our condolences."

I ran upstairs, instinct taking me not to the master bedroom but to Füsun's room—the little bedroom I had dreamed of for so many years.

My lovely was lying doubled up in bed and crying. When she saw me she straightened herself, and I sat down beside her. We instantly threw our arms around each other, embracing with all our strength. She rested her head between my neck and chest, weeping convulsively.

Dear God, what great happiness it was to hold her in my arms! I felt the world's profundity, its unbounded beauty. With her head resting on my shoulder, her chest pressed against mine, I felt as if it were not just she but the entire world in my arms. Her shaking upset me, grieved me deeply, in fact, but what bliss it brought me, too! I stroked her hair with care and tenderness, combing it gently with my fingers. Every time my hand returned to her roots so my fingers could pass once more through her hair, her entire body quaked as she burst into tears once more.

I called to mind my own father's death so that I might better share in her grief. But much as I'd loved my father, there'd always been a tension between us, a rivalry of sorts. Füsun, by contrast, had loved her father deeply, tirelessly, and without effort or reservation, just as one might love one's home, and one's street, and the sun that shone down on them. And it seemed to me that her tears were shed not just for her father but also for the state of the world, and the course of life.

"Don't worry, my darling," I whispered into her ear. "Everything will be fine from now on. From now on everything will work out. We are going to be very happy."

"I don't want anything anymore!" she said, wailing more fiercely. As I felt her shudder in my arms, I looked long and hard at the furniture, the drawers, the little nightstand, Feridun's film books, and so much else. For eight years, how much I had longed to come into this room where Füsun kept all her dresses, and all her other belongings.

As her sobbing intensified, Aunt Nesibe came in. "Oh Kemal," she said, "what are we going to do? How can I live without him?" Sitting down on the bed, she, too, began to cry.

I spent the night in Çukurcuma. Sometimes I would go downstairs to sit with the friends and acquaintances who had come to offer condolences, and then I would go back upstairs to comfort Füsun, still crying in her room; I would stroke her hair and give her a fresh handkerchief. As her father's body lay in the next room, and the friends and acquaintances gathered together downstairs sat drinking tea and smoking cigarettes and watching television in silence, Füsun and I lay side by side, locked in an embrace, for the first time in nine years. I breathed in the scent of her neck, her hair, her skin perfumed with the scent that the exertions of crying had released. Then I would go back downstairs to serve the guests.

Feridun was unaware of what had happened, and that night he did not come to the house. It is only now, years later, that I can fully appreciate the thoughtfulness of the neighbors in acting as if it was entirely natural that I be there, indeed as if I were Füsun's husband. I'd met them all in the course of my visits to Çukurcuma, sometimes in the street, and sometimes when they called at the house, and to offer them tea and coffee, to empty their ashtrays, to offer them pastries hurriedly acquired from the corner bakery was for me a welcome distraction, as it was for Füsun and Aunt Nesibe. At one point three men—the Laz carpenter whose shop was just up the hill, the eldest son of Rahmi Bey (whose artificial hand will be familiar to all museum visitors), and an old friend who often came to play cards with Tarık Bey in the afternoons— embraced me each in turn, repeating the traditional entreaty not to die with the dead. But as I grieved for Tarık Bey, there was also inside me a boundless will to live; as I considered the new life now awaiting me, I felt deeply happy, and on this account ashamed.

After the banker he'd invested with went bankrupt and fled the country, Tarık Bey began to spend time at an association set up by a number of other "banker victims" (as the newspapers liked to call them). The association had been established to find a legal means of recovering the money that the retirees and petty clerks had lost to the bankers, but in this it had been unsuccessful. As Tarık Bey would sometimes relate to us, barely containing his laughter, the members (whom he sometimes described as a "brainless rabble") were so fractious that planning discussions would typically degenerate into argument, with victims kicking and punching one another. Sometimes, after a great deal of shouting, they would force through a petition, which they'd submit to the ministry or leave at the door of a bank or a newspaper with no professed interest in helping them. Some members would pelt banks with rocks, bellowing their grievances, sometimes assaulting bank clerks. After several unsavory incidents in which bankers' doors had been kicked down and their homes and offices looted, Tarık Bey distanced himself from the association, but that summer, while Füsun and I were sweating for her driver's license and swimming in the sea, he'd begun attending meetings once again. That afternoon some development at the association had particularly annoyed him, and he'd gone home complaining of chest pains; as the doctor who'd come hours too late was able to confirm with one look, he'd died of a heart attack.

Füsun was all the more distraught at not having been at home when her father died. Tarık Bey must have lain in bed for a long time, waiting for his wife and daughter. Aunt Nesibe had taken Füsun along that day to a house in Moda to finish a dress that was a rush order. In spite of all the assistance I had given the family, from time to time Aunt Nesibe still went

off with that sewing box with the picture of Galata Bridge on it, to work at various houses at a daily rate. In no way was I insulted, as other men might have been, by Aunt Nesibe's persistence; rather, I was impressed that she still sewed, even though she knew she could count on me for support. Still, I was troubled whenever I heard that Füsun had accompanied her, asking myself what my beauty, my one and only, could be doing in those strangers' houses; but she went only rarely, and even more rarely spoke to me about those sewing day trips, though when she did she always described them as pleasant excursions, in terms reminiscent of her mother's visits to Suadiye so many years ago, with such joy in her voice as she told me of drinking *ayran* on the Kadıköy ferry, and of throwing *simit*s to the seagulls, that I hadn't had the heart to tell her that when we were married and living among the rich, neither of us would enjoy meeting those people whose houses she'd visited as a seamstress.

Long after midnight, when everyone had left, I curled up on the divan in the back room downstairs. To sleep in the same house with Füsun, for the first time in my life . . . this was the greatest happiness. Before drifting off to blissful sleep, I listened first to Lemon rattling about in his cage, and then to the ships sounding their whistles.

I woke up with the morning call to prayer; by now the ships on the Bosphorus were more insistent, and in my dream Füsun's ferry ride from Karaköy to Kadıköy had merged with Tarık Bey's death.

From time to time, I heard foghorns, too, and the whole house was bathed in the pearly white that was particular to foggy days. Passing in silence through the white dreamscape, I made my way up the stairs. There, on the bed where she and

Feridun had spent the first happy nights of their marriage, I found Füsun fast asleep, with her arms draped around her mother. I sensed that Aunt Nesibe had heard me. I gave the room one last careful peek: Füsun really was asleep, and Aunt Nesibe was pretending.

Going into the other room, I gently lifted the sheet they'd draped over him, and looked for the first time at Tarık Bey's body. He was still wearing the jacket he'd put on to attend the meeting at the banker victims' association. His face was ashen, the blood having gathered at the nape of his neck. It was as if the stains and moles and wrinkles on his face had grown larger in death. Was this because his soul had left him, or because his body had already begun to decay and change shape? Death's terrifying presence was much stronger than the love I felt for Tarık Bey. Rather than feel for him, or put myself in his shoes, I wanted only to flee. But I did not leave the room.

I'd loved Tarık Bey because he was Füsun's father, because we'd spent so many years at the same table, drinking *rakı* and watching television. But as he'd never really opened himself up to me, I'd never felt truly close to him. In truth, we'd never been fully satisfied with each other, but in spite of that we still managed to get along.

As I thought all this over, I realized that Tarık Bey, like his wife, had known from the beginning that I was in love with his daughter. Or rather, I did not so much realize this as confess it to myself. He'd almost certainly known very early on that I'd been so irresponsible as to sleep with his daughter when she was but eighteen years old, and, inevitably, dismissed me as a heartless rich man, a boorish philanderer. As I was the one who had forced him to marry his precious girl off to a penniless boy with no prospects, he could not but have hated me! But he

had never once shown his resentment; or perhaps I had never once wanted to see it. I might say he had both resented and forgiven me, as thieves and gangsters keep company by turning a blind eye on one another's iniquities and disgraces. This was why, after the first few years, he'd ceased to be the man of the house, just as I had ceased to be the guest: We had become partners in crime.

As I looked at Tarık Bey's frozen face, a long-suppressed memory surfaced: I was reminded of the fear and awe that had printed itself on my father's face as he faced death. Tarık Bey's heart attack had lasted longer: He'd met death and struggled with it, and so on his face there was no awe. He'd bitten his lips on one side, as if to fight the pain, and the other side of his mouth was open, as if grinning. At the table he'd always had a cigarette in that corner of his mouth, and a *rakı* glass in front of him. But in the room there was no charge issuing from the objects that had surrounded him in life; there was only the fog of death and the void.

The white light flooding the room came mostly from the left-hand side of the bay window. Looking outside I saw the narrow street was empty. Because the bay window extended as far as the middle of the street, I could imagine myself suspended above it in midair, in fog so thick that I could only just see the corner where the street met Boğazkesen Avenue, the entire neighborhood asleep in the fog, a cat confidently slinking slowly down the street.

Just over his bed, Tarık Bey had hung a framed photograph from his days as a teacher at Kars Lycée: It showed him standing with his students at the end of a play they had performed in the famous theater that dated back to the time when the city had belonged to the Russians. The top of the bedside table and

its half-open drawer also brought back strange memories of
my father. It emanated a sweet fragrance, a mixture of dust,
medicine, cough syrup, and yellowing paper. Above the drawer
I saw a water glass containing his false teeth and a book by his
beloved Reşat Ekrem Koçu. Inside the drawer there were old
medicine bottles, cigarette holders, telegrams, folded doctors'
reports, newspaper articles about bankers, electric and gas bills,
coins now gone out of circulation, and many other odds and
ends.

Before any of the day's visitors gathered at the Keskin
house, I left for Nişantaşı. My mother was up and having
breakfast in bed, eating from a tray Fatma Hanım had brought
her and propped on a pillow: boiled eggs, marmalade, black
olives, and toasted bread. She perked up when she saw me.
When I told her about Tarık Bey, her face dropped, and she
looked genuinely sorry. I could tell that she felt Nesibe's grief.
But beneath that I sensed something else.

"I'll be going back there," I said. "Çetin can bring you to
the funeral."

"I'm not going to the funeral, my son."

"Why not?"

First she gave two ridiculous excuses. "There's been no
announcement in the papers. Why are they in such a big hurry?"
and "Why aren't they having the funeral at Teşvikiye Mosque?
Everyone else started their funeral processions there." I could
see that she felt deeply for Nesibe, whom she'd liked so much,
and with whom she'd had such good fun during the days when
Nesibe had come to the house to sew. But underneath there
was something else, something unyielding. When she saw how
unsettled I was by her refusal, and how determined to know the
true reasons for it, she lost her temper.

"Do you want to know why I'm not going to the funeral?" she said. "Because if I do, you'll marry that girl."

"Where did you get that idea? She's married already."

"I know. It will break Nesibe's heart. But my son, I've known all about this for years. If you insist on marrying her, it won't be a pretty picture to most people."

"Does it really matter, Mother dear? People will always talk."

"Please, I beg of you, don't take offense." Looking very serious, she set her toast on the tray, and next to it, her knife, smeared with butter; and she looked intently into my eyes. "At the end of the day, what other people say has no importance whatsoever. Of course, what's important is the truth, the honesty of our feelings. I have no complaints about that, my son. You fell in love with a woman. . . . And that's wonderful, my son. I can't complain about that. But has she ever loved you? What has she done over the past eight years? Why has she still not left her husband?"

"She's going to leave him, I am certain of it," I lied ashamedly.

"Look, your dear departed father was smitten with a poor woman young enough to be his daughter. . . . He was obsessed with her. He even bought her a house. But he kept everything hidden; he didn't make a fool of himself as you have done. Even his closest friend had no idea." She turned toward Fatma Hanım, who had just entered the room, and said, "Fatma, we're having a little talk." When Fatma had withdrawn, shutting the door behind her, my mother continued. "Your dear departed father was a man of character and intelligence, and a gentleman, too, but even he had his weaknesses and desires. Years ago you asked me for the key to

the Merhamet Apartments and I gave it to you, but knowing you to be your father's son, I warned you. 'For goodness' sake, be careful,' I said. Didn't I? My son, you didn't listen to me at all. All right, you say to me that if it's your fault, where is Nesibe's sin in all this? What I can never forgive is this torture she and her daughter have subjected you to, these ten long years."

I did not say, It's been eight, not ten, Mother. "All right, Mother," I said. "I know what to say to them."

"My son, you can't find happiness with that girl. If you could, you'd have found it by now. I don't think you should go to the funeral either."

I did not infer from my mother's words that I had ruined my life: Quite to the contrary, she'd reminded me, and I felt this all the time now, that I was soon to share a happy life with Füsun. And so I was not in the least angry with her; I even smiled as I listened to her lecture, my only wish being to return to Füsun's side at once.

Seeing she'd made no impression on me, my mother was incensed. "In a country where men and women can't be together socially, where they can't see each other or even have a conversation, there's no such thing as love," she vehemently declared. "By any chance do you know why? I'll tell you: because the moment men see a woman showing some interest, they don't even bother themselves with whether she's good or wicked, beautiful or ugly—they just pounce on her like starving animals. This is simply their conditioning. And then they think they're in love. Can there be such a thing as love in a place like this? Take care! Don't deceive yourself."

Finally my mother had succeeded in angering me. "All right then, Mother," I said. "I'm off."

"When they hold funerals in neighborhood mosques, the women don't even attend," she called after me, as if this had been her real excuse all along.

Two hours later, as the crowd at Firuzağa Mosque dispersed after funeral prayers, I saw women among the mourners embracing Aunt Nesibe, though admittedly they were few. I remember seeing Ceyda and also Şenay Hanım, proprietor of the now defunct Şanzelize Boutique, as I was standing beside Feridun in his flashy sunglasses.

In the days that followed, I went to Çukurcuma early every evening. But I sensed a great uneasiness in the house, and at the table. It was as if the gravity and contrivance of the situation had now been uncloaked. It had always been Tarık Bey who was best at pretending not to see what was going on between us: It was he who'd excelled at acting "as if." Now that he was gone, there was no acting naturally, nor could we fall back into the comfortable, half-rehearsed routines of the past eight years.

75

The İnci Patisserie

ON A RAINY day at the beginning of April, after chatting with my mother for most of the morning, I went to Satsat at around noon. As I was drinking my coffee and reading the paper at my desk, Aunt Nesibe phoned. She asked me not to come to visit for a while, saying that there'd been some unpleasant gossip going around the neighborhood, and that though she couldn't go into detail over the phone, she had good news for me. With my secretary, Zeynep Hanım, listening in the next room, I did not inquire how things were going, not wishing to make my concern for Aunt Nesibe too obvious.

For two days I waited, eaten alive by curiosity, until—once more, just before noon—Aunt Nesibe came to see me at Satsat. Despite all the time we'd spent together over the past eight years, it was so strange seeing her at the office that I stared at her blankly as if at some visitor from the provinces or the outskirts of the city, who, having come to exchange a defective Satsat product or to collect her complimentary calendar or ashtray, had found her way upstairs by mistake.

By then Zeynep had figured out that the stranger was someone very important to me; perhaps she could tell from my awkwardness or Aunt Nesibe's ease, or perhaps she'd already heard a few things. When she asked us how we'd like our Nescafés, Aunt Nesibe said, "I'll have Turkish coffee, my girl—if that's possible."

I closed the connecting door. Aunt Nesibe sat down across from me at my desk and looked me straight in the eyes.

"Everything's settled," she said, her manner suggesting not so much a happy outcome as life's tendency to put things aright in the simplest way. "Füsun and Feridun are separating. If you let Feridun have Lemon Films he'll be very accommodating. This is what Füsun wants, too. But first the two of you will have to talk."

"Do you mean me and Feridun?"

"No, I mean you and Füsun."

After watching the first glow of happiness spread across my face, she lit herself a cigarette, crossed her legs, and told me the story, not in a needlessly dilatory way, but enjoying every bit just the same. Two days earlier, Feridun had come to the house having drunk a good deal; telling Füsun that he and Papatya had split, he said he wanted to come back to the house, and to Füsun. But, of course, Füsun wouldn't have him back, and a terrible row ensued, and what a pity, what a shame it was that the neighbors, the entire neighborhood, had heard them shouting (this was why Aunt Nesibe had asked that I not visit for a while). Later on Feridun telephoned, and after he and Aunt Nesibe arranged to meet in Beyoğlu, both husband and wife agreed to a separation.

There was a silence. "I've changed the locks on the front door," said Aunt Nesibe. "Our house is no longer Feridun's house."

For a moment it was as if all the traffic clattering past Satsat had fallen silent, along with the wider world. Seeing me transfixed by what she'd said, my cigarette burning down unnoticed in my hand, Aunt Nesibe retold her story from the beginning, this time lavishing more detail. "To tell the truth,

I could never feel any anger toward that boy," she said, in a worldly-wise tone of voice that implied she had known from the start how all this would turn out. "Yes, he has a good heart, but he's also very weak. What mother would want a bridegroom like that?" she said, and then fell silent. I was expecting her next to say something like, Of course, we had no choice, but she said something utterly different.

"I've experienced a bit of this in my own life. It's very difficult, being a beautiful woman in this country especially a divorcée—more difficult, even, than being a beautiful girl. . . . When men can't get what they want from a beautiful woman, they do evil things to her—you know this, too, Kemal; and Feridun protected Füsun from all those evils."

For a moment I wondered whether I was one of the evils Feridun had protected her from.

"Of course, it shouldn't have taken this long to sort things out," she continued.

Calm but amazed, I said nothing: It was as if I had never noticed before what a strange shape my life had taken.

"Of course, Feridun has a right to Lemon Films," I said after some time. "I'll speak to him. Is he at all angry with me?"

"No," said Aunt Nesibe, frowning. "But Füsun wants to have a serious talk with you. There is so much inside her that has gone unsaid. You'll talk."

We decided that Füsun and I should meet at two in the afternoon three days hence, at the İnci Patisserie in Beyoğlu. Aunt Nesibe did not prolong the conversation; she pretended to be uncomfortable speaking in such strange surroundings, but, good woman that she was, she did not try to hide her contentment when she left.

On the afternoon of Monday, April 9, 1984, I went to Beyoğlu as happy and excited as a teenager going to see the lycée girl he had been dreaming about for months. At first I was too restless to sleep and then too impatient to get through the morning. So I'd asked Çetin to drop me off at Taksim early. It was sunny there, while İstiklal Avenue was as always in shadow, and I sought the refuge of its cool shade, its shop windows, its cinema entrances; even the smell of damp and dust in the passages I had visited with my mother as a child was inviting. I was dizzy with blissful memories and the promise of a happy future, the contagious optimism of the crowds swirling past me in search of a nice meal, a diverting film, a few things to buy.

I went into Vakko, Beymen, and a couple of other stores in search of a present for Füsun, but I couldn't decide on anything. To work off nervous energy, I walked all the way to Tünel, and exactly half an hour before the appointed time, in front of the Mısırlı Apartments, I saw Füsun. She was clad in a lovely spring dress, large, bright polka dots on a white background with a pair of provocatively glamorous sunglasses and was looking at a shop window. She hadn't noticed me, but I noticed her, and in particular that she was wearing my father's earrings.

"What a coincidence" were my first clumsy words.

"Oh . . . hello, Kemal! How are you?"

"It's such a beautiful day, I had to get out of the office," I said, as if we'd had no plan to meet in half an hour, and had run into each other by chance. "Shall we walk?"

"First I have to find a particular type of button for my mother," said Füsun. "She is under a lot of pressure completing an urgent dress order, and so after you and I have spoken, I'm going back to the house to help her. Shall we go to the Passage of Mirrors to find her a wooden button?"

We went not just to the Passage of Mirrors but to several other passages, too. How lovely it was to watch Füsun talk to the shop assistants, looking over samples of all colors, rummaging through trays of old buttons, chatting away as she searched for a set.

"What do you say to these?" she said, having found some buttons.

"They're beautiful."

"All right, then."

She paid for the buttons that I would find nine months later, in her chest of drawers, still in their wrapping paper.

"Come on now, let's walk a little," I said. "I spent eight years dreaming about meeting one day in Beyoğlu and walking along together."

"Really?"

"Truly."

We walked for a while without speaking. From time to time I, too, would look into a shop window, though it wasn't the merchandise that drew my eye, but her beautiful reflection in the glass. Men were not the only ones noticing her in the Beyoğlu crowds; it was the women, too, and Füsun liked that.

"Let's sit down somewhere and have a piece of cake," I said.

Before Füsun could answer, a woman broke through the crowd and crying with delight threw her arms around her. It was Ceyda, and her two children: a boy of eight or nine and his younger brother, both in short pants and white socks, both healthy-looking and vivacious; as their mother spoke to Füsun, they eyed me curiously: They had Ceyda's huge eyes.

"How lovely to see you two together!" said Ceyda.

"We ran into each other just a few minutes ago," said Füsun.

"You look so nice together," said Ceyda. They lowered their voices to continue their conversation inaudibly.

"Mother, I'm bored, can we please go?" said the older child.

I remembered sitting with Ceyda in Taşlık Park eight years ago, when this child was in her belly; as we'd gazed down at Dolmabahçe, we'd talked about the pain I was in. But recalling that time I was neither sad nor overcome by emotion.

After Ceyda had left us, we slowed down in front of the Palace Cinema where they were showing *That Troublesome Song,* starring Papatya. During the past twelve months, Papatya had (if the papers were to be believed) broken some world record by playing the lead in no fewer than seventeen films and *photoroman*s. The magazines were peddling a lie about her being offered starring roles in Hollywood, and Papatya had kept the story line bubbling by posing with Longman's textbooks and telling lies about taking English lessons, and her willingness to do whatever she could to represent Turkey abroad. As Füsun examined the film stills in the lobby, she noticed me paying close attention to her expression.

"Come on, darling, let's go," I said.

"Don't worry, I'm not jealous of Papatya," she said sagely.

We continued along in silence, gazing into shop windows.

"Sunglasses are very becoming on you," I said. "Shall we step inside for a profiterole?"

We'd arrived at the İnci Patisserie at the exact time her mother and I had arranged for the rendezvous. Without hesitation we went inside: An empty table beckoned at the back, just as in my dreams of the past three days. We ordered the profiteroles, for which the patisserie was famous.

"I'm not wearing sunglasses to look good," said Füsun. "Whenever I think of my father, it brings me to tears. You do understand that I am not jealous of Papatya, I hope?"

"I understand."

"Still, I'm impressed by what she's done," she continued. "She put her mind to something, and she refused to give up, and she succeeded, just like a character in an American film. If I regret anything, it's not having failed to become a successful actress like Papatya; it's having failed to fight for what I wanted in life, and for that I have only myself to blame."

"I've been pressing my case for nine years, but that is not always the best way to get what you want in life."

"That may be true," she said coldly. "You spoke to my mother. Now it's time for you and me to speak."

Exuding self-assurance, she took out a cigarette. As I leaned forward with my lighter, I looked into her eyes and—in a whisper, so that no one in this tiny patisserie could hear me—I told her once again how much I loved her, how our bad days were over, and how, despite all the time we'd lost, a great happiness awaited us.

"I feel the same way," she said in a measured, cautious voice. Her gestures were tense, her expression anything but natural, from which I concluded there was a tempest raging inside her that required all her strength to suppress. Seeing how forcefully she was exerting herself to do the right thing, I loved her more than ever, but I also feared the intensity of what was brewing inside her.

"After I'm officially divorced from Feridun I want to meet all your family, your friends, everyone," she said, sounding like the pupil at the head of the class, laying out her future. "I'm not in any hurry. We can take our time. . . . After I've divorced

Feridun, of course your mother has to come to us to seek permission. She and my mother will get along fine. But first she has to telephone my mother and apologize for not coming to my father's funeral."

"She was very unwell."

"Of course. I know."

We fell silent, and for a time picked at our profiteroles. As I watched her mouth, now filled with sweet chocolate and cream, it was not desire I felt, but love.

"There is something you must believe, and I expect you to behave accordingly. At no point during my marriage with Feridun did we have marital relations. You absolutely must believe this! In this sense I am a virgin. I shall be with only one man in my life, and that man is you. We can draw a veil over those two months that preceded the past nine years." (Actually, dear reader, it was a month and a half, less two days.) "It will be as if we've just met. So it will be just as in those films—I married someone, but I remained a virgin."

She smiled slightly as she uttered the last two sentences, but having grasped the seriousness of her demands, I only frowned soberly and said, "I understand."

"We'll be happier if we do it this way," she said as one would utter any judicious pronouncement. "There's one more thing I want. Actually, this was not my idea—it was yours. I want us all to tour Europe together in your car. My mother will come to Paris with me. We can go to the museums, look at all the pictures. Before we marry, I also want to buy things there that I can take to our house, as my trousseau."

Hearing her speak of "our house" I broke into a smile. Even as she issued her commands she smiled slightly as she spoke, as a chivalric commander emerging victorious might

declare his righteous terms at the end of a long war. Later, when she said, "We'll have a big, beautiful wedding at the Hilton, like everyone else," she frowned gravely. "Everything will be as it should be, down to the last detail," she said, without affect, as if having no memories, good or bad, of my engagement party there nine years earlier, and simply wanting all to be correct.

"That's how I want it, too," I said.

For a time we were silent.

The İnci Patisserie had been an important landmark of my childhood excursions to Beyoğlu with my mother, and in thirty years it hadn't changed a bit, though it was more crowded than I remembered, and that made it harder to speak.

When, for a moment, a mysterious silence fell over the whole patisserie, I whispered that I loved her very much and would obey her every wish, desiring nothing else in the world than to spend the rest of my life with her.

"Really?" she said, in the same childish manner as when doing her math homework.

She was confident and determined enough to laugh at her own words. Carefully lighting another cigarette, she enumerated her other demands: I was never to hide anything from her, I would share all my secrets, and whatever question she asked about my past, I was to answer it truthfully.

As I listened, everything I saw engraved itself upon my memory: Füsun's stern, willful expression, the patisserie's ancient ice cream machine, and the framed photograph of Atatürk, whose frown so closely resembled Füsun's. We decided that the engagement should happen before we went to Paris, and that it should be a small family affair. We spoke of Feridun with respect.

Returning to the subject of sexual relations, she expressed her clear wish to wait until after marriage in the following terms: "Don't try to force me, okay? It won't work anyway."

"I know," I said. "Actually, I'd prefer this to be an arranged marriage."

"It can almost count as one!" she said, sounding so very certain.

She went on to say that without a man in the house anymore, the neighbors might jump to conclusions if I continued coming to supper every night. (Every night?) "Of course, I don't really care about the neighbors; they won't be my neighbors for long," she said later. "I just can't have those same sweet conversations without my father there. It's so painful."

For a moment I thought she was going to cry, but she held herself together. The patisserie had swinging doors, but now a great influx was holding them open. A crowd of lycée students in navy jackets, their thin ties askew, were pushing their way in, laughing boisterously and jostling one another. Before long we rose to leave. Taking no end of pleasure from escorting Füsun through the Beyoğlu crowds, I walked silently by her side as far as Çukurcuma Hill.

The Cinemas of Beyoğlu

WE MANAGED to honor the spirit of the conditions Füsun had set out at the İnci Patisserie. I immediately arranged for an army friend of mine, a lawyer who lived in Fatih—a world away from Nişantaşı—to represent Füsun in what was, after all, a straightforward case, since the couple had made a mutual decision to divorce. Füsun had told me with a smile that Feridun had also considered asking me to recommend him a lawyer. Though I could no longer visit her in Çukurcuma, we met every other day in Beyoğlu and went to see a film.

Even as a child, I'd always treasured the coolness of the Beyoğlu cinemas as the streets grew warmer with the progress of spring. Füsun and I would meet in Galatasaray, and after considering all the posters we would select a theater, buy our tickets, and step into the cool, dim, and mostly empty seats, where, by the light reflected off the curtains, we would find a secluded place at the back, to hold hands, and watch the film at leisure, like people with all the time in the world.

At the beginning of summer, when the cinemas began to show two or three films for the price of one, I remember a day when I'd sat down, adjusting my trousers to be as comfortable as possible, setting my newspapers and magazines on the empty seat beside me, thus deferring my blind search for Füsun's hand, and before I could act, it landed on my lap like an impatient sparrow, opening expectantly on my belly for a moment, as if

to ask, Where are you? And at that moment, moving faster than my soul, my hand wrapped itself longingly around hers.

Those Beyoğlu theaters with summertime double features (the Emek, the Fitaş, and the Atlas) and even those showing three films (the Rüya, the Alkazar, and the Lale) did away with the traditional five-minute intermission midfilm; and so it would not be until the lights went up between features that we would see what sort of an audience we'd been sitting with. During these intervals, as we watched the lonely men in wrinkled clothes, holding wrinkled newspapers, sprawled or reclining or doubled over in the seats of these huge, mildewy, dimly lit halls, and the elderly dozing in corners, and those desirous souls who had such a hard time wrenching themselves from the dream world of the film back to the reality of the dusty, murky theater, Füsun and I would exchange our news in whispers, though never holding hands. It was at one such interval, in a box at the Palace Cinema, that Füsun whispered the words I'd been awaiting for eight years: She and Feridun were officially divorced.

"The lawyer has the papers," she said. "Now I am legally a divorcée."

In that instant the gilded ceiling of the Palace Cinema, its faded glamour and its peeling paint, and its curtains, and its stage, and its drowsy slouching patrons, engraved itself forever in my memory. Even as recently as ten years ago, couples still used theater boxes at the Atlas and the Palace as they used Yıldız Park, to hold hands and kiss in private; while Füsun wouldn't let me kiss her while we were sitting in a box, she did not stop me from resting my hand on her legs or petting her knees.

My last meeting with Feridun reached the necessary resolution, but contrary to my hopes and expectations, it left

me with a bad taste in my mouth. I'd been shocked by Füsun's insistence at the İnci Patisserie that they'd never made love, and by her demand that I believe this, because, after all, I (like so many men in love with married women) had been secretly clinging to this idea for eight long years. This is, in fact, the crux of our story, for it explains why I had been able to stay in love with her so long.

Had I dwelled long and hard and openly on the notion of Füsun and Feridun's enjoying full marital relations (a painful proposition I'd tested once or twice with no desire to repeat the experience), my love could not have survived. Yet, when, following years of successful self-deception, Füsun had commanded that I had no choice but to believe it, I immediately and unequivocally told myself that it couldn't be true, and indeed even bristled at the thought that she was tricking me. But as Feridun had in fact left her after six years of marriage, the deception clung by a reed of hope, though a moment's thought to the contrary would make me unbearably jealous and also angry at Feridun, keen to humiliate him. We had muddled through eight years without conflict precisely because I'd felt no anger toward this man. Eight years on, it was easy to understand how their happy sex life had permitted Feridun to tolerate me, especially at the beginning. Like any man who is happy with his wife but also enjoys the company of friends, Feridun had wanted to spend the evenings in the coffeehouse relaxing and talking about work. As I looked into Feridun's eyes, I was obliged to accept another fact I had long hidden from myself: that my presence had curtailed the happiness Füsun might have shared with her husband during the early years of their marriage.

It was during my last meeting with Feridun that I first heard the murmurings of the jealousy that had been lying voiceless and dormant for eight years, in the oceanic depths of my consciousness, and I decided then and there, as I had with certain old friends of my circle, that I would never see him again. Those who knew how, for many years, Feridun had been like a brother to me, and those who had pined for Füsun before I even knew her, may find it inscrutable that I should have borne him such ill will just as things were going my way. Suffice it to say that after so many years of seeing Feridun as an enigma, I was coming to understand him, and with that, let us close the subject.

Feridun's eyes betrayed his own jealousy, though small, of the happiness Füsun and I had before us. But during that long final lunch at the Divan Hotel, we plied ourselves with enough *rakı* to relax us; and so after ironing out the details of transferring full rights to Lemon Films to Feridun's name, we were able to turn to another subject that soothed and charmed us both: Feridun was soon to start shooting his art film, *Blue Rain*.

I'd drunk so much that with an unsteady gait I went straight home, without even stopping off at Satsat, and immediately fell into bed. I remember remarking to my worried mother when she came to check on me, before dropping off, "Life is beautiful!" Two days later, on an evening when the skies were ripped open by thunder and lightning, Çetin drove my mother and me to Çukurcuma. My mother pretended to have forgotten her refusal to attend Tarık Bey's funeral, and being agitated, as she always was on such occasions, she did not stop talking the whole way. "Oh, look how nicely they've done those sidewalks," she said as we came closer to Füsun's house.

"I've always wanted to see this neighborhood. What a lovely hill that is. What nice snug places they seem to have here." As we entered the house, a cool wind swept up the dust from the cobblestones, presaging rain.

My mother had previously telephoned Aunt Nesibe with her sympathies, and the two women had met a few times. And yet this visit to ask for Füsun's hand seemed at first to be a condolence call, the occasion to express our regrets at Tarık Bey's passing. But everyone felt that the regrets expressed went far deeper. After the requisite pleasantries and formalities ("How lovely it is here. Oh how I've missed you. I can't tell you how sad we were to hear . . .") Aunt Nesibe and my mother embraced and began to cry, whereupon Füsun fled the room, running upstairs.

When a lightning bolt struck somewhere nearby, the two women released each other and straightened up. "Dear God!" my mother said. Then, as the rain came pouring down and the sky continued to rumble, the twenty-seven-year-old divorcée brought us coffee on a tray that she carried as daintily as any eighteen-year-old who has just entered society. "Nesibe, Füsun is your spitting image!" said my mother. "How clever and knowing she looks when she smiles. What a beauty she's become!"

"No, she is much more intelligent than I am," said Aunt Nesibe.

"Mümtaz, may he rest in peace, he always used to say that Osman and Kemal were more intelligent than he was, but I was never sure he believed it. Who says the younger generation must have more brains than we do?" my mother said.

"The girls are certainly smarter," said Aunt Nesibe. "Did you know, Vecihe"—for some reason, she was unable to, or

wouldn't, address her as "Sister Vecihe" in her old reverential way—"what I regret most in life?" She went on to tell how for a long time she'd dreamed of opening a shop and making a name for herself, but could never find the courage, only to live to see "people who don't even know how to hold a pair of scissors or sew a stitch now own the finest fashion houses."

Together we went to the window to watch the rain and the runoff pouring down the hill.

"Tarık Bey, may he rest in peace, was very fond of Kemal," said Aunt Nesibe as she sat down at the table. "Every evening he'd say, 'Let's wait a little longer. Kemal Bey might be coming.'"

I could tell that my mother did not care for these words at all.

"Kemal knows his mind," said my mother.

"Füsun knows what she wants, too," said Aunt Nesibe.

"They've already made their decision," said my mother.

But that was as close as my mother got to asking Aunt Nesibe for her daughter's hand.

Aunt Nesibe and Füsun and I each drank our usual glass of *rakı;* my mother drank only rarely, but she asked for a glass, too, and after two sips turned cheerful—not so much because of the effect of ingesting the *rakı* itself, but because of the fragrance, as my father used to say. She recalled the days when she and Nesibe had stayed up until dawn to complete an evening gown. They both enjoyed reminiscing about the weddings and dresses of that era.

"Vecihe's pleated dress was so celebrated that afterward other women in Nişantaşı asked to have an identical one made for them. Some of them even bought the same material in Paris, placing it right on my lap, for me to sew, but I refused," said Aunt Nesibe.

When Füsun rose ceremoniously from the table and went over to Lemon's cage, I got up, too.

"For God's sake, don't bother with that bird while we're still eating!" my mother cried. "Don't worry, you have plenty of time left to spend together. . . . Stop, stop right there, I'm not letting either of you back at the table until you've washed your hands."

I went upstairs to wash, and Füsun, who could have washed her hands downstairs in the kitchen, followed me up. At the top of the stairs I took her by the arms and kissed her passionately. It was a deep and mature kiss, lasting ten or twelve seconds. Nine years ago we had kissed like children. But there was nothing childish about this kiss, with its slow, powerful soulfulness. Then Füsun went downstairs ahead of me, at a run.

We got through supper with little further merriment, and keeping a close watch on what we said; as soon as the rain had let up, we left.

"Mother dear, you forgot to ask for the girl's hand," I said, as we were driving home in the car.

"How often did you go over there, all these years?" my mother asked. When she saw me at a loss for words, she snapped, "Whatever is done, is done. . . . But Nesibe said one thing that really hurt. Maybe it's because you hardly ever stayed in to eat supper with your mother that it broke my heart to hear it." She stroked my arm. "But don't worry, my son, I didn't mind. Even so, I just couldn't bring myself to ask for her hand, as if she were still a lycée girl. She's been married and divorced; she's a full-grown woman. She has a head on her shoulders, and she knows what she's doing. You two have talked everything over and agreed on everything. So why the need for all the pomp and ceremony? If you ask me, even an engagement is

unnecessary. . . . Stop prolonging things and creating fodder for gossips—just get married. . . . Don't bother going to Europe, either; these days you can find everything you want in the shops in Nişantaşı, so what's the point of trudging over to Paris?"

Seeing my determined silence, she closed the subject.

When we got home, before going to bed, my mother said, "You were right, though. She's a beautiful woman, and intelligent. She'll be a good wife for you. But be careful, she looks as if she's suffered a great deal. I may not know the half of it, but take care not to let the anger, the grudge, whatever it is she's harboring inside her, poison your life."

"It won't!"

Quite to the contrary, with every day, the bond between us grew stronger, and with it our attachment to life, to Istanbul, its streets, its people, and all else. Sometimes while holding hands in a cinema, I would feel a light shiver passing through her. Sometimes she would lean into me, or even rest her head gently on my shoulder. She would sink into her seat to get closer, and I would take her hands between mine, sometimes stroking her leg, like a feather's touch. During the first weeks Füsun had not liked sitting in a box, but now she didn't object. Holding her hand allowed me to measure her reflexive responses to the film, just as a doctor might with the tips of his fingers probe a patient's innermost parts, and I drew enormous pleasure from taking the pulse of her emotional responses to the film.

During intermission, there was cautious talk about the preparations for our trip to Europe, and about beginning to appear together in public, but I never mentioned my mother's thoughts on an engagement party. I, too, had slowly come to see that an engagement party would bring only trouble, encouraging a lot of gossip, and causing disquiet even inside

the family: If we invited a great many the gossip would be of how many we'd invited; if we invited fewer the gossip would be of how few. It seemed to me that Füsun was slowly coming to the same awareness, or at least I thought this was why she, too, avoided talk of the engagement. So it was without discussion that we somehow agreed to skip the engagement and marry at once after our return from Europe. As we smoked our cigarettes during the intervals between films, and at the Beyoğlu patisseries we'd gotten into the habit of visiting afterward, our greatest pleasure was dreaming up things we'd do on our trip. Füsun had bought a book written for Turks called *Europe by Car* and always took it along to the cinema, and as we turned the pages we would plan our itinerary. We would spend our first night in Edirne, then drive straight through Yugoslavia and Austria. I bought my own guidebooks, as well, and Füsun especially liked to look at the photographs of Paris in them. "Let's go to Vienna, too," she would say. Sometimes staring at the pictures of Europe in a book, she would fall into a strange, mournful silence as she drifted off into a daydream.

"What's wrong, darling? What are you thinking?" I would ask her.

"I don't know," Füsun would say.

Because Aunt Nesibe, Füsun, and Çetin had never been outside Turkey before, they were applying for their first passports. To save them from the torture of visiting the various state bureaucracies and the torment of waiting in all those long lines, I brought in Selami, the police chief who took care of such matters for Satsat. (Careful readers will remember that it was this same retired constable whom I had asked to track down Füsun and her family eight years before.) Anchored by love, I had not been outside Turkey for nine years, and so it

was I came to discover that I no longer felt the need for travel, where before, if I'd been cooped up in this country for more than three or four months, I'd be out of sorts.

It was a hot summer day when we went to sign papers at the Security Services Passport Office at the Governor's Headquarters in Babıali. This old building, once home to prime ministers, pashas, and grand viziers, had since been the scene of numerous raids and political murders described in lycée history books, but as with many great Ottoman buildings that had survived into the Republican era, its former gilded splendor had worn away, as thousands of weary souls entered it daily to spend hours standing in line, first to acquire documents, then to have them stamped, and then signed, an eternity that inevitably led to arguments and scuffles, the whole scene suggesting Judgment Day. In the heat and humidity, the documents in our hands quickly turned soggy.

Toward evening we were sent to the Sansaryan Building in Sirkeci for another document. As we walked down Babıali Hill, just before the old Meserret Coffeehouse, Füsun stepped into a small teahouse without asking permission of any of us and sat down at a table.

"What is it with her now?" said Aunt Nesibe.

While she and Çetin Efendi waited outside, I went in.

"What's wrong, darling, are you tired?"

"I've had it. I don't want to go to Europe anymore," said Füsun. She lit a cigarette, inhaling deeply. "The rest of you can go, by all means—get your passports—but I've run out of energy."

"Darling, hang on, we're almost there."

She held out for a while longer, showing a bit of temper, but in the end, inevitably, she came with us, my beauty. We

endured a similar tantrum when applying for visas at the Austrian Consulate. Hoping to save them from the queues and humiliating interviews, I'd prepared documents describing Aunt Nesibe, Füsun, and also Çetin Efendi as highly paid "specialists" in Satsat's employ. They granted us all visas, all but Füsun, who because of her young age, looked suspicious, and was called for a visa interview. I went in with her.

Six months earlier, an angry applicant who had been repeatedly denied visas over many years had shot an employee of the Swiss Consulate in the head four times; following that incident the visa sections of consulates had instituted strict security measures. Now applicants were no longer permitted to converse face-to-face with European visa officials, but rather, like death row prisoners in American films, were separated from the officials by bars and bulletproof glass, and obliged to converse by phone. Still people would crowd the entrance, prodding and pushing as they struggled to reach the visa section, or to enter the garden or courtyard. Turkish staffers (particularly in the German Consulate, where it was said that in the space of two days they became "more German than the Germans") would scold the crowd for failing to line up decorously, shoving them around and singling out the ill-attired to say, "You're wasting your time here," by way of thinning the herd. And so most applicants were practically jubilant to be granted interviews, taking their place nervously before the bars and the bulletproof glass, like so many students sitting down to a difficult exam, peaceful and compliant as lambs.

Because we'd pulled strings, Füsun had no need to wait in any queue, and went into the interview smiling; but when, shortly, she emerged, she was purple in the face, and without so much as looking in my direction she went out to the street.

I followed her out, catching her when she paused to light a cigarette. She wouldn't tell me what had happened, but went into the National Sandwich and Refreshment Palace, where, having taken a seat, she announced, "I don't want to go to Europe anymore. I give up."

"What happened? Aren't they giving you a visa?"

"They asked me about my whole life. They even asked why I got divorced. Even how did I support myself. They even asked me that. So I'm not going to Europe. I don't want visas from any of them."

"I can find another way to arrange things," I said. "Or we could take a car ferry straight to Italy."

"Kemal, believe me, I no longer want to take this trip to Europe. I can't even speak the languages, and it makes me ashamed."

"Darling, we could still see just a bit of the world. . . . In other places, there are people who live differently, and more happily. We can walk down their streets holding hands. There's more to this world than Turkey."

"Ah, to be worthy of you I need to see some of Europe, is that it? Well, I've also given up on the idea of marrying you."

"We'll be so happy in Paris, Füsun."

"You know how stubborn I can be, Kemal. Don't pressure me, you'll only make me dig in."

But I did press her, and years later, whenever I recalled how I'd insisted and felt the sting of remorse, I also remembered that it had been my fantasy for years to make love to Füsun in a hotel along the journey. With the help of Selim the Snob, who imported paper from Austria, Füsun's visa came through one week later. It was around the same time that we were also

able to obtain the documentation to take the car abroad. We were sitting in a box at the Palace Cinema when I gave Füsun her passport, whose pages were now covered with colorful visas for all the countries we'd be visiting en route to Paris; at that moment I felt a strange pride at being a good husband. Years before, when I was seeing ghosts of Füsun on every corner, I'd encountered her apparition at the Palace Cinema, too. Taking her passport, she smiled at first, before assuming a dour expression as she turned the pages, inspecting each visa in turn.

Through a travel agency I booked three large rooms at the Hôtel du Nord in Paris, one for me, one for Çetin Efendi, and one for Aunt Nesibe and Füsun. I'd stayed at other hotels in Paris during the years Sibel was at a university, but like a student who dreams of the places he'll go when he's rich, I had a fantasy of the happy days I would spend one day in that venerable hotel, which seemed a place out of old films and memories.

"There's no need for this. Get married and then go," my mother kept saying. "Come on, if you're going to travel with the girl you love, why not make the most of it? . . . Why drag Nesibe and Çetin Efendi there with you? First get married; that way the two of you can fly to Paris and honeymoon by yourselves. . . . I could talk to White Carnation and have the whole thing written up as the sort of romantic story that everyone loves, and then in two days it will be forgotten, yesterday's news. That old world is gone, anyway. Everywhere you look it's all parvenus from the provinces."

For my part, I kept saying: "And how am I supposed to manage without Çetin? Who's going to drive me around?

. . . Mother dear, you've only left the Suadiye house twice all last summer. Don't worry, we'll be back before the end of September. When you return to Nişantaşı at the beginning of October, Çetin will be there to drive you, I promise. . . . And Aunt Nesibe will find you a dress for the wedding."

77

The Grand Semiramis Hotel

ON AUGUST 27, 1984, at a quarter past twelve, Çetin parked the car in front of the house in Çukurcuma, ready to drive to Europe. It had been exactly nine years and four months since Füsun and I had met at the Şanzelize Boutique, but I did not give this coincidence much thought, nor did I dwell upon the ways in which my life and my character had changed in the intervening years. We had been delayed by my mother's tears and ceaseless flow of advice, and also by the traffic, but none of it could dull my determination to end this chapter of my life and set out on our journey at once. After waiting endlessly for Çetin Efendi to load Aunt Nesibe's and Füsun's suitcases into the trunk, I grew outwardly petulant at the sight of smiling, waving neighbors and the children swarming around the car, but inside I felt a pride that I did not wish to acknowledge. As we headed down to Tophane, Füsun waved at Ali, returning from football practice. I told myself that soon Füsun and I would have a child like Ali.

As we drove over the Galata Bridge, we opened the windows, happily breathing in that familiar Istanbul smell of sea and moss, pigeon droppings, coal smoke, car exhaust, and linden blossoms. Füsun and Aunt Nesibe were sitting in the back. I was in front with Çetin—just as in my dreams—and as we drove through Aksaray past the city walls, past one poor neighborhood after another, rumbling over the cobblestone

streets, in and out of potholes, I would occasionally throw my arm over the back of the seat and turn around to give Füsun a contented smile.

Outside the city limits, beyond Bakırköy, moving past little factories and depots, new neighborhoods and motels, I caught sight of Turgay Bey's textile mill, which I'd visited nine years earlier, but now I could barely remember the jealousy that had stung me that day. Once the car had crossed the limits of Istanbul, all the suffering I'd endured for the love of Füsun was suddenly reduced to a sweet story that could be told in one breath. After all, a love story that ends happily scarcely deserves more than a few sentences! Perhaps this is why we became increasingly quiet once we'd left Istanbul behind. Even Aunt Nesibe—though full of mirth at the outset, and asking questions like, "Oh, we didn't forget to lock the door, did we?" and admiring everything she saw through the window (even the emaciated old nags grazing in an empty lot)—had by the time we'd reached Büyükçekmece Bridge, fallen asleep.

As Çetin was filling the tank at the Çatalca exit, Füsun got out of the car with her mother. After buying a packet of the local fol cheese from an old lady selling her wares beside the road, they went into the teahouse next door, ordered tea and simits to accompany the cheese, and tucked into their makeshift feast. As I sat down with them, it occurred to me that if we continued at this pace, our European tour would last months, not weeks. Did I complain? No! As I sat across from Füsun, silently watching her, I felt the same sweet ache spreading through my chest and my stomach as I'd felt in early adolescence at a dance party, or upon meeting a beautiful girl at the start of summer. It was not the deep and corrosive agony of thwarted love that had once been so familiar, but a requited lover's sweet impatience.

At 7:40 the sun shone into our eyes before sinking below the line of the sunflower fields. Not long after Çetin Efendi had turned on the headlights, Aunt Nesibe said, "For the grace of God, everyone, let's not drive in this darkness!"

On the two-lane road the trucks bearing down on us from the opposite direction did not even bother to dim their lights. Just past Babaeski, my eyes were drawn to the blinking purple neon sign of the Grand Semiramis Hotel; it seemed a good place to stop for the night. I asked Çetin to slow down; making a turn in front of Türk Petrol, we heard the dog's woof, woof, woof warning us off. Çetin stopped in front of the hotel, where my heart began to beat wildly, bursting with feeling, and the awareness that at this place, after nine years of longing, my dreams would come true.

The three-story hotel was quite clean and, except for its name, a modest establishment; the retired army officer at the desk (a cheerful picture of him armed and in uniform hanging above reception) accommodated my request for three rooms, one for Füsun and Aunt Nesibe, one for Çetin Efendi, and one for me. When I found mine, I lay down on the bed and, gazing at the ceiling, it occurred to me that enduring this entire journey while sleeping alone in the room next to Füsun's might be even worse than having waited nine years.

Later, as she entered the small dining room downstairs, I noticed that Füsun's manner perfectly befitted the surprise I had prepared for her. It was the sort of entrance one might have made into the sumptuous salon hung with velvet curtains of a grand hotel in some glittering European seaside resort of the nineteenth century: She was beautifully made up and wearing a perfume that I had given her years earlier—Le Soleil Noir (I display the bottle here)—and her lipstick shade matched the

red of her dress (also in this exhibit), which brought out the lustrous undertones of her black hair. Sitting at the other tables were tired families—workers returning from Germany; from time to time curious children and lustful fathers would turn around to look at us.

"That red looks lovely on you tonight," said Aunt Nesibe. "It will look even better in the hotel in Paris, and when we go out. But, darling, don't wear it every night we're on the road."

Aunt Nesibe shot me a look requesting that I second her advice, but no words came from my mouth. It wasn't merely that, in fact, I wanted her to wear this dress every night, for in it she was so extraordinarily beautiful; it was also that I was as tense as a young lover who, sensing that his happiness is very close at hand, still fears what might go wrong; and so I was struck dumb. I sensed that Füsun, sitting just across from me, felt something of the same anxiety, as she avoided my gaze, and smoked awkwardly as a schoolgirl novice, turning away to exhale.

As we looked over the hotel's rather plain menu, which had been approved by Babaeski Council, there was a long, strange silence, as if this were the moment to review the last nine years of our lives.

When a waiter finally appeared, I ordered a large bottle of Yeni Rakı.

"Why don't you have a drink tonight, too, Çetin Efendi, so that we can make a toast," I said. "You won't be driving me home after supper."

"God bless you, Çetin Bey, you've spent enough time waiting," said Aunt Nesibe, full of appreciation. And then, still holding his attention, she looked at me and said, "If you have patience, and put yourself in God's hands, there is no heart you cannot win, no fortress you cannot capture—isn't that so?"

When the rakı arrived, I poured out a generous amount for Füsun—as I'd done for the others—adoring the way she smoked when she was nervous, staring at the tip of her cigarette. We'd all, Aunt Nesibe included, taken our rakı on the rocks, and as the liquid clouded, we drank it in like some potion. After a while I relaxed.

The world was a beautiful place, in truth. It was as if I were noticing this for the first time, though I had already known that I would be caressing Füsun's fine body, her long arms, and her beautiful breasts for the rest of my life, that resting my head against her neck and breathing in her scent I would sleep in peace for years to come.

I did as I'd done as a child, first concentrating to put out of my mind whatever the cause of my happiness, so that I might then look around me with fresh eyes and see the beauty of everything anew: on the wall a fetchingly elegant photograph of Atatürk in a frock coat, beside it a panorama of the Swiss Alps, a prospect of the Bosphorus Bridge, and—a souvenir of nine years ago—an image of Inge posing sweetly with a bottle of Meltem. I saw a clock showing the time to be twenty past nine, and a sign on the wall behind the reception desk warning that "couples will be asked to present a marriage certificate."

"Withering Slopes is on tonight. Should we tell them to find the channel?"

"There's still time, Mother," said Füsun.

A foreign couple in their thirties came into the dining room. Everyone turned around to look at them, and they greeted us politely. They were French. In those days very few tourists from the West came to Turkey, but those who did came mostly by car.

When the time came, the hotel owner sat down in front of the television with his wife, who was wearing a headscarf, and his two grown daughters—one of whom I'd seen earlier in the kitchen—whose heads were not covered; with their backs to their guests, they settled in to watch the latest episode in silence.

"Kemal Bey, you won't be able to see from there," said Aunt Nesibe. "Why don't you come sit next to us?" whereupon I wedged my chair into the narrow space between Füsun and her.

Withering Slopes was set in the Istanbul hills, but I cannot say that I took much of it in, with Füsun pressing against me with her bare arm! My left arm, especially my forearm, pressed against her, was aflame. My eyes were on the screen, but it was as if my soul had entered Füsun's.

A third eye, an inner one, feasted on Füsun's neck, and her beautiful breasts, and the strawberry nipples at the tips of those breasts, and the whiteness of her stomach. Füsun kept pressing against me, and she slowly increased the pressure, so that the Batanay Sunflower Oil ashtray into which she stubbed out her cigarette, even the lipstick-stained cigarette ends, escaped my notice.

When the episode had ended, the television was switched off for the night. The hotel owner's elder daughter turned on the radio and found some sweet, light music that the French couple appreciated. Returning my chair to its rightful place, I very nearly tripped, having drunk so much. Füsun had had three glasses, by the report of my third eye, which kept count.

"We forgot to make a toast," said Çetin Efendi.

"Yes, let's make a toast," I said. "In fact, the time has come for us to have a small ceremony. Çetin Efendi, you are now going to officiate."

With a flourish, I produced the engagement rings I had bought a week earlier at the Covered Bazaar, and took them out of their boxes.

"This is the right way to do things, sir," said Çetin Efendi, warming at once to the situation. "You can't get married without first getting engaged. Let's see now, could you present to me your hands?"

Füsun had already offered hers, smiling excitedly.

"There's no turning back after this," said Çetin Efendi. "But then there will be no need. You are going to be very happy, I'm sure of it. . . . Now, give me your other hand, Kemal Bey."

He slipped the rings on us, without delay, and we heard clapping: the French couple, who had been watching us, and a few other sleepy guests who joined in. Füsun was smiling prettily, looking at the ring on her hand with the delight of someone choosing rings at the jeweler's.

"Does it fit, darling?" I asked.

"It fits," she said, making no effort to hide her utter satisfaction.

"It looks lovely on you."

"Yes."

"Dance, dance!" said the French couple.

"Yes, let's see you dance," said Aunt Nesibe.

The sweet music wafting from the radio was good for dancing. But was I able to stand?

We both got up at the same time, and I took Füsun by the waist, enfolding her in my arms, feeling under my fingers her hips, her ribs, her spine.

Füsun, less tipsy than I was, took the dance seriously, holding on to me with genuine emotion. I wanted to whisper

into her ear, telling her how much I loved her, but I was suddenly struck shy.

Actually, we were both rather drunk, but something kept us from letting ourselves go. A little later, when we sat down, the French couple clapped again.

"I'd better be getting to bed," said Çetin Efendi. "We have a long ride ahead of us. I should look the engine over in the morning before we go. We're setting off early, aren't we?"

If Çetin hadn't jumped up so abruptly, Aunt Nesibe might have lingered too.

"Çetin Efendi, could you give me the keys to the car?" I asked.

"Kemal Bey, we've all had a lot to drink tonight, so please, I beg you, don't even touch that steering wheel."

"I've left one of my bags in the trunk, and it has my book in it."

As I took the key from his extended hand, Çetin Bey pulled himself up straight, and then he bowed down in the exaggerated gesture of respect he had once reserved for my father.

"Mother, how am I going to get into the room without waking you?" Füsun asked.

"I'll leave the door unlocked," said Aunt Nesibe.

"Or I can come up with you now and take the key."

"There's no hurry. The key will be in the lock on the inside of the door," said Aunt Nesibe, "but I won't turn it. Come up whenever it suits you."

When Aunt Nesibe and Çetin Efendi had left, we were at once more relaxed and more agitated. Füsun was acting like a bride on her first night with a man, and she kept averting her eyes. But I sensed an emotion other than the accustomed bashfulness. I wanted to touch her. I reached out to light her cigarette.

"Were you going to go up to your room to read your book?" asked Füsun, as she started to get up.

"No, darling, I thought we could go for a spin in the car. The night is so beautiful."

"We've both had a lot to drink, Kemal. It's out of the question."

"But we could be together."

"Just go upstairs and go to bed."

"Are you afraid I'll wreck the car?"

"I'm not afraid."

"Then let's go; we can take a side road and get lost in those hills and forests."

"No, go upstairs and get to bed. I'm getting up now."

"Do you mean to leave me alone at the table on the night of our engagement?"

"No, I'll stay a bit longer," she said. "Actually, it's very nice sitting here."

As the French couple watched from their table, we must have sat at ours in silence for almost half an hour. From time to time our eyes met, but with each meeting our gaze was turned inward. There was a strange and eclectic film playing in my mind's cinema, splicing together memories, fears, desires, and so many other things whose meanings I could not decipher. Later on, a large black fly hovering between our glasses became part of the film, too. My hand, and the hand with which Füsun was holding her cigarette, and the glasses, and the French couple kept drifting in and out of the frame. Besotted though I was with drink and love, there was still a part of me that needed to find a logic in the film, that wanted the world to see that there was nothing between Füsun and me but love and happiness. I was as determined to work this out as the drowsy

fly scampering among the plates. I smiled at the French couple to make a show of our happiness, and they smiled back in the same way.

"Why don't you smile at them, too?"

"I have smiled at them," said Füsun. "What more do you want—a belly dance?"

Because I kept forgetting Füsun was very drunk and because I took everything she said seriously, her remarks sometimes irked me. But my contentment was not to be shattered, as I'd succeeded in drinking myself into that state of mind wherein all the world is one, and there is but one world. This, I concluded, was the theme of the film starring the fly and my memories. Everything I had ever felt for Füsun, all the pain I had suffered for her, was now at one with the beauty and confusion of the world, and in this extraordinarily beatific feeling of unity and completion, my spirit found its long sought peace. But then, my attention turning to the fly, I began to wonder how it could walk so far without its legs getting tangled up. Then the fly vanished.

As I held Füsun's hand in mine on the tabletop, I could feel the peace and beauty within me passing through my hand to hers, and from hers to mine. Her beautiful left hand was like a tired hunted animal that my right hand had turned on its back, roughly mounting it, almost crushing it. The whole world aswirl inside my head, inside both our heads.

"Shall we dance?" I said.

"No . . ."

"Why not?"

"I don't feel like it right now!" Füsun said. "I'm happy just like this."

When I realized she was referring to our hands, I smiled. It was a moment outside of time, as if we'd been sitting there hand

in hand for hours, or had only just arrived. I looked around and saw that we were the only ones left in the restaurant.

"The French have left."

"Those people weren't French," said Füsun.

"How could you tell?"

"I saw their license plate. They were from Athens."

"Where did you see their car?"

"They're about to close the restaurant, let's go."

"But we're still here!"

"You're right," she said in a voice of maturity.

We sat hand in hand for a while longer.

Taking a cigarette from the packet, and lighting it deftly, she smiled at me as she took a long drag. This too seemed to last hours. A second feature had just begun to play in my mind when she slipped her hand from mine and rose to her feet. I was walking after her and soon headed upstairs, paying close attention to the back of her dress, fortunately without stumbling.

"Your room is there," said Füsun.

"First let me escort you to yours, your mother's room."

"No, you go to your own room," she whispered.

"I'm so upset, you don't trust me. How will you be able to spend the rest of your life with me?"

"I don't know," she said. "Go on now—off to your room."

"What a beautiful night," I said. "I'm so very happy. For as long as we live, each and every moment will be as happy as this—I promise."

She saw me drawing nearer, to kiss her, but before I could, she had embraced me. I kissed her passionately, almost forcing myself on her. For the longest time we kissed, at one point my eyes opening to see in the narrow, low-ceilinged corridor a

picture of Atatürk. And I remember between kisses pleading with Füsun to come to my room.

Someone in one of the rooms coughed politely. A key turned in a lock.

Füsun pulled away from me and, turning in to the corridor, vanished.

I looked forlornly after her, before going to bed still wearing my clothes.

Summer Rain

THE ROOM was not pitch-dark; there was light coming in from the gas station and the Edirne road. Was that a forest in the distance? I could just make out a flash of lightning in the far-off sky. My mind was open to the entire universe, and everything in it.

A long time had passed when there was a knock on the door. I answered it.

"My mother seems to have locked me out," said Füsun, peering through the darkness, trying to see me.

I took her hand and pulled her in. Lying down on the bed still in my clothes, I pulled her down beside me, and I embraced her, drawing her still closer. She nestled up to me, like a cat come in from a rainstorm, resting her head on my chest. She pulled me toward her with all her might, as if our happiness could only grow the nearer we drew to each other; and I noticed she was shivering. I felt that, as in a legend, we would die then and there unless we kissed. I remember how we kissed, before I pulled off her now very rumpled red dress, and how long and deeply we kissed after that, how the embarrassing report of the bedsprings would cause us to slow down, and how aroused I became when her hair swept over my chest and face; but if I particularize, let no one imagine that we lived these moments in full consciousness, or that I remember each and every one. The whiplash of living at once what I had been awaiting for

years, the sheer disbelief at finding happiness in this world, had reduced the pleasures to a series of luminous moments, discrete and without measure, like so many fireflies, beaming and vanishing in an instant. But the images entering my head beyond my control, as in a dream, molded into one general impression.

I remember that we climbed in between the sheets and that whenever my skin touched hers, it burned. I was in a trance, immersed in nine-year-old memories that, unbeknownst to me, I'd forgotten, but which now revived, animated by other details of those happy days that I was reliving in my enchantment. As the long-suppressed hope for happiness mingled with the joy and triumph of wishes fulfilled (I had already swallowed each of her breasts whole), the lived moment became a blur—a confusion of pleasures and emotions. Even as I rejoiced at having in the end mastered her, I could not but feel for her, admire everything about her—her moan of pleasure, her childlike way of clinging to me, the sudden sparkle of her velvet skin. One sublime moment I remember clearly: She was sitting on my lap, her face lit up by the headlights of the trucks rumbling past (their tired engines echoing our low, deep moans), when, looking joyously into each other's eyes, we were surprised; a strong, unexpected gust of wind rattled everything for a moment, and somewhere in the distance a door slammed, and the leaves on the trees shook as if sharing a secret with us. A far-off flash of lightning filled the room with an instant of purple light.

As we made love with fervor that only grew and grew, our past, our future, and our memories became as one with that moment's ecstatic escalation. Trying to stifle our cries, and bathed in sweat, we continued to consummation. Afterward,

Füsun nestled up close, and I—utterly content with life, and the world, and everything in it, radiant with beauty and meaning—buried my head in her neck, and breathing in her dizzying scent, drifted off to sleep.

Much later, in a dream, I was visited by images of happiness. Here, for the benefit of visitors to the museum, I display images from my reverie. The sea in my dream was indigo, like the sea of my childhood. And like our arrival in Suadiye at the beginning of summer, our outings in rowboats, the happy days when I would water-ski, the evenings I'd gone fishing just for sport—memories that always awakened in me a sweet impatience—the stormy sea of my dream seemed to stir such contented restlessness of early summer. Just then I saw soft little clouds passing slowly overhead, one resembling my father. In the ocean, amid the storm, I saw a ship slowly bobbing and disappearing, as well as black-and-white images reminiscent of my childhood comics, and other dark, faint, yet frightening pictures and memories. They had the feel of memories long lost and recently recovered. Images of Istanbul in old films, snowy streets, monochrome postcards passed before my eyes.

These dream images taught me that the happiness of being alive could never be separated from the pleasures of seeing this world.

Then a strong gust swept over me, bringing all these images to life, and chilling my still sweaty body. The leaves of the acacia trees seemed to radiate light as they swayed back and forth, rustling sweetly in the wind. When the wind grew stronger, the rustling of leaves and branches turned into an ominous moan, and with it a long rumble of thunder crackled, so loud that I woke up.

"How beautifully you were sleeping," said Füsun, and she kissed me.

"How long was I asleep?"

"I don't know. The thunder woke me just now."

"Were you afraid?" I asked, wrapping my arms around her, and drawing her close.

"No, I wasn't at all afraid."

"It will begin to rain in a moment. . . ."

She rested her head in the crook of my neck, and for a long time we lay there in the darkness, gazing out the window. In the distance the cloudy sky glowed intermittently with a pink and purple light. The passengers in the noisy trucks and buses tearing down the Istanbul–Edirne road seemed not to see this far-off storm, as if only we were aware of that strange corner of the world.

Before we heard the passing traffic, the high beams would shine into the room, silently widening on the wall on our right until they'd lit up the entire room, and by the time we heard the rumble of an engine, the light would change shape and disappear.

Now and then we kissed, when not watching the play of the lights upon the wall, fascinated as children discovering a kaleidoscope. Under the sheets our legs lay stretched out side by side, like husband and wife.

We began to explore each other again with caresses, lightly at first, exercising caution, finding even more beauty and meaning in our coupling, now that we were not quite so drunk. I kissed her breasts and her sweet-smelling throat at length. When first becoming aware in my early youth of the brute, implacable force of sexual desire, I remember calming myself with this wishful thought: A person married to a beautiful

woman could make love to her from dawn till dusk, wasting no time on anything else. Now the same childish thought crossed my mind. An infinity stretched out before us. The world though half shrouded in darkness had come close to paradise.

When the powerful lights of a bus shone into the room, I looked at Füsun's face, at her alluring lips, and I saw that her thoughts had drifted far away. My sensation stayed with me long after the lights had vanished. I kissed Füsun's stomach. From time to time the road fell silent, and I could hear the buzzing of a cicada. And was it the croaking of frogs far away, or was it the world's fine inner music, the susurrus of the grass, the deep, low hum that came from the earth itself, and nature's steady breathing, too soft to be heard when in the midst of life? I continued to kiss her stomach, my tongue traveling idly over her smooth skin, even as a mosquito bit my back and continued to make its annoying whine heard. As a cormorant happily diving in water will come up for air, so would I lift my head from time to time, to search the ever changing light for Füsun's eyes.

As we made love, drinking in at length the pleasures of discovering each other anew, we repeated the things we had done before; and in one part of my mind I was recording every moment, never to be erased, and classifying it methodically:

1. The joyful recognition of some of Füsun's gestures, first identified during the forty-four days we had spent making love nine years earlier, in 1975. Her moans, the innocent tenderness that illuminated her face—the way she frowned when intrigued to find me grasping her powerfully by the waist to reverse our positions; the felicitous fit of our various appendages,

as if the elements of our respective anatomies were pieces of a single instrument ordinarily disassembled; the way, when we were kissing, her lips would open up like a flower—these were the details I'd recalled and dreamed of for nine years, longing to relive each one.

2. The many little particulars that I had forgotten and so had been unable to dream about, now recalled with surprise as I watched Füsun enacting them: the way she'd use two fingers like a pair of tongs to take my wrist, the twitch of the mole right below her shoulder (many other moles were just where I'd left them); the way her eyes would cloud over at the height of pleasure before refocusing on the little things around her (the watch left on the tabletop, or the electric wires running the perimeter of the ceiling); the way she would relax her grip after holding me tight, making me think that she was about to pull away, only to grab me all the more forcefully—that night I remembered all these forgotten little mannerisms that now gave our lovemaking an earthy quality that rescued it from becoming some surreal fantasy fed by nine years of dreaming and imagining.

3. A number of habits, manifestly new, of which I had no recollection, which surprised and unsettled me to the point of jealousy. The digging of her fingernails into me; her way of becoming lost in thought at the most intense moments of lovemaking, as if to ponder her bliss or its meaning; the habit of going suddenly limp, as if having fallen off to sleep, or of sinking her teeth into my arm or my shoulder, as if to cause me real pain—these things made me think that she was not the

old Füsun. I was content at one point to put it all down to the novelty of this experience: During our forty-four days together nine years ago we had never spent a night together in the same bed. Still, I was troubled no less by the ferocity of her lovemaking than by her tendency to passively withdraw into private thought.

4. The simple fact of her being someone else now. The eighteen-year-old girl I had known and made love to was still living within her, but as the years passed, she had been buried deeper and deeper within, like the sapling encased in the bark of the tree. I loved the Füsun now lying at my side far more than I'd ever loved the young girl I'd met so many years before. Time had favored us both with growth of wisdom, and of depth, it pleased me to see.

Giant raindrops began to fall on the windowpanes and windowsills. As the sky thundered, the downpour began. And as we listened to the heavy summer rain, wrapped in each other's arms, I fell asleep.

When I awoke the rain had stopped. Füsun was not beside me but on her feet, putting on her red dress.

"Are you going back to your room?" I said. "Please don't go."

"I'm going to look for a bottle of water. We seem to have had a lot to drink. I'm terribly thirsty."

"I'm thirsty, too," I said. "Stay, I'll go. I saw some bottles in the restaurant refrigerator."

But by the time I had got out of bed, she'd quietly opened the door and left. So I got back into bed, and happily imagining that she would soon return, I fell asleep.

Journey to Another World

MUCH LATER, when I awoke, Füsun had still not returned. Thinking she had gone to her mother's side, I got out of bed and lit a cigarette at the window. The sun had not yet risen, but in the gloom I could make out just the hint of daylight and the fragrance of wet earth. The neon signs of the gas station up the road, and of the Grand Semiramis Hotel, were reflected in the puddles on the edge of the asphalt and in the polished chrome bumpers of the Chevrolet in the adjacent parking lot.

I saw that the restaurant where we'd had dinner and performed our engagement ceremony the night before had a small garden, its chairs and cushions now sopping wet. Just beyond, a naked lightbulb was strung to the branch of a fig tree, and in the light filtering through its leaves I could see Füsun sitting on a bench. She was half turned toward me, smoking as she awaited sunrise.

I threw on my clothes and went straight down. "Good morning, my beauty," I whispered.

She said nothing, lost in thought and shaking her head like someone preoccupied with great troubles. On the chair right beside the bench I saw a glass of *rakı*.

"While I was getting the water, I noticed there was an open bottle of this, too!" Her impish expression reminded me that she was Tarık Bey's daughter.

"Assuming we aren't going to spend the most beautiful morning the world has ever seen drinking, what are we going to do?" I said. "It will be hot on the road. We can sleep all day in the car. . . . Is this seat taken, young lady?"

"I'm not a young lady anymore."

I did not answer, but sat down beside her, and taking her hand just as I'd done in the Palace Cinema, I settled in to admire the view with her.

Sitting there in silence we watched the world around us slowly brighten. There were still purple lightning bolts in the distance, and orange clouds shedding their rain on some part of the Balkans. An intercity bus rumbled past. We gazed at its red taillights until they disappeared.

A dog with black ears approached us with care from the gas station, wagging its tail amicably. It was a dog of no distinction, an ordinary mutt. After sniffing me, and then Füsun, he rested his head on her lap.

"He's taken a shine to you," I said.

But Füsun didn't answer.

"Yesterday as we were coming in, he barked at us three times," I said. "Did you notice? There was once a china dog just like him on top of your television."

"You stole that one, too."

"I wouldn't say 'stole.' Your mother, your father, all of you knew about it from the first year."

"True."

"What did they say about it?"

"Nothing. It upset my father. My mother would act as if it didn't matter. And I wanted to become a film star."

"You still can be."

"Kemal, that's a lie you've just told me. You don't even believe it yourself," she said in a serious voice. "That really makes me angry—how good you are at telling lies."

"What makes you say that?"

"You know perfectly well that you have no intention of helping me become a film star. There's no longer any need, after all."

"What do you mean? If it's what you really want, it's perfectly possible."

"It's been what I really wanted for years, Kemal. And you know that."

The dog nestled up to Füsun.

"It's the spitting image of that china dog. Especially those ears, half black, half wheaten—they're identical."

"What did you do with all those dogs, and combs, and watches, and cigarettes, and everything else?"

"I took comfort from them," I said, now a little resentful myself. "The whole collection resides in the Merhamet Apartments. I could feel no shame about it with you, my lovely. When we get back to Istanbul, I'd like you to see it."

She looked at me and smiled. There was compassion in that smile, and, at least in my opinion, just as much mockery as my story, and my obsession, merited.

"So you want to take me back to that dusty *garçonnière,* is that it?" she said.

"There's no longer any need for that," I said in some pique, throwing her words back at her.

"That's right. Last night you tricked me. You robbed me of my greatest treasure without benefit of marriage. You took possession of me. And people like you never marry what they've already had. That's the kind of person you are."

"You're right," I said, half angry, half playful. "This is the one and only thing I've been waiting for all these years. Why should I get married now?"

At least we were still holding hands. Hoping to smooth it over before the game turned serious, I kissed her passionately on the lips. Füsun submitted at first, but then she drew away.

"I could kill you," she said, standing up.

"Because you know how much I love you."

I wasn't sure she'd heard me. My beauty, truly angry now, walked off in a drunken huff, her high heels clicking furiously.

She did not go back into the hotel. The dog was following her, and together they headed out to the highway, turning in the direction of Edirne, Füsun in the lead, and the dog trailing. I finished the *rakı* left in Füsun's glass (as I'd sometimes done at the house in Çukurcuma, when no one was looking). For a long while I watched them from behind. The Edirne road stretched out straight ahead of them to the horizon, almost into infinity, and with Füsun's dress ever easier to spot as the sky brightened, there seemed no danger of her vanishing from sight.

But after a time I could no longer hear her footsteps across the fields. And when I could see no more the red speck that was Füsun, when she had vanished into infinity, like a heroine at the end of a Yeşilçam film, I became uneasy.

A few minutes later I saw the red speck again. She was still walking on, my angry beauty. A great tenderness was born in me as I considered it: We would spend the rest of our lives making love as we had done last night and having tiffs as we'd done this morning. Even so, I longed to make the arguments fewer, the rough patches smoother, and Füsun happy.

Traffic was building on the Edirne–Istanbul road. A pretty woman in a red dress with such beautiful legs was bound to be

harassed. I got into the '56 Chevrolet and set off down the road to find her.

A kilometer and a half on, I spotted the dog under a plane tree. He was sitting there waiting for Füsun. I felt a sharp pang inside me, and my heart knocked against my chest. I slowed down.

ALTAT TOMATOES, a large billboard proclaimed, amid gardens, fields of sunflowers, little farmhouses. The Os had been peppered with bullets, target practice for bored passengers driving past. The holes had had time to rust.

One minute later, seeing the red speck on the horizon again, I laughed giddily. I slowed, as I drew closer to her, still stalking angrily along the right side of the road. She didn't stop when she saw me, or when I reached across to open the passenger-side window.

"Come on, darling, hop in and let's go back. It's getting late."

But she didn't answer.

"Füsun, please believe me, it's going to be a very long drive today."

"I'm not coming. The rest of you can go on without me," she said, like a rebellious child, still not slowing.

I'd reduced speed to keep pace with her and was calling to her from the driver's seat.

"Füsun, my darling, look at how beautiful the world is— open your eyes to this glory," I said. "Why poison life with anger and arguments?"

"You don't understand at all."

"What don't I understand?"

"Because of you, I haven't had the chance to live my own life, Kemal," she said. "I wanted to become an actress."

"I'm sorry."

"What do you mean, you're sorry?" she said, furious.

Sometimes I wasn't able to keep the car abreast of her, and we couldn't hear each other.

"I'm sorry," I said again, shouting this time, thinking she hadn't heard me.

"You and Feridun, you deliberately kept me from having my chance in films. Is this what you're sorry for?"

"Did you really want to become like Papatya and all those drunken women at the Pelür?"

"We're all drunks now, anyway," she said. "And I would never have been like them, I assure you. But you two were so jealous, so afraid I might find fame and leave you, that you had to keep me at home."

"You were always a bit timid about going down that path alone, Füsun, without a powerful man at your side. . . ."

"What?" she said, now palpably enraged.

"Come on now, darling, jump into the car. We can argue about it as much as you like over drinks tonight," I said. "I love you with all my heart. We have a wonderful life ahead of us. Please just get in."

"On one condition," she said, in the same childish voice she had used so many years before, the time she asked me to return her childhood tricycle to the house.

"Yes?" I asked.

"I'm driving."

"The Bulgarian traffic police are even more corrupt than ours. I hear there are lots of roadblocks, just so they can take bribes."

"No, no," she said. "I want to drive it now, back to the hotel."

I stopped the car at once and opened the door. As I was changing places, I pinned Füsun to the hood of the car and kissed her with all my might. And wrapping her arms around my neck, squeezing with all her strength, and pressing her beautiful breasts against me, she set my head spinning.

She slid into the driver's seat. Starting the engine as carefully as she had done during our first lessons in Yıldız Park and deftly releasing the handbrake, she crawled out into the road, propping her left arm on the open window, just like Grace Kelly in *To Catch a Thief*.

We moved ahead slowly, searching for a place to make a U-turn. She tried to make a full U at the junction of the main road and a muddy country lane, but she couldn't manage it, and the car came to a shuddering halt.

"Watch the clutch!" I said.

"You didn't even notice the earring," she said.

"What earring?"

She'd started the car up again, and we lurched forward.

"Not so fast!" I said. "What earring?"

"The one on my ear . . . ," she moaned, like someone just coming out of anesthesia.

Dangling from her right ear was her lost earring. Had she been wearing it while we were making love? Could I have missed such a thing?

The car was gathering speed.

"Easy does it!" I shouted, but she'd pressed the accelerator right down to the floor.

In the far distance, her friend the dog seemed to have recognized Füsun and was coming out into the middle of the road to meet the car. I was hoping he would take note of the speed and get out of the way, but he didn't.

Now going even faster, ever faster, Füsun honked the horn to warn the dog.

We jerked to the right, and then to the left, the dog still far ahead of us. Suddenly the car began moving in a straight line, as a sailboat will cut straight through the waves without listing when the wind has died. But this line, though straight, deviated from the road. It was when I saw we were speeding not toward the hotel, but right for a plane tree on the side of the road, that I realized an accident was inevitable.

Truly I knew then, in the depths of my soul, that we had come to the end of our allotted portion of happiness, that our time had come to leave this beautiful realm, by way of racing toward the plane tree. Füsun had locked onto it, as onto a target. And so it was I felt, my future could not be parted from hers. Wherever we were going, I would be there with her, and we were never to enjoy the happiness one could find on this earth. It was a terrible shame, but it seemed inevitable.

All the same, I shouted, "Watch out!"—a pure reflex, as if Füsun could not see what was happening. In fact, it was the instinctual shout of someone trying to escape a nightmare and return to the beauty of ordinary life. If you ask me, Füsun was a little drunk, but driving at 105 kilometers an hour, headed for the 105-year-old plane tree, she seemed to know exactly what she was doing. And so I understood we had reached the end of our lives.

My father's twenty-five-year-old Chevrolet went hurtling with impressive speed and power into the plane tree on the left-hand side of the road.

Beyond the tree amid a field of sunflowers was a house—a small factory, actually, that produced Batanay sunflower oil, the

very brand the Keskins used for cooking, as we had both noted when speeding along the road, just before the accident.

Months later I found the wreck, and I remembered, as I touched the various parts of the ruined Chevrolet, what I had recalled in my dreams: that just after the crash, Füsun and I had looked into each other's eyes.

Füsun knew she was about to die, and during those two or three seconds she told me with her pleading eyes that she didn't really want to, that she would cling to life as long as she could, hoping for me to save her. But I could only smile at my beautiful fiancée, still so full of vitality, the love of my life to the last, and believing I was about to die as well, I felt glad of being under way to a different world.

All memory of what happened next eluded me during my months lying in a hospital and for years thereafter; so what follows is based on the report of others, and on what I was able to glean when I returned to the site of the accident many months thereafter.

Six or seven seconds after the crash, Füsun died of injuries sustained when the car crumpled like a tin can and the steering column pierced her chest. Her head smashed with full force against the windshield. (It would be another fifteen years before seatbelts became compulsory in Turkish cars.) According to the accident report displayed here, her skull was crushed, tearing the meninges of the brain whose wonders had always surprised me, and she'd suffered a severe laceration of the neck, as well as several broken ribs and glass splinters in her forehead. All the rest of her beautiful being—her sad eyes; her miraculous lips; her large pink tongue; her velvet cheeks; her shapely shoulders; the silky skin of her throat, chest, neck,

and belly; her long legs; her delicate feet, the sight of which had always made me smile; her slender honey-hued arms, with their moles and downy brown hair; the curves of her buttocks; and her soul, which had always drawn me to her—remained intact.

After the Accident

I would now like to offer a brief account of the twenty-odd years that followed, bringing my story to a close without undue delay. Eventually I would be told that my surviving the accident was the fortuitous result of having opened the passenger-side window, so that I could converse easily with Füsun while driving beside her, and of my having instinctively shot my arm out just before the crash. The impact had caused a few small hemorrhages in my brain, and the swelling that resulted left me in a coma. In that state I was transported by ambulance to Istanbul University's Çapa Hospital, where I was placed on a respirator.

For a month I lay in intensive care, unable to speak. Words did not enter my head; the world had frozen over. I will never forget when Berrin and my mother came to visit, tears in their eyes at the sight of the tube in my mouth. Even Osman showed an unaccustomed compassion, though from time to time there was something in his expression that said "I told you so."

If Zaim, Tayfun, Mehmet, and various other friends eyed me with similar expressions—half reproach and half sorrow— it was because the police report attributed the accident to driving under the influence of alcohol (the role of the dog having gone unnoticed) and because the press had embellished the story with a dose of scandal. The Satsat employees were as respectful as ever, and touchingly empathetic.

After six weeks they got me started on physical therapy. Learning to walk again felt like starting life over, and as I embarked on my new existence, I thought about Füsun constantly. But thinking about her now had no connection to the future, or to the desire I'd once felt; slowly Füsun became a dream of the past, the stuff of memories. This was unbearably painful, now that suffering for her no longer took the form of desiring her, but of pitying myself. I was at this point—hovering between fact and remembrance, between the pain of loss and its meaning—when the idea of a museum first occurred to me.

I sought consolation in Proust and Montaigne. I would sit across the table from my mother at supper, the yellow pitcher resting between us, and as we ate I would pay little mind to the television. My mother felt that Füsun's death was something akin to my father's, and that since we'd each lost our most beloved, we had unlimited license to sigh and brood to our hearts' content and apportion blame together. Vaporous *rakı* glasses had figured prominently in both deaths, and so, too, had the secret world that each of the departed harbored within, until the pressure grew so great that there was no choice but to tell the secret. My mother didn't care for this second similarity, but I wanted to lay everything out for consideration.

During the first few months after my release from the hospital, whenever I went to the Merhamet Apartments to sit down on the bed and smoke a cigarette and view the surrounding objects, a feeling awoke in me that if I could tell my story I could ease my pain. But to do so I would have to bring my entire collection out into the open.

I longed to patch things up with Zaim and have him again as my confidant. But in January 1985 I heard from Hilmi the Bastard that he and Sibel were very happy together and

expecting a child. Hilmi the Bastard also told me that Nurcihan and Sibel had fallen out over something trivial. There was no reconnecting with them. Nor could I go to the new clubs and restaurants frequented by the old clientele of the Pelür and Garaj; my story was important to me and I did not wish to see it reflected in other people's eyes, or to be seen as a broken wretch. For this reason, during a first and last visit to Şamdan, I laughed and joked and teased Tayyar, the aging waiter, whom I knew from the Pelür, making sure everyone noticed my high spirits, thus leaving the gossips to conclude that "in the end" I had "saved" myself from "that girl."

One day I ran into Mehmet on a corner in Nişantaşı, and we agreed to meet for a meal on the Bosphorus, "just us men." The Bosphorus restaurants had ceased to be places people saved for special occasions; now one went any day of the week. Sensing my curiosity, Mehmet began by telling me what all my old friends were up to. He said that he and Nurcihan had gone to Uludağ with Tayfun and his wife, Figen; that Faruk (the same Faruk whom Füsun and I had run into at Sariyer Beach) had been effectively bankrupted by high inflation, on account of dollar loans, but had fended off ruin by taking out more bank loans; and that though there was no ill feeling between Mehmet and Zaim following Nurcihan and Sibel's falling-out, he no longer saw Zaim. Before I could ask why, Mehmet explained that Sibel had been needling Nurcihan for becoming too "à la Turca," going to *gazino*s to hear classical singers like Müzeyyen Senar and Zeki Müren, and fasting during Ramadan ("Is Nurcihan really fasting?" I asked with a smile). But I recognized at once that this was not the real reason for the rift between these two old friends. Mehmet, imagining I wished to return to my old world, wanted to pull me back to his side.

But he'd misread my intentions. Six months after Füsun's death, I knew categorically that I could never return to that world.

After drinking a little *rakı*, Mehmet confessed that while he loved Nurcihan dearly and had the utmost respect for her (this second feeling having assumed recently elevated importance), he did not find her as attractive as he had before she'd given birth. After enjoying a long and romantic courtship, getting married, and starting a family, they had quickly reverted to their former selves, with Mehmet resuming old habits. Sometimes leaving the children with his mother, he and Nurcihan would go out together, but more typically he would go out to new clubs and bars alone, the sort of places favored by advertisers and the rich, to which in his determination to lift my spirits and regain my camaraderie he was now introducing me, as he would the city's up-and-coming neighborhoods.

Another evening, Nurcihan came out with us. We went to a big new part of town just beyond Etiler that had sprung up in the space of a year, to eat a strange menu of dishes presented as American cuisine. Nurcihan did not mention Sibel, nor did she inquire about my feelings in the wake of Füsun's death. One thing she said I took to heart, however; in the middle of the meal, apropos of nothing, she said she knew "deep in her bones" that I would one day be very happy. I had never more keenly felt that the chance for happiness in this life was forever lost to me. Perhaps this is why, although Mehmet seemed very much the old Mehmet, with Nurcihan I felt as if I were meeting a new person, as if all those memories in common no longer existed. It also occurred to me that the restaurant's atmosphere, and these new city streets, which didn't agree with me at all, may have also contributed to my feeling.

There were more of these new streets, these strange new concrete neighborhoods with each passing day, and they served only to reinforce my impression since getting out of the hospital that with Füsun's death, Istanbul had become a very different city. Let me say now that this feeling was my most important preparation for the many years of wandering that lay ahead.

It was only when calling on Aunt Nesibe that I could feel the old Istanbul, the city I had so loved. One evening, after the first tearful visits, she, dispensing with formalities, told me I could go upstairs to look at Füsun's room whenever I wished, and take away with me as much as I wanted.

Before going upstairs I performed what had been our ritual: I went over to Lemon's cage to check his food and water. This, like any recollection of our suppers together, of our conversations while watching television, of everything else we had shared sitting at the table, was enough to bring tears to Aunt Nesibe's eyes.

Tears . . . Silences . . . Because memories of Füsun were too painful for either of us to bear, I would be quick about the requisite preliminaries before going up to her room. Once a fortnight I would walk down to Çukurcuma from Beyoğlu, and as Aunt Nesibe ate supper we would watch television in silence, and after paying some attention to Lemon, who was slowly growing older and more quiescent, I would go look through Füsun's bird pictures, one by one, after which review, announcing the need to wash my hands, I would head upstairs, my heart beating ever faster as I entered Füsun's room and opened up her drawers and cupboards to go through her things.

All the presents I'd brought her over the years—the combs and brushes and little mirrors, and butterfly brooches

and earrings—she had arranged in the drawers of the little cabinets. There were things I had forgotten ever having given her—socks for the tombala sack, the wooden buttons I had thought I was buying for her mother, hair clips, as well as the toy Mustang Turgay had given her, and the love letters I had sent via Ceyda—to find these artifacts weighed on me so that I could never linger more than half an hour among these drawers and cupboards that still bore her scent. Sometimes I would sit on the bed and relax with a cigarette, sometimes, to stem my tears, I would stand at the window, or on one of the balconies on which she had painted her birds, before picking up a sock or a comb or two to take away with me.

By this time I had realized that I would have to find a place to gather together all the objects that connected me to Füsun, from the first things collected on impulse to the items now retrieved so deliberately from her room—perhaps the entire contents of the house—but I had no idea where such a place could be. It was only after I had begun my travels, visting the world's smaller museums one by one, that I could at last answer this question, and understand its full significance.

One snowy evening during the winter of 1986, when we had finished our supper, I was sifting through the butterfly brooches, earrings, and pins that I'd bought for Füsun over all those years, though to no avail, when I happened on a box at the back of a drawer, and within it I found the pair of butterfly-shaped earrings, each bearing the initial F, that she had been wearing at the time of the accident, despite having insisted for years that she'd lost one of them. I took the earrings and went downstairs.

"Aunt Nesibe, these seem to have been put into Füsun's jewelry box very recently," I said.

"Kemal, my boy, whatever Füsun was wearing that day—her red dress, her shoes, everything—I hid from you, because I didn't want to add to your grief. Then I said to myself that I'd better put them where they belonged, and here you have noticed at once."

"Was she wearing both the earrings?"

"Before she went to your room that evening, my darling girl was still planning to come sleep in our room. I was just pretending to be asleep, when suddenly she pulled these earrings from her handbag and put them on. When she left the room, I said nothing. I wanted you to be happy at long last."

I had never told Aunt Nesibe that Füsun had told me her mother had locked the door.

How could I have failed to notice the earrings as we were making love? Then another question occurred to me.

"Aunt Nesibe, years ago I told you that I'd left one of these earrings by the mirror in the bathroom, the very first time I visited this house. I even asked you, 'Have you seen them?'"

"I have no idea, my son. Don't delve into these things and make me cry. I do remember that she wanted to surprise you by putting on a certain pair of earrings in Paris—she had said something like that, but I never knew which earrings she meant. Ah, she so wanted to see Paris, my dear Füsun."

Aunt Nesibe began to cry, for which, afterward, she apologized.

The next day I booked a room at the Hôtel du Nord. In the evening I told my mother that I was leaving for Paris, that a trip would do me good.

"Oh, I'm so glad," said my mother. "And you can do some good for the business, for Satsat. Your brother shouldn't take over everything."

The Museum of Innocence

I HAD NOT said, This trip to Paris is not on business, Mother. For if she'd asked my reason, I could not have offered her a proper answer, having concealed the purpose even from myself. As I left for the airport, I considered my journey in some sense the atonement I had obsessively sought for my sins, among them, my having failed to notice Füsun's earring.

But as soon as I had boarded the plane, I realized that I had set out on this voyage both to forget and to dream. Every corner of Istanbul was teeming with reminders of her. The moment we were airborne, I noticed that outside Istanbul, I was able to think about Füsun and our story more profoundly. In Istanbul I'd always seen Füsun through the prism of my obsession; but in the plane I could see my obsession, and Füsun, from the outside.

I felt such consolation, the same deep understanding, as I wandered idly around museums. I do not mean the Louvre or the Beaubourg, or the other crowded, ostentatious ones of that ilk; I am speaking now of the many empty museums I found in Paris, the collections that no one ever visits. There was the Musée Édith Piaf, founded by a great admirer, where by appointment I viewed hairbrushes, combs, and teddy bears; and the Musée de la Préfecture de Police, where I spent an entire day; and the Musée Jacquemart-André, where other objects were arranged alongside paintings in a most original way—I

saw empty chairs, chandeliers, and haunting unfurnished spaces there. Whenever wandering alone through museums like this, I felt myself uplifted. I would find a room at the back, far from the gaze of the guards who paid close attention to my every step; as the sound of traffic and construction and the urban din filtered in from outside, it was as if I had entered a separate realm that coexisted with the city's crowded streets but was not of them; and in the eerie timelessness of this other universe, I would find solace.

Sometimes, thus consoled, I would imagine it possible for me to frame my collection with a story, and I would dream happily of a museum where I could display my life—the life that first my mother, and then Osman, and finally everyone else thought I had wasted—where I could tell my story through the things that Füsun had left behind, as a lesson to us all.

On visiting the Musée Nissim de Camondo, whose founder I knew to have come from one of Istanbul's most prominent Jewish families, I was emboldened to believe that in the Keskins' set of plates, forks, knives, and my seven-year collection of saltshakers, I, too, could have something worthy of proud display, and the notion set me free. The Musée de la Poste made me realize I could display the letters I had written to her, and the Micromusée du Service des Objets Trouvés legitimated the inclusion of a wide range of things, so long as they reminded me of Füsun, for example, Tarık Bey's false teeth, empty medicine boxes, and receipts. It took me an hour in a taxi to reach the Musée Maurice Ravel, formerly the famous composer's house, and when I saw his toothbrush, coffee cups, china figurines, various dolls, toys, and an iron cage that immediately called to mind Lemon, with an iron nightingale singing within it, I very nearly wept. To stroll through these Paris museums was to be

released from the shame of my collection at the Merhamet Apartments. No longer an oddball embarrassed by the things he had hoarded, I was gradually awakening to the pride of a collector.

I did not, however, invoke such concepts at that time, gauging my spiritual alteration instead by the simple awareness that I felt happy the moment I entered one of these places, and began to dream of telling my story through objects. One evening while drinking alone in the bar of the Hôtel du Nord, gazing at the strangers around me, I caught myself asking the questions that occur to every Turk who goes abroad (if he has some education and a bit of money): What did these Europeans think about me? What did they think about us all?

Eventually I thought about how I might describe what Füsun meant to me to someone who knew nothing about Istanbul, Nişantaşı, or Çukurcuma. I was coming to see myself as someone who had traveled to distant countries and remained there for many years: say, an anthropologist who had fallen in love with a native girl while living among the indigenous folk of New Zealand, to study and catalog their habits and rituals, how they worked and relaxed, and had fun (and chatted away even while watching television, I must hasten to add). My observations and the love I had lived had become intertwined.

Now the only way I could ever hope to make sense of those years was to display all that I had gathered together—the pots and pans, the trinkets, the clothes and the paintings—just as that anthropologist might have done.

During my last days in Paris, with Füsun's birds on my mind, and a bit of time to kill, I went to the Musée Gustave Moreau, because Proust had held this painter in such high esteem. I

couldn't bring myself to like Moreau's classical, mannered, historical paintings, but I liked the museum. In his final years, the painter Moreau had set about changing the family house where he had spent most of his life into a place where his thousands of paintings might be displayed after his death, and this house in due course became a museum, which encompassed as well his large two-story atelier, right next to it. Once converted, the house became a house of memories, a "sentimental museum" in which every object shimmered with meaning. As I walked through empty rooms, across creaking parquet floors, and past dozing guards, I was seized by a passion that I might almost call religious. (I would visit this museum seven more times over the next twenty years, and each time as I walked slowly through its rooms I felt the same awe.)

On returning to Istanbul, I went directly to see Aunt Nesibe. After telling her about Paris and its museums, and sitting down to eat, I went straight to the matter foremost in my mind.

"You know that I've been taking away things from this house, Aunt Nesibe," I said, with the ease of a patient who can at last smile about an illness he was cured of long ago. "Now I'd like to buy the house itself—the entire building."

"What do you mean?"

"I'd like you to sell me the house and all its contents."

"But what will happen to me?"

We talked it through in a way that was only half serious. I spoke almost ceremoniously: "I would like to find a way to commemorate Füsun in this house." I also suggested to Aunt Nesibe that she would not be happy in this house, lighting the stove on her own, though, if it was her wish, she could stay. Aunt Nesibe cried for a time at the thought of spending her life alone. But then I told her that I had found her an excellent

apartment in Nişantaşı, on Kuyulu Bostan Street, where she'd once lived.

"Which building is it in?" she asked.

A month later we'd bought Aunt Nesibe a big apartment in the nicest part of Kuyulu Bostan Street, just a little way beyond her former apartment (and right across the street from the tobacconist, the newsagent, and the shop owned by Uncle Sleaze the child molester). She deeded to me the whole building in Çukurcuma, including the ground-floor flat and all the movables. On the advice of my lawyer friend who had handled Füsun's divorce, we made an inventory of the building's entire contents and had the document duly notarized.

Aunt Nesibe was in no hurry to move to her new home in Nişantaşı. With my assistance, she had new lighting installed and bought furniture as carefully as a girl might build her trousseau, and every time we saw each other she would tell me with a smile that there was no hope of her ever being able to leave the house in Çukurcuma.

"Kemal, my son, I can't leave this house and all its memories. What are we to do?" she would say.

"We will turn the house into a place where we can display our memories, Aunt Nesibe," I would reply.

As my journeys gradually became longer, I saw her less often. Because I still did not really know what to do with the house, its contents, and all those things of Füsun's, which were so precious to me I hardly dared to look at them, for fear my gaze might do them harm.

My visit to Paris served as the model for my subsequent travels. On arriving in a new city I would move into the old but comfortable and centrally located hotel that I had booked from Istanbul, and armed with the knowledge acquired from

the books and guides read in advance, I would begin my rounds of the city's most noteworthy museums, never rushing, never skipping a single one, like a student meticulously completing an assignment. And then I would scan the flea markets, the shops selling trinkets and knickknacks, a few antique dealers; if I happened on a saltshaker, an ashtray, or a bottle opener identical to one I'd seen in the Keskin household, or if anything else struck my fancy, I would buy it. No matter where I was—Rio di Janeiro, Hamburg, Baku, Kyoto, or Lisbon—at suppertime I would take a long walk through the backstreets and far-flung neighborhoods; peering through the windows, I would search out rooms with families eating in front of the television, mothers cooking in kitchens that also served as dining rooms, children and fathers, young women with their disappointing husbands, and even the rich distant relations secretly in love with the girl in the house.

In the morning, after a leisurely breakfast at the hotel, I would kill time on the avenues and in the cafés until the little museums had opened; I'd write postcards to my mother and Aunt Nesibe, peruse the local papers, trying to figure out what had happened in Istanbul and the world, and at eleven o'clock I would pick up my notebook and set out hopefully on the day's program.

One cold and rainy day, while walking through the galleries of the Helsinki City Museum, I happened on just the sort of medicine bottles I'd found in Tarık Bey's drawers. Prowling the mildewy rooms of a museum in the small city of Cazelles, near Lyon in France (a converted former hat factory with no visitors but me), I saw hats exactly like those my mother and father had once worn. As I was viewing the playing cards, rings, necklaces, chess sets, and oil paintings of the State Museum of

Württemberg, located in a tower of the old castle in Stuttgart, I was inspired by the belief that the Keskins' possessions (like my love for Füsun) deserved display in comparable splendor. The smallest detail demanded the most exacting investigation: I spent an entire day in the Musée International de la Parfumerie in the South of France, some distance from the Mediterranean, in Grasse, the world capital of perfume, struggling to identify Füsun's scent. At Munich's Alte Pinakothek (whose stairs would serve as a model for those in my own museum) the sight of Rembrandt's masterpiece *The Sacrifice of Abraham* reminded me of having told Füsun this story many years earlier, and of the moral of giving up the thing most precious to us while expecting nothing in return. I gazed at length at George Sand's lighter, her jewels, her earrings, and locks of her hair, which were stapled to a piece of paper, until there, in the Musée de la Vie Romantique in Paris, I shivered. In the Göteborgs Historiska Museum, which narrates the history of that city, I sat patiently before the china tiles and plates imported by the East India Company. In March 1987 a suggestion by a former classmate now working at the Turkish Embassy in Oslo brought me to the Brevik Town Museum; on finding it closed, I went back to Oslo for the night, returning the next day to view the exhibits, which included a three-hundred-year-old post office, a photographer's studio, and an old pharmacy. It was in Trieste, where the Civico Museo del Mare is housed in an old prison, that I first realized what many other museums would remind me of: being awash with memories of Füsun, the Bosphorus ferries (for example, the *Kalender*) would need to be represented by some model alongside other totems of my obsession. In Honduras, for which I had a hard time acquiring a visa, the Museum of Insects and Butterflies in La Ceiba, where I walked among tourists in

shorts, led me to imagine that I could display all the butterfly barrettes I'd bought for Füsun over the years as if they were real butterflies; and that, by extension, I could organize and show all the mosquitoes, blackflies, horseflies, and other insects from the Keskin household. In the Chinese city of Hangzhou, in the Museum of Chinese Medicine, I felt that I had come face-to-face with one of Tarık Bey's very own medicine boxes. I would note with pride at the Musée du Tabac, just opened in Paris, that its collection was not nearly as extensive as the one I had built up over eight years. One bright spring day in Aix-en-Provence, I remember gazing with boundless happiness and admiration upon the shelves of pots and pans and other objects in the sun-drenched rooms of the Musée de l'Atelier de Paul Cézanne. At the pristine and perfectly maintained Rockox House in Antwerp I had occasion to remember that in small museum houses the past is preserved within objects as souls are kept in their earthen bodies, and in that awareness I found a consoling beauty that bound me to life. But still I wonder if I could ever have learned to appreciate my own collection in the Merhamet Apartments, let alone nurtured any hope of showing it proudly to others, had I not first gone to Vienna to see the Sigmund Freud Museum, crammed with the statues and the furniture of the famous psychoanalyst. Was a visit to the old barbershop in the Museum of London on every London trip during my first traveling years merely an expression of nostalgia for my Istanbul barbers, Basri and Cevat the Chatterbox, or something more? At the Florence Nightingale Museum, housed in a London hospital, I was hoping to find a painting or an object that the famous nurse had brought back from Istanbul, where she'd run a hospital during the Crimean War, but the memento I found was not just from Istanbul—it was a barrette

identical to one of Füsun's. In the Musée de Temps in Besançon, France, formerly a palace, as I wandered among the clocks, listening to the deep silence, I thought about museums and time. In Holland, gazing at the minerals, fossils, medals, coins, and old utensils in the old wood-framed display cupboards, amid the silence of the Teylers Museum in Haarlem, I had an intimation that I would be able to say what it was that gave life meaning, and offered me the greatest solace, but as with the first blush of love, I couldn't at first express what bound me to such places. In Madras, at the Fort St. George Museum, situated in the first fort built by the English in India, it was hot and very humid; and as I stood beneath an overhead fan, surrounded by letters, oil paintings, coins, and everyday objects, I felt the same elation. It was while strolling through the Castelvecchio Museum in Verona, ascending its staircases to marvel at how the architect Carlo Scarpa had arranged for the light to drape like silk over the statues, that I first came to understand how my pure contentment flowed not just from these museums as collections, but from the harmony in the arrangement of their pictures and objects. But it was not until I visited the Museum der Dinge in Berlin, once accommodated in the Martin Gropius Building and later made homeless, that I saw this truth another way: One could gather up anything and everything, with wit and acumen, out of a positive need to collect all objects connecting us to our most beloved, every aspect of their being, and even in the absence of a house, a proper museum, the poetry of our collection would be home enough for its objects. When I first set eyes on Caravaggio's *The Sacrifice of Isaac* at the Uffizi in Florence, first tears came to my eyes, at the thought of never having had the chance to see this painting with Füsun, and then I saw in the painting that the unremarked lesson of

Abraham's sacrifice was that it is possible to substitute for one's most cherished object another, and that this was why I felt so attached to the things of Füsun's that I had collected over the years. Every time I went to London I visited Sir John Soane's Museum; after walking through its gorgeously cluttered, crowded rooms and admiring his arrangement of the paintings, I would sit alone in a corner, listening for many hours to the noise of the city, thinking that one day I would exhibit Füsun's things in just this way, and that when I did, she would smile down on me from the realm of the angels. But not until I found myself in the sentimental collection which was on the top floor of the Museu Frederic Marès in Barcelona, perusing its romantic assortment of barrettes, pins, earrings, playing cards, keys, fans, perfume bottles, handkerchiefs, brooches, necklaces, handbags, and bracelets, did I realize at last what I could do with Füsun's things. And on my first tour of America—where I spent more than five months visiting 273 museums—I recalled that same emotional experience while visiting New York's Glove Museum. Then at the Museum of Jurassic Technology in Culver City, California, I remembered again why some museums had the power to make me shudder: They induced the feeling that I had become suspended in one age while the rest of humanity lived in another. In the town of Smithfield, North Carolina, at the Ava Gardner Museum, from which I stole a charming exhibition plaque reproducing a tableware advertisement in which she appeared, at the sight of Ava's yearbook picture, her nightgowns, her mittens, and her boots, I so ached for my lost Füsun that I very nearly aborted my journey and returned to Istanbul. Fortunately, after two days of studying the collection of soda and beer cans at the recently opened and soon to close Museum of Beverage

Containers and Advertising near Nashville, while still longing to go home, I found the will to carry on. It was five weeks later, in Saint Augustine, Florida, at the (soon to close) Tragedy in U.S. History Museum, where, upon seeing the chrome-plated gauges and the rusting, crumpled wreck of the 1966 Buick in which Jayne Mansfield had been crushed to death, I at last decided to return to Istanbul. As it happens, I had by then concluded that the true collector's only home is his own museum.

I did not remain for long in Istanbul. Following Çetin's directions, I drove to the garage owned by Şevket Usta, who specialized in Chevrolets, in the streets behind Maslak; in the empty lot behind the garage one look at our '56 Chevrolet under a fig tree produced a paroxysm of emotional turmoil. The trunk was open, with chickens from the adjacent coop wandering through the wreck, and around it children were playing. According to Şevket Usta, some parts had been salvageable, among them the gas cap, the gearbox, and the handle of the rear window, all sold to owners of other '56 Chevrolets, a sizable market as most of the city's taxis were now the same model. When I poked my head into the wreck, to peer at where the fuel gauge and the speedometer had once lodged in mint condition, and the radio knobs, and the steering wheel, I caught the scent of leather rising from the seat coverings in the gentle heat of the sun, and my head began to swim. By instinct, I touched the steering wheel, which seemed almost as old as I was. And soon the intensity of the memories compressed into these remains overwhelmed me and I broke down.

"Kemal Bey, what happened? Why don't you sit down over there," said Çetin, his voice full of understanding. "Children, could you bring us a glass of water?"

For the first time since Füsun's death, I'd been on the brink of crying in public. A boy apprentice, sooty as a coal digger and covered in axle grease, but with immaculately clean hands, brought us tea on a tray with the logo CYPRUS TURK (I record this by force of habit; visitors should not waste time looking for it in the Museum of Innocence); as we drank our teas, after a bit of bargaining, we bought back my father's car.

"So where are we going to put this, Kemal Bey?" asked Çetin Efendi.

"I want to spend the rest of my life under the same roof with this car," I said with a smile, but Çetin Efendi understood at once that I was earnest, and unlike the others, he did not say, "Oh, please, Kemal Bey, life must go on—you can't die with the dead." Had he done so, I would have explained that the Museum of Innocence was to be a place where one could live with the dead. Though I had prepared this answer in advance, the words now stuck in my throat: Prompted by pride, I said something altogether different.

"There are lots of things stored in the Merhamet Apartments. I want to bring them together under one roof and spend the rest of my days among them."

I had many heroes in mind, who, during the last years of their lives, like Gustave Moreau, had arranged for their homes to be turned into museums posthumously. I loved the museums they'd created, and so I continued my travels, revisiting the hundreds I'd come to know and cherish and going to the thousands of others I still longed to see.

Collectors

THIS IS what I observed while traveling the world, and wandering through Istanbul. There are two types of collectors:

1. The Proud Ones, those pleased to show their collections to the world (they predominate in the West).
2. The Bashful Ones, who hide away all they have accumulated (an unmodern disposition).

The Proud regard a museum as a natural ultimate destination for their collections. They maintain that whatever a collection's original purpose, it is, in the end, an enterprise intended for proud display in a museum. This view was common in the official histories of small, private American museums: For example, the brochure for the Museum of Beverage Containers and Advertising describes how the collector Tom picked up his first soda can on the way home from school. Then he picked up another, and a third, keeping what he found until after a time his ambition was to "collect them all" and exhibit them in a museum.

But the Bashful collect purely for the sake of collecting. Like the Proud, they begin—as readers will have noticed in my own case—in pursuit of an answer, a consolation, even a palliative for a pain, a resolution of difficulty, or simply out of

a dark compulsion. But living in societies where collecting is not a reputable act that contributes to learning or knowledge, the Bashful regard their compulsion as an embarrassment that must be hidden. Because in the lands of the Bashful, collections point not to a bit of useful information but rather to a wound the bashful collector bears.

I would come upon these dark sentiments in many places over the years, but it was in the early months of 1992, among those in Istanbul who specialized in film paraphernalia, that I caught my first glimpses of "collectors' embarrassment," while hunting for posters, lobby photographs, and ticket stubs from films we'd seen in the summer of 1976, to display in the Museum of Innocence.

It was after having haggled at length that Hıfzı Bey sold me an assortment of lobby photographs from films like *Love's Agony Ends in Death* and *Caught in the Crossfire,* and after he had told me again and again how pleased he was by my interest in his collection, he turned wistful.

"It saddens me, Kemal Bey, to part with things that are so dear to me," he said. "But how I wish that the people who mock my hobby, and make fun of me—the ones who ask, 'Why do you cram the house with this filth?'—how I wish they could see someone like you, a cultured man from a good family, finding something to value in my collection. I don't drink, or smoke, or gamble, or fool around with women. My only vice is collecting photographs of stars and films. . . . Might you be interested in stills from scenes on the *Kalender* in *Hear My Mother's Lament,* in which Papatya played when still a young girl? She's wearing a pinafore, and her shoulders are bare. . . . If you would care to come to my humble abode this evening, I could show you photographs taken during the filming of *Black Palace,* which

was never completed, due to the suicide of its lead, Tahir Tan. Until now, no one but me has seen them. I also have pictures of Inge, the German model who appeared in the advertising campaign for Turkey's first domestic fruit-flavored soda—she went on to play a kindly, Turk-loving German aunt in *Central Station,* which was part of the first wave of Turkish-German film productions. I have lobby photographs of her with the man she falls in love with in the film; he is played by Ekrem Güçlü, and they are kissing on the lips."

When I asked about other lobby photographs I was seeking, Hıfzı Bey told me that there were quite a few collectors whose homes were packed to the rafters with photographs, films, and posters. When their rooms were so full of photographs, posters, newspaper cuttings, and magazines that no room remained to live in, their families would abandon the house (most had never married anyway), and the collectors would be free to begin to pick up everything they could get their hands on, until their houses turned into such rubbish dumps that no one could even enter them. Doubtless some of these famous collectors would have what I was after, but they would never be able to extract the items from the heaps that were their homes—it was hard enough for them to get through the front door.

Even so Hıfzı Bey proved helpless in the face of my entreaties, and he was able to get me into some of the rubbish dens that had become legendary among the Istanbullus during the 1990s.

Sifting through the detritus in these houses I was able to find most of the lobby photographs that I would go on to display in my museum, along with the Istanbul views, quite a few postcards, cinema tickets, restaurant menus that it had not occurred to me to save at the time, rusty old tin cans, pages

from yellowed newspapers, paper bags with company logos, medicine boxes, bottles, photographs of film stars and other celebrities, and also pictures of ordinary, everyday Istanbullus that spoke more eloquently than anything of the place where Füsun and I had once lived.

The owner of an old two-story house in Tarlabaşı looked relatively normal, but sitting on a plastic chair surrounded by piles of paper and odd objects, he declared with a reticent pride that he had amassed 42,742 items.

I felt the same shame while inspecting the holdings of a retired meter reader, having only just managed to enter the house in which he and his bedridden mother lived in a room heated by a gas stove. (The rest of the place was as frigid as it was inaccessible, though at some remove I glimpsed old lamps, Vim cans, and a few toys familiar from childhood.) What made me feel ashamed was not the retired meter reader's mother, who berated and humiliated her son incessantly: It was knowing that all these things, saturated with memories of people who had once walked the streets of Istanbul, and lived in its houses, and were now mostly dead, would eventually disappear without ever having been brought together in a museum, or sorted, or set within a frame. I had recently heard the drama of the Greek photographer who had, for forty years, been taking pictures at weddings, engagement parties, business meetings, and restaurants in Beyoğlu; having run out of space, and knowing his pictures were no longer wanted, he set about burning his entire stock of negatives in an apartment furnace. There was simply no demand for these photographs and negatives recording the weddings, festivities, and other gatherings of an entire city, not even free of charge. The owners of the rubbish dens would be objects of ridicule in apartment houses and

neighborhoods, feared as much for their being solitary cranks as for combing trash bins and consorting with junk dealers. Hıfzı Bey had already told me, without undue bitterness, in a tone more suggestive of one imparting life's verities, that after these solitaries died, their piles of accumulated objects would, with a quasi-religious ferocity, be consigned to an empty neighborhood lot (where lambs were sacrificed on holidays)— to be burned or left for the junk man or the rubbish collector.

In December 1996 a lone hoarder ("collector" would be the wrong word) named Necdet Adsız, who lived in Tophane, a mere seven-minute walk from the Keskins' house, was crushed to death beneath the accumulated piles of paper and old objects in his little house, not to be discovered, let alone mourned, until four months later, when in summer the stench coming from the house grew unbearable. With the piles pressing up against the front door, the firemen were obliged to enter through the windows. By describing the incident in half-mocking, half-scaremongering terms, the papers sowed among the people of Istanbul even more apprehension than already existed concerning all manner of collectors. There is a further strange detail that I hope the reader will not find superfluous, and that comes to me owing to my ability in those days to think about all things connected to Füsun at the same time. Necdet Adsız, the man crushed to death beneath his hoard, whose body was left to rot, was the same Necdet whom Füsun had mentioned at the end of the engagement party at the Hilton, when the subject of séances came up—the friend she'd assumed to be dead.

That their life's work was an embarrassment to be kept secret and hidden, and that beneath it they felt a shame with even deeper roots, I saw in the eyes of my fellow collectors, whom I would like to thank here for their contributions to my museum

and to Füsun's memory. I have already mentioned Halit Bey the Invalid, the celebrated postcard collector, whom I sought out between 1995 and 1999, fired by the ambition to acquire postcards of every street and neighborhood I had ever visited with Füsun. There is another (with no wish to be named) whose collection of doorknobs and keys I was delighted to exhibit after he explained that every resident (by which he meant every male) of Istanbul touched about twenty thousand door handles in his lifetime, and so it was virtually certain that "the hand of the one I loved" had touched a great many of his specimens. Then there is Siyami Bey, who spent the last thirty years of his life collecting photographs of every ship to pass through the Bosphorus since the invention of photography, and who was kind enough to give me copies of those photographs for which he had doubles. I would like to acknowledge him here, first for providing the means to show my visitors the ships whose whistles I heard while thinking of Füsun, or walking through the city with her, and second for being, like a Westerner, free of shame about exhibiting his collection.

It was from another collector who, more typically, preferred anonymity, that I acquired the assortment of little paper portraits of the dead that mourners would pin to their collars at funerals between 1975 and 1980: After driving a hard bargain for each and every one of them, he asked the essential question I so often heard from these types, often in a demeaning tone, to which I recited my usual answer.

"I'm setting up a museum, you see. . . ."

"I'm not asking what you're going to do with them. What I'm asking is, why do you want these things?"

He was giving expression to the understanding that anyone obsessed with collecting objects and storing them away must

be in the grip of heartbreak, deep distress, or some ineffable psychological wound. So what was my problem? Was I troubled at the loss of someone dear whose picture I had been unable to pin to my collar at the funeral? Or was I, like the man asking the question, suffering from something deep, unmentionable, and shameful?

As personal museums were almost nonexistent in the 1990s, the collectors of Istanbul were secretly contemptuous of themselves and of their obsessions, and no less so of one another, whom they excoriated openly, the tirades only worsening if complicated by jealousy. When Aunt Nesibe had moved to Nişantaşı and the architect İhsan began work on the Keskin house, aiming to turn it into a real museum, it was bruited about scornfully that I was "making a private museum, just as in Europe!" and in the same breath that I was rich. My hope was that this might soften their disdain and let them see not someone driven by a deep unspoken psychological wound—not half cracked, in other words, as they were—but someone collecting things for a museum as one might in the West, simply on account of being rich and inclined to celebrate his collection.

At the insistence of Hıfzı Bey, and in the hope of chancing upon a few reminders of Füsun that might have a place in my story, I attended a meeting of the Lovers of Collectible Objects Association, the first such group in Turkey, then recently established. There, in a little wedding salon rented for the morning, I felt myself a leper among society's lepers.

There were those familiar to me by name as collectors (including seven already known to the reader, such as Cold Suphi, the matchbox collector), and they treated me even more shabbily than they might have done a regular Istanbul collector

or one of their own. The mostly silent stares of suspicion, as if I were a spy, an interloper, broke my heart. Hıfzı Bey's subsequent and apologetic explanation suggested that to see even a rich man driven to soothe his troubled heart by acquiring objects awoke in them feelings of revulsion and hopelessness. For they were simple folk, so innocent as to imagine that their sin, their mania for collecting things, was an illness that wealth would surely have cured. But in time, as the gossip about my love for Füsun became common knowledge, these first serious collectors of Istanbul not only helped me but also shared their stories of struggle to emerge from underground and bring the fruits of their labors into the public domain.

Before transporting to Çukurcuma one by one the objects I'd stored at the Merhamet Apartments, I took a panoramic photograph of the collection that now filled most of the room where Füsun and I had made love twenty years earlier. (By now, too, the cries of children playing football in the back garden had been supplanted by the roar of an air conditioner.) When I brought these things together with the objects already assembled in the Çukurcuma museum house—those I had found during my travels, the Keskins' old possessions, the things I had extracted from the rubbish dens, and from members of the Association, as well as those received from various witnesses of my story—a thought that had occurred to me during my travels abroad, especially my visits to flea markets, took form before me, vivid as a painting.

All these objects—the saltshakers, china dogs, thimbles, pencils, barrettes, ashtrays—had a way of migrating, like the flocks of storks that flew silently over Istanbul twice a year to every part of the world. In the flea markets of Athens and Rome I had seen lighters identical to one I had bought for

Füsun—and there were others almost exactly like it in Paris and Beirut. This saltshaker, made in a small Istanbul factory, which sat on the Keskin table for two years, was to be seen in restaurants in the poorer parts of Istanbul, but I also noticed it in a Halal restaurant in New Delhi, in a soup kitchen in an old quarter of Cairo, among the wares the peddlers set out on the canvases they spread on the sidewalks of Barcelona every Sunday, and in an unremarkable kitchen supply store in Rome. What is certain: Someone somewhere had produced the first of these saltshakers, and then others made molds from them for mass production in many other countries, so that over the years, millions of copies had spread out from the southern Mediterranean and the Balkans, to enter the daily lives of untold families. To contemplate how this saltshaker had spread to the farthest reaches of the globe suggested a great mystery, as great as the way migratory birds communicate among themselves, always taking the same routes every year. Another wave of saltshakers would always arrive, the old ones replaced with the new, as surely as a south wind deposits its debris on the shore, and each time people would forget the objects with which they had lived so intimately, never even acknowledging their emotional attachment to them.

I brought my entire collection to the newly converted museum, along with the bedframe, the musty mattress, and the blue sheet on which Füsun and I had made love in the Merhamet Apartments, storing these last three objects in the attic. When the Keskins had lived in the house, the attic had been the domain of mice, spiders, and cockroaches, and the dark, mildewy home of the water tank; but now it had become a clean, bright room open to the stars by a skylight. I wanted to sleep surrounded by all the things that reminded me of Füsun

and made me feel her presence, and so that spring evening I used the key to the new door on Dalgıç Street to enter the house that had metamorphosed into a museum, and, like a ghost, I climbed the long, straight staircase, and throwing myself upon the bed in the attic, I fell asleep.

Some fill their dwellings with objects and, by the time their lives are coming to an end, turn their houses into museums. But I, having turned another family's house into a museum, was now—by the presence of my bed, my room, my very self—trying to turn it back into a house. What could be more beautiful than to spend one's nights surrounded by objects connecting one to his deepest sentimental attachments and memories!

Especially in the spring and summer, I began to spend more nights in the attic flat. İhsan the architect had created a space in the heart of the building, which I could see through a great opening between the upper and lower levels; I could pass the night in the company of each and every object in my collection—commune with the entire edifice. Real museums are places where Time is transformed into Space.

My mother was uneasy about my living in the attic of my museum, but because I ate lunch with her regularly and had reconnected with some of my old friends (though never with Sibel and Zaim), and went on summer yacht trips to Suadiye and the Princes' Islands, and because she, too, had come to believe in this as the only way I could bear the pain of having lost Füsun, she did not say a word; contrary to everyone she knew, she was prepared to regard my creation of a museum in the house where the Keskins had lived, exhibiting things that told the story of my love for Füsun, and the life we had shared, as perfectly normal.

"And oh, of course you must take all the old things in my wardrobe, too, and in my drawers. . . . I'll never have a reason to wear those hats again, and the same goes for those handbags, and your father's old things. . . . Take my knitting set, too, and the buttons and swatches. There's no point in spending money on seamstresses now that I'm in my seventies," she would say.

Whenever I was in Istanbul, I would pay monthly visits to Aunt Nesibe, who seemed happy with her new apartment and her new circle of friends. It was upon returning from my first visit to the Museum Berggruen in Berlin that I told her excitedly about the agreement I'd heard about between the founder, Heinz Berggruen, and the municipal government, a pact whereby he would be allowed to spend the rest of his days in the garret of the house he'd bequeathed to the city, to display the collection he had accumulated over a lifetime.

"While strolling through the museum, visitors can walk into a room or climb the stairs and find themselves face-to-face with the person who created the collection, until the day he dies. Isn't that strange, Aunt Nesibe?"

"May God ordain that your time will be late in coming," said Aunt Nesibe as she lit a cigarette. Then she wept a bit for Füsun, and with the cigarette still in her mouth, and the tears still streaming down her cheeks, she gave me a mysterious smile.

Happiness

IN THE middle of one moonlit night passed at the house in Çukurcuma, I awoke in my little curtainless attic room, bathed in a sweet glow, and gazed down at the empty space of the museum below. The silvery moonlight pouring through the windows into my museum, which sometimes seemed as if it might never be completed, gave the building and its empty center a frighteningly vacant aspect, as if it were continuous with infinite space. My entire collection of thirty years stood nestled in the shadows on the lower floors, encroaching like the gallery of a theater upon this emptiness. I could see it all— the things that Füsun and her family had used in this house, the rusting wreck of the Chevrolet, every fixture from the stove to the refrigerator, from the table on which we ate supper for eight years to the television we had watched while eating; and like a shaman who can see the souls of things, I could feel their stories flickering inside me.

That was the night I realized that my museum would need an annotated catalog, relating in detail the stories of each and every object. There was no doubt that this would also constitute the story of my love for Füsun and my veneration.

In the light of the moon, each and every thing tucked into the shadows, as if part of the empty space, seemed to point to an indivisible moment, akin to Aristotle's indivisible atoms. I realized then that just as the line joining together

Aristotle's moments was Time, so, too, the line joining together these objects would be a story. In other words, a writer might undertake to write the catalog in the same form as he might write a novel. But having no desire to attempt such a book myself, I asked: Who could do this for me?

This is how I came to seek out the esteemed Orhan Pamuk, who has narrated the story in my name, and with my approval. Once upon a time his father and uncle did business with my father and the rest of us. Coming as he did from an old Nişantaşı family that had lost its fortune, he would, I thought, have an excellent understanding of the background of my story. I had also heard that he was a man lovingly devoted to his work and who took storytelling seriously.

I went to my first meeting with Orhan Bey well prepared. Before I spoke of Füsun, I told him that over the previous fifteen years I had traveled the world, visiting 1,743 museums in all, saving all of my admission tickets, and to pique his interest, I told him about the museums devoted to the memory of his favorite writers: When he heard that the only genuine piece in the F. M. Dostoevsky Literary-Memorial Museum in Saint Petersburg was a hat kept under a bell jar, with a caption saying "This truly belonged to Dostoevsky," perhaps he would give me a smile. What would he have to say about the Nabokov Museum in the same city, which during the Stalin era had served as the office of the domestic board of censors? I told how, having visited the Musée Marcel Proust in Illiers-Combray and having seen the portraits of those who had served as models for his works, I left none the wiser about his novels, though possessing a clearer idea of the world in which the author had lived. No, I did not find the idea of a writer's museum absurd. For example, at Spinoza's house in the small

city of Rijnsburg in Holland, I thought it was fitting that they had gathered together all the books in his library which were enumerated in an official report issued after his death, ordering them from largest to smallest, as was customary in the seventeenth century. And what a happy day I had walking through the labyrinth of rooms at the Tagore Museum, gazing at the author's watercolors, and recalling the dusty, musty scent of the first generation of Atatürk Museums, all the while listening to Calcutta's unending roar! I talked of visiting Pirandello's house in the city of Agrigento, Sicily, and seeing photographs that might have been of my own family; of the city views from the windows of the Strindberg Museum in the Blue Tower in Stockholm; and of the gloomy little four-story house in Baltimore that Edgar Allan Poe had shared with his aunt and his ten-year-old cousin Virginia, whom he would later marry. I found it so familiar: Of all the museums I visited, it was this tiny four-story Baltimore Poe House and Museum, which now sits in the middle of a poor, outlying neighborhood, that reminded me most of the Keskin household, its forlorn air, its rooms, and its shape. But as I told Orhan Bey, the most magnificent writer's museum I had seen was the Museo Mario Praz on Giulia Street in Rome. If he ever managed to make an appointment to visit, as I had done, the home of Mario Praz, the celebrated historian and author of *The Romantic Agony,* who had an equal passion for visual art as for literature, he must, I advised, read the book in which the great author told the story of his wondrous collection like a novel, room by room, object by object. By contrast, the house in Rouen where Flaubert was born was full of his father's medical books, so there was no need for a writer to visit the Musée Flaubert et d'Histoire de la Médecine. Then I looked carefully into our author's eyes:

"While Flaubert was writing *Madame Bovary,* inspired by his beloved Louise Collet, to whom he had made love in horse carriages and provincial hotels, just as in the novel, he kept in a drawer a lock of her hair, as well as a handkerchief and a slipper of hers, and he would, from time to time, take these things out to caress them, looking in particular at the slipper to recall how she walked—as you certainly know from his letters, Orhan Bey."

"No, I didn't know that," he said. "But I love it."

"I once loved a woman so much that I, too, hid away locks of her hair, and her handkerchiefs, and her barrettes, and everything she ever owned, and for many years I found consolation in them, Orhan Bey. May I, in all sincerity, tell you my story?"

"Of course, go right ahead."

So it was during our first meeting, at Hünkar (the restaurant that had replaced the now defunct Fuaye), that I told him my whole story—not in a disciplined way, but jumping back and forth—in the space of three hours. I was overexcited, and had drunk three double *rakı*s, and I think my elation got the better of me, making my story sound to some degree ordinary.

"I knew Füsun," said Orhan Bey. "I remember her from the engagement party at the Hilton. I was so very sorry to hear she had died. She used to work at that boutique down the road. I even danced with her at your engagement party."

"Is that true? She was such an exceptional person, wasn't she. . . . I'm not talking about her beauty, but her soul, Orhan Bey. When you were dancing with her, what did you say to each other?"

"If you really have all of Füsun's things in your possession, I would like to see them."

First he came to Çukurcuma, showing a genuine interest in this collection I'd assembled and this museum I'd made from an old house, an admiration he made no effort to conceal. Now and then he would pick up an object, for example, the yellow pump that Füsun was wearing the first time I saw her in the Şanzelize Boutique, and he'd ask me to tell him its story, and so I would.

Later on we began to work in a more organized fashion. Whenever I was in Istanbul he would come to my attic once a week, always asking me why the objects and photographs I had recalled and organized in a row had to appear in the same order in the boxes and display cases of the museum and why each had to be mentioned in its particular chapters. With the greatest pleasure I would tell him. He listened very carefully to everything I said, and when I saw him taking notes I was pleased—and proud.

"Please finish this novel now, so that people who are interested can tour the museum with the book in hand. As they walk from case to case in my museum, seeking a better understanding of my love for Füsun, I'll come down from my attic room in my pajamas and wander among them."

"But you haven't finished your museum either, Kemal Bey," Orhan Bey would say by way of reply.

"There are many museums in the world I have yet to see," I would say with a smile. And then I would try, yet again, to explain the spiritual effect that the silence of museums had on me, what sublime happiness it was to be in a far corner of the world on an ordinary Tuesday morning, strolling through a forgotten museum in an out-of-the-way neighborhood, and evading the scrutiny of the guards. Whenever I returned from my travels I would ring Orhan Bey at once, and tell him about

the museums I'd seen, bringing tickets and brochures out of my pocket, as well as the little trinkets and directional signs that I had pocketed in the museums I most liked.

It was just after my return from one such journey that, after telling him my story, and describing the museums I'd visited, I asked him how the novel was progressing.

"I am writing the novel in the first person singular," said Orhan Bey.

"What do you mean?"

"In the book you are telling your own story, and saying 'I,' Kemal Bey. I am speaking in your voice. Right now I am trying very hard to put myself in your place, to be you."

"I understand," I said. "So tell me, have you ever been in love this way, Orhan Bey?"

"Hmmmmm . . . We aren't talking about me," he said, and he fell silent.

After working together for a long while, we had some *rakı* in my garret. Talking about Füsun and our life together had tired me. After he left, I stretched out on the bed where Füsun and I had once made love (more than a quarter century ago) and thought about why I felt so strange about his telling the story from my point of view.

Though I had no doubt that it would remain my story, and that he would treat it respectfully, the idea of his speaking in my voice was disturbing. It seemed a failure of courage, a sort of weakness on my part. While I thought it perfectly normal to tell the story to visitors myself, pointing out relevant objects along the way, for Orhan Bey to put himself in my place, for him to make his own voice heard in place of mine—this annoyed me.

I was feeling that way two days later, when I asked him about Füsun. That night we again met in the attic of my museum, and

had already polished off our first glass of *rakı,* when I said, "Orhan Bey, could you please tell me about your dance with Füsun the night of my engagement party?"

For a while he was reluctant—I think he was embarrassed. But when we'd each had another *rakı,* Orhan Bey described with such feeling how he'd danced with Füsun a quarter century ago that he immediately won my trust as the ideal person to tell my story to museum visitors in my voice.

It was around then that I decided my voice had been heard too much anyway, and that it was time I left it to him to finish my story. From the next paragraph until the end, it will, in essence, be Orhan Bey who is telling the story. Having paid Füsun such sincere, detailed attention during their dance, he will, I am sure, do no less in these last pages. Farewell!

HELLO, THIS IS ORHAN PAMUK! With Kemal Bey's permission I shall begin by describing my dance with Füsun: She was the most beautiful girl there that night, and there were many men waiting their turn to dance with her. I was not handsome or flamboyant enough to catch her eye, and, though five years older than her, I was not, how shall I put it, mature enough, and in those days I didn't have much self-confidence, either. My mind was crammed with moralistic thoughts and books and novels that made it impossible for me to enjoy the evening. That her mind was occupied with very different matters you will already know.

Yet despite all this, after she had accepted my invitation to dance, as I followed her to the dance floor, I entered into a reverie at the sight of her tall form, her bare shoulders, her magnificent back, and her fleeting smile. Her hand was light

but warm to the touch. When she put her other hand on my shoulder there was a moment when I could not have been prouder had she been my own, and not merely my momentary dance partner. As we swayed lightly across the floor, I was driven to distraction by the closeness of her skin, her perfect posture, the liveliness of her shoulders and her breasts, and though I did my best to resist her attractions, I was unable to stop the fantasies racing through my mind: We left the dance floor hand in hand, going upstairs to the bar; we were falling madly in love; we were kissing under those trees just over there; I was sure we would be getting married!

Just to get the conversation going, I said the first thing that came into my head ("When I'm walking down the street in Nişantaşı, I sometimes see you in the shop"), but my dull words only reminded her that she was a very beautiful shopgirl, and she was unimpressed. Anyway, by the middle of the first dance, she had already worked out that I wasn't up to much, and had begun looking over my shoulder at the people sitting at the tables, and trying to see who was dancing with whom, keeping track of the many men who had shown an interest in her, to see whom they were laughing and talking with now, and sizing up the most charming and beautiful women, to plan her next move.

I had respectfully (but also with delight) placed my right hand just above her beautiful hip, and with the tips of my first two fingers could feel every movement of her spine, down to the merest flutter, as if taking her pulse. Her curiously erect posture set my head spinning, and for years I would be unable to forget it. There were moments when I could feel in my fingertips the blood coursing through her body, the very life, and then suddenly she would fixate on something new, causing her organs to flinch, a frisson through her elegant frame, and

it was all I could do not to embrace her with every bit of my strength.

As the dance floor became crowded, another couple bumped into us from behind, and for a moment our bodies were pressed together. After that shockingly intimate instant, I remained silent for some time. As I gazed upon her neck and her hair, I was so swept up in the fantasy of happiness with her that I would have gladly abandoned my books and my dreams of becoming a novelist. I was twenty-three years old and quick to anger when the bourgeoisie of Nişantaşı, even my own friends, would laugh at my decision to become a novelist, snidely telling me that no one my age could possibly have enough understanding of life for that. Exactly thirty years later, as I revise these lines, I would now like to add that I believe these people were right. Had I had any understanding of life then, I would have done everything in my power to intrigue her during our dance, I would have believed that she could take an interest in me, and when she slipped out of my arms, I would not have stood there so helplessly watching her go. "I'm tired," she said. "Would you mind if I sat down after the second dance?" I was walking her back to her table, a courtesy I had learned from films, when I suddenly couldn't hold myself back.

"What a boring lot," I said priggishly. "Shall we go upstairs and find a comfortable place to sit and talk?" It was so noisy that she couldn't really hear me, but she understood immediately from my expression what I was after. "I have to sit with my mother and father," she said, as she politely drew away.

When he realized that I had chosen to end my story there, Kemal Bey congratulated me. "Yes, that would be just like Füsun. You understood her very well!" he said. "I would also like to thank you profusely for resisting the urge to omit

those details damaging to your pride. Yes, that is the crux of it, Orhan Bey—pride. With my museum I want to teach not just the Turkish people but all the people of the world to take pride in the lives they live. I've traveled all over, and I've seen it with my own eyes: While the West takes pride in itself, most of the rest of the world lives in shame. But if the objects that bring us shame are displayed in a museum, they are immediately transformed into possessions in which to take pride."

This was the first in a series of didactic pronouncements that Kemal Bey delivered himself of in his small attic chamber as we drank into the night. I was unfazed, mostly because everyone who runs into a novelist in Istanbul feels moved to edifying declarations and suchlike, but (as Kemal Bey so often suggested to me) I, too, was becoming confused about what to include in the book, and how to go about it.

"Do you know who it was that taught me the central place of pride in a museum, Orhan Bey?" Kemal Bey asked me during another late-night session in the attic. "The museum guards, of course. No matter where I went in the world, the guards would answer my every question with passion and pride. At the Stalin Museum in Gori, Georgia, an elderly woman guard spoke for almost an hour of what a great man Stalin was. And it was thanks to an amiable guard at the Museum of the Romantic Era in the city of Oporto in Portugal, who proudly talked with me at length, that I discovered in Carlo Alberto, the exiled king of Sardinia, who spent the last three months of his life in that building in 1849, a profound influence on Portuguese romanticism. Orhan Bey, if someone asks a question at our museum, the guards must describe the history of the Kemal Basmacı collection, the love I feel for Füsun, and the meanings invested in her possessions, with the same dignified air. Please put this in the book, too. The

guards' job is not, as is commonly thought, to hush noisy visitors, protect the objects on display (though of course everything connected to Füsun must be preserved for eternity!), and issue warnings to kissing couples and people chewing gum; their job is to make visitors feel that they are in a place of worship that, like a mosque, should awaken in them feelings of humility, respect, and reverence. The guards at the Museum of Innocence are to wear velvet business suits the color of dark wood—this being in keeping with the collection's ambience and also Füsun's spirit— with light pink shirts and special museum ties embroidered with images of Füsun's earrings, and, of course, they should leave gum chewers and kissing couples to their own devices. The Museum of Innocence will be forever open to lovers who can't find another place to kiss in Istanbul."

I would sometimes tire of this declamatory style so reminiscent of the more outspoken political writers of the seventies, which Kemal Bey would adopt after two glasses of *rakı,* that I would stop taking notes, and in the days that followed I would have no wish for his company. But the twists of Füsun's story, and the singular atmosphere created by the museum's objects, were such that after a time I would always be drawn back, again want to visit the attic, to listen to this timeworn man deliver long monologues about Füsun, becoming more animated the more he drank.

"Never forget, Orhan Bey, that the logic of my museum must be that wherever one stands inside it, it should be possible to see the entire collection, all the display cases, and everything else," Kemal Bey would say. "Because all the objects in my museum—and with them, my entire story—can be seen at the same time from any perspective, visitors will lose all sense of Time. This is the greatest consolation in life. In poetically well

built museums, formed from the heart's compulsions, we are consoled not by finding in them old objects that we love, but by losing all sense of Time. Please write this in the book, too. Let us not conceal the way in which I had you write it, or how you went about your work. When it is done, please give me all the drafts and your notebooks, so that we can display them, too. How much longer will it take? Those who read the book will certainly wish to come here to see locks of Füsun's hair, her clothes, and her other belongings, just as you have. So please put a map at the end of the novel, so that anyone who cares to can make their way by foot through Istanbul's streets. Those who know the story of Füsun and me will certainly remember her as they walk those streets and see those prospects, just as I do, each and every day. And let those who have read the book enjoy free admission to the museum when they visit for the first time. This is best accomplished by placing a ticket in every copy. The Museum of Innocence will have a special stamp, and when visitors present their copy of the book, the guard at the door will stamp this ticket before ushering them in."

"Where shall we put the ticket?"

"They should put it here, of course!"

THE MUSEUM OF INNOCENCE

SINGLE ADMISSION ONLY

"Thank you. And at the end, let's put an index of names, Orhan Bey. It is thanks to your account that I remembered how many people witnessed our story or were otherwise acquainted with it. Even I have a hard time keeping all the names straight."

In fact, Kemal Bey did not like my seeking out the people mentioned in the story, but he tolerated my novelist's ways. Sometimes he was curious to know what the people I'd tracked down had said, or what they were doing now; sometimes he had no interest in them whatsoever, and could scarcely understand my interest in them.

For example, he could not begin to comprehend why I wrote a letter to Abdülkerim Bey, Satsat's distributor in Kayseri, or why I met him during one of his visits to Istanbul. As for Abdülkerim Bey, who left Satsat to become the Kayseri distributor for Tekyay, the firm Osman founded with Turgay Bey, he regarded Kemal Bey's story as the tale of love and disgrace that had brought down Satsat.

I was able to locate Sühendan Yıldız (also known as Conniving Sühendan), the actress who perennially played the she-devil and who had observed our lovers' first months at the Pelür. She told me that while she had known Kemal Bey as a desperately lonely man, and though like everyone else she'd been well aware of how besotted he was with Füsun, she felt little pity for him, generally disapproving of rich men who prowled the film world for beautiful girls. Sühendan had, in fact, pitied Füsun, "whose impatience to play in films and be a star was something akin to panic." Had she succeeded, surrounded by all those wolves, she would have come to a sad end anyway, Sühendan supposed, never understanding why Füsun had married "that fatso" (Feridun). As for the grandson for whom she was knitting a tricolor jumper in those days,

he was now exactly thirty years old, and whenever he saw on television an old film in which his grandmother had starred, he could barely contain his laughter, but was also shocked to see how poor Istanbul had been in those days.

Basri the Nişantaşı barber had once been my barber, too. He was still working, and was inclined to speak with love and respect more about Mümtaz Bey than about Kemal Bey. Mümtaz Bey had been an affable, generous, good-hearted man, always ready with a joke. I discovered nothing noteworthy from Basri the barber, or indeed from Hilmi the Bastard and his wife, Neslihan, Hayal Hayati, or Salih Sarılı (another Pelür regular) or Kenan. Ayla, the downstairs neighbor whom Füsun hid from Kemal, now lived in a side street in Beşiktaş with her engineer husband and her four children, the eldest of whom was now at university. She told me that she had valued Füsun's friendship, and had loved everything about her—her joie de vivre, her wit, the way she spoke—to the point of adopting Füsun as her role model, but sadly Füsun had never reciprocated her desire for close friendship. The two girls would get dressed up and go out together to Beyoğlu, to the cinema. A neighborhood friend who worked as an usher at the Dormen Theater would let them into rehearsals. Afterward they would stop somewhere for a sandwich and an *ayran,* protecting each other from the men who bothered them. Sometimes they would go into Vakko or some other fashionable shop, pretending to be paying customers, and have great fun trying on clothes, looking at themselves in the mirror. They would be laughing and talking when suddenly Füsun would become fixated on something and all the joy would drain out of her—as it would sometimes in the middle of a film—but she never told Ayla what was bothering her. Everyone in the neighborhood had been aware

of Kemal Bey's comings and goings—they knew he was rich, and not quite right in the head—but no one had said anything about love. Like everyone else in Çukurcuma, Ayla had known nothing about what had happened between Füsun and Kemal in earlier years, and "anyway" she no longer knew anyone in the neighborhood.

The White Carnation had, in the course of twenty years, risen from gossip columnist to editor of the daily celebrity supplement in one of the country's leading newspapers. In addition, he edited a monthly gossip magazine focused on the scandals and love affairs of stars in domestic films and television series. Like so many journalists whose false reports had hurt people or even shattered their lives, he had forgotten what he had written about Kemal, asking me to pass on his greetings, along with his deepest respects to his esteemed mother, Vecihe Hanım, whom he had been in the habit of ringing for news now and again, until very recently. Imagining I had approached him about a book I was writing set among film stars and therefore likely to enjoy brisk sales, he was friendly and more than obliging in his offer of help: Did I know that the child resulting from Papatya's failed marriage with the producer Muzaffer now, though still quite young, owned one of Germany's leading tourism agencies?

Feridun had severed all ties with the film world to found a highly successful advertising firm. On hearing that he had called it Blue Rain, I was reminded that he had not abandoned the dreams of his youth, but I dared not ask him anything about his film that had never been made. Feridun shot commercials full of Turkish flags and football matches that advertised great pride in the modest international success of Turkish biscuits, Turkish blue jeans, Turkish razors, and Turkish hoodlums.

He had heard about Kemal Bey's plans for a museum, but it was I who informed him that I was writing a book "telling Füsun's story": With extraordinary candor, carefully choosing his words, he told me how he had loved only once in his life, but that Füsun had never paid him any heed, and so he'd been careful not to relive that sorrow by falling in love with her again once they were married, particularly since he knew that Füsun married him only because she'd been "obliged" to do so. I liked his honesty. When I was leaving his stylish office, he asked me with the same cautious courtesy to convey his greetings to "Kemal Bey," after which he warned me, with a frown: "If you write anything bad about Füsun, Orhan Bey, rest assured that I will come after you." Then regaining the light and easy manner that suited him so well he asked a favor: Could he use the first sentence of my novel *The New Life* in a campaign for Bora, a new product from the soft drinks giant that used to make Meltem, with which his firm had long-standing ties?

With his retirement settlement, Çetin Efendi had bought a taxicab, which he rented to another driver, though sometimes, despite his advanced age, he would take it out himself into the streets of Istanbul. When we met at a taxi stand in Beşiktaş, he told me that Kemal had never changed since boyhood: In essence, he was one who relished every moment of life, ever open to the world and to other people and possessed of a childlike optimism. In this sense, wasn't it strange, I asked, that his life had fallen prey to such a black passion. But if I had ever met Füsun, Çetin Efendi explained, I would have understood why Kemal Bey had fallen so hard for this woman. They— Füsun and Kemal—were essentially good and innocent souls who suited each other perfectly, but as God had been unwilling

to let them be together, we mortals were in no position to question the outcome too closely.

On our first meeting after his return from a long journey, after Kemal Bey had told me about the museums he had visited, I told him about my conversation with Çetin Efendi, repeating word for word what he had said about Füsun.

"Visitors to my museum will learn of our story one day, and anyhow, will know in their hearts what sort of person Füsun was, Orhan Bey," he said. We started drinking at once—by now I truly enjoyed drinking with him. "As they go from display case to display case, and box to box, looking at all these objects, visitors will understand how I gazed at Füsun at suppertime for eight years, and when they see how closely I observed her hand, her arm, the curl in her hair, the way she stubbed out cigarettes, the way she frowned, or smiled, her handkerchiefs, her barrettes, her shoes, and the spoon in her hand" (I did not say, "But Kemal Bey, you failed to mention the earrings.") "they will know that love is deep attention, deep compassion. . . . Please finish the book now, and also write that each and every object in the museum must be softly lit from within the display cases in a way that conveys my close and devoted attention. When visitors to our museum view these objects, they should feel respect for my love and compare it with memories of their own. The premises should never be crowded, so that the visitor can examine unhurried each object, and view the pictures of the Istanbul neighborhoods we visited hand in hand, getting a leisurely feel for the entire collection as a totality. In fact I hereby declare that no more than fifty at a time should be admitted to the Museum of Innocence! Groups and school classes must make appointments to visit our museum! In the West museums are getting more and more crowded, Orhan Bey. European

families go out together on a Sunday to visit a great museum, just as we used to get into our cars for a Sunday drive down the Bosphorus. And they sit in the museum restaurants and laugh, just as we do in Bosphorus restaurants. Proust wrote of how the furnishings of his aunt's house were sold to a brothel after her death, and how every time he saw her chairs and tables in this place he felt as if every object was crying. When the Sunday crowds pour through museums, the collected objects cry. In my museum, they won't be ripped from their own house, at least. I'm afraid that this museum craze in the West has inspired the uncultured and insecure rich of this country to establish ersatz museums of modern art with adjoining restaurants. This despite the fact that we have no culture, no taste, and no talent in the art of painting. What Turks should be viewing in their own museums are not bad imitations of Western art but their own lives. Instead of displaying the Occidentalist fantasies of our rich, our museums should show us our own lives. My museum comprises the life I shared with Füsun, the totality of our experience, and everything I've told you is true, Orhan Bey. Perhaps some things will not be clear enough for every reader or visitor, for even though I have told you my story, described my life with utmost sincerity, even I cannot know how much I have understood it as a whole. We can leave that job to future scholars, and the articles they will write for *Innocence,* the museum magazine. Let them be the ones to establish the structural relations between Füsun's barrettes and brushes and the deceased canary Lemon. If future generations find the account of our life exaggerated, if they are nonplussed by the pain I suffered in love's name, or by Füsun's suffering, or the way we diverted ourselves from all this by looking into each other's eyes at supper, or found happiness holding hands

at the beach and the cinema, the guards must impress upon the incredulous that everything as represented is true. But don't worry, I don't doubt that future generations will understand our love. The contented university students who travel here from Kayseri by bus fifty years from now, the Japanese tourists lined up at the door clutching cameras, the single women who end up in the museum having lost their way in the street, and the happy lovers of tomorrow's happy Istanbul will—upon studying Füsun's clothes, and the saltshakers, the clocks, the restaurant menus, the old Istanbul photographs, and our shared childhood toys and other objects—find a profound understanding of our love and our lives virtually inescapable. I hope the crowds will also visit our temporary exhibitions, devoted to the ship photographs, soda caps, matchboxes, clothespins, postcards, pictures of stars and celebrities, and earrings gathered together by my obsessive collector cohort, my strange brethren, whose acquaintance I've made in their rubbish dens or through their Association. These exhibitions, and the stories behind them, should also in due course have their own catalogs and novels. As visitors admire the objects and honor the memory of Füsun and Kemal, with due reverence, they will understand that, like the tales of Leyla and Mecnun or Hüsn and Aşk, this is not simply a story of lovers, but of the entire realm, that is, of Istanbul. Would you like another *rakı*, Orhan Bey?"

In the early hours of April 12, 2007—Füsun's fiftieth birthday—Kemal Basmacı, the hero of our novel and the founder of our museum, was asleep in a large room overlooking the Via Manzoni in the Grand Hotel de Milan, the establishment in which he stayed every time he visited that city, when he suffered a heart attack and died, age sixty-two. Kemal Bey would take every opportunity to go to Milan, to "experience"

(as he put it) the Bagatti Valsecchi Museum, which he esteemed "one of the five most important museums in my life!" (By the time of his death he had visited 5,723 museums.) "Museums are (1) not to be strolled around in but to be experienced, (2) made up of collections expressive of the soul of that 'experience,' (3) not in fact museums but merely galleries when emptied of their collections." These are the last thoughts of his that I recorded. What most enchanted Kemal Bey about this house (renovated by two brothers in the nineteenth century to replicate a sixteenth-century Renaissance palazzo, and then converted to a museum in the twentieth century) was that its wondrous, historic collection comprised nothing but the ordinary everyday appurtenances of the brothers' lives (the old beds, lamps, Renaissance mirrors, pots and pans).

Most of the people whose names I have listed in the index attended his funeral in Teşvikiye Mosque. Kemal's mother, Vecihe, observing from the balcony as was her wont, was wearing a headscarf. We who stood tearfully in the courtyard could hear her crying as she bade farewell to her son.

Many of Kemal Bey's relatives and close associates had refused to see me while he was alive, but in the first few months after his funeral they began to seek me out, one after the other, an orderly progression that, though strange, had its logic. The reluctance to approach me I attribute to the false but widely held impression that my books set in Nişantaşı denigrated everyone mercilessly. Sadly, there had been so much gossip, and so many accusations, that it was generally believed I had misrepresented not just my mother, my older brother, my uncle, and the rest of my family, but many other Nişantaşı notables as well, including the celebrated Cevdet Bey, his sons, and his family; my poet friend Ka; and Celâl Salik, the famous assassinated columnist,

whom I had so admired; the well-known shopkeeper Alaaddin; as well as high-ranking state dignitaries, religious leaders, and military commanders. Zaim and Sibel were fearful of me without ever having read my books. Zaim was much richer than he'd been as a young man. Meltem soda had fizzled out, but the firm itself was going strong. They entertained me very graciously in their magnificent house in the Bebek hills overlooking the Bosphorus, honored, they said, to receive the one who had undertaken to write Kemal's life story (those closer to Füsun would call it Füsun's story). But I was not to make my story one-sided: I was to listen to them as well.

First of all, they wanted to tell me about a huge coincidence: Half a day before his death, on the afternoon of April 11, they had run into Kemal Bey on the streets of Milan. (At once I felt that they had invited me over expressly to tell me this.) Zaim and Sibel and their two pretty, clever daughters, who joined us for supper, twenty-year-old Gül and eighteen-year-old Ebru, had gone on a three-day trip to Milan, just for pleasure, *un petit séjour,* as Sibel said. When Kemal had set eyes on the family enjoying their multicolored cones of orange, strawberry, and melon ice cream, and peering into shop windows, and laughing jovially as they strolled down the street, he at first saw only Gül, and her resemblance to her mother was so great that he went up to her and said, "Sibel! Sibel! Hello, this is Kemal."

"Gül looks so much like I did in my twenties, and that day she just happened to be wearing an old knitted stole I'd worn in those years," said Sibel Hanım, beaming with pride. "But poor Kemal, he looked so tired, so disheveled, broken down, and deeply unhappy. Orhan Bey, I felt so bad to see him that way. I wasn't the only one—Zaim was heartsick, too. The man to whom I'd become engaged at the Hilton, who so loved

life, who was always so charming, and so full of fun—he'd vanished, and in his place was an old man cut off from the world and life itself, with a long face, and a cigarette hanging from his mouth. If he hadn't recognized Gül, we would never have known him. He hadn't just aged; he'd fallen apart. I felt so sorry for him. Especially since this was the first time I'd seen him in who knows how many years."

"It would have been thirty-one years after your last meal together at Fuaye," I said.

There was an eerie silence.

"So he told you everything!" Sibel said a short while later, her voice full of pain.

As the silence continued, I realized what it was that they really wanted to tell me: They wanted readers to know how much happier their life together was compared to the story I was telling, and what a beautiful and normal life it was.

But after the girls had gone to their rooms, when we were drinking our cognacs, I realized that there was another thing that the couple was struggling to express. On her second glass, Sibel explained herself in a forthright way that I appreciated, without beating around the bush as Zaim had: "At the end of the summer of 1975, after Kemal had confessed to me that he was badly smitten by the late Füsun Hanım, I pitied my fiancé and wanted to help him. With the best of intentions, we moved together to our *yalı* in Anadoluhisarı so that I could nurse him back to health, Orhan Bey, and we stayed there for a month." (In fact, they stayed for three.) "Actually, this is no longer important. . . . Today's young people don't worry about things like virginity." (This wasn't true, either.) "But even so, I am going to ask you especially to make no mention of those days in your book, because they are humiliating for me. . . .

This might not seem so important, but it was expressly because she'd gossiped about this matter that I fell out with my best friend, Nurcihan. The children wouldn't care, but their friends, and all those gossips. . . . Please don't let us down. . . ."

Zaim told me how much he'd loved Kemal—such a sincere person he was, whose friendship he'd always sought—and how much he missed him. "Is it true that Kemal collected all of Füsun Hanım's possessions? Is there really going to be a museum?" he asked, half in awe, half in fear.

"Yes," I said. "And with this book, I shall be the museum's chief promoter."

When I took my leave of their house, rather late though still laughing and carrying on with them, for a moment I put myself in Kemal's shoes. If he were still alive, if he had taken up again with Sibel and Zaim (this was indeed possible, contrary to what he imagined), Kemal would have left their house that night feeling as I felt—both content and guilty about his solitary life.

"Orhan Bey," said Zaim at the door. "Please don't forget Sibel's request. We at Meltem Enterprises, of course, wish to make a donation to the museum."

That night I also realized it was pointless speaking to other people: I did not want to tell Kemal's story as others saw it; I wanted to write it the way he had told it to me.

It was out of simple doggedness that I went to Milan, where I discovered what had upset Kemal so on the day he had run into Sibel, Zaim, and their daughters: Just before that chance encounter he had gone to the Bagatti Valsecchi Museum, finding that it was in terrible disrepair, and that in an effort to raise funds, a part of it had been rented out as a boutique of the famous designer Jenny Colon. The women who worked as guards in the museum, in black uniforms, were

in tears on receiving my report of his death, and the directors, who confirmed that a Turkish gentleman came to visit them without fail every few years, had also been distraught.

This alone convinced me that I had no need to hear any more gossip to finish my book. I would only have wished to see Füsun, and to hear her. But before I could visit the ones who knew her best, there were the invitations from those who feared my book and insisted on receiving me in their houses preemptively, which invitations I accepted just for the pleasure of some company and sharing a meal.

And so it was that in the course of a very quick supper I was advised by Osman not to write this story at all. Yes, it might be true that it was his late brother's negligence that had plunged Satsat into bankruptcy, but all his late father's other firms were now engines of Turkey's export boom. They had many vicious competitors, and a book like this, beyond causing heartbreak and endless gossip as well, would only make Basmacı Holding a laughingstock and by association give Europeans just another excuse to laugh at us and put us down. Even so, I was able to leave the house with a lovely souvenir, a marble from Kemal's childhood that Berrin Hanım handed to me in the kitchen, out of her husband's view.

As for Aunt Nesibe, to whom Kemal had introduced me, she told me nothing new when I went to see her in her apartment on Kuyulu Bostan Street. Now she wasn't crying just for Füsun, but also for Kemal, whom she described as her "only son-in-law." She mentioned the museum but once: She used to have an old quince grater, and having got it into her head to make quince jelly, she wondered whether the grater she could find nowhere had perhaps wound up in the museum. I would surely know. If it was there could I bring it with me on

my next visit? As I said good-bye at the door, she said, "Orhan Bey, you remind me of Kemal," and she burst into tears.

Six months before his death, Kemal had introduced me to Ceyda, Füsun's closest confidante, who in my view not only knew all Füsun's secrets but understood Kemal best, too. This introduction had come about partly because Ceyda Hanım liked novels and had wanted to meet me. Her sons, now in their thirties and engineers both, were married, and their lovely brides, whose pictures she showed me, had already given her seven grandchildren. Her rich husband (he was the Sedircis' son!), who was much older than Ceyda, looking slightly drunk and slightly senile, showed no interest in us or our story, even when Kemal and I admitted our overindulgence with *rakı*.

Ceyda told me with a sweet smile how Füsun had discovered the earring Kemal had left in the Keskins' bathroom on the evening of his first visit, and how though she'd told Ceyda about it right away, they'd decided together that Füsun should feign ignorance, just to punish Kemal. Like so many of Füsun's secrets, that story Kemal Bey had already extracted from Ceyda years earlier. He had smiled painfully when he told it to me, pouring us each another glass of *rakı*.

"Ceyda," said Kemal later, "when I came to you for news of Füsun, you and I would always meet in Maçka, Taşlık. As you were telling me about Füsun, I would admire the view of Dolmabahçe from Maçka. When I checked recently, I discovered that I have accumulated many pictures of that view."

As we'd been talking about photographs, and perhaps also to honor her visitors, Ceyda Hanım allowed as how just the other day she'd happened on a photograph that Kemal Bey had never seen. "This had us all excited," she said. The photograph, taken during the finals of the 1973 Milliyet Beauty Contest, was

of Hakan Serinkan whispering to Füsun the cultural questions that she would be asked to come on stage. The famous crooner, now a deputy for an Islamist party, had been very much taken with Füsun.

"It's a shame neither of us made it through, Orhan Bey, but to the end we behaved like the good lycée girls we were, though we laughed ourselves to tears that night," said Ceyda. In a flash, the pale photograph appeared on the wooden coffee table; the moment he saw it, Kemal Bey's face went as white as ash, and he fell into a long silence.

Because Ceyda's husband had no taste for the beauty contest story, we would not be looking much longer at Füsun's old photograph. But at the end of the evening Ceyda, understanding as ever, offered it to Kemal Bey as a present.

After leaving Ceyda's house in Maçka, I walked toward Nişantaşı with Kemal Bey, through the silence of the night. "I'll walk you as far as the Pamuk Apartments," he told me. "Tonight I won't be staying at the museum, but with my mother in Teşvikiye."

But five buildings before we reached the Pamuk Apartments, just in front of the Merhamet Apartments, he stopped and smiled.

"Orhan Bey, I read your novel *Snow* all the way to the end," he said. "I don't like politics. So please don't be offended if I say I found it a bit of a struggle. But I liked the ending. And at the end of our novel I would like to do the same as that character in *Snow* and address the reader directly. Do I have this right? When will your book be finished?"

"After your museum," I said. By now this had become a standard joke between us. "What are your last words for the reader?"

"I'm not going to say, as your character did, that readers cannot possibly understand us from afar. On the contrary, visitors to the museum and people who read your book will most certainly understand us. But there is something else I want to say."

He took Füsun's photograph from his pocket and in the pale light of the streetlamp in front of the Merhamet Apartments he looked lovingly at her. I drew up beside him.

"She's beautiful, isn't she?" he said to me, just as his father had said to him thirty-odd years ago.

There we stood, two men, gazing with love, admiration, and respect at the photograph of Füsun in a black swimsuit embroidered with the number nine—at her honey-hued arms, and her face (betraying no joy, only sadness), and her splendid body, both of us struck by the depth of her humanity, the radiance of her soul, despite the thirty-four years that had elapsed since the photograph had been developed.

"Please put this photograph in your museum, Kemal Bey," I said.

"My last words in the book are these, Orhan Bey, please don't forget them. . . ."

"I won't."

He kissed Füsun's photograph lovingly, and placed it with care into the breast pocket of his jacket. Then he smiled at me, victorious.

"Let everyone know, I lived a very happy life."

2001–2002, 2003–2008

INDEX OF CHARACTERS

Tom Holland is the author of *In the Shadow of the Sword*; *Rubicon*, which was shortlisted for the Samuel Johnson Prize and won the Hessell-Tiltman Prize for History; *Persian Fire*, which won the Anglo-Hellenic League's Runciman Award 2006 and the highly acclaimed *Dynasty*. He recently published a translation of Herodotus.

'Holland's masterly account of this first wicked century of the Roman empire is, at its heart, a political analysis ... the story he tells strides onwards across the landscape of grief and horror without pause or stutter ... Holland is unshockable as he proceeds with breezy, clear-eyed analysis from one degrading display of cruelty and paranoia to the next ... It is down to his skill as a storyteller that there's no difficulty in imagining that it might all happen again tomorrow'

Adam Nicolson, *Sunday Times*

'Deft and skilful ... Among the many virtues of Tom Holland's terrific history is that he does not shrink from seeing the Roman emperors for what they were: "the west's primal examples of tyranny" ... *Dynasty* is both a formidable effort to compile what we can know about the ancient world and a sensational story' Nick Cohen, *Observer*

'This is a wonderful, surging narrative – a brilliant and meticulous synthesis of the ancient sources ... This is a story that should be read by anyone interested in history, politics or human nature – and it has never been better told'

Boris Johnson, *Mail on Sunday*

Also by Tom Holland

Rubicon:
The Triumph and Tragedy of the Roman Republic

Persian Fire:
The First World Empire and the Battle for the West

Millennium:
The End of the World and the Forging of Christendom

In the Shadow of the Sword:
The Battle for Global Empire and the End of the Ancient World

TOM HOLLAND

DYNASTY

The Rise and Fall of the House of Caesar

For Katy
'at simul heroum laudes et facta parentis
iam legere . . . '

ABACUS

First published in Great Britain in 2015 by Little, Brown
This paperback edition published in 2016 by Abacus

13 5 7 9 10 8 6 4 2

A CIP catalogue record for this book
is available from the British Library.

ISBN 978-0-349-12383-7

Typeset in Spectrum by M Rules
Printed and bound in Great Britain by
Clays Ltd, St Ives plc

Papers used by Abacus are from well-managed forests
and other responsible sources.

MIX
Paper from
responsible sources
FSC® C104740

Abacus
An imprint of
Little, Brown Book Group
Carmelite House
50 Victoria Embankment
London EC4Y 0DZ

An Hachette UK Company
www.hachette.co.uk

www.littlebrown.co.uk

Contents

Acknowledgements

As ever with my books, I owe a huge debt of gratitude to numerous people for their help. To my various editors, Richard Beswick, Gerry Howard, Frits van der Meij and Christoph Selzer, for their support, assistance and advice. To Iain Hunt, for all the care and patience he has brought to disentangling the knots of my manuscript – maps, timelines, end notes and all. To Susan de Soissons, the finest and kindest publicity director a writer could hope to have. To Patrick Walsh, best of agents, and everyone at Conville and Walsh. To Guy de la Bédoyère, Paul Cartledge, Catharine Edwards, Llewelyn Morgan and Andrew Wallace-Hadrill, for generously bringing to bear the full illuminating light of their scholarship on my manuscript, and exposing many an error. To Dan Snow, who more than made up for distracting me from the politics of the first century ad during the 2014 Scottish independence referendum campaign by reading a first draft of *Dynasty*, to invaluable effect. To Jamie Muir, who (as he has done ever since I wrote *Rubicon*) read each successive chapter as I printed it off – and then went the extra mile by accompanying me deep into the Teutoburg Forest. To Gareth Blayney, for his beautiful illustrations of ancient Rome, and for agreeing to bring all his talent to bear on the cover of this book. To Sophie Hay, for her kindness, generosity and enthusiasm, her photographs, her companionship on the road trip to Nemi and Spelunca, and her careful tracking of my Twitter avatar's evolution. To Laura Jeffrey, for her whole-hearted enjoyment of the

plumbing on Caligula's pleasure-boat. To Stephen Key, for selflessly negotiating the roads between Rome, Nemi and Spelunca on behalf of Sophie, Laura and myself. To Mattia Buondonno, for his ebullient hospitality at Pompeii. To Charlie Campbell, for providing me with the opportunity to hit a six, bowl the Crown Prince of Udaipur, and play at Lord's – and thereby feel for myself what it must have been to rank as *Augustus*. To my cats, Edith and Tostig, for only periodically sitting on my keyboard. To my beloved wife, Sadie, for living these past years with the Caesars as well as me. To my younger daughter, Eliza, for (oh so perversely) choosing Nerva as her favourite emperor. To my elder daughter, Katy, to whom with all my love I dedicate this book.

Maps

The Julians and Claudians

Julius Caesar

Drusus Claudianus

Scribonia = Octavius/AUGUSTUS = Livia = Tiberius Claudius NERO

Marcus Agrippa = Julia = TIBERIUS = Vipsania

Gaius Julia Lucius Agrippa Agrippina = Germanicus
 Postumus (I)

Nero Drusus CALIGULA = Milonia Drusilla
 (III) Caesonia

 Julia
 Drusilla

----- Adopted
 = Married

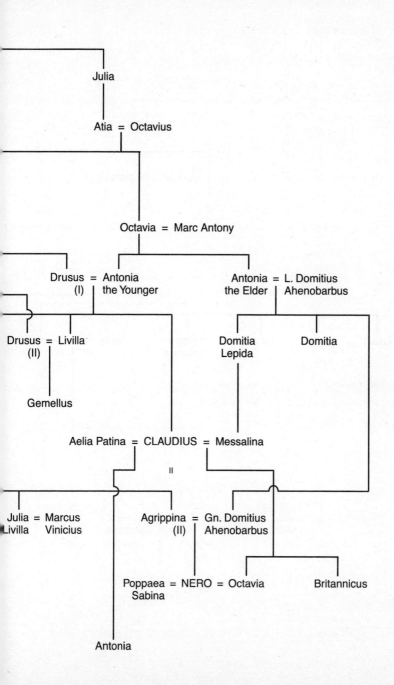

Preface

AD 40. It is early in the year. Gaius Julius Caesar Augustus German-
icus sits on a lofty platform beside the Ocean. As waves break on the
shore and spray hangs in the air, he gazes out to sea. Many Roman
ships over the years have been lost to its depths. Strange monsters are
rumoured to lurk in its grey waters, while beyond the horizon there
lies an island teeming with savage and mustachioed head-hunters:
Britain. Perils such as these, lurking as they do on the very margins
of civilisation, are fit to challenge even the boldest and most iron-
willed hero.

The story of the Roman people, though, has always had about
it an aura of the epic. They have emerged from dim and provincial
obscurity to the command of the world: a feat like no other in his-
tory. Repeatedly put to trial, repeatedly surviving it triumphant,
Rome has been well steeled for global rule. Now, seven hundred
and ninety-two years after her founding, the man who ranks as her
emperor wields power worthy of a god. Lined up alongside him on
the northern beach are rank upon rank of the most formidable fight-
ing force on the planet: armour-clad legionaries, catapults, battlefield
artillery. The Emperor Gaius scans their length. He gives a command.
At once, there is a blaring of trumpets. The signal for battle. Then
silence. The Emperor raises his voice. 'Soldiers!' he cries. 'I command
you to pick up shells. Fill your helmets with the spoils of the Ocean.'[1]
And the legionaries, obedient to their emperor's order, do so.

Such, at any rate, is the story. But is it true? Did the soldiers really pick up shells? And if they did – why? The episode is one of the most notorious in the life of a man whose entire career remains to this day a thing of infamy. Caligula, the name by which the Emperor Gaius is better known, is one of the few people from ancient history to be as familiar to pornographers as to classicists. The scandalous details of his reign have always provoked prurient fascination. 'But enough of the emperor; now to the monster.'[2] So wrote Gaius Suetonius Tranquillus, a scholar and archivist in the imperial palace who doubled in his spare time as a biographer of the Caesars, and whose life of Caligula is the oldest extant one that we possess. Written almost a century after the Emperor's death, it catalogues a quite sensational array of depravities and crimes. He slept with his sisters! He dressed up as the goddess Venus! He planned to award his horse the highest magistracy in Rome! Set against the background of such stunts, Caligula's behaviour on the Channel coast comes to seem a good deal less surprising. Suetonius certainly had no problem in explaining his behaviour. 'He was ill in both body and mind.'[3]

But if Caligula was sick, then so too was Rome. The powers of life and death wielded by an emperor would have been abhorrent to an earlier generation. Almost a century before Caligula massed his legions on the shores of the Ocean and gazed out to Britain, his great-great-great-great-uncle had done the same – and then actually crossed the Channel. The exploits of Gaius Julius Caesar had been as spectacular as any in his city's history: not only two invasions of Britain but the permanent annexation of Gaul, as the Romans called what today is France. He had achieved his feats, though, as a citizen of a republic – one in which it was taken for granted by most that death was the only conceivable alternative to liberty. When Julius Caesar, trampling down this presumption, had laid claim to a primacy over his fellow citizens, it had resulted first in civil war, and then, after he had crushed his domestic foes as he had previously crushed the

Gauls, in his assassination. Only after two more murderous bouts of slaughtering one another had the Roman people finally been inured to their servitude. Submission to the rule of a single man had redeemed their city and its empire from self-destruction – but the cure itself had been a kind of sickness.

Augustus, their new master had called himself, 'The Divinely Favoured One'. The great-nephew of Julius Caesar, he had waded through blood to secure the command of Rome and her empire – and then, his rivals once dispatched, had coolly posed as a prince of peace. As cunning as he was ruthless, as patient as he was decisive, Augustus had managed to maintain his supremacy for decades, and then to die in his bed. Key to this achievement had been his ability to rule with rather than against the grain of Roman tradition: for by pretending that he was not an autocrat, he had licensed his fellow citizens to pretend that they were still free. A veil of shimmering and seductive subtlety had been draped over the brute contours of his dominance. Time, though, had seen this veil become increasingly threadbare. On Augustus's death in AD 14, the powers that he had accumulated over the course of his long and mendacious career stood revealed, not as temporary expediencies, but rather as a package to be handed down to an heir. His choice of successor had been a man raised since childhood in his own household, an aristocrat by the name of Tiberius. The many qualities of the new Caesar, which ranged from exemplary aristocratic pedigree to a track record as Rome's finest general, had counted for less than his status as Augustus's adopted son – and everyone had known it.

Tiberius, a man who all his life had been wedded to the virtues of the vanished Republic, had made an unhappy monarch; but Caligula, who had succeeded him in turn after a reign of twenty-three years, was unembarrassed. That he ruled the Roman world by virtue neither of age nor of experience, but as the great-grandson of Augustus, bothered him not the slightest. 'Nature produced him, in

my opinion, to demonstrate just how far unlimited vice can go when combined with unlimited power.'[4] Such was the obituary delivered on him by Seneca, a philosopher who had known him well. The judgement, though, was not just on Caligula, but on Seneca's own peers, who had cringed and grovelled before the Emperor while he was still alive, and on the Roman people as a whole. The age was a rotten one: diseased, debased, degraded.

Or so many believed. Not everyone agreed. The regime established by Augustus would never have endured had it failed to offer what the Roman people had come so desperately to crave after decades of civil war: peace and order. The vast agglomeration of provinces ruled from Rome, which stretched from the North Sea to the Sahara, and from the Atlantic to the Fertile Crescent, reaped the benefits as well. Three centuries on, when the nativity of the most celebrated man to have been born in Augustus's reign stood in infinitely clearer focus than it had done at the time, a bishop named Eusebius could see in the Emperor's achievements the very guiding hand of God. 'It was not just as a consequence of human action,' he declared, 'that the greater part of the world should have come under Roman rule at the precise moment Jesus was born. The coincidence that saw our Saviour begin his mission against such a backdrop was undeniably arranged by divine agency. After all – had the world still been at war, and not united under a single form of government, then how much more difficult would it have been for the disciples to undertake their travels.'[5]

Eusebius could see, with the perspective provided by distance, just how startling was the feat of globalisation brought to fulfilment under Augustus and his successors. Brutal though the methods deployed to uphold it were, the sheer immensity of the regions pacified by Roman arms was unprecedented. 'To accept a gift,' went an ancient saying, 'is to sell your liberty.' Rome held her conquests in fee; but the peace that she bestowed upon them in exchange was not necessarily to be sniffed at. Whether in the suburbs of the capital

itself, booming under the Caesars to become the largest city the world had ever seen, or across the span of the Mediterranean, united now for the first time under a single power, or in the furthermost corners of an empire whose global reach was without precedent, the *pax Romana* brought benefits to millions. Provincials might well be grateful. 'He cleared the sea of pirates, and filled it with merchant shipping.' So a Jew from the great Egyptian metropolis of Alexandria, writing in praise of Augustus, enthused. 'He gave freedom to every city, brought order where there had been chaos, and civilised savage peoples.'[6] Similar hymns of praise could be – and were – addressed to Tiberius and Caligula. The depravities for which both men would end up notorious rarely had much impact on the world at large. It mattered little in the provinces who ruled as emperor – just so long as the centre held.

Nevertheless, even in the furthest reaches of the Empire, Caesar was a constant presence. How could he not be? 'In the whole wide world, there is not a single thing that escapes him.'[7] An exaggeration, of course – and yet due reflection of the mingled fear and awe that an emperor could hardly help but inspire in his subjects. He alone had command of Rome's monopoly of violence: the legions and the whole menacing apparatus of provincial government, which existed to ensure that taxes were paid, rebels slaughtered, and malefactors thrown to beasts or nailed up on crosses. There was no need for an emperor constantly to be showing his hand for dread of his arbitrary power to be universal across the world. Small wonder, then, that the face of Caesar should have become, for millions of his subjects, the face of Rome. Rare was the town that did not boast some image of him: a statue, a portrait bust, a frieze. Even in the most provincial backwater, to handle money was to be familiar with Caesar's profile. Within Augustus's own lifetime, no living citizen had ever appeared on a Roman coin; but no sooner had he seized control of the world than his face was being minted everywhere, stamped on gold, and

silver, and bronze.* 'Whose likeness and inscription is this?' Even an itinerant street-preacher in the wilds of Galilee, holding up a coin and demanding to know whose face it portrayed, could be confident of the answer: 'Caesar's.'[8]

No surprise, then, that the character of an emperor, his achievements, his relationships and his foibles, should have been topics of obsessive fascination to his subjects. 'Your destiny it is to live as in a theatre where your audience is the entire world.'[9] Such was the warning attributed by one Roman historian to Maecenas, a particularly trusted confidant of Augustus's. Whether he really said it or not, the sentiment was true to the sheer theatricality of his master's performance. Augustus himself, lying on his deathbed, was reported by Suetonius to have asked his friends whether he had played his part well in the comedy of life; and then, on being assured that he had, to have demanded their applause as he headed for the exit. A good emperor had no choice but to be a good actor – as too did everyone else in the drama's cast. Caesar, after all, was never alone on the stage. His potential successors were public figures simply by virtue of their relationship to him. Even the wife, the niece or the granddaughter of an emperor might have her role to play. Get it wrong, and she was liable to pay a terrible price; but get it right, and her face might end up appearing on coins alongside Caesar's own. No household in history had ever before been so squarely in the public eye as that of Augustus. The fashions and hairstyles of its most prominent members, reproduced in exquisite detail by sculptors across the Empire, set trends from Syria to Spain. Their achievements were celebrated with spectacularly showy monuments, their scandals repeated with relish from seaport to seaport. Propaganda and gossip, each feeding off the other, gave to the dynasty of Augustus a celebrity that ranked, for the first time, as continent-spanning.

* The earliest portrait of a living Roman on a Roman coin seems to have been of Julius Caesar. It was minted in 44 BC – the year, not coincidentally, of his assassination.

To what extent, though, did all the vaunting claims chiselled into showy marble and all the rumours whispered in marketplaces and bars approximate to what had actually happened in Caesar's palace? To be sure, by the time that Suetonius came to write his biographies of the emperors, there was no lack of material for him to draw upon: everything from official inscriptions to garbled gossip. Shrewder analysts, though, when they sought to make sense of Augustus and his heirs, could recognise at the heart of the dynasty's story a darkness that mocked and defied their efforts. Once, back in the days of the Republic, affairs of state had been debated in public, and the speeches of Rome's leaders transcribed for historians to study; but with the coming to power of Augustus, all that had changed. 'For, from then on, things began to be done secretly, and in such a way as not to be made public.'[10] Yes, the old rhythms of the political year, the annual cycle of elections and magistracies that once, back in the days of the Republic, had delivered to ambitious Romans the genuine opportunity to sway their city's fate, still endured – but as a largely irrelevant sideshow. The cockpit of power lay elsewhere now. The world had come to be governed, not in assemblies of the great and good, but in private chambers. A woman's whisperings in an emperor's ear, a document discreetly passed to him by a slave: either might have a greater impact than even the most ringing public oration. The implication, for any biographer of the Caesars, was grim but inescapable. 'Even when it comes to notable events, we are in the dark.'[11]

The historian who delivered this warning, although a close contemporary of Suetonius, was immeasurably his superior as a pathologist of autocracy – indeed, perhaps the greatest there has ever been. Cornelius Tacitus could draw on an intimate understanding of how Rome and her empire functioned. Over the course of a glittering career, he had spoken in the law courts, governed provinces, and held the highest magistracies to which

a citizen could aspire; but he had also demonstrated a canny, if inglorious, instinct for survival. The dynasty that ruled Rome as he came of age was no longer that of Augustus, which had expired amid a welter of blood back in AD 68 – but it was potentially no less murderous for that. Rather than stand up to its exactions, Tacitus had opted to keep his head down, his gaze averted. The crimes of omission in which he felt himself complicit seem never entirely to have been cleansed from his conscience. The more he came to stand at a distance from public life, the more obsessively he sought to fathom the depths of the regime under which he was obliged to live, and to track how it had evolved. First he narrated the events of his own youth and adulthood; and then, in his final and greatest work, a history that has been known since the sixteenth century as *The Annals*, he turned his gaze back upon the dynasty of Augustus. Augustus himself, and his fateful primacy, Tacitus chose to analyse only in the most oblique manner: by focusing, not upon the man himself, but rather upon his heirs. Four Caesars in succession accordingly took centre stage: first Tiberius; then Caligula; then Caligula's uncle, Claudius; and finally, the last of the dynasty to rule, Augustus's great-great-grandson, Nero. His death it was that marked the end of the line. Again and again, membership of the imperial family had been shown to come at fatal cost. By AD 68, not a single descendant of Augustus remained alive. Such was the measure of the story that Tacitus had to tell.

And of something else as well: the challenge of telling the story at all. Mordantly, in the first paragraph of *The Annals*, Tacitus spelt out the problem. 'The histories of Tiberius and Caligula, of Claudius and Nero, were falsified while they remained alive out of dread – and then, after their deaths, were composed under the influence of still festering hatreds.'[12] Only the most diligent research, the most studied objectivity, would do. Painstaking in his efforts to study the

official records of each emperor's reign, Tacitus made equally sure never to take them on trust.* Words, under the Caesars, had become slippery, treacherous things. 'The age was a tainted one, degraded by its sycophancy.'[13] The bleakness of this judgement, bred as it was of personal experience, ensured that Tacitus's bitter scepticism ended up corroding all that it touched. In *The Annals*, not a Caesar who claimed to be acting in the best interests of the Roman people but he was a hypocrite; not an attempt to stay true to the city's traditions but it was a sham; not a fine-sounding sentiment but it was a lie. Rome's history is portrayed as a nightmare, haunted by terror and shadowed by blood, from which it is impossible for her citizens to awake. It is a portrait of despotism that many subsequent generations, witnessing the dimming of their own liberties, have not been slow to recognise. Wherever a tyranny has been planted on the ruins of a previously free order, and whenever specious slogans have been used to mask state-sanctioned crimes, it has been remembered. The dynasty of Augustus still defines the look of autocratic power.

That it should so haunt the public imagination comes, then, as little surprise. When people think of imperial Rome, it is the city of the first Caesars that is most likely to come into their minds. There is no other period of ancient history that can compare for sheer unsettling fascination with its gallery of leading characters. Their lurid glamour has resulted in them becoming the very archetypes of feuding and murderous dynasts. Monsters such as we find in the pages of Tacitus and Suetonius seem sprung from some fantasy novel or TV box-set: Tiberius, grim, paranoid, and with a taste for having his testicles licked by young boys in swimming pools; Caligula, lamenting that the Roman people did not have a single neck, so that he might

* The recent discovery in Spain of a decree issued under Tiberius has shed intriguing light on Tacitus's methods. There can be no doubt that he had detailed knowledge of its wording; nor that he fully appreciated the degree to which it expressed, not the truth, but rather what those who had composed it wished to be taken for the truth.

cut it through; Agrippina, the mother of Nero, scheming to bring to power the son who would end up having her murdered; Nero himself, kicking his pregnant wife to death, marrying a eunuch, and raising a pleasure palace over the fire-gutted centre of Rome. For those who like their tales of dynastic back-stabbing spiced up with poison and exotic extremes of perversion, the story might well seem to have everything. Murderous matriarchs, incestuous power-couples, down-trodden beta males who nevertheless end up wielding powers of life and death: all these staples of recent dramas are to be found in the sources for the period. The first Caesars, more than any comparable dynasty, remain to this day household names. Their celebrity holds.

All of which, it is as well to admit, can be a cause of some embarrassment to historians of the period. Tales of poison and depravity, precisely because so melodramatic, have a tendency to make them feel uncomfortable. The more sensational a story, after all, the less plausible it is liable to seem. The truth of the allegations laid against the Julio-Claudians – as the dynasty of Augustus is conventionally known by scholars – has for this reason long provoked disagreement. Could Caligula, for instance, really have been as mad as Suetonius and other ancient authors claimed? Perhaps, rather than insane, his more flamboyant stunts had simply been garbled in the transmission? Was it possible, for instance, that behind the seeming lunacy of his order to pick up seashells there was in fact a perfectly rational explanation? Many scholars have suggested as much. Over the years, numerous theories have been proposed. Perhaps – although no source mentions it – there had been a mutiny, and Caligula was looking to punish his soldiers by giving them some demeaning task? Or maybe he wanted them to look for pearls, or else for shells that he could then use to ornament water features? Or perhaps *concha*, the Latin word for 'shell', was in fact being used by Caligula to signify something quite different: a kind of boat, or even the genitals of a whore? Any of these suggestions are possible; none of them is definitive. Like a vivid dream,

the episode seems haunted by the sense of some unfathomable logic, some meaning that all our efforts to understand it are doomed never quite to grasp. Such is often the frustration of ancient history: that there are things we will never know for certain.

None of which need necessarily be cause for despair. Known unknowns are not without their value to the historian of the first Caesars. The question of what precisely Caligula might have been getting up to on that Gallic beach will never be settled decisively; but what we do know for certain is that Roman historians did not feel that it particularly needed an explanation. They took for granted that ordering soldiers to pick up shells was the kind of thing that a bad, mad emperor did. The stories told of Caligula – that he insulted the gods, that he took pleasure in cruelty, that he revelled in every kind of sexual deviancy – were not unique to him. Rather, they were a part of the common stock of rumour that swirled whenever a Caesar offended the proprieties of the age. 'Leave ugly shadows alone where they lurk in their abyss of shame':[14] this po-faced admonition, delivered by an anthologist of improving stories during the reign of Tiberius, was one that few of his fellow citizens were inclined to follow. They adored gossip far too much. The anecdotes told of the imperial dynasty, holding up as they do a mirror to the deepest prejudices and terrors of those who swapped them, transport us to the heart of the Roman psyche. It is why any study of Augustus's dynasty can never simply be that, but must also serve as something more: a portrait of the Roman people themselves.

It is also why a narrative history, one that covers the entire span of the Julio-Claudian period, offers perhaps the surest way of steering a path between the Scylla of flaccid gullibility and the Charybdis of an overly muscle-bound scepticism. Clearly, not all stories told about the early Caesars are to be trusted; but equally, many of them do provide us with a handle on what most probably inspired them. Anecdotes that can seem utterly fantastical when read in isolation often appear

much less so with the perspective that a narrative provides. The evolution of autocracy in Rome was a protracted and contingent business. Augustus, although ranked by historians as the city's first emperor, was never officially instituted as a monarch. Instead, he ruled by virtue of rights and honours voted him in piecemeal fashion. No formal procedure ever existed to govern the succession; and this ensured that each emperor in turn, on coming to power, was left with little option but to test the boundaries of what he could and could not do. As a result, the Julio-Claudians presided over one long continuous process of experimentation. That is why I have chosen in this book to trace the entire course of the dynasty, from its foundation to its final bloody expiration. The reign of each emperor is best understood, not on its own terms, but in the context of what preceded and followed it.

And all the more so because the study of the period, as is invariably the case with ancient history, can sometimes resemble the frustration of listening to an old-fashioned car radio, with various stations forever fading in and out of audibility. If only, for instance, we had the account by Tacitus of Caligula's actions on that beach by the Channel – but alas, we do not. Everything that *The Annals* had to report about the years between the death of Tiberius and the halfway stage of Claudius's reign has been lost. That Caligula, the most notorious member of his dynasty, should also be the Julio-Claudian for whose reign the sources are the patchiest is almost certainly not a coincidence. Although two thousand years of repetition might give us the impression that the narrative of the period has long since been settled, in many cases it has not. It remains as important, when studying ancient history, to recognise what we do not know as to tease out what we do. Readers should be aware that much of the narrative of this book, like the pontoon bridge that Caligula once built between two promontories in the Bay of Naples, spans turbulent depths. Controversy and disagreement are endemic to the study of the period. Yet this, of course, is precisely its fascination. Over the past few decades, the range and vitality of

scholarly research into the Julio-Claudians have revolutionised our understanding of their age. If this book manages to give readers even a flavour of how exciting it is to study Rome's first imperial dynasty, then it will not have failed in its aim. Two millennia on, the West's primal examples of tyranny continue to instruct and appal.

'Nothing could be fainter than those torches which allow us, not to pierce the darkness, but to glimpse it.'[15] So wrote Seneca, shortly before his death in AD 65. The context of his observation was a shortcut that he had recently taken while travelling along the Bay of Naples, down a gloomy and dust-choked tunnel. 'What a prison it was, and how long. Nothing could compare with it.' As a man who had spent many years observing the imperial court, Seneca knew all about darkness. Caligula, resentful of his brilliance, had only narrowly been dissuaded from having him put to death; Claudius, offended by his adulterous affair with one of Caligula's sisters, had banished him to Corsica; Agrippina, looking for someone to rein in the vicious instincts of her son, had appointed him Nero's tutor. Seneca, who would ultimately be compelled by his erstwhile student to slit his own veins, had no illusions as to the nature of the regime he served. Even the peace that it had brought the world, he declared, had ultimately been founded upon nothing more noble than 'the exhaustion of cruelty'.[16] Despotism had been implicit in the new order from its very beginning.

Yet what he detested Seneca also adored. Contempt for power did not inhibit him from revelling in it. The darkness of Rome was lit by gold. Two thousand years on, we too, looking back to Augustus and his heirs, can recognise in their mingling of tyranny and achievement, sadism and glamour, power-lust and celebrity, an aureate quality such as no dynasty since has ever quite managed to match.

'Caesar and the state are one and the same.'[17]

How this came to be so is a story no less compelling, no less remarkable and no less salutary than it has ever been these past two thousand years.

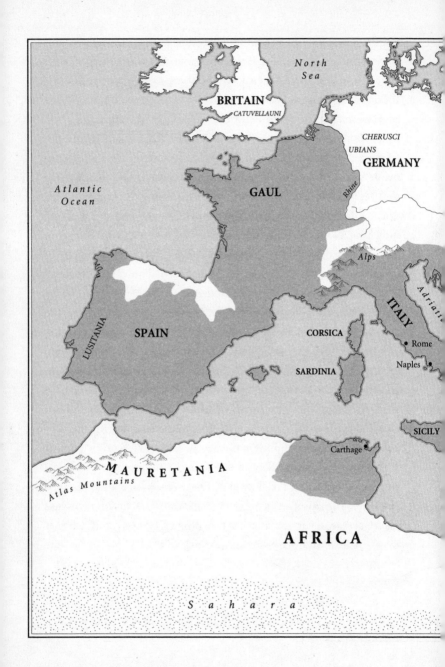

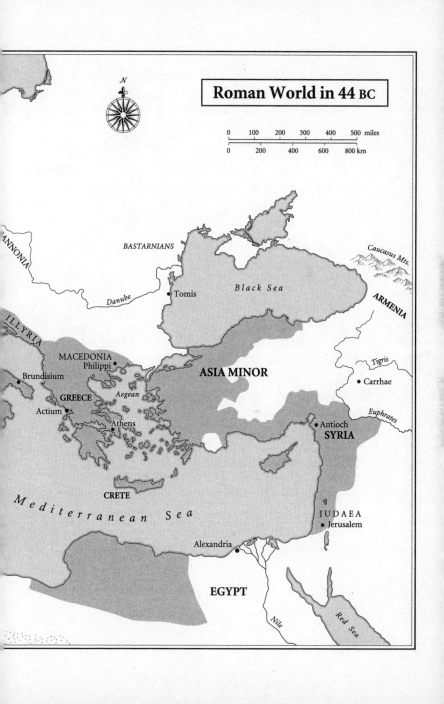

Roman World in 44 BC

0 100 200 300 400 500 miles
0 200 400 600 800 km

N

PANNONIA

BASTARNIANS

Danube

Tomis

Black Sea

Caucasus Mts.

ARMENIA

ILLYRIA

MACEDONIA
Philippi

Brundisium

GREECE

Actium

Aegean

Athens

ASIA MINOR

Tigris

Carrhae

Euphrates

Antioch
SYRIA

CRETE

M e d i t e r r a n e a n S e a

JUDAEA
Jerusalem

Alexandria

EGYPT

Nile

Red Sea

Guard, preserve and protect the way things now stand: the peace we enjoy, and our emperor. And when he has done his duty, after a life that I pray may be as long as possible, grace him with successors whose shoulders will prove as sufficient to support the burden of our global empire as we have found his to be.

— Velleius Paterculus (c. 20 BC–c. AD 31)

The stain of the wrongs committed back in ancient times by these men
Will never fade from the history books. Until the very end of time,
The monstrous deeds of the House of Caesar will stand condemned.

— Claudian (c. AD 370–404)

I

PADRONE

1

CHILDREN OF THE WOLF

The Making of a Superpower

The story of Rome began with a rape. A princess, a consecrated virgin, was surprised and ravished. Various accounts were given of the fateful assault. Some said that it happened in her sleep, when she dreamed that a man of miraculous beauty led her down to a shady river bank, and abandoned her there lost and alone. Others claimed that she was seized in the middle of a thunderstorm, while collecting water from a sacred grove. One story even told of a mysterious phallus which sprang up from the ashes of the royal hearth and took, not the princess, but her slavegirl. All were agreed, though, on the resulting pregnancy; and most – a few curmudgeonly revisionists aside – had no doubt that the rapist was a god.[*] Mars, the Spiller of Blood, had planted his seed in a mortal womb.

Two god-like boys were duly born of the rape. These twins, the offspring of their mother's shame, had no sooner been delivered than they were dumped into a nearby river, the Tiber. Still the wonders

[*] Two historians, Marcus Octavius and Licinius Macer, claimed that the rapist had been the girl's uncle, who then, 'to conceal the result of his criminal action', killed his niece, and handed her newborn twins over to the swineherd.

did not cease. Swept along on the floodwaters of the river, the box to which the two babies had been consigned eventually ran aground below a steep hill named the Palatine. There, in the mouth of a cave, beneath the dripping, fruit-laden branches of a fig tree, the twins were discovered by a she-wolf; and the wolf, rather than devouring them, licked them clean of mud and offered their hungry mouths its teats. A passing swineherd, witnessing this miraculous scene, came clambering down the slopes of the Palatine to their rescue. The she-wolf slunk off. The two boys, rescued by the swineherd and given the names Remus and Romulus, grew up to become peerless warriors. In due course, standing on the Palatine, Romulus had seen twelve eagles: a sure sign from the gods that he should found, there on the summit of the hill, the city which ever afterwards bore his name. It was he who ruled Rome as its first king.

This, at any rate, was the story told centuries later by the Roman people to explain the origins of their city, and the sheer glorious scale of their martial achievements. Foreigners, when they learnt of it, certainly found it all too plausible. That Romulus had been fathered by Mars, the god of war, and suckled by a she-wolf appeared – to those brought into bruising contact with his descendants – to explain much about the Roman character.[1] Even a people like the Macedonians, who under Alexander the Great had themselves conquered a vast empire, almost to the rising of the sun, knew that the Romans were a breed of men quite unlike any other. One brief, opening skirmish, fought to indecisive effect in 200 BC, had been enough to bring this home. Five centuries and more had passed since the age of Romulus – and yet there still clung to the Romans, so it appeared to their opponents, something of the chilling quality of creatures bred of myth. The Macedonians, retrieving their dead from the battlefield, had been appalled by the shambles they discovered there. Bodies mutilated and dismembered by Roman swords had soaked the earth with blood. Arms with the shoulders still attached, severed heads,

reeking puddles of viscera: all bore witness to a pitch of violence more bestial than human. No blaming the Macedonians, then, for the panic they had felt that day, 'when they discovered the kind of weapons and the order of men they had to face'.[2] A dread of lycanthropes, after all, was only natural in civilised people. The wolvish nature of the Romans, the hint of claws beneath their fingernails and of a yellow stare behind their eyes, was one that people across the span of the Mediterranean, and far beyond, had learned to take for granted. 'Why, they admit themselves that their founders were suckled on the milk of a she-wolf!' Such was the desperate rallying cry of one king before his realm too was dragged down to ruin. 'It is only to be expected that they should all of them have the hearts of wolves. They are inveterately thirsty for blood, and insatiable in their greed. Their lusting after power and riches has no limits!'[3]

The Romans themselves, of course, saw things rather differently. It was the gods, they believed, who had granted them their mastery of the world. The genius of Rome was for rule. Yes, there might be those who excelled in other fields. Who, for instance, could rival the Greeks when it came to the shaping of bronze or marble, the mapping of the stars or the penning of sex manuals? Syrians were pre-eminent as dancers; Chaldaeans as astrologers; Germans as bodyguards. Only the Roman people, though, possessed the talents sufficient to conquer and maintain a universal empire. Their achievements brooked no argument. When it came to the sparing of the subjected, and the crushing of the haughty, they reigned supreme.

The roots of this greatness, so they believed, reached back to their very beginnings. 'The affairs of Rome are founded upon her ancient customs and the quality of her men.'[4] From the earliest days, the measure of the city's prowess had been the readiness of her citizens to sacrifice everything in the cause of the common good – even their lives. Romulus, building a wall around his foundation and ploughing a furrow, the *pomerium*, to hallow all that lay within it as ground

sacred to Jupiter, king of the gods, had known that more was needed to render Rome truly inviolable. So Remus, his twin, had willingly offered himself up as a human sacrifice. Jumping across the boundary, he had been struck down with a shovel; 'and thereby, with his death, he had consecrated the fortifications of the new city'.[5] The primal earth and mortar of Rome had been fertilised by the blood of the war god's son.

Remus was the first to die for the good of the city – but certainly not the last. Five kings followed Romulus on the throne of Rome; and when the sixth, Tarquin the Proud, proved himself a vicious tyrant more than deserving of his nickname, his subjects put their lives on the line and rose in rebellion. In 509 BC, the monarchy was ended for good. The man who had led the uprising, a cousin of Tarquin's named Brutus, obliged the Roman people to swear a collective oath, 'that they would never again allow a single man to reign in Rome'. From that moment on, the word 'king' was the dirtiest in their political vocabulary. No longer subjects, they ranked instead as *cives*, 'citizens'. Now, at last, they were free to show their mettle. 'They began to walk taller, and to display their abilities to full advantage – for it is the nature of kings that they will hold good men in more suspicion than the bad, and dread the talents of others.'[6] No longer was there any need, in a city liberated from the jealous gaze of a monarch, to veil its citizens' yearning for glory. The measure of true achievement had become the praise of the Roman people. Even the humblest peasant, if he were not to see himself reflected in the mirror of his fellows' scorn, was obliged to shoulder his duties as a citizen, and prove himself a man – a *vir*.

Virtus, the quality of a *vir*, was the ultimate Roman ideal, that lustrous fusion of energy and courage which the Romans themselves identified as their chiefest strength. Even the gods concurred. In 362 BC, a century and a half after the downfall of Tarquin the Proud, a terrifying portent afflicted the centre of Rome. Below the Palatine,

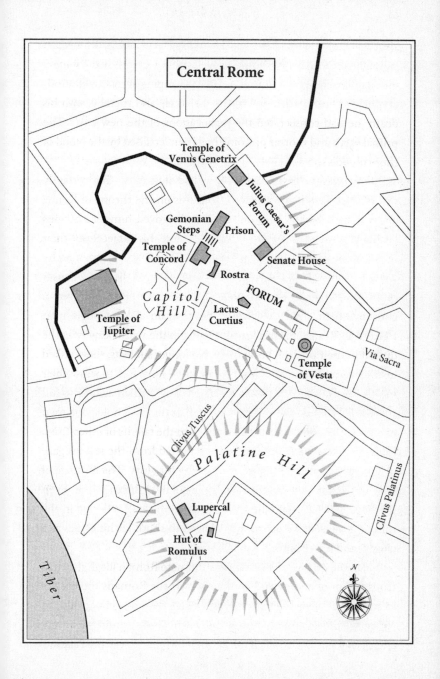

Central Rome

Temple of
Venus Genetrix

Julius Caesar's
Forum

Gemonian
Steps

Prison

Temple of
Concord

Senate House

Rostra

FORUM

Capitol
Hill

Lacus
Curtius

Temple of
Jupiter

Temple
of Vesta

Via Sacra

Clivus Tuscus

Palatine Hill

Clivus Palatinus

Lupercal

Hut of
Romulus

Tiber

N

in the level expanse of paved ground known as the Forum, a great chasm opened up. Nothing could have been more calculated to strike terror into Roman hearts. The Forum was the very hub of civic life. It was where statesmen addressed the people, where magistrates dispensed justice, where merchants hawked their goods, and where virgins consecrated to the service of Vesta, the goddess of the hearth, tended an eternal flame. That a gateway to the underworld had opened up in a place so fundamental to Roman life clearly betokened something terrible: the anger of the gods.

And so it proved. A sacrifice was demanded: 'the most precious thing you possess'.[7] What, though, was Rome's most precious possession? The question provoked much scratching of heads – until at length a young man named Marcus Curtius spoke up. Manliness and courage, he told his fellow citizens, were the greatest riches possessed by the Roman people. Then, arrayed in full armour, he climbed onto his horse, spurred it forward and made straight for the abyss. Over its edge he galloped. He and his horse plunged together into its depths. The chasm duly closed. A pool and a single olive tree were left to mark the spot, abiding memorials to a citizen who had perished that his fellows might live.

So highly did the Roman people prize this ideal of the common good that their name for it – *res publica* – served as shorthand for their entire system of government. It enabled the blaze of an individual citizen's longing for honour, his determination to test body and spirit in the crucible of adversity and emerge from every ordeal triumphant, to coexist with an iron sense of discipline. The consequences of this, for the Republic's neighbours, were invariably devastating. By 200 BC, when the Macedonians experienced for the first time the wolf-like savagery of which the legions were capable, Rome was already mistress of the western Mediterranean. Two years previously, her armies had delivered a knockout blow to the one power that had presumed to rival her for the title: a metropolis of merchant-princes

on the coast of North Africa by the name of Carthage. Rome's victory had been an epochal triumph. The death struggle between the two cities had lasted, on and off, for over sixty years. In that time, war had reached the gates of Rome herself. Italy had been soaked in blood. 'The convulsive turmoil of the conflict had brought the whole world to shake.'[8] Ultimately, though, after a trial that would have seen any other people suing desperately for terms, the victors had emerged so battle-hardened as to seem forged of iron. Small surprise, then, that even the heirs of Alexander the Great should have found the legions impossible to withstand. King after king in the eastern Mediterranean had been brought to grovel before Roman magistrates. Weighed against a free and disciplined republic, monarchy seemed to have been found decisively wanting. 'Our emotions are governed by our minds.' So the ambassadors of one defeated king were sternly informed. 'These never alter – no matter what fortune may bring us. Just as adversity has never brought us low, so have we never been puffed up by success.'[9]

The man who spoke these words, Publius Cornelius Scipio, was certainly in a position to know. He was the epitome of success. His nickname, 'Africanus', bore stirring witness to his role as the conqueror of Rome's deadliest foe. It was he who had wrested Spain from the Carthaginians, defeated them in their own backyard, and then brought them to accept the most abject terms. A few years later, on the state roll of citizens, the name of Scipio appeared resplendent at the top of the list. This, in a society such as Rome's, was an honour like no other. Hierarchy was a defining obsession of the Roman people. All were officially graded according to a sliding scale of rank. The status of a citizen was calibrated with severe precision. Wealth, family and achievement combined to pinpoint precisely where, within the exacting class system of the Republic, each and every Roman stood. Even at the summit of society, status was ferociously patrolled. The highest-ranking citizens of all were enrolled in their

own exclusive order: the Senate. This required of its members, in addition to riches and social standing, a record of service as magistrates sufficient to qualify them to be the arbiters of Rome's destiny. So sensitive, and so influential, were their deliberations that 'for many centuries not a senator breathed a word of them in public'.[10] As a result, unless a statesman could make his voice heard among their counsels, he might just as well have been dumb. Yet the right of a senator to speak to his fellows was not a given. The men called first in debate were always those who, by virtue of their pedigree, their moral standing and their service to the state, had accumulated the greatest prestige. *Auctoritas*, the Romans termed this quality – and the Republic, by placing Scipio first on the roll of its citizens, was granting its backing to the prodigious heft of his authority. The conqueror of Carthage had, by universal consent, 'attained a unique and dazzling glory'.[11] Even among the ranks of Rome's highest achievers, Scipio Africanus was acknowledged to have no rival. He was *Princeps Senatus*, 'the First Man of the Senate'.

Yet in this primacy lurked peril. The shadow cast by Scipio over his fellow citizens was one that could not help but provoke resentment. The guiding principle of the Republic remained what it had always been: that no one man should rule supreme in Rome. To the Roman people, the very appearance of a magistrate served as a reminder of the seductions and dangers of monarchy. The purple that lined the border of his toga had originally been the colour of kingship. 'Lictors' – bodyguards whose duty it was to clear a path for him through the crowds of his fellow citizens – had once similarly escorted Tarquin the Proud. The rods and single axe borne by each lictor on his shoulder – the *fasces*, as they were known – symbolised authority of an intimidatingly regal scope: the right to inflict both corporal and capital punishment.* Power of this order was an awesome and

* Lictors did not carry the axe within the limits of Rome itself. This symbolised the right of citizens to appeal against capital convictions.

treacherous thing. Only with the most extreme precautions in place could anyone in a free republic be trusted to wield it. This was why, in the wake of the monarchy's downfall, the powers of the banished king had been allocated, not to a single magistrate, but to two: the consuls. Like a strong wine, the splendour of the consulship, and the undying glory that it brought to those who won it, required careful prior dilution. Not only could each consul be relied upon to keep a watchful eye upon the other, but the term of a consulship was set at a single year. The prestige enjoyed by Scipio, though, dazzled in defiance of any such limits. Even the grandest of the Republic's elected magistrates were liable to find themselves diminished before it. The Senate House, as a result, began to sound with mutterings against the Princeps.

The truth was that glamour, in the Republic, had always been regarded with deep suspicion. Crow's feet and flintiness of manner were what the Roman people expected of their statesmen. The very word 'senator' derived from the Latin for 'old man'. The meteor of Scipio's career, though, had blazed from a scandalously youthful age. He had been appointed to the command against the Carthaginians in Spain when he was only twenty-six. He had won his first consulship a mere five years later. Even his elevation to the rank of *Princeps Senatus* had come at an age when other senators, far below him in the foothills of achievement, were still scrabbling after junior magistracies. Forging a dashing career of conquest before the jowls had begun to sag was, of course, what Alexander had so ringingly accomplished. Resentful senators were hardly reassured by this reflection. Alexander, after all, had been a foreigner – and a king. Renowned as he was for the god-like scale of his ambitions, it was unsettling to many senators that the self-promotion of such a troubling figure should have been aped by one of their own. Scipio, it was claimed, had been fathered on his mother by a snake; had won his victory in Spain thanks to the timely assistance of a god; had only to cross the Forum

late at night for dogs to cease to bark. Princeps he may have been, but stories such as these implied a status that was off the scale.

And as such, intolerable. In 187 BC, when Scipio returned from a campaign in the East, his enemies were waiting for him. He was charged with embezzlement. Ripping up his account books before the full gaze of the Senate, Scipio indignantly reminded his accusers of all the treasure that he had won for Rome. It made no difference. Rather than risk the humiliation of conviction, the Princeps retired for good to his country estate. There, in 183 BC, he died a broken man. The fundamental principle of political life in the Republic had been brutally illustrated: 'that no one citizen should be permitted an eminence so formidable that it prevents him from being questioned by the laws'.[12] Even a man as great as Scipio Africanus had found it impossible, in the final reckoning, to argue with that.

Wolf-bred the Romans may have been – but the future of the Republic, and of its liberties, appeared secure.

The Great Game

Or was it?

Scipio had submitted to the laws of the Republic – that much was true. Nevertheless, the sheer potency of his charisma hinted that the advance of the Republic to superpower status might not be without its pitfalls. Scipio's opponents had prided themselves on an obdurate provincialism. They took for granted that Rome's ancient customs were the best. Already, though, the limits of such conservatism were becoming apparent. Scipio was merely an outrider. The increasing tangle of Rome's diplomatic commitments, the incomparable proficiency of her legions, and her refusal to tolerate so much as a suggestion of disrespect combined to present her leading citizens with temptations of literally global scope. A century and more after

the death of Scipio, the new darling of the Roman people had won for himself wealth and celebrity beyond the wildest dreams of earlier generations. Pompeius Magnus – 'Pompey the Great' – could boast a career that had fused illegality and self-aggrandisement to sensational effect. At the age of twenty-three, he had raised his own private army. A series of glamorous and lucrative commands had followed. Not for the man once nicknamed 'the youthful butcher'[13] the grind of a conventional career. Startlingly, he managed to win his first consulship – at the tender age of thirty-six – without ever having joined the Senate.

Even worse outrages were to follow. The proprieties of the Republic were trampled down in cavalier fashion. In 67 BC, Pompey was given a command that, for the first time, embraced the entire Mediterranean. A year later, he went one better by obtaining for himself *carte blanche* to impose direct rule over vast swathes of enticingly unannexed territory. The eastern reaches of Asia Minor, as the Romans called what is now Turkey, and the whole of Syria were gobbled up. Pompey was hailed as 'The Conqueror of all Nations'.[14] When he finally returned to Italy, in 62 BC, he came trailing more than glory in his wake. Kings were his clients and kingdoms his to milch. His legions owed their loyalty, not to the Republic, but to the man who had enabled them to asset-strip the East: their triumphant general, their *imperator*. As for Pompey himself, he had no time for false modesty: riding through the streets of Rome, he posed and preened in the cloak of Alexander the Great.

No one, not even the most embittered conservative, could deny his pre-eminence. 'One and all acknowledge his unrivalled status as Princeps.'[15] Unlike Scipio, Pompey did not owe this title to any vote of the Senate. Instead, like the incense he had brought back in groaning wagon trains from the East, his *auctoritas* hung dense over Rome, perfumed and intangible. The length and scope of Pompey's campaigning had made a mockery of the traditional rhythms of

political life in the Republic. The prospect of sharing his commands with a colleague, or of having them limited to a single year at a time, had never crossed his mind. What was the Senate, that it should hobble 'the tamer of the world'?[16] Pompey had secured his victories, not despite, but because of his criminality. The implications were unsettling in the extreme. Laws that had served Rome well in the days of her provincialism were palpably starting to buckle now that she ruled the world. The same kings who crept and cringed in Pompey's train only served to demonstrate what dazzling pickings might be on offer to a citizen prepared to disdain the venerable safeguards against monarchy. Rome's greatness, long treasured by her citizens as the fruit of their liberty, now appeared to be menacing the Republic with the decay of its freedoms.

Except that Pompey, despite his muscle, had no wish to impose himself upon his fellow citizens at the point of a sword. Though he had always been greedy for power and fame, there were boundaries that even he flinched from crossing. A dominance that did not rest upon the approbation of his peers was a dominance not worth having. Military despotism was out of the question. Greatness, in the Republic, was nothing unless defined by the respect of the Senate and the Roman people. Pompey wanted it all. It was this that gave his enemies their chance. Though too intimidated by the resources available to the new Princeps to launch a prosecution against him, they could certainly deny him their co-operation. The result was paralysis. Pompey, to his shock and indignation, found his measures blocked in the Senate, his settlements left unratified, his achievements sneered at and dismissed. Politics as normal? So Pompey's enemies dared to hope. The one abiding constant of life in the Republic, it seemed, still held true. No one so overweening that he might not be taken down a peg or two.

A few of Pompey's chief rivals, though, when they studied the crisis afflicting their city, did so with a more pitiless and predatory

gaze. No less than their fellow senators, they were prompted by the spectacle of a fellow citizen holding the gorgeous East in fee to bitter emotions of jealousy and fear; but what they could also recognise in it was the dawning of an intoxicating new age of possibility. No longer was a mere consulship to be reckoned the summit of a Roman's ambition. Appetite was coming to exceed the capacity of the Republic's institutions to sate it. Prizes on a global scale now appeared tantalisingly within reach: 'the sea, the land, the course of the stars'.[17] All it needed was the nerve to reach out and seize them.

In 60 BC, as Pompey's enemies continued to snarl and snap at the heels of the great man, two of Rome's most formidable operators were plotting a manoeuvre of momentous audacity. Marcus Licinius Crassus and Gaius Julius Caesar were men whose envy of the Princeps was exceeded only by their determination to emulate him. Both had good cause to set their sights high. Crassus had long sat like a spider at the heart of a monstrous web. A proven general and a former consul, his *auctoritas* was nevertheless a thing of shadow as well as brilliance. Like Pompey, he had recognised that the surest wellsprings of power in Rome were no longer the traditional ones. Although perfectly at home on the stage of public life, his true genius was for pulling strings from behind the scenes. Rich beyond the dreams of anyone in Rome, and displaying consistency only in his infinite capacity for opportunism, Crassus had employed his seemingly inexhaustible wealth to ensnare an entire generation of men on the make. Most, once they accepted his credit, then found it impossible to clear the interest. It took a man of rare political talent to break free and emerge as a player in his own right.

Such a man was Caesar. In 60 BC, he was forty years old: the scion of an ancient but faded family, notorious for his profligate dandyism and massively in debt. No one, though, not even his enemies – of whom there were plenty – could deny his talents. Charm fused with ruthlessness, dash with determination, to potent effect. Although

clearly the inferior of Crassus, let alone Pompey, in terms of resour-
ces and reputation, what Caesar could offer the two men was a firm
grip on the official reins of power. In 59, he was due to serve as one
of the two elected consuls of the Republic. Clearly, with the com-
bined backing of Pompey and Crassus behind him, and with his own
ineffable qualities of cool and resolve to draw upon, he would be
able – however illegally – to neutralise his consular colleague. The
consulship would become, in effect, that of 'Julius and Caesar'.[18] He
and his two allies would then be able to ram through a whole hit-list
of measures. Pompey, Crassus, Caesar: all were likely to profit splen-
didly from their three-headed partnership.

And so it proved. Subsequent generations would distinguish in the
birth of this 'triumvirate' a development as fateful as it was ominous:
'the forging of a conspiracy to take captive the Republic'.[19] In truth,
the three dynasts were doing nothing that political heavyweights
had not been busy at for centuries. Business had always been con-
ducted in Rome by the fashioning of alliances, the doing-down of
rivals. Nevertheless, the consulship of Julius and Caesar did indeed
constitute a fatal waymark in her history. When Caesar's heavies
emptied a bucket of shit over the rival consul, beat up his lictors, and
strong-armed the wretched man into effective retirement, it heralded
a year of illegalities so blatant that no conservative would ever forget
or forgive them. That the deals forced through by Caesar served the
interests of his two allies quite as much as his own did not prevent
the consul himself from being held principally to blame. His foes were
now viscerally committed to his destruction. Caesar, no less passion-
ately, was committed to the pursuit of greatness.

Understandably, then, he had made sure while still consul to book
for himself the most splendid insurance policy possible: a governor-
ship of tremendous scope. In the spring of 58, Caesar headed north
to take command of three whole provinces: one in the Balkans, one
directly on the northern frontier of Italy, and one on the far side of

the Alps, in southern Gaul. Here, he could reckon himself secure from his enemies. It was forbidden for any magistrate of the Roman people to be brought to trial – and Caesar's term as governor had been set at a constitutionally outrageous five years. In due course, it would end up double that.

The junior partner of Pompey and Crassus Caesar may have been – but neither had succeeded in leveraging their alliance to more promising effect than the new governor of Gaul. A decade's worth of immunity from prosecution was only the start. Equally priceless were the opportunities offered for glory-hunting. Beyond the Alps, and the limits of Roman power, lay the wilds of *Gallia Comata*, 'Long-Haired Gaul'. Here dwelt teeming hordes of barbarians: spike-haired, semi-nude warriors much given to sticking the heads of their ene-mies on posts and downing their liquor neat. For centuries, they had embodied the Republic's darkest nightmares; but Caesar – boldly, brilliantly, illegally – had no sooner arrived in Gaul than he was look-ing to conquer the lot. His campaigns were on a devastating scale. A million people, so it was said, perished over their course. A million more were enslaved. For a decade, blood and smoke were general over Gaul. By the end of Caesar's term as governor, all the tribes, from the Rhine to the Ocean, had been broken upon his sword. Even the Germans and the Britons, savages on the edge of the world whose prowess was as proverbial as it was exotic, had been taught respect for Roman arms. Meanwhile, back in the capital, Caesar's fellow citizens thrilled to the lavishness of their new hero's generosity, and to the sensational news of his exploits. Caesar himself, rich in fame and plunder, and with an army of battle-seasoned legions at his back, had won for himself by 50 BC an *auctoritas* fit to rival that of Pompey. His enemies in the Senate, counting down the days until he finally relinquished his governorship, knew now more than ever that they could not afford to miss their chance.

To Caesar, the conqueror of Gaul, the prospect of being harried

through law courts by a crew of pygmies was intolerable. Rather than suffer such a humiliation, his intention was to move seamlessly from provincial command to a second consulship. To achieve this, though, he would need allies – and much had changed during his absence from Rome. The triumvirate had only ever been as strong as its three legs – and, by 50 BC, one of those legs was gone. Four years earlier, Crassus had left for Syria. Desperate to follow the trail blazed by Pompey and Caesar, he had secured a command against the Parthians, the one people in the Near East still presumptuous enough to defy Roman hegemony. The expedition had promised pickings splendid enough to satisfy even Rome's most notoriously avaricious man. The Parthians ruled an empire that was fabulously wealthy. It stretched from the Indian Ocean, that 'pearl-bearing sea',[20] to the uplands of Persia, where, it was confidently reported, there stood a mountain made entirely of gold, to Mesopotamia, where untold luxuries – silks, and perfumes, and aromatic drinking-cups – were available in its teeming markets.

Unfortunately, though, the Parthians were not only rich, but underhand. Rather than stand and fight, they preferred to shoot arrows from horseback, repeatedly wheeling and retreating as they did so. The invaders, ponderous and sweaty, had found themselves helpless against this womanish tactic. In 53 BC, trapped on a baking plain outside the Mesopotamian border town of Carrhae, Crassus and thirty thousand of his men had been wiped out. The eagles, silver representations of the holy bird of Jupiter which served each legion as its symbol and its standard, had fallen into enemy hands. Together with Crassus's head, they had ended up as trophies at the Parthian court. To dare, it turned out, was not always to win.

As for Rome, the damage inflicted upon her by the defeat at Carrhae was even more grievous than had at first appeared. A body-blow had been struck which threatened the stability of the entire Republic. With Crassus gone, the field of players in the great game of Roman

politics had narrowed at a perilous moment. It was not only conservatives, resolved to preserve the fabric of the state's functioning and its traditions, who felt threatened by the brilliance of Caesar's achievements. So too did his surviving triumviral partner, Pompey the Great. As Caesar and his enemies in Rome manoeuvred with increasing desperation for advantage, both were in direct competition for the support of the Princeps. This, although it played to the great man's vanity, also left him feeling subtly diminished. Caesar or Caesar's enemies: the terms of the most excruciating choice that Pompey had ever been obliged to make were being defined for him by his erstwhile junior partner. That being so, the rupture between the two men was, perhaps, in the final reckoning, inevitable. In December of 50 BC, when one of the two consuls for the year travelled to Pompey's villa outside Rome, presented him with a sword, and charged him to wield it against Caesar in defence of the Republic, Pompey replied that he would – 'if no other way can be found'.[21] This reply alone helped to ensure that it would not. Caesar, given the choice whether to submit to the law and surrender his command, or to stand firm in defence of his *auctoritas* and declare civil war, barely hesitated. Not for him the self-restraint of a Scipio. On 10 January, 49 BC, he and one of his legions crossed the Rubicon, a small river that marked the frontier of his province with Italy. The die was cast. 'The kingdom was divided by the sword; and the fortune of the imperial people, who had the sea, the land and the whole world in their possession, was inadequate for two.'[22]

Holding Out for a Hero

The aptitude of the Roman people for killing, which had first won them their universal dominion, was now unleashed upon themselves. Legion fought with legion, 'and the world itself was maimed'.[23]

The war launched by Caesar's crossing of the Rubicon would last for more than four years and sweep from one end of the Mediterranean to the other. Not even the defeat of Pompey in open battle, and his subsequent murder and decapitation while on the run from his victorious rival, could bring the conflict to an end. From Africa to Spain, the killing went on. Pompey, 'his powerful trunk left headless on a beach',[24] was only the most prominent of the multitudes consigned to foreign dust. The inheritance of tradition and law that had once joined the Roman people in a shared unity of purpose meant nothing to soldiers who now looked for reward, not to antique notions of the common good, but to the commander who rode at their head. Captives were flung from walls or else had their hands cut off. The corpses of freshly slaughtered Romans were used by other Romans to build ramparts. Legionaries, as though they were mere Gauls, set the heads of their countrymen on pikes. To such a pass had the bonds of citizenship come.

That rival wolfpacks should have fallen to savaging one another came as no great surprise to those across whose lands they were snapping and snarling. Provincials had long had their own take on the origins of their masters. They understood better than the heirs of Romulus themselves what it meant to be bred of a wolf. Stories that to the Roman people had always been a cause of pride took on a very different light when seen through the eyes of the conquered. Hostile spin had increasingly served to blacken Rome's native traditions. It was said that Romulus, standing on the Palatine, had seen not eagles but vultures, passing on their way to feast on carrion; that the first Romans were 'barbarians and vagrants';[25] that Remus, rather than selflessly offering up his own life for the good of the city, had in fact been murdered by his brother. 'What sort of people, then, are the Romans?'[26] This question, long demanded by those who hated and feared them, was one to which the Romans themselves could no longer provide a confident answer. What if their enemies were right?

What if Romulus had indeed murdered his brother? What if it were the fate of the Roman people to repeat the primordial crime of their founder until such time as the anger of the gods had been satisfied, and all the world been drowned in blood? Fratricide, after all, was not easily appeased. Even soldiers brutalised by years of conflict knew that. In the spring of 45 BC, as Caesar advanced across the plains of southern Spain to confront the last of the armies still in the field against him, his men captured one of the enemy. The prisoner, it turned out, had slain his own brother. So revolted were the soldiers by this crime that they beat him to death with clubs. One day later, in a victory that finally ranked as conclusive, Caesar wrought such slaughter on his opponents that thirty thousand of his fellow citizens were left on the battlefield as food for flies.

The ruin inflicted on Rome, though, was not to be measured solely by the casualty figures. Untold damage had also been done to the vital organs of the state. Caesar himself, whose genius was of a thoroughly unsentimental nature, could recognise this more clearly than anyone. The Republic, he scoffed in an indiscreet moment, was 'a mere name – without form or substance'.[27] Nevertheless, even though he had made himself undisputed master of the Roman world, he was still obliged to tread carefully. The sensibilities of his fellow citizens were not lightly offended. Many, amid the tempest-wrack of the age, clung to the reassurance provided by their inheritance from the past like drowning men to flotsam.

On his return to Rome from the killing fields of Spain, Caesar duly opted to throw money at the problem. He wooed the Roman people with spectacular entertainments and the promise of *grands projets*. Public feasts were held at which thousands upon thousands of citizens were lavishly wined and dined; a cavalcade of elephants lumbered through the night with torches blazing on their backs; a plan was drawn up to reroute the Tiber. Meanwhile, Caesar worked to conciliate his enemies in the Senate – not so easily bought – with

flamboyant displays of forgiveness. His willingness to pardon opponents, to back them for magistracies and to flatter them with military postings was a thing of wonder even to his bitterest foes. He graciously ordered to be restored the same statues of Pompey which had been toppled and smashed by his partisans.

Yet there was, in this same exercise of clemency, more than a whiff of what made so many of his peers resent and detest him. Merciful he may have been – but mercy was properly the virtue of a master. Caesar felt no call to apologise for his dominance. Penetrating intelligence combined with the habits bred of long achievement and command to convince him that only he had the solving of what appeared otherwise an insoluble crisis. The traditions of the Republic, shot through as they were with the presumption that no one citizen should establish permanent supremacy over his fellows, were plainly difficult to square with this conviction. Caesar had not won himself the mastery of Rome only to share it now with men whom he despised. Accordingly, looking to veil what otherwise ran the risk of appearing nakedly despotic, he did what Roman policy-makers, no matter how radical or bold, had invariably done when faced with a challenge: he looked to the past. There, mouldering in the venerable lumber-box of the Republic, was to be found a precedent potentially well suited to Caesar's needs. Provision for a citizen to exercise supreme authority over the Roman people during a time of crisis did in fact already exist. *Dictator*, the post was called. Caesar duly dusted the office down. Only a single adjustment was required to tailor the dictatorship to his requirements: the antique scruple which decreed that no citizen be trusted with it for longer than six months naturally had to go. Already, before leaving for Spain, Caesar had been appointed to the position for ten years. Early in February 44, he went one better. By a decree of the Senate, he was appointed 'Dictator For Life'.

Here, for citizens hopeful that the antique virtues of their

people might be renewed, and the wounds of civil war healed, was a portentous and chilling moment. Functional Caesar's new office may have been – but that was precisely what rendered it so ominous. It was not only the Dictator's peers, their prospects of attaining the political heights now definitively blocked until such time as Caesar should die or be removed, who were liable to find it baneful. So too were all those left nervous and bewildered by the calamities that had overwhelmed their city. Perpetual dictatorship implied perpetual crisis, after all. 'The Roman people, whom the immortals wish to rule the world, enslaved? Impossible!'[28] Yet clearly it was possible. The favour of the gods had been lost. The golden threads that linked the present to the past seemed snapped. The providence that had brought Rome her greatness now appeared suddenly insubstantial and delusory, and the city itself, that seat of empire, diminished. Perpetual dictatorship denied to the Roman people what, ever since Romulus first climbed the Palatine, had seemed their birthright: self-confidence.

Even Caesar himself, perhaps, was prey to a certain anxiety. No matter how contemptuous of the Republic and its traditions he had grown, he did not scorn the aura of the wondrous that clung to his city. Beyond the Senate House and the crowded jumble of the Forum, he had used the riches plundered from Gaul to build a slimline second forum; and here, in the centre of the city's most cutting-edge development, he had opened a portal onto the fabulous prehistory of Rome. A temple clad in the brightest marble, the building caught in its sheen haunting and primordial reflections. Once, before the Republic, before the monarchy, before even Remus and Romulus themselves, there had been a Trojan prince; and this Trojan prince had been the son of Venus, the goddess of love. Aeneas, as befitted a man with immortal blood in his veins, had been entrusted by the gods with a truly awesome destiny. When Troy, after a ten-year siege, had finally fallen to the Greeks and gone up

in flames, Aeneas had been undaunted. Lifting his aged father, that one-time paramour of Venus, up onto his shoulders, and gathering together a crowd of fellow refugees, he had made his escape from the burning city. Eventually, after numerous adventures, he and his band of Trojan adventurers had arrived in Italy. Here he had put down new roots. It was from Aeneas that the mother of Remus and Romulus was descended. This meant that the Romans too ranked as his descendants – as 'Aeneads'.[29] Caesar's new temple, dedicated to the divine mother of the Trojan prince, was, then, for his battered and demoralised countrymen, an opportunity to be reassured as to their splendid pedigree.

It was also something more. Venus was, in the opinion of Caesar, doubly his ancestress – his *genetrix*. His family, the Julians, laid claim directly to her bloodline. The son of Aeneas, they reported, had called himself Julus: a genealogical detail which, naturally enough, they regarded as clinching. Others were not quite so certain. Even those who did not openly dispute it inclined to the agnostic. 'At such a remove, after all, how can one possibly state for certain what happened?'[30] Caesar himself, though, with his temple to Venus Genetrix, was brooking no argument. The Romans were a chosen people – and he the definitive Roman.

That Caesar was indeed a man whose talents outsoared 'the narrow confines common to man',[31] and whose energies, however monstrous, possessed an almost divine power, was a truth so self-evident that not even his bitterest foes could deny it. The temple to Venus Genetrix, by holding a mirror up to Caesar himself as well as to the vanished age when gods had slept with mortals, eerily blurred the boundary between the two. Approach its steps, and there, next to the steady plashing of two fountains, stood a bronze statue of his horse.* This remarkable beast, which had front hooves exactly

* The statue was originally of Alexander's horse. Caesar had brought it to Rome from Greece, and replaced Alexander's head with his own.

like the hands of a man, could only ever have been mounted by a hero – and sure enough, 'it had refused to let anyone else ever ride it'.[32] Then, inside the temple, glittering amid its shadows, waited the reminder of another epic aspect of Caesar's career. Back in 48, midway through the civil war, he had met with the ruler of the one Greek monarchy permitted by the Republic to subsist in a nominal, if enervated, independence: Cleopatra, the Queen of Egypt. Caesar, never one to look a gift-horse in the mouth, had promptly got her pregnant. This exploit, which had provided his enemies with no end of prurient sniggers, was now cast by the temple in its proper, glorious light. It was why, sharing the temple of Venus Genetrix with a statue of the goddess herself, there stood a gilded bronze of Cleopatra. Just as Aeneas, that father of the Roman people, had lived in an age when heroes slept by right with queens amid the convulsions of great wars and the wreckage of nations, so too, it was revealed, did the contemporaries of Caesar. Dictator though he was, he ranked as something more as well. That he was dismissive of the Republic rendered him, in his own opinion, only the more, not the less, antique. It confirmed him as a hero of ancient epic.

On 15 February, a few days after Caesar's appointment as 'Dictator For Life', came the perfect opportunity to put this conceit to the test. The date was a potent one, both joyous and haunted. As adrenaline-fuelled as any in the Roman calendar, it was simultaneously stalked by the dead, who had been known to mark the festival by rising from their graves and roaming the streets. The crowds for it built early. People milled through the Forum, or else gathered on the far side of the Palatine, below the cave where Remus and Romulus had long, long before been fed by the she-wolf: the 'Lupercal'.* In the mouth of the cave, below the branches of the sacred fig tree, oiled men known

* Varro, the most learned of Roman scholars, explained that the she-wolf was to be identified with a goddess named Luperca. In Latin, '*lupa pepercit*' meant 'the she-wolf spared them'.

as *Luperci*, naked save for a loincloth of goatskin, stood shivering in the winter breeze. Also made of goatskin were the thongs they held in their hands, and which women in the crowds below, many of them stripped to the waist, would invariably blush to see waved in their direction. Naturally, it took a certain physique to carry off a loincloth – and especially so in February. Most of the men, sure enough, were strappingly young. Not all, though. One of the *Luperci* was almost forty – and a consul, no less. The spectacle of a magistrate of the Roman people 'naked, oiled and drunk'[33] was one fit to appal all those concerned for the dignity of the Republic. Not that the consul himself greatly cared. Marc Antony had always enjoyed tweaking the noses of the uptight. Still ruggedly handsome, even in middle age, he was a man who valued his pleasures. More significantly, though, he had a seasoned eye for a winner. So well had Antony served Caesar in Gaul and during the civil war that he had come to rank as the Dictator's chief lieutenant. Now he was going to perform another service. Antony knew that Caesar was waiting on the far side of the Palatine Hill, sat on a golden throne in the Forum. No time to delay, then. All was ready. Goats had been offered up in sacrifice, and a dog. Their blood had been smeared across the foreheads of two young boys and then immediately wiped clean; the two young boys, as they were obliged to do, had burst out in wild laughter. Time to go. Time to celebrate the Lupercalia.

As the men in their skimpy loincloths fanned out from the Lupercal and began running round the spurs of the Palatine, their course was one that plunged them deep into the mysteries of their city's past. Whipping half-naked women as they sped by, bringing down the goat-thong lash so hard that blood was left beading the welts, the *Luperci* were acting in obedience to an oracle given two centuries before. 'The sacred goat must enter the mothers of Italy.'[34] If not, then every pregnancy was doomed to end in stillbirth. This was why, at the Lupercalia, women would offer themselves up willingly

to the lash. Better broken skin, after all, than penetration by a goat of a different kind. Yet the origins of the Lupercalia were older by far than the oracle. Running into the Forum, the *Luperci* approached a second fig tree, one that marked the political nerve centre of the city, the open space where the Roman people had always traditionally met in assembly: the *Comitium*. Here the Senate House stood; and here, at the founding of the Republic, was where a speaker's platform, the *Rostra*, had first been raised. Already, even then, the Comitium had been fabulously old. There were some who claimed the fig tree which stood beside the Rostra to have been the very one beneath which Remus and Romulus had been nursed by the she-wolf, magically transplanted there from the Palatine by a wonder-worker back in the time of the kings. The confusion was telling. The memories that the Roman people had of their past were a swirl of paradoxes. Now, as the *Luperci* ran with their goat-skin thongs from one fig tree to another, those same paradoxes were being brought thrillingly to life. On a day when the human mingled with the wolvish, the carnal with the supernatural, the anxiety-racked Rome of Caesar's dictatorship with the phantom city of the kings, who could tell what might not happen?

Antony, running with the rest of the *Luperci* down the length of the Forum, came to a halt before the Comitium. Here too Caesar's workmen had been busy. The site of the Senate House, incinerated during a riot eight years earlier, was still covered in scaffolding. Other monuments, many of them fabulously ancient, had been flattened to make way for a gleaming level pavement. The Rostra, demolished along with much else, had been rebuilt complete with stylish poly-chrome cladding. This, as Antony approached it, was where Caesar sat waiting. Dictator of the Roman people, it was only fitting that he should preside over the Lupercalia enthroned amid building works and shining marble, public markers of his resolve to renovate the state. Which did not mean, of course, that he aimed to set it upon

wholly new foundations – quite the contrary. What better day than the Lupercalia, when the youth of Rome ran like wolves, to remind the Roman people that the wellsprings of their history were more primordial by far than the Republic? As token of that, Caesar himself had come to the festival dressed in the ancient costume of the city's kings: purple toga and calf-length boots in fetching red leather. And now Antony, reaching the Comitium, halting directly in front of the Dictator, stepping up to the Rostra, held forward all that was needed to complete the ensemble: that ultimate symbol of monarchy, a diadem entwined with laurel.

A few desultory rounds of applause greeted the gesture. Otherwise all was leaden silence. Then Caesar, after a pause, pushed the diadem away – and the Forum echoed to tumultuous cheering.

Again Antony pressed the diadem on the Dictator; again the Dictator refused it. 'And so the experiment failed.'[35] And Caesar, rising to his feet, ordered that the diadem be presented to Jupiter – 'for Rome would have no other king'.[36]

He was correct. Despite the palpable inadequacies of their battered political order, and notwithstanding the many calamities that had left the Republic a broken, bleeding thing, the Roman people would never permit a mortal to rule over them as king. The word remained one 'they could not bear so much as to hear'.[37] Caesar, by laying claim to a perpetual dictatorship, and putting his fellow senators so utterly in the shade, had signed his own death warrant. Exactly one month after the festival of the Lupercalia, on the 15th or 'Ides' of March, he was struck down beneath a hail of daggers at a meeting of the Senate. The leader of the conspiracy, and its conscience, was a Brutus, descended from the man who had expelled Tarquin and ended the monarchy. Brutus and his fellow assassins, who killed Caesar in the name of liberty, devoutly believed that his death would be sufficient to save the Republic. Others, clearer-sighted, were more despairing. They feared that the murder of Caesar solved nothing. 'If a man of

his genius was unable to find a way out,' one such analyst asked, 'who will find one now?'[38] What if the crisis had no solution? What if Rome herself were finished?

And perhaps more than Rome. In the fretful days and weeks that followed Caesar's assassination, evidence of a seemingly cosmic doom was to be seen in the skies. The days began to darken. The sun was lost behind a bruised and violet gloom. Some, like Antony, believed that it was turning its gaze away in horror 'from the foul wrong done to Caesar'.[39] Others, more bleakly, dreaded retribution for the crimes of the entire age, and the onset of an eternal night. These anxieties intensified yet further when a comet was seen burning in the sky for seven days in a row.* What did it mean? Once again, there was a variety of opinions. Already, in the immediate wake of Caesar's death, crowds of angry mourners had set up an altar to him in the Forum; and now, as the fiery star streaked across the sky, a conviction gathered weight that the soul of the slain Dictator was ascending to heaven, 'there to be received among the spirits of the immortal gods'.[40] Others, though, were unconvinced. Comets, after all, were baneful things. Readers of the future, practised in the interpretation of such wonders, had no doubt that a sign of fearful portent was being given. An age was passing, the world nearing its end. One soothsayer, warning that it was forbidden humanity to know the full scale of the horrors that were fast approaching, and that to reveal them would cost him his life, delivered his prognostications even so – and promptly dropped dead on the spot.

Meanwhile, in Rome, in legionary camps and in cities across the empire, hard men spoke fine words and methodically planned for war.

And wolves, in lofty cities, made the nights echo with their howls.

* No fewer than nine of the sources which mention this comet date it to the week of Caesar's funeral games – which, if true, would immeasurably have added to its impact.

2

BACK TO THE FUTURE

A Tide in the Affairs of Men

Late one January, a decade and a half before the soul of the murdered Caesar blazed across the skies of Rome, a girl was born destined herself to become a god.[1] Even in the womb, the immortals had been keeping careful watch over her. Pregnancy was a perilous business. Only supernatural oversight could guarantee success. Right from the moment of conception, the unborn child had been growing under the protection of a succession of deities. As she finally emerged into the world from her squatting mother, to be raised aloft by the midwife, washed clean of blood and then given her first taste of milk, various goddesses were still on hand to keep track of her progress: Levana, Rumina, Potina.*

The gods, though, were no longer alone in deciding whether the infant would survive. 'The ten long months of tedious waiting'[2] endured by her mother were over – and now the girl had passed into the power of her father. A Roman was made, not born. A baby in its first week of life was a nameless, rightless thing, 'more like a plant

* Levana derived from the Latin for 'to lift', *levare*, and presided over the raising of a child by the midwife immediately after birth.

than a human being' until the loss of her umbilical cord.³ Whether in
that time she would be acknowledged or exposed and left to die was
the decision of her father, and her father alone. No man in the world
held quite such authority over his offspring as a Roman.* The abso-
lute rule denied a consul was readily ceded by children to their father.
A son might come of age, marry, win the utmost glory and honour,
and yet still remain under the *patria potestas*, 'paternal control'. A fath-
er's power over his child was literally one of life and death. This did
not mean, however, that it was widely exercised. Just the opposite.
Absolute power was combined, in the Roman parenting ideal, with
mercy, forbearance and devotion. 'What father, after all, is in a rush
to lop off his own limbs?'⁴ Even the disposal of an unwanted newborn,
though perfectly legal, tended to be shrouded in secrecy. It spoke of
poverty, or adultery, or perhaps deformity in the child. Invariably, it
was a matter of shame.

There was to be no rejection that January, though. Eight days
after the girl's birth, at a ceremony which combined solemn rituals
of purification with joyous partying, she was finally given a name:
Livia Drusilla.† Her father could well afford to raise her. Marcus Livius
Drusus Claudianus boasted a name as distinguished as any in Rome.
From his own father, a famously principled statesman who in his day
had been the city's foremost champion of the poor, he had inherited
connections that spanned the whole of Italy.5 The name of 'Livius
Drusus', in a time of upheaval and civil conflict, had considerable
heft. It was not, though, the only one to which the infant Livia Dru-
silla was heir. In Rome, where the great game of dynastic competition
was at least as much about forging alliances as foiling rivals, adoption
was a widely practised tactic. It was considered perfectly legitimate for

* Although, as the Romans themselves were graciously prepared to acknowledge, the
Galatians ran them a close second.
† A boy, for reasons that even the Romans found mysterious, would be given his name
after nine days.

the son of a skilful politician to be adoptive rather than natural – and such a man was Drusus Claudianus. It was his last name that revealed as much. Legally the son of Livius Drusus though he had ended up, he had not abandoned the memory of the house into which he had been born. That he was called 'Claudianus' marked him out, not just as someone adopted, but as the scion of a family as celebrated and formidable as any in Rome.

The fame of the Claudians was as ancient as the Republic itself. Attius Clausus, the founder of the dynasty, had migrated to Rome from the Sabine hills a few miles to the north of the city a mere five years after the expulsion of Tarquin the Proud. Less than a decade later he had become consul. From that moment on, the Claudians had never ceased to dominate the magistrate lists of the Republic. Staggeringly, they had even managed to secure five dictatorships. The name of the most celebrated Claudian of them all, an iron-willed innovator and reformer by the name of Appius Claudius 'the Blind', was stamped across the very plains and valleys of Italy. In 312 BC, at a time when the Republic was looking to secure its still precarious control of the peninsula, he had ordered the building of a mighty road southwards from Rome. Known as the Via Appia, this was ultimately extended as far as Brundisium, the great port on the heel of Italy which served as the gateway to the East. Such a feat of engineering, the mooring which bound Rome to her wealthiest provinces, was precisely the kind of accomplishment which best illustrated, in the opinion of foreign observers, 'the greatness of her empire'.[6] Who were the Claudians to disagree?

Having the most famous road in the world named after one's ancestor was, in the carnivorous struggle for magistracies that formed the essence of political life in Rome, a priceless advertisement. The hold of the Claudians on the people's affections was formidable and self-perpetuating. Glory in war and prodigality in peace kept their name permanently burnished. Attius Clausus, arriving in Rome

back in the first decade of the Republic, had come trailing a great band of clients with him, and this power of patronage, swelling over the succeeding centuries, translated for the Claudians into a peerless election-winning machine. Webs of obligation enmeshed the generations. Whether it was a favour done to a family on the make or an aqueduct built to benefit the whole of Rome, the Claudians had a rare talent for making offers that others could not refuse. It kept them *nobilis*, 'well-known'. Men from humbler backgrounds, who found nobles such as the Claudians a near-insuperable obstacle on the road to their own advancement, could only fume. The glamour of the nobility inspired envy and resentment in equal measure: 'All those born of noble family have to do is sleep for the Roman people to bestow upon them every kind of perk.'[7]

This, though, was an exaggeration. If nobility brought advantage, it also brought brutal pressure. No one became a senator, still less a consul, by right of birth. Even a Claudian had to win election. Boys raised on tales of Appius Claudius could hardly help but feel a monstrous burden of expectation. And not only boys. Girls too were rigorously schooled in the duty owed their ancestry. Naturally, there could be no question of them ever running for the consulship, commanding an army or building a road. As women, they had no political rights at all. Yet they too were expected to have aspirations. *Virtus* was not just for men. A girl, when she stood in the hallway of her father's house and saw there wax masks of her ancestors suspended from the wall, their eyeballs made of glass, their gaze blank and impenetrable, their appearance eerily lifelike, was no less liable to feel haunted by their example than a boy.

The annals of the Claudians were filled with the deeds of women. One, a virgin consecrated to the service of Vesta, and therefore sacrosanct, had fearlessly ridden in her father's chariot to protect him from enemies who were looking to drag him down; another, anxious to demonstrate that 'her rectitude was of the most old-fashioned kind',[8]

had done so in spectacular fashion by pulling a boat single-handed up the Tiber. Showing off her virtue, though, was not all that the young Livia could look forward to in adulthood. The decades prior to her birth had seen a subtle shift in the status of noble women. Whereas once they would have passed into the power of a husband on marriage, increasingly they were kept under the *patria potestas*. The prime loyalty of a Roman wife remained to her father's line. A Claudian matron, possessed of the steely self-assurance that had long been her family's birthright, was rarely content with a merely ornamental role. Rather than serve meekly as an appendage to her husband, she tended to operate to a distinct agenda. Even as her brothers strutted and fretted upon the public stage, she could be a player behind the scenes. More than many senators, she stood at the heart of things. Slapped down by a woman of status, even a former consul might feel obliged to hold his tongue.*

In the first decade of Livia's life, authority of this order still counted for much. Far from intimidating them, the monstrous shadows cast by Pompey and Caesar only encouraged in the Claudians an opportunism regarded as excessive even by the standards of the time. The head of the family, Appius Claudius Pulcher, was both implacable and shameless in his pursuit of Claudian interests. Content that the gods alone merited his respect, he paid obsessive attention to oracles and the entrails of animals, while behaving towards his fellow citizens with such arrogance and rapacity as to end up a byword for both. Entrusted on the eve of the civil war with reform of the Senate, he expelled swathes of his colleagues for vices of which, as his furious opponents did not hesitate to point out, he himself was invariably the most notorious exemplar. Not even his effrontery, though, could compare with that of his younger brother. Blending hauteur and

* The great orator Cicero records a five-word put-down delivered to him by Servilia, who was both the former mistress of Julius Caesar and the mother of Marcus Brutus, Caesar's most eminent assassin. 'I bit my tongue,' Cicero records.

demagoguery to ground-breaking effect, Publius Clodius brought gangsterism to the very heart of Rome. Paramilitaries passionately loyal to him squatted out in the Forum, menaced his rivals, and even at one point took to chanting aspersions on Pompey's masculinity. Meanwhile, as Clodius's street-gangs roamed the city, his sisters padded like restless cats from marriage to marriage, working their own magic in the family cause. The eldest, the dark-eyed and brilliant Clodia Metelli, was Rome's undisputed queen of chic. The mingled devotion and dread which she inspired in her admirers was a fitting measure of the reputation secured by her family in the face of Pompey's dominance and the gathering might of Caesar. 'When injured, they resent it; when angered, they lash out; when provoked, they fight.'[9] Even in the mood of crisis that preceded the crossing of the Rubicon, the power of the Claudians retained its allure of menace.

Nevertheless, it came at a price. In an era dominated by upstart warlords, the ferocity required of the Claudians to maintain their ancestral primacy struck a perturbing and scandalous note. The legacy they were fighting to defend could not help but end up tarnished by it. Increasingly, the pride of the Claudians in their lineage was cast by their adversaries as something altogether more sinister: 'a timeless and inborn arrogance'.[10] Antique Claudians of previously unimpeachable reputation began to be painted by chroniclers in melodramatic colours as rapists and would-be kings. Achievements were counterpointed with monstrous crimes. Long-forgotten figures of scandal gained a lurid new prominence. Set against the ruggedly pious builder of the Appian Way, for instance, was his grandson, who, informed on the brink of a naval battle that the sacred chickens would not eat, had ordered them dumped into the sea. 'If they won't eat, let them drink,'[11] he had sneered – and promptly lost his fleet. Then there was his sister who, delayed while riding through the streets of Rome by a milling crowd of citizens, had lamented in a piercing voice that her brother was not around to lose a second

fleet. Monsters of insolence such as these, in the age of Clodius and his sisters, loomed ever more grotesquely in the public imagination. No one could deny the range and extent of Claudian prowess; but increasingly the history of the family was cast by their enemies as a record of darkness as well as light. For every benefactor of the Roman people, it seemed, there had been a Claudian trampling and treading them down.

Better arrogance, the Claudians themselves might have retorted, than mediocrity. Yet even they, when the firestorm of civil war finally swept down upon Rome in 49, found it impossible to maintain their traditional independence of action. Already, three years before Caesar's crossing of the Rubicon, Clodius had been murdered in a brawl on the Appian Way. Appius Claudius, torn between backing Pompey and backing Caesar, frantically sought guidance from the gods, and then resolved his dilemma by dying before battle could be joined. Livia's father, who at the time of her birth had been a partisan of Caesar, kept his head down, quietly nurturing his resentment of his erstwhile patron's ever more excessive dominance. When the Dictator was murdered, Drusus Claudianus publicly approved the deed. The conviction of Caesar's assassins that by killing him they had set Rome's time-hallowed political order back on its feet might almost have been designed to appeal to a Claudian. The times, though, remained confused. The heavens were dark, after all, and a comet was blazing through the sky. Nothing could be taken for granted. Only by husbanding their full strength could the Claudians hope to reclaim their rightful place in the affairs of the Roman people. That, at any rate, was how Drusus Claudianus read the situation. Accordingly, he drew up a plan. He would marry off his daughter.

Livia herself by this stage was more than ready for such a step. She was in her mid-teens, after all, and time was getting on. Many aristocratic girls were married off as young as twelve. A nubile daughter was too priceless an asset for a noble to delay putting her to dynastic

purposes for long. Drusus Claudianus, though, had preferred not to hurry things. His eye was fixed on a particular prize. For many generations now, the descendants of Appius Claudius had consisted of two distinct offshoots. One of his sons, Claudius Pulcher, had fathered the line to which Drusus Claudianus himself belonged, and which, in the first decade of Livia's life, had so fixated and appalled the Roman people. The descendants of a second son, Claudius Nero, had been altogether more modest in their achievements. The last Nero to hold the consulship had done so all the way back in 202, at a time when Scipio had still been busy fighting Carthaginians. What, though, if the two lines were to be reunited? Only give Livia a Neronian husband, and the result would be a potent consolidation of Claudian resources. A generation which had flowing in its veins the mingled blood of both Pulchri and Nerones would be a formidable one indeed. The times being what they were, it was certainly worth a try.

And an eligible Neronian, by great good fortune, just happened to be ready to hand. Tiberius Claudius Nero was some two decades older than Livia, and well set on a promising career. He had enjoyed a good civil war. Correctly identifying Caesar as a winner, he had commanded a fleet, secured various honours, and been sent on the Dictator's business to Gaul. Now, on his return to Rome, he was offered Livia's hand. Tiberius Nero accepted it. He also took on board something else: the politics of his prospective father-in-law. With a disdain for consistency that marked him out as a true Claudian, the man who had basked in Caesar's favour now coolly stood up in the wake of his patron's murder to propose honours for his killers. This volte-face was only incidentally about the rights and wrongs of the assassination itself. Tiberius Nero was laying down a marker. Emerged at last from Caesar's shadow, Rome's most celebrated dynasty was back. The future, like the past, was being cast as Claudian.

Already, though, events were overtaking these hopes. As maids under the direction of her mother fussed around Livia, braiding her

hair into the ferociously complex 'towered crown'[12] demanded by tradition of a bride, fresh and murderous novelties were brewing in the world beyond. To these, the bridegroom in his gleaming white toga, arriving at the house of his wife-to-be, was as yet oblivious. That danger might reach directly into the home of a great nobleman was a prospect too sinister and monstrous to contemplate. The house of even the humblest Roman stood directly under the protection of the gods. It was what defined him as civilised, as a man rooted to the city in which he lived. 'What more sacred than the house of a citizen, no matter his class – what more hedged about by every kind of religious safeguard?'[13]

To this question, a girl on her wedding day served as a notably reassuring answer. The six ornate tresses into which Livia's hair had been woven gave her the look of a virgin pledged in service to Vesta, the goddess of the hearth. Her veil, coloured saffron to match the one worn by the priestess of Jupiter, had been dyed by specialists using the same stamens of crocuses that would-be mothers sampled as an aid to fertility.[14] A divinely sanctioned fusion of virginity and fecundity: what more could a bridegroom want? Tiberius Nero, at the end of a wedding banquet hosted by his father-in-law, duly wrested Livia from her mother's arms and led her, as though taking her captive, to his own house on the Palatine. This pretended abduction of a bride harked back to an episode from the very beginnings of Rome. Once, in the reign of Romulus, when the original settlers of the city had found themselves lacking in women, they had stolen the daughters of the neighbouring people, the Sabines; and it was as a memory of that primal rape, perhaps, that a bride wore in her towering hairdo, interwoven with marjoram and flowers, a single spearhead. Yet though 'war and conflict had attended the earliest pairing of man and woman in Rome',[15] the arrival of his new bride into Tiberius Nero's home was greeted, not with foreboding, but with jokes, cheering and applause. Just as the stolen brides of the first Romans had bred a race

of heroes, so Livia, it was trusted, would now perpetuate the Claudian line. She would do so as the guardian of her husband's hearth, its flame banked up every evening and rekindled every new day. Like the ramparts of Rome itself, the walls of a citizen's home stood inviolate and sacrosanct. As Tiberius Nero lifted his bride up into his arms and carried her over the threshold, Consevius, the god of conception, already had his eye on the couple. In 42 BC, on 16 November, Livia gave birth to a son. Like his father, the boy was named Tiberius Claudius Nero. In this tiny child, all the ambitions of the two great Claudian lines met and were joined.

But too late. Even as their son was being delivered, the hopes that had brought Livia into Tiberius Nero's marital bed lay in ruins. The brief year of their married life together in Rome had witnessed a reign of terror on a scale unmatched in the city's history. The days when its destiny could be swayed by the jostling for position among its leading families, and by their competition for magistracies and honours, had been terminated once and for all. Not merely put into the shade, as they had been by Caesar's dictatorship, many of the great dynasties of the Republic had suffered hideous mutilation. The violence unleashed against them had been both calculated and savage. Even as Tiberius Nero and Livia were blithely celebrating their nuptials, the adherents of the slain Dictator had been preparing to seize the initiative in the most brutal fashion imaginable. A year and a half of manoeuvring against Caesar's assassins had secured for them the mastery of the western provinces, and of Rome itself. Then, one night late in 43, almost a year to the day before the birth of Livia's son, whitened boards had appeared in the Forum. They carried the names of men charged with treachery to Caesar. Rewards were offered for their murder. 'The killers are to bring their heads to us.'[16] Among those proscribed had been Livia's father. Luckier than the 2300 reported to have perished, Drusus Claudianus had managed to slip the bounty-hunters and make his

way east, where Brutus, still at liberty, was busy recruiting armies
for the looming showdown.

Sure enough, the renewal of open civil war had not been long in
coming. Early in 42, the defenders of Caesar's memory had formally
consecrated their murdered patron as a god. Over the succeeding
months, they had spent the riches purloined from the proscribed
on legions of their own before finally, towards the end of the cam-
paigning season, they crossed from Italy to Greece. Advancing into
Macedonia, they had confronted their adversaries on a plain east
of the city of Philippi. Two terrible battles had ensued. Victory in
the death-struggle had ultimately gone to the adherents of Caesar.
Brutus had fallen on his sword. The aristocracy, already scarred as a
result of the proscriptions, had suffered a second lethal culling. 'In
no other conflict did men possessed of the most illustrious names
endure a bloodier toll.'[17] Among the dead, fallen like Brutus on his
own sword in the wake of the battle, was Drusus Claudianus. The
news reached Rome a few weeks later. Livia learned of her father's
death as she was giving birth to his grandson.

That she was safe in Rome at all owed everything to Tiberius
Nero's slippery opportunism. Sensing the way the wind was blow-
ing, he had made sure to renew his old allegiance to the now deified
Caesar. As a result, despite the ruin of her father's fortunes and the
forfeiture of his property, Livia was able to deliver her son in sur-
roundings befitting her rank. The Palatine, where Romulus had once
built his thatched hut, was now easily the most exclusive district in
Rome. The hut itself, reverently kept in a continuous state of repair,
still stood above the cave of the Lupercal, but otherwise there was
nothing on the hill that did not scream privilege. The Claudians,
naturally, had long enjoyed a prominent position there. It was on the
Palatine that Clodia Metelli had hosted the most fashionable soirées
in Rome, and Clodius, after knocking through two already hefty
mansions, based himself in flamboyantly imposing headquarters.

Tiberius Nero, however much he may have mourned the slaughter of his class at Philippi, would have been reassured, as he paced his splendid house, that he had made the right call. Better a shift of loyalties, after all, than the loss of his property on the Palatine.

Yet even as his son was being raised up in the midwife's arms, he knew his fortunes now stood on precarious foundations. Memories of the proscriptions were still raw. The shock given to the self-assurance of Rome's elite was not easily suppressed. Nowhere, not even the most exclusive residence, could any longer be considered secure. The first victim of the proscriptions had been murdered in his own dining room, with his guests gathered all around him, in the innermost sanctum of his home. Bursting in on their quarry, the soldiers had shown no compunction in defiling this scene of hospitality. A centurion, drawing his sword, had decapitated the wretched host, then warned the other diners with a gesture of his blade that any fuss would see them suffer the same fate. Terrified, they had remained lying where they were until late into the night, as the headless corpse slowly stiffened beside them, and blood soaked through the couch onto the floor. What once had served as the marks of a citizen's greatness – a fine house, beautiful sculptures, a swimming pool – had become, during the frenzy of the proscriptions, the opposite: potential death warrants. Even Claudians had learned to dread the midnight knocking at the door. Always now, at the back of the mind, there lurked the dread of what might follow it: 'soldiers rushing in, the forcing of locks, menacing words, fierce looks, a glitter of weapons'.[18]

Clearly, then, to those of the nobility who had survived the carnage of the proscriptions and Philippi, and now found themselves stumbling out from their bolt-holes into an utterly transformed political landscape, the need to arrive at a permanent accommodation with their new overlords was a desperate one. Three men had claimed licence to rule the world as Caesar's avengers. Their compact

was not, as the original triumvirate had been, a murky arrangement of the kind traditional among Roman power-brokers, but something altogether more revolutionary: a formal grant of absolute rule. Legally, the goal of the Triumvirs had been defined as 'the restoration of the Republic' – but no one was much fooled by that fine slogan. The Caesarian leaders had not waded through blood merely to abdicate their hard-won supremacy. In the wake of Philippi, the only resistance to them still to be found was in Sicily, where Pompey's son Sextus had established a rackety piratical regime. Otherwise, the authority of the Triumvirate was absolute. Yet its continuance could hardly be taken for granted. Triumvirs, as everyone was all too well aware, had a habit of falling out. The Roman upper classes, as they sought to set their fortunes back on a solid foundation, were accordingly faced with a potentially life-and-death decision: which member of the Triumvirate to back.

One could immediately be discounted. Marcus Aemilius Lepidus was an old associate of Caesar's whose impeccable pedigree and wide array of connections could not conceal his essential mediocrity. Demoted to serving as the watchman of Italy during the Philippi campaign, he was already on the way out. This left Rome and her empire divided, in effect, between two very different warlords. One, like Lepidus, was a noble of illustrious heritage and proven loyalty to Caesar: none other than the consul who had run with the *Luperci*, Marc Antony. His role in the proscriptions notwithstanding, there were many among the Roman elite who could not help but admire him. At Philippi, it was Antony's prowess as a general that had won the day. Amid the carnage of the battlefield, he had stripped off his cloak and draped it over Brutus's corpse. Resourceful, buccaneering and generous, his virtues were of a kind to which the Roman people had always warmed. He may have been a Triumvir – but Antony, to his erstwhile peers, offered at least the reassurance of familiarity.

Which was more than could be said for his partner in the rule of

the world. Nothing, perhaps, better exemplified the upheavals and convulsions that had afflicted the Roman people since the murder of Caesar than the rise to dominance of the man born Gaius Octavius. His greatness served as a bitter reproach to the maimed aristocracy. His ancestry was sufficiently obscure that enemies could charge one of his great-grandfathers with having been 'a freed slave, a rope-maker',[19] and another an African perfumier turned baker – and be believed.* His childhood had been spent, not on the heights of the Palatine, but in a dusty town named Velitrae, some twenty miles down the Appian Way.† His brief career had consisted of a sustained and merciless assault on the most sacred traditions of the Republic. Eight months after the murder of Caesar, when barely nineteen, he had staged an abortive military coup. Ten months later, he had swept into Rome at the head of a private army. Consul when not yet twenty, legally appointed Triumvir, and commander alongside Antony of nineteen legions at Philippi, no one in his city's history had won for himself such power so fast, so young. Neither moral-ity nor considerations of mercy had been permitted to stand in his way. While Antony had gazed in sorrow at his fallen adversary on the battlefield of Philippi, his youthful colleague had shed no tears. Instead, ordering Brutus's corpse decapitated, he had packed the head off to Rome. There, with pointed symbolism, it had been placed at the foot of the statue where Caesar had died.[20]

'The malice of those who have plotted against us, and who brought Caesar to his fate, cannot be mollified by kindness.'[21] With these words, the Triumvirs had justified their sanctioning of murder

* The enemy was Antony. In reality, the family was old and wealthy, but had only recently attained a degree of political prominence. Octavius's father was the first of his line to enter the Senate, and would have run for the consulship after serving a term of office in Macedonia had he not died while returning to Rome.

† The room which had served the young Octavius as his nursery was subsequently left with such a charge of the supernatural that anyone who tried to sleep in it would be hurled out through the doorway by invisible forces.

and civil war. To Gaius Octavius, the obligation to avenge Caesar had provided particular licence for his deeds. On the eve of Philippi, he had publicly sworn to build a temple in Rome to Mars the Avenger: a declaration that fighting in a civil war was not, to him, a crime, but an urgent and pious duty. The young man was the grandson of the Dictator's sister – but he was also something spectacularly more. Caesar, blessed with an eye for talent, and lacking a legitimate son of his own, had moved before his death to adopt Octavius as his heir. This, of course, was the same tactic that had seen Livia's father adopted by Livius Drusus: a perfectly legitimate expression of the perennial struggle of Roman nobles to maintain their lineage and entangle their peers in sticky webs of obligation. Adoption by Caesar, though, had provided Octavius with a leg-up like no other. The gawky eighteen-year-old from Velitrae had been graced with two priceless inheritances: his great-uncle's fortune and his prestige. Caesar's money had granted legions; his name, *auctoritas*. So potent were these bequests that they would prove to have lit in the teenage Octavius an ambition such as no young Roman embarking on his career had ever before thought to nurture: to win sole and permanent supremacy for himself. When it was subsequently confirmed that the comet seen above Rome had indeed been his adoptive father's soul streaking heavenwards, his legacy had become even more awe-inspiring. The young man once known as Gaius Octavius could now lay claim to a nomenclature of almost superhuman resplendence. For all that his enemies delighted in calling him 'Octavianus', he himself scorned the name. Not merely Caesar, he insisted on being known as Caesar *Divi Filius* – 'Son of a God'.

To the Roman elite, all this was liable to seem more sinister than splendid. Confronted by the chill and alien figure of the young Caesar, most nobles instinctively recoiled. Those who had survived the slaughter of Philippi tended to seek refuge, for want of any better alternative, in the train of Antony. Others faced a trickier choice.

While Antony, in the division of the world that followed Philippi, had been granted responsibility for the East, the young Caesar had returned to Italy. Nobles such as Tiberius Nero, resident in Rome, found the Son of a God resident directly on their doorstep. With Antony far distant, and the young Caesar's murderousness in defence of his own interests a matter of all too public record, most opted, unsurprisingly, to keep their heads down. A few, though, did begin to plot. Feelers were put out to Antony's agents in Italy. Whispered schemes to restore the Republic began to circulate once again in exclusive circles. When Antony's brother, Lucius, became consul and spoke in unsubtle terms of freeing Rome from tyranny, hatred of the young Caesar and everything he represented burst into open flames. Nowhere did they blaze more violently than in Etruria and Umbria, celebrated and beautiful lands north of Rome, where rivers glided beneath towering crags on which stood ancient ramparts. One of these hill-towns, Perusia, now became the stronghold of Lucius and his army. Men from across Italy flocked to join them. Most were destitute, with only their lives left to lose; but not all, by any means. Some were senators – and among their number was Tiberius Nero.

In this desperate throw, he was accompanied by his wife and infant son. Roman women did not normally travel with their husbands to war, but the times were far from normal. The world had been turned upside down – and even male prerogatives were starting to fray. During the proscriptions, condemned men, as they hid out in attics or stables, had found themselves humiliatingly dependent on their wives. The shocking tale was told of one woman, notorious for her affairs, who had betrayed her husband to bounty-hunters, and then married her lover the same day. Many wives, though, had proven themselves both faithful and heroic. One, in a particularly hardy show of courage, had even braved a beating from Lepidus's heavies to beg for her husband's life. 'They covered you with bruises,' he recalled later in grateful admiration, 'but never broke your spirit.'[22] Other

women, in an even more remarkable display of masculine resolve, had taken to the streets. Early in 42, at a time when the extortions of the Triumvirate were bleeding Rome dry, an entire delegation of them had marched on the Forum. Climbing on to the Rostra, their spokeswoman had boldly awakened memories of a murdered tradition: freedom of speech. Hortensia was the daughter of Hortensius Hortalus, one of the greatest orators of his day, whose fearlessness in eviscerating his opponents could be measured by the splendid riches it had won him: a dining table on which, for the first time in Rome, peacock was served; an incomparable wine cellar; a mansion on the Palatine. Now, speaking as men no longer dared to speak, his daughter had fearlessly arraigned the Triumvirs themselves. 'Why should we women pay taxes,' Hortensia had demanded, 'when we have no part in the honours, the commands, the rule of the state?'[23] To this question, the Triumvirs had responded by having the women driven from the Forum; but such was their embarrassment that they did eventually, with much bad grace, agree to a tax cut. The episode was one that Livia would doubtless have noted with interest. It taught a lesson fit for the times. Such were the evils to which Rome was prey that a woman might find herself obliged, just perhaps, to take the defence of her patrimony into her own hands.

Meanwhile, of course, it was to her husband that Livia looked to ensure their son the gilded future befitting a child with the mingled blood of two Claudian lines in his veins. It did not take long, though, for her confidence in Tiberius Nero to start appearing horribly misplaced. Signing up to an insurrection against the young Caesar did not turn out to have been a sensible move. Calamity followed fast upon calamity. Lucius's rebellion was crushed with predictable ruthlessness. Even though Lucius himself was pardoned, other senators were not so lucky. The young Caesar, as though offering up a blood-sacrifice to his deified father, had large numbers publicly executed on the Ides of March.[24] There could be no doubt, then, that Tiberius, despite

managing to flee the sack of Perusia with his family, was in mortal danger. Arriving in Naples, he tried to instigate another uprising. It too was crushed. Taking to the countryside, the fugitive couple were almost betrayed by the crying of the infant Tiberius, and only just managed to evade the soldiers pursuing them. Making their escape to Sextus Pompey's pirate base in Sicily, they were greeted with such *froideur* that Tiberius Nero, prickly as only a Claudian down on his luck could be, ended up heading off east in a huff. Rebuffed in turn by Antony, he then managed briefly to find a bolt-hole in Greece, before being forced on the run yet again. As they made their escape through a forest, a fire broke out. Livia's dress was left charred. Even her hair was singed. Meanwhile, back in Rome, her husband had been officially proscribed and his house on the Palatine confiscated. As the mother of the heir to the Claudians, Livia was entitled, perhaps, to feel that enough was enough.

By the summer of 39, when a treaty patched up between the Triumvirs and Sextus Pompey provided exiles such as Tiberius Nero with an amnesty, Livia could have been left with no illusions as to the brute realities of the new order. She returned to a Rome in which her circumstances were sadly diminished. Even the fact that her husband had got her pregnant again failed to improve her mood. Tiberius Nero had proven signally unequal to Livia's hopes for herself and her heirs. There could be no disputing the courage she had shown in accompanying him on his disastrous travels. Ultimately, though, her loyalty was not to him but to her father's line. Blue-blooded, beautiful and not yet twenty, Livia knew that she still had plenty to offer a man. All it needed was a match worthier than Tiberius Nero.

Meanwhile, in the splendid mansion on the Palatine that had belonged to Hortensius Hortalus until its confiscation in the proscriptions, the young Caesar was also tiring of his spouse. Scribonia was a woman of frigid dignity – or, as her husband preferred to put it, with notable lack of gallantry, 'a wearing tendency to argue'.[25]

She lacked what even her enemies were willing to grant that Livia possessed in abundance: charm and sex appeal. Nor, despite the fact that she came from a noble and powerful family, could Scribonia's pedigree possibly compare with that of a Claudian. To the young Caesar, whose status as the 'Son of a God' had made him seem only the more vulgar in the eyes of the authentic nobility, marriage into Rome's most celebrated family had everything to recommend it. He might be master of half the world – but he was still sensitive to the charge of being a parvenu. That Livia possessed physical attractions in addition to everything else merely confirmed him in his decision. By the autumn of 39, only a few months after her return from exile, he had made his move on the pregnant wife of Tiberius Nero.

The cuckolded husband himself, too demoralised by now to stand on his dignity any further, was so desperate to repair his fortunes that he almost forced Livia on the young Caesar. Adding to the mingled shock and delight with which the Roman people greeted the emerging scandal was the fact that Scribonia too was heavily pregnant. Only once she had given birth to a daughter, Julia, did her husband feel decently able to divorce her. By the autumn of 39, the young Caesar was betrothed to Livia. The wedding itself still had to wait. To marry a woman pregnant by another man was a step too offensive to propriety even for the son of a god. At last, though, on 14 January 38, Livia gave birth to her second child, a boy named Drusus. Three days later, she was married to the young Caesar. Tiberius Nero, playing the role of her dead father, gave his former wife away. Livia's return to the Palatine was formally sealed.

She was destined to remain there, its undisputed mistress, for the rest of her life. Her new husband understood full well what he had obtained by marrying her. 'He would never cease to love her, esteem her, stay true to her.'[26]

Livia, at any rate, was secure at last.

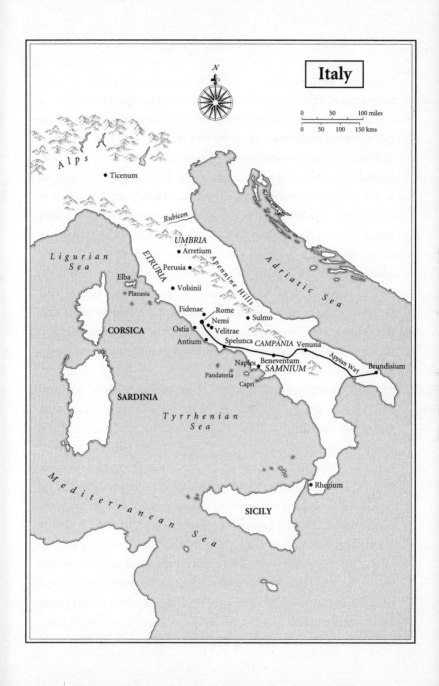

Italy

Alps

Ticenum

Rubicon

Ligurian Sea

UMBRIA

Arretium

ETRURIA

Perusia

Apennine Hills

Elba

Planasia

Volsinii

Adriatic Sea

Fidenae

Rome

Nemi

Sulmo

CORSICA

Ostia

Velitrae

Antium

Spelunca

CAMPANIA

Venusia

Appian Way

Naples

Beneventum

Brundisium

Pandateria

SAMNIUM

Capri

SARDINIA

Tyrrhenian Sea

Rhegium

Mediterranean Sea

SICILY

The Roman Spring

It was not only nobles who risked losing everything to the criminal and disorienting age presided over by the young Caesar.

Early in 41 BC, a few months after the bloodiest campaign in Roman history had exhausted itself at Philippi, a troupe of scarred and burly men headed south along the Appian Way. As they advanced up the slopes of an ancient volcano named Mount Vulture, they followed a standard topped by that ultimate bird of prey, the eagle. Farmers watching it pass might well have found themselves eyeing its silver beak and talons with trepidation. They knew what its arrival signalled. The young Caesar, with vengeance on the assassins of his adoptive father now secured, had faced a most invidious task on his return to Italy. Some 50,000 of his soldiers, battle-hardened veterans all, were looking to him expectantly for their reward. And what they wanted was the prize for which, more than any other, they had been willing to cross the seas and slaughter their fellow citizens: a plot of land.

Even before Philippi, the Triumvirs had earmarked territory around eighteen Italian cities for confiscation. These plans were necessarily on a massive scale. It has been estimated that at Philippi a quarter of all citizens of military age fought on one side or the other.[27] Now, with the return home of the victors, expropriation became the order of the day. Landowners across some of the most fertile regions of Italy learned to dread the appearance on their property of demobbed soldiers. 'Everywhere, in every field, such confusion!'[28] Villas, farm equipment, slaves, might all be seized. The larger the estate, the more scope there was for the surveyor, armed with his 'pitiless measuring-rod',[29] to divide it up and settle entire units at a time. Resistance was brutally crushed. Generally, though, like doves before the approach of an eagle, the dispossessed knew better than to fight back. Some were permitted to stay on as tenants. They were

the lucky ones. Most were left with no choice but to bow their heads before the evils of the age, and leave their stolen homes. 'Fortune turns everything upside down.'[30]

The same spectres of larceny and violence that had brought terror to the nobility during the proscriptions were now general across Italy. While it was the prosperous lowland regions they stalked most menacingly, well-watered fields were not their sole temptation. On Mount Vulture, where wolves still haunted expanses of thick forest, and during summer the fields were baked by scorching winds, the poverty of the soil did not spare the locals from ruin. Too much else was at stake. No one concerned with the mastery of Italy could afford to neglect the spot. Already, 250 years before the arrival on Mount Vulture of the young Caesar's veterans, Roman settlers had established a colony on its flank. Venusia, planted on a crag midway between two ravines, had served Rome as a key forward post, her gateway to the south. Italy back then was still little more than a geographical expression, the Romans themselves merely one among a patchwork of peoples. Others could boast characters no less distinctive. There were the Etruscans, whose sway at one time had extended beyond their native Etruria as far south as Rome itself, and whose talent for reading 'auspices' – supernatural markers of the future revealed through the flight of vultures or the dietary habits of chickens – was unrivalled. There were the Marsians, near neighbours of the Romans up in the Apennine hills, whose singing could make snakes explode. There were the Samnites, whose ancestors in ancient times had been led by a mysterious ox to the harsh mountain fastnesses above Naples, and who for more than fifty years, back in the fourth century BC, had obdurately defied the southward thrust of the legions. In time, though, they and all the other peoples of Italy had been broken; and gradually, as Roman supremacy established itself throughout the peninsula, Italians had come to think of themselves as sharing a common identity. Venusia, raised to stand sentinel over the Appian

Way as it left Samnium and descended towards the Adriatic, had begun to lose its founding purpose. The assurance it had once provided the Roman people, 'that it would block any hostile incursion',[31] had become redundant. No longer did it serve as a frontier town.

Let it fall into the wrong hands, though, and the city could still present a menace. It did not need ancient history to teach the young Caesar this. As recently as 91 BC, the people of Venusia had joined various other Italians, from the Marsians to the Samnites, in open rebellion against Rome. An independent state had been proclaimed. Its coins had portrayed a wolf trampled under foot by a bull. Yet, however savage the war had been before its final suppression, and however severe the fright it had given Rome, the insurrection itself had been bred less of hatred than of a snubbed devotion. The ambition of most Italians had been to share in Roman power, not annihilate it. To visit Venusia was immediately to understand why. Civic amenities rose everywhere. Baths, aqueducts, amphitheatres: none of these had come cheap. Italians, whether as soldiers or merchants, had profited splendidly from their mistress's conquest of the Mediterranean – which was why, when the Senate approved a proposal that people across the peninsula become full citizens of Rome, the insurrection had promptly collapsed. From that moment on, the whole of Italy had ranked as Roman.

By the time that the veterans of Philippi arrived in Venusia to evict the local landowners and divide up their fields into neat chequerboard plots, such an identity was all that most Italians had left them. Fifty years previously, in the wake of the great rebellion against Rome, many of the inhabitants of Venusia had been enslaved and scattered far and wide. The children of new arrivals had filled the city's leading school: 'the intimidating sons of intimidating centurions'.[32] Then, with the outbreak of civil war, an entire generation of young men had been conscripted. 'Curved sickles were straightened out and forged into swords.'[33] Many had perished in foreign

fields. Those who returned did so with few loyalties save to their comrades and their generals. Now, like the blades of a giant plough, the surveyors of the young Caesar had arrived to slice up Venusia yet again. Few of the customs once characteristic of the region had been able to survive such repeated harrowings. 'So utterly have they deteriorated that everything which once made them distinctive – differences of language, armour, dress and so on – has completely vanished.'[34]

Even so, there were still some Italians who suffered the knowledge of this as a form of bereavement. One last firestorm of destruction remained to come. When Antony's brother Lucius raised the banner of armed opposition to the young Caesar in 41 BC and barricaded himself behind the walls of Perusia, the motives of those who flocked to him were various and confused. While a few, like Tiberius Nero, were inspired by dreams of restoring the Republic, and others, the vast majority, were men left impoverished and embittered by the appropriation of their lands, there were some whose dreams of a time before Rome, when their cities had been free, had life in them yet. Unlike in Venusia and Samnium, where the spirit of rebellion had been extinguished beyond all hope of resurrection, in the rich lands further north, and in Etruria especially, it still flickered faintly.

Not for long, though. The young Caesar was hardly the man to tolerate any challenge to his authority. The brutality with which he and his lieutenants crushed Lucius's uprising brought ruin to many an ancient and famous town. Some, like Perusia, were burned to the ground; others hit with fines so exorbitant that their citizens were forced to abandon them altogether. Ever more refugees were added to the bands of the dispossessed. Amid the blackened fields and bandit-haunted woods of Etruria, phantoms could easily seem a more vivid presence than the living. Survivors were left to mourn 'the devastated hearths of the Etruscans, that ancient race'.[35]

Yet where there was misery, there lurked opportunity as well. Cross the corpse-strewn hills from Perusia, and the traveller would come to a city blessed with what had become, amid the evils of the age, that most useful of attributes: a powerful patron. Arretium, which had lost its independence to Rome centuries before, had as its most prominent citizen a man who claimed descent from Etruscan royalty, no less. To the Roman nobility, the lineage of which Gaius Maecenas boasted was so contemptible as to border on the sinister; but Maecenas himself, a man much given to florid showmanship, felt no need to pander to the sneering of senators. The chaos that spelt doom to so many others had been the making of him. Restless and clear-sighted, he had glided with great facility to the heart of the new order. Backing the young Caesar as a winner right from the start, he had profited massively from his punt. Not everything stolen from the proscribed had gone to fund the triumviral war effort. Those sufficiently alert to the new wellsprings of power, provided they only had the talent and nerve to take advantage of them, had been able to drink deeply of spectacular riches. Certainly, even his enemies had no doubt of Maecenas's ability. 'He was a man who, whenever the occasion required it, would literally never sleep – and who was as quick to see what needed to be done as he was skilled in achieving it.'[36] The young Caesar, in his resolve to win for himself impregnable dominance over his fellow citizens, had urgent need of such lieutenants. This was why, even as Etruria blazed, the fixer from Arretium enjoyed his ear.

The violence, the theft, the calculated atrocities: these, for a new regime desperate to establish itself upon a firm footing, had been unavoidable. But Maecenas, like his master, understood that arbitrary illegalities could never hope to secure its long-term future. His preening as the heir of Etruscan kings was not merely a calculated defiance of Rome's traditional power-brokers, to whom Arretium was a backwater best known for churning out cheap pots. It also

served as a reassurance to the class of people who had borne the brunt of the appropriations: Italy's landowners. The young Caesar, now that he had settled his veterans, desperately needed to broaden his support. This, in light of what his return from Philippi had meant for Italy, might have seemed a grotesque hope. Yet so convulsive were the horrors of the age, so devastating the vicissitudes of civil war, so absolute the seeming abandonment of the world by the gods, that someone, anyone, was desperately needed now to offer Rome a ray of hope. A regime that could restore to a bruised and terrified people a measure at least of peace might be forgiven much. Even, perhaps, the circumstances of its own rise to power.

For most Romans, though – whether they lived in the city itself or in the towns and villages of Italy – the future seemed only to be darkening. Victory over Lucius had failed to clear the field of the young Caesar's enemies. On Sicily, Sextus Pompey remained as entrenched as ever, and certainly in no mood to do the heir of his father's nemesis any favours. Instead, posing as a favourite of the sea god, he amused himself by sporting an aquamarine cloak and throttling the shipping lanes. As a result, a further tightening of the screw was now added to the miseries consequent on blackened fields and military requisitions. Thanks to a blockade of the grain ships that might otherwise have helped to feed a starving people, by 38 BC famine was gripping the land. Bands of murderous vagrants infested the roads. In Rome, where the slums seethed with refugees, hunger gave a desperate edge to the mood of misery and rage. Proposals for a fresh round of taxes, aimed at funding the destruction of Sextus, precipitated open rioting. The young Caesar was stoned in the streets. Only with difficulty did he escape the mob. Later, when the bodies of those killed in the clashes were slung into the Tiber, gangs of desperate thieves waded out and stripped them bare. Such were the straits, it seemed, to which the Roman people had been reduced. Nothing was left them save to scavenge corpses.

That Rome was doomed, that her streets might end up abandoned to beasts of prey, that the city itself be turned to ashes: these were fears some now openly acknowledged.

> *It is true: a harsh fate pursues*
> *the Romans, and the crime of fratricide,*
> *since the blood of blameless Remus*
> *was spilt on the ground — a curse on his heirs.*[37]

Well might the man who delivered this grim prognosis have felt a sense of despair. Quintus Horatius Flaccus — Horace — was a genial man; but he spoke for any number of Italians caught up in 'the cruel miseries of exile, the miseries of war'.[38] The son of a wealthy auction-eer from Venusia, he had fought at Philippi on the side of Caesar's assassins. Years later, veiling the horror of the carnage behind amused self-deprecation, he would describe how he had managed to escape the battle only by tossing away his shield and then relying on a supernatural mist; but in grim reality, he had seen enough of Roman slaughtering Roman always to be haunted by the experience. Certainly, after Philippi, he had lost his appetite for carrying on the fight. When an amnesty offered him the chance to head home, he seized it. The surveyors, though, had reached Venusia before him. His lands were gone. Resistance, with the shadow of proscription still hanging dark over those who had fought for the Republic at Philippi, was out of the question. Horace duly joined the flood of those made homeless, and headed for Rome. Here, either by scraping together what remained to him of his patrimony or by tapping a powerful contact, he managed to secure for himself a post as an accountant in the government treasury. A living, to be sure — but a sorry come-down for a one-time landowner, even so. Horace, who combined his evident head for figures with a genius for self-expression, dared to explore in verse the fracturing of the age. Existence was precarious,

and the worst might yet be to come. A world in which men could be evicted from their lands upon a whim was one in which no one, not even the seeming winners, stood secure. 'Let Fortune rage, then, and stir up fresh convulsions. How much worse will she make things than they already are?'[39]

A pointed question – and one which the young Caesar, who had murdered and extorted his way from out-of-town obscurity to the mastery of Italy, could hardly help but be haunted by himself. He knew from the scale of his ascent, none better, just how far he had to fall. Cornered by the starving mob, pelted with stones and filth, rescued only with difficulty from being torn to pieces, he had stared the precariousness of his dominance directly in the face. Yet only two years later, Fortune had once again confirmed the young Caesar as her favourite. In September 36, Sextus Pompey was trapped off the east coast of Sicily and his fleet destroyed. Although Sextus himself managed to escape, his power was broken for good, and within a year he was dead. Meanwhile, back in Italy, the young Caesar was being hailed for the first time in genuinely rapturous terms. 'All the towns gave him, at the age of twenty-eight, a seat among their gods.'[40] No spitting hatred now. Whereas Philippi had brought nothing but misery to Italy, the joy of the naval victory over Sextus was something in which everyone could share. Sicily with its rich fields was restored to the young Caesar's rule. Ships bringing food began to dock once again at Italian ports. The blockade was over for good. In Rome, a golden statue of the victor was placed by official vote of the Senate on a column adorned with appropriate naval décor. 'Peace, long ravaged by civil strife,' read the inscription on its base, 'he restored by land and sea.'[41]

At last, it seemed, enthusiasm for the new regime was starting to reach beyond those who had profited from it personally. The young Caesar, alert as ever to opportunity, moved with his customary deftness to encourage this trend. Conscious of how loathed the

Triumvirate had become, and eager to hint at a brightening future, he began to pose with smooth shamelessness as the defender of all that he had spent so long attacking. Taxes were remitted, and documents from the dark days of the proscriptions burned with much ostentation. A few cosmetic powers were restored to the traditional magistracies of the Republic. Lepidus, long since neutered, was formally retired and packed off into exile. Meanwhile, the young Caesar himself began to hint that the Triumvirate itself should be retired.

Naturally, he avoided putting this fine-sounding sentiment into anything like action. Such a step, as yet, was out of the question. Even with Sextus and Lepidus both cleared from the board, there remained another player very much in the game. In the East, Antony showed no sign of losing his taste for power. Why would he? His appetites had always been on a swaggering scale. While the young Caesar, back in Rome, 'wore himself out with civil strife and wars',[42] Antony had been revelling in everything that the wealthy provinces and kingdoms of the eastern Mediterranean had to offer. Legions, riches, adulation: all were his. With the world now starkly divided between the two surviving Triumvirs, it was the younger man whose position still appeared the weaker. Yet in the glamour that was Antony's as the master of the East, there lay, perhaps, a weakness. And weakness, as countless others had learnt to their cost, was something that the young Caesar had a lethal genius for sniffing out.

Certainly, to a man of his proven murderousness, character assassination was a minor consideration. A decade on from the proscriptions, it was his rival's good name that he was now looking to dispatch. He knew the potency of rumour, 'which revels in filling people up with endless gossip, and blends equally what is true and not into a single song'.[43] Calumnies as shocking as they were colourful duly began to swirl through Rome. Antony's every action was cast in the worst possible light. His affectations, it was whispered, had degenerated into something monarchical, more appropriate

to a silken Oriental despot than a magistrate of the Roman people. Corrupted by the soft temptations of the East, Antony had taken to urinating into a golden chamberpot. He blew fortunes on dinner parties. Most shocking of all, he had succumbed to the wiles of the Queen of Egypt. Picking up where Caesar had left off, Antony had bedded Cleopatra; but his resulting infatuation had got the better of him, and he was now little more than her plaything and her dupe. That he was married to Octavia, the sister of his triumviral colleague and an impeccably respectable matron, shamed him not a jot. Instead, in a calculated insult to the young Caesar, he had packed her off back to Rome. The truest insult of all, however, was to the dignity of the Roman people. Now, when the Queen wanted a foot-massage, it was Antony who obliged. The implications, to those who believed such stories, were sinister in the extreme. Who was to say how far Cleopatra's ambitions might not extend? What if Antony, in thrall to such a siren, should help her to the rule of the entire East? What if he should help her – horror of horrors – to the rule of Rome?

Articulated as it was with subtle and venomous brilliance, this image of Antony as a man seduced from all his natural loyalties began to take on a life of its own. Inevitably, the more damage was done to his reputation, the more brightly did his rival's shine by comparison. Particularly devastating was the contrast to Cleopatra presented by Livia, that dutiful heiress of the Claudian line. Her doting husband duly sought to rub it in. In 35, he secured permission to set up public statues of Livia, and Octavia too. He also won for the two women a privilege that was naturally out of the question for Cleopatra: formal sanctions against anyone offering them insult. These measures were passed readily enough. Livia, whose breeding and public displays of modesty were exemplary, was widely admired in senatorial circles. Nor were the nobility alone in seeing her as one of their own. Many Italians did as well. Marcus Livius Drusus, her adoptive grandfather, had been their champion as well as the hero of the Roman poor. In

91 BC, he had sought to push through a law granting them citizen-
ship. One evening, in the hall of his own house, an unknown assassin
had struck him down with a shoemaker's knife. It was grief and fury
at this murder of their champion that had done much to push the
Italians into open revolt. Almost sixty years on, he remained widely
cherished as a martyr. Livia, as his heir, was heir as well to his renown.
Her presence next to the young Caesar, devoted and adoring, served
as a growing reassurance to Italians that her husband too, despite the
proscriptions, despite the expropriations, despite Perusia, might after
all be on their side.

The surest boost to this reassurance, however, was the palpable
improvement in his record. With his authority at last secure across
the entire western half of Rome's empire, he now devoted skills once
deployed in the cause of criminality to the restoration of law and
order. Pirates were cleared from the seas and bandits from the hills of
Italy. The one-time terrorist promoted himself as a dutiful public ser-
vant. Opportunism was replaced by a show of sober competence. As
he had done since the beginning of his adventuring, the young Caesar
displayed a keen eye for talent. Ability, not pedigree, remained the
surest way to his favour. Upstarts continued to thrive. Senators might
still roll their eyes at this; but for most citizens, relief that the worst
seemed to be over, that the flood-tide of chaos appeared to be ebbing,
outweighed even the pleasures of snobbery. For a decade now, ever
since the Ides of March, the funeral games of the murdered Dictator
had been raging. What mattered to the Roman people was no longer
who won, but simply that there be a definitive winner. Bloodied and
exhausted, they had grown too war-weary to care very much who
ruled them – just so long as they were granted peace.

'Harmony enables small things to flourish – while the lack of it
destroys the great.'[44] The man whose favourite saying this was knew
well of what he spoke. Marcus Vipsanius Agrippa, who from the first
appearance of the young Caesar on the political scene had ranked

alongside Maecenas as the most trusted of his partisans, came from a background of staggering obscurity. 'Having such a son did not make the father any better known.'[45] Agrippa brushed all such condescension aside. Charmless and dour, his passion was for the reality rather than the appurtenances of power. Always one pace behind the young Caesar, the image of the honest deputy, as colourless and dull as his leader appeared refulgent, he rested content in the knowledge of just how much he was needed. Agrippa shared with the taskmaster he served so loyally an unspoken secret. The young Caesar was a hopeless general. Rumours of uselessness in battle had always shadowed him. At Philippi he had managed to lose his tent to the enemy while spending most of the campaign sick; in the war against Sextus he had suffered two resounding defeats. Agrippa, by contrast, was a natural. He it was whose speed of manoeuvre had served to bottle up the rebels in Perusia; who had equipped the young Caesar's fleet with metal claws fired from catapults; who had brought Sextus to ultimate defeat. Rugged peasant resolve and an eye for innovation: these were the very qualities that had first set Rome upon her path to greatness. Agrippa, far from cringing before the nobility, regarded himself as the authentic representative of his city's antique virtues. Aggressive in his humility, he was willing literally to plumb the depths in the service of the Roman people.

So it was, in 33 BC, that the conqueror of Sextus descended into the murk and filth of Rome's sewers. For generations, ambitious nobles had regarded the aedileship – the magistracy responsible for the city's physical infrastructure – as a mere stepping-stone to more glamorous postings; but Agrippa, already the second most powerful man in Rome, did not disdain its duties. He welcomed the chance to get his hands dirty. A vast workforce was set to emptying and scrubbing clean the sewers – after which, in a triumphant demonstration of how practical were the benefits to be had from the new regime, Agrippa had himself rowed along the central drain. Meanwhile, even

as the city was being given this enema, other workmen were busy restoring the aqueducts and building a whole new one, the 'Aqua Julia'. 'In such quantities was water brought into Rome that it flowed like rivers through the city and its sewers. Almost every house was given cisterns and service-pipes, and fountains were everywhere.'[46] Feats of public service such as these were in the noblest, most muscular Roman tradition. Harking back to the heroic age of Appius Claudius, who had alternated winning battles with building roads, Agrippa was simultaneously working to usher in a new age – one that would see the city emerge cleansed of all its grime. Nothing was beneath his notice. Even barbers were recruited to the cause. Come a public holiday, and they would be sponsored to provide a free shave. Such was the future to which Agrippa, on behalf of his god-like leader, was guiding the Roman people: one scraped clear of all its stubble.

Even men with good cause to loathe the young Caesar – men who had fought against him at Philippi, men who had lost their lands – might recognise the appeal of such a programme. In 36 BC, at a party held to celebrate the defeat of Sextus, Horace had willingly toasted the victory, 'to the music of flute and lyre'.[47] His host that evening had been the subtlest and most valued of the young Caesar's advisors, a man as close as any to the heart of the regime. Where Agrippa was abrasive, Maecenas was perfumed and smooth, practised less at killing than at 'reconciling friends at odds'.[48] Horace, in offering this judgement, spoke from personal experience. Shortly after his arrival in Rome, broken and embittered, he had been introduced to the great man. Tongue-tied with nerves, he had barely been able to confess his circumstances. 'Nine months later, an order came, summoning me to be numbered among your friends.'[49] It was an offer not to be refused.

The relationship between the two men, although never one of equals, was soon affectionate and close. Maecenas combined an

aptitude for intimacy with a connoisseur's eye for genius – and Horace offered him both. Inevitably, friendship with a power-broker of such intimidating influence came with strings attached. Travelling with Maecenas on the young Caesar's business, Horace would sometimes be obliged to turn a blind eye, to affect a diplomatic conjunctivitis; pestered by others to betray his friend's secrets, he would have no choice but to pose as 'a prodigy of silence'.[50] Yet the compromises were never simply one-way. Horace did not renounce his past; nor, though he paid affectionate tribute to Maecenas, did he permit himself to become his patron's shill. He remained too independent, too much his own man, for that. In an age when the reach of poetry might be great, and the needs of the regime served by Maecenas no less so, he signally failed to offer the young Caesar public praise. With Antony still in command of a host of legions in the East, and the menace of war louring increasingly heavy, too much hung in the balance. Like so many others, Horace had learnt the hard way the perils of nailing colours to a mast.

Maecenas, subtle and penetrating, understood this perfectly well. He knew that Horace, like the Roman people as a whole, could not, in the final reckoning, be brutalised into loyalty. Their hopes had to be met, their terrors eased. They needed to be wooed. What, then, did Horace want? The liberty for which he had fought at Philippi was dead – irrevocably so. His hopes now were more limited, and as solid as his own round paunch. 'These are the objects of my prayers. A plot of land – not so very large. A garden, a spring beside the house, its water ever-flowing, and a small wood on a slope.'[51] Such a dream was shared by many others across Italy: by those granted land, by those robbed of it. Now, with the great cycle of civil wars approaching at last its definitive climax, the yearning of the Roman people for peace was more desperate than ever. Victory, in the final reckoning, was likeliest to go to whichever of the two surviving warlords could satisfy it the best.

By 32 BC, the young Caesar was ready at last to go for broke. The war of words no longer sufficed. It was time to meet Antony in open battle. Not that the young Caesar actually named Antony as his opponent. He had no wish to cast the war as one fought against fellow citizens. Instead, it was Cleopatra, whose baneful powers of seduction had already made a slave of Antony and eunuchs of his followers, whom he selflessly pledged to destroy. This he did in a manner that was fast becoming the keynote of his regime: by blending nostalgia with innovation. Back in ancient times, so it was said, a declaration of war had always been accompanied by the ritual hurling of a spear. Particularly memorable was the one thrown by Romulus, which on landing had sprouted branches and turned into a tree. Although it lay beyond even the young Caesar to emulate that particular stunt, his revival of the ceremony did satisfyingly showcase him as the defender of antique Roman virtue. It was not, though, the only step he took. A far more radical measure had also been adopted: one that served to define him in a way quite without precedent. 'The whole of Italy swore loyalty to me of its own accord, and demanded me as leader in war.'[52] This claim, as it happened, was not entirely free of spin. The oath had in fact been the young Caesar's own idea, and very far from voluntary – but a masterstroke, even so. By appealing to the towns and villages beyond Rome for support, even before he had obtained a decree from the Senate, he potently signalled his ambition to fight as their champion. Back in the days of their revolt against Rome, the Italians had sworn a mass oath of loyalty to the cause of freedom. Now, en masse, they pledged their loyalty to the young Caesar. Less than a decade after his return from Philippi had wrought misery and upheaval across Italy, he could head back to war as its champion. When finally, in the spring of 31, he crossed the Adriatic to meet with the enemy in northern Greece, he took with him – in addition to his battleships and legions – a weapon that his rival could not hope to combat. No longer was he merely at the head

of a faction. 'Leading the Italians into battle, with the Senate and the people, and the gods both of the household and the city,'[53] he had become something infinitely more potent: the face of the once and future Rome.

Granted, not everyone in Italy swallowed this. Some towns stayed faithful to Antony. Taxes imposed to fund the war effort resulted in much grumbling. In Rome there was even a full-blown riot. In general, though, people across Italy were content to hold their breath and wait. Infallible portents indicated that the crisis was ready to peak. The incineration by lightning of a two-headed snake, almost a hundred feet long, that had appeared in Etruria and caused enormous damage, was particularly noted. Sure enough, by summer it was clear that the fortunes of war were moving the way of the young Caesar. Antony, outmanoeuvred by Agrippa, was bottled up beside a promontory called Actium. In September, news reached Italy of a decisive development. Antony had launched a desperate attempt to force the naval blockade. Although he and Cleopatra had both made their escape, most of his fleet had surrendered. So too, a week later, had his legions.

The following spring, and the young Caesar was ready to wrap up his victory for good. Advancing on Egypt, he was met with barely a fight. First Antony perished by his own hand, then Cleopatra. The rule of her dynasty perished with her. Egypt was now the young Caesar's to do with as he wished. So too the world. For thirteen long years, ever since the Ides of March, it had been ravaged by wars and horrors so devastating that many had dreaded the complete collapse of Roman power, and the end of the world. Now at last the conflict was done.

'Time for a drink.'[54] Horace's relief, as he raised a toast to the defeat of Cleopatra and the victory of the young Caesar, was palpable. Maecenas, whose responsibility it had been during the months of his leader's absence abroad to maintain order in Italy, was no doubt

delighted to sense it. He knew just what he had in his reflective and independent-minded friend: a mirror held to all those who, storm-tossed by the evils of the age, had somehow attained dry land. 'What are self-sufficiency and happiness? The ability to say: "I have lived."' Maecenas could not return to Horace the lands stolen from him: they were gone for ever. He could, though, make some recompense now that the regime he served was secure at last. Shortly after Actium had ensured that he would not, after all, be appearing on any proscription list of Antony's, he gave to his friend an estate just north of Rome, amid the Sabine hills. It was, in every sense, the answer to Horace's prayers. No wonder it seemed to the poet a place hallowed by the joy he took in it. It was peaceful, it was beautiful, it was every-thing that the decade he had just experienced was not. In the farm's fields, the crops grew with supernatural abundance; in its woods, the kids could roam without fear of the wolf, that beast of Mars. The gods, long absent from Italy, were back.

Or so Horace, and many, many others like him, now dared to hope.

The Spoils of Honour

'Conquering your neighbours was your chief preoccupation.'[55] So it was said of Romulus. Fighting foreigners, not themselves: this, everyone could agree, was the proper business of the Roman people. Naturally, in war as in peace, it was essential to respect legal niceties. Unprovoked aggression, while only to be expected from wild beasts and barbarians, was behaviour inappropriate to a civilised people. 'When we go to war, it is for the sake of our allies – or to uphold our empire.'[56] So it had always been. When Romulus attacked his neighbours, it had been with the resolve never to tolerate disrespect. Retribution for insult or injury had always been swift. One local king,

ambushed and routed after presuming to raid Roman territory, had been cut down by Romulus himself. Here, in this slaying of a general by his opposite number, had been an exploit fit to illumine the succeeding ages. What more glorious feat of single combat could possibly be envisaged? Romulus, after stripping the blood-soaked armour from his foe, had borne it proudly back to Rome.

There was only one god worthy to receive the dedication of such a prize: Jupiter, the king of the gods himself. Hung at first from the branches of a sacred oak, the 'spoils of honour' had subsequently been moved into a temple custom-built for the purpose, the very first to be consecrated in the city. 'Here,' Romulus had decreed, 'was where, in days to come, anyone who emulates me by killing a general or a king with his own hands, shall lay the stripped arms – the "spoils of honour".'[57]

In the event, over the long and glorious course of Roman history, only a couple of other men had ever managed the feat. One was Cornelius Cossus, a cavalry officer who was supposed to have lived in the first century of the Republic, and the second a contemporary of Scipio Africanus by the name of Marcellus. The days when a commander would meet with his opposite number in single combat seemed to belong to a vanished age of heroes. Over time, the temple in which the 'spoils of honour' were stored had itself begun to crumble. Venerable though it was, it had long since been overshadowed. The steep hill on which it stood, across the Forum from the Palatine, had always been the seat of the gods. The Capitol was where, back in the golden age before history's beginning, Jupiter's father Saturn had established his throne. It was also where Rome's largest temple had been raised in the final decades of the city's own monarchy. Burned down in 83 BC, it had promptly been rebuilt on an even more grandiose scale. That it too was dedicated to Jupiter only served to emphasise the pokiness of Romulus's original temple. As Rome, in the terrible decade that followed the Ides of March, grew

ever shabbier, so the city's oldest shrine seemed on the verge of col-
lapse: 'roofless and dilapidated with age and neglect'.[58]

Yet all along, beneath the cobwebs and the dust, the temple
had been sheltering a weapon with the potential to set kingdoms
tottering. Stored inside the crumbling walls, alongside the 'spoils of
honour' and a lightning bolt made of stone, lay an antique spear. It
was this that the young Caesar, when declaring war on Cleopatra in
32 BC, had hurled in accordance with venerable custom.[59] Nothing
could better have served to associate him with the martial virtues
of Rome's founder. Heading off to war, he did so as a second Rom-
ulus. Meanwhile, back on the Capitol, workmen were moving in.
Comprehensive repairs were begun to Rome's oldest temple. So
comprehensive, indeed, as to rank as an almost total rebuild. The
young Caesar knew better than to neglect the home front. The
hammering and chiselling in the heart of the city provided a perfect
accompaniment to the news coming in from Actium and Egypt.
Even though the new Romulus was likelier, in truth, to pass a battle
vomiting in his tent than engaging in hand-to-hand combat with
enemy generals, that was beside the point. By 29, when he finally
returned from the East with Antony and Cleopatra both dead, and
the whole world seemingly his, it was to a city in which the well-
spring of Rome's martial traditions had been rebranded as his own.

It was not enough to be a victor. *Auctoritas*, that ineffable quality
of prestige which served the Roman people as their surest measure
of greatness, required a man to look and behave like a victor as well.
The young Caesar, whose talents as an actor were no less formidable
than his ambition, had long been sensitive to this. At Philippi, the
prisoners-of-war had pointedly refused to salute him; at Perusia,
the besieged defenders had mocked him as 'Octavia'.[60] By 38, he had
had enough. Licking his wounds after a particularly humiliating
reverse at the hands of Sextus, he had drawn a veil over his military
inadequacies by means of one of his favourite and boldest expedients:

beefing up his name.[61] A new one had begun to feature on his coins. Henceforward, these proclaimed, he was to be known as *Imperator Caesar* – 'Caesar The Victorious General'. Many commanders had been hailed as such on the field of battle, but none before had ever dreamed of making it so thoroughly and immodestly his own. Once Sextus was out of the way, the freshly minted Imperator Caesar had gone to great lengths to live up to his bold new nomenclature. In 35, he had headed across the Adriatic to the Balkans, there to test himself against bands of obstreperous barbarians named Illyrians. Two years of sporadic campaigning had enabled him to chalk up a succession of much-publicised victories. The tribes of Illyria had been variously ambushed, besieged and massacred. Some eagles captured a decade and more previously had been redeemed from captivity. Imperator Caesar himself had sustained a heroic wound to his right knee. Here, in the pacification of Illyria, had been a splendid appetiser for the even more glorious victories that were to follow. When, in the summer of 29, the conqueror of Egypt returned home from his settlement of the East, the refulgence of his *auctoritas* filled the whole world with its blaze. Imperator Caesar had become the sum of his name.

Italy, meanwhile, had been awaiting the conqueror with a degree of nervousness. Memories of his return from a previous civil war were still raw. As after Philippi, so after Actium the victor came trailing a monstrous number of land-hungry soldiers. His own recruitment drive and defections from his foes had combined to set him at the head of almost sixty legions. Such was the mood of anxiety that even Horace found himself pestered for inside information. 'Where does Caesar mean to give his soldiers the land he has promised them?'[62] The question weighed on everyone's mind. Given how brutally the returning hero had consolidated his power in the early years of his career, it could hardly have done otherwise. Yet the trepidation was to prove misplaced. The murderousness of the young Caesar's early career had been the measure of his weakness, not his strength. Now,

with no foe left standing to oppose him, and the wealth of the East at his back, naked gangsterism no longer served his interests. The surest buttress of power he possessed was his *auctoritas* – and the surest buttress of that was his ability to serve the Roman people as the restorer and guarantor of peace.

That he had secured his greatness over the corpses of his fellow citizens was a truth no longer in anyone's interest to dwell upon. In January 29, six months before Imperator Caesar's return from the East, the Senate had formally approved his stupefying new first name. His status as the supreme exemplar of Rome's glory, the embodiment of the military virtues that had won her an empire and then come close to destroying her, was now official. The days when predatory noblemen waded through blood after dominance were over. Henceforward, there was to be only one. 'Let the better reign singly.'[63] On 13 August, this was made manifest in the most public way imaginable when Imperator Caesar finally entered Rome. Riding in formal procession through the city, pulled by four horses in a chariot ornamented with gold and ivory and followed by his army, he celebrated his martial prowess as only a Roman knew how.

The 'triumph', as this ritual was called, trailed a reassuringly venerable pedigree. Scholars traced its origins back to the very beginnings of Rome.[64] It was said that Romulus, after stripping his fallen adversary of the 'spoils of honour', had then blazed a trail by making his way into the city 'dressed in a purple robe and wearing a crown of laurel on his head'.[65] True or not, triumphs had long been serving the Roman people as waymarks on their road to empire. Scipio, Pompey and Julius Caesar had all celebrated them. None, though, could compare for sheer magnificence with the show now being put on by Imperator Caesar. Three whole days were required to celebrate the sweep of his victories. Illyria, Actium and Egypt: each was the focus of a separate triumph. 'The streets resounded to joy, games and applause.'[66] The climax came when the fabled riches of

Cleopatra's kingdom, all the most fabulous pickings that the land of the pharaohs had to offer, were paraded before the crowds. Roman jaws collectively dropped. The exotic was not the only focus of the celebrations, though. Entering Rome on the morning of his first triumph, Imperator Caesar had been conducted into the city by the virgin priestesses of Vesta; riding through the streets, he had been followed by the leading magistrates of the Republic. Simultaneously ground-breaking and backward-looking, his triumphs – the first ever to be celebrated on three consecutive days – offered his fellow citizens both spectacle and reassurance. The Roman people recognised, as they were meant to recognise, that they were watching the ultimate in triumphs.

And when the processions were done, when the crowds had melted away and the gilded chariot been put into storage, what remained of those three remarkable August days were memories, and the sense of a new beginning. For all that they might enjoy a good triumph, the Roman people had had their fill of militarism. 'No son of mine will be a soldier.'[67] There were many, over the past twenty years, who had come to feel the same. Imperator Caesar understood this perfectly well. He could not possibly enjoy popular support while also keeping the military underpinnings of his regime exposed nakedly to view. Accordingly, even as the clamour and dazzle of his triumphs were filling the streets of Rome, measures were being taken to disperse his vast train of soldiers.

With the riches of conquered Egypt behind him, Imperator Caesar could well afford to throw money at the problem. No need for confiscations now. Instead, vast sums of money were spent on buying up land for thousands upon thousands of demobbed soldiers. Some were settled in Italy, others in colonies abroad. None of them made trouble; none of them cut up rough. No feat of governance on such a mammoth scale had ever before been attempted by a Roman statesman – still less pulled off. The achievement was welcomed, not

surprisingly, with widespread and heartfelt gratitude. The promises of Imperator Caesar, it appeared, were not just specious talk. Peace, after all the horrors of civil war, was a prospect genuinely in view. 'The violent age of battle grows mild.'[68]

Not everywhere, though. The empire of the Roman people, bordered as it was by vast numbers of contumacious barbarians, could hardly afford to beat all its swords into ploughshares. Some legions, at any rate, were still needed to stand sentry. Gaul and Spain, Syria and Egypt, would certainly require garrisons. The Balkans too, despite the heroic performance of Imperator Caesar against the Illyrians, remained a festering source of trouble. Tribes of the kind who lurked beyond the Danube, bearded, shaggy-chested and armed with poisoned arrows, did not – as was the habit of civilised people – build cities and remain in them, but were instead forever on the move. In the summer of 29, even as Imperator Caesar was staging his triumphs in Rome, crisis was brewing in the badlands beyond the province of Macedonia. A tribe called the Bastarnians, who normally lurked in dank forests by the mouth of the Danube and were known, as a result, as the People of the Pine Trees, were heading southwards. Travelling in such numbers that they had even brought their wives and children with them, they were a patent menace. With their wagon train rumbling ever closer to Macedonia, the duty of the governor was clear. Even if the Bastarnians had no intention of actually crossing onto Roman soil, their temerity in approaching the frontier could not be allowed to go unpunished. The situation demanded a pre-emptive strike.

Such, at any rate, was the thinking of the governor himself. In marshalling his legions, ordering them to march out into the barbarian wilds and setting himself at their head, he was displaying the same dauntless spirit that had won the Roman people their empire in the first place. Romulus, no doubt, would have done the same. Yet back in Rome, the sudden flaring of war in the Balkans was

signally unwelcome. Only one man was permitted to play at being Romulus – and it was not the governor of Macedonia. Thirty years earlier, when the deified father of Imperator Caesar had himself been the governor of a frontier province, his march northwards to stem a migration of barbarians had been the first step in his conquest of the whole of Gaul. No one needed any reminding of what had followed on from that. Yet Imperator Caesar was in a bind. He could not simply forbid a Roman aristocrat from doing what a Roman aristocrat was supposed to do. The dark days of the proscriptions, when his power had been naked and sanguinary, were past. He had no wish to rule as a despot. Do that, and he risked perishing as his deified father had done, beneath a hail of senators' knives. Hence his dilemma. Somehow, he had to find a way of securing the co-operation of the Senate, while at the same time denying its big beasts any taste of authentic power.

And indisputably, the governor of Macedonia ranked as a big beast. Marcus Licinius Crassus was the grandson and namesake of the billionaire whose manoeuvrings had done so much to make the political weather in the decade before the crossing of the Rubicon and the eruption of civil war. The grandson was very much a chip off the old block. He had negotiated the treacherous rapids of the age with skill, leveraging abrupt shifts of loyalty to great effect. Abandoning Sextus Pompey in the nick of time, he had transferred his support to Antony; then, just before Actium, he had jumped ship once again. Displaying an eye for business that would have done credit to his grandfather, Crassus had driven an impressively hard bargain. Imperator Caesar had agreed to reward him for his treachery with a consulship, and then, when his term of office was done, a province with its own complement of legions. Twenty-four years had passed since the death of his grandfather amid the sands of Carrhae, and the loss to the Parthians of his eagles. The humiliation of the defeat was still vividly felt by the Roman people – and by Crassus, especially so.

Now, by blundering their way towards his province, the Bastarnians had presented him with the perfect opportunity to ease it. He would wipe clean the slate of his family's honour with barbarian blood.

The Bastarnians themselves, when they realised the full scale of the force that was advancing against them, responded with panic. Their king, a man named Deldo, sent envoys to Crassus, 'urging him not to chase them – since they had done the Romans no harm'.[69] Their pursuer, greeting the ambassadors with a smooth show of hospitality, offered them a drink – and then another, and another. The more inebriated the envoys became, the more he pumped them for information. The Bastarnians, it turned out, were hunkered down with their wagons beyond a nearby forest. Once he was certain of his quarry's dispositions, Crassus did not hesitate. Orders were given. Even though it was dark by now, his men began to advance.

Meanwhile, on the far side of the forest, it was becoming clear to the Bastarnian king that his envoys would not be returning. Then, as dawn broke, Deldo made out, beyond the blaze of watchfires, Roman scouts on the edge of the forest. Warriors with sheath-knives drawn and bow-strings of horsegut tautened almost to breaking point began to spill out from the ring of wagons. A hail of arrows, their tips dipped in venom, rattled down upon the Roman scouts. Some fell; others melted back into the forest. Bastarnian warbands, plunging into the murk, pursued them as they fled. Battle-cries of triumph sounded above the crashing of the undergrowth. None of the Bastarnians – and certainly not their king – paused to think they might be blundering into a trap.

That, though, was precisely what Crassus had set. The ambush, when it was sprung, proved devastating. The Bastarnian warbands were wiped out and their corpses left to fertilise the roots of the forest; their women and children were rounded up; their wagons put to the torch. A message of Roman greatness, written in blood and fire, was being sent far across the Balkans. Most glorious of all

was the memorial to the victory won by Crassus himself. It was upon his sword and nobody else's that the king of the Bastarnians had perished. Deldo's armour, stripped from his corpse, constituted a trophy such as no Roman general had won in centuries. Crassus's soldiers, when they hailed him on the field of battle as *imperator*, were saluting him as well as something more: only the fourth man in their history to win for himself the 'spoils of honour'.

To Imperator Caesar, of course, the news could hardly have been less welcome. His triumphs, his building programme on the Capitol, his very name: all had been designed to establish him in the minds of the Roman people as the epitome of the victorious general. That another *imperator* might now parade through the streets of Rome with armour stripped from a barbarian chieftain, and place it in the same temple that he had been restoring with such expense and show, was an intolerable prospect. It directly menaced his *auctoritas*. As such, it was not to be borne. Nothing better demonstrated the embarrassment felt at Crassus's feat than the knee-jerk desperation of the attempt to stymie it. Imperator Caesar had long since mastered the art of veiling his own interests behind a smokescreen of often bogus tradition – and now he attempted the trick once again. Renovation of the ancient temple on the Capitol, it was abruptly announced, had turned up a remarkable find. Workmen had discovered an ancient linen corselet. Imperator Caesar himself, 'the restorer of the very temple, had seen it with his own eyes'.[70] An inscription on the corselet proved that it had belonged to none other than Cornelius Cossus, the second of the three heroes to have dedicated the 'spoils of honour' to Jupiter. Not only that, but it revealed a hitherto unsuspected fact. Cossus, contrary to what the annals and histories of the Republic had always claimed, had in fact been a consul when he won his famous trophy. Perhaps, then, in light of this revelation, there was a case for arguing that Crassus, as a mere governor, was not qualified to present the 'spoils of honour'?

In fact, there was not. That Crassus had been a governor rather than a consul when he slew the king of the Bastarnians did not alter the reality that he had been in sole command. Nevertheless, the waters had been successfully muddied. With Crassus absent in Macedonia for at least another year, there was time enough for Imperator Caesar to neutralise any potential damage. There could certainly be no doubting now the urgency of the challenge that faced him. His *auctoritas* had to be rendered impregnable. So it was, throughout 28, that he renewed his efforts to cast himself as the defender of all that was noblest and best in the inheritance of the Roman people: 'the man who had given back to them their laws and rights'.[71] Any lingering traces of the terrorist he had once been, and of the criminality for which he had been notorious, were systematically erased. All unconstitutional measures enacted during the dark days of the proscriptions and the civil wars were solemnly rescinded; free elections to magistracies restored; eighty silver statues of himself, the height of upstart vulgarity, melted down. In their place, Imperator Caesar accepted no honour 'inconsistent with the customs of our ancestors'.[72] The man who in the early days of his career had sanctioned the murder of senators now sat in honour at their head. Gratefully, he received from them the venerable title once worn by Scipio Africanus: *Princeps Senatus* – 'First Man of the Senate'.

The graciousness of Imperator Caesar in restoring to the Roman people their abrogated liberties naturally deserved no less. And there was more to come. On 13 January 27, in a spectacular gesture of renunciation, the man who had extinguished the flames of civil war and won for himself the rule of the world informed the Senate that he was laying down all his powers. Henceforward, he was content to serve simply as what he had been for the past four years, an elected consul. 'The public welfare,' as he would later put it with sonorous modesty, 'I transferred out of my power into those of the Senate and the Roman people – to do with as they judged best.'[73] What the

Senate judged best, after listening to Imperator Caesar with carefully rehearsed surprise, was to salute him as a hero in the noblest traditions of the Republic. Almost two decades earlier, at the feast of the Lupercalia, a panting and thong-clad Antony had presented the Deified Julius with a royal diadem; but now, when the Senate in their turn pressed a crown upon a Caesar, it was to honour him, not as the master, but as the servant of the Roman people. The 'civic crown' was a simple wreath of oak leaves which celebrated, as its name implied, the shared bonds of citizenship. Only a Roman who had saved the life of another in battle, 'slaying the adversary who had been threatening his fellow, nor ever giving ground',[74] was fit to be awarded it. Who more deserving, then, than the man who had kept the empire itself from implosion? Imperator Caesar, grateful to the Senate for the honour shown him, did not hesitate to accept it. The modesty of the award was precisely what rendered it so precious. Orders were given for it to be placed where all could see it: directly above Imperator Caesar's front door. There it was to hang perpetually – a reminder 'of the citizens he had saved'.[75]

What other noble could hope to compete with this – the mingled glory and humility of it? *Auctoritas* of such an order put every magistracy, every lineage, every battle honour in the shade. There were few in the Senate House, as they listened to Imperator Caesar declare himself 'a mild man, interested only in a quiet life',[76] who would have doubted that. To be sure, his claim to be restoring to senators their ancient licence to compete for honours was no mere sham. Had it been otherwise, their resentment of his regime would have smouldered with the same desperation that had proved so fatal to his deified father. Imperator Caesar needed their backing. The changes that he offered them were genuine. The Senate was to become what it had been before the civil wars: the surest path to high office. Elections were to be open. Competition was to be unconstrained. Imperator Caesar himself, far from merely allocating magistracies to

his favoured candidates, would be obliged to canvass for them, and cast his vote just like everyone else. The pre-eminence of the Senate, it might have seemed to the more trusting of its members, had indeed been burnished and redeemed.

Yet even though the lustre of the Republic's ancient offices still burned brightly, the changed nature of the world inhabited by those who aspired to hold them was not easily ignored. Reminders of it loomed everywhere. Crossing the Forum that morning to hear Imperator Caesar speak, senators had made their way past gleaming new monuments raised to the glory of the Deified Julius and his son: temples, statues, arches. Glancing up at the roof of the recently completed Senate House, it would have been impossible for them to miss a statue of Victory, her feet treading down the globe. Now, watching Imperator Caesar deliver his momentous address, they could see directly behind him a second statue of Victory, conspicuous on a pillar and surrounded by trophies pillaged from Egypt. For some, the intimidating glamour of it all proved too much. Displays of loyalty lurched into melodramatic excess. One senator, after yelling that he would rather die than outlive Imperator Caesar, rushed from the Senate House into the streets, where he began urging the crowds to swear the same. Even the Tiber seemed overcome. Bursting its banks, it flooded the low-lying districts of Rome – a clear sign from the gods that they intended Imperator Caesar 'to have the whole city under his authority'.[77] To primacy of such an order, the formal title of *Princeps Senatus* hardly did justice. No formal title could. The greatness of Imperator Caesar far outsoared the capacity of any single rank or honour to define it. Best, then, perhaps, to think of him simply as *princeps*: the 'first man' of Rome, and of the world.

Imperator Caesar, as ever, was having it both ways. His resignation of formal powers was no resignation of power. The carnivorous rivalries that had brought the Republic to ruin were not being unleashed anew. Aristocrats with famous names might compete for high office,

just as their ancestors had done – but they would be doing so in the manner of captive tigers, padding around the confines of an ornate and splendid zoo. The response to the Princeps's speech from within the Senate House itself, minutely orchestrated as it was, made sure of that. Even as Crassus, in his winter quarters, was recovering from a second hard season of campaigning, measures were being taken to ensure that great dynasts like him would never again have the opportunity to go adventuring against barbarians. No sooner had the Princeps sat down after finishing his speech than pliant senators were rising and begging him not to abandon his military command. The Princeps, stern and selfless, refused. The senators continued to beg. The Roman people still needed a guardian of their liberty. That being so, the placemen asked, would the Princeps not accept a command such as Pompey or his own deified father had once held, embracing a number of provinces and set at ten years? Nothing remotely contrary to tradition, nothing remotely smacking of monarchy, about that. The Princeps pondered this argument. Then, after due reflection, he acknowledged that the senators perhaps had a point. Reluctantly, dutifully, nobly, he shouldered the command.

Gaul and Spain, Syria and Egypt: these were the pick of the provinces awarded by a grateful Senate to Imperator Caesar. Together, they provided him with a force of over twenty legions. Henceforward, those who commanded them in the field would do so as his subordinates – his 'legates'. No more were men with famous names to go glory-hunting after 'spoils of honour'. Crassus himself, in Macedonia, was permitted to keep his province – but his wings had been decisively clipped. When he returned home in the summer of 27, the Princeps did not feel it worth the bother of denying him his triumph. Crassus duly paraded his trophies and prisoners through Rome. Enthusiasm for his exploits was widespread. Horace was just one of many to toast them.[78] There was no mention, though, of the 'spoils of honour', nor any visit paid to the tiny temple of Jupiter. Crassus, after his moment

in the sun, faded from public attention. His days of campaigning were over. His successors as governor of Macedonia, although not appointed directly by the Princeps, were dull men, and obscure. One of them, it was true, did go so far as to launch an unprovoked attack on a nearby friendly king – but he was immediately hauled back to Rome, and put on trial for illegal adventuring. The Princeps himself deigned to appear as a witness for the prosecution. Governors after that made sure to stay well within the borders of Macedonia.

None of which meant that the Roman people were deprived of martial adventures to cheer. Quite the opposite. The Princeps took his provincial responsibilities very seriously. There remained a world still to be conquered and pacified, and he intended to prove himself worthy of this earth-shaking mission. Victories over barbarians were the necessary justification of his command. So it was that wars blazed along almost every frontier for which the Princeps had responsib- ility. His legates embarked on a programme of expansion without precedent in Roman history. Legions tracked the course of the Nile deep into Ethiopia; penetrated the remote desert sands of Arabia; tamed the bandits of the Alps. To people back in Rome, it began to seem that even the most remote and savage of nations might soon be brought to bow their necks. 'Caesar,' wrote Horace in a state of high excitement, 'is heading off against the Britons, to the very ends of the world!'[79] In fact, Caesar was not. He had a different target in mind. It was in Spain, where the tribes of the northern mountains had for two centuries defied the advance of Roman arms, that the Princeps, early in 26, took up personal command. Divine backing for this move was made spectacularly clear early on in the expedition, when a lightning bolt grazed the litter in which he was being carried, incinerating a nearby slave. That Jupiter was plainly keeping a personal eye on his favourite turned out to be just as well – for the campaigning did not play to the Princeps's strengths. So debilitating did he find the style of guerilla warfare favoured by the natives that, as was invariably his

habit when in the field, he retired to his sickbed – whereupon the barbarians, in a spasm of fatal over-confidence, engaged in open battle and were brought to defeat. The ever loyal Agrippa then mopped up the rest. The Princeps himself, naturally enough, took all the credit.

The willingness of the Roman people to indulge him in this, to bring out the garlands and to crack open jars of wine on his return from Spain, mingled flattery with palpable nervousness. The health of the Princeps was shattered. Physicians diagnosed abscesses of the liver. Many feared the worst. 'While Caesar holds the world in his hands, I need have no fear of civil war or a violent death.'[80] So declared Horace, speaking the simple truth. Settled contentedly on his Sabine farm, he had no wish to lose the fruits of peace. Neither did the vast majority of his fellow citizens. Early in 23, when the Princeps grew so ill that his death was hourly expected, the whole of Rome held its breath. There were some, no doubt, in their yearning to be free of his dominance, who prayed for it; but there were many more who did not. The slender thread from which the stability of the world hung stood nakedly exposed. The Princeps, even as he tossed and sweated on his sickbed, drew his own conclusions. When eventually he recovered, redeemed from death's door by a vigorous course of cold baths, it was with the determination not to let the crisis go to waste. It was now much more apparent to him than before that widespread backing existed for his primacy. He moved fast to take advantage.

On 1 July 23, the Princeps announced that he was laying down his eleventh consulship. Once again, as had been the case four and a half years previously, a gesture of renunciation veiled what was simultaneously an entrenchment of his supremacy. The shadow-play that had characterised the original bargain struck between him and the Senate was now refined to yet further heights of ambivalence. Certainly, there was much in the terms of the new arrangement to delight upwardly mobile elements in the Senate. No longer would

one of the two consulships be clogged up by the Princeps, year after year after year. Opportunities to secure Rome's pre-eminent magistracy were doubled overnight. The old days of the Republic, and of its most competitive traditions, did indeed appear restored. Naturally, though, this came at a price. The Senate had its own side of the bargain to meet. Awesome new powers were ceded to the Princeps. The right to summon senators whenever he wished, to present them with legislation, and to outrank even those governors who were not officially his legates: all these privileges were agreed and ratified. Four years previously, Imperator Caesar would not have dared to demand them. Now things were changed. His *auctoritas*, that thing of dazzling light and deepest, darkest shadow, had gained fresh muscle, fresh teeth.

A year later, when the ravages of hunger and plague led the people of Rome to riot, and to declare that only his appointment as Dictator would serve to redeem the city, the Princeps dismissed them in affronted terms. Falling to his knees, he tore and ripped at his clothes. Time was when, coming to the Senate House, he had worn armour beneath his toga – but now, baring his chest, he begged the people to stab him rather than force him to be Dictator. Calculated these histrionics may have been, but his indignation was genuine. It no longer needed the example of his deified father to make him recoil from emulating it. Greatness such as he had won for himself was not to be constrained within the limits of any formal position. His power, like the perfume of the richest incense, had percolated to every nook, every cranny of the Roman state. No need, then, to offend tradition by desecrating it. What had he done, after all, if not make it his own? Now, when people gazed at the Princeps, they did not see the executioner of the Republic. Rather, they saw its embodiment. 'What is Caesar, if not the state itself?'[81]

Ever since the age of nineteen, when he had declared himself the avenging son of a god, the one-time Gaius Octavius had known that

the surest reality lay in the eye of the beholder. What people could be persuaded not to see was quite as important as what they could. Marcus Crassus, desperate to redeem the disgrace of his grandfather's fate, had cornered a barbarian king and felled him with his own sword; but the Princeps, when he set out in September 22 directly for the eastern provinces, knew better than to trust to steel alone. The blaze of his reputation, fit as it was to overawe both the Parthians and his fellow citizens back home, was a surer weapon by far. Rather than risk the fate of Crassus by going to war, the Princeps opted instead to open negotiations directly with Phraates, the king of Parthia.

The gambit was unparalleled. No previous *imperator* had ever thought to settle a dispute with barbarians except by force of arms. Only a leader of god-like prestige could possibly have thought to fly in the face of such unyielding martial precedent – just as only a leader of god-like prestige could possibly have made it pay. Phraates, relieved to be treated as an equal by the bellicose and unpredictable superpower on his doorstep, duly accepted the offer of a negotiated peace. As a token of goodwill, he handed over precisely what the Princeps had travelled east to obtain: the eagles captured from Crassus at Carrhae. A glorious achievement. What was the stripping of armour from some stinking Balkan chieftain to compare?

Returning to Rome after three years away, the Princeps made sure to rub the point home. On the sacred hill of the Capitol, where the first ever battle honours won by a Roman had been placed many centuries before, he ordered a small temple built. Here it was, for the while, that the standards were to be kept: a function designed, like its location, to echo that of the ancient temple of Jupiter.[82] The Princeps, with his customary blend of subtlety and precision, knew exactly the message that he was broadcasting to his fellow citizens. Although he might not have killed a rival general, he had won for himself the very ultimate in spoils of honour. Truly, he was the second Romulus – the founder anew of Rome.

On the day of the city's founding, twelve eagles had flown over the Palatine. The sign had been touched by an awesome, super-human power, a power described by the Romans as *augustus*. Back in 27 BC, when the Senate had been pressing on the Princeps his globe-spanning provincial command, one of its members had seized on the word as the perfect adjective to describe him. Other senators, alert to the taste of Imperator Caesar for accumulating new names, had been pushing for him to be called 'Romulus' – but the entire Senate, the moment *augustus* was mentioned, had known at once that nothing else would do. The Princeps himself, reluctant to bear the name of a king, had concurred. So it had come to pass. Imperator Caesar, by official vote of the Senate, had been awarded the additional name of 'Augustus'. Less menacing than 'Romulus', it was also fantastically more impressive. '*Augustus* is what our fathers call anything holy. *Augustus* is what we call a temple that has been properly consecrated by the hand of the priests.'[83]

A man with such a name had no need of formal rank. Neither king, nor dictator, nor even consul, he was something infinitely more. The gods had given to Rome, in her hour of most desperate need, a touch of the divine. They had given her Imperator Caesar Augustus.

The God Father

During one of his periodic bouts of illness, the Princeps decided that he could do with a secretary. Casting around for a suitable candi-date, his eye fell on Horace. Witty, personable and discreet, the poet appeared the perfect fit. Horace himself, though, was appalled. He had not escaped the grind of accountancy only to be chained to another man's ink and scrolls. Summoning all his immense reser-voirs of tact, he duly made his excuses. He too, he explained to the

Princeps, suffered from ill health. The offer, very regretfully, was one that he would have to refuse.

This rejection, coming as it did from someone who had fought on the losing side at Philippi, might have seemed a bold one. The aura of violence and menace that had clung to Augustus when he was a young man still lingered faintly. It could be hard for those of a certain generation to see the Princeps raise his hand in a gesture of salute, and not remember a story told of him as a triumvir: of how with his own fingers he had once gouged out the eyes of a suspected assassin. Times, though, had changed. Augustus himself had been anxious enough about the story explicitly to deny it. His youthful atrocities had long since served their purpose. Now that he had won for himself the mastery of the Roman state, he had no further need of cruelty. Displays of mercy better served his love of power. Augustus was perfectly content to tolerate what he no longer had cause to fear. In the temple to Venus Genetrix built by his deified father, the statue of Cleopatra still touched the shadows with a shimmering of gold. Iullus Antonius, the dashing and cultivated son of Antony, was brought up in Octavia's household and married off to a niece of the Princeps. Men who had fought for Pompey, who had commanded legions at Philippi, who kept statues of the Deified Julius's assassins in their homes, were encouraged to serve as consuls. Augustus had no interest in pursuing vendettas once his own security was no longer at stake. Horace could turn down the offer of a secretaryship and still retain his favour.

Indeed, the Princeps was widely known as a man who could enjoy a joke against himself. Meeting a young man who looked just like him, he asked, '"Tell me, was your mother ever in Rome?" "No," came the answer. "But my father was – often."'[84] Anecdotes such as these did wonders for the Princeps's image. It helped as well that he could give as good as he got. Augustus's sense of humour, like that of the vast mass of his fellow citizens, inclined to the

raucous. Dwarves, cripples, people with gout: all prompted him to celebrated witticisms. Maecenas was joshed by the Princeps for his 'loose, effeminate and languishing style',[85] Horace for being fat. Augustus meant it all affably enough. That he addressed the poet as 'the very cleanest of pricks'[86] was a mark of affection, not contempt – and he was perfectly capable, in his dealings with those he cherished, of displaying sensitivity and charm. Yet there remained a toughness, an asperity about his character that reminded those with a taste for snobbery of the small-town conservatism from which he had sprung. Whether cheering on boxers in back streets, sporting a battered sunhat or roaring with laughter at the sight of a hunchback, Imperator Caesar Augustus retained just a hint of the provincial.

None of which did him any harm among the mass of the Roman people. It gratified them to think of the Princeps as a man without airs and graces. Intimate personal details, carefully leaked, helped to cast him as a citizen of honest, simple tastes. It was common knowledge that a man whose name served to place him midway between the earth and the heavens ate much like a peasant, that his bread was coarse and his wine of an unfashionable vintage. Divine appetites, even in the son of a god, were capable of causing bitter resentment. Augustus had discovered this the hard way. In the aftermath of Philippi, when the world had seemed abandoned by the gods, aping the absent immortals had become quite the craze among ambitious warlords. A former consul might think nothing of painting his body blue, putting on the fish's tail appropriate to a sea god and flopping around on all fours. Augustus, in the first throes of his passion for Livia, had staged a particularly provocative masquerade. At a time when Rome was in the grip of famine, he had held a drinking party to which all the guests had come dressed as immortals. The groom himself had starred as the golden and eternally youthful god of light and music, Apollo. Down in the streets of the starving city, outrage

at the news had blended with bitterness and scorn. 'Yes, to be sure,' men had cried, 'Caesar is Apollo – Apollo the Torturer.'[87]

The people of Rome had particular reason to associate a god more commonly worshipped as the patron of prophecy and self-discipline with vicious cruelty. In the Forum, next to the sacred fig tree, there stood the statue of a pot-bellied man with a wine-sack on his shoulder. This was Marsyas, a satyr who had once challenged Apollo to a musical contest, been cheated of the victory that was rightfully his, and then been flayed alive for his presumption. Such, at any rate, was the version of the story told by the Greeks – but in Italy an altogether happier ending was reported. Marsyas, they claimed, had escaped the irate Apollo and fled to the Apennines, where he had taught the arts of augury to the natives and fathered the snake-charming Marsians. Rome was not the only city to commemorate him. Statues of Marsyas were to be found in public squares across Italy. For all that the satyr might be shown with leg irons on his ankles, he stood defiantly unchained. He had slipped the bonds of his divine master. So it was that he served Italians as 'a symbol of liberty'.[88]

Augustus, who in almost everything save his ambition was deeply conservative, had far too much respect for tradition ever to think of having such a venerable memorial removed from the Forum. Nevertheless, the statue of Marsyas was troubling to him on a number of levels. At Philippi, where his own watchword had been 'Apollo', that of his opponents had been 'liberty'. Not only that, but Marsyas was believed by his devotees to have been sprung from his would-be flayer's clutches by a rival god named Liber, an anarchic deity who had taught humanity to enjoy wine and sexual abandon, whose very name meant 'Freedom', and who – capping it all – had been worshipped by Antony as his particular patron. The clash between the erstwhile Triumvirs had been patterned in the heavens. Antony, riding in procession through Cleopatra's capital, had done so dressed as Liber, 'his head wreathed in ivy, his body draped in a robe of saffron

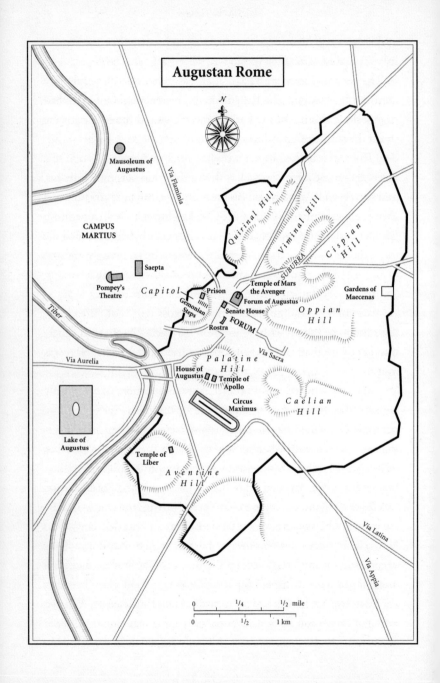

Augustan Rome

N

Mausoleum of Augustus

Via Flaminia

CAMPUS MARTIUS

Quirinal Hill

Viminal Hill

Cispian Hill

Saepta

SUBURRA

Pompey's Theatre

Capitol Prison Temple of Mars the Avenger

Gemonian Steps Senate House Forum of Augustus

Tiber

Rostra **FORUM**

Oppian Hill

Gardens of Maecenas

Via Aurelia

Via Sacra

Palatine Hill

House of Augustus Temple of Apollo

Circus Maximus

Caelian Hill

Lake of Augustus

Temple of Liber

Aventine Hill

Via Latina

Via Appia

0	1/4	1/2 mile
0	1/2	1 km

gold'.[89] Visiting Asia Minor, where in ancient times the contest between Apollo and Marsyas had been staged, he had been greeted by revellers dressed as satyrs. The night before his suicide, ghostly sounds of music and laughter had filled the Egyptian air; 'and men said that the god to whom Antony had always compared himself, and been most devoted, was abandoning him at last'.[90]

Meanwhile, back in Rome, the victory of Antony's conqueror had been Apollo's triumph as well. The patching-up of Jupiter's ancient temple on the Capitol had been as nothing compared to the stupefying redevelopment of the hill on the facing side of the Forum. In 36 BC, shortly after the defeat of Sextus Pompey, lightning had struck the Palatine. A god had spoken – but which god? Augurers sponsored by Rome's most eminent devotee of Apollo had dutifully served up the answer. For almost a decade, in obedience to their ruling, cranes and scaffolding had crowded the summit of the Palatine. Only by October 28 had the work finally been completed. The Roman people, just as they were meant to do, had gawped at it in awe. Planted on the hill above the Lupercal, next to where the hut once built by Romulus out of humble wood and thatch still stood in a state of improbable conservation, there now gleamed a monument built to the most advanced international standards. Raised on a massive marble pediment, adorned with doors of ivory, and crowned by a four-horse chariot made of bronze, 'the snow-white temple of brilliant Apollo'[91] made a literally dazzling addition to the Roman skyline. On one side of the Palatine it loomed over the Forum; on the other over the charred remains of an ancient temple of Liber.[92] That this had burned down in the same year as Antony's defeat at Actium only rammed the message home. Augustus, triumphant in all his enterprises, had backed a heavenly winner.

Nevertheless, he had not forgotten how easily the poor and starving had once been roused to curse him for impersonating Apollo. Even though the Princeps had never stinted in his devotion to the

god of light, he knew better now than to parade his sense of iden-
tification at drunken dinner parties. Behaviour like that smacked
altogether too much of Antony. Augustus preferred a perpetual play
of radiance and shadow to be evident across his face. His image was as
tightly controlled as it was charged with ambivalence. The portrait
of him fashioned by sculptors offered to the Roman people a fitting
reflection of the infinite subtleties and paradoxes of the man himself.
In the jug ears of his statues it was possible to catch the glimpse of a
thoroughly human Princeps: one whose eyebrows met above his nose,
whose teeth were bad, and whose anxieties about his height were such
that he wore platform heels. Yet he was a handsome man for all that;
and it was his conceit, one that plenty were willing to flatter, that he
had only to fix people with 'his clear and brilliant gaze'[93] for them to
lower their eyes, as though before the sun. In his statues, the jug-eared
Princeps appeared as beauteous as Apollo. Suspended midway between
youth and maturity, between melancholy and triumph, between the
mortal and divine, he was a Roman in every sense *Augustus*.

There was certainly to be no place in his portraits for the thinning
hair and sagging jowls that once, in the heyday of the Republic,
had served as the markers of high-achieving statesmen. What need
for Augustus to emphasise his experience? All stood in awe of his
achievements. He had accomplished more than any number of
senators scored with wrinkles. The close association between ugli-
ness and *virtus*, always cherished by conservatives, was hardly one to
appeal to Augustus. The Princeps, rather than reining in his taste for
self-promotion, aimed instead to mould tastes to the contours of his
own. Never before in history had so many portraits of a single man
been manufactured, disseminated and put on public display. A new
orthodoxy was being marketed to the Roman people: that power
should be good-looking. Evident to all those who gazed upon the
statues of Augustus, it could increasingly be read as well in an even
more prominent sphere: the fabric of the city.

Rome, although 'the seat of empire and of the gods',[94] had long presented a face woefully inadequate to her status as the capital of the world. Brown smoke from thousands upon thousands of workshops and hearth-fires hung in a pall over cramped shanty towns. Steepling apartment blocks shored up by brace-work clung precariously to the slopes of the city's hills. Blackened temples crumbled amid labyrinths of twisting and filthy streets. Compared to the gleaming cities of the East, where kings descended from the generals of Alexander the Great had burnished their capitals in swaggering fashion, Rome was a shabby and monochrome sprawl. So drab were its mud bricks and blotchy tufas that ambassadors from eastern monarchies, when they first began to arrive in the city, had found it hard to stifle their sniffs of disdain. Yet the lack of *grands projets*, which to Greeks appeared the symptom of a comical backwardness, had traditionally served the Roman people them- selves as evidence of their liberty. Coloured marble, pompous avenues, urban planning: what were these, if not the prerogatives of kings? No one, in a free republic, could be permitted such sinister grandstanding. This was why, in the last feverish decade before the crossing of the Rubicon, the sudden appearance in Rome of a rash of grandiose monuments had served as portents of the Republic's ruin. Just as Julius Caesar had funded his own forum, complete with marble temple and statue of his horse, so had Pompey the Great put his name to the city's first theatre built of stone. These rival developments, set as they were against the squalor and decay general in the rest of the city, had glittered like gold fillings amid a mouthful of bleeding gums. Both had served the glory, less of the Roman people, than of their respective sponsors – and unsurpris- ingly so. To fashion out of an urban agglomeration as chaotic and ramshackle as Rome a capital worthy of a global empire was a project of renewal beyond anything that anyone had ever before attempted. Only a citizen possessed of limitless resources, infinite

auctoritas and plenty of time could even think to embark upon it. Only a citizen, in short, like Augustus.

Naturally, the attentions lavished by the Princeps upon the city were hardly selfless. Nothing that he did ever was. His aim, as it had always been, was to wipe the floor with any hint of competition. Even the dead were fair game. The heirs of Scipio Africanus, for instance, looking to remind the Roman people of their pedigree, had surmounted the processional way that wound up the side of the Capitol with a novel form of architectural showmanship: a colossal arch. Augustus, as only he could, now went decisively one better. Dominating the road that led from the Forum up to the Palatine, his own version was a perfectly judged exercise in putting even the most distinguished dynasties in the shade. Ostensibly dedicated to his birth father, who had died when the infant Octavius was only four, the monument nevertheless strongly hinted at an altogether more glamorous lineage. Rather than portraits of his mortal ancestors, the arch featured an astonishing statue of Apollo, complete with chariot and four horses, all carved out of a single block of stone. Subtly yet decisively, Augustus had cast the sniggering jokes about his parentage on their head. While the arch did not explicitly confirm the rumour reported of his mother, that nine months before his birth she had been visited while asleep in the temple of Apollo by a serpent, who had left on her body a miraculous 'mark in colours like a snake',[95] it did nothing to deny it. Such was the dimension of ambivalence in which Augustus always preferred to operate. Reluctant to offend Roman sensibilities by claiming Apollo as his father, yet perfectly content to make play with it, he was, as ever, having his cake and eating it.

The tightrope he walked in achieving this was necessarily precarious. It took a peculiar genius to pose as a being almost at one with the gods and simultaneously as a man of the people. Spectacular pretension was fused in Augustus with almost unearthly reserves

of patience and self-discipline. The gleaming new temple of Apollo, even as it shed its lustre upon the Princeps's adjacent house, also opened up to ordinary citizens what had previously been the preserve of oligarchs. Libraries, courtyards and porticoes, annexed to the main body of the temple, now dominated the summit of the Palatine. Against such a backdrop, the private residence of the Princeps himself could not help but seem modest to the point of frugality. Even though Hortensius, its original owner, had been notorious in his own lifetime for the effeminate character of his extravagance, trends had long since moved on. New markers of luxury now adorned the homes of the super-rich. At a time when Maecenas, that celebrated arbiter of taste, was busy introducing the heated swimming pool to Rome, the Princeps's house struck those familiar with top-end properties as 'notable neither for scale nor style'.[96] Not for him a tower of the kind that Maecenas had built as the centrepiece of his exquisite palazzo, a folly so steepling that it afforded its owner views of the distant Apennines. Augustus, a man wealthier than the Republic itself, did not need to demonstrate to anyone just how well endowed he was.

And in this, as he well knew, he was at one with the sentiments of the mass of the Roman people. 'While they may approve of beautifying public monuments, they have no time for private luxury.'[97] The self-made followers of Augustus, gorged as they were on the plunder of civil war, did not serve their leader's purposes by flaunting their appropriations. Maecenas, by virtue of his devotion to fashion, stood at risk of becoming unfashionable. His sprawling gardens next to one of the city gates had been built over a paupers' cemetery; his achingly modish topiary was fertilised by 'the bleached bones'[98] of the poor. Infinitely better qualified to serve as the public face of the new regime was the dour and hard-faced Agrippa. Despite himself having come from nowhere into possession of Antony's splendid mansion on the Palatine and entire territories overseas, he retained

the crowd-pleasing image of a bluff peasant. Not hesitating to bait the nobility, he pressed for the nationalisation of privately owned works of art. Such treasures, he argued, were properly the Roman people's to enjoy. The Princeps himself, who had laboured so hard to seduce and reassure the aristocracy, was hardly the man to put such a proposal into action; but nothing that Agrippa ever said or did was without his master's sanction. Augustus, with his unparalleled nose for sniffing out advantage, had distinguished in the attitude of the upper classes to the masses a yet further source of profit. On the one hand, it was a point of principle among those committed to the noblest traditions of the Republic that it was 'for the Roman people to grant all powers, all commissions, all commands';[99] on the other, that these same Roman people were 'the bilge-water of the city'.[100] Here, amid the murk of such contradictory opinions, was ample opportunity for Augustus to consolidate his position yet further. Who better qualified than the Restorer of the Republic, after all, to realise the full potential of hypocrisy?

That it was indeed the Princeps, with his healing hands, who had salved the bleeding state back to health was a conceit that few, in the wake of the civil wars, had any great interest in disputing. When a golden shield listing Augustus's cardinal virtues was hung inside the Senate House, the inscription recorded that it had been placed there by *Senatus Populusque Romanus*, 'The Senate and the Roman People'. Yet this fine-sounding slogan, even as it proclaimed harmony between the city's elite and its masses, hinted as well at division. The commitment of Rome's citizens to the common good, so precious to them as an ideal, had been accompanied right from the beginnings of their city by a rival drumbeat. When Romulus, standing on the Palatine, witnessed twelve eagles passing overhead, he had been in competition with his twin. Remus, from his own vantage point just south of the Palatine on a summit named the Aventine, had seen a paltry six birds; and from that moment on, the rival destinies of the twin

hills had been fixed. Just as the Palatine had always provided the city with its most exclusive hub of power, so did the Aventine serve as the stronghold of the disadvantaged, of the poor – of the *plebs*. Always, behind the civic unity which was the proudest boast of the Republic, there had throbbed the pulse of class resentments. The poor, sneered at by the upper classes as *plebs sordida* – 'the great unwashed' – had a long and proud tradition of standing up for their rights. Repeated attempts to crush their freedoms had been heroically resisted.

The most venerable monument to such resistance, built on the lower slope of the Aventine centuries before Antony had thought to co-opt it, was none other than the shrine of Liber. It commemorated an occasion way back in 494 BC when the plebs, oppressed by debt and the exactions of the rich, had staged a mass walk-out. Heading upriver from Rome, the strikers had camped on a hill overlooking the Tiber. Here, in a pointed retort to the institution of the consulship, they had elected two officials of their own – 'tribunes'[101] – to serve as guardians of their interests. The tribunes, the plebs had agreed, were to be regarded as sacrosanct. The life of anyone who laid so much as a finger on them was to be forfeit. Blood-curdling compacts to that effect had been sworn. The Roman upper classes, with great reluctance, had been brought to swallow these terms. Centuries on, and the tribunate had emerged to become one of the most potent offices in the entire Republic. It remained sacrilege to assault any citizen who held it. A tribune could impose the death penalty on those who challenged his authority; veto legislation of which he did not approve; summon the Senate and introduce measures of his own. Privileges of this order, freighted as they were by tradition and potentially awesome in their scope, could hardly help but pique the interest of the Princeps.

And sure enough, in due course, he had made his move. Laying down his consulship, he had reaped momentous compensation. Many of the most formidable powers ceded to him by the Senate

in 23 BC, and which had served to buttress his primacy to such deci-
sive effect, were those of a tribune: the *tribunicia potestas*. The plebs
themselves, far from resenting this appropriation of their hard-won
prerogatives by Rome's richest man, were instead confirmed in their
view of him as their champion. It certainly came as no novelty to
them that a man of high-class pedigree might wish to exercise the
tribunicia potestas. A hundred years before, two grandsons of Scipio
Africanus, Tiberius and Gaius Gracchus, had served as tribunes;
more recently, the rumbustious career of Clodius Pulcher had been
launched on the back of a tribunate. A palpable flavour of class
warfare clung to the memories of all three men. Hostile elements
in the Senate had been provoked to open violence by their agitating.
Blood had flowed in the streets of Rome. Both the Gracchi brothers
had been assassinated: Tiberius clubbed to death with a stool-leg
and Gaius decapitated. As for Clodius, it was the riots following
his murder by a political adversary that had led to the immolation
of the original Senate House. Perhaps, then, among the ranks of
the senators, there was a flutter of nervousness that Augustus, in
laying down the powers of a consul, should have taken up those of
a tribune.

If so, then they mistook their man. An operator as consummately
sphinx-like as the Princeps had no interest in playing the demagogue.
No matter that he had been endowed with the *tribunicia potestas*, he was
not a tribune. The people's favourite, he offered himself as well to the
Senate as their protector. Just how combustible the plebs might still
be, and just how dependent the rich were upon Augustus to keep
secure for them their swimming pools, their works of art and their
exquisite topiary, had been made unsettlingly apparent to them in
the wake of his departure from Rome. Between 23 and 19 BC, with the
Princeps absent in the eastern Mediterranean, the city had seethed
with factionalism and street fighting. Riots had flared. Murders had
spiked. A consul had nervously requested extra bodyguards. Order

had been restored only when the Princeps finally returned from the East, bringing with him in triumph the standards won back from the Parthians. The lesson had been well and truly rubbed home. 'When Augustus was absent from Rome, the people were fractious – and when he was present, they behaved themselves.'[102]

Guardian of the Senate and champion of the plebs: the Princeps was both of these, and more. For too long, the Republic had been its own worst enemy. Together, the greed of the mighty and the brutishness of the masses had brought it to the verge of ruin. Had the gods not sent Augustus to redeem Rome from the misery of the civil wars, then city and empire alike would surely have perished. The duty of the Princeps was clear: to stand guard over the Republic and protect it from itself. Revolution could not have been further from his mind. His heaven-sent responsibility it was to remind Senate and people alike of what they had originally been. Restore to them their ancient birthright of *virtus* and discipline, and his mission would be complete. 'The good man,' he once ringingly declared, 'is the one who has no intention of altering the traditional way of doing things.'[103] All that Augustus had ever done, all the changes that he had ever made, all the manifold breaks with recent custom for which he had pushed, had aimed, not at novelty, but rather at the opposite: the return to the Roman people of their ancestral inheritance of greatness.

Once, the gods had graced Rome with their favours and their protection. Incense had perfumed the flames of sacrifice and veiled the sun with smoke; the blood of white oxen had spilled from axe-blows onto the earth; festivals of primordial antiquity had given order to the city's year. But then, over time, as the processions had come to be abandoned, so the rituals had been forgotten and the stones of the shrines grown mute. Horace had been only one of many to shudder at the sight of temples sharing in the general dilapidation of the city. 'The sanctuaries with their dark images stand ruined, befouled with smoke.'[104] Struggling to keep afloat during the difficult years that

had followed his return from Philippi, haunted by his memories of citizen slaughtering citizen and impoverished by the loss of his lands, the poet had drawn the obvious conclusion. 'The gods, because neglected, have brought a whole multitude of evils on sorrowing Italy.'[105] Augustus, charged as he was by the heavens with purging the Republic of its sickness, fully concurred with this diagnosis. His repairs to the ancient shrine on the Palatine in which the 'spoils of honour' were kept had been only a start. Crumbling and roofless temples were an affront both to the gods and to the dignity of the Roman people: pustules upon the face of the city. Augustus, with the wealth of the world his to command, could well afford the necessary medicine. What had been decayed was to become pristine; what had been black was to become white; what had been mud-brick was to become marble. As the scaffolding came down from the temple of Apollo on the Palatine, so it went up across the rest of Rome. Even Livia, who sponsored the sprucing-up of a sanctuary on the Aventine much favoured by respectable matrons, got in on the act. As for the Princeps himself, he would end up funding the restoration of no fewer than eighty-two temples. If some were only given a lick of paint or a layering of stucco, then most were endowed with as handsome a makeover as the world's finest architects could provide. Entire mountains were levelled to provide them with the necessary supplies of stone. So, at any rate, ran the joke. It was beauty, not antiquity, that counted now. 'The temples of our ancestors were all well and good – but golden ones are more delightful. Majesty, after all, is what becomes a god.'[106]

And the gods themselves clearly concurred. By 17 BC, a decade on from the settlement that had seen Imperator Caesar named Augustus, it was evident that Rome had once again become a place hallowed by the favour of the heavens. 'The world was pacified. The rightful political order was restored. All stood easy and prosperous.'[107] As May turned to June, the Roman people were invited to celebrate

a profound mystery: the turning of the centuries and the dawning of a new cycle of time. Entertainments were staged; chariot races held; lavish banquets thrown. First, though, for three days in succession, the gods were given their due of sustenance and blood; and by night, illumined by the torches which had been handed out free to the entire population of the city, the Princeps himself led the celebrations. To the Moerae, the three white-robed Fates who directed the city's destiny, he offered a sacrifice of lambs and goats; and then, to the goddess of childbirth, a gift of cakes. A golden age was being born – and just in case there was still anyone who had failed to take in the message, a poem composed specially for the occasion by Horace was sung on both the Capitol and the Palatine, with the aim of ramming it home. 'Grant riches, and progeny, and every kind of glory to the people of Romulus.'[108] Many who heard this prayer sounding out across the Forum, hymned by a choir of girls and boys of spotless probity, and framed by a skyline edged with gold and gleaming marble, would doubtless have reflected that the gods had already obliged. 'Truth, and Peace, and Honour, and our venerable tradition of Probity, and *Virtus*, long neglected, all venture back among us. Blessed Plenty too – why, here she is with her horn of abundance!'[109]

And still, over the course of the years that followed, it overflowed. Rome was fast becoming beautiful. The gods were not alone in being graced with home improvements. The Roman people, as they watched their native city grow ever less shabby, ever more resplendent, began to take for granted the apparently limitless coffers of their Princeps. His generosity seemed to know no bounds. When, for instance, the heirs of Pompey the Great found themselves too poverty-stricken to maintain the upkeep of their ancestor's great stone theatre, who should step in but Augustus? Other noble families too, knowing that they could not hope to compete in such stakes, had long since withdrawn from the fray. Whether it was building bath complexes on a scale vaster than any seen before, or

renovating in an eye-poppingly sumptuous manner the hall in which the Roman people cast their votes, or else improving the city's roads, Augustus and his ever-loyal henchman Agrippa were the only show in town.

So selfless was the Princeps's concern for the good of his fellow citizens that even the memory of his own friends might be sacrificed to it. One such was Vedius Pollio, a financier who had done much to boost the tax efficiency of Rome's provinces in Asia Minor, and grown obscenely rich on the back of it. When he died in 15 BC, and left the Princeps the vast property that he had built on a spur above the Forum, Augustus had it ostentatiously flattened. The site was then given to his wife. Livia, no less conscious than her husband of her responsibilities towards the Roman people, had it rebuilt in splendid fashion, complete with colonnades and fountains, and presented to the delighted public. So, in the new age presided over by Caesar Augustus, was the selfish greed of plutocrats justly treated. 'An example had been well and truly made.'[110]

The death of Vedius, a one-time nobody who had profited from the carnage and upheavals of the civil wars to emerge as one of the wealthiest men in Rome, spoke of the passage of the years. Those who could remember a time before the crossing of the Rubicon, when citizens had contended with one another in a free Republic, were growing old. Late in 13 BC, when Lepidus passed away, many were surprised to discover that the former triumvir had not died years before. Formally stripped of his powers back in 36, and exiled to an obscure corner of Italy, he had spent two decades and more in wraith-like retirement. Only a single honour had been left to him: the office of *Pontifex Maximus*, the High Priest of Rome. Naturally, there was never any doubt as to his successor. The Roman people had long been pressing Augustus to strip Lepidus of the post; but the Princeps, sternly set against sacrilege, had refused. Now, in 12 BC, men and women from across Italy flocked to Rome to hail his election.

The new Pontifex, meanwhile, was moving with his customary eye for the main chance to turn the office to his own advantage. Tradition prescribed that he move into an official mansion in the heart of the Forum, where he could serve as guardian to the virgins who tended the eternal hearth-flame of the city. Augustus, who had not the slightest intention of abandoning the Palatine, instead settled upon a compromise as pious as it was self-serving: he had part of his house dedicated to the goddess Vesta. His private residence, connected as it already was to the great temple of Apollo, took on a new sheen of sanctity. Augustus himself moved one step closer to heaven.

The man who had once scandalised the guardians of Roman tradition by making himself consul at the tender age of nineteen was now in his fifties. Even as his statues continued to portray him as preternaturally fresh-faced, his wrinkles were growing deeper. Already, some of the closest partners of his youth were succumbing to age. Agrippa, exhausted by his labours, died only a few months after the election of Augustus as Pontifex; four years later, Maecenas was consigned to his grave. In his will, he requested his old friend to 'remember Horace as you do myself'[111] – and sure enough, when the poet too died fifty-nine days later, Augustus had him laid to rest near Maecenas's tomb.

Here, to a man notorious for his bouts of ill health, were ominous reminders of his own mortality; and yet, for all that, the Princeps did not die. Quite the opposite. Miraculously, as the decades slipped by, he seemed to be growing haler. Age, it turned out, agreed with him. Far from sapping his *auctoritas*, grey hair only burnished it. A veteran grown old in the service of his city: here was the kind of authority figure with whom the Roman people were instinctively familiar. In 3 BC, Augustus turned sixty. A few months later, he was elected consul for the first time in many years. Still, though, his fellow citizens were not done with paying him honour. In January, a delegation of plebeians travelled to his coastal retreat and begged him to

accept a new title: 'Father of his Country'. Augustus refused. Then, on 5 February, all ranks of society came together to press the honour on him. When the Princeps, back in Rome, arrived at a theatre, everyone in the audience hailed him with the title. Shortly afterwards, at a meeting of the Senate, the assembled senators added their own voices. 'We join with the Roman people,' declared their spokesman, 'in saluting you as Father of our Country.' This time Augustus did not turn down the title. 'All that I ever hoped for,' he declared in a choked voice, 'I have now achieved.' And as he spoke, his eyes began to fill with tears.[112]

Imperator Caesar Augustus had embarked on his rise to power as the avenger of his deified father. 'That was his task, his duty, his priority.'[113] Now, forty years and more on, it was he who had become the father. Early that summer, on 12 May, the Princeps formally dedicated a building that, more than all the many others he had bestowed upon the Roman people, served as the monument to his extraordinary career. His temple to Mars the Avenger, vowed long before on the eve of Philippi, had been completed only after an inordinate length of time. Reluctant to stir up memories of his youthful confiscations of land, Augustus had shrunk from forcing through compulsory purchases. As a result, his agents had found themselves embroiled in any number of property disputes. Some owners had refused pointblank to sell. Strange angles, forced on the architect by this obduracy, had begun to appear in the outline of the development. Redesign had followed redesign. The delays had lasted years. In the end, Augustus's patience had snapped. He had ordered the temple finished, come what may. Even as the day of its dedication drew near, building materials were still being gathered up and paint slapped on. Yet no amount of last-minute hurry could impair its jaw-dropping impact. Augustus's great programme of renewal had achieved its supreme masterpiece. To a people whose descent from Mars was evident in the emergence of their city from backwoods obscurity to the rule of

the world, he had paid his most splendid tribute: 'an achievement on a scale worthy of the god'.[114]

War had been the making of Augustus as it had been of Rome, and the Princeps did not shrink from acknowledging the fact. The duty he had owed his deified father was inscribed on the face of a gleaming new forum. Statues of the Julians, with Aeneas himself resplendent in the centre, stood positioned in a semicircle to one side of the temple of Mars the Avenger. Yet the drenching of Philippi in Roman blood was not the only vengeance commemorated in the great complex. So too was an altogether happier triumph. The standards lost by Crassus to the Parthians at last had a setting worthy of Augustus's feat in winning them back. Transferred from their makeshift home on the Capitol, they now adorned the inner sanctum of Mars's towering temple. No matter that it was Augustus who had redeemed them – the victory was one in which all the Roman people could share. Outside, gazing down from the front of the temple across the coloured flagstones of the Forum, a semi-naked Mars was portrayed with sword and spear in hand, his foot placed on the world. Augustus was not so vainglorious as to pretend that Rome's global sway was entirely down to himself.

Quite the opposite, in fact. Facing the statues of the Julians, on the far side of the Forum, was another half-ring of statues. In their centre stood Romulus, complete with the 'spoils of honour'; around him, forming a veritable hall of fame, all the many other heroes who had contributed to Roman greatness.[115] These, so Augustus declared, were the models who had served to inspire him in his service to Rome. His line of descent from them was quite as clear as that from the family of Julius Caesar. He embodied nothing alien, nothing remotely out of accord with the best of Roman practice. The same would doubtless be true of those 'who might follow him as Princeps'.[116] There had been no revolution. Rome past and Rome future: they met, and were reconciled, in the figure of a single man.

Imperator, Augustus, Father of his Country: the one-time Gaius Octavius was entitled to feel, as he presided over the dedication of his splendid new temple complex, that he had very little left to prove. Who now could reasonably doubt that he was, as he had always believed, the favourite of the heavens? 'You are the greatest ever Princeps.'[117] So Horace had written shortly before his death. This verdict had not been flattery – merely a statement of obvious fact. Augustus had given peace to his fellow citizens, reconciled them to the gods, and restored to them their hope.

Surely now nothing could go wrong?

3

THE EXHAUSTION OF CRUELTY

Back to Basics

Naturally, there were whisperings of scandal.

There always had been. Gossip was part of the air that citizens breathed. Wherever people gathered, they would pause and swap the rumours that passed for news. A story had only to be heard in the Forum for it to spread with remorseless inevitability out through the maze of the city's back-alleys, into workshops and narrow cul-de-sacs, and tiny, hidden squares where pigs rooted for garbage and fullers hung their washing out to dry. The Roman people had always had a puritanical streak. No vice was so private that it could be kept from them for long. Political life in Rome was not named *res publica* for nothing. The jeers and hisses of a crowd were sure to pursue even the most eminent of men caught up in any impropriety. Graffiti scrawled and scratched across the city served up to everyone who could read them such a relentless dishing of dirt that people fretted the sheer weight of it all might bring walls crashing down. Even the illiterate would shit on the monuments of those who had offended them. The Romans were a people with a rare genius for throwing mud.

No one, then, could possibly have stood at the head of their

affairs for as long as Augustus had done, and not found his white toga marked along its hem with the occasional splash of filth. The sensational circumstances of his marriage to Livia remained vivid in the minds of his fellow citizens. A man capable of jumping someone else's pregnant wife was clearly capable of jumping anyone. Even though the precise details of his presumed affairs were hazy, Augustus's womanising was something widely taken for granted. Livia, far from making trouble, was said to have maintained her hold on her husband by turning a blind eye to his many adulteries, and keeping him well supplied with virgins. Friends of the Princeps, looking to extenuate this goatish behaviour, insisted that his affairs were the result of calculation, not of lust, and that he only ever bedded the wives of senators he wished to keep an eye upon. Others were not so sure. A man as promiscuous as Augustus was reputed to be seemed, to many citizens, lacking the self-control that was properly the mark of a Roman. Unchecked sexual appetites, while only to be expected in a woman – or, of course, a Greek – were hardly appropriate to a citizen steeled in the noblest traditions of the city. Energies devoted to sleeping around were better suited to serving the glory of the Roman people. Augustus's reputation as a serial adulterer, far from boosting the aura of his machismo, cast him instead in an effeminate and sinister light. No man could be reckoned truly a man who was the slave of his own desires. Playboys who chased after married women were well known to be womanish themselves. The Princeps, it was whispered, smoothed his legs by singeing off their hairs with red-hot nut shells.

A shocking detail, to be sure. Nevertheless, as Augustus himself appreciated, it could have been far worse. Compared to Antony, he had got off lightly. None of the allegations laid against him remotely began to compare with the deadly tidal wave of effluent that he himself had unleashed against his great rival. The damage done to his reputation was never critical. Indeed, the stories told of his effeminacy titillated less because they appeared plausible than

because, in large part, they did not. Far from scorning the morals of those who slandered him, the Princeps shared them to the depths of his marrow – and the Roman people knew it. When Augustus let it be known that he wore clothes woven for him by his wife, no one thought to accuse the richest man in the world of hypocrisy for wearing homespun. Just as Livia had brought a touch of patrician class to his household, so also did she serve it as a living embodiment of antique virtues. As the partner of Augustus, no hint of adulterous passions ever attached to her. A woman who knew what it was to lose everything, she guarded her status as wife of the Princeps with a chaste and icy self-discipline. She understood full well that 'her looks, her words, her every action, were a focus of intense attention'.[1] Never seen in public without the *stola*, the long, voluminous and stiflingly cumbersome dress which served the Roman matron as the symbol of her modesty, Livia knew to perfection what her husband required of a woman. In private, she served as his closest confidante; in public, as a living emblem of piety and traditional values.

Admiration for the virtues associated by the Roman people with their stern and heroic past was the reverse face of their addiction to gossip. Wealth and pedigree had never served them as the exclusive determinant of status. 'The Romans did not think it proper that a man should be free to get married or have children merely as he pleased – nor that he should be permitted to live and indulge himself according to his own personal preferences and appetites.'[2] Surveillance in Rome was both relentless and officially sanctioned. Citizens had always been divided with great precision into classes – and behaviour unworthy of the class to which a man had been assigned would invariably see him demoted. The Princeps, as befitted his status at the summit of the pecking order, took this regulation of his fellow citizens very seriously indeed. The return of peace to Rome after the chaos and upheavals of civil war had also meant the restoration of state-determined hierarchies. In 28 BC, and then again twenty years

later, Augustus submitted the entire civil population to a census. Not surprisingly, he kept a particularly beady eye on the top end of society. The census of 28 BC resulted in a wholesale slimming down of the Senate, which was then purged again in 19 BC. Mortifying though this naturally was for those expelled, it greatly enhanced the prestige of those who had made the cut. Augustus's ruthless streamlining boosted the dignity of the entire order. *Maiestas*, this was termed in Latin: the aura of majesty and greatness that, back in the days when a citizen's vote still counted for something, had been regarded as the prerogative of the Roman people as a whole. It was the Princeps himself, of course, who most formidably embodied *maiestas* – but not exclusively so. A Senate worthy to share with him in the heroic project of redeeming the Republic was a vital part of his purpose, after all. Not even Imperator Caesar Augustus could shoulder that particular burden alone.

Yet there remained a snag. The more exclusive an order the Senate became, the fewer senators there were to assist with the demands of a global empire. Clearly, then, it was essential to find an alternative reservoir of talent. The effective administration of the world required nothing less. Fortunately, even before establishing his regime, the Princeps had identified a possible solution. It was Maecenas, ever the trend-setter, who had blazed the trail. Immense though the responsibilities vested in him by Augustus had been, he had never held any official magistracy. Instead, rather than enter the Senate and compete for public office, he had rested content with the highest rank open to a private citizen: that of an *eques*, or knight. Once, back in the rugged early days of Rome, it was possession of a horse that had qualified a citizen to be registered among the city's elite; but that, of course, lay long in the past. Many knights, over the course of the previous century, had grown so fabulously rich on the back of empire that they had ended up boasting whole stables of thoroughbreds. With senators legally banned from dirtying their

hands in the sordid business of overseas trade, the field had been left clear for equestrian financiers to gorge themselves on the wealth of Rome's new provinces. Then, amid the implosion of the Republic, the character of the order had begun to change. Plutocrats were joined by 'men made knights by the maelstrom of conflict'.[3] Officers who had fought on the winning side in the civil war; aristocrats from obscure Italian towns keen to better themselves; even, disconcertingly, the occasional son of a slave made good: all had come to sport the golden ring which marked a knight. Men such as these were the Princeps's kind of people. Tough and high-achieving, they constituted precisely what he needed: a ready officer-corps. Torn as he was between respect for the Senate as an order and a lurking suspicion of its individual members, Augustus could hardly help but warm to the new breed of equestrian. The hand of his friendship, as Maecenas could vouch, might bring many favours. Even as the Senate rejoiced in the brilliant and growing blaze of its *maiestas*, so, in the shadows, knights were quietly thriving. No longer, under Augustus, were commands and offices the sole preserve of elected magistrates. Gradually, obliquely, they were being privatised.

Such a policy, by its nature, could not possibly be acknowledged. Augustus himself, never appearing so conservative as when engaged in innovation, looked to the past as well as to the future. The more he broke with tradition by entrusting knights with public office, the more he masked the policy behind celebrations of their primordial purpose. Phantasmal cavalrymen in antique armour, charging down adversaries from the epic days of early Rome, haunted his imaginings. Those who betrayed this heritage were made to pay. When a knight was found to have cut off his two sons' thumbs, thereby invaliding them out of military service, the Princeps imposed on him an exemplary penalty. The wretched man was sold at public auction; then, bought by one of Augustus's proxies, he was banished in disgrace to the country. Nor was he alone in being expelled. Knights who

failed to measure up to the exacting standards expected of them by the Princeps were quite as likely to be drummed out of their order as senators. Reviving a venerable custom, Augustus even subjected them to an annual inspection. Every 15 July, equestrians were obliged to parade through the streets of Rome, riding in serried ranks, as though just arrived from battle. Those with rewards for valour were expected to wear them. Those too old for the saddle were expected to come on foot. It was, most people agreed, 'a tremendous sight, and worthy of the greatness of Rome's dominion'.[4]

Not everyone, though. Some equestrians, even as they joined the parading of homespun, peasant virtues through the capital of the world, struggled to keep a straight face. Times had moved on. The hamlet of wooden huts and cattle byres ruled by Romulus was now a wonderland of gold and marble. 'We live in a civilised age. Rustic boorishness, of the kind displayed by our forefathers, is a thing of the past.'[5] So spoke a poet, youthful and chic, who had emerged in the second decade of Augustus's supremacy to become the toast of the city's *avant garde*: the authentic voice of Roman metrosexuality. His distaste for the life of the countryside so idealised by the Princeps was bred of personal experience. For all his urbanity and sophistication, there was a provincial quality to Publius Ovidius Naso – Ovid. He was not a native of Rome. Sulmo, a fat, lazy town some ninety miles east of the capital, was inhabited by a people who less than a century before had been enthusiastic participants in the Italian Revolt, and were notorious for the aptitude of their witches. Hemmed in all around by precipitous mountains, Sulmo was separated from the metropolis by forests teeming with wolves and bandits. Ovid's own family, although equestrian for several generations, had remained firmly based in their native town, big fish in a tiny pond. But then, as for so many others in Italy, everything had changed. With the rise to power of Augustus, dazzling new opportunities had opened up for families such as Ovid's. His father

had seized on them with relish. Packing off his two sons to Rome, he had invested heavily in their education. When Ovid's elder brother died at twenty, Ovid himself was left alone to carry the burden of his father's ambition. 'The Senate House was waiting.'[6] The young man's heart, though, was never in it. 'I lacked both the physical toughness for such a career, and the aptitude. I flinched from the stresses of ambition.'[7] The stern demands placed on him by his father, the glorification by the Princeps of Rome's ancient past, the trumpeting of martial values – all left the young Ovid cold. It was not merely that he rejected them; he found them risible.

In this, he was recognisably of a new generation. Born a year after Julius Caesar's murder, Ovid had never known what it was to live in a free republic. Nor, though, did he have personal experience of the horrors endured by his elders: fighting amid foreign dust against fellow citizens; losing ancestral fields to strangers; watching cities burn. Rejoicing in the blessings of peace and prosperity brought by Caesar Augustus, Ovid knew what he had been spared, and was duly grateful for it. Yet he saw in them not a restoration of Rome's ancient and god-given order, but something very different: the essence of what it meant to be modern. 'The present,' he rejoiced, 'suits me down to the ground.'[8] In the cityscape fashioned by Augustus to serve as a mirror to the favour of the gods, and as a monument to the glory both of the Roman people and of himself, Ovid discovered a playground. The delight he took in it was exultant – but not of a kind to please the Princeps. His pastimes were altogether too edgy, too counter-cultural for that. When Ovid strolled up to Apollo's temple on the Palatine, or haunted the shady colonnades raised on the site of Vedius's palace, or visited the arches of Pompey's theatre, it was not to admire the architecture. He was scoping out girls.

To boast of this, as Ovid freely did, and to pose as a universal 'tutor in love',[9] was highly shocking to a moral and iron-willed people such as the Romans. Time was, long before Augustus brought in his own

census, that a senator had been demoted for kissing his own wife in public. Only when startled by thunder, one venerable moralist had grimly joked, was it permissible for a woman to fall into the arms of her husband.[10] Standards had eased over the years; but the notion that a citizen might freely abandon a career of service to his fellows, devoting himself instead to the arts of the bedroom, retained its power to shock. Ovid, with almost wilful glee, paraded his scorn of what he mocked as priggish convention. 'Not for me our traditional virtues.'[11] Caesar Augustus, celebrating the greatest and most spectacular triumph ever witnessed in Rome, had ridden through the capital parading the trophies of victory won from the Queen of Egypt. Ovid, beating himself up for slapping his girlfriend, imagined her led bruised and pale in a very similar triumph, cheered on by watching crowds. 'Hooray for the brave, bold man – he's vanquished a girl!'[12]

A joke, as Ovid well knew, that could hardly fail to bring a smile to the lips of those sophisticated enough to grasp his meaning. Mockery of the great was as much a tradition in salons as it was in slums. Augustus, who affected to have restored freedom of speech together with all the other liberties lost during the civil wars, was hardly one to bother himself with the occasional fleabite. This did not mean, though, that poets – or anyone else – had licence to write whatever they liked. Appointed as he was by the gods to the great task of saving and regenerating the Roman people, Augustus could not possibly tip the wink at any corrosion of their ancestral values. A citizen was made, not born. A male, after all, was not necessarily a man. Just as Rome had hauled herself up from powerless obscurity to the rule of the world, so was it necessary for each and every Roman to be forged over the course of his life to the requisite standard of masculinity. Softness, both of body and spirit, was a perpetual menace. It had to be guarded against at all costs. Augustus had not blessed the city with monuments of dazzling beauty and polish only to see them become

a cruising ground for lounge lizards. The fruits of peace would be worthless if all they bred was an epicene obsession with sex.

'Everything comes down to this: self-control.'[13] Which did not mean, of course, that a citizen was expected to live like a eunuch. Quite the contrary. A Roman penis was potent, masterful, prodigious. In a city where the phallus was everywhere to be seen, protecting doorways as a symbol of good luck, guarding crossroads or scaring off birds in gardens, ramrod size was much admired. A generously endowed man hitting the bath-house might well be greeted with 'a round of nervous applause'.[14] A citizen equipped with such a weapon, particularly a young one, 'in whom a degree of animal-spirits was natural',[15] could hardly be expected to keep it permanently sheathed. Even the sternest of moralists acknowledged this. Why else, after all, were there whores? A brothel was not so different from a latrine: dirty and disreputable, yes, but serving an essential purpose as a receptacle of human waste. A man could no more be expected to ignore his sexual needs than he could a full bladder. Not for nothing did the same word, *meio*, mean both 'urinate' and 'ejaculate'. A thrust or two, deep and quick, like the stabbing of a sword into the guts, 'right the way up to the hair and the hilt of the balls',[16] and the business would be done. Whether into the vagina, the anus or the mouth, it made no real difference – just so long as it was masterful. Nor did it greatly matter who took the penis thrust – man or woman, boy or girl – provided that one crucial qualification, one essential safeguard, was respected. Free-born Romans, male and female both: these were strictly, absolutely off-limits.

The taboo was as potent as it was ancient. Cleaving to it was how the Romans defined themselves as a people. They regarded purity, 'that chiefest prop of men and women alike',[17] not as a drab or passive virtue, but as something lambent, edged about by flame. Like the hearthfire which it was the sacred duty of every Roman wife to guard, it could not be extinguished without terrible sacrilege. This was why,

of all the offences that an unchecked sexual appetite might prompt a citizen to commit, there was none so unsettling to his fellows as adultery. To cuckold a man was not merely to take possession of his wife; it was also to shaft the husband himself. Lurking in the stories whispered about Augustus's affairs with women from senatorial families was a bitter reflection on his dominance. No one, after all, could hope for recompense from the Princeps. Whatever the truth of the gossip, nothing better rammed home to men their impotence before his greatness than that it rendered him immune from the right of a cuckold to vengeance. This, as prescribed by tradition, was of a ferociously brutal order. The wife caught *in flagrante*, so one famously stern moralist had ruled, might be murdered on the spot.[18] The lover too, according to some – although others, more liberal, recommended simply castrating him, or perhaps shoving a mullet up his anus. The threat of violence, savage and potentially murderous, hung over every adulterous contact.

Or did it? There was, perhaps, for those up to speed with the times, something just a little bit provincial, just a little bit musty, about an antique sexual taboo. 'How like a rustic, to get upset when your wife cheats on you.'[19] So Ovid, a man with his finger on the pulse of high society, observed with practised smoothness. Yet if the cuckold who kicked up a fuss was a boor, then so too was the one who failed to a spoilsport. The various prohibitions and perils erected by custom in the path of the adulterer were liable to strike the seasoned connoisseur of erotic pleasure less as deterrents than as incentives, spicing up the fun. 'We always want what we're not allowed.'[20] Ovid, in offering this sage observation, was putting his finger on a mocking truth. Forbidden fruit tasted the sweetest. 'Prohibitions, trust me, only encourage bad behaviour.'[21] This, in a city as addicted to gossip as Rome, was a paradox that plenty were prepared to swallow. Speculation as to what might be going on in the city's most exclusive bedrooms naturally transfixed the public. That adultery was regarded

by the upper classes as one tremendous game, in which the rules were there to be broken, and the measure of cool was to smuggle a lover into the marital bed, was widely taken for granted. No smoke without fire, after all. Proofs of the adulterous and effeminate character of Rome's fast set were everywhere to be seen. In the dandyishly loose way they wore their togas; in their clean nails, sprucely clipped nasal hair and sinister lack of body odour; above all, in the oiled sheen of their limbs. For a man to shave his armpits was, everyone could agree, simply good manners; but to do as Augustus was said to have done, and depilate the legs, was disgusting, plain and simple. Body hair was the mark of a man. Everyone knew, though, that adulterers cared nothing for that. Smooth skin, not a pelt, was what they brought to seduction. It was all most deviant and alarming. Even Ovid might sometimes be provoked to pontificate: 'Men are all such fashion-victims these days that, really, we can hardly blame women for feeling the pressure.'[22]

None of which stopped the poet himself from cheerily offering grooming tips to his male as well as his female fans. Ovid, though, did not have the care of Roman morals in his charge. Frivolous metrosexuality, in the opinion of the man who did, was part of the problem, not a solution. Augustus, who had brought order where previously there was chaos, who had lavished on his fellow citizens the riches of conquered kingdoms, who had transformed their city into a capital of unrivalled beauty and splendour, did not care to think that his labours might merely have contributed to a softening of their ancestral virtues. Such a prospect was too appalling to be borne. The Romans were either the heirs of their upright forefathers or they were nothing. The Princeps's ambition was simple: that his fellow citizens should be true to all that was best about their past. They were the Romans: the lords of the world, the people of the toga. This, in the mirror that he had set up to his fellow citizens, fashioned out of monuments, and festivals, and all the various fruits

of peace, was the reflection that he wished them always to catch of themselves.

Yet what if they caught something else? Perhaps there lay a warning in a recent scandalous development in the field of interior decoration. In bedrooms across Rome, walls and ceilings were coming to be lined with mirrors. Even beyond the limits of the city, out in his rural retreat among the Sabine hills, Horace had signed up to the craze. Notoriously, so had a billionaire by the name of Hostius Quadra. The mirrors on his walls boasted a particularly distinctive feature: everything reflected in them appeared larger than it actually was. 'So it was that the freak made a show of his own deviancy.'[23] As one girl gave him a blow-job, and he licked out a second, so his anus, in a hideous desecration of all that a Roman should properly be, was shafted by a man with a giant cock – which, seen in the mirror, appeared possessed of truly gargantuan size, 'larger than his capacity to take'.[24] To groom, depilate and titivate like a woman was one thing; but to be fucked like one was a hideous extreme of degradation. What else was it, after all, but the willing surrender of everything that made a Roman a man? In the grotesquely reflected couplings of Hostius Quadra was to be caught the spectacle of a terrifying abyss, one into which any citizen who surrendered to self-indulgence might end up sinking.

'Every part of me is given over to filth.'[25] The monstrous quality of this boast ensured that Augustus, when Hostius Quadra eventually came to be murdered by his own slaves, refused to have them punished. As a statement of the Princeps's disapproval, this could hardly have been more ringing. Another entrant had been added to his public hall of shame. Yet there was an irony to the billionaire's fate that Augustus himself no doubt found deeply troubling. By venerable tradition, the regulation of morals within a household was a matter for the citizen who stood at its head. It was not the business of anyone else to get involved. A Roman unable to control the behaviour of his own dependants barely ranked as a Roman at

all. How, then, to judge a city in which it was slaves who punished the master? As one, it seemed, in which ancient certainties had been disconcertingly upended. In which fathers could no longer be trusted to discipline their children, nor husbands their wives. In which the morals of the Roman people required the regulation, not just of custom, not just of ancestral example, but – shamingly – of law.

A challenge that Augustus felt he could not duck. When Horace, looking to explain the implosion of the Republic, had identified the cause as a septic addiction to adultery, he had done so in total seriousness. Fond of a mirrored bedroom he may have been himself – but he had no doubt that the origins of the civil war, that supreme catastrophe, had lain in deviancy and licence. 'Such was the wellspring of the calamities that flooded our country, our people.'[26] What else, indeed, could it possibly have been? Everyone knew where the ultimate roots of crisis in a state lay: not in constitutional or social tensions, let alone in the unfathomable workings of finance, but in the degeneration of its morals. Seen in this light, the depravities of monsters such as Hostius Quadra served as an ominous warning. The pus had not been wholly drained from the body politic. Beneath the brilliant show of the city rebuilt by the Princeps, it was still festering and breeding. How, then, charged as he was by the gods with the salving of Rome back to health, could Augustus not enforce an iron-bitted cure? 'All very well wringing our hands – but we need measures to fit the crime.'[27]

So it was, soon after his return in triumph from the East, bringing with him the standards lost by Crassus, that the Princeps had made his move. In 18 BC, a law was passed that aimed to regulate the marital behaviour of the upper classes. The heroic early days of Rome, when men had wed only virtuous matrons, breeding vast numbers of infant citizens on them for the good of the Republic, were to be revived by means of legislation. Bachelorhood, social *mésalliances*,

childlessness: all were severely penalised. Then, a few months later, came a law that poked its nose even more intrusively into the affairs of senators and equestrians. Adultery was made a public offence. Cuckolds were legally obliged to divorce their cheating wives. Those who did not, whether out of embarrassment or perhaps, more sinisterly, because they took a sordid pleasure in the business of their own humiliation, were to be charged with pimping. Adulterers, meanwhile, were to suffer swingeing financial penalties and exile to an island. Adulteresses too – and banned from ever again marrying a free-born citizen. Even their dress was to proclaim their shame. Not for them the *stola*, that emblem of womanly rectitude. 'When they step out, it is generally in a dark toga – to distinguish them from matrons.'[28] A bitter degradation. The toga was not only the dress of a male citizen; it was also the most distinctive costume worn by a whore. No longer deserving of the honour and respect due a Roman matron, the convicted adulteress was to be ranked legally with the lowest of the low: prostitutes, madams, even actresses. Like them, she was to take her place among the moral underclass, the dregs of society – the *infames*.

Smouldering resentment among the aristocracy, who viewed the legislation as an assault both on their own privacy and on Roman tradition, did nothing to affect the Princeps's resolve. He knew his duty. Long before the joyous moment in 2 BC, when by universal acclamation the title 'Father of his Country' was awarded to Augustus, his status had become self-evident. He was, in effect, 'a universal parent'.[29] Like the model of a father, he had chided, guided and loved the Roman people. Licence had been tamed. Effeminacy and adultery had been reined in. 'Households had been rendered chaste, cleansed of depravity, and all the stains of misbehaviour checked by custom and law.'[30] There certainly seemed no need for the Father of his Country, a few weeks after his tear-choked acceptance of the title, to dread 17 March, the

annual festival of Liber. Once, when he had still been merely one of two rival warlords, things had been different. Back then, when the devotees of Antony's divine and disturbing patron celebrated the god's festival, bearing in wild procession through the streets a giant phallus, the menace to ancestral virtues would have been palpable. Horrified conservatives had been attempting to geld the worship of Liber ever since its first manifestation in Rome, almost two centuries before. It was all wine, and late nights, and debauch. Appetites, no matter how deviant, were satisfied without heed to propriety. Everybody slept with everybody else. A more scandalous mockery of Roman values it was hard to imagine. Yet now, with Antony long dead, and every citizen a dependant of the Father of his Country, it was mockery that stood defeated, Roman values triumphant. Two months after the festival of Liber, in the new forum that he had peopled with statues of the city's antique heroes and adorned with battle trophies, Augustus dedicated his great temple to Mars. Companion of legionaries in the line of battle, the rapist of Romulus's mother, swift and brutal in all that he did, the god offered as stern a model of masculinity as Liber did not. Of one thing, at any rate, the Roman people could be confident. Mars was not the kind to depilate himself.

Beyond the great wall which served the god's temple as a flood barrier, though, the tides of appetite surged on. In hallways and courtyards, and under the noses of stern fathers, secret assignations were still being made. Amid stifled laughter, those in the know continued to whisper reports of scandalous doings. Meanwhile, in the ancient forum, the statue of Marsyas, that servant of Liber, stood where he had always done: a symbol of licence at its most defiant.

'Set strictures on a person all you like, but the mind remains adulterous.' So observed Ovid, pushing as ever at the boundaries of what it was acceptable to say. 'You cannot regulate desire.'[31] Time would soon discover whether he was right or not.

Family Trees

One day, it was said, shortly after Livia's second betrothal, a remark-able event occurred. An eagle, swooping down over where she was sitting, dropped a white chicken into her lap. Even more aston-ishingly, the hen – which was perfectly unharmed – had a sprig of fresh laurel in its beak. An awesome portent, self-evidently. Bird and laurel were both duly removed for safekeeping to a Claudian estate just outside Rome, at Prima Porta, on a promontory above the Tiber. Here, the hen produced a brood of chicks, while the sprig of laurel, planted in one of the villa's borders, sprouted to luxuriant effect. The implication of the episode, as time went by and Livia's hold on Augustus tightened, appeared evident enough to most people: 'that she was destined to hold the power of Caesar in a fold of her robe, and keep him under her thumb'.[32]

To some, though, the mysteriously burgeoning bush hinted at a different meaning. The laurel was no ordinary tree. Lightning was powerless to strike it; its leaves served to fumigate spilt blood; it was sacred to Apollo. All of which made it a perfect emblem of Augus-tus – and sure enough, when the Senate awarded him the name in 27 BC, they also decreed that his house be publicly adorned with laurel, 'veiling the doors, wreathing the holy gates with a chaplet of dark leaves'.[33] Soon, it began to seem sacrilege for anyone else to sport it. As for Augustus himself, only the laurel dropped into Livia's lap would do. Celebrating his three great triumphs, the Princeps had held one of its branches in his hand, and been wreathed in its leaves.

Compared to the blaze of such greatness, the glimmering of other men's victories inevitably came to seem as nothing. Crassus, after celebrating his own triumph, had vanished into obscurity. The days were passing when even the most blue-blooded of nobles could expect to ride through Rome crowned with laurel. It was those who stood closest to the Princeps who understood this best. Agrippa,

The Julians and Claudians under Augustus

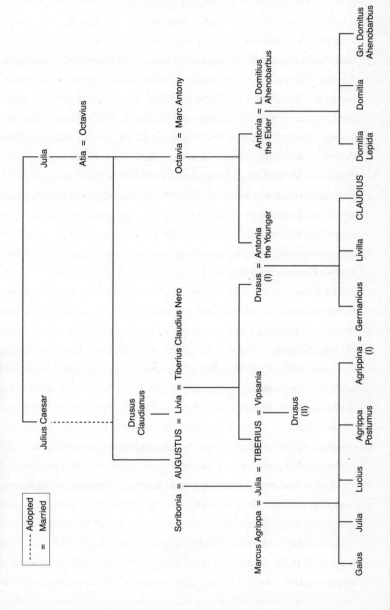

although the greatest general of his generation, had consistently refused a triumph. He knew better than to upstage Augustus. 'Practised in obedience to that one man as he was, he aimed for the obedience of everybody else in turn.'[34] Between the traditional show of power and the reality, the gap was widening fast. Soon enough, even those who lacked Agrippa's acuity had been brought to recognise this. In 19 BC, a general by the name of Lucius Cornelius Balbus paraded through the streets of Rome in recognition of his victory over a tribe of Africans. It marked the end of an era. Never again would a private citizen celebrate a triumph.

Did this mean, though, that in the future only Augustus himself would have the right to the honour? Perhaps not. Something more than laurel, after all, had been dropped into Livia's lap. So full of squawking white chickens was the villa to which the original hen had been removed that it came to be known as 'The Coop'.[35] Clearly it was foreordained that Augustus should have many descendants. Nevertheless, a puzzle remained. Even though it was Livia who had welcomed the white hen into her lap, and she already had two sons, she seemed unable to give her second husband an heir. The older she grew, the clearer it became that Augustus was going to be left with just one child: a girl. Julia, his daughter by the cantankerous Scribonia, certainly provided him with a useful pawn in the great game of his dynastic ambitions; but a pawn was not enough. Augustus, like the head of any other household, required a male heir. So it was, taking a leaf out of his own great-uncle's book, that he had looked to his sister. Octavia, much admired and impeccably virtuous, had played a key role in the crisis that had led up to Actium. Married to Antony as a token of the compact between the two triumvirs, she had then been rejected by him in favour of the Queen of Egypt, sent packing back to Rome and ignominiously divorced. Throughout it all she had maintained perfect dignity; and when, in the wake of her brother's victory over her erstwhile husband, she had consented to

bring up the dashing young Iullus Antonius, Antony's son by an earlier wife, the Roman people were only confirmed in their admiration for her as a paragon of womanhood. The young Antonius had duly been raised alongside Octavia's children. Two of these, Antonia the Elder and Antonia the Younger, were his own half-sisters. The others were Octavia's by her first husband – and one of these children was a boy. Marcus Claudius Marcellus was handsome, charismatic, and touched by the mystique of his distant ancestor, the war hero who had once captured the 'spoils of honour': qualities more than fit to tickle his uncle's fancy. In 29 BC, the boy had ridden alongside the Princeps as he celebrated his triumph. Two years later, he had been given a taste of active service in Spain. Then, in 25 BC, had come the ultimate mark of favour: marriage to the fourteen-year-old Julia. Augustus, it seemed, had anointed his heir.

Time, though, would see him shrink from the implications of this decision. In 23 BC, as he was lying on his sickbed, he had slipped off his signet ring and pressed it into the palm, not of Marcellus, but of Agrippa. Augustus, who knew what it was to be plunged as a young man into the snake-pit of Roman politics, had clearly doubted his nephew's ability to survive and thrive in it as he had done. That, though, was hardly the limit of his anxieties. More than the future of his own household lay at stake, after all. Any heir of his would have a claim to the rule of the world. Yet here loomed a paradox. The bundle of powers and honours that Augustus had won for himself was nothing that could be passed on readily to a successor. Even to make the attempt would be to confirm what he had spent so long denying: the brute fact of his autocracy. No matter how battered and traumatised by civil war, the Roman people were not prepared to tolerate the rule of a king. Augustus was merely the first citizen of a free republic: such was the universal conceit. Only a man who shared in his prestige could hope, in the final reckoning, to succeed him as Princeps.

Marcellus, popular and glamorous though he was, did not yet rank as such a figure. Nor, as it turned out, would he ever. A few months after Augustus, defying the odds, had been successfully nursed back to health, Marcellus fell sick in his turn. Death, cheated of the uncle, claimed the nephew instead. Devastated, Octavia retired from all public appearances, and was said never to have smiled again. The Roman people shared in her grief. The memory of Marcellus, so promising, so lustrous, so young, would long be cherished. Perhaps, in the sheer scale of the public mourning, the glimpse was to be caught of a new age: one in which the blaze of Augustus's charisma, aureate and superhuman as it was, would serve to illumine every member of his family. What were the lilies and the bright flowers scattered in memory of Marcellus, if not a tribute paid to the radiant dawning of this light? Even in the blackness of death, the young man's profile appeared back-lit. The effulgence that haloed it was that of the *Domus Augusta* – the 'August Family' of the god-like Princeps.

All of which ensured that the widowed Julia, still only sixteen, could not possibly be left single for long. There was, in effect, a single candidate to hand. Augustus had already signalled as much back when he had given Agrippa his ring. 'Kill him or make him your son-in-law'36 – such was the cheerily cynical advice of Maecenas. Augustus, who relied far too much on his old *consigliere* even to contemplate the first option, duly went for the second. Despite already being married to one of Julia's cousins, Agrippa obediently divorced her, taking the Princeps's daughter as his wife. The marriage, in the event, proved a great success. To Agrippa it served as public confirmation of his pre-eminent status, not merely as the deputy but the heir-apparent of Caesar. Augustus, meanwhile, was provided with a perfect opportunity to hedge his bets. Even as the laurel bush planted at Prima Porta flourished and spread, so was Julia doing her filial duty by giving birth to a succession of children. Two were girls: one named Agrippina after her father, and the second, with an even

more notable lack of originality, Julia. But there was more – much more. In 20 BC, Julia had given Augustus his first grandson, a healthy young boy called Gaius. Three years later came a second, Lucius. The Princeps was ecstatic. No sooner had Lucius been born than he adopted both brothers. Now at last he had his sons.

Agrippa, whatever his private feelings, did not complain. He grasped perfectly how much brighter the prospects of Gaius and Lucius would blaze for bearing the name of Caesar. He knew too that he remained the heir presumptive. In 18 BC, he had even been granted a share of the *tribunicia potestas*, powers that were among the most formidable of those wielded by the Princeps. The road ahead appeared clear at last. When the Princeps died, Agrippa would step into his shoes; and when Agrippa died, Gaius Caesar. This, in a great family like the Julians, was how arrangements and alliances had always been fashioned. Far from promoting some sinister brand of hereditary monarchy, the Princeps's plans for his family were of a thoroughly traditional kind. The bonds of loyalty and obligation that Augustus saw as securing the future of Rome were such as any true-born citizen could value and respect. Who was there, ploughing the fields and tending the gardens only lately fertilised by civil bloodshed, to argue with that?

Not many, as it turned out. The Roman people's devotion to Marcellus turned out to have been no flash in the pan. When Agrippa, exhausted by his many exertions, died in 12 BC, the loss of the man whom Augustus had been banking upon to succeed him immediately won novel and eager attention for the next generation of the August Family. Fascination with the Princeps's grandchildren was widespread. There was certainly no lack of them. Julia, who had been pregnant when her husband died, had ended up giving birth to a third son: Agrippa Postumus, as he was inevitably known. It was his two older brothers, though, who were the real darlings of the Roman people. Although Gaius was eight and Lucius only five, anticipation

of their future greatness served to cloak both boys in potent glamour. This was something new. Children had never before demanded much attention in Rome. Even the most precocious of debutants on the political stage – Scipio, Pompey, Augustus himself – had already come of age when they first made their entrance. It was the measure of the Princeps's aura that it continued to bathe all the members of his household – even the youngest – in its light. Enthusiasm for the two infant princes exceeded all expectations. Paraded whenever there was a requirement for the August Family to be seen, they embodied for the Roman crowds a winning combination of magnetism and boyishness. Here, in this popularity of theirs, was all that Augustus could possibly have hoped for. Adopted as the people's favourites, Gaius and Lucius offered to their grandfather a precious reassurance that heredity might after all be viable. The notion of a ruling dynasty, it seemed, was not entirely beyond the pale.

Except that Augustus himself still felt torn. In 6 BC, when the Roman people voted for the fourteen-year-old Gaius to become consul, he was appalled. Summoning an assembly, he berated them for their frivolity. The pleasure that he took in Gaius's popularity competed in his heart with sterner impulses. Just as he had shrunk from entrusting the rule of the world to Marcellus, so now he flinched from placing it irrevocably in the hands of an untempered boy. Augustus had not laboured for decades to restore the noblest and most exacting traditions of the Republic, only to make a mockery of them himself. The loss of Agrippa was painfully, bitterly felt. Yet how to replace him? His old comrade had possessed rare capabilities. Loyalty to the Princeps himself; flinty virtues of the kind that would have been familiar to Romulus; experience such as could only be forged at the head of legions, steeling mind and body alike in the service of Roman greatness: these had been Agrippa's qualities. What odds on finding a second such paragon? Impossibly long, it might have seemed.

And yet, as so often in the career of the Princeps, the gods appeared to be smiling on him. A solution to the problem of how best to meet the loss of his trusted deputy was staring him in the face. The obvious replacement could hardly have been more ready to hand: a perfect candidate to play Agrippa's role. From infancy, he had grown up a member of the August Family itself; and from the age of sixteen, when he had accompanied Augustus on his campaign in the wilds of northern Spain, he had devoted himself to the service of the Roman people. Seasoned in the business of both war and state, he was a man who had already achieved much on behalf of his fellow citizens. Now, it seemed, he was primed to achieve much more, in the service both of the Princeps and of Rome. There was really only a single drawback. Whereas Agrippa had always been Augustus's creature, from a background so humble that the disdainful nobility had scorned to attend his funeral, Livia's son Tiberius Claudius Nero was head of the most celebrated and brilliant family in Roman history. The son both of a Nero and of a Pulcher, the blood of the Claudians flowed doubly in his veins. Such a man had expectations that owed nothing to Augustus.

Livia's second marriage had not diminished one jot the loyalty that she felt to her ancestral line. Moving into her new husband's home, she had made sure to take her two boys with her. Tiberius and Drusus had grown up doubly privileged, as stepsons of the Princeps and as heirs to the incomparable traditions of their Claudian forebears. Naturally, there had been the odd indignity to swallow. Accompanying Marcellus in his stepfather's triumph, for instance, the young Tiberius had been obliged to ride on the left-hand, less prestigious side. Yet slights such as this were vastly outweighed by the advantages to be had from their mother's marriage to Augustus. Unlike most other heirs to the great dynasties of the Republic, Tiberius and Drusus did not have to kick their heels in the gilded cage of Rome. Instead, they were permitted to embark on careers of the kind

that only a generation before would have been taken for granted as the birthright of their class. In the Alps, in the Balkans, in the forests and bogs of Germany, the two brothers won a succession of glorious victories. Of these, it was the accomplishments of Drusus that glittered the more brightly, those of Tiberius that were the harder-won. The younger brother, to whom charm came easily, had a talent never possessed by the elder for making himself loved; and yet Augustus, who would often complain behind Tiberius's back of his 'austere and uncompromising disposition',[37] understood what it signified, and respected it. To serve as head of the Claudians was no light responsibility. Tiberius, who combined the hardiness of a natural soldier with the aptitudes and interests of a scholar, was uncompromisingly old-fashioned. The codes and standards of behaviour that had first set his people, back in the heroic days of Appius Claudius, on the road to the rule of the world, animated him in everything that he did. To Tiberius, the Republic that Augustus claimed to have nursed back to health was no fiction, no empty word, but rather the living essence of what it meant to be a Roman. The Princeps, who affected to believe the same thing, had no problem with this nostalgia for Rome's traditional order. Quite the contrary: it only confirmed him in his high regard for Tiberius as a man of principle. So it was, in the wake of Agrippa's death, that he had issued an order to his stepson. Take the action, Tiberius was instructed, that would signal to the world his new and favoured status. Divorce his wife; marry Julia; become not just the stepson but the son-in-law of the Princeps.

Yet there remained limits to what even Augustus could command. Licensed though he was as head of the August Family to meddle all he pleased in the marital arrangements of its various members, Tiberius hardly made for an easy puppet. While he had been left with no choice but to take Julia as his wife, he did not have to pretend that he liked it. Already married prior to Agrippa's death to his daughter, Vipsania, Tiberius had found the separation a wretched

experience. The couple had been happy: Vipsania had given her husband both a son, named Drusus after his uncle, and her devotion. Tiberius, who normally made sure to keep his emotions on a tight leash, had found it impossible to conceal his agony at the separation. Chancing to meet with Vipsania some time later, he followed her with such a look of hangdog bereavement that orders came from on high to ensure that it never happened again. The causes of Tiberius's unhappiness, though, ran deeper than divorce from a much-loved wife. The role Augustus expected of him could not help but be profoundly humiliating to a Claudian. To lurk in the wings as a potential caretaker, and to hear in the cheers and applause that greeted a pair of untested boys whenever they appeared how much more popular they were than him, were no easy experiences for so proud a man. Illusions that on a distant frontier might conceivably have some life in them were hard to sustain in the presence of two princelings. Torn between his loyalty to Augustus and his contempt for the monarchy so patently embodied by Gaius and Lucius, Tiberius did not find Rome a happy place to be. Unsurprisingly, he preferred distant, dangerous frontiers. There, at any rate, the values that he prized still had a role to play. Not only that, but he did not have to spend time with his wife.

Which in turn was a great relief for her. Julia, strong-armed by her father into a third marriage, was as different from her dour and dutiful new husband as it was possible for two people brought up in the same household to be. True, she had quite fancied Tiberius once, back when she was still married to Agrippa – or so it was said. Julia was the kind of woman who attracted such gossip. Wilful, sophisticated and high-spirited, she was much loved for her generosity of spirit, and much admired for her intelligence and wit. Far from dismissing the rumours of adultery, she dared to mock the censoriousness of those who spread them. How could the stories that she had cheated on Agrippa possibly be true, she was once asked, when Gaius and Lucius

looked so very like him?' 'Why,' she answered, 'because I only ever take on passengers after the cargo-hold has been loaded.'[38] The joke, in light of everything that her father stood for, could hardly have been more shocking. It certainly helped to confirm all with a taste for boldness and subversion in their affection for her. The first woman to have the sacred blood of Augustus flowing in her veins, she was also the first to make play with what that might mean in practice. Not for Julia the hypocrisies with which Livia so soberly veiled herself. Scolded for not emulating her father's ostentatious frugality, she only laughed. 'While he may forget that he is Caesar, I never forget that I am Caesar's daughter.'[39]

Caesar himself, unsurprisingly, was not amused. When the Princeps declared that he had 'two wayward daughters to put up with, Julia and the Roman Republic',[40] his tetchiness was laid revealingly bare. The challenges of fatherhood were many. In his dealings with his fellow citizens, Augustus laid claim to the rights and responsibilities of a parent; conversely, in making arrangements for his daughter, he could never treat her as though she were merely his child. By keeping her in his marriage-bed, Tiberius was serving the needs of the Princeps no less surely than he did when off slaughtering barbarians. Augustus, who had briefly contemplated pairing Julia up with an obscure and inoffensive knight, so anxious was he to keep the mother of his heirs from ambitious paramours, had never knowingly failed to neutralise a problem. Tiberius and Julia both knew this well enough. In the first years of their marriage, the couple duly struggled to put a good face on matters. When Tiberius left for a provincial command in the Balkans, Julia went with him. Shortly afterwards, she gave birth to a son. On her husband's return to Rome, she joined with Livia in hosting a banquet for the leading women of the city in his honour, while Tiberius himself feasted the people on the Capitol. All might have seemed well enough.

But it was not. The fissure between the couple was widening all

the time. Between the witty, quicksilver Julia and her husband, 'who ever since a child had been far too serious and austere for jokes', there was a natural lack of empathy.[41] Then came two bereavements in quick succession. First, they lost their son; then, as Livia and Julia were preparing a second banquet, this time in honour of Drusus's return from the front, news arrived from Germany. Drusus was dead. His horse had rolled on him, his leg had been crushed and gangrene had set in.* Tiberius, alerted to the news, had ridden hundreds of miles through barely pacified territory, accompanied by a single guide, and reached his brother just before he died. As a display of fraternal love, it was worthy of the noblest traditions of their ancestors – and fittingly so, for Drusus too had been a great admirer of republican virtues. No effeminate extremes of mourning, then, for the bereaved Tiberius. Instead, as though walking through the landscape of some ancient annal, he escorted the corpse back to the capital on foot, dry-eyed, grim-set. Such were the obsequies appropriate to a Roman hero. 'It was not only in war that discipline had to be maintained, but in mourning as well.'[42] Yet everywhere, to Tiberius's disgust, the corpse of Drusus was greeted by wild displays of emotional incontinence. Even the soldiers wept. Arriving back in Rome, Tiberius's sense of living out of time, in a world neglectful of all that had made the city great, grew ever more oppressive. True to his heritage as a Claudian, he had laboured tirelessly in the cause of the Roman people, on remote frontiers, amid dripping forests, in rough-hewn camps – and yet the glory that this had won him was tarnished. In 7 BC he was granted a triumph, and a year later the grant of *tribunicia potestas* that Agrippa had once enjoyed: honours that Tiberius found so delusory as to seem mocking. The cheers that followed him as he rode in his triumphal chariot through Rome were faint compared to those that greeted the teenage Gaius; the awesome

* Or possibly he suffered internal injuries. 'He died on his way to the Rhine of some illness,' is Dio's helpful version of what happened (55.1.4).

powers of a tribune did not inhibit his wife from looking down her Julian nose at him. Everything about his situation, to a man of his pride and prickliness, was insupportable.

In 6 BC, five years into his marriage, Tiberius finally snapped. The grant of *tribunicia potestas*, which to the outside world appeared the mark of his greatness, plunged him into despair. When Augustus, making clear that he had only ever approved it in the first place because he wished his son-in-law to shoulder the more tedious and demanding of his responsibilities, ordered Tiberius east on a diplomatic mission, he was met with a blunt refusal. Unused to taking no for an answer, the Princeps reiterated his instructions. Tiberius promptly went on hunger strike. He wished to lay down all his public offices, he announced. He wished to retire. Furious and baffled, Augustus demanded openly in the Senate that he change his mind. Livia, even more appalled by her son's wilfulness, entreated him in private. Tiberius remained obdurate. Eventually, after a four-day standoff, it was Augustus who blinked first. As though to rub his victory home, Tiberius then promptly headed east – not as the deputy of Caesar, but as a private citizen. Settling on the Greek island of Rhodes, he there devoted himself to all the traditional pleasures of a dignified retirement: literary studies, chatting to philosophers, snacking on fish. Horace, taking possession of his Sabine farm, had done much the same, fashioning out of the delight that he took in his leisure joyous and immortal poetry: an affirmation that war was over, a celebration of the coming of peace. The statement being made by Tiberius, though, was a very different one. Claudians were hardly given to retiring from public life – and especially not to an island full of Greeks. That Rome's foremost general, 'the most eminent after Augustus of all her citizens', had now despaired of it offered sobering food for thought. A damning health-check had been delivered on the state of the Republic. Tiberius, by so ostentatiously doing nothing, had known full well what he was doing.

Yet in the event, he was barely missed. So furious had Augustus been in the immediate wake of the standoff with his son-in-law that it had literally made him ill. Nevertheless, for all his rage and perplexity, it turned out that he could cope perfectly manageably without Tiberius. Perhaps, had some pressing military emergency erupted, it would have been different; but all seemed well in Rome. The frontiers remained stable, the provinces at peace. Not only that, but Gaius and Lucius, schooled closely in the arts of governance by its greatest living practitioner, would soon be men. One year after Tiberius's departure for Rhodes, Gaius was honoured by the equestrians with an unprecedented rank: 'Princeps of Youth'. Simultaneously, he was inducted into the Senate, designated consul five years ahead, and given a major priesthood. In 2 BC, Lucius too was introduced by Augustus to the Senate, and proclaimed a 'Princeps of Youth'. '*Virtus*,' as Ovid put it, with a perfectly straight face, 'flourishes young in a Caesar.'[43]

The course of the future seemed set fair. Though Livia, mourning the death of her younger son and the disgrace of her elder, might despair of the prospects of the Claudians, those of the Julians seemed secure. In the villa at Prima Porta, the white chickens continued to lay their eggs, and the miraculous laurel tree still spread its branches. Father of his Country, Augustus was father as well of two brilliant princes. It seemed that his troublesome daughter and mulish son-in-law could both be put safely to the back of his mind.

The Arts of Love

August, 2 BC. The dog days of summer. In the hills beyond Rome, sheep and bullocks sought shelter from the scorching heat wherever they could find it, while men offered sacrifice to cooling springs. In the great city itself, narrow streets sweltered beneath the stench of

brown smog. Caesar Augustus, concerned as ever for the well-being of his fellow citizens, had recently taken steps to complement the flow of water along the capital's aqueducts, and from the beautiful marble fountains erected decades earlier by Agrippa, by building a massive lake. Stretching some 1800 feet by 1200, it stood on the far bank of the Tiber, and was crossed by a spectacularly engineered bridge. Here, sparing no expense, the Princeps chose to celebrate the great events of the previous few months: his becoming the Father of his Country, and the dedication of his splendid temple to Mars. Out on the lake, entire squadrons of warships re-enacted the battle of Salamis, the heroic victory of 480 BC in which the Greeks had defeated a fleet of invading barbarians.

Echoes of a more recent victory were hard to miss. It was thanks to the rout of Cleopatra and her jabbering, animal-worshipping hordes at Actium that Augustus, for almost thirty years now, had been able to nurse the shattered Republic back to its present golden state of health. Nostalgia, though, was only a part of the Princeps's message. He was looking to the future as well. The barbarians defeated at Salamis had come from the same lands now ruled by the Parthians – and the time had come, so Augustus felt, for the eastern front to receive renewed attention. Tiberius, the man originally entrusted with the mission, had flunked the challenge; but Gaius Caesar, recently turned eighteen, was ready at last to take up the reins. The following year he would leave for the East. As spectators on the banks of the artificial lake cheered the splintering of timbers and the sinking of battleships, a stirring vision was being offered them of the future – one in which 'the final gaps in Caesar's rule of the world are plugged'.[44]

Not that all the audience were necessarily much interested in the Princeps's ambitions. Ovid, visiting the naval extravaganza, barely had eyes for the battle itself. He was there to ogle women. 'The crowds being what they are, there is someone for everybody's tastes.'[45] More

than a decade and a half had passed since the criminalisation of adultery, but Ovid, the most fashionable poet in Rome, still dared to make titillating play with his taste for married women. No better time to satisfy it than the long, hot, lazy afternoons of summer. The half-closed shutters of a bedroom, the play of shadow and sunbeams, the soft-footed tread of some other man's wife, her long hair loose, her white throat bare, her dress thin and skimpy: Ovid was not afraid to pray publicly for 'the enjoyment of many such a siesta'.[46] Deliciously, seditiously, beyond the gleam of the war god's new temple and the forest of masts out on the Princeps's artificial lake, Rome still sheltered shrines to forbidden pleasure.

As Augustus would soon find out for himself. Shortly after his re-enactment of the battle of Salamis, near the same Rostra in the Forum from which he had originally proposed his laws against adultery, a crown of flowers appeared on Marsyas's head. Who had put it there? Gossip fingered a truly scandalous culprit: none other than the Princeps's own daughter. Rumour had been swirling around Julia for a long while – and now, in the hour of her father's apotheosis, it reached critical gale force. It was whispered that she had taken not one, but a whole multitude of lovers. That she had partied by night in the Forum, and stained the Rostra with her adulterous affairs. That she had sold herself to strangers beneath the statue of Marsyas. Not a law of her divine father, not a value, but she had disgraced it. That in itself was scandal enough – but there was worse. The rumours, fetid and unsourced though they were, hinted darkly at treason. Among Julia's lovers was the son of her father's greatest enemy. Sharing torchlit revels with Iullus Antonius, she had been paying honour to Liber, the patron of Antony. The insult to all that her father stood for, to all that he had achieved, could hardly have been more pointed. No wonder, when at last the news of Julia's escapades was broken to the Princeps, that the informers dared to hint at 'plots against his life'.[47]

As a young man, a terrorist barely out of his teens, the future Augustus had spared no one, shown no compunction, in securing his goal of absolute predominance. Decades had since passed, softening the memory of his youthful cruelty: 'He well deserves the name of father.'[48] Julia herself, as wilful as she was bold, had dared to imagine as Tiberius had done, that the Princeps might safely be crossed. A fatal mistake. Those with clearer insight into Augustus's nature knew better than to imagine that a leopard could ever entirely change its spots: 'I would certainly not describe as mercy what was actually the exhaustion of cruelty.'[49] Augustus's powers, as a father, were those of death as well as life. In the humiliation inflicted upon him by his daughter he found, as he had so often done before when confronted by setbacks, only an opportunity to entrench his greatness yet further. No one, after he had dealt with Julia and her lovers, was to be left in any doubt that the Father of his Country reserved the right to destroy as well as cherish those in his power. Rather than draw a veil over the scandal, he opted to expose the whole sordid business to the Senate. His voice raw with shock and horror, Augustus braved the hidden smirks of the listening nobility. A mortifying indignity, certainly – but all for long-term advantage. Senators were being exposed to a fact of political life long veiled behind the Princeps's show of patience and forbearance: that he could, if he so wished, annihilate anyone he pleased.

It was Iullus Antonius who paid the ultimate price. Whether his affair with Julia had been as scandalous as the gossip had it, let alone as sinister in its implications as Augustus seems to have suspected, no one could know for sure. The truth of his ambitions was as veiled in shadow as his midnight revels had been. The baseness of his ingratitude, though, was beyond doubt. His suicide echoed the end of his father. Julia's fate was, if anything, even more cruel. Branded an adulteress, she paid the price laid down by her own father's law: exile to an island. Pandateria, the remote and windswept destination chosen

to serve as her prison, was furnished with an agreeable enough villa, yet this hardly served to make up for its downside: that it was dull beyond words. Only Scribonia, her aged mother, was permitted to accompany her there. Otherwise, all company was banned, and even slaves had to be thoroughly vetted before they were permitted to make the crossing to the island. Wine too was forbidden, and all but the plainest food. Julia, whose scorn for the bogus economies of her father's household had always so amused her admirers, found herself condemned to a living nightmare of austerity and tedium.

Meanwhile, back in Rome, the fast set of whom she had been the undoubted queen reeled in stunned horror. A wave of copycat prosecutions threatened a witch-hunt. Even though the Princeps dismissed many of the accusations, a mood of dread settled over the city's salons. 'Who can deceive the sun?'[50] Ovid, casting its golden blaze as an all-seeing spy, imagined its gaze as capable of penetrating even the darkest bedroom, of fathoming the secrets of even the most careful adulterers. Yet even as he confessed to his nervousness, he refused to surrender to it. 'My sexual tastes are deviant,' he cheerily admitted, 'nor is it the first time they have got me into trouble.'[51] Nor, perhaps, the last. Julia might have been banished to a grim existence redolent of antiquity at its most brutally primitive, all weaving at the loom and turnips, but Ovid was not intimidated. He refused to abandon those values of urbanity and sophistication that he saw as embodying the true spirit of the age. In the months after Julia's exile, when the mood in elite circles was all paranoia, Ovid busied himself with a project that could hardly have been more provocative: a guide to the arts of love. Naturally, he made sure to hedge it about with the odd caveat. 'I reiterate – there's nothing illegal about my fun and games. No woman is caught up in them who shouldn't be.'[52] He protested too much, of course. In the wake of Rome's most notorious sex scandal, it took a peculiar degree of courage – or insouciance – to enthuse as Ovid did about the thrills and pleasures

of seduction. Even more to give tips to a woman on how best to slip a guard, write messages in secret ink, and conduct an affair behind the back of an over-protective father. Advice such as this, in the wake of Julia's downfall, was as close as anyone among her circle dared come to open dissidence.

Out in the streets, it was different. Julia, witty and blessed with the popular touch, was the people's princess. The great events staged that year by Augustus, and which the entire city had been invited to celebrate, had only fed the public fascination with her. She was loved not just as Caesar's daughter but as the mother of two dashing boys. Both had played a key role in the dedication of the temple of Mars, and preparations for Gaius's departure on his mission to the East could hardly help but stir thoughts in people's minds of the wretched Julia, bereft now of her young princes. Beyond the splendour of Augustus's new forum, in the shadow of its massive screening wall, narrow streets slippery with filth teemed with people who saw in Caesar's daughter, in her sufferings and her sorrows, a glamorous proxy for their own misery. In squalid, crowded courtyards, in teetering tenement blocks, in slums far and wide across the city, the poor mourned the downfall of their favourite. Only months after the people had joined as one with the Senate to hail Augustus as Father of his Country, the unity that he had laboured so hard to foster was fraying. Demonstrations and demands for Julia's return, chanted publicly in the streets, contributed to the sense of a darkening mood. The newly dedicated temple of Mars, seen from the warren of alleys that stretched beyond it, began to seem less a monument to the greatness of a united people, more an embattled island amid a hostile sea.

Augustus himself, having just bared his teeth at the aristocracy, was hardly likely to yield to the mob. Nevertheless, as befitted a man endowed with the *tribunicia potestas*, he was sensitive to its hissing. He had long since learned to keep a beady eye on what happened in the slums. No regime could prosper that was content to leave them

unregulated. This was not the least among the many insights that
Augustus had brought to the art of government. 'The poor are
like the paltry, obscure places into which shit and other refuse are
dumped.'[53] While sufficiently a man of his class to take this com-
monplace for granted, Augustus had nevertheless come to appreciate
how vital it was to plumb their depths. His agents, over the course of
the decades, had duly fathomed the city's bowels. Registers of every-
thing from prostitutes to snack bars had been assiduously compiled.
Loose roof-tiles, dangerous paving-stones, leaking water-pipes: all
had attracted the attention of ever more officious aediles. Plans of
properties and lists of householders were drawn up in exacting detail.
The image that haunted Ovid, of Augustus as the sun, his eye forever
probing shadows, was one that the agents appointed to map the city,
his many surveyors and officials, would doubtless have recognised.
No matter that Rome's snarl, away from the gold and marble of the
Princeps's *grands projets*, remained as much a warren as ever, the gaze
of Caesar had come to penetrate even its darkest, most insalubrious
corners. The great labyrinth of the vastest city on the planet, one that
no one previously had ever before thought to trace, held few secrets
from Augustus.

And knowledge, as so often, was power. It was a father's right, of
course, to track what those under his authority were up to – not
just to punish them when they did wrong, but to keep them secure
from peril. In Rome, potential calamity was only ever a spark away.
In 7 BC, arsonists had started a fire that at one point had threatened
the Forum itself with immolation. Augustus, responding to this
near-calamity in predictable fashion, had sponsored yet more lists.
Officials were instructed to ensure that even the meanest attic in a
high-rise be armed with a bucket. Health and safety regulations like
these, by ensuring that neighbourhoods were less likely to go up in
flames, reaped the Princeps massive reward. In a tinder-box such as
Rome, there existed no surer path to popularity than the provision to

nervous citizens of a reliable fire service. Augustus was not the first to have realised this. Back in 19 BC, with the Princeps absent in the East, a bold and ambitious nobleman named Egnatius Rufus had funded his own supply of firefighters, ending up so popular in consequence that it had completely turned his head. Seduced into aiming at the consulship against the explicit wishes of Augustus, he had sent the proxies appointed by the Princeps to administer Rome scrabbling to contain the damage. In the event, the coup had fizzled out ingloriously. Egnatius's attempt on the consulship had been suppressed, and Egnatius himself, flung into prison, had 'there met with the end that his life so richly merited'.[54] Augustus, though, had learnt his lesson. Only one man could be permitted to serve the city and its teeming masses as their guardian – and it was not Egnatius. Nothing to the benefit of the people but it was to proceed from the Princeps himself.

Which was why, despite their indignation at Julia's fate, Augustus could feel confident that their demands for her return were unlikely to degenerate into rioting, or worse. Seen from the summit of the Palatine, the city's smog-wreathed workshops and tower blocks might have appeared perfervid with menace: Rome's heart of darkness, from which Clodius, in the dying days of the Republic, had recruited his paramilitaries, and from which mobs, reduced to skin and bone by the various wars of the Triumvirate, had periodically erupted. Those days, though, seemed over. Augustus himself, armed with maps and detailed breakdowns of the city's population, had successfully brought order where before there had been only chaos. In 7 BC, prompted by his reform of the fire service, he had made a tour of Rome's various neighbourhoods. Rather than venture into the shapeless tangle of side-alleys, he had focused his attention on the crossroads, the *compita*, which stood at the heart of every district. These, like the knots of a giant net, spanned the city. Control the city and control the urban fabric. Augustus, like a master huntsman, knew what it took to make a catch.

The origins of the *compita*, so the Roman people believed, reached way back to the time when kings had ruled the city, and were the focus of intense local devotion and pride. Mysterious twin spirits, known as Lares, stood guard over them, and were celebrated every year in a wild festival named the Compitalia. Sacrifices were made before each crossroads shrine. Everyone, no matter how lowly, no matter how wretched, would be invited to join in the fun; even slaves would dress up for the occasion. All of which, not surprisingly, had long been regarded with deep suspicion by conservatives in the Senate. Their concern, though, was rooted in something more than simple snobbery. The Compitalia had often literally been a riot. This was why, in 64 BC, the Senate had voted to suppress it. Yet the ban had not lasted for long. Clodius, whose genius for street fighting had seen him refine it into a veritable political art, had made sure of that. Patronage of the festival had been a key factor in his ground-breaking brand of gangsterism. It had enabled him not only to recruit supporters, but to fashion them into a city-wide organisation. *Compita*, after all, were everywhere in Rome. 'The city has a thousand Lares.'[55]

What Clodius had achieved, by transforming their shrines into hubs for his own personal ambitions, was not forgotten. The poor, it seemed, could provide even the most blue-blooded nobleman with a political base. This, as Egnatius's abortive coup had demonstrated, was bound to serve power-hungry senators as a standing temptation. Clearly, then, the Princeps had been left with no choice but to put a stop to it for good. Rather than ban the Compitalia, though, as the Senate had always sought to do, he had made himself its patron. Augustus was never the man to suppress a venerable custom – not when he could twist it to his own ends. By touring the city's crossroads, by centring the provision of firefighting and other services on them, and by gracing them with marks of his favour, he had won hearts and minds across the entire immensity of Rome.

Potential trouble spots had been transformed by his initiative into
nerve centres of the regime.

Even in the darkest slums, then, even in the very roughest quar-
ters, the authority of the Princeps blazed radiantly. Early in 1 BC,
when Gaius set out, via the frontier on the Danube, on his mission
to the East, he did so from the great temple of Mars, surrounded by
the marmoreal splendour of its colonnades, in the presence of the
standards won back from Parthia, before the awful gaze of the war-
god. No dirtying of sandals in the filth of the side-alleys for Caesar's
son. Yet there too, in the neighbourhoods beyond the new forum,
his departure was much on people's minds. Head from the temple of
Mars into the steaming agglomeration of workshops, fast-food stalls
and brothels known as the Suburra, then skirt southwards, and a
citizen would come to an ancient street, named after the cobblers
who had once lined it the Vicus Sandalarius.* At the end of the street
was a *compitum*; and here, newly chiselled, stood an altar. It had been
placed beside the crossroads just a few months earlier by the officers
responsible for the adjoining quarters: men of thoroughly humble
origin, but no less conscious of their dignity for that. There had cer-
tainly been no protests at Julia's fate from these officials. Entrusted
by Augustus with the key responsibilities of local government, per-
mitted an escort of lictors on public holidays, men literally at the
centre of all that went on in their neighbourhood, they could hardly
have been more in the Princeps's debt. The new altar set up beside
the crossroads was an expression of their gratitude. One side was
carved with laurel, another with trophies of victory. Its front featured
Augustus and Livia, who were portrayed standing on either side of
Gaius, gazing at him approvingly. Julia was notable by her absence.
The officials who had commissioned the relief, raising their gaze
from the swirl and clamour of their own little patch of Rome, could

* In due course, after a century or so of gentrification, it would end up as the centre
of the city's book trade.

feel themselves, however tangentially, embroiled in global affairs. Mars was not the only god summoned to keep watch over Gaius on his travels. So too were the Lares; and so too a novel and awesome power now increasingly honoured alongside them. Instituted by the Princeps on his tour of the *compita* in 7 BC, its cult had already taken root across the whole of Rome, wherever there was a crossroads to be found and a new altar raised: the animating spirit, the *Genius*, of Caesar Augustus himself.

With divine backing of this order, it seemed out of the question that anything could go wrong for Gaius. 'Grant him the popularity of Pompey, the boldness of Alexander, and my own good fortune.'[56] So Augustus prayed. Nor were gods the only guardians he made sure to provide his adoptive son. Marcus Lollius, a veteran of numerous provincial commands who also, perhaps tellingly, had long enjoyed a bitter feud with Tiberius, was assigned to the young prince as his mentor, and to serve Augustus as his eyes and ears. Watched over by the heavens and guided by a seasoned counsellor, Gaius was soon winning golden opinions. Cutting a dash wherever he went, he processed through the cities of the East to the furthermost limits of Roman power. Here, on an island in the Euphrates, he enjoyed a flamboyant and successful summit with the king of Parthia; shortly afterwards, and he was busying himself with the slaughter of various barbarians, 'for the better security of all mankind'.[57] Unsurprisingly, news of Gaius's progress was greeted with rapturous excitement back in Italy. The hopes invested by the Roman people in their favourite could hardly have been more promisingly fulfilled. 'Not only had he governed well, but he had defeated or received into alliance the fiercest and most powerful of peoples.'[58] The gods, it seemed, had been listening to his grandfather's prayers.

Abruptly, though, they withdrew their favour. First, in a spectacular bust-up, Lollius was accused of taking bribes from various local potentates, and pressured into drinking poison. Then, late in AD 2,

the devastating news reached Gaius that his brother Lucius had fallen sick and died in Gaul. The following year, meeting the commander of an Armenian fortress for a parley, Gaius himself only just survived a treacherous attempt on his life. Even though he went on to secure a notable victory over the Armenians, the wound his would-be assassin had given him failed to heal, and Gaius, his health and self-confidence shot, fast became a shadow of his former self. When he wrote to Augustus with a request to lay down his command, the Princeps ordered him home, and Gaius duly embarked on the long journey back from the eastern front. It was too late. Gangrene had set in. By mid-February AD 4, after an agonising journey across icy mountains and then by merchant vessel along the southern coast of Asia Minor, Gaius was finally ready to take ship for Italy. He never boarded it. On the 21st, the adopted son and appointed heir of Imperator Caesar Augustus breathed his last.

Back in Rome, the news broke like a thunderclap. Ovid, who had woven into his guide to seduction the stirring announcement that Gaius was destined to conquer Parthia, opted not to remove it from his published poem, but instead to let it stand, a memorial to high hopes raised and dashed. 'Your twin fathers, Mars and Caesar – both have endowed you with their awesome power.'[59] Sentiments such as this, transmuted from flattery into mockery by Gaius's pathetic end, could hardly help but raise a sardonic smile in the circles where Ovid mixed. Out on the streets, it was different. There, grief at the fate of Julia's two sons was raw. Once again, agitators took to demanding the return of their princess from over the water. Once again, Augustus refused. 'Fire will sooner mix with water,' he vowed, 'than she will come back.'[60] When they heard this, protestors lined the Tiber and hurled flaming torches into its currents. Even Augustus was unsettled. The continuing violence of the agitation, despite the fact that years had passed since the exile of his daughter, perturbed him. After a decent interval, so that he did not seem to be buckling under

pressure, he gave orders for Julia to be transferred from her bleak and treeless prison to confinement in Rhegium, a naval base in the toe of Italy. It was hardly Rome; but even the dreariness of a provincial port was an improvement on Pandateria.

Nor was Julia alone in being sprung from an island confinement. For her erstwhile husband too, the past years had been difficult ones. Tiberius's retirement to Rhodes had inexorably become an exile. Divorce from his wife, the necessary consequence of her adultery, had been a divorce from Augustus as well. Then, the following year, his grant of *tribunicia potestas* had expired, an ominous development for a man who had so wilfully alienated the Princeps. His legal immunity from insult and prosecution was no more. Tiberius, it appeared, had grievously miscalculated. Although, as a Claudian, he could still command influence across the Roman world, his prestige was in eclipse. Cities began to throw down his statues; puppet kings to snub him. Then, with Gaius's arrival in the East, his plight had taken a further turn for the worse. One night, at a drunken dinner party, a companion of Tiberius's stepson had offered to take ship to Rhodes and bring back the head of the 'exile', as he was derisively known. Gaius had refused – but when Tiberius, alarmed by news of the episode, asked for permission to head back for Rome, that too had been refused. A year had passed. Tiberius had continued to beg for an end to his exile. Finally, in AD 2, permission had been granted – but on humiliating terms. Though head of the Claudians, and his people's greatest general, Tiberius was forbidden to take part in public life. When the news reached Rome of Gaius's death, he was living in a location that could not have spoken more loudly of his retirement from both the Senate and military service: the gardens of Maecenas.

But now, abruptly, everything was transformed. Augustus faced a shattering moment of crisis. The loss of Gaius, the golden youth who had been both his son and his grandson, his 'sweetest little donkey',[61] was more than a devastating personal blow. It had also ruined his

dearest hopes for the succession. Of his five grandchildren, only three were now left him – and of these, two were girls. It was true that Agrippina, ambitious and self-assertive, 'had a masculine cast of mind, with no concern for feminine foibles'[62] – but the notion of a woman, no matter how able, ruling the world was clearly a nonsense. Julia, meanwhile, was quite another matter. Chic and flamboyant, she showed alarming signs of taking after her mother in more than name. To boast both the largest house in Rome and the smallest dwarf, as she did, was hardly the surest way to her grandfather's heart. That left Agrippa, the posthumous son and namesake of Augustus's great brother-in-arms; and sure enough, on 26 June AD 4, the Princeps duly adopted him as his son. The boy, though, was only fifteen – and Augustus, by now two decades nearer to the grave than he had been when adopting Gaius and Lucius, dreaded that time was running out. For all that he still looked youthful and serene in his statues, he was now sixty-six years old, by any reckoning an old man. Death might claim him at any moment. It was out of the question, after all his long labours, that he should put his achievements at risk by leaving the world in the hands of a child. That being so, there was really only one course open to him. Shortly after the news of Gaius's death had reached Rome, Augustus arranged for Tiberius to be awarded a fresh grant of the *tribunicia potestas*. Then, along with Agrippa Postumus, he adopted at the same time a second son. Tiberius Claudius Nero became a Caesar.

It was, for Augustus, a painful compromise. True, there could be found in his adoption of two heirs an echo of the consulship, that venerable institution which had ensured for so long that no one man should wield supreme power in Rome – but that echo was deceptive. Augustus understood, none better, the true nature of the regime that he had forged; and he knew Tiberius. Agrippa Postumus was likely to prove no match for the flinty head of the Claudians. The Princeps had made his decision – and it was one that had, to all intents and

purposes, sidelined his own flesh and blood. Not, of course, that he was prepared to acknowledge this. His regime remained publicly as Julian as ever. Tiberius, by virtue of his adoption, had ceased to rank legally as a Claudian at all. Not only that, but Augustus went to great lengths to ensure that the twin lines of his household, his own and that of Livia, would end up so tightly intertwined as to be indistinguishable. The robustly competent Agrippina was duly given in marriage to Tiberius's nephew, the son of Drusus, that much mourned hero of the German front. Simultaneously, despite already having a son of his own, Tiberius was obliged by the Princeps to adopt Germanicus, as he was known in honour of his dead father. Julians and Claudians, their distinctiveness blurred by adoptions, their identities blended by marriage, were to share a common destiny. Proud and ancient though their two respective lines were, it was the glory of Augustus to offer both a resplendent new status. Neither Julian nor Claudian, the future was to belong instead to a single house: the August Family.

Such was the spin, at any rate. Plenty had their doubts. Agrippa himself, as the Julian most obviously blocking a Claudian monopoly on power, certainly had few illusions as to how exposed he was. Young and inexperienced, he made no attempt to hide his resentment from his grandfather. By the time that he came officially of age, a year after his adoption by Augustus, he had already developed a reputation for surliness and aggression. Out on the streets, though, the mood of violence was altogether more threatening to the Princeps's plans. Enduring affection for Julia and her children combined with distaste for Claudian ambitions to render Tiberius a profoundly unpopular choice of heir. The stiffness which Tiberius himself prized as an ancestral Roman value was widely viewed by the urban poor as an expression of coldness and hauteur. The grant of *tribunicia potestas* to a man so unapologetically blue-blooded could not help but seem to the plebs a provocation. It was to protect the rights of the people

that the office of tribune had first been instituted; and the Princeps, for as long as he had been at the centre of Roman affairs, had shown himself their protector and friend. But now, as Augustus aged and the power of Tiberius waxed, the plebs were gripped by a new mood of unease. Troubles came not as single spies, but in battalions. News of revolts and barbarian raids arrived from distant frontiers. Sardinia was briefly lost to pirates. Money to fund the military budget began to run out, and Augustus, in a desperate attempt to plug the gap, was reduced to introducing the first direct tax on Rome's citizens for over a century and a half. Meanwhile, the great programme of urban regeneration, which had provided work for so many, was grinding to a halt. A plague broke out. Misery filled the crowded slums, and the pits of the *carnarium*, dumping grounds for carcasses and every kind of refuse, were kept open day and night. Then fires swept through the city, so devastating that they completely overwhelmed the ability of the local authorities to combat them, and the Princeps was left with no choice but to fund a new and centralised service. The *Vigiles*, crack squads of firefighters, were paramilitary in purpose as well as organisation, for they were mandated to police the streets as well as to put out conflagrations. That Rome was in an ominously combustible mood was all too clear to Augustus. Worse than plague, worse than fire, was the return to the city of a menace that had last gripped it back in the darkest days of the Triumvirate: famine. As a young man, Augustus had been cornered by a starving mob and almost torn to pieces. He knew what it was to look into the eyes of the hunger-stricken. Now, informed that the granaries were almost empty, he made sure to let everyone know that he was contemplating suicide.

There were plenty, it seemed, who wished he would act on his threat. Even though the grain shortage was ultimately mastered, the mood of crisis was not. Some were daring to think the unthinkable. The great fire, it was reported, had originated in different places across the city, 'but all on the same day',[63] a clear sign of arson. Then,

at the height of the famine, fly-posters had appeared on buildings across Rome, openly calling for the Princeps to be toppled. Attempts by his agents to trace their source had failed. No single man, they concluded, 'could possibly have planned or initiated such a manifestation'.[64] To the Princeps himself, though, the protests appeared anything but spontaneous. He sniffed conspiracy. Already, in the same year that he adopted Tiberius, he had uncovered a plot against his life by Pompey's grandson. On that occasion, revealing through an imperious display of mercy the full force of his contempt, he had taken the conspirator to one side, given him a tongue-lashing, and then graciously permitted him to serve as consul. Such mercy could easily be afforded. A nobleman, even one with the blood of Pompey the Great flowing in his veins, presented no plausible threat. His peers, although brought to tolerate the supremacy of the August Family, would never permit one of their own to emerge as Princeps.

But what of conspiracy from within the August Family itself? That, Augustus knew, was where the surest menace lurked. Battered by fiscal crisis, struggling to combat the miseries that repeatedly swept Rome, grown neurotic and sour with age, he had no patience with family sentiment. When evidence was uncovered implicating Agrippa Postumus in sedition, the Princeps spared the nobleman involved in the plot but crushed his own grandson. Agrippa was formally disinherited, exiled from Rome, and then banished to a remote island off Corsica named Planasia. Here he was placed under a close military guard. His property was transferred to the military treasury. All mentions of him as a member of the August Family promptly ceased: he became a non-person.* Augustus himself never spoke of his youngest grandson again, except to refer to him and his mother Julia as two ulcers, two boils.

* Take, for instance, an arch built at Ticinum in northern Italy (modern Pavia) in AD 7 or 8, which celebrated the August Family with ten statues – including the dead Gaius and Lucius. Their younger brother was notable only by his absence.

And soon a third would erupt. In AD 8, a decade after Julia's ruin, news broke of an eerily similar scandal. Her daughter and namesake, already notorious for the raciness of her lifestyle and her taste in dwarves, was found guilty of adultery. A third member of the August Family was exiled to a barren island. Yet as with the elder Julia, so with the younger. Amid the swirl of innuendo, the gossip of sexual misdemeanours, there were whispers of vastly more serious offences. Rumours, garbled and contradictory though they often were, hinted at an attempted coup. There had been a plot, it was said, to spring the elder Julia and Agrippa Postumus from exile. Whole armies had been primed to expect them. Augustus, meanwhile, was to have been assassinated in the Senate House. Quite how accurate the various details of this conspiracy were, let alone how they might have fitted together, was impossible to clarify. Nevertheless, as workmen moved in to demolish the palatial complex of the younger Julia's house, and guards waited to put to death the baby with which she was pregnant, it was clear that the charge of adultery veiled as much as it revealed. It was telling, for instance, that Julia's husband, supposedly the injured party, should have been put to death as a criminal.[65] Nor, perhaps, was it entirely a coincidence that another man too, someone long celebrated for his tweaking of the Princeps's tail, should have been dealt a blow almost as devastating. Julia was not alone, that fateful year of AD 8, in being delivered a sentence of exile.[66]

Calamity caught up with Ovid on the island of Elba. Planasia, where the wretched Agrippa Postumus languished under armed guard, could be seen from where the poet was staying as a blue smudge on the horizon; a grim reminder of Augustus's vengeful anger. Not that Ovid needed much reminding. He was already up to his neck in trouble. When a ship arrived from the mainland, the news it brought was so grim that it reduced him to tears. Havering initially between confession and denial, he finally broke down,

and revealed all to the friend with whom he was staying. The wrath of the Princeps, which Ovid had long been courting, had finally caught up with him. His guide to seduction, in which he had advised women how to cheat behind the backs of their men, and paid ironic tribute to the dead Gaius as a favourite of the gods, was still being read by the trendsetters, still provoking smiles of amusement among the fast set: a feat of lèse-majesté for which the author, it appeared, was now at last to be made to answer. But there was worse. What exactly it was that Ovid had done, what the 'mistake'[67] that now threatened him with ruin, he would never publicly state; but he would go on to offer certain clues. His fault had been one that it was perilous to mention in public. He had seen something that he should not have done, 'a deadly outrage'.[68] Whatever it was that he had witnessed, it had served to bring down on his head 'the richly merited wrath of Caesar'.[69] In the tense and scandal-racked context of that fateful year, there was only one episode sufficient to explain such terrible fury. Whether by accident or as the result of his own imprudence, Ovid had clearly found himself sucked into the slipstream of Rome's most lethal rivalry: the struggle between Julians and Claudians for the rule of the world.[70]

When Ovid boarded ship from Elba and bade his host farewell, it was the last time the two friends would ever see each other. That December, 'shivering with the bitter cold', the poet took another ship, 'out into the waters of the Adriatic'.[71] Not for him, though, the short voyage to some island off the coast of Italy. Augustus, who had interviewed the desperate and repentant poet personally before settling his fate, had chosen for him a very different destination. For Ovid, that most urbane, most fashionable of men, the place nominated to serve as his prison could not have been more terrible.

He was bound for the ends of the earth.

Heart of Darkness

'Nothing lies beyond it except for cold, and hostile peoples, and the frozen waves of an ice-bound sea.'[72]

Ovid was appalled to find himself in Tomis. It was very much not his kind of town. Planted centuries earlier by Greek colonists on the bleak and gale-lashed coast of the Black Sea, it stood on the outermost limits of Roman power. Even though Ovid was exaggerating grotesquely when he complained that Tomis was one perpetual winter, the reality of its balmy summers did little to ease his mood of depression.* It was hard to imagine a town less like Rome. The water was brackish. The food was appalling. No one spoke Latin, and even the Greek spoken by the Tomitans struck Ovid as halfway to gibberish. Surrounded as he was by treeless desolation, the pleasures of the world's capital shimmered in his memory like hallucinations. 'Here,' he reflected mournfully, 'it is I who am the barbarian.'[73]

To Ovid, a man as fashionable as anyone in Rome, it came as a shock to live among provincials who did not even realise that they were provincial. Within the low, crumbling fortifications of Tomis, there was no one to share with him his anguished homesickness for metropolitan chic. Beyond its walls, things were even more savage. The Danube, which lay some seventy miles to the north, featured on the maps of Caesar and his strategists as an immense natural frontier, a wide-flowing impediment to the brutes who lurked beyond it; but on the ground things were alarmingly different. During winter, when even the sea beyond the delta might turn to ice, the river would freeze solid; and then, mounted on swift ponies, their beards white with frost, barbarians from the savage wastes beyond the Danube would appear, predacious and unsparing. Plumes of smoke wisping above the sunless horizon would mark villages put to the

* The city of Constanta, as Tomis is now known, is today one of Romania's most popular beach resorts.

torch, bodies left twisted by poisoned arrows, the survivors tethered and driven off with their belongings. In his nightmares, Ovid would imagine himself dodging missiles or else shackled in a coffle, and wake to find the rooftops bristling with a stubble of arrows. Looking out at the warbands as they circled the walls of Tomis, he would feel himself penned inside a sheepfold. Rome seemed not merely distant, but impotent. 'For all her beauties, the vast majority of mankind barely registers her existence.' It was, for a man as devoted to the metropolis as Ovid, a devastating discovery to make. 'They do not fear the armed might of the Romans.'[74]

But there was even greater cause for anxiety. When Ovid looked at the Tomitans, he saw a people barely distinguishable from the barbarians at their gates. The men wore sheepskin trousers and were unspeakably hairy; the women carried water-pots on their heads. No one in Rome had lived like this for centuries. Back amid the gilded sophistication of his former life, Ovid had laughed at the nostalgia of the Princeps for the days of Romulus, and dismissed the first Romans as murderers, rapists, brutes. Now, transplanted to the ends of the earth, it was as though he had been exiled to the distant past as well. On the frontier between civilisation and barbarism, Ovid found himself in a realm where men seemed halfway to beasts – or worse. They were, he complained, 'more savage than wolves'.[75] Stranded on the margins of Roman power, he could gaze into the darkness that stretched far beyond it and feel its immensity, its potency, its colossal disdain for everything that he was. No wonder, marking the degenerate Greek spoken by his fellow townsmen, he began to fret that he might be losing his Latin. A potential for barbarism lurked within Romans too. The founder of their city, after all, had sucked on the teat of a wolf. Once, where now fountains burbled and porticoes offered shade to men of fashion, people had 'lived like beasts'.[76] Rome too, Ovid knew, had been one of the dark places of the world.

Perhaps, though, it was only out on the margins of civilisation, far

from the fleshpots of the capital, that a man could properly appre-
ciate just how far the Roman people had come since those distant
days – and what the qualities were that had made possible their rise
to greatness. Ovid, exiled to 'a frontier zone just recently and precar-
iously brought under the rule of law',[77] was having his metrosexual
nose rubbed by the Princeps in a brutal fact. There could be no arts
of peace without a mastery of war. It was not, in the final reckoning,
good drains or gleaming temples, let alone a taste for poetry, that dis-
tinguished a civilised man from a savage, but steel: the steel it took to
stand shield to shield in a line of battle, and then advance. Wolf-bred
though a Roman was, his proficiency at inflicting slaughter was not
that of a wild beast. Training, rigid and relentless, had forged him into
a single link in a mighty chain. A soldier was not permitted to marry:
his comrades were all he had. A legion was less a pack of animals
than it was a killing machine. Soldiers worshipped Mars as *Gradivus* –
the god who gave them the courage to advance, step by measured
step, obedient to the blasts of the war-trumpet, no matter what the
danger. Against their relentless, heavy tread, there was little prospect
of victory. Even the wildest, most bloodthirsty warband, when it
charged a legion, was liable to break in the end. Unlike the savages
from across the Danube, 'always descending like birds when least
expected',[78] a Roman army was schooled in endurance. Its soldiers
had been trained, no matter what, to eviscerate a foe, advance, and
then, covered in blood, to eviscerate again. Had they not been, then
their aptitude for inflicting slaughter on those who dared to oppose
them would never have become so potent. 'It is discipline, strict mil-
itary discipline, that is the surest guardian of Roman power.'[79]

Everything followed from this: the refusal to buckle in the face
of setbacks; the dogged pursuit of victory, no matter how seemingly
insuperable the odds; the patience to persevere in the face of repeated
reversals and revolts. The Balkans, rather than the desolation of
untamed menace that Ovid imagined them to be, were in fact, by

the time of his arrival in Tomis, almost tamed for good. The process had been long and gruelling. Many years had passed since the future Augustus, eager for martial glory, had proclaimed the pacification of Illyria, and Crassus, a decade later, routed the Bastarnians. The greatest feats of all had been achieved by Tiberius, who in the years before his retirement to Rhodes had subdued what is now Hungary, a savage region infested by wild boars and even wilder tribesmen. The Pannonians, as they were called, were to prove themselves inveterately rebellious. Sporadic bushfires of revolt had combined, in AD 6, into a single terrifying conflagration. Merchants had been slaughtered, isolated detachments wiped out, Macedonia invaded. In the face of this devastating insurgency, even the Princeps had panicked. Unless urgent steps were taken, he had warned the Senate in hysterical tones, the Pannonians would be at the gates of the city in ten days. Fortunately, back from Rhodes, Rome's best general had once again been his to command. Tiberius, patient and relentless, was ideally suited to the crushing of guerillas. As attentive to the welfare of his own men as he was to the risks of ambush, he had blocked his ears to the shrill demands from the capital for immediate results. Slow and steady did it. 'The safest course, in the opinion of Tiberius, was the best.'[80] Week by week, month by month, he had broken the Pannonians. Their surrender had finally come in AD 8, a mass prostration before the victorious general on a river bank. The following year, even as Ovid was gawping in alarm at his first sight of barbarians, fire and slaughter were being visited upon the final, mountainous strongholds of rebellion in the Balkans. After the young Germanicus, entrusted with his first command, had proved himself as ineffectual as he was dashing, Tiberius moved in to deliver the *coup de grâce*. The pacification was complete at last. A vast block of territory, stretching from the Black Sea to the Adriatic and from Macedonia to the Danube, had been secured for good. Tiberius richly merited the gratitude of the Princeps and the approbation of his fellow citizens.

'Victory, her wings beating as ever above Rome's great general, had wreathed his bright hair with laurel.'[81]

But there remained work to be done. Ovid was not alone in marking how barbarians beyond the Danube were perfectly capable of negotiating the immense flow of its waters. Even the most formidable of natural boundaries could be crossed. The implications, for those tasked with securing the frontier, were tantalising as well as troubling. It remained the proud boast of the Roman people that their conquests were never made for conquest's sake. Their wars were fought, not out of avarice or blood lust, but rather to safeguard their city's honour and the interests of their allies. They had subdued the world, in effect, in self-defence. This was why, in the opinion of Roman statesmen, 'our global dominion may more properly be termed a protectorate'.[82] Would the heavens otherwise have permitted it to come about? Merely to ask the question was to answer it, of course. Clearly, then, it was for the world's own good that it be placed, to its outermost limits, under the tutelage of Rome. The long and glorious age of peace presided over by Augustus rested, in his own proud words, on 'the subjection of the entire globe to the rule of the Roman people'.[83] In practice, of course, as all those peering across the Danube were well aware, the subjection of the globe still had a way to run. Yet that it would come, and to the benefit of those conquered as well as of the conquerors themselves, was a conviction the Roman elite increasingly took for granted. The promptings of ambition and responsibility alike, not to mention obedience to the self-evident will of the gods, urged continued expansion. At stake was the ultimate in prizes: 'empire without limit'.[84]

What this meant in practical terms could best be seen beyond the currents of a river almost as broad and formidable as the Danube itself: the Rhine. When Augustus, looking to win the favour of the war god, had planted a temple of Mars on its western bank, he had dedicated to the shrine, in a formidable statement of intent, the

sword of Julius Caesar. The conquest of Gaul, which had success-
fully drained for good a great sump of pestiferous barbarism, was
the obvious model to follow. Caesar himself, in pacifying the west-
ern reaches of the Rhine, had recognised that he could not afford to
leave the eastern bank to its own devices. Twice he had bridged the
river; twice he had delivered to the Germans who lurked beyond
it a punitive demonstration of Roman might.* Decades on, it
remained as pressing a task as ever to whip the various tribes beyond
the border into line. Gaul could not be policed adequately, still less
fattened up into the cash-cow it otherwise promised to become,
with savages forever breaking in from across the Rhine. This had
been embarrassingly brought home in 17 BC, when Marcus Lollius,
the future guardian of Gaius, had accidentally run into a German
warband, suffering the loss of an eagle. Depending on who reported
it, this defeat had ranked as either a fleeting discomfiture, speed-
ily rectified by Lollius himself, or else a crippling blow to Roman
prestige, almost on a par with the defeat of Crassus. Whatever the
truth of the incident, it had decided the Princeps, ever cautious,
ever decisive, to adopt an altogether more proactive response to
the problem of the Germans. Travelling north of the Alps, he had
personally set in train a momentous series of policies. The better
to tax it, Gaul had been subjected to an intrusive census. A mint,
guarded by an elite squad of a thousand paramilitaries, had been set
up in the recently founded colony of Lugdunum – the future Lyon.
Gold and silver, coined in prodigious quantities, loaded into wagons
and transported northwards along an ever-expanding network of
roads, had given a prodigiously muscular heft to the Roman pres-
ence in the West. Spasms of resentment in Gaul had been brutally
stilled; a chain of six legionary fortresses built along the line of the
Rhine; licence given by Augustus to cross the river and embark on

* There is no evidence that the 'Germans' had any notion of themselves as a distinct
group of tribes, or thought of the lands east of the Rhine as a place called 'Germania'.

the pacification of Germany itself. A feat as great and terrible as any in the history of Roman arms now beckoned: the winning for civilisation of the outermost limits of the world.

'It takes courage to advance into a forbidden realm of shadow.'[85] When Drusus, on his final campaign, had found himself hundreds of miles east of the Rhine, on the banks of a second mighty natural barrier, a river named the Elbe, a spectre in the form of a colossal woman had materialised before him and forbidden him to cross it. That the lands of the north were the haunt of phantoms and hideous monsters came as no surprise. In the gloomy forests which covered vast reaches of Germany, giant bull-like creatures roamed, and mysterious entities named elks, without ankles or knees; in the icy waters of the Ocean, which would retreat and then advance twice a day, tearing loose oak trees and engulfing entire plains beneath their flood-tides, there shimmered 'the outline of enigmatic beings – half-men, half-beast'.[86] Just as Ovid, peering askance at the Tomitans, had fingered them as lycanthropes, so in the savage reaches of Germany were the borders between animal and human even more unsettlingly blurred. Chieftains who wished for a policy briefing, it was reported by Roman scholars who had made a close study of German customs, were likeliest to consult a horse. Conversely, 'the towering stature of the Germans, their fierce blue eyes and reddish hair',[87] spoke of a nature barely less bestial than that of some steel-clawed bear, padding over mountain slopes. Geography could not be bucked. Their bogs and trees shrouded in a perpetual drizzle, Germans were the spawn of their environment. The gods, who had considerately endowed Rome with a climate ideally suited to the growth of a mighty city, had doomed the inhabitants of the chilly North to a backwardness that was at once torpid and ferocious, dull and intemperate. Landscape, weather, people: Germany was unredeemably savage.

Or was it? Much the same, after all, could once have been said of

the Gauls. Bad memories of them in Rome ran very deep. Back in 390 BC, a Gallic horde had erupted into Italy, annihilated six whole legions and sacked the city itself. Only with the conquests won by Augustus's deified father had Gaul finally ceased to be a place of dread. Now, fifty years on, great changes were afoot beyond the Alps. Roman rule had brought to a people once notorious for their trousers and their gravy-soaked moustaches, their drunken brawling and their taste for collecting heads, a very different way of life. The grandsons of chieftains who had hurled themselves half-naked against the invading legions now draped themselves in the toga and rejoiced in the name of 'Julius'. Rather than guzzle wines indiscriminately, they were coming to develop a nose for the classiest Italian and Eastern *grands crus* – and even, remarkably, to plant the odd vineyard themselves. Most promisingly of all, dotted across a landscape that had previously boasted only villages and rough stockades perched on hills, cities were starting to appear: islands of civilisation complete with flashy monuments and street-grids. Augustus, who had brought the fruits of peace to his fellow citizens, had brought them to the Gauls as well. Foundation after foundation duly proclaimed its gratitude: Augustodurum and Augustomagus, Augustobona and – just to vary things – Caesarobona. The most spectacular of all the Gallic monuments to the Princeps had been raised by Drusus in Lugdunum, where an altar to Rome and Augustus, complete with a double ramp and two giant winged statues of Victory, had been inaugurated in 12 BC.[88] It provided, on neutral ground, and in a city that served as the hub of the provincial road system, a focus of loyalty for the whole of Gaul. Noblemen from more than sixty different tribes had flocked to its opening. As its first high priest, a man had been elected whose name, Gaius Julius Vercondaridubnus, perfectly expressed in its fusion of the native with the Roman the emerging *mestizo* order. Something startling had begun to glimmer: a future in which the Gauls, perhaps, would no longer rank as barbarians at all.

Children of the wolf: Romulus, the founder of Rome, and his twin brother Remus are suckled in the 'Lupercal', a cave on the side of the Palatine Hill. The River Tiber reclines on his elbow beside them. (Wikipedia)

The murderers of Julius Caesar flee the scene of his assassination, as imagined by Jean Léon Gérome in 1859. (© Walters Art Museum, Baltimore, USA / Bridgeman Images)

Livia Drusilla. Beautiful, clever and fabulously well-connected, she would end up garlanded with honours unprecedented for a Roman woman.

(Photo: Tom Holland)

Caesar Son Of A God rests his foot on the globe.

(© bpk / Münzkabinett, Staatliche Museen zu Berlin)

Marcus Vipsanius Agrippa: a supreme *consigliere*.

(© Marie-Lan Nguyen / Wikimedia Commons)

Romulus carries armour stripped from an enemy king: the 'spoils of honour'. He was the first of a tiny number of Roman commanders to kill his opposite number in single combat. The painting is from the outside of a shop in Pompeii, but portrays a statue commissioned by Augustus, and placed in the Temple of Mars the Avenger.

Augustus as *Pontifex Maximus*, pious and austere in his service of the gods.

The Temple of Mars the Avenger, dedicated by Augustus on 12 May 3 BC, many decades after he had first vowed it to the god. (Illustration by Gareth Blayney)

Rome was a city in which the phallus was omnipresent. The penis of a Roman was expected to be as masterful as it was potent. (The Art Archive / Mondadori Portfolio/Electa)

The August Family as Augustus wished it to be seen. Agrippa, toga over his head, stands on the far left; the woman next to him (although it is just possible she might be Livia) is almost certainly Julia, his wife. The two boys are Gaius and Lucius: simultaneously the grandsons and the adopted sons of Augustus. (De Agostini Picture Library / G. Dagli Orti / Bridgeman Images)

Tiberius and his mother.
(Photo: Tom Holland)

Marsyas, a satyr believed by the Greeks to have been flayed alive, was believed by the Italians to have made a narrow escape, and fled to Italy. A statue of him in the Forum served the Roman people as a venerable symbol of liberty. (De Agostini Picture Library/Getty Images)

An altar raised at the crossroads of the Vicus Sandalarius. Gaius stands flanked by Augustus and Livia. (The Art Archive / Museo della Civilta Romana Rome / Gianni Dagli Orti)

Into the woods. The heights above the slaughter-ground which wiped out P. Quinctilius Varus, governor of Germany, and three entire legions. (Photo: Tom Holland)

A Roman cavalry mask, found on the site of the battle of the Teutoburg Pass. (Photo: Jamie Muir)

Augustus Caesar triumphant. A woman symbolising the civilised world crowns him with a wreath of oak leaves, while below him barbarians grovel as a victory trophy is raised. (© Ullsteinbild / Topfoto)

On his death bed, Augustus is said to have asked whether he had played his part well in the comedy of life. Even as an old man, he kept up his front. (Photo: Tom Holland)

Figs: reputedly, Augustus's favourite food. (Photo: Sophie Hay)

Pianosa, the small island off the west coast of Italy to which Agrippa Postumus was exiled. It was one of a number of islands used by Augustus and his successors as prisons for disgraced members of the dynasty. (Agefotostock TIP-MO232601)

'Enslaved as they have been, and living as their captors instruct them to live, they are all of them now at peace.'[89]

And if the Gauls, why not the Germans? Admittedly, it was taken for granted by the Roman high command that the further from civilisation they advanced, the wilder and more obdurate their opponents were bound to become; but the two and a half decades of their campaigning beyond the Rhine gave them good grounds for hope. The priority, of course, had been the same as it ever was with barbarians: to demonstrate that resistance was futile. Season after season, columns of legionaries had duly tramped eastwards out of their winter quarters. Most of the German tribes, confronted by the steel-lined scale and sophistication of Roman military operations, had ended up offering churlish submission. One of them, the most ferocious of all, had even donated to Augustus as a token of their friendship the most precious object in their possession, a great bronze cauldron consecrated by the blood spilled into it from the slit throats of their prisoners. Any opposition, it went without saying, had been dealt with in brisk and imperious fashion. Tiberius, confronted by one of the tribes who had presumed to steal Lollius's eagle, had coolly rounded up all 40,000 of its members and dumped them on the far side of the Rhine. Deportations, though, had been the least of it. Massacres and mass enslavement had repeatedly served to rub German noses in the brute fact of Roman power. The very landscape had come to bear the invaders' stamp. Canals had been scored across the watery flatlands; roads cleared through the forests; pontoons laid out over bogs. Even the mighty Elbe, for all that it had stood proof against the ambitions of Drusus, had been vanquished in the end. No phantom women had appeared when, almost a decade on, another Roman army had arrived on its banks. At its head there had ridden a nobleman by the name of Lucius Domitius Ahenobarbus, or 'Bronze Beard': a legate who more than compensated for the notorious quality of his cruelty and arrogance by being married to

Antonia, the elder of the Princeps's two nieces. He had crossed over the Elbe – a momentous achievement. The river, according to the most up-to-date calculations of the best cartographers, was believed to be almost as close to China as it was to the Atlantic. By compelling the tribes on its far bank to acknowledge Roman authority, Aheno-barbus had brought the giddy dream of global rule that much closer to fulfilment. With the Germans pacified for good, who would there be to stop Rome's onward march to the eastern Ocean?

It had taken the Princeps's deified father ten years to bring Gaul to heel; and his own armies, by AD 9, had been operating in Germany for more than double that time. Ahenobarbus, before departing the Elbe for the security of his winter quarters, had erected on its far bank an altar to Augustus. It was the second such monument he had established during his term of office. The first, planted at the opposite end of Germany, stood on the western bank of the Rhine, in the lands of a tribe, the Ubians, who had been firm allies of Rome since the time of Julius Caesar. The twin altars, framing as they did the vast expanses in between, served as potent symbols of Augustus's gathering confidence that what had for so long been a war zone was ready at last to be settled as a province. The prize was a rich one – pot-entially much richer than had first been thought. Germany, it turned out, offered more than merely swamps and forests. There were rich agricultural lands as well, and supplies of iron, and fine-quality goose-down, and a curious concoction fashioned out of goat lard and ashes named 'soap'. Already, since its introduction to Rome, high society had come to swear by it. In a city that had always valued blondes, this was perhaps only to be expected. Used in the right proportions, the miraculous product could give a hint of gold to even the dullest locks. Fashion victims, it was true, had to be careful not to go over-board: excessive application had been known, on a few calamitous occasions, to result in women going bald. Here too, though, it was a German export that provided the remedy. Ovid, in the happy days

before his exile, had exulted in the boost given by the conquest of Germany to the potential sex appeal of his girlfriends. 'Send for the tresses of German prisoners,' the poet had advised one lover after an unfortunate accident with hair dye. 'You'll look splendid, adorned in the tribute shorn off all those victims of our triumphs.'[90]

Nevertheless, prized though auburn wigs were, the real wealth of Germany was to be found, not in the hair of its women, but in the sword-arms of its men. Like a wild beast tamed to human purposes, a barbarian brought to acknowledge Roman superiority could, with careful handling, be trained in the requirements of military discipline. Combine these with his own native muscle and ferocity, and the result could hardly fail to be impressive. Just how impressive, indeed, was evident from the patronage of Augustus himself. The Princeps, who could have recruited warriors from any corner of the world to serve him as his bodyguards, had opted for Germans. Nostalgia for the simple days of Romulus had doubtless predisposed him to recognise in these hairy primitives certain welcome virtues. Savages they might be – but they were noble savages. Lacking the benefits of civilisation, they also lacked its degeneracies. 'No one in Germany finds vice a laughing matter.'[91] There, it was reliably reported, adultery in a woman was punished by shaving her bald, stripping her naked and whipping her the length of her village. Instincts as robust as these, if they could only be put to the service of Rome, promised much benefit.

The Ubians, with their long track-record of loyalty, had been serving alongside the legions since the time of Julius Caesar; but the widening of operations eastwards had required the enrolment of auxiliaries from tribes across Germany. One of these, a people named the Batavians, warriors of exceptional prowess who inhabited the watery flatlands where the Rhine met with the Ocean, had been signed up wholesale. Other tribes, less amenable to Roman blandishments, were subject to more targeted recruitment. When Tiberius, shortly

before his posting to Pannonia, had followed in his brother's footsteps by leading an amphibious expedition to the Elbe, he had made sure to woo the elites in his path with honours, grants of citizenship and glamorous commands. The results, amid the traumatic convulsions of the revolt in Pannonia, had stood Rome in good stead. In the Balkans, German contingents had served Tiberius loyally and well. Meanwhile, in Germany itself, the tribes had remained at peace. No attempt had been made to capitalise upon Rome's distraction. The Princeps's instincts appeared proven correct. Germany had been won for civilisation. It was ready to be given laws, a census, taxes: to become a province.

In AD 9, even as Tiberius was visiting fire and death upon the Balkans, travellers to the northern frontier would have found a very different scene. The Rhine was less a frontier than a highway. The markers of Rome's military presence were, of course, everywhere to be seen: sprawling legionary bases, supply depots, ships loaded with battle-engines churning up the river. Not all the traffic, though, was military. Boats carried grain as well as troops, barrels of wine as well as horses. Though most of this produce was destined for the mess-halls of the some 60,000 soldiers who constituted the occupation force, by no means all of it was. As in Gaul, so in Germany: the provincial authorities were eager to give the natives a taste of Roman living. In the territory of the Ubians, the altar to Augustus erected by Ahenobarbus was already coming to provide an equivalent to Lugdunum, a cult centre and capital rolled into one. Patches of concrete were starting to dot the river bank. Even beyond the Rhine, in the dreary expanses where men thought nothing of sporting topknots and tight trousers, and women draped themselves in low-cut animal skins, it was no longer all wattle-and-daub. The odd refuge from barbarism was being painstakingly developed. Fifty miles and more east of the Rhine, it was now possible for travellers to enjoy a taste of the urban: raw, half-built settlements, it was true, but endowed with water pipes,

and apartment blocks, and statues of Augustus.* Clearly, if a stone forum could be built amid the wilds of Germany, then it could be built anywhere. The future looked bright indeed. 'With cities being founded, and the barbarians adapting to a whole new way of living, they were on their way to becoming Roman.'[92]

Naturally, some regions remained more secure than others. For twenty years now, ever since the time of Drusus, the surest road taken by the legions into the heart of Germany had been along the course of a river named the Lippe. Flowing westwards as it did into the Rhine, its waters provided Roman shipping with ready access to the vitals of barbarian territory. The same bristling array of camps and supply depots that marked the frontier with Gaul now lined the Lippe. No longer, though, for the occupying forces, was the advance along its banks necessarily a march into a heart of darkness. The provincial authorities could now rely on sympathisers within the tribes themselves to assist in the ongoing project of pacification. North of the Lippe, for instance, strategically placed midway between the Rhine and the Elbe, were the lands of a people named the Cherusci. Fractious though they had proven in the early years of Roman engagement in Germany, Tiberius had since brought them decisively to heel. Their chiefs, like many others, had been wooed and recruited as auxiliaries. Service alongside the legions had provided them with an immersive crash-course in Roman military culture. Typical was a young chieftain named Arminius, who had returned home to his tribal homeland fluent in Latin and garlanded with honours. Not merely a Roman citizen, he now ranked as an equestrian. 'Battle-hardened, quick-witted, and with an intelligence well in advance of the normal barbarian',[93] he was ideally qualified to serve the provincial authorities as their eyes and ears in the tribal

* The key find which has served to demonstrate the scale and ambition of Roman urbanism east of the Rhine was made in the late 1990s, at Waldgirmes, some sixty miles beyond the river, in the state of Hesse.

heartlands. Arminius had been schooled in the *modus operandi* of the legions. He knew how their commanders thought. He understood their ambition to tighten Rome's grip on those zones where her writ as yet ran only feebly. Accordingly, when he brought news to the provincial authorities that a revolt was brewing in the northern reaches of Germany, where the legions had only sporadically penetrated, he received a ready hearing. Rebellions were best nipped in the bud. Though summer was already fading, it did not take long for three of the five legions stationed in Germany to be commissioned with crushing the insurgency. Off the legionaries duly set. Heading out along trackways long since cleared by military engineers, there was nothing at first to obstruct the task force, no one to block its passage. Viewed from a distance, it would have seemed less a column of men, horses and wagons than some monstrous and predatory beast. Like a serpent it snaked and glittered, but the very earth shook with its passage.

In command rode the man who had issued the legions with their marching orders. Publius Quinctilius Varus, Augustus's legate in the region, was a man experienced in stamping out bushfires. A decade earlier, when faced, as governor of Syria, with a series of Jewish uprisings, he had proved more than equal to the challenge. It was not his capabilities as a general, though, that had principally recommended him to the Princeps. Augustus, ever careful to whom he gave the command of five legions, trusted Varus as his own creature: a man who had been married to one of Agrippa's daughters, and then to his own great-niece. Such a consideration would have counted for nothing, though, had Varus not also demonstrated throughout his career impressive competence in the various duties expected of a provincial governor: the provision of internal security; the administration of justice; the screwing of the natives for taxes. These, in Augustus's opinion, were precisely the talents that the semi-formed province beyond the Rhine now urgently demanded. After decades in which

Roman leaders had only ever shown themselves to the Germans at the head of an army, Varus had begun to offer them a glimpse of something else. Peace, after all, had its own awesome aspects. The toga, the lictors, the *fasces*: these too, when it came to persuading barbarians to pay Roman taxes and to obey Roman laws, had their roles to play. Yes, Varus would not hesitate to apply devastating military force when necessary; but it was his intention, now that Germany was conquered, to win the peace as well as the war.

Passing through the lands of the Cherusci, the governor could feel reassured that his strategy was the correct one. As a general at the head of some 18,000 troops, he presented his hosts with the same show of martial invincibility that Germans everywhere had learned to dread; but as the legate of Augustus, he was simultaneously the face of Roman peace and order. Ties of mutual advantage had come to bind both provincial administrators and German warlords; if Varus had any cause to doubt this, he had only to look at his own retinue. There, riding with his auxiliaries, ever ready with advice, giving it in fluent Latin, was Arminius, prince of the Cherusci and Roman equestrian. As Varus and his legions headed further north, into regions where Rome's military engineers had rarely ventured, the guidance of a man familiar with such uncertain paths as did exist through the forests and marshes was invaluable. When Arminius offered to scout ahead of the column's vanguard, to check for ambushes and to clear the way, Varus naturally accepted. Who better than one of their compatriots, after all, to catch the insurgents napping?

Arminius, though, did not come back. Nor did any of the other detachments that Varus had sent out. The seeming explanation was not long in coming. Labouring through thick forest, preoccupied with felling trees and bridging ravines, the long and straggling Roman column was surprised by a sudden rattling of spears. From the deepest shadows they came; and as rain began to fall, turning the mountainside to mud and thickening the gloom, so the pattering of

iron javelin-heads turned to a hail. The legionaries, prevented by the terrain from taking up their customary battle formations, had no choice but to toil on through the darkness of the forest, stumbling over the grasping roots and the corpses of their fallen comrades, until at last they reached a spot sufficiently open to serve them as a camp. Here, as the soldiers hurried to raise earthen palisades, and rain steamed and hissed into their watchfires, Varus was able to take stock. His situation was less than perfect, but hardly critical. Ambushes had always been an occupational hazard of campaigning beyond the Rhine. Even Drusus had suffered a few. The key, when pinned down in a hostile landscape, was to travel light and play things safe. Accordingly, Varus gave orders for the wagons in his train to be burned, the better to expedite an about-turn to the security of Rome's militarised zone. With awkward terrain both to the north and south of him, the route that he settled on was the obvious, indeed the only one. Skirting dense forest and mountains, it would take him and his legions through what was marked on Roman charts as '*Teutoburgiensis Saltus*' – the Teutoburg Pass.[*]

Accordingly, the next day, the long column of soldiers wound like a waking serpent out of its night camp, and headed into open country. To the left of the Romans rose oak-covered hills; to their right, a lush expanse of meadows and marshland, dotted with abandoned farmsteads and bright with the wildflowers of late summer. Nervous muleteers, ripping up handfuls of grass, began stuffing them into the bells slung around the necks of pack-animals, anxious to muffle the clappers. A wise precaution. Attacks were still coming whenever the woods along the path thickened. Varus, though, scorned to pursue his assailants. The barbarians, spectral troops

[*] *Saltus* in Latin can mean both 'pass' and 'forest'. Tacitus's use of the word to describe the site of the battle has traditionally been translated as 'forest'; but the definitive identification of the battle-site with the foot of the Kalkriese Berg in southern Saxony, first made in the 1990s, now enables the correct translation to be made.

emerging from out of the trees to hurl their weapons before receding and vanishing again, could hinder but not halt the column's advance. After three days of running battles, the legionaries had only been confirmed in their deep contempt for the German way of war. Weary and grimed with blood though they were, and despite the trail of corpses in their wake, they knew that in all the qualities required of a soldier, whether training, equipment or discipline, they still ranked as infinitely the superior. No wonder that the insurgents, lacking as they did even rudimentary armour, and armed only with weapons of crudely forged iron, refused to stand and fight. Instead, like insects bred of some undrained bog, they swarmed, and buzzed, and bit.

The third day of marching, and the marshes to the right of the legions, as though in mockery of the pestilential quality of their adversaries, were starting to darken and spread. Meanwhile, to their left, the forests on the hills were getting thicker. The wilds of Germany had never seemed so savage – nor the security of the militarised zone, with its camps, its hot baths, and its paved roads leading to the outside world, more enticing. On the legions tramped.

It began to rain. Ahead, grey and dim through the drizzle, loomed a forested spur jutting out from the line of the hills. Rather than attempt to clamber directly across it, the legionaries swung northwards, following its curve. As they did so, they found the bogs closing in on them. Streams scored the pathway, and the mud began to deepen into mire. Splashing and slipping, the legionaries stumbled on. Only at the very edge of the marshes was there anything like firm footing to be found – but it was impossible even for the most professional of soldiers to keep to the trackway, narrow and irregular as it was, and retain their coherence as a column. As a result, the further the legions advanced along the base of the hill, the more they began to lose order. Still worse, though, was to come. The column, even as it began to disintegrate, was being funnelled along its left flank, not by the natural contours of the hill, but by walls built of

strips of turf, and topped with a palisade. Had any of the legionaries paused amid the driving rain and the chaos of the advance to study these impediments, then they would have recognised something startling about their design: that it bore the unmistakable stamp of their own construction methods. What were the walls doing there – and why would anyone trained in Roman warcraft have wanted to build them along the margins of a barbarian swamp? Perhaps, the obvious, the only answer had begun to dawn on some even before the harsh, reverberating war-cry for which the Germans were notorious abruptly sounded above the drumming of the rain; before spears in a deadly hail began to shred the length of Varus's line; before the slaughter became general. But by then, of course, it was too late.

The ambush was total. To the legionaries, it was as though monsters bred of the forest's own stock and stone were emerging from behind their ramparts to attack them, howling in barbarous tongues, thousands upon thousands, a horde vast beyond anything that a single tribe could possibly have mustered. No time, though, to take stock. The chaos in the Roman column was complete. Already, bodies punctured with spears lay awash in the shallows of the bog; now came an even deadlier harvesting. Swords slashing and hacking at the legionaries fashioned bloody havoc. Disoriented, rain-blinded, panicking, the soldiers had no prospect of taking up battle stations. Within minutes their column was irrevocably broken. Piles of the dead lay strewn along the reddening foreshore. The wounded, their entrails spilling into the mud or their bones broken, screamed for mercy, but there was none to be had, and their assailants moved among them, spearing or bludgeoning the dying wherever they lay. Soon, all along the reeking strand, the barbarians were fanning out, hunting what survivors remained. Some had sought to flee into the marshes, but there was no escape to be had there, only the sucking of mud among the reeds as their assailants waded after them. One of the standard-bearers, wrenching his eagle from its post, had wrapped it in

his cloak and plunged with it beneath the bloody swamp-waters – but to no avail. Both he and his eagle, along with the two other standards, were taken. Meanwhile, those in the rear of the column had been frantically turning tail; but they too were hunted down. Only a very few, by hiding among the trees like beasts, managed to evade the pursuit. Otherwise, of the army led by Varus into the Teutoburg Pass, three whole divisions of the most formidable fighting force on the planet, there was no one left. The massacre was absolute.

Varus himself, desperate not to be taken prisoner, had fallen on his sword. Other officers were not so lucky. Rather than dispatch them along with the other Roman wounded, the victors had rounded them up alive. The captives had a dark foreboding of the horrors now in store. Everyone who served in Germany had heard tales of the deadly rituals practised by the natives in their swamps and groves. Their gods were greedy for human blood. Variety was the spice of death. And so it proved. Some prisoners found themselves being herded stumbling through the shallows of the marsh, then bound securely, and drowned where the mud was deepest; others were led into the forest. Here, where huge numbers of the barbarians had assembled, those officers with a particular grasp of German affairs had their best and last opportunity to work out just what might have happened to their army. No one tribe could possibly have summoned the numbers that had erupted from the woods above the pass. Someone, somehow, had forged a confederation out of the notoriously disputatious barbarians. No chance, though, to enquire directly. 'At last, you viper, you have ceased to hiss.'[94] So cried one German in triumph to a prisoner whose mouth he had sewn up after first hacking out the tongue. It was possible, though, for those whose eyes had not been gouged out, to look around them as they were being dragged to their deaths, and to mark one barbarian in particular who was presiding supreme over the rituals. His identity, to the officers who had long thought of him as a comrade, would have come, on a day

of horrors, as one final, deadly shock. As their throats were slashed open, or they choked at the end of ropes slung over a tree, or waited kneeling for their heads to be severed with the blow of a sword, they would have known that the man who had destroyed both them and the dearest ambitions of Imperator Caesar Augustus was that princely equestrian of the Roman people, Arminius.

Cherchez la Femme

Tiberius was badly prone to spots. Tall, muscular and well propor-tioned, with piercing eyes that could supposedly see in the dark, and sporting the mullet that had long marked the Claudians as tonsorial trendsetters, he was by any reckoning handsome – except for the pimples. They would suddenly erupt all over his cheeks in a violent rash. Good-looking though he was, he never could stop the acne.

The blaze of a great feat too might end up spotted. Tiberius's record of service to Rome was on a par with that of the greatest generals in the city's history, and yet repeatedly he had found his victories tarnished by sudden disasters. In 9 BC, his victories in the Balkans had been overshadowed by the death of his brother in Ger-many; in AD 6, his string of successes in Germany by rebellion in the Balkans. Now, in the hour of his supreme achievement, the news arrived in Rome of a calamity beyond the city's worst nightmares. The numerous celebrations scheduled to mark the final defeat of the Pannonian insurgents were abruptly cancelled. A triumph was out of the question while the slaughtered remains of three legions lay as food for German wolves and ravens. The Roman people gave themselves over to mourning – but also to panic. A primordial dread, which the vastness and sweep of their conquests had served only to pacify, not eliminate, flared back into life: of barbarians descending on them from the depths of the gloomy north, erupting into Italy,

crashing over their defences, making their city flow with blood. Reports that three great columns of fire had been seen rising above the Alps did nothing to calm nerves; nor a sudden plague of locusts in the capital itself. The presumption of Roman invincibility, which the Roman people themselves had come almost to believe, gave way among many citizens to its opposite: a despairing conviction that their empire was doomed.

Alarm was hardly eased by the evident twitchiness of the Princeps himself. To a man who had entrusted his own security to German troops, the revelation of Arminius's treachery came as a bitter personal blow. His guards were hurriedly reassigned to a variety of inaccessible islands. Other Germans in the capital, no matter their business, were expelled, while a state of emergency was declared on the city's streets. Meanwhile, in a house now safely denuded of barbarians, Augustus roamed around refusing to have his hair cut, and banging his head against doors. All his life, he had known with a supreme genius how to make play with the shadow-zone that lurked between appearance and reality: not just to veil his own power before his fellow citizens, but also, beyond the limits of Rome, to intimidate all who presumed to doubt Roman might. The agitation that he had betrayed in the Senate when brought news of the Pannonian revolt had shown how alert he was to the element of bluff in this; but now, in the wake of the disaster in Germany, he found himself staring it full in the face. How was his great innovation of a standing army to cope with such a shock? The military foundations on which Roman supremacy depended, tested already to their limits in Pannonia, now stood revealed as alarmingly slight. Twenty-eight legions had been serving as the empire's garrison – a total reduced, after a single day's slaughter, by a ninth. The shock to Augustus's confidence was hardly surprising. Never at his best in a military crisis, the howl with which he repeatedly rent the Palatine mingled impotence with fury. 'Quinctilius Varus, give back my legions!'[95]

A vain prayer, of course. Instead, some other way had to be found to plug the gap. Already, the insurgency in the Balkans had stretched Rome's reserves of manpower almost to breaking point. Now, with the whole northern frontier in flames, the Princeps was left with no alternative but to impose measures that his lengthy stewardship of the Republic was supposed to have done away with: the summoning of veterans out of retirement, forced conscription, the execution of malingerers. At the head of this makeshift army of the north, barely rested though he was from the rigours of the Balkans, rode the only conceivable candidate for the job, Rome's man for a crisis, as tireless as he was able. Five years earlier, arriving in Germany, Tiberius had been greeted by those who had previously served under him with effusive displays of emotion. Veterans familiar with his painstaking style of generalship had mobbed him with tears in their eyes, yelling out their battle honours and hailing his return. Now, with the screams of Varus's legions echoing in every soldier's imagination, the arrival on the Rhine of a general famed for refusing to risk the lives of his men with pointless displays of machismo was all the more welcome. Showboating was absolutely not what the crisis required.

Instead, the desperate need was for retrenchment. So grievous had been the blow dealt by Arminius to Rome's prestige and manpower that everywhere north of the Alps now seemed at risk. Steadily, remorselessly, as was ever his way, Tiberius set about the task of shoring up Roman authority. First Gaul, then the defences along the Rhine were stabilised. Girt around as they were by formidable palisades, and protected by the natural moat of the river, the huge camps on the western bank that for decades had provided the legions in Germany with their winter bases remained secure. East of the Rhine, it was a different story. There, a devastating firestorm kindled in the wake of Arminius's victory had overwhelmed the forward bases of Rome's push towards the Elbe. Half-finished towns stood abandoned. Statues of Augustus lay smashed amid rubble and weeds. Skeletons

littered charred fortresses. Only a single base had been successfully evacuated – but that too, the moment the hurried withdrawal from it had been completed, had gone up in flames. It was as though the entire infrastructure of occupation had never been.

Familiar as he was with the perils of guerilla warfare, Tiberius knew better than to plunge into an untamed wilderness before first making sure of his rear. Lacking in drama though this task might be, it was no less critical for that. For a year and more, Tiberius duly confined himself to firming up the Rhine defences. Military bases were upgraded; units transferred from other provinces; the conscripts from Italy integrated into the overall command. By AD 11, eight legions stood camped out along the Rhine where before there had been only five, while in Gaul barely a horse was left. Only now did Tiberius finally venture to the far side of the river. The sorties were predictably punitive. Crops and villages were burned. Military roads were cleared of nettles. A zone along the entire eastern bank of the Rhine was secured. From here, were it to prove the wish of the Princeps, the reconquest of Germany could certainly be attempted – but Tiberius was under no illusions as to what a challenge it would represent. Beyond the Rhine, peril now lurked everywhere. A single error, a single failure to catch the flitting of a shadow on the slope of a hill or in the depths of a forest, and disaster might be total. No one, from the lowest to the highest, could afford to drop his guard. When a senior officer sent a band of soldiers over the Rhine to escort one of his former slaves on a hunting expedition, Tiberius was so irate that he immediately stripped the man of his command. The situation was far too tense for any hint of frivolity. Tiberius himself, practising what he preached, kept his baggage train to a minimum, made himself available day or night to his officers, and invariably slept without a tent.

This close, almost neurotic attention to detail, although reaping him no decisive victories, was sufficient to secure him a more limited

aim. The Germans had been left in no doubt as to the capacity of the Roman war machine to regenerate itself. Three years on from the ambush at the Teutoburg Pass, legions were once again marching through Germany. Tiberius, who had avoided every ambush set for him and even survived an assassination attempt, could be well pleased with his efforts. Gaul and the Rhine stood secure. Barbarian hordes would not be descending on Italy after all.

The 'sole defence of the Roman people'[96] had achieved all that he possibly could have done. 'The vigilance of one man, and one alone,' as Augustus put it, 'has redeemed our affairs from ruin.'[97] In AD 12, with the end of the campaigning season and the return of his legions to their bases on the Rhine, Tiberius laid down his command at last, and headed back to Rome. There, the weather had been terrible all autumn, with black skies and endless rain. Abruptly, though, on the morning of 23 October, the clouds lifted, and bright sunshine began to dry the streets where crowds had massed to cheer Tiberius's triumph. The only showers that day would be of rose petals. Bright blazed the parade of captured weapons and armour, the collars hammered around the necks of fettered prisoners, the standards borne in stately-moving procession. Golden trophies, lit by the sun, gilded the marble of the Forum's buildings with their reflections, while finely decorated effigies, fashioned out of silver and carried aloft in front of Tiberius's chariot, portrayed for the Roman people the many victories won by him on their behalf. 'Barbarian towns, walls breached, inhabitants vanquished. Rivers, and mountains, and battles in deep forests.'[98]

Yet for all the clamour and spectacle, there was something lacking. A faint pall of dissatisfaction, of the kind that Tiberius had so often laboured under, loured over his great moment. The crowds were celebrating, not his stabilisation of the region beyond the Rhine, but his pacification of the Balkans. His mighty achievement in securing the Roman people from barbarian incursions, unglamorous as

it was, went unsaluted. His fellow citizens, most of whom had never in their lives smelt the raw timber of a newly built palisade, still less the stench of a German bog, found little to interest them in the wearisome details of frontier duty. What they wanted was evidence of dash and daring – qualities which Tiberius had never had much interest in flaunting. The virtues he prized were altogether more antique ones, the attributes of the Roman people at their most heroic and upstanding: duty, determination, self-discipline. Riding in his chariot through the streets of Rome, stern-faced and stiff-necked, he scorned to play up to the cheering. Spectators who wanted a crowd-pleaser had to look elsewhere – and the perfect idol, as it happened, was ready to hand.

Among the battle honours paraded in Tiberius's triumph, some were listed as belonging to a second and altogether more swashbuckling commander: Germanicus. That the young man's escapades had often flirted with disaster, and on more than one occasion required his uncle to bail him out, was of no concern to most. What mattered were his affability, his style, his fresh-faced, dynamic good looks. Indeed, so keen was Germanicus to appear to best effect that he had gone to inordinate efforts to bulk up his naturally weedy calves. Vanity of such an order was a part of his inheritance. His father's son, Germanicus bore the stamp as well of a grandfather even more illustrious and charismatic than Drusus: for his mother was Antonia the Younger, the daughter of Marc Antony by Octavia. 'Whether in war or peace, you are the flower of our younger generation.'[99] Tiberius, flinty man of tradition that he was, had no time for such shameless gushing – but the Roman people, in the wake of their brief but intense infatuation with Gaius, remained in thrall to the cult of youth. Now, in the debonair Germanicus, they had a fresh heart-throb. Tiberius, by comparison, could hardly help but seem a man out of fashion.

Yet he was doubly caught in a bind. Despite his age and his many

years of service to Rome, he remained legally a dependant, subject to the *patria potestas* of Augustus. The authority of a father, to a man so wedded to the values of his class as Tiberius, was not readily bucked. The same ideals that had inspired in him his lifelong republican contempt for monarchy also made him painfully aware of the duty that he owed the Princeps as a son. In another age, Tiberius's lineage and his many battle honours would have combined to win for him what the Claudians had always most craved: primacy among their peers. Not now. Primacy would come to him only by right of succession. Tiberius could not change this. His loyalty to Augustus was not just to a father, but to the saviour of Rome. Mortifying though it was that his own record of service should carry less weight in the affairs of the city than the favour of an ageing autocrat, too much was owed the Princeps to permit him to surrender to resentment. The same gratitude that fostered in Tiberius emotions of deep humiliation served to trump them as well. Trapped in a role that he despised, his very principles served only to confirm him as its captive.

The debt of duty, though, was not only to Augustus. 'I obeyed my parents. I gave way to their authority. Just or unjust and harsh, they always found me obedient and compliant.'[100] A mother was no less the guardian of the stern traditions of the Roman elite than a father; and Livia, for half a century her husband's constant and trusted companion, was nothing if not a model of matriarchal severity. In all the years of her marriage, she had never once let Augustus down. Obliged to serve him simultaneously as a paragon of domestic virtue and as *Romana princeps*,[101] the 'first lady of Rome', she had displayed a talent for squaring circles that 'was a match for the subtlety of her husband'.[102] When Livia attended a sacrifice, it was with her homespun *stola* pulled modestly over her head; when she kept to her loom, it was with her hair worn in a style of such ostentatious simplicity that ladies' maids across the empire breathed thanks to her for making it *à la mode*. No one, now that Livia was seventy years old, would have

cause to doubt her forbidding chastity, nor upbraid her for behaving in a manner inappropriate to her station. Augustus was not the only one to be blessed in his relationship to such a paragon. A war hero of the venerable kind that Tiberius aspired to be was almost required to have a virtuous mother. Livia's brand of rectitude was no less true to the ideals of her family than was that of her son. 'Her behaviour' – as even those suspicious of her were obliged to acknowledge – 'was decidedly old school.'[103]

Which only made those who mistrusted her more suspicious still. It was, of course, taken for granted by all right-thinking citizens that women should keep their noses out of affairs of state: 'What an appalling business it would be were they to seize what are properly exclusive to men: the Senate, the army, magistracies!'[104] Augustus, conservative in everything except his own appetite for supremacy, naturally concurred – and Livia knew it. Yet the exercise of author-ity, in a state where the supremacy of its first citizen had long since ceased to depend upon formal position, was shadowed by ambiva-lence. Power, as it evaded its ancient limits, had begun to evolve and mutate. Although Livia held no formal rank, her privileges were of an order to put many a senator in the shade. Legal immunity from insult, that traditional prerogative of a tribune, had been hers since the distant days of the Triumvirate. She also enjoyed, by virtue of a series of decrees enacted by her husband, a quite exceptional degree of financial independence. Most conveniently of all, in a city from which carriages had traditionally been forbidden, she had the right to zip about in a *carpentum*, a lavishly decorated two-wheeler that trad-itionally only the most senior of priests had been permitted to use. The Roman people, alert as they were to the subtle markers of status that signalled a patron worth having, did not need anyone to join up the dots. They knew what they had in Livia. A woman graced by miraculous white chickens and laurel sprigs, whose name appeared above the entrance to many a renovated shrine, 'who alone had been

found worthy to share Caesar's celestial bed'[105] – here was potency of a rare and awesome order. The authority that clung to her was like a perfume: rich, expensive, rare. Across the Roman world, her name had begun to be paired with that supernatural manifestation of her husband's greatness, his *Genius* – joined together as names on altars, as silver statues, as carvings of snakes. To keep a woman in her place was one thing – but a goddess quite another. Nevertheless, those who approached Livia for a favour tended to do so in hope as well as fear. 'Only when she helps people out of danger, or else endows them with some honour, does she manifest her power.'[106]

A reassurance which – as Livia herself, close and canny, perfectly understood – was as liable to raise hackles as to dampen gossip. She knew her city, and how the currents of rumour and slander eddied ceaselessly through its streets. Even praise might be a source of trouble. When Ovid, out of touch and despairing, publicly urged his wife to beg 'the First Lady'[107] for his release, the silence from the Palatine was deafening. To allude openly to Livia's influence over her husband, to imply that decisions might be taken on the say-so of a woman, to cast corridors or bedrooms as cockpits of power, were insults to the Princeps as well as his wife. The Senate House, as it had ever been, was the only proper stage for the discussion of affairs of state. So sensitive was Augustus to the charge that a woman's whisperings might sway him more effectively than the oration of a consul that he had ordered a daily record to be kept of all his household's activities. 'Say nothing and do nothing that you would not wish to see recorded in it openly'[108] – so Augustus had advised Julia and her daughters. Two of them had ignored the warning and paid a terrible price. To Livia, though, the Princeps had issued no such warning. There had been no need. Augustus had enough experience of his wife's discretion to know that it could be relied upon. Nevertheless, for everyone in Rome obsessed by the doings of the August Family, this begged an intriguing question. Had the taint of open scandal

failed to attach itself to Livia because she was genuinely above suspicion – or was it rather because she was so deep in all her schemings?

Mother to Tiberius, she had become a stepmother as well. Not for her, certainly, the public thunderbolts unleashed by her outraged husband at Julia. It was Livia, when her disgraced stepdaughter was transferred from the prison island of Pandateria to Rhegium, who had obligingly seconded her some slaves;[109] Livia too, when Julia's own daughter was exiled in turn, who had stepped in with financial support. Not everyone, though, was convinced by these displays of philanthropy. 'For all the pity that Livia made sure to show her step-relatives in their ruin, she had worked hard, while everything was going well for them, to stab them in the back.'[110] Such, at any rate, was the allegation. The evidence for it, although circumstantial, struck many as convincing. Stepmothers in Rome were widely presumed to be malignant. In a city that had long viewed marriage as a manoeuvre in the battle for dynastic advantage, this was perhaps only to be expected. That Livia, with the world's most powerful man in her bed, should have sought to boost her son's expectations hardly came as a revelation. Doubly a Claudian, she had never forgotten the debt that she owed her peerless ancestry. Although reserved and careful in most things, the pride that she took in her line of descent was one emotion that she scorned to veil. Just outside Rome, overlooking one of the city's arterial roads, an ancient temple restored by Livia proclaimed it to the world. There, chiselled onto an immense frieze, her name appeared, resplendent above the traffic.[111] 'Wife of Caesar Augustus' – so she described herself. Strikingly, though, the epithet came second to another: 'Daughter of Drusus'. Pushy parenting, to a woman such as Livia, was not a crime but a solemn duty.

Yet just how far was she willing to go? Many, when they reflected upon how ravaged the August Family had been by disaster, suspected her of having played most foully. The downfall of Julia and her daughter were not the only calamities to have afflicted Augustus's

plans for the future, after all. Since 29 BC, when Tiberius, riding in his stepfather's triumphal chariot, had stood on the left side of Metellus, the Princeps had suffered repeated bereavements. Again and again, his heirs had died in mysterious circumstances. Almost every Julian blocking Livia's son from the succession had fallen by the wayside. Marcellus, Lucius, Gaius: all were gone. No evidence existed sufficient to pin the blame for their deaths upon Livia – but that, to those who suspected her of responsibility, was precisely her fiendish cunning. A murder that left no traces was, notoriously, *muliebris fraus*,[112] 'a woman's machination'. The killers of Julius Caesar had struck their victim down in the open, stabbing and slashing at his body with their blades, leaving his corpse fretted all over with gashes; but when a man was given poison, he might not even realise that he was being murdered. No brute strength was required to slip a tincture into a goblet of wine. Subtly and silently, the venom would work its lethal magic. Little risk, given a practised hypocrisy on the part of the perpetrator, of her ever being fingered. Only by sucking on a citron, an exotic fruit from the forests of the distant East, might the victim hope to save himself – for no surer antidote existed than its bitter juice. 'It will help, when drinks have been poisoned by a pitiless stepmother, to drive the dark venom from the limbs.'[113] Perhaps, then, had Gaius and Lucius only been kept better supplied with Median citrus, the prospects for Tiberius's succession would have been very different.

Or perhaps not. Paranoia itself was a kind of poisoning, after all. Gossip and slander were the venoms of the mind. If Livia were truly what she seemed to be when she appeared arrayed in her *stola* before the Roman people – pious, loyal to her husband, the embodiment of Justice and Peace – then the blackening of her name was a crime as monstrous as those of which her critics accused her. If the sober virtues of Livia herself were to be cast as hypocrisy, then so too were those of the August Family as a whole. Far from serving as a model of traditional Roman values, the outward gleam of its sanctity would

stand revealed as a sham, rotted from within by murderous and despotic passions. Clearly, with Augustus an increasingly enfeebled septuagenarian, and global peace dependent upon a secure and peaceful succession, such a prospect was beyond the pale.

'Do not be unduly indignant, should anyone speak ill of me':[114] so the Princeps had once counselled Tiberius. Now, in his old age, he was growing impatient with his own advice. No matter how venerable the city's traditions of invective, no matter how devastatingly he had himself exploited them back in his youth, how could he responsibly permit them to endanger the stability of the state? The security of the Roman people, so Augustus had come to feel in his old age, was more important than any right to freedom of speech. Already, Ovid had been dispatched into exile. Then, 'imposing an unprecedented punishment on literature',[115] the Princeps had condemned to the bonfire copies of a subversive history of the civil wars by a lawyer named Titus Labienus – a sentence so devastating to the author that he had committed suicide in protest. Finally, in a salutary demonstration of the new limits that were coming to be set upon the licence of libel, a second lawyer, a witty and waspish orator by the name of Cassius Severus, was banished to Crete for the crime of diminishing the *maiestas*, the 'majesty', of the Roman people. Here, for those concerned to uphold their city's traditional liberties, was a chilling and ominous precedent. The charge of *maiestas*, as it was familiarly known, had long been applied to treasonable actions – but never before to words. That, though, in effect, was the offence for which Severus had been condemned: 'defaming with vituperative writings eminent men and women'.[116] What punishment might be imposed for defaming the most eminent of them all – the men and women of the August Family – was left hanging in the air.

Ever since the gods, taking pity on the Roman people, had graced them with the peace brought by Augustus, the *pax Augusta*,[117] the world had dwelt in the shadow of what might happen when the

Princeps died. By AD 13, when Tiberius was formally endowed by the Senate with powers equivalent to those of his adoptive father, it seemed that the answer had been definitively provided. Whatever Tiberius's private reservations, there could be no shirking now that the weight of responsibilities had been laid upon his shoulders both by Fate and by Augustus. Still, though, the ambivalences of his position continued to flicker and cast their shadows. Even as the Princeps's officially appointed colleague, Tiberius could not be declared his successor – for Rome, of course, was not a monarchy, nor her First Citizen a king. The regime fashioned by Augustus had been shaped to his own contours, and to his alone. That Tiberius could boast the most blue-blooded lineage in Rome; that he was his city's greatest general; that he had begun to manoeuvre his friends and associates into key provincial commands: these advantages, on their own, remained insufficient to secure him ultimate primacy. Only by squeezing and cramping himself into the mould of rule forged by the Princeps could he hope to obtain that, and to assure Rome and the world of peace. His own identity was insufficient. He had no choice but to subsume it into that of Augustus. His authority would never cease to derive from his relationship to the Princeps – and to his mother. Just as malign gossip about the August Family would corrode the foundations on which it rested, so would an assurance that no secrets were being kept, no unspoken rivalries festering, serve to buttress them. Caesar's household had to be above suspicion.

It was not enough, though, in a city such as Rome, merely to lean on a lawyer or two and imagine that gossip could thereby be silenced. No matter how secure Tiberius's position might appear, the partisans of Augustus's daughter had not forgotten that the Princeps had a second male heir: his grandson. Although condemned to penal custody, Agrippa Postumus remained very much alive. For all the ruthlessness shown by Augustus in dispatching him to a remote and barren island, his execution had

clearly been a step too far. Those loyal to Julia and her children inevitably kept him in their hearts, while suspecting the worst of Livia. Agrippa, it was officially reported, had something not quite right with him: he was violent, savage, obsessed by fishing. Yet peculiarities of this kind, even if accurately reported, need not have resulted in exile. There was a second member of the August Family, of the same generation as Agrippa, whose infirmities were, if anything, even more of an embarrassment. Back in 10 BC, on the same day that Drusus was dedicating the altar of Augustus at Lyon, his wife Antonia had gone into labour and delivered him a second son. Tiberius Claudius Drusus, as the boy was named, had proven a mortifying contrast to the dashing Germanicus: 'a work of nature only half-completed',[118] as Antonia bitterly put it. He twitched and shook; he dragged his right leg; when he spoke, he barked in a barely intelligible manner, like some sea animal, and when he grew angry, he slobbered and blew spumes of snot. That these disabilities did not prevent Claudius from displaying a notably intellectual turn of mind hardly mattered. Since there was clearly no prospect of his ever attaining the magistracies and commands appropriate to his birth, Augustus and Livia had settled that he should be excluded from public life for good. What they had not done was to send him away from Rome under armed guard. Even when, following in the footsteps of Titus Labienus, Claudius embarked on a history of Augustus's rise to power, Livia's reaction to this lethally subversive choice of research topic was merely to hush it up. 'To give a frank and true account,' she told her grandson bluntly, 'is not an option'[119] – and left it at that. Agrippa would have been so lucky.

A year on from the granting to Tiberius of powers equivalent to Augustus's own, the rumours continued to swirl. It was reported that Agrippa, during his violent fits, would curse Livia by describing her insultingly as a 'stepmother';[120] it was reported too that Augustus,

waking up at last to the wiles of his wife, had travelled in secret to Planasia, where he had embraced his grandson and burst into tears. 'Such marks of affection had they shown one another,' so the gossip ran, 'that the young man seemed likely to be restored to his grand-father's house.'[121] Yet the viral nature of these claims only emphasised what no one had any real interest in acknowledging: the degree to which, after forty years and more of Augustus's supremacy, decisions vital to the future of the Roman people were now veiled from their view.

Certainly, when the Princeps did cross with Livia and his retinue from the mainland, in the summer of AD 14, it was not to Planasia, but to Capri. Set like a jewel in the Bay of Naples, conveniently close to the glittering array of amenities that lined the arc of the Italian shore, but removed enough to offer him genuine privacy, it was a favourite residence of the Princeps. Here, despite a bad bout of diarrhoea, he distracted himself by giving banquets and handing out presents to assorted teenagers; and then, after four days, he returned to the mainland. With him went Tiberius, who was travel-ling onwards to the Balkans, there 'to consolidate in peace what he had conquered in war';[122] and the pair of them, once they had landed at Naples, rejoined the Appian Way and continued into Samnium. Only at Beneventum, the capital of the region, did they finally part. Augustus, with Livia still beside him, turned and headed back for Rome. His stomach, though, was still giving him trouble, and after leaving Samnium, he felt so ill that he was forced to halt his journey and take to his sickbed. By an eerie coincidence, the old family prop-erty where he found himself was the one in which, seventy-two years earlier, his father had died: a sign sufficiently ominous to prompt Tiberius's urgent summoning to his bedside. Opinion differed as to what happened next. Some said that Tiberius arrived too late; others that he came just in time for the dying Augustus to embrace him 'and commend to him the continuation of their joint work'.[123] But

one thing was certain. As Augustus breathed his last, it was his wife to whom he turned. A kiss – and then his final words. 'Remember our union, Livia, for as long as you live – and so farewell.'[124]

The fateful moment, long dreaded, long anticipated, had come at last. Livia, at any rate, was well prepared for it. Already, both the villa and the neighbouring streets had been sealed off by her guards. Only when everything was ready for the transport of the corpse to Rome was the news of her husband's death finally broken to the world. Escorted by his bodyguard of lictors, all of them dressed in sombre black, and travelling by night to avoid the heat of the summer sun, Imperator Caesar Augustus then set out on his final journey. Knights and councillors from towns along the Appian Way accompanied him by torchlight; so did Tiberius, and so did Livia. It took them a fortnight to reach Rome; and at some point during those two weeks, between the departure of the cortège from the villa in which Augustus had died and its final arrival at his house on the Palatine, a centurion came galloping furiously towards the procession. Reining in his horse and swinging down from his saddle, he demanded to be brought before Caesar. Led into the presence of Tiberius, the travel-stained officer saluted him. 'What you ordered is done,' declared the centurion briskly. 'Agrippa Postumus is dead.' Tiberius, frowning, gave every impression of astonishment. 'But I gave no such order!' Then a pause. 'This will have to be accounted for in the Senate House.'[125]

He spoke as what he was: an aristocrat wedded to the traditions of his class. Naturally, when confronted by a crime as grievous and unforeseen as the murder of Augustus's grandson, he took for granted his duty to inform the Senate. That, after all, was what Rome was about. Among his confidants, however, there was consternation. One of them, learning of Tiberius's intentions, immediately alerted Livia. 'Domestic secrets,' he warned her, 'and friends' advice, and assistance provided by the security services – all must be kept hushed

up.'[126] Tips that she hardly needed, of course. She knew better than anyone what was at stake. A command to execute the grandson of Caesar could only have come from the top: from Augustus, from Tiberius – or from herself. Since Augustus had never had any of his relations put to death, and Tiberius's surprise at the news from Planasia was self-evident, Livia had every reason to keep the crime from investigation by the Senate. A word in her son's ear, and the whole business was dropped. On the arrival of the funeral cortège in Rome, no mention was made of the execution of Agrippa Postumus. 'A cover-up ensured silence on the matter.'[127]

When the will of Augustus was formally opened and read out to the Senate, it confirmed in awful terms the disinheritance of his bloodline. 'Since cruel fate has snatched from me my sons, Gaius and Lucius, let Tiberius be my heir.'[128] Livia had triumphed. The dues of obligation owed to her Claudian forebears had been paid in full. The moment, appropriately for a woman of such infinite ambivalence, was marked by paradox. It was decreed by her husband's will that she be graced with the title Augusta and adopted posthumously as his daughter. Livia had become a Julian.

On the day of her husband's funeral, Julia Augusta – as she was now formally known – accompanied his corpse from the Palatine down to the Forum, where Tiberius and her grandson Drusus both delivered eulogies; then, travelling a short distance to where the pyre had been built, she watched in dignified silence as senators lifted the body up onto the brushwood. The fire caught; the flames began to lick; an eagle was released and soared up into the sky. Later, to a senator who claimed to have witnessed the spirit of Augustus similarly rising from the pyre and ascending into the heavens, Livia granted a massive donative. It was money well spent. When the Senate met for the first time a week after the funeral, on 17 September, it was to confirm that the dead Princeps was indeed to be worshipped as a god. His wife was appointed his priest. This, in a city where all the

priesthoods except for those of Vesta were monopolised by men, was unprecedented. Astonishingly, Livia was even given a lictor.

After the burning of Augustus's body, the pall of ashes had soon cleared, and even though the remains of the pyre had continued to glow for four days, the pious and dutiful Augusta had been able on the fifth day of her vigil to gather up his bones and place them in a nearby mausoleum, readied for the purpose more than forty years before. A second pall, though, was not so easily dispelled. That Rome, with the execution of Agrippa Postumus, was now once again a city in which murder might be deployed as a manoeuvre in the great game of dynastic advancement was a fact no less true for being too dangerous to acknowledge. Already, as Tiberius prepared to shoulder the burden of rule bequeathed him by his deified predecessor, his reign had fallen into shadow. 'The execution of Agrippa Postumus was the first crime committed under the new Princeps.'[129] Which naturally begged a menacing question: how many more would there be?

II

COSA NOSTRA

4

THE LAST ROMAN

Taking the Wolf by its Ears

Much had changed, though, over the course of his long supremacy, on the field of Mars. Even before his first appearance on the political scene, the ambitions of rival warlords had seen the ancient parade ground of the Roman people starting to vanish beneath marble and parkland. It was on the Campus that Pompey had planted his vast stone theatre; it was on the Campus that Antony had boasted a notoriously luxurious garden.[1] Both, inevitably, had ended up under the wing of Augustus – who had then, as was his habit, trumped them with spectacular developments of his own. Presented with a greenfield site right on the doorstep of Rome, he had naturally seized the opportunity to set his stamp on it once and for all. Mourners, as they gathered on the Campus to witness the final journey of the Princeps to his funeral pyre, had been able to admire an assemblage of his *grands projets*. Altars, temples, obelisks: all redounded to his glory. Particularly imposing was the mausoleum in which Livia had reverently deposited his ashes. Though it was common for tombs to line the approaches of Rome, none could possibly compare for sheer scale with that of Augustus. Built in the early years of his supremacy,

it provided him in death with the kind of ostentatious residence that he had always been chary of in life. Certainly, no other citizen had thought to commission for himself a vast tumulus, complete with a marble base, a ring of poplars, and a gilded self-portrait on the top. A worthy resting place for the mortal remains of a god.

All of which, from the perspective of his adopted son, only made it the more intimidating to follow in his footsteps. Already, reading out Augustus's will to the Senate, Tiberius had choked, begun to sob, then handed over the document to Drusus to complete on his behalf. A revealing moment. Flinty as Tiberius was, and contemptuous of histrionics, he was hardly the man to fake a breakdown. A veil had briefly been lifted on the ferocious stresses that came with being the heir of Augustus. A fortnight later, on 17 September, the pressure had been ratcheted up even more. The Senate's decision to confirm the divinity of the dead Princeps meant that Tiberius, just like Augustus, had become *divi filius*, 'the son of a god'. A glamorous-seeming promotion, to be sure – but not one that necessarily worked to his advantage. Even though Ovid, desperate enough by now to try anything, would soon be lauding Tiberius from the distant shores of the Black Sea as 'equal in *virtus* to his father',[2] such praise was off-key, sycophantic, embarrassing. No one could equal Augustus. He had saved the Republic, redeemed the Roman people. Tiberius, no less than anyone else, had grown up in his shadow – and everybody knew it. The mould of what it meant to be an *imperator*, an 'emperor', had been irreducibly set. Even dead, Augustus continued to set the standard. Lying on his deathbed, he had demanded applause for his performance in 'the comedy of life';[3] but his heir, never a good actor, was now being obliged to take on the role of Augustus himself. Trapped on a stage-set not of his own making, the new Princeps had no choice but to act out a part already scripted for him by a god. The more that Tiberius Julius Caesar laid claim to the inheritance of his adoptive father, the less he could be himself.

'Only the deified Augustus had the strength of mind to cope with the burden of his responsibilities.'[4] Addressing the Senate in the wake of its confirmation that the dead Princeps had indeed ascended to the heavens, Tiberius spoke plainly. He was in his fifties. His eyesight was going. It was out of the question that he do as invited, and adopt the title of 'Augustus'. If anything, Tiberius informed his fellow senators, he would like to retire and live as a private citizen. Let the Senate rule. Patently, this was an attempt to play the same game that Augustus, veiling his dominance behind a show of false modesty, had always exploited to such brilliant effect – but it was also something else. Oppressed by the obligation to dissolve his identity into that of someone who had just been declared a god, Tiberius was making one last, despairing attempt to be his own man.

In his heart, after all, he remained what he had always been: an aristocrat among aristocrats, and proud of it. The dying Augustus, after his last conversation with Tiberius, was said to have expressed pity for the masses, fated 'to be ground between such remorseless jaws'.[5] The ideals with which the new Princeps identified were those of his ancestors from the upright, primeval days of the Republic: Claudians who, in the conflict between aristocracy and plebs, had stood resolute for the interests of their class. It was Tiberius's intention, in his first policy statement to the Senate, to present a measure that not even the most reactionary of them would have contemplated. A few decades earlier, out on the Campus, the old wooden voting-pens where the Roman people still gathered to elect their consuls had been given a comprehensive makeover. What had originally been nicknamed the 'sheepfold' was now, thanks to the sponsorship of Agrippa, an array of marble porticoes and colonnades: the Saepta. So beautifully did it gleam, indeed, that elections seemed rather wasted on it. With the voters of the *comitia centuriata* only meeting on an irregular basis, the complex had come to serve as one of Rome's premier venues for extravaganzas and luxury shopping.

Now, in his address to the Senate, Tiberius took the final, logical step. Elections in the Saepta, he announced, were terminated. No longer would the *comitia centuriata* be assembling to vote for magistrates. Competition for the consulship was henceforward to be confined to the Senate House. Why should the plebs, raucous and vulgar as they were, be trusted with a responsibility that properly belonged to their betters? Only senators, those repositories of all that was best and noblest about the Republic, could be permitted to exercise it. The age-old dream of Roman conservatives down the ages seemed fulfilled at last. 'The lower orders, while not cringing before their betters, were to respect them; the mighty, while not despising their inferiors, were to keep them under their thumb.'[6]

A manifesto calculated to enthuse the Senate, it might have been thought. Tiberius was banking, though, upon two mutually exclusive fantasies: that senators would prove worthy of the great charge laid upon them; and that they would willingly and without compulsion do so by acknowledging him as Princeps. Three-quarters of a century before, returning home in triumph from his pacification of the East, Pompey had nurtured a similarly fond hope: that the Senate would recognise its duty to the Republic by freely doing as he said. The challenge of squaring that particular circle had helped to precipitate civil war and the ultimate dominance of Augustus; now, as senators listened to Tiberius in bemused silence, it resulted only in awkward squirming. The subtlety of what he wanted was far too knotted for them to unpick. That they should cast off the habit of obedience to an autocrat and reclaim their ancestral liberties, only then to demonstrate their principles by hailing him as Princeps: here was a paradox that few of them could fathom. The more that Tiberius insisted upon the pre-eminence of the Senate, the more the Senate insisted upon his. They understood – or rather, they thought they understood – the rules of the game. 'How long, O Caesar, will you suffer the Republic to lack a head?'[7]

The Julians and Claudians under Tiberius

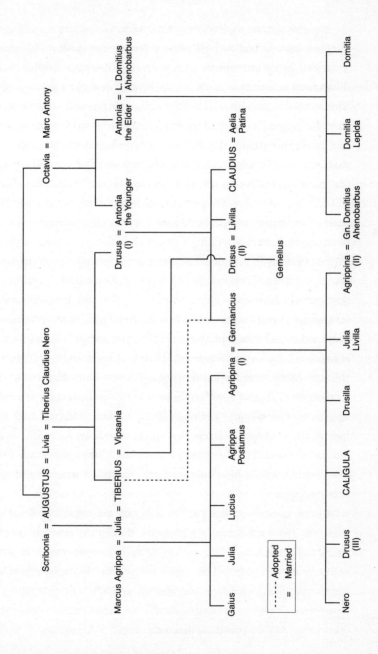

Sure enough, by the evening of the 17th, a long, exhausting and fractious session had arrived at its foregone conclusion. Tiberius, frustrated in his attempt to emerge from Augustus's shadow, had reluctantly accepted, if not the supremacy pressed on him by the Senate, then at least that he would no longer refuse it. Yet the senators too, bemused by their dawning realisation that his hesitancy had been more than just a show, were left unsettled. The genius of Augustus had been for veiling the compromises, the contradictions, the hypocrisies of his regime. But Tiberius, racked by self-contempt, lacked a ready facility for putting his fellow senators at ease. He had been too long away from Rome – in Rhodes, the Balkans and Germany – to have anything like an instinctive command of their various factions and cliques. Augustus, sensitive to the problem, had attempted to ease it shortly before his death by formally 'entrusting the Senate to Tiberius'[8] – just as an anxious parent might make provision for his sons. This, though, when the new Princeps was reminded of it, and urged to accept the title of 'Father of his Country', only compounded his embarrassment. How was the founding claim of the new order, that the supremacy of Rome's first citizen was not equivalent to that of a monarch, to survive such a blatant transfer of title? Unsurprisingly, Tiberius turned it down. After all, had the new Princeps simply done as the Senate urged, and accepted that 'he had succeeded to the station of his father',[9] then the façade of a free republic would have sustained catastrophic damage – perhaps beyond repair.

All the same, the price paid by Tiberius was crippling. Rigid of principle, awkward of manner, hypocrisy did not come nearly as naturally to him as it had done to Augustus. The result, paradoxically, was to make him seem all the more a hypocrite. 'In his speeches, he never articulated what he really wanted, and when he did express a desire for something, invariably he did not mean it. His words only ever conveyed the opposite of his true purpose.'[10] A damning, but not

unjustified, verdict. The bewilderment that senators felt in trying to fathom Tiberius's enigmatic silences, his muscle-bound circumlocutions, was due reflection of the Princeps's own tortured conscience. No matter how genuine the respect he felt for the Senate's venerable heritage of free speech, no matter how unvaryingly he showed his respect for the consuls by rising to his feet at their approach, there was one tradition that he would not, could not, honour. Tiberius, who had been leading his fellow citizens into battle since his early twenties, had spent many decades watching them bare their teeth and extend their claws. He knew what milk had been imbibed by the infant Romulus. To lead the Roman people, so he declared, was 'to hold a wolf by its ears'.[11] That being so, he was not prepared to take any chances. Even before he could move to deprive the *comitia centuriata* of their votes, he had already trampled upon another cherished tradition. Arriving in Rome with the corpse of Augustus, he had done so accompanied by a large retinue of troops. In the Senate House, in the Forum, in all the various places consecrated to the ancestral right of the Roman people to express themselves as they pleased, there had sounded the clattering of *caligae*, hobnailed military boots. *Pomerium* or not, spears and swords were everywhere in evidence.

True, there was something of a costume drama about many of these weapons, the parade-ground touch of a vanished era. The guards who attended the Emperor, when they walked the streets of Rome, sported arms reminiscent of the days of Pompey and Julius Caesar. They also made sure to wear civilian dress. Innovation fused with heritage, and menace with reassurance: here, unmistakably, was the touch of Augustus. Almost half a century before, during his heroic defence of the Roman people against Cleopatra, he had been guarded, as was the right of any magistrate on campaign, by a *cohors praetoria*, a 'commander's unit'. Rather than disband this on his return from Egypt, as custom would have dictated, he had discreetly maintained it. Although he had stationed some of the Praetorians

outside Rome, others had been billeted in various unobtrusive loca-
tions within the city itself. By 2 BC, the Roman people had become
sufficiently habituated to these guards that Augustus had felt able
to formalise their existence. Prompted, perhaps, by the shock of
his daughter's downfall, he had instituted an official command.[12]
Clearly, it was out of the question for a senator to be entrusted with
such a sensitive responsibility; and so Augustus had appointed two
equestrians. Neither he nor Tiberius would ever openly have admit-
ted it, of course, but both men, in their preparations for the transfer
of power, had realised that ensuring the loyalty of the Praetorians was
now the key to securing Rome.

Sure enough, a few months before his death, Augustus had given
his guards a massive pay rise; and in due course, when the oath of
loyalty to Tiberius came to be sworn, only the consuls had taken pre-
cedence over their commander. Seius Strabo, the Praetorian prefect,
was an Etrurian from the determinedly provincial town of Volsinii,
famous for the invention of the hand-mill and not a great deal else;
but he was competent, cultured and, crucially, an equestrian. He also
had a son, Aelius Sejanus, who, despite an early posting on Gaius's
ill-fated expedition to the East, had since become a much-valued
partisan of Tiberius. The new Princeps did not take long to demon-
strate his appreciation. One of his first appointments was to promote
Sejanus to the joint command of the Praetorians alongside his father.
Those alert to the substance of power, rather than to its show, had
no doubt as to the implications. Tiberius's agonising in the Senate
House was, to all intents and purposes, an irrelevance. 'In the military
sphere, there had been no prevarication; instead, he had immediately
adopted and begun exercising the powers of a Princeps.'[13]

Except that the military, of course, were not confined to Rome.
Out on the frontiers, the perks and donatives lavished on the Prae-
torians had not gone unnoticed. In Pannonia and Germany, where
the desperate efforts of the previous decade had required conscripts

to be force-marched to the front and reservists chivvied out of their retirement, resentments ran particularly deep. 'Floggings and injuries, harsh winters and summers on manoeuvre, grim war and peace without profit – all relentless!'[14] No sooner had tidings of Augustus's death reached the northern front than mutterings like these were flaring up into direct insubordination. With startling speed, the flames of mutiny began to spread along the Danube and the Rhine.

Brought the news, Tiberius was appalled. He knew, none better, the vital importance of keeping the frontiers secure. It was the measure of his dismay that he sent as his emissary to Pannonia both his only natural son, Drusus, and his most trusted lieutenant, Sejanus. The mission was to prove perilous. Riding into the very heart of the camp, Drusus found his attempts at negotiation confronting a firestorm of rage. When his withdrawal was blocked, it seemed, as dusk fell, that he and his whole escort might be lynched. Drusus, though, was not his father's son for nothing: obdurate and untiring in equal measure, he spent the night working on the mutineers, summoning them, by the pale light of a full moon, to a sense of their duty. Gradually he worked them round. When, by lucky chance, a lunar eclipse cast the camp into sudden darkness, the soldiers took it for an omen, wailing that the gods were sickened by their crimes. By daybreak, the mutiny was effectively over. Two of the ringleaders were put to death that same morning, and others hunted down. Steady rain then extinguished the final embers of revolt. Drusus, who had never before been inside a legionary camp, let alone been given responsibility for three legions, had risen to a mortal challenge with courage and skill. He could be well satisfied with his efforts. So too, back in Rome, could Tiberius.

Nevertheless, the jolt given to his confidence was a jarring one. As a general, he had always set a premium on obligation and commitment. The oath of duty spoken by a legionary, the *sacramentum*, was of a peculiarly fearsome order, and to break it a terrible thing. The

men who swore it, although granted by its terms a licence denied
civilians to fight and kill, were simultaneously deprived of rights
that were the essence of citizenship. There was nothing of Rome's
chaotic snarl of streets in the measured grid of a legionary base. No
matter where it might be planted, whether beneath the grey clouds
of the North or the broiling African sun, its plan would be identical
to that of every other camp across the empire. Within its ditches
and palisades, discipline was absolute. Everyone, from general to
lowest recruit, knew his place. The self-description of one particular
centurion might well have applied to all. 'For I am a man set under
authority, with soldiers under me: and I say to one, "Go," and he
goes; and to another, "Come," and he comes.'[15] It was the pledge of
the citizen who swore the *sacramentum* that he would readily commit
himself to obedience. The sanctions against insubordination were
correspondingly ferocious. Not for nothing was the emblem of the
centurion a vine-stick. So notorious was one particular martinet for
breaking his on the backs of his men that he was nicknamed 'Bring
Me Another'.[16] Cornered by the mutineers in Pannonia, he had been
torn to pieces. In Germany too, it was the centurions who bore the
brunt of the soldiers' hatred. In Vetera, a huge legionary base stand-
ing guard over the confluence of the Rhine with the Lippe, many of
the officers were pinned to the ground and given sixty strokes with
their own rods, before being flung into the river. Then, drunk on
their own violence, the mutineers began to contemplate savageries
better suited to the barbarians they were supposed to be standing
guard against: the abandonment of their positions, the sacking of the
Altar of the Ubians, a bare sixty miles to the south, the despoliation
of Gaul. Such, it seemed, was the menace of a wolf that had tossed
off its rider.

 In the event, although the mutiny in Germany was on a much
graver scale than that in Pannonia, it too was suppressed – and by a
son of Tiberius to boot. Germanicus, adopted by his uncle a decade

earlier, had followed his first consulship in AD 12 by travelling north of the Alps, there to serve as governor of Gaul and commander-in-chief of the German front. News of the mutiny reached him hot on the heels of the announcement of Augustus's death; and so naturally he headed directly to the Rhine. There, lacking the helpful intervention of an eclipse, and desperate not to risk the frontier firmed up with such effort by Tiberius, he adopted a number of expedients. Concessions were combined with executions, histrionic appeals with threats. Sure enough, by mid-autumn, order had been restored. The legionaries of Vetera, in a violent spasm of repentance, first massacred the more mutinous among their own comrades, then demanded of Germanicus – who with his customary showiness had affected to be appalled by the slaughter he found in their camp – that he lead them against the barbarians. A quick strike across the Rhine, the incineration of fifty square miles' worth of villages, and the soldiers were left much cheered up. 'Returning to camp for winter, it was with their confidence boosted, and recent events quite forgotten.'[17]

But Tiberius did not forget them. There had been a sinister dimension to the mutiny in Germany lacking in Pannonia. The concentration of troops along the Rhine, as Tiberius himself knew better than anyone, was easily the most formidable in the entire empire – and Germanicus, on his first arrival in Vetera, had been pressed by the mutineers to ride at their head on Rome. That Germanicus himself had reacted with horror to the suggestion, displaying throughout an unimpeachable loyalty to his uncle, had not set Tiberius at rest. Reports of the events in Vetera provided an uncomfortable parody of his own coming to power. The stilted expressions of support that he had received from the Senate seemed mocked by the violent enthusiasm of the legionaries for his nephew; his own agonised prevarications, when set against the flamboyant shock displayed by Germanicus at the soldiers' urgings, could not help but seem the more insincere. Most unsettling of all, to a man appalled by any hint

of mob rule, were the reports of the mutineers' ultimate ambitions. 'They wished to have a new leader, a new order, a new system of government; they presumed to threaten the Senate, even the Princeps, with new laws – laws which were to be dictated by themselves.'[18] Nothing, to the man who had just terminated centuries of voting on the Campus, could possibly have appeared more monstrous.

It did not, though, come as a total shock. Tiberius had painful memories of the irresponsibility of the masses: of their scorn for the discipline and self-control that were properly the virtues of the Roman people; of their shiftless enthusiasm for the young, the glamorous, the wilful; of their identification with his former wife and her children. All the more alarming, then, that the canker of insubordination should have infected soldiers he had personally trained, in camps he had buttressed himself. Indeed, it had seemed, during the worst moments of the mutiny, that very little was sacred. Visiting senators had been manhandled, a former consul almost lynched. Even Germanicus himself, defying the mutineers' demands, had at one point been jeered and menaced: for when he had declared, with a typical flourish, that he would rather stab himself than betray Tiberius, a soldier had drawn a sword and offered him the loan of it. Popular though he was among the legions in Germany, there were others more popular yet. Germanicus had a woman of radiant glamour present with him on the frontier. Not all Julia's children were dead or exiled. Agrippina, the last of Augustus's grandchildren still at liberty, had been married to Germanicus a decade earlier – and during the mutiny had accompanied her husband to the Rhine. A bold step for a pregnant woman, but Agrippina was of a fiery and martial disposition, and had known what she was doing.

For many decades now, the legions had been encouraged 'to display a particular fidelity and devotion to the August Family'.[19] Who were senators, then, to command their loyalty, compared to a

woman whose grandfather had for so long been their paymaster, and whose mother was still hedged about with tragic glamour? The two emotions of self-interest and sentimentality had combined to ensure a warm welcome for Agrippina on the Rhine. It helped too that she had brought with her the youngest of her three sons, a precocious infant by the name of Gaius. Kitted out in a miniature soldier's uniform, the toddler had fast become the idol of the camp. *Caligula*, the legionaries nicknamed him, 'Military Bootikins'. As the mutiny reached its climax, Germanicus had capitalised upon the affection in which the boy and his mother were held by ostentatiously sending the pair of them to a local tribe of Gauls for safekeeping. So upset had the soldiers been by this reproach to their honour, and so ashamed, that they had promptly submitted. The suppression of the mutiny had been Agrippina's as well as her husband's.

The news, lapped up by an adoring public back in Rome, endowed the city's golden couple with a more aureate glow than ever. Just a hint of the cutting-edge as well. Wives did not normally accompany magistrates of the Roman people abroad. 'Not only are women frail and ill suited to hardship, but when they slip the leash they become vicious, scheming and hungry for power.'[20] Such had long been the considered wisdom of moralists. But there were other traditions as well. In the stirring tales of heroism that the Roman people never tired of relating, even in an age when most of them had never been in a war, women too had their roles to play. The presence on the Rhine of Augustus's granddaughter had something of a scene conjured up from a nobler, remoter age. In the earliest days of Rome, after all, when the tides of war had often reached the city's gates, women had been no less on the front line than Agrippina was now. They too had heard the blast of trumpets; they too, standing on battlements, had watched the glinting of iron as their husbands marched off on campaign. It was not wholly unknown, in the stories told of Rome's early days, 'for a girl to serve as a beacon of courage to men'.[21] Past and

future; duty and dash; fortitude and flamboyance: Germanicus and Agrippina seemed to offer the Roman people a taste of everything they most admired.

The next two years of campaigning would set the seal on this mystique. Whereas the measure of Tiberius's success as General of the North had been that he gave people back in Rome nothing to talk about, his nephew's ventures across the Rhine provided them with a constant adrenaline rush. There were ghosts stalking the untamed forests and bogs of Germany – and Germanicus, with his taste for the grand gesture, his relish for taking chances, his inimitable capacity for avoiding disaster by the skin of his teeth, was set on staring the spectres in the face. For two years, he committed himself to a cause that Tiberius had scorned to make his priority: vengeance. Arminius, the treacherous schemer who had brought three legions to their ruin, was relentlessly harried. His wife and unborn son were captured; his allies suborned; his forces cornered, after two long summers of campaigning, and put to the sword. A monument fashioned out of captured arms was raised to Tiberius on the battlefield, while archers busied themselves shooting down the numerous fugitives who had attempted to hide in trees. Germanicus, it seemed, had proven himself worthy of his admirers' most heated expectations.

Except that there remained much to be done. The victory was incomplete. Arminius, elusive as ever, had managed to hack his way to freedom after disguising himself by smearing his face with gore. Such a camouflage was fitting. Everywhere beyond the Rhine, it had sometimes seemed, was streaked with his bloody fingerprints. During his first summer of campaigning, Germanicus had made a point of visiting the Teutoburg Pass, where there were still great piles of whitening bones to be seen, and rusting spear-tips, and skulls nailed to trees – and then, after touring the scene of horror, had laid the first turf of the funeral mound with his own hand. The dead,

though, were not easily confined to their graves. Shortly after the burial of the slaughtered legionaries, Severus Caecina, Germanicus's deputy in northern Germany, had found himself trapped by Arminius between forest and bog; and that night, as the darkness thickened and Caecina tried to snatch some sleep amid the howling and chanting of the expectant barbarians, he had dreamed that the blood-boltered Varus rose from the marshes, summoning him and trying to take him by the hand. Frantically, Caecina had thrust the spectre back into the swamps; but although the next day he had succeeded in extricating his men from the trap and breaking free for safety, rumours of his annihilation had already reached the Rhine. Panic had duly swept the camp on the western bank. Cries had gone up to demolish the bridge. Only Agrippina had stood firm. When Caecina and his exhausted men finally reached the river, it had been to find Augustus's granddaughter waiting at the bridgehead, ready with food, bandages and congratulations. Such was the measure of Germanicus's charisma that even a near-disaster could add to his legend.

By the autumn of AD 16, two of the three eagles lost by Varus had been redeemed. 'One more summer of campaigning, and the war will be over!'[22] So Germanicus promised. One last stiffening of the sinews; one final push. The Roman people, seduced as they were by the record of their hero's exploits on the eastern front, and by their city's birthright of victory, were more than happy to rally behind such slogans. Not Tiberius, though. Yes, honour had demanded that fire and slaughter be visited upon the contumacious Germans, and that Germanicus, as the man destined to rule the Roman world, be given experience of what it meant to lead legions in war – but enough was enough. The lure of ultimate victory was as insubstantial as a mist over a German bog. Not only that – it was cripplingly expensive. Braving a return along the North Sea coast after his victory over Arminius, Germanicus and his fleet had been

caught up in an autumn storm and suffered devastating losses. Every brush with disaster, no matter how thrilling it might be to follow from a distance, could not help but remind Tiberius of the fate of Varus. Accordingly, despite Germanicus's frantic insistence that one final season of campaigning would ensure that Roman rule was extended once and for all to the Elbe, the hero of the hour was summoned home.

There, signal honours awaited him: a second consulship, a triumph. Tiberius, determined to banish any whisperings of a breach between him and his prospective heir, lavished gold on the cheering crowds. His nephew's youth and magnetism were actively trumpeted. An arch built in the Forum hailed the recapture of the eagles lost by Varus. No matter the Emperor's private conviction that the campaigning had in reality been a waste of effort and expense, he made sure to welcome home Germanicus as 'the conqueror of Germany'.[23]

Not everyone was convinced by this display of family affection. Some, puzzled as to why the General of the North should have been recalled just as victory seemed within his grasp, freely attributed it to his uncle's jealousy. The charge was venomously unfair – and yet, for all that, not lacking an element of truth. Though Tiberius had been obediently following the wishes of Augustus in grooming Germanicus for greatness, it would have been hard for him to track his nephew's progress and not feel a stirring of envy. He remained what he had been since his first awkward speeches to the Senate as Princeps: a man profoundly uncomfortable in his own skin. The task of taking on the semblance of Augustus had not grown any easier with time. Oppressed by its demands, Tiberius had begun to live in shadow. The comet-blaze of his nephew's celebrity increasingly gave to his own reticent and withdrawn nature the quality of enigma. 'What a contrast there was between the young man's easy manner, and his exceptional good humour, and the haughty

and opaque reserve which characterised how Tiberius spoke and appeared.'[24] While Germanicus roamed the wilds of Germany and sailed the northern Ocean, Tiberius skulked in Rome, never once in two years setting foot outside the city. The austere aristocrat who had been testing himself since the age of sixteen in combat against Rome's foes, who had once turned his back on Augustus rather than compromise his dignity, who had always scorned the smooth and practised hypocrisies of the fashionable elite, now found himself obliged to negotiate a swamp more treacherous than any he had faced beyond the Rhine. Such a world was better suited to the talents of his mother than to his own; and when his enemies, sneering at him behind his back, jeered that it was the Augusta who had secured him his rule of the world, rather than his own record of *virtus*, the mockery stung. Not surprisingly, then, when senators proposed with practised malice that the title 'Son of Livia' be included on his inscriptions, Tiberius responded with fury. Rather than risk substantiating the charge that he had profited from her influence, let alone that he remained under her thumb, he made a point of avoiding his mother's company whenever he could. Repeatedly he warned the Augusta: 'do not meddle with affairs of importance inappropriate to a woman.'[25]

He still needed her, though. Reports from the Rhine of Agrippina's performance in the mutiny had served as a salutary reminder to Tiberius that the bloodline of Augustus, charged as it was with a mystique that he could never hope to share, retained its hold upon the affections of the Roman people. Agrippina herself, though a rogue and unwelcome presence in the house of which he was now the head, was married to the hero of the hour, and therefore in effect beyond his control. Not so her mother. Julia's final ruin had been sealed by her father's death. By the terms of Augustus's will, everything permitted her in her exile – her allowance, her household, her possessions – had become Livia's. The Augusta, although by now

formally a Julian, had shown the woman who was simultaneously her stepdaughter and adoptive sister not a shred of family feeling. Instead, chill and implacable, she had ordered all supplies to the wretched exile cut off. Julia, deprived of all hope, had starved herself to death. No one doubted that Livia, in the exercise of this cruelty, had been serving her son's interests. Clearly, people presumed, 'he had calculated that the sheer length of her exile would prevent her death from being noted.'[26]

In the clandestine and increasingly murderous battle between the bloodline of Augustus and that of his wife, it was Livia who had triumphed. Her son ruled as emperor; her grandson had no conceivable rival as his heir. In the great mausoleum of Augustus, whose priest and daughter Livia had become after the reading of his will, no space was given to the ashes of the disinherited Julia. Claudians had become Julians, and Julians, purged amid conditions of squalor and secrecy, had vanished altogether from the roster of the August Family. The blaze of the deified Augustus's glory illumined only the single daughter: Julia Augusta, the woman who had previously been his wife. It shed its lustre upon only the single son: Tiberius Caesar Augustus. To those who gazed full upon the brilliance and did not think to shade their eyes, there seemed no shadows, no hint of darkness, only gold. Tiberius, as Augustus had been, was 'the very best a Princeps can be'. The son of a god, he served as a model fit to be copied by all mankind. 'Great though he is as the ruler of the Roman world, he is greater still as an example to it.'[27]

Praise that would have brought a bitter smile, perhaps, to Julia's pinched lips as she lay starving, or to Agrippa Postumus, as he rotted on Planasia, dreaming of freedom, fated never to leave. Except that the obscurity of their deaths, veiled as they were from the gaze of the world, encouraged people to wonder. Two years after Agrippa's supposed execution, a remarkable rumour began to sweep Rome. 'The news was only whispered at first – as forbidden stories always

are.'[28] Augustus's grandson, so it was reported, had cheated death. 'Preserved by the heavens',[29] he had slipped his guards, procured a boat, reached the mainland. The Roman people, their love for Julia's children undimmed, began to speak of it in ever more breathless tones. Senators and equestrians, too, so it was said, were rallying to Agrippa's cause – even members of the imperial household itself. They were sending the young man funds; they were sending him inside information. The whole of Italy seemed to be yearning for the story to be true.

Few, though, ever saw the man who claimed to be Agrippa. He was constantly on the move, avoiding public spaces, keeping to the night. When at last he was captured, it was by subterfuge. Tiberius's agents themselves had been operating in murk and shadow; and when they tricked their elusive quarry into believing them to be his supporters, and met him in conditions of strictest secrecy, there was no one to witness his abduction to the Palatine. There, in the house of Caesar, the truth soon came out. The man whose claims had set all Italy seething was an imposter, a former slave of Agrippa's by the name of Clemens. Obdurate in the face of torture, he refused to betray his associates; and so Tiberius, who had no wish to give the affair any further publicity, decided to let sleeping dogs lie. He instructed that no further inquiries were to be held. The whole business was to be covered up. As for Clemens himself, he was naturally to be executed, and his body covertly dispatched.

First, though, so it was reported, Tiberius himself made sure to study the imposter; and then, marking the slave's close resemblance to his dead master, even down to the styling of his hair and beard, addressed him directly. 'How did you manage it? How did you make yourself into Agrippa?'

Back came the mocking answer, as though from the depths of the Emperor's most private fears. 'Why – in the same way that you transformed yourself into Caesar.'[30]

The People's Prince

When Tiberius persuaded Germanicus to return from the German front, it was partly by appealing to his sense of fraternal affection. 'Leave your brother, Drusus, the chance to win some glory of his own'[31] – so the Emperor had urged. It was an effective tactic. The bond between the two young men was a close one. Cousins as well as adoptive brothers, both were capable of taking pleasure in the achievements of the other. While it had been essential that Germanicus, as the elder and the chosen heir of Augustus, be trusted first with the command of legions in war, now that he had been successfully blooded, and had burnished his name to a dazzling sheen, it was Drusus's turn. Tiberius was worried that his son was altogether too fond of his pleasures. He needed toughening up. Accordingly, with the Germans too busy licking their wounds to be any further trouble, Drusus was given an immense command spanning the whole of the Balkans. Here, he proved as deft and effective an operator as he had done on his previous trip to the region. Tribes beyond the frontier were successfully destabilised, various warlords brought to sue for asylum, Roman power further entrenched. Tiberius, surveying the achievements of Germanicus and Drusus along the vast sweep of the northern frontier, could justly feel that the future was bright.

Romulus and Remus were not the only models of brotherhood to be found in the annals of the Roman people. More positive exemplars were also to hand. Tiberius himself, who had braved peril and exhaustion to be at his brother's side as he expired, served as stirring proof of that. 'Affections later in life ought never to diminish such a primal love.'[32] Indeed, the bonds of fraternity could link even those who did not share the same blood. Ferocious though competition among the Roman elite was, it did not always have to result in enmity. Shared experiences could on occasion serve to foster a sense

of mutual loyalty. For the ambitious, after all, there was only ever one ladder to climb; and a high achiever, as he mounted rung after rung, might repeatedly find himself on campaign or in office with the same colleague. Memories of comradeship might well reach all the way back to adolescence. Tiberius's own experience was typical. His colleague during his second consulship in 7 BC had been a man he had first served alongside when he was sixteen, during the war fought by Augustus in the wilds of northern Spain.[33] Forty years on, the two seasoned servants of the Roman people had many memories in common. Gnaeus Calpurnius Piso was someone whom Tiberius was proud to call a friend.

It took a special kind of breeding for a man to be treated by a Claudian as a peer. Piso's ancestry blended descent from the second of Rome's seven kings with a record of achievement that even Tiberius could rate. The commitment of his family to the traditional values of the Republic was of a famously obdurate order. His father, unlike Tiberius's own, had consistently opposed the ambitions of the House of Caesar – and as a result, had found himself again and again on the losing side. Only in 23 BC, when Augustus persuaded him to serve as consul, had he finally been reconciled to the new regime. That same June, with the Princeps so ill that he had summoned Agrippa to his side, and handed over his ring in the belief that he was dying, he had also given Piso's father a book carefully detailing his stewardship of Rome's military and financial resources. A telling gesture. It had mattered profoundly to Augustus that men of pedigree and principle be suborned to his cause – and Piso's father had been as prized a catch as any.

Piso himself was very much his father's son. 'A man of few vices, he had only this flaw: that he mistook inflexibility for constancy.'[34] Whether this did qualify as a flaw was, of course, a matter of opinion. What might appear rigidity and arrogance to those outside the ranks of the ancient nobility was prized by men such as Tiberius and

Piso as essential bulwarks of their city's greatness. 'Just as following the customs of our ancestors produced outstanding figures, so did these same excellent men make sure to preserve our traditional way of life, and the institutions of their forefathers.'[35] Now, more than ever, amid all the bewildering sea-changes of the new age, it was the duty of those who led ancient houses to maintain the moorings that anchored their city to the bedrock of the past.

This was why, during his joint consulship with Piso, Tiberius had funded the restoration of a monument in the Forum that for a century and more had served as its most notorious shrine to reaction. There was no building in Rome more ironically named than the Temple of Concord. Originally built in 121 BC, it commemorated the bloodiest outbreak of class warfare in the city's history. Conservatives in the Senate – an ancestor of Piso's prominent among them – had waged an ultimately murderous campaign against those two doughty tribunes of the plebs, the Gracchi. It was not only the two brothers themselves who had been murdered; thousands of their followers had ended up as corpses in the Tiber. Tiberius, by ostentatiously repairing the monument built to this repression, had been laying down a marker. To be sure, that his gesture had infuriated the great mass of the Roman people was regrettable – but it could not be helped. The existence below the Capitol of the beautifully refurbished Temple of Concord, complete with his own name over the doorway and a lavish complement of artworks, made a statement that no one could mistake. Endowed though he had been with a tribune's powers since AD 4, Tiberius continued to identify himself with the oldest, sternest, stiffest values of his class. 'Worthy of my forebears, careful of the Senate's interests, steadfast in danger, and fearless of such resentment as I may incur serving the public good':[36] his was a manifesto worthy of Appius Claudius the Blind. That his first dealings with his fellow senators as Princeps had been awkward in the extreme had done nothing to shake his resolve. Concord between the Senate and the People of

Rome, yes – but on the Senate's terms. There was to be no pandering to the masses on Tiberius's watch.

The backing of men like Piso, however, was crucial. The failure of most senators to meet his high expectations of them continued to nag at the Princeps. As on the Rhine, so in the Senate House, he trod a slow but determined step. Although senators down on their luck might well be given a helping hand if he judged them deserving, those who sat silent and nervous in debate, waiting for him to take a lead, were rarely so blessed. Though Tiberius was a masterly orator, endowed with tremendous qualities of sarcasm and dignity, of irony and power, the effect of his presence on those intimidated by his greatness was only to make them shrink all the more. Sometimes he would keep silent; at other times intervene abruptly; at other times yet lose his temper altogether and erupt. Many senators, unsure what rules they were meant to be playing by, found themselves lost and bewildered; and there were occasions when Piso, habituated as he was to his friend's way of thinking, would publicly alert him that he had placed them all in an invidious situation. Such interventions, far from provoking the Princeps, invariably struck home. Independence of mind was precisely what Tiberius wished to foster – provided, of course, that it conformed to the ideal which men like Piso, of proven pedigree and record, so notably embodied. Genuine debate, under such circumstances, was not out of the question. Sometimes, it was almost possible to believe that the Princeps did indeed take his place in the Senate merely as one among many. Once, Piso even won backing for a motion that Tiberius and Drusus had both publicly opposed. No matter that it was then promptly vetoed, all the senators could briefly feel good about themselves. It was, everyone in the House had been able to agree, 'a particularly good illustration of the democratic form of government'.[37]

Not that anyone outside its walls greatly cared. After all, the vast mass of the Roman people, denied by Tiberius their right to a

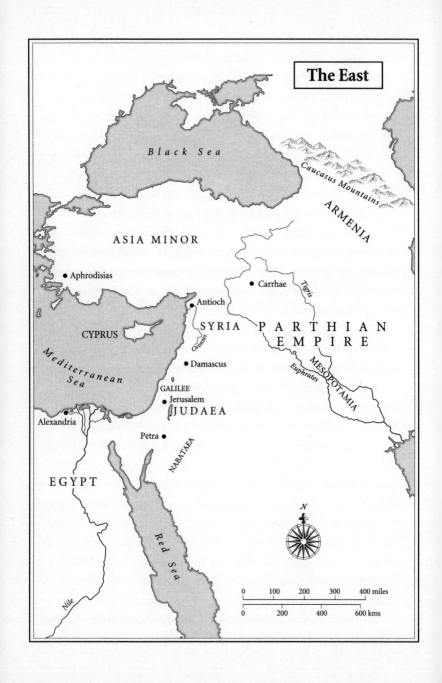

meaningful vote, no longer had a stake in the election of their magistrates. Instead, they had other favourites. They had not forgotten their devotion to the glamorous and tragic family of Julia. The same star quality that had seduced mutinous legionaries on the Rhine now had the crowds swooning in Rome. On Germanicus's return from the front, the whole city had streamed out to welcome him, Agrippina and their children. Little Gaius, not yet five years old, and whose nickname of 'Caligula' appealed to everything that was most sentimental about the Roman people, was their particular darling. During Germanicus's triumph, he had ridden proudly beside his father. Also present in the chariot had been his two elder brothers, Nero and Drusus, and their baby sisters, Agrippina and Drusilla. Everything about the spectacle might have been calculated to delight the cheering masses – and appal Tiberius. Germanicus, it seemed, could not help but cut a dash.

All of which placed the Princeps in a quandary. Clearly, with the wishes of Augustus still sacrosanct, Tiberius remained committed to grooming his nephew for the succession – and Germanicus's apprenticeship was far from over. Now that he had completed his term of office north of the Alps, it was time to broaden his horizons and send him east. There, trouble was brewing again. The flashpoint was one that had long been a cause of tension between Rome and Parthia. The kingdom of Armenia, a land of icy mountains, thick forests and notoriously effective poisons, lay sandwiched uncomfortably between the rival empires: too indigestible to be swallowed, too tasty to be left alone. Tiberius himself, almost forty years before, had been sent there by Augustus on his first independent mission – and a great success it had turned out to be. A puppet king had been imposed at the point of a sword; the right of Rome to meddle in Armenian affairs triumphantly affirmed. Where there was opportunity, though, there inevitably lurked peril. It was in Armenia, after all, that Gaius Caesar, Augustus's precious grandson, had received his fatal wound. Tiberius,

whose own rise to greatness would never have happened without Gaius's untimely death, had good reason to appreciate the disaster that might overtake a headstrong prince. Nor was it only Germanicus's personal safety at stake. The annihilation of Crassus and his legions at Carrhae still cast a long shadow. Embark on too madcap an adventure, and the entire Roman order in the East might be put in peril. Tiberius knew, as he weighed up his options, that whatever he did would be a risk.

In AD 17, shortly after celebrating his triumph, Germanicus was formally appointed by the Senate to the command of the eastern provinces, with an authority over the region's various governors equivalent to Tiberius's own. 'There can be no prospect of a settlement there,' the Princeps informed the House with a perfectly straight face, 'unless his wisdom be brought to bear on it.'[38] Shortly afterwards, Germanicus set out on his mission. With him went the seemingly ever-pregnant Agrippina and the young Caligula. First stop was a courtesy call on Drusus's headquarters in the Balkans; second, the bay of Actium. Almost fifty years had passed since Germanicus's two grandfathers, the one natural and the other adoptive, had met on its waters to decide the fate of the world; and the young man's imagination, as well it might have done, 'conjured up for him vivid scenes of tragedy and triumph'.[39] Then, like so many pilgrims before him, he headed on eagerly to the Greek world's most celebrated tourist attraction. Crowned by the Parthenon, garlanded and perfume-hung with memories of past achievement, Athens had always shimmered in the yearnings of Roman romantics. Horace had studied in its schools; so too Ovid, who on his journey into exile had found himself haunted by memories of his happiness there as a young man. History and philosophy, art and *savoir faire*: the city had it all. 'Athens, once mistress over waves and land, has now made Greece a slave to beauty.'[40] The highly cultured Germanicus, whose idea of relaxation was to pen a Greek comedy or two, was duly smitten. So

too were the Athenians. They may have fallen from their past great-ness, but they had no rivals when it came to buttering up dignitaries. To a man such as Germanicus, who liked nothing better than being liked, it was heaven. Sailing on from Athens, his spirits were much buoyed. When Agrippina, just before landing in Asia Minor, paused on the island of Lesbos to give birth to a third daughter, Julia Livilla, it seemed that the gods were smiling on him and his mission.

Trouble was already brewing, though. Not far behind, blunt and unaccommodating where Germanicus himself had been emollient and affable, travelled a legate with a very different take. Piso, who regarded rudeness to foreigners as one of the primordial virtues which distinguished a Roman aristocrat from lesser men, had no time for diplomatic niceties. Arriving in Athens, he delivered a speech that was pointedly rude. The Athenians were unworthy of their heritage; they were scum, the dregs of the earth. Chauvinism such as this, a bristling contempt for the Greeks as a conquered and decadent people, was the reverse of the cultural cringe so recently displayed by Germanicus – a cringe, Piso informed his hosts, that was incompatible with Roman dignity. His point made, he continued on his way – only to be caught in a storm off Rhodes. Saved in the nick of time by a warship doubling as a lifeboat, Piso's mood was hardly improved by discovering that the man to whom he owed his life was Germanicus. The meeting between him and his rescuer was as stiff as it was brief. Only a day after he had narrowly avoided shipwreck, Piso was on his way again. His destination: the province which more than any other served as the key to Roman security in the East, a land of famous and teeming cities, fabulous wealth, and a frontier directly abutting the Parthians. Piso was heading east as the new governor of Syria.

That Tiberius, like Augustus, thought long and hard before appointing anyone to a military command went without saying. Syria, which had a garrison of four full legions and lay many weeks

distant from Rome, was a more sensitive command than most. Delegation did not come easily to the Princeps. As a general in the field, his attention to detail had been remorseless – but as emperor, with the whole world his responsibility, he had reluctantly accepted that he could no longer afford to micromanage. True, he often seemed on the verge of surrendering to temptation, of setting off on a grand tour of the provinces, of attempting to monitor every last aspect of Rome's dominions; but again and again he would cancel his travel plans. 'Callippides', men began to call him, after a famous mime whose party trick had been to imitate the sprinting of an athlete while staying rooted to the spot.

The dispatch of Piso to Syria was Tiberius's most Callippidean manoeuvre yet. Chopping and changing governors was not his normal style. His preference was for keeping them in place. 'Even corrupt legates?' he was once asked. 'Better blood-glutted flies on a wound than thirsty ones,' came the mordant reply.[41] The circumstances now, though, were exceptional. Despite having brought himself to trust Germanicus with the administration of the East, Tiberius could not bear, in the final reckoning, to leave his nephew unsupervised. He needed someone in Syria he could trust. The loyalties of the incumbent governor, whose daughter was due to marry Nero, Germanicus's eldest son, were far too split for comfort. Only a man in whom the Princeps had absolute confidence, who shared his values, his instincts and his background, would do. So it was, as Germanicus made his way to Armenia, there to follow in Tiberius's own footsteps and impose Rome's choice of a king, that Piso, after landing in Syria and travelling some fifteen miles upriver, arrived in the great metropolis which served the whole of Roman Asia as its cockpit: Antioch.

Like Alexandria, the city had originally been a capital of kings. Founded in 300 BC by a general of Alexander the Great, the sway of its rulers had once reached as far afield as India. Although it was a

parvenu among the ancient foundations of Syria, Antioch had long since outgrown them all. Laid out by its founder on a grid pattern between the river Orontes and the towering peaks of an adjacent mountain, peopled by transplanted Athenians, and endowed with every appurtenance of a Greek city, from theatres to gymnasia, it had firmly stamped the Levant with the brand of Macedonian ownership. For two and a half centuries, fatted on the riches of Asia, it had served as a showcase for royal excess. Ivory tusks and huge silver dishes, jewel-encrusted diadems and immense public banquets, golden jars filled to overbrimming with cinnamon, and marjoram, and nard: 'to gaze at all the wealth on display was to be struck with wonder and stupefaction.'[42] With avarice as well, of course, in the case of a man like Pompey; and sure enough, in 63 BC, the vain and venal conqueror had no sooner appeared with his legions in Syria than he was swallowing it up. Almost eight decades on, the new governor, as he arrived to take up his post, would have seen reassuring marks of Rome's dominance everywhere in the erstwhile seat of empire. To enter Antioch was to be left in no doubt that it lay now beneath the claws of the wolf. Above a gleaming new gateway in the eastern wall was set a statue of Romulus and Remus, complete with lupine wet-nurse; midway along its central thoroughfare, gazing serenely out across the city from atop a column, stood a statue of Tiberius. Meanwhile, in the governor's headquarters, where soldiers were garrisoned, tax records stored and law courts established for the brisk and ready sentencing of criminals, Roman supremacy had its intimidating apparatus. Nowhere else in the city, nor in the province beyond, was there any conceivable rival to Rome's monopolisation of force. A governor had the right to crucify, or burn, or throw to beasts anyone he pleased. Piso, as the man who commanded such terrifying powers, was aptly a figure of dread and awe.

Which said, the presence on the scene of Germanicus naturally complicated matters. Piso's authority was not as absolute as it would

otherwise have been. Confident that Tiberius intended him to serve as a counterbalance to the young prince, he duly set about shoring up his support among the province's garrison. Although, on previous tours of duty, he had shown himself a ferocious martinet, he now relaxed the leash restraining the legions under his command, and granted his men licence to throw their weight around even more brutally than they were normally permitted to do. Provincials, of course, already knew to tread carefully with their occupiers. A legionary might well force a civilian to serve him as a porter or provide him with a billet – and no woman, certainly, ever met a Roman soldier without a certain measure of dread. Now, though, with the slackening of their discipline, the military were given the run of both towns and countryside. The new governor was hailed appreciatively by his men as 'the Father of the Legions'.[43] Meanwhile, his wife, an intimate of Livia's by the name of Plancina, aped the role played by Agrippina in Germany. Attending manoeuvres, she paraded her own interest in the welfare of the troops. Piso began to grow in confidence. When orders arrived from Armenia for reinforcements, he felt sufficiently sure of himself to ignore them. Germanicus, embroiled as he was in settling the frontier to the north, had no choice but to swallow this insubordination; and in the event, displaying an acumen and a diplomatic finesse that made a mockery of his uncle's forebodings, he was able to achieve with his own resources all that he had been sent to do. Unsurprisingly, though, when he and Piso met again in the winter quarters of one of the four Syrian legions, relations between the two men were frostier than ever. 'When they parted, it was in open enmity.'[44]

Yet there was more to this clash of egos than the awkward circumstances of their mutual appointments. Deep issues of principle, reaching to the heart of Rome's new order, were at stake. Twenty-five years previously, Tiberius had retired to Rhodes rather than endure the presumptions of a jumped-up princeling; but then, when

Gaius had come to the East armed with powers equivalent to those wielded by Germanicus now, the older man had been left with no choice but to bite his tongue and swallow repeated snubs. Piso, a man of Tiberius's own generation and background, was determined not to suffer a matching humiliation. Like his friend, he scorned the notion of monarchy; like his friend, he cleaved to the virtues and principles defined for him by his ancestors. Tiberius himself – who twice, first in Pannonia and then in Germany, had saved the Republic – Piso was willing to acknowledge as Princeps; but not Germanicus. It was as a Roman aristocrat that he intended to govern his province.

Matters came to a head at a banquet hosted by the king of Nabataea, a land ruled from the rose-red city of Petra, and which had long been subordinated by treaty to Rome. When the king, as a gesture of hospitality, presented his guests with golden crowns, a heavy one for Caesar's son and a lighter one for everyone else, Piso snorted in derision. Who did Germanicus think he was – a Parthian? Ever since the time of Scipio Africanus, it had been a point of principle among the Roman elite that they were the superiors of even the showiest Oriental. The dignity of the Republic, Piso believed, obliged him to maintain a principled contempt for everyone and everything in his province. Degenerate though Athens might have been, it was as nothing compared to the degeneracy of Antioch. The city's Greek façade did not prevent its Roman masters from rating its inhabitants as, at best, mere imitations of Greeks. The crowds thronging its streets had long since come to possess a *mestizo* quality. Descendants of the Athenians settled there by its founder mingled with natives from across the entire Near East. In Rome, where unguents from Syria were highly prized, the oil with which dandies would perfume and anoint their hair struck moralists as repugnantly suggestive of the country as a whole. To men such as Piso, everything about the Syrians was unsettling. Their merchants were too smooth-tongued; their priests too effeminate; their dancing girls altogether too depilated.

From the tops of mountains, where ecstatic worshippers would offer up sacrifice to eerily formless gods, to the depths of Antioch's bars, where bodies moving to the sound of tambourines would writhe in the deviant fashion for which Syrians were notorious, the province seemed to fester with slavishness and immoderation. Confronted by such a country, what was a Roman to do but cling all the more tightly to the standards of his own?

Except that Germanicus, whose courtesy and grace towards a whole assortment of foreigners had so provoked the ire of Piso, could legitimately point out that xenophobia was not the only tradition inherited from the great men of their past. The same Scipio Africanus who had always sternly upheld the majesty of the Republic in the face of Oriental monarchy had also, while touring the Greek cities of Sicily, done the locals the courtesy of copying their fashions. Now, as Germanicus continued his tour of duty by travelling from Syria to Egypt, he repeated the trick. Arriving in Alexandria, he dismissed his guards, put on sandals and dressed up as a Greek. This, to the inhabitants of a city founded by Alexander the Great, whose incomparable library boasted more volumes of Athenian literature than Athens herself, and who bitterly resented that a palace once occupied by their own monarchs should have ended up the headquarters of a foreign governor, was a wildly popular gesture. As in the capital, so in the Roman world's second city: Germanicus's easy charm proved adept at winning hearts and minds.

This was a considerable feat. No Roman had matched it since the time of Antony. The Alexandrians were notoriously hard to please. Perverse and flighty, they were so prone to street brawling that even a woman might think nothing of 'grabbing a man's genitals in a fight'.[45] Now, though, when the Alexandrians rioted, it was out of enthusiasm for their guest. He and Agrippina, the crowds began to chant, were both of them '*Augustus*'. Germanicus, appalled, promptly ordered the demonstrations broken up. It would not do, as he was

all too painfully aware, to be hailed by a title that 'only his father and grandmother were entitled to wear'.[46]

But too late. News that Germanicus was playing to the gallery in Alexandria could hardly help but reach Tiberius – and it did not go down well. However sensitive a posting Syria might be, Egypt was even more so. Such was its wealth, after all, that it had effectively bankrolled Antony's bid for world domination – a detail that no Caesar was ever likely to forget. Augustus, for all his boast that he had 'added Egypt to the empire of the Roman people',[47] had kept such a vice-like grip upon the new province that it had ranked, in practice, as his own personal fiefdom – a display of neurosis that Tiberius had naturally made sure to emulate. No members of the Roman elite were permitted to enter Egypt without his express permission; only equestrians were ever appointed to govern it; even a hint of uppitiness, and a governor would ruthlessly be removed from office. Indeed, it was the measure of Tiberius's anxiety to secure the province that within months of succeeding Augustus he had appointed as his legate in Alexandria none other than Seius Strabo, erstwhile prefect of the Praetorians, and father of his most trusted partisan. Meanwhile, beyond the purlieus of the great harbour-city, along the banks of the Nile, where ancient, animal-headed gods were still worshipped by Egyptians who might not speak a word of Greek, nor ever have seen a Roman, the distant Princeps was being honoured in primordial fashion. Just as once, back in the fabulous mists of time, Egyptian scribes had chiselled into temple walls the names of their own native kings, carefully set within regular ovals, so now, whenever fresh ovals came to be engraved, they would contain within them the name of Tiberius. In Egypt it was less as the first citizen of the Roman people that he ruled than as a pharaoh.

Nothing, then, could have done more to set the Princeps twitching than to have the grandson of Antony and the granddaughter of Augustus hailed as gods in Alexandria. When Germanicus returned

to the city from a Nile cruise, it was to find a furious missive wait-
ing for him from Rome. Had the terms of Tiberius's criticisms not
chimed so readily with those of Piso, then the contretemps would
doubtless soon have been forgotten – for Germanicus, after all, had
never intended to step on his uncle's toes. As it was, he returned to
Syria to find its governor newly emboldened. The campaign of insub-
ordination waged by Piso had hit fresh heights of insolence during his
absence – and Germanicus, when he discovered that his every last
order had been countermanded, decided that enough was enough.
Silver-haired Piso may have been, of an ancient family, and seasoned
in the service of the Republic – but Germanicus tore a strip off him
nevertheless.

The governor, his dignity fatally injured, resolved to depart
Antioch. Before he could leave, though, news came that his adver-
sary had fallen ill. Piso's spirits duly soared – only to be dashed by an
update, which reported a recovery, and that the whole of Antioch
was offering up sacrifices in relief. Piso, whose judgement was by
now fatally clouded by the sheer intensity of his loathing for Ger-
manicus, sponsored his lictors to break up the celebrations, and then
retreated down the Orontes to await further developments. These, as
it turned out, were already spiralling out of control. Antioch was rife
with talk of poison and sorcery. Not only, it seemed, had Germanicus
suffered a relapse, but his servants, pulling apart his bedroom, had
discovered marks of witchcraft secreted in the walls and under the
floorboards: bones, dried blood, smears of ash. Germanicus himself,
as he lay dying, had specifically fingered Piso as the man responsible.

So it was, for the second time, that the journey of a young Caesar
to the East ended in calamity. Yet though the loss of Gaius had cer-
tainly been a grievous blow to Augustus, and though Livia's hand in it
would subsequently be darkly suspected, it had not set off such rever-
berations as the death of Germanicus now threatened. His last words,
delivered with his customary heightened emotion from the capital

of Roman Asia, could hardly have been less helpful to Tiberius. First, he had openly accused the Princeps's legate and friend of plotting his murder. Then, even while urging Agrippina to rein in her instinctive tendency to grandstand, he had simultaneously instructed everyone else gathered around his deathbed to take full advantage of it. 'Display before the Roman people the granddaughter of the deified Augustus, and recite to them the names of my children!'[48]

Such an appeal embodied everything that the Princeps had always most mistrusted in his nephew; yet even as Germanicus was delivering it, the man sent to Asia to serve as a check upon his instincts, and to embody the stern and flinty instincts of Tiberius himself, was only stoking the flames. Piso remained too blinded by the insult done his honour to let it lie. At the news of his rival's death he flung open temples in his joy, raising sacrifices to the gods and lavishing fresh donatives on his men. Then, when the senators in Germanicus's train appointed one of their own number, a former consul by the name of Sentius, to serve as governor in his place, Piso resorted to force in defence of what remained, after all, legally his office. Citizen faced citizen: 'Pisonian' took up arms against 'Caesarian'.[49] Fifty years after the battle of Actium, it seemed that the evils of civil war, 'long since laid to rest by the divine will of the deified Augustus, and by the virtues of Tiberius Caesar Augustus',[50] were returning to plague the world.

The human face of the crisis, as the dying Germanicus had known it would be, was provided by Agrippina. Rather than wait for spring, she embarked for home the moment that the ashes of her husband's pyre had cooled. Pausing only to swap insults with Piso after an inadvertent brush with his flotilla, she set sail across the wintry seas for home. When she finally docked at Brundisium, it was as though the whole of Italy had massed to greet her. As the pale-faced widow appeared on the gangplank, the urn containing her husband's ashes in her hands, and Caligula and little Julia Livilla by her side, the sobs and wails of the crowd blended into a single animal howl of pain. Ever

since the definitive confirmation of Germanicus's death, Rome had been sodden with grief. 'Not an honour that love or wit could devise but it had been bestowed upon him.'[51] Now, in the slow and stately journey of his ashes towards the city, there was the flavour of one final tribute: not merely a funerary procession but a triumph. Praetorians provided the fallen hero with his escort; lictors reversed their *fasces* and standards were stripped of their adornments; incense burned by mourning bystanders wreathed with its bitter perfumes the entire length of the Appian Way. Forty miles south of the capital, the ashes were met by Germanicus's brother, the shambling and decidedly unheroic figure of Claudius, by his adoptive brother, Drusus, and by the four children that he and Agrippina had left behind them in Italy. Then, on reaching Rome, the procession was joined by the two consuls and an array of senators. Through packed streets muffled save for the wailing of mourners it continued along its way. Only out on the Campus did it finally come to a halt. Illumined by the blaze of a multitude of torches, and watched by the black-mantled silhouette of Agrippina, Germanicus's mortal remains were reverently consigned to their final resting place: the great Mausoleum of Augustus.

Meanwhile, of his uncle, the First Citizen of the Republic, there was not a sign. As ever, Tiberius regarded the parading of grief as beneath his dignity. Neither he, nor Livia, nor Germanicus's mother were glimpsed in public. Who were any of them, as they mourned their loss, to be dictated to by the lachrymose self-indulgence of a mob? The mood of the city, though, was turning ugly. The absence of the Princeps from the very public displays of mourning was read as an insult. Worse — as a confession of guilt. Germanicus's dying charge, that Piso had poisoned him, was on everybody's lips. Such an accusation was not easily rebutted. For Tiberius to have pointed out, as he might well have done, that the climate of the Levant was notoriously unhealthy, that many there had succumbed to disease, that the

supposed marks of witchcraft found under Germanicus's floorboards might just as plausibly have been animal remains, would have been insufferably demeaning; and yet his silence hung heavy in the air. The Roman people, in their grief and their anger, did not find it hard to adduce a motive. Gazing on their hero's widow, they hailed her as the last grandchild of Augustus left standing. Raising their hands to the heavens, they prayed that her children 'would outlive their foes'.[52]

Tiberius was bitterly stung. Although he had always been contemptuous both of the plebs and of those who sought to woo them, it did not stop him from flinching on occasion at the consciousness of his unpopularity. To be scorned as a cuckoo in the nest, streaked with the blood of innocent fledglings, threatened damage to more than his reputation. The Princeps was not alone in being menaced by the crisis. The Senate, whose authority and values Tiberius had always aspired so dearly to uphold, had begun to feel threatened too. There was an acrid flavour to the city's mourning for its favourite. It was widely believed out on the streets that Germanicus had been murdered because of his friendship for the masses. He had favoured equal rights for all, so it was rumoured, and aimed to restore to the Roman people their lost liberties. The crowds, when they gathered with their torches on the Campus to greet the funeral procession, had done so ranged as though in assembly, ready to vote. Clinging as he was to the ears of the wolf, Tiberius could feel the rising of its hackles, sense the baring of its teeth, smell the hunger on its breath. He knew that it wanted meat.

Nothing for it, then, but to toss it prey. The sacrificial victim, as Tiberius was painfully aware, selected himself. Piso's attempt to clutch onto his province had not gone well. Routed in battle and flushed out from his bolt-hole by Sentius, he had been left with no alternative but to sue for terms. The best he could obtain was a safe-conduct back to Rome. Sailing up the Tiber into the eye of the storm, he and his wife settled for a calculated display of *sangfroid*. Rather than

cringe before the fury of the Roman people, he opted to dock, at the busiest time of day, directly opposite the Mausoleum of Augustus, where Germanicus's ashes had only recently been laid; and then, that same evening, to host a slap-up dinner party. Down in the Forum, where the garlands adorning Piso's villa could clearly be seen, the crowds seethed in disbelief. Next day, to no one's surprise, an official indictment was registered with the consuls.

Still Piso's peers shrank from applying the *coup de grâce*. The consuls referred the investigation to the Princeps; the Princeps to the Senate. Piso, indomitable as ever, refused point-blank to confess the crime of which everyone outside the courtroom had already convicted him: he had not, he insisted over and again, poisoned Germanicus. True, this did nothing to exonerate him from the other accusations; for it could hardly have been more self-evident that he was guilty of rank insubordination, and of fomenting civil war. Yet even in pressing these charges, the prosecution had cause to hesitate. Not a senator but he was uncomfortably aware that Piso had been the legate of Caesar. Correspondence between the two men, despite requests, remained strictly embargoed. As for Tiberius himself, he was the most uncomfortable of all. The Princeps remained on the horns of a truly agonising dilemma. Spare Piso, and the darkest suspicions of the Roman people would be confirmed; wash his hands of an old friend, throw a trusted ally to the wolves, permit a man of ancient and distinguished family to be lynched by a mob, and the betrayal would be devastating. So Tiberius havered; and out on the streets the fury and indignation grew.

The climactic eruption, when it finally came, forced everybody's hand. Demonstrators toppled Piso's statues, hauled them to the base of the Capitol, then dragged them halfway up the flight of steps that led to the summit of the hill. Here, in full view of the Forum, they set about smashing them to pieces. The symbolism could hardly have been more pointed. On one side of the Gemonian Steps, as they were

known, loomed the city's only prison, where criminals were held before execution; on the other, the Temple of Concord, recently and controversially renovated by Tiberius. The Princeps, recognising the direct challenge to his authority, sent in the Praetorians to save and restore the statues, then to escort Piso himself in a litter back to his house. The next morning, in a gesture of continued defiance, the accused returned to the Senate House; but he knew, the moment he walked in, that the game was up at last. Not a sympathetic look; not a voice that wasn't raised in anger. Most chilling of all was the expression of Tiberius: 'pitiless, passionless, closed to all emotion'.[53] That evening, when Piso returned home, he readied himself for bed as he had always done; and then, while his wife was out of the room, ordered the doors to be closed, and cut his throat.

In death as in life, the vengeance of the bereaved plebs pursued him. The Senate, obedient to their hatred, declared it a crime for any to mourn Piso, ordered all portraits of him destroyed, confiscated half his property, and commanded his son to change his name. Copies of their decree were dispatched to cities and camps across the known world. Simultaneously, with unctuous formality, senators expressed their gratitude to the Princeps for avenging Germanicus. The Roman people, though, remained contemptuous and unconvinced. They knew that Tiberius, rather than permit the total ruin of Piso's family, had expressed pity for it in its disgrace, and for the terrible end of Piso himself. Their suspicions of the Princeps still festered. An opponent of their interests, yes – but a murderer of their champions too. To be branded with such a reputation was grim enough. But there was worse. The Senate, the body in whose interests Tiberius had been willing to sacrifice his popularity with the plebs, had been left badly bruised by the crisis. The fate of Piso, who had first been recruited by the Princeps as an ally and then abandoned, struck many senators as salutary. Far from serving them as a model of antique rectitude, Tiberius appeared to many in the wake of events in Syria a veritable

monster of hypocrisy. The scorn with which he had always regarded those who did not adhere to his own stern codes of morality was now met in the Senate House by a matching suspicion of him. Inexorably, even those allies whom Tiberius most needed were starting to worry whether he could be trusted at all.

And perhaps, among their number, in the wake of so toxic a crisis, was Tiberius himself.

Consigliere

Rome was a city crowded by the dead. Even though ascension into the heavens, whether on a comet-blaze or the beating of an eagle's wings, was an apotheosis granted only a Caesar, there were other ways of becoming a god. The blood of pigs, spilt over the earth of freshly dug graves, could serve to consecrate the spirits of even the humblest. Raise prayers to the departed, scatter violets on their tombs, make them offerings of meal, and salt, and wine-soaked bread, and they in exchange would stand guard over the living. *Manes*, these shades were called: spirits who could be summoned from the underworld to extend the lives of those who mourned them, to offer advice in dreams, to protect the harvest in the fields. Back in the days of Rome's rise to greatness, during the terrible war that had finally witnessed the annihilation of Carthage, they had even fought by the side of the Roman siege force, after its commander had dedicated the city to them as a blood-offering.[54] The living were keen, therefore, to honour the *Manes* with appropriate festivals. In February, for ten whole days, temples would be closed, fires extinguished on altars, and magistrates appear only in the plainest of clothes. It was perilous to deny the dead their due. One year, it was said, feeling neglected, they had risen from their tombs. As funeral pyres blazed eerily across Rome, a phantom throng of the departed had filled the city with their howling.

'Actually, I find this quite hard to believe.'[55] Ovid was not alone in his scepticism. Anyone with intellectual tastes, and the money to afford their cultivation, was liable to dismiss the *Manes* as superstition. Some philosophers, fashionable and bold, went so far as to teach that nothing of the spirit survived the grave. Nevertheless, even among the smartest of the smart set, the yearning for immortality abided. Ovid himself, whose exile to the Black Sea had offered him a grim taste of what it might be to descend into the underworld, had grown far too familiar with the threat of oblivion not to fight it to the end. Back in AD 17, amid the various excitements of Germanicus's triumph and his departure for the East, news of the poet's death had created barely a ripple in Rome. His voice, though, had not been wholly silenced. One last collection of poems, one final testament, had remained to be published. 'Time erodes both steel and stone.' So Ovid had written in the months before his death. Nevertheless, from beyond the grave, he continued to defy its corrosive power. So long as he had readers, he was not, perhaps, wholly dead. Time, to that degree, had been cheated. 'The written word defies the years.'[56]

Poets were not alone in appreciating this. The great knew it too. Their names were inscribed everywhere in Rome: on the pedestals of statues, on monuments in the Forum, on publicly displayed lists of consuls and priests, and generals awarded a triumph, reaching way back to the origins of the city. The surest punishment was not death but to be consigned to oblivion. In Spain, the awareness of this had prompted the widespread vandalising of Piso's monuments, while on the Greek island of Samos, in a burst of misapplied enthusiasm, the locals had chiselled out the name of his brother by mistake. In Rome too, the people had clamoured for Piso's name to be erased from every inscription in which it appeared; but this Tiberius had refused. Content though he was to license its removal from a statue of Germanicus, he would go no further. Something more than pity for his old friend had stayed his hand. Rome would no longer be

Rome without the record of all that its great families had achieved. The Princeps knew himself the guardian, not just of his city's future, but of its past.

Tiberius had no illusions as to what this might mean in practice. Bleak, sardonic and much schooled in ambivalence, he was the opposite of naïve. Once, when an acquaintance of his youth attempted to remind him of times gone by, he cut the man off in mid-flow: 'I do not remember what I was.'[57] Much the same might have been said of the vanished Republic. The virtues and ideals to which Tiberius remained emotionally committed were no longer what they were – and Tiberius knew it. The last generation that remembered them as more than quaint anachronisms was inexorably passing away. In AD 22, sixty-three years after the slaughter at Philippi, a particularly venerable mooring to the past was snapped when Junia, the aged sister of Brutus, died. Her brother, who had assassinated one Caesar and perished fighting another, had continued to rank under Tiberius as what he had been ever since his death: a non-person. 'The best cure for a civil war is to forget that it ever happened.'[58] Silence, though, could sometimes be deafening. At Junia's funeral, the effigies of her ancestors, fashioned out of 'shining stone and ingenious wax',[59] had accompanied her to her tomb – but of her brother, the most celebrated of all her relatives, there was no portrait to be seen. Neither was there one of her long-dead husband, a second conspirator against the Dictator by the name of Cassius – and who also, like Brutus, had perished by his own hand on the battlefield of Philippi. Two conspicuous absentees. Watching the procession, no one could fail to be aware of the twin assassins, risen from the land of the dead to greet Junia, prominent among the *Manes*. The old lady's will, when it was read, turned out to contain a second, even more pointed omission. All the leading citizens of Rome were saluted – all save one. Of the Princeps there was not a mention.

Tiberius disdained to show resentment. Women, in his bitter

experience of them, were most trouble when closest to home. Rich and well-connected though Junia had been, she was neither the richest nor the best-connected woman of her generation. That honour, as Tiberius knew none better, rested with a very different widow. In AD 22, the same year that saw Junia make her departure for the underworld, the equally venerable Augusta had herself fallen ill – only to stage a full and sprightly recovery. No one was much surprised. Livia Drusilla, as she had once been called, was well known for her mastery of drugs. There was more, though, to her aura of indestructibility than a well-stocked medicine box. The Augusta, who had cloaked herself in the privileges bequeathed her by her deified husband much as she had always draped herself in her *stola*, was a woman like none in her city's history. Everything about her was exceptional. Priest, tribune, even princeps: never before had male rank worn such disorienting female form. All that, and a mother too. 'How excellently the Augusta served the Republic by giving birth to its Princeps':[60] so the Senate had formally pronounced. A story told of the tree sprung from the laurel sprig dropped decades before into Livia's lap repeated the compliment in eerier form. It was said that its leaves had begun to wither just before Augustus breathed his last – even as one of its branches, carried by Tiberius in his triumph and then planted next to the original tree, had begun to flourish. It was as though the line of the Caesars itself had become the Augusta's to nurture, tend and own. *Genetrix orbis*, people had begun to call her – 'procreatrix of the world'.[61]

Not, of course, that this did much to improve her son's mood. There was more at stake for Tiberius than personal resentment. He could not help but view the abiding influence of the Augusta on affairs of state, despite his best efforts to rein her in, as a standing menace to his own authority. Her meddling in the trial of Piso had been particularly toxic. Plancina, the condemned man's wife, had been a favourite of the Augusta's – and the Augusta made sure to

look after her favourites. Even as Tiberius was washing his hands of Piso, he had been obliged to come to the Senate and appeal to them for Plancina's life. A mortifying experience. The crimes of which Plancina had stood accused, from poisoning to witchcraft, could not have been more sordidly feminine – nor could the spider's web of the Augusta's intrigues, long kept hidden from public view, have been more embarrassingly laid bare. Tiberius, whose distaste for the company of women was matched only by his disapproval of their involvement in affairs of state, had been left doubly besmirched. The dark insinuations of Agrippina that the Princeps was a schemer of murderous hypocrisy, implacably hostile to her and to her children, appeared, to her many admirers, substantiated. Agrippina herself, cheated of her vengeance on Plancina, was left all the more embittered. Relations between her and the Augusta went from bad to worse.

Tiberius, trapped as he was between his mother and his stepdaughter, found himself hopelessly entangled in the meshes of court gossip. On a previous occasion, rather than tolerate the various compromises and humiliations of dynastic manoeuvring, he had walked out on Rome altogether. As Princeps, of course, he could hardly retire to Rhodes – but with Drusus, his son, now seasoned in the demands of leadership, a man with both a triumph and two consulships to his name, Tiberius could at least contemplate a measure of retirement. Anything to get away from the two importunate widows in his life.

Except that soon there would be three. Livilla, the sister of Germanicus and Claudius, was a woman whose husbands had always been characterised by their great expectations. The first had been Augustus's grandson, Gaius; the second her own cousin, Drusus. An ugly duckling as a child, she had grown up a famous beauty, commended to the Senate by her husband as his 'best beloved'.[62] Tiberius too had reason to value her: in the grim weeks that followed Germanicus's death, she had provided her uncle with a brief respite

from the crisis by giving birth to twin boys. Livilla, though, was decid-
edly not a woman to bring harmony where there was discord. As a
child, she had been notably spiteful, mocking her younger brother
Claudius for his disabilities – and as an adult, she would prove no
less malevolent. Fractious, flighty, and bitterly resentful of anyone
who threatened her children's prospects, she combined a roving eye
with a deep capacity for hatred. By AD 23, only a couple of years after
her husband had publicly praised her to his fellow senators, their
marriage was in crisis. Drusus himself, whose taste for fast living had
never left him, and whose brutality was so pointed that sharp swords
were called 'Drusian' in his honour, appeared to be entering into a
sharp decline. Hot-tempered and violent, he was increasingly the
worse for drink. At one point, at a party with Sejanus, his erstwhile
partner in the suppression of the Pannonian mutiny, he had lost his
temper and punched the Praetorian prefect in the face. His father,
alarmed, began to worry for his health. Then, in September, Drusus
fell seriously ill. By the 14th, he was dead.

Twice, first with the loss of Agrippa, then with that of Gaius,
Augustus had been poleaxed by such a blow. Tiberius, frozen-faced
as ever, scorned to betray his grief. Arriving in the Senate House, he
calmed the ostentatious displays of mourning. 'I look for a sterner
solace. I keep the Republic in my heart.' Even so, there could be no
disguising the scale of the calamity that had befallen him and his
plans. Bluntly, the Princeps spelt out the implications to his fellow
senators. He had been banking upon Drusus, he explained, to mould
and train Germanicus's sons, who bore in their veins, thanks to their
mother, the blood of the deified Augustus. Ushering in Caligula's
two elder brothers, Nero and Drusus, Tiberius commended them
to the House. 'Adopt and guide these young men – these offspring
of an incomparable bloodline.'[63] It was a raw and painful moment.
Tiberius's increasing sense of exhaustion; his longing for a partnership
that might help to alleviate it; his yearning to believe that loyalty to

Augustus might yet be squared with the traditions of the Republic: all were laid bare. When the Princeps ended his address by promising, in a tone of high emotion, to restore to the consuls the reins of power, he may even have believed what he was saying.

If so, however, it was only for a moment. Tiberius's words were met in the Senate House with sullen scepticism. His listeners had heard it all before. Tiberius too, after a decade of struggling to educate senators in what he expected from them, had begun to despair of their partnership. 'Men readied for slavery,'[64] he had taken to muttering under his breath as he left the House. Hardly surprising, then, with Drusus dead and the Senate a broken reed, that Tiberius should have begun to cast around elsewhere for support. Heir of the Claudians though he might be, he did not scorn the ambitions of the upwardly mobile – provided only that they were able. Men of the meanest origins imaginable, even men rumoured to have been fathered by slaves, had been known to get Tiberius's backing. 'His achievements,' so the Princeps observed of one such parvenu, a gladiator's son who would eventually rise to become governor of Africa, 'are paternity enough.'[65] The more isolated and weary Tiberius came to feel, the more cause he had to value such servants. This was why, in the desolating aftermath of Drusus's death, he did not turn to one of his own bloodline for succour, nor to one of the companions of his youth, nor to anyone in the Senate House, but to a mere equestrian, an Etrurian from a drab and provincial background: Lucius Aelius Sejanus.

Even while Drusus was alive, Tiberius had been honouring the Praetorian prefect with marks of favour. Other people brought him problems; Sejanus brought him solutions. When Pompey's great theatre caught fire, it was the Praetorians who rushed to fight the flames and prevent them spreading; in recognition of this, and in obedience to Tiberius's evident wishes, the Senate voted to honour the Prefect with a bronze statue in the rebuilt complex. Naturally, the majority

of senators did so through gritted teeth, but there were sufficient of them alert to the shifting tides of influence, or who had been admitted to the Senate by Sejanus's influence, to provide the Prefect with a potent faction. By AD 23, the year of Drusus's death, he had begun to establish himself even more decisively as the coming man. In the north-easternmost corner of Rome, on one of the highest vantage points in the city, workmen had been labouring for two years on a massive construction project. Walls of brick-faced concrete and gateways bristling with towers sheltered within them a massive grid of barracks: the unmistakable stamp, branded onto the very fabric of Rome, of a legionary camp. No longer, under Sejanus's prefecture, were the Praetorians to be scattered across the city. The days of veiling their existence were over. Instead, concentrated within a single fortress, and commanded by officers appointed by the Prefect himself, they were now directly in the capital's face. Equestrian Sejanus may have been, but what magistracy was there open to a senator that could compare for sheer intimidating menace with command of the Praetorian camp?

Sejanus himself, though, was painfully aware that his power as yet rested on shifting sands. He held no magistracy, was not even a senator. His authority was no more legally grounded than that of Maecenas had been. Without Tiberius he would be nothing – and Tiberius was sixty-five. The death of Drusus, though, had enabled Sejanus to glimpse a dazzling opportunity: the chance to establish himself, not as a Maecenas, but as an Agrippa. The August Family, now that Tiberius had lost his son, consisted principally of untested boys. Were the Princeps himself now to die in turn, there would be an urgent need for someone to serve as regent to his heir. After all, as Tiberius himself had openly acknowledged to the Senate, Germanicus's sons would never prove worthy of their descent from Augustus without attentive grooming. Sejanus, skilled as he was in the near impossible task of reading his master's thoughts and

fathoming the many ambivalences that characterised them, had long since recognised the paradox that lay buried in their depths. Between Tiberius's devotion to the Senate as he imagined it should be, and his contempt for it as it actually was, existed an irreconcilable tension. To an operator as penetrating and subtle as Sejanus, there lurked here a tantalising opportunity. The faith that Tiberius had so publicly expressed in the Senate as the guardian of young Nero and Drusus was a precarious thing. Confidence and suspicion, in the Emperor's mind, were merely different sides of the same coin. Admiration for the codes of his class, for the traditions of the Senate, for the legacy of the Republic: all might easily be corrupted. The task of perverting Tiberius's instincts, and playing upon all that was most paranoid in his complex and mistrustful mind, was one for which Sejanus, in the event, would prove lethally fitted.

The key to the Prefect's strategy was Agrippina. Haughty, combustible, and impatient to see her sons elevated to the rank that she believed appropriate to their lineage, everything about her served to rub Tiberius up the wrong way. When Sejanus whispered in his master's ear that her ambitions were breeding factionalism in the Senate, just as those of her mother had once done, the Princeps was inclined to believe it. The first open flashpoint between the two came early in January 24. It was the turning point of the Roman year, and Janus, the god after whom the month was named, served as its gatekeeper. Two faces he had: one gazing backwards, at time past, and one looking fixedly into the future. An appropriate moment, then, for priests to offer up prayers for the safety of the Princeps. That particular year, though, there was a change to the formula. The names of Agrippina's two eldest sons, Nero and Drusus, were mentioned alongside that of the Emperor. Tiberius exploded. When he demanded to know of the priests whether the boys had been included at their mother's request, they flatly denied it; but the Princeps was barely mollified. The sinister precedent of the teenage Gaius and Lucius, shamefully

over-promoted decades previously, still weighed on his mind. In a speech to the Senate, Tiberius sternly warned against spoiling the young princes. Agrippina, meanwhile, was only confirmed in her resentment of him. Relations between the two turned icier still.

Sensing his opportunity, Sejanus made sure not to waste it. His priority, if he were to isolate Agrippina and weaken her hold over her sons, was to destroy her allies in the Senate. Naturally, under a Princeps as respectful of legal proprieties as Tiberius, there could be no question of resorting to open violence in pursuit of this goal – but Sejanus had no need to do so. It was the law itself which constituted his weapon of choice. Over the course of the year, a number of prominent men who had seen service with Germanicus were brought to trial by the Prefect's allies in the Senate. The charges ranged from extortion to *maiestas*. One committed suicide before a verdict could be reached; others were dispatched into exile. Nothing about the process ranked remotely as unconstitutional. The law courts had always been an arena in which the great manoeuvred for advantage. The ability to sway judges was a talent that had been the making of many an ambitious senator. Although to defend a man from the hounding of his enemies was traditionally regarded as the more honourable course for an orator to take, no disgrace attached itself to prosecution. Tiberius, who had himself secured the conviction of a would-be assassin of Augustus when only twenty, certainly saw nothing untoward about it. 'It is perfectly acceptable to bring prosecutions, just so long as it is done as a service to the Republic, in the cause of bringing down its enemies.'[66] How, then, could the Princeps fail to approve what was hallowed by both tradition and his own example?

Sejanus, though, with his pathologist's eye, had penetrated more deeply into the changed circumstances of the age than his master. The law, long cherished by senators as the bulwark of their liberty, now promised the man ruthless enough to exploit it the perfect opportunity to terrorise even the boldest among the elite into abject

submission. The irony of this was peculiarly bitter. What had deliv-
ered the Senate into Sejanus's hands was an innovation originally
designed to enhance its dignity. Once, back in the rumbustious days
of the Republic, trials of the great had been a public entertainment,
staged before the full gaze of the Roman people – but no longer.
Instead, under Augustus, senators had been granted leave to sit in
judgement on their own, in the privacy of the Senate House. At the
time, they had greeted this as a novel and welcome burnishing of
their status. Now, too late, they found that it had been a trap. The
senator sitting in judgement on a peer accused of treason against
the Princeps could not help but feel exposed. His vote was bound
to be monitored. So too the enthusiasm with which he pushed for
conviction. The more splenetically he demanded punishment, the
more would his loyalty be noted. Sejanus had no need to bully his
enemies into silence. He could leave senators themselves to do that.
Paranoia and ambition would combine to keep them all at one
another's throats.

Nevertheless, keen to rub his message home, the Prefect made
sure to demonstrate what the penalty for any outspokenness would
be. First, the inveterately abrasive Cassius Severus, who had been
exiled to Crete in the dying days of Augustus's reign, was retried and
sentenced to an altogether bleaker prison: a tiny rock in the Aegean.
Then, the following year, came an even more ominous development.
Back in 22, when the Senate had voted to place a statue of Sejanus in
Pompey's theatre, only one senator, a noted historian by the name
of Cremutius Cordus, had dared to protest. Now, three years on, the
Prefect unleashed his attack dogs. The charge against Cremutius was
a novel and chilling one: that in his history he had praised Brutus
and Cassius, and named them 'the last of the Romans'.[67] When the
wretched historian, rising to his feet, protested to his fellow senators
that the liberty to praise the dead, no matter who they were, was an
ancient birthright of their city, and one that Augustus himself had

personally sanctioned, Sejanus's agents howled him down. 'And as they barked at him, he knew himself cornered.'[68] Leaving the Senate, Cremutius headed directly home. There, he starved himself to death. An application by the prosecution that he be force-fed, the better to inflict on him an edifying punishment, was registered too late with the consuls to be put into effect. His books, by official decree of the Senate, were burned.

The fate of Cremutius, destroyed because of what he had written about the past, offered to senators the glimpse of a terrifying future. It was one in which every bond of citizenship, every link of friendship, every web of favour and obligation, threatened a snare. A shared confidence at a dinner party, a snatch of conversation in the Forum: risk suddenly lurked everywhere. 'To comment on anything was to risk prosecution.'[69] Familiarity, in such a world, was a kind of infection.

The gods clearly agreed. As though in mockery of the new spirit of dread abroad in the Senate, they now sent to Italy a disease that spared the masses, and women of every class as well, but struck devastatingly at men of the elite. Manifesting itself first as an inflammation of the chin, before going on to cover the entire face and upper body 'with a hideous scale',[70] it was spread by their habit of kissing. *Mentagra*, Tiberius termed it, grimly humorous as ever – 'gout of the chin'.[71] By an official edict, he forbade citizens to give one another even the most innocuous peck upon the cheek. Gestures that once had served to celebrate a shared union now spelt only danger. The more intimate a relationship, the more it threatened calamity. The Roman upper classes knew themselves disfigured, blighted, sick.

So too, looking in the mirror, did the Princeps himself. Bald and bent with age, his face had grown ulcerous with sores. Whether it was *mentagra* itself that had come to afflict him, or some other ailment, Tiberius needed no reminder of how treacherous close contacts might be. Within his own household, attempts to patch over the various rivalries and hatreds festering within the August Family were

barely more effectual than the plasters that speckled his face. No moment so sacred, no moment so intimate, that it might not start to suppurate.

Even a sacrifice raised to Augustus was capable of being ruined. It was Agrippina, bursting in on her uncle as he was seeking the favour of his deified predecessor, who desecrated one such ritual. Distraught that yet another of her intimates was being brought to trial, she laid the blame, not on Sejanus, but on Tiberius himself. The sight of her uncle standing before a statue of her grandfather, his head piously covered by his toga as befitted a priest, drove Agrippina into a paroxysm of fury. 'A man who offers up victims to the god Augustus,' she spat, 'ought not to be persecuting his descendants! You think that his divine spirit has been interfused into mute stone? No, if you want his true semblance, then look for it in me – a woman with his heavenly blood in her veins!' Tiberius only fixed Agrippina with a baleful gaze, then reached out and held her with his skinny hand. 'So,' he hissed, 'you think that your not being in power means you suffer persecution?'[72]

It still needed one final confrontation, one climactic insult, before the breakdown in relations between the two could be rendered terminal; and it was engineered, inevitably, by Sejanus. The Prefect, who had his agents everywhere, even among the circle of Agrippina's friends, employed them to deliver a fatal warning: that Tiberius was planning to poison her. The charge could not have been more grotesque – but Agrippina believed it. Invited to dine with her uncle, she ostentatiously refused to touch her plate. When Tiberius, scarcely able to believe his eyes, directly offered her an apple, she passed it to an attendant uneaten. That a man who had first drawn his sword in defence of Rome while he was in his teens, who had twice saved his city's dominions from implosion, who over the course of his long and incomparably distinguished career had fought many a battle, staring into the whites of his adversaries' eyes, meeting their steel with his

own, and washing himself in the gouts of their blood, should now be charged with so underhand, so offensively feminine a crime: here was a mortal slight.

And not only to the Princeps. To the Augusta as well. The rumours reported of her activities had, if anything, grown only darker since her elevation to near-divine status. It was whispered, and widely believed, that Augustus himself had been the victim of her lethal facility with poison. On the last day of his life, it was reported, Livia had gone out into the garden of the villa where they were staying, and smeared the fruit of the fig tree that was growing there with venom – which Augustus, whose love of figs was well known, had promptly devoured. Now, by spurning Tiberius's offer of fruit so blatantly, Agrippina was raking up the embers of this slander, insulting the mother as well as the son. The Princeps, scorning to dignify his step-niece's gesture with a direct acknowledgement, turned instead to the Augusta. 'Who can blame me,' he demanded, 'that I should contemplate stern measures against a woman capable of alleging that I would poison her?'[73]

He had already put in place one particular measure. He flatly refused to grant Agrippina permission to remarry. So badly had this gone down with her that she had ended up sobbing into her sickbed. Surely, she had pleaded, there were men in Rome who would reckon it no dishonour to shelter the wife of Germanicus and his children? Indeed there were – which was precisely why, of course, Tiberius refused to countenance it. A widowed member of the August Family was dynastic gold. It did not help that rumour linked Agrippina to a man the Princeps particularly detested: an able and ambitious ex-consul by the name of Asinius Gallus, whose contributions to debates in the Senate had always been reliably snide.[74] Worse, Gallus had been married to Vipsania, the woman divorced by Tiberius many years previously on the orders of Augustus, and who had always remained the one true love of his life. The prospect of welcoming such a man

into the August Family was too monstrous to be borne. Gallus's personal failings, though, were not the principal stumbling block. Had he never been a trouble-maker, had he instead been a loyal and supportive ally, the Princeps would still have refused permission. Agrippina, and Livilla as well, were far too valuable to be sprung from their widowhood.

Even Tiberius's most trusted deputy had been unable to shake him from this resolution. Agrippina was not the only person in his immediate circle with marriage on the mind. Back in 23, the year of Drusus's death, Sejanus had divorced his wife, Apicata. Despite giving him three children, her rank had failed to keep pace with the Prefect's ambitions – and so, naturally, she had had to go. For two years, Sejanus had bided his time. When he finally made his move, in 25, his aim could hardly have been set higher. Writing to Tiberius, it was to make a formal request for the hand of Livilla. A rare false step. Taken by surprise, the Princeps prevaricated. Reluctant though he was to deliver Sejanus a direct snub, he made clear his reservations. Allowing Livilla to marry, he explained, would inevitably intensify the rivalry between her and Agrippina. The two women already detested each other. To worsen their mutual hatred was a risk not worth the payback. 'It would effectively split the House of Caesar in two.'[75] Sejanus, taking the hint, had beaten a retreat.

The episode, though, had not been without value to the Prefect. Tiberius, normally so close and secretive, had revealed depths normally kept well concealed. Sejanus appreciated better than anyone else in Rome the full degree of his master's exhaustion: with the women in his household, with the various factions in the Senate, with the capital itself. 'So it was that Sejanus began to cast the drudgeries of the city, its jostling crowds and all the people endlessly pestering Tiberius, in the worst light possible; and to speak in praise of calm and solitude.'[76] These sentiments were nothing

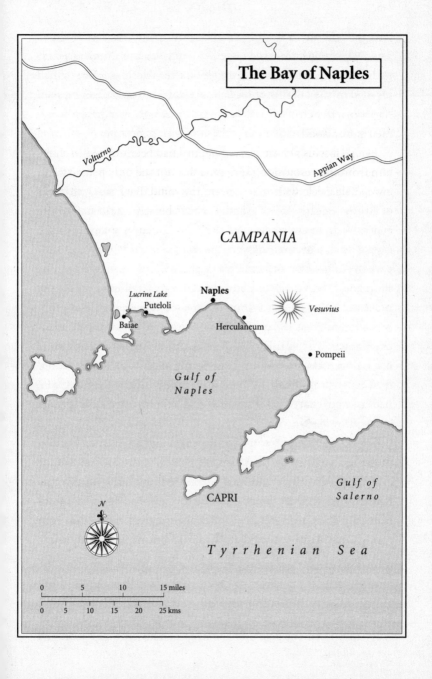

The Bay of Naples

CAMPANIA

Lucrine Lake
Puteloli
Baiae
Naples
Vesuvius
Herculaneum
• Pompeii

Gulf of Naples

CAPRI

Gulf of Salerno

Tyrrhenian Sea

Volturno

Appian Way

| 0 | 5 | 10 | 15 miles |
| 0 | 5 | 10 | 15 | 20 | 25 kms |

radical. Retirement was not an alien principle to the Roman elite. The citizen who had served his fellows well was rarely begrudged his withdrawal from the political rough-and-tumble. Just as Horace had revelled in the charms of his Sabine farm, so would distinguished senators retreat from Rome to enjoy the out-of-town leisure activities appropriate to their rank: chatting with philosophers, showing off priceless works of art, adding extensions to their already massive villas. Swanky estates were to be found dotted across the Italian countryside; but the largest concentration lay along the coast south of Rome. In the Bay of Naples, which boasted real estate more expensive than anywhere save the most exclusive quarters of the capital itself, so numerous were the villas lining the coast 'that they gave the impression of forming a single city'.[77] Some might hug the shoreline, others perch on cliffs – but all bore dazzling witness to the premium set by eminent Romans on a sea view. A high-end property overlooking the Bay of Naples had long been an accepted mark of greatness. The villa left by Julius Caesar to Augustus, perched as it was on a rocky promontory, was renowned as a particular beauty spot. Augustus himself, by dying after a pleasant few days on Capri, had enjoyed what many Romans would have regarded as the perfect send-off.

Loyalty to him in Campania, the region which boasted the Bay of Naples, had been particularly strong. Back in the dark days of the civil wars, when Italy had been menaced by pirate fleets, Agrippa had moored his ships directly among the bay's most famous oyster beds, in a sheltered stretch of water named the Lucrine Lake, not caring what damage they did. The civil wars, though, had ended, and the fleet had been moved to a new base on a nearby promontory, where any damage to shellfish could be kept to a minimum. The Bay of Naples, beautiful and deliciously expensive, had come to serve as the principal ornament of the peace presided over by Augustus. Even the beasts of the deep had arisen to applaud it: a

dolphin, as though sent by the gods to proclaim the new era, had befriended a boy who lived beside the Lucrine Lake and carried him every day to school. The story, which seemed conjured from a vanished world of myth, exemplified the distinctive appeal of the Bay of Naples, combining as it did the height of fashion with a distinctively antique feel. Certainly, to a man of Tiberius's sophisticated cultural tastes, the region offered more than just baths and oysters. If not quite as Greek as Rhodes, the island to which he had retired many years previously, it preserved a flavour of something inestimably precious: a touch of the settlers from Greece who, many centuries before, had come sailing into the bay and founded Naples. Nowhere, in short, promised the grim and weary Princeps a more tempting refuge. Naturally, it was out of the question for him to relinquish the charge entrusted him by the gods and the deified Augustus – but this did not have to be an insuperable problem. Campania was only a single day's ride away from Rome. A Princeps of sufficient acumen could certainly look to rule the world from there. It would need only one thing: a deputy back in the capital able and loyal enough to merit his trust.

Already, in AD 21, Tiberius had tested the waters by spending much of the year in Campania. Now, five years on, he planned an even lengthier stay. Setting out from Rome, he travelled relatively light. Only a single senator accompanied him. Also in his train were an assortment of literary scholars, men who shared Tiberius's fascination with abstruse details of mythology, and who could cope with the fiendishly difficult quizzes that the Princeps was in the habit of springing on his guests. Sejanus too, ever the devoted deputy, rode with the party. Although, as his master's proxy in the capital, he could hardly be spared for long, he and the rest of the party made a leisurely speed. Sixty-five miles south of Rome, Tiberius turned off the Appian Way and headed along a side-road for the coast. Here, waiting for him on the seafront, stretched an

enormous estate: the villa of Spelunca. Sheer scale, though, was not the only aspect of the complex appropriate to his greatness. Beyond the residential quarters, up hills and past promontories, amid arbours and pavilions, in gardens, by walkways and on cliffs, works of art had been placed with masterly precision, so as to seem almost alive when illumined by torches and framed by the twilight. Some were antiquities, some freshly sculpted – but all bore witness to their owner's distinctive interests. Holding up a mirror to his fascination with the dimensions of myth, Spelunca served the Princeps as a landscape of fantasy – peopled by gods, and heroes of epic, and fabulous beasts. An emperor in such a theme park of wonders might well feel, even if only for an evening, that he had left the pressures of the capital far behind.

Once, back in the time of Aeneas, a second hero – a Greek – had come sailing past Spelunca. Although called Odysseus by his own people, in Latin he was known as Ulysses. Famously crafty and famously long-suffering, he had spent ten long years struggling to get home from the sack of Troy – fighting off monsters and negotiating with witches as he did so. Tiberius, who knew for himself what it was to struggle against debacles and domineering women, clearly felt an affinity with the hero.[78] Down by the sea, where a natural cave looked out onto the waters once plied by Ulysses, Tiberius had fashioned the most remarkable dining space in the world. *Haute cuisine* was one of the few extravagances on which the notoriously stingy Princeps delighted in lavishing his wealth. A noted wine snob, with a taste for vintages that had been treated with smoke, he also took a particular interest in vegetarian cooking – whether it was discovering a new variety of asparagus, sourcing exotic root vegetables from Germany, or insisting over the heads of rival gourmands that cabbage was far too delicious to rank as vulgar.

Nowhere, though, had his fascination with the arts of the table expressed itself more innovatively than at Spelunca. Pools washed

with sea water enabled fish to be cooked fresh on site; pontoons over the shallows permitted guests to enjoy their banquet directly in the mouth of the cave, to the lapping of the sea all around them; flickering torches lit the inner depths of the grotto. 'There, nature had ingeniously imitated art'[79] – but not so ingeniously as art had then embellished nature. Immense statues illustrating various exploits of Ulysses provided diners with an incomparable tableau. A monster rose out of a pool inside the cave; a one-eyed giant sprawling on his back filled its innermost recess. Fine food, spectacular sculpture and a setting pregnant with myth: even Tiberius could feel happy at Spelunca.

Perhaps, though, it was possible to be too close to the world of epic. The giant eerily illuminated by torches in the rear of the cave had been the son of Neptune, god of the seas, who was known, thanks to his habit of lashing out periodically with his trident, as 'Earth-Shaker'. The tremor, when it came that evening, hit Spelunca without warning. Boulders began to fall, crashing down onto the mouth of the grotto. Numerous attendants bringing food were crushed in the avalanche, while the guests, rising in panic, fled for safety across the shallows. The elderly Tiberius, struggling to his feet, was unable to make his escape from the cliff-face – and the Praetorians, when they came hurrying to the scene of disaster and saw only rubble where the Princeps had been lying, inevitably feared the worst. Clambering over the debris, they heard the voice of their prefect calling out to them; and when they pulled away the boulders, it was to find Sejanus crouching over his master on hands and knees, the embodiment of a human shield.

A miracle – and pregnant with meaning, clearly. Tiberius himself took away two lessons from the episode. First, that he had in Sejanus an incomparably trustworthy servant, a man who could be trusted with anything. Second, that the gods had delivered him a warning never again to set foot in Rome.

Caprice

AD 28. The first of January. A propitious and joyous time. It was a day when the perfume of burning saffron hung heady over the Forum; when temples were unbolted and altars reconsecrated to the gods; when fat bullocks were led up to the summit of the Capitol and their necks bent to the axe. Meanwhile, in the Senate House, a letter was being read out from the Princeps, offering the traditional season's greetings. Few senators were expecting any surprises. It was a holiday, after all.

This time, though, there was to be a twist. A year and more Tiberius had been absent in Campania – but he still had his eyes and ears in Rome. The man he had taken to calling 'the sharer of his cares'[80] was tireless in his cause. Sejanus had his spies everywhere – sniffing out subversion, keeping track of sedition. Now, Tiberius informed the Senate, a particularly shocking instance of *maiestas* had been uncovered. An equestrian by the name of Titius Sabinus had spoken blatant treason to one of Sejanus's undercover agents. Three more of them, squeezed into Sabinus's attic, had overheard every last word. Since all four of the Prefect's agents were prominent senators, there could be no disputing their evidence. Sabinus had slandered the Princeps, suborned his servants, plotted against his life. Clearly, then, his fellow senators knew what they had to do. And do it they duly did.

When the Praetorians came for Sabinus, they jerked a hood down over his head, then slung a noose around his neck. His despairing protest, bleak and punning, was worthy of Tiberius at his most sardonic: a muffled lamentation that sacrifice was being offered up, not to Janus, but to Sejanus.[81] Then he was hauled away, his destination the city's prison. Unbolted that same day as Rome's temples had already been, it swallowed up Sabinus into its bowels. Soon afterwards, a limp bundle was slung out onto the Gemonian Steps. There, where Piso's statues had been vandalised eight years earlier, the corpse of

the executed man was exposed to the gaze of the Forum. As crowds gathered, drawn by the spectacle, his dog stood guard over the body and howled inconsolably. When people tossed it scraps of food, it would carry them back to its master and lay them beside the corpse's mouth; and when, in due course, men came with hooks to drag Sabinus to the Tiber, the dog followed the body all the way to the river, then jumped in after it, 'trying to keep it from sinking'.[82]

Ever given to sentimentality, the Roman people could recognise in the misery of this faithful hound a mirror of their own grief for the family of Germanicus. Sabinus had been a close associate of their dead favourite, and in his fatal discussions with Sejanus's *agent provocateur* had aggressively expressed his pity for Agrippina. Tiberius's departure from Rome had done nothing to ease the pressure on the unhappy widow. Just the opposite. Operating on the presumption that the Princeps had washed his hands of Agrippina once and for all, Sejanus had felt licensed to work ever more openly for the downfall of her family. His particular target was her oldest son, Nero – who, as the heir apparent, represented the most immediate threat to the Prefect's own prospects. It helped that Nero himself was brash and headstrong; helpful too that Drusus, the next in line, was so consumed by envy of his elder brother that he preferred to side with Sejanus.

Only Caligula, the youngest of Agrippina's three sons, was too clear-sighted to play the Prefect's game. Still in his mid-teens, the travails of his family had already bred in him a pitiless appreciation of how capricious and cruel the workings of power could be. Certainly, he felt no obligation to share in the doom closing in on his family – not if he could possibly help it. Accordingly, when Agrippina was obliged by Sejanus to leave Rome, and found herself placed under effective house arrest in Campania, Caligula turned for sanctuary to the one person with sufficient authority still to defy the Prefect. 'Ulysses in a *stola*',[83] he nicknamed the Augusta – high praise indeed, coming from an operator of his already seasoned aptitude for

cunning. She in her turn delighted in her great-grandson as a chip off the old block. Caligula – for the moment, at any rate – could reckon himself safe.

Which was just as well. The noose was tightening all the time. With Sabinus dead, Tiberius wrote again to the Senate, praising it for its prompt action in keeping the Republic from danger, and hinting darkly at further plots. Even though he mentioned no names, everyone knew whom he meant. When Sejanus, in his regular briefings, warned his master of the iniquities of Agrippina or the thuggishness of Nero, there was no one now to contradict him. So determined had Tiberius been to leave behind the gossip and importunities of court life that even Campania had proven inadequate to his purposes. Within a few months of his arrival there, he had abandoned its various pleasure resorts, evacuating himself and his retinue to Capri, the private island bequeathed him by Augustus. There, where no one could approach its two jetties, let alone land on them, without his express permission, he could feel far from the madding crowd at last. From his family too. Decades previously, campaigning in Pannonia or Germany, Tiberius had always been a general to put a premium on security. The man who on his campaigns had invariably slept without a tent, the better to avoid the risk of assassination, now lived in dread of his own relatives: a frightened and unhappy woman, a gauche and inexperienced boy. What had once been a healthy instinct for self-preservation was darkening, in old age, into paranoia.

Tiberius's retreat to his cliff-girt island, though, was no abdication. He remained too much a man of duty to turn his back entirely on the charge bequeathed him by Augustus. The Princeps held true to his responsibilities both to the August Family and to the Roman people. So it was, even as Agrippina found herself placed under ever stricter supervision, that he arranged to provide her daughter and namesake with a match worthy of her status: Gnaeus Domitius Ahenobarbus, impeccably aristocratic son of the first Roman commander to cross

the Elbe. So it was too, whether by inviting privileged guests over to join him on Capri, or by going on the odd foray to the mainland, that the Princeps set limits on his isolation. He would still, every once in a while, make himself available to the privileged few. Those who wished to see him, though, had no alternative but to do so fully on his terms. Tiberius had not the slightest intention, as yet, of heading back to Rome. Even the grandest senators were obliged to beat a path to Campania – where they might well find their access to the Princeps held up or even barred by Sejanus. Many, to their indignation, were reduced to camping out on the Bay of Naples, among the various other suitors. The shame of it was deeply felt. To be reduced to crawling before a mere equestrian; to begging him for favours; to serving his interests in exchange for his patronage, like the humblest, most cringing of spongers: these, for the elite of Rome, were unconscionable humiliations. Yet what was the alternative? Senators found themselves stumbling through a strange and terrifying world – one in which everything seemed turned on its head. Honours, once the badges of glory and achievement, now served to brand those who gained them as crawlers. Pedigree and independence of mind, the qualities most admired by Tiberius in his fellow senators, seemed ever more likely to spell their ruin. 'As for a famous name – that threatened death.'[84]

And, of course, it threatened no one more than Augustus's descendants. A year on from the execution of Sabinus, and two deaths served to herald the endgame. The first was that of Agrippina's wretched sister Julia, exiled more than twenty years by her deified grandfather, and breathing her last on the tiny island where she had been languishing ever since. She had been a prisoner so long that it came as news to many people in Rome that she had not died years before – but the same could hardly be said of the second loss suffered by the August Family in 29. The death of the Augusta, whose father had perished at Philippi, who had shared the bed of a god, and who

had been awarded more titles, honours and tokens of rank than any other woman in her city's history, was experienced by the Roman people as a fateful moment, one last farewell to a past already becoming legend. So moved were senators that they even voted to raise an arch in her honour. Tiberius, whose grief at the loss of his mother appeared decidedly muted, did not approve. The proposal was quietly buried. So too, with the stern admonition that the Augusta herself would never have been so vain as to lay claim to divine honours, was a senatorial vote to declare her a goddess. The funeral itself was a modest affair. Tiberius, who had been vacillating for days about whether to leave Capri for the ceremony, did not in the event appear. The Augusta's body had already begun to stink by the time it was finally consigned to the flames. The funeral address was delivered, to universal praise, by the seventeen-year-old Caligula.

Who was painfully aware, of course, even as he gave his speech, that the future had just turned a little more uncertain. Others too had good cause to be nervous. Over the next few years, many of the Augusta's protégés would be brought to ruin. These ranged from consuls to women such as Piso's widow, Plancina. Most prominent of all, though, was Agrippina. No matter that she and her grandmother had never got along, the Augusta had always been a woman to hold Tiberius to his obligations. For as long as he had been Princeps, she had served him as a living reminder of his duty to Augustus – who had never left anyone in any doubt that the sons of Germanicus were his appointed heirs. Certainly, in the minds of their devoted admirers, it was no coincidence that a letter from the Princeps denouncing both Agrippina and her eldest son, Nero, should have arrived in the Senate House almost the moment that the Augusta's funeral was done. As crowds massed in the Forum, brandishing likenesses of Agrippina and Nero and chanting that the letter was a fake, the senators squirmed. Unclear what it was exactly that the Princeps intended them to do, they did nothing. Menaces

from Sejanus, and a second letter from Tiberius, left them no room for doubt. Obediently, the Senate then did as prompted. Agrippina and Nero were both condemned as conspirators against the Princeps, and Nero, for good measure, declared a public enemy. But were these measures really sufficient to the horror of their crimes? If only, the Senate added unctuously, they could be sentenced to death! Tiberius, though, had other plans. As ever, he was guided both by what was strictly legal, and by the example of Augustus. Nero and his mother, shackled and under heavy guard, were transported to separate prison islands off Italy. Agrippina, in a twist typical of Tiberius's baleful humour, was sent to Pandateria, where Julia, her mother, had long before been sent by Augustus.

For the Princeps, ever one to savour a grudge, the official condemnation of his ex-wife's daughter was a delicious vindication of his darkest suspicions. For Sejanus too it was a mighty triumph. He knew, however, to a degree unsuspected by Tiberius, how foully he had played in framing Agrippina; and he knew as well, high though he had mounted the ladder, how parlous were the rungs he still had left to climb. Two goals remained to be met: the final elimination of Germanicus's heirs; and the establishment of a right of guardianship over Drusus's. Of the two sons that Livilla had delivered her husband back in 20, only one now remained to her, a nine-year-old nicknamed in memory of his dead sibling 'Gemellus' – 'the Twin'. Were Germanicus's two remaining sons to be declared public enemies, as Nero had already been, then Gemellus, as Tiberius's grandson, would be the only heir left standing.

Not that Sejanus was alone in appreciating this. Livilla, who had enjoyed Agrippina's downfall as much as anyone, was fully alert to the ally she had in the Prefect. The prospect of seeing her son as Princeps, over the heads of Nero, Drusus and Caligula, was one calculated to delight her envious and ambitious spirit. Already she had played an enthusiastic part in Sejanus's schemes. Her daughter, Gemellus's

elder sister, had been married to Nero, and on Livilla's instructions
had served the Prefect as his eyes and ears. Just as Sabinus had been
doomed by spies in his attic, so Nero had been betrayed in his bed.
There was nowhere, it seemed, beyond the Prefect's reach.

Yet even as his fellow citizens, cringing before his fame and
power, began to pay him honours so extravagant that they seemed
to cast him, not as the servant of the Princeps, but as his partner,
Sejanus never forgot how precarious the foundations of his great-
ness remained. That his statues were paired with those of Tiberius;
that formal delegations had taken to meeting him at the city gates
whenever he returned to Rome; that some had even begun to offer
sacrifices to his image, almost as though he were the DeifiedAugustus
himself: none of this deceived the Prefect. His fortunes still hung by
a thread. Without the favour of Tiberius, he would be nothing. A
year on from the downfall of Agrippina, a fresh triumph over her
sons served, by a frustrating irony, only to emphasise this all the
more. The same dirty tricks that had done for Nero now secured
the condemnation of Drusus as well. The suborning of the young
man's wife, the briefings against him by security agents, the slanders
whispered in his grand-uncle's ear by Sejanus himself, proved more
than sufficient to doom him. Proclaimed by the Senate a public
enemy, as his elder brother had been, Drusus was immured in a
dungeon on the Palatine. Now, with only Caligula standing between
Gemellus and the succession, Sejanus had ultimate victory almost
in his grasp. Almost – but not quite. Caligula, who had been staying
with his grandmother, Antonia, after the death of the Augusta, was
summoned by Tiberius to Capri. There, of course, he was effectively
beyond the Prefect's reach. That Caligula himself was as much the
hostage as the guest of his great-uncle helped Sejanus not at all. To
frame a young man directly under Tiberius's nose was an almost
impossible challenge – even for a practitioner in the arts of disinfor-
mation as seasoned as the Prefect.

What, though, if he could end his dependence on the patronage of his master? In Rome, a shift in the balance of power between the two men was increasingly bruited. Tiberius, absent from the capital for four years, had begun to seem to many a shrunken and faded figure – 'the lord of an island, nothing more'.[85] The Prefect himself knew better; but he also knew that his patron, weary of Rome and weary of life, would not be around for ever. Time was running out. Having come so far, Sejanus could no longer depend for his future prospects upon the favour of a sick and aged man. To win he would have to dare.

When news reached Rome that Nero, transported to a penal island the year before, was dead, few failed to detect the hand of the Prefect in his miserable and squalid end. A guard, it was rumoured, had appeared before the prisoner, brandishing a noose and a butcher's hook; and Nero, rather than suffer himself to be murdered, had committed suicide. Whether true or not, it added to the aura of menace that clung to Sejanus: the man who commanded access to the Princeps, who had built a legionary camp directly overlooking Rome, who had deployed terror more blatantly in the city than anyone since the darkest days of the Triumvirate. Yet even as he intimidated the Roman people, he made sure to woo them as well. When Tiberius, in a telling mark of favour, arranged for him to become consul and agreed to serve as his partner, Sejanus naturally revelled in his official status as the colleague of the Princeps. Now at last he was a senator; now at last he wielded power that was legally sanctioned. Simultaneously, though, as a man who had risen from provincial obscurity to dizzying heights, his election provided him with the perfect opportunity to pose as something more: as a man of the people. After the formal vote in the Senate House, the new consul-elect staged a flamboyant parade around the Aventine, the hill of the plebs. Here, in a pointed echo of the elections on the Campus banned by Tiberius, he hosted an

assembly. The potential insult to his master was massive – but Sejanus was content to take the risk. Princeps, Praetorians, people: he needed them all.

By 31, the year in which he entered his consulship, the Prefect could feel confident that all his schemes, all his manoeuvrings, all his ambitions were close to fruition. Although Caligula, infuriatingly, remained at liberty, the sense that Tiberius was finally ready to take the decisive step and reveal his long-term plans for his 'partner in toil'[86] began to build with the heat of summer. That spring, bidding his deputy farewell after a consultation with him on Capri, the Princeps had freely expressed his devotion, hugging his deputy tightly and declaring that he could as easily spare his own body and soul as Sejanus. Still, though, even as rumour and counter-rumour swept Rome, no definitive statement arrived in the sweltering city.

Summer turned to autumn. The Prefect continued to sweat. Finally, on 18 October, the long-awaited moment arrived. It was dawn. As Sejanus, standing on the steps of the great temple of Apollo, where the Senate was due to meet that day, gazed out from the Palatine at the waking city, he was joined by a fellow prefect. One-time commander of the city's firefighters, the *Vigiles*, Sutorius Macro had just come from Capri – and he bore with him a letter from the Princeps. It was addressed to the new consul, Memmius Regulus, a trusted henchman of Tiberius who had taken office only three weeks before, and was presiding over the Senate that same morning. In strictest confidence, Macro revealed the letter's contents to his commander. Sejanus was to be given the *tribunicia potestas*, the privileges of a tribune. Momentous news indeed. Back in the days of Augustus, first Agrippa and then Tiberius himself had been granted the identical bundle of powers – and on both occasions, it had served to mark the respective men as the partner of Augustus's labours. Unsurprisingly, then, Sejanus was as delighted as he was relieved. As

he hurried inside the temple, the look on his face was one that every-one could read. Cheers greeted him, and bursts of applause. When he took his place, senators flocked to sit beside him, eager to bask in his glory. Macro, meanwhile, handed over the letter from Tiberius to Regulus. Then he turned and left. Sejanus, listening impatiently to the letter as the consul began to read it out, did not bother to wonder where he might be headed.

Tiberius, of course, had never been a man to cut to the chase. Nevertheless, as senators listened to Regulus read out his letter, they found themselves growing perplexed. Far from praising Sejanus, the Princeps seemed to have only criticisms of his colleague. The placemen who had bunched themselves around him began to inch nervously away. Sejanus himself, listening in consternation, could not move – for various magistrates had stepped forward to block his path. Only after Regulus had ordered him three times to stand did he finally rise to his feet – by which stage it was clear to everyone that Tiberius had cut his deputy loose. When the consul ordered Sejanus to be led from the chamber and incarcerated in the same prison that had once held Sabinus, no one attempted to defend him. As news of the Prefect's downfall swept across Rome, crowds began to mass in the Forum, booing and jeering the prisoner, and toppling his statues as he was dragged past them in chains. When Sejanus sought to cover his head with his toga, they yanked it off him and began punching and slapping him about the face. So much for his attempts to woo the Roman people. Worse than a failure, they had cost him the backing of his patron.

That afternoon, with Sejanus languishing in the city prison, sen-ators reconvened amid the splendour of the building opposite, the Temple of Concord. There, in the supreme monument to the sup-pression of uppity commoners, they voted for him to be executed. He was garotted that same evening, and his corpse slung out, as Sabinus's had been, onto the Gemonian Steps. For three days, teeming crowds

of those who had detested the Prefect for his arrogance, his cruelty and his ambition gleefully kicked and trampled it to a pulp. Only once it had been reduced to an unrecognisable mess was the body finally dragged away on a hook. Slung into the Tiber, the man who had aspired to govern the world ended up as food for fishes.

Meanwhile, flashed along a chain of bonfires, the news was being brought to Capri. As he waited on the island's highest cliff to receive it, Tiberius had been taking nothing for granted. A ship lay at anchor, ready to evacuate him to a legionary base in the event of his plans going wrong. Dread of Macro failing to seize command of the Praetorians, of Sejanus defying the attempts to topple him, of losing his hold on Rome: Tiberius, whose suspicions of Germanicus's family had induced in him such creeping paranoia, had suddenly realised the full, appalling scope of his error. Obsessed as he was by scotching Agrippina, he had failed to consider that he might all along have been nursing a viper at his breast.

It was Antonia, the grandmother of Caligula, who had opened his eyes to the danger. The old woman, having already watched two of her grandsons destroyed by the Prefect, had been frantic to stop him framing a third. Accordingly, in a letter sent to her brother-in-law by her most trusted slave, a Greek by the name of Pallas, she had spelt out her suspicions. To the naturally secretive and suspicious Tiberius, who for so long had cherished his deputy as the one man he could trust, the realisation that Sejanus might have been playing him for a fool was devastating. Even the possibility that the Prefect might pose a menace had been sufficient to doom him. Slowly, surely, inexorably, Tiberius had drawn up his plans. Consummately skilled though Sejanus was in the arts of guile and conspiracy, his master had outsmarted him. The Prefect, taken wholly by surprise, had found himself entangled in a web more lethal than any that he had spun. The spider had ended up a fly.

Nor was Sejanus the only one to perish. Many others were

dragged down with him. Some – his eldest son, his uncle – were formally sentenced to death, others lynched by vengeful mobs. The Praetorians, who felt a particular need to demonstrate their loyalty to the Princeps, did so by rampaging through the city, burning and looting as they went. 'Not a person of Sejanus's faction, but he was trampled down by the Roman people.'[87] The deadliest vengeance of all, though, was taken by Apicata, his abandoned wife. Writing to the Princeps, she levelled allegations against Sejanus so monstrous, so unspeakable, that she killed herself the moment she had made them.[88] Tiberius, having unsealed the letter, read with mounting horror of just how far, and how terribly, he had been deceived. For a decade, Apicata claimed, his most trusted servant had been having an affair with Livilla. Together, the pair of them had poisoned Drusus. There had been no limit to the ambitions, the depravity and the treachery of the couple. Remembering how Sejanus had once requested the hand of his niece, Tiberius could feel the scales dropping from his eyes. A eunuch of Drusus's, a physician of Livilla's: both, when they were tortured, confirmed the truth of Apicata's claims. Tiberius was duly convinced. Handed over to her mother, Livilla was locked up in a room and starved to death. Her statues, her inscriptions, her very name: all were obliterated. Senators, frantic to demonstrate their loyalty to the vengeful Princeps, queued up to damn her memory. Meanwhile, with Sejanus's eldest son already put to death, orders were given for his two youngest children to be taken to the city prison. One, a boy, was old enough to understand what lay ahead; but his little sister, bewildered and not knowing what she had done wrong, kept asking why she could not be punished like any other child – with a beating? Since it would naturally have been an offence against the most sacred traditions of the Roman people to put a virgin to death, the executioner made sure to rape her first. The bodies of the two children, once they had been strangled, were dumped on the Gemonian Steps.

So many judicial murders, so many corpses left to the gaze of the Forum. When Agrippina perished on her penal island, two years to the day after the execution of her deadliest enemy, Tiberius made great play of his mercy in not having had her strangled or exposed on the Gemonian Steps. The downfall of Sejanus had done nothing to ease his mistrust of her. She and Nero had remained in captivity. So too had Asinius Gallus, the man suspected by Tiberius of plotting to marry Agrippina, and whose condemnation a cowed and compliant Senate had been nudged into pronouncing back in 30. For three years the wretched man had been kept in solitary confinement, given just enough to keep him alive, and forcibly fed whenever he attempted to go on hunger strike. To Tiberius, torn between a vengefulness grown more cruel and fearful with old age, and an abiding instinct to procrastinate, such a punishment – a living death – had represented the perfect compromise. Gallus, Agrippina, Drusus: all three, when they finally perished, did so of hunger. Drusus's end was particularly terrible. Like his mother, who had lost an eye during the course of one beating, he had been in the charge of brutal gaolers, soldiers and ex-slaves, who did not hesitate to use the whip on the son of Germanicus at the slightest hint of disobedience. In the final week of his life, he was reduced to gnawing on the contents of his mattress. When he died, it was with screams and imprecations. His final curse on Tiberius was a chilling one: as a monster who had drowned his own family in blood.

When these details were reported to senators, they listened in perplexity, puzzled that a man as secretive as the Princeps should ever have permitted the reporting of such horrors. Tiberius, though, felt no compunctions. The eyes of the Roman people had to be opened. Menace lurked everywhere. Even among his closest advisors, his own family, treason was a constant. It gave Tiberius no pleasure to acknowledge this. He had loved Sejanus, and he had loved his brother – two of whose grandsons had ended up starving to death

in his prisons. The Senate too, that body in which the Princeps had always placed such trust, and in whose interests he had always laboured so hard, had shown itself rotten with ingratitude. To purge it of the taint of collaboration was a murderous task. On one particularly fell day, twenty senators, Sejanus loyalists all, were executed in a single dispatch. Guards ringed the corpses, forbidding relatives and friends to display any marks of grief; and when the bodies were finally hauled from the Gemonian Steps and dumped into the Tiber, they drifted away ponderously on the currents, a rotting tangle of carrion. Yet Tiberius, when he felt that his own security was not at stake, was still willing to grant mercy to a colleague – and to confess to the Senate his state of anguish. 'Every day, I feel myself succumbing to misery.'[89]

Most rife of all with treachery, though, and most seductive, was the capital itself. Every year, in the wake of Sejanus's downfall, the Princeps would set out for home; and every year, rather than enter the city, he would wander the countryside beyond it, or else make camp in the shade of its walls, before scuttling crab-like back down the coast to Capri. To be a permanent exile from Rome was more than he could bear; to return there, impossible. It was a torture that might have been designed by the gods. Certainly, there could be no doubting their hand in Tiberius's reluctance to pass the city gates. The earthquake at Spelunca had been only one of many portents sent to ward him from the city. On one occasion, as he approached Rome, he went to feed his pet snake and found it dead, devoured by ants. So transparent a warning of the menace presented to him by the mob was this that he had immediately turned round in his tracks. Tiberius was skilled in the reading of such signs. Right from the earliest days, they had accompanied his career. While he was a student, 'a donkey had given off large sparks as it was being groomed, thus predicting his future rule';[90] while a young officer, 'altars consecrated by victorious legions in times of old had blazed into sudden fire.' An adept

of primordial wisdom, of veiled mysteries, of the science of the stars,
Tiberius knew how to trace the patterns cast on mortal affairs by the
shadow of the heavens.

Such learning, of course, could be dangerous in the wrong
hands. Back in 12 BC, Augustus had confiscated and burned more
than two thousand books which claimed to reveal the future; two
years into Tiberius's reign, the Senate had ordered all astrologers
out of Italy. Particularly prominent ones risked being thrown off
a cliff. Knowledge of where the world was heading had become
far too sensitive to be permitted the average citizen. A Princeps,
by contrast, needed all the guidance he could get. Tiberius's own
instructor in occult studies was an astrologer by the name of
Thrasyllus, whose talents had first impressed him during his exile
on Rhodes, and who had since become a bosom companion.* The
presence by his side of such a seasoned observer of the constellations
was a great reassurance to the Princeps. The pulse of things still
needed to be kept. Quarantined as he was from the sordid mass of
humanity, Tiberius aimed to fix his gaze instead on higher things,
upon wonders untouched by equivocating senators, fractious mobs
and ambitious widows.

Even Augustus had found Capri a fitting home for marvels. His
villa had been liberally adorned with them: the bones of giants, the
skeletons of sea monsters. Tiberius too had a fascination with such
treasures – so much so that his curiosity about them was celebrated
across the world. Brought the tooth of a colossal hero whose remains
had been exposed by an earthquake in Asia Minor, he had reverently
measured it, then commissioned a full-scale model of the dead man's

* Various stories are told of how this particular astrologer passed the audition. Accord-
ing to one account, he accurately foretold that Tiberius was planning to throw him off
a cliff; according to another, he correctly identified a ship approaching Rhodes as the
bearer of a summons back to Rome.

head.* Such attention to the details of the fantastical was typical of Tiberius. When a merman was spotted playing a conch shell in a Spanish cave, or a mysterious voice was heard crying out from a Greek island that Pan, a god with the legs and huge genitals of a goat, was dead, the Princeps demanded a full report. Witnesses were grilled, official inquiries set up. Nowhere, though, did the Princeps's obsession with squaring the rival dimensions of the earthly and the heavenly, the mortal and the supernatural, express itself to more spectacular effect than on his island retreat. Twelve separate villas, some converted by the Princeps and some built from scratch, dotted the island in transparent homage to Mount Olympus, home of the twelve most powerful gods of Greece. Some of these complexes stood perched on cliffs, louring over sea-lanes once navigated by Ulysses and Aeneas; others led down to caves, where, set amid the lapping of blue waters, statues of mermen and sea-nymphs adorned the flame-lit depths. Everywhere, grottoes, gardens and porticoes, graced by the Princeps with learned, teasing names and fashioned in obedience to his immaculate taste, provided the perfect setting for young actors to pose as Pans and nymphs. As at Spelunca, so on Capri: Tiberius dwelt amid a mythological theme park.

And by 37, eleven years after his departure for Campania, he was coming to seem almost a figure of myth himself. It was inevitable, in a city as addicted to scandal as Rome, that the Princeps's lengthy absence on a private island should have fuelled the rumours told of him. His brooding shadow still lay heavy over the capital. The plebs had neither forgotten nor forgiven his haughty contempt for them, nor the Senate his brutal purging of the supporters of Agrippina and Sejanus. The smears of blood on the Gemonian Steps were not easily washed away. Tiberius had come to seem, in his old age, a ghoulish figure of dread: embittered, paranoid and murderous. Of what hellish cruelties

* The 'hero' was almost certainly a mastodon or mammoth. See Mayor, p. 146.

he might be capable away from the public gaze, amid the seclusion of Capri, was a question fit to send shivers up the spines of eager Roman gossips. Many stories were bandied about. It was claimed, for instance, that a few days after the Princeps's first arrival on the island, while he was standing on a cliff, a fisherman had clambered up the rocks, bringing with him a huge mullet as a gift for Caesar; and that Tiberius, the man whose fearlessness in the service of Rome even his bitterest enemies acknowledged, had been terrified by the intruder. So terrified, in fact, that he had ordered his guards to seize the wretched trespasser and scrub his face with the mullet. The man, screaming, was said to have cried out in the midst of this torture, 'I only thank the stars I did not give him the huge crab I also caught!'[91] And so Tiberius ordered him scrubbed with the crab as well. Rome too, so many had come to believe, had been similarly treated by the Princeps. She had become, under his rule, a face shredded and bloodied to the bone.

That Tiberius was capable of being vengeful hardly came as news. More unsettling, perhaps, were the vices that he had previously kept concealed. To the Roman people, privacy was something inherently unnatural. It permitted aberrant and sinister instincts free rein. Only those with sexual tastes they wished to keep veiled from their fellow citizens could have any reason to crave it. Hostius Quadra had indulged his unspeakable perversities in the isolation of a mirrored bedroom – but Tiberius, for eleven years, had enjoyed the run of an entire island. People in Rome were not fooled by his high-flown pretensions to scholarship. They suspected that his claims to an interest in the arcane details of mythology were merely an excuse to indulge in pornographic floor-shows. Decades before, when the future Augustus had celebrated his marriage to Livia, crowds in the streets below had rioted when news broke that the wedding guests were dressed up as gods. Now, though, in the playground that Tiberius had made of Capri, there were no censorious mobs to keep the Princeps's fantasies in check. The nymphs and Pans with which he peopled his

grottoes were not there merely to pose. Rapes and fantastical copulations were rife in the tales told of the gods. What greater pleasure, then, for an old man fascinated by their doings than to watch their couplings being graphically restaged?

The frisson derived not just from the performances but from the cast. All his life, Tiberius had been pledged to certain fundamentals: the dignity of the Senate, the ideals of the aristocracy, the virtues of his city's past. Yet as Ovid, left to die by the Princeps at the ends of the world, had always understood, 'desire is fuelled by prohibitions.'[92] Tiberius's choice of performers could hardly have been more transgressive. Young and attractive, many were not merely paragons of modesty but children of the Princeps's own class. 'Beauty and good bodies; uncorrupted innocence and distinguished ancestry: these were what turned him on.'[93] Obliged to pose as prostitutes, to hawk for business like the lowest class of sex worker, to perform sometimes three or four at a time, the offspring of the nobility summoned to Capri could hardly have been more humiliated. The spectacle of their degradation was a hideous desecration of everything that the man watching it had always held most dear. But that, of course, for the Princeps, was precisely what made it so exciting.

Naturally, he despised himself for it. Tiberius, heir to the Claudian name, the greatest general of his generation, a man who by virtue of his many services to the Republic would have deserved to rank as Princeps even had his divine father not adopted him, knew the standards by which he would be judged – for he shared them. But he was weary. Twenty long years he had been holding the Roman wolf by its ears. Almost into his ninth decade, he felt himself a man out of time. His best hopes for his city had turned to dust. The Senate had failed him. Indeed, it was the measure of his peers' depravity that so many had become complicit in his own. Men whose record of service to Rome reached back to the days of the kings, when gods had still walked the earth, now competed to pimp their children to him.

Faced by the evidence of such degeneracy, Tiberius no longer felt any great concern to secure the future of his fellow citizens.

Which was just as well – for the ruin that had left the August Family maimed and bleeding spelt potential calamity for the Roman people as well. The House of Caesar would soon need someone new at its head – but who? No one seasoned in the arts of war and peace, as Tiberius himself had been when he succeeded Augustus, was ready to hand. Indeed, male heirs of any description were decidedly thin on the ground. There was Claudius, the twitching, stammering brother of Germanicus – but a man with such literally crippling disabilities was never going to make a Princeps. Then there was Gemellus – but he was still very young, and Tiberius himself, painfully conscious of Livilla's affair with Sejanus, could hardly help but wonder whether his grandson truly was his grandson. That left Caligula, the people's favourite. His popularity – owing as it did everything to his parents, and absolutely nothing to any actual record of service – was a perilous attribute to have, of course. There were plenty in Tiberius's train who thought it inconceivable that the grim old man would ever permit a son of Agrippina to succeed him. Caligula, so Thrasyllus prophesied, was as likely to become emperor as he was to ride a horse across the sea. No one, though, was more alert to the perils of his situation than Caligula himself. He knew better than to give his great-uncle the slightest cause for resentment. His face remained a mask. 'Not a peep was heard from him at the condemnation of his mother, the destruction of his brothers.'[94]

Such a display was sufficient for Tiberius. As a man who in his old age had surrendered to the pleasures of hypocrisy, it amused him to wonder what emotions his great-nephew might be veiling behind his inhuman show of composure. Caligula, if truth be told, did not seem a man much given to grief at the suffering of others. Quite the contrary – he gave every impression of enjoying it. Slavishly obedient to the Princeps in everything, it was the darker dimensions of Tiberius's

whims and pleasures for which he showed the greatest enthusiasm. The horrifying fate of Agrippina and his brothers did not inhibit him from taking an intimate personal interest in the punishment of criminals. He was also more than happy to keep pace with his great-uncle's relish for mythological re-enactments. Ever since his childhood, when the soldiers of the Rhine had strapped him into the miniature pair of boots that gave him his nickname, Caligula had displayed a taste for dressing up. Capri, that wonderland of stage sets, enabled him to give it free rein. Wigs and costumes of every kind were his to try on, and opportunities to participate in pornographic floor-shows freely granted. Tiberius was happy to indulge his great-nephew. He knew what he was leaving the Roman people in the form of their favourite – and he had ceased to care. 'I am rearing them a viper.'[95]

Many, of course, in Rome, would have retorted that it took one to know one. Memories of the man the Princeps had once been were long since faded. As tales of the great war hero who had twice hauled the Republic back from ruin gathered dust, fresher stories told of Tiberius now had currency among his fellow citizens. No rumour of his perversities was so hideous that it could not be believed in Rome. That he had trained little boys to slip between his thighs as he went swimming and tease him with their licking; that he had put unweaned babies to the head of his penis, as though to a mother's breast; even, most repellently of all, that he enjoyed cunnilingus. Yet beyond the streets and taverns of Rome, where slanders of the mighty, and mockery of their pretensions, had always bred, there were others who saw Tiberius in a very different light. In the provinces, where the twenty-three years of stability that he had provided the world might win him praise even among the notoriously snippy intellectuals of Alexandria, he had ended up widely admired as a prince of peace. 'For wisdom and erudition,' one declared flatly, 'there is nobody of his generation to compare.'[96] Bloodstained pervert and philosopher-king: it took a man of rare paradox to end up being seen as both.

By March 37, though, it was clear that Tiberius's long and remarkable career was nearing its end. After one last abortive attempt to enter Rome, he had returned to Campania, where storms and a stabbing pain in his side prevented him from crossing back to Capri. Despite a customarily stern-willed attempt to pretend that nothing was wrong, he was eventually forced to retire to bed. Shortly afterwards a terrible earthquake shook the Bay of Naples. On Capri, which for so many years had provided Tiberius with his home and his refuge, a towering lighthouse built on the island's highest cliff was toppled into the sea, and its fires extinguished.97 The old man, skilled in the art of reading the purposes of the gods, had no need of Thrasyllus to tell him what the sign portended. Sure enough, from his bed, he made dispositions for the transfer of power. In his will, both Caligula and Gemellus were named as his heirs, but the Princeps had no illusions as to what his grandson's fate promised to be. 'You will kill him – and then someone else will kill you.'98 So Tiberius had once told Caligula. Unsurprisingly, then, as he felt death come upon him, he found it hard to let go of his signet ring. Even after removing it he could not bring himself to hand it over, but instead held it tight in his palm, and for a long while lay motionless. In time, many stories would be told of what happened next: that Caligula had assumed his great-uncle dead; that just as he was being hailed as the new emperor, news had been brought that the old man was still alive; that Macro, a seasoned operator who had long since attached himself to the rising, not the setting, sun, had ordered Tiberius suffocated beneath a pillow. The truth was less melodramatic. The Princeps, stirring at last, had called for his attendants. None had come. Tottering to his feet, he had called out again – then collapsed.

'Reckon yourself happy only when you can live in public.'99 Such was the Roman conviction.

Tiberius Julius Caesar Augustus had died alone.

5

LET THEM HATE ME

Show Time

In Rome, news that the old man had died at last was greeted with predictable gallows humour. 'To the Tiber!' went up the cry.[1] Caligula, conscious that the dignity of the role bequeathed him by Tiberius would hardly be enhanced by handing over his predecessor's corpse to be dragged through the streets on a meat hook, refused. Arriving from Campania in the city he had last seen six years before, he was dressed soberly in mourning. The funeral he gave Tiberius was dignified and ornate. The speech over the body was delivered by Caligula himself. The ashes were laid to rest in the great Mausoleum of Augustus.

So far, though, and no further. Escorting the funeral cortège, the new Princeps had been mobbed the length of the Appian Way by joyous crowds, cheering him and hailing him as their chick, their little one, their darling. Caligula, who for so long as his great-uncle was alive had betrayed not a flicker of grief for his murdered mother and brothers, now played with relish to the gallery. The speech he gave over Tiberius's corpse was largely a paean to Germanicus. Then, a few days later, he set out for the prison islands on which Agrippina

and Nero had perished. Ostentatiously braving stormy weather, so as to make his filial piety all the more evident,[2] he returned up the Tiber with their ashes, placed them in litters normally used for carrying the statues of gods, and had them interred amid much sombre and flamboyant pomp in the Mausoleum of Augustus. The Roman people, ecstatic that their favourite had at last come into his own, gave themselves over to wild celebration. For three months the smell of roasting meat hung pungent over the city, as hundreds of thousands of cattle were immolated in a grand gesture of gratitude to the gods. After the long winter of Tiberius's old age, spring, it seemed, had come at last.

Not that Caligula was naïve enough to take this mood of optimism for granted. Although he had long been isolated from the capital, his time on Capri had not been wasted. His presence at Tiberius's side had given him an instinctive and pitiless understanding of the workings of power. Unlike his grimly austere predecessor, who had scorned to lavish bribes on the people, Caligula was more than happy to buy popularity. The treasury was full – and the new Princeps took full advantage. Donatives were splashed out on the citizens of the capital, on the legions and – most generously of all – on the Praetorians. Nor was the Senate neglected. Caligula showed himself alert to its sensitivities. The serving consuls were permitted to serve out their term of office; and when the Princeps did finally lay claim to the consulship, three months into his reign, his choice of colleague signalled a pointed rejection of his predecessor. Claudius, Caligula's uncle, had hitherto been denied even the most junior magistracy; but now, at the age of forty-six, he was elevated simultaneously into the Senate and to the consulship. More was to follow. Giving his first address as consul, Caligula explicitly repudiated all the most detested features of Tiberius's reign: the informers, the treason trials, the executions. To the listening Senate, it sounded almost too good to be true.

Which perhaps it was. When senators, in the wake of Caligula's speech, rushed through a decree that it be read out every year, the measure reflected less their joy at a new beginning than dread that he might change his mind. There was no one in the Senate, after the traumas and tribulations of the previous reign, who could believe any longer in the silken hypocrisies that had once served to veil what Rome had become. The true balance of power had been too nakedly exposed for that. The Senate itself, like a battered wife frantic to forestall a beating, had made sure, in the first days of Caligula's reign, to deny him nothing. An attempt by Tiberius in his will to secure a share of his inheritance for Gemellus had been speedily annulled; 'the absolute right to decide on everything'[3] bestowed with a solemn and awful formality upon Caligula. Few senators had been put at ease by their new master's smooth assurances. The man who as a toddler had posed as a soldier was now acting out a new role, that of Augustus. No matter how convincing his performance, everyone suspected that it was just that: a performance.

There was only one shred of reassurance. The new emperor was not, as Tiberius had been when he succeeded Augustus, a man battle-hardened in the service of Rome – and Caligula seemed to appreciate as much. Ever at his ear was the man who had done more than anyone to facilitate his accession, the Praetorian prefect Macro. This in itself, to senators who had learned to dread overreaching equestrians, was hardly a recommendation – except that Macro was no Sejanus. High-minded and bluntly spoken, he did not hesitate to lecture his young protégé on what was expected of a Princeps: 'for, like any good craftsman, he was keen that his own handiwork, as he saw it, not be damaged or destroyed'.[4] Granted, senators could hardly help but feel a little twitchy at the very public drills that Caligula insisted on having the Praetorians perform for their benefit; but Macro was not the only advisor by the emperor's side. There was also one of the Senate's own.

Four years before becoming emperor, Caligula had been married to the daughter of a man particularly prized by Tiberius, a one-time consular colleague of Drusus's by the name of Junius Silanus; and Silanus, even though his daughter had since died in childbirth, retained signal status as the emperor's father-in-law. Like Macro, he presumed a right to serve as Caligula's guide in the various arts of governance; unlike Macro, he did so as a representative of the antique virtues of the nobility. 'Well bred and eloquent, his rank was a commanding one.'[5] It was no shame for anyone, even a Princeps, to be swayed by such a man. Certainly, Caligula showed himself a quick learner. The prosperity and order that Rome's dominions had enjoyed under Tiberius continued unbroken. The frontiers held firm; the appointments to provincial commands were shrewdly chosen; peace was universal across the Roman world. In the capital itself, workmen who had long cursed Tiberius's refusal to invest in infrastructure projects were delighted when Caligula commissioned two new aqueducts and a thoroughgoing upgrade of the Palatine. Books that had been banned under his predecessors, including the speeches of Titus Labienus and Cassius Severus, and the histories of Cremutius Cordus, were restored to public circulation. 'With such moderation did Caligula behave, in short, and such graciousness, that he became ever more popular, both with the Roman people themselves, and with their subjects.'[6]

Nevertheless, in the Senate, they still held their breath. Popularity and youth, to conservatives, could hardly help but seem a sinister combination. Not since the darkest days of the Triumvirate had Rome been so dependent upon the whims of so young a man. Senators observed with alarm that their new emperor, even as he posed before them as a new Augustus, played a very different part when before the plebs. Caligula, it was evident, positively revelled in the applause of the masses. When he insisted that they greet him, not with pompous or stuffy formality, but as though he were a citizen

just like themselves, they delighted in his common touch; when he restored to them the right abolished by Tiberius to vote for magistrates, they hailed him as the people's friend. What they adored most of all, however, was the sheer blaze of his glamour. He might be prematurely balding, and possessed of large feet and his father's spindly legs, yet Caligula knew how to thrill a crowd. The Roman people were bored of grim old men. Now at last they had an emperor who seemed to glory in living the dream. That summer, opening a new temple to Augustus, Caligula rode to the inauguration in a gilded triumphal chariot. Six horses pulled him. 'This,' so it was noted, 'was something wholly cutting edge.'[7]

Cheers and chariots went naturally together. In a triumph, the pace was stately, the rider arrayed in purple and gold; but there were other spectacles more dangerous, more thrilling, more visceral. Between the Palatine, home of Caesar, and the Aventine, that great smog-wreathed warren of slums, stretched a long, straight valley; and here, ever since the days of Romulus, perilously rickety chariots had been racing one another up and down its course. The Circus Maximus it was called – and fittingly so. No other city in the world could boast a vaster stadium. Even Augustus had found himself intimidated by the sheer heaving mass of spectators who would cram themselves into its stands on race days. Although, back in the year of Actium, he had commissioned a box in the Circus, the 'Pulvinar', for his own private use, and justified it, with a familiar sleight of hand, by sharing it with symbols of the gods, he had rarely used it. He had found himself altogether too conspicuous, too exposed, when sitting there. Instead, rather than endure hundreds of thousands of eyes fixed upon him, he had preferred to watch the races from the upper storeys of friends' houses. Augustus, incomparable as he had always been in his ability to distinguish between the reality and show of power, had known what he confronted in the Circus – and had respected it. To feel the blast of its noise hot against the face was to feel the breath of the wolf.

Which was why, when sitting in the Pulvinar, Augustus had always made sure to behave like a fan. It was important that the First Citizen be seen to share in the pleasures of the Roman people. Even so, there were limits. Augustus had not bestowed the gifts of peace and order upon the world only to tolerate a free-for-all at sports events. The long-standing presumption of most spectators that they should be allowed to sit wherever they pleased had struck the Princeps as deeply offensive. Entertainment was all very well – but not at the expense of proprieties. As in the bedroom, so on the bleachers – Augustus had sought to regulate his fellow citizens' appetites by means of legislation. With great punctiliousness, the banks of seating in public venues had been divided up between various categories of Roman. Senators, naturally, had been awarded the best vantage points; women the worst. Wear a blinding white toga, and a man could expect to sit near the front; wear a dark and grimy tunic, and he would have to take his luck at the back. Soldiers, foreign ambassadors, boys and their tutors: all had been allocated their respective blocs. The larger the venue, of course, the harder these rules were to police; and the Circus Maximus itself, as the largest venue of all, was correspondingly the most challenging to regulate.[8] Nevertheless, the principle established by Augustus was one that everyone who benefited from it could recognise as eminently sound. Rich or poor, male or female – all had to know their place. Entertainments were serious matters. They provided mirrors in which the entire Roman people, from First Citizen to the basest ex-slave, could see themselves reflected. Macro, speaking in his young master's ear, sought to spell out the implications. 'What matters when you watch the races in the Circus is not the sport itself, but rather to behave appropriately in the context of the sport.'[9]

There was, though, another perspective. Despite the many years that he had spent away from Rome, Caligula had not been wholly cut off from the capital's youth culture. The offspring of

The Julians and Claudians under Caligula

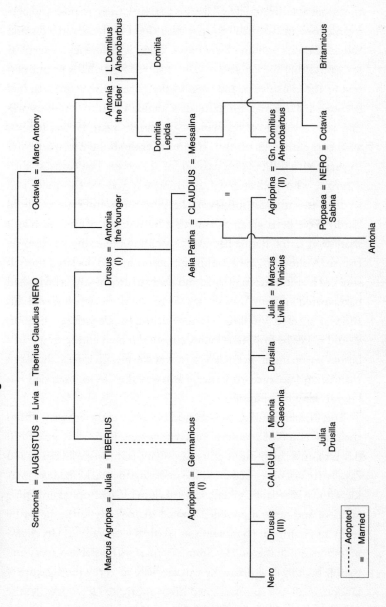

the nobility summoned by Tiberius to Capri, there to pose and per-form as prostitutes, had brought with them to the island a distinct touch of metropolitan chic. One of these, a performer so adept at sex games that he was said to have ensured his father's promotion first to the consulship, and then to the governorship of Syria, had become a particular intimate of Caligula's. Aulus Vitellius was racy in every sense of the word. Not merely a fan, he was himself an accomplished charioteer. Naturally enough, he had made sure to share with Caligula his passion for the sport. The contrast with Tiberius, who had despised anything enjoyed by the mob, and scorned to squander money on keeping them entertained, could hardly have been greater. Now that he was out of the old man's shadow at last, Caligula had every intention of blazing an opposite course. Although, on becoming emperor, he had declared himself shocked by the antics on Capri, and ready to drown anyone who had participated in them, the joke was firmly on those who believed this show of outrage. Vitellius, whose youthful brush with prostitution would never be forgotten by his enemies, remained the Emperor's bosom companion. Even as Macro was sternly advising Caligula to maintain his distance from the pleasures of the Circus, his friend was busy stoking his obsession.

The Roman people, long starved of public extravaganzas, found their new emperor a most munificent sponsor. Races were held from dawn to dusk; glamorous entertainments, featuring wild beasts and cavalry manoeuvres, laid on in the intervals; the tracks made to spar-kle with vivid reds and greens. Caligula himself, far from maintaining an aloof and neutral presence, rooted shamelessly for his favourite team. Its champion charioteer was lavished with gifts, and its cham-pion horse, Incitatus or 'Hot Spur', supplied with a stable of ivory and marble built by Praetorians. Simultaneously, in a crowning gesture of fandom, Caligula commissioned his own private racecourse, on the far side of the Tiber from central Rome, complete with an obelisk

brought specially on a massive transport ship from Egypt. Restrained in his enthusiasm he was not.

But that, for Caligula himself, was precisely the point. Back in the days of Augustus, the relish of Rome's trendsetters for offending the stuffy and the uptight had ended up so dangerous as to risk criminal charges. Now, with Caligula installed on the Palatine, one of their own enjoyed the whip-hand. The proprieties that his great-grandfather had been so anxious to uphold were, to the youthful Princeps, things to be mocked, subverted, undermined. His apprenticeship on Capri, where he had watched the sons and daughters of senators hawk themselves like streetwalkers, had opened his eyes to the extremes of novelty and spectacle the power of an emperor might command. Far from veiling his own supremacy, he delighted in flaunting it. There was to be no watching chariot races from neighbouring buildings for Caligula. Instead, resplendently visible in the Pulvinar, the toast of a grateful and cheering people, a patron such as the Circus had never before enjoyed, he delighted in what it meant to rule as the master of Rome.

He presided over magnificence; but he presided as well over peril. Races were potentially lethal events. Even a charioteer as skilled as Vitellius walked with a permanent limp, the result of an accident. He had been lucky. Crashes were often fatal. Many a citizen, in the dark days of the civil wars, had dreaded that Rome herself was doomed to end up a mess of splinters, shattered axles and tangled reins. Now, whenever a chariot careered out of control and left a twisted body crumpled on the side of the track, it served the Roman people as a very different reminder: of Caesar, who had graced them with spectaculars beyond their forefathers' wildest imaginings, and was the master of death as he was of life. And they loved him for it.

In the Circus, to manoeuvre for victory was invariably to risk life and limb. In the world beyond the race track it could sometimes be the same. That October, eight months after coming to power,

Caligula fell dangerously ill. Alarmed by the potential threat to their own positions, Macro and Silanus immediately scouted around for a new protégé. There was only one possible candidate. Even as Caligula lay at death's door, his two most prominent henchmen began clearing the way for Tiberius's grandson, the eighteen-year-old Gemellus, to take over the reins. But they had moved too fast. In the Circus, the charioteer who clipped the hub of a rival's wheel while attempting to overtake would invariably end up broken and mangled in the dust. Macro and Silanus had committed a similarly fatal error. Caligula did not die. Instead, he made a full recovery. Rising from his sickbed, he moved with lethal dispatch and cunning.

First to perish was the hapless Gemellus. Charged with treason, he was paid a visit by two senior officers, who considerately instructed him in the best way to commit suicide, and then stood by as he demonstrated the efficacy of their lesson. Macro, as the man with the Praetorians at his command, presented Caligula with a potentially greater challenge – but one to which he showed himself no less equal. Like a sacrificial bull being adorned with garlands, the Prefect was first graced with the supreme honour of the governorship of Egypt, and then, before he could leave for his province, ordered to kill himself. The charge, a highly plausible one, was that he had referred to Caligula as 'his work': self-evidently, a mortal insult to the Princeps's dignity. Macro's suicide left only Silanus standing; but he too, once it had been intimated to the Senate that he no longer retained his son-in-law's favour, took the hint, slitting his own throat with a razor. Caligula could be mightily pleased with the skill that he had brought to clearing the stage.

To Rome's elite, of course, the ease with which their young emperor had liquidated his two most formidable allies came as an altogether less pleasant revelation. If power-brokers of the stature of Macro and Silanus could be forced to kill themselves, then nobody was safe. 'Remember,' Caligula was said to have told his

grandmother, 'I am allowed to do anything to anybody.'[10] Unlike Tiberius, he did not feel the slightest embarrassment at the awesome scope of his power – and the discovery of how readily he had been able to dispose of his unwanted mentors only encouraged him to test its limits further still. No paying lip-service to the ideals of the vanished Republic for Caligula. They bored him – and he had no patience with being bored. Nevertheless, in trampling them down, he was not going wholly against the grain of the past. The colour and clamour of the Circus, to which he had become so addicted, were traditions as venerable as any in Rome. The Senate House, to a man of Caligula's instinctive showmanship, could hardly help but seem dreary in comparison. Resolved as he was not merely to preside supreme over the cockpit of power, but to make a display of it, he looked elsewhere for his inspiration: to the Roman genius for putting on a show.

The pleasure that Caligula took in watching other people suffer was nothing new. For centuries, the Roman people had been assembling en masse to enjoy the spectacle of men contending in desperate struggle, and to exercise over them the powers of life and death. Traditionally, these shows had been mounted in the heart of Rome, in the Forum itself. There, across from the Senate House, the great men of the Republic had regularly commissioned the building of temporary wooden amphitheatres, staging in them, for the benefit of potential voters, contests between trained killers named 'gladiators'. Fighters bound, if volunteers, by a fearsome oath to endure 'brandings, fetters, whippings, and death by sword',[11] these men ranked as the lowest among the low – and yet, for all that, the attitude of spectators was not merely one of contempt. The Roman people admired courage and martial proficiency. Julius Caesar, when he was still a man on the make, had sought to win the love of his fellow citizens by equipping gladiators, for the first time, with silver armour; but later, after his crossing of the Rubicon, he had trained his legions to fight

as though they themselves were in the arena. Senators proscribed by the Triumvirate had been known to do as a defeated gladiator would, and bare their throats to the swords of their assassins. Former consuls had not been ashamed to look to the example of such slaves and find in them a model of their own ancestral *virtus*. Amid the horrors of civil war, the whole of Rome had become an amphitheatre.

Much, of course, had changed since then. Augustus had brought the blessings of peace to Rome. The days when ambitious noblemen could hope to win supremacy for themselves by staging dazzling shows in the Forum were long gone. There was effectively only one patron left: Caesar. A Princeps, it went without saying, could spend as lavishly he pleased. The result, over the course of Augustus's primacy, had been ever more spectacular games. Ten thousand gladiators had fought in eight alone. Rule by a Princeps, though, was not necessarily good news for the fans. Tiberius, whose contempt for public entertainments had been total, had naturally scorned to squander money on gladiators. Following the death of Drusus, who had loved watching them with a passion extreme even by Roman standards, and had been nicknamed after a particularly famous one as a result, the staging of blood sports had ground to a halt. Star gladiators themselves had mourned the lack of opportunity to demonstrate their skills. 'What a golden age we have lost!'[12] Indeed, so desperate had the Roman people become to feed their addiction that in AD 27, when an entrepreneur staged a gladiator show in the nearby town of Fidenae, 'huge crowds of men and women, of every age'[13] had flocked from the capital to watch it. The result had been the worst disaster in the history of Roman sport: the amphitheatre, unable to cope with the sheer volume of spectators, had collapsed under their weight, crushing thousands to death. The horror of this calamity would long be remembered – for it had struck a particular nerve. The crowds who went to watch other men die did not care to be reminded of their own mortality. 'Kill him! Lash him! Burn him!'[14]

The excitement that spectators took in watching trained warriors fight for their lives was all the greater for knowing themselves to be the masters. Caligula, as passionate a fan of gladiatorial combat as Tiberius had been dismissive of it, understood this with icy clarity. More than that – it amused him to make play with the knowledge.

Only menace a man with violent death, and his struggle to evade it could provide rich entertainment – no matter the victim's rank. Who better to put this proposition to the test than Caligula, whose sense of humour was as malicious as his powers were absolute? His chosen victim, an equestrian by the name of Atanius Secundus, was guilty of little more than excessive flattery. Back when the Princeps was on his sickbed, Atanius had sworn an extravagant oath. Only restore Caligula to health, he had promised the gods, and he would fight as a gladiator. Naturally, he had not expected to be taken up on this vow. His aim had been merely to stand out from the other sycophants. Once back up on his feet, though, the Emperor took Atanius at his word. With a perfectly straight face, Caligula ordered the wretched equestrian into the arena, to fight there for the amusement of the crowds. Predictably enough, paired against a trained killer, Atanius did not last long. The spectacle of his body being dragged away across the sands of the arena on a hook provided Caligula's joke with more than just a cruelly emphatic punchline. It also delivered a threat. No equestrian could sit in an amphitheatre, in one of the seats reserved for him by law, and watch in equanimity as one of his own was made an object of public diversion. Senators too were bound to feel unsettled. The menace was implicit. No one so high-ranking, it seemed, but Caligula reserved for himself the right to make sport with his death.

It was, for the Roman nobility, all most disconcerting. The notion that a Princeps might regard them with derision was as novel as it was shocking. No matter how painful their subordination to the new order established by Augustus, neither Augustus himself nor Tiberius

had ever sought deliberately to rub their noses in the dirt. Just the opposite. Both men had been firm believers in the values upheld by Rome's traditional elite. Caligula, though, was revealing himself to be a very different order of Princeps. Raised on the private island of an autocrat, seduced by the cheers of the Circus, backed by the swords of Praetorians, he felt not the slightest empathy with the presumptions of his own class. A year and more after his accession to the rule of the world, he still paid a certain mocking obeisance to his partnership with the aristocracy; but it was evident that he was starting to weary of smoothing their ruffled feathers. As a signal of this, he took a title in September 38 that earlier, out of respect for the grey hairs and craggy self-regard of the Senate, he had pointedly refused: 'Father of his Country'. The chance to humiliate his elders had simply become too good to miss.

Indeed, in so far as Caligula felt loyalty to anything, it was to his family – and to his sisters in particular. Julia Livilla, the baby girl born on Lesbos during Germanicus's fateful journey to the East, was now a young woman in her early twenties; her two elder sisters, Agrippina and Drusilla, were both already married. All three, while Tiberius was alive, had shared with their brother the perils of being their mother's children; all three, when Caligula finally came into his inheritance, had been graced with spectacular honours. Privileges were lavished on them that it had taken Livia a lifetime to acquire. Even consuls, when they took a vow of allegiance to Caligula, were obliged to include his three sisters in the oath. The most startling novelty of all, though, was their appearance on a coin minted during their brother's first year in power, and which portrayed them in the guise of winsome deities. Never before in Roman history had living individuals been represented on a coin as gods. Well might traditionalists have flared their nostrils.

Truth be told, the fondness of Claudians for their siblings had long been a cause of suspicion. Back in the dying days of the Republic,

Clodius's intimacy with his three sisters had provoked dark and delighted accusations of incest. Now, almost a century on, the same rumours inevitably began to swirl around the children of Germanicus.* Given the prurient taste of the Roman people for scandal, they could hardly have done otherwise. What, though, was idle gossip to perturb the master of the world and his sisters? Agrippina, in particular, was hardly the kind of woman to care what her inferiors thought. In ambition and self-assurance no less than her name, she was every inch her mother's daughter. Married off by Tiberius to the thuggish but impeccably aristocratic Domitius Ahenobarbus, she was the only one among her siblings to have had a child – and a son, what was more. Unsurprisingly, her hopes for the boy were of the highest order. Like her mother, though, she had a tendency to push too hard. Eager to alert the world to the fact that Caligula had no children of his own, she asked him to name her son, confident that the choice would signal a glorious future for the boy – only to have her brother smirk, glance across at their twitching, dribbling uncle, and suggest 'Claudius'.

In the event, Agrippina had to be content with calling her son Lucius Domitius Ahenobarbus, after his father. She knew better than to force the issue. Fond though Caligula was of his eldest sister, he was unwilling to offer either her or Julia Livilla marks of favour at the expense of his favourite, Drusilla. No one was dearer to him. Even though she had already been married off by Tiberius before he came

* The earliest datable allusion to Caligula committing incest with his sisters is in *The Antiquities of the Jews*, written by Josephus more than half a century after his death (19.204). Josephus, though, was well informed about Caligula's reign, and drew on sources written much closer in time to it. As ever in a city as addicted to scurrilous gossip as Rome, the existence of a rumour did not mean that it was actually true. No contemporaries of Caligula mention it; and it was only with Suetonius that the rumours really took wing. 'Have you committed incest with your sister?' he described Caligula as asking his friend, the noted wit Passienus Crispus. 'Not yet,' Passienus is said to have replied, quick as a flash (quoted by the Scholiast on Juvenal: 4.81).

to power, this had not prevented her brother, once emperor himself, from supplying her with a new and altogether more glamorous husband in the form of his principal favourite, Marcus Aemilius Lepidus. The great-grandnephew of the most ineffectual of the Triumvirs, Lepidus was said to have had a youthful and passionate fling with Caligula – and whatever the truth of such scurrilous gossip, it was certainly the case that the two men were very close. The Emperor had not only fast-tracked his friend through assorted magistracies, but had then explicitly named him as 'successor to the throne'.[15] It was the wife, though, not the husband, whom Caligula truly adored. During his illness, he had made this clear in the most startling manner. Rather than explicitly name Lepidus as his successor, he had instead appointed Drusilla herself as 'heir to his worldly goods and power'.[16] Not even Livia at her most ambitious could have dreamed of such an honour.

Unsurprisingly, the devastation that Caligula felt in the summer of 38, when his beloved sister died, was so flamboyant as to prompt unprecedented displays of mourning. Too distraught to attend her funeral, he retreated to an estate outside Rome, where he sought to distract himself from his misery by playing board games and alternately growing and hacking at his hair; and then, when these measures proved inadequate, by drifting around Sicily and Campania. Meanwhile, back in Rome, a resourceful senator declared that he had seen Drusilla ascending to heaven – and Caligula, rather than mock the man for his sycophancy, as he might normally have done, gave him a massive reward. Drusilla was officially declared divine, the third member of the family, after Julius Caesar and Augustus, to become a god. Life-sized golden statues of her were placed in both the Senate House and the temple of Venus Genetrix; anything that smacked of fun was officially cancelled; a man who sold hot water for adding to wine was promptly put to death on a charge of *maiestas*. The Roman people, 'unsure whether Caligula wished them to mourn his sister or worship her',[17] cowered in the shadow of his terrifying grief.

By the early autumn, when Drusilla's elevation to the heavens was officially confirmed, the Emperor had recovered sufficiently to look to the future. Reminded by his sister's death of his own mortality, he briskly procured himself a new wife. That Lollia Paulina had already been married to Memmius Regulus, the consul who had presided over Sejanus's downfall, naturally bothered Caligula not a jot. Lollia was both beautiful and fabulously rich, with a taste for wearing pearls and emeralds wherever and whenever she could sport them. Although she was the granddaughter of the Lollius who had lost an eagle to the Germans and then committed suicide on the eastern front, no stain had been left on her eligibility by this disgrace. Any son she bore would be worthy to rank as a Caesar.

Naturally, Caligula's patent determination to father an heir did nothing for the prospects of either Agrippina or Lepidus, but the Princeps was in no mood to care about that. The more he adjusted to the seeming limitlessness of his own supremacy, the less inclined he was to tolerate anything that might obstruct it. Graced as he had been with an excellent education, and with years of literary chat at Tiberius's table, he had no problem in quoting from the classics to justify himself: "'Let there be one lord, one king.'"[18] In token of this, in the New Year, the Emperor entered his second consulship. Although he only held it for a month, his brief term of office served its purpose: to remind the Senate that he could take up and discard Rome's supreme magistracy as and when he pleased. Simultaneously, in the background, an ominous and familiar drumbeat was striking up again. Men who under Tiberius had languished in prison, and been released by Caligula in the joyous first flush of his coming to power, began to find themselves under arrest once more. The charge of *maiestas*, abolished with great fanfare in the first weeks of his supremacy, was quietly resurrected. Terror was blended with flashes of Caligula's customary malevolent humour. When a junior magistrate by the name of Junius Priscus was discovered, after he had been put to death, to be

much poorer than he had always maintained, the Emperor laughed, and declared that he had died beyond his means. 'He fooled me. He might just as well have lived.'[19]

The joke, as so often with Caligula, derived from the scorching quality of his gaze: from his willingness to strip away the veil of dissimulation, to expose the sordid baseness of human instincts, to question whether anyone ever did anything save for motives of self-interest. The Roman people had long made much of their supposed virtues; but Caligula, so unsparing in the analysis of his own motivation, was no longer interested in pandering to their self-conceit. For two years, he had indulged senators in the pretence that they were partners with him in the rule of the world. Now he was bored of it. The record of their cant stank to the heavens. Almost seventy years before, on that fateful day when Augustus had been voted his new name, he and the Senate between them had woven a fabric of illusion so subtle that few since had been prepared so much as to acknowledge its existence. Now Caligula was ready to rip it down and trample it under foot.

His trap had long been set. In the first weeks of his supremacy, he had informed the Senate in a tone of gracious magnanimity that all the paperwork relating to the *maiestas* trials under Tiberius, all the transcripts of those who had brought accusations against their fellows, all the details of the various senators who had stabbed one another in the back, were burned. But he had lied. He had kept the records – and now he ordered them read out to the Senate. His listeners' mortification was almost beyond enduring. But there was worse to come. Painstakingly, with relish, Caligula detailed every opportunistic shimmy of which the Senate had been guilty. Its members had licked the feet of Sejanus and then spat on him when he was down; they had cringed and grovelled before Tiberius and then traduced him the moment he was dead. Tiberius, though, had seen through them to their malign and contemptible core – and had advised on

how to handle them. 'Make your priorities your own pleasure and security. For they all detest you – they all long to see you dead. And if they can, they will murder you.'[20]

The naked brutality of the regime that had planted itself, over the course of the previous century, within the heart of Rome, and what had once been a free republic, now lay visible to all. Whatever else might be said about Caligula, he was at least being honest. It was an honesty, though, as pitiless as the African sun. Where were senators to hide now? Nothing of the hypocrisies with which they had been cloaking and adorning themselves was left to them. Their mingled servility and malignity had been brutally exposed to the world. It was not only the Senate, though, that Caligula was attacking. The lies told by his predecessors, the deified Augustus and Tiberius, also stood revealed. The pretence to which both men had clung, that Rome remained a republic, had become unsustainable. The power of the emperor was total – and Caligula no longer saw any point in disguising it. As token of this, he declared the charge of *maiestas* officially restored, and commanded that his words be inscribed upon a tablet of brass. Then, without waiting to hear what the Senate had to say, he turned on his heels and walked briskly out.

As it was, the Senate had nothing to say. So stunned and appalled were its members that they sat frozen in silence. It took them a whole day before they were finally able to present their response. By an official vote of the Senate, it was decreed that Caligula be thanked for his sincerity, praised for his piety and granted annual sacrifices in recognition of his clemency. It was agreed as well that he should be granted an 'ovation', a lesser form of triumph that entitled a general to ride in procession through Rome on horseback. He should celebrate it, the Senate declared, 'as though he had been victorious over his enemies'.[21]

Which in a sense he had been. Telling senators to their faces that they hated him and wished him dead, Caligula had taunted them

that they would continue to honour him 'whether they wished to or not'.[22] Behind their pinched and frozen faces, though, there was anger as well as fear. Nor were these emotions confined to the Senate House. Even in Caligula's own innermost circle, even among those few people he genuinely loved, there was a growing anxiety about the future. Senators were not the only people whose self-esteem the Emperor was happy to trample down. Certainly, he had no intention of letting his sister's ambitions stand in the way of his own. Less than a year after his marriage to Lollia Paulina, Caligula divorced her, on the grounds that she was unable to give him a child. Determined not to make the same mistake twice, he then promptly married his mistress, who had not only had three children already, but was heavily pregnant by him. Milonia Caesonia was neither young nor beautiful – but whatever it was that Caligula wanted in a woman, she had it. Like her husband, she enjoyed dressing up, and would often ride by his side in military procession, decked out in a cloak and helmet; while should Caligula, ever one for a titillating tableau, demand that she pose nude for his friends, she would readily oblige. Such was evidently the way to his heart – for he was to prove as constant in his devotion to her as he had been in his affection for Drusilla. Unsurprisingly, then, the birth to Caligula of a daughter, named Julia Drusilla by the delighted father, was greeted by both Lepidus and Agrippina with sullen and brooding resentment. Both, in their different ways, had felt themselves tantalisingly close to securing the succession; both, confronted by Caesonia's evident fertility, knew that their prospects had suffered a potentially fatal blow.

Late that summer of 39, on the last day of August, Caligula celebrated his birthday. He was twenty-seven. He had been emperor for two and a half years. He could be well pleased with all that he had achieved for himself in that time. A cowed Senate, a grateful people, a city endowed with plentiful shows and extravaganzas: Rome was well on its way to being moulded to his wishes. For now, though, it

was time to look further afield. Brought up as he had been among the legions of the Rhine, Caligula knew perfectly well that Rome was not the world. The job that his father had begun remained to be completed: the barbarians of Germany, who had defied both Augustus and Tiberius so effectively, were Caligula's to conquer. All very well to stage fights in the city's arenas; but there were real battles, fought by real soldiers against real adversaries, to be staged as well.

Gaius Julius Caesar Augustus Germanicus was going to war.

A Joke Too Far

Even in a city as habituated to gossip as Rome, there was a special quality to rumours from a distant front. The news of a campaign would spread first as a murmuring; then, as the hum increased to a roar, people would start shouting and perhaps, if there were victories to celebrate, breaking into applause. Caligula's departure for the Rhine promised everyone in the capital rare excitement. Not since the days of Germanicus had there been such a marshalling of military capabilities – and Caligula, unlike his father, would be riding to war as emperor. Hopes were high. The Germans, their great victory over Varus by now a distant memory, had returned to their customary state of feuding. The Cherusci, Arminius's tribe, were particularly diminished. Arminius himself, whose fame had come to serve as a standing provocation to rival chieftains, was long since gone from the scene – murdered in the year that Germanicus, his great opponent, had also died. The Roman people, long starved of the thrills that tales of conquest had traditionally provided them, could look forward with relish to learning the details of Caesar's doings.

Nor were they to be disappointed. Even though, in the event, the stories reported of Caligula that autumn would touch only rarely on martial exploits, they were to prove no less sensational for that.

Peril there certainly was – but the chief threat to the Emperor's life was not to be found beyond the Rhine. Instead, if the astonishing rumours that began to sweep Rome were true, it lay altogether closer to home. Even before Caligula's departure from the capital, hints of a crisis that reached right to the top were setting tongues to wag. In early September, both consuls had been summarily dismissed from office, their *fasces* snapped into pieces, and one of them forced into suicide.[23] Then, accompanied by Lepidus, his two sisters and a retinue of Praetorians, the Emperor had set off for the German front at breakneck pace. So fast had he travelled, it seemed, that his arrival on the banks of the Rhine had taken the legate there by complete surprise. Gnaeus Cornelius Lentulus Gaetulicus was a seasoned operator, a former intimate of Sejanus who had survived his patron's downfall by dropping discreetly menacing reminders of just how many legions he had under his command. Tiberius, too jaundiced greatly to care, had been content to let him be; but at damaging long-term cost. Much as Piso had done in Syria, Gaetulicus had cemented his authority over his men by cutting them plenty of slack – with the result that the frontier, rotted by a decade of his lax discipline, was no longer fit for purpose. Flabby and decrepit centurions lazed around in their tents, even as barbarians, slipping across the border in growing numbers, capitalised with glee on the renewed opportunities for raiding.

Caligula, whose earliest memories were of his father's frenetic efforts to repair the Rhine defences, was not impressed. Caught short by the Emperor's sudden arrival, Gaetulicus was arrested, interrogated and put to death. His replacement, a noted martinet by the name of Galba, bore witness yet again to Caligula's eye for talent. It was not long before the new general on the Rhine had toughened up his men sufficiently to start scouring Gaul clean of all intruders. Caligula himself, meanwhile, was busy proving himself his father's son. First he systematically weeded out all incompetent and unfit

officers; then he embarked on a number of sallies against the Germans. Though it was late in the campaigning season, he was hailed by the troops under his command no fewer than seven times as '*imperator*'.* Meanwhile, in preparation for the following year's campaigning season, two new legions were in the process of being recruited: the first to be raised since the annihilation of Varus's army thirty years before.[24] Retiring for the winter to Lugdunum, Caligula could feel that he had made his mark.

Except that barbarians, all along, had been the least of his worries. Back in Rome, where reports of the Emperor's seven victories over the Germans were, of course, assiduously promoted, the tides of gossip surged with very different news. The execution of Gaetulicus, coming as it did so soon after the removal of two consuls, had not gone unnoticed. All three men, it was whispered, had been embroiled in the same conspiracy. It was this that explained why Caligula, determined to foil it, had left for the German front at such a furious pace. By late autumn, the news was official. Gaetulicus had indeed been executed for his 'nefarious schemes':[25] a plot to raise the armies of the Rhine against Caligula and install a new emperor in his place.[26] But who? The answer, when it came, constituted the most unexpected, most shocking revelation of all. The first token of it arrived with a delegation sent by the Emperor to the great temple of Mars the Avenger, with orders to present to the god three daggers; the second

* It is Dio, even as he claims that Caligula 'had won no battle and slain no enemy', who lets slip this detail (59.22.2). Two contradictory traditions are to be found intertwined in the reports of historians such as Suetonius and Dio: in one, Caligula's military record is a laughable thing of whim and folly; but in the other, he is portrayed as a stern and effective disciplinarian in the best tradition of his father and Tiberius. Even though the fog that envelops this period of his reign is unusually dense, there are enough scattered details to make it probable that Caligula did make a tour of the Rhine in the autumn of 39, did stamp his authority upon the legions stationed there, and did win a few scattered engagements. Equally, it has to be acknowledged that Caligula may not have advanced to the Rhine until shortly after the New Year.

in the person of his sister, Agrippina. Just as her mother had done when bringing back the ashes of Germanicus from Syria, she arrived in Rome clasping a funerary urn. And in the urn were the remains of Lepidus.

Far from veiling the scandal, Caligula had chosen to make a full spectacle of the sordid details. Lepidus, the friend he had blessed with every conceivable favour, was reported to have grievously betrayed him. He had bedded both Agrippina and Julia Livilla; had conspired with the two sisters to seize supreme power; had spun a web of conspiracy that reached from the Senate House to the Rhine. Whether it was Gaetulicus, in a doomed attempt to secure a pardon, who had betrayed Lepidus's role in the plot, or some other informer, no one could quite be sure; but there was no doubting the molten quality of Caligula's hurt. Lepidus himself, ordered to bare his throat to an officer's sword, had been swiftly dispatched; Agrippina, once she had obeyed her brother's orders and borne her dead lover's remains all the way back to Rome, was sent with her sister into exile. Like their mother and grandmother before them, the pair were transported to barren islands off the Italian coast, while their household possessions – jewels, furniture, slaves and all – were flogged off in Lugdunum to status-hungry Gauls.

Worse for Agrippina was to come. Shortly after the revelation of her treachery, her husband, the brutish Domitius Ahenobarbus, succumbed to dropsy, and her son, for whom she had played so dirty and hard, came into the care of his aunt, Domitia. 'No less beautiful or wealthy than Agrippina, and of a similar age',[27] the two women were natural rivals; and Domitia, keen to win her nephew's heart, made sure to spoil him rotten. Agrippina, who had always been as strict with the boy as she was ambitious for him, was appalled. Rotting on her prison island, though, there was little that she could do. She had already lost her freedom; now it seemed as though she might lose her son. Even so, as Caligula made sure to remind both Agrippina and

Julia Livilla, they had even more to lose. 'I have swords in addition to islands.'[28]

Consuls, army commanders, even members of the Emperor's own family – all had joined in the conspiracy against him, and still their plotting had failed. Nevertheless, the shock to Caligula's self-assurance had been seismic, and his bitterness towards his sisters unsurprising. Though he had moved swiftly and ruthlessly to crush rebellion along the Rhine and to stabilise Rome's most militarily significant frontier, he had been left with little choice but to spend the winter reining in his plans for the conquest of Germany. The risk of further treachery was simply too great. The scale of Caligula's suspicions was laid bare when the Senate, frantic to cover its own back, sent a delegation of grandees led by Claudius to congratulate him on his foiling of Lepidus's conspiracy. The Emperor treated the embassy with open contempt. Most of the senators were refused entry to Gaul as potential spies; Claudius, when he arrived in Lugdunum at the head of the few granted access to the city, was pushed fully clothed into the river. Or so the story went. True or not, the rumour rammed home the point that Caligula wished to make. Those who had betrayed him could no longer expect to receive any marks of courtesy or respect. Both the Senate and his own family had been marked down as a nest of vipers. The state of war between emperor and aristocracy was now official.

All of which made it essential for Caligula to return to Italy as soon as possible. Nevertheless, this presented him with a challenge. It was clearly out of the question to depart the North without some feat to his name that he could promote in Rome as a ringing victory. So it was, with the first approach of spring, that he returned to the German front, where he inspected troops, noted with approval the improvements made by Galba to standards of discipline, and ventured another sally across the Rhine.[29] In the event, though, it was not Germany which was to provide Caligula with the coup he so desperately needed, but Britain.

There, despite the fact that no legions had crossed the Channel in almost a century, Roman influence had been steadily growing. With the island carved up between an assortment of fractious and ambitious chieftains, it was only to be expected that Rome should provide them with the readiest model of power. The most effective way for a British warlord to throw his weight around was to ape the look of Caesar. The king who entertained his guests with delicacies imported from the Mediterranean, or portrayed himself on silver coins sporting a laurel wreath, was branding himself a man on the make. Such displays of self-promotion did not come cheap or easy – and it was no coincidence that the most powerful of the island's chieftains had always made a point of staying on the right side of Rome. Cunobelin was the king of a people named the Catuvellauni, whose sway extended over much of eastern and central Britain; but that had not prevented him from setting up offerings on the Capitol, and from being assiduous in returning any Roman seafarers shipwrecked off his kingdom. Unsurprisingly, then, when one of Cunobelin's sons was exiled after launching an abortive land-grab on Kent, the presence of Caesar on the opposite side of the Channel ensured that there was only one place for him to head.

Caligula, naturally, was delighted by this unexpected windfall. The arrival of a genuine British prince could hardly have been more timely. It was a simple matter, receiving the surrender of such a man, to represent it as the surrender of the whole of Britain. Couriers were promptly dispatched to Rome. They were ordered, on their arrival in the city, to ride as ostentatiously through the streets as possible, to proceed to the temple of Mars, and there to hand over the Emperor's laurel-wreathed letter to the consuls. The Roman people had their tidings of victory.

And sure enough, borne on the surging of rumour, the news of it was duly repeated through the city: the dangers braved by Caesar, the captives he had taken, the conquest he had made of the Ocean. These

were the kinds of detail that his fellow citizens had always loved to hear. Yet even as they were being repeated across Rome, from the Forum to taverns and washing-hung courtyards, other accounts of Caesar's doings in the North were also circulating: cross-tides of gossip altogether less flattering to Caligula. It was claimed that he had scarpered back across the Rhine at the merest mention of barbarians; that the spoils of his supposed conquest of the Ocean were nothing but chests filled with shells; that the captives he was bringing back with him to Rome were not Germans at all, but Gauls with dyed hair. Caesonia, ever her husband's partner in bombast and theatricality, was even claimed to be sourcing 'auburn wigs'[30] for them to wear. How was anyone in Rome, far removed from the front, to judge between two such different slipstreams of propaganda? Caligula himself, returning at high speed from the Channel for Italy, had no doubt what was at stake – nor whom to blame for the blackening of his war record. 'Yes, I am heading back – but only because the equestrians and the people want me back,' he informed a delegation of senators who had travelled north to meet him. 'Do not think me a fellow citizen of yours, though. As Princeps, I no longer acknowledge the Senate.'[31]

Chilling words – and rendered the more so by Caligula's habit of slamming his palm down hard onto his sword hilt as he spoke them. The envoys' cringing was understandable; yet, if they imagined that the Emperor intended to limit himself merely to executing his opponents, they had underestimated the full shocking scope of his ambitions. The experience of the previous autumn, when it had seemed that the entire Roman nobility was ranged against him, had decided Caligula for good. His aim now was to hack away at everything that sustained the prestige and self-regard of the Senate, and to demolish the very foundations of its hoary *auctoritas*. This was why, rather than accept its tremulous offer of a triumph, he had contemptuously swatted it aside; and it was why, dismissing the envoys from

his presence, he forbade any senator from so much as coming out
to greet him on his approach to Rome. 'For he did not wish it to be
hinted even for a moment that senators had the authority to bestow
upon him anything capable of redounding to his honour – since that,
after all, would imply that they were of a higher rank than himself,
and could grant him favours as though he were their inferior.'[32] A
penetrating insight. For decades, secure within its chrysalis, protected
by the cunningly crafted hypocrisies of Augustus and the superseded
traditions so valued by Tiberius, a monarchy had been pupating; now,
with the return of Caligula from war, it was ready to emerge at last,
to unfurl its wings, to dazzle the world with its glory. No longer was
there to be any place for the pretensions of the Senate – only for the
bond between Princeps and people.

Which was why, when Caligula arrived outside Rome from his
northern adventure in May 40, he did not enter the city, but headed
on south, to the Bay of Naples.* Here, where for generations the
super-rich had devoted themselves to upstaging one another with
extravagant displays of spending, he had prepared the ultimate in
showstoppers. No coastal villa, no ornamental folly, no luxury yacht,
could possibly compete. Cargo ships conscripted from across the
Mediterranean had been lashed together to form an immense pon-
toon. Stretching three and a half miles, it linked Puteoli, Italy's largest
and busiest harbour, with Baiae, its most notorious pleasure resort.[33]
Piles of earth had been compacted along the bridge, and service sta-
tions complete with running water built along its course, so that it
looked like nothing so much as the Appian Way. Arriving in Baiae,
Caligula offered sacrifice first to Neptune, the lord of the seas, and

* Dio, writing in the early third century ad, implies that Caligula travelled to the Bay
of Naples in the spring of 39, in the wake of his devastating speech to the Senate; but
Seneca, in his essay On the Shortness of Life (18.5), makes it clear that the journey took place
the following year. If absolute certainty is impossible, the context weights the balance
of probability massively towards 40 rather than 39.

then – for what he was about to do had been consciously designed to awe and stupefy the world – to Envy. Ahead of him, the pontoon bridge with its great road of earth stretched all the way to Puteoli; behind him, fully armed, there waited a glittering line of horsemen and soldiers. Caligula himself, crowned with oak leaves and arrayed in the breastplate of Alexander the Great, climbed up into his saddle. Back from conquering the Ocean, he now intended to demonstrate his mastery of the seas in the most jaw-droppingly literal manner. The signal to advance was given. Caligula, his golden cloak gleaming in the summer sun, clattered forwards onto the bridge. 'He has no more chance of becoming emperor than he does of making a tour of the Bay of Baiae on horseback.'[34] So the soothsayer Thrasyllus had once told Tiberius. But Emperor Caligula had become – and now, sure enough, he was riding across the sea.

Never before had the Roman people seen anything quite like it. Massed in rapt stupefaction on the shore, the watching crowds were witnessing both a parody and an upstaging of Rome's haughtiest traditions. The unmistakable echoes of a triumph in Caligula's extravaganza existed only to put in their place all those hidebound and plodding generals who had been content, in celebrating their victories, to retrace the same unvarying route through the streets of Rome. To submit to convention was to submit to the guardians of convention – and Caligula was having none of it. Primordial custom decreed that a general embarking on his triumph be received by the chief magistrates of the Republic, and by the Senate; but none of these was to be seen on the Bay of Naples. Instead, Caligula had made sure to surround himself, pointedly, with those whom he felt he could trust: the Praetorians, his soldiers, his closest friends. The bridge of boats was no place for old men. To be an intimate of the Emperor's was, almost by definition, to share his taste for putting on a show. Just as Caligula himself, the day after crossing the sea to Puteoli, posed for the return journey in a chariot

drawn by the most famous racehorses in Rome, so his friends, as they followed him back across the bridge, rattled along in chariots from Britain.* A touch of the exotic was only to be expected in a triumph; but Caligula, fresh though he was from the Channel, was hardly the man to confine himself to parading his mastery of the barbarous North. From the setting of the sun to its rising, the whole world was his to command – for which reason, in token of his universal supremacy, he made sure to ride with a Parthian hostage, a princeling, by his side. Not a detail of the pageant, not a flourish, but it had been painstakingly planned. Even darkness failed to dim the show. As twilight fell, so bonfires in a great arc blazed from the heights above the bay, illuminating the men who had participated in the crossing where they lay feasting on boats anchored the length of the bridge. As for Caligula himself, he remained on the pontoon; and when he had eaten and drunk enough, he amused himself by treating some of his companions much as he had done his uncle, and pushing them into the sea. Finally, determined that the celebrations not end in anticlimax, he ordered that some of the vessels where his men lay feasting be rammed. And as he watched the action, 'so his mood was all elation'.[35]

Spectacle, mockery, violence: Caligula had long displayed a genius for combining them in the cause of his pleasure. From the bridge of boats, he could make out on the horizon the silhouette of Capri, where he had studied at his great-uncle's feet the various arts of fusing display with humiliation. Tiberius, disgusted by his own proclivities, had preferred to keep them veiled from the eyes of the Roman people – but not Caligula. The tastes that he had honed on his predecessor's private island, whether for role-play or for obliging

* Suetonius does not specify the chariots' place of origin, but the word he uses to describe them, *esseda*, refers to war-chariots of the kind used in earlier centuries by the Gauls, and in Caligula's time exclusively by the Britons. Maecenas, ever at the forefront of innovation, was supposed to have owned 'a British *essedum*'. (Propertius: 2.1.76)

the offspring of senators to hawk themselves like prostitutes, had at last come into their own. No longer did Caligula feel the slightest qualms about parading them. What were standards of behaviour inherited from a failed and toppled order to inhibit the 'Best and Greatest of the Caesars'?[36] He had ridden on water, after all. Resolved as Caligula was to rub the noses of the nobility in their own irrelevance and desuetude, there was nothing any longer to keep him from the greatest stage of all. He had been away on his travels a whole year. Now, at last, it was time to return to Rome.

Caligula entered the city on 31 August, his birthday. The Senate had marked the occasion by voting him renewed honours; but the Emperor, although content on this occasion to accept them, made sure as he did so to flaunt the true basis of his authority. Soldiers surrounded him as he paraded through the streets: Praetorians, legionaries, a private bodyguard of Germans. So too did the Roman people; and Caligula, pausing in the Forum, clambered up onto the roof of a basilica and began showering them with gold and silver coins. In the resulting stampede, huge numbers were crushed to death – including over two hundred women and a eunuch. Delighted, Caligula repeated the stunt several days running. 'And so the people loved him – because he had bought their goodwill with money.'[37]

Not the goodwill of the aristocracy, though. Among them, there was only renewed despair. They knew perfectly well what the Emperor was up to. The powers of patronage that had always been the surest basis of their *auctoritas* were being simultaneously parodied and undercut. Worse – when Caligula sent plebs scrabbling in the dirt after his munificence, he was reminding ambitious senators that they were no less dependent on his caprices. Even the noblest of magistracies, those hallowed by the many great men elected to them over the course of the centuries, were in his gift. Caligula, unlike his predecessors, did not hesitate to rub in the fact. Skilled as he was 'in discerning

a man's secret wishes',[38] he brought a lethal and merciless precision to the art of mocking them. Aspirations that for centuries had steeled the nobility in the service of the Republic were made the object of corrosive jokes. When Caligula declared his intention of appointing Incitatus, his favourite horse, to the consulship, so cruel was the satire that it seemed to the aristocracy almost a form of madness.

Yet escape from it seemed impossible. Helpless as senators were to suborn either Praetorians or German bodyguards, what practical hope did they have of liberating themselves? When Caligula, reclining at a banquet with the two consuls, suddenly chuckled to himself, murmuring that with a nod he could have both their throats cut on the spot, he was playing mind games with the entire aristocracy. 'Let them hate me, so long as they fear me.'[39] This line, a quotation from an ancient poet, summed up what had become, in the wake of the great conspiracy against him, the Emperor's settled policy towards the Senate. Surveillance bred terror – and terror bred surveillance. When a second plot was exposed shortly after Caligula's return to Rome, it was a senator who betrayed it.[40] The guilty men, all of them of the highest rank, were hauled before the Emperor where he was staying in his mother's villa outside the city. First he had them lashed; then tortured; and then, when they had confessed everything, gagged. By now it was night, and torches lit the gardens where Caligula and his dinner guests were strolling beside the river. The prisoners, pushed to their knees on the terrace, were forced to bend their necks. The shredded clothes stuffed into their mouths ensured that no defiant final words could be uttered before their heads were hacked off.

'Whoever heard of capital punishment by night?' To many senators, the real scandal of the business was less the executions themselves than that they had been laid on as an after-dinner entertainment. 'The more that punishments are made a public spectacle, so the more they are able to serve as an example and a warning.'[41]

Here was the authentic voice of the Roman moralist, convinced that anything staged in private was bound to foster depravity and deviance. The presumption was a venerable one: prominent citizens should never, under any circumstances, be permitted private lives. Stories of what Tiberius had got up to on Capri served as a particularly salutary warning of what was bound to happen otherwise. Nevertheless, there were other lessons as well to be drawn from the episode. It was on Capri, after all, that Caligula, granted licence by his great-uncle, had honed his various tastes for dressing up, for participating in mythological floor-shows, for witnessing the upper classes debase themselves. In truth, those who imagined that the only purpose of inflicting punishment was to educate the Roman people in the responsibilities of citizenship were grievously behind the times. Caligula made sport with senators so as to intimidate the entire elite – but also because it amused him. If sometimes the vengeance he meted out to his victims was necessarily as swift as it was discreet, then his preference in general was for toying with them in public. 'Only strike such blows as permit a man to know he's dying.'[42] The maxim was one that Caligula treasured.

What Capri had been to Tiberius, the whole of Rome was now to his heir: a theatre of cruelty and excess. Few senators were skilled enough to negotiate its disorienting terrors. One such was Lucius Vitellius, the father of Caligula's great friend, and a former consul with an impeccable record of achievement. Summoned back from Syria, where his feats as governor had included compelling the king of Parthia to bow before his legions' eagles, he feared – correctly – that his very accomplishments had made him an object of suspicion. Accordingly, for his interview, he dressed in the coarse clothing of a plebeian, then veiled his head as though approaching the altar of a god. Prostrating himself with a flamboyant flourish, Vitellius hailed the Emperor as divine, raising prayers to him and vowing him sacrifice. Caligula, not merely mollified, was highly amused. Yes, it

was a game – of the kind that the younger Vitellius, familiar with the workings of Caligula's mind from their time spent together on Capri, had doubtless tipped off his father about. It was not, though, entirely so. Many decades before, at the wedding feast of Caligula's great-grandfather, the guests had come dressed as gods, provoking indignant crowds to riot; but now Augustus himself had ascended to the heavens. How, then, when Caligula appeared in public dressed as Jupiter, complete with golden beard and thunderbolt, were people to react? A cobbler from Gaul, laughing at the spectacle and telling the Emperor to his face that he was 'utterly absurd',[43] was sent on his way with a smile; but when a famous actor, an intimate of Caligula's named Apelles, was asked who seemed the greater, Jupiter or Caligula himself, and could only swallow and stammer, the reprisal was swift. The Emperor appreciated quick thinking as well as respect, and Apelles had failed him on both counts. The whipping given the wretched actor was apt as well as cruel. Not only did Apelles in Latin mean 'skinless', but Caligula was able to inform the wretched man, as the hide was flogged off his back, that his screams were so exquisite as to do him perfect justice as a tragedian. Between reality and illusion, between the sordid and the fantastical, between the hilarious and the terrifying, lay the dimension where it most delighted Caligula to give his imagination free rein. It took a man of Vitellius's rare perspicacity to appreciate this, and follow the implications through. 'I am talking to the moon,' Caligula once casually informed him. 'Can you see her?' Vitellius, dropping his eyes to the ground, smoothly played along. 'Only you gods, O Master, are visible to one another.'[44]

Because Vitellius understood the rules of the game, and was skilled at it, he was admitted to the highly exclusive circle of senators whom the Emperor was still prepared to acknowledge as friends. Most, bewildered by the sheer ferocity of the assault upon their dignity, found themselves helpless to serve as anything save the butts of his malevolent humour. Nothing entertained Caligula more than

to fashion situations in which the elite would be obliged to humiliate themselves. Like the connoisseur of suffering that he was, he relished the opportunity to subject his victims to careful study. When he abolished the reserved seating that Augustus had instituted in arenas, it amused him in the extreme to observe senators and equestrians scrabble after places along with everyone else, 'women next to men, slaves next to free'.[45] Equally, there were times when he might enjoy a more intimate perusal of the extremes of misery to which a man could be reduced. On the same day that he had executed on a trifling charge the son of an equestrian named Pastor, Caligula invited the father to a banquet. Guards were stationed with orders to watch the wretched man's every last facial tic. Caligula, toasting his health, gave him a goblet of wine to drink – and Pastor drained it, 'although he might as well have been drinking the blood of his son'. Whatever was sent Pastor's way – whether perfume, garlands or lavish dishes – he accepted with a show of gratitude. Onlookers, not knowing his son's fate, would never have guessed the depths of misery masked by his frozen expression. The Emperor knew, though – and he knew the reason why Pastor wore such a fixed smile on his face. 'He had another son.'[46]

Caligula, who had himself lived under the suspicious gaze of Tiberius for years, never once in all that time betraying so much as a hint of grief for his mother and brothers, had fathomed a menacing truth. The sacred bonds of duty and obligation which, back in the days of the Republic, had enabled prominent families to perpetuate their greatness down the generations could now, under a Caesar such as himself, be made to entangle them, to catch them in a net. Six months after Caligula's return to the capital, his residence on the Palatine was crowded with hostages: 'the wives of Rome's leading men, and those children possessed of the bluest blood'.[47] Tiberius had retreated to Capri before surrounding himself with the offspring of the nobility; but Caligula, 'when he installed them and subjected

them to sexual outrage',[48] had no intention of veiling the scandal. Quite the contrary. Over half a century before, Augustus had declared adultery a crime, sentencing women who cheated on their husbands to dress as whores. Caligula, installed in the very house of Caesar, preferred to turn such legislation on its head. Building work had extended the warren of houses and alleyways that constituted the imperial residence all the way to the Forum; and now, with the wives and children put up there in lavishly furnished rooms, 'young and old alike' were invited to ascend the Palatine and peruse the wares.[49] The affront to the aristocracy, even after everything else that they had suffered, could hardly have been more devastating. To the values enshrined by Augustus too. A brothel in the house of the August Family was a development fit to have made even Ovid suck in his breath. It was Caligula's most shocking, most transgressive, most subversive joke of all.

'Manifold though his vices were, his truest bent was for abuse.'[50] By AD 41, four years after his accession to the rule of the world, Caligula's genius for insult had the entire Roman elite cowering in its shadow. It was enough for one of his agents to enter the Senate House, fix a senator with his glare and charge him with hating the Emperor for the colleagues of the accused man immediately to leap up and tear him to pieces. No one, and certainly not Caligula's intimates, could ever afford entirely to relax. The Emperor liked to keep them all on their toes. One close friend, a former consul named Valerius Asiaticus, was publicly reproached for his wife's inadequate performance in bed – a rebuke that Caligula found all the more droll for the fact that Valerius was 'a proud-spirited man, and notably thin-skinned'.[51] Even a Praetorian might not be spared mockery. A senior officer named Cassius Chaerea, a grizzled veteran who had seen distinguished service on the Rhine and fought under Germanicus, provoked the Emperor to particular hilarity. Bluff and tough though Chaerea was, in the sternest tradition of the Roman military, his voice was discordantly

soft; and so Caligula would give him as a watchword, whenever he was on duty, some phrase appropriate to a woman. It was not only the Emperor himself who was reduced to hysterics by this; so too were the other Praetorians. Caligula, as ever, knew precisely how to wound.

And knew as well how to turn it to his own advantage. When he called Chaerea 'girl',[52] or made obscene gestures with his finger whenever the Praetorian had cause to kiss his hand, the pleasure that he took in probing his victim's sensitivities was not his only reason for doing so. Caligula had need of a heavy to do his dirty work for him – and he judged correctly that Chaerea would make all the more effective a torturer or enforcer for his desperation to avoid the slur of effeminacy.

Nevertheless, it was a finely balanced call. Terror bred terror, after all. Caligula's capacity to trust those in his entourage, grievously wounded as it had been by Lepidus and his two sisters, had, with the exposure of the second plot against him, received a near fatal blow. The man who delivered it, a senator named Betilienus Capito, had been the father of one of the conspirators. Obliged to watch his son's decapitation, he had declared himself complicit in the plot as well – and had then, in great detail, provided what he claimed to be a list of everyone else involved. Almost no one close to Caligula was absent from it: his most trusted friends; the Praetorian high command; even Caesonia. 'And so the list was treated with suspicion; and the man was put to death.'[53] Nevertheless, Capito had achieved his aim. The terror that Caligula inspired in those around him was more than reciprocated by the paranoia that they induced in him. Indeed, the New Year saw him so twitchy that he made plans to leave Rome once again. As before, he aimed to follow in his father's footsteps. With a tour of the Rhine already under his belt, Caligula now turned his gaze towards the East. In particular, he yearned to see Alexandria; he spoke openly of his love for the city, 'and of how he planned to

head there with all imaginable haste – and then, on arrival, to stay a considerable time'.[54] The end of January was duly set as the date for his departure.

First, though, there were games to celebrate. Staged in honour of Augustus, they were held in a temporary theatre erected on the Palatine – and so much did Caligula enjoy them that he added three extra days to the scheduled programme. On 24 January, the final day of the festival, and with his departure for Alexandria imminent, the Emperor was in an unusually relaxed and affable mood. The spectacle of senators scrabbling after unreserved seats afforded him as much amusement as it had ever done; at the sacrifices to Augustus, the splashing of blood onto one of his companions, a senator named Asprenas, made him laugh.* Then, to liven things up still more, he ordered huge quantities of sweets to be tipped out over the stands, and rare birds. As the spectators scrabbled after these treats, elbowing and shoving each other frantically, so Caligula's mood was even more improved. Finally, to set the seal on a thoroughly enjoyable morning, he watched a performance by Rome's most famous star, an actor named Mnester, as beautiful as he was talented, and with whose charms Caligula was notoriously besotted. The tragedy featured both incest and murder; and accompanied as it was by a farce in which there was much vomiting up of guts, not to mention a crucifixion, it left the arena awash with artificial blood.

Lunchtime arrived, and Caligula decided to dine and refresh himself in his private quarters. He and his entourage accordingly rose and left the forecourt in which the temporary stands for the games had been raised. They entered the August House, and Claudius and Valerius Asiaticus, leading the way, continued towards the baths along a corridor lined with slaves; but Caligula, informed that some

* So, at any rate, reports Josephus, whose account is the most detailed and contemporary that we have. According to Suetonius (*Caligula*: 57.4), the blood was that of a flamingo – and it was Caligula himself who was splashed by it.

Greek boys of noble family were rehearsing a musical performance in his honour, turned aside to inspect them. As he walked down a side-alley, his litter-bearers behind him, he saw approaching him Cassius Chaerea, together with a second officer, Cornelius Sabinus, and a troupe of Praetorians. Approaching the Emperor, Chaerea asked for the day's password. The reply, inevitably, was a mocking one – whereupon Chaerea drew his sword and struck a blow at Caligula's neck.[55]

His aim was not all it could have been. The blade, slicing through the Emperor's shoulder, was obstructed by his collarbone. Groaning in agony, Caligula stumbled forwards in a desperate effort to escape. Sabinus, though, was already onto him. Seizing the Emperor by the arm, he bent him over his knee. Down rained the swords of the Praetorians. It was Chaerea, aiming a second blow better than his first, who succeeded in decapitating his tormentor.[56] Even then, the Praetorians' blades continued to flash and hack. Several thrust their swords through the dead man's genitals. Some, rumour would later have it, even ate the Emperor's flesh.[57] One thing was certain: Chaerea found the taste of vengeance sweet. Only when Caligula's body had been mangled almost beyond recognition did he and his accomplices finally slip away, running through a set of alleyways and concealing themselves in what had once been Germanicus's house.

By now Caligula's litter-bearers, who initially, and with great courage, had sought to stave off the assassins with their poles, had also fled. Even when the Emperor's German bodyguard, alerted to their master's murder, came hurrying to the scene and drove off the remaining Praetorians, they left his trunk and severed head alone. As they spilled out through the streets of the Palatine, hunting the assassins, the corpse of Caligula lay where his murderers had left it. There it was found by Caesonia and her young daughter: a child that Caligula, witnessing her viciousness, and the relish she brought to

scratching the faces of her playmates, had laughingly acknowledged his own. And there in turn they were found, mother and daughter together, prostrated by misery and covered in Caligula's blood, by a Praetorian sent to hunt them down. Caesonia, looking up at the soldier, urged him through her tears to 'finish the last act of the drama'[58] – which he duly did. First he slit her throat; then he dashed out her daughter's brains against a wall.[59]

So perished the line of Caligula: dead of a joke taken too far.

6

IO SATURNALIA!

Master of the House

Chaos spelt opportunity. None knew this better than the House of Caesar itself. This was why, ever since Augustus had emerged to supremacy from the horrors of civil war, it had jealously denied to anyone outside its own exclusive circles the chance to capitalise upon its often murderous rivalries. Now, though, with the assassination of Caligula, the dice had been thrown up in the air. The Palatine, from where Augustus had upheld the peace of the world, was given over to riot and confusion. German swordsmen, combing its tangle of alleyways and corridors, searched for the killers in a blood lust of their own. When they ran into Asprenas, the unfortunate senator whose toga had been dirtied during the sacrifices, they cut off his head. Two other senators were dispatched with equal brutality.

Meanwhile, in the theatre, confused rumours were sweeping the stands. No one could be certain that Caligula was truly dead. Some reported that he had escaped his assassins and made it to the Forum, where he was whipping up the plebs – 'who in their folly had loved and honoured the emperor'.[1] Senators sat paralysed, torn between their longing to believe the reports of their tormentor's death and

their dread that it was all a trick. Their nerves were hardly settled by the sudden arrival of a posse of Germans, who, after brandishing the heads of Asprenas and the two other murdered senators in their faces, dumped them on the altar. Only the timely arrival of an auctioneer famed for his booming voice, who confirmed for the benefit of every-one in the theatre the death of the Emperor, and successfully urged the Germans to put up their swords, prevented a massacre. Caligula would no doubt have been disappointed.

Meanwhile, down in the Forum, some of the more ambitious among the Senate were already calculating what his elimination might mean for them. When indignant crowds surrounded Valerius Asiaticus and demanded to know who had murdered their beloved emperor, he replied with cheery insouciance, 'I only wish that I had.'[2] Clearly, the insult to his wife had not been forgotten. More was at stake, though, than the satisfaction of personal pique. Without an obvious heir to Caligula on hand, a dizzying prospect had abruptly opened up before the nobility. That afternoon, as the Forum seethed with protestors, it was no emperor who appointed guards to keep order, but the two consuls. When senators convened to debate the future, they did so not in the Senate House rebuilt by the Caesars, but high up on the Capitol, in the great temple of Jupiter, on a site redolent of Rome's venerable past. 'For those schooled in virtue, it is enough to live even a single hour in a free country, answerable only to ourselves, governed by the laws that made us great.'[3] So declared one of the consuls in a tone of soaring self-satisfaction. When Cassius Chaerea, reporting to the Senate that evening, solemnly asked the consuls for the watchword, the answer proclaimed to the Roman people that their ancient constitution was restored: 'liberty'.

Except, of course, that it would take more than fine words to resuscitate the Republic. The regime founded by Augustus had put down roots so deep that only those at its heart could glimpse how far they reached. Senators, whose rank was fixed for them by law,

and whose stage was a debating chamber in which everyone sat on open display, were ill-placed to trace them. Few now lived on the Palatine, that great labyrinth of alleyways, corridors and courtyards, into which even the murderers of an emperor had been able to vanish with impunity. One who still did was Caecina Largus, an Etrurian like Maecenas, and of the same family as Germanicus's deputy on the Rhine. In the garden of his mansion there stood some beautiful lotus trees, of which Caecina was inordinately proud – as well he might have been, for from beneath their shade he was better placed than any number of his colleagues to monitor the *arcana imperii*, 'the secrets of power'. Currents were flowing of which the senators on the Capitol were only dimly aware. However proudly Chaerea might strut, Caecina knew that most Praetorians had no stake in any return to the Republic. Roaming the Palatine in the wake of Caligula's murder, they had been hunting his killers, not siding with them. Unsurprisingly, then, rather than join his colleagues in their grandstanding on the Capitol, Caecina opted to play a different game. Other, more certain routes to influence lay open. Caecina was not alone in suspecting that Rome's future had already been decided for her.

Some months before his assassination, Caligula had summoned the two Praetorian prefects to a private interview. Their names had appeared alongside Caesonia's on the list of conspirators drawn up by Capito – and Caligula demanded reassurance, despite his reluctance to believe them guilty. The two prefects, frantically assuring him of their loyalty, had lived to tell the tale – but the suspicions aroused by the meeting had not been eased. Both men knew full well what their fates might be were they to lose Caligula's favour; but they appreciated too the stake that they, and all the Praetorians, had in the survival of the House of Caesar. Who, though, could they adopt as a plausible candidate for the rule of the world? Lucius Domitius Ahenobarbus, the son of the exiled Agrippina and the only living male descendant of Germanicus, was a tiny child. Someone else

would have to do. Someone adult, obviously, and a member of the August Family – and yet so despised and discounted by his relatives that not even Caligula had got around to eliminating him. Seen from such a perspective, the solution to the prefects' dilemma was obvious. Indeed – there was only one.

News of what the Praetorians were up to reached the senators on the Capitol as they were still debating the future of the Republic. It was claimed that Claudius, in the wake of his nephew's assassination, had hidden himself behind a curtain. A Praetorian, hurrying past, had seen his feet sticking out and pulled the curtain aside. When Claudius, falling to his knees, had begged for mercy, the soldier, raising him back onto his feet, had hailed him as *imperator*. A man less qualified to receive such a salute than the sickly and decidedly civilian Claudius it would have been hard to imagine, of course; but that had not prevented the Praetorians from bundling him into a litter, abducting him to their camp, and there, en masse, 'endowing him with supreme power'.[4] So, at any rate, it was reported to the Senate – who greeted the news with predictable consternation. Urgently, the consuls sent a summons to Claudius. He replied, in a tone of theatrical regret, that he was being kept where he was 'by force and compulsion'.[5] Notable scholar that he was, he knew his history. He appreciated that the surest way to win legitimacy as a Princeps was to insist that he did not want to be one. Just as Augustus and Tiberius had done before him, Claudius kept lamenting that he had no taste for supreme power – even while taking every step he could to secure it. One day into the restoration of the Republic, and already it was effectively dead.

By the following morning, with Claudius still securely ensconced in the Praetorians' camp, and crowds down in the Forum chanting for an emperor, the Senate was left with little choice but to accept this. All that remained for it to do was to question whether a man who dribbled and twitched, who had never served with the legions,

and who was a Caesar neither by blood nor by adoption, was really the best man for the job. Various senators, demonstrating a signal failure to understand the rules of the game, immediately set about pushing their own claims. One, a former consul and noted orator by the name of Marcus Vinicius, could at least boast a link to the August Family – for he had been married for almost a decade to Julia Livilla, Caligula's disgraced youngest sister. A second, a man who had conspiracy and ambition running in his veins, sat at the heart of numerous spiders' webs. Annius Vinicianus was, as his name suggested, a relative of Marcus Vinicius, but he had also been a close friend of the executed Lepidus and knew Chaerea well. Unsurprisingly, then, there were plenty who detected his fingerprints all over Caligula's assassination. Vinicianus himself, by putting his name forward, did nothing to scotch such rumours.

It was not the habit of the Roman people, though, to favour men who operated in the shadows; and this was why, when Valerius Asiaticus put himself forward as a third candidate for the rule of the world, he could do so as a man renowned for the splendour of his lifestyle. His property empire stretched from Italy to Egypt; his gardens, a wonderland of exotic blooms and no less extravagant architecture on the heights above the Campus Martius, were the most celebrated in Rome; his sense of dignity, which Caligula had so wilfully offended, was true to the haughtiest traditions of the Republic. To the cowed ranks of the aristocracy, Valerius Asiaticus provided a welcome dash of colour, a reminder of what they had once been, before the rise to power of the Caesars. Despite that, though, he had no more realistic prospect of succeeding to the rule of the world than any of the various other senators making their pitch that morning. Not all his glamour and swagger could compensate him for one besetting drawback: he was not from Rome, nor even from Italy, but a Gaul. How could such a man hope to displace the brother of Germanicus, the nephew of Tiberius, a Claudian? Sure enough, by the afternoon of 25

January, Valerius Asiaticus – and everyone else on the Capitol too – had bowed to the inevitable. Through gritted teeth, senators who only the previous day had been talking in elevated tones about the restoration of liberty voted to entrust a man most of them despised with the full bundle of powers lately wielded by Caligula. Additionally, they granted him a title that the Senate had never before needed to bestow upon a Princeps: 'Caesar'. That evening, when the fifty-year-old invalid whom his own mother had described as 'a freak of a man'[6] left the Praetorian camp and headed back into the centre of Rome, there to take possession of the Palatine, he did so as the bearer of an appropriately splendid new name: Tiberius Claudius Caesar Augustus Germanicus.

The new emperor had played dangerously, but he had played well. As a young man, denied the opportunities provided as a matter of course to other members of the August Family, he had developed such a passion for gambling that he had even written a treatise on the subject: an addiction that, naturally enough, had only confirmed in their scorn those who regarded him as weak-minded. Yet it was Claudius who had enjoyed the last laugh. Though the odds had always been stacked against him, he had demonstrated an unexpected ability to play them. In the supreme crisis of his life, he had placed a bet that had won him the world. Not since Julius Caesar's crossing of the Rubicon had there been quite so blatant a military coup.

Naturally, like the shrewd and calculating operator that he had revealed himself to be, Claudius chose to veil this as well as he could. He knew that his position remained precarious. He was certainly in no position to enforce a rule of terror. Although Chaerea was put to death – as he had to be for his crime of murdering an emperor – and Cornelius Sabinus, who had joined in Caligula's assassination, committed suicide, deaths were otherwise kept to a minimum. In the Senate, everyone breathed a huge sigh of relief – and particularly those who had publicly opposed Claudius becoming emperor. When

they agreed to vote him the same wreath of oak leaves awarded many decades previously to Augustus, 'because he had preserved citizens' lives',[7] it was more than an empty gesture. Coming after the terrors and humiliations inflicted on them by Caligula, an emperor who made play of his clemency was hardly to be sniffed at, after all. Claudius, who had suffered mockery his whole life, was sensitive to the dignity of others. Despite his lameness, he always made a point of rising to his feet when addressed by his fellow senators; and some- times, should a particularly elderly senator be struggling to hear what was being said, he would permit the old man to sit on a bench reserved for magistrates. Claudius, unlike his nephew, was not a man to cause deliberate offence.

Nevertheless, he had no illusions as to his popularity with the Senate. Anxiety about his own personal security shaded into para- noia. All those allowed into his presence were first subjected to a vigorous frisking; he never dined but there were soldiers beside him; and when, a month after coming to power, he finally entered the Senate House for the first time, he did so accompanied by guards. Claudius knew what he owed the Praetorians – and he was not afraid to acknowledge it. One of his coins was stamped with an image of their camp; another showed him shaking hands with their standard- bearer. The friendship between emperor and Praetorians had been expensively bought. Vast handouts, equivalent to five times their annual pay, were lavished on them, a bribe so blatant that its nature could not possibly be concealed.[8]

Nor was that all. Ever since the accession of Tiberius, the legions on the frontiers had regarded it as their right to receive enormous donatives from a new Caesar. This was hardly a tradition that Claudius was minded to buck. Yet it confronted him with a massive financial headache. Even at the best of times, the funding of Rome's armies swallowed up a huge proportion of the annual budget. 'No peace without arms – and no arms without pay.'[9] Yet money, by the

standards of the August Family, was precisely what Claudius had always been short of. Caligula, as much for his own amusement as for any other reason, had systematically mulcted his uncle of such millions as he could. At one stage, in order to raise the sums necessary to qualify for continued membership of the Senate, Claudius had been reduced to selling off his properties. Now, as emperor, the need to secure military backing faced him with a bill equivalent almost to Rome's entire annual intake of revenue. How to pay it?

The best bets are those placed with privileged knowledge. Claudius, practised gambler that he was, understood this as well as anyone. To have accepted the support of the Praetorians without first securing the funds necessary to keep them on-side would have been a lethal misjudgement. Claudius needed the backing of accountants as well as soldiers. In this, luck had favoured him. The two prefects had not been alone in lending him their support. At their fateful meeting with Caligula, a third man had been summoned for a grilling. Gaius Julius Callistus was a functionary, not a soldier – but no less a linchpin of the regime for that. While others busied themselves with the show of power, he presided over its secret workings. Consummate insider that he was, he understood what the House of Caesar had become: no longer, as Augustus had pretended it to be, the residence of a private citizen, but the sprawling nerve centre from which the world was run. Each day, just as at the home of any great nobleman, suitors would cluster at its gates, visitors pay their respects and eminent guests be entertained; but within its labyrinthine complex, away from the reception halls and the sumptuous banqueting rooms, operations were of an order that very few could comprehend. Every senator needed an agent to keep track of his assets; but none had assets on the scale of Caesar. There were his estates to run, of course, and his mines, and his warehouses: his *patrimonium*, as they were collectively called. But there was more. It was from the Palatine that the finances of the entire Roman world were administered: the taxes;

Germanicus: Tiberius's nephew and the darling of the Roman people.
(Photo: Tom Holland)

Agrippina lands at Brundisium with the ashes of Germanicus, as portrayed by Benjamin West in 1768. (Philadelphia Museum of Art, Pennsylvania, PA, USA / Purchased with the George W. Elkins Fund, 1972 / Bridgeman Images)

Spelunca, where Tiberius fashioned a mythological theme park and narrowly avoided being crushed to death while dining outside this cave. (Photo: Tom Holland)

The steep cliffs of Capri helped to render the island an impregnable retreat for Tiberius in his final years, and foster rumours of unspeakable depravities. (Photo: Tom Holland)

Caligula addresses the Praetorian Guard. Mention of the Senate, standard on the coins issued by Augustus and Tiberius, is notable by its absence. (© bpk / Münzkabinett, Staatliche Museen zu Berlin)

'Nature produced him, in my opinion, to demonstrate just how far unlimited vice can go when combined with unlimited power.' Caligula, as anatomised by the philosopher Seneca. (Photo: Tom Holland)

A basement chamber on the Palatine which may, just conceivably, mark the very spot where Caligula was assassinated. (Photo: Sophie Hay)

In this 1871 painting by Sir Lawrence Alma-Tadema, Caligula lies dead at the base of a bust of Augustus, while Claudius is discovered cowering behind a curtain. (© Walters Art Museum, Baltimore, USA / Bridgeman Images)

Two captives led into slavery by a soldier. For many slaves, servitude constituted a living death; for a tiny minority, a gateway to power. (Wikimedia)

Claudius, flat-stomached conqueror of the fabulous lands beyond the Ocean, forces himself on a hapless and submissive Britannia. (© Dick Osseman)

The very model of a pious Roman matron: Messalina, with Britannicus on her arm. (De Agostini Picture Library / G. Dagli Orti / Bridgeman Images)

Gardens, in a city as crowded and polluted as Rome, were a supreme mark of status. Ownership, though, was known to spell peril as well as prestige. (Photo: Tom Holland)

The new harbour at Ostia. Begun and largely completed by Claudius, it was completed by Nero – who did not hesitate to take the credit.

It's complicated . . . Nero with his mother.

A ship sinks in the Bay of Naples, as portrayed in the bath-house beside the Marine Gate in Pompeii. (Photo: Tom Holland)

Gelding clamps: applied by slavers to handsome boys, and by devotees of the Syrian Goddess to themselves. (© The Trustees of the British Museum)

The Great Fire of Rome, as imagined by Hubert Robert in the early 1770s. (Musée des Beaux-Arts Andre Malraux, Le Havre, France / Bridgeman Images)

The bronze colossus commissioned by Nero to stand guard over the entrance to the Golden House. Following his death, the statue would give its name to the great amphitheatre raised on the site of Nero's levelled architectural extravaganza: the Colosseum. (© bpk / Antikensammlung, Staatliche Museen zu Berlin / Johannes Laurentius)

Nero Claudius Caesar Augustus Germanicus. (The Art Archive / Museo Capitolino Rome / Araldo De Luca)

the funding of the legions; assorted mints. Augustus, although he had made a point of leaving his accounts to be read out by Tiberius to the Senate on his death, had been purposefully vague: 'Those who want the details can consult with the requisite officials.'[10] Two and a half decades on, it was Callistus who had the figures at his fingertips, and knew the secret location on the Palatine where the reserves of coin were stored. Accused by Caligula of treachery, after his name too had appeared on Capito's list, he had faced the same excruciating dilemma as the two prefects: whether to hope that his protestations of innocence would be believed, or to conspire in the promotion of a new Caesar. That Claudius had been able to fund his coup showed the choice that Callistus had made.

Other aides prominent in Caligula's service had been eliminated in the wake of the coup: from his personal minder to the official who kept tabs on the aristocracy, and was never seen without twin books, 'Sword' and 'Dagger'. Even the two Praetorian prefects were forcibly retired in due course. Not Callistus, though. He remained under Claudius where he had been under Caligula: at the heart of power. Like Caecina Largus, the senator who owned one of the few private residences left on the Palatine, he was too shrewd, too know-ledgeable, too valuable an ally to be cast aside. Caecina claimed his reward a year after the coup, when, as the new emperor's colleague, he served as a consul of the Roman people. Callistus, by contrast, was granted no such honour. His role remained, to outward show, far humbler. As Caecina strode through the Forum to the Senate House, guarded by his lictors, Callistus was up on the Palatine, surrounded by scrolls, vetting petitions to the Emperor. Yet the rewards enjoyed by the secretary were, according to many measures, no less than those enjoyed by the consul. Just as Caecina could boast a garden famous for its lotus trees, so had Callistus commissioned thirty pillars fashioned out of an eye-wateringly expensive brand of marble for his dining room. Although not a consul himself, he thought nothing of

vetting candidates for the office. 'Indeed, so great was his wealth and the dread which he inspired that his power verged on the despotic.'[11] Yet this man notorious for his 'arrogance and the extravagant uses to which he put his authority'[12] was neither a senator nor an equestrian – nor had he even been born a citizen. Callistus, the man who had helped to topple one emperor and who controlled access to another, had spent his early life as the lowest of the low: a slave.

The clue lay in his name. 'Callistus' meant 'Gorgeous' in Greek, and was the kind of thing that no self-respecting Roman would ever allow himself to be called. As a name given to a slave, though, it was the height of fashion – partly because it provided a hint of foreign sophistication, and partly because everyone knew that Greeks made the best slaves. The real giveaway, though, was that Callistus had also adopted Caligula's first two names, Gaius Julius. Wearing these marked him out as a man who had been set free by an emperor – as an *Augusti libertus*. Hardly a status to impress a senator, of course – except that even the grandest of noblemen knew, to their agonised regret, that lineage was no longer everything. Having the ear of Caesar might count for at least as much. As in the Senate, so in the back rooms of the Palatine: climbing the rungs of the ladder promised splendid rewards to those who could make it to the top.

Most, of course, were never in a position to try. Caesar's household teemed with slaves, and if many of these were employed in the basest of menial tasks, then others specialised in duties that offered them little better prospect of promotion. To be stuck with responsibility for the polishing of the emperor's mirrors, or the care of his perfumed oils, or the making of his fancy dress was hardly to be on the high road to influence and wealth. Secure a post handling his finances, though, and opportunities were altogether more promising. Even out in the provinces, the slaves who handled Caesar's accounts or dispensed cash to the legions on his behalf often did very well for themselves. One accountant in Gaul was the owner of sixteen slaves,

including a doctor, two cooks and a man charged with looking after his gold, while a steward in Spain was notorious for dining off silver plates, and ended up so fat that he was nicknamed 'Rotundus'. Unsurprisingly, though, it was in Rome that advancement could be quickest. On the Palatine, 'ever at Caesar's side, tending to his affairs, privy to the holy secrets of the gods',[13] a slave was as well qualified as anyone to fathom the *arcana imperii*. Play his hand wrong and he might end up like the secretary of Augustus who, caught red-handed selling the contents of a letter, had his legs broken. Play it skilfully and he might end up like Callistus: not only rich, powerful and feared, but a freedman.

That they were willing to make citizens of slaves had always been a sacred tradition of the Roman people. Even their penultimate king, a much admired warrior and administrator by the name of Servius Tullius, had allegedly once been of servile rank. It was true that Claudius himself – whose private interests included ancient history as well as gambling – disputed this tradition, and claimed that the king had originally been an Etruscan adventurer named Mastarna; but most Romans had no time for such scholarly petti-fogging. That Servius had been born into servitude was evident both from his name and from his insistence, made in the teeth of aristocratic opposition, that the Roman people would be strength-ened, not weakened, by welcoming into their ranks such slaves as they chose to liberate. 'For you would be fools,' he had told his fellow citizens, 'to begrudge them citizenship. If you think them unworthy of its rights, then do not set them free – but why, if you think them estimable, turn your backs on them solely because they are foreign?'[14] The logic of this had seemed unanswerable; and so it was, over the course of the centuries, that slavery had served many an able man as a staging post on a journey to becoming Roman. When a law was passed in 2 BC, limiting how many slaves could be set free in a citizen's will, it made explicit what had always been a

guiding principle of slave-owners in the city: that only the talented were qualified to join their ranks.

To walk the Forum, then, and to see foreigners for sale at the foot of the Palatine, their limbs shackled and their feet chalked white to mark them as imports, was, just perhaps, to see the high achievers of tomorrow. 'No one knows what he can do till he tries.' Such had been the maxim of a celebrated wit named Publilius Syrus, who as his name implied had originally been brought in chains to Italy from Damascus, but had gone on, after winning his freedom, to become Rome's leading dramatist, and to be crowned as such by Julius Caesar himself. His cousin, similarly enslaved, had ended up the city's first astronomer. Another freedman, originally transported in the same slave ship as the two cousins, had founded the study of Latin grammar, teaching Brutus and Cassius, no less. Rome, over the years, had measurably benefited from the influx of foreign talent. 'It's no crime,' as Ovid had once put it, 'to have had chalked feet.'[15]

Even the right to run for office, although denied to freedmen themselves, was open to their sons. Many had taken advantage. Although the magistrate who could trace his lineage back to a slave would naturally do all he could to hush it up, everyone knew that 'numerous equestrians, and even some senators, were descended from freedmen'.[16] Augustus himself, so stern in his insistence upon the proprieties of status, had been perfectly content to count the sons of one-time slaves as his friends. Vedius Pollio, the financier with the notoriously extravagant home furnishings, had been one such. So too had been an altogether more estimable adornment of the Augustan regime, the man entrusted by the Princeps with the hymning of Rome's rebirth, a poet still admired and treasured decades after his death. 'I am the son of a man freed from slavery.'[17] Horace, certainly, had never thought to deny it.

Yet even while honouring the debt he had owed his father, whose devotion and financial backing had given him such a stellar start in

life, he had never entirely been able to escape a certain queasiness. 'No amount of good fortune can change a man's breeding.'[18] Horace had been sufficiently a Roman to dread that slavery might leave an ineradicable taint. The surest measure of a freedman's achievement was to father a son who despised what he had been. Perhaps this was why, far from being a soft touch, the slave-owning sons of former slaves tended to be notorious for their cruelty. Vedius Pollio, excessive in all things, had enjoyed feeding clumsy pageboys to enormous flesh-eating eels. Even Augustus had been shocked. Yet, however novel a spectacle a fish tank flecked with human body parts might be, it only made manifest what it was about slavery that made freedmen so keen to demonstrate that they had escaped it for good. To be a slave was to exist in a condition of suspended death. Such was the law. Although, under normal circumstances, it was forbidden a master to kill his slaves, there was otherwise no form of violence so terrible that it could not legally be inflicted upon a human chattel. The maid who inadvertently yanked her mistress's hair might well expect to have a hairpin jabbed into her arm; the waiter who stole from a banquet to have his hands cut off and slung around his neck. Dream of dancing, and a slave was bound to be whipped. At its most brutal, the scarring from such an ordeal would leave a permanent fretwork upon the back. Thongs tipped with metal were designed to bite deep. Unsurprisingly, then, it was required by law of a slave-dealer to state whether any of his wares had ever sought to kill themselves. Barbarians who committed suicide rather than suffer to be enslaved, as did an entire tribe taken prisoner during Augustus's Spanish campaign, were rather admired. Equally, by the same reckoning, those who submitted to servitude showed themselves fitted to be slaves. The baseness of it could never entirely be escaped. Freedom was like an unscarred back: once lost, it was lost for good.

The presence of a man such as Callistus at the heart of power was, then, profoundly disturbing to many Romans. Everyone took for

granted that slaves, by nature, were prone to any number of con-
temptible habits. Rare was the owner who did not complain about
their tendency to lie and thieve. It was evident from his obscenely
well-appointed dining room that Callistus was no less inclined to
pilfer as a freedman than he had been as a slave. Indignation, though,
was not the only response to the spectacle of his wealth. There was
anxiety as well. The man who had sold Callistus to Caligula was
often to be seen standing outside his house, waiting in line for the
chance to beg a favour – and being turned away, to rub salt into
the wound. Such a sight served to remind slave-owners of a truth
that few of them cared to dwell upon: that fortune was fickle, and
that just as a slave might become a free man, so might a free man
become a slave. 'Scorn, then, if you dare, those to whose level, even
as you despise them, you may yourself well descend.'[19] Many cen-
turies before, while lecturing the Roman aristocracy on the need to
accept freedmen as fellow citizens, Servius Tullius had made a similar
point: that of 'how many states had passed from servitude to liberty,
and from liberty to servitude'.[20] It was perhaps no coincidence that
Servius should also have prescribed that slaves, during the festival of
the Compitalia, be the ones who made sacrifice to the Lares – and
that they be permitted, what was more, to dress and behave like free
men for the duration of the festivities. Other days of the year wit-
nessed similar scenes of misrule. Early in July, slavegirls would put
on their mistresses' best clothes and offer themselves up for wild sex
to passers-by; in December, the cry of '*Io Saturnalia!*' would herald an
even more riotous celebration of role reversal, in which slaves were
allowed to put aside their work and be feasted by their masters. It
was, most people agreed, 'the best day of the year'[21] – and yet a world
in which every day was Saturnalia was hardly one in which even the
most party-loving citizen would care to live. Proprieties had to be
maintained – for if they were not, then who could say where things
might not end?

Enough had happened in recent history to suggest the answer. Not the least horror of the civil war had been the dread that the distinction between slave and free, so fundamental to everything that made the Roman people who they were, had begun to blur and come under threat. Former slaves, in blatant disregard of the law, had dared to usurp the privileges of equestrians, 'strutting around, flashing their wealth';[22] simultaneously, amid the chaos of the times, many a citizen had vanished into the chain-gangs of unscrupulous slavers. The problem had become so serious that Tiberius, during his first term as a magistrate, had been charged with touring slave-barracks across Italy and setting free all kidnapped prisoners. The order brought to the world by Augustus had, of course, helped to restore the chasm of difference that properly separated citizen from slave; but to those sensitive about their status, the character of his regime had only served to open up fresh wounds. Caligula, with his unerring talent for inflicting maximum pain, had naturally made sure to jab at them hard. On one occasion, in the full view of the Senate, a venerable former consul had expressed his gratitude for being spared execution by sinking to his knees – and Caligula had extended his left foot to be kissed, as he would have done to a slave. It had amused him too, as he dined, to be waited on by eminent senators dressed in short linen tunics, and to have them stand subserviently at his head and feet. Most devastatingly of all, he had granted slaves the right to bring charges against their masters: a licence of which many had taken enthusiastic advantage. Here, for the elite, had been one final, culminating horror: to discover that Caligula had his eyes and ears even in their homes, even in their most intimate moments, even among their basest menials.

Claudius, who had himself had a capital charge brought against him by one of his slaves, and only narrowly escaped conviction, was sympathetic to the sensitivities of his fellow senators. In token of this, one of his first acts as emperor was to sentence a lippy slave to a public

flogging in the Forum. Claudian that he was, and scholar of Roman tradition, he was no revolutionary. Nevertheless, he had good reason to keep Callistus in his post. Unlike other men of his rank, Claudius had been confined by his disabilities to the domestic sphere in which talented freedmen were liable to make the running – and was in consequence unusually alert to their capabilities. Inexperienced as he was in the arts of government, yet earnestly resolved to provide the world with efficient administration, he had no wish to deprive himself of able subordinates.

Accordingly, far from slapping Callistus down, Claudius looked around for other, similarly talented freedmen to serve alongside him. One candidate selected himself: Pallas, the slave who had been entrusted by Claudius's mother with the letter to Tiberius that had ultimately served to bring down Sejanus. Freed in token of his services shortly before Antonia's death, he combined formidable administrative ability with an absolute loyalty to the Claudian house. So too did a third freedman, a master of back-room dealing by the name of Narcissus, who owed his power partly to the fact that he had been owned by the Emperor himself and partly to his own consummate skills as a fixer. Naturally, to resentful outsiders, his influence over Claudius could hardly help but seem sinister in the extreme: definitive proof that the new emperor was as befuddled and gullible a fool as everyone had always said he was. In truth, though, it illustrated the opposite: that Claudius was vastly more interested in setting his administration on a firm footing than with what his critics might have to say. He knew that he had no legal right to the Palatine, and that his possession of it was entirely a result of his coup; he knew too that his best chance of keeping hold of it was to exploit its resources to the full. The world needed good governance – and Claudius, in his determination to provide it, was content to grant his ablest freedmen such authority as they needed to be effective. No longer was there to be any pretence that Caesar's household was anything but what it was: a court.

Inevitably, despite these changes, the essentials of the regime remained unaltered. Claudius's reliance on his triumvirate of talented freedmen, while it boosted the efficiency of his government, did nothing to calm the swirl of intrigue and the scrabbling after power that had long been such features of life on the Palatine. The endless contest for advancement and advantage went on as it had ever done – but now with the addition of a new raft of power-brokers. Some adapted well to this development; others did not. Lucius Vitellius, ever alert to changes in the wind, smoothly added statues of Pallas and Narcissus to his household shrine, managing to remain as high in favour under Claudius as he had been under Caligula; but another senator, an experienced general named Silanus, proved hopelessly unequal to the demands of faction-fighting on the Palatine. Outmanoeuvred by his enemies, he was put to death on the orders of the Emperor only a year after Claudius had come to power. The precise details were murky, as so often with such cases; but all were agreed that the *coup de grâce* had been applied when Narcissus, hurrying to his master at daybreak, had reported seeing him murdered by Silanus in a dream. The episode made Claudius look both vindictive and credulous – an impression not helped by the damage already done to his authority by another, infinitely more titillating incident. Sex, incest and exile: less than a year after his seizure of power, the new emperor had found himself embroiled in an all too familiar kind of scandal.

It had begun, as so often before, with an attempt to project an image of domestic harmony. Keen to assert his authority as the head of the August Family, Claudius had summoned back his two nieces from the exile to which Caligula had sentenced them; but Julia Livilla, unlike Agrippina, had failed to learn her lesson. It was reported that she had begun an affair with a senator widely hailed – not least by himself – as the most brilliant man of his generation: a dazzling orator and intellectual by the name of Seneca. Nor was that

the most titillating detail. It was rumoured as well that Julia's uncle, smitten by her youthful charms, had been spending altogether more time with her than was decent for an old man. Whatever the truth of this, it was certain that the mere rumour of it had made her a mortal enemy. Claudius's young and beautiful wife, Valeria Messalina was as well connected as she was famously pearly toothed. Like Julia, she was a great-grandniece of Augustus and had not the slightest intention of ceding advantage to a rival. Nor did it help that she was the daughter of Domitia Lepida, whose sister had taken the young Domitius under her wing after his mother's exile by Caligula, and was cordially detested by Agrippina as a rival for her son's affections. Unsurprisingly, then, relations between Claudius's wife and his two nieces were toxic. When news of Julia's affair with Seneca became common currency, it was Messalina whom many suspected of the leak. It certainly spelt disaster for the couple. Seneca was exiled in disgrace to Corsica, and Julia – once again – to a prison island. There, shortly afterwards, she was starved to death. A year on from the coup that had brought Claudius to power, all his talk of a new beginning already seemed so much hot air.

The most grievous blow to his reputation, though, was yet to come. A year after his coup, Claudius remained twitchy and insecure. That his administration was decidedly less murderous than his predecessor's did not impress his critics. Senators who had expressed their resentment of him on the fateful day of Caligula's assassination continued to scorn him as a fool, while the execution of Silanus at the behest of a freedman seemed to offer a grim portent of where his regime might be heading. Particularly resentful was Annius Vinicianus, whose ambition to lead the Roman world had been so decisively trumped by the Praetorians' support for Claudius, but whose relish for spinning subtle webs of conspiracy remained undimmed. A year on, midway through 42, he was ready to attempt a coup of his own. In the Balkans, the commander of two legions

had committed to backing the insurrection; in Rome, numerous senators and equestrians. Delivered an insulting letter demanding that he retire, Claudius was so flustered that he briefly despaired of his prospects; but it was not in vain, as it turned out, that he had paid such hefty bribes to the military. The soldiers in the Balkans refused to join the uprising; their commander committed suicide; so too did Vinicianus. Others implicated in the conspiracy, hesitating to follow their leaders' example, had to be shamed into doing so. Most notorious for his hesitation was a former consul named Paetus. Holding his sword in a shaking hand, but dreading to fall on it, he had it snatched from him by his wife, who then promptly dropped onto it herself. 'See, Paetus,' she declared with her dying breath, 'it does not hurt.'[23]

The stern quality of this admonishment, redolent as it was of Roman womanhood at its most antique and heroic, was much admired; for everything else about the abortive coup had been squalid in the extreme. Once again, as in the darkest days of Tiberius's reign, there were corpses being dumped on the Gemonian Steps and hauled away on meat-hooks. Indeed, to bruised and bewildered senators, their world seemed as upended as it had ever been. Some of the conspirators had saved their skins by bribing Narcissus to intervene on their behalf; others, even more shockingly, had been put to torture. Here was the true measure of the scare that Claudius had been given: for there was only one class of person who could legally be subjected to such an indignity during an investigation into treason, and that was a slave. Specialists skilled in the art of extracting information tended to be found among private firms of undertakers, who would offer their services as a supplement to their regular income. Such men were proficient in using the rack to separate limbs from limbs, in applying pitch or scalding metal to bare flesh, in wielding an iron-tipped whip.[24] That such horrors had been inflicted upon senators and equestrians left scars upon the entire Roman elite that could not

easily be healed. What were all the fine-sounding claims by the new emperor to clemency but a grotesque joke, and what all his publicly stated ambitions to serve as a new Augustus but a monstrous charade? The Senate licked its wounds, and did not forget.

Nor, after the first shock of the conspiracy against him had subsided, and he had found time to gather his breath, did Claudius. His first year as emperor had been potentially crippling to his reputation, and therefore to his long-term prospects – and he knew it. He did not despair, though. He knew too the infinite resources available to him as Caesar, and that there was much that even a man such as himself, old, incapacitated and widely despised as a fool, could do. No matter what, he remained the most powerful man in the world.

The following year, Claudius was determined, would see him demonstrate it once and for all.

Bread and Britons

In AD 42, one year after Claudius had come to power, a Roman governor by the name of Suetonius Paulinus led an army to the limits of Mauretania, and then beyond. The Moors, a people who lived just across the straits from Spain, and were renowned for their ability to hurl javelins while riding bareback and their high standards of dental hygiene, had long been within Rome's orbit; but only recently had the decision been taken to absorb them formally into the empire. There was much in Mauretania to excite the interest of the Roman upper classes – including, not least, its manufacture of the purple dye used to colour their togas. The last king of the Moors – who, by virtue of his descent from Antony and Cleopatra, had been related to Caligula – had opted, when summoned by his cousin to Lugdunum, to sport a particularly flashy shade of cloak. A fatal act of one-upmanship. Back in Mauretania, the Moors had

greeted news of their king's execution with outrage. Rebellion had flared.

Claudius, inheriting the crisis from Caligula and reluctant to see it get out of hand, had duly ordered the kingdom transformed into a province. A hard-headed decision, made for hard-headed reasons – but not exclusively so. Scholar that he was, Claudius had an interest in distant regions that touched on more than affairs of state. South of the cities that lay just inland from the sea, where merchants from Italy were regular visitors and the architecture aped the best of Rome and Alexandria, there stretched an altogether different world. Inhabited by tribes so unspeakably savage that they ate flesh raw and thought nothing of drinking milk, it had never before been penetrated by Roman arms. In turn, beyond them loomed an even more fantastical land, one long believed to be swathed in perpetual clouds, and where the inhabitants were reported never to have dreams. Suetonius Paulinus was leading his men up into the Atlas mountains, 'the pillar which supports the sky'.[25]

Reality, in the event, did not quite measure up to the fables told of the mountain range. There were deep snowdrifts, even in summer – but no perpetual clouds. The deserts beyond the Atlas mountains were scorching, and covered in black dust. The natives lived like dogs. Nevertheless, the expedition was not entirely a wasted effort. The forests that surrounded the mountain range, Paulinus reported back to Rome, were filled with wonders: towering trees with leaves that were covered with 'a thin downy floss'[26] much like silk; wild elephants; every conceivable kind of snake. Back in Rome, Claudius was delighted by the news. It played to all his passions. As a private citizen, denied by his disabilities the chance to travel, he had lovingly transcribed the details of exotic flora and fauna into a panoramic gazetteer: the aromatic leaves sprinkled by the Parthians on their drinks; a centaur born in northern Greece that had died the same day. Now, as emperor, he had a far broader stage on which to display

his enthusiasms. Roman conquerors had long been in the habit of bringing back to their city plants and animals from remote lands. This was why, in gardens of the kind owned by Valerius Asiaticus, the smog-choked citizen might have a chance to breathe in the scents of distant forests, and to marvel at the blooms of strange flowers. It was also why beasts like those discovered by Paulinus were regular sources of entertainment in Rome. Pompey had exhibited the first rhinoceros to be seen in the city, Julius Caesar the first giraffe. Augustus, as a token of his victory over Egypt, had ridden through Rome with a hippopotamus waddling in his train, while Claudius himself, on formal occasions, might order elephants hitched to his chariot. It was no coincidence that all these creatures, and many more, had come from Africa – for the continent was famed as 'the wet-nurse of wild beasts'.[27] Naturally, though, merely to exhibit them gave the Roman people an inadequate sense of the animals' ferocity, and of the achievement that transporting them from the ends of the earth represented. More educational, and certainly more crowd-pleasing, was to pit them in battle against trained huntsmen, and have them fight to the death. Only then could spectators gain a due sense of what legates like Paulinus, when they tamed lands teeming with lions and crocodiles, were achieving on behalf of the Roman people. Only then could they begin to appreciate the task undertaken by Claudius Caesar in pacifying and ordering the world.

Not that the subduing of wild beasts was the only measure of Roman greatness. At the opposite end of the world, amid the surging and the heaving of the Northern Ocean, lay challenges even more formidable than those met by Paulinus. No one could know for sure what lay beyond the limits explored by Roman fleets, although travellers spoke of islands inhabited by freakishly barbarous people, some with horses' hooves, others with ears so huge that they covered up their otherwise naked bodies – and ultimately, far beyond them, the mysterious land of Thule, and a terrible sea of frozen ice.

For Claudius, the wilds and wonders of the Northern Ocean had a particular resonance, for it was his father, back in 12 BC, who had been the first Roman commander to sail it. Twenty-eight years later, Germanicus had repeated the exploit; and even though, since then, no Roman general had led a fleet across the Ocean, Claudius now had the chance to emulate his father and brother. Yet his ambitions did not stop at exploration. Lame though he was, and fifty-four years a civilian, he aimed at an even more heroic feat: the completion of a conquest left undone by Julius Caesar. It was time, not merely to cross the Ocean, but to carve out from it a new province: to win for the Roman people the island of Britain.

There were good reasons for Claudius to command its invasion in the early summer of 43. Circumstances had rarely looked so promising. The island itself was convulsed by dynastic upheavals. Not only had Cunobelin, the veteran chieftain of the Catuvellauni, recently died, leaving his lands to two sons, but a neighbouring kingdom on the south coast had collapsed into such savage factionalism that its king had fled to the Romans. Simultaneously, on the opposite side of the Channel, preparations for an amphibious assault were well advanced. At Boulogne, where Caligula had ordered the construction of a towering lighthouse, some two hundred feet high, to light the way across the Ocean, a fleet sufficient to transport four legions awaited the command to set sail. The soldiers massing there bore witness to years of forward planning. Caligula's expedition to the North had not, as his critics charged, been a mere exercise in wild irresponsibility. It was thanks to the two legions recruited on his orders that a substantial invasion force could be readied without unduly weakening the Rhine defences. Meanwhile, on the Rhine itself, all was quiet. So well had Galba's campaign of pacification gone that Claudius, in his role of commander-in-chief, had been awarded triumphal honours. Two of the more contumacious German tribes had been decisively crushed. The glow of victory had been further

burnished by the recapture of an eagle lost to Arminius. No better portent could possibly have been imagined.

Or could it? To the legionaries camped out on the Channel coast, anything that stirred up memories of the fate of Varus was liable to provoke deep unease. Bad enough as it was to be trapped on the wrong side of the Rhine, how much more terrifying was the prospect of being stranded on the wrong side of the Ocean. Few knew much about Britain – but what they did know was deeply off-putting. The natives were, if anything, even more barbarous than the Germans. They painted themselves blue; they held their wives in common; they wore hair on the upper lip, an affectation so grotesque that Latin did not even have a word for it. Nor were their women any better. They were reported to dye their bodies black, and even on occasion to go naked. Savages capable of such unspeakable customs were clearly capable of anything; and sure enough, just as it was part of the terror of the Germans that they practised murderous rites in the depths of their dripping forests, so did the Britons have priests who, in groves festooned with mistletoe, were reported to commit human sacrifice and cannibalism. These 'Druids', as the priests were called, had once infested Gaul as well, until their suppression on the orders of Tiberius; but across the Ocean, beyond the stern reach of Roman law, they still thrived. 'Magic, to this very day, holds Britain in its shadow.'[28] No wonder, then, ordered to embark for a land of such sorcery and menace, that many soldiers should have blanched. Soon enough, murmurings were turning to open insurrection. Legionaries began to lay down their arms and refuse point-blank to board the transport ships.

Up stepped Narcissus. Sent ahead of his master, who had no intention of venturing to Britain until he could be confident that the invasion was a success, the freedman boldly addressed the mutineers and began to lecture them on their duty. He was immediately drowned out by howls of derision. The mood was turning uglier by

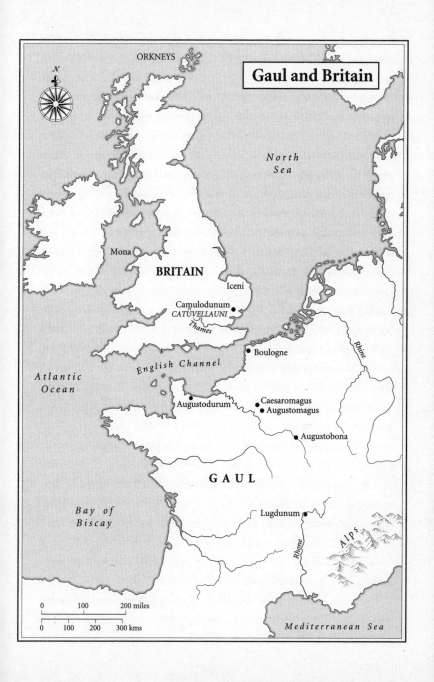

the minute. It seemed that discipline had been entirely lost. Then all at once, one of the legionaries yelled '*Io Saturnalia!*' – and his comrades started to laugh. The cry was echoed across the entire camp. Abruptly, a holiday spirit took hold of the soldiers. The threat of violence was dissolved and the army brought back to obedience. When the legions boarded the transport ships, it was as though for a festival. Nor, from that point on, did anything further happen to shake their discipline. Instead, all went as well as the planners of the invasion could possibly have hoped. The seas for the crossing were calm; three bridgeheads established unopposed; the Britons twice defeated, and one of the two Catuvellaunian chieftains left dead on the battlefield. True, resistance was far from crushed. The surviving son of Cunobelin, a wily and indefatigable warrior named Caratacus, remained on the loose, while to the north and west of the island, in lands where even clay pots were a novelty, let alone coinage or wine, there lurked tribes who had barely heard of Rome. Nevertheless, with a crossing secured across the Thames and an encampment planted on the river's northern bank, the time had clearly come to send for the commander-in-chief. The glory of securing the final defeat of the Catuvellauni, and receiving their formal submission, belonged to one man, and one alone.

Hobble-gaited though he was, Claudius did not make a wholly improbable conqueror. Tall and solidly built, he had the white hair and distinguished features that the Roman people expected of their elder statesmen; and there was no difficulty, whenever he sat or stood still, in accepting that he might indeed rank as an *imperator*. For Claudius himself, who all his youth had been cooped up in his study while his elder brother played the war hero, the chance to lead an army into battle was a dream come true. He did not waste it. Advancing at the head of his legions, he did so as the embodiment of Roman might. The Catuvellauni, duly intimidated, began to melt away. The advance along the north coast of the Thames estuary towards their

capital, a straggling complex of dykes and round-houses named Camulodunum, met with scant opposition. Camulodunum itself, with only rough-hewn fortifications and a demoralised garrison to defend it, rapidly fell. Entering the settlement in triumph, Claudius could legitimately exult that he had proven himself worthy of the noblest and most martial traditions of his family. The potency of his name now reached even further than that of Drusus or Germanicus had done. Shortly after the storming of Camulodunum, there arrived at Claudius's headquarters a slew of British chieftains – and among them was the king of a cluster of distant islands named the Orkneys, thirty in number, and so far to the north that their winter was one perpetual night.[29] Receiving the submission of such an exotic figure, Claudius could know his dearest ambitions for the invasion had been fulfilled. 'The Ocean had been crossed and – in effect – subdued.'[30]

Then, sixteen days after first setting foot in Britain, the Emperor was off again, back to Rome. He had no need to linger on a dank and amenity-free frontier. Let his subordinates pursue Caratacus, storm hill-forts and complete the pacification of the island. Claudius had accomplished what he had set out to do. The Britons themselves, after all, had never been the principal target of his exertions. He had always had other opponents more prominently in mind. The gravest threat to his security had never been Caratacus but his own peers. Seasoned gambler that he was, he had weighed the odds carefully before deciding to absent himself from the capital for six months. Even with Vinicianus and his fellow conspirators dead, the embers of insurrection were not completely stamped out. Shortly before Claudius's departure, an equestrian had been convicted of plotting against him and flung off the cliff of the Capitol; then, a portent that invariably foretold some calamitous upheaval to the state, an eagle-owl had flown into the sanctum of Jupiter's temple. Not surprisingly, before leaving on campaign, Claudius had made sure to take

every precaution. The administration of the capital itself had been entrusted to that impeccably loyal courtier, Lucius Vitellius. Other, less tractable senators, meanwhile, had been graced with the supreme honour of accompanying Caesar to Britain. Prominent among them had been Valerius Asiaticus and Marcus Vinicius – both of whom, not coincidentally, had once asserted their own claims to supreme power. Now, with the conquest of Britain, there was no longer the remotest prospect of anyone wrenching it from Claudius's grasp. The glory of his successes filled the world. In Corsica, the exiled Seneca – desperate to be allowed home – hailed the triumphant *Imperator* as 'the universal consolation of mankind';[31] in the Greek city of Corinth, his victory was granted its own cult; on the far side of the Aegean, in the city of Aphrodisias, a vividly sculptured relief portrayed Britannia as a hapless and bare-breasted beauty, wrestled to the ground by an intimidatingly well-muscled Claudius. The man scorned all his life by his own family as a twitching, dribbling cripple stood, in the imaginings of distant provincials, transfigured into something infinitely more swaggering: a world-subduing sex god.

Naturally, though, it was in Rome that Claudius's victory made the biggest splash. The Senate, alert to what was expected of them, duly voted the returning hero a full complement of honours: a triumph, lots of statues, a particularly flashy arch. His family too basked in his glory. Messalina was granted the same right to zip around Rome in a *carpentum* that Livia had previously enjoyed, while their infant son was awarded the splendid name 'Britannicus'. Here, to a Caesar always painfully conscious that he lacked the blood of Augustus in his veins, were developments ripe with promise. Already, the previous year, he had secured for Livia the divine honours that both Tiberius and Caligula had neglected to award her – thereby ensuring himself a status as the grandson of a god. But it was not enough merely to draw on the past for legitimacy. Claudius knew that he had to look to the future as well. Now, with the gilding of his

dependants, he had made a start. He had laid the foundations for a dynasty all of his own.

As a historian, and an attentive student of the past, the Emperor had a well-honed understanding of what it took to be regarded by the Roman people as a great man. His supreme role model, and the man whose name he swore his oaths by, was Augustus – as it was bound to be. Nevertheless, just as Tiberius had done, he thrilled to the tales inherited from Rome's distant past. The virtues and values of the Republic at its most heroic never ceased to move him. Both as an antiquarian and as a Claudian, he felt profoundly bonded to traditions that had originated centuries before Augustus. To invade Britain, with its chariots, its mud huts and its phantom-haunted groves, had been, for a man like Claudius, to travel back in time to the very beginnings of his city, to that fabulous age when citizens had assembled on the Campus Martius before marching off to war against cities barely a few miles away. Claudius, in token of this, made sure to restage his storming of Camulodunum directly on the Campus, so that for one day at least, amid the marble, the fountains and the softly ornamented arbours, the violent flash of weaponry might be witnessed there once again.

Then, in AD 51, came an even more glittering opportunity for him to pose like a hero from a history book. Caratacus, after a bold and increasingly desperate series of last stands, had finally been taken prisoner by a rival chieftain, sold to the invaders and brought to Rome in chains. The nobility of his bearing as he was paraded through the streets excited much admiration; and Claudius, with the eyes of the Roman people fixed firmly on him, knew from his reading of history precisely what to do. Long ago, Scipio Africanus had captured an African king, and then, after leading him in his triumph, ordered him spared – a gesture of imperious magnanimity. Claudius, to wild approbation, now did the same. Upon his command, the shackles were struck off the British king. Caratacus, free to wander round

Rome and to gaze at the people who had defeated him, played his part in the drama by wondering aloud that they should ever have aspired to conquer his own mean and backward land. The occasion, everyone could agree, had been like an episode from some collection of improving tales. In the Senate, Claudius was fêted with extravagant praise. 'His glory was equal to that of anyone who had ever exhibited a captured king to the Roman people.'[32]

Naturally, Claudius himself was far too shrewd to put much faith in this gushing. He knew that resentment of him in the Senate still ran deep. The Senate, though, was not Rome. Claudius, steeped as he was in the annals of his city, knew this better than anyone. Unlike Tiberius, whose own devotion to the inheritance of the past had only confirmed him in his instinctive disdain for the mob, his nephew looked more fondly on the plebs. He could appreciate, thanks to his years of study, that the many remarkable achievements of the Republic had owed quite as much to the people as to the Senate. This was why, a year before the capture of Caratacus, Claudius had capitalised upon his triumphs in Britain to make a potent gesture. Over the centuries, ever since Romulus had first ploughed the *pomerium*, various conquerors had extended the sacred boundary which marked the limits of Rome – for only those who had added to the possessions of the city were permitted by tradition to do so. This, at any rate, was the claim made by Claudius in a speech to the Senate – and who was there, knowing of his exhaustive antiquarian researches, to dispute his assertion?[33] For eight hundred years, ever since Romulus had bested Remus in their contest to found a city, the Aventine had lain beyond the limits of the *pomerium* – but no longer. On the orders of the Emperor, stone markers began to sprout, girding its slopes at regular intervals and proclaiming the hill no less a part of Rome than the Palatine. Back in the days of Tiberius, the attempt by Sejanus to woo the inhabitants of the Aventine had helped to precipitate his downfall; but now, seventeen years on, Tiberius's nephew held it no shame to

court them. Claudius, it went without saying, had not forgotten his history. He knew full well what was commemorated by the shrine to Liber on the slopes of the Aventine: the class war won by the plebs in the first decades of the Republic, and the establishment of their political rights. Each marker stone, stamped as it was with the Emperor's prerogatives, served as a reminder that he held it a privilege to wield the powers of their tribunes. A conqueror, yes – but a friend of the people too.

Nor, in his own opinion, was there anything remotely un-Claudian about this. In contrast to his grim and haughty uncle, Claudius did not interpret the inheritance of his family's past as a licence to scorn the interests of the plebs. Just the opposite. Lavishing funds on structures that could serve the good of every citizen was a prized and venerable tradition among the Roman aristocracy. Why else would Appius Claudius, flush with the booty he had won in the service of the Republic, have spent it on a road? The thought of blowing it on some flashy but useless monument, in the manner of a pharaoh, could not have been more alien to the dictates of his city. Centuries on, it remained a proud boast of the Roman people that their most impressive structures, unlike those of foreign despots, were thoroughly practical in their purpose. 'Far better them than some pointless pyramid.'[34] Claudius, who could still remember what it was to count the coppers, agreed. Earnest as he was in his respect for the traditional values of his fellow citizens, he had no wish to squander money on projects that would fail to serve their long-term interests. Now that the bribes he had lavished on the armed forces in the first days of his supremacy were behind him, it was his aim to order his finances sensibly and spend the proceeds well. Plunder from Britain helped; so too the acumen of Pallas. Widely though the freedman might be detested as a vulgar upstart, there could be no faulting his head for figures. Evidence for this was twofold: that Claudius did not, like his predecessor, end up detested for his

exactions; and that he was able, all the same, to invest spectacularly in infrastructure.

The result, in a city where building sites had invariably been the surest source of employment, was a far more reliable source of income than promiscuous handouts of the kind favoured by Caligula. The prime focus of Claudius's engineering ambitions, though, lay well beyond the bounds of the capital itself. This was not because Rome, in the wake of its renovation by Augustus, had ended up so beautified that it had no need of further improvements. Quite the opposite. It was precisely because multitudes still festered in sprawling, smog-choked slums which seemed, to the rich in their airy villas, 'like the paltry, obscure places into which dung and other refuse are thrown',[35] that Claudius had resolved to sluice out the ordure. As a private scholar, he had been fascinated by hydraulics, writing knowledgeably about floodwaters in Mesopotamia; but naturally, historian that he was, he also looked to precedent to guide him in his actions. Others too in his family, from Caligula all the way back to the inevitable Appius Claudius, had commissioned aqueducts in their time. None, though, had brought to completion anything quite on the scale of the pair built by Claudius. Extending over many miles, crossing deep valleys and running through steep hills, they almost doubled the supply of water flowing into the heart of Rome. Everywhere in the city, even in the meanest quarters, where the snarl of back-alleys was matted with refuse and shit, lead pipes fed gushing fountains and provided a cooling touch of distant mountains. Although it was Caligula who had originally commissioned the two aqueducts, the achievement was very much Claudius's own. On their final approach towards the city, the towering grandeur of the arches as they strode across the fields, never betraying so much as a hint of a limp, was complemented by the distinctive character of their stonework: rugged and determinedly old-fashioned, as though hewn from the bedrock of Rome's past. 'Who can deny that they are

wonders without rival in the world?'[36] Embittered senators, perhaps – but not the plebs. They knew they had in Claudius a leader who took seriously his duties to them as their champion.

Not, of course, that these duties were any longer what they had been in the distant age commemorated by the shrine to Liber on the Aventine. The days when the plebs had agitated for political rights were gone, and no one in Rome's slums greatly missed them. Why bother with elections, after all, when they never changed anything? This was why Caligula's restoration to the Roman people of their right to vote had been greeted with such yawns of indifference that it had soon discreetly been abandoned. Realities had changed – and everybody knew it. What mattered most to the poor, in a city so vast that many had never even seen a cornfield, still less harvested one, was to banish the spectre of famine – and only Caesar could guarantee that. In shouldering the responsibility for keeping his fellow citizens fed, Claudius was naturally concerned for his own survival – for he knew that even Augustus, in the dark days of the Triumvirate, had only narrowly avoided being torn to pieces by a starving mob. Yet as with the building of aqueducts, so with famine relief: the obligations laid upon an emperor had a venerable pedigree. The cause of keeping the Roman people fed had been championed by some of their most celebrated tribunes. It was Gaius Gracchus, in 123 BC, who had first legislated to subsidise the price of bread, and Clodius, sixty-five years later, who had introduced a free ration for every citizen. Augustus, although he privately disapproved of the dole, fretting that it would soften the moral fibre of the Roman people and keep them from honest toil, had known better than to abolish it – for of all the many bonds between plebs and First Citizen, there was none more popular with the plebs themselves. They valued it not simply because it kept them fed, but as an expression of their civic status. 'No matter a man's character, whether upstanding or not, he gets his dole by virtue of being a citizen. Good or bad, it makes no difference.'[37]

Only in Rome, of all the cities in the world, did Caesar provide a corn dole; and only citizens, among the multitudes who inhabited the capital, were entitled to receive it. Any notion that the poor merited charity simply by virtue of being poor was, of course, too grotesque to contemplate. Everyone knew that people only ever suffered poverty because they deserved it. This was why, for instance, when Judaea was hit by shortages so terrible that it seemed to those suffering them that there must surely be 'a great famine over all the world',[38] Claudius took no steps to intervene – for what responsibility did he have to mere provincials? To fellow citizens, though, he did feel a duty of care – which was why, no sooner had he become emperor, than he was obsessing about the grain supply to Rome.

There had been troubles with it since the summer before his accession, the lingering after-effect of his nephew's most spectacular stunt. Without ships, of course, Caligula would never have been able to ride his horse across the sea; but without ships, there could be no transportation of grain from abroad. Rome, like an immense and insatiable belly, had long exhausted the ability of Italian farmers to keep her fed. This was why, from Egypt to Mauretania, the spreading fields of Africa were devoted to servicing the hunger of the capital. Every summer, massive freight ships would head for the Bay of Naples – for Puteoli, the city to which Caligula had crossed from Baiae, was the nearest port to Rome with docks sufficiently deep to harbour their bulk. Then would come the next stage of the journey: the reloading of the grain, half a million tons of it each year, onto smaller vessels, and the journey up the coast to the mouth of the Tiber.[39] There, surrounded by marshes and salt-flats, stood the port of Ostia; and beyond Ostia, lining the sixteen miles of quays that separated it from Rome, warehouse after giant warehouse, each one with windows so high and slit-like that they seemed a line of fortresses. There was much that could go wrong between Puteoli and the safe arrival of the grain in these depots; and Claudius, once the immediate threat

of famine had been lifted, therefore resolved to attempt a solution appropriate to the greatness and ambition of the Roman people. As earnest as he was bold, as obsessed by the minutiae of detail as he was by the sweep of his global role, as ready to supervise plans beside a mudbank as he was to command the hollowing-out of the seabed, he aimed at an achievement no less heroic than the conquest of Britain. When engineers, informed of his intention to construct a deep-sea harbour at Ostia, threw up their hands in horror 'and told him on no account to contemplate it',[40] he ignored their warnings. He was Caesar, after all. If it served the good of the Roman people to refashion the land and sea, then Claudius would do it.

The project was set in train even as he was busy preparing for the invasion of Britain. Claudius himself was a regular visitor to the site. When it was reported one day in Rome that he had been ambushed there and killed, it was widely believed. The plebs, distraught, held the Senate to blame, and only a hurried announcement from the Rostra that the rumour was false and all was well, stopped them from rioting. Although Claudius seemed to many senators a ridiculous and sinister figure, the Roman people knew better; their devotion to him, bred of his palpable concern for their interests, demonstrated that an emperor might be lacking in glamour and still end up taken to their hearts. Caligula, building his private racecourse, had adorned it with an obelisk transported from Egypt; but Claudius, towing the ship that had brought it into the mouth of the Tiber, ordered it sunk, and used as the base for a lighthouse. Breakwaters too were built, and a mole extending the entire way out to the lighthouse, and all the appurtenances of an up-to-date, international port. The achievement, directly on the doorstep of the capital, brought home to the Roman people everything that made the scale and scope of their sway so astonishing: their absolute centrality in the scheme of things; their command of the world's resources; their dominion over the globe. Even the monsters of the deep, like the elephants and serpents

stalked by Suetonius Paulinus, could be brought to acknowledge it. When a whale strayed into the half-completed harbour, Claudius summoned a squad of Praetorians to fight it from boats. Understandably, then, he found it hard to keep away from the site. Nowhere else provided him with a more fitting context in which to operate as the kind of ruler he aspired to be. Nowhere else enabled him to feel more exultantly what it was to be a Caesar.

Except that Ostia, by keeping him from Rome, was distracting him from his own household and its functioning. In AD 48, while he was on site at the mouth of the Tiber, Claudius received an unexpected request for an interview. The girl asking it, a concubine of the Emperor's named Calpurnia, was one of his favourite bed partners, and so naturally he granted it. Coming into his presence, so halting and stammering was Calpurnia that she sounded much like Claudius himself; but eventually, after a supreme effort, she managed to reveal what she had come to report.

And as he listened, Claudius Caesar realised to his horror that he had been made to look the fool that his enemies had always alleged him to be.

Deadlier than the Male

The art of attracting an emperor's attention was a fine one.

When Calpurnia came into Claudius's presence, she was accompanied, for good measure, by a second of his concubines. Those who wanted his ear often made sure to exploit his sexual tastes, for everyone knew that he only ever slept with women. Like his concern that people should feel free to break wind at table, or his insistence on adding three new letters to the Latin alphabet, the complete lack of interest he had always shown in forcing himself on male partners marked Claudius out as a true eccentric. Not that people particularly

disapproved – for it was the way of the world that different men had different foibles, and just as some might prefer blondes and others brunettes, so were there a few who only ever fucked females, and a few who only ever fucked males.[41] That Galba, for instance, was the mirror image of Claudius – liking as he did 'mature, hard-muscled men'[42] – never did any harm to his standing as a model of martial rectitude. Seasoned soldier that he was, he well knew what it was to seize control, to thrust hard, to take possession.

Which was, it went without saying, the responsibility of every citizen who chose to have sex. Nothing was more shocking to Roman sensibilities than the man who, as Hostius Quadra had so notoriously done, submitted for his own pleasure to being fucked. The sword-stab of a penis was, of course, precisely what the female body had been shaped by the gods to receive; but the male body too was not lacking in orifices. Pay obeisance with the mouth or the anus to another man's cock, and a citizen was doubly shamed. It was not just that he was playing the part of a woman (although that was, of course, bad enough); it was also that he was playing the part of a slave. Just as it was the privilege of the free-born, male and female alike, to have any violation of their bodies condemned as a monstrous crime, so was it the duty of slaves to serve a master's every conceivable sexual need. For some, indeed, it might be their principal responsibility. Pretty boys, long-haired, smooth-shaven and glistening with oils, were must-have accessories at any fashionable *soirée* – and all the more so if twins. One senator, in the time of Augustus, had abandoned subtlety altogether, employing waitresses who served entirely in the nude. Every slave knew, as a matter of course, that the threat of rape, like that of corporal punishment, might be realised at any moment.

This did not mean that a master was necessarily incapable of tenderness: Lucius Vitellius, for instance, ended up so besotted with one of his slavegirls that not only did he free her, but he took to mixing

up her spit with honey and using it as a throat medicine. Such cases, though, were the exception that proved the rule. In general, the right of a master to glut his sexual appetites on a slave, rather as he might blow his nose or use a latrine, was taken for granted. It was a perk of ownership, plain and simple. 'No sense of shame is permitted a slave.'[43]

Except that freedom itself, in a city where even senators had been subjected to the rack and whip, was no longer all it had been. The implications, even for the grandest, were unsettling in the extreme. In AD 47, a year before Calpurnia came calling on Claudius at Ostia, one of the Senate's most flamboyant and charismatic figures had been destroyed. Valerius Asiaticus, charged with a variety of crimes, had been arrested in the pleasure resort of Baiae and hauled back to Rome in chains. His prosecutor had been an old associate of Germanicus's, a man as opportunistic as he was remorseless, by the name of Publius Suillius Rufus. His talent, given a victim, was for sinking his jaws in deep – and sure enough, at a private trial attended by both Claudius and Lucius Vitellius, Suillius had done just that. Rounding off the various charges, he had accused Asiaticus, for good measure, of the very ultimate in deviancy: of being 'soft and giving, like a woman'.[44] The prisoner, silent until then, had found this particular slander too much. 'Ask your sons, Suillius,' he had yelled. 'They will confirm that I am all man.' Desperate, aggressive banter – but also something more. The scorning of Suillius, a father to sons used by Asiaticus as women, had been the scorning too of an order so rotten that it had given power to such a man. Later, once Asiaticus had been sentenced to death, but permitted, on the recommendation of Lucius Vitellius, to choose how he died, he had made his contempt for Claudius's regime even more explicit. He would rather, he had declared, have perished at the hands of Tiberius or Caligula than on the say-so of the smooth-tongued Vitellius – whose mouth was rancid from his addiction to lapping at genitals. And then, having made sure that

the flames of his pyre would do no damage to the trees of his beloved garden, Asiaticus had slit his wrists.

Defiant assertion of his own masculinity and suicide: no other means had been available to him, in the final reckoning, of maintaining his dignity as a citizen. That Claudius, paranoid and insecure, had feared to let him live was clear enough; but that was hardly the whole story. Senators, convinced as they were that the Emperor was mentally deficient, saw in Asiaticus's fate confirmation of all their darkest suspicions: that he was the gullible plaything of perverts, and even worse. 'He, more conspicuously than any of his peers, was ruled by slaves – and by women.'[45] Certainly, when it came to identifying the person ultimately responsible for the downfall of Asiaticus, the consensus was clear. Messalina had envied him his gardens and wanted them for herself. Worse: he had died to satisfy her passion for Mnester, former paramour of Caligula and Rome's most famous actor, who was rumoured to have been conducting affairs with both Messalina herself and an equally high-ranking beauty named Poppaea Sabina. The prosecution of Asiaticus had enabled two birds to be killed with one stone: for among the charges levelled against him had been one of adultery with Poppaea. Messalina, far from keeping discreetly to the sidelines, had been present at his secret trial; and she had deployed her agents, even as Asiaticus was being condemned, to bully her rival into suicide. Nothing, in short, could possibly have been more demeaning or grotesquely sordid. One of the most eminent senators in Rome, a man who had once aspired to rule the world, had been sacrificed upon the altar of a woman's jealousy.

'How shaming it is to be submissive to a girl.'[46] Ovid's maxim was one that Roman moralists had always taken for granted. Whether on the battlefield or in the bedroom, so clearly had men been intended by the gods to hold the whip-hand that very few of them ever thought to question it. 'An unhappy state indeed it would be which saw women usurp masculine prerogatives – be it the Senate, the

army or the magistracies!'[47] The very prospect was incredible. Never-theless, in a city where a feminine tiff over an actor appeared to have ended up destroying a two-times consul, it was clear that something had gone badly wrong. That women of wealth and breeding might exploit their influence on behalf of their menfolk was one thing; that they should openly flaunt it quite another. No matter the rumours whispered of Livia, she had always made a point, before ascending into the heavens and taking her place beside Augustus on his celes-tial throne, of operating from the shadows. Certainly, she had never thought to play her husband for a fool. That, though, it seemed – if the increasingly feverish swirlings of gossip were to be trusted – was precisely what Messalina was doing. A few days after the suicide of Poppaea Sabina, Claudius had invited her husband to supper and asked him where his wife was. Told that she was dead, he had simply looked bemused. Messalina, it seemed to those who despised the Emperor, had him wrapped around her finger. As gullible as he was besotted, he had delivered the great and the good into her hands. Consuls, a Praetorian prefect, the granddaughter of Tiberius: all had been eliminated as a result of her manoeuvrings. Those who prized their skins made sure to crawl to her. Lucius Vitellius, that veteran trimmer, had even begged permission to take off her shoes, 'and once he had removed her right slipper, he slipped it between his toga and tunic, carrying it round with him the whole time, and every so often kissing it'.[48] Not merely degrading, it was emasculating in the extreme.

And perhaps, for that very reason, truth be told, just a bit erotic. Ovid, had he lived to see the former governor of Syria raining kisses on a woman's slipper, would not have been unduly surprised. He had always enjoyed exploring the paradoxes that hedged propriety about.

> Don't be ashamed (though shameful it is – which is why it's fun)
> To hold a mirror in your hand as though you were a slave.[49]

As with adultery, so with role reversal: the greater the taboo, the more of a thrill it might be to break it. The pressure on a male always to take the lead, always to exact submission, served to close off whole dimensions of pleasure. That it was the responsibility of a respectable matron, while being fucked, to lie back passively and leave the action to her partner, was taken for granted by moralists; but that did not prevent some women, greatly daring, from spicing things up during sex by actually moving – almost as though they themselves were the males. Shocking, yes, and threatening to the masculinity of any self-respecting citizen, to be sure; but there were, for the man who found his partner bucking her thighs in time to his thrustings, or grinding her buttocks, or sucking and licking his cock, undeniable compensations. That a woman might be so sexually aggressive as to play the role of a man was certainly, for any self-respecting citizen, a most unsettling possibility; but there was rarely anything so deviant that some would not find it exciting. A woman such as Messalina was presumed to be, predatory in her ambitions and demonic in her taste for blood, was a figure fit to stalk fantasies as well as fears. Young, beautiful and dangerous, she was the very stuff of pornography.

There had always been something peculiarly delicious about the idea of the house of Caesar as a brothel. Tiberius, during his retirement on Capri, and Caligula, on the Palatine itself, had both made salacious play with it; but, as ever in a city as obsessed with rumour as Rome, it was gossip that gave it legs. Assiduous promotion of the August Family as the embodiment of traditional values had, as its dark side, the kind of stories told about Augustus's daughter: of how, 'wearying of adultery, she had turned to prostitution',[50] and ended up hawking her favours from the Rostra. Julia, though, had been loved by the Roman people; and so the stories told of her, scandalous though they were, had not been without a certain affection. Messalina, vindictive and murderous, seemed an altogether more terrifying figure. Her clitoris, it was darkly whispered, was of such monstrous

size as to constitute 'a raging hard-on'.[51] With her hair concealed beneath a blonde wig and her nipples painted gold, she was said to work shifts in a low-rent brothel; to host parties on the Palatine at which the husbands of prominent women would watch on as they were cuckolded; to have challenged one of Rome's most experienced prostitutes to an all-day sexathon, and won. Such stories, though originally bred of Messalina's readiness to sniff out her opponents and destroy them, increasingly served to cast her as the opposite of calculating. A woman who, in terms of her talent for eliminating her enemies, ranked closer to a Sejanus than a Julia, she had come to be seen by the Roman people as a very different order of creature: carnivorous, irresponsible and heedless of every risk.

Which left her exposed. When Calpurnia and her fellow concubine arrived in Ostia and came into the presence of their master, their role was much like the one that Pallas, by taking Antonia's letter to Capri, had played in the ruin of Sejanus. Like Tiberius, Claudius had been more than happy to leave his dirty work to another, sanctioning his wife's manoeuvrings against men like Asiaticus while simultaneously playing up to his reputation for absent-mindedness. The comparison, though, did not end there. Just as Tiberius, reading Antonia's letter, had realised with an abrupt shock that he might be in mortal danger from a helpmate he had always trusted, so Claudius now suffered a similar moment of vertigo. Messalina, Calpurnia reported, was engaged in overt treachery. Astonishingly, she had taken as a lover the most handsome man in Rome, a consul-designate by the name of Gaius Silius – and actually married him. 'The people, the Senate, the Praetorians: all have witnessed the wedding!'[52] Claudius, whose first instinct when taken by surprise was invariably to panic, promptly went into a meltdown. It was bad enough that she had impugned his masculinity, his ability to maintain order in his own household, and, by extension, his competence as emperor; but there was worse. By marrying Silius, and permitting him to take possession of what was

properly Caesar's, she appeared to be signalling a coup. 'Am I still in power,' Claudius kept wailing, 'or has Silius taken over?'[53]

Bundled into a carriage by his two most trusted senatorial aides, Vitellius and Caecina Largus, he remained in a state of shock as together they hurried back to Rome. When Messalina, riding out to meet him, vainly attempted to force an interview, he sat in silence; nor did the appearance on the roadside of their two children, seven-year-old Britannicus and his elder sister, Octavia, crack the frozen quality of his expression. Even when Claudius arrived in the Praetorian camp and addressed the assembled soldiers, he could barely bring himself to speak. 'No matter how justified his outrage, he was hobbled by shame.'[54]

Actions, though, spoke louder than words. Claudius's decision to take shelter in the Praetorian camp demonstrated both the scale of his alarm and his resolve to crush any hint of sedition. Silius and various of his high-born associates had already been rounded up. Hauled before the Praetorians, they were dispatched with brisk efficiency. Mnester too, despite histrionic appeals for mercy, was among those decapitated: for clearly, despite Claudius's initial instinct to spare him, it was out of the question to pardon a mere actor when so many senators and equestrians had already been put to death. Only the odd plea for mercy was granted. When a son of Suillius Rufus, demonstrating the truth of Valerius's accusations against him, declared that he could not possibly have committed adultery with Messalina because it was his habit, whenever having sex, 'to play the role of a woman',[55] he was dismissively sent on his way. Otherwise, though, the bloodbath was total. Claudius might be panicky, and reluctant under normal circumstances to indulge in repression; but he could always be relied upon to take no prisoners when faced by a crisis.

Meanwhile, only his wife remained on the loose. Frantic with misery, Messalina had taken shelter in the gardens purloined from Asiaticus just the previous year. There, sobbing among the

flowerbeds, she was watched over by her mother, Domitia Lepida, who sought to comfort her daughter, in the noblest tradition of Roman parenthood, by urging her to prepare for an honourable death. In the event, though, terror won out over courage. When a squad of soldiers arrived in the gardens, Messalina could not bring herself to slit her own throat. Instead, it was left to a soldier to run her through. Her corpse was then dumped at her mother's feet. Her legacy was not only a name that would long serve the Roman people as a byword for nymphomania, but a sense of palpable bewilderment. Something about the episode struck many as not quite right. When people sought to explain what could possibly have persuaded Messalina, in a city as addicted to gossip as Rome, to imagine that she could get away with marriage to Silius, many shrugged their shoulders and confessed themselves bewildered. Had she really been swept to her doom by sheer lust? Or had Claudius been right to suspect a plot? But if a plot, then why had Messalina been willing to stake the prospects of her children on a conspiracy so self-evidently incompetent and half-baked? None of it quite made sense.

A familiar frustration, of course. The secrets of Caesar's household were invariably impenetrable to outsiders. The weakness of Claudius's position, which saw him as reliant upon freedmen as senators, had only made the situation worse. Conflicts on the Palatine, where rival factions fought in its subterranean depths for influence, only rarely disturbed the surface. Messalina herself, far from scorning to engage in the power struggles of her husband's freedmen, was rumoured to have slept with one of them, and then – once he had outlived his usefulness – to have had him put to death. True or not, it was certain that by the time of her downfall she had made enemies of Narcissus, Callistus and Pallas; and that the fingerprints of Narcissus, in particular, were all over her ruin. It was he who had sent the two concubines to their master in Ostia; who had assured Claudius of the truth of their story, when both Vitellius and Caecina had

seemed reluctant to confirm it; who had shouted down Messalina when she sought an interview with her husband. Astonishingly, for the duration of the crisis, he had even managed to secure command of the Praetorians – thereby ensuring that those put to death were eliminated directly on his orders. By the time the carnage was done and all the blood mopped up, anyone in a position to contradict the story of Messalina's marriage to Silius had been silenced for good.

Whether it had truly happened, or whether Messalina had been the victim of a subtly crafted fiction, no one would ever know. Her statues were removed from their plinths, her name from every inscription. Narcissus, meanwhile, long obliged by his status as a freedman to operate without official recognition, was now graced by his master with a fleeting but authentic taste of the limelight. By formal decree of the Senate, and as a mark of gratitude for his actions in preserving the Roman state, he was granted an honorary magistracy. It was, for a one-time slave, an unprecedented mark of favour. *Io Saturnalia* indeed.

Yet it was the nature of Caesar's household that its rivalries were like the hydra. Slice off one head and another would quickly sprout. The success of Narcissus in dispatching Messalina, and the predominance that it had brought him in the back-rooms of the Palatine, itself disturbed the balance of power that had long prevailed among Claudius's three most trusted freedmen. Callistus and Pallas remained as clear-sighted about the workings of their master's court as they had ever been. Indeed, when Callistus died soon after the great *dégringolade* of 48, it served perhaps as the ultimate measure of his influence: for he was one of the few men at the heart of power to enjoy a natural death. Pallas too, while having little choice in the short term but to swallow Narcissus's pre-eminence, had no intention of ceding it permanently. He knew his master well. More clearly than his rival, he could appreciate the scale of the humiliation that had been visited on Claudius, and the inevitable insecurities that it

had served to reawaken. Messalina had been a mother as well as a wife; and her downfall had wreaked terrible damage on her children's prospects. How, after the scandal visited on his family, was Claudius to promote it as a model of Roman virtue now? As things stood, his task had been rendered impossible; and for as long as that remained the case, he was bound to feel that his legitimacy as ruler of the world stood in question. The old problem, that Claudius was no more descended from Augustus than any number of other ambitious senators, had abruptly come back into focus. There was, though, an obvious solution to hand. Pallas, clearer-sighted than Narcissus, knew that his master would have little alternative but to adopt it.[56]

During the years of Messalina's primacy, Agrippina had made sure to keep her head down. Her son had the blood of Germanicus as well as of Augustus flowing in his veins; and she herself, for good measure, was famously beautiful. The fate of her younger sister, exiled and eliminated after provoking Messalina's jealousy, had served Agrippina as a standing admonition; and so, rather than engage in court intrigue, she had devoted her energies to repairing her finances. Marriage to a fabulously wealthy senator had helped, as had his death a short while afterwards. Claudius, frantic for a way to burnish his own legitimacy after the calamity of Messalina's downfall, did not have far to look. That Agrippina was his own niece was indisputably a problem: so revolted by incest were the Roman people that it ranked alongside treason as one of only two charges that admitted the evidence of tortured slaves. Nevertheless, far from attempting to veil it, or having Agrippina adopted first into another family, as he might otherwise have done, Claudius was obliged to trumpet that he was marrying his own 'nursling'[57] – for it was precisely his niece's pedigree that rendered her so invaluable to him. Smooth as ever, it was Vitellius who served as fixer. Standing up before the Senate, he played it with his customary skill. After praising Claudius, with a

perfectly straight face, as a model of sobriety, he urged a change to the law that forbade an uncle to marry his niece – for the good of Caesar himself, of Rome and of the world. 'For surely it was by the foresight of the gods themselves that our Princeps – who never sleeps with a wife who is not his own – has been provided with such a widow!'[58] Senators erupted in wild applause; out in the Forum, a carefully assembled crowd joined in with no less ecstatic cheering of their own. The Senate and the Roman people were united as one. Who, then, was Claudius to resist their demands?

Many, of course, away from the various stage-managed shows of enthusiasm, were shocked by what they regarded as a legal sleight of hand, and feared that no good could possibly come from such 'an illegal and deplorable union'.[59] Agrippina herself, though, was not among them. Marriage to the aged and dribblesome Claudius, no matter how physically unsatisfying it might be, marked as triumph-ant a return to the centre of power as her original fall from it had been precipitous. Naturally, a woman willing to prostitute herself to her own uncle could hardly expect to be spared the mockery of the Roman people; but their abuse, even so, was leavened with a certain grudging respect. Unlike the Emperor's previous wife, Agrippina was not diagnosed with nymphomania. 'In her private doings she was always most respectable – except when she had a sniff of power.'[60] Just as Augustus was said only ever to have committed adultery in order to spy on a woman's husband, so were Agrippina's supposed infidelities attributed to her implacable determination to reach the top. Such ambition, shocking and unnatural though it obviously was in a woman, marked her out as an indisputable heavyweight. 'Her style of dominance was not just abrasive – it was essentially masculine as well.'[61]

Forebodings that the world had been delivered up to the rule of a mistress as imperious as she was determined were only strengthened the following year. Few doubted the intensity of Agrippina's hopes for

her son; and sure enough, it came as no great surprise when, in AD 50,
thirteen-year-old Domitius was formally adopted by his stepfather as
a Claudian. No longer Lucius Domitius Ahenobarbus, the boy could
now boast the altogether more impressive name of Nero Claudius
Caesar Drusus Germanicus. Portraits of young Nero, round-faced
and still with a hint of baby fat, immediately began to proliferate. It
was his mother, though, whose radiance was truly coming to fill the
world. Honours that not even Livia had enjoyed were lavished on her
by her husband. For the first time, an emperor permitted his wife to
be graced with the awesome title of 'Augusta' while he was still alive;
to be shown in sculptures wearing the crescent-shaped diadem of a
goddess; to appear with him on his coins. These, prior to the down-
fall of Messalina, had been minted on their reverse side with images
designed to proclaim Claudius's many triumphs; but no longer. Now,
where previously there had been soldiers, and triumphal arches,
and self-aggrandising slogans, there gleamed only the heads of Agrip-
pina and Nero. The sheer scale of the crisis required nothing less. The
grievous wound inflicted on the August Family could not possibly
be allowed to suppurate. Its future had to be presented, at all costs,
as stable.

Naturally, those predisposed to see Claudius as a pliable dolt, the
plaything of women and slaves, were only confirmed by this in their
contempt for him. The Emperor himself, as he had done throughout
his life, shrugged it all aside. At stake, so he believed, was not merely
his own survival but the long-term security of the Roman people.
Claudius had appreciated from an early age the terrible consequences
of civil war. As a young man, embarking on a history of Augustus's
rise to power, he had been roundly scolded by Livia and his mother,
and persuaded to abandon it. 'No one,' they had told him, 'could ever
give an accurate or frank account of what had really happened.'[62]
Decades on, the menace of what might happen were he to slip, to
squander the legacy of Augustus, to betray the inheritance of a peace

that had lasted now for decades, still haunted Claudius. Schooled as he was in the history of the Republic at its flintiest and most austere, he understood that the ideal of citizenship might sometimes demand sacrifice. With Messalina consigned to oblivion and Britannicus still only nine years old, he could not rely on his own son to take the helm of the world. Claudius was old, and in declining health: it was too dangerous to leave Nero untutored in the demands of ruling Rome. Certainly, that winter, there were reminders everywhere of how narrow was the thread by which Caesar's fortunes might hang. Ominous-looking birds were seen flocking above the Capitol. Earthquakes shook the city. Meanwhile, in the warehouses along the Tiber, reserves of grain were running low. A hungry mob, cornering Claudius in the Forum, would have torn him to pieces had he not been rescued by a detachment of troops. It was a salutary lesson. The love of the people, the steel of the Praetorians: these were things that an emperor had to hug close to his chest.

As soon as he could, then, Claudius set about providing his prospective heir with both. The perfect opportunity was not long in coming. On Nero's fifteenth birthday, one year ahead of schedule, he was permitted to celebrate his coming-of-age. First, he lavished donatives on both the Roman people and the Praetorians; then he led the Praetorians on parade. Shortly afterwards, for good measure, he made his maiden speech in the Senate. Meanwhile, as Nero was busy cutting a dash in his gleaming new toga, or presiding over the Circus arrayed in best triumphal regalia, Britannicus was left to mope around wearing the distinctive striped toga of a child. When he briefly sought to fight back against his stepbrother's grandstanding by calling him 'Domitius', Agrippina went straight to Claudius and had the boy's teachers replaced with nominees of her own. Britannicus's principal tutor was put to death on a charge of plotting against Nero. The Augusta had form when it came to executing manoeuvres of this kind. She did not care to see anyone

occupy a significant post unless he owed it to her. This was why, soon after her marriage to Claudius, she had persuaded him to appoint to the command of the Praetorians a man whose record of service to her family was as impeccable as his lack of pedigree was glaring. That Sextus Afranius Burrus was a distinguished officer, and even had a mutilated hand to prove it, did not alter the fact that he was irredeemably provincial – 'and as such could hardly help but be aware who was responsible for his promotion'.[63]

Below the surface waters of Caesar's household, where monsters of the deep fed on those weaker than themselves and yet were always hungry, Agrippina had shown herself as predacious as anyone. 'It is not arms which constitute the surest safeguard of power, but the ability to bestow favours.'[64] So Seneca, with the perspective provided by distance, had observed from his exile on Corsica. Agrippina, content to demonstrate the truth of his *aperçu*, had arranged, following her marriage to Claudius, for his recall to the capital. Her son needed a tutor – and who better than Rome's foremost intellectual? Seneca, naturally, had leapt at the chance. The chance to educate a future ruler of the world, as Aristotle had taught Alexander the Great, was every philosopher's dream. Not that Agrippina wanted her son taught anything as impractical as philosophy: rather, it was Seneca's talent for giving a speech that she had hired. Sure enough, when Nero stepped onto the floor of the Senate House, it was evident that his tutor had done his work. As senators grown lined and craggy in the service of Rome listened to the sixteen-year-old give them the benefit of his views on foreign affairs, they could detect no sign of nerves. Unlike Claudius himself, he appeared to the manner born. Fluent, strapping and intimidatingly bumptious, Nero could hardly help but present a contrast to the aged Emperor. His very youth, an inevitable cause of perturbation in a Senate House still scarred by its memories of Caligula, seemed transformed almost into a source of strength.

Nero was not the only one entering into manhood. In AD 53, in a seeming confirmation of his status as favoured heir, he married Octavia, Claudius's daughter by Messalina. There was, though, a second message broadcast by the marriage. Britannicus was only a year younger than his sister, and it served as a reminder to the Roman people that he too was on the verge of leaving childish things behind. Whether in the Senate, the Praetorian camp or the bars and street-markets of the city, he still had backers. In the household of Caesar too. Pallas, whose early support of Agrippina had seen him rewarded with public honours fit to put even those granted to Narcissus in the shade, was yet to establish total supremacy. Taking Britannicus by his hands, Narcissus would hug him and urge the boy to grow up fast. Claudius too, embracing his son, promised him, if he came of age, 'an account of all that he had done'.[65] By AD 54, when Britannicus turned fourteen, such a moment was plainly not far off. Nero had been arrayed in the toga of a man for the first time when he was only fifteen: why not the younger sibling too? Claudius began to talk openly of how much he was looking forward to the ceremony. Give it another year, and he would have double the number of candidates to succeed him – and then, of course, Nero's future might no longer look so assured.

It was certainly hard to doubt that some great perturbation was brewing. Blood rained from the sky; the Praetorian eagles were struck by lightning; a pig was born with the talons of a hawk. Meanwhile, in the law courts, Britannicus's grandmother, Domitia Lepida, was arraigned on a number of capital charges. Few doubted who lay behind the prosecution, for among the accusations was that she had deployed sorcery against the Emperor's wife. Nero – on his mother's instructions, it was said – appeared as a witness for the prosecution. Domitia Lepida, inevitably, was sentenced to death. Then, in October, the most formidable of Agrippina's adversaries departed Rome. Narcissus, as befitted the vastly wealthy man that he had become,

suffered from gout; and for such an ailment there was no surer remedy than to take the waters in Campania. Naturally, he had no intention of risking a lengthy holiday. He could not afford to be away from the capital for long. But just a short break – what could possibly go wrong?

The answer came at dawn on 13 October – just three months before Britannicus was due to come of age. Claudius, it was reported, had been taken dangerously ill. The Senate was convened. Consuls and priests alike offered up prayers for Caesar's recovery. Meanwhile, on the Palatine, all the gates stood barred, while squads of soldiers blocked off the various approaches. Even so, there remained scope for optimism. Throughout the morning, reassuring bulletins were released, and various comic actors could be seen heading into Caesar's house – for Claudius, it was said, as he lay on his sickbed, had asked to be entertained. Then abruptly, at midday, the gates were flung wide open. Out came Nero, accompanied by Burrus, the new prefect of the Praetorians. A cheer was raised by the men standing guard; Nero was ushered into a litter; he and an escort of soldiers then headed straight for the Praetorian camp. Here, he announced to the listening men the news that Claudius was dead – before lavishing on them yet another eye-watering bonus. Then to the Senate House. Its members knew the role expected of them. All the various powers and honours possessed by his predecessor were bestowed with universal acclaim upon Nero. There was only one that the seventeen-year-old new Caesar, with becoming modesty, turned down: that of 'Father of his Country'. Plump, smooth-cheeked and with the rosebud lips of a girl, Nero knew better than to court needless ridicule. Then, by winning for his adoptive father divine honours, he secured for himself one final, clinching title: 'Son of a God'.

And Claudius? What had happened to him, that he had departed the Palatine so abruptly for the golden throne of an immortal? Rome had been stalked by fever all that year, and Claudius, sickly since

birth, was sixty-three years old: it was hardly implausible that he might have died of natural causes. Inevitably, though, in a city ever alert to the faintest whisperings of criminality, the circumstances of his death raised eyebrows. When Nero, with a casual quip, declared 'mushrooms to be the food of the gods, since it was by means of a mushroom that Claudius has become a god',[66] it seemed to many that he was dropping a hint as to what had actually happened. Various accounts of the murder were given: that Agrippina had commissioned a notorious poisoner to lace a dish of mushrooms; that she had done the deed herself; that she had persuaded her husband's physician to stick a venom-drenched feather down his throat. No one could know for certain; everyone suspected the worst.

As for Nero, whether his mother had played foully on his behalf or not, he knew what he owed her. That evening, when asked for the first time as Caesar to give the Praetorians the watchword, he did not hesitate. The phrase he chose was an unstinting acknowledgement of his debt: 'Best of Mothers.'[67]

7

WHAT AN ARTIST

Mamma Mia

No member of the August Family had ever swung between such extremes of calamity and triumph as Agrippina. Alone among the numerous descendants of Augustus sentenced to exile, she had clawed her way back from ruin. She could never forget what it was to fail. For a year and more, the island to which she had been dispatched by her vengeful brother had mocked her with a barren parody of greatness. To the Roman elite, nothing screamed success quite like a sprawling estate with water features; and this, in her exile, Agrippina had been granted. Her prison had boasted much that would not have disgraced a villa on the Bay of Naples: artificial fishponds, fresh shellfish and – of course – a sea view. All these various luxuries, though, had only emphasised the misery of exile. Isolation corroded every delight. It was ambience as well as setting that made for pleasure. Even Baiae, despite its exquisite beauties, would have counted for little without the strains of gossip and music that were forever drifting on its perfumed breezes.

Without its marinas too. The Bay of Naples, churned though its shipping lanes were by hulking freighters bound for Puteoli, and by

the galleys of Caesar's fleet, was far from devoted to the demands of trade and defence. To drift past the various piers and grottoes that adorned the shoreline, escaping the heat of summer on the cool and crystalline waters of the bay, had long been a particular delight of the Roman elite. Caligula, predictably, had taken it to a new level of excess. Even as his sisters were rotting on their prison islands, he had cruised the coast of Campania in specially commissioned galleys, complete with baths, fluted pillars and vines. Nothing quite so exclusive as a palace that could float. Indeed, so close was the association in the minds of the Roman super-rich between pleasure and water, and between luxury and boats, that the bays of Campania were hardly sufficient to meet it. Any stretch of water was a potential source of enchantment. Caligula, when not in the mood to head for Baiae, had been alert to alternative options. Some twenty miles south of Rome, for instance, set among a ridge of hills above the Appian Way, stood the peaceful, grove-fringed lake of Nemi. Here, eager to sample its delights in style, Agrippina's brother had ordered the construction of a mammoth houseboat.* No expense had been spared – that, of course, went without saying. Mosaics, marble inlay, gilded roof tiles: Caligula's pleasure barge boasted them all. Even the lead pipes had been carefully stamped with his name. To Agrippina, long since redeemed from her exile, the boat served as a reminder of everything that had been denied her during her term of disgrace. That the same vessel commissioned by the brother who had incarcerated her was now the property of her son could hardly help but bring a certain smile to the Augusta's face.

Or perhaps not. Sumptuous though the boat was, and stunning

* Two ships were built on Caligula's orders at Lake Nemi: the first seems to have been a floating palace, the second a floating temple. They were still afloat in Nero's lifetime, but were then dispatched to the bed of the lake, where they remained for almost two thousand years. Recovered in 1929, they were destroyed in 1944 – though whether by American artillery fire, German arson or the cooking fires of Italian refugees has never been conclusively settled.

its setting, on a lake so perfectly circular and glass-like that it was known as the Mirror of the Moon, there was, for anyone as alert to the demands of power as Agrippina, a hint of the sinister about Nemi. This was not at first apparent. Like the Bay of Naples, the slopes of the lake appeared monuments to suburban chic. Julius Caesar himself had once built a villa there; Augustus's mother had come from the nearby town. Yet just as in Rome, amid the concrete and the marble of the Palatine, there remained memorials to the distant age of Romulus, so at Nemi, casting a chill over the scenes of luxury, there flickered the shadows of something very ancient indeed. Aeneas was not the only hero to have travelled to Italy in the wake of Troy's fall. In Greece, Agamemnon, the king who had served as commander-in-chief of the returning armies, had been murdered by his queen, Clytaemnestra; and she in turn, on the command of the gods, had been killed by their son, a young man named Orestes. Fearsome demons known as the Furies, armed with whips and torches of fire, had then pursued him for the monstrous crime of matricide. Orestes, in the course of his wanderings, had headed west, bringing with him a statue of Apollo's twin, the virgin huntress Diana; and at Nemi, in a grove above the lake, he had established a shrine to the goddess. From then on, in memory of the founder of the cult, its priest had always been a fugitive: an escaped slave who, after breaking into the sanctuary, had challenged the incumbent and succeeded in slaying him. A fatal victory – for every priest had to live with the knowledge that the time would come when he in turn would perish at the hands of his successor. For a thousand years and more, murder had followed murder in an endless cycle. Caligula, arriving at the shrine, and learning that the priest had been *in situ* for years, had amused himself by sponsoring a younger, fitter contender; but the last laugh had been on him. No less than the sanctuary at Nemi, the household of Caesar was a potential killing zone, where death might come at any minute to

those who failed to watch their backs. Like the priest of Diana, Caligula had ended up sprawled in a puddle of blood – and Agrippina, whose own return from exile would never have happened without his elimination, had no intention of suffering his fate.

Certainly, she had good cause to keep the goddess of Nemi in mind. Already, on her marriage to Claudius, she had sought to expiate the offence of incest by sponsoring propitiatory rites with her husband in the sacred grove. Then, a few months later, Claudius had made a formal dedication to Diana: a request to the goddess that she keep both him and Agrippina safe, and Nero and Britannicus too. It had not been enough. The goddess had abandoned Claudius. Lamps still blazed in the shrine that he had commissioned at Nemi; but now he was dead, and it was widely rumoured that his wife had been responsible. True or not, Agrippina knew better than to rely for her own security on lighting candles to Diana. The lesson of the sanctuary at Nemi had not been lost on her. The goddess favoured those who made their own luck. So it was, with Claudius barely dead, that Agrippina had dispatched orders to her agents in Asia, instructing them to poison the province's governor – who, like her son, happened to be a great-great-grandson of Augustus. Such, at any rate, was the assumption in Rome, when the news arrived there of the wretched man's death. It was a perfectly reasonable one to make. The fate of Narcissus, arrested as he hurried back from Campania, had left no one in any doubt that Agrippina was clearing the decks. The suicide in custody of Claudius's favourite freedman had set the seal on her control of the Palatine. With Pallas now even more securely in charge of its finances than he had been before, Burrus in command of the Praetorians, and Seneca on hand to orchestrate dealings in the Senate, she could boast placemen everywhere. When senators voted her the Priesthood of the Deified Claudius, and double the number of lictors granted to Livia in her widowhood, it set the seal on an astonishing comeback. 'She dared to strive after the rule of the sacred

world.'[1] Never before had the Roman people been able to say that of one of their women.

Yet the summit attained by Agrippina was a precarious one. Her very feat of scaling it could hardly help but inspire in most men bitter mistrust. Senators, summoned to meet on the Palatine, deeply resented what all of them knew was her brooding presence behind a curtain, listening in on their every word. Seneca too, despite everything that he owed her, was profoundly unsettled by her pretensions. Daughter of Germanicus that she was, Agrippina saw no reason why she should not stamp her authority as firmly upon the frontiers as upon domestic affairs. She certainly had form when it came to setting her mark on military matters. Back when the chained Caratacus was led before Claudius, there had been Agrippina as well, sitting directly beside her husband, enthroned beneath the eagles – 'an unprecedented thing'.[2] Her abiding interest in Germany, where her father had performed such heroic deeds and she herself had lived as a child, had seen the capital of the Rhine renamed after her, so that the Altar of the Ubians had become *Colonia Agrippinensis* – the future Cologne. Now, though, in the first months of her son's reign, attention was focused not on the northern frontier, but on Armenia, where the Parthians were busy attempting to replace a Roman-backed king with a puppet of their own – a crisis which Agrippina was resolved to take the lead in handling. When an Armenian embassy arrived in Rome, she took for granted that she should be seated beside her son to receive them. Seneca, an inveterate civilian, but whose scholarly temperament and lifelong respiratory problems had only heightened his respect for the martial traditions of the Roman people, was appalled. Determined that at least some bounds of propriety be respected, he instructed Nero to rise from his seat, step down to meet his mother and take her to one side. Scandal was duly averted.

'It was I who made you emperor.'[3] So Agrippina was forever

reminding her son. Nero, barely sixteen, and schooled as only a
Roman child could be in the habit of deference to his parent, had
little choice but to listen. Various innovations proclaimed as much
to the Roman people. On Nero's coins, his profile and Agrippina's, of
matching size, were shown facing one another, as though in celebra-
tion of their partnership; on his inscriptions, he made sure to include
the line of descent from his mother as well as his father. Nevertheless,
there had to be limits. He was ruler of the world, after all. He could
not afford to appear henpecked by his mother. Instead, shrewd
enough to recognise just what a *consigliere* he had in Seneca, Nero
was content, even now that he was Caesar, to remain the student of
his old tutor. Advised to meet the crisis in Armenia with iron-fisted
determination, he boosted troop numbers along the eastern front
and dispatched a veteran of the German frontier to take command
of the situation – with the result that, soon enough, the Parthians
were scrabbling to sue for terms. Meanwhile, back in Rome, Nero
continued to pose with great aplomb as the model of a beneficent
ruler. Graciously, he refused an offer from the Senate to erect statues
of him fashioned out of gold and silver. He declared an end to the
treason trials that had so stained the reputation of Claudius – and
kept his word, what was more. On one occasion, brought a death
warrant to sign, he sighed, then lamented with great theatricality
that he had ever learned to write. 'No chance did he miss, in short, to
parade his generosity, his mercy and his graciousness.'[4]

It was the nature of the factions lurking beneath the surface of
Caesar's household always to seek out fresh battlefields. Now, in
the struggle to market the young emperor, Agrippina and Seneca
had found the perfect focus for their growing rivalry. Two potent
but contradictory versions of Nero's image were being sold to the
world: as the dutiful son of the Augusta, the daughter of Germani-
cus, without whom he would have been nothing; and as the father
of his people, wise beyond his years, 'always forbearing in the care of

his children'.[5] Nero himself, like a doll, found himself forever being draped in robes that others had chosen for him. Yet it was not easy to kick against this indignity. Agrippina had allies everywhere, and the burnishing that her incomparable ancestry gave to Nero's legitimacy was beyond price. Seneca, meanwhile, learned like no one else in the traditions prized by the Roman establishment, was invaluable for his ability to shape them to his master's needs. Neither could be jettisoned; and Nero, alert to the weakness of his own position, knew better – as yet – than to try.

Nevertheless, the more wearisome he found his mother and tutor, the more he yearned to flex his muscles. Opportunities were hardly lacking. When, chafing against the marriage to Claudius's daughter forced on him by Agrippina, he began to look around for a woman better suited to his tastes than the earnest and high-minded Octavia, he soon found one in the shape of a former slave named Acte. Agrippina was predictably appalled. 'A housemaid as my daughter-in-law?'[6] It was not to be borne. Rather than back down, though, Nero turned for assistance to his tutor – who promptly arranged for one of his associates to serve Acte and her lover as a go-between. Yet Seneca, even as he was assiduously promoting his youthful pupil as the model of responsibility, faced challenges of his own. Nero, bored of spending his time living up to his tutor's stern ideals, wanted to let off steam. He was strongly encouraged in this ambition by a young rake named Marcus Salvius Otho, whose flamboyant extravagance and taste for tossing unfortunates up and down in military cloaks made him very much a man after Nero's own heart. Otho, unlike Seneca, was not forever nagging him about his duty; Otho, unlike Seneca, was familiar with the seamiest, the most vice-ridden quarters of Rome. Whole new dimensions of experience and opportunity, barely hinted at in books of philosophy, were waiting to be discovered in the streets of the city: a thrilling prospect for any young man who, like Nero, 'had a love of the incredible'.[7] Increasingly, it was not Seneca

who 'shared with him all his plans and secrets',[8] still less Agrippina, but companions like Otho.

Nevertheless, there remained at the heart of the young Caesar's regime the same throbbing, ominous tension between the show and the reality of power as had been present from the moment of his accession. Nero knew – because his mother was always reminding him of it – that he would never have ascended to the rule of the world without her manoeuvrings and manipulations; he knew too that he was not the only candidate to rule as Caesar. Always, hanging over his head, a reminder to him that he was not indispensable, lurked Britannicus. This had been brought unsettlingly home to Nero during the first Saturnalia of his reign, when his stepbrother, ordered as a forfeit to stand up and sing, had intoned a lament for his displacement. Agrippina, determined to keep her son in check, did not hesitate to menace him with the prospects of his rival. When Nero, greatly daring, dismissed Pallas from his post on the Palatine, his mother's fury at the sacking of her most valued agent was something terrible. 'I will take Britannicus to the Praetorian camp! The soldiers there will listen to the daughter of Germanicus!'[9] A mortal threat – and Nero knew it. Agrippina, as she had done all her life, played hard, and she played to win – even against her own son.

Bitter and humiliated, Nero vented his fury in the readiest way available: by repeatedly sodomising his stepbrother. Rape was, of course, the most physically brutal means a Roman had of asserting his dominance over a rival; but it was, in Nero's case, an expression of impotence as well. His mother, it seemed, had won. When, midway through 55, he invited Agrippina to a feast, making sure to host Britannicus and Octavia as well, there did not appear much doubt as to who held the whip-hand in the August Family. Then, in the course of the meal, Britannicus abruptly began to choke. His eyes bulged, he gasped for breath, his body went into spasm. All around him, his fellow guests rose in consternation – but Nero, lying back on his

couch, watched on unconcerned. 'Epilepsy,' he murmured coolly – then glanced across at his mother. Agrippina, her face set, did her best not to betray her horror; Octavia too. The corpse of Britannicus, painted white to disguise its hideous discoloration, was bundled out of the Palatine that night.[10] As it was being borne across the Forum, so rain began to fall and washed the powder away. The storm, though, did not prevent a pyre from being lit on the Campus Martius and the body hurriedly cremated. The remains were buried in the Mausoleum of Augustus. With Britannicus dead, the line of the Claudians – that most formidable of all Roman families – was dead as well. Nothing was left but 'dusty ash and pale shadow'.[11]

Agrippina, who had fought so hard to disinherit Britannicus, now found herself mourning him with unforced abandon. Whether, as Nero solemnly persisted in claiming, he had succumbed to an epileptic fit, or else to something more sinister, the consequence was the same: there was no longer a ready heir on the Palatine. Any prospect of keeping Nero on a tight leash was now effectively gone – as Nero himself soon made clear. Politely but firmly, Agrippina was ushered from Caesar's house into her grandmother's old villa next door. She was stripped of her bodyguard; her face began to vanish from the coinage. No longer did suitors flock to her doors in the hope of patronage: an infallible symptom of trouble in a city such as Rome. Nostrils alert to the scent of blood duly began to flare. Agrippina had many enemies – and they were hungry to drag her down. Prominent among them, of course, was Domitia, her old rival for Nero's affections, and whose sister, Domitia Lepida, had been convicted on a capital charge just prior to Claudius's death. Agrippina's fingerprints had been all over that particular case; now, eager for vengeance, Domitia sought to pay her back in like coin. Her chosen agent was one of her freedmen, an actor much admired by Nero named Paris. Arriving on the Palatine under cover of darkness, and ushered into the Emperor's presence, he levelled a range of sensational accusations

against Agrippina. That she was the lover of Nero's cousin, a great-grandson of Tiberius's by the name of Rubellius Plautus. That she intended to marry him. That she was plotting to replace her son with her new husband, and then to rule the world by his side. Nero, all the more paranoid for having drunk too much, was thrown into a full-scale panic. Summonses were immediately sent to Seneca and Burrus. Seneca arrived first, and Nero – according to one report – talked wildly of sacking the Prefect for being his mother's creature. The prospect of how the Praetorians might react to this move was a sobering one, though, even for someone as furiously inebriated as Nero; and sure enough, by the time of Burrus's arrival on the Palatine, he had repented of it. On one thing, though, he remained set. The time had come to solve the problem of his mother's mischief-making once and for all. The command he gave Burrus could not have been more explicit or shocking: to kill Agrippina.

But even Caesar could go too far. Burrus told Nero to his face that he was drunk, and would see things differently in the morning. Blunt by nature, the Prefect spoke with the self-assurance of a man alert to how loyal his men still remained to Germanicus's daughter. Sure enough, the attempt to eliminate Agrippina ended up spectacularly rebounding on its perpetrators, for it had shocked Seneca and Burrus into recognising just how exposed they would be without her. Ultimately, they had little choice but to sink or swim with the Augusta. A cursory investigation into the charges against their erstwhile patron, and their triumvirate was quietly patched up. Rather than challenge it, Nero opted to beat a tactical retreat. Not only was Agrippina fully exonerated of the charges against her, but she took the opportunity to seize back lost ground. Domitia was publicly humiliated by having her rights of patronage over Paris abolished, while others among Agrippina's accusers were banished, and her own partisans promoted. No one familiar with the constantly shifting balance of power on the Palatine could doubt what had happened. Nero had been forced into

open concessions. The limits of his authority – Caesar though he was – stood glaringly exposed.

'Power comes in many forms.' So Seneca, after Nero's first turbulent year as emperor, reminded his master. 'A princeps has the sway of his fellow citizens, a father his children, a teacher his pupils, officers the soldiers appropriate to their rank.'[12] Yet Seneca, despite recognising that the very word 'princeps' had become something of a misnomer, and that Nero's powers were more properly those of a king, was betraying his blinkers. His understanding of how power should properly be exercised still drew on the primordial traditions of the Roman people: obedience to those placed in command; admiration for the iron disciplines of family and legion; respect for duty. These were the virtues of which Augustus had approved, and Tiberius, and Claudius. And yet all the while there lay over the teeming and brilliant capital, with its theatres and circuses, its games and plays, its processions and festivals and races, the heady perfume of a very different brand of power. Seneca, it was said, had dreamed the night after he had first been introduced to Nero that he was teaching Caligula; and perhaps the vision had been prophetic. To win the love of the people; to pander to their enthusiasms; to woo them with entertainments beyond their wildest imaginings: these were the policies by which Nero's uncle had lived and died.

Fifteen years on from his assassination, the hatred of the Roman elite for Caligula remained as venomous as ever. To Agrippina, in particular, the notion of presenting her brother to Nero as a role model could hardly have been more monstrous. To Seneca too: for Caligula had despised and mocked the philosopher as a pedlar of platitudes, and flirted with putting him to death. There were some in Nero's circle, though, who had fonder memories. Aulus Vitellius, that seasoned veteran of Caligula's revels, had made sure, with the practised smoothness that came naturally to his family, to slip into the new emperor's affections; and he, as a man who had raced

chariots and bore the sports injury to prove it, could hardly have been more sympathetic to Nero's taste for glamour. Across the Tiber from the Palatine, marked by Rome's tallest obelisk, stood the private racecourse begun by Caligula but never finished: a dereliction which, encouraged by cronies such as Vitellius and Otho, Nero intended to correct. Like uncle, like nephew: compared to spectacle, and boldness, and the approbation of the Roman people, who cared what po-faced conservatives might think?

Except that, for the moment, Nero's dreams outpaced his nerve. When Seneca, appalled that his erstwhile pupil should be flaunting an interest in the Circus, let alone angling to ride chariots himself, sought to check his enthusiasm, the two men arrived at a compromise. Even though Nero's grandfather had been celebrated for his skill on the racecourse, and his father, scandalously, had run down a child while speeding on the Appian Way, Nero himself was content to practise in private. That the sport was unworthy of him, though, a distraction from worthier pursuits, he refused point-blank to accept. It was, he informed Seneca, the pastime of ancient kings, fêted in the songs of poets, favoured by the gods. For Caesar to drive a chariot was not, no matter what the fustier brand of senator might insist, an offence against the majesty of Rome – it was the opposite. Times had changed. To veil the blaze of charisma such as Nero's was pointless. One might as well hood the sun.

Even Augustus, after all, despite his posing as a magistrate of the Roman people, had dared to hint at what it meant to rule the world. It was why he had fostered the rumours that his mother had been impregnated by a snake; why, at his wedding feast, he had come as Apollo; and why, in the library on the Palatine, he had sanctioned a statue of himself dressed as his divine patron. Many were the attributes of the god. Climb from the Forum to Caesar's house, and there, above the road, surmounting the great arch built by Augustus, citizens could behold the famous sculpture of Apollo driving the

chariot of the sun; if they continued to the summit of the hill and entered his temple, they would find waiting for them in the sanctum a very different portrayal of the god, garbed in the robes of a professional musician and holding a lyre, the seven-stringed *cithara*. What Augustus, nervous of how the Roman people might react, had been content merely to insinuate, Nero, youthful and golden, exulted in. Not content with completing the private circus begun by Caligula, he aimed to go one better by mastering the notoriously challenging *cithara* and singing his own compositions to it. Rare was the spare moment that he did not spend picking at its strings or fine-tuning his voice. Light and music, attributes of the most beautiful, the most terrible of the gods, were attributes worthy too of a youthful Caesar. Far from disgracing him, as Seneca charged, Nero's mastery of chariot and lyre, once honed to a superhuman pitch and made manifest to the Roman people, would serve to proclaim a golden age.

Such, at any rate, was the long-term ambition. For the moment, though, it remained a fantasy. Not yet out of his teens, Nero still struggled to dazzle the world as he knew himself capable of dazzling it. Too much stood in his way. The sour disapproval of withered and bony-fingered senators; the perpetual ebb and surge across the Palatine of the various tides of faction; the precarious loyalties of the Praetorians: all served as a block on the ambitions of the youthful Caesar. Nevertheless, the more habituated to power Nero became, the readier he was to explore what he might achieve with it. In 57, when he was nineteen years old, he inaugurated a new amphitheatre on the Campus Martius. Built in under a year, and incorporating beams fashioned out of 'the largest tree ever seen in Rome',[13] it was constructed on a scale commensurate with its sponsor's ambitions. Nevertheless, despite the vastness of the space, he had no interest in staging anything so vulgar as a simple bloodbath. Just as the amphitheatre itself, with its nets of gold wire suspended over the arena on elephant tusks, was decorated with an artist's attention to detail, so

did the entertainments reflect Nero's fascination with dissolving the boundaries between the everyday and the fantastical. Those who crammed onto the bleachers were being invited to enter a world ancient and cruel, in which monsters were bred of unnatural lusts, and men with wings fashioned out of wax and feathers sought to fly. For the entertainment of the spectators, a woman imprisoned inside a heifer made of wood might be mounted by a bull, or a performer suspended high above the arena be let drop. Myth was rendered a thing of thrilling spectacle in which the screams, the scents of fear and the carnage were viscerally real. On one occasion, Nero himself was splattered by the blood of a man who had flown too close to the sun.

As Claudius had demonstrated, there were few limits to what a Caesar might commission, if he only had the vision and the cash. Nero prized ingenuity, and was certainly no less fascinated than his predecessor by great feats of engineering. In Ostia, the quays and breakwaters of the emerging port continued to swarm with workmen, and Nero, when it was formally completed, did not hesitate to take the credit.[14] Merely to bend the sea to his will, though, was inadequate to the scale of his ambitions. 'Never have there been spectacles to compare – for they put everything we have seen into the shade!'[15] The enthusiasm felt for Nero's shows, even among the most jaded of the Roman people, was as joyous as it was unforced: due reflection of the remarkable feats achieved by those responsible for their staging. Even as engineers at Ostia were turning the sea into dry land, so their colleagues in the heart of Rome, on the Campus Martius, were turning dry land into sea. The great naval battle of Salamis, re-enacted decades earlier by Augustus, was staged a second time in Nero's amphitheatre. Scenes were laid on to stupefied spectators that might have seemed conjured up from Puteoli or Baiae: the beating of oars; the gliding of war galleys; the surfacing of strange creatures of the deep. Indeed, so daring were some innovations that

they would have startled onlookers even in the Bay of Naples. Particularly wondrous was a mechanical yacht that, as though it were being shipwrecked, 'seemed to disintegrate, releasing wild animals as it did so – and then, reassembling itself, to appear as good as new'.[16] Even Nero was impressed.

Agrippina, marking her son's taste for lavishing money on wonders and entertainments, was less so. As only a woman who had lost a fortune could do, she valued money. Incontinent spending struck her as both unwise and dangerous. When Nero bestowed a spectacular bonus on one of his freedmen, she ordered the money tipped out in a great pile in front of him, so that he could see for himself how much of a fortune he was squandering. Nero, with an insouciant shrug, immediately ordered it doubled. 'I hadn't realised that I was being so stingy.'[17] The older he became, the more tedious he found his mother's constant nagging. The demands of duty, of responsibility, of statecraft, increasingly oppressed and aggravated him. Infuriatingly, though, he found them impossible to dismiss. He was married to them, after all. His wife, the earnest and austere daughter of Claudius, was a living, breathing reminder of everything he owed his mother. That Agrippina was as close to Octavia as Nero found her uncongenial only intensified his irritation with the pair of them. Uxurious by nature, he deeply resented his loveless marriage. Acte, whose enduring hold on his affections had enabled her to grow sensationally rich, remained much cherished by Nero; but she, of course, as a one-time slavegirl, could not possibly become his wife. Then, in 58, he fell in love again – and this time the object of his passion was a very different class of woman. Poppaea Sabina, the daughter and namesake of the rival hounded to her death by Messalina, was beautiful, intelligent and stylish; but crucially, she was also the granddaughter of a man who had won a consulship. Her breeding, while hardly on a level with Octavia's, was far from contemptible. It was possible for Nero to look at her and imagine her his wife.

Naturally, there were various obstacles to be cleared first. The first of these, and the least insuperable, was Poppaea's husband – who happened to be Nero's close friend, Otho. Out on the streets of Rome, where the details of Caesar's love life were relentlessly picked over, the precise circumstances of Poppaea's bed-jumping were much debated: had Otho boasted of his wife's sex appeal once too often, or had he married her to facilitate his friend's cheating on Octavia? Whatever the precise truth, it is certain that by 58 Nero had decided that he wanted Poppaea exclusively for himself. Weighing up whether to have his friend put to death or merely banished to the limits of the world, he opted for the course of mercy, dispatching Otho to Lusitania, out on the Atlantic margins of Iberia, there to serve as its governor. Bosom companion or not, Poppaea's husband had outlived his usefulness. Keeping things under wraps had never been Nero's style. He preferred to flaunt his passions. There was to be no more veiling the affair.

Nero himself, of course, could afford to shrug aside the resulting scandal; and so, as it turned out, could Poppaea. The jealous hatred of those who traduced her as 'an arrogant whore'[18] was a price worth paying for Caesar's devotion. As ambitious as she was glamorous, the radiance of Poppaea's charisma exemplified everything that Nero most admired in a woman. Even the colour of her hair, neither blonde nor brunette, marked her out as eye-catching: praised by Nero as 'amber-coloured',[19] it was soon setting the trend for fashion victims across the city. Set against Poppaea's allure, the unhappy Octavia could hardly help but seem further diminished. The prospects of Agrippina too: indeed, it was the measure of just how challenging it had become for her to keep Nero in check that the rumours of her desperation alleged some shocking details. That she was aiming to wean her son from Poppaea by seducing him herself. That she had begun to make moves on him, painted and dressed like a prostitute, whenever he was drunk. That Seneca was so anxious

about Agrippina's behaviour that he had sent Acte to warn Nero of the damage to his reputation. There were others, though, who alleged the opposite: that it was Nero himself, and not his mother, who had made the first move. The reality, of course, was lost to impenetrable murk. The delight that rumours of incest brought the Roman people was invariably exceeded only by the impossibility of knowing whether they were true.

Yet when it came to identifying the source of the gossip, the challenge was not insurmountable. Agrippina was a woman respected even by her enemies for her iron self-discipline – whereas Nero positively loved to shock. It was noted that he kept as one of his concubines a woman who looked exactly like Agrippina, 'and that whenever he fondled her, or showed off her charms to others, he would declare that he was sleeping with his mother'.[20] An outrageous boast – but almost designed, it might have been thought, to test the waters of public opinion. It was as though Nero, by deliberately scandalising the bounds set on the common run of humanity, wished to test just how far he dared to go. How did it feel, he seemed to be asking himself, to break a fatal taboo?

Long before, back when Nero was born, Agrippina had consulted an astrologer to discover what was written in the stars about her son. Two things, the astrologer had informed her: that he would rule the world – and kill his mother. 'Let him kill me,' Agrippina was said to have retorted, 'provided only that he rules.'[21] Was the story true? If so, then the fraying of relations with her son would doubtless have brought the prophecy often to mind. By early 59, though, the tensions between them appeared to be easing. Nero, in an ostentatious gesture of goodwill, invited his mother to share a holiday with him at Baiae. In mid-March, Agrippina arrived by ship from Antium, the town just south of Rome where her son had been born twenty-one years before. Nero greeted her in person, then escorted his mother to her villa, a sumptuous mansion once

owned by Hortensius Hortalus. Here, leading her down to its jetty, he presented her with a splendidly outfitted gift: her very own yacht. That evening, Agrippina took a litter north along the coast to Baiae, where Nero was staying. Greatly affectionate, he gave her the place of honour next to himself, and talked with her until the early hours. By now, with night lying velvet over the Bay, it was too dark for her to take a litter back home; and so Nero, informing his mother that her new yacht was docked outside, escorted her down to the marina. There he embraced and kissed her. 'For you I live,' he whispered, 'and it is thanks to you that I rule.'[22] A long, last look into her eyes – and then he bade her farewell. The yacht slipped its moorings. It glided out into the night. Lights twinkled on the shore, illumining the curve of 'the loveliest bay in the world'[23] while stars blazed silver overhead. Oars beat, timbers creaked, voices murmured on the deck. Otherwise, all was calm.

Then abruptly the roof fell in. Agrippina herself was saved from being crushed to death only by the raised sides of her couch; but when the yacht, after drifting idly for a few minutes, began to rock and tilt, she was flung into the sea. A friend of hers, bobbing beside her, was so frantic to be rescued that she cried out, 'I am Agrippina'; but no sooner had she done so than she was being clubbed to death by oars and poles. Agrippina herself, keeping as silent as she could, swam away from what now stood revealed as a death-trap; and as she swam, she met with some fishermen, who pulled her from the waters and rowed her ashore.[24] From there, shivering and bleeding, she staggered back to her villa. All too aware of who most likely lay behind her attempted murder, but painfully conscious too, cornered as she was, that she had little choice save to play the innocent, she sent a message to Nero informing him of what had happened. Then she tended to her wounds.

Meanwhile, outside, crowds had gathered along the shore, a blaze of lanterns amid the dark of early morning. The bay echoed at first

to their lamentations and prayers; but then, informed of Agrippina's survival, they gathered around her villa and made ready to rejoice. Suddenly, though, there sounded the beating of hooves. A column of armed men came galloping down the road. The crowds outside were roughly dispersed; soldiers surrounded the villa, then forced their way in. They found Caesar's mother in a dimly lit room, attended by a single slave. Agrippina confronted them boldly, but her insistence that Nero could not possibly have meant them to kill her was silenced when one of the men coshed her on the head. Dazed but still conscious, Agrippina looked up to see a centurion drawing his sword. At this, rather than protest any further, she determined to die as who she was: the daughter of Germanicus and the descendant of a long line of heroes. 'Strike my belly,'[25] she commanded, pointing to her womb. Then she fell beneath the hailstorm of her assassins' swords.

The shock of the crime echoed to the heavens. After the hurried disposal of Agrippina's body, her ashes were interred beside Julius Caesar's old villa, on a promontory overlooking the sea; and from this headland, it was reported, would repeatedly sound the blare of trumpets, to be echoed by other blasts from around the bay. Some said that Nero, retreating from the scene of the murder to Naples, was visited by his mother's ghost; and that he was haunted in his dreams, just as Orestes had been, by the whips and fiery torches of the Furies. His taste for bringing to life ancient myth had long been on show; but now, in the most shocking and audacious manner, he had himself taken centre stage as a hero of legend. All his devotion to theatricality, all his enthusiasm for stagecraft, all his relish for posing as someone infinitely beyond the run of common mortals, had contributed to an incomparable spectacular – and the news of it filled the world. The yacht that had capsized his mother was modelled, it was reliably reported, on the collapsing boat witnessed by Nero back in Rome; viewing Agrippina's corpse prior to

its cremation, he was said to have stripped it naked, inspected it closely and then murmured, 'I did not know I had so beautiful a mother.'[26] Nero himself, far from punishing those who spread such rumours, seemed to revel in the melodrama of it all. When graffiti appeared in Rome, charging him with matricide, he made no effort to track down the culprits; and when a famously stern moralist by the name of Thraesa Paetus, rather than concur with the formal condemnation of Agrippina as a traitor, opted to walk out of the Senate House in protest, Nero overlooked the offence. He knew the Roman people and he had judged their response correctly. He had gauged that his crime, precisely because so titanic, would end up only adding to his charisma. No mean or squalid matricide, he had successfully cast himself as a figure of tragic glamour, as a new Orestes. When he returned to Rome from Campania, the crowds lined up to meet him as though for a triumph.[27]

Nero's feelings of relief could not have been sweeter. He had played for perilously high stakes – and he had won. Right up to the end, Agrippina had maintained her hold on the affection of the Praetorians. When Nero, brought the news of her escape from the booby-trapped yacht, had ordered a detachment of them to her villa, there to finish her off, Burrus had told him flatly that they would never kill the daughter of Germanicus. Only with her execution by a specially commissioned hit-squad, and the coming of dawn, had Nero been able to relax: for Burrus, bowing to the brutal change of circumstances, had ordered his senior officers to present them-selves to Caesar and congratulate him 'on foiling his mother's evil schemes'.[28] Nor had Seneca managed to keep his hands any cleaner. Obliged by Nero to ghost a letter of self-exculpation to the Senate, he too had found himself complicit in the murder. The only saving grace for him and Burrus was that at least they were not alone. Nero, on his return to Rome, proclaimed games that were to be 'the great-est ever',[29] a celebration of his victory over his mother. The entire

Roman people were summoned. All were invited to dabble their fingers in the blood of Agrippina.

It was an offer which few refused. Staged in a range of venues across the city, the games were as spectacular as Nero had promised. An equestrian rode an elephant down a tightrope. Plays with the latest in special effects thrilled audiences with fiery spectacles of destruction. Lavish numbers of tokens were scattered among the crowds, entitling the lucky recipients to everything from jewels to wild animals, from blocks of flats to gold. Meanwhile, in the Forum, Nero himself was busy offering up sacrifice. That a lightning bolt had recently incinerated the table at which he was dining; that a woman had given birth to a snake; that there had been an eclipse: these, under normal circumstances, might have appeared menacing portents of doom. And perhaps they were; but if so, then they served only to enhance, not diminish, the glitter of Nero's stardust. By killing his mother, after all, he had saved Rome from her inveterate and ruinous lust for power; and he had done so at heroic cost. It was for the sake of his fellow citizens that he had taken upon himself the guilt of matricide; now, by celebrating their own salvation, the Roman people could share a role in the remarkable drama. When a comet, bright and ominous, appeared in the cloudless skies above Rome even as the festivities were in full swing, many feared the worst; but many more looked to Nero as what he claimed to be – their saviour. A century before, in the wake of the Ides of March, the blaze of a star across the heavens had heralded calamity for the entire world; but not now. Seneca, with no choice save to carry on playing the role of Nero's accomplice, duly hailed the role of his master: 'He has succeeded in redeeming comets from their evil reputation.'[30] A fitting tribute: for Nero, that summer of 59, had successfully transfigured murder into sacrifice, ambition into selflessness, and matricide into piety. Comet or not, there could be no doubting who was the star.

But it was not enough for Nero merely to play the impresario. That same summer of 59, he hosted another festival, a private celebration staged to mark the first shaving of his beard. The games were held on the far side of the Tiber, between the lake where Augustus had hosted his famous re-enactment of the battle of Salamis and the river itself. The entertainments lasted into the early hours. There were banquets held on barges, groves filled with grappling couples, and at midnight Nero himself, to exultant cheers, sailed out from the lake into the Tiber: touches of Baiae in the heart of Rome. The main focus, though, was on theatrical extravaganzas – and these, as the public games had done, featured performers from the cream of the elite. 'Neither breeding, nor age, nor public office served to inhibit them.'[31] One dancer, a former sister-in-law of Claudius's, was in her eighties.[32] The climax of the entertainments, though, was the stage debut of Nero himself. Plucking at the lyre, he sang to his audience of gruesome maimings and murders from ancient myth: of a boy castrating himself; of a mother killing her son. It was, for the twenty-one-year-old Caesar, a moment of the giddiest rapture. The spectators cheered and applauded. 'Our Apollo,' they cried, 'our Augustus!'[33] For some, though, the delight rang rather hollow. Burrus was there, with officers and soldiers of the Praetorians; so too Seneca, whose elder brother had introduced Nero onto the stage, and who himself had been obliged, in company with the Prefect, to serve as their master's cheerleaders, waving their arms and flapping their togas. 'The more instruments of torture the torturer has on display, the more he is liable to achieve – indeed, the very appearance of them is likelier to break a man than the patient endurance of pain.' So Seneca, without ever mentioning Nero, would later confide to a friend. 'In a similar manner, nothing is better able to brainwash and enslave us than the dazzle of spectacle.'[34]

And Nero, having now successfully tested the waters, had only just begun.

All the World's a Stage

In AD 60, almost two decades after crossing the Atlas mountains, Sueto-nius Paulinus was near to completing an expedition at the opposite end of the world.[35] As in Mauretania, so in Britain: his progress had been gruelling. The capture of Caratacus, far from signalling the end of British resistance, had provided only a brief respite from the task of pacification. Wales, where the Catuvellaunian chieftain had made his last stand, was the particular challenge. Mountainous and inhabited by notoriously untameable tribesmen, it had defied a succession of Roman governors. Suetonius, whose record in crossing mountains was second to none, had been the obvious man to finish the job. Sure enough, two years on from his appointment to Britain, he had succeeded in stamp-ing the mark of Roman supremacy upon even the wildest reaches of the country. Only the island of Mona – modern-day Anglesey – still held out. And now, with his infantry massed in flat-bottomed boats and his cavalry instructed to breast the shallows, Suetonius was ready to cross the straits and finish off resistance for good.

But would his soldiers do as commanded? Mona was crammed with refugees; and these, crowding the shoreline, howled and chanted to such baleful effect that the legionaries found themselves briefly frozen with terror. There were women brandishing torches, who, with their black robes and tangled hair, looked like nothing so much as Furies; and there were Druids. But then, summoning up their courage, Suetonius's men began to make for the opposite shore. In the event, it proved a walkover. Soon the defenders were being set ablaze with the flames of their own torches. Charred corpses were left scattered across the beaches. Then it was the turn of the island's sacred groves to be felled: for Mona was dreaded by the invaders as the chief shrine of the Druids, and of the terrifying spirits appeased by their murderous rites. The defeat of barbarian savagery and the purging of shrines festooned with human entrails – Suetonius had achieved a

double exorcism. The news of his feat, when it was reported back in Rome, served as a stirring reminder to the inhabitants of the capital that there still existed, in the remote corners of the world, thrilling dimensions of heroism and sorcery. Nowhere, it seemed, no matter how distant, lay beyond the reach of the Roman people.

A message that Nero, despite his own complete lack of military experience, was naturally keen to promote. Why should the blaze of his charisma not find reflection even in the darkest wastes of the North? A particular triumph was achieved when one of his event managers, sent to source amber directly from the Baltic, returned laden with spoils. The agent had made such a success of his mission that he brought back riches sufficient to adorn an entire arena. Nets; weapons; even the stretchers used to remove dead gladiators: all were made to gleam the colour of Poppaea's hair. 'So globalised has every-thing become,' wrote Seneca in wonder, 'that nothing is left in its accustomed place.'[36] Whether in Nero's amphitheatre, with its glint of amber and its bears set to hunt seals, or amid the bustle of markets sell-ing goods from as far afield as India, or on the hill above the Campus, where a great map illustrated for the benefit of passing citizens the full, dazzling extent of their sway, reminders of Rome's status as the ultimate in world cities were inescapable.* All roads led there, and all roads led from there. In the Forum, to mark the official spot where they began and ended, Augustus had erected a milestone sheathed in bronze: the centre of the world. Contemplating the immense spider's web that Roman greatness had succeeded in spinning across moun-tains, forests and seas, some still wondered just how far its threads might end up reaching. 'Perhaps, in time to come, an age will dawn when the Ocean loosens the bonds of things, when the full breadth of

* There is an intriguing possibility that the bears which are described by the poet Cal-purnius Siculus as savaging seals in Nero's wooden amphitheatre might be polar bears. Tellingly, though, there is no mention of their fur being white, and so the balance of probability must sadly be against it.

the earth will stand revealed, when new worlds will be disclosed, and when Thule itself serve merely as a way-stop to other lands.'[37]

Seneca, when he imagined Roman ships powering their way to as yet undiscovered continents, did not necessarily approve. As a philosopher, he saw nothing to celebrate in perpetual motion. The prosperity that was the mark of a great empire was, in his opinion, a treacherous and soul-destroying thing, characterised by perpetual restlessness, and destined only to torment itself. Yet even as he praised the delights of poverty, he could not help but be swept along by what he condemned. Nero's matricide, far from shocking Seneca into resignation, had only confirmed him in his determination to cling to power. The less inclined the youthful Caesar was to take his advice, the more of a responsibility he felt to continue providing it. So Seneca remained at Nero's side; and by staying there found himself prey to the manifold temptations that power on a global scale presented. 'The wise man has no need to send legates overseas, to mark out camps on enemy shores, to decide where best to plant garrisons and forts.'[38] No doubt – and yet Seneca himself, as Nero's most trusted advisor, had little choice but to immerse himself in precisely such details. He was up to date on reports from the British front, and alert to conditions on the island. He had convinced himself that there existed, in the ambition of its chieftains to conform to the new order, a rare investment opportunity; and so he had lent them the funds they required to build, to dress and to live like Romans. But he had miscalculated. The Britons had little understanding of the workings of finance, nor were they in any position to pay back the hefty interest being charged on their borrowings. Adding to Seneca's discomfort was his growing awareness of how great a drain on Roman manpower the conquest of the island was proving to be. Access to British hoodies and hunting dogs hardly compensated for the huge expense of keeping four legions in the field. There had even been talk of cutting Rome's losses and

withdrawing altogether.* Seneca, better placed than anyone to do
a spot of insider dealing, duly ordered his agents in Britain to call
in his loans.

The timing proved unfortunate. Debt collectors were already out
in force across the new province. Officials with responsibility for its
finances, determined to screw out such income as they could, had
begun to exact demands of tribal leaders who ranked legally, not
as subjects, but as allies of Rome. One such was Prasutagas, king of
the Iceni, a tribe in the flat and rolling lands to the north of Camu-
lodunum. Anxious to safeguard the interests of his daughters, he
had named them as his heirs alongside Nero. On his death, though,
the Roman authorities had moved to annex everything. The entire
kingdom was stripped bare. Prasutagas's two daughters, far from
being treated with the respect due their rank, were both raped, and
his wife, a flame-haired warrior queen named Boudicca, bound to a
whipping post and lashed. It was to prove a fatal error.

Seneca, had he been present, would not have been surprised, for
he had no illusions as to the nature of human rapacity. 'Were a true
representation of our lives to be flashed before your mind's eye, you
would think yourself watching a city just taken by storm, in which
all regard for modesty and right had been abandoned, and the only
counsel was that of force.'[39] Yet Seneca himself was hardly innocent
of what he condemned. Two years earlier, Suillius Rufus, the muck-
raking prosecutor who had helped to bring down Valerius Asiaticus,
had publicly charged him with draining the provinces dry; and even
though Seneca, pulling strings, had arranged for his accuser to be con-
victed of embezzlement, and sent into exile, the allegation had stung.
After all, seated as he was at the heart of the great web of Roman
power, he had only to tug upon a single thread of it for villages at the

* It is Suetonius (*Nero*: 18) who tells us this. Although he does not specify a date, it is
evident from Nero's determination to crush the insurrection in Britain that he would
never have countenanced the province's abandonment in the wake of Boudicca's revolt.

far end of the world to be trampled down by soldiers, and women
left bruised and bleeding. For all his scruples, and even if he had not
intended it, Seneca too had played his part in the harrowing of the
Icenian tribal lands. Doubtless this was why the gods, when they
warned, in the wake of the whipping given to Boudicca, of imminent
and terrible calamity, chose to send portents both to Britain and to
Rome. Even as flood-tides in the Thames estuary turned to blood,
leaving shapes like corpses on the beaches, so was barbarous laughter
heard coming from the empty Senate House, and screams from Nero's
amphitheatre. The world had shrunk for ill as well as good.

News that Boudicca, with the scars still fresh on her back, had
summoned the Iceni to revolt and was sweeping all before her,
reached Suetonius even as he was catching his breath after the
capture of Mona. Mustering a squad of cavalry, he climbed back
into his saddle at once. Then, instructing the two legions under
his immediate command to follow as fast as they could, he made
directly for the eye of the storm. The nightmare that had never
ceased to haunt the invaders since their first arrival in Britain, the
dread that their occupation would end as Roman rule beyond
the Rhine had ended, amid slaughter, fire and ruin, appeared on
the verge of fulfilment. Camulodunum, rebuilt in the wake of its
capture by Claudius as a showcase of what Roman town-planners
could achieve, had been levelled to the ground. Littering the debris
were the corpses of butchered prisoners and the bronze fragments
of dismembered Caesars. High-born women, their severed breasts
sewn to their mouths, rotted on spikes. Meanwhile, of the two
legions not serving in Wales, one had already been ambushed and
almost completely wiped out, while the second, summoned by
Suetonius to join him, was ordered by its own acting commander
to stay in barracks. Many senior officials, rather than risk the fate of
Varus's men, had already fled to Gaul. A single error by Suetonius,
and Britain would be lost for good.

In the event, though, the province was saved. Suetonius, after taking the pulse of the insurrection in person, retreated, successfully made a rendezvous with his advancing legions and then waited to meet the firestorm. Two more Roman settlements were left as smoking rubble before the fateful moment came. The Britons, rather than adopt the tactics of Arminius and melt into the landscape the better to wage guerilla warfare, opted instead for a full-frontal assault. The result, secured in the teeth of satisfyingly massive odds, was a massacre. When the casualty figures were published, it was claimed that some eighty thousand Britons had perished for the loss of only four hundred Roman dead. Boudicca, whose gender and general savagery had made her seem to her adversaries an Amazon unleashed from the realms of myth, committed suicide. So too, brought the news of Suetonius's victory, did the legionary commander who had refused his summons to battle. It was all thoroughly stirring: 'a day of great glory, redolent of some victory won in ancient times'.[40] The Roman people, thrilling to the dispatches from the British front and revelling in how disaster had been averted, could enjoy the reassurance that they remained the same people they had ever been.

Not that martial virtue alone had ever been sufficient to explain their rise to greatness. The genius granted them by the gods was for peace as well as war. When the reprisals launched by Suetonius threatened to get out of hand, Nero was sufficiently perturbed to send one of his freedmen to report back to him on the situation; and sure enough, soon afterwards, Boudicca's conqueror was recalled. From the earliest days of their city, Rome's leaders had appreciated that generosity in victory was the surest way of securing their ends: 'for little is gained by conquest if it is followed by oppression'.[41] Romulus's abduction of the Sabine women, although inevitably it had led their outraged fathers and brothers to descend on Rome vowing vengeance, had culminated, not in slaughter, but in a peace

treaty, and in the Sabines becoming Roman. Since then, many other
Italian peoples had followed along the same path. The Marsians, the
Samnites, the Etruscans: all had come to rank as the fellow citizens
of their conquerors. No longer, though, were Rome's horizons con-
fined to lands south of the Alps. If Italy could end up Roman, then
why not the world? It was her mission, some had begun to claim, 'to
unite previously distinct powers, to soften patterns of behaviour, to
provide a common language to the numerous peoples hitherto div-
ided by their savage tongues, to civilise mankind – in short, to unite
all the peoples of the world, and to serve them as their fatherland'.[42]

Amid the charred fields of Britain, such a claim might have
seemed grotesque; except that the official appointed by Nero to
stabilise the shattered province's administration, and who had first
called for Suetonius to be replaced, was not an Italian but a Gaul.
Julius Classicianus served as a living reassurance to the Britons that
Roman rule offered more than simple oppression. Citizen of Rome,
yet married to the daughter of a Gallic chieftain, he was ideally placed
to mediate between conquerors and conquered. Rather than tighten
the screws on his subjects, he opted to build bridges. The Britons,
having been brutally taught the price of resistance, were now graced
by Classicianus with the benefits of submission. The policy proved
strikingly effective. Wounds began to heal, the embers of insurrection
to fade. Soon, even with memories of Boudicca's revolt still raw, it
was being decided in Nero's councils to reduce the garrison in Britain
from four legions to three. The Ocean remained to Rome.

Naturally, there were limits to what could plausibly be achieved.
No matter how successful the process of pacification, chieftains as
barbarous as those of the Britons could never hope to share in the
rule of the world. There were many in Rome who felt the same about
Classicianus and his kind. Although the aristocrats of southern Gaul
had been under Roman rule for almost two centuries, and had bred,
in the flamboyant form of Valerius Asiaticus, a man who had briefly

aspired to rule as Caesar, resentment at their presence in the Senate
House had never entirely faded. In AD 48, in a debate on whether
to admit chieftains from the central and northern reaches of Gaul,
opposition to the prospect had been ferocious. Allow the descendants
of men who had fought Julius Caesar, worn trousers and dripped
gravy from their facial hair, into the Senate House? 'Why, it would
be to import hordes of foreigners, in the manner of a slave-dealer.'[43]
In truth, though, such complaints about Gallic savagery were dis-
ingenuous. It was not the backwardness of the Gauls that provoked
the true resentment but the opposite: their growing wealth. Many a
senator, denied the opportunity to boost his fortunes as his ancestors
had once done, by looting barbarians, found himself impoverished by
comparison with Gallic magnates.

Yet this, to those with an eye to the future, was precisely what
made it so pressing to recruit them into the ranks of the Roman
elite. Gaul, with its fertile soil and manpower, was already richer than
many regions of Italy. Its aristocracy could not possibly be permitted
to go their own way. Claudius, with the perspective that came from
his deep reading in history, had made this argument with typical
subtlety and erudition. 'Everything we now believe to be the essence
of tradition,' he had reminded his fellow senators, 'was a novelty
once.'[44] Why, Clausus, his own ancestor, the founder of the Claudian
line, had been an immigrant. Senators had duly approved Claudius's
speech. Gauls had been admitted into their ranks. The Senate House
had ended up just that little bit more multi-ethnic.

Meanwhile, beyond its walls, in the teeming streets of a city whose
population now numbered well over a million, many had begun to
wonder what precisely it meant to talk of the Roman people. Rome,
as Claudius had reminded the Senate in his speech, had been founded
on immigration. Exotic languages had been heard in the city for cen-
turies. Street names still bore witness to the settlement of foreigners
on them in ancient times: the Vicus Tuscus, where Etruscans had

once congregated, and the Vicus Africus. Yet even as many Romans saw in their city's diversity the homage paid by the world to its greatness, and a potent source of renewal, so others were less convinced. All very well to host immigrants, so long as they ended up Roman; but what if they preserved their barbarous ways, infecting decent citizens with their superstitions? 'In the capital, appalling customs and disgraceful practices from across the world are forever cross-pollinating and becoming fashionable.'[45] A sobering reflection, to be sure: that to serve as the capital of the world might render Rome less Roman.

Such an anxiety was nothing new. Back in the first century of the Republic, a mania for outlandish cults had seen the Senate legislate to ensure that only the traditional gods be worshipped, and only with traditional rites. Since then, there had been numerous attempts to purge the city of alien ways. In 186 BC, the Senate had even launched a campaign of suppression against the worship of Liber, on the grounds that a Greek soothsayer had perverted its rituals and fostered unspeakable orgies. Egyptians and astrologers from Mesopotamia also tended to be regarded by most right-thinking citizens with profound suspicion. More alarming yet were the Syrians, with their devotion to a goddess, lion-flanked and jewel-adorned, whose cult, sinister as only a Syrian cult could be, had long been a thing of revulsion to every decent Roman. There was no value so fundamental, no propriety so settled, that her worshippers might not trample on them, and howl in exultant frenzy as they did so. Appearing to slaves in visions, the Syrian Goddess had been known to encourage them to rebel; driving mad her most frenzied devotees, she would inspire them to make a sacrifice of their testicles. *Galli*, these self-castrated priests were called: wretches who, abandoning the privileges and responsibilities of manhood, had willingly chosen to become women. With their painted faces and their feminine robes, their depilated bodies and their braided hair dyed blonde, they could not possibly have been

more offensive to Roman sensibilities. Unsurprisingly, then, the authorities had done all they could to prevent their fellow citizens from joining their ranks, banning the practice of self-castration outright at first, and then, from 101 BC, permitting it only under the tightest of regulations. Yet this had done nothing to diminish the popularity of the cult: disturbingly, it had turned out, some Romans quite fancied living as women. By the time that Claudius, surrendering to the inevitable, finally lifted all legal restrictions on citizens becoming *Galli*, processions in honour of the Syrian Goddess, complete with flutes, tambourines and spectacular displays of self-laceration, had become a common sight in Rome. Naturally, those who held fast to traditional values continued to find it all revolting. 'If a god desires worship of this kind,' Seneca declared flatly, 'then she does not deserve to be worshipped in the first place.'[46] For those on the cutting edge of fashion, however, a protestation of devotion to the Syrian Goddess had become an easy and entertaining way to shock. Rumour had it, for instance, that she was the only deity for whose cult Nero had any respect.

Yet when it came to sheer jaw-dropping weirdness, not even the beliefs of the Syrians could compare with those of their near neighbours, the Jews. Immigrants from Judaea had been settling in Rome for two centuries, mainly in the cheap housing on the far side of the Tiber, where the principal temple of the Syrian Goddess was also to be found; and in all that time, they had never lost their distinctiveness. No people in the world had customs more perverse or ludicrous. They abstained from pork; they took every seventh day off; they obstinately refused to worship any god save their own. Yet Jewish practices and beliefs, although self-evidently grotesque, were not without a certain glamour. Like the cults of the Egyptians or the star charts of the Mesopotamians, they were capable of seducing those with a taste for the exotic. This was why, from the moment that Jews had first settled in the city, the authorities had periodically sought to

expel them. The policy, though, had never proven effective. Whether
in 139 BC, when the Jews had been banned from Rome 'for trying to
corrupt Roman values',[47] or in AD 19, when Tiberius had repeated
the measure, or thirty years later, when Claudius had banished them
yet again for making trouble at the instigation of a sinister-sounding
agitator named Chrestus,* they had always crept back. A decade on
from their expulsion by Claudius, they had once again returned to
Rome. The fascination that they were capable of exerting, and the
corresponding sense of alarm that they provoked in those contemp-
tuous of foreign rituals, reached to the very top. 'They are the most
wicked of peoples.'[48] Seneca's mistrust of the Jews would only have
been confirmed for him by the reported interest of Poppaea in their
teachings. The appeal of alien superstitions, it seemed, reached even
into Caesar's bedroom. Many in Rome, when they contemplated the
slave quarters of their own homes, or the shrines in the streets raised
to mysterious gods, or the tenements crammed with immigrants
from every corner of the world, dreaded what loathsome practices
might be brewing in their city.

Nervousness about mass immigration and the peculiar cults that
it had brought to Rome came to a head in 61, when the City Prefect,
the man charged with the maintenance of order in the capital, was
stabbed to death. His killer was one of his own slaves – and this, by
the terms of a stern law passed half a century before, required that
every slave in the murdered man's household be executed. The sav-
agery of the penalty generated widespread revulsion; and it seemed,
in a debate on the matter in the Senate House, that clemency might

* Suetonius. *Claudius*: 25.4. It is possible, indeed probable, that this is an allusion to
arguments in Rome's Jewish community about the claims to messianic status of Jesus.
Chrestus, it is true, was a common name, particularly for slaves; but against that, there
is no recorded instance of a Jew in Rome ever being called it. A number of scholars have
suggested that Suetonius might have derived his information from a police report,
and that 'Chrestus' is a mistransliteration of 'Christus' – Christ. The truth, though, is
ultimately unknowable.

prevail. In the event, what swung senators into backing the execution of the many hundreds of slaves owned by the murdered Prefect was a blood-curdling reminder of the numerous alien practices that had been imported into Rome. 'Nowadays, the slaves in our households come from across the world, and engage in every kind of weird cult – or none at all. Terror tactics alone can serve to keep this rabble in check.'[49] The law was duly upheld, the death sentence confirmed. Out on the streets, where many of the protestors were themselves freedmen, or else the descendants of slaves, furious demonstrations were held. Crowds armed with stones and torches sought to prevent the sentence from being carried out. Nero, rather than permit agitators to override the law, issued them with an official rebuke, and ordered soldiers to line the route along which the wretched slaves were led to their deaths. Yet there were limits to the vindictiveness that he was prepared to sanction. When it was proposed that the freedmen of the murdered Prefect be rounded up and deported, Nero vetoed the motion. 'What mercy has failed to moderate,' he declared, 'should not be aggravated by savagery.'[50]

Nero had a particular talent for judging the mood on the street. Unlike most senators, whose prejudices against the *plebs sordida* were rarely bred of personal experience, he was familiar with the seamiest reaches of the city. As a young man, he and Otho had often gone slumming together. Disguised as slaves, they had drunk, pilfered and brawled their way through the reddest of red-light districts. Respectable opinion, naturally enough, had been scandalised – particularly when a senator who had punched the man attempting to mug him, only to discover later that it was Caesar and make the mistake of apologising in public, had been obliged to commit suicide. Yet Nero, by plunging into the bowels of Rome, was educating himself as surely as he had done by listening to the lectures of his tutor. Virtue, Seneca taught, was a thing of the city's heights, where the air was rarefied and regal; vice a thing of its murkiest depths. 'It tends to skulk in the

shadows, around the public baths and the saunas, in places nervous of the authorities, soft, enervated and dripping with wine and perfumes, either pallid or made up as one would paint a corpse.'[51] Fulminations like this, far from warning Nero off the city's lowlife, had naturally only encouraged him to sample its pleasures. When it came to breaking the Roman people to his will, he was seasoned as Seneca never would be. He knew when to feed them a carrot; and he knew when to wield a stick.

A clear measure of this was provided by the man appointed as Prefect of the *Vigiles*. Ofonius Tigellinus was a notorious chancer who might easily have ended up being fingered by the Watch rather than serving as their commander. As good-looking as he was impoverished, his initial career as a gigolo had seen him bed – or so it was rumoured – both Livilla and Agrippina. Convicted of adultery and exiled to Greece, he had been reduced to the humiliating extremity of working in trade, before a pardon from Claudius had enabled him to return to Italy and set up as a racehorse trainer. It was in that role that Tigellinus had become an intimate of Nero – who made him rich, and an equestrian to boot. Thuggish enough to keep order in the streets, but steeped at the same time in their pleasures, he was ideally suited to his master's purposes. Tigellinus's elevation to the prefecture of the *Vigiles* was to prove just a start. In 62, the most sensitive of all the posts open to an ambitious equestrian became vacant when Burrus, after a long fight against throat cancer, finally died. Honest and trustworthy, he had been a very different order of man from Tigellinus; and Nero, in recognition of this, made sure to split the command. Nevertheless, as one of the two Praetorian prefects, Tigellinus was now ideally placed to do his master's dirty work – and there was, as it happened, a particularly urgent job that needed doing.

Three years had passed since the murder of Agrippina, and now at last Nero was ready to cut the final thread that bound his regime to that of his predecessor. Despite her husband's humiliatingly

flamboyant affair with Poppaea, Octavia had been safe for as long as Burrus was alive. Beautiful, dignified and pathetic, she was precisely the kind of woman whom the Roman people loved. When Nero had once floated the possibility of divorcing her, Burrus had been openly dismissive. 'Sure,' he had scoffed, 'and be certain to return her dowry.'[52] Now, though, Burrus was gone; and his replacement had no loyalty to the family of Germanicus. When Nero instructed his new Prefect to dispose of Octavia, Tigellinus did not hesitate. The charge, as it invariably was whenever it became necessary to dispose of an inconvenient princess, was adultery. That the Prefect was a man as notorious for his promiscuity as his victim was celebrated for her modesty did not for a moment give him pause. 'Her private parts are cleaner than your mouth!'[53] So spat one of Octavia's attendants after being tortured by Tigellinus to make her testify against her mistress. He shrugged the insult aside. Most of Octavia's maids were all too ready to jump from a sinking ship. She was duly convicted of an affair with a slave. Yet just as Burrus had warned they would, the Roman people refused to tolerate the disgrace of Claudius's daughter. Rioting broke out. Poppaea's statues were toppled, Octavia's garlanded with flowers. Briefly, Nero wobbled. He proposed to remarry his unhappy wife. But then, with the fabrication of an altogether more detailed and watertight case against her, he rediscovered his courage. A second conviction was secured, and Octavia imprisoned on Pandateria. There, not long afterwards, she was put to death. Her head, dispatched to Nero, served as a trophy for his new wife: Poppaea Sabina.

A century before, when assassins in the employ of the Triumvirs had made a harvest of aristocratic heads, the winnowing had heralded global war. Not now, though. Poppaea's cradling of Octavia's head, no matter how indignantly the news of it might make crowds in the Roman streets seethe, did not threaten the order that Nero, for almost a decade, had provided the world. The provinces remained at

peace; the frontiers held secure. In 63, a year after the decapitation of Octavia, an enduring peace was negotiated between Rome and Parthia. It was agreed that Tiridates, a son of the Parthian king, should sit on the Armenian throne, but that at some point soon he should travel to Rome, there to receive his diadem in person from the hands of Caesar. A spectacle was thereby promised that could not have been more calculated to tickle Nero's fancy. For centuries, the Roman people had seen it as their birthright to grace kings with their favour; but never before had there been the prospect of seeing it staged for real in the heart of their city.

True, Nero himself had been nowhere near Armenia. When the Senate hailed him as *Imperator*, or when an arch was raised in honour of his victory on the summit of the Capitol, complete with a statue of him in full triumphal regalia, the fact that he had never seen a legion, still less led one into battle, was a minor detail. Nero understood that image, to a people far removed from the rigours of army life, was infinitely more vivid than garbled rumours of distant battles. What mattered to his fellow citizens was not whether flies had crawled over his wounds on some hellish and barbarous frontier, but the conviction with which he could embody their yearning for a prince of peace. 'There will be no more civil wars of the kind with which Rome once convulsed the globe; no more battles like Philippi to lament.'[54] Nero's task was to make the city, and the world, believe it.

The same responsibility, of course, had animated the career of Augustus and led to the establishment of the rule of the Caesars in the first place; but times were now far different, and the opportunities open to a talented and ambitious Princeps with them. Such, at any rate, was the conviction that Nero, after almost a decade in power, had come to hold. The old, uptight way of doing things, and the tedious inheritance from the past of obligations and taboos, were no longer to be borne. Restrictions on Nero's freedom of action had become intolerable to him. All were to be swept away. Octavia's

head was not the only one to have been delivered to the Emperor in 62. His assassins had also been commissioned to eliminate two prominent senators linked by blood to the August Family. One was Rubellius Plautus, the great-grandson of Tiberius rumoured to have been Agrippina's lover, and who had been living in placid exile on the Aegean coast; the other a descendant of Augustus's sister. Brought the news of these murders, senators shuddered. This was not least because, for the first time since Nero's coming to power, one of their own had just been condemned on a charge of *maiestas*. It was an agent of Tigellinus, informed that a magistrate had not only written a satire on the Emperor but actually read it out at a dinner party, who had brought the prosecution; and even though the death sentence, following an intervention by the indomitable Thraesa Paetus, had been commuted to one of exile, every senator could recognise the warning that had been served.

To Seneca, in particular, it had come as both a shock and a humiliation. Lashed as he was to the wheel of Nero's regime, he found himself powerless either to change what he saw as its increasingly disastrous course or to abandon ship. The best he could manage was to secure from his erstwhile pupil permission to retreat into semi-retirement. There, his mood continued to darken. Whether in his worsening health, in the person of a decrepit and toothless porter whom he had last seen as a handsome slaveboy, or in a clump of gnarled plane trees planted by his own hand in his youth, he found marks of decay everywhere. Even the world itself, it seemed to Seneca, was faced with ruin. His imaginings were haunted by the threat of a universal apocalypse. The end, when it arrived, would come from the sea: 'From the West the waves will roll in, and from the East. A single day will suffice to entomb the human race. All venerable things that have been preserved by fortune's favour and exalted by it, everything that is noble and beautiful, every great throne, every great people — all will be swallowed up.'[55]

Destruction, though, might be creative. This was what Nero had come to believe. No bad thing, in his opinion, for a world grown smoky and dull to be washed clean. Better a new beginning than a living death. The same crowds who had rioted in favour of the dull and sober Octavia would never, had they succeeded in their aims, have come to enjoy the spectacle of Poppaea as Caesar's wife. Proclaimed Augusta by a besotted Nero only a few months after their marriage, she blazed and glittered as neither Livia nor Agrippina had ever dared to do. Her mules were shod with gold; she bathed in ass's milk to preserve her perfect complexion; she gave her name to entire brands of beauty treatment. 'I hope I die before I get old'[56] – this prayer of Poppaea's, uttered after catching herself at an unfavourable angle in a mirror, summed up everything that her husband most adored about her. It spoke to one of his profoundest convictions: that it was only shallow people who did not judge by appearances. Spectacle, illusion, drama: these were the dimensions of rule that truly mattered. Attentive though Nero might be to the grind of business, his true obsession was with a project that he felt to be altogether worthier of his time and talents: to fashion reality anew.

In the summer of 64, he duly set himself to transforming his capital into a setting worthy of his hopes and ambitions for it. Rome's public places became the venue for a series of spectacular banquets. 'It was as though the entire city were now to serve as Nero's palace.'[57] Most extravagant of all was a party hosted by Tigellinus beside a lake on the Campus Martius. As he had done at the games held on the opposite side of the Tiber four years before, Nero gorged himself on a raft luxuriously outfitted with soft purple rugs and cushions. Boats adorned with ivory and gold towed him across waters filled with exotic sea beasts. The oarsmen, grouped according to age and specialisation, constituted the cream of Rome's male prostitutes. Meanwhile, on the banks of the lake, the Roman people flocked to a sensational array of entertainments. The clamour for these was hardly surprising. Food

and drink were provided indiscriminately, while on the quays stood brothels staffed by the most remarkable array of whores in the history of Rome. There were slaves and free; professionals and virgins; the dregs of the slums and the wives of eminent senators – and none was permitted to refuse a client who wished to sleep with her. It was, for the crowds who flocked to use them, a dream come true: a magical fusion of the pleasures of the street with those of the palace.

Nero, familiar with both, had recognised a profound truth about the Roman people: that in their fascination with the shocking and illicit there lurked opportunity as well as menace. Scandal was corrosive to the authority of a natural showman only if there were an attempt to cover it up. Flaunt it, revel in it, rub the noses of the dull, the dreary and the unfashionable in it, and the authority natural to a Caesar would grow only the more brilliant. A few days after Tigellinus's great banquet, Nero was ready to put this thesis to an even more extravagant test. Like one of the *Galli*, he had himself painted and dressed as a woman, and then, amid a blaze of wedding torches, married to one of his freedmen. Far from veiling a ceremony that could not have been more perfectly calculated to outrage conservative opinion, he staged it in public – 'even the part that night hides when the bride is a woman'.[58] It was all a sham, of course. That Nero meant nothing serious by it was precisely the point. Even his veneration of the Syrian Goddess was not what it had been. Time would see him urinate on her statue. As a comet glowed eerily in the skies above Rome, and those appalled by their ruler's antics dreaded the worst, those with a keener understanding of fashion could not help but revel in the world of fantasy that Nero had conjured into being. It was one in which anything had come to seem possible.

And so it proved. On the evening of 18 July, two days after the comet had finally faded from sight, and as a full moon gleamed bright in the sky, fire broke out in Rome.[59] It began at the southern end of the Circus, in shops packed with flammable materials, and in next

to no time was raging out of control along the entire length of the valley. Soon it was spreading at terrifying speed through the cramped wooden tenements of quarter after quarter, and racing up the slopes of Rome's hills. The *Vigiles* proved powerless to stop it. Panic swept the city. Many rallied to the support of their neighbours, helping those who were disabled to escape the onslaught of the flames; but others, roaming the streets in gangs, set to looting abandoned homes and to torching areas that were not yet on fire. Who these vandals were, no one could be certain, for rumour spread as wild through the city in its agony as the savage flames themselves. Crowds of refugees, smoke-blackened and homeless, took refuge where they could; and Nero, who had been away in Antium when the fire began, but had come hurrying back to take charge of the disaster, opened up both the public buildings on the Campus and his own private estates. Meanwhile, as shanty towns sprouted amid marble and flowerbeds, the silhouette of the city behind them was topped across its expanse by a towering tsunami of flame. Only after six days, and a frantic labour of demolition to create a firebreak, was it finally stopped. Even then, the nightmare was not over. Fire broke out a second time, raging for a further three days before once again being extinguished – this time, as it proved, for good.

The devastation had left anything between a quarter and a third of the world's capital as smoking rubble.[60] Nero, anxious to know the worst, and also to prevent the looting of such valuables as had survived, forbade anyone to return to the districts scorched by the fire until his own work-gangs had sifted the rubble. The reports brought back by the Emperor's surveyors could hardly have been more grim. Many of the city's most celebrated landmarks lay in ruins. From temples founded by Romulus and Servius Tullius to Nero's own great wooden amphitheatre, buildings from every era of Rome's history had been reduced to ashes. Irreplaceable trophies and treasures, priceless memorials to her past, were lost for ever. So too,

more pressingly for the homeless, was an immense proportion of the city's housing stock. Hundreds of thousands of people had been left without either belongings or shelter. The mood, not surprisingly, was as angry as it was desperate. That a fire so calamitous and extensive could have been the result merely of accident seemed to defy all probability. People had not forgotten seeing gangs of mysterious hooded figures flitting amid the smoke and flames, brandishing torches. Who had they been? Feverishly, both in what survived of the city and in the immense expanse of tents and ramshackle hovels that now covered both the Campus and Nero's private gardens, the question was asked and debated. Rome's suffering citizens were sure of only one thing: that the arsonists, once they were identified, deserved to suffer a fate as monstrous and terrible as their crime.

All of which played to Nero's strengths. Who better to devise a theatrical display of retribution than the man who had attempted to drown his own mother with a booby-trapped yacht? Sure enough, once the guilty had been successfully identified and arrested, they were subjected to deaths as grotesque as they were excruciating. Some, for the entertainment of spectators, were torn to pieces by hunting dogs; others were crucified in ways calculated to make them look ridiculous. The need to mock the arsonists as well as to punish them was a pressing one – for otherwise they would have risked haunting the imaginings of the Roman people. The culprits turned out to be the embodiment of everything that decent citizens had always most feared about immigration: the adherents of a sinister, not to say sociopathic, cult. 'Christians', they were called, after their founder, a criminal who had been executed in Judaea back in the days of Tiberius. Worse even than the Jews – whose teachings were at least ancient ones – they were motivated by 'a hatred for the norms of human society':[61] contempt for the gods, and scorn for all those not in their sect. Who could doubt, gazing at the smoking ruins of Rome, that they were the very embodiment of the enemy within? Now,

though, thanks to Caesar's tireless efforts, they had been identified, and all was well. Nero, ever the showman, devised a particularly brilliant reassurance of this to his fellow citizens. Not all the Christians were hunted like wild beasts or nailed to crosses. Some, smeared with pitch and set alight, served as human torches: a punishment to fit their crime.* Erected in the Emperor's private gardens, they illumined the flowers and grottoes which Nero had invited the Roman people to come and explore. Nero himself, dressed as a charioteer, wandered affably among them, mingling with the crowds: the very model of a responsible and popular Princeps. The message was clear. Fire had been tamed, and a menacing superstition with it. The future, thanks to Caesar's stewardship of it, was radiant. Where before there had been darkness, now all was light.

And already, barely the moment the rubble had cooled, this was becoming manifest across the blackened and traumatised capital. Nero had exciting plans for Rome. A city notorious for the cramped and twisting alleyways of its slums, in which teetering, wooden highrises had always cast entire neighbourhoods into permanent shadow, was to receive a comprehensive upgrade. As no one had been in a position to do for centuries, Nero aimed to redraw the map. There was to be no place for ugliness, cheapness and squalor in his capital. Boulevards that were broad and spacious; apartment blocks that did not reach for the sky, but were instead built on a human scale; streetfronts built of stone and adorned with colonnades: these were his prescriptions for a Rome renewed. Even as workmen grateful to be rescued from destitution laboured to clear up the rubble and dump it in the marshes beyond Ostia, Nero was busy with his architects, poring over plans. There was no time to lose. With incentives on offer to those who completed their projects of rebuilding fast, a city brought utterly low was soon being raised back to its feet. Seventeen

* According to St Jerome, the total number of Christians martyred by Nero was 979.

years earlier, in the Saepta, Claudius had exhibited what was claimed to be a phoenix: a miraculous bird that, every 540 years, would incinerate itself in a mighty bonfire and then emerge from the flames reborn. The display had not been a success. 'No one doubted that it was a fake.'[62] What Nero was sponsoring, though, was far from a fraud. Rome had been consumed by fire; now, amid a mighty shimmering of golden plumage, she was coming back to life. A phoenix, beautiful and splendid, was emerging from the ashes.

Nowhere was this more dazzlingly evident than in the valley between the Palatine and a pair of hills to its east, the Caelian and the Oppian. Here, the damage had been particularly devastating. Fire had incinerated everything in its path, including a palatial development of Nero's and a half-built temple to Claudius. Even the Palatine had been swept by the inferno. Flames had lapped at the temple of Apollo itself. Buildings dating back to the time of the kings were gone, and all the venerable houses of the aristocracy that still, a century after the Republic's collapse, had lined the road that led from the Forum and served as a memorial to the power of Rome's ancient families. In disaster, though, lay opportunity. The fire had left free for development the primest real estate in the world. It was hardly in Nero's nature to let such an opportunity go to waste. Ambitious though his plans were for his fellow citizens, they were not as ambitious as his plans for himself. How could an artist of his vision possibly be expected to confine his living quarters to the Palatine? It was far too cramped, too stuffy. Extend his house to the bounds of the Caelian and the Oppian, though, and at last Nero would be able to live as a man properly should. Like Apollo, whose genius for poetry and music he was so touched by, and like the sun, whose proficiency at driving a chariot he had been emulating for many years, he merited a home appropriate to his infinite talents. He deserved a house that would induce gasps of wonder from the Roman people, and dazzle them with its blaze: a Golden House.

So that was what Nero commissioned. His two architects were justly celebrated, engineers famous for their ability to work with rough terrain and turn it to their advantage; his chief painter, a man so conscious of his dignity that he only ever did his decorations in full toga. Men like these, rising to the challenge set them by Caesar, proved fully equal to his hopes. The Golden House, as they sketched it out for Nero in their plans, was to offer the Roman people nothing less than a vision of what it meant to rule the world. Naturally, the complex would consist of exquisite living quarters, imposing façades and great works of art – that much went without saying. More than that, though, planted in the heart of the largest city ever known, they planned to build something utterly unexpected: a beautiful park. It was to feature a great lake, with buildings set around it to represent cities; tilled fields and vineyards; woods and pastureland. Animals both wild and domesticated were to roam it. Not just a palace, it offered infinitely more. It was to be a portrayal of all the lands and seas that lay under the sway of Caesar.

The world ruled by Rome was to be brought to the very heart of Rome.

Gilding the Darkness

In May 64, three months before the firestorm that engulfed Rome, Nero travelled to Naples. Although he had never needed any excuse to visit the city, his purpose on this occasion was a specific one. Five years after the party held to mark the first shaving of his beard, Nero had decided to go public with his talent for the lyre. Where better to make his debut than in Italy's most celebrated Greek city? Sophisticated and cosmopolitan, Naples promised just the kind of audience that Nero wanted. He knew that traditionalists in Rome were bound to fume. Indeed, that was all part of the fun. The spectacle on offer

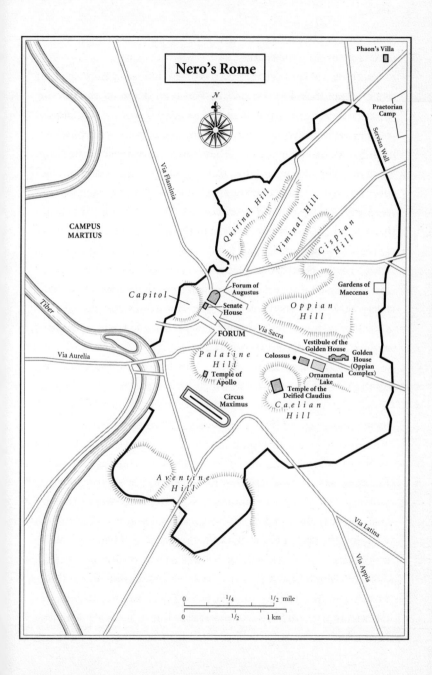

was not merely innovative, after all, but positively *avant garde*: 'an emperor treading the boards'.[63]

Nothing was left to chance. Nero's preparations for the great event were meticulous. For months, he had been doing all the obvious things that a singer could do to strengthen his voice: giving himself regular enemas, lying on his back with a lead weight on his chest, eating nothing for days at a time but chives soaked in oil. He had even brought along a claque of five thousand cheerleaders, and ordered his guards to swell the audience so that there would be no chance of empty seats. He need not have worried. The shows were a sell-out. It was not only locals who flocked to the theatre, but fans from out of town as well. Among them were a posse of visiting Alexandrians, whose rhythmic style of applause so delighted Nero that he ordered his own personal cheerleaders to learn from them how it was done. Every inch the personable superstar, he would mingle with his audience after each show, bantering with them in Greek and dining in public. It was all a great success.

Except that one night, during the run of Nero's shows, an earthquake hit the theatre in which he was performing and badly damaged it. Nero himself, pointing to the fact that no one had died, hailed it as a sign of divine approval, and promptly wrote a poem announcing as much. Others were not so sure. To those appalled by Nero's flouting of traditional sensibilities, it seemed as though the foundations of everything that had made Rome great were being violently shaken. Put to the torch as well – for the inferno later that summer was on a scale so patently calamitous as to suggest a fateful disorder in the affairs of gods and men. Although, in the immediate wake of the fire, Nero made efforts to appease the heavens with supplications as showy as he could possibly make them, neither they nor the execution of the sinister and patently seditious Christians prevented whisperings against Caesar himself. No matter how energetic he might show himself in tackling the aftermath

of the catastrophe, and no matter how glittering his plans for the reborn city, he could do little to alleviate the immediate misery of people who had lost everything to the fire. Even as the months passed, and the rubble was cleared away, anger continued to fester. Many citizens, nostalgic for the cramped quarters which on Nero's orders were being replaced with sweeping boulevards and low-rise accommodation, complained that in the new city there would be no escaping the sun. Others, even more agonisingly, had to watch as surveyors mapped out the lineaments of lakes and fields over what only a short while before had been their homes. 'An overweening estate has robbed the poor of their dwellings.'[64]

And not only the poor. Senators too had lost properties to the Golden House. Even those whose real estate had not been appropriated knew that Nero, by planting a park in the middle of the city, was placing his foot directly on the corpse of their prestige. For a century and more, the shade of a garden perfumed with exotic blooms had been the ultimate badge of status in Rome. From Maecenas to Messalina, the elite of the city had hankered after them with slack-jawed longing. Now, though, the game was up. Ringed as it was by hills, the sprawling parkland of the Golden House offered to the gaze of everyone in Rome a glimpse of the pavilions and lawns that previously had been the prerogatives of the super-rich. To the poor, at least, it offered a feel of fresh breezes, a break from the monotony of smoke and brick; to senators only a confirmation that they were as nothing compared to Caesar. 'There stands in the city now only the single house.'[65]

That the familiar sights of central Rome should have been lost to countryside bore witness to what senators found most disorienting about Nero: his ability to dissolve the boundaries of everything that they had always taken for granted. To many it seemed an unnerving power, for it hinted at something more than human. Nero himself, it was true, hardly seemed sprung from a dimension of the

supernatural. Bull-necked and podgy, he had never quite lost his baby fat. The image of Caesar, though, was not bound by flesh and blood. Nero, who had transformed a yacht into a death-trap, and the Campus into a brothel, knew how to play tricks with people's expectations. In the workshop of Zenodorus, the world's most famous sculptor, a head almost four metres high was being fashioned out of bronze.[66] Designed to top an immense statue that, when completed, would stand guard over the entrance to the Golden House, it portrayed that golden charioteer of the heavens, the Sun. There was, though, in the contours of the god's face, more than a suggestion of a second charioteer. The Colossus, as the bronze would come to be known, 'was designed to resemble the Princeps'.[67] When completed, the statue was to be crowned by the rays of the sun and portrayed as the guardian of the world. Visible from across the city, it would hint at a status for Nero verging on the divine.

Yet if his face, seen from a certain angle, seemed ablaze with the eeriness of someone more than human, then so also, seen from another, did it seem shadowed by the savagery of a beast. Of the many strange sex games with which Nero was reported to have indulged himself, none was more unsettling than one which had combined a simulation of criminals being torn to pieces with the nauseating practice of oral sex. Men and women – or boys and girls, according to some reports – had supposedly been bound to stakes; Nero, dressed in the skins of a wild animal, had then been released from a cage and pretended to gnaw at their private parts.[68] Scandalous on every level, as his floor-shows were invariably devised to be, the performance had made sinister play with the origins of the Roman people – whose city, as everyone knew, had been founded by a wolf-suckled king. Now, with much of Rome in ruins, it was as though Nero intended to found it anew. It was even claimed that he wished to rename it after himself: 'Neropolis'[69] True or not, such rumours had wide currency. Of a man whose face, seen from a certain angle, might seem that of a

god, and from another that of a werewolf, almost anything could be
believed. And so it was, in the months that followed the catastrophe
of the fire, that a claim was first heard in elite circles so stupefying,
so utterly monstrous, that to countenance it was to cast Nero as a
criminal without parallel in the history of his city: that he, the heir of
Augustus and First Citizen of his people, was the very man who had
burned Rome down.

The surest evidence for this appalling charge was, of course, the
use to which he had put the calamity; but it was noted as well that
the fire, when it began again the second time, had originated on an
estate owned by Tigellinus. Flamboyant and murderous, Nero cer-
tainly had form when it came to crimes on a mythical scale. What
was a spot of arson, after all, to a self-confessed matricide? Just as
the guilt he had shown at his mother's murder was as theatrical as
it was self-indulgent, so in a similar manner, it was claimed, he had
been inspired by the spectacle of Rome burning to play on his lyre
and sing of the fall of Troy. Quite where Nero was supposed to have
given this performance was much disputed. Some said in his palace,
others on its roof, others yet on the tower in Maecenas's gardens. The
precise details, to those convinced of his culpability, were unimport-
ant. Rumour, as ever in Rome, had a habit of fuelling itself. That
the moon had been full in the sky on the night of the conflagration,
rendering it most unsuited to a project of arson; that Nero had
thrown himself into the task of fighting the blaze with energy and
commitment; that the costs of repairing the damage were crippling:
none of these considerations served to extinguish the talk of his
guilt.* Instead, just as the fire itself had done, it spread furiously, and

* All the ancient historians of antiquity whose work has survived take Nero's guilt for
granted, with the telling exception of Tacitus. 'Whether the disaster was the result of
accident or the criminality of the Princeps,' he tells us, 'is uncertain. There are histori-
ans who back both points of view.' The same is true today – although with a substantial
majority of historians inclined to exonerate Nero. The verdict I would deliver is one
of 'not proven' – which is, under the circumstances, more than damning enough.

it spread fast – and soon enough, come the New Year, it was starting to lick at the foundations of Nero's regime.

'Murderer of mother and wife, a driver of chariots, a performer on the public stage, an arsonist.'[70] The list of charges was long. Few in the upper echelons of Roman society doubted that Nero, if permitted to live, would add to it. To kill a Caesar was, of course, a fearsome thing; but by early 65, enough were convinced of its necessity to start plotting Nero's liquidation. Large numbers of senators and equestrians were recruited to the conspiracy; so too, no less crucially, assorted Praetorians. Most senior of all the officers to join it was Faenius Rufus, who, on the death of Burrus, had been appointed prefect alongside Tigellinus, and whose reputation for honesty was as impressive as his colleague's was shameful. The presence of such a man in the ranks of the plotters helped to boost numbers, steady the waverers, and give to the conspiracy a broader base than any since that against Julius Caesar, more than a century before. Not that the conspirators had any intention of restoring the Republic. Thrasea Paetus, the man who more than any other had come to serve as the conscience of the Senate, and who sedulously marked the birthdays of Brutus and Cassius, was not invited to join the plot. Instead, the intention was to replace Nero with a new Caesar. Almost half a century after the disgrace and suicide of Gnaeus Calpurnius Piso, it was a scion of the same illustrious family whom the conspirators had fixed upon to serve as their figurehead. Gaius Calpurnius Piso combined a distinguished career of public service with an easy and ready charm: men could imagine him as emperor and not shudder at the prospect. True, he lacked even the vaguest link to the August Family; but that could be overcome. Octavia had not been the only daughter born to Claudius. There was a second, still alive, and in her thirties: Antonia. It was agreed among the conspirators that Piso should divorce his wife and marry her. The link that this would establish to Augustus, although tenuous, would be sufficient – it was hoped – to satisfy the Roman

people. Piso's own talent for popularity could then be relied upon to
do the rest. Even Seneca, torn between residual loyalty to Nero and
horror at what his pupil had become, was prepared to countenance
the prospect of a new Caesar. Some among the conspirators went
so far as to hope that he might end up emperor himself. Although
the ailing philosopher, now in semi-retirement, refused to receive
Piso in person, he did not betray the pretender when sounded out.
Instead, he temporised. 'Let him know,' he told Piso's emissary with
pointed ambivalence, 'that my own security is bound up with his
well-being.'[71]

Visions of a universal cataclysm continued to haunt the old man.
In his nightmares, he could imagine the sky turning to black, and
the whole world lost to darkness. There was, though, in the con-
templation of utter calamity, a kind of liberation. When the worst
came to the worst, submission could no longer be an option. 'No
man is more unhappy than he who never faces adversity. For he is
not permitted to prove himself.'[72] Time was when the leading men
of the Senate would have demonstrated the truth of this maxim on
the line of battle, serving the greatness of their city amid viscera and
swarms of thirsty flies, or else perishing in the attempt; but those days
were gone. Now, the field of courage open to Rome's most eminent
citizens was shrunken and diminished. Not, though, the qualities
required to take up position on it. 'No matter how it manifests itself,
the measure and value of *virtus* never change.'[73] The courage required
to strike at Nero in the Circus, in the full view of the Roman people,
as the conspirators planned to do, was a fearsome thing. When it had
been suggested to Piso that he invite his victim to Baiae, to the luxuri-
ous villa that he owned there, and commit the deed in private, he had
refused in tones of contempt. It had to be public, or not done at all.
Unless Nero's blood were spilled in the capital, it would never serve
to wash clean his crimes. So it was that Flavius Scaevinus, the senator
who had laid claim to the honour of striking the first blow, did not

trust to his own dagger, but removed one from a temple. The murder was to be nothing squalid. Rather, it was to be a sacrifice.

Yet to live in hope, as Seneca knew, was to live as well with the prospect of failure. 'Those who do so find that the immediate future is forever slipping their grasp, and that desperation then steals in, and the dread of death, that curse which renders everything else a bane.'[74] And so it proved. When news was finally brought to Seneca, waiting anxiously on his estate, of how the conspiracy had fared, it could not have been worse. A freedman in the household of Scaevinus, his suspicions roused after being asked to sharpen his master's dagger, had betrayed the plot. Piso, despite being urged by his backers to launch a coup, had reflected in despair on Nero's popularity with the Roman people, and killed himself. Arrests had been made across the city. Line after line of shackled suspects had been put on trial. Informers had been marshalled, confessions taken, the guilty put to death. 'The origins, progress and suppression of the conspiracy had been fully documented.'[75] There was nowhere left to hide. When Seneca, returning to Rome from Campania, was stopped four miles outside the city by a Praetorian officer and asked to explain the message he had sent to Piso, he knew that nothing he could say, no denials or protestations of innocence, were liable to save him. All his life he had been obsessed by death. The ability to stare it in the face – and if needs be to welcome it – had always been for him the measure of a man. Now at last the moment of his own trial had come. Seneca prepared himself to pass it.

Official confirmation from Nero that he was indeed to kill himself arrived at his villa borne by a squad of Praetorians. His suicide, in the event, was to prove protracted and agonising. First he cut his wrists, then his ankles, and finally behind his knees; but not enough blood would flow. A cup of hemlock, prepared for just such an eventuality, failed in its work as well. Only when Seneca was taken into his bath-house and placed by his slaves in steaming water did he at last

feel his life ebb away. He died as he had lived, a philosopher. In his last moments, though, even as he dictated edifying precepts to his attendant secretaries, he could not help but linger on the supreme, the scarring failure of his life. Just before slitting his wrists, Seneca had formally accused his erstwhile pupil of the crimes that he had been obliged for so long to whitewash. 'After Nero had murdered his mother and brother, what remained for him save to kill his teacher and mentor?'[76] These words, as the dying man had known they would be, were widely bruited, a prosecution from beyond the grave. Nero himself, for all the delight that he reportedly took in the news of Seneca's suicide, could hardly help but be stung. First his mother, now his tutor: both had perished with condemnations of him as a monster on their lips.

Ever since his adoption by Claudius, Nero's longing to bask in the cheers of the Roman people had been at war with his sense of paranoia. It was in the struggle to balance these instincts that he had repeatedly sacrificed those who were closest to him. Now, though, with the revelation of Piso's plot, the full scale of his unpopularity with the Roman elite had been starkly exposed. A stone had been lifted, and hatreds rendered visible to Nero's gaze that seemed to him as contemptible as the scurrying and writhing of a multitude of creeping things. That the Senate had turned out to be consumed by its hatred of him came as no great surprise, for Nero had delighted in scandalising it and scorning its ideals. Altogether more of a shock had been his discovery of treason in the camp of the Praetorians. Faenius Rufus, their prefect, had played a desperate double game, torturing and executing his fellow conspirators even as he sought to tip them the wink whenever no one else was watching; but that particular game had been brought to an end when his cover was blown by an indignant Scaevinus. Other officers, though, rather than conceal their role in the conspiracy, had gloried in it. Why, Nero demanded of one, had he broken his oath of loyalty? 'Because,' the centurion

replied, 'there was no other way to redeem you from your crimes.'[77] Most, though – so Nero had to reckon – were less fastidious in their morals. Accordingly, in the wake of the conspiracy's suppression, and the execution of the various officers who had proven themselves treacherous, he made sure to throw money at the problem. Massive bonuses, fresh privileges: nothing was too good for the Praetorians. As for prefects, Nero had wearied of men with scruples. Tigellinus's new colleague was a man with a reputation as evil as his own. Nymphidius Sabinus was a tall, grim-faced man, the grandson of Claudius's potent freedman, Callistus. His mother was rumoured to have worked as a whore in the slave quarters on the Palatine. His father, so the rumour had it, was Caligula.

Well might the Senate cower. Nero's boredom with its pretensions, long self-evident, had now patently metastasised. The promotion of Nymphidius, the awarding to Tigellinus of a statue both on the Palatine and in the Forum, the lavishing of honours on henchmen who had helped to secure convictions during the treason trials: all proclaimed it loudly. It was not only Nero's suspicion of the nobility, however, that had been confirmed for him by the exposure of Piso's conspiracy. So too had his need to be loved. Sure enough, barely had the blood of the executed conspirators dried than Nero was readying himself to fulfil at long last a much-cherished ambition and perform on the ultimate public stage: Rome itself.

The background to the occasion was sombre. Plague had struck the city. The streets echoed to mourning and were filled with funeral fires. The crowds, as they filled the theatre, were in a mood to have their spirits raised. Nero duly obliged. To the horror of watching senators, but the delight of his adoring fans, Caesar appeared on stage and recited a poem. He then left the theatre; but the assembled crowds, stamping and applauding, demanded his return, urging him to 'make a public show of all his various talents'.[78] Aulus Vitellius, skilled in the stage-management of such things, promptly hurried

after his master. Declaring himself the spokesman of the people, he announced that it was their universal desire to see Caesar enter the contest for best musician. Coyly, Nero allowed his arm to be twisted. Changing into the long flowing robe and platform heels of a *citharode*, he returned to the stage, lyre this time in his hands. His fingers brushed the strings; he cleared his throat; he began to sing. Not even the sweat that was soon pouring down his face could bring him to pause. Only when he was finally done with his performance did he sink to his knees and soak up the ecstatic applause. The verdict of the judges, when it was announced, came as no great surprise. Nero, awarded the palm of victory, had the grace to look relieved; but the true prize was to be heard in the cheering of the crowds. Rhythmic and measured, it echoed to the Roman sky. Nero, as he soaked it up, was able to know himself truly adored.

Which was just as well – for the memory was one that he would soon have all the more reason to cherish. Profoundly though he craved the devotion of the Roman people, there could be no doubting the true love of his life. As glamorous, fashionable and unfeasibly sexy as ever, Poppaea Sabina was now doubly precious to Nero – for she was pregnant too. Already, a couple of years earlier, she had borne her husband a daughter; although the baby had died young, there could be no doubting her ability to give him an heir. It was, then, doubly a calamity when Nero added to the long list of people whose lives he had brought to an end the one that he could least bear to lose. He had never meant to kill Poppaea. It had been foolish of her to nag him, of course, especially when all he had done was to come home late one evening from the races. He had been tired, and pretty much bound to lash out; but even so, he should never have kicked her in her swollen stomach.

Nero's grief, suffused as it was with guilt, was of a suitably titanic order. At Poppaea's funeral, he incinerated an entire year's supply of perfume – and then burned some more, just for good measure.

Rather than watch the body of his beloved turn to ashes, he chose, like a pharaoh of old, to embalm it, before consigning it to the Mausoleum of Augustus. Poppaea herself was declared a goddess, and money extorted from the leading women of Rome to build her a temple. No longer the wife who had died in squalid and miserable circumstances, her swollen belly livid with bruising, she reigned instead eternal in the heavens, the presiding deity of beauty and desire: 'Venus Sabina'.[79]

It was all very Nero. Those who had come to dread and detest him could hardly help but recognise in Poppaea's unhappy fate something of Rome's own. A city too, after all, might be abused, and pummelled, and kicked. Poppaea's death, coming as it did so soon after the suppression of Piso's conspiracy, had done nothing to calm Nero's nerves. 'No matter how many people you put to death,' Seneca had told him in the wake of Agrippina's murder, 'you can never kill your successor.'[80] The warning was one to which Nero, at the time, had been content to pay lip-service; but not now that he had lost his unborn child. With no one of his own blood now to succeed him, his dread of potential rivals had become even greater. He and his mother between them had already done much winnowing, and there remained, with the exception of Nero himself, only a single male descendant of Augustus left alive. Lucius Junius Silanus was young, but he was not naïve. When a posse of soldiers arrived in the remote Italian town to which he had been exiled, he resisted arrest. The attempt was doomed. Strong though he was, he had no sword. The centurion in charge of the death squad cut him down. Other eminent victims soon followed. Some, like Thrasea Paetus, were old enemies of an emperor no longer prepared to tolerate so much as a hint of opposition. Others were men altogether too seasoned in the command of legions for Nero's comfort. Others yet were men famous for their wealth. A year on from the judicial killings that had followed Piso's conspiracy, and

it seemed to Rome's elite that the entire nobility was drowning in a superfluity of blood.

Yet the perfumes that Nero had burned in Poppaea's honour and the spices with which he had packed her corpse were reminders that what he could brutalise he could also beautify. The money plundered from senators executed for treason did not just sit in his coffers. Nor did the ever heavier taxes that he had begun to impose on the provinces, nor the income from the fertile estates of Africa that he had moved to appropriate from their owners, nor the treasures that his agents were looting from temples across the entire span of the Roman world. Desperately expensive though it was to rebuild a city as vast as Rome, Nero was hardly the man to stint on the repairs. He had no option but to extract money from whatever source he could – for to economise was unthinkable.

Any lead was worth following up. When an equestrian from Carthage reported a sensational dream, in which he had been shown a great cache of bullion buried under his fields, left there a millennium before by the founder of his city and waiting to be discovered, Nero had dispatched an entire squadron of treasure-hunters to recover it. That a long and increasingly frantic excavation had turned up nothing, and that the Carthaginian himself, mortified in the extreme, had ended up killing himself, was an embarrassment, to be sure; but not a terminal one. Nero remained true to what he saw as his highest responsibility: to delight his fellow citizens. In the early summer of 66, the long-anticipated arrival in Rome of Tiridates, who had at last travelled from Armenia to receive his crown, provided a perfect opportunity to dazzle the Roman people – literally. On the day of the ceremony itself, the sun rose over a Forum crowded with citizens dressed in togas of blinding whiteness, and lined by Praetorians whose armour and standards 'flashed like shafts of lightning'.[81] Once the coronation had been completed, it was staged a second time in the Theatre of Pompey, where the stage, the walls and even the props

had been gilded to extravagant effect. There, beneath a rich purple awning which portrayed Nero as a celestial charioteer surrounded by golden stars, Tiridates paid him obeisance. No one could doubt, looking at the king in his barbarous robes prostrating himself before Caesar, that the far ends of the world had come in submission to its centre. It was indeed, as everyone said, 'a golden day'.[82]

What did it matter that shanty towns filled with those made homeless by the fire continued to dot the city's outskirts, or that in close rooms heavy with the sweat of desperation there was no pro- roguing the treason trials just because the king of Armenia was in town? And later, when Tiridates had gone back home, the gold had been stripped from Pompey's theatre and the rose petals swept up from the Forum, still there was no diminution in the blaze of Nero's glamour. Looming beyond the Forum rose the base of the massive bronze fashioned by Zenodorus, the half-constructed Colossus that, when completed, would brush the stars with the rays of its diadem. Beyond it in turn stretched the lake, the forests and the fields which simulated, in the heart of the capital, all the manifold natural beaut- ies of the world. Meanwhile, gilded and adorned with jewels, the façade of the Golden House extended from the side of the Oppian Hill, and all the summer long seemed lit by fire. It was as though, in the midst of the scorched and nervous city, the Sun himself had built his palace.

Nero could afford to scorn his enemies. For a decade and more he had been straining on the leash, eager to break free from the pre- scriptions of a crabbed and superseded order and to create, as befitted the supreme artist that he was, his own reality. The Senate, wounded and demoralised, appeared powerless to resist him; the people, enrap- tured by his command of fantasy and spectacle, eager to participate in his reconfiguring of what it might mean to be a Roman. There seemed nothing that Nero, if he wished it, could not ultimately bend to his will.

Back to Reality

Early in the autumn of AD 66, a great fleet of ships bearing Caesar and his entourage pulled into the harbour of Corinth.[83] Situated on the narrow isthmus that separated mainland Greece from the Peloponnese to the south, the city was very much Nero's kind of place. Celebrated for its prostitutes and bronzes, it also boasted a famous festival: the Isthmian Games. Every two years, huge crowds would gather outside Corinth to gawp at a variety of sporting and artistic contests. 'All of Asia and Greece come together for these games.'[84] Now, though, a visitor from Italy was planning to make his presence felt at the event. Nero, fresh from his triumphs in Naples and Rome, was ready to take the festival circuit of Greece by storm.

Obedient to his orders, organisers of the most prestigious games had rescheduled their events to ensure that they could all be held in the single year. As a result, the Olympics had been postponed for the first time in their history, while other festivals had been specially brought forward. Nero intended to compete in them all. That done, he aimed to continue eastwards, there to win yet further glory by subduing the barbarians who lurked beyond the Caucasus. Not since Claudius's expedition to Britain had a Caesar left for the provinces; and not since Augustus had toured the eastern Mediterranean and won back the eagles from Parthia had quite such an extended absence from Rome been planned by a ruler of the world. The hype, as Nero headed east, was immense. One astrologer foretold that he would make an island of the Peloponnese by cutting a canal through the Isthmus, a second that he would sit on a golden throne in Jerusalem. The whole of Greece was agog.

Meanwhile, back in Rome, there were plenty who regarded Nero's eastern adventure with disgust. The more exclusive the circles, the greater the sense of outrage tended to be. The contempt was, of course, entirely mutual. To watch Nero's travelling companions

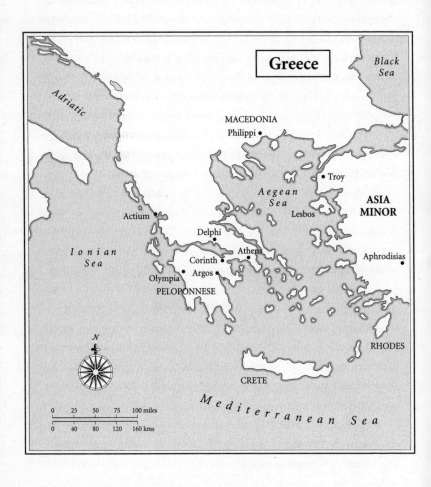

descend the gangplanks onto Corinthian soil was to know that the
Roman elite had been put decisively in the shade. Not since Tiberius's
retirement to Capri had access to Caesar been so humiliatingly barred
to them. Heading down the Appian Way to take ship for Greece,
Nero had been alerted to yet another plot against his life, its exposure
confirming him in a suspicion of the Senate that would have done
credit to Caligula. 'I detest you, Caesar, for being of senatorial rank.'[85]
This joke, often repeated in his presence by a particular henchman
of his, a hobbling one-time cobbler named Vatinius, never failed to
bring a smile to Nero's lips. True, not all senators were banned from
his presence. Looking ahead to the projected campaigning in the
Caucasus, Nero had made sure to bring with him on his travels the
odd seasoned campaigner. Typical was a former consul by the name
of Vespasian. A veteran of the conquest of Britain, his war record had
just about served to compensate for his unfortunate habit of falling
asleep during Nero's recitals. Yet in truth, Vespasian was only of
marginally better stock than Vatinius, and not all his commands and
magistracies could obscure the fact that his grandfather had worked
as a debt collector. For those in the Senate who could still trace their
ancestry back to the heroic beginnings of Rome, it was a profound
humiliation. What was there to choose between a former cobbler
and a peasant who had risen to become a consul? That Vatinius was
a malicious and disreputable parasite and Vespasian a decorated war
hero made barely a difference. Both had the ear of Caesar. The world
was turned upside down.

But there was worse. Soldiers and courtiers were not the only
people in the retinue of Augustus's heir. There were also to be found
in it teeming hordes of musicians, voice coaches and personal train-
ers – for Nero, as a contender in the Olympic or Isthmian Games,
could hardly be expected to function without vast numbers of back-
room staff. In Greece, the home of drama and competitive sport,
the notion that what happened in a theatre or on a race track might

hold up a mirror to the broader world was a familiar one; but never before had anyone thought to blur the boundaries between them to quite such dizzying effect. Nero was not, as most visitors to the province were, a tourist. He had no interest in merely poking around the sights. The Greece that he had come to experience was not the land of art and antiquities, but of still living myth. A games staged in Olympia, or on the Isthmus, or in Argos, where Agamemnon had once reigned, or at Delphi, where Apollo had his most famous shrine, offered communion with the legendary heroes of the past in a way that no corresponding festival in Rome ever could.

It was this that gave to all those who competed in them their glamour; and it was why, despite his status as Caesar, Nero refused to take first place for granted. Without the edge of genuine competition, after all, his victories would be worthless. Hence, just like any other entrant in the games, he was prey to stage-fright, bitched about his rivals behind their backs and lived in dread of the judges. Ruler of the world or no, he could not afford a performance that would make him look a fraud – and everyone knew it. That the judges, at event after event, had little choice but to award him first prize did not diminish the genuine awe felt by many spectators at his feats. The greatest festivals in Greece had all been founded by gods or heroes of royal blood; and now, with the arrival of Caesar to headline at them, the ancient days of song and legend seemed renewed. Across the East, wherever theatres were to be found and sporting contests staged, the glamour of his achievements could hardly help but blaze. Senators in Rome might scoff, but Nero had his eyes fixed, not just on the capital, but on all the lands that he ruled.

In Greece, he could breathe more freely. Visitors to the great festivals there were attuned to his sensibility. Back in Rome, for instance, even Nero had hesitated to perform as an actor. Those who made a show of their bodies before the public gaze, draping themselves in exotic costumes and speaking other people's lines, were regarded

by upstanding citizens as little better than whores. It was this that explained their presence alongside adulterers and gladiators among the class of people defined by the law as *infames*. Disapproval of the theatre was a venerable Roman tradition. Moralists had always condemned it as a threat to 'the qualities of manliness for which the Roman people are renowned'.[86] Actors, it was sternly noted, were inclined to effeminacy. They rarely had due respect for the boundary that existed between male and female. Only strictness could serve to patrol it. An actor who had found it amusing to keep a married woman as a page, her hair cut short to look like a boy's, had been whipped and banished from Rome on the personal instructions of Augustus himself. Those who played others in public threatened subversion at every level. Even the most basic fundamentals risked being undermined. Seneca, watching a play in which a slave played Agamemnon and imperiously threw his weight around, had been prompted to reflect on the illusory nature of rank itself. 'Who is the "Lord of Argos"?' he had mused. 'Why, only a slave!'[87]

No such anxiety, though, was likely to trouble Caesar. That Nero, like so many of the heroes who featured in the repertoire, was descended from a god, and wielded kingly power, gave to his appearance on the stage a quite exceptional heft. Acting came naturally to him. Back in the first days of his rule, addressing the Senate, he had delivered a speech composed for him by Seneca and been roundly mocked for it behind his back: 'for those with long memories noted that he was the first emperor to rely on borrowed eloquence'.[88] Even then, though, Nero had penetrated to the heart of what it meant to be a Princeps. To rule as Caesar was to play a part. The performance was all. Now, arrived in Greece, Nero's aim was to make this apparent to the entire world. Taking to the stage, sometimes his mask would be painted to look like the hero he was playing, sometimes to look like himself. No one could mistake the point that was being made. The events of Nero's life, its many trials and tribulations, were as worthy

a subject of drama as anything conjured up from myth. To watch him star as Orestes was to know that the murder of Clytaemnestra had been rivalled by a second, no less terrible act of matricide. When he played the part of a woman giving birth, who could not reflect on the tragedy that had seen him lose his heir? When he wore a mask fashioned after the features of Poppaea, who could not be reminded of the homicidal fits of madness sent by the gods upon many an ancient hero, and pity Nero likewise? It was a bravura act. Vision, audacity, conceit: his performance boasted them all. Only Nero could have attempted it; only Nero could have pulled it off to such stunning effect.

Resurrecting Poppaea on the stage was only a beginning, though. Beyond the theatre too, Nero aimed to bend reality to his will. His sense of bereavement remained unassuaged. In the wake of Poppaea's death, he had briefly considered marrying Antonia, the only surviving child of Claudius; but when she, not surprisingly, had shown herself reluctant to wed her sister's killer, he had opted instead to have her put to death for treason. Tellingly, his choice of a new wife had been a woman very like Poppaea. Statilia Messalina, lately married to a consul executed in the wake of Piso's conspiracy, was stylish, beautiful and clever. Nevertheless, not even the fascination she shared with Nero for training and strengthening her voice could compensate, in her new husband's opinion, for her one abiding drawback: she was not Poppaea.[89] This was why, just as Nero had once delighted in sleeping with a whore who looked like his mother, he had ordered a hunt to be made for a *doppelgänger* of the wife he had kicked to death. Sure enough, a woman with a close resemblance to Poppaea had been located, and delivered to his bed; but he had soon wearied of her. Then someone else had been tracked down: someone soft-skinned, amber-haired, irresistible. To Nero, brought this prize, it was as though his dead wife had been restored to him. So completely did he imagine himself to be gazing on her face again, caressing her

cheeks and taking her in his arms, that Poppaea seemed to him redeemed from the grave. Nevertheless, there was a twist. For all the eeriness of the resemblance, it was not a woman who had been found for Nero – nor even a girl. The lookalike, so perfect as to convince a grieving husband, was not perfect in every detail. The double of Poppaea Sabina, Nero's greatest love, was a boy.

Nothing was more ephemeral than beauty of such a kind. Like the blossoms of spring, it afforded a delight that was all the sweeter for being so fleeting. It was this quality that rendered boys with exquisite looks such luxury items of merchandise. Rather like Lucrine oysters, they were prized highly by those who bought them precisely because they were so quick to go off. A slave-dealer, desperate not to lose value on his merchandise, might use ants' eggs to retard the growth of hair in a boy's armpits, and blood from lambs' testicles to keep his cheeks smooth; an owner, rather than accept that a treasured catamite had hit puberty, might dress him as a girl 'and keep him beardless by smoothing away his hairs, or else plucking them out by the roots'.[90] The grim truth was, though, that there existed only one reliable option for preserving the springtime of a boy's looks; and Nero had duly taken it.

Sporus, he had nicknamed his victim, 'Spunk'. Even when mocking traditional values, Nero remained sufficiently a Roman to find eunuchs a bit of a joke. If not quite as sinister as the *Galli*, whose castration was self-inflicted, boys gelded on the orders of their masters trailed after them the unmistakable perfume of the countercultural. Soft, infertile and indelibly associated with the harems of eastern despots, they could hardly have been less in tune with the stern virtues of Roman manhood – which was, of course, for those with an eye to fashion, precisely the point. Maecenas, while administering Italy during the Actium campaign, had scandalised conservatives by appearing in public with an escort of two eunuchs; Sejanus, confirming moralists in their loathing for him, had owned one called

'Boy Toy', whose record sale-price, even decades later, could still provoke gasps of wonder.[91] Nero, though, as was his invariable habit, had gone just that little bit further in scandalising respectable opinion. Yes, Sporus had been gelded to ensure the preservation of his beauty – but that was not the only reason for castrating him. It was not a eunuch that Nero was interested in taking to bed, after all, but his dead wife. He wanted Poppaea Sabina back.

And so that was the name given to her double. As his instructress in becoming an Augusta, Sporus was assigned a woman of high rank named Calvia Crispinilla, whose qualifications as a wardrobe mistress could hardly have been bettered. Modish and aristocratic, she had also won herself a notorious reputation as 'Nero's instructress in sexual pleasures'.[92] Delivered into Calvia's hands, Sporus was duly arrayed in Poppaea's robes, his hair teased into her favoured style and his face painted with her distinctive range of cosmetics. 'Everything he did, he had to do it as a woman'[93] – and a wife of Caesar's at that. As Nero toured Greece, so Sporus travelled with him, borne in the litter of an Augusta and attended by a bustling train of maids. Only one thing remained to complete the transformation. The nuptials, when they were staged during the course of Nero's sojourn in Greece, positively screamed tradition. The bride, veiled in saffron, was given away by Tigellinus; wild celebrations were held throughout the province; prayers were even raised to the gods that the happy couple would have children. Only one thing prevented the illusion from being complete: the new Poppaea Sabina's lack of a woman's anatomy.

Even that was not for want of trying. Nero, if he could have done, would have excised the maimed remnants of genitals from Sporus altogether, parted the living flesh of the wretched boy's groin and opened up a passageway to an implanted uterus. The blatant impossibility of fulfilling such an ambition did not prevent huge rewards being offered to anyone who might achieve it – whether by surgery, or else by darker means. The cutting of a channel where

before there had been none was precisely the kind of project that had always tickled Nero's fancy. Back in Italy, he had ordered the construction of a canal stretching all the way from Puteoli to the Tiber, a distance of some 150 miles. Then in Greece, rising to the challenge set by the oracles, he had no sooner arrived in Corinth than he was giving orders for a canal to be hacked out through the Isthmus. An engineering project designed to facilitate the flow of trade, it was also something much more. The ceremony which inaugurated the project could hardly have made this more explicit. Emerging from a sumptuous tent, Nero kicked things off by singing a hymn about sea nymphs; then, taking a golden pitchfork, he struck the earth with it three times. Snipping the Peloponnese from mainland Greece, he proudly declared, would be on a par with anything achieved by the heroes of legend. Fantasy and a spectacular infrastructure project; golden pitchforks and gangs of toiling prisoners; songs about sea nymphs and the sweat and strain of cutting through hard rock: it was all inimitably Nero.

But what if reality, rather than submitting to the dictates of his imagination, insisted on defying them? Sporus's groin remained without a vagina; the canal that was supposed to link Puteoli to the Tiber appeared stuck in the Bay of Naples; the excavations at the Isthmus prompted dark warnings behind Nero's back that he was trespassing on the affairs of the gods. Meanwhile, beyond the stadia and theatres of Greece, on distant frontiers and in remote provinces, the affairs of the world did not stay still. Reports from the East were particularly ominous. In Judaea, long-simmering tensions had finally exploded into open revolt. News of a failed attempt to restore order in Jerusalem had been reported to Nero shortly after his arrival in Corinth. Rather than abandon his tour of Greece and head to Judaea himself, he had opted to send the best man ready to hand: Vespasian. Meanwhile, back in Rome, rumours that the Senate was to be abolished, and responsibility for the provinces handed over to equestrians

and Nero's freedman, were doing nothing to steady nerves. Spies, keeping track of potential conspiracies, noted an alarming increase in correspondence between various governors in Gaul and Spain. Prominent among them was Nero's legate in Lugdunum, a senator descended from one of the Gallic royal families, by the name of Gaius Julius Vindex. 'Physically fit and mentally alert, seasoned in war and bold enough not to shrink from a perilous enterprise, he combined a deep love of liberty with immense ambition.'[94] Such qualities, in the death throes of the Republic, might well have marked him out as a contender in the great game of the civil wars; but those days were long gone. No one now could hope to rule the world who was not a descendant of Augustus. Of that much Nero was confident. Nevertheless, when it was reported to him that Vindex had been in communication with Galba, who for eight years had been serving as a governor in Spain, he did feel a slight fluttering of alarm. Seasoned by now in what it took to nip treachery in the bud, he gave orders to his spymasters. Galba was to be eliminated. Then, having issued those instructions, Nero turned his attentions back to a more important matter: his ongoing tour of Greece.

His boldest and most hair-raising feat was achieved, fittingly enough, on the greatest sporting stage of all. Of the many events staged at Olympia, none could compare for sheer peril and excitement with the chariot race. Reaching back to the origins of the games, it was the festival's ultimate showcase for skill and courage. Nero, by entering it, was taking his life in his hands – and all the more so because, rather than the normal complement of four horses, he intended to race with a team of ten. It was the god-like thing to do, of course; but it also required extremes of practice that no one distracted by the care of the Roman world could possibly have attained. Unsurprisingly, then, amid the dust, the collisions and the hairpin bends, Nero was thrown. Watching as he lay on the baked dirt of the race track, curled up against the lethal passage of the other chariots,

inches from being crushed to death, no one would have blamed him for retiring from the contest. But he was Caesar, and made of sterner stuff. Dazed and bruised, Nero insisted on clambering back into his vehicle and renewing the contest. Although it proved beyond him to complete the race, the crowds still rose to applaud him. The judges awarded him first prize.

The seal was set on a remarkable love affair. For the first time, a Caesar had appealed over the heads of the senatorial elite, not simply to the Roman people, but to those without citizenship, to provincials. On 28 November 67, at a grand ceremony in Corinth, Nero made this official. 'Men of Greece, I bestow on you a gift beyond your wildest expectations.' Their taxes, he informed them, were abolished – a magnificent gesture. 'I grant you this favour out of good will, not pity, and as a mark of gratitude to your gods, whose care for me both by land and sea I have always found so constant.'[95]

Meanwhile, though, across the remainder of the Roman world, there was no let-up in the screwing out of taxes. Even as Judaea burned, provincials elsewhere were being bled white to pay for Nero's rebuilding of Rome and his projected campaigns in the East. In Gaul, in Spain and in Africa, resentment of his agents, 'whose exactions were as criminal as they were cruel and oppressive',[96] was steadily mounting. Whereas in Greece and the provinces to the east Nero's achievements were widely bruited, in Spain mockery of him was widespread, and satires against him openly repeated. Galba, who had intercepted the message sent from Greece that he should be put to death, pointedly made no attempt to suppress them. Still, though, he hesitated to make his opposition to Nero's regime public. Other governors too, terrified of provoking their master's suspicions and mistrustful of each other, likewise preferred to lurk and wait, and see what might happen.

Few had any doubts as to the stakes. For a century, the world had been at peace. No one could remember a time when citizen

had fought with citizen. Nevertheless, memories of the great blood-letting of the civil wars, when the Roman people had almost destroyed themselves, and the world with them, remained vivid. Seneca, in plighting himself to the service of Nero, had reached for language that he knew his young master would particularly appreciate. Only if kept hitched to the chariot of a Caesar, he had declared, would the Roman people be spared calamity: 'for were they to slip the reins, then all their greatness and power would surely be shattered into splinters'.[97] The conceit was not his own. Maimed horses, splintered wheels, corpses lying broken in the dust: again and again, in the world before the rise to supremacy of Augustus, men had glimpsed in these spectacles an image of much greater ruin. What feeling more terrifying for a people, after all, than to know themselves hurtling out of control, and powerless to stop it? 'As when chariots burst out from the barriers, gathering speed with each lap, and the driver, borne along by the horses, tugs upon the reins in vain, and finds the car does not obey them.'[98] Understandably, therefore, those with legions at their backs hesitated to come out in open insurrection; understandably, too, the news of Nero's crash in the Olympic Games, when reported back in Rome, prompted considerable reflection.

In the event, the freedman he had appointed to administer the capital in his absence had to travel to Greece in person, to persuade his master of the scale of the gathering crisis and the desperate need for his return. Spited of the chance to proceed to the Caucasus and play at being a general, Nero was not the man, of course, to let that stop him making a splash. His entry into Rome was as spectacular as any procession ever witnessed in the city. Indeed, in a conscious echo of the triumphs awarded his great-great-grandfather, he rode in the chariot once used by Augustus. Nero, though, was celebrating victories that no Roman had ever won before. He wore on his head the wreath of wild olive that proclaimed him a winner at the Olympic

Games; by his side stood the world's most famous *citharode*, whom he had defeated in open contest. Banners proclaimed Nero's titles, and all the numerous crowns that he had won in Greece were borne before him, for the edification and delight of the Roman people. Meanwhile, along the perfumed procession route, songbirds were released, and ribbons and sweets tossed to the cheering crowds. 'Hail to Nero, our own Apollo!' they cried. 'Augustus! Augustus! O Divine Voice! Blessed are they that hear you!'[99]

No matter the gloomy warnings of his security advisors, Nero could feel confident that he still enjoyed the love of the Roman people. He had always relied upon his incomparable mastery of image to dazzle and confound his enemies, and he had no intention of changing that now. Yet the ultimate test was fast approaching. In Gaul, where Julius Vindex had been biding his time, waiting for the right moment to raise the banner of rebellion, Nero faced an adversary with a mastery of propaganda almost the equal of his own. In March 68, a coin was minted on Vindex's orders which showed two daggers, and a cap of the kind worn by slaves when granted their freedom. It was a pointed illustration. One hundred and eleven years earlier, in the wake of the Ides of March, Brutus had issued a near-identical design; and now it was the Ides of March again.[100] Nero, who had retired to Naples for the spring, received the news of the revolt from Vindex himself. A letter from the rebellious governor reached him on 19 March, the anniversary of his mother's death. The coincidence, once again, was pointed. Vindex had a talent for drawing blood. Not content with addressing Nero as 'Ahenobarbus', he rubbed salt in the wound by deriding the Emperor's ability as a musician. Nero, stung to the quick, could not help but betray his indignation. 'Repeatedly he would corner people, and demand, did they know of anyone who ranked as his equal?'[101]

In general, though, he affected dismissive contempt towards the threat of rebellion. More than a week had passed before he made a

formal response to Vindex's insulting letter, and in that time he had made sure to pursue his customary interests with a perfect show of calmness and indifference. Nero knew what he faced in Vindex. The muscle-bound sense of duty, the parading of martial values, the harping on moral codes bred of an age when the Roman people had subsisted on turnips: it was everything he most despised. In his attempt to reach over the heads of the senatorial elite to the masses who cared nothing for their antique pretensions he had deliberately mocked everything that Vindex represented: and he continued to mock it now. Rather than address the Senate in person, he sent them a letter, explaining that he had a sore throat and needed to save his voice for his singing. When he did invite some prominent senators to a consultation, he spent most of the meeting showing them his plans for a new kind of hydraulic organ, and even promised to play it for them in due course – 'just so long as Vindex does not object'.[102] Nero's sarcasm was bred, not of insouciance, but of the very opposite: determination never to respond to his enemies' propaganda on its own terms. Leaving a drunken banquet one evening, he declared his intention to appear before Vindex's legions unarmed and do nothing but weep; 'and then, after he had persuaded the rebels by that means to change their minds, he would the next day rejoice among his rejoicing subjects, and sing hymns of victory – which, indeed, he ought at that very moment to be composing'.[103]

Behind the scenes, though, Nero was taking the threat to his regime very seriously indeed. Although he could not resist commissioning a wagon train to transport his various props to the front, nor arming his concubines like Amazons and giving them all a military short back and sides, he knew better than to rely on theatricals. So it was that he summoned the expeditionary force he had readied for the Caucasus campaign to Italy, conscripted vast numbers of marines, and even slaves, into hurriedly raised legions, and dispatched them northwards, there to patrol the frontier with Gaul. To command

them, he chose a former governor of Britain by the name of Petron-
ius Turpilianus, who had proven his loyalty to Nero's satisfaction
by taking a prominent role in the suppression of Piso's conspiracy.
Simultaneously, letters were sent to the recently appointed General
of the North, a man of noted integrity named Virginius Rufus, with
orders to muster the legions of the Rhine and march south against
Vindex. So it was, then, even as he chatted away nonchalantly to
senators about musical instruments, that Nero could contemplate
with satisfaction the pincer movement threatening his foes. The
rebels appeared certain to be crushed. For good measure, though,
Nero made sure to offer a fortune to whomever could bring him
Vindex's head.

But then, in mid-April, the news took a turn for the worse. Galba,
showing his hand at last, had declared himself a legate, not of Caesar,
but of the Senate and the Roman people. Recognising in the blue-
blooded veteran of the German front an altogether more formidable
class of adversary than Vindex, Nero promptly fainted. When he
came to, and was reassured by his old nurse that many princes in
the past had faced similar evils, he brushed aside this well-meaning
attempt to console him by informing her, in a tone of some asperity,
that his own woes were wholly without precedent. Worse, though,
was to come. Galba's rebellion prompted numerous others who had
been patiently biding their time to join him. Some familiar names
were among their ranks. Otho, erstwhile husband of Poppaea, had
leapt at the chance to return from Spain, where he was serving as
one of its governors, and had unhesitatingly pledged his loyalty to
Galba. Meanwhile, in Africa, the sinister Calvia Crispinilla, tutor to
the wretched Sporus in the arts of being an Augusta, had thrown
in her lot with the province's governor, and incited him to join the
insurrection. Then, in May, came the bitterest blow, a defection all
the more cruel because it came garbed in the robes of triumph. The
armies of the Rhine, meeting with Vindex's forces, had annihilated

their opponents. Vindex himself had committed suicide. Rather than renew their oaths to Nero on the battlefield, though, the victorious legions had hailed their general as emperor. Virginius, true to his reputation for moral probity, had turned them down; but only then to declare his neutrality in the looming struggle for control of the world. Meanwhile, it was reported of Petronius, the general entrusted by Nero with the defence of northern Italy, that he too was wavering in his loyalties. The habit of obedience to the House of Caesar, forged by Augustus and his heirs over a century and more, appeared suddenly on the verge of collapse. The old wolfishness, the savagery that in the earliest days of Rome had seen Remus felled by Romulus, had not, after all, it seemed, been tamed for good. Rushing to meet each other in the ecstasy of mutual slaughter, the legions of Virginius and Vindex had both ignored their commanders' efforts to hold them back. 'The crash of the battle had been terrible – like that of charioteers whose horses refuse to obey them.'[104] As in the terrible days before the rise to supremacy of Augustus, so now. Events were careering madly out of control.

And Nero, seasoned charioteer that he was, knew it. Brought the news of Petronius's defection while he was dining, he tipped over the table in his fury, and dashed a couple of precious goblets to the floor. Then, after making sure to source a supply of poison, he left behind him the sprawling magnificence of the Golden House and headed for one of his estates further out of town. Here, wrestling with his options, he abandoned himself to despair. Even the Praetorians, whose love he had always gone to such extremes to court, appeared to be wavering. When Nero urged their officers to rally to him, they temporised. 'Is it really such a terrible thing to die?'[105] These words, addressed by a Praetorian officer directly to Nero's face, were like a touch of ice. Evidently, the cancer of disloyalty was starting to reach into the very heart of his regime. Were there any so close to him now that they could still be trusted not to switch sides? Certainly, there

was no sign either of Tigellinus or of his colleague as Praetorian pre-
fect, Nymphidius Sabinus. Both, Nero had to reckon, had abandoned
his cause. Both, in his hour of need, had proven themselves true to
their reputations as venal and treacherous.

In a mood of mounting desperation, Nero now began to turn
other plans over and over in his mind. Perhaps, come the morning, he
should head to the Forum dressed in black and make a direct appeal
to the Roman people, employing all his talent for pathos? Or perhaps
he should flee to Alexandria? Nero decided to sleep on it. His dreams,
though, were fitful. Waking up at midnight, he found to his horror
that the villa was almost empty. His guards had gone, and his friends,
and even the caretakers – who, to add injury to insult, had stolen his
supply of poison. Briefly, Nero wondered whether to hurl himself
into the Tiber; but then, after a histrionic dash out into the night,
he decided that he was not yet ready to abandon hope altogether,
and returned inside. A few loyal companions still remained to him:
Sporus, his beautiful woman's face and amber hair a reminder of
happier days, and three attendants. One of these, a freedman by the
name of Phaon, offered his master the use of a villa to the north of
Rome. Unable to think of any better bolt-hole, Nero accepted. Still
barefoot, he wrapped himself up in a faded cloak and covered his
head, and then, after mounting a horse, held a handkerchief up to
his face. As lightning jagged in the sky, and the earth quaked, he and
his four companions cantered out into the streets and embarked on
their escape from Rome.

The journey was a hair-raising one. Riding past the Praetorian
camp, the five horsemen could hear wild slogans being shouted:
prophecies of doom for Nero and of success for Galba. A passer-
by, seeing the speed at which they were riding, assumed that they
were hunting the fugitive emperor, and cheered them on. Most
heart-stopping of all, when Nero's horse was startled by the stench
of a corpse abandoned in the road, and he let slip the handkerchief

covering his face, a retired Praetorian recognised him. The soldier did nothing, though, beyond saluting him; and so Nero, against the odds, was able to make it to Phaon's villa. Yet even here, there were fresh indignities to endure. Because Phaon insisted that they enter by the back, Nero was required to stumble through reeds and brambles, and then, after his companions had dug a tunnel, to squeeze himself under the wall. Shattered and despairing, he tottered into the slave quarters and flung himself down in the first room he came to, a mean and squalid chamber with no furniture for him to rest on beyond a lumpy mattress. Here, mourning the ruin that had overwhelmed him, Nero ordered his companions to prepare him a pyre and dig him a grave. Still, despite the urgings of his companions, he hesitated. The scale of his downfall numbed him. He could not bring himself to take the final step. Instead, he could only weep, and lament the loss to the world that his death would spell.

Then a letter arrived, borne by one of Phaon's couriers.* Nero snatched it from the man's hand. He read it, and as he did so, he turned paler still. The Senate had declared him a public enemy. No mercy was to be shown him. Senators, as though in honour of a time when there had been no Caesars to put them in the shade, had sentenced him to a death as antique as it was savage. He was to be stripped naked, yoked and led through the streets, and beaten to death with rods. Rather than suffer such a fate, Nero knew, he had no choice but to finish things off himself. He picked up a pair of daggers, tested their points, then put them down again. 'The fatal hour,' he cried out, 'has still not come.'[106]

But it had. Even as he was instructing Sporus to mourn him as a wife properly should, by wailing and tearing at her hair and robes, he heard the sound of hoofbeats thundering towards the villa. Again, he

* An intriguing implication of this letter is that Phaon had tipped people off as to where he was going. The arrival of a death squad soon afterwards implies that agents of Galba would have been among them.

reached for his dagger. This time, with the aid of a freedman, he summoned the courage to drive it into his throat. A centurion, rushing into the room, attempted to staunch the flow of blood with his cloak, but it was too late. 'Such loyalty,'[107] the dying man murmured; and then his eyes began to bulge horribly. Nero Claudius Caesar Augustus Germanicus was dead.

And with him the entire dynasty of which he had been the last surviving member. Its extinction came as no surprise to those versed in the art of reading omens. In the villa once owned by Livia, in the laurel grove, stood four withered trees. Each one had been planted by a Caesar; and each one, shortly before the Caesar's death, had died. Then, shortly before Nero's suicide, the tree that he too had planted had begun to wither – and with it, from the roots up, the entire laurel grove. The chickens too, bred of the hen dropped miraculously into Livia's lap, had all expired. The meaning could hardly have been any clearer. The line of the Caesars was destined to end with Nero – and so it had proved. To be sure, emperors would follow in his wake, and all would be graced with the title of Caesar. None of them, however, would rule as descendants of Augustus. Galba, too old, too stern and too mean to delight a people still half in love with Nero, did not last long; and sure enough, in January 69, beside the spot in the Forum where Marcus Curtius had once vanished into the abyss, he was hacked to death. Otho followed three months later; eight months after him, Vitellius. Three emperors had perished in the space of a year. In the end, it was left to Vespasian, back from the Jewish war, to establish himself as master of the world. More than that, he succeeded in founding a new dynasty. When he died in his bed a decade later, he was succeeded by his eldest son, who in turn was followed by his younger brother. Like Augustus and Claudius, Vespasian even ended up a god.

Never again, though, would the Roman people be ruled by emperors touched by the sheer mystique and potency that membership of

the August Family had bestowed upon the heirs of Augustus. Nero, taking to the stage, had been right to recognise within himself the quality of myth. All his family had possessed it. The blood in their veins had been touched by the supernatural. The dynast who had healed the wounds of civil war, and planted in the midst of a king-hating people an impregnable and enduring autocracy, was justly reckoned a god. The name of Augustus would remain a sacred one for as long as there were men who wore the title of Caesar. It served as an assurance to humanity that a man midway between the earthly and the divine might indeed reign as a universal prince of peace, and ascend triumphant to heaven. Augustus, victorious over his enemies as no man in history had been, had triumphed eventually over death itself. So too had his heirs. Even Caligula had haunted the house where he was murdered, and the gardens where his body was burned. When Nero killed himself, and brought the bloodline of Augustus to extinction, many simply refused to believe it. Decades on, across the Roman world, people were convinced that he would come again. 'Everybody wishes he were still alive.'[108]

Even those who had suffered most terribly at his hands, and had every reason to execrate his memory, could not help but acknowledge the charisma of the House of Caesar. Some three decades after Nero's suicide, a Christian named John recorded a vision of the end days revealed to him by an angel. Out of the sea he had seen a seven-headed beast rise; 'and one of its heads seemed to have a mortal wound'.[109] What was the wound, so many who read John's vision would wonder with dread, if not the sword blow to the throat with which Nero had ended his own life?* The wound, so the angel had

* Victorinus of Pettau, a bishop from Pannonia who was martyred in AD 303, was the first Christian writer to interpret the wound to the beast's throat as an allusion to Nero's suicide. The Geneva Bible comments on it: 'This may be understood of Nero, who moved the first persecution against the Church, and after slew himself, so that the family of the Caesars ended in him.'

revealed to John, was destined to be healed; and the beast, which 'was, and is not',[110] would rise from the bottomless pit. On its back would ride a woman; and the woman would be 'arrayed in purple and scarlet, and bedecked with gold and jewels and pearls, holding in her hand a golden cup full of abominations and the impurities of her fornication'.[111] Rarely before had the Rome ruled by the August Family been made to sound so glamorous.

'What an artist perishes with me.'[112] So Nero, with his customary lack of modesty, had declared as he steeled himself to commit suicide. He had not exaggerated. He had indeed been an artist – he and his predecessors too. Augustus and Tiberius, Caligula and Claudius: each, in his own way, had succeeded in fashioning out of his rule of the world a legend that would for ever afterwards mark the House of Caesar as something eerie and more than mortal. Painted in blood and gold, its record would never cease to haunt the Roman people as a thing of mingled wonder and horror. If not necessarily divine, then it had at any rate become immortal.

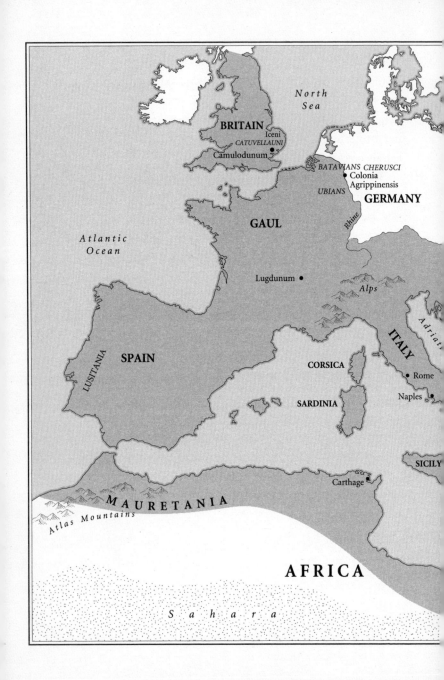

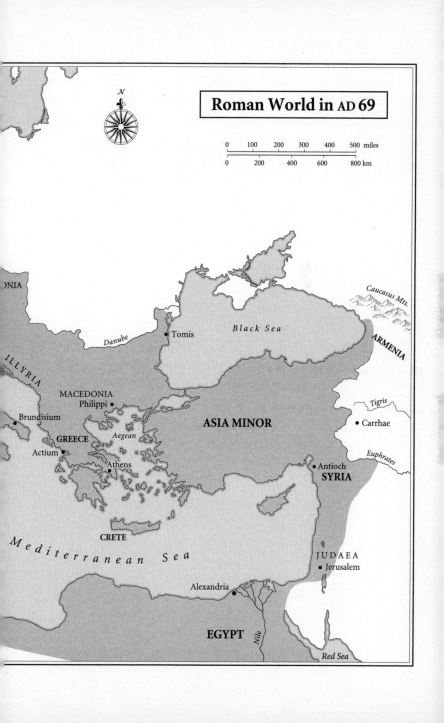

Roman World in AD 69

0 100 200 300 400 500 miles
0 200 400 600 800 km

Caucasus Mts.

ARMENIA

Black Sea

Danube • Tomis

ILLYRIA

MACEDONIA
Philippi •

Brundisium •

GREECE

Actium •

Aegean

Athens •

ASIA MINOR

Tigris

• Carrhae

Euphrates

• Antioch
SYRIA

Mediterranean Sea

CRETE

JUDAEA
• Jerusalem

Alexandria •

EGYPT *Nile*

Red Sea

TIMELINE

38: Marriage of Livia to Caesar *Divi Filius*. Birth of her second son, Drusus. Caesar *Divi Filius* starts to call himself *Imperator Caesar*.

33: Agrippa, as aedile, sluices out Rome's drains.

31: Battle of Actium. Maecenas gives Horace a Sabine farm.

30: The deaths of Antony and Cleopatra. The annexation of Egypt.

29: Imperator Caesar celebrates three triumphs. Crassus defeats the Bastarnians.

28: Completion of the temple of Apollo on the Palatine.

27: Imperator Caesar becomes Augustus. The 'Augustan settlement'.

23: Augustus, seemingly on his deathbed, recovers. He lays down his consulship, and is awarded new powers by the Senate. Death of Marcellus.

22: Augustus leaves Rome on a tour of the East.

21: Agrippa marries Julia.

20: Augustus reclaims the eagles lost by Crassus. Birth of Gaius to Agrippa and Julia.

19: Augustus returns to Rome.

18: Augustus's adultery laws. Birth of Lucius, Gaius's younger brother.

17: Rome celebrates the dawning of a new cycle of time. Augustus adopts Gaius and Lucius. Marcus Lollius loses his eagle to a German raiding party.

15: Birth of Germanicus.

12: Augustus becomes *Pontifex Maximus*. The death of Agrippa. Drusus inaugurates an altar to Rome and Augustus in Lugdunum.

11: The marriage of Tiberius and Julia. The birth of Claudius.

 8: The death of Horace.

 9: The death of Drusus. Tiberius escorts his body back to Rome.

 6: Tiberius retires to Rhodes.

 2: Augustus is awarded the title 'Father of his Country'. He dedicates the temple of Mars the Avenger. Julia is engulfed by a sex scandal, and exiled.

 1: Gaius sets out for the East.

AD 2: Tiberius returns to Rome. The death of Lucius.

4: Death of Gaius. Augustus adopts Tiberius, who adopts Germanicus.

6: The Pannonian Revolt.

8: The exile of Augustus's granddaughter, Julia. The exile of Ovid.

9: Ovid arrives in Tomis. The battle of the Teutoburg Pass.

10: Tiberius takes command of the German front.

12: Tiberius returns to Rome for his triumph. The birth of Caligula.

14: The death of Augustus. Tiberius becomes Princeps. The execution of Agrippa Postumus. Mutiny in Pannonia and on the Rhine.

15: Sejanus becomes sole Praetorian prefect.

16: Tiberius recalls Germanicus to Rome. The capture of Clemens.

17: Germanicus leaves for the East. The death of Ovid.

19: The death of Germanicus. The return of Agrippina to Italy. The death of Arminius.

20: The trial and suicide of Piso.

23: The death of Tiberius's son, Drusus.

25: Sejanus tries, and fails, to marry Livilla. The trial of Cremutius Cordus.

26: Tiberius leaves Rome for Campania.

27: Tiberius settles on Capri. The collapse of the amphitheatre at Fidenae.

28: The trial of Titus Sabinus.

29: The death of Livia. The exile of Germanicus's wife, Agrippina.

31: Caligula is summoned to Capri. The fall of Sejanus.

33: The death of Agrippina.

37: The death of Tiberius. Caligula becomes emperor. He falls ill, then recovers. The birth of Nero.

38: The death and consecration of Drusilla.

39: Caligula denounces the Senate, marries Milonia Caesonia, and leaves for Germany. The execution of Lepidus, and the banishment of Caligula's two surviving sisters, Agrippina and Julia Livilla.

40: Caligula on the shores of the Channel, before returning to Italy. He crosses a bridge of boats at Baiae. He enters Rome, and suppresses a conspiracy.

41: The assassination of Caligula. Claudius becomes emperor. Agrippina and Julia Livilla are recalled from exile. Julia Livilla is promptly sent back into exile. Seneca is exiled to Corsica. The deification of Livia.

42: A coup against Claudius is suppressed. Suetonius Paulinus crosses the Atlas mountains. Work begins on developing Ostia.

43: The invasion of Britain.

47: The trial and suicide of Valerius Asiaticus.

48: The downfall of Messalina.

49: Claudius marries Agrippina. Seneca is recalled from exile.

50: Claudius adopts Nero.

51: The capture of Caratacus.

53: Nero marries Octavia.

54: The death of Claudius. Nero becomes emperor.

55: The death of Britannicus.

58: Nero falls in love with Poppaea Sabina.

59: The murder of Agrippina. Nero celebrates the first shaving of his beard.

60: Boudicca's revolt.

61: The murder of the City Prefect by one of his own slaves.

62: The death of Burrus and promotion of Tigellinus to the Praetorian prefecture. Nero divorces, exiles and executes Octavia. He marries Poppaea Sabina.

64: Nero performs in public for the first time, in Naples. Tigellinus's party on the Campus Martius. The Great Fire of Rome.

65: Piso's conspiracy. Seneca commits suicide. The death of Poppaea Sabina.

66: The visit of Tiridates to Rome. Nero leaves for Greece.

67: Nero competes in the Olympic Games and marries Sporus. He returns to Rome.

68: The rebellion of Julius Vindex. The death of Nero. Galba becomes emperor.

69: The death of Galba. Otho, Vitellius and Vespasian become emperor in succession.

DRAMATIS PERSONAE

Before Augustus

ROMULUS: Founder and first king of Rome.

REMUS: His twin brother. Killed in mysterious circumstances.

TARQUIN THE PROUD: The last king of Rome, expelled in 509 BC.

BRUTUS: Tarquin's cousin, and leader of the revolution that founded the Republic.

CORNELIUS COSSUS: The second Roman general, after Romulus, to win the 'spoils of honour'.

MARCUS CURTIUS: A Roman who sacrificed himself for the good of his city by jumping into a mysterious chasm.

SCIPIO AFRICANUS: The conqueror of Carthage.

MARCELLUS: The third Roman general, after Romulus and Cornelius Cossus, to win the 'spoils of honour'.

TIBERIUS GRACCHUS: Tribune and champion of the plebs. Murdered in 133 BC.

GAIUS GRACCHUS: Younger brother of Tiberius Gracchus. Tribune and champion of the plebs. Murdered in 121 BC.

MARCUS LIVIUS DRUSUS: Champion of the Italians, whose murder in 91 BC helped to prompt their revolt. Livia's adoptive grandfather.

POMPEY 'THE GREAT': The most powerful man in Rome during the last decades of the Republic.

SEXTUS POMPEY: His son. A piratical opponent of the Triumvirs following Julius Caesar's assassination.

CRASSUS: A fabulously wealthy power-broker who died fighting the Parthians in 53 BC.

HORTENSIUS HORTALUS: An orator famous for his brilliance and high living.

HORTENSIA: His daughter.

CASSIUS: Assassin of Julius Caesar.

BRUTUS: Assassin of Julius Caesar. Descended from the Brutus who expelled Tarquin the Proud.

JUNIA: His sister. Long-lived.

ANTONY: Lieutenant of Julius Caesar. Triumvir. *Bon viveur*.

LUCIUS: Antony's brother.

IULLUS ANTONIUS: Antony's son.

CLEOPATRA: The Queen of Egypt. Paramour first of Julius Caesar, then of Antony.

LEPIDUS: Triumvir and Pontifex Maximus.

The Julians

AENEAS: Son of Venus. A Trojan prince who fled the sack of his city for Italy.

JULUS: The son of Aeneas. Ancestor of the Julians.

JULIUS CAESAR: The conqueror of Gaul whose crossing of the Rubicon led to civil war and his own subsequent dictatorship. Assassinated in 44 BC.

OCTAVIUS: Great-nephew and adopted son of Julius Caesar. Triumvir. Ended up as Imperator Caesar Divi Filius Augustus, and ruled as Princeps until his death in AD 14.

SCRIBONIA: His first wife.

JULIA: The daughter of Augustus and Scribonia. Close friends with Iullus Antonius. Exiled in 2 BC.

OCTAVIA: Augustus's sister. Married to Antony, then divorced. Step-mother to Iullus Antonius.

MARCELLUS: Son of Octavia by her first marriage. Descended from the Marcellus who won the 'spoils of honour'. Died in 23 BC.

ANTONIA THE ELDER: Elder daughter of Octavia and Antony.

ANTONIA THE YOUNGER: Younger daughter of Octavia and Antony. Mother of Germanicus, Livilla and Claudius.

GAIUS: Oldest son of Julia and Agrippa. Adopted by Augustus. Died in AD 4 in Asia Minor.

JULIA: Oldest daughter of Julia and Agrippa. Owner of the smallest dwarf in Rome. Exiled in AD 8.

LUCIUS: Second son of Julia and Agrippa. Adopted by Augustus. Died in AD 2 in southern Gaul.

AGRIPPINA (I): Second daughter of Julia and Agrippa. Married Germanicus. Mother of Nero (i), Drusus (iii), Caligula, Agrippina (ii), Drusilla and Julia Drusilla. Returned to Rome with her husband's ashes in an urn. Fell out spectacularly with Tiberius.

AGRIPPA POSTUMUS: Third son of Julia and Agrippa. Adopted by Augustus, then exiled by him in AD 9.

The Claudians

ATTIUS CLAUSUS: Migrated to Rome in 504 BC. Founder of the Claudian line.

APPIUS CLAUDIUS THE BLIND: Builder of the Appian Way.

CLAUDIUS PULCHER: Son of Appius Claudius. His descendants, the Pulchri, constituted the more high-achieving branch of the Claudians.

CLAUDIUS NERO: Son of Appius Claudius. Ancestor of the Nerones, whose achievements under the Republic failed to measure up to those of the Pulchri.

APPIUS CLAUDIUS PULCHER: Notoriously arrogant head of the Claudians during the last decade of the Republic. A fan of oracles.

CLODIUS PULCHER: His younger brother. Tribune and paramilitary.

CLODIA METELLI: Eldest of the three sisters of Appius Claudius and Clodius. Famously *soignée*.

DRUSUS CLAUDIANUS: A partisan of Julius Caesar who then became a follower of his assassins. Livia's father.

LIVIA DRUSILLA: Mother of Tiberius and wife of Augustus. Ended up a goddess.

TIBERIUS CLAUDIUS NERO: First husband of Livia. Unsuccessful rebel.

TIBERIUS: The elder son of Livia and Tiberius Claudius Nero. Son-in-law, then adopted son of Augustus. Rome's most effective general. Succeeded Augustus as Princeps. Ruled from AD 14–37.

DRUSUS (I): The younger son of Livia and Tiberius Claudius Nero. Married to Antonia the Younger. Led a Roman army to the Elbe. Father of Germanicus, Livilla and Claudius.

VIPSANIA: Tiberius's much-loved first wife, until he was obliged by Augustus to divorce her. Subsequently married to Asinius Gallus.

DRUSUS (II): The son of Tiberius and Vipsania. Married to Livilla. Father of Gemellus.

GERMANICUS: The elder son of Drusus and Antonia the Younger. Dashing. Married to Agrippina (i).

LIVILLA: The daughter of Drusus and Antonia the Younger. Bitchy. Married to Drusus (ii).

GEMELLUS: The son of Drusus (ii) and Livilla. Tiberius's grandson.

CLAUDIUS: The younger son of Drusus and Antonia the Younger. Prone to stammering and dribbling. Emperor from AD 41 to 54.

ANTONIA: Daughter of Claudius and his second wife, Aelia Patina.

MESSALINA: Wife of Claudius. A great-grandniece of Augustus. Notorious for her love-life.

OCTAVIA: Daughter of Claudius and Messalina. Nero's first wife. Their marriage was not a success.

BRITANNICUS: Son of Claudius and Messalina. The last of the Claudians.

The Julio-Claudians

NERO (I): Eldest son of Germanicus and Agrippina (i). Came to a sticky end.

DRUSUS (III): Second son of Germanicus and Agrippina (i). Came to a sticky end.

CALIGULA: Youngest son of Germanicus and Agrippina (i). Properly called Gaius, 'Caligula' was a nickname given him as a young boy. Emperor from AD 37 to 41.

LOLLIA PAULINA: Famously rich and beautiful. Caligula married her in AD 38, then divorced her six months later.

MILONIA CAESONIA: Caligula's last wife. Enjoyed dressing up.

JULIA DRUSILLA: The daughter of Caligula and Milonia Caesonia. Reportedly an unpleasant child.

AGRIPPINA (II): Eldest daughter of Germanicus and Agrippina (i). Sister of Caligula, niece and wife of Claudius, mother of the Emperor Nero.

NERO: The son of Agrippina (ii) and Gnaeus Domitius Ahenobarbus. Adopted by Claudius in AD 50. Emperor from AD 54 to 68.

DRUSILLA: Second daughter of Germanicus and Agrippina. Caligula's favourite sister. Ended up a goddess.

JULIA LIVILLA: Youngest daughter of Germanicus and Agrippina. Exiled by both Caligula and Claudius.

The Ahenobarbi

LUCIUS DOMITIUS AHENOBARBUS: Married to Antonia the Elder. The first Roman general to cross the Elbe.

GNAEUS DOMITIUS AHENOBARBUS: His son. Married to Agrippina (ii). Father of Nero.

DOMITIA: Nero's aunt, who looked after him during his mother's exile.

DOMITIA LEPIDA: Domitia's sister. The mother of Messalina.

Augustus's Rome

MARCUS AGRIPPA: Augustus's *consigliere*. Married to Julia (i).

MAECENAS: Descendant of Etruscan kings. Patron of poets.

HORACE: Poet and – thanks to Maecenas – owner of a Sabine farm.

VEDIUS POLLIO: Financier who flashed his cash too much for Augustus's liking.

EGNATIUS RUFUS: Sponsor of firemen and would-be consul.

HOSTIUS QUADRA: Notorious as the most depraved man in Rome. Fond of mirrors.

OVID: Poet. A *flâneur* who pushed at limits.

TITUS LABIENUS: Historian, whose account of the civil wars was burned on Augustus's orders.

CASSIUS SEVERUS: Sharp-tongued lawyer.

Governors and generals

MARCUS LICINIUS CRASSUS: Grandson of the Crassus killed at Carrhae. Governor of Macedonia, but not as decorated a general as he would have liked to be.

BALBUS: The last citizen from outside the August Family to celebrate a triumph.

LOLLIUS: Governor of Gaul who lost an eagle to a war-band of Germans. Guardian of Gaius on his eastern tour. Grandfather of Lollia Paulina.

VARUS: Governor of Germany. Led three legions into the Teutoburg Pass. Did not lead them back out.

CAECINA: Germanicus's deputy in Germany.

GNAEUS CALPURNIUS PISO: Governor of Syria. Close associate of Tiberius and opponent of Germanicus. Ended up in serious legal difficulties.

PLANCINA: Piso's wife. Friend of Livia.

SENTIUS: Appointed governor of Syria by enemies of Piso.

GALBA: Appointed to the command of the Rhine by Caligula. Appointed to Spain by Nero.

SUETONIUS PAULINUS: As governor of Mauretania he crossed the Atlas mountains, and as governor of Britain suppressed Boudicca's revolt.

Praetorians

SEIUS STRABO: An Etrurian. Appointed Prefect by Augustus. Ended up as Governor of Egypt.

AELIUS SEJANUS: His son. Promoted by Tiberius to the joint command of the Praetorians, then served as sole Prefect. Tiberius's right-hand man.

APICATA: Sejanus's wife. Divorced in AD 23.

MACRO: Prefect in succession to Sejanus.

CASSIUS CHAEREA: A grizzled veteran with a soft voice.

CORNELIUS SABINUS: Praetorian officer. Colleague of Cassius Chaerea.

BURRUS: Agrippina's protégé, appointed as Prefect under Claudius. Famed for his blunt speaking.

TIGELLINUS: Gigolo, racehorse trainer and party animal. Appointed one of two prefects by Nero in succession to Burrus.

FAENIUS RUFUS: Tigellinus's colleague as Prefect.

NYMPHIDIUS SABINUS: Prefect in succession to Faenius Rufus. Rumoured to be Caligula's son.

Victims

CREMUTIUS CORDUS: A historian who named Brutus and Cassius 'the last of the Romans', and paid for it.

ASINIUS GALLUS: Husband of Vipsania, Tiberius's divorced wife. Fatally prone to snideness.

TITIUS SABINUS: An associate of Germanicus. Victim of a sting.

JUNIUS SILANUS: Former consul. Father-in-law of Caligula.

ATANIUS SECUNDUS: Equestrian. Victim of his own hyperbole.

JUNIUS PRISCUS: Not as rich as he was rumoured to be.

PASTOR: Father of a murdered son.

ASPRENAS: A senator spattered with flamingo blood.

SILANUS: The victim of a bad dream.

POPPAEA SABINA (i): Love rival of Messalina.

SUILLIUS RUFUS: Notorious prosecutor. His comeuppance arrived in the end.

RUBELLIUS PLAUTUS: Tiberius's great-grandson. Suspected of having an affair with Agrippina (ii).

LUCIUS JUNIUS SILANUS: Nero excepted, the last surviving descendant of Augustus.

THRAESA PAETUS: Famously upright, in the sternest moral tradition of the Senate.

Conspirators

MARCUS AEMILIUS LEPIDUS: Caligula's close friend, and intimate of his sisters.

GAETULICUS: A henchman of Sejanus. Commander of the Rhine under Tiberius and Caligula.

BETILIENUS CAPITO: Father of a murdered son.

MARCUS VINICIUS: Married to Julia Livilla. Would-be emperor in the wake of Caligula's death.

ANNIUS VINICIANUS: Friend of Lepidus. Would-be emperor in the wake of Caligula's death.

PAETUS: Not as brave as his wife.

GAIUS SILIUS: The most handsome man in Rome. Reported to have made an unwise marriage.

GAIUS CALPURNIUS PISO: Distinguished, well-bred and ambitious to reach the top – despite not being related to the August Family.

FLAVIUS SCAEVINUS: A senator in possession of a dagger removed from a temple.

Survivors

MEMMIUS REGULUS: Consul and trusted henchman of Tiberius. Husband of Lollia Paulina, before Caligula obliged him to divorce her.

THRASYLLUS: Tiberius's astrologer. Avoided being thrown off a cliff.

LUCIUS VITELLIUS: Governor of Syria. Returned from his term of office to establish himself in Rome as a trusted agent of both Caligula and Claudius. A smooth operator.

CAECINA LARGUS: An early backer of Claudius to be emperor. Owned a house on the Palatine complete with lotus trees.

Freedmen and Slaves

CLEMENS: Slave and look-alike of Agrippa Postumus – or was he?

PALLAS: Former slave of Antonia the Younger. One of Claudius's most valued freedmen.

CALLISTUS: Powerful freedman under Caligula and Claudius. Died in his bed. The grandfather of Nymphidius Sabinus.

NARCISSUS: The third of Claudius's triumvirate of powerful freedmen. Not an admirer of Messalina.

CALPURNIA: One of Claudius's concubines.

ACTE: Nero's first girlfriend. Presided over his funeral.

SPORUS: A young boy possessed of girlish looks. Castrated, then married, by Nero.

PHAON: Owner of a villa north of Rome.

Actors and Artists

APELLES: Actor, with a tendency to stammer without a script.

MNESTER: Actor. Much admired by Caligula.

PARIS: Actor. Much admired by Nero.

ZENODORUS: Sculptor of Nero's Colossus.

Gauls

GAIUS JULIUS VERCONDARIDUBNUS: High priest of Rome and Augustus at Lugdunum.

VALERIUS ASIATICUS: Fabulously wealthy. Would-be emperor in the wake of Caligula's assassination. Owner of expensive gardens.

JULIUS CLASSICIANUS: Appointed by Claudius to restore the administration of Britain after Boudicca's revolt.

JULIUS VINDEX: A descendant of kings with a rebellious instinct.

Barbarians

DELDO: King of the Bastarnians.

PHRAATES: King of Parthia and enthusiast for détente with Augustus.

ARMINIUS: Roman equestrian and chieftain of the Cherusci.

CUNOBELIN: King of the Catuvellauni.

CARATACUS: His son. Leader of British resistance to the Roman invasion.

PRASUTAGAS: King of the Iceni.

BOUDICCA: Queen of the Iceni. Fiery.

TIRIDATES: King of Armenia. Crowned in Rome by Nero.

Friends and Foes of Nero

SENECA: Philosopher, rhetorician and writer. Exiled by Claudius, but brought back to Rome by Agrippina (ii). Nero's tutor.

AULUS VITELLIUS: Son of Lucius Vitellius. Friend of Caligula and Nero. Charioteer.

OTHO: Partner of Nero's night-time revels. Husband of Poppaea Sabina (ii).

POPPAEA SABINA (II): Amber-haired beauty, and daughter of Messalina's great rival. The love of Nero's life.

VATINIUS: Nero's court jester.

VESPASIAN: Seasoned general of humble background. Fought in Britain and accompanied Nero to Greece.

STATILIA MESSALINA: Nero's third wife. A noted intellectual.

CALVIA CRISPINILLA: Sporus's instructress in the art of being a woman.

PETRONIUS TURPILIANUS: Former governor of Britain. Commander of Nero's troops in Italy.

VIRGINIUS RUFUS: Commander of the Rhine.

NOTES

Unless otherwise stated, 'Tacitus' refers to *The Annals*; Valerius Maximus to *Memorable Doings and Sayings*; Livy, Justin, Florus, Appian, Dionysius of Halicarnassus, Cassius Dio, Velleius Paterculus and Herodotus to their respective Histories; Lucretius to *On the Nature of Things*; Petronius to *The Satyricon*; Lucan to *The Civil War*; Strabo to his *Geography*; Aulus Gellius to *Attic Nights*; Macrobius to *The Saturnalia*; Pliny to Pliny the Elder, and his *Natural History*; Artemidorus to *The Interpretation of Dreams*; Vitruvius to *On Architecture*; and Frontinus to *On Aqueducts*.

Preface

1 Suetonius. *Caligula*: 46
2 Ibid: 22
3 Ibid: 50.2
4 Seneca. *To Helvia*: 10.4
5 Eusebius. *The Proof of the Gospel*: 3.139
6 Philo. *On the Embassy to Gaius*: 146–7
7 Ovid. *Letters from Pontus*: 4.9.126
8 Mark 12.17
9 Cassius Dio: 52.34.2
10 Ibid: 53.19.3
11 Tacitus: 3.19
12 Ibid: 1.1
13 Tacitus: 3.65
14 Valerius Maximus: 3.6. preface
15 Seneca. *Letters*: 57.2
16 Seneca. *On Clemency*: 1.11.2
17 Ovid. *Sorrows*: 4.4.15

1　Children of the Wolf

1　Witness, for instance, a dedication made in the late third or early second century BC by a Greek on the Aegean island of Chios, which showcased Romulus and Remus. 'According to the story,' the inscription read, 'it came about that they were begotten by [the war god himself], which one might well consider to be a true story because of the bravery of the Romans.' Quoted by Wiseman (1995), p. 161.

2　Livy: 31.34

3　Justin: 38.6.7–8

4　Ennius: fragment 156

5　Florus: 1.1.8

6　Sallust. *The Conspiracy of Catiline*: 7.1–2

7　Livy: 7.6.2

8　Lucretius: 3.834

9　Livy: 37.45

10　So, at any rate, reports Valerius Maximus: 2.2.1

11　Livy: 38.53

12　Livy: 38.50

13　Valerius Maximus: 6.2.8

14　Cicero. *On Piso*: 16

15　Cicero. *On his House*: 66

16　Manilius: *Astronomica*: 1.793

17　Petronius: 119

18　Suetonius. *The Deified Julius*: 20

19　Livy. *Periochae*: 103

20　Propertius: 3.4, line 2

21　Appian: 2.31

22　Lucan: 1.109–11

23　Petronius: 121

24　Virgil. *Aeneid*: 2.557. In the poem, the headless corpse is Priam's; the detail that Virgil was echoing a description of Pompey we owe to Servius. The description was almost certainly from Asinius Pollio's history of the civil war. (See Morgan (2000), pp. 52–5.)

25　Dionysius of Halicarnassus: 7.70.1

26　Justin: 28.2.8

27　Suetonius. *The Deified Julius*: 77

28　Cicero. *Philippics*: 6.19

29　Plutarch. *Titus Quinctius Flaminius*: 12.6

30　Livy: 1.3. The observation probably dates to the decade after Caesar's assassination. See Luce.

31　Cicero. *In Defence of Marcellus*: 27

32 Pliny: 8.155
33 Cicero. *Philippics*: 3.12
34 Ovid. *Fasti*: 2.441. Ovid transposes the oracular command to the time of Romulus, but its actual date was 276 BC. See Wiseman (2008), p. 76.
35 Plutarch. *Julius Caesar*: 61.4
36 Cassius Dio: 44.11.3
37 Cicero. *Republic*: 2.30.52
38 Gaius Matius, a businessman whose entire career was marked by a deep suspicion of politics. He is being quoted with deep disapproval by Cicero. *Letters to Atticus*: 14.1
39 Josephus. *Antiquities of the Jews*: 14.309
40 From the *Memoirs* of Augustus, fragment 6. Quoted by Ramsey and Licht, p. 159.

2 Back to the Future

1 Livia was born, almost certainly in Rome, on 30 January 59 – or possibly 58. See Barrett (2002), pp. 309–10
2 Virgil. *Eclogues*: 4:61
3 Plutarch. *Roman Questions*: 102
4 Seneca. *On Mercy*: 1.14.3
5 Barrett (2002: p. 348, n. 18) notes the lack of explicit evidence identifying Livius Drusus as the adoptive father of Drusus Claudianus, but acknowledges the circumstantial evidence to be overwhelming.
6 Dionysius of Halicarnassus: 3.67.5
7 Cicero. *Against Verres*: 5.180
8 Cicero. *On the Responses of the Haruspices*: 13.27
9 Cicero. *For Marcus Caelius*: 21
10 Tacitus: 1.4.3. Scholars are agreed that the darkening of the Claudians' reputation occurred at some point in the first century BC; Wiseman (1979) convincingly dates it to the late 50s and 40s.
11 Valerius Maximus: 1.4.3
12 Lucan: 2.358
13 Cicero. *On his House*: 109
14 For the significance of the crocus stamen as a flower part used 'to promote women's menstrual and reproductive cycles', see Sebasta, p. 540, n. 33.
15 Plutarch. *Romulus*: 15.5
16 Appian: 4.11
17 Velleius Paterculus: 2.71.2
18 Valerius Maximus: 6.8.6
19 Suetonius. *The Deified Augustus*: 2

20 Although according to Dio (47.49.3), it was lost at sea. Another tradition is recorded by Plutarch (*Brutus*: 53.4), who reports that Antony had Brutus's body cremated and the ashes sent home to his mother.

21 Appian: 4.8

22 'In Praise of Turia': the quoted passage comes from a eulogy carved by a mourning husband on the tombstone of his wife. The dead woman has long been identified with a paragon of selfless heroism named Turia, who – according to an anecdote recorded by Valerius Maximus (6.7.2) – risked everything to save her husband from the evils of the Proscriptions. Classicists, as is their way, are now more sceptical than they were of this identification – but not entirely dismissive.

23 Appian: 4.4

24 Suetonius (*Augustus*: 15) says that 200 senators and knights were offered as a literal sacrifice. The story clearly derives from a hostile source – but although much exaggerated, it is clear that that its origin must lie in an authentic episode.

25 Suetonius. *Augustus*: 62.2. Suetonius is quoting Augustus's own words (fragment 14).

26 Ibid

27 By Brunt (1971), pp. 509–12

28 Virgil. *Eclogues*: 1.11–12

29 Propertius: 4.1.130

30 Virgil. *Eclogues*: 9.5

31 Horace. *Satires*: 2.1.37

32 Ibid: 1.6.72–3

33 Virgil. *Georgics*: 1.505

34 Strabo: 6.1.2

35 Propertius: 2.1.29

36 Velleius: 2.88.2

37 Horace. *Epodes*: 7.17–20

38 Horace. *Odes*: 2.13.28

39 Horace. *Satires*: 2.2.126–7

40 Appian: 5.132

41 Ibid: 5.130

42 Plutarch. *Antony*: 24

43 Virgil. *Aeneid*: 4.189–90

44 Seneca. *Letters*: 94.46. The quotation is from Sallust, *The Jugurthine War*: 10.6.

45 Seneca. *On Benefits*: 3.32.4

46 Strabo: 5.3.8

47 Horace. *Epodes*: 9.5

48 Horace. *Satires*: 1.5.29

49 Ibid: 1.6.61–2

50 Ibid: 2.6.58

51 Ibid: 2.6.1–3

52 *Res Gestae*: 25.2

53 Virgil. *Aeneid*: 8.678–9

54 Horace. *Odes*: 1.37.1

55 Ovid. *Fasti*: 1.30

56 Cicero. *On Duties*: 2.26

57 Livy: 1.10

58 Cornelius Nepos. *Life of Atticus*: 20.3

59 Or rather, in accordance with what the young Caesar and his agents claimed to have been venerable custom. Just as likely is that the entire ritual was made up. See Wiedemann, p. 482.

60 The name was stamped on sling-shot. The young Caesar was also accused on the sling-shot of being a 'cocksucker' and having a loose anus. See Hallett (2006), p. 151.

61 The link between the defeat by Sextus and the adoption of the name *Imperator* was first made by Syme in a classic essay (1958).

62 Horace. *Satires*: 2.6.55–6

63 Virgil. *Georgics*: 4.90

64 For the impenetrable nature of the murk that envelops the origins of the triumph, see Beard (2007), pp. 305–18.

65 Dionysius of Halicarnassus: 2.34.2

66 Virgil. *Aeneid*: 8.717

67 Propertius: 2.8.14

68 Virgil. *Aeneid*: 1.291

69 Cassius Dio: 51.24

70 Livy: 4.20

71 An inscription from a recently discovered coin, minted in 28 BC. See Rich and Williams.

72 *Achievements of the Deified Augustus*: 6.1

73 Ibid: 34.1

74 Aulus Gellius: 5.6.13

75 The inscription is from a coin minted in 19 BC. See Dear, p. 322

76 Cassius Dio: 53.6

77 Ibid: 53.20

78 Horace. *Odes*: 3.8.18

79 Ibid: 1.35.29–30

80 Ibid: 3.14.14–16

81 Ovid. *Sorrows*: 4.4.13–16

82 Some scholars dispute whether this temple was in fact built, but the

evidence – consisting as it does of both coins and the explicit statement of Dio that it was indeed raised on the Capitol 'in imitation of that of Jupiter' (54.8) – seems to me irrefutable.

83 Ovid. *Fasti*: 1.609–10
84 Macrobius: 2.4.20
85 Ibid: 2.4.12
86 Quoted in Suetonius. *Life of Horace*
87 Suetonius. *The Deified Augustus*: 70.2
88 Servius. *On the* Aeneid: 4.58
89 Velleius Paterculus
90 Plutarch. *Antony*: 75
91 Virgil. *Aeneid*: 8.720
92 Just as the vast temple of Jupiter on the Capitol was dedicated to Juno and Minerva as well, so did Liber share his temple with Ceres and Libera. Wiseman (2004: p. 68) convincingly argues that this was no coincidence, and that the temple of Liber was consciously founded as a counterpoint to the huge temple on the Capitol.
93 Suetonius. *The Deified Augustus*: 79.2
94 Ovid. *Sorrows*: 1.70
95 Suetonius. *The Deified Augustus*: 94.4
96 Ibid: 72.1
97 Cicero. *In Defence of Murena*: 76
98 Horace. *Satires*: 1.8.16
99 Cicero. *On the Agrarian Law*: 2.17
100 Ibid. *To Atticus*: 1.19.4
101 The number of tribunes increased over the succeeding decades. By 449 BC, there were ten.
102 Cassius Dio: 54.10
103 Macrobius: 2.4.18
104 Horace. *Odes*: 3.6.1–2
105 Ibid: 7–8
106 Ovid. *Fasti*: 1.223–4
107 'In Praise of Turia'
108 Horace. '*Carmen Saeculare*': 47–8
109 Ibid: 57–60
110 Ovid. *Fasti*: 6.647
111 From Suetonius's life of Horace
112 Suetonius. *The Deified Augustus*: 58.2
113 Ovid. *Fasti*: 3.709
114 Ibid: 5.553
115 Suetonius reports that all these statues were dressed as though for the

celebration of a triumph; but we know from the fragments of them found that in fact some of them were shown wearing togas.

116 Suetonius. *The Deified Augustus*: 31.5

117 Horace. *Odes*: 4.14.6

3 The Exhaustion of Cruelty

1 *Funeral Lament for Drusus*: 351. In *Poetae Latini Minores* 1, ed. E. Baehrens (1879)

2 Plutarch. *Life of Cato the Censor*: 16

3 Ovid. *Loves*: 3.15.6

4 Dionysius of Halicarnassus: 6.13.4

5 Ovid. *The Art of Loving*: 3.121–2

6 Ovid. *Sorrows*: 4.10.35

7 Ibid: 4.10.37–8

8 Ovid. *The Art of Loving*: 3.122

9 Ibid: 1.17

10 Cato the Censor, in Plutarch's life of him: 17

11 Ovid. *Loves*: 1.15.3

12 Ibid: 1.7.38

13 Cicero. *Tusculan Disputations*: 2.53

14 Petronius: 92. The tone is satirical but matter-of-fact.

15 Pliny the Younger. *Letters*: 3.1.2

16 *Priapea*: 25.6–7

17 Valerius Maximus: 6.1. preface

18 Cato the Elder: fragment 222. Later jurists ruled that, although the father of a woman taken *in flagrante* might legally kill her, a husband could not – unless his wife's lover was of low or sordid social standing.

19 Ovid. *Loves*: 3.4.37

20 Ibid: 3.4.17

21 Ibid: 3.4.11

22 Ovid. *On Women's Facials*: 25–6

23 Seneca. *Natural Questions*: 1.16.6

24 Ibid: 1.116.9

25 Ibid: 1.16.7

26 Horace. *Odes*: 3.6.19–20

27 Ibid: 3.24.33–4

28 Pseudo-Acro, scholiast on Horace: 1.2.63. Quoted by McGinn, p. 165

29 Tacitus. *Annals*: 3.28

30 Horace. *Odes*: 4.5.21–2

31 Ovid. *Loves*: 3.4.5–6

32 Cassius Dio: 48.52

33 Ovid. *Sorrows*: 3.1.39–40
34 Velleius Paterculus: 2.79.1
35 Pliny: 15.137
36 Cassius Dio: 54.6
37 Suetonius. *Tiberius*: 51.2
38 Macrobius: 2.5.9
39 Ibid: 2.5.8
40 Ibid: 2.5.4
41 Philo. *Embassy to Gaius*: 167
42 Seneca. *To Polybius, On Consolation*: 15.5
43 Ovid. *The Art of Loving*: 1.184
44 Ibid. 1.177–8
45 Ibid, 1.175
46 Ovid. *Loves*: 1.5.26
47 Pliny: 7.149
48 Seneca. *On Mercy*: 1.10.3
49 Ibid: 1.11.2
50 Ovid. *The Art of Loving*: 2.573
51 Ibid: 2.552–3
52 Ibid: 2.2.599–600
53 Artemidorus: 2.9
54 Velleius Paterculus: 2.91.4
55 Ovid. *Fasti*: 5.145–6
56 Plutarch. *Moralia*: 207e
57 From a Messenian inscription discovered in 1960. Quoted in Zankel, p. 259.
58 From a decree of the town council of Pisa. Reproduced in Lott (2012), p. 72.
59 Ovid. *The Art of Loving*: 1.203
60 Cassius Dio: 55.13.1
61 From a letter written by Augustus to Gaius in AD 1, and quoted by Aulus Gellius: 15.7
62 Tacitus: 6.25
63 Ulpian. *Digest*: 1.15.3
64 Cassius Dio: 55.27.1
65 Confusion surrounds the fate of Julia's husband, since a man of his name who appears on an inscription in a list of priests is described as dying in AD 14. A commentary on the poet Juvenal, though, makes it clear that he was executed. The priest was therefore almost certainly his son.
66 Some scholars (e.g. Claassen, pp. 12–13) date Ovid's exile to AD 9 but internal and external evidence alike seem to me definitively to point to AD 8. Legally speaking, Ovid was not an exsul, an *exile*, but a *relegatus* – someone 'relegated' from Rome, but without the loss of his civic rights. Ovid himself, though,

often referred to his loneliness and misery as an '*exsilium*' – as well he might have done.

67 Ovid. *Sorrows*: 2.207

68 Ibid: 6.27

69 Ovid. *Black Sea Letters*: 2.2.19

70 For a survey of the many theories about Ovid's exile, see Thibault. My reading of it follows Green (1989). As Claassen comments (p. 234), 'No other explanation than a political one can make sense of Ovid's exile.'

71 Ovid. *Sorrows*: 1.11.3–4

72 Ibid: 2.195–6

73 Ovid. *Sorrows*: 5.10.37

74 Ovid. *Letters from Pontus*: 1.2.81–2

75 Ovid. *Sorrows*: 5.7.46

76 Ovid. *Fasti*: 2.291

77 Ovid. *Sorrows*: 2.199–200

78 Ibid: 5.10.19–20

79 Valerius Maximus: 6.1.11

80 Velleius Paterculus: 2.115.5

81 Ovid. *Sorrows*: 2.171–2

82 Cicero. *On Duties*: 2.27

83 The opening of Augustus's record of achievements, the *Res Gestae*

84 Virgil. *Aeneid*: 1.279

85 Albinovanus Pedo: 3, quoted in Benario, p. 166. 'The realm of shadow' is specifically a reference to the Wadden Sea. The poem describes a naval expedition in AD 16.

86 Tacitus: 2.24

87 Tacitus. *Germania*: 4

88 Or possibly, on some interpretations, in 10 BC.

89 Strabo: 4.4.2

90 Ovid. *Amores*: 1.14.45–6

91 Tacitus. *Germania*: 19

92 Cassius Dio: 56.18

93 Velleius Paterculus: 2.118.2

94 Florus: 30.3

95 Suetonius. *The Deified Augustus*: 23

96 Ibid. *Tiberius*: 21.3. The phrase was Augustus's own.

97 Ibid. Augustus was quoting – or rather adapting – the poet Ennius.

98 Ovid. *Black Sea Letters*: 2.1.37–8

99 Ibid: 2.1.61–2

100 Seneca. *On Benefits*: 3.38.2

101 *Consolation to Livia*: 356

102 Tacitus: 5.1
103 Ibid
104 Cicero. *On the Republic*: 1.67
105 Ovid. *Black Sea Letters*: 3.1.118
106 Velleius Paterculus: 2.130.5
107 Ovid. *Black Sea Letters*: 3.1.125
108 Suetonius. *The Deified Augustus*: 64.2
109 Such, at any rate, is the evidence of an inscription found at Rhegium, which records a freedwoman of Julia's having a mother who was a freedwoman of Livia's. See Barrett (2002), p. 51.
110 Tacitus: 4.71
111 The inscription is quoted by Flory, p. 318. The temple was that of *Fortuna Muliebris*, 'Female Fortune'. The same inscription can be found on the Arch of Ticinum: '*Drusi f. uxori Caesaris Augusti*'.
112 Livy: 8.18.6
113 Virgil. *Georgics*: 128–30
114 Suetonius. *The Deified Augustus*: 51.3
115 Seneca the Elder. *Controversies*: 10, Preface 5
116 Tacitus: 1.72
117 Velleius Paterculus: 126.3
118 Suetonius. *The Deified Claudius*: 3
119 Ibid: 41.2
120 Cassius Dio: 55.32
121 Tacitus: 1.5
122 Velleius Paterculus: 11.123.1
123 Ibid: 11.123.2
124 Suetonius. *The Deified Augustus*: 99.1
125 Tacitus: 1.6. Pettinger (p. 178, n. 28) convincingly argues that the details of this episode derived from Tacitus's reading of a source unconsulted by other historians: the memoirs of Germanicus's daughter (and the mother of the Emperor Nero), Agrippina. 'Tacitus, in using the private memoirs of the younger Agrippina, has landed a scoop . . .'
126 Ibid
127 Suetonius. *Tiberius*: 22
128 Ibid: 23
129 Tacitus: 6

4 *The Last Roman*

1 The garden had originally belonged to Pompey.
2 Ovid. *Black Sea Letters*: 4.13.27

3 Suetonius. *The Deified Augustus*: 99.1
4 Tacitus: 1.11
5 Suetonius. *Tiberius*: 21.2
6 Velleius: 2.126.3
7 Tacitus: 1.13
8 Cassius Dio: 56.26
9 Velleius: 2.124.2
10 Cassius Dio: 57.1
11 Suetonius. *Tiberius*: 25.1
12 The suggestion is Syme's (1986), p. 300
13 Suetonius. *Tiberius*: 24.1
14 Tacitus: 1.17
15 Luke 7.8
16 Tacitus: 1.23
17 Ibid: 1.51
18 Velleius: 2.125.1–2
19 '*Senatus Consultum de Cn. Pisone Patre*': line 161
20 Tacitus: 3.33. The words are those of Severus Caecina, Germanicus's deputy on the Rhine, following his return from the front. The influence of Agrippina on his sentiments can only be surmised.
21 Valerius Maximus: 3.2.2
22 Tacitus: 2.26
23 Velleius: 2.129.2
24 Tacitus: 1.33
25 Suetonius. *Tiberius*: 50.3
26 Tacitus: 1.53
27 Velleius: 2.126.3
28 Tacitus: 2.39
29 Ibid: 2.40
30 Ibid
31 Tacitus: 2.26
32 Valerius Maximus: 5.5
33 See Syme (1980), p. 336: 'the surmise is easy'.
34 Seneca. *On Anger*: 1.18
35 Cicero: *The Republic*: 5.1.2
36 Tacitus: 4.38
37 Cassius Dio: 57.15
38 Tacitus: 2.43
39 Ibid: 2.53
40 Artemon. *Anthologia Graeca*: 12.55
41 Paraphrase of an anecdote in Josephus's *Antiquities of the Jews*: 18.171–6

42 Polybius: 31.4

43 Tacitus: 1.55

44 Ibid: 2.57

45 Philo. *Special Laws*: 3.174

46 Ehrenberg and Jones, p. 138 (320b)

47 *Res Gestae*: 27

48 Tacitus: 2.71

49 'Senatus Consultum de Cn. Pisone Patre': lines 55–6

50 Ibid: line 46

51 Tacitus: 2.83

52 Ibid: 3.4

53 Ibid: 3.15

54 See Versnel, pp. 383–7

55 Ovid. *Fasti*: 2.551

56 Ovid. *Black Sea Letters*: 4.8.49–51

57 Seneca. *On Benefits*: 5.25.2

58 Seneca the Elder. *Controversies*: 10.3.5

59 Statius. *Silvae*: 3.3.200–1

60 'Senatus Consultum de Cn. Pisone Patre': lines 115–16

61 A phrase that appears on a number of Tiberius's coins.

62 Tacitus: 3.34

63 Ibid: 4.8

64 Ibid: 3.65

65 Ibid: 11.21

66 Cicero. *On Duties*: 2.50

67 Tacitus: 4.34

68 Seneca. *To Marcia, On Consolation*: 22.5

69 Tacitus: 6.7

70 Pliny: 26.2

71 For the likelihood that Tiberius coined the word, see Champlin: http://
 www.princeton.edu/~pswpc/pdfs/champlin/090601.pdf, pp. 5–6

72 Tacitus: 4.52

73 Ibid: 4.54

74 For the rumours linking Gallus to Agrippina, see Shotter (1971), pp. 454–5

75 Tacitus: 4.40

76 Ibid: 4.41

77 Strabo: 5.4.8

78 For the likelihood that Tiberius identified with Ulysses, see Stewart, pp.
 87–8. For a fascinating meditation on the broader implications of this self-
 identification, see Champlin's *Tiberiana* essay, 'Tales of Brave Ulysses'. Juvenal,
 writing a century later, explicitly compared Tiberius to Ulysses (10.84).

79 Ovid. *Metamorphoses*: 3.158–9

80 Cassius Dio: 58.4

81 I am indebted to Llewelyn Morgan for pointing this out.

82 Pliny: 8.145

83 Suetonius. *Caligula*: 22.2

84 Tacitus: 3.55

85 Cassius Dio: 58.5

86 Tacitus: 4.2.

87 Valerius Maximus: 9.11.ext.4

88 The details of Apicata's suicide are derived from an inscription which records that someone connected to Sejanus – almost certainly his wife – committed suicide eight days after the execution of Sejanus himself. It is possible, though, as Jane Bellemore has argued, that the person referred to in the inscription was not Apicata but Livilla – in which case we would have evidence that the couple had secretly married at some point. The case is open.

89 Tacitus: 6.6

90 Plutarch: fr. 182, in *Plutarch's Moralia*, ed. F. H. Sandbach (1969)

91 Suetonius. *Tiberius*: 60

92 Ovid. *Loves*: 3.4.25

93 Tacitus: 6.1

94 Tacitus: 6.20

95 Suetonius. *Caligula*: 11

96 Philo. *Embassy to Gaius*: 142

97 For the location and height of this lighthouse, see Champlin (*Journal of Roman Studies*, 2011), p.96.

98 Tacitus: 6.46

99 Seneca. *Letters*: 43.3

5 Let Them Hate Me

1 Suetonius. *Tiberius*: 75.1

2 Suetonius. *Caligula*: 15.1

3 Ibid: 14.1

4 Philo. *On the Embassy to Gaius*: 41

5 Tacitus: 3.24

6 Josephus. *Antiquities of the Jews*: 18.256

7 Cassius Dio: 59.7.4

8 Augustus's legislation on seating had initially targeted theatres, then amphitheatres – but the precise legal situation of the Circus Maximus is not clear. According to Cassius Dio (55.22), senators and equestrians were

allocated seats there by Augustus; but Suetonius describes them as sitting among the rest of the Roman people until the time of Claudius (*Deified Claudius*: 21.3).

9 Philo. *On the Embassy to Gaius*: 45
10 Suetonius. *Caligula*: 29
11 Petronius: 117
12 Seneca. *On Providence*: 4.4
13 Tacitus. 4.62
14 Seneca. *Letters*: 7.5
15 Cassius Dio: 59.22.7
16 Suetonius. *Caligula*: 24.1
17 Seneca. *To Polybius on Consolation*: 17.5
18 Homer. The *Iliad*: 2.204. Caligula is described as quoting it in Suetonius's biography of him (22.1).
19 Cassius Dio: 59.18.5
20 Ibid: 59.16.5–6
21 Ibid: 59.16.11
22 Ibid: 59.16.6
23 See Winterling (2011), p. 108, for this interpretation of an event that Cassius Dio (59.20.1–3) has badly garbled.
24 See Barrett (1989), pp. 125–6. The clinching evidence for Caligula's recruitment of the two legions is provided by the tombstone of a centurion: Smallwood, p. 278.
25 From an inscription recording the *Acta Fratrum Arvalium* – the protocols of a priestly brotherhood named the Arvals. It appears in Smallwood, p. 14.
26 The link between Gaeticulus and Lepidus is only made specific once, in a throwaway comment by Suetonius (*The Deified Claudius*: 9.1). It is strongly implied, though, by Cassius Dio, who describes the executions of the two men, and the exile of Caligula's two sisters, in consecutive sentences.
27 Tacitus: 12.64. Tacitus muddles the Domitia who looked after Nero with her sister, Domitia Lepida.
28 Suetonius. *Caligula*: 29
29 The attack was probably against a tribe called the Canninefates, who lived on an island in the Rhine delta. It appears to have been, at best, indecisive. See Tacitus, *Histories*: 4.15.3.
30 Persius: 6.46
31 Suetonius. *Caligula*: 49.1
32 Cassius Dio: 59.23.3
33 Or so says Suetonius (*Caligula*: 19.1). Cassius Dio says the bridge went from Puteoli to a place near Baiae named Bauli; Josephus that it went to Misenum,

a town on the same promontory where Baiae is located, but too far from
Puteoli to be credible.

34 Suetonius. *Caligula*: 19.3

35 Cassius Dio: 59.17.11

36 Suetonius. *Caligula*: 22.1

37 Josephus. *Antiquities of the Jews*: 19.121

38 Philo. *On the Embassy to Gaius*: 263

39 Quoted by Suetonius (*Caligula*: 30.1) from the poet Accius

40 This is nowhere stated specifically, but can be deduced by cross-referencing
the account of the conspiracy in Cassius Dio with Tacitus's mention of a
senator forced to commit suicide under Nero who, twenty-six years earlier,
had betrayed a conspiracy to Caligula. See Barrett (1996, pp. 156–7) and
Winterling (2011, pp. 136–7).

41 Seneca. *On Anger*: 3.19.2

42 Suetonius. *Caligula*: 30.1

43 Cassius Dio: 59.26.9

44 Ibid: 59.27.6

45 Josephus. *Antiquities of the Jews*: 19.86

46 Seneca. *On Anger*: 2.33.4

47 Cassius Dio: 59.29.9

48 Ibid

49 Suetonius. *Caligula*: 41.1. The story has been widely doubted, but attempts
to explain it away seem to me less plausible than the supposition that it was
simultaneously an attack on the prestige of the nobility, a satire on Augustan
values, and a typically Caligulan amplification of the sexual fantasies enacted
on Capri.

50 Seneca. *On Firmness*: 18.1

51 Ibid: 18.2

52 Cassius Dio: 59.29.2

53 Ibid: 59.25.7

54 Philo. *On the Embassy to Gaius*: 338

55 This account derives principally from Josephus, whose sources for the
assassination of Caligula were excellent. Suetonius gives two alternative
accounts, which nevertheless differ only slightly in the details. According to
one of them, the first blow to hit Caligula was to the chin.

56 Such, at any rate, is the evidence of Seneca (*On Firmness*: 18.3).

57 Cassius Dio: 59.29.7

58 Josephus. *Antiquities of the Jews*: 19.199

59 It is Josephus who tells us that Caesonia was killed several hours after her
husband's death. According to Suetonius, she and her daughter were with
Caligula when he was attacked, and died alongside him.

6 Io Saturnalia!

1 Josephus. *Antiquities of the Jews*: 19.115

2 Ibid: 19.159

3 Ibid: 19.168

4 Cassius Dio: 60.1.3

5 Suetonius. *The Deified Claudius*: 10.3

6 Ibid: 3.2

7 The phrase is found on a coin of Claudius's, dated AD 41/2. The formula *EX.S.C.* confirms that it was a decree of the Senate's.

8 See Suetonius, *The Deified Claudius*: 10.4. For the finances of Claudius's expenditure on the military, see Campbell (1984), pp. 166–8 and Osgood (2011), pp. 35–7.

9 Tacitus. *Histories*: 4.74

10 Suetonius. *The Deified Augustus*: 101.4

11 Josephus. *Antiquities of the Jews*: 19.64

12 Ibid: 19.65

13 Statius. *Silvae*: 3.3.64–6

14 Dionysius of Halicarnassus: 4.23.2

15 Ovid. *Loves*: 1.8.64

16 Tacitus: 13.27

17 Horace. *Satires*: 1.6.45

18 Horace. *Epodes*: 4.6

19 Seneca. *Letters*: 47.10

20 Dionysius of Halicarnassus: 4.23.2

21 Catullus: 14.15

22 Horace. *Epodes*: 4.5

23 Pliny the Younger. *Letters*: 3.16.6

24 See Bradley (1994), pp. 166–7

25 Herodotus: 4.184

26 Pliny: 5.1.14

27 Vitruvius: 8.2.24

28 Pliny: 30.13

29 The surrender of the king of Orkney to Claudius comes in a late history, that of Eutropius but seems to derive from a reliable source. Tellingly, the detail that the Orkneys are thirty in number comes from a geographer, Pomponius Mela, who was writing even as Claudius was returning from Britain, and bruiting his achievements. See Stevens (1951 (1)). An alternative theory holds that Eutropius had confused Claudius's campaign with a later one, that of Tacitus's father-in-law, Agricola, who in AD 83 sent a fleet which circumnavigated Britain.

30 Suetonius. *The Deified Claudius*: 17.3

31 Seneca. *To Polybius on Consolation*: 14.1

32 Tacitus: 12.38

33 Boatwright convincingly argues that Claudius made the entire tradition up, relying on his reputation for antiquarian scholarship to ensure that the claim would be widely accepted.

34 Frontinus: 16

35 Artemidorus: 2.9

36 Pliny: 36.123

37 Seneca. *On Benefits*: 4.28.2

38 Acts 11.28

39 The estimate of the annual amount of grain imported is Aldrete's (p. 134).

40 Cassius Dio: 60.11.3

41 See Williams (2010), p. 190, for this analogy.

42 Suetonius. *Galba*: 22

43 Seneca. *Trojan Women*: 91

44 Tacitus. 9.2, 'Mollitiam corporis' – literally, 'softness of body'. *Mollitia*, when applied to a man, did not just mean soft, but soft like a woman: the kind of man, in other words, who allowed himself to be fucked.

45 Cassius Dio: 60.2.4

46 Ovid. *Loves*: 2.17.1

47 Cicero. *Republic*: 1.67

48 Suetonius. *Vitellius*: 2.5

49 Ovid. *The Art of Loving*: 3.215–16

50 Seneca. *On Benefits*: 6.32.1

51 Juvenal: 6.129

52 Tacitus: 11.30

53 Ibid: 11.31

54 Ibid: 11.35

55 Ibid: 11.36. See Williams (2010), p. 217, for the strong likelihood, if not absolute certainty, that the Suillius Caesonius mentioned by Tacitus as 'playing the woman's role' was the son of Asiaticus's prosecutor. As Williams says, 'This is a rare moment in the midst of the innuendoes and accusations that pervade Roman texts, a moment when we come temptingly close to being able to ascertain what actually happened.'

56 Tacitus (12.1–2) describes Narcissus, Callistus and Pallas as each pitching a different woman to their master: a scene so reminiscent of the episode from Greek mythology in which three goddesses staged a beauty pageant before the Trojan prince Paris as to be obviously fictional. Nevertheless, with Pallas a strong partisan of Agrippina's, and Narcissus just as obviously opposed to her cause, it does provide an entertaining allegory of Claudius's court.

57 Suetonius. *Claudius*: 39.2

58 Tacitus: 12.6

59 *Octavia*: 142. The play was traditionally, if implausibly, ascribed to Seneca. Its true authorship remains unknown.

60 Tacitus: 12.7

61 Ibid

62 Suetonius. *Claudius*: 41.2

63 Tacitus: 12.42

64 Seneca. *To Polybius on Consolation*: 12.3

65 Suetonius. *Claudius*: 43

66 Cassius Dio: 61.35.4

67 Suetonius. *Nero*: 9

7 *What an Artist*

1 *Octavia*: 156

2 Tacitus: 12.37

3 Cassius Dio: 61.7.3

4 Suetonius. *Nero*: 10.1

5 Seneca. *On Mercy*: 1.14.2

6 Tacitus: 13.13

7 Ibid: 15.42

8 Suetonius. *Otho*: 3.1

9 Tacitus: 13.14

10 So, at any rate, says Tacitus. Suetonius claims that Britannicus was cremated the day after his death.

11 *Octavia*: 169–70

12 Seneca. *On Mercy*: 1.16.2

13 Pliny: 16.200

14 It is possible that Nero's successors agreed. Trajan, an emperor in the early second century ad, and who was consistently rated by the Romans as their best, is supposed to have declared that 'no emperor had been the equal of Nero during the first five years of his reign'. Trajan too built a great harbour at Ostia; and it has been credibly suggested that he was paying tribute to Nero's own record there (Thornton, 1989).

15 Calpurnius Siculus: 7.45–6

16 Cassius Dio: 61.12.2

17 Ibid: 61.5.4

18 *Octavia*: 125

19 Pliny: 37.50

20 Cassius Dio: 61.11.4

21 Ibid: 61.2.2

22 Ibid: 61.13.2

23 Horace. *Epistles*: 1.1.83

24 So reports Tacitus, at any rate. According to Cassius Dio, Agrippina made it to the shore unaided. Dio also reports that the ship sank straight away.

25 Tacitus: 14.8

26 Cassius Dio: 61.14.2

27 For the theatricality of Agrippina's murder, see Baldwin and especially the brilliant book on Nero by Champlin (2003), pp. 84–111.

28 Tacitus: 14.10

29 The games were called by Nero *Ludi Maximi*, 'The Greatest Ever Games'.

30 Seneca. *Natural Questions*: 12.3

31 Tacitus: 14.15

32 This was Aelia Catella, cited by Cassius Dio (61.19.2). 'Aelia Catella is assumed a daughter of Sex. Aelius Catus, hence sister of Aelia Patina' (Syme 1986, n. 79). Aelia Patina had been Claudius's second wife. He had married her in 28 and divorced her in 31.

33 Cassius Dio: 19.20.5

34 Seneca. *Letters*: 14.6

35 Tacitus, although our best source for the events of Boudicca's revolt, mistakenly dates it to AD 61.

36 Seneca. *Medea*: 371–2

37 Seneca. *Medea*: 376–9. The play is ostensibly referring to the Greek hero Jason and his voyages with the Argonauts, but it is clear that Seneca has Roman expansion into Britain on his mind as well.

38 Seneca. *On Benefits*: 7.3.2

39 Seneca. *On Benefits*: 7.27.1

40 Tacitus: 14.37

41 Tacitus. *Agricola*: 19

42 Pliny: 3.39

43 Tacitus: 11.23

44 Ibid: 11.24

45 Ibid: 15.44

46 Quoted by Augustine in *The City of God*, 6.10

47 Valerius Maximus: 1.3.3

48 Quoted by Augustine in *The City of God*, 6.11

49 Tacitus: 14.44

50 Ibid: 14.45

51 Seneca. *On the Happy Life*: 7.3

52 Cassius Dio: 62.13.2

53 Ibid: 62.13.4

54 Calpurnius Siculus: 1.49–51

55 Seneca. *Natural Questions*: 3.29.9
56 Cassius Dio: 62.28.1
57 Tacitus: 15.37
58 Ibid
59 According to Chinese records, the comet was visible for seventy-five days, between 3 May and 16 July. See Rogers, p. 1953.
60 Cassius Dio (62.18.2) says that two-thirds of Rome was destroyed, while Tacitus (15.40.2) says of the fourteen districts into which the city was divided, only four were left untouched by the fire. Archaeological evidence suggests that they were both exaggerating. See Newbold, p. 858.
61 Tacitus: 15.44
62 Pliny: 10.2.5
63 Pliny the Younger. *Panegyric in Praise of Trajan*: 46.4
64 Martial. *On Spectacles*: 2.8
65 Ibid: 2.4
66 The estimate is Albertson's, who suggests, based on the various figures given for the height of the statue, that was 31.5 metres tall.
67 Pliny: 34.45
68 For an elucidation of this extraordinary episode, reported by both Suetonius and Cassius Dio, see Champlin (2003), pp. 169–71.
69 Suetonius. *Nero*: 55
70 Tacitus: 15.67
71 Ibid: 15.60
72 Seneca. *On Providence*: 3.3
73 Seneca. *Letters*: 71.21
74 Ibid: 101.10
75 Tacitus: 15.73
76 Ibid: 15.62
77 Ibid: 15.68
78 Ibid: 16.4
79 Cassius Dio: 63.26.3
80 Ibid: 62.18.3. Seneca delivered the warning in the wake of Agrippina's murder.
81 Ibid: 63.4.2
82 Ibid: 63.6.1
83 No chronological account of Nero's sojourn in Greece has survived. Estimates of when precisely he might have arrived in Corinth range from August to November.
84 Livy: 33.32
85 Cassius Dio: 63.15.1
86 Valerius Maximus: 2.4.2
87 Seneca. *Letters*: 80.7

88 Tacitus: 13.3

89 An ancient commentator on the satirist Juvenal tells us that an aristocratic and intimidatingly learned woman who is described by the poet as taking an interest in the arts of oratory was none other than Statilia Messalina. *Scholiast on Juvenal*: 6.434

90 Seneca: 47.7. The details of how to keep boys hairless derive from Pliny: 30.41.

91 The translation of 'Paezon' as 'Boy Toy' is Champlin's (2012), p. 380. The gasps of wonder are Pliny's (7.129).

92 Tacitus. *Histories*: 1.73

93 Dio Chrysostom. *On Beauty*: 11

94 Cassius Dio: 63.22.1

95 From an inscription found in 1887 at Karditza, Greece. Smallwood, p. 64

96 Plutarch. *Galba*: 4.1

97 Seneca. *On Mercy*: 1.4.2

98 Virgil. *Georgics*: 512–14

99 Cassius Dio: 63.20.5

100 Evidence for this having been more than coincidence is circumstantial but strong.

101 Suetonius. *Nero*: 41

102 Ibid

103 Ibid: 43

104 Plutarch. *Galba*: 6.3

105 Suetonius. *Nero*: 47.2. The line is a quotation from Virgil.

106 Suetonius. *Nero*: 49.2

107 Ibid: 49.4

108 Dio Chrysostom. *On Beauty*: 10

109 Revelation 13.3

110 Ibid: 17.8

111 Ibid: 17.4

112 Both Suetonius (*Nero*: 49.1) and Cassius Dio (6.29.2) record it. It was evidently, as Dio says, 'a much quoted saying'.

BIBLIOGRAPHY

Albertson, Fred C., 'Zenodorus's 'Colossus of Nero', *Memoirs of the American Academy in Rome* 46, 2001

Aldrete, Gregory S., *Floods of the Tiber in Ancient Rome* (Baltimore, 2007)

Alston, R., Aspects of Roman History AD 14–117 (London, 1998)

Andrade, Nathanael J., *Syrian Identity in the* Greco-Roman *World* (Cambridge, 2013)

Andreau, Jean and Raymond Descat, *The Slave in Greece and Rome*, tr. Marion Leopold (Madison, 2006)

Badel, Christophe, *La Noblesse de l'Empire Romain: Les Masques et la Vertu* (Seyssel, 2005)

Baker, G.P., *Tiberius Caesar* (New York, 1928)

Baldwin, B., 'Nero and his Mother's Corpse', *Mnemosyne* 32, 1979

Ball, Warwick, *Rome in the East: The Transformation of an Empire* (London, 2000)

Balsdon, J.P.V.D., *The Emperor Gaius (Caligula)* (Oxford, 1934)

Barrett, Anthony A., *Caligula: The Corruption of Power* (New Haven, 1989)

——*Agrippina: Sister of Caligula, Wife of Claudius, Mother of Nero* (London, 1996)

——*Livia: First Lady of Imperial Rome* (New Haven, 2002)

Barry, William D., 'Exposure, Mutilation, and Riot: Violence at the 'Scalae Gemoniae' in Early Imperial Rome', *Greece & Rome* 55, 2008

Barton, Carlin A., *Roman Honor: The Fire in the Bones* (Berkeley and Los Angeles, 2001)

Bartsch, Shadi, *Actors in the Audience: Theatricality and Doublespeak from Nero to Hadrian* (Cambridge, Mass., 1994)

Batty, Roger, *Rome and the Nomads: The* Pontic-Danubian *Realm in Antiquity* (Oxford, 2007)

Bauman, Richard A., *Women and Politics in Ancient Rome* (London, 1992)

Beard, Mary, 'The Sexual Status of Vestal Virgins', *Journal of Roman Studies* 70, 1980

——*The Roman Triumph* (Cambridge, Mass., 2007)

Bellemore, Jane: 'The Wife of Sejanus', *Zeitschrift für Papyrologie und Epigraphik* 109, 1995

Benario, Herbert W., 'The Text of Albinovanus Pedo', *Latomus* 32, 1973

Bergmann, M., 'Der Koloss Neros, die Domus Aurea und der Mentalitätswandel im Rom der frühen Kaiserzeit', *Trierer Winckelmannsprogramme* 13, 1993

Bicknell, P., 'The Emperor Gaius' military activities in AD 40', *Historia* 17, 1968

Bingham, S., 'Life on an island: a brief study of places of exile in the first century AD', *Studies in Latin Literature and Roman History* 11, 2003

Birley, Anthony, 'Sejanus: His Fall' in *Corolla Cosmo Rodewald. Monograph Series Akanthina 2*, ed. Nicholas Sekunda (Gdansk, 2007)

Boatwright, M.T., 'The Pomerial Extension of Augustus', *Historia* 35, 1986

Bradley, Keith, *Suetonius' Life of Nero: An Historical Commentary* (Brussels, 1978)

——'The Chronology of Nero's Visit to Greece A.D. 66/67', *Latomus* 37, 1978

——'Nero's Retinue in Greece, A.D. 66/67', *Illinois Classical Studies* 4, 1979

——*Slavery and Society at Rome* (Cambridge, 1994)

Bradley, Keith and Paul Cartledge (eds), *The Cambridge World History of Slavery: The Ancient Mediterranean World* (Cambridge, 2011)

Brunt, P.A., *Italian Manpower, 225 B.C.–A.D. 14* (Oxford, 1971)

——*Social Conflicts in the Roman Republic* (London, 1971)

——'The Role of the Senate in the Augustan Regime', *Classical Quarterly* 34, 1984

——*The Fall of the Roman Republic, and Related Essays* (Oxford, 1988)

Buckley, Emma and Martin T. Dinter, *A Companion to the Neronian Age* (Chichester, 2013)

Campbell, Brian and Lawrence A. Tritle (eds), *The Oxford Handbook of Warfare in the Classical World* (Oxford, 2013)

Campbell, J.B., *The Emperor and the Roman Army* (Oxford, 1984)

Cancik, Hubert and Helmuth Schneider (eds), *Brill's New Pauly* (Brill, 2009)

Carandini, Andrea, *La Casa di Augusto dai 'Lupercalia' al Natale* (Rome, 2008)

——*Rome: Day One*, tr. Stephen Sartarelli (Princeton, 2011)

Carey, Sorcha, 'A Tradition of Adventures in the Imperial Grotto', *Greece & Rome* 49, 2002

Carlson, Deborah N., 'Caligula's Floating Palaces', *Archaeology* 55, 2002

Cartledge, Paul, 'The Second Thoughts of Augustus on the res publica in 28/7 B.C.', *Hermathena* 119, 1975

Chamberland, Guy, 'A Gladiatorial Show Produced *In Sordidam Mercedem* (Tacitus *Ann.* 4.62)', *Phoenix* 61, 2007

Champlin, E., 'Nero Reconsidered', *New England Review* 19, 1998

——*Nero* (Cambridge, Mass., 2003)

——'Nero, Apollo, and the Poets', *Phoenix* 57, 2003

——'God and Man in the Golden House', in Cima and la Rocca

——'Sex on Capri', *TAPA* 141, 2011

——'Tiberius and the Heavenly Twins', Journal of Roman Studies, 101, 2011

——'Seianus Augustus', *Chiron* 42, 2012

——*Tiberiana 1–4*, Princeton/Stanford Working Papers in Classics http://www.princeton.edu/~pswpc/papers/authorAL/champlin/champlin.html

Chilver, G.E.F., *A Historical Commentary on Tacitus' Histories I and II* (Oxford, 1979)

Cima, Maddalena and Eugenio la Rocca, *Horti Romani* (Rome, 1995)

Claassen, Jo-Marie, *Ovid Revisited: The Poet in Exile* (London, 2008)

Claridge, Amanda, *Rome: An Oxford Archaeological Guide* (Oxford, 2010)

Coarelli, Filippo, *Rome and Environs: An Archaeological Guide*, tr. James J. Clauss and Daniel P. Harmon (Berkeley and Los Angeles, 2007)

Coates-Stephens, Robert, *Porta Maggiore: Monument and Landscape: Archaeology and Topography of the Southern Esquiline from the Late Republican Period to the Present* (Rome, 2004)

Cohen, Sarah T., 'Augustus, Julia and the Development of Exile *Ad Insulam*', *Classical Quarterly* 58, 2008

Coleman, K.M., 'Fatal Charades: Roman Executions Staged as Mythological Enactments', *Journal of Roman Studies* 80, 1990

Colin, Jean, 'Juvénal et le mariage mystique de Gracchus', *Atti della Accademia delle Scienze di Torino* 90, 1955–6

Commager, Steele, 'Horace, *Carmina* 1.37', *Phoenix* 12, 1958

Cooley, Linda, 'The Moralizing Message of the *Senatus Consultum de Cn. Pisone Patre*', *Greece & Rome* 45, 1998

Corbier, Mireille, 'Child Exposure and Abandonment', in Dixon (2001)

Cornell, T.J., *The Beginnings of Rome: Italy and Rome from the Bronze Age to the Punic Wars (c. 1000–264 BC)* (London, 1995)

Crook, John, *Consilium Principis: Imperial Councils and Counsellors from Augustus to Diocletian* (Cambridge, 1955)

Dalby, Andrew, *Empire of Pleasures: Luxury and Indulgence in the Roman World* (London, 2000)

D'Amato, Raffaele, *Arms and Armour of the Imperial Roman Soldier: From Marius to Commodus, 112 BC–AD 192* (Barnsley, 2009)

D'Arms, John, *Romans on the Bay of Naples: A Social and Cultural Study of the Villas and Their Owners from 150 B.C. to A.D. 400* (Cambridge, Mass., 1970)

Dasen, Véronique and Thomas Späth, *Children, Memory, and Family Identity in Roman Culture* (Oxford, 2010)

Davis, P.J., *Ovid and Augustus: A Political Reading of Ovid's Erotic Poems* (London, 2006)

Dear, David R., *Roman Coins and Their Values: The Republic and the Twelve Caesars 280 BC–AD 96* (London, 2000)

De La Bédoyère, Guy, *Defying Rome: The Rebels of Roman Britain* (Stroud, 2003)

Demougin, S., *L'Ordre Équestre sous les* Julio-Claudiens (Paris, 1988)

Dixon, Suzanne, *The Roman Mother* (London, 1988)

——*The Roman Family* (Baltimore, 1992)

Dixon, Suzanne (ed.), *Childhood, Class and Kin in the Roman World* (London, 2001)

Drogula, Fred K., 'Controlling Travel: Deportation, Islands and the Regulation of Senatorial Mobility in the Augustan Principate', Classical Quarterly 61, 2011

Dueck, Daniela, *Strabo of Amasia: A Greek Man of Letters in Augustan Rome* (Abingdon, 2000)

Dupont, Florence, *Daily Life in Ancient Rome*, tr. Christopher Woodall (Oxford, 1992)

Du Quesnay, Ian M. Le M., '*Amicus Certus in Re Incerta Cernitur*: Epode 1', in Woodman and Feeney

Eck, Walter, *The Age of Augustus*, tr. Deborah Lucas Schneider and Robert Daniel (Oxford, 2007)

Edmondson, Jonathan (ed.), *Augustus* (Edinburgh, 2009)

Edwards, Catherine, 'The Truth about Caligula?', Classical Review 41, 1991

——*The Politics of Immorality in Ancient Rome* (Cambridge, 1993)

——*Death in Ancient Rome* (New Haven, 2007)

Ehrenberg, V. and A.H.M. Jones, *Documents Illustrating the Reigns of Augustus and Tiberius* (Oxford, 1955)

Elsner, Jás and Jamie Masters, *Reflections of Nero: Culture, History & Representation* (London, 1994)

Erdkamp, Paul (ed.), *A Companion to the Roman Army* (Oxford, 2011)

Evenpoel, Willy, 'Maecenas: A Survey of Recent Literature', Ancient Society 21, 1990

Eyben, Emiel, *Restless Youth in Ancient Rome*, tr. Patrick Daly (London, 1993)

Fagan, Garrett G., 'Messalina's Folly', Classical Quarterly 52, 2002

——*The Lure of the Arena: Social Psychology and the Crowd at the Roman Games* (Cambridge, 2011)

Fantham, Elaine, *Julia Augusti: The Emperor's Daughter* (Abingdon, 2006)

Favro, Diane, *The Urban Image of Augustan Rome* (Cambridge, 1996)

Fears, J. Rufus, 'The Theology of Victory at Rome: Approaches and Problems', *Aufstieg und Niedergant der römischen Welt* 2, 1981

Ferrill, A., *Caligula: Emperor of Rome* (London, 1991)

Flory, Marleen Boudreau, 'Sic Exempla Parantur: Livia's Shrine to Concordia and the Porticus Liviae', *Historia* 33, 1984

Flower, Harriet I., 'Rethinking "Damnatio Memoriae": The Case of Cn. Calpurnius Piso Pater in AD 20', *Classical Antiquity* 17, 1998

——'Piso in Chicago: A Commentary on the APA/AIA Joint Seminar on the "Senatus Consultum de Cn. Pisone Patre"', *American Journal of Philology* 120, 1999

——'The Tradition of the *Spolia Opima*: M. Claudius Marcellus and Augustus', *Classical Antiquity* 19, 2000

——*The Art of Forgetting: Disgrace & Oblivion in Roman Political Culture* (Chapel Hill, 2006)

Flower, Harriet I. (ed.), *The Cambridge Companion to the Roman Republic* (Cambridge, 2004)

Forsythe, Gary, *A Critical History of Early Rome: From Prehistory to the First Punic War* (Berkeley and Los Angeles, 2005)

Fraenkel, Eduard, *Horace* (Oxford, 1957)

Freudenburg, Kirk, 'Recusatio as Political Theatre: Horace's Letter to Augustus', *Journal of Roman Studies* 104, 2014

Galinsky, Karl, *Augustan Culture* (Princeton, 1996)

——*The Cambridge Companion to the Age of Augustus* (Cambridge, 2005)

Gambash, Gil, 'To Rule a Ferocious Province: Roman Policy and the Aftermath of the Boudiccan Revolt', *Britannia* 43, 2012

Gibson, A.G.G., *The* Julio-Claudian *Succession: Reality and Perception of the 'Augustan Model'* (Leiden, 2013)

Ginsburg, Judith, *Representing Agrippina: Constructions of Female Power in the Early Roman Empire* (Oxford, 2006)

Goldsworthy, Adrian, *Antony and Cleopatra* (London, 2010)

Goodman, Martin, *The Roman World: 44 BC–AD 180* (London, 1997)

——*Rome & Jerusalem: The Clash of Ancient Civilizations* (London, 2007)

Goudineau, C. and A. Ferdière (eds), *Les Villes Augustéennes de Gaule* (Autun, 1985)

Gowing, Alain M., *Empire and Memory: The Representation of the Roman Republic in Imperial Culture* (Cambridge, 2005)

Grandazzi, Alexandre, *The Foundation of Rome: Myth and History*, tr. Jane Marie Todd (Ithaca, 1997)

Gray-Fow, Michael J.G., 'Why the Christians? Nero and the Great Fire', *Latomus* 57, 1998

Green, C.M.C., 'Claudius, Kingship, and Incest', *Latomus* 57, 1998

——'The Slayer and the King: 'Rex Nemorensis' and the Sanctuary of Diana', *Arion* 7, 2000

Green, Peter, '*Carmen et Error*: The Enigma of Ovid's Exile', in *Classical Bearings: Interpreting Ancient History and Culture* (Berkeley and Los Angeles, 1989)

Grether, Gertrude, 'Livia and the Roman Imperial Cult', *American Journal of Philology* 67, 1946

Griffin, Jasper, 'Augustus and the Poets: "*Caesar qui cogere posset*"', in Miller and Segal

Griffin, Miriam T., *Nero: The End of a Dynasty* (New Haven, 1984)

——*Seneca: A Philosopher in Politics* (Oxford, 1992)

Grossi, Olindo, 'The Forum of Julius Caesar and the Temple of Venus Genetrix', *Memoirs of the American Academy in Rome* 13, 1936

Gruen, Erich S., *The Last Generation of the Roman Republic* (Berkeley and Los Angeles, 1974)

——*Culture and National Identity in Republican Rome* (Ithaca, 1992)

Grüll, Tibor and Lászlo Benke, 'A Hebrew/Aramaic Graffito and Poppaea's Alleged Jewish Sympathy', *Journal of Jewish Studies* 62, 2011

Gurval, Robert Alan, *Actium and Augustus: The Politics and Emotions of Civil War* (Ann Arbor, 1998)

Habinek, Thomas and Alessandro Schiesaro (eds), *The Roman Cultural Revolution* (Cambridge, 1997)

Hallett, Judith P., 'Fulvia, Mother of Iullus Antonius: New Approaches to the Sources on Julia's Adultery at Rome', *Helios* 33, 2006

Hallett, Judith P. and Marilyn B. Skinner, *Roman Sexualities* (Princeton, 1997)

Harrison, S.J., 'Augustus, the Poets, and the Spolia Opima', *Classical Quarterly* 39, 1989

Hekster, O. and J. Rich, 'Octavian and the Thunderbolt: The Temple of Apollo Palatinus and Roman Traditions of Temple Building', *Classical Quarterly* 56, 2006

Henderson, John, 'A Doo-Dah-Doo-Dah-Dey at the Races: Ovid *Amores* 3.2 and the Personal Politics of the *Circus Maximus*', *Classical Antiquity* 21, 2002

Herbert-Brown, Geraldine (ed.), *Ovid's Fasti: Historical Readings at its Bimillennium* (Oxford, 2002)

Hersch, Karen K., *The Roman Wedding: Ritual and Meaning in Antiquity* (Cambridge, 2010)

Hind, J.G.F., 'The Middle Years of Nero's Reign', *Historia* 20, 1971

——'The Death of Agrippina and the Finale of the "Oedipus" of Seneca', *Journal of the Australasian Universities Language and Literature Association* 38, 1972

——'Caligula and the Spoils of Ocean: A Rush for Riches in the Far North-West?' *Britannia* 34, 2000

Hopkins, Keith, *Sociological Studies in Roman History, Volume 1: Conquerors and Slaves* (Cambridge, 1978)

——*Sociological Studies in Roman History, Volume 2: Death and Renewal* (Cambridge, 1983)

Houston, George W., 'Tiberius on Capri', *Greece & Rome* 32, 1985

Humphrey, J., *Roman Circuses: Arenas for Chariot Racing* (London, 1986)

Hurlet, Frédéric, *Les Collègues du Prince sous Auguste et Tibère: de la Légalité Républicaine à la Légitimité Dynastique* (Rome, 1997)

James, Simon, *Rome and the Sword* (London, 2011)

Jenkyns, Richard, *Virgil's Experience: Nature and History: Times, Names, and Places* (Oxford, 1998)

Jeppesen, K.K., '*Grand Camée de France*: Sejanus Reconsidered and Confirmed', *Mitteilungen des Deutschen Archäologischen Institut, Römische Abteilung* 100, 1993

Joshel, Sandra P., 'Female Desire and the Discourse of Empire: Tacitus's Messalina', *Signs: Journal of Women in Culture and Society* 21, 1995

Judge, E. A., '"Res Publica Restituta": A Modern Illusion?', in *Polis and Imperium: Studies in Honour of Edward Togo Salmon*, ed. J.A.S. Evans (Toronto, 1974)

Keppie, Lawrence, '"Guess Who's Coming to Dinner": The Murder of Nero's Mother Agrippina in its Topographical Setting', *Greece & Rome* 58, 2011

Kiernan, V.G., *Horace: Poetics and Politics* (Basingstoke, 1999)

King, Charles W., 'The Roman *Manes*: the Dead as Gods', in *Rethinking Ghosts in World Religions*, ed. Mu-chou Poo (Leiden, 2009)

Kleiner, Fred S., 'The Arch in Honor of C. Octavius and the Fathers of Augustus', *Historia* 37, 1988

Knapp, Robert, *Invisible Romans* (London, 2011)

Knox, Peter E: 'The Poet and the Second Prince: Ovid in the Age of Tiberius', *Memoirs of the American Academy in Rome* 49, 2004

Koortbojian, M., The Divinization of Caesar and Augustus: Precedents, Consequences, Implications (Cambridge, 2013)

Kovacs, Judith and Christopher Rowland, *Revelation* (Oxford, 2004)

Kuttner, *Dynasty and Empire in the Age of Augustus: the Case of the Boscoreale Cups* (Berkeley and Los Angeles, 1995)

Lacey, W.K., 'Octavian in the Senate, January 27 B.C.', *Journal of Roman Studies* 64, 1974

Lange, Carsten Hjort, *Res Publica Constituta: Actium, Apollo and the Accomplishment of the Triumviral Assignment* (Leiden, 2009)

Leach, Eleanor Winsor, 'Claudia Quinta (*Pro Caelio* 34) and an altar to Magna Mater', *Dictynna* 4, 2007

Lega, C., 'Il Colosso di Nerone', *Bullettino della Commissione Archeologica Comunale in Roma*, 1989–90

Leitão, David D., 'Senecan Catoptrics and the Passion of Hostius Quadra (Sen. Nat. 1)', *Materiali e Discussioni per l'Analisi dei Testi Classici* 41, 1998

Lendering, Jona and Arjen Bosman, *Edge of Empire: Rome's Frontier on the Lower Rhine* (Rotterdam, 2012)

Levick, Barbara, 'Tiberius' Retirement to Rhodes in 6 BC', *Latomus* 31, 1972

——*Claudius* (Oxford, 1990)

——*Tiberius the Politician* (London, 1999)

——*Augustus: Image and Substance* (Harlow, 2010)

Littlewood, R.J., 'Ovid among the Family Dead: the Roman Founder Legend and Augustan Iconography in Ovid's *Feralia* and *Lemuria*', *Latomus* 60, 2001

Lobur, John Alexander, Consensus, Concordia *and the Formation of Roman Imperial Ideology* (London, 2008)

Lott, J. Bert, *The Neighbourhoods of Augustan Rome* (Cambridge, 2004)

——*Death and Dynasty in Early Imperial Rome* (Cambridge, 2012)

Luce, T.J., 'The Dating of Livy's First Decade', *TAPA* 96, 1965

Lyne, R.O.A.M., *Horace: Behind the Public Poetry* (New Haven, 1995)

MacMullen, Ramsay, *Enemies of the Roman Order: Treason, Unrest, and Alienation in the Empire* (Cambridge, Mass., 1967)

Malitz, Jürgen, *Nero*, tr. Allison Brown (Oxford, 1999)

Malloch, S.J.V., 'Gaius on the Channel Coast', *Classical Quarterly* 51, 2001

Mattingly, David, *An Imperial Possession: Britain in the Roman Empire* (London, 2006)

——*Imperialism, Power and Identity: Experiencing the Roman Empire* (Princeton, 2011)

Mayor, Adrienne, *The First Fossil Hunters: Paleontology in Greek and Roman Times* (Princeton, 2000)

McGinn, T.A., *Prostitution, Sexuality, and the Law in Ancient Rome* (Oxford, 1998)

McPherson, Catherine, 'Fact and Fiction: Crassus, Augustus and the *Spolia Opima*', *Hirundo* 8, 2009–10

Meiggs, Russell, *Roman Ostia* (Oxford, 1960)

Michels, Agnes Kirsopp, 'The Topography and Interpretation of the Lupercalia', *TAPA* 84, 1953

Miller, Fergus and Erich Segal, *Caesar Augustus: Seven Aspects* (Oxford, 1984)

Miller, J.F., *Apollo, Augustus, and the Poets* (Cambridge, 2009)

Momigliano, Arnaldo, *Claudius: The Emperor and his Achievements* (Oxford, 1961)

Morgan, Llewellyn, 'Tacitus, *Annals* 4.70: An Unappreciated Pun', *Classical Quarterly* 48, 1998

——'The Autopsy of C. Asinius Pollio', *Journal of Roman Studies* 90, 2000

Murdoch, Adrian, *Rome's Greatest Defeat: Massacre in the Teutoburg Forest* (Stroud, 2006)

Murison, C.L., *Galba, Otho and Vitellius: Careers and Controversies* (Hildesheim, 1993)

Nappa, Christopher, *Vergil's* Georgics*, Octavian, and Rome* (Ann Arbor, 2005)

Newbold, R.F., 'Some Social and Economic Consequences of the A.D. 64 Fire at Rome', *Latomus* 33, 1974

Nicolet, Claude, *The World of the Citizen in Republican Rome*, tr. P.S. Falla (London, 1980)

Oliensis, Ellen, *Horace and the Rhetoric of Authority* (Cambridge, 1998)

Olson, Kelly, *Dress and the Roman Woman:* Self-presentation *and Society* (Abingdon, 2008)

Oost, Stewart Irvin, 'The Career of M. Antonius Pallas', *American Journal of Philology* 79, 1958

Osgood, Josiah, *Caesar's Legacy: Civil War and the Emergence of the Roman Empire* (Cambridge, 2006)

——*Claudius Caesar: Image and Power in the Early Roman Empire* (Cambridge, 2011)

Parker, Philip, *The Empire Stops Here: A Journey Along the Frontiers of the Roman World* (London, 2009)

Perrin, Y., 'Êtres Mythiques, Êtres Fantastiques et Grotesques de la Domus Aurea de Néron', *Dialogues d'Histoire Ancienne* 8, 1982

Pettinger, Andrew, *The Republic in Danger: Drusus Libo and the Succession of Tiberius* (Oxford, 2012)

Pollini, John, *From Republic to Empire: Rhetoric, Religion, and Power in the Visual Culture of Ancient Rome* (Norman, 2012)

Potter, David S. (ed.), *A Companion to the Roman Empire* (Oxford, 2010)

Potter, D.S. and D.J. Mattingly: *Life, Death, and Entertainment in the Roman Empire* (Ann Arbor, 1999)

Powell, Lindsay, *Eager for Glory: The Untold Story of Drusus the Elder, Conqueror of Germania* (Barnsley, 2011)

Raaflaub, Kurt A. and Mark Toher (eds), *Between Republic and Empire: Interpretations of Augustus and his Principate* (Berkeley and Los Angeles, 1990)

Ramsey, John T. and A. Lewis Licht, *The Comet of 44 B.C. and Caesar's Funeral Games* (Chicago, 1997)

Renucci, Pierre, *Caligula l'Impudent* (Paris, 2007)

Rich, J.W., 'Augustus and the *Spolia Opima*', *Chiron* 26, 1996

———'Augustus's Parthian Honours, the Temple of Mars Ultor and the Arch in the Forum Romanum', *Papers of the British School at Rome* 66, 1998

Rich, J.W. and J.H.C. Williams, '*Leges et iura p. R. restituit*: A New Aureus of Octavian and the Settlement of 28–27 BC', *Numismatic Chronicle* 159, 1999

Rogers, Robert Samuel, 'The Neronian Comets', *Transactions and Proceedings of the American Philological Association* 84, 1953

———'Heirs and rivals to Nero', *TAPA* 86, 1955

Roller, Duane W., *Through the Pillars of Herakles: Greco-Roman Exploration of the Atlantic* (London, 2006)

Roller, Matthew B., *Constructing Autocracy: Aristocrats and Emperors in Julio-Claudian Rome* (Princeton, 2001)

Romm, James, *Dying Every Day: Seneca at the Court of Nero* (New York, 2014)

Rose, C., *Dynastic Commemoration and Imperial Portraiture in the Julio-Claudian Period* (Cambridge, 1997)

Rosenstein, Nathan, *Imperatores Victi: Military Defeat and Aristocratic Competition in the Middle and Late Republic* (Berkeley and Los Angeles, 1990)

Rosenstein, Nathan and Robert Morstein-Marx, *A Companion to the Roman Republic* (Oxford, 2010)

Rousselle, Aline, 'The Family under the Roman Empire: Signs and Gestures', in *A History of the Family*, vol. 1 (Cambridge, 1996)

Rudich, Vasily, *Political Dissidence Under Nero: The Price of Dissimulation* (London, 1993)

Rutledge, Steven H., *Imperial Inquisitions: Prosecutors and Informants from Tiberius to Domitian* (London, 2001)

Saddington, D.B., '"Honouring" Tiberius on Inscriptions and in Valerius Maximus – a Note', *Acta Classica* 43, 2000

Sailor, Dylan, *Writing and Empire in Tacitus* (Cambridge, 2008)

Saller, R., 'Anecdotes as Historical Evidence for the Principate', *Greece & Rome* 27, 1980

Scullard, Howard Hayes, *Scipio Africanus in the Second Punic War* (Cambridge, 1930)

Seager, Robin, *Tiberius* (Oxford, 2005)

Sealey, Paul R., *The Boudiccan Revolt Against Rome* (Oxford, 2004)

Sebasta, J.L., 'Women's Costume and Feminine Civic Morality in Augustan Rome', *Gender and History* 9.3, 1997

Shatzman, Israël, *Senatorial Wealth and Roman Politics* (Latomus, 1975)

Shaw, Brent D., 'Raising and Killing Children: Two Roman Myths', *Mnemosyne* 54, 2001

Shotter, D.C.A., 'Tacitus, Tiberius and Germanicus', *Historia* 17, 1968

——'Tiberius and Asinius Gallus', *Historia* 20, 1971

——'The Fall of Sejanus: Two Problems', *Classical Philology* 69, 1974

——'Cnaeus Calpurnius Piso, Legate of Syria', *Historia* 23, 1974

——'Agrippina the Elder – A Woman in a Man's World', *Historia* 49, 2000

Sijpesteijn, P., 'Another ovaia of D. Valerius Asiaticus in Egypt', *Zeitschrift für Papyrologie und Epigraphik* 79, 1989

Sinclair, Patrick, 'Tacitus' Presentation of Livia Julia, Wife of Tiberius' Son Drusus', *American Journal of Philology* 111, 1990

Small, Jocelyn Penny, *Cacus and Marsyas in* Etrusco-Roman *Legend* (Princeton, 1982)

Smallwood, E. Mary, *Documents Illustrating the Principates of Gaius, Claudius and Nero* (Cambridge, 1967)

Speidel, M.A., 'Roman Army Pay Scales', *Journal of Roman Studies* 82, 1992

Stevens, C.E., 'Claudius and the Orcades', *Classical Review* 1, 1951

——'The Will of Q. Veranius', *Classical Review* 1, 1951

Stewart, A.F., 'To Entertain an Emperor: Sperlonga, Laokoön and Tiberius at the Dinner-Table', *Journal of Roman Studies* 67, 1977

Swain, Simon (ed.), *Seeing the Face, Seeing the Soul: Polemon's* Physiognomy *from Classical Antiquity to Medieval Islam* (Oxford, 2007)

Swan, Peter Michael, *The Augustan Succession: An Historical Commentary on Cassius Dio's Roman History, Books 55–56 (9 B.C.–A.D. 14)* (Oxford, 2004)

Syme, Ronald, *The Roman Revolution* (Oxford, 1939)

——'Seianus on the Aventine', *Hermes* 84, 1956

——'*Imperator Caesar*: A Study in Nomenclature', *Historia* 7, 1958

——'Livy and Augustus', *Harvard Studies in Classical Philology* 64, 1959

——'Domitius Corbulo', *Journal of Roman Studies* 60, 1970

——'The Crisis of 2 B.C.', *Bayerische Akademie der Wissenschaften*, 1974

——'History or Biography: The Case of Tiberius Caesar', *Historia* 23, 1974

——*History in Ovid* (Oxford, 1978)

——'The Sons of Piso the Pontifex', *American Journal of Philology* 101, 1980

——*The Augustan Aristocracy* (Oxford, 1986)

Tatum, W. Jeffrey, *The Patrician Tribune: Publius Clodius Pulcher* (Chapel Hill, 1999)

Taylor, L.R., 'Horace's Equestrian Career', *American Journal of Philology* 46, 1925

———'New Light on the History of the Secular Games', *American Journal of Philology* 55, 1934

Thibault, John C. *The Mystery of Ovid's Exile* (Berkeley and Los Angeles, 1964)

Thomas, Yan, '*À Rome, pères citoyens* et cité des *pères* (IIe siècle av. J.C.-IIe siècle ap. J.C.)' in Aline Rousselle, Giulia Sissa and Yan Thomas, *Famille dans la Grèce et à Rome* (Paris, 1986)

Thompson, E.A., 'Early Germanic Warfare', *Past and Present* 14, 1958

Thornton, M.K., 'The Enigma of Nero's Quinquennium', *Historia* 22, 1973

———'Nero's Quinquennium: The Ostian Connection', *Historia* 38, 1989

Todd, Malcolm, *The Early Germans* (Oxford, 2004)

Torelli, Mario, *Studies in the Romanization of Italy*, tr. Helena Fracchia and Maurizio Gualtieri (Edmonton, 1995)

———*Tota Italia: Essays in the Cultural Formation of Roman Italy* (Oxford, 1999)

Townend, G.B., 'Calpurnius Siculus and the *Munus Neronis*', *Journal of Roman Studies* 70, 1980

Townsley, Jeremy, 'Paul, the Goddess Religions, and Queer Sects: Romans 1:23–28', *Journal of Biblical Literature* 130, 2011

Treggiari, S., *Roman Freedmen During the Late Republic* (Oxford, 1969)

Van Voorst, Robert E., *Jesus Outside the New Testament: An Introduction to the Ancient Evidence* (Grand Rapids, 2000)

Versnel, H.S., 'Two Types of Roman *Devotio*', *Mnemosyne* 29, 1976

Vout, Caroline, *Power and Eroticism in Imperial Rome* (Cambridge, 2007)

Walbank, Frank W., 'The Scipionic Legend', in *Selected Papers: Studies in Greek and Roman History and Historiography* (Cambridge, 1985)

Wallace-Hadrill, Andrew, '*Civilis Princeps*: Between Citizen and King', *Journal of Roman Studies* 72, 1982

———*Rome's Cultural Revolution* (Cambridge, 2008)

Warden, P.G., 'The Domus Aurea reconsidered', *Journal of the Society of Architectural Historians* 40, 1981

Wardle, David, 'Caligula's Bridge of Boats – AD 39 or 40?' (*Historia* 56, 2007)

Warmington, B. H., *Nero: Reality and Legend* (London, 1969)

Weaver, P.R.C., *Familia Caesaris: A Social Study of the Emperor's Freedmen and Slaves* (Cambridge, 1972)

Weinstock, Stefan, '*Victor* and *Invictus*', *Harvard Theological Review* 50, 1957

Welch, K.F., *The Roman Amphitheatre: From its Origins to the Colosseum* (Cambridge, 2007)

Welch, Tara S., *The Elegaic Cityscape: Propertius and the Meaning of Roman Monuments* (Columbus, 2005)

Wells, C.M., *The German Policy of Augustus: An Examination of the Archaeological Evidence* (Oxford, 1972)

Wells, Peter, *The Barbarians Speak: How the Conquered Peoples Shaped Roman Europe* (Princeton, 1999)

——*The Battle That Stopped Rome: Emperor Augustus, Arminius, and the Slaughter of the Legions in the Teutoburg Forest* (New York, 2003)

Whitmarch, Tim, 'Greek and Roman in Dialogue: the Pseudo-Lucianic *Nero*', *JHS* 119, 1999

Wiedemann, Thomas, 'The Fetiales: A Reconsideration', *Classical Quarterly* 36, 1986

Wilkinson, Sam, *Republicanism During the Early Roman Empire* (London, 2012)

Williams, Craig A., *Roman Homosexuality* (Oxford, 2010)

Williams, G., 'Did Maecenas "Fall from Favor"? Augustan Literary Patronage', in Raaflaub and Toher

Wilson, Emily, *Seneca: A Life* (London, 2015)

Winterling, Aloys, *Politics and Society in Imperial Rome*, tr. Kathrin Lüddecke (Oxford, 2009)

——*Caligula: A Biography*, tr. Deborah Lucas Schneider, Glenn W. Most and Paul Psionos (Berkeley and Los Angeles, 2011)

Wiseman, T.P., *Clio's Cosmetics: Three Studies in* Greco-Roman *Literature* (Leicester, 1979)

——*Remus: A Roman Myth* (Cambridge, 1995)

——*The Myths of Rome* (Exeter, 2004)

——*Unwritten Rome* (Exeter, 2008)

Wistrand, E., *Horace's Ninth Epode and Its Historical Background* (Göteborg, 1958)

Wood, Susan, '*Memoriae Agrippinae*: Agrippina the Elder in Julio-Claudian Art and Propaganda', *American Journal of Archaeology* 92, 1988

——'Diva Drusilla Panthea and the Sisters of Caligula', *American Journal of Archaeology* 99, 1995

——*Imperial Women: A Study in Public Images, 40 BC–AD 68* (Leiden, 1999)

——'Tacitus' Obituary of Tiberius', *Classical Quarterly* 39, 1989

Woodman, A.J., 'Amateur Dramatics at the Court of Nero: Annals 15.48–74', in *Tacitus and the Tacitean Tradition*, ed. T. J. Luce and A. J. Woodman (Princeton, 1993)

Woodman, A.J. (ed.), *The Cambridge Companion to Tacitus* (Cambridge, 2009)

Woodman, Tony and Dennis Feeney, *Traditions and Contexts in the Poetry of Horace* (Cambridge, 2002)

Woods, David, 'Caligula's Seashells', *Greece & Rome* 47, 2000

——'Caligula, Incitatus, and the Consulship', Classical Quarterly 64, 2014

Woolf, Greg, *Becoming Roman: The Origins of Provincial Civilization in Gaul* (Cambridge, 1998)

Yavetz, Z., *Plebs and Princeps* (Oxford, 1969)

——'Seianus and the Plebs. A Note', *Chiron* 28, 1998

Zankel, James E. G., 'New Light on Gaius Caesar's Eastern Campaign', *Greek, Roman and Byzantine Studies* 11, 1970

Zanker, Paul, *The Power of Images in the Age of Augustus*, tr. Alan Shapiro (Ann Arbor, 1990)

INDEX